PHL

KT-521-116

Sculptures

AFRICA ASIA OCEANIA AMERICAS

THE
**PAUL HAMLYN
LIBRARY**

DONATED BY
THE PAUL HAMLYN
FOUNDATION
TO THE
BRITISH MUSEUM

opened December 2000

WITHDRAWN

Musée du Louvre, Pavillon des Sessions

Sculptures

AFRICA ASIA OCEANIA AMERICAS

Réunion
des Musées
Nationaux

*musée du quai Branly

This exhibition was organised by the Musée du Quai Branly.

Curator: Jacques Kerchache
Architect: Jean-Michel Wilmotte
Exhibition design: Jean-Michel Wilmotte and Jacques Kerchache.

Cover:
Sculpture from Chupícuaro
600-100 BCE.
Mexico
Musée du Quai Branly, Paris
Photograph Hughes Dubois

© Réunion des Musées Nationaux, 2001
49, Rue Étienne-Marcel
75001 Paris

ISBN 2-7118-4234-7
EK 19 4234

THE BRITISH MUSEUM
THE PAUL HAMLYN LIBRARY
WITHDRAWN

730.089
KER

Scientific editor of catalogue

Jacques Kerchache

with Vincent Bouloré

We would like to express our deepest gratitude to all those whose generous participation made this exhibition possible, and particular:

Claude Allègre
Minister of Education,
Research and Technology

Catherine Trautmann
Minister of Culture and Communications

Alain Juppé
Former Prime Minister, Mayor of Bordeaux

Alain Richard
Minister of Defence

Dominique Baudis
Mayor of Toulouse

Guy Lengagne
Mayor of Boulogne-sur-Mer

Michel Mercier
Chairman, Rhône Regional Council

Marie-Josée Roig
Mayor of Avignon

Julien Andres
Deputy Mayor of Toulouse

Françoise Cachin
Director, Musées de France

Jean-Jacques Aillagon
President of the Centre Georges Pompidou

Henry-Claude Cousseau
Director, Musées d'Aquitaine

Louis David
Director of the Muséum d'Histoire Naturelle de Lyon

Michael D. Eisner
President of the Walt Disney Company

Hélène Lafond
Director of the Musée d'Aquitaine

Mercedes de la Garza
Director of the Museo Nacional de Antropología, Mexico

Françoise Poiret
Director of the Musée du Château, Boulogne-sur-Mer

Pierre Provoyeur
Director of the Musée Calvet, Avignon

Admiral Georges Prud'homme
Director of the Musée de la Marine

Jean-Michel Humbert
Assistant Director of the Musée de la Marine

Gérard Régnier
Director of the Musée Picasso

Werner Spies
Director of the Musée National d'Art Moderne
Centre Georges Pompidou

Claudine Sudre
Director of the Muséum d'Histoire Naturelle de Toulouse

The Academia Sinica, Taipei

Dr. Yuan-Tseh Lee
President

The Réunion des Musées Nationaux

Irène Bizot
General Administrator

The Musée du Louvre

Pierre Rosenberg
Chairman and Director

The Musée de l'Homme

Jean-Claude Moréno
Provisional Administrator of the Muséum National d'Histoire Naturelle

The Musée National des Arts d'Afrique et d'Océanie

Germain Viatte
Director

The Laboratoire des Musées de France

Jean-Pierre Mohen
Director

H.E. Adolfo Carjaval
Ambassador of Colombia to France

H.E. Juan Cueva
Ambassador of the Republic of Ecuador to France

H.E. Maria Luisa Federici Soto
Ambassador of Peru to France

H.E. Sandra Fuentès Berain
Former Ambassador of Mexico to France

H.E. Mario Salvo Horvilleur
Ambassador of Nicaragua to France

H.E. Denis Bauchard
Ambassador of France to Canada

H.E. Christian Connan
Ambassador of France to Mali

H.E. Yannick Gérard
Ambassador of France to Pakistan

H.E. Philippe Peltier
Ambassador of France to Nigeria

Gérard Chesnel
Director of the Institut Français of Taipei

And also:

Fiorella Allio
Dominique Bagault
Eliane Bohnert
Georges Bonani
Thierry Borel
Jean-Louis Boutaine
Michèle Braconier
Bénédicte Chantelard
Patrick Le Chanu
Professor Chi-Lu Chen
Constance de Corbière
Pierre Olivier Costa
Joël Courtemanche
Michèle Danchin
Catherine Debaisieux
Michèle Dejean
Alain Dhersigny
Wanda Diebolt
Jean-Claude Dran
Marie-France Fauvet-Berthelot
Claire Filhos-Petit
Pierre Fournier
Marie Teresa Franco
Ileana Gaita
Lucia Garcia Noriega
Carlos Giordano
Luis Mario Daniel Goeritz Rodriguez
Odile Guillon
Cheng-Kuang Hsu
Anne-Catherine Kenis
Marie-Odile Kleitz
Hélène Lassalle
Françoise Mardrus
Benoît Mille
Katia Mollet
Alejandra de la Paz
Marielle Pic
Elisa Porto
Guirec Querre
Elisabeth Ravaud
Alain Renard
Olivier Richard
Dory Sanchez de Wetzel
Martin A. Sklar
Maria del Socorro Villareal
Felipe Solis
Augusto Thornberry
Jy-Peng Tsao
Helène Valladas
Jean-Paul Vandenbossche
Anne Vincent

Our sincere thanks also go to all those
who prefer to remain anonymous.

Through the months of preparation for
this catalogue and exhibition I have
enjoyed much support and encourage-
ment. I would like here to restate my
gratitude towards all those who offered
help and advice. They are:

Christine Albanel, Rémy Audouin,
Gaëlle Baltzer, Monique and Jean-Paul
Barbier, Vincent Bouloré, Élisabeth Boyer,
Bernadette Caille, Jean Chauplanaz,
Hélène Dano-Vanneyre, Élisabeth David,
Marine Degli, Hughes Dubois,
Béatrice Foulon, Maurice Godelier,
Hubert Goldet, Jean Grisoni,
Virginie Jamin, Jean-Michel Huguenin,
Hélène Leloup, Guy Ladriere,
Muriel Lardeau, Martine Lévy,
Anne de Margerie, Stéphane Martin,
Constance de Monbrison,
Christiane Naffah, Magali Noël,
Jean-Louis Paudrat, Bruno Pfäffli,
Alain Seban, Alain Schoffel,
Louis de Stricker, Germain Viatte.

This catalogue is also a homage
to the late Sylviane Jacquemin, whose
writings on Oceanic art played such
a valuable role in this project.

J. K.

*"…we come from all the shores of the earth.
Our race is ancient, our face is nameless.
And time knows much about all the men we once were."*

Saint-John Perse, *Chroniques*, 1960

It is now nearly a century that the world's great museums first became the "extraordinary sea-marks" of our cultural geography, the place where transformations are compared, mirrors of a humanity in search of language, rich soil on which the most universal and the most singular tropisms flourish.

Ambitious factors in the formation of taste and personality, museums are also part of a fast-developing leisure society. With real lucidity – and often a true capacity to anticipate the future – they are questioning the evolution of their own social and pedagogical role in the face of the onslaught of images and the changes in the modes of information and the transmission of knowledge. At the same time, their symbolic role is greater than ever. Because they display or ignore, render sacred or demythologise, museums have become full-fledged actors in the heart of the city.

Museums will indeed come to embody a political dimension in the society of the 21st century. It is in the name of that dimension that I would like the "early arts", the "distant arts" – to borrow the poetic expression Félix Fénéon used in 1920 to refer to the arts of Africa, Asia, Oceania, the Arctic and the Americas – to take their rightful place in the museums of France.

Thanks to the unwavering support of the governments of Alain Juppé and Lionel Jospin, this museum will open in 2004 along the Quai Branly in Paris. Beginning in 2000, the Louvre will place at this new institution's disposal a group of permanent galleries in the Pavillon des Sessions, where over one hundred masterpieces will be displayed.

Organised around two sites, this museum will be dedicated to giving proper representation to arts and civilisations that have remained misunderstood for too long.

Starting in April 2000, at the very heart of the Louvre, the world's largest museum, a series of galleries stretching over 1,400 square metres will feature a selection of exceptional works on permanent display.

This selection, guided by Jacques Kerchache, whose knowledge of the world's collections of the so-called primitive arts is no doubt without equal, claims to be neither a digest of the cultural history of four continents, nor even an "ideal museum". Nor will it serve as a prefiguration, a replica in miniature, of the future museum along the Quai Branly, which is to fulfil a very different role, featuring an incomparably greater number and diversity of works.

The layout of the new galleries has been designed with visitors to the Louvre in mind. Literally "overexposed" to masterpieces and confronted by the most varied styles and materials, they will enter this beautiful installation to discover, I am convinced, pieces of art that do indeed measure up to the Louvre's purest treasures.

While the architect Jean-Michel Wilmotte perfectly adheres to the spirit of the site and respects the indispensable continuity of the galleries leading from or to the Louvre's other collections, and while the rigorous selection of these exceptional works places them immediately on an equal footing with the nearby masterpieces of Western art, two particularities of the Pavillon des Sessions already announce the future Quai Branly building.

First, several works on loan from other museums, both French and foreign, are included amongst sculptures that became part of French collections years ago, a

number that has recently grown with the addition of several very generous donations and a few judicious acquisitions. I would like to thank the friendly foreign governments, foreign public institutions and local French public institutions that have contributed to the regional and international dimension of this project.

Second, there is the creation of a multimedia interpretation area immediately next to the objects on display. Visitors will thus have access to a complete bank of historical, iconographic and audio information related to the societies that created the works on display.

The conflict between the so-called "aesthetic" and "ethnographic" approaches no longer applies. With its two sites, the Musée du Quai Branly will be the concrete demonstration of this affinity.

Thanks to this new building, the collections of the ethnographic laboratory of the Muséum National d'Histoire Naturelle and the Musée National des Arts d'Afrique et d'Océanie are to be combined in material and technological conditions that are worthy of them, thus allowing for a new approach to this outstanding ensemble.

Great or small, admirable according to the most demanding criteria or simple tokens of another way of living and creating, the works on display will no longer be monopolised by an authoritative, inevitably Eurocentric and reductive discourse, be it one of aesthetic emotion or scientific demonstration.

Whether we like it or not, behind their display case, skilfully lit and protected in part from the ravages of time, museum pieces no longer belong to "real life". How those who explain and present these pieces of art to the public see such work is necessarily partial, in the broad sense of the term. This is why I hope that the future institution will remain largely open to temporary exhibitions and that its museology will prove capable of evolving rapidly enough to avoid the inevitable dust that settles on any museum presentations.

It has been many years since the great creations of Western societies were granted this independence. Historical, aesthetic, sociological and technical discourses build up around them while respecting their mystery and accepting that part of the truth that always escapes the interpreter, the visitor, even the creator himself.

I hope that through the Musée du Quai Branly the same respect will be extended to other non-European societies throughout the world. That an historical perspective will be restored to them. That their rites, their mysteries and their contradictions will be taken into consideration. That they will be shown to the public in a way that neither stresses their foreignness, nor seeks to bridge the chasm that may still lie between them and us. The spirit of this project is also to enter into a new, responsible dialogue with the countries that are at the source of these sculptures, to remain open to their point of view, to collaborate closely with them.

This then is the mission of the future museum, to make a truly unique collection accessible at last, to develop a modern museology, to present knowledgeable and – if necessary – impertinent temporary exhibitions, to make available to all audiences, through the most modern technologies, a vast collection of documentary information.

Culture is the genius of a particular people, their singularity, the message they bring to the world. As a place for sharing, for honouring, this museum will demonstrate that any hierarchy between the arts, like the hierarchy between peoples, is very much a thing of the past. What counts is the genius of humanity, of all human beings.

Jacques Chirac
President of the French Republic

"Each culture remains authentic by enriching itself by contact with others."

Claude Lévi-Strauss

A little more than one hundred masterpieces of the "distant arts" have just found a home in the heart of the Louvre. After more than a century of bitter debates, these pieces are at last presented to us, "prised from their rites and sites" of course, as Jean-Louis Paudrat so neatly put it, yet bearing witness to that universal artistic genius whereby a part of the world ceases to be a spectacle and becomes our most intimate link with what is human.

One hundred. Some will say that this is a terribly small number when compared to the magnificent diversity of the arts in Africa, Asia, Oceania and the Americas. Clearly, though, no one is laying claim here to either exhaustiveness or objectivity. This selection is really a manifesto. It is also an invitation to see the world and delight the eye, to wander and to wonder.

Today, so-called "primitive" art is on its way toward a new future. It has entered the 21st century with a different face. This art is no longer pure decorative expression, nor merely a source of inspiration for Western artists in search of formal solutions. Primitive art has finally been accepted as something to be considered for itself, with all the complexity and recognised difference of the societies that gave rise to its creation, yet without defying universal admiration on the grounds of its – by definition – "alien" context.

Each culture naturally tends to define itself as the measure of all others. This ethnocentric attitude generates a number of misunderstandings, which the proposed Musée du Quai Branly is meant to help dispel.

André Malraux used to say that "as sharks are preceded by their pilot fish, so too our view is preceded by a pilot view, which proposes a meaning for what it is looking at... We think, quite wrongly, that we are free of that view." To change our view, our view of the work of art and our view of the other, that is indeed the ambition of this undertaking, which is to take shape in two stages.

In 2000, first of all, primitive art enters the Louvre, the temple of Western art and its sources, and inevitable venue for the solemn expression of artistic recognition. No other step could better symbolise the will of the French people than to present, alongside the *Winged Victory* and the *Mona Lisa,* sculptures that have long been recognised by the specialists as masterpieces while being almost completely unknown to the general public.

Subsequently, in 2004 a new museum devoted to the arts of Africa, Asia, Oceania and the Americas is to open along the Quai Branly in Paris. It is to be a "school" to train the museumgoer's eye, one that will restore to the works on display their primacy through a presentation conducive to emotional response, while offering numerous historical, functional and contextual keys to reading the pieces, thanks especially to the museum's vast documentary resources. Naturally, the Musée du Quai Branly will be a place for the presentation and conservation of collections of art, but also for research, teaching, cooperation and national and international dissemination of knowledge. The museum will thus serve as a generous tool for learning and exploring, for coming together and collaborating, an institution open to the world and opening onto the world.

It is through our way of seeing objects that our view of humanity must change. Praise of difference and respect for otherness must lead to exchange, not closure. To respect others is to recognise their singularity but also to welcome them as equals. The capacity for excellence, in the field of art as in any other, is

universal. Such a capacity boasts neither country nor homeland. The Musée du Quai Branly has already laid the foundations for this new type of relationship with the source countries.

The subtle, inspired selection proposed by Jacques Kerchache would not have been possible without the generous assistance of several foreign countries and a number of French museums that were willing to place one or more objects on permanent loan in the Louvre. I would like to warmly thank these institutions.

At this time, conventions regarding cultural cooperation have been signed with the Federal Republic of Nigeria and French Polynesia. Thus, concrete measures for joint endeavours, notably for the creation of temporary exhibitions, scientific databanks and multimedia products, are being put into place four years before the opening of the museum's main building.

The Musée du Quai Branly will be no ghetto. As the head of a network, a locus where all other points converge, the museum aspires to be the missing link that will at last enable André Malraux's dream to become a reality, "to render humanity's capital works of art accessible".

Stéphane Martin
President of the Musée du Quai Branly

Authors

Jean Paul Barbier
Founder and Director of the Musée Barbier-Mueller, Geneva

Ezio Bassani

Puríssima Benítez-Johannot
Assistant Keeper, Musée Barbier-Mueller, Geneva

Marlène Biton
Professor of Art and Art Science at the Université de Paris I
UMR-CNRS – Paris I
Aesthetics of Contemporary Art

Roger Boulay
Mission Chief at the Musée National des Arts d'Afrique
et d'Océanie, Paris
Mission Chief at the Centre Culturel Tjibaou, Nouméa

Claire Boullier
Doctoral student in art, lecturer at the Université de Paris I

Vincent Bouloré
Doctor of Arts and Art History, Université de Paris I
Art historian

Bien Chiang
Institute of Ethnology, Academia Sinica, Taipei, Taïwan

Christian Coiffier
Lecturer at the Muséum National
d'Histoire Naturelle, Paris
Head of the Oceania Department at the Musée
de l'Homme, Paris

Marie-Yvonne Curtis
Doctor of Ethnology and Anthropology (Art History)

Michel Davoust
Researcher at the CNRS, Paris

Christian Duverger
Director of Education, Head of Studies at the École
des Hautes Etudes en Sciences Sociales, Paris

Ekpo Eyo

Robert Farris Thompson
The Colonel John Trumbull
Professor of the History of Art, Yale University

Gregory Forth
Professor in the Department of Anthropology,
University of Alberta

Perkins Foss
Teacher, Plymouth State College, University
of New Hampshire
Art historian

Yves Le Fur
Keeper of the Oceania section at the Musée National
des Arts d'Afrique et d'Océanie, Paris

Danielle Gallois
Agrégée d'arts plastiques
Doctor of Anthropology of Art, Université de Paris I
Painter

Mercedes De La Garza
Director, Museo Nacional de Antropología, Mexico City

Sophie Goedefroit
Lecturer, Université de Lille

Michael Gunn
Curator' Oceanic Art, Department of Arts of Africa,
Oceania and the Americas, Metropolitan Museum of Art,
New York

Kirk W. Huffman
Honorary Keeper, Cultural Centre du Vanuatu
Associate Researcher, Museum of Australia, Sydney

Carol S. Ivory
Associate Professor of Art History,
Washington State University

Sylviane Jacquemin †
Affiliated with the Oceania département Océanie
of the Musée National des Arts d'Afrique et d'Océanie, Paris

Hélène Joubert
Keeper of the Africa section at the Musée National
des Arts d'Afrique et d'Océanie, Paris

Adrienne L.Kaeppler
Curator of Oceanic Ethnology, Smithsonian Institution,
Washington D.C.

Christian Kaufmann
Keeper at the Museum der Kulturen, Basel

Jacques Kerchache
Scientific adviser to the Musée du Quai Branly, Paris

Raoul Lehuard
Anthropologist, alumnus of the École des Hautes Etudes
en Sciences Sociales, Paris

Jacques Lombard
Anthropologist
Director of Research at the Institut de Recherche
pour le Développement, Paris

Marie Mauzé
Ethnologist
Researcher at the CNRS
Researcher at the Laboratoire d'Anthropologie Sociale
(Collège de France, CNRS, EHESS), Paris

Pascal Mongne
Art historian

Douglas Newton
Emeritus Curator
The Metropolitan Museum of Art, New York

Jean-Paul Notué
Professor of Art History and Anthropology, Université de
Yaoundé I
Associate researcher at IRD-Orstom

Catherine Orliac
Researcher at the CNRS, Laboratoire d'Ethnologie
Préhistorique de Nanterre and Laboratoire Ethnobiologie-
Biogéographie at the Muséum National d'Histoire Naturelle,
Paris

Michel Orliac
Researcher at the CNRS, Laboratoire
d'Ethnologie Préhistorique, Maison de l'Ethnologie
et de l'Archéologie, Paris

Ponciano Ortiz
Instituto Nacional de Antropología e Historia,
Veracruz

Esther Pasztory
Lisa and Bernard Selz Professor in Pre-Columbian
Art History and Archaeology, Columbia University

Jean-Louis Paudrat
Lecturer, Université de Paris I

Carmen Rodriguez
Instituto Nacional de Antropología e Historia,
Veracruz

Jean-Loup Rousselot
Assistant Director and Keeper of the North American
Collections, Staatliches Museum
für Völkerkunde, Munich

Leon Siroto
Doctor of Ethnology, Columbia University, New York
Independent researcher

Felipe Solís
Subdirector of Archaeology, Museo Nacional
de Antropología, Mexico City

Richard F. Townsend
Keeper of the Department of African and Amerindian
Art, The Art Institute of Chicago

Manuel Valentin
Lecturer at the Muséum National
d'Histoire Naturelle, Département d'Afrique Noire,
Musée de l'Homme, Paris

Alain Viaro
Professor, teacher at the Institut Universitaire
d'Etudes du Développement (IUED), Geneva
Associate researcher at the Centre de Recherches sur l'Asie
Moderne (CRAM)

Deborah Waite
Professor of Art History

Jean Yoyotte
Honorary Professor at the Collège de France,
Head of Studies at the École Pratique des Hautes Etudes

Contents

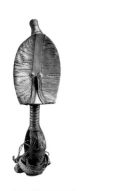

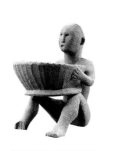

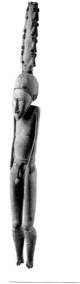

Seeing the Work of Art

The time for contempt is past. "Primitive art" has just entered the Louvre.

More than the outcome of an individual initiative, the event represents the collective realisation of a dream that many have harboured for nearly a century now – poets, artists and scientists, politicians and ordinary citizens.

I am thinking of Guillaume Apollinaire who, as early as 1909 in *Le Journal du Soir,* insisted that "the Louvre ought to accept certain exotic masterpieces whose appearance is no less moving than that of fine specimens of Western statuary."[1] But I also have in mind other well-known figures who made clear their wish to see in the Louvre what was called "the distant arts" in those days, personalities like Paul Guillaume, who responded with conviction and good judgement to Félix Fénéon's questionnaire, "Will they be admitted to the Louvre?" which appeared in 1920 in the *Bulletin de la vie artistique.* Stressing African art, his interest in which would never lapse, Guillaume predicted that, "no other art having more directly influenced the artistic forms of an age, Negro art will enter the Louvre one day as an explanation".[2]

Fifty years later, André Malraux expressed the obvious truth of this statement: "Many would like to see Negro art in the Louvre, where it will indeed enter one day."[3]

Claude Lévi-Strauss implicitly voiced the same wish in 1943, although it was the "Indian tribes of the northern Pacific coast" that he was referring to: "The day is probably not far off when the collections from this part of the world will leave the ethnographic museums in order to take their place in the fine arts museums, between ancient Persia or Egypt and medieval Europe, because this art is not unequal to the greatest of them all [...] it has shown a diversity that is superior to theirs, and has displayed a talent for renewing itself that is apparently inexhaustible."[4]

I, like so many others, was heir to the long intellectual and artistic tradition of demanding a place for the so-called primitive arts in the world's most beautiful museum. In 1990, after a number of years travelling the planet to get a better idea of the world's corpus of primitive arts and the civilisations that produced them, I decided to launch a manifesto whose title left no doubt in readers minds: *Let masterpieces the world over be born free and equal.* It called for the opening of a department in the Louvre devoted to the arts of Africa, Asia, Oceania and the Americas.

To give an idea of how high interest in this question still ran within the French intellectual community, I need only recall that this manifesto drew nearly 300 signatures of artists, writers, philosophers, anthropologists and art historians.

Ten years later, through the determination of the President of the Republic, Jacques Chirac, who is passionately attentive to human creativity expressed in the arts around the world, and eager to give cultures and civilisations that are still too often poorly understood their rightful place in our institutions, France has made an historic gesture. "Primitive art" has entered the Louvre, which has at last become a museum for all humanity, with the art created by all humanity.

The Pavillon des Sessions is neither a "showcase" nor an "antenna" of passing importance. It is the site of a legitimate recognition and, as such, made to endure. Among the many examples of changing ways of seeing that punctuate this history, I would like to pick out the tears, the bloody tears of Coatlicue, an Aztec sculpture whose fate is particularly emblematic.

Like most pre-Columbian gods, Coatlicue was marked out for destruction by Cortés's men in the sacred precinct of the Templo Mayor, between 1519 and 1521. The natives'"idols" were to perish before all-powerful Christianity.

Only a few vestiges survived, miraculously saved from the ravages of the conquistadors. And, for nearly three centuries, the ruins of a brilliant civilisation lay dormant, lost in oblivion.

On 13 August 1790, two pre-Columbian sculptures, including the goddess Coatlicue, were discovered beneath Mexico City's parade ground, where the Templo Mayor once stood. Viceroy Revillagigedo had this "curious example of American antiquity" transported to the city's university. The Dominicans who taught at the Real Pontificia Universidad, however, thought it dangerous to exhibit such an effigy of evil before the eyes of their students, and considered the statue's aspect "unworthy of figuring near the Greco-Roman copies" donated to the school by Charles III. They also feared no doubt that the view of this piece might awaken the occasional stray desire for independence among young Mexicans and that the religion of their Aztec forebears might be reborn from its ashes. So they buried Coatlicue beneath one of the building's patios.

Later, when the scholarly traveller Baron Alexander von Humboldt came to Mexico City in 1802 to visit different archaeological sites, he expressed the wish to see Coatlicue. He knew about the statue through Antonio de León y Gama's drawings and descriptions, which were conserved in the Vatican. With difficulty he prevailed upon the authorities and obtained permission to unearth the statue momentarily. Shortly after it was brought to light, Coatlicue was carefully returned to its hiding place, safe from the eyes of the city's inhabitants.

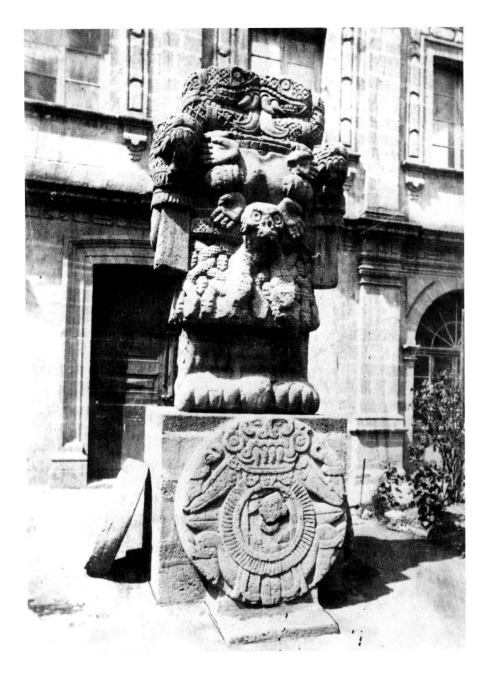

Fig. 1
Coatlicue photographed by Désiré Charnay
between 1880 and 1882
Photographic library
of the Musée de l'Homme, Paris

In the 19th century, classicism, springing from Greco-Roman tradition, constituted the foundation of good taste, and Coatlicue passed for monstrously ugly. With its formal exuberance, the statue corresponds to those "bizarre combinations" that Longpérier described in 1850 in his notice touching on the monuments displayed in the American Antiquities gallery of the Louvre.

In 1821, Coatlicue was exhumed for good but still relegated to a corner of a hallway, hidden behind furniture and plants. This is one of the reasons why the piece does not figure in travellers' descriptions from the period.

It was only in the last two decades of the 19th century that the statue began to be rehabilitated. The piece was brought inside the Mexico City Museum and finally recognised for its true worth, eventually sparking the enthusiasm of such as André Breton. The French Surrealist sang the praises of the piece in 1938, writing that "Mexico, poorly roused from its mythological past, continues to evolve under the protection of Xochipilli, the god of flowers and lyrical poetry, and Coatlicue, goddess of the earth and violent death, whose effigies, dominating all the others by their pathos and intensity, exchange winged words and hoarse cries from one end of the national museum to the other, above the heads of Indian peasants, who are the most numerous visitors and the most contemplative."[5]

Artists have always entertained a privileged relationship with other works of art based upon their experience of the tangible. I have striven to adopt that singular view which weaves strangely familiar ties between human beings and works of art. That view has accompanied me throughout my journey.

I wanted to sharpen that view, enrich my knowledge of the repertory of signs, by establishing a systematic critical inventory based upon an experience that covers some 20 years in museums and their reserves as well as private collections.

The vaster the field to be explored, the greater the number of examples, the better prepared one is to see, discern, choose and compare.

Without this global inventory of forms which supposes daily interaction with sculpture, it would have been impossible for me to detect in each culture the standards, the moulds, the "strong points", the exemplary works in terms of quality, that make up the framework of the collection now on display in the Louvre.

In preparation for the opening of the Pavillon des Sessions, a selection had to be made amongst the sculptures in various public collections in France: the Musée de l'Homme, the Musée National des Arts d'Afrique et d'Océanie, and certain regional museums. Moreover, these collections were enriched and improved thanks to a budget specially allocated by the government for acquiring new pieces.

Although no claim was made to exhaustiveness, it seemed pertinent nonetheless to add works that had made their absence felt in the four cultural areas, for example, a *uli* sculpture from New Ireland for Oceania, a sculpture of Chupícuaro for Meso-America, a Nuna sculpture from Burkina Faso for Africa, and a sculpture from the Nias Islands that once belonged to André Breton for Asia.

Autobiographical by nature, any choice demands extreme vigilance, much work, and great humility. A "top one hundred" is not strictly necessary.

The project's goal was not to exhibit in the Pavillon des Sessions "beautiful objects" that are likely to figure in a "catalogue of fashionable opinions", but rather to be as faithful as possible to the artist's intentions in a space that enables us to glimpse the path taken by the creative impulse.

We are, however, constantly beset by devices that aim to divert us, that is, everything that can condition our gaze and distract from sculpture as sculpture.

It is not the story of the masterpiece that makes the masterpiece. Knowledge of the country in which the piece was created, or of its "pedigree", need not be essential to its reception for viewers wishing to guard against any and all kinds of "trafficking in influences".

Similarly, the aesthetics of the patina, the age, the rarity of the material employed are not criteria for judging quality. Nor, however impressive, is monumentality, for dimension is not a principle of excellence.

All these temptations detract from critical judgement and do not favour access to the work of art, in which only the artist's integrity, project and gesture should be considered. No translation is needed for that. Why resort then to the crutch of ethnography, primitivism and the preconceived notions of thinking in "labels", which are sources of confusion? There are no proofs in art.

Nor for that matter is there a single way of understanding works of art. The aim of the Musée du Quai Branly will be precisely

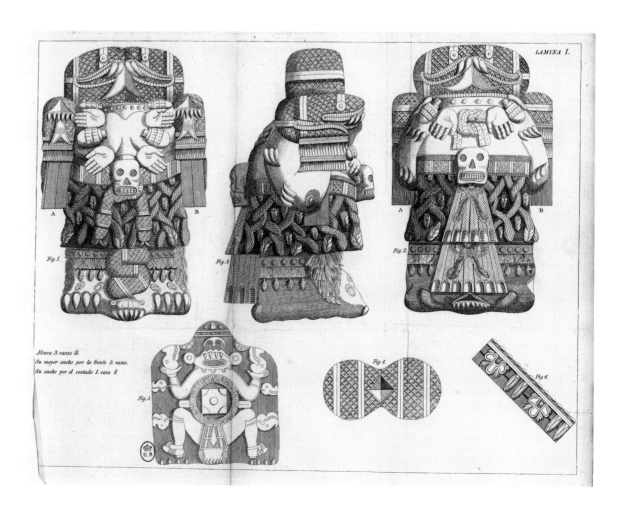

Fig. 2
Depiction of Coatlicue by
León y Gama, 1792
Bibliothèque Nationale
de France, Paris

that, to improve our level of understanding by placing the pieces once again in an historical, socio-economic, political and religious context with the addition of other "media": dance, music, architecture, etc.

The Surrealists dreamed of changing our lives; André Breton also spoke of "changing [our] sight".[6]

Sculpture is both writing in three dimensions that one must learn how to read and, when successfully executed, "a whole that is not perfect but which you can put your trust in", as Louise Bourgeois so aptly said.[7]

To respect the modesty of such a commitment is to opt for sobriety, notably in terms of how one chooses to present works of art.

I wanted both to avoid any effect of dramatisation or theatricalisation that might recall the curio collections of another age, and to elude the pitfalls of exoticism.

Moreover, it seemed indispensable that the new galleries remain coherent with respect to the rest of the Louvre, so that the arts of Africa, Asia, Oceania and the Americas were not marginalised or frozen in a system of specific representation that would require a particular installation or casing. In its mode of conception, the display architecture is meant to serve the works of art. I have always been wary of abusive display installations that run counter to their independence.

It was of capital importance to reinforce the transparency around the object and respect both the empty space intended by the artist and the free movement of museum visitors. Space to breathe is indeed fundamental, as much for the pieces on display as for the museumgoer. We can smooth the way for the latter, furthermore, by paying careful attention to the visit laid out for him, a progression that is surely not innocent, yet in no way resembles a compulsory itinerary. I believe that there is no art that will suit everyone, but that art must remain at each individual's disposal.

It was equally important that we create a sequence, not a mere juxtaposition, a logical articulation in the geographical and historical layout of the collection as a whole, and above all that we stress the affinities between the works of art in order to engender that step-by-step resonance, that encounter between artists through the prism of the object without lessening the immanence of the sacred.

Finally, it seemed pertinent to show a diversity of forms within one and the same cultural identity, as in Fang statuary, for instance, where it is easy to imagine how great the competition amongst sculptors must have been. Behind the exemplary work of art there is always an artist who took risks and, by the very act of creating something, invites us to share a unique experience.

Even if the museum is both a construct where the arbitrary certainly has a place, why not abandon ourselves to the pleasure of seeing in sculpture, as Paul Valéry once wrote, "form become emotion"?

Yet the Pavillon des Sessions is not only a magnificent venue for exhibiting works of art, for the philosophy behind this project is to affirm that there is no individual outside of culture and no hierarchy amongst cultures.

By taking this initiative, France has committed itself to instituting a new dialogue with the countries that gave rise to the cultures represented in the Louvre.

Far from any postcolonial guilt complex, but in the transparency of reciprocal relationships, this commitment entails preserving and presenting in the most dignified and respectful way possible the great works of humanity's cultural heritage. I have taken care to reveal not so much the "difference" of the other and his art, which some claim is irreducible, as the manifest participation of extra-Western civilisations in the humanist legacy, made accessible at last to one and all through a few of these civilisations' most perfectly realised creations.

In this endeavour to open up to the world, as opposed to withdrawing into an "identity" that is so often the watchword of demagogy, what better mediator could there be than the work of art that speaks to us across the centuries?

And indeed, what remains of lost cultures if not the traces left by artists?

JACQUES KERCHACHE
Translation: Charles Penwarden

1 G. Apollinaire, 1991, vol. II, p. 123.
2 P. Guillaume, in F. Fénéon, 1920b, p. 696.
3 A. Malraux, 1976, p. 261.
4 C. Lévi-Strauss, 1975, vol. I, pp. 8-9.
5 A. Breton, 1991, p. 37.
6 Declaration made by A. Breton at the Gutierrez exhibition, 22 April 1938, Mexico City; reprinted in A. Breton, 1992, vol. II, pp. 1260-62.
7 Interview with Louise Bourgeois by Bernard Marcadé (February 1993), in C. Guichard, 1993.

Objects from the Americas, Reflections of the New World

"Und ich hab aber all mein lebtag nichts gesehen, das mein hercz
also efreuet hat als diese ding. Dann ich hab daring gesehen
wunderfiche künstliche ding und hab mich verwundert der subtilen
jingenia der menschen in frembden landen…"[1]

ALBRECHT DÜRER

On 27 August 1520, in the Brussels market, Albrecht Dürer discovered the Aztec "treasures" sent back by Cortés a few months earlier and brought to northern Europe by emperor Charles V. These few lines jotted down in his travel diary record the encounter – probably the first – between one of the greatest artists of the Renaissance and the first American objects shown to the European public.

"Astonishing works of art", "subtle skill" – these words have disturbed art historians ever since. How should we understand them? Do they express a real admiration or do they reveal nothing but curiosity? Today, should we interpret this as the celebrated engraver's eulogy of an unknown art form, or the simple and sincere surprise of a humanist and aesthete faced with something strange and foreign to him? This question has never been resolved, yet it represents the beginning of one of the most significant controversies in the history of mentalities, one that would involve issues of faith, philosophy and science. A debate that was to spread, swell and be given new impetus, having been forged and hammered for almost half a millennium: Europe's image of the Americas as produced through the depictions, beings, products and above all objects that were brought back from the New World to the Old.

Columbus'non-discovery

As amazing as it might seem, the discovery of the New World did not much disturb the Old. No storm or even clap of thunder swept the heavens, the courts and the cities of Europe. The news did not spread like lightening, for there was no news. The discovery of the *Mundus novus*, or rather the realisation of its existence, was late and slow. For more than a generation it was thought that Columbus had travelled to "the West Indies", and this name prevailed over that of "America". Nevertheless, the tales and accounts of those who returned, and the (often distorted) images that began to circulate, led Europe to discover an unknown world, thus enriching the primitive fantasies already sustained through

contact with Africa and the Orient, of monsters and giants, savages and mysterious lands. This vision of a new Elsewhere was to constantly develop thanks to the people, animals and things now pouring out of the holds of ships in the ports of Spain and Portugal, France, England and Flanders.

First of all, there were the men and women, these famous first "Indians" from the Caribbean islands and the coast of Brazil (fig. 1). Then there were the animals, so strange to Europe that they provoked a degree of interest that is hard to imagine today. Some of the reports of monstrous animals were invented of course, taken straight from medieval bestiaries. But some were real, brought back alive or stuffed, or at least described and illustrated.[2] Finally plants played an even more important role, as many were easily acclimatised to European latitudes and soils. They were soon to spread throughout the Old World and conquer its fields and orchards in less than three centuries.

While the people, animals and plants taken from the Americas fascinated princes and courts in Europe, the same cannot be said

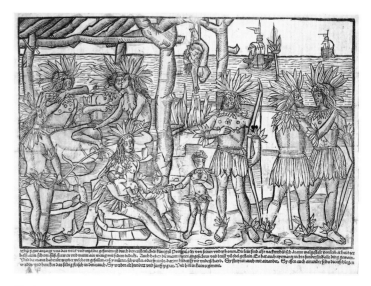

Fig. 1
"Peoples of the Recently-Discovered Islands"
Bayerisches Staatsbibliothek, Munich
This engraving, probably done in Augsburg around 1505, is one of the oldest European representations of Indians. Starting in the 16th century, hundreds of these "Indians" would be shipped across the Atlantic to be paraded before royal courts and princes. Few of them ever returned home.

for the objects the people made. In truth, they attracted very little attention. These products of indigenous societies in Brazil and the Caribbean were they not merely the humble evidence of the "savages" thought to populate the Far East of Asia?

America recognised

Yet a map of the globe shown in two hemispheres, drawn up in 1507, exploded this vision and changed the face of the world. Based on reports from explorers, a mapmaker from Lorraine named Waldseemüller conceived of a new continent and baptised it "America". This was the intuition of a genius – there was no hard evidence for it at that time. It was to be confirmed some 20 years later by the first circumnavigation of the globe, the voyage led by the Portuguese navigator Magellan. Later came even more proof, the spectacular conquests of Mexico and Peru.

Finally the Spanish Conquistadors came to the American mainland, and stumbled upon great kingdoms, assaulted and defeated them. The news of the conquest of Mexico reaching the empire of Charles V, with the descriptions of the cities travelled through and the palaces visited and often pillaged, and even more the arrival in Spain and eventually the rest of Europe of the "treasures" seized by the victors, obviously aroused an unprecedented interest. Hundreds and even thousands of all kinds of objects – we will probably never know exactly how many – crossed the ocean between 1518, the date of the first shipment sent by Juan de Grijalva,[3] and the end of the 16th century (in other words, long after the conquest of Mexico and Peru).

Thus Europe "discovered" the arts of the great New World civilisations: gold and silver work, of course, but also fabrics, jewellery made from precious stones; sculptures in stone; wood and bone; ceramics; paintings; castings in stucco; leather work; objects created out of palm leaves or a paste made from corn or sugar cane stalks; and feathers. These "treasures", acquired as booty or welcome gifts, were highly popular in the royal courts and among scholars and artists as well as the common people in cities where they were put on display, as attested to by Dürer and many others.

The first collections

All these objects from the societies of the Antilles and the coasts and the civilisations of the continental interiors which suddenly appeared in Europe in the wake of the first voyages of discovery, brought back first by explorers and then Conquistadors and colonisers, were gathered and preserved in the earliest European collections of New World items. They were displayed in a manner very particular to that era, known as a cabinet of curiosities.

These were jumbles of odds and ends apparently piled one on top of one another rather than related to each other. There was little distinction between the products of nature and those of the human hand and mind. In a sense, the cabinet of curiosities is one of the Renaissance's most characteristic creations. Here, humanism seeking to embrace the whole visible world tried to arrange and display everything that the earth and human society had brought forth: the known as well the misunderstood. *Naturalia* in the first place, embracing mineralogy, botany and zoology (preserved animals and skeletons). Then came *Artificialia*, namely objects produced by man, usually exotic, but also scientific instruments. *Curiosa*, finally, with the rarest of rare items, such as "unicorn horns" and "giants'teeth", anatomical wax castings and other oddities. Similarly known as *Wunderkammer* and *cámara de maravillas*, they would spread throughout Europe until the end of the 18th century. They were the ancestors of today's museums. Each of them, depending on the pockets of the collector, ranging from princes to rich burghers, gave the Americas pride of place.[4]

France, of course, had its own curiosity cabinets. The oldest is certainly that of François I. Later, under Henry IV, this collection became the famous *cabinet des singularitez* overseen by André Thevet and Jean Moquet after him. Unfortunately, almost all of them were dispersed during the French Revolution. Those groups of items that survive today constitute the oldest American collections in France's leading museums. For example, a number of carved wood war clubs by the Tupinamba people in Brazil – which probably reached France in the early 16th century and now are kept in the Musée des Antiquités Nationales in Saint-Germain-en-Laye near Paris – are among the oldest American objects in French collections.

Renaissance Europe could however not easily comprehend this strange continent that was beginning to appear before its eyes because at the same time another new world was also coming into view, a world that was far removed, albeit not geographically but mentally and aesthetically: Ancient Greece and Rome. This ancient

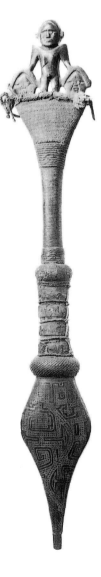

Fig. 2
Ceremonial staff
Early 17th century
Hard wood, fibres and resins
Sainte-Geneviève library, Paris
This piece, from the curiosity cabinet of the Sainte-Geneviève Abbey (to which it was given in 1687), was made in the Guyanas or the region around the mouth of the Amazon and probably can be attributed to the Marajo culture. Topped with a figure holding a trophy head in each hand, it may be a staff of command.

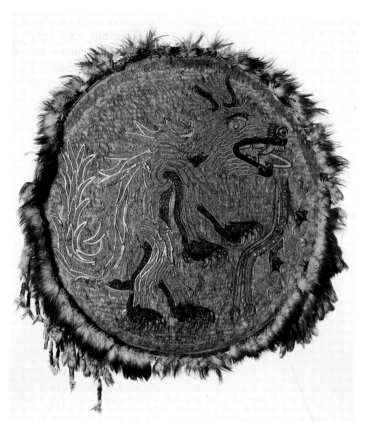

Fig. 3
Aztec roundel
Today in the Vienna Museum für Völkerkunde, this piece was part of the famous Ambras treasure. It is a *chimalli*, a kind of dress shield carried by Aztec war chiefs, decorated with a representation of Ahuitzotl, a sea monster in the Aztec pantheon. This roundel is made of tropical bird feathers and ornamented with gold leaf and strips.

Despite their initially great success in the Old World, the chronicles of the Conquistadors, missionary accounts and Indian documents and works of art fell into oblivion. Many of them simply vanished, destroyed by ignorance or the ravages of time. For instance, of the approximately 150 gold and feathered Aztec rondaches sent to Europe after the conquest of Mexico, only six are known to exist anywhere in the world today (fig 3).

Since it was first discovered, North America was considered of far less interest to Europe. Yet little by little this continent of harsh winters, great forests and vast rivers, of nomadic and often warlike peoples, became the object of colonial contention. Franco-British rivalry, Indian alliances and the objects brought back in huge quantities all combined to create a very different picture in the popular imagination than that of the tropical regions.

Thus, for two centuries a distant Europe created an exotic New World in its own mind, an image based on and in fact distorted by what Europe "knew" of these wildernesses: their strange animals and plants and their no less wild peoples with powerful and fearsome civilisations, the heroic tales of the European conquest and the uniqueness of the objects brought back. All this gave the imagined America a face that was a reflection of Europe's own, a Baroque face.

Baroque is certainly the perfect word to describe the "savages" (American, of course) figuring in so many royal and comic ballets of the 17th century and even in the plays of Molière. Nothing could be more Baroque than Huascar, the Inca prince in Rameau's dramatic ballet *Les Indes Galantes*, where the palace and finery owe more to Western Classicism than reality, or the allegories of a continent where big-bosomed virgin warriors ride to battle on alligators. And Baroque is certainly the only possible term for the European settings fashioned for American jewellery, and above all the *américaineries* (fig. 4) following the example of French *chinoi-*

past recently discovered, or rather rediscovered, was endowed with great authority and became the reference against which everything else was measured. If ancient Greece and Rome represented Beauty, the Americas could only be "barbaric". The consequences were enormous – the *salons d'antiques* were dedicated to the fine arts and works of Ancient Greece and Rome, while the aptly-named curio cabinets were stuffed with products of the earth and distant "savages". This was the birth of a terrible dichotomy that was to govern museums for centuries, persisting in spite of revolutions and even a certain shift in mentalities. We are still suffering its consequences.

The Americas in baroque Europe

The 17th and 18th centuries in turn forged their own particular image of the Americas, founded on ignorance and forgetting. Under the thumb of the world's leading colonial power of that time, Latin America was cut off from the rest of the world. Those palaces and temples that had survived the Conquest and missionary zeal lay buried under colonial buildings. Foreign travellers, whose presence was severely restricted, were few and discrete. As can be imagined, traders, smugglers, spies and pirates took little interest in Indian civilisations.

Fig. 4
Américaineries
Schatzkammer der Residenz, Munich
Olmec mask in greenstone (jade or jadite) in a European mounting, representing a sitting figure
Made of gold, silver, gilded bronze, onyx and precious stones, and enamel, the setting is attributed to Wilhelm de Groff, circa 1720.

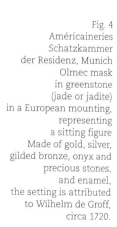

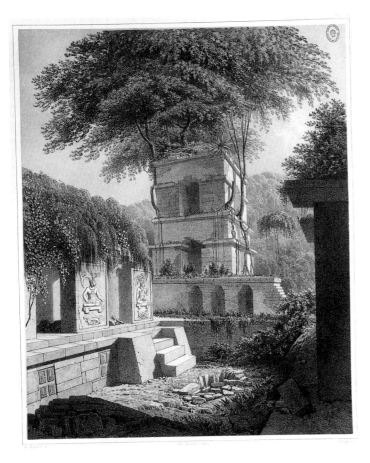

Fig. 5
View of Palenque
Lithograph made from a drawing by Maximilien de Waldeck, circa 1830
Photographic library of the Musée de l'Homme, Paris
The first Maya city discovered (or rediscovered) at the end of the 18th century,
Palenque was the most celebrated and visited Maya site in the 19th century.

series and *turqueries*: Indian warriors tastefully dressed like Romans, Aztec or Inca temples and palaces inserted into Italian landscapes, and European objects made to look like Indian art. In the Old World's imagination the Americas were truly Baroque.

The Enlightenment and the great philosophies and theories of natural history added their own touch to this picture, in which the Americas now looked a little "better" but equally unreal. Indians went from being fierce and often monstrous "cannibals" to "noble savages", sweet and indolent creatures close to Mother Nature but far from the sciences and arts and thus incapable of "civilisation". The same impulse that cast a soft light on the peoples of the Americas made it impossible to even consider them capable of making works of art.

From *américainerie* to *américanisme*

The 19th century, marked by political and social revolution, was also one of tremendous upheavals in science, all of which inevitably affected the relationship between the Old and New Worlds. At the start of the century, Romanticism was predominant in this regard. Attracted by the memory of vanished worlds and the mysteries associated with them which people were so ready to believe, fascinated by this formerly inaccessible continent suddenly unveiled by its emancipation from Spain and the emergence of new republics, the Romantic trend can be considered the intellectual source of a new science which was soon to be known in France as *américanisme*.

Drawing on the idea that the Iberian powers and they alone were responsible for all the evils suffered by the continent, and adhering to an *indigénisme* that amounted to a cult of the indigenous peoples, this young and bold current rediscovered (this word is no exaggeration) the Americas. Explorers combed jungles and deserts in search of ruins; researchers dusted off the documents of the Conquest and long forgotten indigenous manuscripts. Collectors and enthusiastic amateurs took to assembling holdings of objects old and new that prefigured the future ethnography museums.

But it was a time of reinvention just as much as discovery. It hardly needs to be pointed out that this *américanisme* was not the field of study we know today. It was a child of its times and even more of a particular a turn of mind. In fact, to us today it seems utterly fantastic when we read Chateaubriand's love story named after its Indian protagonist, Atala, or the explorer Waldeck's account of the elephant trunks he imagined he saw in the low reliefs of the Mayan city of Palenque (fig. 5). In his celebrated *Antiquities of Mexico*, Lord Kingsborough[5] described the Biblical origins of the Precolumbian civilisations. An unsympathetic critic remarked that this magnum opus was less believable than *A Thousand and One Arabian Nights* and a lot less funny.

The times were changing. A totally unmethodological research driven by passion and imagination and accepting the wildest hypotheses could not long survive in a world undergoing the transformations of the industrial and technological revolution. During the second half of the 19th century, Romantic *américanisme* gave way to an approach that laid claim to being or at least becoming more scientific.

Archaeological expeditions had been carried out in the Near East for a long time; now they began to proliferate in the Americas. Rough-hewn explorers were replaced by scientists from a multitude of disciplines (archaeology, ethnology, linguistics, anthropology) in the service of powerful and prestigious institutions. One of the oldest of these still extant is the Paris Société des américanistes.[6]

These *américanistes*, whether professional or amateur, were simultaneously avid researchers, intrepid travellers and fearless trailblazers. The many objects they brought back from their expeditions were sometimes discovered in the course of specific investigations and sometimes stumbled upon by chance during their wanderings. Thousands of objects were gathered throughout the 19th century (and more particularly the last three decades). These objects constituted the second great wave of *américaniste* collecting. Far more intense than that of the 16th century, it gave Europe's American collections the character they have today.

Paris played a key role in this. As early as 1827, the Louvre started to gather together the exotic cultural objects then scattered throughout the capital. This project began as an ethnographic department in the Musée de la Marine that was part of the Louvre complex. But with a gathering impetus from enlightened amateurs and eminent museum members, there arose and developed the idea of a real museum of American arts and antiquities that would give the products of the New World the same status as those of classical Europe. The Musée américain du Louvre opened its doors in 1850,

under the direction of Adrien de Longpérier, head of the museum's antiquities department. It can be considered Europe's first museum exclusively dedicated to the Americas.[7] It was highly popular with the public and its collections expanded rapidly. They held more than 1,600 archaeological items (mainly from Mexico and Peru) collected since 1825. Among the most prestigious of its collections was that assembled by Latour-Allard, renowned in the scientific community for its Aztec sculptures. One of them was particularly well known because it had figured in Kingsborough's book – the Quetzalcoatl (fig. 6) today in the Louvre's Pavillon des Sessions. Less famous, but equally characteristic of the history of American collections in France is the *teponaztli* (fig. 7) now also in the Pavillon des Sessions. Brought to France by the painter Édouard Pingret, this Aztec drum shows the degree to which "classically" trained artists of that time were fascinated by "exotic" forms of expression.

But the time was not yet ripe. After being moved hither and yon around the Louvre courtyard, the Musée américain closed in 1887, and its collections were transferred to the Musée d'Ethnographie in Paris'Palais du Trocadéro. The Europe of that era was so swelled up with its own economic and political power, so sure of the God-given nature of its prerogatives and so convinced by the philosophical and religious values it propagated, that it could not possibly form an objective idea of the world it was colonising. Under the influence of the grand theories of the latter 19th century (notably positivism, Darwinism and Marxism), the social sciences became highly ethnocentric if not downright racist, an affliction that was all the more virulent in so far as these men believed themselves to be scientists and humanists. Like all the fields of study whose object was humanity, *américanisme* and its vision of the American continents was deeply influenced by this development, which left

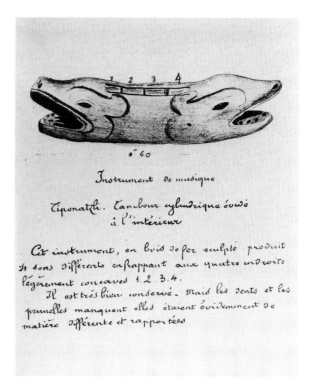

Fig. 7
Pingret's *teponaztli*
Library of the Musée de l'Homme, Paris
Now forgotten, Édouard Pingret (1788-1875) was a prolific producer of history paintings and military scenes. A number of his canvases are in the Galerie des Batailles in the palace of Versailles. While not much is known about his biography, we do know that he lived and worked in Mexico from 1850-54, and that he accumulated a major collection of more than 2,500 pieces. After his return to France he tried, time and again, and in vain, to sell his holdings to the Musée américain at the Louvre. His collection was dispersed after his death. All that is known to have come from it is this *teponaztli*, probably the principal work of his collection, rediscovered almost a century later. It was acquired by the Musée de l'Homme in 1952. Like many painters, Pingret was in the habit of keeping sketchbooks. This drawing of the *teponaztli* is a page from one of them, devoted to his collection.

its imprint on the European vision of the New World for a long time to come.

The character of the museum displays during this period clearly betrays a biased outlook (fig. 8). Instead of the fine Aztec and Inca artworks that had won the hearts of collectors and museum directors during the Romantic period, these new exhibitions featured vitrines piled high with thousands of small pieces – potsherds, terracotta figurines, domestic pottery, stone tools, arms and utensils, all supposedly indicating the "primitiveness" of the people who made them. The "Noble Savage" was replaced by the "Redskin".

The 20th century and the primitivist revolution

World War I destroyed not only regiments and cities but concepts as well. Out of that tragedy arose a new world, battered but now free of obsolete certainties. Political upheaval was followed by intellectual upheaval. One of the new ideas was the "Primitivism". Finally, the non-European civilizations were establishing a place in the history of mentalities. The new world benefitted from this development especially due to the influence of the Surrealist movement.

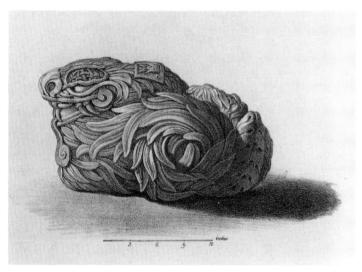

Fig. 6
The Latour-Allard Quetzalcoatl
Library of the Musée de l'Homme, Paris
Latour-Allard, born into a New Orleans family, is presumed to have returned to Europe around 1826 with a collection of Mexican antiquities whose exact provenance is unknown. If certain sources are to be believed, at least part of it may have come from the pieces gathered by Captain Dupaix during his travels through Mexico between 1803-1806 on behalf of Charles IV of Spain. But there is no definitive evidence that this famous Quetzalcoatl was collected by the Spanish officer. This piece was already quite well known by 1830 not only because of its artistic qualities but also because of the air of mystery that the Romantics attributed to this feathered serpent. It was, of course, illustrated in Kingsborough's book, in an engraving by Aglio.

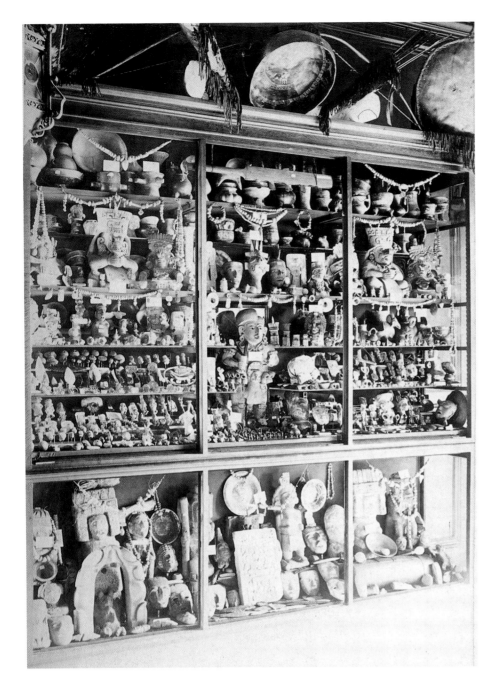

Fig. 8
Mexican showcase
Library of the Musée de l'Homme, Paris
This vitrine (shown in a 1889 photograph)
houses the personal collection of the
Parisian Eugène Goupil. Many of these
pieces previously belonged to Eugène Boban,
who had spent 25 years in Mexico and later
bought the holdings of various private
collectors in Paris. As a result, he became
the capital's most outstanding *américaniste*
antiquarian and bibliophile. The pell-mell
piling of all sorts of American pieces,
classified by type of object rather than
by origin, is typical of the ethnocentric
style of museums at that time.

For the first time in the long history of the relationship between the two worlds, intellectual and scientific Europe was to glorify Indian America, or even more, to idealise it, i.e., recreate it once again in the image of a sincere but still unrealistic *mea culpa*. The writings of the great masters of Surrealism on this subject are highly edifying in terms of the history of ideas.

Both opinion-makers and the general public fell in love with Precolumbian and ethnological American art. The high point of this wave was probably represented by the 1928 Paris exhibition entitled *The Ancient Arts of the Americas*. Its consequences were far-reaching.[8] A new kind of collector appeared on the stage, considerably enlarging the small circles of connoisseurs that had dominated the field until then.

The long road from Dürer to Breton

It has now been just over 500 years since the first "contact between the two worlds", a euphemism for a fatal clash in which the victors imposed their laws, their faith and their own world on the vanquished. But it would be a shame if the Old World were to take refuge in a convenient admission of guilt for past crimes and errors, driven more by fashion and hypocrisy that any real regret. History is, in fact, made of violence and war, and all peoples, invaders and invaded in turn, have been inextricably trapped in it. The past of the Americas provides proof for this sad and fascinating fact. As we all know, both the anti-Spanish "Black Legend" and the pro-Spanish "Golden Legend" were both the result of the profound distortions of history produced by dogmas and rivalries.

But beyond the destruction of cities and societies, we must not forget that the true mix of cultures forged a new and culturally very rich world. Beyond the clash of civilisations, it cannot be denied that Europe was immensely interested in the peoples it tried to rule. For more than half a millennium, a paradoxical relationship marked by fascination, relative oblivion, distortion, negation and idealisation has grown up between the two worlds. Throughout this time a continual swinging of the pendulum back and forth between pro and anti "indigenism" has characterised the history of mentalities among Europeans. Will the new millennium see this back and forth motion finally move forward in a straighter line? Will the native peoples of the Americas win once and for all the recognition Europeans have so often denied them? Or should we fear a backlash as the pendulum moves in reverse again? Such a development would seem nearly impossible in light of the scientific and intellectual advances we have seen. And yet the demons of ethnocentrism, incomprehension and intolerance are still at large, as France, like every other country, has recently witnessed.

Do the native societies of the Americas and their art really need European approval? Are they made greater by our appreciation or lesser by our scorn? Isn't there something insulting and un- bearably condescending about admitting their art into the "Temple of Beauty"? In short, is it desirable – and desired – that their work be represented in the Louvre?

To doubt this would be to forget that native American art is simply reclaiming its rightful place in a Louvre which has already expressed its admiration three times: in Henry IV's cabinet of *singularitez*, in the Musée Americain and finally in the Pavillon de Marsan.

It would mean forgetting that the "admiration" it earned from Dürer to Breton, no matter what particular meaning history infused it with at any one moment, is a reflection of a taste in full evolution and that today it is appreciated by a far wider public than ever before. Isn't this the point – the only point? And while the museum-as-institution has been subject to scathing criticism, isn't this one way and perhaps the best way to accomplish that?

In sum, now more than ever it is relevant to recall the lyrical words of Paul Valéry written on the front gable of the Palais du Trocadéro. They have retained all their power; it is up to us to prove their truth.

"On the passer-by it depends
If I be tomb or treasure
If I speak or hold my tongue
It is all up to you, my friend
Do not enter without pleasure."

PASCAL MONGNE
Translation: Leo-Stephen Torgoff

1 "And in my whole life, I have never seen anything that so filled my heart with joy as these things. Among them I see astonishing works of art, and I am amazed by the subtle skill of these men in foreign lands…" (A. Dürer, 1956)
2 These included parrots (especially macaws), which were to become a huge hit because of the variety of their plumage, whose colours surpassed that of their African cousins. They eventually became a symbol of the New World.
3 A few months before Cortés, this Conquistador sailed along the Mexican coast without succeeding in penetrating into the interior.
4 The most celebrated of these was the so-called Ambras collection, now in the Vienna Museum für Völkerkunde, given by Charles V to his brother, the archduke Ferdinand de Tyrol. According to legend (probably untrue), this collection included the "gifts" Moctezuma gave Cortés upon his arrival in Tenochtitlán, the Aztec capital.
5 A rich enthusiast fascinated by ancient Mexico, Edward Kingsborough spent his life and fortune publishing indigenous documents and travellers' accounts. His monumental *Antiquities of Mexico*, whose nine volumes came out between 1831 and 1848, brought him financial ruin. He died in debtor's prison at the age of 42.
6 Founded in 1895, the Société des américanistes de Paris is actually the successor to the Société américaine de France which was founded in the first part of the 19th century.
7 It must be pointed out that the first exhibition of Precolumbian objects, brought back from Mexico by the art lover and businessman William Bullock, took place in London in 1824.
8 Inaugurated in 1928 in the middle of the Marsan pavilion in the Palais du Louvre, this exhibition had a major impact on the public and on intellectuals. It was the first exhibition specifically devoted to native American objects in France since the opening of the Musée Américain at the Louvre 70 years earlier. It presented more than 1,200 pieces from all over the two continents. Half of them were on loan from foreign museums, the other from numerous private collectors in Paris, a sign of the intelligentsia's great interest in this art. Among the many famous figures whose collections were represented were Raoul d'Harcourt, Louis Capitan, Créqui-Monfort, Marcel Mauss, Paul Rivet and, of course, André Breton.

North American Objects in French Collections

France held colonies in North America from the mid-16th century (1534), when Jacques Cartier landed on the Gaspé peninsula and claimed it in the name of François I, to the early 19th century (1803), when Napoleon I sold Louisiana to the United States. But these dates are somewhat deceptive. The real end of France's status as a major power on the continent came in 1763 with the signing of the Treaty of Paris that put an end to the Seven Years' War between England and France. This treaty stripped France of all its possessions on the North American mainland, although France later very briefly recovered Louisiana before the U.S. made it an offer it could not refuse. Further, French colonial policy was not effectively implemented in North America until 1608, when Samuel de Champlain founded Quebec. It was also at this time that France interfered directly in the relationships between Indian tribes, backing the Hurons against the Iroquois, who in turned allied with the British. New France (the French possessions in Canada) became a crown colony in 1663; the Compagnie des Indes Occidentales was founded the same year. French exploration became more intense in the second half of the 17th century as trading outposts were established in the Mississippi Valley. René-Robert Cavelier de la Salle took possession of Louisiana in 1682. Explorers and *coureurs des bois* penetrated deeply into what is now the Canadian West and the Plains region of what is now the U.S., while French Jesuits and other missionaries (Récollets) stepped up their evangelisation efforts.

The first collections

The first North American objects to reach France were acquired by Cartier in 1535 and 1542 from Indians in the Saint Lawrence River Valley. These utensils and garments given to the king bore witness to the discovery of new lands and peoples.[1] Naturally these objects found a place in François I's cabinet of curiosity. The royal collections continued to expand throughout the course of the 16th and 17th centuries. Representatives of Indian nations seeking to cement a trading alliance with France are said to have given several seashell wampum belts to Champlain in 1611; these, too, ended up in Henry IV's *cabinet de singularitez* in the Tuileries palace.[2] Physicians, scientists and explorers also added works of native manufacture to the exotic natural specimens in their private cabinets of curiosity. "American" objects such as birch bark canoes, pipes, spoons, snow shoes and

so on – whose exact provenance was of no concern at that time – were appreciated for the strangeness of their materials and their rarity of execution. In 1667, the Royal Library's Cabinet des Antiquités et des Médailles on rue Vivienne in Paris began to display New World artefacts. The late 17th century was to witness a strong interest in Hellenic and Roman art to the detriment of Indian *raretez*. Nevertheless explorers such as Cavelier de la Salle continued to build up collections of materials from Canada and the Mississippi Basin. During the 18th century, some remarkable pieces, probably brought back by the Marquis de la Galissonnière, France's governor of Canada in 1747-49, became a part of the

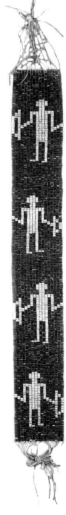

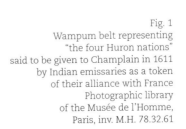

Fig. 1
Wampum belt representing
"the four Huron nations"
said to be given to Champlain in 1611
by Indian emissaries as a token
of their alliance with France
Photographic library
of the Musée de l'Homme,
Paris, inv. M.H. 78.32.61

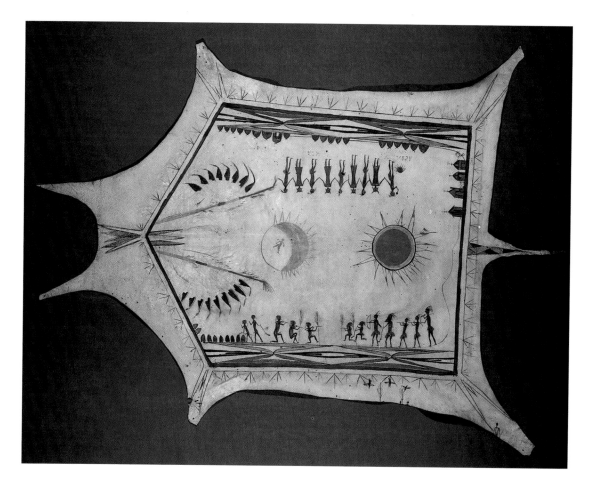

Fig. 2
Painted hide showing
three Quapaw villages at the
confluence of the Mississippi
and Arkansas rivers.
Roman letters identify
the first of these as the village
of Akansea, visited
by the French explorers
Louis Joliet and Jacques
Marquette in July 1763.
Photographic library
of the Musée de l'Homme, Paris, inv.
M.H. 34.33.7

king's collection at the Jardin des Plantes.[3] It is likely that the influx of American objects continued to swell French collections after 1763, but documentation is sketchy. The objects carried home at the end of the 18th century and the early 19th by French explorers and traders – including Marchand (1791) and Roquefeuil (1828) – seem to have simply vanished from the public collections. In general, of the thousands of objects brought to Europe in the 16th and 17th centuries, only some 300 are estimated to have survived. This is due to the fact that only a small percentage of them were kept in the collections belonging to the king, princes, and religious and educational institutions. In France today, there are only 21 pieces from before 1750. Several of these are painted hides.[4]

France may have lost its colonies, but it retained a nostalgic attachment to the first Americans. This can be seen in its 18th century literature, which contrasts the positive image of the "Noble Savage" with Europe's vice-ridden and corrupt ruling regimes. Gradually, these pieces shed their status as simple objects of curiosity and began to be considered for their scientific interest and educational value. During the 1780s, the Marquis de Sérent, tutor to the children of the Comte d'Artois, created a natural history cabinet at Versailles. It comprised most notably a "complete set of garments of a Canadian Savage", including "Naskapi" (Algonquin) leggings, moccasins, a child's painted cloak and a feather headdress.[5]

As a consequence of the confiscation of royal and noble property during the French Revolution, several major public

collections of a scientific character were created. For example, the king's former collections in the Jardin des Plantes became the Muséum d'Histoire Naturelle, and its ethnographic holdings were greatly expanded when more than a hundred objects from Canada, the northern U.S. and Guyana were transferred to this new institution from the National Library's Cabinet des Antiques.[6] During the 19th century, there were several attempts to establish an ethnographic museum in Paris. The Musée de la Marine (Naval Museum) was founded as part of the Louvre in 1827 and opened to the public a decade later. The increasing number of gifts it was receiving led to the creation of an annex specifically dedicated to popularising "the industry and arts of the different races, gathered during the course of voyages sponsored by the State".[7] In 1845, George Catlin, a painter and spokesman for an Indian group, "mahout to the Indians" as Baudelaire called him, came to Paris after touring England. Catlin and his troupe of Iowa Indians made quite a splash at the Louvre. King Louis-Philippe personally received the dancers at the Tuileries palace and commissioned Catlin to execute a series of paintings illustrating the French discovery of Louisiana.[8]

The Musée Ethnographique at the Louvre was a success with the public from the start, but it soon became the target of criticisms on the part of experts because the objects were displayed in a way that had not really broken with the cabinet of curiosity approach. For instance, the walls were cluttered with spears, hatchets and canoe paddles, while other artefacts filled up display cases or were shown being worn by mannequins. As an observer

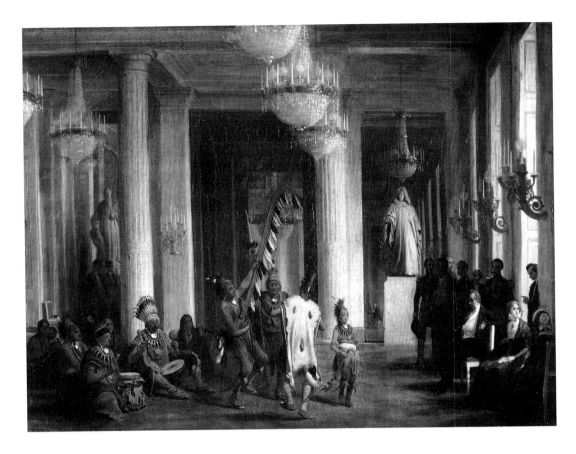

Fig. 3
Troupe of Iowa Indian dancers
brought to France by the
painter George Catlin,
performing for Louis-Philippe
in the Salon de la Paix
at the Tuileries palace,
21 April 1845
Oil on canvas, painted
by Karl Girardet, 1845
Musée National
du Château de Versailles

of that period wrote, "The panoplies and trophies [decorating the walls] would seem more appropriate as ornamentation in a painter's or sculpture's studio than for a museum [...] In short, as was said above, this is a superb cabinet of curiosity but it has never been a museum of any scholarly interest."[9]

The Musée d'Ethnographie du Trocadéro (which was to become the Musée de l'Homme in 1937) was inaugurated in 1882. Even before it opened, its founder, Ernest-Théodore Hamy, organised a provisional exhibition in 1878 at the Musée Ethnographique des Missions Scientifiques, where the North American continent was represented by pieces from Alaska and the Northwest Coast brought back by the explorer and linguist Alphonse Pinart.[10] This new museum set out to absorb and reorganise the collections then scattered in various institutions. The core of the Ethnography Museum's collection came from the National Library, to which were added groupings of pieces from the Musée de la Marine; the Pinart collections, archaeological and ethnographic objects gathered during his second North American expedition through the Southwest U.S. and British Colombia;[11] and the Léon de Cessac collection of objects he acquired in California in 1878-79.[12] The new museum also got some of the collections at the Sainte-Geneviève library and about 500 pieces from the Smithsonian Institution (1885), as well as Great Plains Indians' weapons that had belonged to the Ministry of War. In 1934, it received items formerly in the cabinet of curiosities and art objects at the municipal library, which before that had been on display at the Chateau de Versailles until the late 19th century.[13] Most of the objects in this new, centralised collection came from New France, the Mississippi Valley and the Plains region. Thus the museum could boast an extraordinarily interesting assortment of weapons, leggings, tunics, moccasins, bags, headdresses and painted hides. But this acquired wealth should not be misread; after France lost its North American colonies there was no official policy of seeking to acquire North American objects. The only exception was the collecting expedition to the Canadian Northwest led by Paul Coze in 1930 in preparation for the show "Redskins Yesterday and Today" to be held the following year.[14] The rest of the museum's holdings[15] came from permanent loans and private donations including, most famously, some of the Northwest Coast objects that had once belonged to Max Ernst and Claude Lévi-Strauss. After World War Two, France witnessed a new inflow of North American Indian and Inuit objects, although the French government missed an excellent opportunity to acquire, through the intermediary of Lévi-Strauss, a major Northwest Coast collection now in the Portland Art Museum.[16] This is all the more regrettable because, as Patrick Waldberg has pointed out, "This art was then inadequately represented in the Musée de l'Homme and was all but unknown in France, so some real treasures were to be featured in other collections, the most remarkable of which were put together by André Breton, Claude Lévi-Strauss, Robert Lebel, Max Ernst, Dolores Vanetti and Georges Duthuit."[17]

The discovery of Amerindian art

During the 1920s, the Surrealists discovered the art of the Pacific islands and the Americas. In terms of North America, this means in particular Inuit and Northwest Coast art, as can be seen in a "map" published in a special issue of the magazine *Varietés* in 1929 which reduced the U.S. and Canada to Alaska and the Queen Charlotte Islands to the West of British Columbia. Despite the fact that very few such pieces were available on the European market, Breton and Paul Éluard built up a significant collection of objects unearthed in the shops of London and Berlin antique dealers,[18] documented in the catalogue *Sculptures d'Afrique, d'Amérique et d'Océanie* published on the occasion of a sale at Paris' Drouot auction house in 1931.[19] A few Amerindian pieces were presented at the Galerie Surréaliste in 1926 as part of the exhibition *Tableaux de Man Ray et objects des îles* (1926), and then, the following year, at the exhibition *Yves Tanguy et objets d'Amérique*. The gallery owner Charles Ratton organised the first exhibition of Inuit and Northwest Coast art in July 1935, a collection acquired from George Heye, founder of the Museum of the American Indian in New York. Heye sold some of his more recent Amerindian pieces (19th and early 20th centuries) in order to buy the pre-Columbian objects to which he took a fancy at that time.[20] The 1936 *Exposition Surréaliste* juxtaposed "primitive" objects from New Guinea, nearby New Ireland and North America with found objects and ready-mades.

In 1938, while travelling through British Columbia, the Swiss Surrealist painter Kurt Seligmann acquired a heraldic pole in the Skeena River region.[21] He recounted the background and context of this outstanding piece in the *Journal de la Société des Américanistes* (1939). The pole is well known to Parisians as it has been erected in front of the entrance to the Musée de l'Homme. It inspired Georges Duthuit to write, "Mr Kurt Seligmann, a painter of tumult, armour and dreams, had one of those immense heraldic posts hauled back to Paris, and at such inconvenience! Now standing under a portico at the Trocadéro palace, its fierce independence casts additional well-deserved shame on the low reliefs and other nudes that adorn the walls of this supposedly modern establishment."[22] Duthuit's enthusiasm was shared by Benjamin Péret, who wrote an article appearing in the 21 January 1939 issue of the daily *Paris-Soir* under the bombastic title, "The Musée de l'Homme's Centrepiece Inaugurated Last Night – Krikiett, the Tallest Totem Pole in Europe".[23] The following summer, another Surrealist artist, the Austrian Wolfgang Paalen, visited the Pacific Northwest with his wife Alice Rahon and the photographer Eva Sulzer. This was the first time he had ever seen heraldic poles in their original context, and his reaction was a mixture of amazement and disappointment. While he was filled with admiration at the sight of "the first assembly of totem poles" whose stunning beauty in the twilight inspired his highest praise, he was also stupefied to discover "atrocious new totem poles, as ugly as can be" in Sitka. Paalen combed the curio shops and the Hudson's Bay Company stores. In Wrangell, he was fascinated by the two shops owned by a dealer in local arts and crafts named Walter C. Waters. His notes read: "Shop of W.C.W., a real thousand and one nights store where you can find anything: Tlingit and Haida dance masks, Chilkat blankets, narwhal teeth, Eskimo kayaks, utensils and pipes, the innumerable teeth and tusks of mammoths [sic]…" Further, he wrote, "In the other shop: medicine doctor outfits

(mask of a dead slave), headdresses, canoe paddles and a canoe as long and slim as a Viking boat. The old wooden building gives off the same grotesque despair as do some of Max Ernst's paintings and collages."[24] During this visit, Paalen acquired Coppers, Chilkat blankets and a sculpted and painted interior screen showing a bear. For many years the latter was displayed in front of this artist's studio in San Angel, Mexico, before being moved to the Denver Art Museum.[25] Paalen described the imagery in these Northwest Coast poles like this: "Profiles of people and beasts inextricably intertwined, all dimmed in the evening light, issued from innumerable hatchet blows as precise as a wolf's incisors sinking into a victim, the totem poles stand tall, as if they were lances from a gigantic battle painted by Ucello [...] The naked spines of some mythological great communal life outdoors, these totem poles are infused with the same sense of tragedy as the long shadows they cast."[26]

American exile

As refugees in New York in the early 1940s, Breton and his friends were frequent visitors to the North American Indian galleries of the American Museum of Natural History and the Museum of the American Indian. They were particularly interested in Inuit objects as well as those from the Northwest Coast and the Southwestern U.S. The annex of the Museum of the American Indian located in the Bronx, which Claude Lévi-Strauss compared to "a veritable Ali Baba's cave", was full of treasures such as "admirable sculptures from the Northwest Coast, at a time when even specialists held them for nothing more than ethnological specimens".[27] They also liked to hang out in antique shops. On Third Avenue, in 1941, Ernst discovered the shop owned by Julius Carlebach. A combination of some people's acquired knowledge and others' trained eye and of course Carlebach's own business inter-

Fig. 4
Hall of the Northwest Coast tribes at the American Museum of Natural History, New York, March 1943

est allowed this small circle of amateurs with limited means, as Lévi-Strauss emphasised, to acquire relatively small but excellent collections.[28] In a 1949 letter about Lévi-Strauss's latest purchases, Isabelle Waldberg wrote to her husband, Patrick, "We [Breton and the Lebels] very much admired Lévi-Strauss's collection, which still includes the witch doctor you have seen, with the recent addition of several very fine masks, one of which was turned into cash by Max Ernst when he was kicked out of the Guggenheim home [...] As a whole, the collection is very well endowed and very valuable, thanks to the mother of pearl and hardwood pieces, not to mention the Chilkat blankets that now, in this hot weather, seem twice as luxurious as they did in the display case."[29]

Breton, Ernst, Roberto Matta, Seligmann, Lebel, Duthuit and Lévi-Strauss sought to share with others their enthusiasm for this art they so admired. The latter published a celebrated article on Northwest Indian Coast art in the *Gazette des Beaux-Arts* in 1943.[30] Photos of masks, blankets and house poles were published in magazines such as *Dyn* (Mexico), and *VVV* and *View* in New York.[31] In October and November 1942 a Surrealist exhibition was held in New York with the support of the Coordination Council of French Relief. The opening was "dedicated to children playing amidst the smell of cedar", an enigmatic phrase that poetically evoked the works sculpted in cedar by Northwest Coast artists. This show brought together pieces from the collections of "Max Ernst, C. Lévy-Strauss [sic], André Breton, Pierre Matisse, Carlbach [sic] and Segredakis". This group of people had an explicit purpose: "Surrealism is only trying to rejoin the most durable traditions of mankind. Among the primitive peoples art always goes beyond what is conventionally and arbitrarily called the 'real'. The natives of the Northwest Pacific Coast, the Pueblos, New Guinea, the Marquesas, among others have made *objets* which [the] Surrealists particularly appreciate."[32] In 1946, Ernst lent four pieces from his collection for the exhibition *Northwest Coast*

Fig. 6
André Breton in the front room of his studio
on Rue Fontaine in Paris, May 1960

Fig. 5
Display case of Northwest Coast masks
in the exhibition *Chefs-d'œuvre de l'Amérique précolombienne*,
Photographic library of the Musée de l'Homme, Paris, 1947

Painting organised by Barnett Newman at the Betty Parsons Gallery. Abstract Expressionist painters, Mark Rothko and Adolph Gottlieb amongst them, were struck by the stylised representations in these painted and carved in shallow relief objects and cloths, and made an effort to more broadly popularise the beauty of these "treasures of primitive art".[33] After discovering art from Alaska and British Columbia, the Surrealists discovered that of the American Southwest. Ernst and Patrick Waldberg visited Pueblo Indian reservations and Ernst decided to take up residence in the region with Dorothea Tanning. Breton went to the Hopi area and witnessed a number of rituals. The objects collected in New York were soon to be joined by Hopi Kachina dolls, designed to represent spirits to children.[34] The Surrealists' American exile was coming to an end. These adventurers of the mind helped change our sensibilities. Among many other reasons, we must be grateful to them for this and for these masterpieces that are today offered up for our amazement and delight.

MARIE MAUZÉ
Translation: Leo-Stephen Torgoff

1 E.-T. Hamy, 1988, p. 8.
2 A. Vitart, 1993, p. 7.
3 *Ibid.*, p. 33. Also see C.F. Feest, 1993a, pp. 58-59.
4 C.F. Feest, 1984, pp. 85-97; C.F. Feest, 1992, pp. 61-109; C.F. Feest, 1993b, pp. 1-11.
5 See A. Vitart, 1993, p. 38. The collection acquired by the Marquis de Sérent also had two painted hides and two embroidered bags (see C.F. Feest, 1984; and C.F. Feest, 1992).
6 The list of objects is given in E.-T. Hamy, 1988, p. 81 and pp. 87-88.
7 See the draft decree in E.-T. Hamy, 1988, p. 227. According to an 1856 inventory, the Musée de la Marine's holdings included a total of 128 objects from North America (*ibid.*, p. 200). The Musée Américain du Louvre, inaugurated in 1850, mainly focused on pre-Colombian objects (see S. Guimaraes, 1994, pp. 10-11).
8 R. Moore, 1997; G. Catlin, 1959; C.F. Feest, 1984. One of Catlin's canvases was found at the Musée du Louvre in 1963, and twelve more at the Musée de l'Homme a few years later (see S. Guimaraes, 1994, p. 11).
9 Cited in S. Guimaraes, 1994, p. 11. This quotation is from an article that originally appeared in the newspaper *Le Siècle*, 1 October 1850.
10 E.-T. Hamy, 1988, pp. 59-60. Pinart had entrusted his archaeological and ethnographic collections to Hamy for the Universal Exhibition of 1878.
11 Pinart donated part of his archaeological and ethnographic collections to the Musée d'Ethnographie in 1881. Another part was not brought back to France until 1882.
12 De Cessac built up a major collection of Chumash archaeological and ethnographic items, insects and other zoology specimens, etc. Another part of his collection ended up in the Musée des Antiquitiés Nationales in Saint-Germain-en-Laye (see H. Reichlen and R.F. Heizer, 1963, vol. III).
13 A. Vitart, 1993, p. 41; N. Dias, 1991, pp. 174-182. According to Pascal Mongne, there are still seven North American objects in the Sainte-Geneviève library (personal communication, June 1999).
14 See *Bulletin du Musée d'Ethnographie du Trocadéro*, 1988, nos. 2-3 (1931-1932). Mention should also be made of a lesser collection of archaeological and ethnographic objects assembled by E. Dijour in the home of the Thompsons (British Colombia) in 1931. A heraldic pole from British Columbia was given to the museum by theCanadian National Railways in 1930.
15 At the Musée de l'Homme, the collection of Inuit pieces from Alaska , Canada eventually numbered about 600 items (B. Robbe, communication to the "Amériques" work group, 19 November 1998). The most outstanding collections were those brought back by Alphonse Pinart from his first Alaskan expedition of 1870-71, now in the Chateau-Musée of the city of Boulogne-sur-Mer. With regard to American Indian objects, Mongne has recorded some 700 ethnographic objects located in 37 French museums (working paper "Les collections d'Amérique du Nord" given in December 1998 to the "Amériques" work group as part of the Mission de Préfiguration for the Musée de l'Homme, des Arts et des Civilisations).
16 C. Lévi-Strauss, 1979, p. 15; personal communication, 18 December 1998. The Axel Rasmussen collection was purchased by the Portland museum in 1948. Rasmussen assembled it between 1929 and 1940 when he was the Superintendent of Schools in Wrangell and Skagway, Alaska (see E. Gunther, 1966).
17 P. Waldberg, 1958.
18 J. King, 1992, pp. 11-19; M. Mauzé, 1994, p. 35.
19 Thanks to this catalogue, we know the collection included 13 pieces from Alaska, most notably engraved ivory objects, and 33 from the Northwest Coast. *Collection André Breton et Paul Éluard, Sculptures d'Afrique, d'Amérique et d'Océanie*, exhibition at the Charles Ratton gallery, 14 rue de Marignan, 1-27 June, and the Hôtel Drouot, 1 July, auctions 2-3 July.
20 E. Cowling, 1978.
21 More particularly, the Gitskan village of Hagwelget. That same year, Seligmann published an interview with a Tsimshian chief in the last issue of the magazine *Minotaure* (nos. 12-13), and "Keigyett: Myth of the Totem Gyaedem Skannes" in the *Revue du vingtième siècle* (nos. 5-6). See A. Chapman, 1965. S.E. Hauser, 1997, has a few pages describing Seligmann's travels in British Columbia. The totem pole was bequeathed to the Musée de l'Homme by Arlette Seligmann in 1992 (*ibid.*, p. 410, footnote 533).
22 G. Duthuit, 1974, pp. 315-319.
23 "Krikiett, the tallest totem pole in Europe [...] was brought to Paris by a French painter. But in order to obtain the Indians' permission to carry it off, he had to have witch doctors bring him into the clan and promise the chief that the pole would surely be decorated by Lebrun himself." (See S.E. Hauser, 1997, p. 152).
24 W. Paalen, 1994, pp. 8-34. The shaman's garments came from a grave pillaged by Waters and his sons. Paalen gives a list of the objects included in the "booty" (*ibid.*, p. 31).
25 E. Cowling, 1978, p. 492; M. Mauzé, 1994, p. 38; A. Winter, 1992, pp. 17-26; M. Sawin, 1995, p. 253.
26 These excerpts are taken from *Dyn*, 1942-43 (reprinted 1970), no. 1, pp. 33-34.
27 C. Lévi-Strauss, 1977, p. 80.
28 C. Lévi-Strauss, 1977, p. 15; C. Lévi-Strauss and D. Éribon, 1988, p. 51; personal communication, 18 December 1998; E. Carpenter, 1975, pp. 9-10; A. Jouffroy, 1955, pp. 32-39.
29 P. and I. Waldberg, 1992 (letter of 5 June, 1944). The item referred to is not a mask but a Tlingit warrior's helmet which Lévi-Strauss bought from Ernst in 1942 (see pp. 430-432).
30 This article was reprinted in Lévi-Strauss, 1979, pp. 9-14: "In New York [...] there is a magic place where the dreams of childhood hold a rendez-vous, where century-old tree trunks speak and sing, where indefinable objects watch out for the visitor, with the anxious stare of human faces, where animal of superhuman gentleness join their little paws like hands in prayer for the privilege of building the palace of the beaver for the chosen one, of guiding him to the realm of the seals, or of teaching him, with a mystic kiss, the language of the frog or the kingfisher."
31 Cf. W. Paalen, "Totem Art", in *Dyn*, 1942-43 (reprint 1970), vols. IV-V. VVV carried Lévi-Strauss' "Indian Cosmetics" (June 1942) with illustrations of pre-Colombian and Northwest Coast pieces. Its second issue had a brief article by Alfred Métraux on Easter Island. In 1944, Lévi-Strauss published "The Art of the Northwest Coast at the American Museum of Natural History" in *La Gazette des Beaux Arts*. In 1944, he read aloud to avid listeners, Robert and Nina Label, his research on the "Split Representation in the art of Asia and America" published in the French magazine *Renaissance* and reprinted in Lévi-Strauss, 1958, pp. 269-299. Isabelle Waldberg wrote to her husband: "He [Lévi-Strauss] told us about his new theory regarding the relationship between the Northwest Coast, ancient China, the Maoris and the Caduveos, who, as you may recall, are a small tribe of Indians in Paraguay where he spent some time and whose facial paintings he described in the first issue of *Triple V*" (P. and I. Waldberg, 1992, p. 203). Lebel and Ernst developed a plan to write a book on "the primitive arts of North America" for the Jean Bucher gallery (see H. Béhar, 1990, p. 28; V. Gille, 1998, pp. 19-30). Another source indicates that this project – later abandoned – was to be carried out by Breton, Duthuit and Lebel (E. Cowling, 1978, p. 494).
32 *First Papers of Surrealism*, 1942. Starting in the early 1930 there was a renewed interest in Indian art in the U.S., as evinced in the plethora of publications and exhibitions. The show *Indian Art of the United States* held at New York's Museum of Modern Art in 1941 marked a turning point in the way the American political and intellectual elite considered Indian arts. Organised under the aegis of René d'Harcourt and Frederick H. Douglas, and supported by President F.D. Roosevelt, it contributed to a new perception of Indian art as the equal of any and a part of a single world art. This exhibition also influenced the work of the Abstract Expressionists during the 1940s. A public awareness that Amerindian art is part of the U.S.'s national heritage began to grow in the wake of this show.
33 Among the 28 pieces shown, four came from Ernst's collection and 18 were lent by the American Museum of Natural History (see W. Jackson Rushing, 1988, pp. 187-195; and W. Jackson Rushing, 1995).
34 See the articles by F. Ndiaye and V. Gille in *La Danse des Kachina*, 1998; M.E. Laniel-Le François, J. Pierre and J. Camacho, 1992.

Art from the Pacific in French Public Collections

In 1920, when the *Bulletin de la vie artistique* carried out a "Survey on the Far-off Arts" and asked "Will they be admitted to the Louvre?", one of the respondents gave the following lapidary reply: "No, what I have seen from these underdeveloped populations, those of Oceania for example, is not worthy of the Louvre."[1] When we see that the same person readily detected a Chinese influence in certain Kanak and Vanuatan objects, we cannot but be struck by the stereotypes and subjectivity that have shaped this very turbulent debate ever since the 19th century.

These very categorical statements are taken from the emphatic commentary by one Colonel Grossin, whose career, we are told by the man who conducted the survey, Félix Fénéon, had never strayed from the ranks. It is as if he is trying to excuse one of those snap judgements and abusive comparisons that are often the lot of non-European objects. In this case, the link was between the Chinese practice of fishing for sea slugs off the coasts of New Caledonia and the New Hebrides, and the possibility of their presence leading to an artistic influence on these archipelagos.

To which, in an equally lofty tone, Monsignor A. Le Roy replied: "Do the so-called "primitive" populations of Africa, America and Oceania offer artistic manifestations worthy of the name? Yes they do, and in every medium; in drawing, in painting, in sculpture and in architecture, not to mention music, dance, eloquence and poetry."[2]

Without trying to dig up extreme cases, this animated debate reveals all the potential for interest and repugnance, not to mention emotion, imagination and ambiguity, aroused by exotic art – or at least, that we formulate in relation to it.

Certainly, it leaves no room for indifference. In *Nadja*, André Breton even speaks of *amour fou* provoked by Oceanic art, as if this marginalised art invited a highly personal form of appropriation quite apart from any structural logic that might seek to define its specific quality and history.

It is also clear that each of these continents (Africa, Oceania, Americas) follows its own historical path, punctuated by multiple discoveries and encounters with the European world. Encounters with Oceania therefore have their own history, marked by the presence of these objects brought back over the seas, which attest to their specific cultures, to their particular relations with their gatherers and collectors and which are, most of all, tokens of their own inscription and legitimacy in time. Their arrival enters the long history of our museums, running parallel or at a tangent to their development over time.

For two centuries, these objects made their way between various institutions in a sort of dependent state due to the various ideological and scientific currents, without ever finding a definitive home, as if Oceanic art was somehow a multidisciplinary matter. And indeed, that question is still topical today.

Finally, it is true that tribal art has never been seen as an independent entity. We have seen it through the filter of a gaze that has itself never been neutral. Its supposedly "innate, instinctive, spontaneous" side has caused it to be compared to modern and contemporary art, or to the drawings of children or the mentally disturbed. The Dadaist movement and then the Surrealists manifestly saw it in this light, insofar as they threw themselves into a world that liberated the "counterability" of the artist, a kind of automatic writing dictated by an unbridled imagination and unconscious. Once again, this attitude is particularly marked in the case of Oceania.

The age of the Western navigators

"They [the seamen] were most careful to describe the mores of the unknown peoples they met from island to island, across the Pacific, most scrupulous about depicting them and giving an exact image of their homes, of their clothes, of their gods and the beauty of their wives. Thanks to them, perishable objects were carefully kept for our pleasure in the natural history cabinets that the gentlefolk of the Grand Siècle had laid out in the wings of their châteaux. This provides us with sufficient assurance, in the light of exact comparisons of the navigators" bounty, to classify the masterpieces of the Southern Seas and speak without imprudence of pieces from the 17th or 18th century, distinguishing them from the clumsy attempts of modern imitators, and even from the over-hasty production of the workers of the 19th century, who abandoned the shells they had once used to chisel wood, stone and bones, and began using knives and iron files, sold to them by the sailors."[3]

This quotation is richly indicative. Using a few skilfully chosen words, it conveys all the imagery that has crystallised around the dream of the South Pacific, as it was so often expressed in the second half of the 18th century. Elevated to the status of symbols, keywords such as "navigator", "god", "beauty", "women", "island", "cabinet of curiosities", plus the traditional triad of "shell, stone and bone", those guarantors of the pure object that was profaned

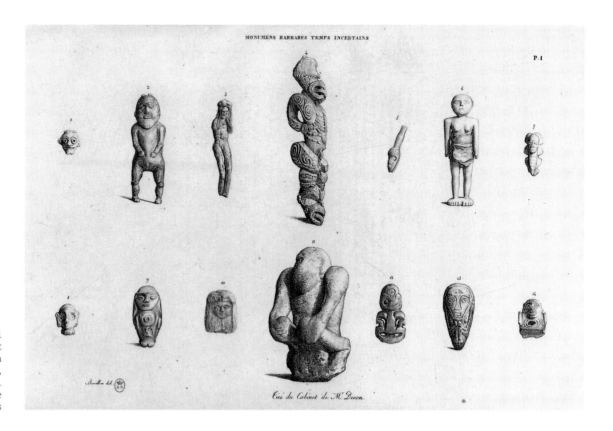

Fig. 1
Objects from the Cabinet
of Vivant Denon
reproduced by A.P. Duval, 1829,
vol. I, pl. 1.
Bibliothèque Nationale
de France, Paris

and perverted from its original significance by the irreversible penetration of European iron, all become lyrical metaphors.

It must be said that the exploration of the Pacific was surrounded with adventure. It was discovered in two successive waves. First came the Spanish navigators, sailing in search of the mythical Austral lands. The pagan, even ungodly population they encountered was irremediably condemned to the kind of mass missionising that they had already undertaken in South America and that had led to the famous Valladolid controversy of 1550, which called into question the humanity of the American Indian. And, significantly enough, the island in the Vanuatu archipelago where Queiros made landfall in 1605 (Santo) was baptised "Terra del Espiritu Santo".

Then, at the end of the 18th century a second wave of discovery, steeped in the humanist values of the Enlightenment, set out in search for the noble savages that featured so prominently in the ideals and fantasies of the philosophers.

One might indeed wonder if the distinction between "civilised Polynesian" and "barbarous Melanesian", as upheld by many evolutionists of the 19th century, did not have its historical origins in the associations made as a result of the following encounters: Melanesian, man without a soul/Spanish conquistadors, and Polynesian, civilised savage/Enlightenment philosophers. Vanuatu (Melanesia) was perhaps identified as the land of the Holy Spirit, but two centuries later Bougainville dedicated Tahiti (Polynesia) to the cult of Aphrodite, the goddess of love, and named it the "New Cythera". The navigators Cook, La Pérouse, Dumont d'Urville, Marion-Dufresne, Bougainville and d'Entrecasteaux became the popular heroes of the maritime odysseys related in the accounts of the expeditions.

This was a fertile century, conducive to the development of the sciences. An age of muses and explorations, the period also formed close links with the Oceanic world. It was discoveries in this area that prompted the first methodological reflections on ethnographic and ethnological study. The foundations of this approach were laid in the recommendations made to navigators regarding observation and collection of samples in the field, but also in the very redefinition of the status of museums, which were now being asked to take responsibility for foreign cultural heritages. The highly educational role of institutions at the beginning of the 19th century partly explains the overabundance of ordinary ethnological articles (baskets, hooks, combs, *tapas*, weapons, etc.): these were deliberately collected because they conveyed material and technological information reflecting the physical and intellectual capacities of the peoples concerned. Viewing the cabinet of curiosities of Baron Vivant Denon (1747-1825), Madame de Genlis marvelled at the delicacy of craftsmanship that she was equipped to appreciate,[4] but said nothing about his sculptures from Tonga, New Caledonia and New Zealand (fig. 1). For many years, such pieces were viewed merely as representations of fetishes and idols; formal considerations did not come into it.

Oddly enough, one of the first objects to attract Parisian connoisseurs was an anthropomorphic bust from Hawaii (p. 322). Very probably brought back by crew members after Captain Cook's third expedition (1776-80), it epitomises the long "initiatory" journey travelled by ethnographic objects. The first reference to this effigy is found in a list indicating its transferral from the Muséum d'Histoire Naturelle to the Musée des Antiquités in 1797.[5]

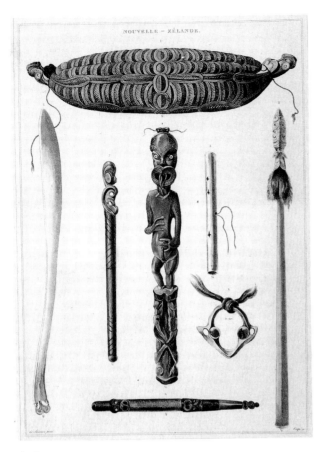

Fig. 2
Plate from the atlas of Dumont d'Urville's first voyage (1830-1835) showing objects from New Zealand

This was an important step, for it lifted the object out of the world of *naturalia* in which it was conventionally set, and where it cohabited with various natural curiosities.

The foundation of the Musée des Antiquités in 1795[6] as part of the future Bibliothèque Nationale, broke with this logic and forged a new alliance with archaeology, looking towards an innovative, comparative approach to ancient civilisations and the mores and customs of different peoples. The collections were to be given a new presentation in the space of the old Jardin du Roi. Although not identified either geographically or historically, the Hawaiian bust can be recognised in the description of an "idol in a kind of rush material formerly covered in feathers with mother-of-pearl eyes and cetacean teeth."[7] In 1839 it was added to the inventory of the Bibliothèque's Cabinet des Médailles at number 76, loosely described as a "basketwork Indian head".[8]

There was nothing extraordinary about this piece's English background. As can be seen from the rich collections of museums in the Nord-Pas-de-Calais area,[9] there was a flourishing trade in exotic art between French and English enthusiasts.

Another equally important object at the Musée des Antiquités has an even more mysterious background. This is a fan handle from Tahiti (p. 318). There are two possibilities here: either it was a miraculous survivor of Bougainville's expedition, or it was part of the collection formed by the Americanist Dombey. We know from Captain Marchand's eyewitness account[10] that Bougainville brought back a few objects, but unfortunately none of these were marked down as such in an official register, for the simple reason

that at the time there were no museums that might house them. Consequently, these objects were scattered among various cabinets or found refuge in the Muséum d'Histoire Naturelle, whose main function had little to do with ethnographic curiosity. For example, the lack of an appropriate institution meant that the Australian and Tasmanian collection brought back by Captain Baudin (1800-04) was presented to Joséphine Bonaparte. The Empress was not overly concerned with these objects and soon lost all trace of them, even though a detailed list had been drawn up by the naturalist and zoologist Péron.[11]

As for Dombey, that hypothesis too subject to all kinds of doubts and speculations. In 1786 the Cabinet des Médailles registered his collection, which included a few shells and wooden idols from "Otaïti".[12] Are we to assume that these included the fan handle, even though we cannot be sure that Dombey stopped at the Society Islands, and when in contrast we know for sure that Bougainville spent some ten days there? There is no factual evidence to support this. All we have to go on is the early date at which these collections were formed, which, for lack of anything better, we can compare with the dates of the first voyages by navigators and men of science. These musings may seem incongruous, but they are inevitable given the nature of European ethnographic collecting in the 18th century.

In the 19th century new museological structures began to appear. The first of numerous attempts to create ethnographic or geo-ethnographic museums was the undertaking of Jauffret, a member of the Société des Observateurs de l'Homme (1799-1805), built around the expedition by Captain Baudin.[13] Then there was the plan submitted to the Louvre by the Comte de Forbin in 1825, the project put forward by Jules de Blosseville, an officer on the Duperrey expedition, and the repeated but never fully realised attempts of Edmé Jomard at the Bibliothèque Nationale.[14] All these initiatives led ultimately to the creation of the Musée de la Marine du Louvre in 1827.

Thus it was that Oceania entered the Louvre under the aegis of naval explorations, in a perfect symbiosis between maritime exploits and Pacific culture. This meant that ethnology tended to be seen in exclusively Oceanic terms, and also encouraged concrete actions to underpin this approach, with objects being exhibited in the room dedicated to the navigator La Pérouse.

The frequency of circumnavigatory expeditions now began to increase. Freycinet (1817-20) was followed by Duperrey (1822-25) and, above all, Dumont d'Urville (1826-1829 and 1837-40). The flow of collections also grew, leading to the foundation of a Musée Ethnographique attached to the Musée de la Marine at the Louvre in 1850. In 1838, on his final voyage, Dumont d'Urville collected a statue from the Gambier Islands[15] which he transferred to the Musée Naval. In 1921, following the Louvre's new policy of relocating its ethnographical collections to provincial museums,[16] the Musée Naval gave the piece to the museum in La Rochelle. Another equally famous statue from the Gambier Islands, known by the name of the god Rao (p. 310), was brusquely seized during this same period, not this time by explorers but by the missionaries who had begun to settle in the archipelago. It too was housed for a while in the Louvre.[17]

The vision of the Pacific had gradually been transformed. The inexorable exploration the archipelagos, whether by missionaries or soldiers, had generated new attitudes towards the natives. At the same time new anthropological theories and disciplines were

emerging, centring on comparativist and evolutionist dichotomies such as barbarian/civilised, savage/culturally developed, which applied in varying degrees to different human species. A new historical era had begun.

The Antipodean crossroads

In the second half of the 19th century the Pacific Ocean became a crossroads much frequented by whalers, sandalwood boats, furriers and other commercial vessels. After Tahiti, Tonga, New Zealand and the Cook Islands in the late 18th century, new Catholic and Protestant missions were set up. This was also the age of annexations and protectorates.

The implantation of the colonial administration meant a change in the way objects were collected. It naturally implied longer sojourns and, consequently, more massive and orderly collecting, in contrast with the brief calls made by the navigators of the later 18th and first half of the 19th century.

Thus the microcosmic approach of the first naturalists, which was based essentially on a system of barter – in other words, direct exchange of an object for scraps and cheap goods[18] (nails, axes, fabric, etc.) – gave way to more radical collecting methods, usually conditioned by religious, colonial, anthropological or simply commercial imperatives. The presence of station ships led progressively to the constitution of series of analogical objects (weapons, stone items, etc.) whose nature was determined either by the marked interest of individuals or the fields of study they were called upon to supply.

One last element to be taken into consideration here is the rise of anthropology and other scientific disciplines, which imparted a new dynamism to the concept of the museum and was conducive to a more precise definition of their specific domains. It should be noted that, until the end of the 19th century, the Musée de la Marine du Louvre was the only Parisian museum that could house ethnographic objects, a task later taken up by provincial museums. The Louvre and the Marine subsequently ceased to have any contact with exotic art. This was an irreversible historical process. Moreover, the various connections then being made between extra-European ethnography and other disciplines were, although questionable, the sign of a genuine interest in defining its true place and significance.

Thus the creation of the Musée des Antiquités Celtiques et Gallo-Romaines (the future Musée des Antiquités Nationales) in 1862, and that of the Musée d'Ethnographie du Trocadéro in 1878, made significant contributions to this new awareness which, it is true, had been sparked by the Louvre itself, which now pursued a selective rather than encyclopaedic conception of the work of art. The almost immediate consequence of these developments was the transferral – via complex mixings and interchangings of the collections – of the Louvre's main collections to these two new institutions. The first received the larger ensemble as a result of the recent development of comparative archeology. The Trocadéro, which was relatively impecunious and whose collections were made up essentially of the objects inherited from the Exposition Universelle, held in the year of its foundation, made approaches to all prospective partners, both institutional and private. Also in 1878, it had received the collections of the Bibliothèque Nationale, featuring the Hawaiian bust (p. 322) and the Tahitian fan handle

(p. 318) mentioned above.[19] However, it was patrons and sponsors who played the dominant role in enriching its resources.

Prince Roland Bonaparte is a perfect example. As a young man he became interested in geography, botany and anthropology, which he studied with Broca.[20] In 1883 he attended the Colonial Exhibition in Amsterdam, where he bought a series of objects from Geelvink Bay. At the 1889 Exposition Universelle in Paris he presented a collection of anthropological-type photographs of Australian aborigines.[21] As president of the Club Alpin, then chairman of the Commission Française des Glaciers, member of the Société de Géographie and chairman of the bureau from 1910 to 1924, Bonaparte proved a generous benefactor, notably facilitating the Musée du Trocadéro's 1887 acquisition of the Oceanic art collected by the diamond merchant Bertin.[22] He continued to make regular contributions to the museum. Apart from a *rei miro* breastplate from Easter Island (p. 331), one of the outstanding pieces he donated is a very rare shield from the Solomon Islands inlaid with mother-of-pearl (p. 284).

Traders also helped enrich the collections. John Higginson settled in Nouméa, New Caledonia, in the 1860s. Aptly nicknamed the "nickel king", he founded his own company in 1876. A true businessman, Higginson opened a sugar refinery in Bourail and a rum distillery at Koné. In 1882 he founded the Compagnie Calédonienne des Nouvelles-Hébrides.[23] In the course of his many travels around Vanuatu he built up a sizeable collection (nearly 200 objects)

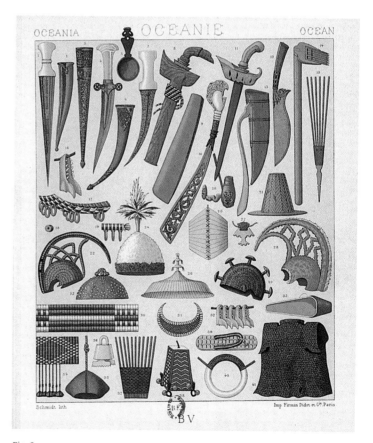

Fig. 3
Plate showing the arts and ornaments of "Oceania",
featuring pieces from Sumatra, Borneo,
the Moluccas, Celebes (Sulawesi)
and the Philippines. From A. Racinet, 1888
Bibliothèque Nationale de France, Paris

Fig. 4
A room at the Musée
d'Ethnographie du Trocadéro, Paris, 1895
Photographic library
of the Musée de l'Homme, Paris

that he donated to the Musée du Trocadéro a few years later, in recognition of the financial advantages granted by the French government to his Compagnie du Nickel. Oddly enough, this collection features only four Kanak objects. Almost all the other objects, including two grade monuments from the Banks Islands (p. 257 and 260), come from Vanuatu.

But Paris was not the only centre for the presentation of extra-European collections. The provinces, too, contributed to the enrichment process, notably through the highly active role played by the ports in preparing sea expeditions, making them points of convergence both for the locally based seafarers and those on temporary postings. Consequently new objects arrived regularly at nearby museums in places such as Brest, Le Havre, Cherbourg, Toulon, Rouen and Rochefort.

However, whereas in Paris the distinction between ethnography and natural history had been made at the beginning of the 19th century, outside the capital the two fields were still linked, not only because of the lack of appropriate institutions, but also out of a desire to maintain the homogeneity of the material that had been collected, which bore obvious witness to a deeply-rooted local maritime tradition.

Thus it was that museums (or, occasionally, other collections) enthusiastically welcomed the products of both natural history and exotic ethnography, and in most cases actually mixed them together in their exhibition galleries because they afforded a global vision of the region's maritime adventures.

The ports along the English Channel and Atlantic coast were particularly favoured in this respect, their attractiveness increasing in the 19th century with the creation of sailors' hospitals and centres for the study of anatomy, health and naval medicine, like the ones at Rochefort and Toulon.

This regional development also reflected the growing disinterest in ethnography at the Musée de la Marine du Louvre. For while, in the years after its foundation in 1827, it solicited contributions from French ports in order to enrich its collection, this relationship was reversed in the second half of the 19th century as its holdings were reallocated to other museums in Paris and Saint-Germain-en-Laye, but also to provincial museums and establishments linked to the Naval Ministry. Hence the enrichment of the various local collections.

The Poitou-Charentes region offers a good example of local development. Here, the intense port activity at Rochefort, consolidated by the creation of a naval medical school, led to a significant growth in the collections both at the school itself and at the Muséum Lafaille in nearby La Rochelle.

There was already a long-standing local tradition in this respect. For example, in partnership with his colleague Garnot, René Primevère Lesson, who was based in Rochefort and sailed with the Duperrey expedition as a surgeon and naturalist, first donated a few pieces to the Musée de la Marine du Louvre.[24] The Muséum de Paris, which now emphasised physical anthropology, received a Maori head. But Lesson did not neglect his home port and presented a second head to the cabinet in Rochefort (it was placed in the museum at La Rochelle a few years later) while a third went into the cabinet of a rich private collector.[25] It would seem that Lesson was particularly interested in craniology. Could this fascination have prompted him to collect the *korvar* from New Guinea (p. 303) that the anthropology laboratory of the Musée de l'Homme also attributes to the Duperrey expedition? This plausible but unconfirmed hypothesis rests on the existence of a lithograph illustrating the atlas of the voyage showing what looks very much like the actual object,[26] and also on the fact that the two donors Lesson and Garnot are again mentioned together.

La Rochelle continued to benefit from its proximity with Rochefort, acquiring a collection of objects from Easter Island through two of the port's sailors. The first of these, the naval surgeon Gille, set sail on the *Dorade* and stopped at Easter Island in 1860, bringing back a two-headed statue that he donated to the museum in La Rochelle.[27] Gille had been called on to stem a smallpox epidemic in the Marquesas Islands.[28] The second was Julien Viaud, better known by his nom de plume, Pierre Loti, who sailed as a midshipman on the *Flore* in 1872 and also stopped at Rapanui. On his return to La Rochelle, he brought back a sculpted lava head.[29] Other pieces from Loti's haul[30] were acquired by the collector Stephen Chauvet, from whom they later found their way to the Trocadéro museum.

Also on this expedition was a third donor, Joseph Aze. Born in Brest, this first class doctor and chief doctor in Tahiti, where he was posted from 1869 to 1873, donated four objects from Easter Island (including the *moai tangata* on p. 337) to the cabinet at the Ecole de Santé Navale in Rochefort to which (having been drawn away from his home town by its rich collection[31]) he had been attached since 1851.

Poitou-Charentes was by no means an isolated example in this respect. The coastal regions of Aquitaine, Brittany, Nord-Pas-de-Calais and Normandy all benefited from these prolonged Pacific stopovers.

In 1925 the human sciences took an important step forward with the creation of an Institut d'Ethnologie at the University of Paris. The new institute's priorities were the training of ethnologists and the teaching of ethnology. In 1926, the Musée d'Ethnographie was brought under the wing of the Muséum d'Histoire Naturelle, thereby enabling Paul Rivet, holder of the anthropology chair at the Muséum, to become director of the Trocadéro establishment. Georges Henri Rivière was immediately appointed to assist him there.[32]

This was also the year when the first Galerie Surréaliste opened in Paris with an inaugural exhibition by Man Ray.[33]

These events marked a real turning point in the fortunes of exotic arts. Not only was the Musée du Trocadéro thoroughly reorganised, but a new impetus was given by artists, collectors and dealers.

The Watershed of the 30s

The painters Georges Braque, Maurice de Vlaminck and André Lhote first discovered African art in around 1905.[34] However, we need to go back more than a decade to find the artist who opened the way for this later generation.

Paul Gauguin left France for Tahiti in the 1890s before travelling on to the Marquesas. His interest in Polynesian mythology and the way Marquesan art[35] fed into his exploration of woodcutting techniques were both major factors in the dissemination of primitive art in the West. This initial interest in Polynesia was stimulated by its complex decorative vocabulary of curves, interlacings and geometrical figures, which attracted the first grammarians and encyclopaedists of decorative art at the end of the 19th century such as Racinet and Owens.

Among subsequent movements, the Fauves (early 20th century, to 1907) and Cubists (circa 1907-10) were inspired by both African and Oceanic art, then grouped together under the names of primitive art or *art nègre*. The German-based movements Die Brücke (1905-13) and Der Blaue Reiter (1911-13) were more drawn to Oceanic art. Here Melanesia came to the fore, with a marked preference for the art of New Guinea and New Ireland.[36]

In 1919 one of the first Parisian exhibitions of African and Oceanic art was held at Galerie Devambez. A few years later (1923), the Pavillon de Marsan at the Louvre hosted the "Exhibition of Indigenous Art from the French Colonies in Africa and Oceania and the Belgian Congo".[37]

However, it was the Surrealists who really established the importance of Oceanic and Eskimo (Inuit) art. André Breton, Philippe Soupault, Louis Aragon and Paul Eluard were among the signatories who "took the vow of absolute Surrealism" in the *Premier manifeste du surréalisme*, which was published on 15 October 1924.[38] On 1 December they published the first issue of *La Révolution surréaliste*.[39] These former contributors to the Dadaist journal (Dada petered out in 1922 after discord between Tzara and Breton) now focused their explorations on automatic writing, basing their art in the life of the unconscious, dreams and psychoanalysis. In 1929, in the Belgian journal *Variétés*, they published a map of "The World in the Age of the Surrealists" in which the relative size of the different geographic areas was determined by the artistic importance attributed to them. Oceania took pride of place (fig. 5).[40]

The year 1931 was another turning point as new colonial, artistic and scientific imperatives emerged which would shape events in the coming decade. Three main factors would determine artistic and ethnological developments. First, the apotheosis of French imperialism, as reflected by the Exposition Coloniale et Internationale at Vincennes[41] and the creation of the Musée Permanent des Colonies. Secondly, the release onto the art market of the major collections of exotic art built up by De Miré, Eluard and Breton. And, thirdly, the new dynamism of the Trocadéro museum's policy with regard to collecting objects in the field.

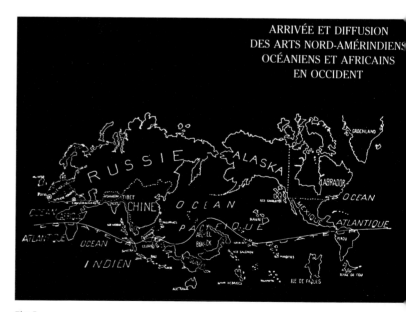

Fig. 5
Surrealist map of the world published in *Variétés*, June 1929

In 1930, with the help of Tristan Tzara and Pierre Loeb, Charles Ratton organised an exhibition of African and Oceanic art at Galerie Pigalle. Among the works on show, number 295 was a piece from New Guinea (p. 299) belonging to the painter Georges de Miré.[42] On 7 May the following year, the Oceanic works from De Miré's collection were put up for auction and the statuette, listed as number 133[43] in the sales catalogue, was acquired by the dealer Louis Carré who later sold it to Picasso in 1944.[44]

The eventful history of this object, which seems to echo the frequent movements of ethnographic collections from one public establishment to another, is symptomatic of the mobility characteristic of exotic art, itself not dissimilar to the fluctuating movements of modern art. Were these peregrinations once again the result of the very intense, personal relationships that owners had to these objects, which meant that they tended to drift from one collection to another, driven by equally intense feelings of attraction or repulsion? For while Breton declared his *amour fou* for objects of Oceanic art,[45] Matisse and Picasso were more doubtful, and even manifested equally significant signs of repugnance for certain objects in particular. Matisse painted the curious Vanuatan ogress figure from his collection as some "magic and terribly savage sculpture from New Guinea" and, only too happy to get rid of it, gave it to Picasso, who in turn described it as a "terrifying figure" and refused the gift on the grounds that his car boot was too small. Funnily enough, Picasso did finally claim the figure in 1957 (fig. 7), some three years after Matisse's death.[46] This tardy act of appropriation can be seen as indicating the beginnings of a conditioned reflex concerning relating to a specific historical collection.

This period was also marked by the close links between artists and dealers. There were regular requests to show the collections of Loeb, Chauvet, Van der Heydt, Ascher, De Miré, Hein, Tual, Ratton, Fénéon, Level and others in exhibitions or books and catalogues on the theme of primitive art. One of these was Portier and Ponceton's *Décoration océanienne*, published in 1931.[47]

One of the most enterprising dealers in this period was Pierre Loeb, also a collector, who organised and gave financial support to exhibitions such as the Miró show put on at his own Galerie Pierre, which he ran with the poet Jacques Viot, in 1925.[48] The Surrealists chose Loeb as their official dealer and asked him to finance field expeditions with a view to acquiring new objects.[49] Viot was again called on and set off for New Guinea in 1929. He brought back a sizeable collection of pieces from the Lake Santani region and around the Humboldt and Geelvink bays. Some of these were exhibited the following year at the Galerie Renaissance.[50] In 1933 Viot, De Menil and Mistler lent a series of *tapas* to the Trocadéro museum. This exhibition was the first to look at regional stylistic variations (those of Dutch New Guinea, now Irian Jaya) rather than giving an overall view of *tapa* making in Polynesia and Melanesia.

The Trocadéro museum had itself been far from idle. Indeed, the 1930s were years of great expeditionary activity. First came the famous Dakar-Djibouti expedition of 1931-33,[51] and this was followed by Pacific expeditions led by Georges Dobo (New Guinea), Patrick O'Reilly (Solomon Islands), Edgar Aubert de la Rüe (New Hebrides), Alfred Métraux and Henri Lavachery (Easter Island, from which they brought back a monumental head found in Anakena Bay in 1935, see p. 327), Maurice Leenhardt (New Caledonia) and the *Korrigane*. The unprecedented enrichment of the collections that ensued has been estimated at over three thousand pieces.

Of all these missions, the *Korrigane* was without a doubt the most picturesque. This was a real expedition in the full sense of the word, a kind of distant echo of the first round-the-world voyages of the 18th and 19th centuries. The crew of thirteen was under the command of Etienne de Ganay. With him sailed the painter Van den Broek d'Obrenan and the photographer Jean Ratisbonne.[52] The operation was financed by the crew members themselves but the Korrigane also benefited from a commission by Paul Rivet. In 1936, after numerous calls at the Marquesas, Tahiti, New Zealand, Fiji, the Loyalty Islands and New Guinea, the crew reported a "bounty" of some two thousand five hundred pieces, including the small sculpture from Santa Cruz and the large hook from the Sepik River region reproduced here (pp. 281 and 295, respectively). The collection was deposited at the Musée du Trocadéro and a part of it exhibited in 1938. Van den Broek d'Obrenan was made head of the museum's Oceania department,[53] a wise decision which ensured that a vigilant eye would be kept on the collections. However, after his death the heirs

Fig. 6
Works from the Pacific and contemporary European artists at the home of Pierre Loeb, photographed by Denise Colomb in 1949. In addition to the Kanak sculpture now exhibited at the Louvre, we can see objects from the lower Sepik region (Papua New Guinea), Alberto Giacometti's bronze *Hand* (1947), a self-portrait by Antonin Artaud (1946, pencil) and a photograph of Pablo Picasso by Man Ray.

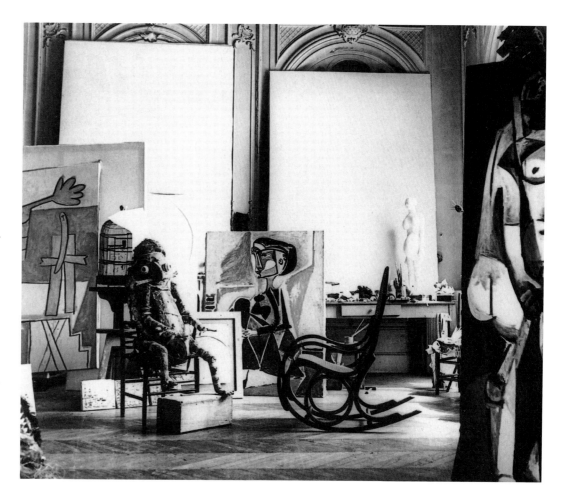

Fig. 7
The Vanuatan overmodelled female effigy, *nevibumbao*, that previously belonged to Henri Matisse, photographed here by André Villers at La Californie, Picasso's villa in Cannes, in 1957. This figure is now part of the collections of the Musée Picasso in Paris (inv. M.P. 3624, bequest of 1979)

withdrew the biggest part of the collection and put it up for sale in 1962, leaving only a smaller part to the museum as compensation. Still, this was soon swelled by the three hundred pieces and more that Françoise Girard, d'Obrenan's successor as head of the department, decided to buy back at the auction.[54]

After this, the frequency of expeditions began to diminish, not least because the Musée d'Ethnographie, or Musée de l'Homme as it was renamed in 1937 (a move which also led to the fusion of the Muséum's prehistoric collections with the already existing ones), had only a meagre budget for such initiatives.

The initiative for new acquisitions would later be taken up by a new museum at Porte Dorée in eastern Paris. Known successively as the Musée Permanent des Colonies, the Musée de la France d'Outre-Mer (1935) and, finally, in 1961, as the Musée des Arts d'Afrique et d'Océanie (MAAO), this institution launched a concerted acquisitions policy supported by funds specially allocated by the new ministry for cultural affairs, created in 1959.

The Oceania section at the MAAO was headed by Jean Guiart, formerly attached to the Oceania department at the Musée de l'Homme and a researcher at the Office de Recherche Scientifique des Territoires Outre-Mer (ORSTOM).[55]

As the 1930s had been at the Trocadéro institution, so the 1960s were a decade of intensive development at the MAAO, accelerated by the field expeditions sent out to buy from local populations and by contact with specialist dealers.

Expeditions were led by Jean Guiart (Vanuatu, New Guinea[56]), Karel Kupka (Australia[57]) and Daniel de Coppet (Solomon Islands[58]), which would enable the subsequent creation of the Melanesian and Australian galleries.

As later events would show, the history of Pacific art collections was far from over. In 1986 and 1992 the Musée des Antiquités Nationales put the former Oceanic collection of the Louvre on permanent loan at the Porte Dorée. These two transfers (which included the fly whisk from the Austral Islands, p. 315, and a figure from Easter Island, p. 333) gave the MAAO's displays the historical foundation which they had previously lacked (products of archaeological excavations, Polynesian and Micronesian objects brought back by the first explorers in the 19th century).

Thus, over the last two hundred years, Oceanic art – and exotic art in general – have been surrounded a whole series of questions, options and choices. The central issues have been the specific identity of exotic art, its (recently acquired) independence, and the continuing classification of such art in three broad geographical categories: Africa, Oceania and the Americas.

Recent attempts to define a specific history of art for each continent and to focus on the role and function of artists are not without precedent. Back in the 1930s a number of exhibitions put on at the Trocadéro touched on these questions of expression and the artistic or even stylistic diversity that had been observed and recorded in a given zone or region. This new perspective confirmed

Fig. 8
Movements of Pacific art collections to and from the various
Parisian museums and institutions, 18th to 20th centuries
From S. Jacquemin, 1991, doc. 2a, p. 319

Diagram labels:

Bibliothèque Sainte-Geneviève —1797→ Bibliothèque Nationale ←1797— Muséum d'Histoire Naturelle

Bibliothèque Nationale —1866→ Musée de l'Armée

Mouvements successifs à partir de sa création

1878-1928

1833

Maison du Roi

Ministère de la Marine

Musée de l'Armée —1898— 1917 — 1932

Musée de l'Homme

1829

1836

Musée du Louvre

1934

1930

1908

Bibliothèque de Versailles

1909 — 1911

1880

Musée des Antiquités Nationales

1923-1923

Musée des Colonies Palais de l'Industrie

1986

Musée d'Ethnographie de La Rochelle

Musée des Arts d'Afrique et d'Océanie

the existence of cultural variations, as highlighted through the presentation of series of objects such as *tapas* from New Guinea and suspension hooks from the Sepik region. While such museum presentations may seem ponderously didactic, they did at least have the advantage of focusing attention not only on the contents of objects but also on their forms, by juxtaposing analogous or dissimilar pieces which, for lack of any other historical information, were at least known to have been collected at the same period.

However, this scientific approach must not be allowed to overshadow the role of individual sensibility in the response to these objects which correspond to criteria quite different from our classical Western references. The door remains open to different levels of interpretation, to the roles of both knowledge and emotion.

As Guillaume Apollinaire pointed out back in 1912: "We could go even further, and there is no reason why we should not set up a great museum of exotic art, which would be to that art what the Louvre is to European art."[59]

<div align="right">

SYLVIANE JACQUEMIN
Translation: Charles Penwarden

</div>

1 Colonel Grossin in F. Fénéon, 1920, p. 727.
2 A. Le Roy in *ibid.*, p. 729. It is interesting to note that the most trenchant opinions expressed in this debate were those put forward by individuals whose careers made them unlikely to be particularly knowledgeable about primitive art. This debate over the presence of primitive art at the Louvre was, nonetheless, initiated by artists. In 1909 Apollinaire expressed himself on the subject with virulence and clarity, condemning the dryasdust and empty Musée du Trocadéro and demanding that primitive art be brought into the Louvre. "The Louvre should house certain exotic masterpieces whose appearance is no less affecting than that of the finest specimens of Western statuary. For some time now many artists have made no secret of their admiration for the unknown sculptors of the Congo, for the passionate precision of certain works by the Kanaks or Maoris." (G. Apollinaire, 1991, vol. II, p. 123).
3 A. Portier and F. Poncetton [1929], p. 5.
4 A. de la Fizelière, vol. I, 1873, p. 66.
5 Archives Nationales, Instruction Publique et Muséum collection, lists of 3 Thermidor and 30 Fructidor, Year V.
6 E.-T. Hamy, 1988, pp. 21-35.
7 Archives Nationales, Instruction Publique et Muséum collection, lists of 3 Thermidor and 30 Fructidor, Year V.
8 Archives of the Cabinet des Médailles, Bibliothèque Nationale, 1839.
9 *La Découverte du Paradis. Océanie. Curieux, navigateurs et savants*, 1997.
10 Archives Nationales, Marine et Colonies collection: "Note des objets remis par le chirurgien Roblet pour être adressés au Citoyen Fleurieu président de l'Institut".
11 J. Copans and J. Jamin, 1978, p. 359-361 ("Inventaire général de tous les objets relatifs à l'histoire de l'Homme – recueillis pendant le cours de l'expédition ou remis à M. Péron, naturaliste et zoologiste du Gouvernement dans cette expédition et présentés par M. Geoffroy et lui à sa Majesté l'Impératrice Joséphine le 9 prairial an XII, par François Péron").
12 Archives of the Cabinet des Médailles, Bibliothèque Nationale; Archives Nationales, Muséum collection: "Extrait de l'inventaire des caisses envoyées par Dombey", 1786.
13 J. Copans and J. Jamin, 1978, pp. 187-194.
14 E.-T. Hamy, 1988, p. 93-97, pp. 125-141, pp. 163-166, pp. 174-184, pp. 217-219.
15 *La Découverte de la Polynésie*, 1972, no. 153.
16 Archives of the Musée de la Marine: "Liste des objets faisant partie de la collection ethnographique du musée de la Marine et remis en dépôt aux musées de La Rochelle".
17 Archives of the Congrégation de Picpus, Rome, 1836.
18 *La Découverte du Paradis*, *op. cit.*, p. 42.
19 Archives of the Cabinet des Médailles, Bibliothèque Nationale, "Catalogue des objets indiens et chinois", 1879.

20 H. Cordier, p. 527.
21 *Collection anthropologique du prince Roland Bonaparte – Australiens* (exhibition), 1889.
22 P. Peltier, 1987, p. 120, note 17.
23 P. O'Reilly, 1953, pp. 120-122.
24 Archives of the Musée de la Marine du Louvre, Duhamel de Monceau inventory. This joint donation consisted of two pan pipes from Tonga and two *tapas* from Hawaii.
25 R.P. Lesson, vol. II, 1839, p. 316.
26 M. Battesti, 1993, p. 83, nos. 1-3.
27 C. and M. Orliac, 1995, pp. 62-63.
28 J. Péré, 1991, p. 26.
29 S. Chauvet, 1935, p. 41. The head was in fact sawn free, it being judged that the trunk and topknot would have made it too heavy to carry on board the *Flore*.
30 J. Péré, 1991, p. 26.
31 S. Jacquemin, personal file, Marine historical department, Vincennes.
32 P. Rivet and G.H. Rivière, 1931, p. 4.
33 *André Breton, la beauté convulsive*, 1991, p. 183.
34 J.-L. Paudrat, 1987, p. 139.
35 R. Goldwater, 1988, pp. 63-83.
36 Among the artists of Die Brücke, Nolde, Kirchner, Schmidt-Rottluff and Pechstein discovered the art of the Palau Islands (Micronesia, now known as the Republic of Belau), then a German colony, at the museum in Dresden. Pechstein and Nolde travelled to the islands in 1913-14.
37 P. Peltier, 1979, pp. 271-273.
38 *André Breton, la beauté convulsive*, 1991, pp. 172-173.
39 *Ibid.*, p. 174.
40 E. Cowling, 1992, pp. 178-179.
41 The Communist League, comprising the French Communist Party and CGTU union, organised a counter-exhibition at the Soviet Pavilion to protest against colonial imperialism. The Party mobilised twelve Surrealist writers including Aragon, Breton, Eluard and Sadoul. The tract they wrote has remained famous: "Do not go to the Exposition Coloniale", it urged, "Answer its speeches and capital executions by demanding the immediate evacuation of the colonies."
42 H. Seckel-Klein, 1998, p. 252.
43 *Vente de sculptures d'Afrique, d'Amérique et d'Océanie*, 7 May 1931, no. 133: "Figure squatting with knees forming a point extending up to the face", pl. VII.
44 H. Seckel-Klein, 1998, p. 252.
45 Breton owned an impressive collection of Oceanic objects, but also Inuit masks and Kachina dolls, which he collected in series, thus reproducing the didactic accumulation of the curio cabinet, only this time with works of art. He also designed displays of Oceanic fishhooks.
46 H. Seckel-Klein, 1998, pp. 252-253.
47 A. Porter and F. Ponceton, [1931], 48 plates.
48 P. Peltier, 1992, pp. 156-157.
49 P. Peltier, 1987, p. 112.
50 P. Peltier, 1992, p. 163.
51 J. Jamin, 1982, pp. 69-101.
52 C. Van den Broek, 1939, p. 7.
53 P. O'Reilly, 1953, pp. 271-272.
54 M.-C. Laroche, 1962, p. 124.
55 P. O'Reilly, 1953, pp. 271-272.
56 Archives of the Musée des Arts d'Afrique et d'Océanie, Oceania section, file on J. Guiart – collector, among other objects of the famous stone from Ambrym (Vanuatu, p. 270).
57 This collection of more than 250 paintings on bark (the other part of which is kept at the Museum der Kulturen in Basel) was analysed in detail by Karel Kupka in a thesis published a few years later (K. Kupka, 1972).
58 Archives of the Musée des Arts d'Afrique et d'Océanie, Oceania section, D. de Coppet file.
59 G. Apollinaire, 1991, vol. II, p. 475.

The Classics of African Sculpture in the Louvre

The African sculptures now on display in the Louvre's Pavillon des Sessions are not those undreamt-of marvels one imagines emerging from obscure museum reserves where they had been gathering dust, awaiting their improbable discovery. For proof, we need only look at the fortunes of these works of art over the years: only two of them, it seems, have never been previously exhibited or, at the very least, published. There was clearly no frenzied search for the new behind the selection proposed by the Louvre. Nor has the wish to avoid an overly personal bias led to a timid or conventional choice. With an eye well trained in "the scrutiny of works of art", and a mind free of their historiography, as well as their hagiography, the person who has brought together these "classics" of African sculpture has heeded only the truth of their forms. In doing so he joins all the men and women before him – artists, dealers, collectors, art writers, museum keepers and occasionally ethnologists – who had already singled out, in another era and under different circumstances, one or more of these pieces. Thus, what we need to briefly retrace here is rather the various steps in this movement towards the recognition of the universal value of these works of art, from their presence in the collections of the specialised museums where they were conserved, to their admission to the Louvre, long delayed but ultimately inescapable.

In the closing months of 1888, visitors entering one of the ground floor vestibules of the Musée d'Ethnographie du Trocadéro, the only venue at the time for the display of objects from the African continent, would have seen the inevitable trophies of primitive arms mounted on the walls. This was the usual decor of universal and colonial exhibitions of the time. One of these presentations, however, a display that did not in fact throw together assegais, cutlasses, machetes or arrow points, would have been quickly recognised by readers of *Le Tour du Monde*. This weekly review had in fact published in an earlier July issue a photograph of the very same group of works along with numerous images illustrating the account of Savorgnan de Brazza's exploration of the Ogooue River basin. Assembled from the materials brought back by those who had followed the heroic "barefoot conqueror" in his second (1879-82) and third (1883-85) missions, this display included seven "idols of Mbueti"[1] which were mounted above a drum. In the African gallery, this composition stood next to another that boasted a group of objects collected by one of Brazza's faithful companions, Joseph Michaud. In the upper section of the display was found the "large red copper fetish of the Ossyeba"

(p. 175), which had been acquired in 1881 between Boue and Zabure as the mission's advanced up the middle Ogooue. The fetish is a highly simplified representation of a human head with an ogival outline, which is made less severe by the slight concavity of the face and the striation of the thin copper strips covering its surface. Until 1951, the piece would remain the only example of this singular style conserved at the Trocadéro. Freed from the exotic decorative setting of the display and returned to the autonomy of its forms, this "large fetish" would be shown in 1935 at the Museum of Modern Art in New York;[2] in 1952, it was included in the major works of statuary making up André Malraux's *Musée imaginaire de la sculpture mondiale*.[3]

African "nail fetishes", on the other hand, first entered the Western imagination as "proof" of some misdemeanour, even a crime, and of sorcery, an accusation levelled against those whose "absurd", "degrading" beliefs had still to be eradicated by the light of reason and the virtue of the true faith. In 1916, some 30 years after the Musée du Trocadéro had obtained its first such specimen,

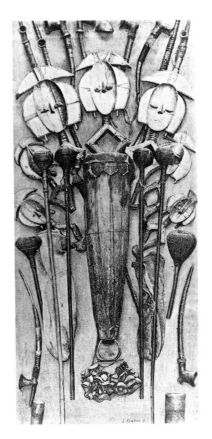

Fig. 1
Photograph (around 1888) of a panoply display at the Musée d'Ethnographie du Trocadéro featuring in particular seven "idols of Mbueti" collected during Brazza's second and third missions
Reproduced in *Le Tour du Monde*, July 1888, p. 39

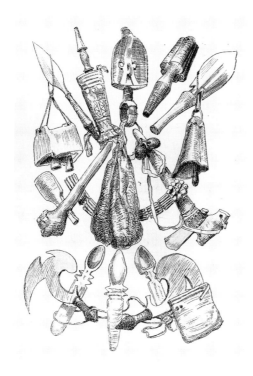

Fig. 2
Engraving (around 1888) after the panoply mounted at the Musée d'Ethnographie du Trocadéro, specimens collected by Joseph Michaud during Brazza's second and third missions Barbier-Mueller Archives, Geneva Reproduced in L. Perrois, 1985, p. 66

sculptures "crude fetishes, the grotesque tokens of ridiculous superstitions". Yet the Trocadéro, where "the collections are mixed to satisfy ethnic curiosity and not aesthetic sentiment", harboured "several first-rate works of art". These notably included "that pearl of the Dahomey collection", the statue of the Abomean Mars (fig. 1, p. 112), which had been plundered after the city's capture by Colonel Dodds' troops. Since 1895, that African Mars had been on display in the museum's first floor near three allegorical figures representing Fon sovereigns before the conquest. For Apollinaire, the Abomean Mars clearly stood out as "the most unexpected and the most graceful *objet d'art* there is in Paris". Grasping the originality embodied in this iron sculpture, which portrays the figure with a surprisingly light touch just as it seems to take a step forward, Apollinaire affirmed outright that "the Negro artist was clearly an innovator".[7]

Since the 1910s, many connoisseurs had come to consider the figures of the Fang and others grouped with them to be the high point of African sculpture. Formerly in use in cults devoted to ancestor spirits, these wooden anthropomorphic figures were each associated with a reliquary and had enjoyed a local diffusion that extended from the Sanaga to the Ogooue, and the Atlantic Ocean to the Kadei. The *bieri* figure with a whistle (p. 163) was

René Verneau, who succeeded Ernest-Théodore Hamy as director of the institution, penned a description of the fetishes then in the museum's collections for the scholarly review *L'Anthropologie*. This collection comprised four "quadruped fetishes", including the canine sculpture (p. 206) that Joseph Cholet had donated to the museum in 1892, and eight "human fetishes". In this same study,[4] Verneau also tried his hand at sounding a theme already popularised by the British and French patriotic press at the time, underscoring the similarity between the irrational behaviour he ascribed to the Africans of the Congo and the Germans of the moment. The latter, as a token of their support for the war waged by their Field marshal, liberally covered his effigies with gold, silver and iron nails. "It is certain," concludes Verneau, "that the German fetish will remain just as powerless as the fetishes of Loango, and that it is not through such savage practices that our enemies will impede the triumph of civilisation." Hardly suspect of paying tribute to the cult of things Germanic, the French poet Guillaume Apollinaire actually succumbed to another spell and added to his library on the Boulevard Saint-Germain a tall Yombe sculpture that was planted all over with blades. Similarly, in an essay tellingly entitled *African Negro Art. Its Influence on Modern Art,* which was published in the United States in 1916, Marius de Zayas included a photograph of one[5] of the 12 "nail fetishes" enumerated by Verneau. Much later, in 1977, the Trocadéro's dog figure preceded the arrival in 1984 of a bristling statue that had once belonged to the "Heresiarch". The dog fetish was also put on display when it was temporarily included in the collection of the Musée National d'Art Moderne for its inaugural presentation at the Centre d'Art et de Culture Georges Pompidou,

An early champion of African art, Apollinaire thought that "the Louvre ought to accept certain exotic masterpieces whose appearance is no less moving than that of fine specimens of Western statuary".[6] Three years later, in September 1912, in a piece for the *Paris-Journal,* the poet would lampoon those who only saw in these

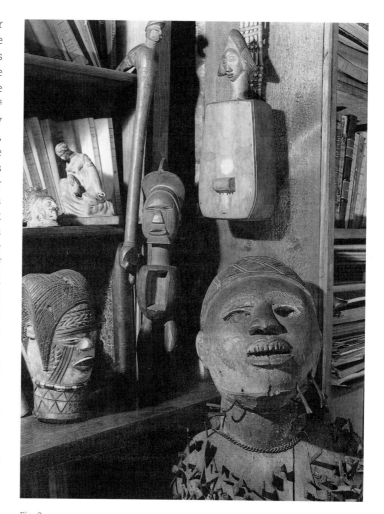

Fig. 3
Mayombe "nail fetish", displayed with other African works of art in Guillaume Apollinaire's library
Photograph René-Jacques (1954)

collected in 1905 or 1906 by Captain Cottes during a mission to fix a clear demarcation between the French Congo and German Cameroon. While the piece did show some wear, its integrity as a sculptural form had apparently been preserved. Yet before 1929, when it appeared in Adolphe Basler's work *L'Art chez les peuples primitifs*,[8] this piece seems not to have drawn the attention that "[...] surely the finest specimen of Fang art in the Musée de l'Homme"[9] deserved. On the other hand, the reliquary figure obtained in 1901 from a member of the colonial administration, a certain Ferrière, who had held a post in the Sangha-Mambere region from 1893 to 1896, was reproduced[10] by Zayas in his 1916 publication as proof of the modernism of "primitive" sculpture. The provenance, according to Leon Siroto's conjecture, was probably the confluence of the Sanaga and the Mbam.

Published in St Petersburg in 1919, five years after the author's death, Vladimir Markov's *L'Art des Nègres (Iskusstvo Negrov)* includes no less than six different views[11] of the Fang statuette (p. 166) that had been sold to the Trocadéro by an anonymous dealer. During the summer of 1913, Markov, a painter and active member of the Russian avant-garde, had visited most of Western Europe's ethnographic museums. Drawing upon his multiple photographs of the structure and details of some 70 objects, Markov wrote one of the two earliest theoretical approaches to Africa's conception of sculpture and form (the other was Carl Einstein's 1915 *Negerplastik*). The seven works he photographed from the Parisian museum's collections included the painted plaster cast[12] of the Songye headrest (p. 192) that was to be acquired by pre-emption in 1986 by the Musée de la Porte Dorée.

The Sakalava funerary post (p. 211), displayed in the Place du Trocadéro, along the edge of the Madagascar Pavilion at the Universal Exposition of 1900, became part of the Musée d'Ethnographie's collections the following year. This piece was soon compared with a similar sculpture collected very likely in 1898 in southwestern Madagascar by Guillaume Grandidier.[13] Émile Heymann, known as the "slaver of Rue de Rennes", would show the latter piece in 1909 to Picasso.[14] The painter declined to purchase the statue, however. It was eventually acquired by the antique dealer Joseph Brummer, who provided Carl Einstein with five photographs of the piece as illustrations for his 1915 study.[15] It later became the property of the sculptor and collector Jacob Epstein after being shown at the exhibition "Native Art of the French Colonies" at the Marsan Pavilion in 1923-24. These two funerary posts probably came from the same atelier if not the same hand, and their expected display side by side was finally proposed by Ezio Bassani in "La Grande Scultura dell'Africa Nera", an anthology-exhibition mounted by Bassani in 1989 in Florence.

As for the "Yangere war tam-tam" (p. 186), this boviform slit drum acquired in the region of Bania in the course of Brazza's fourth mission (1892-94) has no known equal to this day. While described in 1923 by Henri Labouret not as a work of art but as an example of percussion instruments that can emit "drummed languages",[16] the piece would soon win, like the most striking and successful results of Africa's functional aesthetic, its share of admirers (notably when shown at the Galerie Pigalle[17] in 1930).

"No one is blind to [...] the sad condition of the Musée du Trocadéro, its lamentable decline"[18] after 20 years of René Verneau's direction. Verneau's successor in 1928 was Paul Rivet, a specialist of the Americas, while Georges Henri Rivière, whose talented display

for the Marsan Pavilion at the "Ancient Arts of America" exhibition had brought him to Rivet's attention, was promoted to assistant director. Faced with the museum's dilapidated condition, the two men would take pains to revive both the scientific and didactic mission that the endangered institution was no longer able to carry out.

The different versions of the plan for refurbishing the museum drawn up by the two men admitted not the slightest ambiguity as to the institution's vocation. Whereas "the renovated Trocadéro might be based on the misconception of its becoming a fine arts museum, where objects would be assigned their place under the aegis of aesthetics alone",[19] what was really needed was to restore the institution's initial function, in other words to sketch out that "imposing and balanced portrait of archaic civilisations that ethnography must paint".[20] If, as one of the project's variants puts it, an "artistic role" was to be added to the "scientific", "popular educational" and "national" roles that the Musée d'Ethnographie was meant to fulfil, the only beneficiaries mentioned in that regard were "artists and craftsmen [who] will find in the objects of primitive art [...] myriad forms and ornamental designs that will refresh their inspiration to good effect".[21]

According to Rivière's thinking, he faced a confusion fuelled by a "vaulting yet versatile taste" which, in the closing years of the "roaring" twenties, meant that "the favour of the elite now goes to the arts produced by peoples considered primitive and uncivilised".[22] Confronting this confusion he would repeatedly stigmatise these "dismal attempts at secularisation which claim [...] to transform ethnographic objects into handsome pieces of art and arbitrarily amputate them of all that justifies their legal, religious, magic, or humbly and saintly utilitarian character".[23] He derided those who pleaded for "a Louvre that would bring together all the beautiful pieces of primitive art [where], on kingwood pedestals, in splendid isolation, coquettishly lending themselves to the most refined systems of lighting, there would rise, painstakingly plucked and trimmed and stripped down and polished, the masterworks of Pahuin, Polynesian and Aztec art".[24]

Yet hardly had the ink on these sarcastic remarks dried than – in 1932 – the Musée d'Ethnographie's "Salle du Trésor", or Treasury Room, was opened to the public. For Rivière, who was responsible for the creation of this special exhibition space, the gallery represented "a small kingdom [...] made up of certain pieces that are especially remarkable from the artistic point of view [...] brought together for our eyes' delight. This presentation, very much appreciated by our visitors – black marble pedestals, red backgrounds, artificial lighting, recessed display cases – is the work of a great artist, M. Jacques Lipchitz."[25]

Such a concession, moreover, was not the only one. In 1934 the refurbished gallery of sub-Saharan Africa was furnished with a "display devoted to African art".[26] And there were the temporary shows whose titles left no doubt, "Art of the Incas" in 1933 and "Art of the Marquesas Islands" in 1934.

A show devoted to bronze and ivory figures from Benin, the "Exposition de Bronzes et Ivoires du Royaume de Bénin" was announced in July 1931 in the *Bulletin du musée d'Ethnographie du Trocadéro* as an "event that is to have above all an artistic stamp".[27] The show opened on 15 June 1932, the very same day that the museum's Salle du Trésor was unveiled, with some two thousand guests in attendance. The press could hardly fail to cover this double event, a journalist of *La Liberté*[28] entitling his account "The

Transformed Musée d'Ethnographie, a Gem Freed of its Matrix". The proposal for the show actually went back to October 1930[29] and had been submitted to Rivière by Charles Ratton, the Parisian antique dealer who already enjoyed a proven reputation. It was also Ratton who put together the show. Accompanied by a special issue of *Cahiers d'art*[30] and a catalogue (with preface and notices written by Ratton), "Bronzes et Ivoires du Royaume de Bénin" featured a selection from some thirty European collections of over one hundred objects that were representative of an African court art largely unknown to the French public. These pieces had been chosen by Ratton "with an irreproachable soundness of taste".[31]

The ivories featured in the show included four horns on loan from the Cabinet des Médailles of the Bibliothèque Nationale. Of these horns it is not known "under what conditions and at what date they […] first entered the collections of the Kings of France",[32] as Rivière affirms in his preface to the catalogue of the 1935 exhibition sale "Bronzes and Ivories from the Old Kingdom of Benin" mounted in New York by the dealer Louis Carré. Although nowadays it is generally agreed that none of these "olifants" (ivory horns) was sculpted by any of the ivory carvers in the service of the Benin *obas,* the transverse horn (p. 66) that boasts a seated figure on one end is unquestionably part of the corpus of works carved between 1490 and 1550 by Sapi artists of the Sierra Leone coast.[33]

Amongst the hundred or so brass castings selected for the exhibition, twenty-one of those well-known illustrated panels that covered the pilasters of palace buildings until the late 17th century were put on display. The plaque depicting two war chiefs (p. 132), on loan from the antique dealer Ernest Ascher, came from the collection of George W. Neville.[34] A shipping company agent who had been stationed in the British Niger Coast Protectorate beginning in 1880, Neville had also been a civilian member of the expeditionary corps that was to seize the capital of the Kingdom of Benin in February 1897. Ascher acquired this piece in May 1930[35] and sold it ten years later to the Swiss collector Joseph Mueller.

Save for a wood head that was oddly attributed to the Baule[36] and donated to the museum by the Committee of the Ivory Coast at the end of the Universal Exposition of 1900, the Trocadéro, before this event was programmed, possessed no other example of the art of Benin. In London, for instance, Rivière had to pay for a plaque featuring warriors and musicians[37] by dipping into his own salary, while Ratton offered the institution two headdresses and a ceremonial sword.[38] Soon after the opening, a carved elephant tusk, part of Captain C. H. Ringer's spoils, was purchased at the Hôtel Drouot[39] thanks to the generosity of the Musée d'Ethnographie's Friends of the Museum Society.

This association, designated in 1931 as an organisation in the public interest, had been formed "to bring together all those interested in this great museum which is currently being reorganised, and to provide it with the moral and monetary support that will contribute to enriching its collections".[40] Named president of the society at Rivière's urging, and assisted by an executive office that included Paul Guillaume and Charles Ratton, Viscount Charles de Noailles, a collector, art patron and close friend of artists and writers, in particular the Surrealists, was to gather around him some three hundred members. It is worth noting that nearly all of Paris's dealers in non-Western art at the time belonged to the society.[41]

Given the declared intransigence of those working to renovate an institution that was perceived as a scientific one at heart, such collusion with the art world and its market can hardly fail to surprise us. Nevertheless, this policy, less a compromising of principle than a question of cooperation, would prove beneficial in several ways, fostering the institution's modernisation, stimulating gifts, bequests and permanent loans, and attracting record numbers of visitors to a number of spectacular events.

Moreover, restoring the institution's ethnographic vocation implied the renewal not only of research conducted in the field, but of intensified collecting, in order to fill in "before it is too late […] the gaps marring [the] Museum".[42] Published in May 1931, just a few days before the departure of Marcel Griaule's linguistic and ethnographic mission across Africa from Dakar to Djibouti, *Summary Instructions for Collectors of Ethnographic Objects* clearly laid out the procedures for collecting objects. "A collection of ethnographic objects", it is stated, "is neither a collection of curios nor a collection of works of art. The object is no more than a piece of evidence that must be considered in terms of the information it provides about a given civilisation, and not according to its aesthetic value."[43] If "the most common objects are those that teach us the most about a civilisation […] one must not shy from collecting even the humblest, the most contemptible things".[44] given that, "in digging through a scrapheap, one can recreate the entire life of a society, usually much better than by focussing on rich or rare objects."[45]

The members of the Dakar-Djibouti Mission were to scrupulously observe these directives. The 3608 entries making up the inventory of the material they eventually sent back to the museum boast, amongst other samples of a humble daily existence, a series of "devices for hindering suckling", "pincers for plucking lashes", a "penile suspensory", a "footbath", a "chamber pot", an "anal enlarger made of common wood", a "blister punch", a quantity of "toothpicks" and "fingernail picks", a "woman's tampon of chewed tia bark", and so on.

By comparison, the samples that Denise Paulme and Deborah Lifchitz gathered in 1935 during the eight months of their collecting and research mission in Dogonland strike one as certainly more selective. Amongst the some hundred and eighty specimens collected by the two women,[46] we find some sixty statuettes, over eighty locks with incising (including certain anthopomorphic motifs), some ten decorated doors or granary shutters, seven carved heddle pulleys, four masks and a "splendid butter container surmounted by a statuette, so pretty that it will make Ratton ill".[47] Tossed off in a letter Deborah Lifchitz addressed to Michel Leiris, the observation as to the antique dealer's art-induced illness is but one of a number of such remarks sprinkled throughout the correspondence of the two young ethnologists. In the same vein, speaking of the serpentine figure discovered in Yaye (p. 78), she writes, "Let Ratton turn several shades of green […] the head gives off a profound emotion which makes this work a masterpiece in the true sense of the word."[48] In another missive, they wager a dinner at Carette's if envy doesn't provoke a change of colour when Ratton lays eyes on the Yaye figure.[49] Elsewhere she predicts that "before our collection of doors, shutters, locks, all very old and of excellent quality, some admirable […] Ratton will turn pale".[50] Couched in ironic terms, this rivalry between ethnographers and the dealer in antiques expresses a genuine sensitivity to the aesthetic of Dogon sculpture, a sentiment that is

Fig. 4
View of the Salle du Trésor (1932-1935) at the Musée d'Ethnographie du Trocadéro
On the left, the plaque featuring warriors and musicians purchased by G.H. Rivière in London in July 1931
Photograph Sage (1934), Photographic library of the Musée de l'Homme, Paris (inv. 1998.19181)

confirmed in the spontaneity of their correspondence by the frequent use of various telling qualifiers.

The collection the two ethnographers had assembled could not be immediately presented, however, following their return in October 1935, for work had begun the previous August on tearing down the old Trocadéro building. Nevertheless, the following year a series of eight photographs by Man Ray were published in *Cahiers d'art*.[51] Opening with the winding statue of Yaye, carved between the 15th and the 17th century,[52] and ending on the figure with raised arms from Nini that is depicted astride an unidentified mount (p. 85), the series revealed the originality of sculptures that, in Michel Leiris's words, "break clearly with the usual Sudanese output thanks to their surprising pathos".[53]

In June 1938, the Musée de l'Homme was inaugurated in the Passy wing of the Palais de Chaillot. Although "some regret, in the old Musée d'Ethnographie, a certain familiar air (devoid of didactic formality)",[54] the new institution, both a museum for educating the public and a scientific laboratory, hoped to fulfil the ambitions of the programme that had been worked out over the preceding decade. The hope was to join two things, the development of the sciences to which aspire "all those who have made the study of man, physical as well as psychological and social, the starting point of their aspiration toward greater rationality", and the possibility of spreading that knowledge through reconstructive modes that would make it accessible to a wide audience. Through "an entire technique of presentation [...], an artful approach to design [...], the wish to avoid detaching these objects from the

human groups that produced them, along with its opposite, asserts itself. Thus the objects – otherwise strange bits of interstellar rock detached from everything – remain connected with the humanities which gave them life."

Throughout the year following its opening, the Musée de l'Homme was an undeniable success, boasting more than 250000 visitors.[55] To keep alive the memory of their visit, a number of these visitors were to purchase an album[56] featuring forty-two relief views of the most famous specimens from the "Ethnological Laboratory of Contemporary Man and Fossil Man", a proper guide to the collections that was unavailable at the time. These views ran from the "nail fetish used for casting spells" (the Cholet dog fetish), to the plaster cast of the body of poor Saartje Baartman, the "Female Bushman, known as the Hottentot Venus".

The declaration of war and mobilisation of most of the museum's staff brought about a decline in the activities at the institution. Nevertheless, in November 1939 the Minister of the Colonies opened a show entitled "French Sub-Saharan Africa", the first of what was to be a series of temporary exhibitions devoted to "our colonial empire".[57] Because of the circumstances, however, "French Sub-Saharan Africa" was to remain the only show of the series.

In 1944, two minutes signed by Michel Leiris, dated respectively 30 March and 17 April, specified the *Inventory of objects of primary importance from the sub-Saharan department requiring protection*. These lists were short by necessity, since the totality of works singled out for safekeeping had to be contained in some thirty crates and several special packing containers. Leiris's inventory included all

Fig. 5
View of the Salle du Trésor (1932-1935) at the Musée d'Ethnographie du Trocadéro
In the second display case from the left, a Luba ivory headrest on loan from the antique dealer Charles Ratton
Photograph Laniepce (1934), Photographic library of the Musée de l'Homme, Paris (inv. 1998.6686)

the pieces now on display in the Louvre that were in the Musée de l'Homme before the war, save two reliquary lids, the statue purchased by the museum in 1898 and the piece donated by Ferrière in 1901. Although the criteria Leiris followed in drawing up the list are not made clear, we may assume that they were hardly any different from those that were later followed in the selection for the Pavillon des Sessions.

Along with the political decision taken in 1920 to begin preparations for a grand exhibition worthy of the greatest city of a vast empire, it was also agreed that the capital city would finally be provided with a museum devoted to the colonies. As the central monument of the memorable "International Colonial Exposition of Paris", this permanent museum celebrated the expansion of France overseas and, in "a kind of symphony of colonial production",[58] took stock of the civilising and economic work that had been accomplished. Jean Gallotti was appointed as "keeper of the indigenous arts" for the section intended as a synthesis, several weeks after the inauguration and hastily assembled a collection of those "ancient objects that help us understand the artistic aptitudes of the races under our protection".[59] For this group of works, Gallotti had mainly turned to several of the city's reputable dealers and collectors. Jos Hessel, the Galerie Percier and one of its stock holders, André Lefèvre, and the antique dealers Carré and Ratton provided some of the most important African works of art in their possession.[60] It would be two years after the International Colonial Exposition closed before the museum was again opened to the public. Gaston Palewski, a well-known official

in the upper colonial and political administration who was also close to art and museum circles, was put in charge of the reopening. With regard to the display of traditional arts, Palewski made no bones about his "intention to consider objects from the point of view of their aesthetic, not ethnographic, value".[61] The brevity of his mission, however, was to limit the application of this candid orientation to the organisation of a single exhibition, for which nearly 180 mostly African works were selected. Once again these pieces were lent by non-institutional collectors like Paul Guillaume and Charles Ratton, Tzara and Marcoussis, Georges Salles and Helena Rubinstein.[62] Palewski's "aestheticism"[63] had little impact on the museographic viewpoint of the institution's first official keeper, Aimé Merlo. Better known under his pen name Ary Leblond, Merlo had already proved himself at the turn of the century, along with his fellow writer Georges Athénas, alias Marius Leblond, an ardent champion of art's return to its primitive vigour.[64] From the 1920s, on the other hand, he showed little inclination to share "the infetishisation of the most sophisticated of the elites".[65] Thus, for many years Merlo would confine the museum to just a few specific roles. The institution was to serve as a kind of preliminary instruction in life in France's colonies, as a permanent salon for exotic academism, and finally as a conservatory of native handicrafts.

Nevertheless, the collections of "Negro art" in the museum, which became the museum "de la France d'Outre-Mer" or "Overseas France" in 1935, had continued to grow little by little. Besides gifts from individuals and various civil and military organisations with ties to Africa, contributions by organising committees of

colonial expositions or the colonial sections of international expositions did much to enrich the museum's holdings. We find entered in the museum inventory in 1938, for example, along with various sculptures from the remote reaches of Gabon and the middle Congo, a Mbede reliquary statuette with hollow torso (p. 181). The piece, a gift of the French Equatorial Africa Pavilion to the museum after the close of the International Exhibition of Arts and Techniques in Modern Life, had been collected around Okondja, most probably by the region's administrator André Even.

From the end of the war to the period that saw sub-Saharan states gain their independence, there were unmistakable signs of a growing attraction to sub-Saharan art that cannot be simply explained away as the last flashes of an earlier fashion. We see, for example, an increasing number of general or thematic exhibitions being held, and not only in Paris, at the initiative of individuals, associations and municipalities. Overviews, essays, catalogues and special issues of reviews were also being published regularly. Finally, a new generation of collectors had sprung up, stimulated by a market that was diversifying by bringing to light new and unexpected styles.

In the 1950s, certain young dealers, brokers, even simple art lovers travelled from village to village in Guinea, the Sudan (i.e., present-day Mali) and the Ivory Coast, occasionally in the wake of Islamic missionaries or zealots from various prophetic movements. Such was the case of two antique dealers who had recently opened a gallery on Boulevard Raspail in Paris, Hélène and Henri Kamer.[66] The couple was thus able to procure a number of pieces in the early months of 1957 in Guinea, around the town of Victoria. Abandoned by the Nalu not long before the Kamers" arrival, these cult objects included eight mbanchong headdresses that were subsequently sold to mostly American collectors, save one that was acquired by Jacques Lazard (p. 69) which entered the collections of the Musée de l'Homme in 1989. In 1958 the Kamers, in the Sudan this time, obtained four statues whose style was later attributed to the Edye-Djennenké.[67] One of these pieces (p. 88), dated to the 13th century,[68] a supple depiction of an archer with a double quiver, was sold to Pierre Loeb upon their return; in 1977 the Musée des Arts Africains et Océaniens would acquire it, exercising a right of pre-emption.

In 1954 Marcel Evrard presented a series of Dogon and Tellem works at his bookshop-gallery in Lille and later in the same city's art museum and Brussels" Palais des Beaux-Arts. These pieces had been acquired in the field by Pierre Langlois.[69] The following year Evrard financed a prospecting mission by Langlois that was one of the first to explore burial sites in the caves and faults of the Bandiagara Escarpment, and exhibited his discoveries in Paris at La Hune.[70] Evrard himself would travel to the area inhabited by the Dogon in early 1959. Some 40 of the sculptures he collected there were featured in a show at the Hanover Gallery in London in October of that year. The catalogue, entitled "Sculpture of the Tellem and the Dogon", with a preface by Michel Leiris and a brief study penned by Jacques Damase, includes the first two photographic reproductions of a figure with a raised left arm

Fig. 6
View of the "Exposition de Bronzes et Ivoires du Royaume de Bénin", Musée d'Ethnographie du Trocadéro, June-July 1932
In the display case on the right, the Sapi olifant from Sierra Leone (p. 67). At the centre, a trophy head, the property of Louis Carré at the time, serves as a base for an ornately carved tusk. Carré would sell the piece to Picasso in August 1944
Photograph Laniepce (1932), Photographic library of the Musée de l'Homme, Paris (inv. 1998.19133)

(p. 81) collected in the "Ganda [?] Region". Carved sometime between the 15th and the 17th century,[71] the piece probably comes from a burial site overlooking the village of Ireli,[72] like a similar figure collected three years earlier by Langlois and now in the Metropolitan Museum.

A carrier based in Conakry who travelled extensively throughout Western Africa during the first half of the decade, Maurice Nicaud was also an art lover knowledgeable enough to assemble a collection that stands as a reference in sub-Saharan art. In 1954[73] in the Sudan, Nicaud had the good fortune to obtain one of the noblest maternity figures of African art (p. 92). Because the wood of this statue enables us to date its execution to the 14th century, it cannot be grouped with the statuary widely attributed to the Dogon. In those years, when the craze for the arts of distant lands showed no sign of diminishing, the question already posed by Fénéon[74] in 1920 could not fail to come up again. "When will they be admitted to the Louvre?" In November 1948, at the conclusion of the opening of "Evidence of Negro Art", Hubert Deschamps, caught up in the enthusiasm of his guests, was to exclaim into a radio reporter's microphone, "And now, Negro art in the Louvre!"[75] The then director of the Palmes Bookshop where the exhibition was held, and a former governor of the Ivory Coast, Deschamps had founded in 1941, along with the sculptor Pierre Meauzé, Abidjan's Museum of Native Arts. He would also be the first professor to hold the chair of Modern and Contemporary African History at the Sorbonne. In a shift from making demands to taking action, in May 1957 the collector André Lefèvre stipulated in a notarised deed that he "bequeath [s] to the French State a statuette from the Ivory Coast, measuring 55 cm high and representing a cynocephalous monkey [p. 109], on the condition that the French State agrees [...] to display this statuette at the Palais du Louvre as soon as the directors of the Musée du Louvre recognise that the art of sub-Saharan Africa is worthy of representation in the public galleries of the said Palais".[76]

In January 1961, the Musée de la France d'Outre-Mer became the Musée des Arts Africains et Océaniens,[77] the first institution to recognise – inscribed in its very name – the aesthetic value of this art. This change of names was to cool for a time the ardour of those in favour of letting so-called primitive art into the Louvre.

To expand the collections passed on from the Musée de la France d'Outre-Mer, the sub-Saharan Africa section of the new institution was awarded various allocations by the museum trusteeship. The section was also the beneficiary of numerous bequests and long-term loans. Directed by Pierre Meauzé from 1963 to 1976, the section would occupy first two, then four galleries during this period, ensuring the permanent display of some six hundred works.

Two important public sales, in November and December 1965, enabled the museums at the Porte Dorée and the Place du Trocadéro to acquire several of the "classics" of African sculpture for their collections. Thus, when a hundred and fifty lots from Paul Guillaume's collection[78] were put on the block, the Musée de l'Homme was able to add a Vili fan from Loango to the group of sixteen sculptures that the widow of the dealer and collector had

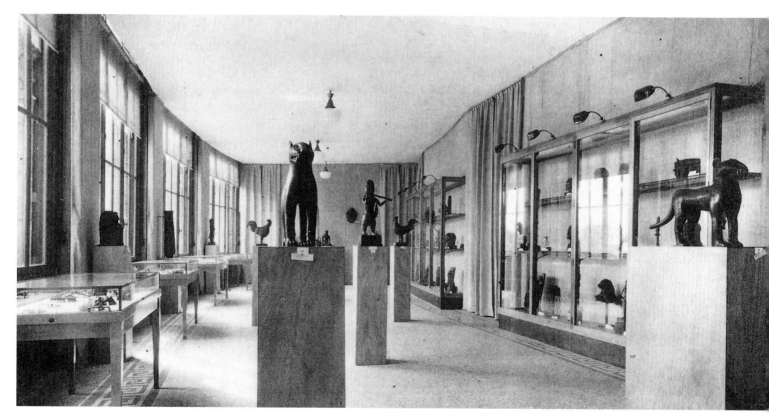

Fig. 7
View of the "Exposition de Bronzes et Ivoires du Royaume de Bénin", Musée d'Ethnographie du Trocadéro, June-July 1932
In the centre, various bronze statues that belonged at the time to the antique dealers Charles Ratton and Louis Carré
Photograph Laniepce (1932), Photographic library of the Musée de l'Homme, Paris (inv. 1998.19134)

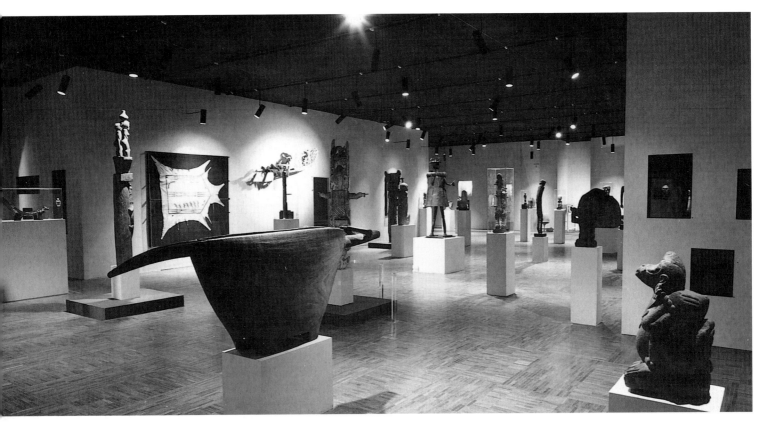

Fig. 8
Partial view of the show "Chefs-d'œuvre du Musée de l'Homme", April-October 1965
Of special note amongst the works on display (from left to right), the Sakalava cenotaph (p. 211), the Yangere slit drum (p. 186),
the effigy of the god Gu (p. 111), and the winding sculpture of Yaye (p. 78)
Photograph X (1965), Photographic library of the Musée de l'Homme, Paris (inv. C65.2708.493)

given the museum in 1941, while the Musée des Arts Africains et Océaniens obtained a Fang reliquary statuette (p. 156) along with the famous Yohure hornbill mask. Having been first reproduced in 1922 in Wilhelm Hausenstein's study *Barbaren und Klassiker* and two years later in *L'Esprit nouveau,* the journal promoting Ozenfant and Jeanneret's purist theories, the Fang statuette travelled to the Durand-Ruel Galleries of New York in 1933 along with several other *bieri* from the Guillaume Collection. There they were displayed next to some thirty works by André Derain in a show contrasting these two distinct classicisms.

On 13 December 1965 the Hôtel Drouot auction house[79] put up for sale part of the "Negro art" collection that the banker André Lefèvre had begun assembling at the end of World War One. This auction, along with the gradual accumulation of over two hundred and thirty works by contemporary artists, gave the Musée des Arts Africains et Océaniens the chance to acquire six objects from this prestigious source. And while complementing a 1954 bequest of thirteen pieces, the Musée de l'Homme was able to obtain, along with four containers from the Belgian Congo, one of a rare number of white masks with a drawn-out oval face (p. 170), the so-called "Modigliani Fang". This piece, moreover, drew the day's highest bid.

Between 1965 and 1972 the Musée de l'Homme mounted five exhibitions in succession under the auspices of a rather active Friends of the Museum Society headed by Alix de Rothschild. These events proved highly popular thanks to the diversity of their themes, the quality of their presentation (due in large measure to the expertise of their curator, Marcel Evrard), and the elegance and

wealth of information of the accompanying catalogues. The first show, entitled "Masterpieces of the Musée de l'Homme" (a provocation in the eyes of a few distressed scholars), included twenty-four "works of art" for its African section, all selected "from the point of view of form alone".[80] According to Jacqueline Delange, the head of the sub-Saharan Africa department at the time, "If an ethnology museum puts on display the most beautiful of its works of art, and essentially puts them on display as such, then the time has come when they can be admired, like the masterpieces of historical civilisations, for what they are, beyond their immediate scientific interest, i.e., as perfect expressions of aesthetic values that are peculiar to the culture from which they spring."[81] Nearly half of those African "masterpieces", labelled as such in 1965, are now on permanent display in the Louvre.

In 1966, "Arts Connus et Arts Méconnus de l'Afrique Noire – Collection Paul Tishman" ("Known Arts and Unknown Arts of Sub-Saharan Africa"), the second of the shows put together with the help of the Friends of the Museum Society, featured a group of a hundred and forty pieces selected by Jacqueline Delange and Marcel Evrard from the Paul Tishman Collection. In less than ten years,[82] this American entrepreneur, spezializing in public construction projects, had assembled a very handsome collection. From 1967 to 1971, the selection from the Tishman Collection, modified according to the collector's ongoing purchases, would travel extensively, from Jerusalem to seven cities in the United States. In 1968, for example, at the County Museum in Los Angeles,[83] two new pieces were added to the show: the commemorative effigy of Bay Akiy (p. 147), a deceased sovereign of the small

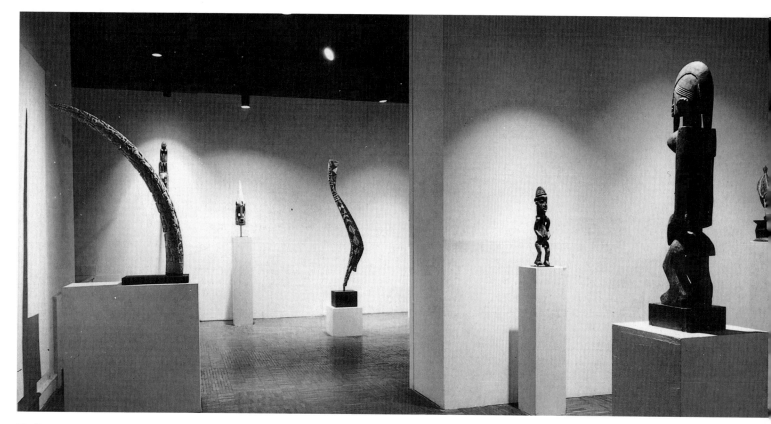

Fig. 9
Partial view of the show "Arts Connus et Arts Méconnus de l'Afrique Noire – Collection Paul Tishman", Musée de l'Homme, March-December 1966
In the middle of the seven sculptures pictured here can be seen one of the Nalu headdresses collected by Hélène and Henri Kamer in 1957
Photograph José Oster, Photographic library of the Musée de l'Homme, Paris (inv. D66.2181.493)

Cameroon kingdom of Isu, this piece having been purchased the year before from Hélène and Henri Kamer; and the sceptre (p. 200) whose ivory finial represents the divinatory power symbolically conferred upon hunting dogs by the Kongo. In 1970, at the Virginia Museum in Richmond,[84] another Kongo emblem (p. 203), a kneeling female figure also sold by Hélène Kamer, became a part of the exhibition. These three works of art also figured in the exhibition "For Spirits and Kings – African Art from the Tishman Collection", which was mounted at the Metropolitan Museum of Art, New York, in 1981. This last event served as a "prelude"[85] to the opening the following year of an entire wing of the museum devoted exclusively to the so-called primitive arts.

The following decade began with an unprecedented exhibition that was to make an enduring mark on its visitors. In late October 1970, "Die Kunst von Schwarz-Afrika" opened at Zurich's Kunsthaus. The show brought together 1172 objects on loan from museums, galleries and private collectors in Europe, the United States and Africa. Offering multiple variants of each of the "ethnic" styles treated, the show brilliantly demonstrated the creative resources displayed by African artists. "Die Kunst von Schwarz-Afrika" also drew extensively upon the collections of French institutions and individuals, including the Musée de l'Homme, the Musée de la Porte Dorée, private collectors like Pierre Guerre, Maurice Nicaud and André Fourquet, and some specialised antique dealers from Paris such as Charles Ratton, Jean Roudillon, Pierre Vérité, Hélène Kamer, René Rasmussen and Robert Duperrier. At this time Jacques Kerchache had a gallery along Rue de Seine[86] where he was introducing, and winning respect for,

singular works executed in styles often unknown to the public. He lent the Kunsthaus forty-eight sculptures, including the ivory finial of a Yombe power staff (p. 197), which arrived in Belgium sometime before 1914.[87]

On 4 November 1972, *Le Figaro* boldly announced this title on its front page, "Negro Art Enters the Louvre"! Readers soon got to the bottom of the editorial dodge when they read the newspaper's more discreet subtitle,[88] "With the Orangerie exhibition". This was the Louvre, perhaps, but not the Palais du Louvre. Curated by Pierre Meauzé, the show featured nearly three hundred and fifty sculptures from public collections in the capital and ten other French cities. Not surprisingly, all of the works selected for the Pavillon des Sessions and coming from these various institutional collections figured in the Tuileries show, including the Nimba mask (p. 71) that had belonged to the Muséum de Toulouse since 1938. The only pieces absent from the display were the *bieri* figure with a whistle from the Musée de l'Homme and the predynastic statuette (p. 63) from the collection of Lyon's Musée Guimet.

In March of the same year appeared the first issue of a quarterly magazine devoted exclusively to the arts of sub-Saharan Africa. Founded by the scholar, collector and independent publisher Raoul Lehuard, *Arts d'Afrique*[89] began to offer readers, along with numerous thematic articles, regular columns on exhibitions, publications and public auctions, an incomparable source of information that has demonstrated for nearly three decades the vitality of a passion shared by an increasing number of art lovers. The cover of the review's first issue pictured the major work of Teke sculpture (p. 184), the *bitegue* statuette collected in 1924 some

sixty kilometres north of Brazzaville by the publisher's father, Robert Lehuard, who then worked as an engineer in the middle Congo.

Throughout the 1970s the trade in African objects intensified. The frequency of public sales bears witness to this bullish market for things African, with over fifty auctions at the Hôtel Drouot. Similarly, the number of specialised galleries was to grow, reaching close to thirty by the decade's end. Some of these galleries even treated audiences that went beyond potential buyers to temporary displays of works from the same culture that were either unknown or rarely exhibited together. In June 1974, for example, at Jacques Kerchache's gallery, art lovers could return to "the sources of sculpture"[90] through the hieratic statuary of the Lobi, then go on to discover, at Hélène Kamer's, some ten venerable Mbembe ancestors, namely, figurative finials decorating the large slit-gongs of southeastern Nigeria. Several months prior to this, Hélène Kamer had sold to the Musée de la Porte Dorée an example of this type of sculpture (p. 137),[91] a drum finial probably dating back some three centuries.[92]

In January 1980 "Treasures of Ancient Nigeria", an extensive cross-section of the terracotta, bronze and ivory sculpture produced in that country, opened at the Detroit Institute of Arts the start of a long itinerary that stretched from Los Angeles to Leningrad with a number of museums in between, including London's Royal Academy, Paris's Grand Palais and Florence's Palazzo Strozzi. The show would enable hundreds of thousands of visitors to discover the existence of an art dating back many centuries in Africa, and to take note – not without surprise on their part – of the classicism of African sculpture in the most distant periods of the continent's past. On the other hand, the modernism of African sculpture, its "affinities" with some of the most innovative works from a century of European and American art, was celebrated in the monumental exhibition "Primitivism in 20th Century Art", mounted at the Museum of Modern Art in 1984. That same year the Center for African Art in New York, which was created at the urging of a group of American collectors, devoted its opening exhibition to the "African Masterpieces from the Musée de l'Homme". With two exceptions, all of the Trocadéro sculptures now on display at the Louvre were part of the one hundred masterpieces shown in New York. These included the Baule mouse oracle with a figure in three dimensions (p. 105) and the ceremonial anthropomorphic ladle (p. 209) that has been attributed to the Zulu.

As a private institution along the lines of the Center for African Art or the Musée Barbier-Mueller in Geneva, the Musée Dapper in Paris was to capture the attention of more than six hundred thousand visitors over a twelve-year period following its creation. Those years were marked by a significant number of exhibitions at the Dapper, twenty-five in all, along with the publication of an equal number of accompanying catalogues. Mounted in June 1986, the museum's very first exhibition, "Openings on African Art", conceived to promote the public's appreciation and awareness of traditional sub-Saharan arts, was held simultaneously in its own galleries and at the Musée des Arts Décoratifs. The latter venue featured some 50 pieces illustrating "the diversity of African works of art both in their power to express and in their formal perfection".[93] Finely chiselled with a firm, sure hand yet measuring just 8 cm, a Waan ivory pendant[94] (p. 195) demonstrated that African artists, when faced with that test of skill that the

miniature poses, did not succumb to affectation and showed themselves quite capable of working into these tiny carvings, with the same resolve, the hallmarks of large sculpture.

The keepers of the Musée National d'Art Moderne wanted to furnish the museum's collections with a few of the "primitive" works of art that had piqued the interest of modern artists and those close to them, writers on art and dealers. The first acquisitions to this end were made during the 1980s, thanks to auctions and various donations. In 1982, for example, the museum obtained the Fang mask that had already passed from Vlaminck's to Derain's studio in 1906 and which Ambroise Vollard later produced a bronze replica of with the help of Aristide Maillol's founder. Apollinaire's "nail fetish" was added to the museum in 1984. And at the close of the decade, in 1989, the museum acquired from the Daniel Cordier Collection several specimens of Kuba raffia cloth similar to pieces that Matisse, Braque and Marcoussis had themselves once owned. In 1984, the widow of the painter Alberto Magnelli made a bequest to the museum, a group of 30 African sculptures[95] selected from some 180 mainly sub-Saharan pieces that the artist had collected before he died in 1971. These included the Fang reliquary figure (p. 159) presented at the Pavillon des Sessions. Through the dynamic structure of its volumes which "answer" one another in a kind of spatial anti-phony, the Fang statue makes clear "the very nature of sculpture" which Magnelli, as he declared, was "specifically" seeking in "the sculptural power and invention of forms" that "Negro art" displayed.[96]

At Jacques Kerchache's initiative, the French daily *Libération* published a manifesto on 15 March 1990 entitled, *Let the master-pieces of the world over be born free and equal*. This document, drawing more than a hundred and fifty signatories[97] from the world of the arts and culture, demanded the immediate creation of an eighth department at the Louvre, to conserve and display exemplary works of art from Africa, the indigenous Americas, Island Southeast Asia and Oceania. Refusing to interfere with the overall plan for the future "Grand Louvre" that had been worked out in 1984, the museum trusteeship, creating a diversion as it were, granted the Musée des Arts Africains et Océaniens several months later[98] an institutional status identical to the one then governing any of the Louvre's seven existing departments.

Of course the institution, now a national museum dedicated to the arts of Africa and Oceania, the Musée National des Arts d'Afrique et d'Océanie, was indeed to benefit from provisions that enabled the directors, while continuing the reinstallation of the museum's display galleries, to reinforce its acquisitions programme and conceive a number of important temporary exhibitions with the active assistance of the Réunion des Musées Nationaux. One direct consequence of this promised renewal of the Musée de la Porte Dorée was the decision taken in 1991 by Pierre Harter, the respected specialist of the highlands of western Cameroon, to donate to the museum a group of fifty-three sculptures from the Grasslands kingdoms.[99] These included one of the major works, a *tukah* mask (p. 152), that the sovereign of Bamendu had offered to Harter in 1957. To this already imposing bequest, which has been on display since 1993 in a specially designed gallery, Harter added another donation the following year, an exceptional Bangwa maternity statue (p. 143) which the antique dealer Jean-Michel Huguenin had sold to the scholar and collector in June 1967.[100]

The purchase in 1996 and 1997 of two hundred and seventy-six Nigerian pieces from the Barbier-Mueller Collection[101] was spectacular proof of France's wish to extend its African cultural heritage to stylistic areas represented by only a few rare examples in the national institutions. This rich acquisition of works includes four major pieces exhibited today in the Pavillon des Sessions. There is a monumental Urhobo statue of a nursing mother (p. 135), which stood for nearly a century in a sanctuary in Eghwerhe, symbolising the permanence of the warrior clan that had founded the community. This sculpture was to figure, after its acquisition by the antique dealer Philippe Guimiot, in the exhibitions mounted in the 1970s in Antwerp and Brussels,[102] demonstrating that collectors and dealers in Belgium did not limit their tastes to works from Zaire. Along with the Neville plaque, the Barbier acquisition also boasted another work of the dynastic art of Benin, a trophy head (p. 128) that is a thin casting using a copperlike alloy and dating from the initial period (late 14th-first half of the 16th century) of metalwork. Frederick Wolff-Knize acquired this head in May 1934 in Berlin at auction,[103] and the piece subsequently came into the possession of the Zurich collector Peter Schnell in 1963 before being purchased by the Barbier family in 1989. Finally, there is the terracotta head and presumed portrait (p. 126) of a "servant" at the court of one of the divine kings who ruled in the holy city of Ile-Ife. To this day, the head remains the sole and unique example in France's public collections of this ancient civilisation, whose arts reached their peak between the 12th and the 14th centuries.

Administrative measures taken at the start of the 1990s raised to the rank of "Grand Département" an establishment now designated to become as it were the "extramural" Louvre of exotic arts. Yet this did not lessen the determination of those who remained convinced that the "world's largest museum", the summit of artistic legitimacy in the eyes of its millions of visitors, would never be complete in the absence of these "major works produced by three quarters of humanity".[104] Sharing these convictions, the President of the Republic expressed, at the start of his term in office, his firm intention to "give the arts of Africa, the Americas and Oceania a just place in our cultural landscape".[105] On 7 October 1996 President Jacques Chirac ordered the creation of a Musée des Arts et Civilisations. As the Élysée's communiqué[106] expressly stated, this institution "will have at its disposal the Sessions hall within the Louvre, where the most prominent masterpieces of the primitive arts will be put on display".

Jacques Kerchache was subsequently appointed to both carry out this selection of "prominent masterpieces" within the collections in the public domain, and propose, to the officials concerned, the purchase of pieces considered indispensable to fulfilling the "exemplary" aspect that the Louvre selection was meant to embody. Special funds were allocated to this end. In 1998 and 1999, eight sculptures that were then without equal in French museums were added to the works making up this national collection. First, with the accord of the Nigerian government, France acquired four archaeological specimens illustrating the most prestigious artistic phases in the history of this African country. While the Musée de la Porte Dorée did indeed possess a few fragments discovered in the alluvial strata of a region extending beyond the findsite of the so-called Nok culture, it was decided that the new collection ought to obtain more complete remains of

this truly ancient civilisation, statues capable of reflecting the grandeur of what was perhaps the oldest centre of figurative sculpture in Western Africa. The purchase of two terracottas from a private collection was negotiated with this in mind. One of these pieces (p. 115), representing a seated male figure whose head rests on the knee of one of his bent legs, is attributed to the Katsina Ala style[107] because of the characteristic elongation of the face. The style's designation comes from the name of one of the most southern sites where relics of the Nok culture have been excavated. The other (p. 119), perhaps a vase used in a local cult or the summit of a sanctuary or altar, was chosen because of the diversity of its iconographic registers. Sokoto pottery, missing from France's national and territorial collections until recently, was discovered in the early 1990s at sites lying along the southern zone of the Nok civilisation's probable range. The pottery is distinguished by a number of differently emphasised formal innovations, such as the highly stylised treatment of the head of a bearded male figure (p. 122), modelled between the 5th and 1st centuries BCE. The earliest Ejagham monoliths, on the other hand, which figure amongst the some three hundred that were erected exclusively in the villages of the Bakor clan, were apparently sculpted at a later date in the early 16th century. Yet analyses of the stratigraphic context of Emangabe, a locality of the Nnam subclan, yield a much earlier dating corresponding to the late 2nd century CE.[108] The austere statue from Etinta vigorously carved in basalt (p. 139), along with the isolated head conserved in the Musée de la Porte Dorée, evinces a style that is associated with the steles of the Nta lineage. This is also the case of the Berlin Museum monolith, whose photographic reproduction was the opening image in the album of illustrations of Carl Einstein's La Sculpture nègre.

Thanks to the budget allocated by the state, four other sculptures, dating from a more recent age, though of no lesser quality, now fell within the means of the proposed new collection. Along with the Teke statuette from the Lehuard Collection and the raised-arm figure collected in Dogon area by Marcel Evrard, the purchase included a male figure from Guinea-Bissau and a rare Nuna sculpture from Burkina Faso. The former is the Orebok spirit effigy (p. 75), plundered in February 1853 on Caravela Island during the punitive mission carried out by the French in the Bissagos Archipelago. The statue was not only the first important object of the Bidjogo culture to be brought back to Europe, but in the eyes of certain connoisseurs it is clearly the Guinean islanders'"masterpiece". The Nuna statue (p. 99), which has never previously been shown in public, decisively breaks with the usual image of Volta decorative arts that the "ethnic" art market offers in endless supply. In truth, this statue stands at the meeting point of several cultures, but beyond that fact, notably through the restrained power of its forms combined with the concentration of its expression, the piece embodies a number of values that lend African statuary its profound originality and dignity.

Along with these purchases, the proposed new collection was enriched by several donations. Through the generosity of Anne and Jacques Kerchache, the collection now includes a Yombe ivory. This carving was an emblem of mystical and political power with which the traditional figures of authority were invested. Donated works also include three sculptures from the collection that Hubert Goldet passionately built up over a period of nearly thirty years to make it one of the five most important private collections in Paris. Dating from the same period (14th century) as the female cup-

bearer of the Museum Rietberg and in all likelihood carved by the same hand, the maternity statue of the Goldet Donation would appear to come from the Bandiagara plateau, either to the north (Tintam or the surrounding villages) or eastern central area (Tombo region). Its exact provenance eludes the specialists, however.[109] The Dogon statuette (p. 95), which the Swiss broker Emil Storrer probably purchased from Charles Ratton at the very start of the 1960s, has been attributed to the "Master of the Oblique Eyes",[110] who was active in the 17th or 18th century in the region of Nduleri. Finally, the Luba headrest (p. 189), the work of a master sculptor from the small kingdom of Kinkondja, is one of only two known examples of headrests with a pair of caryatids that are culturally distinct. One, boasting a "cascade headdress, depicts a Shankadi figure, the other, with a cruciform headdress, a Hemba. Clearly, this iconographic disassociation, transgressing the supposed homogeneity of "ethnic" styles, does not disrupt the unity and balance of this "dream support". Goldet acquired it in 1988, but throughout the 1920s and up to 1933, this headrest had belonged to Baron Henri Lambert, one of those great Belgian collectors whose residences boasted art from all over the world displayed side by side, intelligently and to the best advantage.

Various institutions have also generously placed on permanent loan with the Louvre several major works. The Musée National d'Art Moderne, for example, has lent the Fang reliquary statue that once belonged to Magnelli. The Muséum de Toulouse has parted with the Baga shoulder mask, and Lyon's Musée Guimet with the schist figure from upper Egypt dating from the 5th or 4th millennium BCE. Finally, Walt Disney Imagineering, which has owned the Tishman Collection since the second half of the 1980s, has offered the two Kongo ivories and the statue-portrait representing the king of Isu.

"Will they be admitted to Louvre?" Finally, the "classics" of African sculpture, neither incongruous nor marginal, have been accepted without condescension into this museum, a place symbolising "transformation" that both completes the secularisation of these objects of belief, and revives their presence as sculpture. As André Malraux put it, "A work arises in its age and of its age, but it becomes a work of art by what escapes from it."[111] It behoves this great museum, with its universalist aspirations, to grasp "what escapes from it", from the work of art, and to share this with the broadest possible audience, namely "the power of art to surpass its cultural limits".[112] Responding to a survey conducted by her friend Félix Fénéon, the painter and writer Lucie Cousturier concluded her answer in these terms, "When [...] the Louvre accepts Negro art, it will find not its complement, but its principle. Indeed, this is perhaps how, in reverse, a museum is put together."[113]

JEAN-LOUIS PAUDRAT
Translation: John O'Toole

1 The expression is Léon Guiral's. He was the collector and donator of one of these pieces.
2 *African Negro Art*, 1935, no. 377.
3 A. Malraux, 1952, pl. 407.
4 R. Verneau, 1916, vol. XXVII.
5 M. de Zayas, 1916, pl. 25.
6 G. Apollinaire, 1991, "Sur les musées".
7 G. Apollinaire, 1991, "Exotisme et Ethnographie".
8 A. Basler, 1929, pl. 43b.
9 L. Perrois, 1972, p. 66.
10 M. de Zayas, 1916, pl. 23.
11 V. Markov, 1919, pls. 62-67.
12 *Ibid.*, pl. 55. This cast was a gift to the museum from the Brussels Society of Anthropology in 1892.
13 See *infra*, p. 210.
14 H. Seckel-Klein, 1998, pp. 247 and 249.
15 C. Einstein, 1915, pls. 7-11.
16 H. Labouret, 1923.
17 *Exposition d'art africain et d'art océanien*, 1930, no. 153 repr.
18 G.H. Rivière, 1930, p. 311.
19 G.H. Rivière, 1929, p. 58.
20 *Ibid.*
21 P. Rivet and G.H. Rivière, typed note dated 14 December 1931, quoted by J. Jamin, 1989, p. 117.
22 G.H. Rivière, 1929, p. 58.
23 G.H. Rivière, 1931, quoted in *La Muséologie selon Georges-Henri Rivière*, 1989, p. 94.
24 G.H. Rivière, 1930, p. 310 and p. 311.
25 G.H. Rivière, 1932.
26 M. Leiris, 1934, p. 325.
27 *Bulletin du musée d'Ethnographie du Trocadéro*, July 1931, no. 2, p. 59.
28 *La Liberté*, 16 June 1932.
29 In a letter to Henri Lavachery dated 4 October 1930, C. Ratton informs him that Rivière, whom he had met the preceding evening, had accepted the proposal for a show touching on the art of Benin to be mounted by him (C. Ratton archives).
30 Separately printed from the second part of *Cahiers d'art: Exposition Picasso aux galeries Georges Petit, Bénin*, vol. VII, nos. 3-5, 1932.
31 C. Zervos, 1932, note p. 1.
32 G.H. Rivière, 1935.
33 E. Bassani and W.B. Fagg, 1988, no. 201, p. 250.
34 On George W. Neville and his collection, see A.E. Coombes, 1994.
35 *A Catalogue of the Highly Important Bronzes, Ivory and Wood Carvings from the Walled City of Benin [...] forming the collection of the late G.W. Neville [...] which will be sold by auction [...] by Messers. Foster*, London, 1 May 1930, no. 40, "A Plaque, cast in relief with two figures of Benin Warriors". Purchased by E. Ascher for £99.15.
36 Inv. M.H. 00.44.1.
37 *A Catalogue of Fine Bronzes, Ivory and Wood Carvings [...] which will be sold by action by Messrs. Foster*, London, 16 July 1931, no. 82.
38 Inv. M.H. 32.49.1 and M.H. 32.49.3. The headdresses are more probably from Dahomey than the kingdom of Benin.
39 *Vente de sculptures anciennes d'Afrique, d'Amérique et d'Océanie*, Paris, Hôtel Drouot, 22 June 1932, no. 6.
40 Nonpaginated inset in the catalogue *Exposition de bronzes et ivoires du royaume de Bénin*, 1932.
41 See the list of members of the Society in an appendix to the general assembly report, 29 May 1931.
42 *Instructions sommaires pour les collecteurs d'objets ethnographiques*, 1931, p. 7.
43 *Ibid.*, p. 8.
44 *Ibid.*, pp. 8-9.
45 *Ibid.*, p. 9.
46 Inv. M.H. 35.105.1 to 35.105.184.
47 D. Paulme, 1992, p. 64.
48 *Ibid.*, p. 85.
49 Letter quoted in *African Masterpieces from the Musée de l'Homme*, 1985, no. 14, p. 122.
50 D. Paulme, 1992, p. 33.
51 M. Leiris, 1936, pp. 192-99.
52 14C analysis conducted at the Eidgenössische Technische Hochschule of Zurich: CE 1482-1657.
53 M. Leiris, 1936, p. 194.
54 This quotation, as well as the following two, are excerpted from M. Leiris, 1938, pp. 344-345.
55 *Le Musée de l'Homme – Bulletin mensuel d'informations*, 1939, no. 4, p. 7.
56 *Musée de l'Homme en relief par les anaglyphes* [1939].
57 *Le Musée de l'Homme – Bulletin mensuel d'informations*, 1939, no. 6, p. 1.
58 "Le Musée permanent des Colonies", 1931, p. 23.

59 J. Gallotti, 1931b, np.
60 J. Gallotti, 1931a, p. 70.
61 C. Noll, 1987, p. 52 and p. 53.
62 See *Musée des colonies et de la France extérieure, Cahier des entrées,* 28 July to 15 November 1933, pp. 360-378.
63 D. Taffin, 1993, p. 140, p. 141 and p. 144, note 16.
64 P. Dagen, 1986, p. 36 and p. 37; P. Dagen, 1998, p. 6 and p. 123.
65 M.-A. Leblond, 1924, p. 278.
66 Information on the activities of Hélène and Henri Kamer, Hélène and Philippe Leloup, as well as Hélène Leloup's personal efforts, has been provided by Hélène Leloup over the course of several interviews with the author.
67 H. Leloup, 1994, p. 119 sq. The attribution to the Edye-Djennenké was confirmed by H. Leloup during an interview with the author in December 1999.
68 ¹⁴C analysis conducted at the Eidgenössische Technische Hochschule of Zurich: CE 1197-1295.
69 P. Langlois, 1954.
70 B. Gheerbrant, 1988, p. 41 and p. 189.
71 ¹⁴C analysis conducted at the Eidgenössische Technische Hochschule of Zurich: CE 1464-1643.
72 According to a personal communication of M. Evrard to G. Viatte in April 1999.
73 According to a personal communication of M. Nicaud to H. Goldet.
74 F. Fénéon, 1920a; F. Fénéon, 1920b; F. Fénéon, 1920c.
75 H. Deschamps, 1975, p. 294.
76 Excerpt from administrative documents communicated by G. Viatte to the author.
77 D. Taffin, 1999, p. 115.
78 *Ancienne Collection Paul Guillaume – Art nègre,* 1965.
79 *Collection André Lefèvre – Art Nègre Afrique, Océanie, Divers,* 1965.
80 J. Delange, 1965, p. 44.
81 *Ibid.,* p. 45.
82 For the most part purchased from Hélène and Henri Kamer.
83 R. Sieber and A. Rubin, 1968.
84 *Special Addendum, Sculpture of Black Africa – The Paul Tishman Collection,* 1970, no. 79.
85 "An Exciting Harbinger", in P. de Montebello, 1981, p. 5.
86 Jacques Kerchache was to run his gallery for 15 years. Following its closing in 1980, he put an end to his commercial activities and devoted himself to mounting numerous shows and preparing several publications. He also carried out personal research towards establishing an inventory of the world's heritage of non-Western arts.
87 E. Leuzinger, 1970, no. S17, p. 272.
88 "Sculptures africaines dans les collections publiques françaises", Orangerie des Tuileries, 7 November 1972 – 26 February 1973.
89 The title of this publication was changed to *Arts d'Afrique noire* beginning with the second issue. With the autumn 1990 issue, the subtitle "Arts premiers" was added.
90 J.-D. Rey, 1974, p. 12.

91 This sculpture was not displayed during the show, but did figure on the frontispiece of the catalogue.
92 Referring to the Mbembe drum finial conserved at the Beyeler foundation, L. Homberger (1998, p. 284) writes: "Carbon-14 tests allow specialists to date drums showing the same treatment to three hundred years."
93 *Ouvertures sur l'Art africain,* 1986, p. 7.
94 Reproduced in *ibid.,* p. 17. This pendant from the former C. Ratton Collection was generously donated to the French national collections in 1997 by G. Ladrière.
95 The Donation Susi Magnelli was the subject of a temporary show *(La Collection africaine d'Alberto Magnelli – Donation Susi Magnelli)* which was held at the Musée National d'Art Moderne from 1 February to 20 March 1995.
96 Declaration made by Alberto Magnelli in *Arts primitifs dans les ateliers d'artistes,* 1967, np.
97 Other signatures were added to the original 150 after publication of the manifesto.
98 By decree no. 90-934 dated 19 October 1990.
99 See *Legs Pierre Harter,* 1993.
100 Information kindly provided by J.-M. Huguenin.
101 *Arts du Nigeria – Collections du musée des Arts d'Afrique et d'Océanie,* 1997.
102 *Sculptures africaines – Nouveau regard sur un héritage,* 1975, no. 38; *Arts premiers d'Afrique noire,* 1977, no. 43.
103 Sale in Berlin of paintings and various *objets d'art* at R. Mosse's, 29 May 1934: lot 177 was acquired by F. Wolff-Knize for 1000 marks. Wolff-Knize purchased the plaque featuring a crocodile head (inv. M.H. 39.69.1), which he donated to the Musée de l'Homme in 1939 following C. Ratton's advice. The trophy head would be put on the block at Sotheby's in London on 10 June 1963, lot 149, during the sale at the auction of *Primitive Works of Art from the Collection formed by the late Mr Frederick Wolff-Knize.* On 4 July 1989 J.P. Barbier acquired it for the equivalent of 14 millions French francs.
104 The expression is drawn from the 1990 manifesto.
105 The terms are Alain Juppé's and date from January 1996, when the prime minister invited Jacques Friedmann to address to the President of the Republic "a proposal to reorganise, enrich and display to advantage the national collections in this domain".
106 Carried by Agence France-Presse, 7 October 1996.
107 B. de Grunne, 1998, p. 23 and p. 42.
108 E. Eyo, 1986, p. 103.
109 After localising the atelier in Tintam, a suzerain community dominating 17 surrounding villages, Hélène Leloup has since returned to the conjecture that it may well lie further south, in the region of Kendie in Tomboland (pers. com., April 1999).
110 Attribution proposed by H. Leloup, 1994, p. 177 and p. 178.
111 A. Malraux, 1957, p. 32. On "this theme of the resurrection of forms, i.e., their metamorphosis, which is at the heart of Malraux's thinking about art", see J.-P. Zarader's penetrating essay, *Malraux ou la pensée de l'art* (1998).
112 K. Varnedoe, 1987, p. XIII.
113 F. Fénéon, 1920a, p. 669.

Notice to the reader

Wood dating

Carbon-14 analysis by the Eidgenössische Technische Hochschule Institut für Teilchenphysik, Zurich (The Particle Physics Institute, Science and Technology University, Zurich)

When alive, plants contain an unvarying proportion of carbon-14 (^{14}C) to carbon-12. However, when, say, a tree is felled, the quantity of carbon-14 slowly decreases, halving every 5730 years. It is thus possible to determine when the wood from which a sculpture is made was cut down by assessing the residual proportion or carbon-14 atoms and comparing it to the proportion in a piece of wood dating from 1950 CE (in the Common Era)[1].

These measurements are obtained using accelerator mass spectrometry (AMS). The result of a carbon-14 analysis expresses the age of the radiocarbon in years B.P. (Before Present, the present being, by convention, 1950 CE), with a specified margin (here, 50 years either way): for example, 780 +/- B.P., which translates as 1120-1220 CE. However, this date does not give the historical age, with the actual age of the wood when it was cut down.

Furthermore, natural physio-chemical or biological processes may also cause variations in the proportion of carbon-14. In order to gauge these, and to correct the results, we measure the stable isotope, carbon-13 (^{13}C), the proportion of which does not vary with time. The isotopic measurement of ^{13}C is expressed as the difference, $\partial^{13}C$, between the $^{13}C/^{12}C$ ratio in the sample and the ratio in standard carbon, the reference value for wood being $\partial^{13}C = -25\%$. A variation of 1% in the value of this ratio corresponds to a correction of 16 years. If the value is above -25%, the correction will be greater, i.e., older, and vice versa. For example, $\partial^{13}C = -15\%$ means adding 16 years to the age determined by carbon-14.[2]

Next, a measuring curve, which is plotted to a high degree of precision using carbon-14 measures taken on tree rings of known age (dendrochronology), is used to calculate a historical age on the basis of the radiocarbon age. Because of the statistical imponderables involved in carbon-14 dating and the measuring curve, it is not possible to calculate a precise historical age, only to give a time bracket within which the real age falls, give or take a certain degree of probability. Moreover, nature itself causes temporal variations in the carbon-14 and these imply ambiguities in certain historical periods, meaning that the real age of the wood may fit into several different time brackets (generally more than two for objets less than 300 years old)[3], each with a different degree of probability. By convention, the intervals used correspond to a total probability of 95%. Thus, the result mentioned is determined by that value. For example, when the period established corresponds to a date of 1197-1295 CE, with a probability of 100%, this measurement must be corrected by a preliminary reliability rating of 95%, this rule applying to all time brackets mentioned in the catalogue in the form of a date (CE/BCE) followed by a probability rating, even when this is 100%.

Obtained by dendrochronological correction, the calibrated dates or periods were calculated using the CalibETH programme (see T.R. Niklaus, G. Bonani, M. Simonius, M. Suter and W. Wölfli, "CalibETH: An Interactive Computer Program for the Calibration of Radiocarbon Dates", *Radiocarbon*, vol. 34, no. 3, 1992, p. 483-492).

For example, the results of the wood analysis (concerning the date of felling) on the Ifugao sculpture from the Philippines (p. 237) were formulated in the following terms: the carbon-14 dating carried out on the wood of the sculpture by Dr. Georges Bonani of the Eidgenössische Technische Hochschule, Institut für Teilchenphysik, Zurich, produced the following result: ETH-20604 (test identification number): 535 +/- 40 B.P.; $\partial^{13}C$ [%]: -23.3 +/-; calibrated periods: 1310-1353 CE with a probability of 18.5%, 1384-1444 CE, with a probability of 81.5% [bearing in mind that the total reliability index for these two time brackets or calibrated periods is 95%].

In other cases, when dendrochronological analysis pointed to results that were very definitely outside the period when the work was made, these intervals are not mentioned. Thus the result for the Hawaiian sculpture M.H.79.10.11 (p. 323) is as follows: ETH-20612: 175 +/-40 B.P., $\partial^{13}C$ [%]: -23.6 +/- 1.1; calibrated periods: 1659-1823 CE with a probability of 70.7%, 1832-83 CE with a probability of 10.9% [but since we know that the work was discovered in Hawaii in 1877 and entered the Musée Ethnographique du Trocadéro in 1879, this can be reduced to 1832-77. Likewise, the other time bracket calculated using the programme, 1912-55 CE, with a probability of 18.4%, was eliminated].

Notes

1 CE, standing for the Common Era (equivalent to the Christian Era AD, Anno Domini).
2 S. Bowman, R*adiocarbon Dating. Interpreting the Past*, London, British Museum Press, 1995, p. 21.
3 Regarding objects less than 300 years old, it should be noted that temporal variations in the production of 14C often produce imponderables in measurements (with as many as five possible time brackets for the real age). Carbon-14 analysis of samples from this historical period is thus not always decisive. In such cases, it is advisable to refer to complementary information or other data (historical or stylistic evidence, etc.). Likewise, certain temporal findings can be excluded if these come later than the attested date when the work in question was collected.

Catalogue

AFRICA

Predynastic Amratian-style sculpture

5th-4th millennium BCE
Egypt

Bearded man

Stone (schist)
H. 31.5 cm
Piece collected in Gebelein
On loan from the Muséum d'Histoire Naturelle of Lyon
Inv. 90000172

Main Exhibitions
Paris, 1973; Marseille, 1990;
London, 1995-96.

Main Publications
C. Lortet and C. Gaillard, 1909,
pp. 229-30, fig. 165; *L'Égypte
avant les pyramides*, 1973,
cover and p. 16; J. Kerchache,
J.-L. Paudrat and L. Stéphan,
1988, no. 12, p. 57; *L'Égypte
des millénaires obscurs*, 1990,
no. 359, p. 56; M. Rice, 1990,
fig. II, p. 284; T. Phillips (ed.),
1995, no. 1.6b, p. 57; T. Phillips
(ed.), 1996, no. 1.6b, p. 57.

This is one of the two stone "idols" that entered Lyon's Muséum following the collecting campaign conducted by the museum's director, Charles Lortet, and his assistant, Claude Gaillard, in 1909. Although the zone at the foot of the Gebelein hills, where the burial sites of an important predynastic settlement were located,[1] had been summarily prospected on several occasions by archaeologists between 1884-1900, the area was mainly regularly visited by the agents of antique dealers. The two naturalists from Lyon picked up prehistoric tools here and there, reopened tombs (most of which had already been visited), and acquired a number of objects from the above-mentioned agents.

Both before and after the rediscovery in 1973 of the Museum's Egyptian collection, the two "idols", along with six other remarkable objects that Lortet and Gaillard had published in 1909,[2] were ignored by nearly all the scholarly monographs and general introductions devoted to prehistoric Egypt. This oversight occurred, moreover, despite the unquestionable formal qualities of these pieces and the wealth of interpretations art historians might gather from their unusual features.[3] According to the dispersed indications made by the publishers, these surprising acquisitions had apparently been collected by "a trustworthy person" from beneath recent alluvial or anthropic (*sebakh*) deposits. Considered suspect from the very start, the two long "schist swords" have always been omitted from studies of predynastic arms. In another lot supposedly from Gebelein that Quibell purchased in 1900, the patterns decorating the gold sheath of a ritual blade are simply a copy of the ornamental markings on an Amratian vase that eventually made its way into the MacGregor Collection.[4] It is interesting to note that the successful digs conducted by a number of Italian missions between 1910 and 1937 yielded not a single object that is similar to the strange pieces brought back by Lortet.[5] Candid reservations have only rarely been published,[6] yet such was the suspicion surrounding the objects which came from Gebelein in the early years of the last century that specialists have rightly concluded that this material needs "a thorough reassessment".[7]

Does this find represent a disturbed stratum of display objects, all local creations of great originality and refinement? Or are we faced here with a fabrication that was meant to authenticate *in situ* a rare, spectacular commodity? Scientific appraisal, which has selected this perfectly geometric composition as representative of the primitive arts (a composition that commands attention in its own right), has decided in favour of the former possibility.

The piece is attributed to the so-called Amratian or Naqada II period, which is the middle phase (dated between 4700-4400 and 3900-3800 BCE) in the uninterrupted development of Upper Egypt's regional culture. Around 3200 BCE this culture witnessed the invention of a system of writing and the founding of an initial Pharaonic monarchy.[8] In the Amratian style, small sculptures carved from bone, ivory and soft stone, along with coroplasty (fabrication of small figures) using terracotta and vegetable pastes, offered the living and the dead a highly diverse selection of generally nude or lightly clad anthropomorphic figures. The female figures, slender, with prominent buttocks, outnumber the male. Two practically opposite styles are seen in these works. On the one hand, there is a leaning towards naturalism that picks out the anatomical detail on faces and bodies. On the other, a leaning towards abstraction gives these details only cursory treatment, even eliminates them almost entirely. To judge from the dimensions of the tombs and the grave goods, a certain hierarchy reigned amongst the members of the village communities.[9] Occasionally artists fashioned statuettes from ivory or terracotta that measure over 30 cm high (fig. 1).[10]

The Louvre's schist idol (31.5 cm) radically embraces the trend towards abstraction, completely veiling the figure's anatomy. Lortet and Gaillard compared this carving to a hooded penitent. Rather, the piece appears to represent a man wrapped in a cape from his shoulders to his feet; comparison with the second Gebelein image suggests as much. That piece is carved in light-coloured breccia and measures 50 cm high (fig. 2).[11] Its head, pressed slightly forward, possesses a nose, ears, as well as eyes, with delineated orbits and irises rendered by a

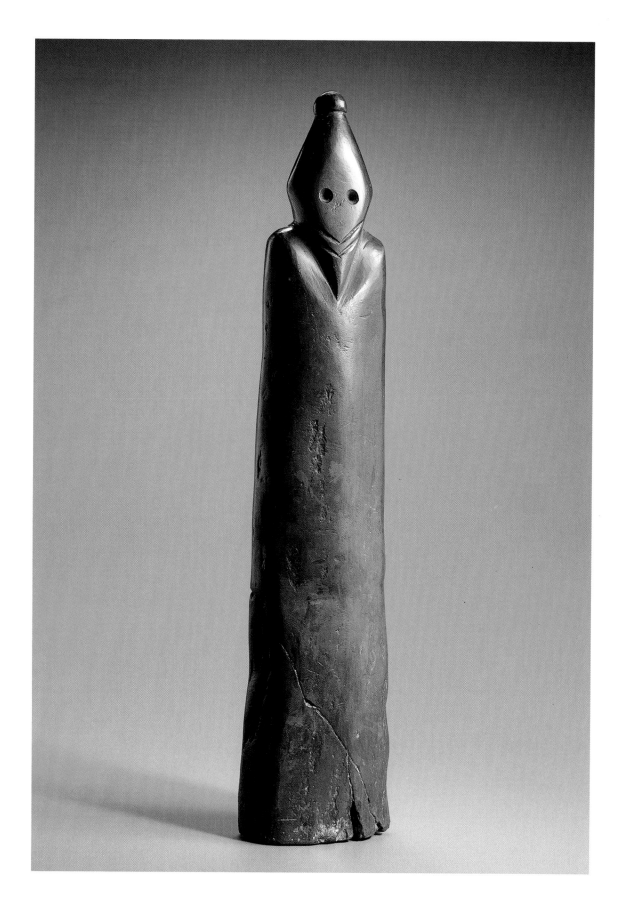

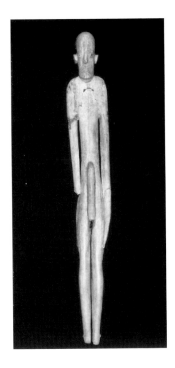

Fig. 1
Predynastic sculpture,
Egypt
Male figure found in
a tomb in Mahasna
Ivory
H. 35 cm
Egyptian Museum,
Cairo, inv. JE 41228

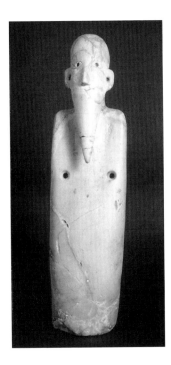

Fig. 2
Predynastic sculpture,
Egypt
Amratian style,
5th-4th millennium BCE
Second bearded figure
from Gebelein
Light breccia
H. 50 cm
Muséum d'Histoire
Naturelle, Lyon,
inv. 90000171

hole. Without question the carving is a superb work of art.

Various simplified bearded figures are common in Amratian carvings, amulets fashioned from ivory, bone or schist (1 to 5 cm high) that are so short they might be taken for busts: rectangular trunks, eyes represented by holes, a triangular beard, occasionally ears as well.[12] These modest trinkets, our two statues, and a third type of object that is also considered to be Amratian (although this category of object may date from the Naqada III period[13]) are clearly related. The last-mentioned group is made up of hippopotamus tusks (about 20 cm high) whose tips are carved in the shape of a bearded man displaying all the sense organs.[14] An "abstract" variety of this type of piece exists; the eyes are similar to those of the breccia statue, whereas a double chevron serves to indicate the lower part of the face, as in the schist sculpture.[15]

Regardless of the excellent artists who carved these statues, the two Lyon idols, considered only for themselves from the point of view of art, are like two extremes on a horizontal sequence of forms. One shows a tendency to naturalism and is expressive, the other is an abstraction evoking the same subject. Given their size, both represent an exceptional performance for the Amratian period, prefiguring the later realisations achieved in archaic Pharaonic statuary. Dating and the meaning of these two artefacts, however, will continue to pose a problem, because of the uncertainties surrounding their archaeological context. The two Gebelein statues obviously portray the same figure or entity as the more modest "bearded idols" and the carved tusks. A number of these tusks, for example, are hollowed out as if to hold some magic substance, while the tips of most are pierced with a hole through which a cord for suspending the piece could be threaded.[16] At best we can say that the bearded Amratian was a being, human or supernatural, whose beard expressed its force and whose power of protection was such that one day it gave rise to two prestigious cult statues, two precious tokens of an art that is both primitive and outside time.

JEAN YOYOTTE
Translation: John O'Toole

1 S. Hendriks, 1995, index, pp. 312-13, s.v., Gebelein.
2 C. Lortet and C. Gaillard, 1909, pp. 225-38; on the same site, pp. 34-36.
3 In his Catalogue of Unstratified and Bought Figurines, P. Ucko lists the two Lyon statues without comment (P. Ucko, 1968, p. 113, nos. 101-102).
4 J. Aksamit, 1989.
5 Despite the credit that Elvira d'Amicone has recently given to the two Frenchmen's systematic (!) work in the area (see A.M. Donadoni Roveri, 1988, pp. 38-39), none of the artefacts that display the special characteristics of the local culture recall the acquisitions made by Lortet and Gaillard.

6 H. Wild, 1948, pp. 56-57, note 4, § g.
7 W.M. Davis, 1981, pp. 36-37.
8 For an introduction to and summary of Amratian society and culture, see J. Vercoutter, 1992, pp. 99-114, and B. Midant-Reynes, 1992, pp. 163-178.
9 At least at Hierakonpolis; see B. Midant-Reynes, 1992, p. 164.
10 Witness the "realistic" male figure of Mahasna (supra, fig. 1; E.R. Ayrton and W.L. Loat, 1991, pl. XI, fig. 1) and the "abstract" female dancer of Maâmeria (W. Needler, 1984, pp. 335-37, no. 267).
11 C. Lortet and C. Gaillard, 1909, pp. 230-32, fig. 166; L'Égypte avant les pyramides, p. 67, no. 3; L'Égypte des millénaires obscurs, no. 358, cov., pp. 55, 57, 104.

12 F. Petrie and J.E. Quibell, 1985, pl. LIX, figs. 1-5, 8-10; F. Petrie, 1920, pl. II, figs. 1-5; H. Wild, 1948, p. 56, no. 4, § d.
13 E. Finkenstaedt, 1979, pp. 51-55.
14 F. Petrie, 1920, pl. I, figs. 1-8; W. Kaiser, 1957, no. 38; W. Needler, 1966, pl. IX, figs. 16-17; W. Needler, 1984, no. 276; A.M. Donadoni Roveri, 1988, p. 33, fig. 27; H. Wild, 1948, pp. 56-57, no. 4 § f.
15 F. Petrie and J.E. Quibell, 1985, pl. LXIV, fig. 81; abstract examples, ibid., pl. LXII, figs. 34-35.
16 W. Needler, 1984, p. 347; E. Finkenstaedt, 1979, p. 55; J. Capart, 1904, p. 191.

AFRICA

Sapi sculpture

15th-16th centuries
Sierra Leone

Horn

Ivory
L. 79 cm
Bibliothèque Nationale, Cabinet des Médailles, Paris
On permanent loan from the Muséum National d'Histoire Naturelle – Musée de l'Homme (since 1933)
Inv. D. 33.6.4

Main Exhibitions
Paris, 1932, 1972, 1977-78;
New York, 1984-85a;
New York, 1988.

Main Publications
J. Laude, 1966, fig. 4, p. 10;
G. Balandier and J. Maquet
(dir.), 1968, p. 417;
R.S. Wassing, 1968, cat. 116,
p. 277; *Sculptures africaines
dans les collections publiques
françaises*, 1972, no. 30, p. 36;
S.M. Vogel and F. N'Diaye, 1984,
no. 35, p. 30, p. 133; E. Bassani
and W.B. Fagg, 1988, fig. 96,
p. 91, fig. 185 (detail), p. 144,
no. 201, p. 250; *Musée
de l'Homme*, 1992,
no. 10378, p. 55.

The precise history of this horn remains a mystery. Until 1932, the year in which it was transferred to the Musée du Trocadéro, the future Musée de l'Homme, this piece was at the Bibliothèque Nationale's Cabinet des Médailles. The Cabinet was founded in 1741 as a repository for the royal collections of medals, *objets d'art* and exotic. It is thus possible that this horn once belonged to the Crown's collection, perhaps even Louis XIV's or the Dauphin's, as one catalogue has advanced,[1] given that this ivory piece was definitely carved at the end of the 15th or in the first half of the 16th century.

Unfortunately, just when the piece entered the Cabinet des Médailles's collection is unknown; furthermore, the provenance of the objects making up the royal collections remains hypothetical for the time being since no document, to my knowledge, has yielded any precise information on the subject despite the research that has been carried out. Georges Henri Rivière, who was then assistant director of the Musée d'Ethnographie du Trocadéro, alluded to this horn and three other specimens that were thought to come from Benin when he wrote, "It is not known under what conditions and at what date the Benin ivories, displayed at the Musée du Trocadéro in 1932, first entered the collections of the Kings of France".[2]

The roughly diamond-shaped lateral mouthpiece carved in relief and cut through the concave section of the tusk, and the absence of small loops for fastening the strap used to suspend the piece, are clear signs that this instrument was fashioned in Africa. Iconographically and stylistically, the human and animal figures carved in the round or in high relief are also African.

With the decorative figures here, one is hard pressed not to think of the small soft-stone figures discovered at various sites in Sierra Leone and Guinea. According to the experts, these statuettes, whose function and symbolism are unknown, were probably carved before the arrival of the Portuguese along the coast in 1460 and during the following century by artists from the Sapi population living in the region at the time.

The analogies are even stronger if we compare the motifs carved on the instrument and those ornemental pieces that were produced for exportation such as saltcellars, pyxides, spoons, forks and oliphants (ivory trumpets and horns). These objects are called Sapi-Portuguese ivories because they were commissioned by Portuguese visitors and sculpted between the end of the 15th and the first half of the 16th century in Sierra Leone. The European clients provided models for decoration which the African sculptors enriched with elements from their own figurative heritage, especially on the saltcellars they carved.[3]

As for the horn here, the elongated crocodiles and snakes devouring small smooth-bodied animals reveal a number of similarities with known Sapi-Portuguese ivories, like the oliphant of Turin's Armeria Reale (inv. 32). Although the snakes carved on the Turin ivory elegantly coil around the horn, the treatment of the scales recalls those on the reptile adorning the ivory instrument in Paris. The head of the latter reptile also presents comparable elements: the outline of the smooth mouth carved in relief, for example, or the protruding eyes represented by two concentric circles. The theme of a bird (a parrot) being attacked by a snake also occurs frequently; a fine example worth consulting is the saltcellar kept in Edinburgh (inv. 1957.1157), which boasts numerous carved crocodiles, snakes and parrots.

The depiction of the human figures, however, yields even more convincing analogies. The shape of the head, for example, and the facial features, as well as the volumes of the trunk and limbs, resemble corresponding elements found on several saltcellars.

Comparison with the figures carved on specimens kept in Vienna's Museum für Völkerkunde (inv. 118.610 a-b) and the Bowes Museum in Durham (inv. X531) brings to light clear similarities. The figures' posture is the same and suggests a certain movement, an effect that is altogether rare in the Sapi-Portuguese ivories or the carvings executed for the local populations. Other analogies can be seen, moreover: the subtle play of longitudinal

and transverse partitions, using rows of bead and twisted-cord motifs, also figures on the two salt-cellars mentioned above. These same elements are characteristic of Manueline architecture which flourished in Portugal at the close of the 15th century and the first half of the 16th, a style that takes its name from the reigning king at the time, Manuel I (1495-1521). These observations allow us to date the ivory trumpet and the two saltcellars, all of which, in light of the preceding analogies, can be attributed to the same sculptor.

With this piece we are indeed in the presence of a great artist. While executing commissions for Europeans, he created this masterpiece, quite unique of its type and truly worthy of a king, to judge from its majestic aspect and sumptuous decoration, a king not of Europe but of sub-Saharan Africa.

EZIO BASSANI

1 *Collections de Louis XIV. Dessins, albums, manuscrits*, 1977, no. 373, p. 322.
2 G.H. Rivière, 1935.
3 E. Bassani and W.B. Fagg, 1988.

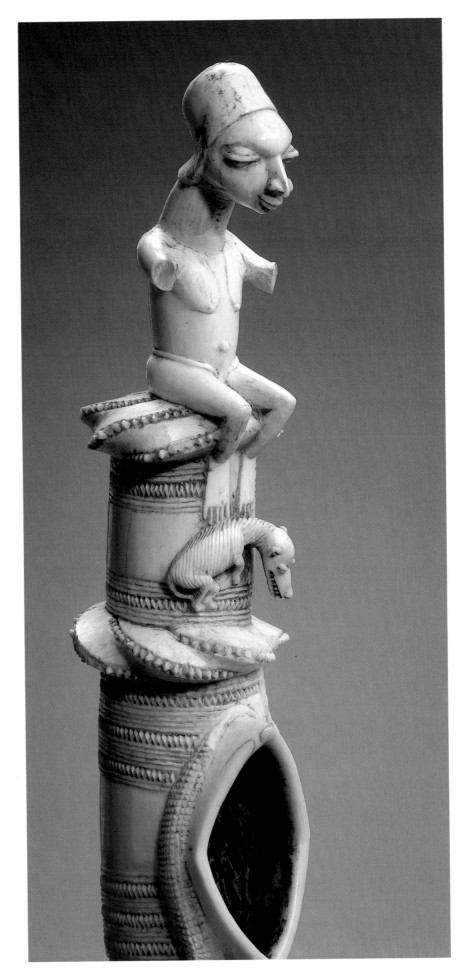

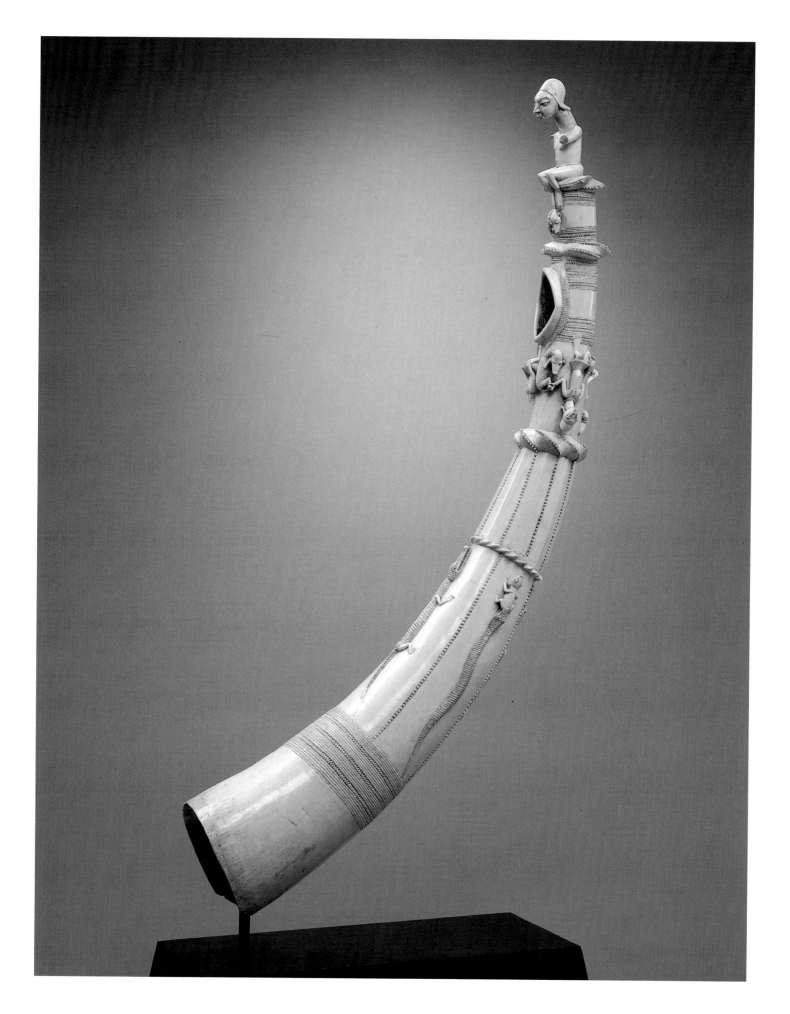

Nalu sculpture

19th-early 20th century
Guinea

Mbanchong headdress in the shape of a snake

(Bansonyi in Susu, *a-Mantsho-ña-Tshol* in Baga Sitemu)
Wood, pigments
H. 240 cm
Collected by Hélène and Henri Kamer, 1957
Formerly the Lazard Collection (Paris), 1957-89
On permanent loan from the Muséum National d'Histoire Naturelle – Musée de l'Homme (bequest from 1989)
Inv. M.H. 989.49.1

Main Exhibitions
Zurich, 1970-71;
Essen, 1971; New York,
1984-85b; Paris, 1993a.

Main Publications
M. Leiris and J. Delange, 1967,
no. 145, p. 141; E. Leuzinger,
1970, E1, p. 77; E. Leuzinger,
1971, E1, p. 81; W. Rubin, 1987,
p. 55; J. Kerchache, J.-L. Paudrat
and L. Stéphan, 1988, no. 49,
p. 96; C. Falgayrettes-Leveau
and L. Stéphan, 1993, p. 52.

This *mbanchong* headdress[1] was collected by Hélène ad Henri Kamer[2] in 1957 along with seven other objects of the same type. The Kamers found these pieces in the village of Victoria (present-day Kanfarande), a Nalu settlement located on the right bank of the mouth of the Nunez, in the present-day prefecture of Boke in northwestern Guinea. Later, following the Kamers' return, these sculptures were put on sale and were acquired by John Huston, Paul Tishman, John and Dominique de Ménil, Nelson Rockefeller and the New York dealer J.J. Klejman.

The piece now in the Louvre was purchased at the same time by Jacqueline and Jacques Lazard. In 1989, following the latter's death, this tall *mbanchong* figure became a part of the Musée de l'Homme's collection thanks to a bequest.

The Boke region, notably the Nalu canton of Kanfarande, was visited in the years 1955-56 by missionaries of a Muslim brotherhood seeking to spread Islam along the coast of Guinea. The peoples of the region, who were animists for the most part, converted to the new faith and abandoned their former religious practices. Their ritual objects, kept hidden away until this conversion, thus came to be burned or sold off by traditional and political chiefs.[3]

Like the Baga and the Landuma, the Nalu are an ethnic minority inhabiting the far northwestern section of the Guinea coast. They were already said to be living there in travel accounts by Portuguese navigators dating from as early as the 15th century. The Nalu are also found in southern Guinea-Bissau. In these low-lying mangroves, rice growing is the main activity and it dominates the material and cultural life of this people; fishing, extracting salt, harvesting cabbage palm and engaging in small-scale trade are secondary activities. During the dry season the men take up wood-working and produce numerous useful objects (stools, spades, mortars, large pestles and so on). Before their conversion, they also fashioned objects meant for the various cults dedicated to ancestor spirits (*mrim/berime*) and guardian genii (*masongko/besongkoe*).

Already observed in Guinea in the early years of the last century,[4] the *bansonyi* mask played an important role in the ritual life of these coastal peoples. According to recent declarations by traditional Nalu chiefs,[5] the *mbanchong*, which represents the spirit of the *ninguinanga* python, was a sacred object that could only been seen by a few rare initiates. In the Nalu pantheon, this serpent figures just after the superior divinity called *mhaalang* or *mangkand*, and acts as the spirit of all the forces of heaven, earth and water. The *ninguinanga* brings human beings prosperity, fidelity and wealth, and protects against all evil spells. For the Nalu, when the *ninguinanga* spirit came to inhabit the receptacle formed by the *mbanchong*, it was likened to a horse; the red streamers that once decorated the statue were considered defensive arms; the eyes, which are reproduced down the length of the statue, shone like mirrors. The *mbanchong* was conserved in the sacred forest and associated with a "magic" stone, a kind of polished stone that symbolised the *mbanchong* spirit. This guardian spirit watched over the entire village and in particular the young boys and adults during circumcision and initiation rites. The carving was then set up in the middle of the forest and the young boys had to "confront a line of men who would strike them"[6] before they could reach the representation of the *mbanchong*, putting to the test their courage and tenacity as new initiates.

When transported, the headdress was carried with the help of a cone-shaped raffia prop set on the head of a man covered with straw and cloth.[7] The *mbanchong* was accompanied by its human guardian. He would also hold the "magic" stone and his arrival in a village was announced with a ringing of bells and blowing of antelope horns so that non-initiated villagers would have time to hide themselves.

The sculpture on display in the Louvre, a monoxylous carving (i.e., fashioned from a single piece of wood), has been worked into a long gracefully curving form – convex above and below, and

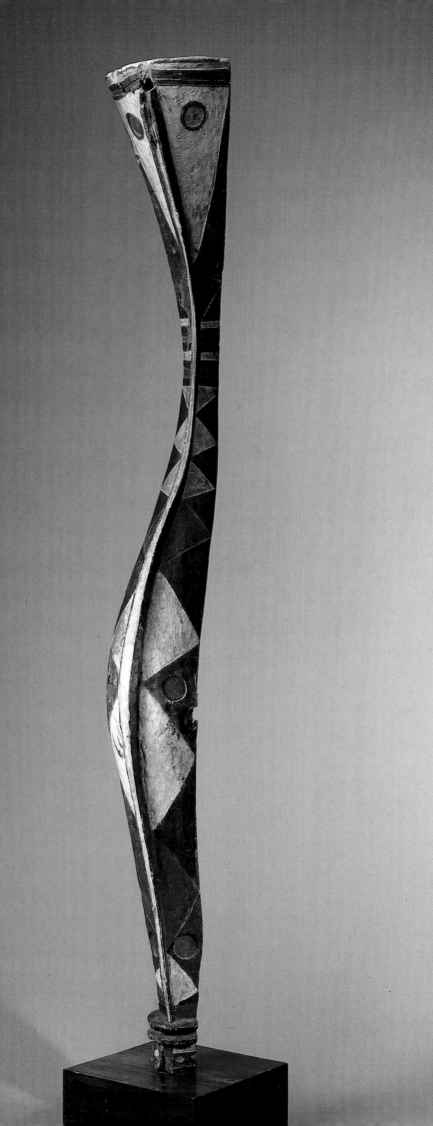

concave in the middle. The shape clearly evokes the winding of a snake.[8] The head, bent backward, is in the shape of a triangle. The convex body shows a bulge along the central axis, thus creating a lateral symmetry. The neck, which is narrow and concave, heightens the flaring, protuberant aspect of the head and body, and mirrors the sculpture's cylindrical base, around which the serpent's tail coils. The motifs decorating this upper section of the mask are for the most part engraved or painted diamond shapes which are repeated along the length of the wood. The central axis divides these shapes into triangles. Those of the head and middle section of the statue are larger than those situated at the neck and base. These varying dimensions in the motifs, along with the alternating colours, serve to emphasise the mask's dynamic character and lend the piece its undulating rhythm. The colours, finally, have a symbolic value. Red alludes to power, white to peace, and black to evil.

Although his identity has not come down to us, the artist who carved the Louvre *mbanchong*, which is considered one of the finest examples of its type, fashioned a work that is remarkable for its aesthetic qualities, a sculpture in which forms and colours unite in a play of dynamic forces in balance. The great expressiveness of this composition was no doubt a token of the success crowning men's ties to the spirit world.

MARIE-YVONNE CURTIS
Translation: John O'Toole

1. A sacred object that is found amongst the Nalu, the Baga and Landuma peoples of Guinea, but whose meanings vary according to the context, this headdress is better known in the literature by its Susu name, *bansonyi* or *simo*, and by the Baga term, *kakilembe*. The Sitemu Baga call it *a-Mantsho-ña-Tshol* ("master of the medicine"). The Landuma term has not been found.
2. See the photograph presented in S.M. Vogel, 1991, fig. 15, p. 45; interviews with H. Kamer-Leloup, June 1993.
3. In a memoir published in 1985-86, Issiaga Sylla recalls Sheik Sayon passing through Kanfarande (formerly Victoria) in the Nalu canton, and indicates that the sacred sites in the neighbourhoods of Bonia and Kanof were destroyed.
4. Jacqueline Delange (1962, pp. 3-7) points out that this sculpture gave rise to remarks in a number of publications. In 1926 the religious order of the Pères du Saint-Esprit of Conakry, in their periodical *La Voix de Notre-Dame*, describe the *bansonyi* as a large mobile scaffold seen during a burial ceremony in Kataco; information touching on the piece was also recorded in the 1936 technical dossier of the Labouret Mission, conserved in the Dakar Museum; in 1943, Béatrice Appia published drawings by students from Monchon, Boke and Boffa depicting their interpretation of the *bansonyi* or *kakilambe*. In the 1960s Thiam Bodel was one of the few ethnographers to have seen the serpent worn during a ceremony staged on his behalf; in 1954 Denise Paulme, on a mission amongst the Baga Fore, took care to gather data on the *bansonyi*.
5. Information obtained during various interviews in the villages of Kukuba, Katufura, Kamkolo (Guinea) and Campeane (Guinea-Bissau) between 1990 and 1996 while preparing a doctoral thesis at Université de Paris I (M.-Y. Curtis, 1996).
6. M. Sampil, 1961.
7. Photograph from the Musée de l'Homme's photography centre, gift of Marceau Rivière, on public display.
8. According to information gathered in the field, it would seem the artist here combined three types of snakes, the spirit of the python, *msibil*; the head and raised body of the cobra, *mkimit*; and the motifs of the Gabon viper, *mforin*.

Baga Buluñits sculpture

19th century
Guinea

Nimba shoulder mask

Wood, brass
H. 140 cm
Collected by Henri Labouret, 1932
On permanent loan from the Muséum d'Histoire Naturelle of Toulouse
Inv. MHNT-ETH. AF 127

Main Exhibitions
Toulouse, 1965; Marseille, 1970; Paris, 1972-73; Florence, 1989; Paris, 1992, 1995-96.

Main Publications
Arts africains, 1970, no. 2; *Sculptures africaines dans les collections publiques françaises*, 1972, no. 160, p. 20; J. Kerchache, J.-L. Paudrat and L. Stéphan, 1988, no. 47. et L. Stéphan, 1988, n° 47,

This *nimba* mask[1] comes from Monchon, a village located in the present-day prefecture of Boffa along the Rio Pongo. This area is settled by the Baga Buluñits,[2] also called the Baga Fore or the Baga of Monchon. Henri Labouret,[3] a former colonial administrator and professor at the École Nationale des Langues Orientales Vivantes, collected the piece in 1932 during one of his ethnographic missions along the Guinea coast in the villages of Tatema, Koba and Monchon.

Another shoulder mask from the same village is part of the collection of the Musée de l'Homme (M.H. 33.40.11). In 1938 Béatrice Appia, on a mission in Guinea at the time, photographed the same type of mask while it was being worn during a celebration in Monchon.[4]

Travelling north along the Guinea coastline from Conakry to Rio Componi,[5] one regularly encounters groups of Baga rice growers living on the low-lying marshy mangrove-covered plains that

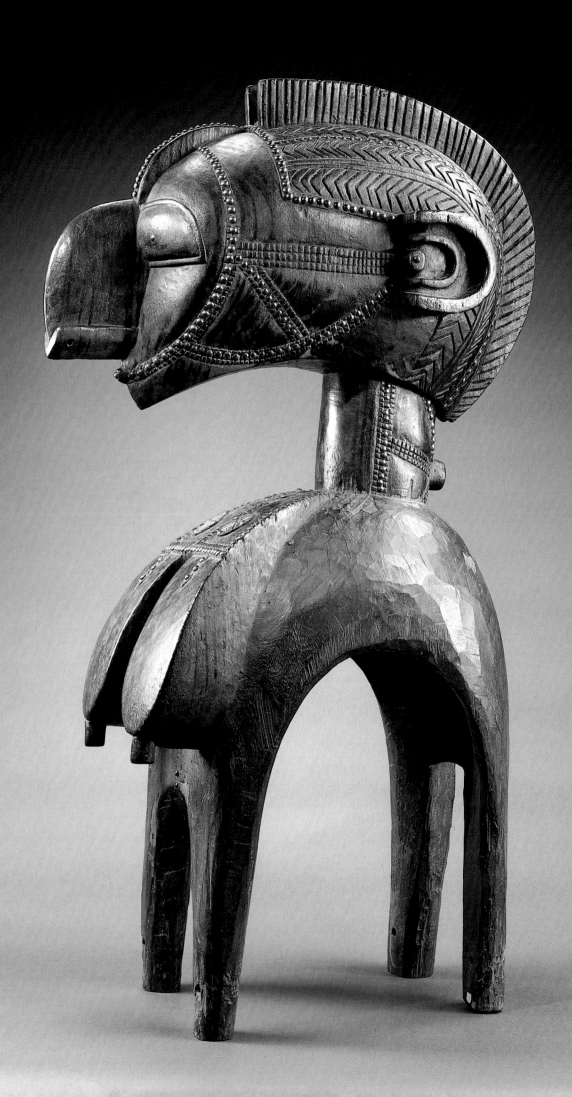

p. 95; E. Bassani, 1989, n° 26;
E. Bassani, 1992, p. 131;
G. Van Geertruyen, 1979, fig. 1,
p. 25; *Masques*, 1995, p. 31;
F. Lamp, 1996, fig. 137, p. 154.

are watered by numerous inlets and rivers. Amongst these groups there exists a subgroup located near Monchon, the Baga Buluñits, who speak a distinct dialect called Tsiloñits. According to oral tradition, the Baga are natives of Futa Jallon in central Guinea. They were forced out of this region in the 18th century by the last wave of Islamic Peulh (Fulah). The traditional society, founded on blood relations, is characterised by a strong gerontocracy. Along with the heads of families, there are village authorities, religious masters, guardians of tradition, all of whom exercise their control in associations and age fraternities that are organised by districts or villages. This framework gave rise to a rich and varied culture whose sculpture constitutes a visible, dynamic support allowing believers to honour spirits, genii and ancestors.

The morphology of the *nimba* mask recalls the features of a nursing woman and probably a *calao*.[6] By its size, weight (over 60 kg) and style, the mask is truly impressive, an imposing wooden bust from which the head emerges. The head boasts a headdress of engraved plaits and is in turn surmounted by a central crest which lends it relief. The face displays a large, exaggeratedly hooked aquiline nose, bulging eyes, a small tubular mouth, and ears that project clearly from the side of the skull. At the front of the bust great elongated breasts with cylindrical nipples hang down. The entire piece rests on four supports. The geometry of the forms are heightened by incised lines, brass furniture tacks and metal inlays. The sculpture's finish is remarkable for its beautiful dark patina, which was obtained by blackening the mask with soot and palm oil.

The *nimba* mask, the exclusive privilege of the ancients, depicts a spirit which serves above all to ensure growth, fertility and fecundity. It represents a single force that helps men, plants and animals to prosper. The mask appears at crucial moments of the agrarian cycle (seeding, replanting and har-vesting), protects pregnant women, wards off sterility, oversees weddings, and guides the deceased to the ancestor world, thus guaranteeing the protection of the community as a whole. It is likewise brought out to honour the visit of a chief or important figure from outside the village.

The *nimba* dance, which Western travellers witnessed in the rice paddies in the 19th century,[7] is considered by the Baga to be quite a beautiful spectacle. The person who wears the mask has to be rather solidly built himself; he is hidden beneath the bust by a costume of raffia and black cloth that covers him to the ankles. Carrying the sculpture on his shoulders and looking out from two holes cut through the wood between the breasts, his movements alternate from slow dance steps to glissades to pirouettes. The dancer moves to the rhythm of large double-headed drums called *sengbe* played by some forty men, and is accompanied by cries and singing from the crowd, especially the women, who toss rice and shake palm branches as an expression of joy. When not in use, the mask is kept in a sacred hut.

Carved to be viewed in profile, this sculpture reveals remarkable balance. The sure, forthright style here is also striking, featuring "an ensemble that is coherent and expressive, conventional and hieratic, whose every element is a clear response to the demands of an ancient tradition".[8] According to the sculptors of the region, these demands bring together beauty, feminine ideal, goodness and generosity. A major work of Baga art,[9] the *nimba* mask has been the inspiration for numerous pieces in the same style, including statuettes, statues and helmet masks. Even today, this carving remains for the Baga, and for all Guineans, a magnificent symbol of an artistic heritage that is very much alive.

MARIE-YVONNE CURTIS
Translation: John O'Toole

1 The name of this headdress poses something of a problem since it has been used by different ethnolinguistic groups. The Baga Sitemu call it *d'mba*, the Baga Pukur, *yamban*, and the Nalu, *mnimba*. The term *"nimba"* which is generally used in the literature, is only employed by the Baga Fore and the Susu. In Guinea-Bissau the word *numbe*, a deformation of *nimba*, is common (see F.R. Quintino, 1964).
2 The Baga of Monchon (or Monson) are called the Baga Fore ("black Baga") by the Susu. According to linguistic research, they call themselves Loñits (in the singular) or Buloñits (in the plural). I use the transcription "Buluñits" proposed by F. Lamp (1996).

3 In 1933 Professor Labouret transmitted to the Musée d'Ethnographie du Trocadéro 444 objects, including 157 from regions inhabited by the Baga and corresponding to various domains.
4 F. Lamp, 1996, fig. 140, p. 159. According to Lamp (*ibid.*, pp. 163-165), the piece in question is in the Musée Barbier-Mueller in Geneva.
5 Ethnologists distinguish six groups of Baga; from north to south they are the Baga Mandori, the Baga Sitemu, the Baga Pukur, the Baga Fore, the Baga Kakissa (Koba and Sobane) and the Baga Kalum (Conakry).
6 Bird symbolising fertility and growth, according to interviews with Baga sculptors conducted by Marie-Yvonne Curtis (M.-Y. Curtis, 1996).

7 This dance was reported by Lieutenant Coffinières de Nordeck in 1886; photographed in 1904 by M.A. Chevrier and published in 1911 by André Arcin; seen and drawn in 1912 by Père Raymond Lerouge in the Baga Sitemu village of K'fin; and referred to in print in 1947 by Bohumil Holas and in 1965 by Bodiel Thiam (M.-Y. Curtis and R. Sarro, 1996).
8 G. Van Geertruyen, 1979, pp. 21-22.
9 In the first half of the 20th century the *nimba* mask was admired by European artists like Pablo Picasso, Henri Matisse and Alberto Giacometti (see W. Rubin, 1987).

Bidjogo sculpture

18th (?)-early 19th centuries[1]
Caravela Island, Bissagos Archipelago, Guinea-Bissau

Seated male *orebok* figure

Yellow hard wood (*Fagara xanthoxyloides,* Rutaceae), lead inlay in one eye, traces of red ochre
H. 37.7 cm
Piece brought back by Commandant Aumont following a French punitive expedition in the archipelago in 1853; remained in Commandant Aumont's family until May 1985,
prior to being sold to Dr Henry-Roger Plénot; formerly the Hélène and Philippe Leloup Collection
Musée du Quai Branly
Inv. 70.1998.8.1

Main Exhibitions
Florence, 1989; Cologne, 1990;
The Hague, 1990-91.

Main Publications
D. Gallois-Duquette, 1981,
figs. 10-11, p. 76, p. 77;
D. Gallois-Duquette, 1983,
fig. 136; *Sotheby's*, 1985,
no. 112; B. de Grunne
and R.F. Thompson, 1988,
no. 184, p. 209; J. Kerchache,
J.-L. Paudrat and L. Stéphan,
1988, no. 42, p. 88; *Afrikanische
Skulptur: Die Erfindung der
Figur – African Sculpture: The
Invention of the Figure*, 1990,
no. 20, p. 107; E. Bassani,
1992, p. 59.

By the early 15th century Venetian and Genovese navigators had encountered the Bissagos Archipelago, stressing the indigenous nature of the islands' inhabitants. In the 16th and 17th centuries, other chroniclers mention raids between islands or coastal villages in which women or cattle were taken by force. Beginning in the 17th century, the Bidjogo were involved in the slave trade, serving as middlemen in this commerce.[2] In the 19th century, the Portuguese became the Bissagos islands' main colonisers; the islanders subsequently resisted British and French expeditions. The history of this sculpture (plundered on Caravela Island on 22 February 1853) is very much a part of this context of aggression and warfare.

The English had by this time imposed their rule on Gambia and Sierra Leone. France maintained a governor in Saint Louis along the Senegalese coast and a "commandant of the western coast" in Gorée (a small island town just opposite Dakar), whose authority was supposed to extend from Mauritania to Susuland in present-day Guinea. The Portuguese were settled south of Casamance and in Bissau. The French were attempting to supplant the English on the island of "Bissagot", from Bolama to the mouth of the Geba River. The Bissagos Archipelago is surrounded by sandy shallows and naturally its geographic position was of significant strategic interest. An alliance was necessary. Thus gifts and treaties with the islands' sovereigns alternated with numerous battles, more often provoked by the French than the islanders.

In 1852 the Bidjogo looted two French ships, including a schooner that had run aground between the islands of Caravela and Carache. The captain and his crew had remained prisoners on Caravela for 16 days before being handed over naked to the Portuguese in Bissau. The reasons for this act are not specified in the archives. However, a letter from the commandant of the western coast in Africa to the minister of the navy in Paris does make clear what motivated the Bidjogo of Cagnabaque. A French trader who had acquired some oxen on cre-

dit refused to honour his debt and the islanders decided "to take payment into their own hands". The ox is a symbolic animal for the Bidjogo and we can easily understand their resentment. In any case, preparations were made for an armed riposte that was to prove the most important military action of the century in the region. The stage was set for Pierre Auguste Eugène Aumont, frigate commander, special commandant of Gorée Island and interim governor of Senegal.[3]

The expedition lasted 40 days, from February to April 1853.[4] The punishment meted out to the inhabitants of Corète (present-day Caravela) was severe. Nearly all the villages (albeit "quite remarkable for their construction and solidity") were burned to the ground along with "all food, animals and ornaments found there". The Bidjogo had fled into the forest, leaving behind several dead villagers including their king, who was stripped of his attributes (ornamental clothes, shield and command staff). Then Cagnabaque was shelled and although these islanders did manage to mount stiffer resistance, some two hundred lives were lost in the process. Defeated, one of the native chiefs was forced to accept a treaty that exempted French navigators from all passage fees. By the end of the year, however, the Bidjogo king declared the agreement null and void (because it was signed "under duress by a chief of secondary importance"), deciding that the islanders would henceforth respect all whites except the French.

Aumont seems not to have played a major role in the second landing and assault.[5] Moreover, as soon as he returned to Gorée, on 26 April, he requested to be replaced and was back in France before long, where he remained until his death in 1873. These facts are not insignificant with regard to placing the statue geographically. This piece, for example, could not have been given to the Westerners because it is a sacred object that was entrusted to a priestess and the king and belonged to the village community. The circumstances rule out such a hypothesis, moreover: if the chiefs of

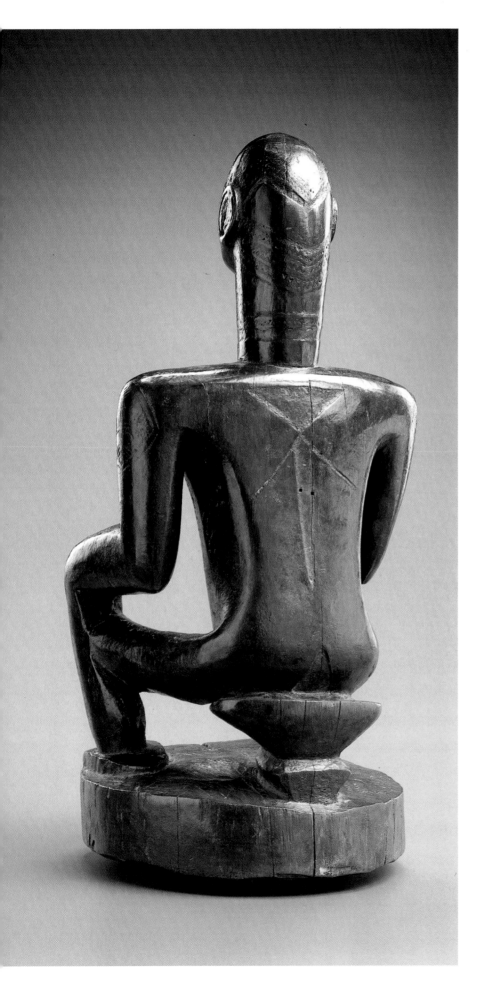

Cagnabaque succeeded in hiding themselves, they must have taken their sacred effigies with them; it is possible that the Aumont figure was picked up in Caravela when the French soldiers recrossed the island the day after the killings had taken place. Perhaps the piece was with the king before he was put to death, like the U-shaped seat carved from the same wood and reserved for elder notables which was also part of the Aumont Collection. The style of this piece recalls several sculptures from Carache (an island that abuts Caravela) which were brought back by the Austrian Bernatzik in 1931. Bernatzik proposed to classify the pieces he had seen in these northern islands by age. Horizontal pieces formed by a parallelepiped extending into a cylinder were probably laid upon the bodies of deceased persons; Bernatzik dated these pieces back three hundred years. The more manifestly anthropomorphic carvings in the shape of a stele on top of a base decorated with two lateral projections that call to mind the seats of elders were judged, again by Bernatzik, to be more recent. Finally, the seated male and female figures with their hands on their knees were considered to be still more recent. According to the Austrian writer, the styles developed from abstract to figurative. The classification of forms in the archipelago seems more complex, however.

Besides the differences between the islands that specialists have already brought to light,[6] there exist objects for private use and other identical pieces that concentrate all the religious force of "the earth" in both a spatial and temporal meaning. The latter objects have a local creole name, *ira grande do chao*, which means "large sacred object of the village". In Bidjogo, this sculpture is called *orebok*, a term that can be translated variously as "spirit", "soul" and "deceased". If we compare this word with *an-orebok* ("the place where the soul goes after death", "the space of the Ancestors", or "glory"), we can better understand that the *orebok-ocoto*, "the great spirit", is both the substratum underlying the intelligence of the creator (*nindu* or *ianu*) and the place where the souls of ancestors are fused. It is interesting to note that one group of the Bidjogo society still bears the name *orebok*, namely, groups of young girls during certain periods that are decided by a priestess; their name in creole, *defuntos* ("the deceased"), underscores their liturgical role.

As in most African societies, boys must go through initiation phases of the "age classes" corresponding to various trials and apprenticeships that are meant to make them adults. Despite the acculturation that is sapping their traditions these days, young Bidjogo must still serve the older age groups while enjoying, before their initiation, the indulgence granted to young people who are not yet considered complete beings. This is the meaning of the celebrations during which dancers with bull- or hippopotamus-headed masks imitate the fury of these wild animals. Following their initia-

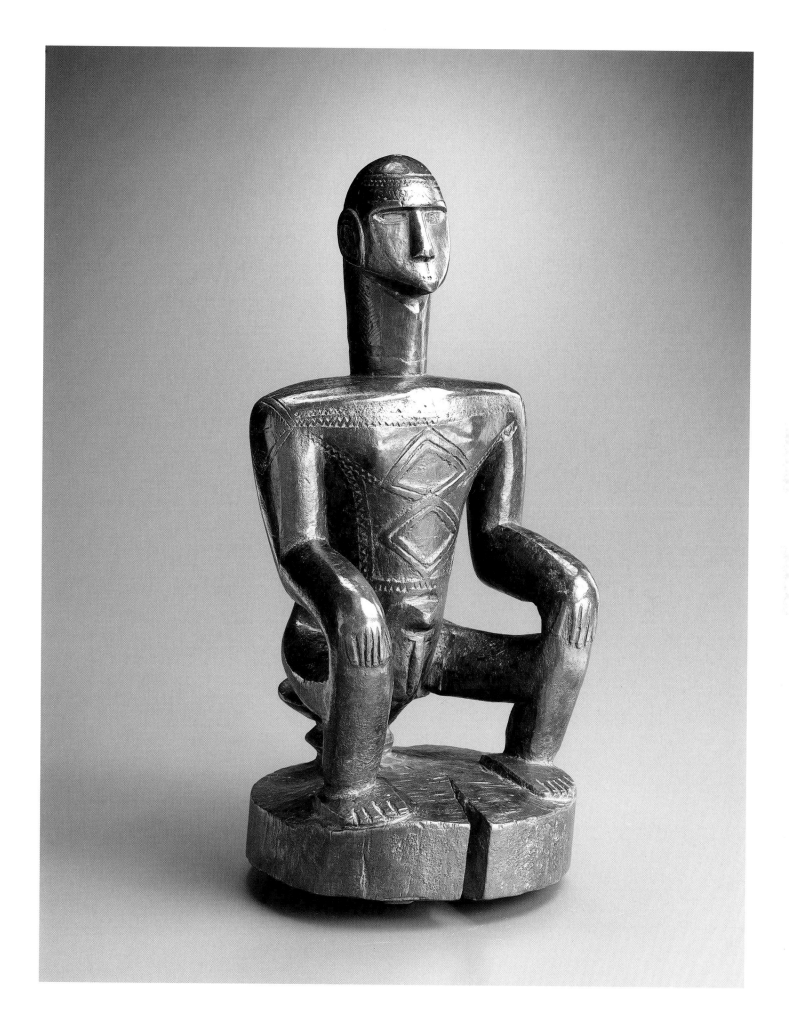

tion (which lasts several years), they are allowed to found a family and take part in the councils of elders.

If one of these boys should unfortunately die before reaching maturity, his soul is doomed to wander the archipelago because it cannot enter the space that is home to the ancestors; this soul is thus considered a threat to Bidjogo society. Such circumstances give rise to a series of events that were, until the 1970s, a fundamental secret of the Bidjogo religious system.[7] A young girl takes the place of a deceased boy from the same clan in order to carry out the initiation that he was unable to complete. She will adopt for certain periods that fit into her own normal life the personality and even the name of the deceased, simulating warrior rites armed with an axe, a spear and a shield while wearing a carving that boasts a marine or animal theme. The girl takes part in the forest retreats until the initiation cycle comes to an end and the soul with which she is invested can continue the route that will lead it to the far western reaches of the archipelago, where it will enter "into its glory". For this reason, when the priestess, at the foot of the altar in the village temple, shakes a small calabash containing seeds before the statue, all those links between the living and the dead, the present and the past, creator and created masculin and feminin world lend meaning to the *orebok* and demand sacrifices of blood and offerings of food.

Although seated on a very low stool, as is customary for elders, the great spirit that was formerly a part of the Plénot Collection stares us down with its proud imposing countenance. Displaying a robust stature and upright torso, this male figure rests his hands symmetrically on his spread knees while his feet point inwards slightly. Numerous raised scarifications (archieved by cutting away the surrounding wood) adorn the torso and shoulders; together these scars are called "the document" by the Bidjogo and prove that he has successfully completed his initiation and possesses the knowledge that comes with that passage. Other incisions on the skull refer to the tonsures and slip coating that was once worn by men to indicate that they were in a period of seclusion.[8] Shaped like a column, the neck supports a small slightly prognathous head, whose

projecting brows allow a splinter of lead (only the left eye has retained this inlay) to shine, lending life to the statue's gaze. Clearly delineated ears indicate the attention paid to requests. This is a dignified being, a judge who knows how to settle a question. The statue's virility is underscored by the genitalia, pectoral musculature and Adam's apple, although the great spirit is occasionally female – all the more so since Bidjogo origin myths give God or God's children a feminine nature, thus sanctioning matrilineal clan descent in the archipelago.

It is the deft combination of both a realism that is rare in African statuary and the balanced monumentality of the sculpture's volumes that gives this *orebok* its formal specificity. The piece here is part of a limited series of seated figures whose hands are placed on the knees, as opposed to a more common type in which the hands are depicted resting on the edges of the stool. Perfectly identifiable as a human being in the role of a chief, the sculpture is a truly admirable work of art. The masses and their articulation beautifully achieve the rhythmic alternation of empty and full spaces whose angularity is tempered by rounded passages in the wood. This dark yellow wood, an extremely hard variety, was chosen by the sculptor from the finest species and worked with the grain of the trunk using few tools: a kind of billhook for felling the tree, adze, and an abrasive tree leaf for smoothing the surface. The sculptor cut and carved according to instructions handed down by Bidjogo elders which in fact allowed him a good deal of discretion. The belly of the great spirit was then smeared with a ground vegetable pulp made up largely of mangrove. Finally, the *orebok* was consecrated before the entire village by the king or the priestess using the blood of the noblest animal for the Bidjogo, the ox.

Until the day it was looted by French soldiers in the forests of Caravela, this *orebok* was regularly honoured with palm oil and palm wine, and blackened each evening with a fire rekindled by the priestess. Thus was the idol's divine energy maintained. Today, the great spirit of Commandant Aumont has lost almost every trace of those libations.

DANIELLE GALLOIS
Translation: John O'Toole

1 Carbon-14 dating carried out on the wood of this sculpture in 1999 by Dr Georges Bonani, Eidgenössische Technische Hochschule, Institut für Teilchenphysik, Zurich, has yielded the following results: ETH-20603: 70 +/- 40 B.P.; $\partial^{13}C$ [‰]: -25.7 +/- 1.1; calibrated periods: CE 1686-1739, with a probability of 22.7%, CE 1809-1929 [this date should actually be reduced to 1853, the year when the piece was collected], with a probability of 76.9%.

2 Because the Bidjogo's belief that they would return to their land after death encouraged suicide if they were sold into bondage, slave traders avoided capturing them.

3 Pierre Auguste Eugène Aumont was born in 1802 into a family of land owners. At the age of 16 he volunteered for service in Louis XVIII's Royal Navy, where he rapidly rose to become an officer and sailed extensively, from Brazil to Newfoundland, the Antilles to Algiers, bringing back with him a wealth of "exotic" objects that would remain in his descendants' possession until 1985.

4 Aumont's expeditionary force was made up of 612 men in three columns (one of which was under his command) transported on five steamers, a brig-gunboat and several cutters.

5 Suffering from "chronic hepatitis and intermit-

tent fevers", Aumont may not actually have been physically able to ensure the command of the operation.

6 On the islands of Formosa, Uno and Orango, a mixture of magic plants is revered, whereas on Cagnabaque, Caravel and Carache a consecrated sculpture puts a human face on this form of worship.

7 D. Gallois-Duquette, 1983.

8 Microchemical and microfluorescent X-ray analyses have brought to light a red ochre that entered into the composition of these headdresses.

AFRICA

Pre-Dogon (?) sculpture

Late 15th-early 17th century
Bandiagara Escarpment, Mali

Wood (*Burkea africana*, Caesalpiniaceae)
H. 132 cm
Collected by Denise Paulme and Deborah Lifchitz between 25 and 30 May 1935 in the village of Yaye
Gift of the Paulme-Lifchitz Mission to the Musée d'Ethnographie du Trocadéro, 1935
On permanent loan from the Muséum National d'Histoire Naturelle – Musée de l'Homme
Inv. M.H. 35.105.106

Main Exhibitions
Paris, 1965; Paris, 1972-73; Saint-Paul-de-Vence, 1973; New York, 1984-85a; Nice, 1980; Florence, 1989; Paris, 1992; Zurich, 1995; Stuttgart, 1998.

Main Publications
M. Leiris, 1936, nos. 6-7, p. 192; M. Griaule, 1947, p. 43, fig. 33; E. Elisofon and W.B. Fagg, 1958, p. 30 (detail) and p. 31, fig. 11; W. Schmalenbach, 1959, p. 36; D. Paulme, 1962, vol. I, pp. 3-4; J.-J. Maquet, 1962, p. 196; A. Theile, 1963, figs. 183-84, p. 258 (detail) and p. 259; *Arts d'Afrique intertropicale*, 1963, p. 1; P. Grimal, 1963, p. 239; J. Laude, 1964b, pl. 1; *Chefs-d'œuvre du musée de l'Homme*, 1965, no. 4, p. 47; *Le Courrier de l'Unesco*, 1965, cover and p. 3 (details), p. 10; M. Leiris and J. Delange, 1967, fig. 247, fig. 248 (detail), pp. 218-19; M. Trowell and H. Nevermann, 1969, p. 102; P.S. Wingert, 1970a, N9, left; *Sculptures africaines dans les collections publiques françaises*, 1972, no. 170, p. 75; *André Malraux*, 1973, no. 757; *Esprits et dieux d'Afrique*, 1980, fig. 10, p. 37; S.M. Vogel and F. N'Diaye, 1985, no. 14, p. 24, p. 112; "Correspondance de Deborah Lifchitz et Denise Paulme avec Michel Leiris – Sanga 1935", 1987, p. 56 and p. 58 (detail); D. Paulme, 1988, fig. 8, p. 49; J. Kerchache, J.-L. Paudrat and L. Stéphan, 1988, no. 265, p. 364; E. Bassani, 1989, no. 34; E. Bassani, 1992, p. 138; *Dogon*, 1994, p. 160; H. Leloup, 1994, pl. 30; *Die Kunst der Dogon*, 1995, no. 73, p. 103; F. N'Diaye, 1995, fig. 11, p. 28; *Dogon-Meisterwerke der Skulptur – Chefs-d'œuvre de la statuaire dogon*, 1998, no. 9, p. 67.

This serpentine sculpture is one of the most famous of the pieces collected in the cliffs of Bandiagara. Inhabited by the Dogon, Bandiagara is itself one of the most closely studied regions in French ethnology, following the passage in 1931 of the Dakar-Djibouti Mission[1] directed by Marcel Griaule (1898-1956). While this work also remains one of the most mysterious in terms of history, style, function and iconography, the circumstances surrounding its collection by Denise Paulme (1909-98) and Deborah Lifchitz (1907-43) during the mission they mounted from Sanga (early February-mid-September 1935[2]) are well known. One of the first written sources is a letter Denise Paulme addressed to André Schaeffner dated 31 May 1935 indicating that the piece had been found in Yaye (near Ireli) where it had been abandoned.[3] Collected in the final days of May 1935,[4] the sculpture was from the very first considered a "masterpiece".[5] The Dogon inhabitants of Yaye told the two French women that the sculpture had been there even before the arrival of their own ancestors.[6]

Cultural, historical and stylistic context

Specialists now agree that the Dogon arrived in this part of the Bandiagara escarpment, between Tireli and Bamba, in the early 15th century. The people who were to become the Dogon, settled today on the plateau and in the cliffs of Bandiagara and on the Seno-Gondo plain, probably arose in the ancient Mande state of Ghana (8th-12th centuries), from which they set out sometime around the 11th century, before the rise of the Mali Empire (13th-16th centuries). There followed a century of wandering during which the Dogon travelled up the Niger River as far as Segu and lived for a time near Djenne. They finally settled in an area southwest of the cliffs.[7] Not far from Sanga, moreover, "vestiges gathered in certain rock faults bear witness to a phase of coexistence in the 15th and 16th centuries of the Dogon and their predecessors".[8] Amongst the latter the best known are the Tellem, to whom a number of statuettes covered with a crusty patina and found mostly between Tireli and Bamba have been attributed.

The wood from which the Yaye statue was carved dates from the late 15th to the early 17th century,[9] a period when the Dogon had probably already reached the region. Chronologically then, this sculpture does not seem to come from a time prior to their arrival in the cliffs. If the statue is the work of an artist who belonged to a non-Dogon culture settled in or around Yaye, he would therefore have been active during the phase of coexistence with the Dogon. Furthermore, the style in this case, which closely follows the wood's natural form, along with the piece's large size and light patina, is not at all characteristic of works by the Tellem, who appear to have died out in the 16th century. Thus, along with the cohabitation of different cultural groups in this sector, there seems to have been a coexistence of several styles – a phenomenon that may also, in this same region of the cliffs, distinguish the different styles attributed to the Tellem.[10]

In a text written in the early 1970s, Jean Laude speaks of a "Yaye style"[11] in connection with this famous statue. In 1988, before mentioning the piece discovered by Denise Paulme, Hélène Leloup states the following with regard to "a group of statues of a distinct style and often large size" which were thought to be pre-Dogon: "Informants said they were made by the Nongom or Niongom. These people were indigenous to the southern cliff, in an area neighbouring the Tellem."[12] According to Leloup, the Yaye style was therefore the "Niongom" style, which along with the Tellem style constituted another pre-Dogon one. However, while the Tellem culture (especially from the archaeo-historical point of view) has been the subject of numerous scientific studies[13] that allow us to clarify typological, historical and stylistic analyses of the figures attributed to the Tellem, knowledge of other pre-Dogon cultures, notably the "Niongom" culture and the style these people would have introduced, remains incomplete. Given the present state of research,[14] it is difficult to carry out a cultural attribution of the statue collected in Yaye

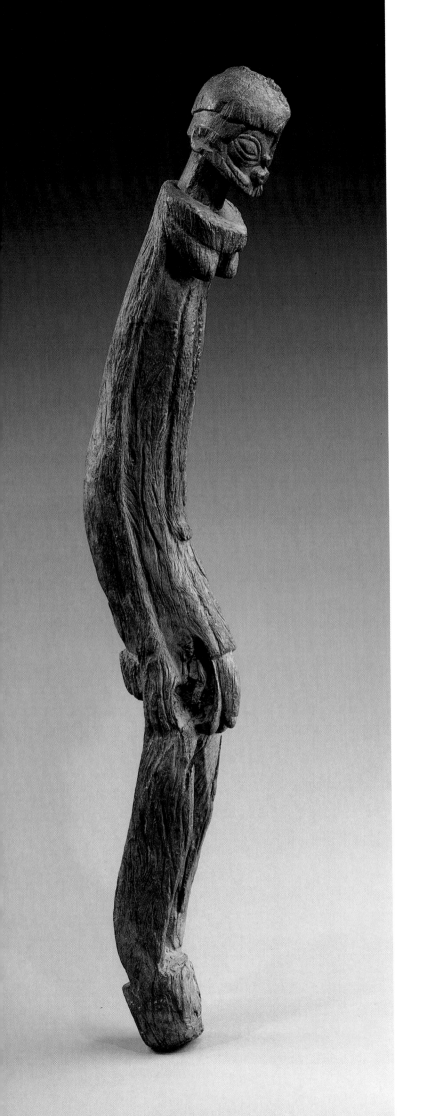
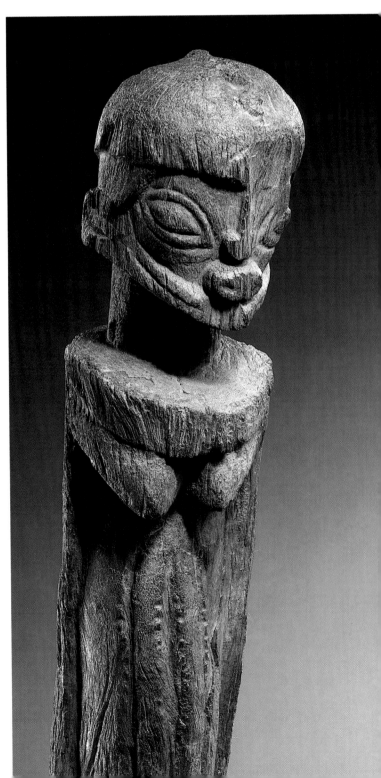

along with those pieces – all undocumented – that are formally quite akin to it; nevertheless, it is possible, drawing on these statues, to propose a stylistic typology.[15]

Finally, it should be noted that this statue has often been characterised as hermaphroditic. This iconographic ambivalence reappears in several pre-Dogon (Tellem or Soninke) and Dogon works.[16] However, while one can detect in these latter works several "echoes" with the myths Marcel Griaule and the French school of ethnology have recorded since 1931, the Yaye figure suggests no such resonances.[17]

Part of an ancient stylistic group that has a number of formal attributes in common with works attributed unambiguously to the Dogon,[18] the large-scale sculpture of Yaye probably constituted for Dogon artists one of their best known sources of sculptural inspiration. Although his name is lost to us forever, the sculptor of the Yaye figure will remain one of the most admired artists in the entire history of African art thanks to his work. In light of his artistic talent, and despite the fact that no other piece by him is known, let us bestow on this ancient creator a purely conventional name referring to this unique sculpture and the site where it was collected: the "Master of Yaye".

VINCENT BOULORÉ
Translation: John O'Toole

1 The Dakar-Djibouti Mission (May 1931-February 1933) represents a fundamental moment for French ethnology. The mission spent seven months in Dogon country.

2 Having obtained a Rockefeller grant which they shared, in January 1935 D. Paulme and D. Lifchitz joined the Sahara-Sudan Mission directed by M. Griaule. The mission stayed in Sanga from 3 February to 25 March of that same year.

3 D. Paulme writes (declaring earlier in the same letter that she had drafted another missive on the previous evening with D. Lifchitz to G.H. Rivière which mentions the Yaye statue): "As for the large statue, I should like to make clear that we have not stolen it, the people allowed us to take it without daring to touch it themselves, [as this form of] worship had been abandoned. We found it in Yaya [Yaye], near Ireli, and I caught sight of it by chance, the head alone visible, stuck beneath a plank behind a granary. I no longer dared to touch it once it had been brought out and felt a lump in my throat and a desire to cry." (D. Paulme, 1992, p. 35.)

4 On 25 May (D. Paulme, 1992, pp. 34-35), in the preceding correspondence with A. Schaeffner (whom she would marry in August 1937), D. Paulme does not mention the statue; given the impact the sculpture had on her, this clearly indicates that the piece had not yet been discovered.

5 Letter from D. Paulme and D. Lifchitz to G.H. Rivière dated 2 July 1935: "The head radiates a profound emotion which makes this work a masterpiece in the full sense of the term." (D. Paulme, 1992, p. 85.)

6 D. Paulme, 1992, p. 85. Concerning the Paulme-Lifchitz Mission, see also D. Paulme, 1977, 1988; "Correspondance de Deborah Lifchitz et Denise Paulme avec Michel Leiris – Sanga 1935," 1987. Concerning Denise Paulme, see D. Paulme, 1979.

7 See J.-L. Paudrat, 1994a, p. 15.

8 J.-L. Paudrat, 1994a, p. 16. The author adds, "Once this period had run its course, [the Dogon's predecessors] may have been absorbed by the Dogon or may have dispersed, or [...] may even have died out, victims of epidemics, famine, or Songhay or Mossi raids."

9 Carbon-14 tests carried out on the sculpture's wood in 1999 by Dr. Georges Bonani of the Eidgenössische Technische Hochschule, Institut für Teilchenphysik, Zurich, have yielded the following results: ETH-20616: 315 +/- 40 B.P.; ∂^{13} [‰]: -25 +/- 1,1; calibrated period: CE 1482-1657, with a probability of 100%.

10 See B. de Grunne, 1993. On the other hand, along part of the Bandiagara plateau, between Pignari and Duentza, another "pre-Dogon" style coexisted with the style developed by the Tellem in the cliffs themselves. This other pre-Dogon style, attributed to the Soninke, suggests a number of similarities with the terracotta of the Inland Niger Delta.

11 Dogon, 1994, pp. 211-12. After mentioning the Yaye sculpture, J. Laude writes (p. 211): "In a village that is part of the Banani cluster of towns, Pierre Langlois discovered a head representing an old man that is probably a fragment of a sculpture similar to the preceding. A third example, showing years of wear, reveals only a silhouette in which a few fleeting indications can be made out. This piece was found in the village of Nandoli." The "head of an old man" is reproduced in P. Langlois, 1954 (fig. 4); the other figure could be the one published by H. Leloup, 1994 (pl. 29).

12 H. Leloup, 1988, p. 47.

13 Between 1964 and 1974 the University of Utrecht's Institute of Anthropology mounted a number of digs around Sanga. The results have appeared in various publications, in particular: R.M.A. Bedaux, 1972, 1974, 1988; R.M.A. Bedaux and R. Bolland, 1980; R.M.A. Bedaux and A.G. Lange, 1983.

14 Besides H. Leloup, J. Bouju (Dogon, 1994, map 3, p. 240) is one of the few authors to mention the "Nongom" amongst pre-Dogon groups, although he places them well to the southeast of the cliffs, both near and beyond the border with present-day Burkina Faso (J. Bouju, in Dogon, 1994, map 2, p. 239, moreover connects the Nongom to the Samo). Another map entitled "Dogon, Kurumba, Kalamse (Nongom) political frontiers in the 17th century" (B. Martinelli, 1995, p. 378) situates these Nongom in the same area.

15 This typology might comprise the following figures: Dogon, 1994, p. 161; H. Leloup, 1994, pl. 31 (M.H. 35.60.273), the iconography of which appears in other figures, notably Dogon, 1994, p. 41, and infra M.H. 35.105.155, p. 85); H. Leloup, 1994, pl. 29, pl. 27 (a comparable object is reproduced in a photograph of the Pierre Loeb gallery in 1962, sixth sculpture from the left. See Il y a cent ans…, Pierre et Édouard Loeb, 1997, p. 47).

16 See respectively infra M.H. 35.105.155 (p. 85); Dogon, 1994, p. 92 (attributed to the Soninke). As regards Dogon works, see for example one of the sculptures S.M. Vogel (1985, p. 9) attributes to the "Master of the Barnes Foundation" or his workshop in Dogon, 1994 (p. 82).

17 J.-L. Paudrat, 1994b.

18 See for example Dogon, 1994, p. 158 (the composition of the breasts in this piece is quite similar), and p. 159. In the latter statue the face (nose, eyes and protruding mouth) and the shape of the beard and ears, amongst other features, offer a number of points of comparison with the Yaye carving. Stylistically, the piece reproduced in Dogon, 1994, p. 159 is in turn similar to the work carved by the "Master of the oblique Eyes" (see infra p. 95).

Tellem (?) Sculpture

15th-early 17th century
Village of Ireli, Bandiagara Escarpment, Mali

"Workshop of the Raised-Left-Arm Pieces"

Wood (*Ficus thonningii*, Moraceae), sacrificial materials
H. 48 cm
Collected by Marcel Evrard in 1958-59 in Ireli; formerly the Patrick Caput Collection
Musée du Quai Branly
Inv. 70.1999.7.1

Main Exhibitions
London, 1959; New York,
1960 (?); Tanlay, 1997.

Main Publications
M. Leiris and J. Damase, 1959,
no. 9; *Sotheby's*, 1986, no. 122;
Dogon, 1994, p. 200; h84

Like most of the sculpture attributed to the Tellem, the Dogon's predecessors in the cliffs of Bandiagara between the 11th and the 15th-16th centuries, this figure with a raised left arm was found between Tireli and Bamba, in a cave overlooking the village of Ireli to be precise. The piece was collected by Marcel Evrard between 1958 and 1959.[1] Following his encounter with Pierre Langlois, M. Evrard, who was copublisher in Lille of the 1954 exhibition catalogue *Art soudanais, tribus dogons*,[2] began to collect works in the villages of Ireli, Kassa, Yugopiri and Bamba.[3] The figure with the raised left arm was reproduced for the first time in 1959 in a catalogue published by the Hanover Gallery with a preface by M. Leiris; all of the objects mentioned in this publication were collected by M. Evrard.

P. Langlois was the first to carry out a collection mission in the cliffs and granaries of the Dogon; the statues found by him which have been attributed to the Tellem were all gathered between Tireli, Sanga and Ireli.[4] In 1955-56, he discovered in this area the first figure with a raised left arm, which is now in the Metropolitan Museum of Art[5] (fig. 2). This piece is similar to the statue subsequently found by M. Evrard.

If the specific function of the masterpieces of Dogon art remains only partly understood, the use to which the Dogon's predecessors put their own sculptures presents an even greater mystery. Many of the statuettes were also used by the Dogon (occasionally right up to their find date in the 1950s), who continued to make frequent offerings and sacrifices to them. Bearing witness to these practices, this figure is covered with a heavily crusted patina, a coagulated deposit that has developed fine cracks over the years. The patina is clearly much more marked on the front of the statue and is made up of millet gruel, blood and bat droppings (the winged mammals having settled in the caves that sheltered these statuettes).

Discovery of the Tellem culture

It was in 1903 that the Dogon first mentioned to a Westerner, Lieutenant Louis Desplagnes, the term "Tellem" in reference to their ancestors in the cliff region.[6] Desplagnes was also the first to bring back Tellem objects to Europe.[7] However, the West would have to wait for the Dakar-Djibouti Mission (1931-33), mounted by M. Griaule, and especially the Paulme and Lifchitz Mission (1935) before other sculptures of this kind were collected. Nevertheless, from Desplagnes until the Griaule[8] and Paulme-Lifchitz missions (all of whom speak of the Tellem peoples), these figures were uniformly attributed to, first, the Habbe by Desplagnes (the name given to the Dogon by their Muslim neighbours) and later the Dogon.[9]

The link between the name Tellem, referring to the Dogon's ancestors, and the statuettes discovered between Tireli and Bamba showing a thick crusted patina was made in the mid-1950s following P. Langlois's suggestion. After this, Western art collectors quickly came to appreciate and identify this particular styles (characterised by a cracked clotted patina and often a singular stylisation of the human body[10]).

There followed between 1964 and 1974 several systematic digs in the Sanga region, mounted by a team from the University of Utrecht's Institute of Anthropology under the direction of Rogier M.A. Bedaux. According to R.M.A. Bedaux, the Tellem culture existed in the sector around Sanga between the 11th and the 15th-16th centuries.[11] The team was only able to study two complete statues in context. One, offering "a rather abstract style", was found "in an easily accessible cave, whose contents may date from the 11-12th centuries".[12] The second piece was discovered along with the fragments of two other figures in a context going back to the 14th-16th centuries.[13] Today, carbon-14 datings carried out on objects attributed to the Tellem since the 1950s[14] coincide with the Tellem phase defined by archaeologists. As for the wood of the piece collected by M. Evrard, it has been found to date from between the 15th and the first half of the

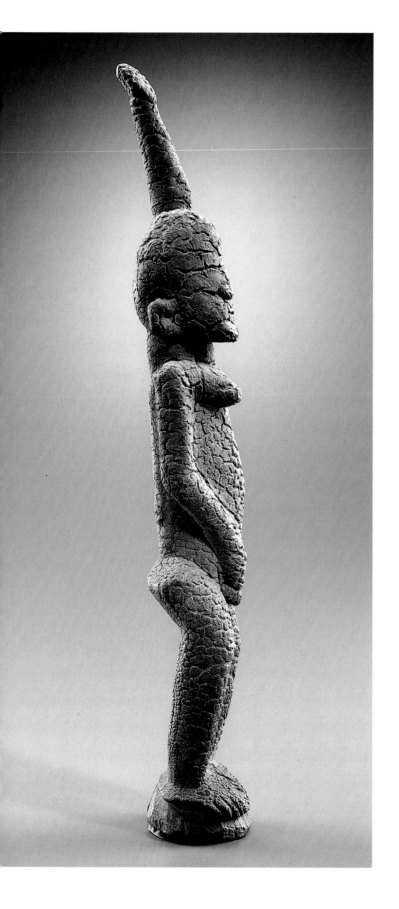
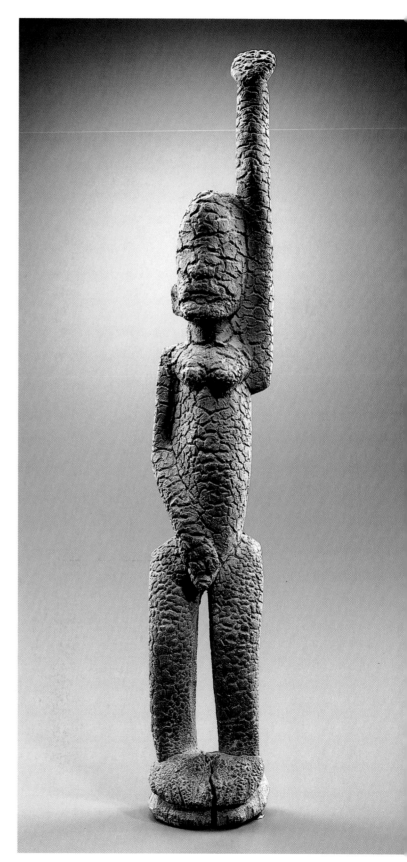

17th centuries.[15] Most probably executed in the 16th century, chronologically this work falls at the end of the Tellem phase or (as a figure carved in a style that is clearly less naturalistic and whose attribution to the Tellem is not sure[16]) at the beginning of the Dogon period.

Style and iconography

The so-called Tellem style can be broken down into several styles which doubtless existed side by side in the very same sanctuaries.[17] In a three-part typology, B. de Grunne proposed to call one the "Ireli style", including in this group (which offers the greatest iconographic variety) the above-mentioned figure in the Metropolitan Museum.[18] The figure with the raised left arm collected by M. Evrard can also be added to this group. Similarly, a third piece with both arms raised,[19] can be placed in this style.

Taking shape before those of the Dogon, the Tellem styles apparently coexisted with those of other pre-Dogon peoples "settled west of the cliffs around the 11th century", such as the Soninke. Several Soninke works have indeed been dated to a period "from the 11th to the 15th century".[20] In the piece collected by M. Evrard, the elongated treatment of the head, the rounding of the skull's summit, the shape of the ears, and the movement imparted to the right arm recall similar features adorning a famous Soninke maternity statue (fig. 1) nursing two infants and dating from the 12th-13th centuries.

Two other figures which H. Leloup attributes to the Soninke,[21] one kneeling and the other standing and covered with a crusted patina which is less pronounced at the rear of the statue, invite comparison with the Louvre's raised-arm statue. The surface deposits, heads, arms and representation of the breasts seem to spring from closely allied stylistic trends. The kneeling figure was most certainly attributed to the Soninke because of its similarity to one of the two small figures set beneath a large Soninke statue (fig. 1, p. 87). This sculpture's morphology, with its plank-shaped body and raised arms, is also comparable to the form of several works attributed to the Tellem (all of which are much smaller). Finally, the important Soninke sculpture and its small lower figures carved in low relief show that the same sculptor could carve in a single piece figures belonging to two different styles. In this instance, one boasts a head with a beard and a headdress that ends at the top in a kind of small bun or outgrowth (similar forms are seen in a great number of other Soninke statues); the other, in a style that one might classify as oval bald-headed, has clearly delineated ears. The latter style is akin to the one seen in the piece collected by M. Evrard, in which we can also make out, beneath the sacrificial deposit (as in the Metropolitan's statuette), the features of a face that is rather reminiscent of several other Soninke sculptures.

The theme of a single raised arm occurs less frequently than two arms pointing heavenwards. The latter theme is common in Tellem art and fairly well represented in Soninke and Dogon works. The palm of the left hand is depicted face up toward the sky, as if the arm was meant to support, hold, or receive some celestial item. Drawn down toward the navel and genitalia, the right arm underscores the femininity of the piece with its clearly delineated breasts. The end of the hand nevertheless touches a discreetly represented male sex organ. A comparable position of the arm (which does not however extend a male member) figures not only in Tellem statuary, but also in Dogon works, where the arms are often quite clearly positioned downwards. In several Dogon and pre-Dogon maternity statues,[22] a similar movement is given to the left arm holding a child. A piece covered with a sacrificial patina, whose arms descend along the thighs, includes a highly stylised child placed diagonally on one side of the belly,[23] as if suspended in midair, adopting a position that recalls the arrangement of the Louvre piece's forearm. Combined with a slightly protruding belly, the position of the arm is linked with femininity and fertility, the latter being associated in turn with the gesture of the raised arm, which is perhaps praying

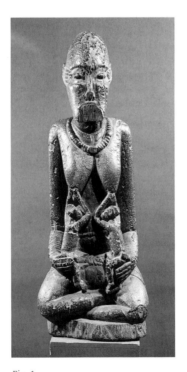 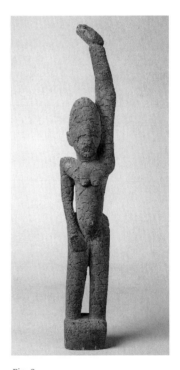

Fig. 1
Soninke sculpture, Inland Niger Delta (?), Mali, 12th-13th centuries
Wood
H. 65 cm
Private collection

Fig. 2
Tellem (?) sculpture, 15th-early 16th centuries
Bandiagara Escarpment, Mali
Wood, sacrificial materials
H. 44.8 cm
The Michael C. Rockefeller Memorial Collection, The Metropolitan Museum of Art, New York, Inv. 1979.206.64

for rain that will fertilise the soil (on which human survival depends of course). The palm is placed face up towards the heavens in order to receive this source of life. The meaning of the left arm appears then to balance that of the right; together the positions of the arms associate femininity and fertility. This androgynous being showing small breasts and discreetly represented male genitalia thus evokes fertility's two poles, the concept of fertility being heightened moreover by a specific arrangement of arms, hands and body. Perhaps this image should also be linked to a certain mythical time according to which, before the creation of the world, the sexes were not separated. This notion is present in the Dogon mythology as it has been brought to light by M. Griaule (in which the Nommo, "the father of men", was hermaphroditic before his sacrifice) and quite probably existed already among the Tellem and the ancient Soninke. The piece collected by M. Evrard is more dynamic and, in its lower section, more supple than the Metropolitan Museum figure. It displays a slightly rounded profile towards the rear which is extremely well balanced, and a different arrangement of the shoulders and breasts, just like the movement of the left hand and the position of the right arm extending to the male genitalia – the forearm and hand offering an especially subtle harmony with the hips and upper thighs. These two statuettes, which were most certainly used by the Dogon, probably come from the same workshop, an atelier we might designate as the "workshop of the raised-left-arm pieces".

VINCENT BOULORÉ
Translation: John O'Toole

1 Communication, M. Evrard to G. Viatte, March 1999; pers. com. G. Viatte, *ibid.*
2 This exhibition, which was initially organised by M. Evrard at his bookshop/gallery in Lille, was later mounted in the city's museum as well as Brussels' Palais des Beaux-Arts. I should also note that P. Langlois first visited the Dogon in late 1952.
3 The last three villages are mentioned in B. de Grunne, 1993, p. 23.
4 B. de Grunne, 1993, p. 21.
5 This figure (*Sculpture from Three African Tribes Senufo Baga Dogon*, Spring, 1959, no. 12: "57.221") was sold to the Museum of Primitive Art (incorporated into the Metropolitan Museum of Art in 1978-79) in 1957 by the Carlebach Gallery, who had probably bought it from H. Kamer (communication, D. Newton to J.-L. Paudrat, January 2001; pers. com. J.-L. Paudrat, *ibid.*).
6 L. Desplagnes, 1907, p. 192. R.M.A. Bedaux and A.G. Lange (1983, p. 5) point out, moreover, that "by the term 'Tellem', the Dogon refer to the peoples they found in certain areas when they arrived at the foot of the cliffs in the 15th century".
7 These include "a statuette [of] carved wood, covered with a limestone deposit" (*Inventaire des collections du musée d'Ethnographie du Trocadéro,* cat. 25; formerly M.E.T.: 59152, M.H. 06.3.7); a headrest (M.H. 06.3.14, formerly M.E.T.: 59161). These figures are reproduced respectively in F. N'Diaye, 1995, p. 25, and C. Falgayrettes, 1989, p. 46. I would like to thank in particular Michèle Danchin of the Laboratoire d'Ethnologie of the Musée de l'Homme, without whom I could not have conducted my research in this institution's archives, especially in the 27 volumes of the *Inventaire des collections du musée d'Ethnographie du Trocadéro.*
8 B. de Grunne (1993, p. 19) reproduces a photographe taken in 1935 – probably during the Sahara-Sudan Mission – by M. Griaule. It shows in Ibi numerous figures with raised arms, some of which are now part of well-known collections.
9 R.M.A. Bedaux (1974, p. 8) notes that M. Griaule never wavered in attributing (in 1950 for example) the headrest brought back by Desplagnes to the Dogon. It was only with Bedaux's research (R.M.A. Bedaux, 1974) that this piece would be attributed to the Tellem with certainty.
10 In 1954, for the first of these objects (presented in his catalogue *Art soudanais, tribus dogons*), P. Langlois used the term *Tellem.*
11 R.M.A. Bedaux and A.G. Lange, 1983, p. 6. Prior to the Tellem period, the only traces of occupation in this region date from the 3rd-2nd centuries BCE, a cultural phase that has been dubbed Toloy (see *ibid.*, p. 5).
12 R.M.A. Bedaux, 1988, p. 45. This object is reproduced in *ibid.*, fig. 18, p. 44.
13 *Ibid.*, p. 45.
14 See for example *Dogon*, 1994, p. 69 ("XVᵉ siècle").
15 Carbon-14 dating carried out on the wood of this sculpture in 1999 by Dr Georges Bonani, Eidgenössische Technische Hochschule, Institut für Teilchenphysik, Zurich, has yielded the following results: ETH-20602: 350 +/- 40 B.P.; $\partial^{13}C$ [‰]: -26.5 +/- 1.1; calibrated period: CE 1464-1643, with a probability of 100%.
16 *Dogon*, 1994, p. 96: plank-shaped statuette (the piece's back bears a small figure with raised arms carved in low relief) that has been dated to the 16th-17th centuries (*ibid.*, p. 247).
17 B. de Grunne, 1993, p. 27.
18 *Ibid.*, p. 24. According to de Grunne, the styles of the two other statues are Kommaga and Nini (like the Ireli style, these terms are based "upon the name of the village where a statue of this type was discovered in a clearly documented way"). Under the term "Ireli style" B. de Grunne includes works that embody, along with the Metropolitan Museum piece, three other stylistic trends: a kneeling figure reproduced by P. Langlois, 1954, fig. 3; a figure shown holding its face in its hands which was collected by D. Paulme and D. Lifchitz in 1935 (M.H. 35.105.125); a work from the "Pierre Matisse Collection" (B. de Grunne, 1993, table p. 20; see also *ibid.*, p. 24).
19 *Ibid.*, fig. 9, p. 27. The iconography of this last-mentioned piece exactly matches a statuette collected (like the rider reproduced *infra* p. 85) in Nini by D. Paulme and D. Lifchitz in 1935 (M.H. 35.105.158). Doubtless for that reason B. de Grunne (1993, p. 24) associated the piece with the "Nini style".
20 *Ibid.*, p. 26 (concerning the Soninke style, see *infra* p. 87).
21 H. Leloup, 1994, pls. 4 and 5 (Leloup employs a term borrowed from L. Desplagnes, "Djennenké", for all these works).
22 See *infra* p. 92.
23 See *Dogon*, 1994, p. 76.

Tellem or Dogon Sculpture

16th century (?)
Bandiagara Escarpment, Mali

Wood (*Ficus sp.*, Moraceae), sacrificial materials
H. 36.5 cm
Collected by Denise Paulme and Deborah Lifchitz in 1935 in the village of Nini
Gift of the Paulme-Lifchitz Mission to the Musée d'Ethnographie du Trocadéro, 1935
On permanent loan from the Muséum National d'Histoire Naturelle – Musée de l'Homme
Inv. M.H. 35.105.155

Main Exhibitions
Paris, 1965, 1972-73; Nice, 1980;
New York, 1984-85a; Zurich,
1995.

Main Publications
M. Leiris, 1936, nos. 6-7,
p. 199; M. Griaule, 1947,
p. 44, fig. 34; A. Malraux,
1952, vol. I, fig. 393; M. Trowell,
[1954], pl. XXVII, A;
W. Muensterberger, 1955, no. 3;
E. Elisofon and W.B. Fagg, 1958,
p. 31, fig. 13; L. Adam, 1959,
pl. 10; D. Paulme, 1962, vol. I,
pl. 2; J. Laude, 1964b, pl. 29;
*Chefs-d'œuvre du musée de
l'Homme*, 1965, no. 5, p. 49;
Le Courrier de l'Unesco, 1965,
p. 12 (right); J. Laude, 1966,
fig. 17, p. 30; M. Leiris and
J. Delange, 1967, fig. 261, p. 229;
M. Trowell and H. Nevermann,
1969, p. 101; R.S. Wassing,
1969, fig. 101, p. 195;
P.S. Wingert (ed.), 1970a,
N9 (right); *Sculptures africaines
dans les collections publiques fran-
çaises*, 1972, no. 164, p. 73;
Esprits et dieux d'Afrique, 1980,
fig. 15, p. 39; S.M. Vogel
and F. N'Diaye, 1985, no. 12,
p. 58 and p. 121; J. Kerchache,
J.-L. Paudrat and L. Stéphan,
1988, no. 832, p. 502; *Musée
de l'Homme*, 1992, no. 9046,
p. 53; D. Paulme, 1992, back
cover; *Dogon*, 1994, p. 199;
H. Leloup, 1994, pl. 43;
F. N'Diaye, 1995, fig. 1, p. 19;
Die Kunst der Dogon, 1995,
no. 34, p. 75; E. Féau and
H. Joubert, 1996, p. 46.

This sculpture was collected in Nini during the Paulme-Lifchitz Mission (1935), in a cult area called a *binu ya*.[1] The site was "abandoned following the death of the woman in whose granary the object was found buried".[2] Besides gathering important ethnographic (notably linguistic) information, the mission collected nearly two hundred objects for the Musée d'Ethnographie du Trocadéro (which became the Musée de l'Homme in 1937). This rich group of objects included the Yaye serpentine sculpture as well as a large number of granary doors and locks.[3]

Along with the *lebe* or *gin'na* cult (whose altar is found inside the Hogon's house[4]), *binu* is the most wide-spread ritual amongst the Dogon. Each demands the use of anthropomorphic statues (*dege*). *Binu* is devoted to a category of mythical ancestors who never met with death. The sanctuary called *binu ya* by D. Paulme corresponds to a holy place reserved for a female *binu* (*ya* indicating the feminine[5]), in other words, to one of these female ancestors (although it is impossible to indicate precisely which ancestor or what exact purpose the "rider" with raised arms served).

Style and stylistic context

There exist several other figures astride a mysterious animal that is always represented without legs. One of these statues, which is also hermaphroditic, is akin to the Nini piece.[6] A second statue, without arms and more clearly female,[7] evinces a style comparable to that of the large Yaye statue. A third reveals a figure with bent legs and heels touching the buttocks, as if kneeling astride some animal.[8]

The style of the Nini rider is also similar to that of a standing figure (collected in the same village by D. Paulme and D. Lifchitz) with raised arms that extend along the back to the height of the navel.[9] Basing his argument on this standing figure, B. de Grunne gave the term "Nini style" to one of the Tellem styles he proposed to define.[10] As several specialists agree that the Tellem cults along with their statues were adopted by the Dogon, the fact

that this piece was still used in ceremonies shortly before being collected in 1935 is consistent with its attribution to the Tellem (who occupied the Nini region between the 11th and the 15th-16th centuries).

The androgynous rider, however, might date from the 16th century.[11] The piece would then fall, at the earliest, at the very end of the Tellem period, during a transitional phase with Dogon culture – unless, inversely, we are dealing with a Dogon work inspired by a Tellem style. The iconography of the raised arms is moreover one of the commonest in Tellem sculpture. Sculpture from the Dogon period perpetuated this iconographic detail, although less systematically.

Iconographic interpretation

The arts of the Dogon area embrace a repertoire of figures and forms whose great range is only equal to the serious difficulty any interpretation presents. The most valuable elements available for deciphering the sculptures – the wood from the oldest pieces dates to as early as the 10th century – are the oral myths collected by M. Griaule and his school from the 1930s onwards. Despite its intense depth and variety, however, this religious memory of the Dogon, which was woven, reworked and clarified over the years and recorded at one particular moment of its existence, poses not a small number of problems when used to decode their sculpture. Such difficulties are naturally even greater when applied to works created by pre-Dogon peoples.

The iconography of the Nini statue can be broken down into several themes touching on the physical attitude adopted by the human figure (the raised arms and position astride the figure's mount), its androgynous appearance, and the identity of the animal being ridden. However, determining with certainty the meaning of forms arising from the functional, iconographic[12] and stylistic aspects of pre-Dogon and Dogon arts is especially difficult. Are the raised arms those of an "individual addressing his request to Amma [the Dogon god believed to have created the world] for rain, necessary to all

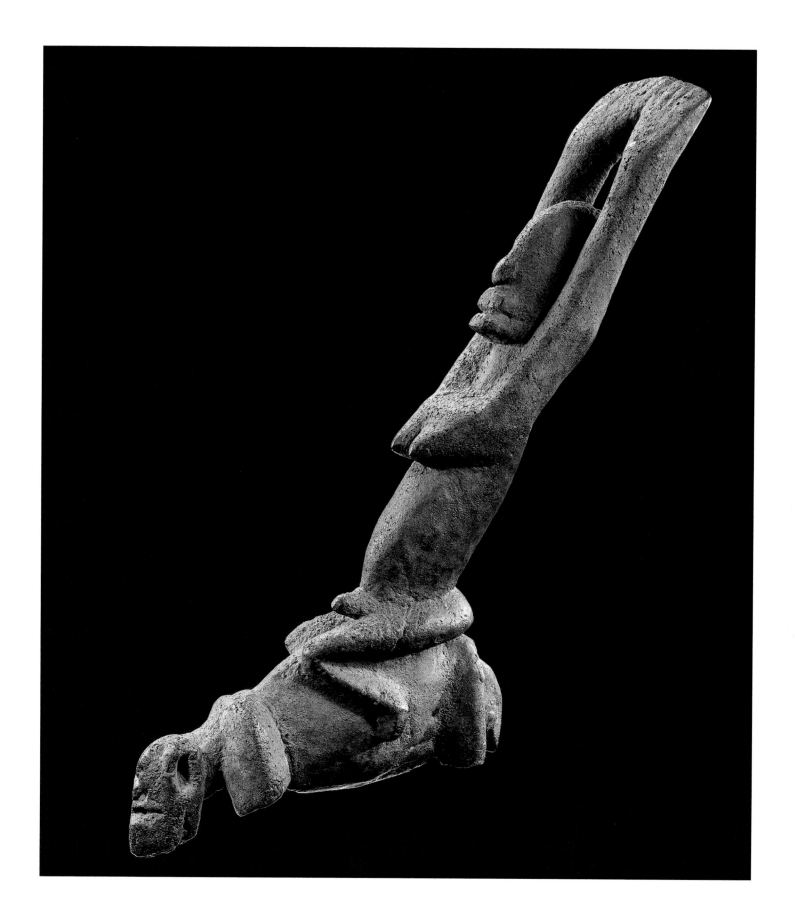

that lives on the earth"? Are they the expression of a "gesture begging pardon for a ritual fault that would have brought on the drought"? Do they evoke "the crucifixion of one of the Nommo [according to Dogon cosmology the Nommo – "father of mankind" – was immolated with his arms raised by Amma, his body dismembered and subsequently pieced together] and his resurrection"?[13] For J. Laude these figures with raised arms offer access to the "notion of death-rebirth".[14] Could this explain the figure's position, which (like a famous Dogon mask that is surmounted by a female figure[15]) seems to suggest birth? Might the statue represent the "Nommo before the sacrifice: the morphology underscoring its androgyny"?[16] What is the animal being ridden, whose legs seem to have been broken off well before the piece was collected? A hippopotamus? A horse? Or both at once, the raised arms here serving as an echo of the former's natural element (water)?

Articulating a subtle semantic network whose interpretation remains ambiguous in many ways, the skilful composition of shapes evinces remarkable technical mastery. Clearly present throughout the piece, especially in the figure's legs (gripping the animal's compact body in a crouching, coiled movement of rare delicacy), this artistic dexterity is the work of a true master sculptor who may have been active in Nini.

VINCENT BOULORÉ
Translation: John O'Toole

1 D. Paulme writes on 6 April 1935 (1992, p. 20): "The day before yesterday, we went to Nini, on the road to Ibi, a little outside Banani. Tiring day, up and down the cliff in the bright sun. Saw admirable statues with raised arms, including one astride an animal in a *binu ya* that is 'wasted' today. Deborah took a small one, no go with the others."

2 M. Leiris, 1936, p. 194.

3 D. Paulme, 1992, p. 85, note 24: "Whereas certain objects were registered with the Sahara-Sudan collection, the Paulme-Lifchitz Mission includes a list of 181 objects, 90% of which are carved doors and locks as well as statuettes."

4 The Hogons are the highest religious dignitaries. They are named in the four initial groups (the Ono, Domno, Dyon and Aru) which, according to the Dogon's historical mythology, originally came from the Mande. The Aru Hogon is considered the spiritual leader of all the Dogon. The *lebe* is an entity "of the cyclical rebirth of the life-giving earth, germination and the growth of plant species"; its altar "is partly made with the so-called transforming earth brought from the Mande and which was divided amongst the four 'tribes' before they dispersed" (J.L. Paudrat, 1994a, p. 14).

5 D. Paulme, 1992, p. 89.

6 *Die Kunst der Dogon*, 1995, no. 33, p. 74. Another (*ibid.*, no. 42, p. 81) is thinner and more drawn out and does not have raised arms.

7 M.H. 35.60.273 reproduced notably in H. Leloup, 1994, pl. 31.

8 *Dogon*, 1994, p. 41 (dating from the 18th-19th centuries).

9 M.H. 35.105.158. See in particular S.M. Vogel and F. N'Diaye, 1985, no. 25, p. 128.

10 B. de Grunne, 1993, p. 24. Besides the standing figure, de Grunne attributes to the "Nini style" three others which he takes to be variants (*ibid.*, table 1, p. 20, p. 24) whose styles and iconographies are relatively similar. He includes in this group (*ibid.*, p. 24) a statuette made up of four figures that once belonged to Lester Wunderman dating back to the 15th century (see *Dogon*, 1994, p. 69 and p. 247).

11 It was impossible for Dr Georges Bonani of the Eidgenössiche Technische Hochschule, Institut für Teilchenphysik, Zurich, to scientifically date the wood of this piece, unlike the tests he carried out in 1999 on other works from the Musée de l'Homme displayed in the Louvre. However, the figure was apparently subjected to carbon-14 dating before this at the behest of Jacqueline Delange and Tamara Northern. That test concluded that the piece dates to "the 15th-16th centuries" (H. Leloup, 1994, pl. 43 and p. 602; F. N'Diaye, 1995, p. 18).

12 The iconographic themes of the Nini figure are indeed found, either mixed or distinct, in works from the Dogon and pre-Dogon periods collected between Djenné and the Seno-Gondo plain.

The themes can be seen in the terracotta statues of the Inland Niger Delta (rider figures, raised arms) and in sculpture attributed to the Tellem, the Soninke (comparable kneeling position, raised arms) and Dogon (hermaphrodism, raised arms, riders, figures with their legs more or less bent beneath their thighs and astride an animal). To clarify these correspondences, it might also be worthwhile mentioning the "syncretic formulation" (J.-L. Paudrat, 1994b, p. 66) of J. Laude, whose influence goes beyond the raised-arms theme for which it was developed: "This theme was illustrated before the arrival of the Dogon; the invaders integrated it in a network of analogies in which it was given other meanings without necessarily losing those that it had previously embodied" (J. Laude, 1964b, p. 201-02, quoted by J.-L. Paudrat, 1994b, p. 66).

13 These quotes are drawn from J.-L. Paudrat, 1994b, p. 63, who in turn borrowed them from, in the first two instances, G. Dieterlen (quoted in *Arts de l'Afrique noire dans la collection Barbier-Mueller*, 1988, p. 59) and J. Laude, 1964b, p. 198.

14 J. Laude, 1964a, p. 65, quoted by J.-L. Paudrat, 1994b, p. 63.

15 See *infra*, fig. 1, p. 91. Numerous female Dogon figures, with or without infants, are represented kneeling in quite similar positions.

16 J.-L. Paudrat, 1994b, p. 65, quoting M. Griaule and G. Dieterlen, 1965, pl. 17, no. 1.

Soninke Sculpture

13th Century
Bandiagara Plateau, Mali

Wood (*Afzelia africana*, Caesalpiniaceae)
H. 68 cm
Collected in 1958 by Hélène and Henri Kamer, formerly in the Pierre Loeb Collection
Purchased in 1977 by the Musée des Arts Africains et Océaniens, Hôtel Drouot
Musée National des Arts d'Afrique et d'Océanie
Inv. MNAN 77.6.1

Main Exhibitions
Paris, 1962; Paris-Brussels, 1979 (?); Nice, 1980; Zurich, 1995; Stuttgart, 1998.

Main Publications
Arts primitifs, 1977, no. 7; *L'Aventure de Pierre Loeb*, 1979, no. 213, p. 105; *Esprits et dieux d'Afrique*, 1980, fig. 13, p. 38; *Musée des Arts africains et océaniens, Guide*, 1987, no. 22, p. 75; H. Leloup, 1988, fig. 5, p. 47; J. Kerchache, J.-L. Paudrat and L. Stéphan, 1988, no. 268, p. 364; L. Stéphan, 1993, p. 105; *Dogon*, 1994, p. 81; H. Leloup, 1994, p. 134; *Die Kunst der Dogon*, 1995, no. 6, p. 49; *Dogon-Meisterwerke der Skulptur – Chefs-d'œuvre de la statuaire dogon*, 1998, no. 5, p. 55.

This statue was once the property of Pierre Loeb (1897-1964) and can be seen in a photograph taken in late 1962 during an exhibition held at his gallery, Galerie Pierre.[1] Along with a second sculpture (in the collection of H. and P. Leloup for many years[2]), which may have been its female counterpart in a sanctuary, and a third work that belonged to the Musée Barbier-Mueller, the piece was acquired in 1958 by Hélène and Henri Kamer.[3]

As is the case with most of the sculpture collected in Dogonland, this piece's use and iconography are unknown. Carvings were displayed at sites of private cults (with altars receiving sacrifices made to the Nommo), and in *binu* and *lebe* sanctuaries. Because the last two cults were more important, we can suppose that those sites sheltered the most famous sculptures.

Stylistic context

B. de Grunne studied the style of several so-called Djenné terracotta rider statues from the Inland Niger Delta that date from the 13th-15th centuries. He pointed out that several of these pieces, like the P. Loeb sculpture, show a series of scarifications at the temples which indicate that these pieces are meant to represent Soninke who arrived before the 13th century in the Djenné area from southern Mali.[4] The sundry lineages making up the Soninke kept horses and, unlike the Dogon (of Mande culture), used scarification to mark and adorn their bodies.[5] B. de Grunne first compared these terracotta equestrian statues with the wooden riders that were attributed to the Dogon at the time and which also invariably showed scarification, then extended the comparison to other scarred works from an area between Pignari and Duentza. He thus came to attribute the scarred wooden statues to the Soninke[6] who had emigrated to the Dogon plateau from the west.[7] Moreover, a wooden rider (14th-15th centuries) holding a bow that is conserved in the Minneapolis Institute of Art[8] is quite similar to the terracotta equestrian figures, probably indicating that the artists of the Inland Niger Delta also w,orked in wood.

Amongst the so-called Soninke wood sculpture showing scarifications along the temples, one piece representing a seated figure with two children seems to date from the 12th-13th centuries (fig. 1 p. 82);[9] this sculpture is no doubt contemporary with the art of the Tellem and the so-called Djenné terracottas (11th-16th centuries). One of the most noteworthy statues attributed to the Soninke style (fig. 1) probably dates from the 14th century at the latest;[10] it depicts a figure with raised arms and two small low relief figures at the waist. The wood of another statue carved in a similar style that is certainly pre-Dogon was found to date from the 10th century;[11] although it possesses no temple scarifications, stylistically the piece does share several

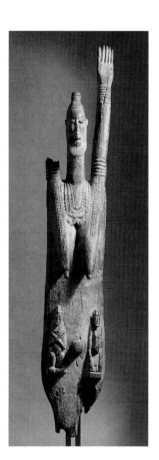

Fig. 1
Soninke sculpture
11th (?)-14th centuries
Bandiagara Plateau,
Mali
Wood
H. 191 cm
Private collection

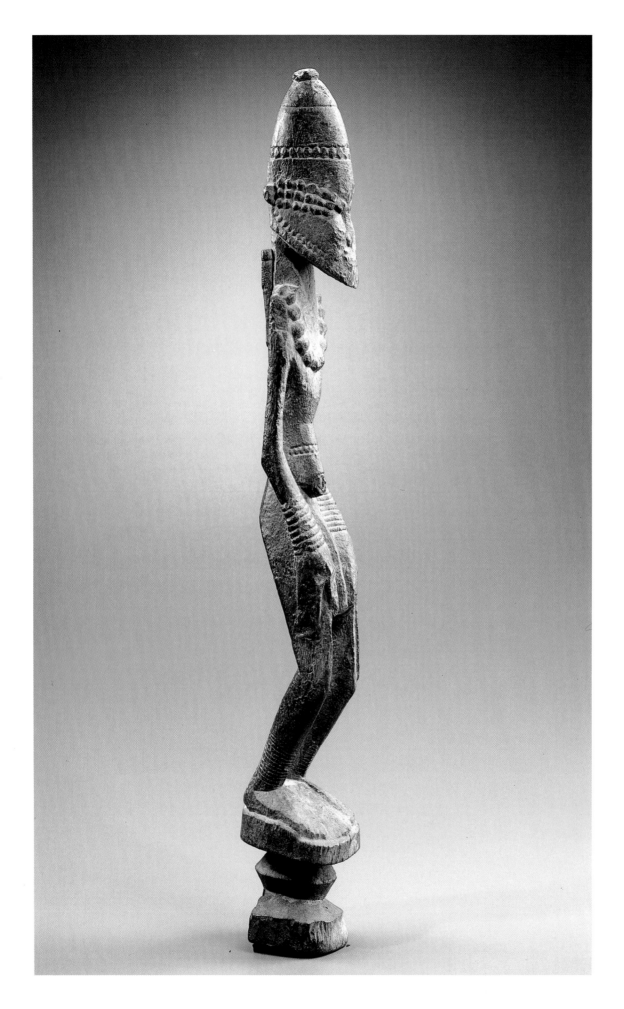

points in common with the Soninke figures, but also with those of the Inland Niger Delta and works that have been attributed to the Tellem. Other statues, which show a black patina, reveal temple scarifications; some of these represent riders and one has been dated to the 14th-15th centuries.[12]

The wood of the P. Loeb statue has been found to date from the 13th century.[13] Contemporary with works from the Inland Niger Delta, this piece might be one of the oldest examples of the Soninke style. Along with the statue from the Musée Barbier-Mueller (recently dated to the 14th century[14]), and the carving that once belonged to H. and Ph. Leloup, and with a piece from the Menil Collection and another from the former Jay C. Leff Collection,[15] the Loeb statue is part of a stylistic ensemble that might also comprise a statue that once belonged to C. Ratton.[16] The P. Loeb figure and the first Soninke wood figures, several of which may have been realised in the Inland Niger Delta before these peoples migrated to the western Dogon plateau, probably precede the works covered with a deep black patina and showing scarifications. The latter date from the same period as the first pieces that can be attributed to the Dogon.

Clearly realised during the pre-Dogon period, the P. Loeb figure may have remained in the possession of a group of Soninke origin right up to the day it was collected. Indeed, people of Soninke extraction have lived for years in the Kani Goguna region in the same villages as the Dogon, with whom they have formed alliances and who have practically assimilated them.

Iconographic interpretation

Similar to the iconography of sculpture from the Inland Niger Delta, the iconography of this ancient Soninke piece can also be compared with that found in Dogon statuary. The Dogon most certainly drew many of their mythological references from the native cultures when they came to settle on the plateau and in the cliffs of Bandiagara in the 15th century. The two conjoined tubes on the back of the piece, for example, recall the quivers (formed by a single sheath, however) adorning certain terracotta figures representing archers[17] or the Minneapolis wooden rider statue. These two sheaths[18] might also be likened to the tuyere of a forge. However, as J.-L. Paudrat points out, this does not justify the conclusion that the statue is a "representation of the first craftsman, the civilising hero",[19] the Seventh Nommo, viz., the blacksmith of Dogon mythology. One can also compare these sheaths (which we must view with respect to the small bow that the figure – like the Minneapolis rider – seems to be holding in his left hand) with the small quiver seen on the back of a seated hermaphrodite figure.[20] Moreover, the left arm of the Loeb Collection figure sports a knife that is similar to the knife represented on the Minneapolis rider just above the left elbow, where it can be easily grasped by the other hand. The pearl necklace and the bracelets are seen on figures from the Inland Niger Delta, as well as on Dogon and Soninke sculptures.[21] The base of the statue, which may have allowed it to be set firmly in the earth without damaging the figure, is comparable to other integrated bases (all of which are in the shape of a truncated cone), e.g., the bases of the Minneapolis rider, a piece representing a kneeling figure, and statuettes attributed to the Tellem.[22]

Is there some link, moreover, between the undulation of this statue (which recalls the same movement imparted to the piece by the "Master of Yaye" and the long blade-mask that was meant to suggest a serpent (into which each elder of the new generation was transformed according to Dogon mythology), executed every 60 years during the *sigi* ceremony marking the "renewal of the world"? Among the Dogon, the carved human figures (*dege*) that are linked to the *binu* altar might represent one of the immortal ancestors before his transformation into a serpent, or a real human being who had founded and created the local altar of a *binu* cult.[23] Specifically, this statue might be intended to suggest a Soninke founder, recognisable from his scarifications and whose attributes, like the ogival headdress, are evidence of the figure's identity and high rank.

This sculpture surely constituted the ancestral image of a distant noble founder from the Inland Niger Delta, a source of inspiration in the 13th century for a remarkable artist who was probably the creator of other works among those that were acquired together before 1960, and whom we might call the "Soninke Master of the P. Loeb Collection".

<div align="right">

VINCENT BOULORÉ
Translation: John O'Toole

</div>

1 This exhibition ran from 25 October to 25 November 1962 (see *Il y a cent ans... Pierre et Édouard Loeb*, 1997, p. 47).

2 Reproduced notably in J. Laude, 1964b, pl. 51; *Dogon*, 1994, p. 156; Leloup, 1994, pl. 20.

3 Today Hélène Leloup; see H. Leloup, 1994, pl. 20. H. Leloup points out, moreover (1988, p. 49), that she obtained the first two statues mentioned here in the 1950s. Henri and Hélène Kamer

subsequently sold one of the two pieces to P. Loeb. H. Leloup (1988) speaks of two other statues in a similar style that were acquired around the same time. One of these two (quite similar to the two preceding pieces) is the Barbier-Mueller sculpture which is reproduced in J. Laude, 1964b, pl. 53, and discussed in B. de Grunne (to be published); the other, according to H. Leloup (1988, p. 49), "the larger, superb,

but damaged, is in a private collection in New York". Mention should also be made of three other sculptures. The first was published in *La Rime et la Raison* 1984, no. 349, p. 368; the second (mentioned in B. de Grunne's forthcoming study), which once belonged to J.C. Leff, is reproduced in *Exotic Art from Ancient and Primitive Civilisations*, 1959, fig. 195, and in *Sotheby Parke Bernet Inc.*, 1975, no. 179, the third is reproduced

in *Arts primitifs, Arts d'Asie*, 2001, no. 32, p. 8. This body of work would be seven, not four in number, six of which have been precisely identified.

4 B. de Grunne, 1987.

5 B. de Grunne, 1987, p. 11, who bases his conclusions on G. Dieterlen, 1975.

6 L. Desplagnes, 1907 (fig. 117), called the Kagoro (the Kagoro forming a Soninke clan according to a forthcoming study by B. de Grunne) of the western cliffs the "Djennenké of the mountain", because they had originated in Djenné, as he understood it. For B. de Grunne (forthcoming), the term Djennenké ("linked to the fortunes of Islam in this region") is not an appropriate term for qualifying these peoples.

7 B. de Grunne, 1991. According to de Grunne (1993, p. 26), these Soninke had settled "in the western cliffs [of Bandiagara] around the 11th century". It is also quite possible that there were several shifts of these populations towards the western cliffs after this period (until the 15th-16th centuries, when the art of terracotta statuary from the Inland Niger Delta eventually disappeared).

8 *Dogon*, 1994, p. 37.

9 B. de Grunne, 1993, p. 29. This sculpture has recently been attributed to the "Inland Niger Delta" (*Dogon*, 1994, p. 114).

10 See *Die Kunst der Dogon*, 1995, no. 3, p. 47. A test mentioned by H. Leloup also points to the 10th-11th centuries as the earliest date for this piece (*Dogon-Meisterwerke der Skulptur – Chefs d'œuvre de la statuaire dogon*, 1998, p. 46).

11 *Dogon*, 1994, p. 34 (see also p. 245 for the dating).

12 *Dogon*, 1994, p. 139.

13 Carbon-14 dating carried out on the wood of this sculpture in 1999 by Dr Georges Bonani, Eidgenössische Technische Hochschule, Institut für Teilchenphysik, Zurich, has yielded the following results: ETH-20619: 780 +/- 40 B.P.; ∂13C [‰]: -21 +/- 1.1; calibrated period: CE 1197-1295, with a probability of 100%. This dating confirms J. Kerchache's earlier attribution to the "proto-Dogon" (see J. Kerchache, J.-L. Paudrat and L. Stéphan, 1988, no. 268, p. 364).

14 B. de Grunne, to be published.

15 See *supra*, note 3. All of these pieces, moreover, boast a high headdress that was often assimilated to the head coverings of the Dogon's high dignitaries, the Hogon, when these pieces were wrongly attributed to the Dogon.

16 *Dogon*, 1994, p. 157. By way of the Soninke statue with two figures in low relief, stylistically we can also link these works to the following, all of which are larger: *Dogon*, 1994, p. 92; *ibid.*, p. 95; *ibid.*, p. 153 (perhaps this is the "superb, albeit damaged" statue mentioned by H. Leloup;

see *supra*, note 3). I should also point out the existence of a large figure reproduced (fifth object from the left) in the Galerie Pierre photograph cited above (see also T. Phillips, 1995, no. 6.20, p. 508); this piece was sold to R. Rasmussen, then P. Loeb, and finally M. and D. Ginzberg (personal com., J.-L. Paudrat, December 1998).

17 B. de Grunne, 1991, p. 87. De Grunne also points out that very old quivers have been found in caves of the Bandiagara Escarpment (1991, p. 82). See also Y.T. Cissé, 1998, pp. 100 and 106.

18 One of the rare equivalents of these sheaths in Dogon statuary is found on a rider statue belonging to the Fondation Mnuchin (see H.M. Cole, 1989, fig. 140, p. 122).

19 J.-L. Paudrat, 1994b, p. 81.

20 S.M. Vogel, 1985, pp. 9-11.

21 Y.T. Cissé, 1998, p. 100; *Dogon*, 1994, p. 108; B. de Grunne, 1991, no. 10, p. 83; *Dogon*, 1994, pp. 114, 82 and 83.

22 *Dogon-Meisterwerke der Skulptur – Chefs-d'œuvre de la statuaire dogon*, 1998, no. 7, p. 59; Dogon, 1994, p. 100 and p. 101.

23 B. De Grunne, 1988, p. 50, basing his conclusions on G. Dieterlen, 1941, p. 221.

Sculpture from the Dogon Plateau

14th century
Mali

"Master of the Red Maternity Statue"

Wood, pigments
H. 75 cm
Acquired by Maurice Nicaud in 1954
Formerly the Maurice Nicaud and Hubert Goldet collections
Musée du Quai Branly (donation 1999)
Inv. 70.1999.9.3

Main Exhibitions
Zurich, 1970-71; Essen, 1971; Florence, 1989; Paris, 1994-95; Zurich, 1995; Stuttgart, 1998.

The style of this magnificent mother-and-child statue is quite similar to that of another female figure (shown with a staff and carrying a receptacle on her head) that is today in Zurich's Museum Rietberg. The wood of the latter piece has been found to date from the 13th-14th centuries,[1] a period when the Dogon had not yet reached the cliffs of Bandiagara. These two statues were collected in the Dogon plateau's northeast, in the remote region of Tintam, which was probably already populated before the arrival of the Dogon.

The piece's style is made up of supple, rounded shapes, especially noticeable in the mother's oval head (where the ears and face are delineated in slight relief), the breasts, which merge with the shoulders and the beginnings of the arms, and the infant's body. The piece also has the same red patina that is seen in the figure holding a staff. One relatively singular detail in this form, the head of both pieces presents the same labret thrust through the lower lip.

Two other statues that are attributed to the Dogon have a similar red patina and certain features that stylistically recall those of the oval-faced maternity statue. These figures with well-defined breasts also display a lower lip that is prolonged by

Main Publications
P. Meauzé, 1967, p. 31;
E. Leuzinger, 1970, A 4, p. 23;
E. Leuzinger, 1971, A 4, p. 27;
J. Kerchache, J.-L. Paudrat
and L. Stéphan, 1988, no. 270,
p. 365; E. Bassani, 1989, no. 38;
E. Bassani, 1992, p. 141;
P. Harter, 1991, fig. 8, p. 21;
Dogon, 1994, p. 113; H. Leloup,
1994, pl. 107; *Die Kunst der
Dogon*, 1995, no. 30, p. 71;
*Dogon-Meisterwerke der Skulpture
– Chefs-d'œuvre de la statuaire
Dogon*, 1998, no. 32, p. 119.

a stem-shaped labret[2] that is larger than the lip ornament of the preceding statues and which extends to a beard on the chin. Designed by the same sculptor, these two figures have raised arms, the left hand extended and the right palm closed. They were collected by the Swiss merchant Emil Storrer (who also probably collected the female statue carrying a vessel[3]). One of these is in the Museum Rietberg;[4] the other, in the Musée Barbier-Mueller, has been dated to the 15th-16th centuries.[5]

Amongst the different works displaying similar stylistic traits (all of which have been grouped with the preceding by H. Leloup under the term "Tintam style"[6]), two large figures with raised arms[7] should also be mentioned here. They are surely amongst the earliest sculptures executed by the Dogon at the time of their arrival along the cliffs.[8] Finally, the maternity statue now on display in the Louvre offers a number of points of comparison with the female figure forming the superstructure of an extraordinary Dogon mask (fig. 1) which no doubt goes back many years as well. The position of this

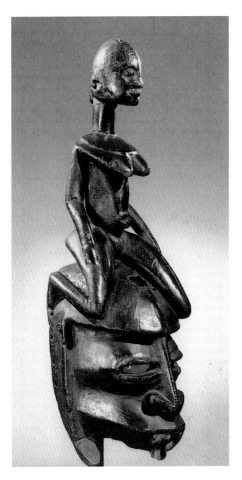

Fig. 1
Dogon sculpture, Mali
Wood, H. 58 cm
Formerly the René Rasmussen
and Gaston de Havenon collections
Private collection

creature calls to mind a woman giving birth; its head is shaped like an oval, moreover, like the head of the red maternity statue. The features of the face, although more clearly modelled in relief, are also rather flat and low set.

The universal maternity theme representing an infant carried on the mother's left side is frequent in Dogon art. The women are depicted standing or seated, as in this case, or even kneeling.[9] They are shown simply holding the child, occasionally nursing it with one hand.[10] Although rarer in Tellem art, the iconography of the mother and child reappears in a Soninke maternity statue (fig. 1, p. 82) featuring twins in this instance. This piece in turn recalls a terracotta statue from the Inland Niger Delta that has two infants near the figure's breasts.[11]

All of these female images unite the themes of fertility and fecundity. Yet "these 'Mother and child' statues, whether nursing twins, or feeding from one hand or holding in their forearm offspring for whom they show no regard, express no feelings of tenderness. These depictions, which do not represent maternal love, seem to figure rather austerely the allegories of Fecundity and Fertility."[12] It is difficult to determine the ritual ends these statues served; writers on the subject speak at times of therapeutic practices, at others of some funerary use linked to women,[13] thus undermining "the hope held by some of establishing a strict correspondence between form and function."[14]

As essential as this relationship may be, the uncertainty surrounding just how it ought to be characterised in no way detracts from the remarkable talent the sculptor has shown in illustrating the maternity theme. He proved quite deft at reconciling the simplicity of the body's depiction (reducing, for instance, to its essential expression the treatment of the hands, the mother's head, her legs, the small child placed within a prolongation of the left arm) with a highly refined organisation of the sculpture's masses. Thus, while the shape of the breasts corresponds to that of the thighs, the drawn-out aspect of the arms is echoed in the long thin calves; the baby's round head balances the same round shape of the mother's head; the cylinder making up the neck is modelled in relationship to the torso and the support of the seat on which, moreover, the artist has carved a crocodile in low relief. The sculptor, finally, has played on the inherent dissymmetry of the mother-and-child theme, shifting slightly the right leg to perfect the composition with a very delicate touch.

The maternity from the Nicaud Collection was surely executed by the same artist as the Museum Rietberg bearing a receptacle, even if the latter piece (whose breasts and hands reveal a different treatment) is noticeably sketchier, less fully realised. In carving this mother and child, the sculptor (who can conventionally be called the "Master of the Red Maternity Statue") seems to have sur-

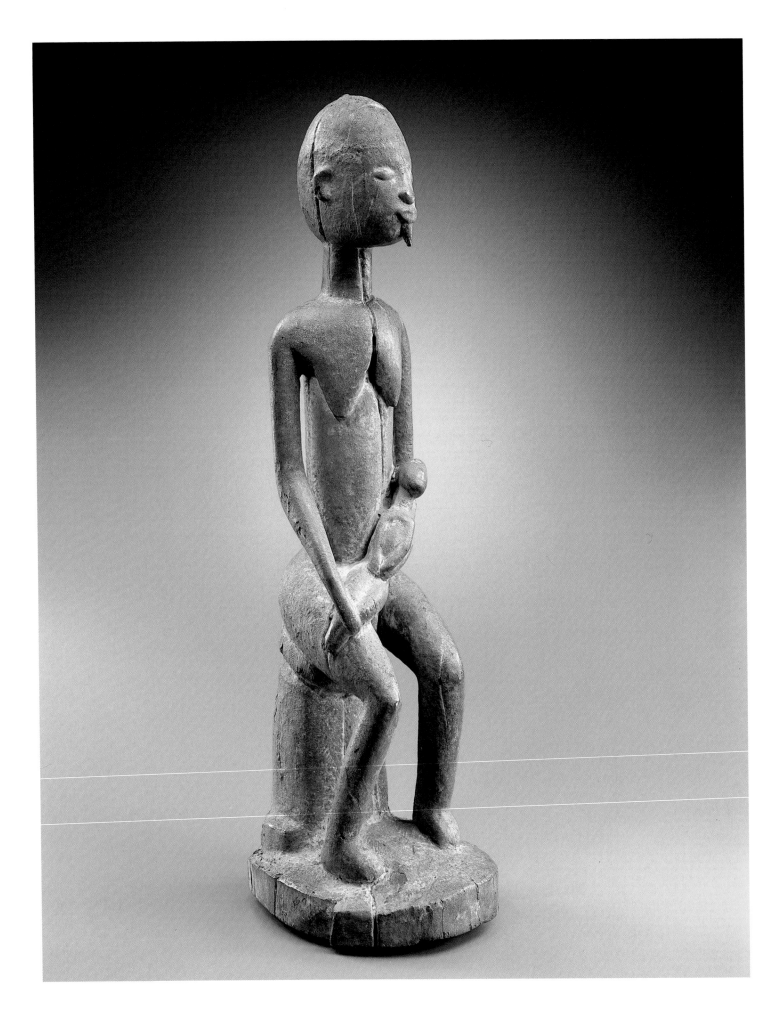

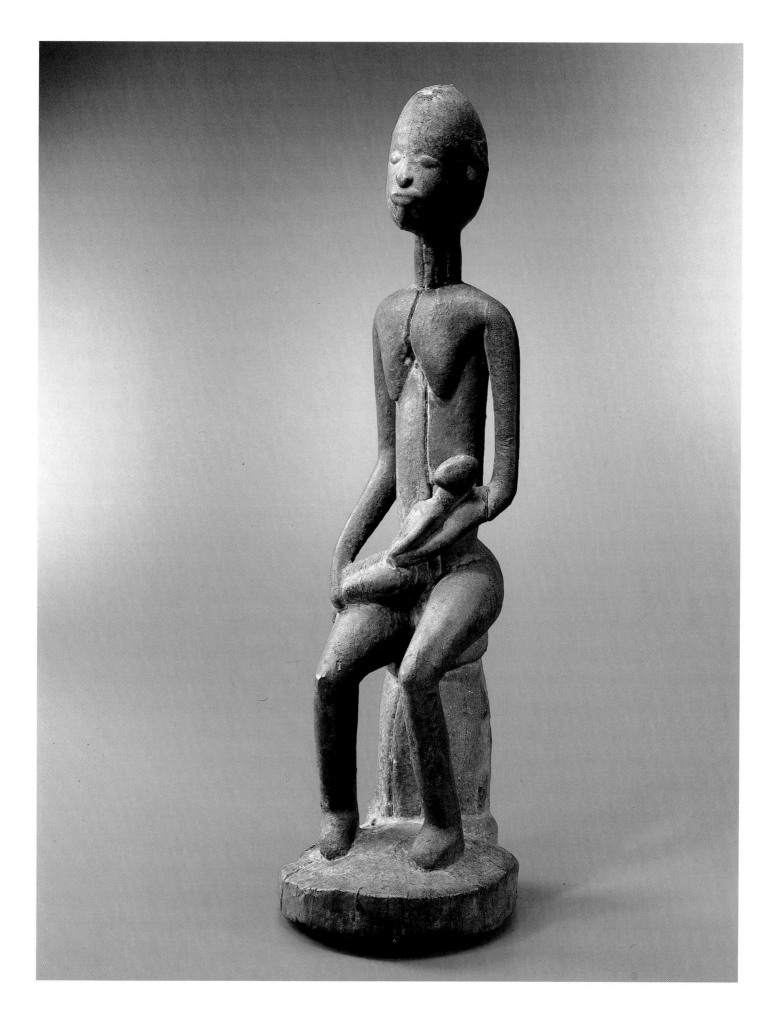

passed himself. The style here enabled him to achieve something little short of the greatest masterworks of world sculpture. Dating carried out on the piece conserved in Zurich indicates that the sculptor was active at a time when the Dogon had not yet settled in the Bandiagara area. Thus, along with the masterpieces collected in the cliffs themselves – be it the statue carved by the "Master of Yaye" or the works attributed to the Tellem – and the ancient Soninke figures that have been found on the plateau, this mother-and-child statue, by opening a new chapter in terms of style, demonstrates the immensely rich artistic output of the pre-Dogon cultures in the region.

VINCENT BOULORÉ
Translation: John O'Toole

1 *Die Kunst der Dogon*, 1995, fig. 29, p. 70.
2 Numerous female statues from the Dogon area display a stem-shaped labret: the female figures in the couple statues conserved in the Barnes Foundation (*Dogon*, 1994, p. 84) and the Metropolitan Museum of Art (*ibid.*, pp. 46 and 85); a large seated figure dating from the 15th-17th centuries (*ibid.*, p. 83; see also fig. 2, p. 96); statuettes by the so-called "Master of the Ogol" (*ibid.*, pp. 74 and 118); a kneeling figure covered with a crusted patina (*ibid.*, p. 107, right). The formal link between this labret and the beard was used by Dogon sculptors to underscore the sexual ambivalence of certain figures. The labret can also be compared with the ring placed in the lower lip of the female figure in the Dogon couple conserved in the Museum für Völkerkunde collected by L. Frobenius in 1908 in the village of Kani Kombole (*ibid.*, p. 89). A comparable ring, even a labret, may have been carved on the lower lip of the female figure that is part of a couple conserved in the Musée Dapper (formerly the Nicaud Collection, *ibid.*, p. 87). Finally, I might point out that H. Leloup (*Dogon-Meisterwerke der Skulptur – Chefs-d'œuvre de la statuaire dogon*, 1998, p. 129), commenting on the red maternity statue in a note, remarks that "labrets of the same size have been found carved in red steatite on the plateau".
3 This work was exhibited in 1970 at Zurich's Kunsthaus, number A 47; it was acquired by the Museum Rietberg in April 1986 from André Held, the piece having belonged previously to Jan Dik, who had purchased it from E. Storrer (personal com., L. Homberger, May 1999).
4 Acquired from E. Storrer in October 1958 (personal com., L. Homberger, May 1999), this piece is notably reproduced in E. Leuzinger, 1978, no. 12, p. 47.
5 B. de Grunne, 1993, p. 27. According to G. Dieterlen (*Arts de l'Afrique noire dans la collection Barbier-Mueller*, 1988, p. 59), the latter was attributed to the Tellem by the Dogon because of the necklace worn by the statue.
6 H. Leloup, 1994.
7 *Dogon*, 1994, p. 26 (dating from the 14th-15th centuries), p. 27.
8 B. de Grunne, 1988, p. 50; 1993, p. 27.
9 See respectively, *ibid.*, pp. 110-11; K. Ezra, 1988, no. 8, p. 44.
10 *Dogon*, 1994, p. 112.
11 B. de Grunne, 1991, fig. 7, p. 83.
12 J.-L. Paudrat, 1994b, p. 73.
13 *Ibid.*, p. 73 and p. 75.
14 *Ibid.*, p. 75. The same author adds further below: "These positive images of pregnant mothers and nursing women apparently contribute to calming the anxiety or the reality of biological misfortune (sterility of humans, unproductivity of crops and, by extension, sickness, famine and death). Their incantatory function is founded on an iconography that, while idealising the representations of the genesial and vital force, foresees a beneficial situation, momentarily interrupted or in danger of being interrupted."

Dogon sculpture

17th-18th century
The Nduleri Region (?), Mali

"Master of the Oblique Eyes"

Wood, metal
H. 59 cm
Formerly the Charles Ratton and Hubert Goldet collections
Musée du Quai Branly (donation, 1999)
Inv. 70.1999.9.2

Main Exhibitions
Paris, 1994-95; Zurich, 1995.

Main Publications
W.B. Fagg and M. Plass, 1964, p. 100; H. Leloup, 1988, fig. 7, p. 48; J. Kerchache, J.-L. Paudrat and L. Stéphan, 1988, no. 271, p. 365; *Dogon*, 1994, p. 109; H. Leloup, 1994, no. 115; *Die Kunst der Dogon*, 1995, no. 10, p. 53.

Making clear its importance in Dogon art, W.B. Fagg (1914-92) was one of the first to publish this piece (in 1964). At the time, it was the property of Charles Ratton.[1]

Where this piece was found, and its function remain uncertain. It may very well have been collected on the Dogon plateau near Nduleri. Passed down over the course of several generations, the statue was probably in the cave of a Hogon, thus serving as an ancestral representation in its sanctuary. Like many other Dogon anthropomorphic statues, this work was thus "kept and viewed as the token and image of an ancestral founder".[2] Unfortunately, nothing of its specific identity has come down to us, this identity doubtless reflecting the sociocultural identity of its owner.[3] In relation to the preceding sculptures, this broken-legged figure reveals a new stylistic sequence in the arts of the

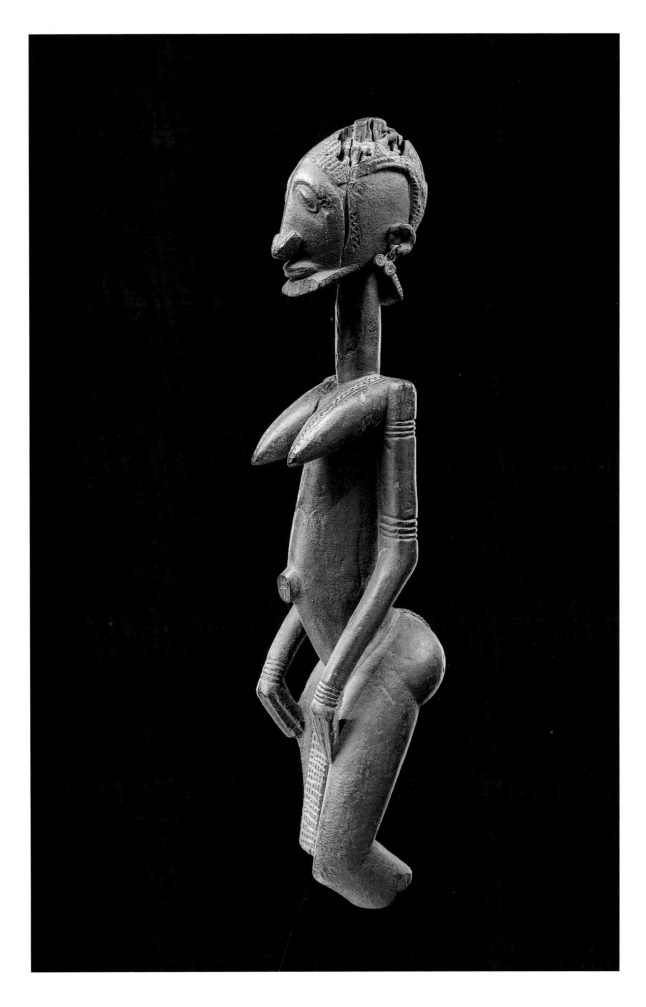

Dogon region. The statue has been found to date from the 17th-18th centuries.[4]

Several statuettes present comparable styles. One is quite similar and, if not by the same hand, surely comes, along with a third piece, from the same workshop.[5] Borrowing an expression used by H. Leloup, one might refer to it as the workshop of "the Master of the Oblique Eyes",[6] from the name given to the master sculptor who executed the piece formerly in the C. Ratton Collection. Moreover, a famous sculpture (fig. 1[7]) shows two balafon players (16th-17th centuries[8]) who sport shaven temples, like the representation carved by the "Master of the Oblique Eyes". According to H. Leloup, this singular piece was found in Nandoli,[9] not far from Kani Goguna on the Bandiagara plateau. Along with many other figures, these works make up a broader stylistic group.[10]

Frequently depicted in Dogon art, the pose of this figure (hands pointing down,[11] the tips of the fingers touching the thighs) is linked to praying. The pose is seen notably in kneeling figures and seated couples.[12] Heightened with bracelets (likewise fairly common in Dogon iconography), this position of the arms and hands can be compared with the pose of certain terracotta works from the Inland Niger Delta.[13] The same holds for the hanging portion of the loincloth which can be seen between the legs.[14] Figuring more sketchily in other Dogon pieces (which also associate a pronounced corporal femininity with a beard[15]), this element, too, can be compared with the embroidered loincloth worn by certain horsemen and other carved figures from the Dogon region.[16]

Other remarkable statues present a less naturalistic manner that recalls the style of the figure that was once part of the C. Ratton Collection (especially in the treatment of the nose and hands). This group of works, one of which has been dated to the 17th century (fig. 2), was executed by the same workshop in which one or several master sculptors worked, or perhaps even the same sculptor at different periods of his life.[17] The piece by the "Master of the Oblique Eyes" was probably executed sometime after these figures; it was designed by a truly original artistic personality whose personal style is part of a very rich period in Dogon art. His style is in turn part of a far broader artistic continuum. From the art of the Inland Niger Delta and Soninke sculpture, to works dating from the Tellem period and the figure carved by the "Master of the Red Maternity Statue", to the more recent pieces from the Bandiagara cliffs, this continuum attests both the high degree of imagination shown by these artists, and the fertility of the cultures in which they lived and worked.

VINCENT BOULORÉ
Translation: John O'Toole

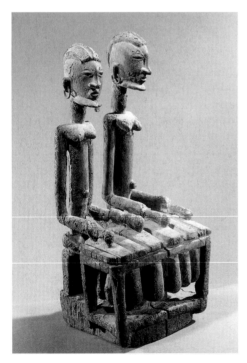

Fig. 1
Dogon sculpture, 16th-17th centuries
Bandiagara Escarpment, Mali
Wood
H. 44 cm
Private collection

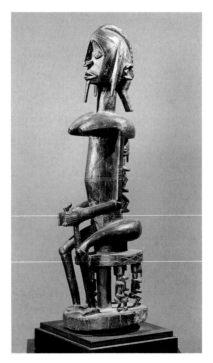

Fig. 2
Dogon sculpture, 17th century
Mali
Wood
H. 77 cm
Private collection

1 C. Ratton bought this sculpture (which he retained practically until his death in 1986) from Emil Storrer, who had therefore collected it some time before (com., H. Leloup to J.-L. Paudrat; pers. com., J.-L. Paudrat, January 1999).

2 J. Bouju, 1994, p. 234.

3 The Dogon belong to one of four initial groups descended from the Mande (Ono, Domno, Dyon and Aru, the first two having settled on the plain, the third on the plateau, and the fourth in the cliffs). Dogon sociocultural and religious identity also depends on two other categorisations. One, called *ginna*, refers to the extended family and involves all the descendants of the same ancestor along the male line of descent. The other, organised according to clan, is larger and functions by reference to a common totemic ancestor, the *babinu*, "said to correspond to this or that part of the body of the 'father of men', Nommo, who was dismembered after being sacrificed" (J.-L. Paudrat, 1994a, p. 13).

4 *Die Kunst der Dogon,* 1995, p. 52.

5 See respectively, H. Leloup, 1994, pl. 114; *Collection Kerbourc'h,* 1993, p. 13.

6 For H. Leloup (1994, pp. 177-78), the sculpture that was formerly part of the Ratton Collection and the piece reproduced in his study (*ibid.,* pl. 114) are in fact the work of one and the same sculptor, called the "Master of the Oblique Eyes". Nevertheless, the shape of the hands, for instance, seems to indicate two different individual styles.

7 This piece recalls a rider statue (*Dogon,* 1994, pp. 134-35) dating from the 16th-18th centuries.

8 *Die Kunst der Dogon,* 1995, p. 54.

9 H. Leloup, 1994, p. 180.

10 *Dogon,* 1994, p. 108; H. Leloup, 1994, pl. 117; *Dogon,* 1994, pp. 48, 53, 110-11, 115; H. Leloup, 1994, pl. 119. Most of the figures mentioned are grouped by H. Leloup (1994) under the term "N'duleri style".

11 A position that can be compared with the pose seen in many other statues in which the hands,

when placed on the abdomen, apparently signify the figure's pregnant state (G. Dieterlen, 1981, mentioned by J.-L. Paudrat, 1994b, p. 75).

12 See respectively, *Dogon,* 1994, p. 108; *ibid.,* pp. 56, 84, 85, 86-87, 89.

13 B. de Grunne, 1988, fig. 10, p. 54.

14 *Ibid.*

15 See *Dogon,* 1994, pp. 90, 91, 110-11. See also *ibid.,* p. 151, a figure attributed to the Soninke.

16 See *ibid.,* pp. 139, 154.

17 The creator of one of these sculptures (a couple published initially in H. Clouzot and A. Level, 1922, fig. 11, p. 221, which belonged to P. Guillaume at the time) was named by convention after the place where the piece was conserved, i.e., the "Master of the Barnes Foundation" (S.M. Vogel, 1985, p. 9).

Nuna sculpture

18th century
Leo Region, Burkina Faso

Wood (*Vitex doniana*, Verbenaceae)
H. 115 cm
Formerly the Samir Borro collection
Musée du Quai Branly
Inv. 70.1998.6.1

Publication
J. Kerchache, J.-L. Paudrat and L. Stéphan, 1988, no. 36, p. 84.

Along with another, smaller female statue now in the Musée Barbier-Mueller (fig. 1), this statue constitutes one of the extremely rare known works in this style. These two figures were collected near Leo in southern Burkina Faso, in a region settled by the Nuna, not far from Lobi territory. The Barbier-Mueller sculpture was collected in 1970 by Henri Kamer[1] and later attributed to the "southern Nuna".[2] The precise ritual ends that these sculptures served remain a mystery. Yet the exceptional artistic quality of the Louvre's statue quite probably reflects its importance in cult worship.

The Nuna are one of the populations of Burkina Faso's southern territories whom the neighbouring Mossi call "Gurunsi", a pejorative term. They are "descendants of ancient peoples who were living in this region before the Mossi invasion from the south in the 15th century".[3] Their "wooden statues are kept by men called *vuru* who control a series of bush spirits".[4]

Settled immediately next to Nuna territory, the Lobi are the only people to have developed a prolific output of statuary. Several of their sculptures are nearly as large as the Nuna's own work. Moreover, they offer a number of stylistic points in common with the latter. Most large Lobi statues also have broken feet, like the two Nuna figures. This probably indicates that these statues were planted in the ground at some permanent site.[5] Amongst the Lobi, these figures belong to the vast group of statuary called *bateba* (a term referring to any anthropomorphic statue[6]). Certain Lobi heads[7] also recall the style seen in the large female Nuna statue. Most Lobi figures, however, show no scarifications, their surface revealing a distinct contrast with the wealth of incisions[8] marking the sculpture now on display at the Louvre.

The incised motifs of the two statues correspond to a series of similar rectangular tegumentary inscriptions, especially on the belly, where a vertical group of markings (each side of which gives rise to a number of diagonal lines) begins between the breasts and descends to the navel. The body of the piece on display at the Louvre, however, with its richly adorned back, offers a surface that has been more elaborately worked by the sculptor. In the

Louvre piece, the distribution of the incised "scarred" elements was conceived in close association with the remarkable arrangement of the statue's volumes. Similarly, the sculpture's face and head boast a number of curved forms that reveal a rare perfection, admirably balancing in profile the mass of the buttocks. These, too, are treated with an extreme degree of artistic sensibility.

The facial striations of Nuna figures also recall the treatment of hair in several Lobi sculptures.[9] Furthermore, links exist between the incised motifs of Nuna statuary and the painted and carved motifs adorning certain masks surmounted by a plank-like superstructure that have been attributed to the Bwa, the Nunuma,[10] and the Nuna (the last named figures boast stylised mouths and noses[11] similar to the same facial features on the Louvre sculpture).

Finally, certain Lobi figures, like the two Nuna statues, would seem to recall a sculpture conserved in the Musée des Arts d'Afrique et d'Océanie[12] which was incorrectly attributed to the Kulango, but has been recently reattributed ("if this is not a work by a brilliantly idiosyncratic Lobi sculptor" [13]) to populations sharing part of their territory with the Lobi in the northeast or living nearby, i.e., the "Dagara/Dagari/Dagaaba", perhaps even (further to the northeast) the so-called Gurunsi groups: "Pwa (Pugula), Sisaala, Kasena, Nuna, Nunuma, Ko and others".[14]

The statuary of the southern Nuna (which may also be linked to the female figures forming the superstructure of certain Mossi masks), like the statuary of other populations living near Lobi territory, may therefore be the outcome of ties that once existed with the Lobi – whose statues, reaching nearly one metre high (without ever attaining the size of the large piece in the Louvre), are more common. Moreover, settled near the Nuna, other populations like the Lodaga (who lived amongst the Lobi, although without the possibility of being assimilated) could well have played an intermediary role between the Lobi and the Nuna in terms of their sculpture.

Thus, a few quite rare sculptors, including the master artist who executed this monumental Nuna figure in the distant past (around the 18th century[15]), succeeded in forging a thoroughly new style. This was the result of the fertile shock that occurred when several artistic influences came together, giving rise to a remarkable statuary, an expression of the most brilliant technique.

VINCENT BOULORÉ
Translation: John O'Toole

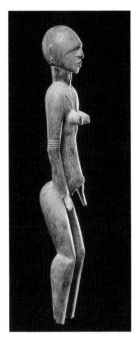
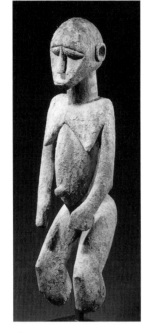

Fig. 1
Nuna sculpture
Leo region, Burkina Faso
Wood
H. 83 cm
Musée Barbier-Mueller,
Geneva
Inv. BMG 1005-4

Fig. 2
Lobi sculpture
Burkina Faso
Wood
H. 59 cm
Private collection

1 Tourmani Triande in H. Kamer, 1973, p. 7; the piece is reproduced in *ibid.*, no. 189, p. 136, where the geographic origin ("Leo region") is mentioned.
2 C.D. Roy, 1988, p. 76.
3 C.D. Roy, 1996, p. 244.
4 C.D. Roy, 1988, p. 76. Roy adds: "These spirits can appear as wooden figures [...] that are kept in reliquaries deep inside the house of the ritual specialist. To conjure up the protection of the spirits for the benefit of his clients, the specialist sacrifices animals over these figures and other objects which are soon covered with a thick layer of blood, feathers and millet gruel."
5 One of the large Lobi statues in situ is reproduced in P. Meyer, 1981, ill. 9. p. 11 (unlike this figure, Nuna sculptures were not displayed in the open).
6 P. Meyer, 1981, p. 56.
7 J. Kerchache, J.-L. Paudrat and L. Stéphan, 1988, no. 39, p. 86.
8 The motifs represented by these incisions are comparable to those carved on Mossi statues (see J. Kerchache, J.-L. Paudrat and L. Stéphan, 1988, nos. 37, 38, p. 85).
9 See for example P. Meyer, 1981, p. 62.
10 See respectively, C. Falgayrettes-Leveau and L. Stéphan, 1993, p. 141 and p. 140. Living northwest of the Black Volta, the Nunuma and the Nuna are, according to C.D. Roy (1987, pp. 204-205), "closely related, but they carve masks whose style is slightly different and are distinct for this reason".
11 See *Arman et l'art africain*, 1996, no. 140.
12 T. Phillips (ed.), 1995, no. 5.113, p. 449. This sculpture was owned by Samir Borro (pers. com., J. Kerchache, May 1998).
13 T.F. Garrard, 1995, p. 449.
14 *Ibid.*
15 Carbon-14 dating carried out on the wood of this sculpture in 1999 by Dr Georges Bonani, Eidgenössische Technische Hochschule, Institut für Teilchenphysik, Zurich, has yielded the following results: ETH-20601: 195 +/- 40 B.P.; $\partial^{13}C$ [‰]: -25.2 +/- 1.1; calibrated period: CE 1649-1706, with a probability of 22.7%, CE 1714-1821, with a probability of 53.4%.

AFRICA

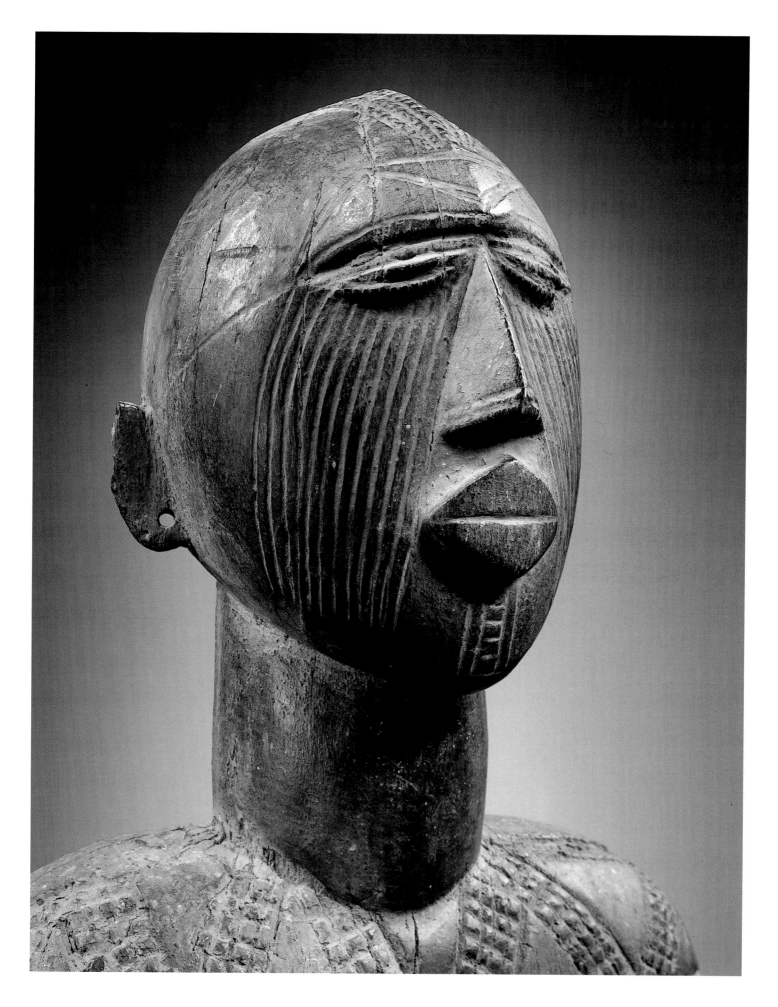

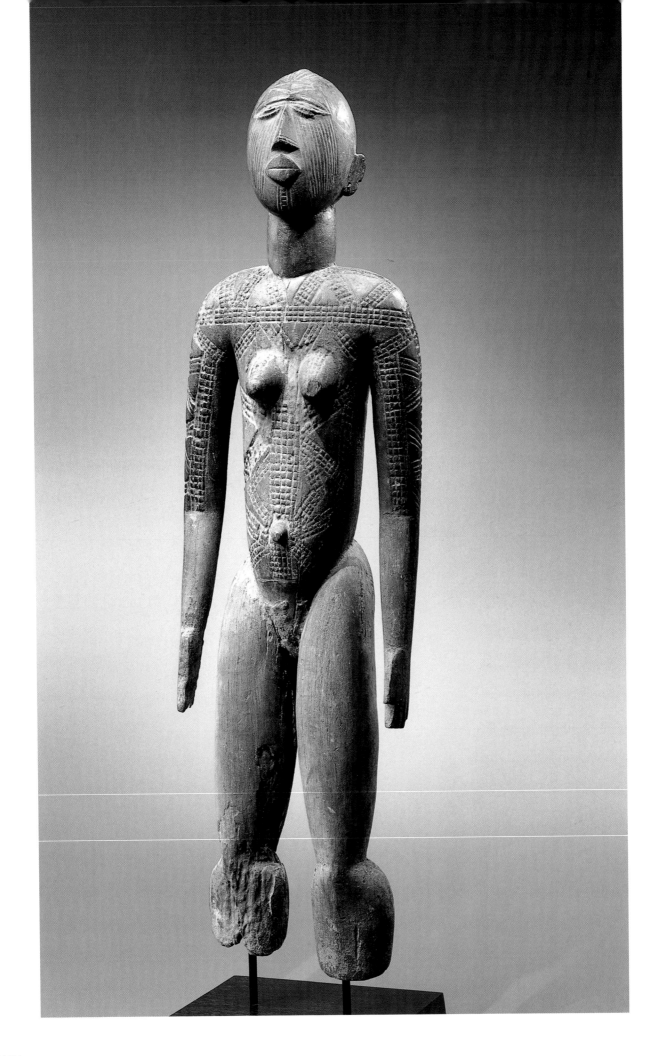

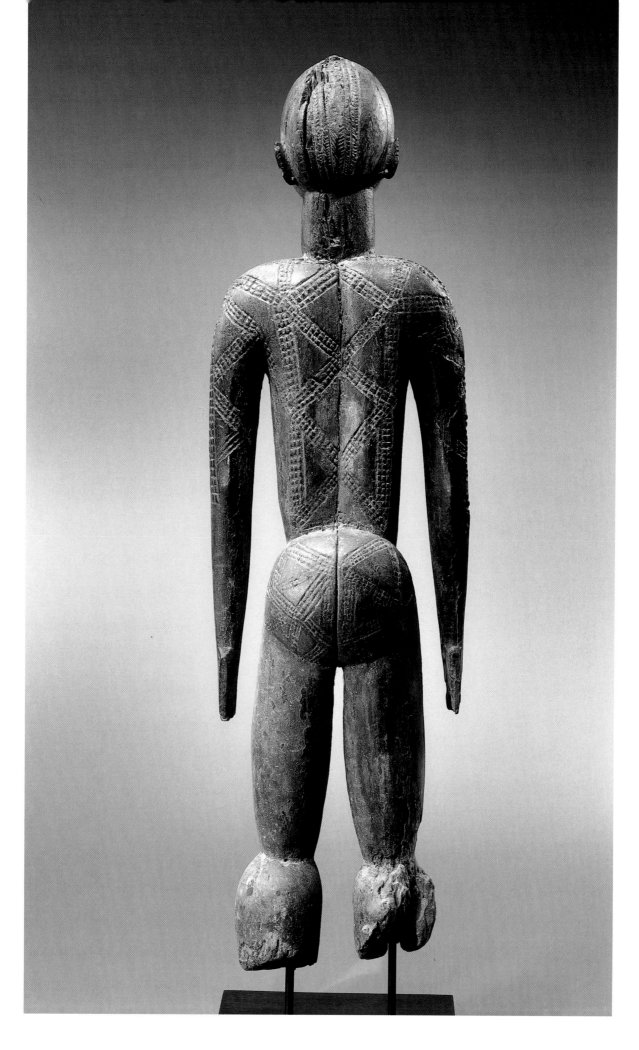

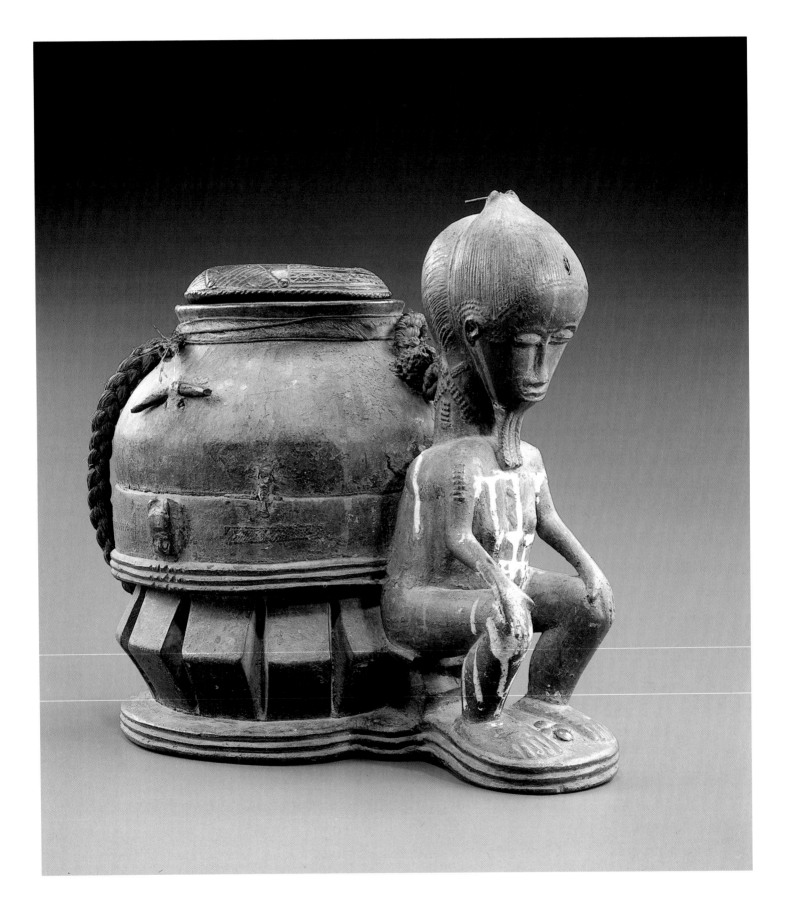

Baule sculpture

Second half of the 19th century
Central Ivory Coast

Mouse oracle (*gbéklé sè*)

Wood (probably *Funtumia elastica*, Apocynaceae; *potombo* in Baule), terracotta, skin, kaolin, rope, metal
H. 25 cm
Collected by Hans Himmelheber in the Baule-Aitu region, first quarter of 1933
Gift of Hans Himmelheber to the Musée d'Ethnographie du Trocadéro, 1933
On permanent loan from the Muséum National d'Histoire Naturelle – Musée de l'Homme
Inv. M.H. 33.132.1

Main Exhibitions
Paris, 1965, 1972-73; New York, 1984-85a; Paris, 1989b; Zurich, 1996-97; New Haven, 1997-98; Chicago, 1998.

Main Publications
H. Himmelheber, 1935, pl. VI, no. 14; H. Labouret, 1934-35, fig. 1, p. 5; M. Griaule, 1947, fig. 81, p. 93; W. Muensterberger, 1955, no. 10; D. Paulme, 1956, pl. XI (upper left); E. Elisofon and W.B. Fagg, 1958, no. 132, p. 104; *Chefs-d'œuvre du musée de l'Homme*, 1965, no. 11, p. 61; *Le Courrier de l'Unesco*, 1965, p. 13; A. Terrisse, 1965, fig. 64, p. 57; M. Leiris and J. Delange, 1967, no. 344, p. 299; B. Davidson, 1967, p. 124; G. Balandier and J. Maquet (dir.), 1968, p. 66; R.S. Wassing, 1969, p. 214, fig. 111; P.S. Wingert (ed.), 1970a, N41 (left); *Sculptures africaines dans les collections publiques françaises*, 1972, no. 68, p. 50; E. Leuzinger (ed.), 1978, no. 39; S.M. Vogel and F. N'Diaye, 1985, no. 41, p. 32, 136; J. Kerchache, J.-L. Paudrat and L. Stéphan, 1988, no. 64, p. 128; *Corps sculptés, corps parés, corps masqués*, 1989, no. 163, p. 200; *Musée de l'Homme*, 1992, no. 10488, p. 55; L. Meyer, 1991, fig. 194, p. 209; V. Bouloré, 1993, p. 29; V. Bouloré, 1996a, ill. 115, p. 173; E. Féau and H. Joubert, 1996, p. 54; V. Bouloré, 1996b, p. 201; P.L. Ravenhill, 1996, fig. 2, p. 407; S.M. Vogel, 1997, p. 269.

The German ethnologist and art historian Hans Himmelheber (born in 1908) collected this sculpture in 1933 during his first voyage to the Ivory Coast. Upon his return, as a way of thanking French authorities for the excellent welcome he had received in what was then the French colony of the Ivory Coast, he presented this piece to the Trocadéro. Himmelheber considered the receptacle to be of major importance.

This object is capital for the history of African art and for the history of Western collections in the 1930s. Indeed, it was after discovering this piece in Paris that the art dealer and collector Charles Ratton (1895-1986) invited Himmelheber in 1933 to begin collecting objects for him.

During his second stay in the Ivory Coast (1934-1935[1]), Himmelheber collected in the Baule region two other mouse oracles that display figures in high relief. With the piece collected in 1933, these are the only known mouse oracles showing this type of figure. Charles Ratton immediately chose one of the two (fig. 1[2]) and the other was sold in September 1935 to the Musée d'Ethnographie in Neuchâtel.[3]

Fig. 1
Baule sculpture, late 19th century
Ivory Coast
Wood, terracotta, skin, pearls, iron and fibre
H. 26 cm
Private collection

Cultural context

The Baule inhabit central Ivory Coast. They were to form a group over a number of years, a process that began in the 18th century, after a series of Akan migrations from Ghana. As they united, they assimilated various elements from non-Akan cultures (notably the southern Mande – Guro, Wan – and the Senufo) that are found today in neighbouring territories.

One of the techniques used by diviners amongst the Baule to exercise an influence over events is divination by mice. This type of oracle makes use of a recipient with two connecting compartments. According to P.L. Ravenhill, "The mouse hides in the lower chamber and comes to the upper chamber when the diviner inserts rice chaff and closes the clay lid. In eating, the mouse rearranges the positions of small beaded or bone shafts attached to a small tray (of either brass or a tortoise carapace). The new arrangement of these elements is read by the diviner and interpreted".[4]

In the late 19th century these objects were quite common amongst the Baule, Guro and Yohure. None of the Guro mice oracles is decorated, whereas those of the Baule – in which the addition of a complete figure remains the exception rather than the rule – often have decorative motifs (small masks in relief, engraved surface and lid, etc.).

The Guro were probably the first population to develop divination using mice. Amongst these people, for example, the ritual material is more important, the vocabulary more extensive, the manipulations and interpretation more skilful. One therefore wonders whether the shape of Baule mouse oracles is not in part intended to replace the loss of semantic information that may have occurred when the technique was borrowed from the Guro. This process of "aesthetisation" could have been transmitted by the Yohure (a group made up of Baule, the Yohure/Baule, and an older group descending from the southern Mande, the Namanle). There exist, for example, mouse oracles which are decorated with low relief heads whose style forms

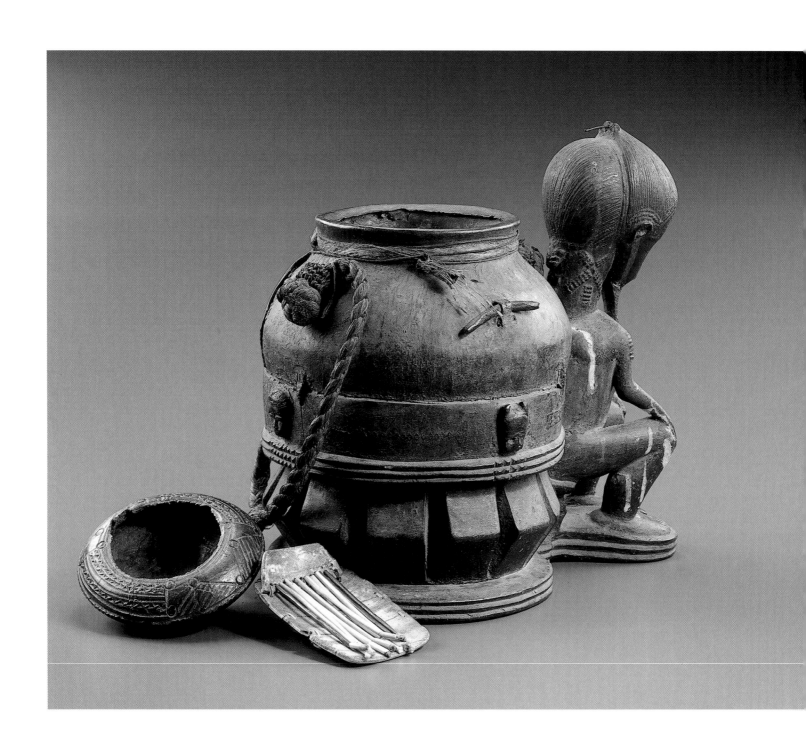

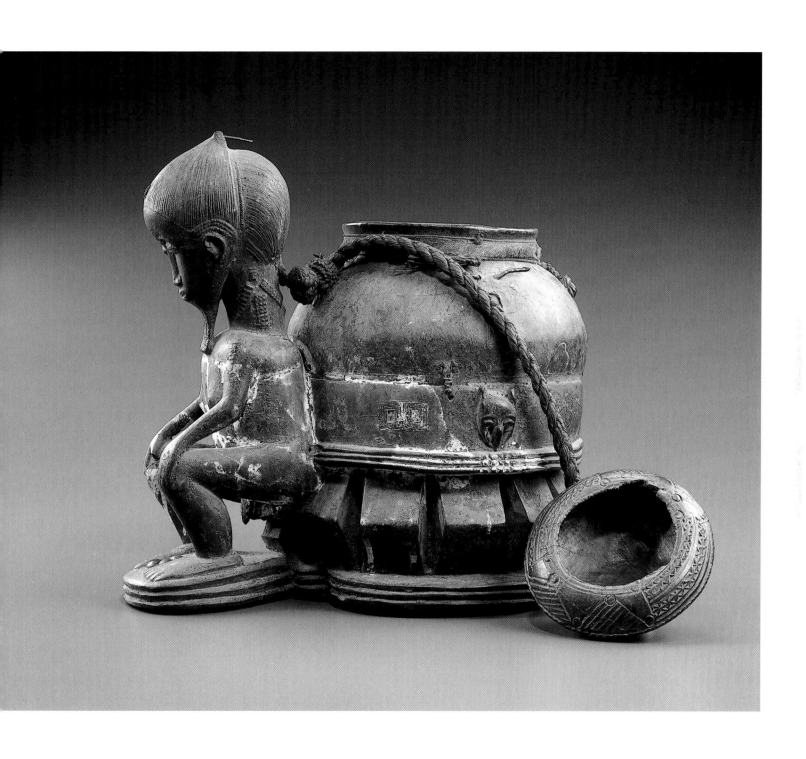

an intermediary between Guro and Baule facial representations. From the point of view of form, it is possible to establish a link, via Yohure mouse oracles, between the oracles of the Guro and the Baule's strictly speaking. From the Guro to the Yohure one finds a striking consistency in objects that display neither sculpture nor decorative motifs. Yet the Yohure, like the Baule, do have artefacts adorned with figurative low reliefs. On the other hand, the former have no mouse oracles that boast complete human figures in high relief. These progressive differences, touching on the change of meaning,[5] may also apply to the differences found in the names used; Guro and Yohure terms are similar, whereas Baule terminology belongs to another linguistic family (namely, the Akan and not the southern Mande).[6]

Iconographic interpretation

Doubtless there exists a link between the pose of the human figure in high relief and the bearing of the diviner. The figure is seated, hands resting on the knees, facing outwards, as if he were awaiting the results of the diviner's questioning of supernatural powers, all the while guarding the container and its contents like a sentinel. Does the figure depict the diviner who, after carrying out various manipulations and before reading the results in the container, remains seated for a moment on a stool?[7] For the Baule, the seated position of certain anthropomorphic masks and various statues[8] clearly refers to the bearing of dignitaries and leaders who, during important events, sat astride their throne with their hands resting on their knees. The seated pose of the figure adorning the mouse oracle (the lower part of the vessel borrows, moreover, the chevron design decorating Baule stools) might be connected to the importance and power of the container's owner, who may himself have been employed by an influential chief. Finally, as H. Himmelheber has already suggested for this type of representation,[9] the figures applied to such mouse oracles could also be the idealised representations of the diviners who had commissioned the piece. These depictions would have been realised according to their wishes, in a flattering style, and with the figure represented in a noble position.

With the Baule's decorated oracle containers, aesthetics clearly seems to take precedence over function. Inspired by a technique of divination that was borrowed from the Guro, shared by the Yohure and eventually popularised amongst the Baule, these works of art remained quite rare in their native culture, where they were created for several high-ranking diviners by a handful of master sculptors. This container, designed and created in the second half of the 19th century, this masterpiece which was later collected by H. Himmelheber amongst the Aitu, was surely the most remarkable of the group.

VINCENT BOULORÉ
Translation: John O'Toole

1 Concerning H. Himmelheber's two expeditions to the lands of the Baule, Guro and Yohure before World War II, see H. Himmelheber, 1935; *Die Kultur der Baule*, 1997.

2 Reproduced for the first time in H. Labouret, 1934-35, fig. 2, p. 7.

3 Inv. 70.3.1. a, b, c, d; reproduced in V. Bouloré, 1996a, ill. 116, p. 173. The other known decorated mouse oracles include the following: Baule container with low relief figures, collected by H. Himmelheber in 1934-35 and acquired by C. Ratton, reproduced in H. Labouret, 1934-35, fig. 3, p. 7, at present in the Musée Barbier-Mueller, Geneva (inv. 1007.148); container with four low relief heads, formerly the E. Winizki Collection, Zurich, reproduced in V. Bouloré, 1996a, ill. 118, p. 173. Amongst the other Baule and Yohure sculptures collected by H. Himmelheber in 1933 in present-day Ivory Coast I should mention the following: a Yohure mask created by the sculptor Kouakoudili, Musée Barbier-Mueller (inv. 1008.8), purchased by Joseph Mueller from C. Ratton, reproduced in H. Himmelheber, 1935, pl. XII, no. 28 (right), and J.P. Barbier (ed.), vol. II, no. 184, p. 110; an elephant mask, Museum für Völkerkunde, Frankfurt am Main (inv. NS 29322), reproduced in H. Himmelheber, 1960, no. 161, p. 214, and P.L. Ravenhill, 1992, 6-25, p. 132; seated figure bearing a cup, formerly the Charles Ratton and Pierre Matisse collections, reproduced in *Réceptacles*, 1997, p. 226.

4 P.L. Ravenhill, 1994, p. 24.

5 The connotations still common today amongst the Yohure seem fairly similar to those that are widespread amongst the Guro and therefore appear to be more elaborate than those attached to Baule mouse oracles.

6 The mouse oracle is referred to as a *moninpô* amongst the Guro, a *monpô* amongst the Yohure and a *gbêklé sè* amongst the Baule.

7 See *Die Kultur der Baule*, 1997, photographs nos. 118-124, pp. 86-89.

8 See J.P. Barbier (ed.), 1993, vol. I, fig. 343, p. 336; see also the statuette mentioned above and reproduced in *Réceptacles*, 1997, p. 226, which is probably the work of the same artist who carved the seated figure that is reproduced in E. Bassani, 1992, p. 155.

9 H. Himmelheber, 1935, p. 52.

Baule sculpture

Late 19th-early 20th century
Central Ivory Coast

Monkey (cynocephalus) bearing a bowl (*mbotumbo?*)

Wood, fabric, sacrificial materials
H. 53.5 cm
On permanent loan from André Lefèvre to the Musée de l'Homme, 1957
On permanent loan from the Muséum National d'Histoire Naturelle – Musée de l'Homme, inv. M.H.D. 57.1.1

Main Exhibitions
Paris, 1964a, 1965, 1972-73;
Nice, 1980; New York,
1984-85a.

Main Publications
Collection André Lefèvre, 1964,
no. 32; *Chefs-d'œuvre du musée
de l'Homme*, 1965, no. 10, p. 59;
A. Terrisse, 1965, fig. 60, p. 53;
M. Leiris and J. Delange, 1967,
fig. 346, p. 301; G. Balandier
and J. Maguet (dir.), 1968,
p. 155; R.S. Wassing, 1969,
cat. 31, p. 249; *Sculptures
africaines dans les collections
publiques françaises*, 1972,
no. 92, p. 59; P.S. Wingert (ed.),
1970a, N41 (right); *Esprits
et dieux d'Afrique*, 1980, fig. 26,
p. 47; S.M. Vogel and F. N'Diaye,
1985, no. 40, p. 78 and p. 135;
J. Kerchache, J.-L. Paudrat
and L. Stéphan, 1988, no. 891,
p. 526; *Musée de l'Homme*, 1992,
no. 10459, p. 54; V. Bouloré,
1990, fig. 2, p. 88; V. Bouloré,
1996b, p. 177.

In 1954 André Lefèvre (1893-1963) bequeathed this sculpture to the French Republic on the condition that the state agree to display it "at the Palais du Louvre as soon as the directors of the Musée du Louvre recognise that the art of sub-Saharan Africa is worthy of representation in the public galleries of the said Palais".[1] The installation of this piece in the Louvre (it had been placed on permanent loan in the Musée de l'Homme in 1957[2]), 46 years after the commitment stipulated in its bequest, thus marks its official entry into France's public collections. A. Lefèvre owned several other objects from Africa (including a famous Fang mask acquired by the Musée de l'Homme in 1965[3]); at his death, his bequest comprised, besides this monkey-headed sculpture, 30 contemporary paintings from a collection begun just after World War One.[4]

The history of this Baule sculpture prior to 1954 is unknown. In 1900 Maurice Delafosse did however mention simian sculptures holding a bowl,[5] attesting to their existence before French colonisation (1893). Moreover, a number of cults that used similar objects fell into disuse and were abandoned in the early 1950s.[6] Most of the figures of monkeys bearing bowls appeared in Western collections around this time.[7]

Aesthetic, stylistic and functional context

These figures belong to what the Baule call *amuen*. This category corresponds to the term "fetish" in colonial literature and is more accurately translated by such expressions as "spirit power" or "power object". The *amuen* are given material existence in helmet masks and monkey statues holding a bowl, which belonged to associations of initiated men. These societies, whose authority is transmitted through these sculptures, are responsible for maintaining social order and give warning of external dangers (enemy incursions, epidemics, etc.). The power of the objects springs from their capacity to act in the village, from their force which is at once threatening, offensive and punitive. Like the composite zoomorphic helmet masks (*bonu amuen*), which they can replace,[8] the bowl-bearing statues draw their power from their aggressive animal-like shape (embodying the power of the bush spirits) and the blood that was regularly spilled to revitalise them.

Their simian aesthetic contrasts with the ideal of human beauty observable in the Baule's many anthropomorphic statues.[9] The bowl is a receptacle used when making sacrifices and offerings, often an egg. The vessel regulates the flow of blood by serving as a link between the head – jutting out over the bowl and allowing the blood to run there after trickling over the snout – and the rest of the body. The recipient thus makes concrete the sacrificial use of the piece and the flow of blood. Common to all the figures of this formal category (whose functions, names and zoomorphic images are nevertheless far from standardised), the bowl sums up the close link between form and function, rendering this link emblematic. From a generic point of view then, the bowl characterises the aesthetic and style of these sculptures.

These objects, like the punitive helmet masks, are not only supposed to guard against various dangers and disorder, but may also be associated with a ritual practice for the protection of initiates (elder men) observing these rites as a way of warding off sorcery and poison. Unlike the *bonu amuen* masks, however, they may also be related to agrarian rites and a form of divination known as *mbra*.[10] The diversity of their functions confirms the variety of the iconography and the words related to them, running from *aboya* (which figures an entity that is less zoomorphic) and *mbotumbo* (representing, as here, a cynocephalus monkey), to *ndyadan* (having a simian aspect), via *asri kofi* (statue of a monkey), *gbokro kofi* (a hyena), *gbekre* (a term often used by M. Delafosse), and even a cult called *kamisa* in the Akwe region.[11] Like the helmet masks, these differences heighten the specificities which can be observed at the level of the various associations and in each village possessing such objects, beyond which the name (the specific functional, iconographic and stylistic identity) is difficult to grasp.

For believers, the spiritual entity in power objects merges with the sculpture embodying it. In these beliefs, the object is perceived as a manipulation of forces that exist in the invisible world. Since the effigy/entity is supernatural, it cannot have been fashioned by human hands. The identity of the object's creator must be kept secret and it is not to the sculptor's advantage to render his style too easily recognisable. On the other hand, the more power that is at stake in a cult object, the greater the risks the sculptor runs should he fail. Baule sculptors, moreover, devoted part of their time to fashioning pieces that guaranteed them important sources of income[12] (anthropomorphic statues, heddle pulleys, facial masks, etc.) and, despite the discretion surrounding the execution of figures presenting a bowl, their art could be called seriously into doubt should the images they had realised prove ineffective. For these reasons, bowl-bearing figures were often commissioned outside the area in which they were supposed to act. The geographic distance and the secrecy shrouding the sculptor's name and origin served as a sign of the sculpture's supernatural essence, its force. Because the formal design (bringing together a figure of aggressive connotations with a sacrificial function signified by the bowl) was one vector of their force, the oldest, the most knowledgeable and the most experienced sculptors had the best chances of being the most appropriate artists for producing an effective object. Yet even amongst the few sculptors who agreed to make these figures, and whose knowledge of the invisible world had attained the high level of culture allowing them to best transcribe in wood the personality of these entities, those craftsman who, like the creator of this monkey-headed sculpture, were fired by genuine artistic genius remained exceptional indeed.

VINCENT BOULORÉ
Translation: John O'Toole

1 Letter from A. Lefèvre dated 8 April (archives of the Direction des Musées de France), communicated by Didier Schulmann. In the same correspondence A. Lefèvre also mentions two other conditions, "that the state agrees to display this statuette in the Musée de l'Homme while awaiting its eventual entry into the Musée du Louvre; and to include it in the temporary exhibitions of the collection of Mr and Mrs André Lefèvre which the state has committed itself to mount according to the terms of their donation of 12 March 1952" (A. Lefèvre is referring here to a bequest of 17 paintings subject to usufruct). A photograph taken by George de Miré is included with the letter. A collector of African, Oceanic and pre-Columbian art since the 1920s, G. de Miré also began working as a photographer towards 1950, creating the illustrations for several works (notably P. de la Coste-Messelière, 1957). The fact that he was the photographer of A. Lefèvre's monkey-headed statue does not imply that he owned the piece earlier, although as an expert he might have facilitated its acquisition.

2 Year in which the donation was ratified by the Direction des Musées de France.

3 See infra, p. 170. A. Lefèvre also owned another Baule monkey figure (see Collection André Lefèvre – Art nègre, Afrique, Océanie, Divers, 1965, no. 166; this object later became the property of C. Ratton, who reproduced it several times in an advertisement that appeared in Objets et Mondes, t. VIII, fasc. 2, 3 and 4, 1968).

4 See Collection André Lefèvre, 1964, introduction by Jean Cassou.

5 M. Delafosse, 1900, pp. 442-43, p. 556 and fig. 3, p. 442, which bears the following caption: "Wooden statue of the cynocephalus monkey-headed god, from Kansi (middle Baule)". This text takes into account observations made in the south and central Baule regions beginning in 1894. M. Delafosse was both the first colonial administrator of the Baule region and the founder of ethnological studies in Ivory Coast.

6 A period of political and economic instability, the decade prior to the independence of Ivory Coast (1960) witnessed a number of movements that called into question traditional religions. The most famous of these movements, beginning in 1950, was the "massa" cult (which disappeared in 1963). It is especially known for the abandonment of ritual objects on a massive scale that it provoked amongst the Senufo, although there were also significant repercussions in Baule territory.

7 One might mention the following sculptures: F. Herreman, M. Holsbeke and J. van Alpen, 1991, p. 16 (acquired in 1962 from C. Ratton); J. Kerchache, J.-L. Paudrat and L. Stéphan, 1988, fig. 65, p. 129; V. Bouloré, 1996b, pp. 184-85, 186, 189 (these two objects having belonged to C. Ratton); V. Bouloré, 1993, fig. 1, p. 27 (formerly the H. and N. Baker Collection); Metropolitan Museum of Art, no. 1978.412.468. Several pieces also entered the museum in Abidjan at this time and are reproduced in B. Holas, 1954 (see in particular fig. 15) and 1956.

8 In the Baule/Warebo village of Andobo Aluibo, for example, a bowl-bearing figure called gbokro kofi replaced two other amuen such as the bonu amuen do and dye (having failed to assist the armed resistance to the French colonisers between 1893 and 1914, numerous bonu amuen were subsequently discredited), before being itself replaced in 1952 (because it proved unable to surmount a social crisis) by two imported cults that had no sculptural support: tetekpan and tigari (see P. Étienne, 1962-64, p. 23).

9 See V. Bouloré, 1996b, pp. 181-82.

10 As regards mbra see S.M. Vogel, 1997, pp. 221-30.

11 As regards these functions and names mentioned by various authors, see V. Bouloré, 1996b, p. 191.

12 Amongst the Baule, although artistic activity is not considered strictly as a profession (see H. Himmelheber, 1935, p. 26; P.L. Ravenhill, 1994, p. 10), sculpting, for the artists in question, was a source of income that often exceeded earnings from their other activity (agriculture). Any reason to doubt their talent could thus have serious consequences for their standard of living and place in society.

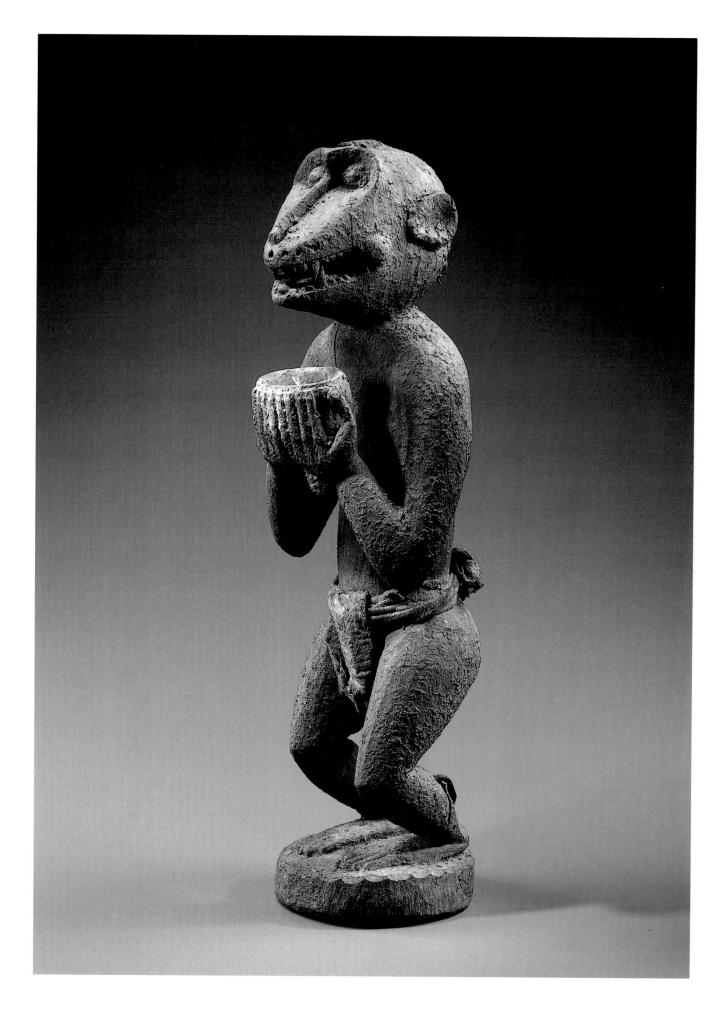

Sculpture dedicated to Gu, the god of wrought iron and war

Executed before 1858 by Akati Ekplékendo, Fen artist[1] from Dume
People's Republic of Benin

Iron, wood
H. 165 cm
Gift of Captain Eugène Fonssagrives to the Musée d'Ethnographie du Trocadéro, 1894
Former invoice number M.E.T.: 34.380
On permanent loan from the Muséum National d'Histoire Naturelle - Musée de l'Homme
Inv. M.H. 94.32.1

Main Exhibitions
Paris, 1923, 1930, 1935, 1965, 1972-73; New York, 1984-85b.

Main Publications
M. Delafosse, 1894; F. von Luschan, 1919, vol. 1, fig. 347, p. 292; H. Clouzot and A. Level, [1925], pl. XXXXIII; S. Chauvet, 1924, p. 7; G.H. Rivière, 1926, p. 178; M. Delafosse, 1927, pl. XXXIX; P. Guillaume and T. Munro, 1929, pl. 1 and 2; C. Kjersmeier, 1935, vol. I, pl. 24; J.J. Sweeney (ed.), 1935, no. 237; W. Evans, [1936], nos. 167 and 168; M. Quenum, 1936, pl. XIII; A. Malraux, 1952, pl. 401; P. Radin and J.J. Sweeney, 1952, pp. 114-115; M. Griaule, 1957, t. 1, fig. 135, p. 88; E. Elisofon and W.B. Fagg, 1958, fig. 139, pp. 110-111; B. Davidson, 1959, pl. 110; B. Davidson, 1961, pl. 11; J. Maquet, 1962, p. 181; D. Paulme, 1962, vol. I, pp. 22 and 23; A. Theile, 1963, fig. 194, p. 274; *Arts d'Afrique intertropicale*, 1963, pl. 14; P. Grimal (dir.), 1963, p. 242; *Chefs-d'œuvre du musée de l'Homme*, 1965, no. 13, p. 65; A. Terrisse, 1965, fig. 79, p. 67; *Le Courrier de l'Unesco*, 1965, p. 18, pp. 22-23; J. Laude, 1966, figs. 63 and 64, pp. 124-25; J. Delange, 1967, fig. 52, p. 64; M. Leiris and J. Delange, 1967, fig. 266, p. 234; L. Pericot-Garcia, J. Galloway and A. Lommel, 1967, fig. 222, p. 162; G. Balandier and J. Maquet (dir.), 1968, p. 117; *Sculptures africaines dans les collections publiques françaises*, 1972, no. 306, p. 115; W. Bascom, 1973, fig. 48, p. 81; *Esprits et dieux d'Afrique*, 1980, no. 38bis, p. 53; S.M. Vogel and F. N'Diaye, 1985, no. 44, pp. 80-81 and p. 137; R. Lehuard, 1986, pp. 20-21; J. Kerchache, J.-L. Paudrat and L. Stéphan, 1988, no. 75, p. 138; S. Barnes and P. Ben-Amos, 1989, cover and fig. 3.2, p. 54; A. Blandin, M. Biton, G. Celis

This statue was brought back to France in 1894 by Captain Eugène Fonssagrives[2] following the conquest of Dahomey. The piece was given to the Musée d'Ethnographie du Trocadéro, the present-day Musée de l'Homme, and was first registered on 30 April 1894[3] under the number 34.380, and subsequently as M.H. 94.32.1 since the reorganisation of the museum inventory.

Maurice Delafosse[4] wrote an article on this piece in 1894 based upon informations obtained from the donor. He notes that Fonssagrives himself presented it "as being the statue of the tutelary god of Ouida,[5] a god he calls Ebo".[6] However Delafosse rightly goes on to point out that the tutelary divinity of Ouidah is not Gu, but the python Dan and that "in the Dahoman language there is no noun that begins with an e". Delafosse adds, "I have every reason to believe that this Ebo is none other than Bo or Gbo, the Dahoman Mars, the spirit of war and giver of victory". The term "Ebo" could simply be an answer to what might have beenFonssagrives'question, What is that? That's a *bo*. In other words, that is the recipient of supernatural forces.[7]

The statue has gone by several names. After Ebo, the name given to the statue by Fonssagrives, the piece was variously called Gbo, Egbo or Bo, and only became Gu, its current name (in French Gou), at the end of World War II. The link between this iron statue and Gu, the *vodun* of iron, the guardian divinity of the forge, metal and war, seemed obvious enough for the piece to be assimilated to the representation of this divinity or *vodun*.

Glele, the king of Dahomey (1858-1889) mounted an attack in the very first year of his reign against Anago-Dume or Dume,[8] a town located some one hundred kilometres northwest of his capital, Abomey, even though the inhabitants of the town, the Yoruba-speaking Fennu, were allied with the Fon population[9] of Dahomey. Amongst the booty Glele brought back with him were this statue and the man who created it, Akati Ekplékendo. Indeed, one wonders if the war wasn't, in the first place, waged with this goal in mind. In any case, although foreign, the *vodun* Gu was adopted in Dahomey since the kingdom readily assimilated whatever seemed beneficial to it.

This statue was displayed in Abomey in a building called a *guho*, located inside King Glele's quarters within the royal precinct. The piece was surrounded by a collection of iron objects, in particular several large sabres, now on display in the museum of Abomey, and rocks that served as burnishers or whetstones (symbolising the perpetuity of the kingdom). It fulfilled a religious function, but as with everything linked to the king, it was also fundamentally political. The piece was meant to receive the promises of heroic acts or challenges proclaimed by warriors just prior to setting out on a military campaign. At such times the building was called "the house of anger" (*adanjeho*). Gu, the god of wrought iron and war, was believed to grant soldiers protection against their enemies.

The materials employed in this statue, its dimensions and the originality of the sculptor's work constitute the characteristic features here. This is indeed the only known iron statue of human proportions from Africa. A second peculiarity is the translation of movement that the slender, slightly parted legs lend to the statue, despite the nature of the materials used here and the weight of the work; Gu's right foot presses forward while the heel of the left leg, which is set back, is partly raised. Finally, the artist made use of materials worked to varying degrees. He seems to have wrenched the metal into shape as much as allowed himself to be inspired by it. The finished sculpture gives an impression of economy and modernity.

Gu also presents a surprising diversity of wrought iron techniques, including forging, aminating, hammering, nailing and riveting. The artist used relatively thin sheets of metal on the surface – especially for the face and tunic – laid over a solid internal structure which gives the statue its rigidity.

Gu is barefooted and, apart from his hat, is clad only in a flared tunic (*kansawo*) that leaves his knees exposed; the tunic is covered with a light gritty finish and is formed by two sheets of metal. The additional width needed to fill out each of the two sheets is provided by three sheet-metal strips, recalling the technique used by tailors.

The statue is solidly attached to a metal base that shows traces of its having been torn and

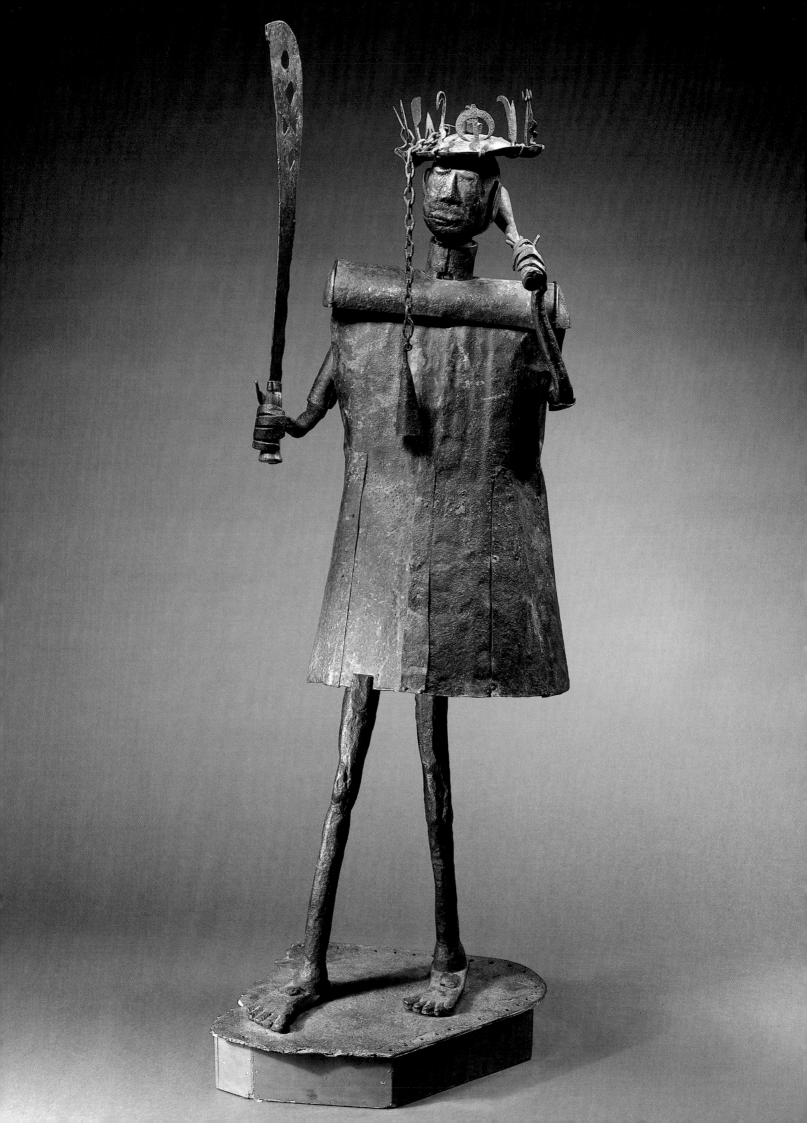

28 regular holes around the flat, unadorned section of its perimeter.

Gu's head sports a curious round hat with an upturned brim that is held in place by a bolt to which a chain is attached. At the other end of the chain is fastened a bell. Rather than a hat, this detail seems to be a sacrificial platter, or *asen*, a portable metal altar fashioned for the souls of the deceased. This enabled the statue to receive libations and sacrifices. M. Delafosse indeed observed traces of blood there in 1894.[10]

Around its circumference the *asen*'s tray bristles with 11 miniature iron instruments that recall the range of the divinity's attributes: agricultural, with the hoe; warrior, with the spear, the sabre, the *gubasa*[11] and the Maxi[12] knife; fishery, with the hook; religious, with the winding snake Dan and the thunder Hebiosso's axe, which confirms the close relationship between these *vodun* and Gu.

Gu bears two other attributes in his hands. In the right is the *gubasa,* he holds a large curving sabre with open-work, a kind of ceremonial scimitar and linked with the *vodun* Gu, as its name suggests. "The blade is cut through with holes depicting an eye, the sun and two triangles juxtaposed at their summit."[13] These symbols situate Gu within the local cosmogonic system. In his left hand, Gu has a bell called the *kpanlingan*, which serves to draw the *vodun*'s attention and mark the pace of prayers and the litanies of royal names. The *kpanlingan* is an object associated with calm and dialogue, and contrasts with the sabre, an instrument of war.

The various attributes of this statue have met with diverse fortunes over the years which have considerably affected its appearance and expressive power. First of all, M. Delafosse, couching his remarks in a colourful style, indicates that Gu had "hanging down his back… two bells similar to those that the Dahomans use in their religious ceremonies and that our peasants suspend from the necks of cows". He goes on to point out that these bells "are attached by chains to two of the hat's ornaments".[14] As early as 1895, however, photographs show only one dorsal chain decorated with a single bell.

For the 1935 show in New York, "African Negro Art", Gu is seen brandishing only his *kpanlingan* bell and not in his left but rather in his right hand, the sabre having disappeared altogether![15] Then it was the bell's turn to vanish. A photograph dating from 1938 or 1939[16] pictures an empty-handed Gu. Since then, two generations of visitors have been unable to see the statue in its entirety.

Quite recently the sabre and the bell were restored to the statue.[17] The sabre appears to be original,[18] but experts are not as sure about the hand bell. Photographs from the 19th century and the first half of the last century show a bell that is made entirely of metal; the bell that now adorns Gu has a wooden handle.

Several other Gu statues from the same cultural area have been attested. They are tall and carved from wood or fashioned from metal, but smaller. This Gu alone displays a force that is truly surprising, an effect created thanks to the violence of its simplicity, corresponding to the qualities attributed to the *vodun*, namely, brutality, vigour, intensity, irascibility, as well as energy, creativity, courage and determination.[19]

MARLÈNE BITON
Translation: John O'Toole

et al., 1992, p. 198; M. Biton, 1994, p. 27 and p. 29; M. Biton, 1996, p. 444; M. Biton, 1999, p. 19-26.

Fig. 1
Sculpture representing the god Gu in the Musée d'Ethnographie du Trocadéro, 1895
Photographic library of the Musée de l'Homme, Paris

1 The Fennu or Jalloku populations of Benin (formerly Dahomey) and Togo are also called the Ife. These terms refer to their geographic origin, the town of Ife (in present-day Nigeria), a religious and cultural centre of the Yoruba.
2 E. Fonssagrives (1858-1937) was part of the marine infantry during various campaigns in Tunisia, Tonkin, Dahomey, China, Morocco, etc.
3 Rare annotations from the inventory registry: date, number, donor, geographic origin of the piece, "Dahomey" and "Statue en fer, Ebo".
4 M. Delafosse, 1894, pp. 145-47.
5 Ouidah, a coastal town of Benin.
6 M. Delafosse, 1894, p. 146.
7 Translation by Akoha Bienvenu, a Fon doctor in linguistic who affirms that "Ebo" could not be Fon-Gbe (the language spoken by the Fon). It is probably a demonstrative followed by the word "bo". This would corroborate M. Delafosse's interpretation.
8 Doume, the geographic origin of this piece, is attested by a *fon* delegation who, during the International Symposium *Bicenteanire du roi Agonglo* (1797-1997) in Abomey, Benin, went on a pilgrimage to Doume to see where Gou was taken out by theirs ancestors.
9 The Fon, a people living on the Abomey plateau.
10 M. Delafosse, 1894, p. 146 and p. 147. In Ilesha (Nigeria), a song recalls that "Ogun wears a hat covered with blood" (P. Verger, 1957, p. 147).
11 "The *gubasa* is a kind of short-handled scimitar with a wide, though blunt blade; it is made of iron, copper, or silver" (P. Hazoumé, 1937, p. 80, no. 3).
12 The *atakle* knife of the Maxi or Mahi, a population living north of Abomey.
13 P. Hazoumé, 1937, p. 80, no. 3.
14 M. Delafosse, 1894, p. 146.
15 "Figure, so-called god of war Egbo", J.J. Sweeney (ed.), 1935, p. 40.
16 Photograph by E. Blumenfeld, *Jazz Magazine*, no. 4324, January 1984, p. 34.
17 Perhaps following an article on the subject (M. Biton, 1994), partly borrowing those of M. Palau-Marti (1967, 1969).
18 M. Palau-Marti (1967, 1969) points out that in the holdings of the Musée de l'Homme he discovered a sabre, registered under the number M.H. X. 66.5, which seems to be the piece that had been missing for some 30 years (66 and X mean that the object in 1966 was considered unknown). Following a trial mounting – which appeared conclusive – captured in a photograph (C.66-3961-493), this sabre then disappeared again for some 34 years.
19 Part of the information given here was provided by Nondichao Bacharou, historiographer of the kingdom of Abomey and Akati Simon (†), blacksmith-sculptor and descendant of the master sculptor Akati Ekplékendo.

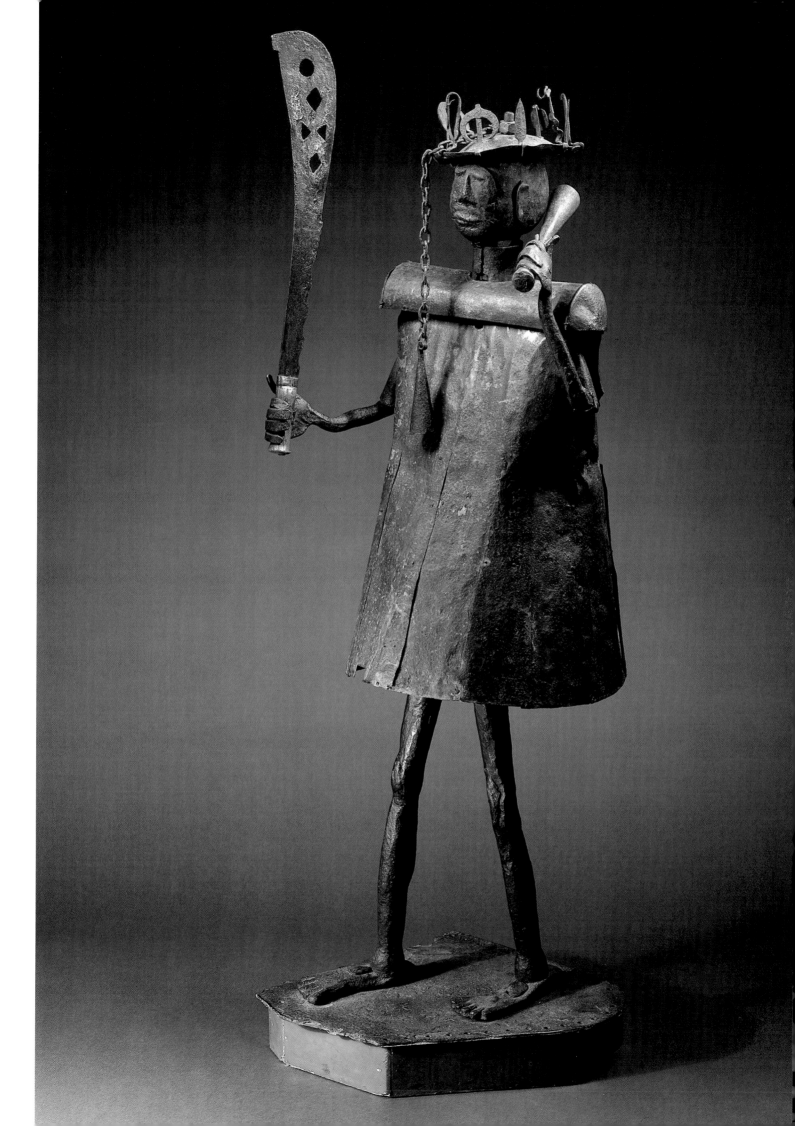

Nok Sculpture

Katsina Ala style, 500 BCE-500 CE
Nigeria

Terracotta
H. 38 cm
Musée du Quai Branly
Inv. 70.1998.11.1

The discovery of the corpus of art in terracotta designated "Nok art" came about in 1928. At that time, only a few broken pieces of the art were unearthed by tin miners on the Jos plateau of central Nigeria. In 1939, a British archaeologist, Bernard Fagg, was appointed to the Nigerian Colonial Service as administrative officer and posted to serve in Jos. Fagg realised the potential archaeological importance of the area. His friendship with the miners enabled him to see many fragments of this art, including an anatomically-modelled seated monkey kept at the Geological Museum in Kaduna, the nearby capital city of the northern region of Nigeria. Soon after, several important pieces of sculpture were retrieved, mostly heads broken from bodies.

One of the most important pieces that came to light was set up on a farm as a scarecrow in the village of Jema'a. Another important find was made by miners in a tin mining paddock, more than 7.5 metres below ground level, in a small village of Nok. When Fagg studied all these pieces, as well as other associated materials including iron implements, fragments of furnaces, cylindrical quartz beads and carbonised seeds from which oil might have been extracted, he came to the conclusion that there had existed a high and sophisticated culture – the "Nok Culture" – that created these sculptures two thousand years ago.

Although Nok sculpture has been widely publicised and celebrated, it is yet to be properly studied and published. Furthermore, very few scientific excavations have been carried out to determine the context in which they were created. Although excavations at Katsinsa Ala, Taruga, Yelwa and Samun Dukiya have produced some reliable information about iron smelting technology and the period in which the culture flourished, it is important to emphasise that these have been done on a very small scale and that the total area so far excavated is insignificant compared to the extensive areas in which the sculptures have been found. When Fagg retired from the Nigerian Colonial Service, all he knew of Nok culture was an area approximately 480 by 160 kilometres straddling the confluence of the Niger and Benue rivers, mostly to the north of the confluence. In the last decade or so, new finds have been reported in the Sokoto River basin north-west of Fagg's original area; another group of terracotta sculptures which may be Nok-related has been found around the ancient city of Katsina, north-east of Sokoto. The sculptures found during this last decade are remarkable in at least two ways. First, they are surprisingly more complete and less fragmentary those from Fagg's original area and, secondly, the clay used in their moulding is more lateritic in colour compared to the beige of the previous finds. This is perhaps due to the fact that the earlier finds came mostly from alluvial deposits. The more complete figures provided visual clues that have helped us reconstruct the kind of society the people of the Nok cultural area lived in.

There are more than 500 Nok specimens around the world, ranging from ten centimetres to almost life-size. They mostly represent human beings, both male and female, as well as some animals. We do not know who these individuals were, but we can assume that the small figures with holes in them were strung and worn as amulets or adornment, while, judging by their elaborate coiffure, intricate headdresses and lavish use of beaded ornaments, the larger pieces of the sculpture most probably represent important personalities or potentates. If we assume that some of these pieces represent rulers, we must also assume that the Nok people may have been part of the beginning process of state formation in Africa.

It should be noted that although there are various sub-styles within the Nok art corpus, certain common and uniform elements are present throughout the entire Nok region and the existence of this culture. These are the depiction of the eyes in the form of a triangle or a semi-circle, the piercing of the eye balls to represent pupils, the piercing of the mouth, nostrils and ears, and the abnormal way of placing the ears far behind and above the eyes. Considering the wide area in which the art has been found, one may postulate that the whole Nok cultural area may have come under whole influence under a common god, king or trade. In any case, there seems to have been strong contacts among these peoples at that very early period in time.

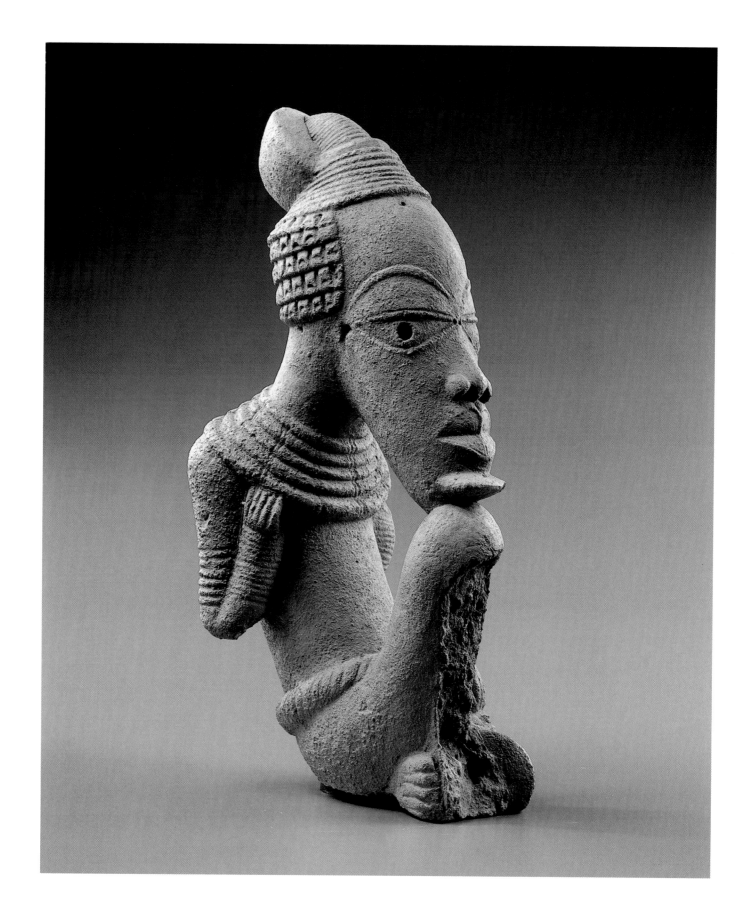

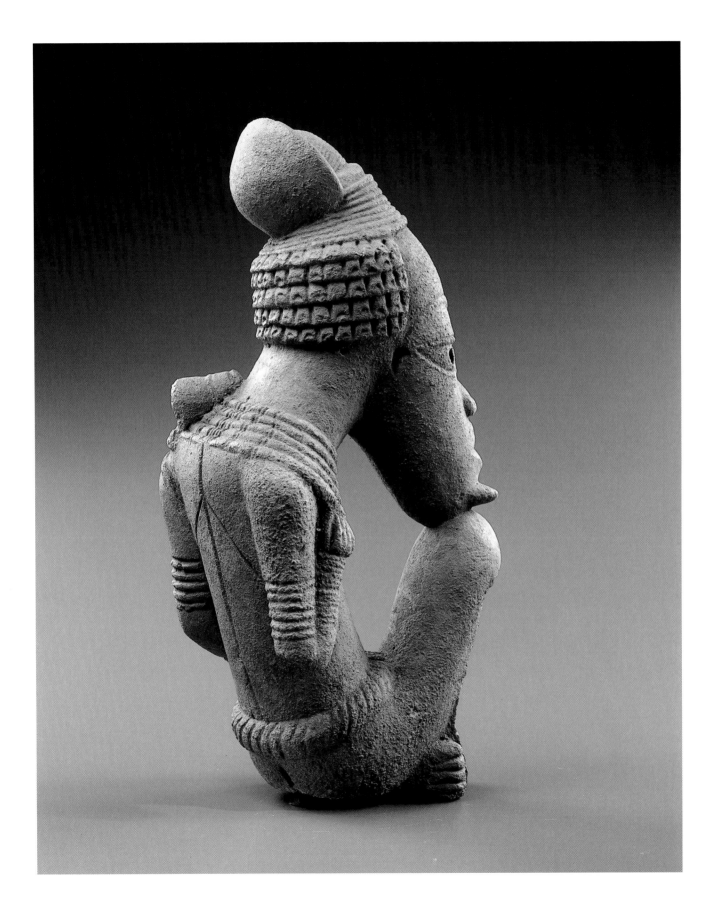

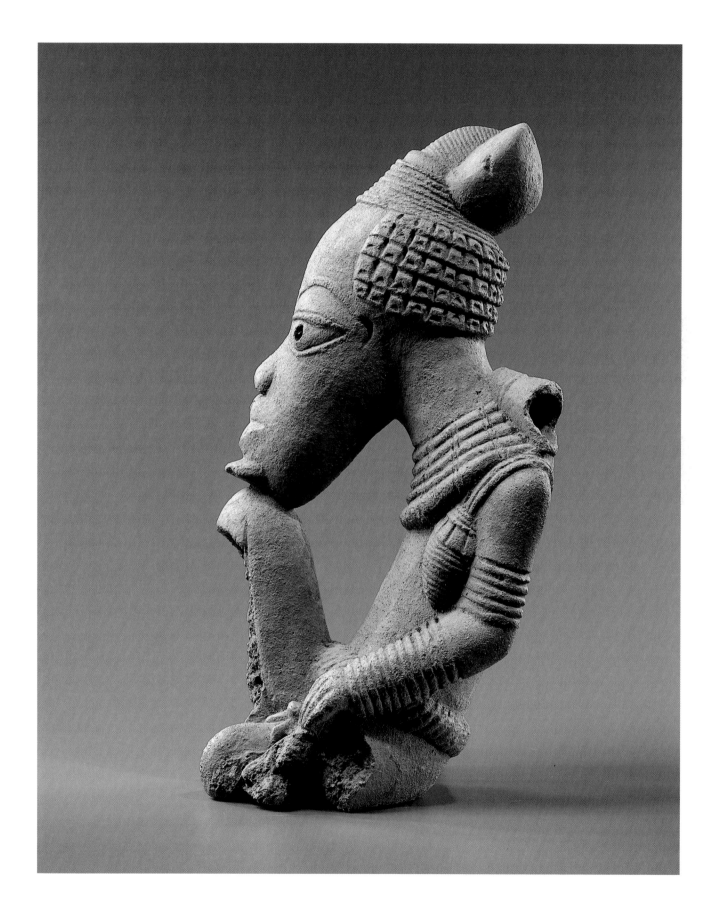

Frank Willett observed that the rendering of Nok animals was more naturalistic than the modelling of humans. The latter were modelled in semi-naturalistic and abstract forms of cylinders, spheres and cones. Perhaps these abstract forms make Nok art a forerunner of our modern art movement. William Fagg (the archaeologist's younger brother) observed that Cezanne's famous dictum exhorting modern artists to utilise natural geometric forms was already practised by the Nok people two thousand years before. The Nok figure under consideration follows this geometric canon: a conical head resting on a bended knee, a conical cap worn over an elaborate coiffure, and the cylindrical, ringed arm and hand. The placing of the cylindrical chin on the knee emphasises the importance of the head as the seat of reason and wisdom. These attributes are further underscored by the prominent beard.

The exact use of this figure is unknown, but it have might been used, like other pieces of the same genre, to ornament a shrine or as a tomb marker, although no tomb has so far come to light in the Nok culture area.

EKPO EYO

Nok sculpture

Between 500 BCE and CE 500
Nigeria

Terracotta
H. 50 cm
Musée du Quai Branly
Inv. 70.1998.11.2

Every aspect of this atypical and surprising piece seems to come together to produce an exceptionally important work of art. Designed around a hollow cylindrical core that is remarkably well preserved given the piece's size, this sculpture presents a unique illustrated story cycle on its exterior surface. Until recently, only isolated fragments of such compositions remained, making it impossible to grasp their meaning and design. As a similar, albeit much more modest, example shows, the different parts in relief are situated on the busts of the standing figures whose heads subsist above; the cylinder is thus the result, as it were, of the fusion of several tubular statues.[1] One must therefore imagine beneath the scenes a continuous bulge which served as a kind of base line for some of them and represented the belt of the standing figures, to which their respective genital coverings were attached. The cylinder descended further to depict the lower members. The complete object probably measured around one metre high. An additional element, a kind of bowl or crater sealing the upper end of the cylinder, indicates that this object had a precise function. Shaped like a truncated cone, it seems to be adapted for a statue with a hollow flared base. The system doubtless allowed one statue to be fitted quite snugly into the other, guaranteeing perfect stability for a large-sized sculpture. This hypothesis is founded on the existence of two complete statues that have conserved such supports.[2]

It is easy to recognise around the edge of the object a succession of scenes drawn from daily life, including farm work, cultivation and harvesting tall cereal plants (probably millet), combing out of grain from the sheaves, carrying urns, preparing, producing and consuming foodstuffs, and "mother-and-child" scenes. Gestures and attitudes, objects and tools are meticulously described with an obvious concern for accuracy. This depiction of a community of men, women and children is infused with life and constitutes a document of the highest archaeological interest, both moving and inestimable for our knowledge and understanding of Nok culture. The sculptures, moreover, largely compensate the sore lack of information from archaeological excavations, offering an invaluable window onto a people that fashioned several hundreds of these admirable and enigmatic terracotta statues. In light of this information, the popu-

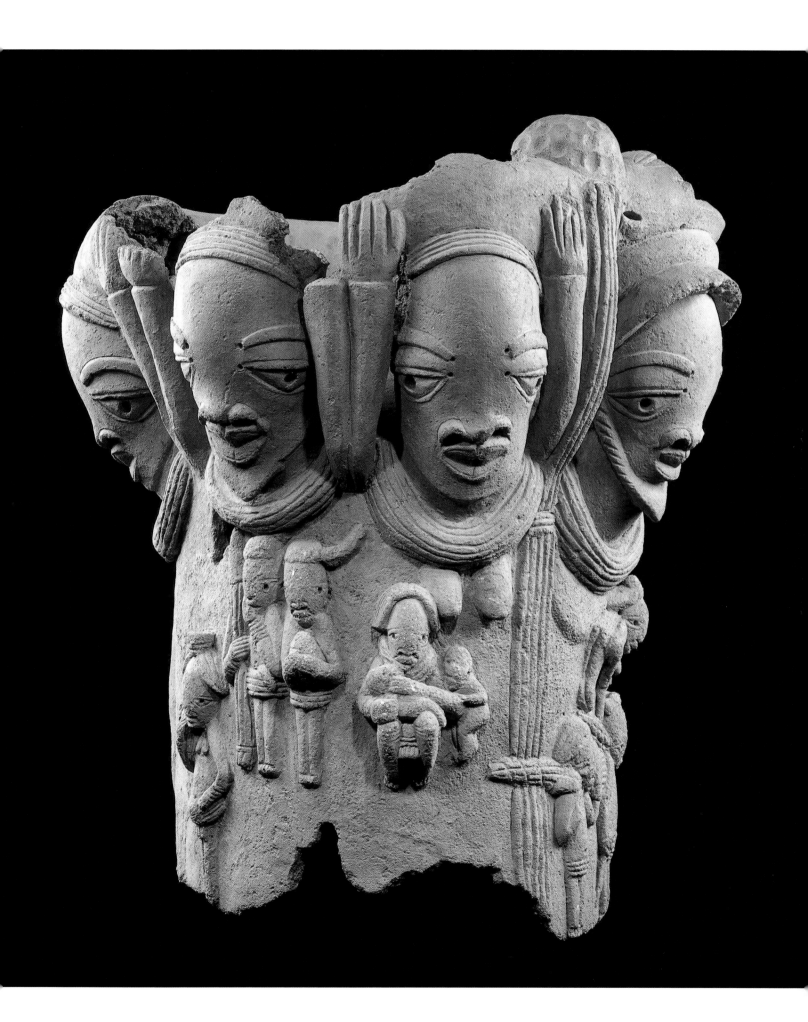

lations belonging to the Nok culture, who also mastered iron metallurgy,[3] appear to have been sedentary farmers[4] whose form of social organisation (including collective work) and the importance of certain beliefs are clearly on display here.

Thus, the six alternately male and female figures stand with raised arms, holding above their heads an imposing snake which they seem to be celebrating. A recurring theme in West African art, this reptile is traditionally linked with the creation of the world, fecundity and the world of ancestors. The fact that it is associated with scenes of farming and depictions of motherhood suggests here the existence of a cult intended to promote procreation and fertility, as well as successful harvests. From all appearances, this support and its statue were associated with a prosperity cult, perhaps addressed to the ancestors of the village community whose fate depended on the afterworld.

Finally, this piece offers one of the oldest examples of the technique of narrative relief and as such is truly capital for the history of sculpture in sub-Saharan Africa. Arranged along two rows against a neutral background and linked amongst themselves, the scenes form the sequential phases of a narrative that is coherent and altogether meaningful. The figures attest the Nok sculptors' remarkable mastery of this particular technique.

Transgressing the frontality that is frequent in African sculpture, with ease the artist places his figures in frontal view, in profile, even in three-quarters view, thanks to a complex system of representation which uses lateral staggering and overlapping of figures and notably genuine foreshortening and gradations of volumes. These techniques enable the artist to capture his figures in the midst of their activities with a convincing rendering of reality, witness the figure that is shown bending towards the ground while looking at the viewer. The veracity and variety of the attitudes and the impression of movement help to impart the feeling of liveliness and spontaneity to these small scenes, contrasting with the more delicate modelling of the heads projecting over them. Nok artists proved themselves consummate sculptors, deftly handling the art of low relief and the technique of modelling in the round while showing a clear inclination for the latter. The two techniques, moreover, are often associated, with the statue itself serving as a support for low relief modelling, one of the originalities of Nok art. Thus flourished in Africa a centuries-old tradition of narrative low relief, as ancient as the African tradition of statuary.

CLAIRE BOULLIER
Translation: John O'Toole

1 C. Boullier, 1996, fig. 54.
2 Corpus, no. CBX28.
3 B. Fagg, 1968, pp. 27-30.
4 Stone hoes collected
 at the excavation sites
 have been studied
 by J.F. Jemkur, 1985, pp. 34-36.

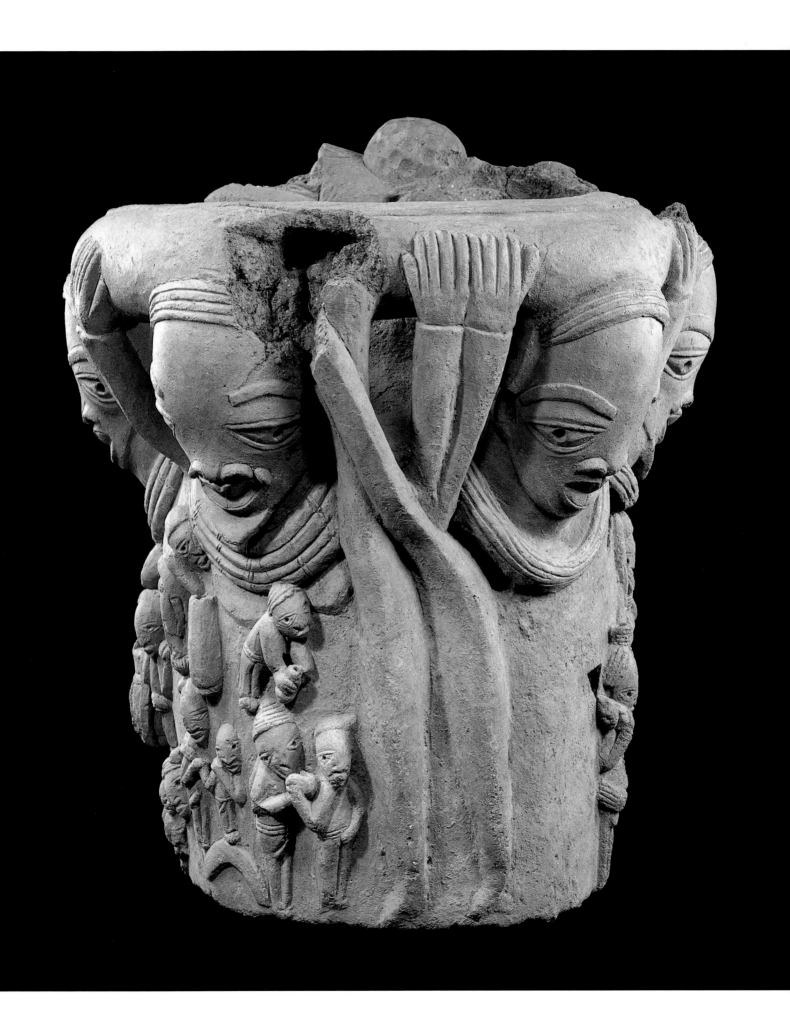

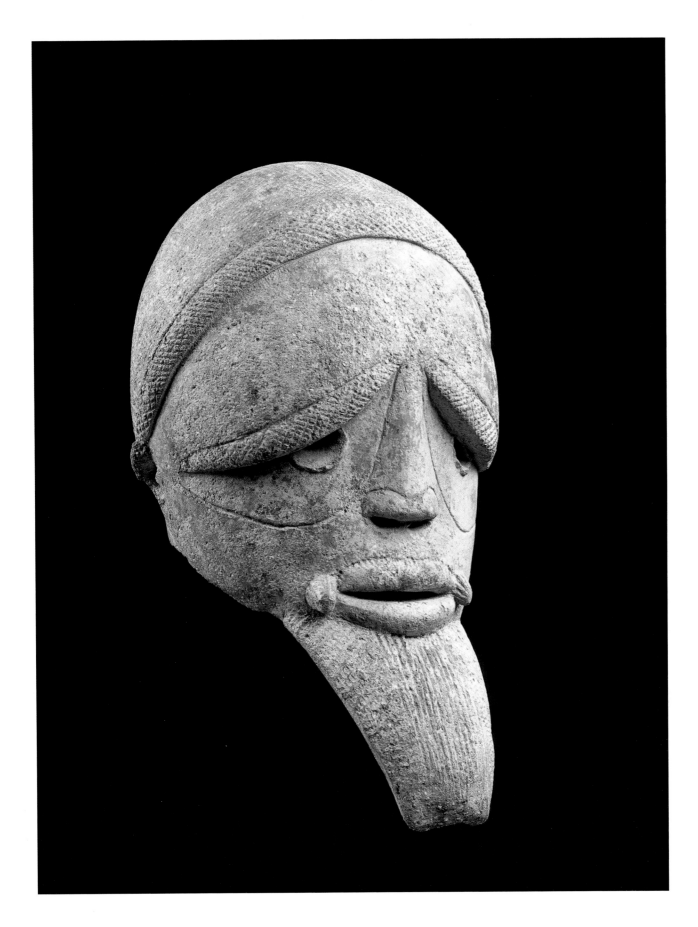

Sokoto sculpture

Between 500 and 100 BCE
Nigeria

Male head

Terracotta
H. 33 cm
Formerly the Claude-Henri Pirat Collection
Musée du Quai Branly
Inv. 70.1999.8.2

Exhibition
Luxemburg, 1998.

Main Publications
K.F. Schaedler, 1997, no. 410,
p. 212; B. de Grunne, 1998,
no. 65, p. 107.

In the northern reaches of present-day Nigeria, an area covered by vast expanses of savanna, the earth has been yielding up great numbers of archaeological remains since the 1990s. These finds have been centred on the Karauchi tumulus and in a region lying between Jado, Maru and Anka. Dating back over one 1000 years, the terracotta statues being excavated, dubbed "Sokoto" (from the name of the Nigerian state that is located just south-east of where the sculptures have been unearthed), form a homogeneous group, clearly defined by their iconographic and formal characteristics. They embody the privileged artistic mode of a specific culture whose nature, historical and geographic extent and possible links with the neighbouring Nok and Katsina cultures have yet to be worked out. But whatever its precise features, Sokoto culture is very much a part of the remarkable florescence of cultures that developed in the valleys of the Niger between the first quarter of the first millennium BCE and the early centuries of our era.[1]

Of the 100 or so Sokoto pieces that have been catalogued, heads have been conserved for the most part. The majority of these are male heads,[2] such as the one seen here. Originally they belonged to statues representing standing figures depicted in a frontal attitude. Certain examples of these statues which have come down to us intact[3] were modelled in this very way. Their hollow cylindrical body possesses a slightly flared base that was left open; on this tube of sorts the upper members, which are always short and slender, are arranged symmetrically with the hands resting on the belly. Except for the arms, the navel is the only other anatomical feature which is represented. Ornaments and clothing are always sober, comprising a tight-fitting cap, a pearl necklace, a belt and occasionally abdominal scarifications or ornaments that consist of double lines arranged around the navel. From all appearances, this figure corresponds to a precise iconographic convention, but in the absence of any reliable archaeological data, it has inspired a welter of interpretations. While we must therefore exercise great caution in trying to grasp the function of this piece, it seems highly probable that it served some funerary use.

From a stylistic point of view, all the Sokoto heads adopt the same characteristic construction, namely, a globular head, a high bare forehead, oblique often projecting brows, pupils that are pierced and outlined by a half-circle, a flat triangular face. The Louvre head should be compared with another statue whose physiognomy makes it nearly an exact twin.[4] A number of characteristic elements are identical on both pieces; the two, for example, display a delicate moustache that underscores the corners of the mouth and a long elegantly arching beard that sprouts from just underneath the lower lip and once rested on the bust, which has since been lost.

Not only do the two faces conform to the same overall composition, they present the same style, point for point. The comparison proves so conclusive that clearly the two works must be by the same hand. The oval shape of the half-open mouth, the flat lips, the treatment of the nose, the bridge of which is set high up, the arrangement of the eyebrows'ridge and the lower edge of the eyes that overlaps well onto the cheeks – these details constitute the very signature of this artist. The Louvre head does stand apart, however, thanks to the remarkable quality of its execution and the care that can be seen in its finish. Indeed, the artist plays with light; here it glides across the smooth surfaces of the statue's slip coating (it subsists in parts), accentuating the perfect curve of the forehead, there it catches on the mat relief of the brows and beard. The orbital arches, surprisingly full, hang gracefully over the eyes, lending the face a gentle sadness. The incised line that customarily emphasises the lower part of the eyes, which the artist did not shy from enlarging enormously here, describes an elegant sweep that runs from the bridge of the nose almost to the ears, mirroring the line of the brows. The simplicity and the balance of the composition, the remarkable mastery of the volumes, heightened by the play of curving lines which create a harmonious correspondence, and finally the admirable subtlety of the modelling stand out here as the clear sign of a great talent.

CLAIRE BOULLIER
Translation: John O'Toole

1 C. Boullier and A. Person, 1999.
2 C. Boullier, 1996, pp. 32-33.
3 C. Boullier, 1996, no. 82.83.
4 Corpus, no. CB77.458.

AFRICA

Sculpture from the Ife civilisation

12th-14th centuries
Nigeria

Head

Terracotta
H. 15.5 cm
Formerly the Barbier-Mueller Collection
Musée National des Arts d'Afrique et d'Océanie
Inv. A.96.1.4

Main Exhibitions
Paris, 1997; Barcelona, 1998;
Madrid, 1999; Seville, 1999.

Main Publications
L. Meyer, 1991, p. 16-17;
*Sculpture. Chefs-d'œuvre
du musée Barbier-Mueller*, 1995,
p. 102; *Arts du Nigeria*, 1997,
p. 24-249; *Africa: magia y poder.
2500 años de arte en Nigeria*,
1998, p. 53.

This male head, remarkable for its subtle, sensitive modelling, belongs to the prestigious corpus of works that has come down to us from the Ife civilisation in the area of West Africa dominated by the Yoruba (southwestern Nigeria[1]). Dating from 1910, the earliest discoveries of similar terracotta pieces on the site of the sacred grove of Iwinrin in Ife sparked little interest until the arrival of Leo Frobenius. The German ethnologist spent three weeks there[2] collecting information and pieces, including the famous bronze head of Olokun. This piece, which has since disappeared,[3] depicts Olokun, the god of salt water in the Yoruba pantheon. The head had been excavated a half century early from its sacred grove.[4] At the time, Frobenius elaborated a theory according to which the "classic" Ife art represented by these exceptional, highly naturalist figures could be linked to the presence of a colony originally from the Mediterranean that had prospered in Yoruba country. His theories were quickly refuted. These images of human perfection were indeed the product of an African culture and owed nothing to the prestigious civilisations of the Mediterranean world.

Comprising a majority of terracotta statues unearthed from various widely scattered sites, as opposed to a smaller number of bronzes from just three excavations,[5] the corpus of Ife art suggests that the technique of modelling terracotta preceded the ability to cast bronze. Dating has confirmed this. These bronze and terracotta works, rediscovered in the 20th century, have spread the reputation of Ife as the art and cultural centre of the Yoruba world, and serve as an additional chronological benchmark in the history of West African arts between the Nok and the Benin civilisations.[6]

Alongside the sundry representations of the Ooni with crown and regalia figure other images: the crowned queen, palace servants, slaves whose size varies according to their social rank. This head, smaller than in real life, probably represents one of the Ooni's servants and adopts the same idealised aesthetic conventions of resemblance as those used to portray the sovereign[7]. The entire surface of the skin is covered with the recurrent parallel-line motif, which has been interpreted as either a rendering of the famous pearl veil in the case of the Ooni's representations, or traces of ritual paint, or genuine scarifications. The headdress shows the natural waves of the hair, represented directly in the wet clay, the surface of which was carefully smoothed in other areas. Turned upside down, a view inside the head clearly reveals the use of the technique of coiling to mount the piece; prints of the fingers that rolled these coils of wet clay and fashioned them into the statue are captured in the terracotta. The colour variations on the surface are due to the conditions during firing. Traces of red polychroming meant to conceal these variations can also be made out. Typical features of Ife art are the conventional representation of the eye, with the corner of the upper lid hanging over the lower, the absence of pupils, and the slight bulge meant to suggest the presence of brows. This head belonged to a standing figure, as the break running from the upper nape to the chin makes clear.[8]

Ife is considered by all Yoruba peoples as the origin of the world, the place where Oduduwa's foot first touched the earth after his descent from the heavens.[9] Yet throughout the course of its history, Ife never dominated the other Yoruba kingdoms politically. Its pre-eminence remained religious above all. Whereas Oduduwa stayed in Ife to rule there, Obatala – whom Olorun (god) had instructed to fashion the human body from the earth before the divine spirit was to breath life into it – took to the forest to challenge Oduduwa's power. In Yoruba cosmogony, the world is shaped like a calabash cut in two with the upper half being Obatala's domain, the lower Oduduwa's. This division makes concrete the rivalry and complementarity that existed between the first of the *orisa* and the deified hero. It is also from Ife that Oduduwa's 16 sons took leave of one Another, bearing with them the pearl crown, symbol of their royal lineage. Even today 21 *oba* (kings) claim to be descended from these royal brothers.

Ife chronology attests to the presence of iron metallurgy before the 9th century CE, witnessed in the famous monoliths decorated with twisted-

headed iron nails (*opa* of Oranmiyan[10]). The so-called "pavement period"[11] between the 11th and 15th centuries corresponds to the years that saw the production of terracotta and figurative bronzes in an idealised naturalistic style, which tended towards a certain simplification between the 15th and 17th centuries before disappearing altogether. The first known terracotta is the famous effigy said to represent Lajuwa the usurper, conserved since time immemorial in the palace of the Ooni and first displayed publicly in 1935. Legend has it that the piece is the portrait of one of the Ooni's servants who concealed the body of his master after his death and took his place. The Ooni is in fact a divine king who rarely appears in public and whose face is hidden from his subjects by a veil of pearls. It is possible that casting and modelling royal heads ceased in the wake of this attempted usurpation.

HÉLÈNE JOUBERT
Translation: John O'Toole

1 The first objects from the Ife culture to be brought back to Europe were three quartz stools which the Ooni of Ife gave to the governor of the colony of Lagos, Sir G. Carter, in 1896.
2 L. Frobenius arrived in Ife in November 1910. He discovered about ten terracotta and bronze heads, which were unearthed and reburied at the foot of a tree that thus served as a landmark for the people of Ife during annual ceremonies at the sites of the sacred groves of Olokun and Iwinrin.
3 A photograph by Charles Partridge dating from 1910 shows this famous piece in the presence of the Olokun priest in Ife. C. Partridge was a British resident in Ibadan at the time and opposed L. Frobenius' plan to take the head to Germany in exchange for a plaster cast. In 1948 the head was sent to Great Britain to be examined and copied. On that occasion W. Fagg concluded that the "original" was likewise a copy.
4 According to tradition, Olokun Grove was supposed to harbour the workshop that produced Olokun's pearls. Olokun was the "wife" of Oduduwa, the first king of Ife. The primacy of the ancient kingdom of Ife may indeed have been based upon this mastery of glass bead production; these pearls were needed to fashion the crowns worn by Yoruba kings (*oba*) claiming to descend from Oduduwa. In 1938, while passing through Old Oyo, the Lander brothers saw and mentioned in their subsequent account the famous pearls that established Ife's reputation.

5 Wunmonije Compound, where accidental discoveries date from 1938; Ita Yemoo, the scene of archaeological excavations carried out by F. Willett in 1957; and Igbo Olokun, a well-known site for many years.
6 Most of these works are now conserved in Nigeria. There exists a group of nine terracottas that Frobenius brought back to Berlin's Museum für Völkerkunde; a bronze and a terracotta in the British Museum; a terracotta in the Brooklyn Museum; and several others in private American collections.
7 The concept of resemblance (*jijora* in Yoruba) refers to the idealised expression that evokes the "outside head" (*ori ode*), i.e., the outer appearance of a being, whose characteristics are aesthetically emphasised. It is therefore the ideal character, in particular self-control (a trait that is highly prized amongst the Yoruba), which is reflected in this image with its serene expression. At the opposite extreme, stylised representations are apparently the figuration of the inner head (*ori inu*), which expresses the lot, the fate that each human being chooses in heaven from Ajala the potter before being incarnated in the shape of a terracotta head.
8 Attesting the existence of quite large-scale standing representations, the art of terracotta sculpture manifests an exceptional mastery of technique. The museum in Ife possesses an impressive terracotta group made up of a seat modelled after ancient quartz thrones with cylindrical feet and loop handles, on which was seated a figure whose feet rested on a stool, flanked by two life-size figures. Each element of the group was modelled separately in clay, then dried in the sun before being baked under a brushwood fire. Only the lower part of this group has come down to us.
9 In Yoruba Ile-Ife means "the land that was extended", but there exist numerous versions of the creation of the earth upon the primordial waters according to which credit goes to either Oduduwa or Obatala, who is also called Orisa-nla, "the Great Orisa".
10 Oranmiyan, the youngest son of Oduduwa, founded the kingdoms of Oyo and Benin according to the myths.
11 Chronology worked out by H.J. Drewal (1976). These pavements made of potsherds and stone fragments seem to correspond to sacred areas, as is suggested by the site of Obalara's Land, excavated by Peter Garlake and the University of Ife in 1971. There a ritual container dating from the 13th-14th centuries was unearthed; this object presents a highly interesting iconography featuring on the same altar the naturalist representation of a head (*ori ode*) and a second, abstract one (*ori inu*). In light of this motif, these images would seem to have had a ritual role: placed on ancestral royal altars, they may have supported a king's regalia, notably pearl crown (*ade*) which served to concentrate royal authority.

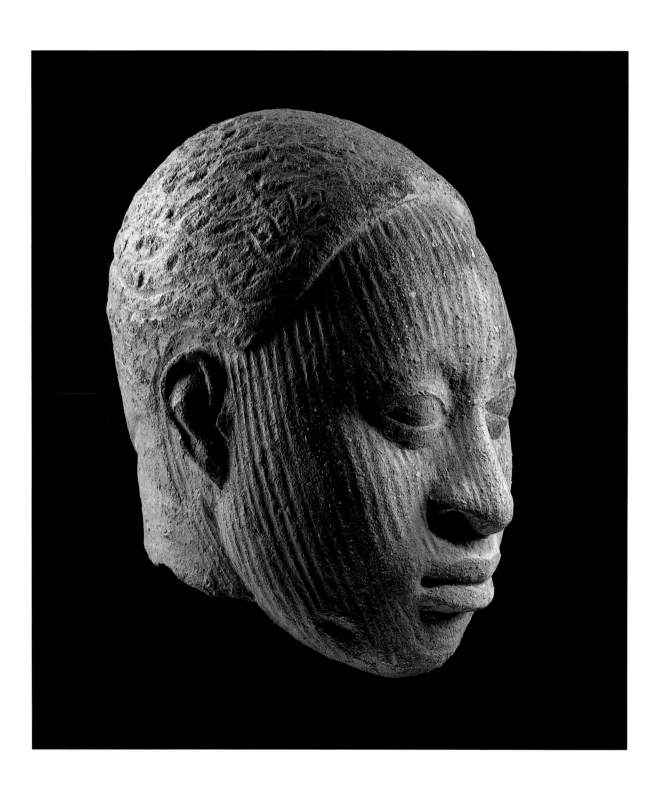

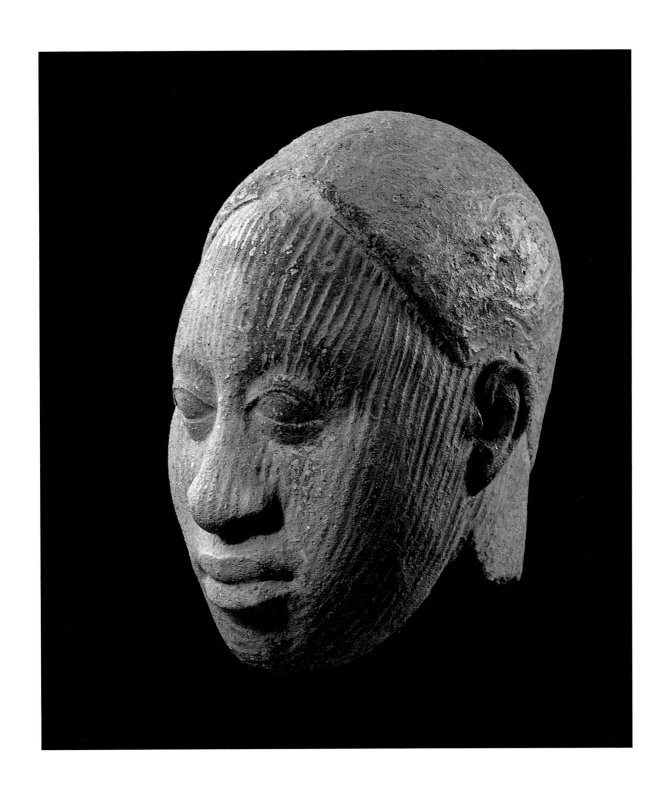

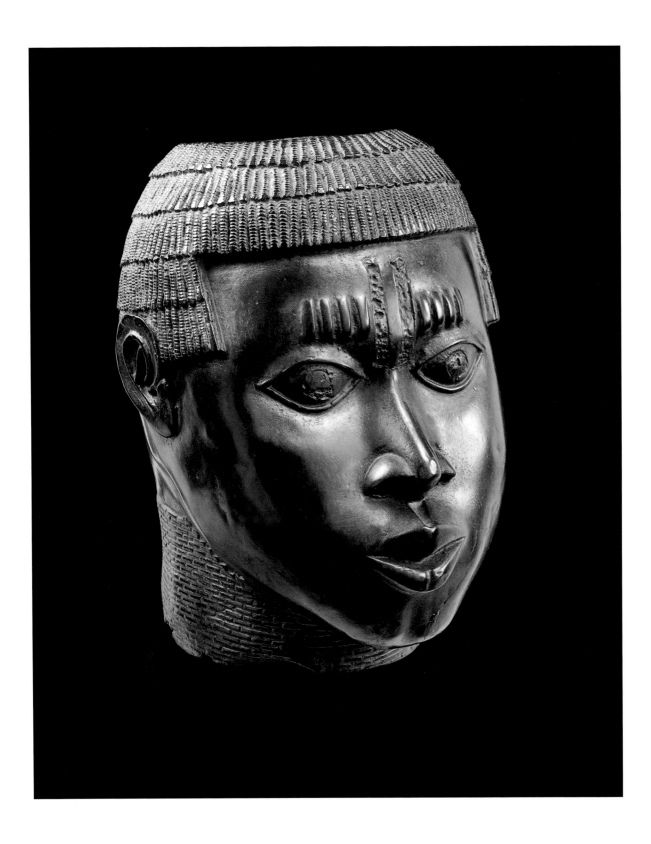

Sculpture from the Kingdom of Benin

Late 15th-mid-16th centuries
Nigeria

Head, *Uhum-welao*

Bronze
H. 21 cm
Formerly in the Peter Schnell (Zurich) and Barbier-Mueller (Geneva) collections
Musée des Arts d'Afrique et d'Océanie
Inv. A. 97.14.1

Main Exhibitions
Zurich, 1970, 1971;
Duesseldorf, 1988;
Frankfurt am Main, 1988;
Munich, 1988-89; Saint-Paul-de-Vence, 1989; Paris, 1997;
Barcelona, 1998; Madrid,
1999; Seville, 1999.

Main Publications
W. Fagg and M. Plass, 1964,
p. 65; E. Leuzinger (ed.), 1970,
p. 53; E. Leuzinger, 1972, p. 159;
P.J.C. Dark, 1975, p. 62;
Arts d'Afrique noire, 1989, cover,
no. 71; P.J.C. Dark, 1982, p. 45;
Christies, 1989, cover, pp. 44-45;
L. Meyer, 1991, p. 53; *Bulletin
Art Tribal*, 1992, cover, pp. 6-8;
*Sculpture. Chefs-d'œuvre
du musée Barbier-Mueller*, 1995,
p. 105; *Arts du Nigeria*, 1997,
cover, p. 29, p. 250; *Africa:
magia y poder. 2500 años
de arte en Nigeria*, 1998,
cover, p. 73.

This head was cast using the lost-wax technique, a method of casting metal first used in Nigeria in the early 10th century[1] that was to attain a remarkable degree of excellence during the heyday of the Kingdom of Benin. The head figures amongst the historic masterpieces of this famous kingdom, which came into contact with the Portuguese in the late 15th century.[2] The category "bronze"[3] covers a prodigious output of artworks in metal extending from the 15th to the late 19th century, when the city of Benin was partly destroyed by a British military expedition. This event in 1897[4] resulted in a massive influx into Europe of bronze, ivory and wood objects which have graced the collections of both individuals and great museums since that time.

For the Bini people cast bronze figures embodied both a commemoration and a narration. This artwork enjoyed a period of exceptional development following the establishment of commercial exchanges with the Europeans. At the start of each new reign, the *oba* would have a bronze head cast *and exhibited on an* ancestral altar in honour of the preceding sovereign. A wealth of objects were placed on the palace's royal altars, from bronze heads recalling earlier reigns over which projected an ivory tusk carved by the craftsmen of the Igbesanmwan guild, to rattle-staffs (*ukhurhe*), hand altars (*ikegobo*), bells, ceremonial sabres (*eben*) and bronze reliefs representing the king and the members of his entourage (*aseberia*).

P. Ben-Amos, however, suggests that the heads fashioned during the initial period of casting (late 14th-early 16th century), during a dynasty of expansionist warrior kings, do not represent ancestors in fact, but rather war and sacrifice trophies.[5] Characteristic of these heads are their naturalist treatment, delicate features and the refinement of their execution. In light of Ben-Amos's analysis then, this piece would be the portrait of a defeated enemy, who can be identified by the two long scarifications on his forehead. These lines were once inlaid with thin strips of iron flanked by two sets of four keloids above the eyes, whose pupils were also once inlaid with iron. Paradoxically, the portraits of

the *iyoba* (mother of the king) display the same scarifications which indicate, in this instance, her spiritual power.[6] The coiffure of short tiered braids is rendered with care, the modelling brings out the cheek bones under the skin, and the neck has a choker with multiple rows of coral beads. The right to wear coral beads (imported from the Mediterranean) was the *oba*'s privilege; they were one of the gifts that he might offer his vassals. This head, displayed on the palace altar, ought apparently to be interpreted as a reminder and warning of the monarch's power. The beads'symbolic red colour, just like the colour of the laterite with which the bronze heads were coated, was meant to provoke fear and thus ward off the forces of evil. The practice of human sacrifice is noted in the accounts of 16th-century travellers and it is possible that images of these victims and rebels were reproduced in bronze,[7] just as the heads of sacrificed rams were depicted in wood. The head embodies, moreover, the idea of destiny and its cult is linked to the cult of the hand, which conveys the idea of material creation.

Legend has it that the current *oba* dynasty is the offspring of the union of an Edo princess and the youngest son of Oduduwa, the king of Ife, who had become Oranmiyan following a problem in the succession.[8] Another long-held tradition posits that metal casting was introduced in Benin from Ife. The naturalism of the heads from the first period defined by W. Fagg, though tempered by a certain geometrical quality, supports the hypothesis of a direct artistic influence between Ife and Benin. The functional evolution of the commemorative heads led to a thickening of the cast metal between the 18th and 19th century, when these statues were used as a base for a carved ivory tusk whose iconography recalled the heroic deeds of the conquering kings. During this latter period, which coincided with the introduction of metal from Europe, a more stereotypical and heavily ornate style evolved.[9]

In the mid-15th century, the great king Ewuare laid out the city that was to excite the admiration of the Portuguese. He divided crafts into guilds and neighbourhoods and clearly separated the

palace confines from that of his subjects. He organised the government and established court etiquette. Under the reign of Ewuare's son, the Iwebo palace association was placed in charge of commercial exchanges with the Portuguese carried out at Ughoton.[10]

Ozolua was the first *oba* to be visited by the strangers who came from beyond the sea bearing precious trade items such as coral, cloth and brass in the form of manillas. The depiction of the last-mentioned article, moreover, was a direct reference to the idea of prosperity. Ozolua's son Esigie is also fondly recalled in the annals and iconography of Benin. This piece was probably cast during his glorious reign, which was marked by his victory over his northern neighbours, the Igala, thanks to the magical help of his mother, Queen Idia. Evincing a highly elaborate technique, this head is probably the most handsome and the finest of the collection of seven catalogued heads dating from that period.[11]

HÉLÈNE JOUBERT
Translation: John O'Toole

1 Following the excavations by Thurstan Shaw in 1959, the site of Igbo Ukwu in Igboland yielded a collection of bronzes dating from the 9th-10th centuries CE. These pieces prove that the lost-wax technique had been mastered before contact between Africans and European along the Gulf of Benin (between 1472 and 1486).
2 The very first Portuguese trader to visit the kingdom was Ruy de Sequeira in 1472. In 1485 Joao Afonso d'Aveira introduced steel flints as a form of currency. In 1490 Duarte Pacheco Pereira was the first European to visit Benin, the kingdom's capital. He has left us a description of this city (*Esmeraldo de situ orbis*, in Hodgkin, 1960).
3 In most cases, the metal is brass, an alloy of copper and zinc, imported from Holland and England as manillas (bracelets used as an early form of currency). Legend has it that casting using the lost-wax technique became widespread during the reign of the *oba* Ewuare. A metal caster by the name of Iguegha supposedly introduced the technique from Ife. The oldest copper-like objects dating to the 13th century were discovered during excavations carried out by Graham Connah at a site of sacrificial inhumation near the *oba*'s palace
4 This event (February 1897), called a "Punitive Expedition", was in response to an ambush in which the general consul of the Niger Coast Protectorate, James Phillips, and his escort were killed. Only two of the party escaped. Yet the *oba* Ovonramwen had warned the consul not to come to the palace during the celebrations of the rites of the Ague festival, which foreigners were forbidden to attend. All of the palace's bronze and ivory works (some 2,400 objects) were carried off and the British Government in London organised an auction to cover the costs of the expedition. Ovonramwen died in exile in Calabar in 1914.
5 A very interesting photograph taken in 1897 by a German merchant named Erdmann and reproduced in F. von Luschan's *Die Altertümer von Benin* (1919) shows a cult staff – to which were fastened two heads – apparently dedicated to the cult of Osun, the god of healers in Edoland. An illustration depicting the burial of an *oba*, which figures in a work by Pieter de Marees around 1600 and comes from Bry's book, represents what might be interpreted as either a scene of human sacrifice with impaled heads, or the site of cult worship in which bronze heads were part of the ritual. In 1699, Van Nyendael gave a description of royal altars displaying bronze heads that served as supports for carved elephant tusks.
6 Notably on bronze and ivory images representing Queen Idia, mother of the great king Esigie, who ruled during the first half of the 16th century. The standard female scarification in Benin comprised three vertical lines on the forehead. Customarily four keloids are considered to indicate either a man who is a foreigner to the Edo's territory, or an Edo woman.
7 The commemorative heads were reproduced in wood, terracotta and bronze. The *oba* head is the object of a cult during the celebration of the Igue rite which culminates the Edo calendar. In turn, the *oba* sends his priests to bless the heads of chiefs through whom he governs.
8 According to oral tradition, the council of the *uzama* ("king makers") had in fact deposed the pretender to the throne and sent for a prince in Ife. Unlike the Yoruba system, in which power was exercised alternately by three families of royal descent, the system of succession in Benin is patrilineal, i.e., the eldest son inherits the throne, and the power of the *oba* is absolute.
9 Under the *oba* Osemwede (1816-1848), the royal crown gained two projections depicting stylised feathers, which were solely used in coiffures of chiefs, powerful warriors, priests and kings.
10 Ughoton figures in various travel accounts as Gwato or Gotton (see O. Dapper, 1686). Ships put in there because they were not authorised to sail any further.
11 Six comparable pieces are conserved in museums in London, Lagos, Philadelphia, Berlin and Oxford. The seventh piece is currently part of a private collection.

Sculpture from the Kingdom of Benin

16th-17th centuries
Nigeria

Plaque

Bronze
H. 40 cm, L. 33 cm
Formerly the Barbier-Mueller collection
Musée National des Arts d'Afrique et d'Océanie
Inv. A.97.4.1

Main Exhibitions
Duesseldorf, 1988; Frankfurt
am Main, 1988; Munich, 188-
89; Saint-Paul-de-Vence, 1989;
Paris, 1997; Barcelona, 1998;
Madrid, 1999; Seville, 1999.

Main Publications
*Arts africains dans les collections
genevoises*, 1973, pp. 52-53;
Sculptures d'Afrique, 1977,
p. 87; *West Afrikanische Tage*,
1982, p. 52; *Hier, aujourd'hui
et demain, dix ans d'activité
du musée Barbier-Mueller*, 1987,
p. 50; *Arts de l'Afrique noire dans
la collection Barbier-Mueller*, 1988,
p. 138; L. Meyer, 1991, p. 118;
Art Tribal, 1992, p. 32; *Sculpture.
Chefs-d'œuvre du musée Barbier-
Mueller*, 1995, p. 104; *Arts du
Nigeria*, 1997, p. 108 and p. 250;
*Africa: magia y poder. 2500 años
de arte en Nigeria*, 1998, p. 91.

In the 16th and 17th centuries, according to the accounts of foreign travellers who were allowed to enter Benin, decorative brass plaques adorned the walls of the *oba*'s palace and the wooden pillars supporting the roofs of the galleries and courtyards.[1] These plaques were of a more or less uniform size and generally were rectangular; they represented various scenes in high and low relief.

Iconographically, they depicted symbolic animal figures evoking the power and divine character of the *oba* (pythons, bottom-dwelling fish, crocodiles), or, as in this case, scenes enlivened with human figures whose size symbolises the Edo system of hierarchy. They also illustrated different aspects of court life in which the *oba*, his assistants and war chiefs, merchants, foreign visitors and other dignitaries were shown singly or in groups. It is not inconceivable that the combination and juxtaposition of such plaques, when they were hanging in place, formed a coherent theme and illustrated a ritual, historical or legendary sequence. Few, however, are considered to refer to a precise tale or event.

The two figures represented here have been identified as dignitaries dressed in military costume, each brandishing a ceremonial sword (*eben*) in his raised left hand. Purely for show, this weapon is readily recognised by its open-work foliate metal blade and ring-shaped handle. The bent right arm is hidden behind a shield in the shape of an escutcheon heightened with delicate guilloche patterns. These two warriors are the same size, adopt the same gestures and the same frontal posture, sport the same costumes and headdresses. They stand out in high relief without any apparent support before a background conventionally adorned with decorative motifs comprising four-petalled flowers placed regularly over the surface.

Both figures wear helmets adorned with bunches of coral beads from which additional fringes of coral beads hang, just like the multiple rows of necklaces decorating the neck[2] (reaching to the mouth), the wrists and the ankles. The faces of these figures recall those seen on commemorative heads, featuring large almond-shaped eyes with the pupils indicated and the edge of the lashes marked by a double line, straight noses with widely spaced wings, and a mouth showing well-defined lips.

Their leopard-tooth necklaces indicate their high social rank while embodying spiritual protection. A sort of quadrangular breastplate reaching to the waist is also linked with the leopard whose eyes and whiskers are seen on either side of a central bar. Around the waist a series of quadrangular brass bells fastened with cloth strips cover part of the short loincloth that is draped over the hips. The hem is made rigid with a bamboo rod.[3] The cloth is decorated with a braided pattern below a four-leaf flower motif that recalls the incised figures on the studded background. This vegetal motif alludes to the aquatic leaves (*ebe ame*) used in healing rites by the priestesses of Olokun, son of Osanobua, the creator. Olokun is associated with water, wealth, beauty, fertility, and is the most highly honoured divinity in Benin. A peaceful god, he incarnates the idea of balance and order which is also reflected in the sculptured representations of the *oba*.

The bells were rung to warn others of the wearer's movements. Like pendants and belt masks, they belonged to the objects fashioned for the *oba* by smiths. The *oba* would subsequently distribute such objects to those who had distinguished themselves in battle or to vassals in order to mark the extent of his authority. Bells were also supposed to have the power to chase away evil spirits. Their presence everywhere in the iconography makes plain their ritual and political importance. All of these ceremonial elements conjure up the idea of power, protection and pomp within the framework of palace ritual.

The plaques were produced by the guild of metal casters, the *Igun-eromwon*, who were past masters in the technique of their art and served the *oba* and chiefs. The protector of the arts and monarch at the head of an empire whose provinces paid tribute to him, the *oba* controlled the entire output of the craftsmen in the city of Benin. Tradition has it that during the reign of Esigie, a man by the name of Ahammangiwa[4] created the plaques and bronzes for the king.[5]

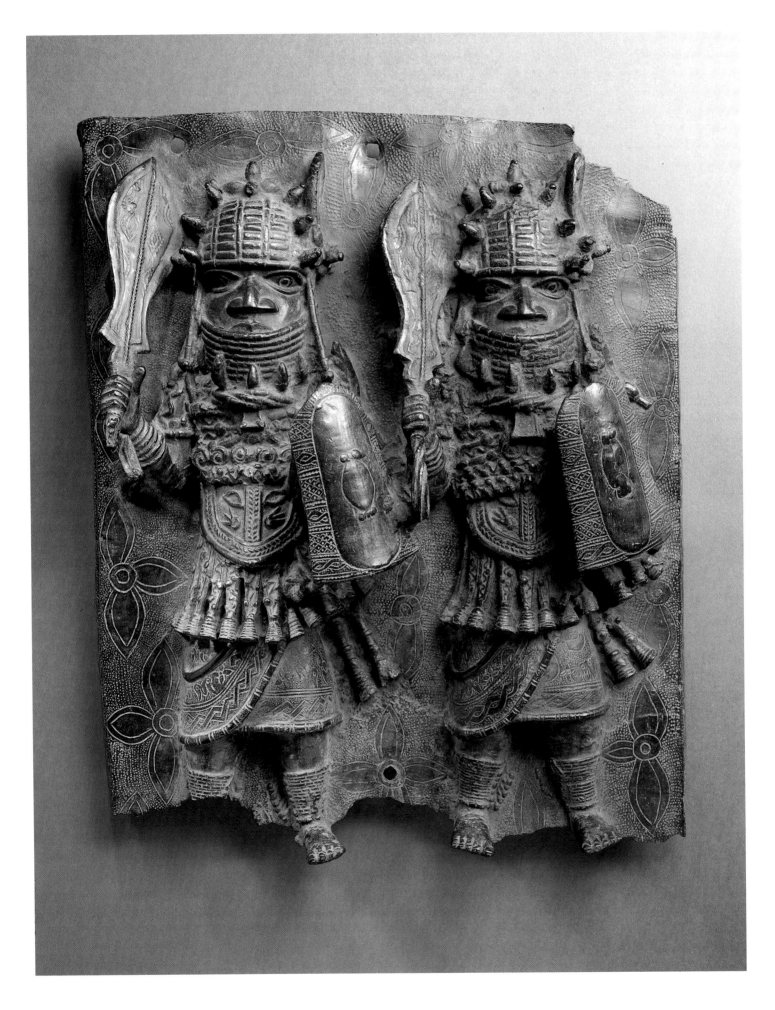

Mentioned by Olfert Dapper in the 17th century, the plaques have holes at their four corners by which they were held in place.[6] However, when the British made their punitive raid in 1897, these plaques were no longer fastened to the palace's pillars, but rather stacked together in a building where they were gathering dust. According to an old palace guard, they were consulted in the past in order to verify questions of etiquette. It is believed that production of these plaques ceased in the early 18th century. This conclusion is based upon a letter that the Dutchman David van Nyendael addressed to the traveller William Bosman, who fails to mention these plaques when he visited the palace, but does relate that in 1702 a very severe hurricane had apparently damaged the building.[7] The plaques could have been taken down at this time and stored in the annex where the British found them in 1897.

HÉLÈNE JOUBERT
Translation: John O'Toole

1 P. Dark has counted some 900 plaques that served to embellish the palace's interior architecture.
2 This necklace, which is called *odigba*, can only be worn by titled nobility in Benin.
3 Bini raffia and cotton cloth was highly prized by travellers, who appreciated the material's delicate quality. Such cloth was regularly exchanged as a primitive form of currency like ivory or pepper. Woven on a vertical loom beginning in the reign of the *oba* Ohen (14th century) by men, all members of the Owina n'Ido guild, the most beautiful examples made use of the appliqué technique for the loincloths worn during royal investitures.
4 See C.H. Read and O.M. Dalton, 1899, re-edition, 1973, p. 6.
5 A plaque in the British Museum in London shows the *oba* Esigie, bare chested, sporting a pointed helmet and seated on a horse or mule, returning in triumph from his campaign against the Igala and the Attah of Idah (1515-1516).
6 The Dutch physician Olfert Dapper was the first to mention the famous brass plaques in his description of the city of Benin. Never having actually travelled to Africa, his *Description de l'Afrique* (1668) is a compilation of various pieces of information gleaned from travel accounts.
7 P. Dark and I. Tunis have put forward the hypothesis that most of these plaques were produced prior to 1640.

Urhobo Sculpture

19th century
Eghwerhe, Nigeria

Statue of Emetejevwe of the Family of the Hero Owedjebor

Wood
H. 142 cm
Formerly in the Barbier-Mueller collection
Musée des Arts d'Afrique et d'Océanie
Inv. A. 96.1.102

Main Exhibitions
Anvers, 1975; Brussels, 1977b; Paris, 1993; London, 1995-96; Berlin, 1996; Paris, 1997.

Owedjebor! Among the Urhobo of the Niger River Delta, this ancient name conjures veneration and respect. Indeed it inspires outsiders with fear. It recalls the founding family of the community of Eghwerhe, located some 20 km north-east of the bustling commercial town of Orho-Agbarho. Owedjebor was a human reputed to be endowed with magical properties. He was said to be able to stop spears with his bare hands and turn his attackers' bullets to water. This culture-hero, however, did not work alone. As is customary for the Urhobo and indeed throughout most of Africa, the family supports the individual. In the case of Owedjebo, oral tradition grants magical powers to

numerous individuals who in a collective presence struggled to establish the settlement of Eghwerhe.[1]

The Urhobo, a relatively small Edo-speaking population who live in the western fringe of the Niger River Delta in Delta State, Nigeria, have a rich and varied artistic tradition which has received only modest consideration in the literature to date. The Urhobo came into existence as a result of various migrations from neighbouring populations (Bini, Igbo, and Ijo); their arts embody a mixture of influences from those groups.

While they are largely land-based people, the Urhobo have close connections to water. Indeed, the livelihood of virtually every Urhobo community depends on the use of a waterway for fishing and transport, and such was even more the case before the advent of roads and motorised vehicles. Beyond its ecological value, each body of water is also believed to have a sacred significance as well. Every founding family is said to have employed magical powers from neighbouring rivers, ponds and lakes in the course of settling a community.

Thus for the Urhobo, bodies of water have both economic and spiritual impact. Water is seen as the mirror of life. Under its shimmering surface there exists another world, *erivwin*, the land of spiritual forces, the land of ancestors, and by extension, the place where controlling forces dwell. The dominating forces of the waters are the *edjo*, who are in some instances envisioned as actual people[2] and in others as amorphous essences, products of the atmosphere, *edjo-enu*, or more colloquially, *edjenu*. The *edjo* have wide powers. They have influence over all aspects of Urhobo existence; indeed, every body of water is believed to contain some supernatural powers. While the *edjo* are related to all aspects of Urhobo existence, their closest connection is to the water, and the very term that is most commonly used for water spirits reinforces this view, in such terms as *edjo re ame*, literally "spirits of the water". Indeed the most commonly heard phrase honouring an *edjo* is *edjo name rhe*, which means, "the spirit comes from the water."

Some 15 miles to the north of the bustling commercial trading centre of Orho-Agbarho lies the small community of Eghwerhe. Today it has a population of perhaps 1,000 people, most of them farmers and traders who travel outside their home village to find work. A century ago, so the elders of Eghwerhe recently reported,[3] the town was a wealthy trading centre for goods coming up from Okan-Agbarho, to the south, where the Warri River makes its turn to the south and onwards toward "Oku", the "big waters" of the Niger Delta. It is through Okan that palm oil was transported southward into Itsekiri country, and trade wealth was largely collected in the villages to the north of Okan, among them Eghwerhe.

In the last quarter of the 19th century, when Eghwerhe prospered as a commercial centre, Urhobo artists carved huge wooden statues, often life-sized and sometimes even bigger. They commemorated the culture heroes, the individuals who with their families are given credit for founding a community. These figures were dramatically sited at the rear of small shrines located alongside the stream that was said to have given the founders their formidable powers. Except for a short festival period, the figures were shut away, to be seen only by those few individuals entitled to enter the buildings for ritual purposes.

Until the early 1970s, one such small shrine was positioned on a side road leading to the waterside sector of Eghwerhe. It contained a formidable, dramatic array of sculptures, each of which depicted a family member. Included was a virtual *dramatis personae* of the supportive family, represented through two generations.[4]

Owedjebor[5] stood at the centre. The founder of Eghwerhe, legend recalls, initially migrated from Benin City, then into Ukuane Igbo to the east, then to Isoko, then to Agbarho. Dominating his martial demeanour were a pair of weapons, a spear aimed downward in his left hand and a curved, Benin-style sword[6] upward in his right.[7] He was flanked on the right by his wife, Aye R'owedjebor, and on his left by his *onotu*, leader of the warriors. Further on the right, on the other side of his wife, was his half-brother Emerititiri, another warrior who would follow his older brother into battle.

At the extreme left side of Owedjebor stood two women: first, the wife of the half-brother, and then, in the corner, the figure that is central to the present discussion, their daughter, Emetejevwe.

Emetejevwe holds an infant to her breast. She sits while others stand, and in a sharp departure from the rigid frontality of the other figures, her torso twists slightly to the side. The general term for this figure is Oniemo, literally, "mother of children". In the shrine setting, then, the figure takes on a greater significance. She represents the nurturing component of the lineage, standing in stark contrast to the warrior image depicted elsewhere. The balance of these two vividly different forces are essential to the balance which they bring to Urhobo civilisation.

As would be appropriate for a woman of such high stature, Emetejevwe wears elaborate beads at the top of her thigh, and at her ankles she wears heavy brass anklets known as *eromon*.[8] Her wrists support thick concave ivory bracelets, *ikoro*. Cut from elephant tusks, these bracelets were worn by women to show that they were of sufficient wealth and status that they were able to shun all physical labour.[9] All the figures in the Owedjebor group display forehead markings of a type called *iwu*.

Main Publications

Sculptures africaines – Nouveau regard sur un héritage, 1975, no. 38, p. 37; P. Foss, 1976, fig. 3, p. 14; *Arts premiers d'Afrique noire*, 1977, no. 43, p. 76; W. Rubin, 1987, p. 342, *Arts du Nigeria*, 1997, p. 92 and p. 272; *Sculptures. Chefs-d'œuvre du musée Barbier-Mueller*, 1995, p. 111; C. Falgayrette-Leveau and L. Stéphan, 1993, p. 9; T. Phillips (ed.), 1995, no. 5.59, p. 394; T. Phillips (ed.), 1996, no. 5.59, p. 394.

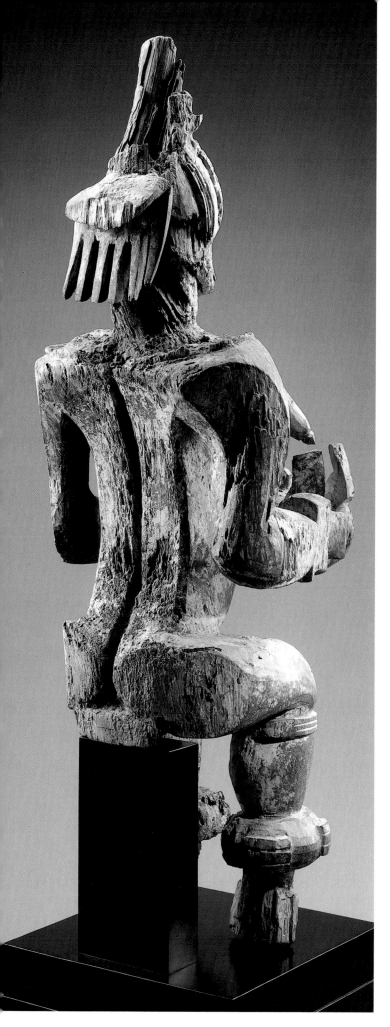
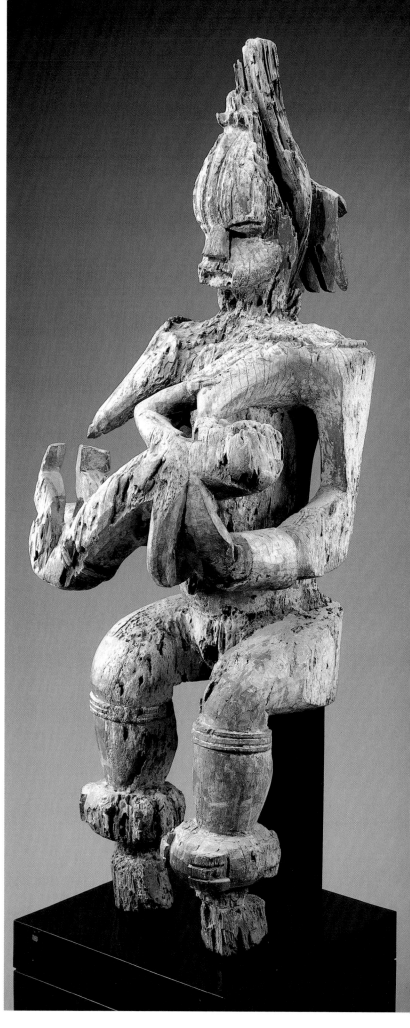

Substantial inquiries suggest that the Urhobo themselves never wore these marks. At least anecdotally, they are said to have been worn by the Ukuane-Igbo groups residing immediately to the east of the Urhobo. Further research is needed to determine when and under what circumstances these marks entered the visual lexicon of Urhobo artists.

PERKINS FOSS

1 Research was initiated in Eghwerhe on 20 March 1967, with subsequent visits in 1969, 1969, 1971, 1972, and most recently in December 1998. Numerous people helped facilitate fieldwork, especially Djerhe Etinagbedia, Orogheneghovweke Eferevbri, J.O. Obodo, Ovwighodemu Obebeduo and William Okorotete. For more material on Urhobo statuary, including data on the Owedjebor group, see P. Foss, 1976, pp. 12-23 and 89-90.

2 Julius Itevue of Utevie-Evwreni (a healer whose professional name is Dr. Gum, interviewed December 1998) described the *edjo* as especially wealthy individuals who wear layers of beads and lavish cloths in the style of Itsekiri chiefs.

3 At a meeting held on May 30, 1999. Partial financial support for the field work carried out on this trip was derived from a generous stipend

from the Réunion des Musées Nationaux, Paris.

4 The images in the shrine, including the nursing mother figure, were last seen in May 1969. At an undetermined date between then and October 1971, all the works of art in this shrine disappeared under circumstances that have never been properly explained.

5 Elders at Eghwerhe was quick to point out that this name is just that, a person's name, and cannot be translated into component parts. The correct pronunciation is *owedjebaw*, and a variant spelling is to drop the final "r" and to mark the final "o" with a sub-critical dot.

6 The sword is of the type known in Benin as "ada." See Philip J. C. Dark, *The Art of Benin*, 1962, fig. 325. Dark cites (*ibid.*, p. 67) a description of these swords as used in Benin: "It was an official sword carried in

front of the king, and certain other high officials…"

7 For further discussion as well as illustration of figures in the Owedjebor group, see P. Foss, 1976, pp. 12-23 and 89-90.

8 This term, commonly used by Urhobo to describe these anklets, is also the general term for any work of art made of brass. It derives from Bini where is has similar dual usage. See H. Melzian, 1937, p. 56.

9 In a museum context, the figure is shown without any clothing. Such would never be the case in an Urhobo shrine, where it would be essential for her buttocks and genitalia to be gracefully covered with a clean white wrapper around her waist. Indeed on more than one occasion, I showed photographs of similar figures to an Urhobo audience, only to be met with cries of shock and indignation.

Mbembe Sculpture

17th century (?)
Nigeria

Part of a Slit-gong

Wood (*Afzelia*)
H. 6.5 cm
Purchased by the Musée des Arts d'Afrique et d'Océanie from H. Kamer, February, 1974
Musée des Arts d'Afrique et d'Océanie
Inv. MNAN 74.1.1

Main Exhibitions
Whashington D.C., 1989; Richmond, 1989; Kansas City, 1989; Paris, 1990; Cologne, 1990; The Hague, 1990-91.

Main Publications
H. Kamer, 1974, frontispiece; P. Meauzé, 1974, pp. 205-06; E. Eyo, 1977, p. 221; C. Noll, 1984, fig. 11, p. 63; *Musée*

Mbembe is the name adopted by a group of people numbering about 40,000 in 1965. At the beginning, they had no common name to describe their unity, and according to Rosemary Harris the name "Mbembe" was given to them by outsiders because they were fond of using the word *mbe* to start a sentence. They are a group that practised both patrilineal and matrilineal kinship systems just like their neighbours to the west, the Yakur. Like most groups in the area, they have age grade systems and other associations to which men and women belong throughout their lives.

In 1905, Charles Partridge published two drums from the villages of Avonum and Ogada (Oshopong) in the Obubra area of the Mbembe territory. Along with carved totem poles, they stood outside the club house in the middle of the towns. A drum was made of a single section of a tree trunk which was

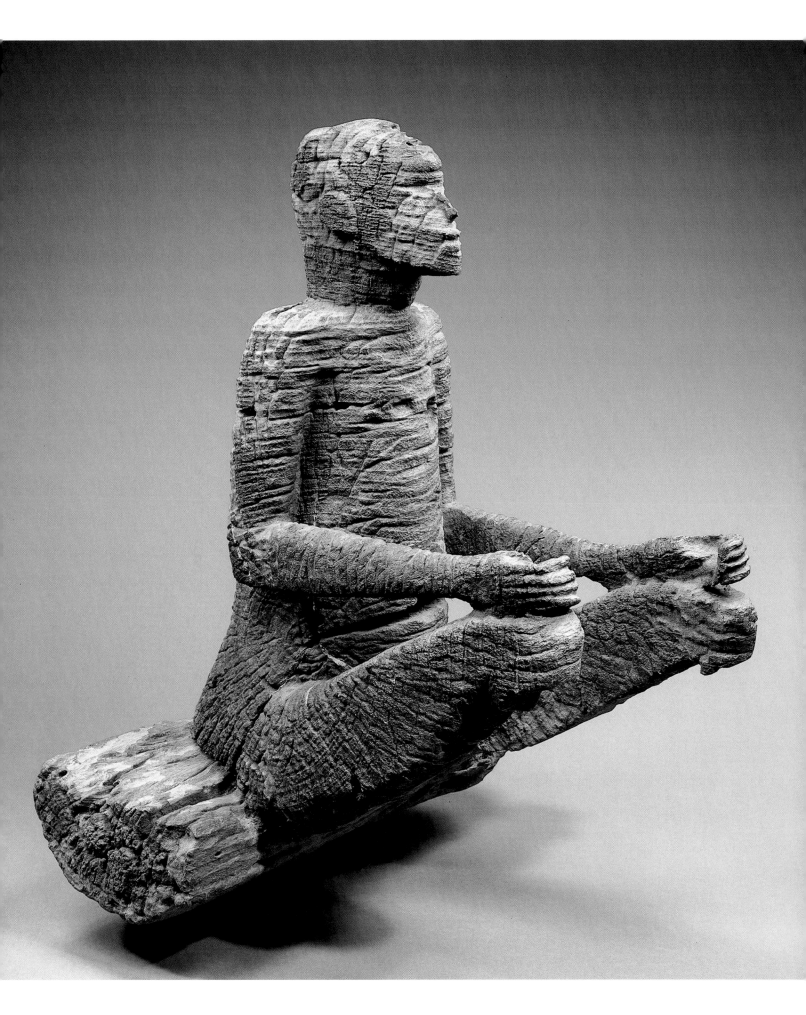

des Arts africains et océaniens, Guide, 1987, no. 58, p. 106; J. Kerchache, J.-L. Paudrat and L. Stéphan, 1988, no. 128, p. 216; M.-T. Brincard (ed.), 1989, no. 51, p. 118; M.-T. Brincard (dir.), 1990, no. 47, p. 107; *Afrikanische Skulptur: Die Erfindung der Figur – African Sculpture: The Invention of the Figure*, 1990, no. 30, p. 132-33.

hollowed out, leaving two apertures at the top and, at one end, a carved human or animal head. The sounding of the drums summoned villagers in times of crises and also made important announcements such as the death of a town head or other important persons within the community. There is usually one such drum representing the collectivity of inhabitants of the community, or a club house such as *Nyamargbe* (leopard society) and other men's clubs. In all cases, the drum is sacred because it is imbued with the spiritual forces of the group or club. It was only sounded by an authorised individual on the instruction of the community head or club leader. When sounded, it can be heard for miles.

The seated figure on this drum is its finial. The horizontal grain seen on it results from the fact that the figure and the drum were carved from the same piece of tree trunk, thus resulting in the grain of the figure being perpendicular to the axis of the figure's head. The beauty and age of the figure have been enhanced by weathering in the wet tropical climate.

This piece might have come out of Mbembeland during the troubled period of the civil war in Nigeria (1960-75). Similar artworks are in the National Museum of African Art, Smithsonian Institution, Washington, D.C., and two others are illustrated in T. Phillips (ed.), 1955. One of the latter, a figure formerly in the Helene Kamer collection, represents a seated figure with both hands on its knees, and the other a standing male figure holding a severed human head against his body with his left hand. In all these cases, the rendering of these figures in blocky physiology with faces looking straight into the horizon conveys a sense of confidence and eternity. The figure may represent a successful warrior who brought home the head of an enemy as a trophy.

EKPO EYO

Bakor Sculpture

Before the 16th century
North-eastern Ejagham, Middle Cross River, Nigeria

Ancestral Stone Monolith (*atal*)

Basalt
H. 174 cm
Musée national des Arts d'Afrique et d'Océanie (on permanent loan)
Formerly in the Pierre Dartevelle collection
Musée du Quai Branly
Inv. 70.1998.4.1

Main Exhibitions
Brussels, 1988; London, 1995-96; Berlin, 1996.

Main Publications
P. Allison, 1968a, pl. 6; P. Allison, 1968b, pl. 34 and pl. 35; J. Kerchache, J.-L. Paudrat and L. Stéphan, 1988, no. 535, p. 414; *Utotombo*, 1988, no. 125, p. 182; T. Phillips (ed.), 1995, no. 5.37b, p. 375; T. Phillips (ed.), 1996, no. 5.37b, p. 375.

The stone monoliths of the north-eastern Ejagham people were first recorded by Charles Partridge, a British District Officer, at the beginning of the last century. In 1905, in his book *Cross River Natives*, he published two views of the arrangement of the stones *in situ*, one in the village of Agba and the other, a single stone which he referred to as the "The Club Stone", in Obubra village. In 1968, Philip Allison, another British officer, published in his *Cross River Monoliths* some 300 monoliths from 29 sites in abandoned and present day villages which he surveyed for the Nigerian Department of Antiquities. Allison described the monoliths as standing in circles or near circles, singly and severally, in village "playgrounds" where community activities were carried out.

This particular monolith was photographed by Allison at Etinta, the premier village of the Nta subclan, one of the five subclans of the Bakor mega clan. Although Allison referred to these stones as *akwanshi*, recent ethnographic and archaeological research in the area has shown that the term *akwanshi* is a misnomer. Actually, the Nta subclan uses the word only to refer to small uncarved stones, about 8 to 16 cm long, heaped together like a cairn in front of the family compound or inside the carved stone circles to represent the departed souls. The more appropriate *atal*, the word commonly used in all the subclans to denote a stone, has now been adopted. Furthermore, it is usual to refer to the geographical location of the carved monoliths as the "Cross River" or "Ikom", but these

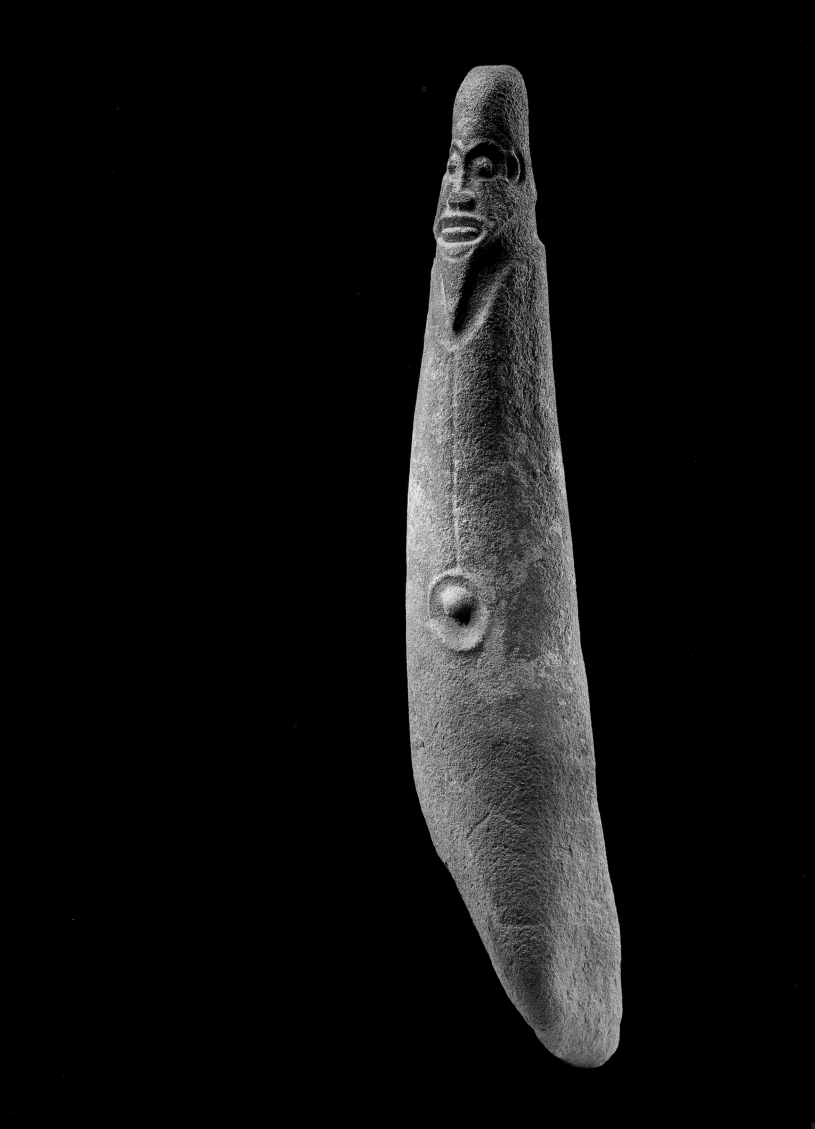

terms give only vague and imprecise descriptions. Since the monoliths are confined to an area of about 550 square kilometres within the Bakor clan, a more circumscribed, smaller and more precise geographical area, the use of "Bakor" to indicate their location would seem more appropriate.

As noted, Partridge referred to the monolith in Obubra as the "The Club Stone". The social organisation of all the Bakor villages is based on the matrilineal system of descent. However, the depth of their descent tree is very shallow and Bakor young people rarely trace their ancestry beyond one or two generations. Although the immediate family is recognised as the basic social unit, at age 10 to 15 everyone belongs to an age association or club, formed every seven years. Individuals identify most closely with their personal association or club and look to them for help in economic activities, life crises and at the moment of their death. Initiation ceremonies for boys usually take place within the circle of monoliths. During this time, a young cotton tree is planted to signify the coming into being of the new association, and a small uncarved stone is buried at its foot. As the tree grows, it envelops the small stone which stands for the soul of the new association, thus symbolising the protection which the association members expect. This ceremony was witnessed in the village of Alok in 1990, and it is believed that other Bakor villages have the same or similar initiation ceremonies. Girls' initiation ceremonies usually take place in the village square and not the playground.

These stones come from the tributaries of the Cross River, sometimes quite a distance from the village. Young men of the age associations display their strength and endurance by hauling the phaliform boulders out of the water and conveying them to the village where they are carved with human features. Each of the carved stones is said to represent an ancestor, a legendary or historical figure or an emblem of a secret society. The Etinta monolith in this publication represents *Ebiabu*, a society responsible for executing death sentences on those who flouted community law.

Each year, when the first crops are ready for harvesting, particularly yams, the monoliths are painted white, yellow and blue and then "fed" mashed yams mixed with palm oil. Palm wine and ordinary water are poured on the stones, as people loudly call out the names of each them and ask for blessings, protection and general help for every member of the community.

This particular monolith was buried in the ground down to just below the navel. Its features are sparse – a circular, protruding navel and a simple tapering head separated from the body by a deep groove giving it a sculptural quality. The long beard and oval mouth with the tongue sticking out give this monolith a simple but authoritative aura befitting an executioner.

EKPO EYO

Bangwa sculpture

First half of the 19th century
Southern Grassland, western Cameroon

Maternity statue depicting a mother of twins (*anyi*)

Wood
H. 78 cm
Piece collected in the small Bangwa kingdom of Nwa-Metaw (Fojumetor) in 1967;
acquired by Pierre Harter in 1967
Formerly the Pierre Harter Collection
Musée National des Arts d'Afrique et d'Océanie (donation, 1994)
Inv. A. 94.11.1

Main Exhibitions
Zurich, 1970-71; Essen, 1971;
Brussels, 1977a; Florence, 1989;
Paris, 1992.

Main Publications
E. Leuzinger, P1, p. 234;
E. Leuzinger, P1, p. 223; R. Brain
and A. Pollock, 1971, pl. 20
and 44, p. 41 and p. 91;
*La Maternité dans les arts
premiers*, 1977, fig. 59, p. 56;
R. Brain, 1980, fig. 9.7, p. 196;
P. Harter, 1986, fig. 4 and I,
p. 11 and p. 33; E. Bassani,
1992, p. 174.

Physician, collector and specialist in the art of Cameroon, Pierre Harter (1928-91) acquired this statue representing a mother of twins (or *anyi*) in 1967 at Jean-Michel Huguenin's gallery in Paris. Several months earlier the statue had been collected in Nwa-Metaw (Fojumetor[1]) during the reign of the tenth *fwa* (chief, king), Fongang. Because the piece served important social and religious functions, it was sold only after being de-sacralised, which can be seen in the amputation of part of the figure's left leg. Produced by a great master carver who apparently came from a kingdom neighbouring Nwa-Metaw, the statue had been preserved and used in the royal treasury since the mid-19th century.[2] Harter bequeathed the main part of his collection to the state just a few months before his death, accompanying his generosity with a proposed gift of this maternity statue in 1991 to the Musée National des Arts d'Afrique et d'Océanie. In 1994 the piece became a permanent part of the museum's collections.

Although a few very rare statues of mothers of twins showing only one child are still used in a several tiny Bangwa enclaves, only eight such pieces are currently known to exist in the West.[3] Moreover, morphological and aesthetic analysis of certain pieces[4] present clear stylistic similarities with the Nwa-Metaw maternity statue and suggest that all these objects were actually carved by a single master sculptor.[5]

The western Bangwa live in the southwestern Grassland, west of the Bamileke Plateau in western Cameroon. They speak *Nwa* or *Nwe*, a variant of the Bamileke languages. They are organised into nine small *gung* (kingdoms or chiefdoms), micro-states that gradually took shape beginning in the 17th or 18th centuries. The Bangwa stand at the confluence of two great cultures, the Bamileke of the savanna to the east and north, and the Ekoi of the Cross River to the west. Thus, along with typically local features, Bangwa art displays stylistic elements that originate in those cultures mentioned above. Their culture, however, remains fun-damentally Bamileke. Social life is organised around the *nefo* royalty, the king (*fwa* or *fon*) and various secret societies.

The renown of Bangwa art is based above all on their statuary, the major pieces being sculptures commemorating their kings, queens, princesses and titled servants, as well as the parents of twins. These works, like the Nwa-Metaw maternity statue, are kept by the members of the *lefem* society (a group of notables who are rich and powerful enough to meet the requirements for entrance into the society[6]). These notables exhibit the statues at burials and royal cults, during a liturgy that is linked with protection of the kingdom, fecundity and fertility of the land, or in the course of the annual propitiatory sacrifices for blessing and purifying the kingdom.

The person shown here is a mother of twins, identified by the coiffure with a special arrangement of the hair worn by such women, the necklace decorated with panther teeth draped over the back and, of secondary importance, the bracelets on the figure's wrists. Besides the seated position and the wealth of bracelets, supposedly of carved ivory, the type of stool, with the geometrical decor of its circular seat, signifies that the figure represented here is an *anyi* of high rank, the wife or mother of the king. The figure has a face treated realistically, a prominent forehead, eyes in the shape of coffee beans, an open mouth, and a gaze that looks into the distance. She is supported by cylindrical legs and is nursing a child. The svelte chest and pendulous breasts tend toward a triangular shape. The abdomen bulges slightly. The right forearm and thumb are exaggeratedly lengthened to better offer the breast to the child without disrupting the balance of the torso. The twin, caught in a very lively pose, lies on his mother's lap. She supports his neck with her left hand. While he suckles, he scratches the *anyi*'s bracelets with one of his hands.

Fecundity, life during gestation and procreation are amongst the subjects to which the Grassland

societies and artists return obsessively. This is reflected in their art by frequent depictions of pregnant women and above all women carrying a child.[7] Bangwa sculpture, moreover, has drawn not a little inspiration from concepts and beliefs touching on twins and their parents. Twins are indeed venerated amongst Bangwa. The birth of twins is considered an extraordinary event, a clear sign of beneficial divine intervention and indeed throughout all the Grassland area. A great celebration is then organised and sculptures are executed in honour of the parents. Such parents sport special ornaments and insignia. They change names as well, the father becoming *tanyi*, the mother *anyi*. In short, this is a public proclamation of the special benediction they have received from the supreme being. A mother of twins is granted exceptional powers. If, for example, she brandishes between two antagonists (individuals or armies) a branch from the tree of peace (*Dracaena deistelina*), a symbol of twins, the quarrel or the conflict is immediately suspended. She is also associated with abundance and the renewal of the forces of the earth. A mother of twins is initiated into the *anyi* society,[8] which dances and sings during burials and important ceremonies. During the annual agrarian rites held in the name of fecundity and the prosperity of the soil and the country, the *anyi* march together dressed in their special insignia (bracelets and necklaces, branch from the tree of peace in one hand, body covered with the red powder of the mahogany tree), blessing and fertilising the earth with sacrifices and the divine *asse* chant. As for the twins themselves, they are seen as magic persons and are likewise thought to possess extraordinary powers.[9]

The pleasing resolution of the composition here, the great liberty taken by the artist in lengthening certain parts of the body and suppressing others while respecting the laws of the Bangwa's sculptural tradition, the inspired materialisation of a moving maternity scene, the remarkable expressive force of a mother nursing a child reinforced by the great symbolic and religious value of the piece – these aspects imbue the Louvre statue with exceptional aesthetic and sculptural qualities, placing it amongst the masterpieces of world art. This piece reveals the hand of a great master carver, an artist with an inventive spirit and a great capacity for abstraction and concentrated composition who deftly balanced naturalism and idealism. Unfortunately, the many attempts to identify this talented sculptor carried out by P. Harter have yet to yield his name.[10]

JEAN-PAUL NOTUÉ
Translation: John O'Toole

1 The terms included in parentheses are the Bangwa royal titles. The colonial administration used them to refer to the territory and the population of the different *gung* (kingdoms or chiefdoms). For easier reading, I have placed the names of these localities, which appear in art books, next to the local terms used by the Bangwa themselves and the postcolonial administration.
2 P. Harter, 1986, p. 314. It seems that the piece was used during the reign of the seventh sovereign Apantu. The patina, as well as a careful examination and stylistic analysis of the statue, suggests such an advanced age, although dating in this instance is difficult to determine with any precision.
3 P. Harter, 1986, p. 316; two of these objects have disappeared, such as the remarkable specimen with its rounded forms conserved in Berlin's Museum für Völkerkunde (IIIC.10.533), reproduced in O. Nuoffer, 1925 (p. 37 and fig. 8). Formally, two other models are rather similar to the Nwa-Metaw sculpture, viz., one brought back by G. Conrau in 1899 (reproduced in K. Krieger, 1965, vol. 1, photograph 96, p. 96) and conserved in Berlin's Museum für Völkerkunde (inv. IIIC.10.531); and the other conserved in the Linden Museum (inv. 33.508).
4 These works are: the piece mentioned above collected by G. Conrau in 1889, the commemorative statue of a seated king of Fotabong Nscheu, and the extraordinary statue of another seated king (private collection, Brussels),

portrayed with one hand on his chin and a forearm excessively lengthened and laden with bracelets. All are reproduced in several works (see R. Brain and A. Pollock, 1971, pls. 56 and 57, pp. 120-21; P. Harter, 1986, figs. 349 and 352, pp. 310 and 315; J.-P. Notué, 1993, no. 27, p. 157).
5 Such a possibility has been raised by several authors: R. Brain and A. Pollock, 1971, p. 122; E. Bassani and R. Bellini, in E. Bassani, 1992, p. 267.
6 The *lefem* meets in the sacred wood (the royal cemetery, also called the *lefem* or *fam*, the holiest sanctuary of the kingdom). The members of this society gather once a week to discuss important affairs concerning the kingdom's survival and to perform sacred music that is meant to bless and purify the country as well as glorify the royal ancestors. This day is a day of rest. Ceremonies marking public celebrations, funerals and work in the fields are prohibited. The king shuts himself up and sees no one. Under the *lefem*'s aegis, a servant (formerly a slave) guards the sacred sculptures and sees to their upkeep. He used to serve for nine years and during this time abstained from all sexual relations. At the end of this period, he was made a nobleman and as a reward was given a wife, generally a princess.
7 This theme recalls the Virgin and Child of medieval Christian imagery, or Isis and a small Horus in Egyptian depictions. The mother-and-child theme is fairly common in African art.
8 There is a hierarchy amongst the *anyi* based

on their social rank (mothers of twins who are queens take precedence over all other *anyi*), seniority in terms of when they gave birth to twins, the number of children at one time (twins or triplets) and the number of times twins were born to the same woman.
9 Twins, for example, are thought to have the power to make women who bless them fertile. The Bangwa assimilate them to snakes and sincerely believe that they can in fact become serpents. Twins call to mind complementarity, duality, equality. They symbolise peace and successful alliance. The display of twin statues during religious ceremonies assumes an important symbolic and social function since they are associated with the cult of the earth, fecundity and the purification and protection of the country.
10 P. Harter (1986, p. 314) thinks it likely that this artist came from one of Nwa-Metaw's neighbouring kingdoms, probably Fotabong. However, the kingdom might also be Lebang-Fontem, the provenance of a great number of important Bangwa works (Fatabong Ncheu, Foretia, Foreke Foa, presented in the art books as important artistic centres, are localities in the kingdom of Lebang), judging from the treatment seen in the pieces from that centre.

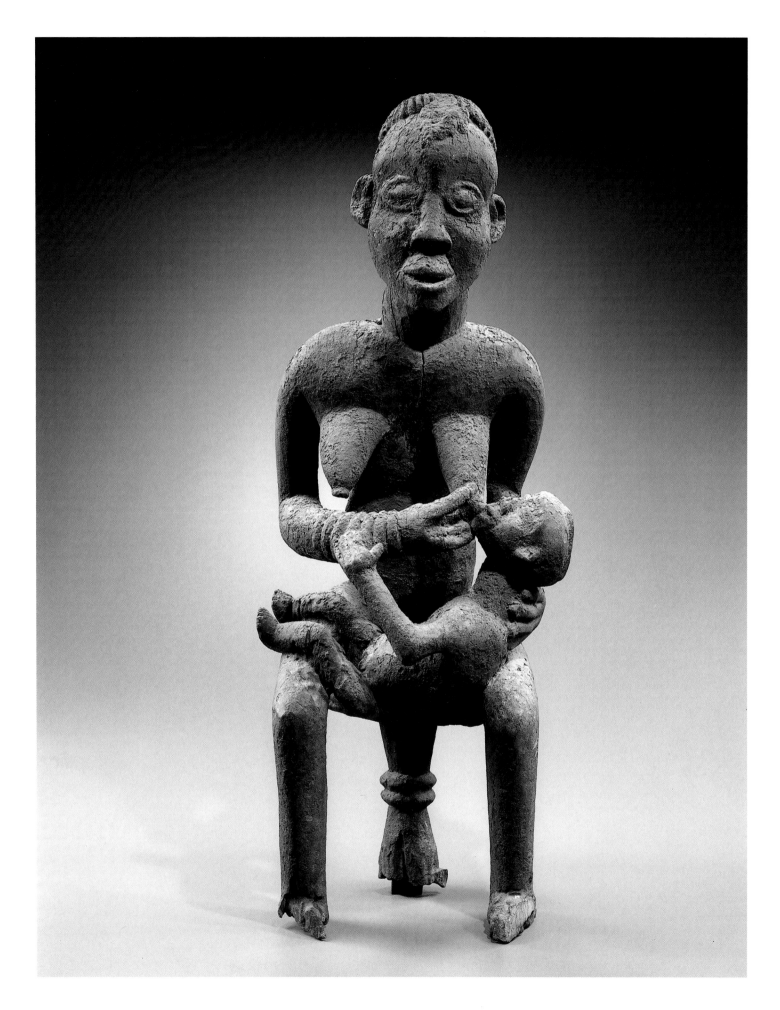

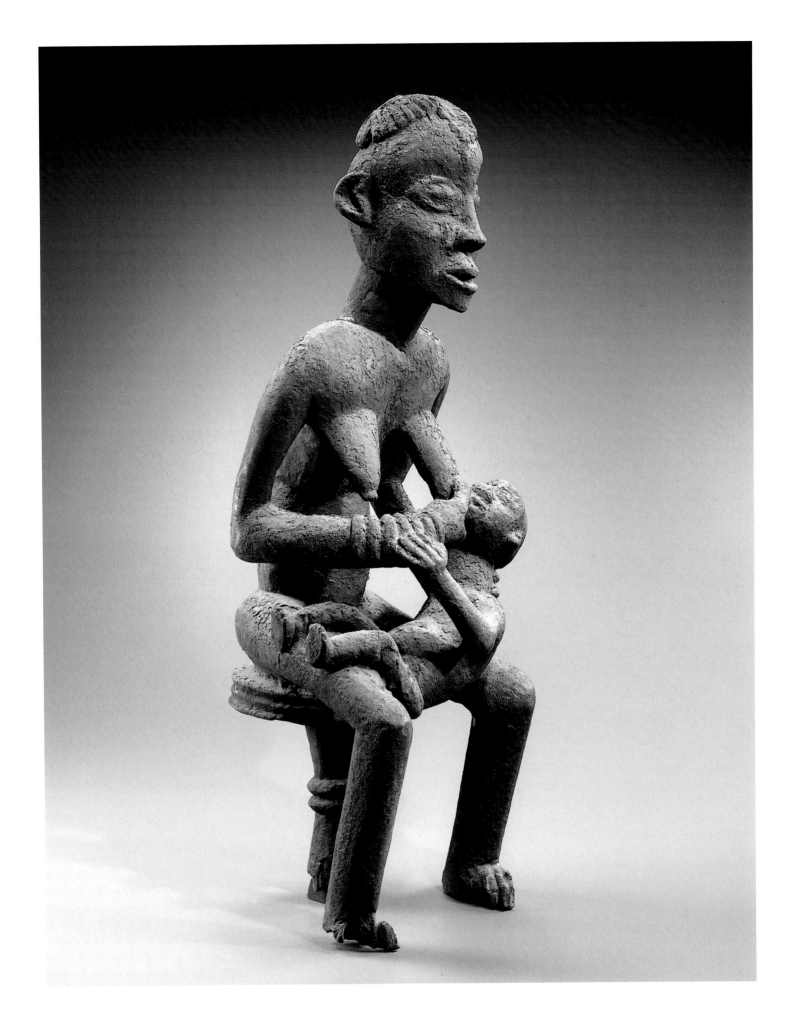

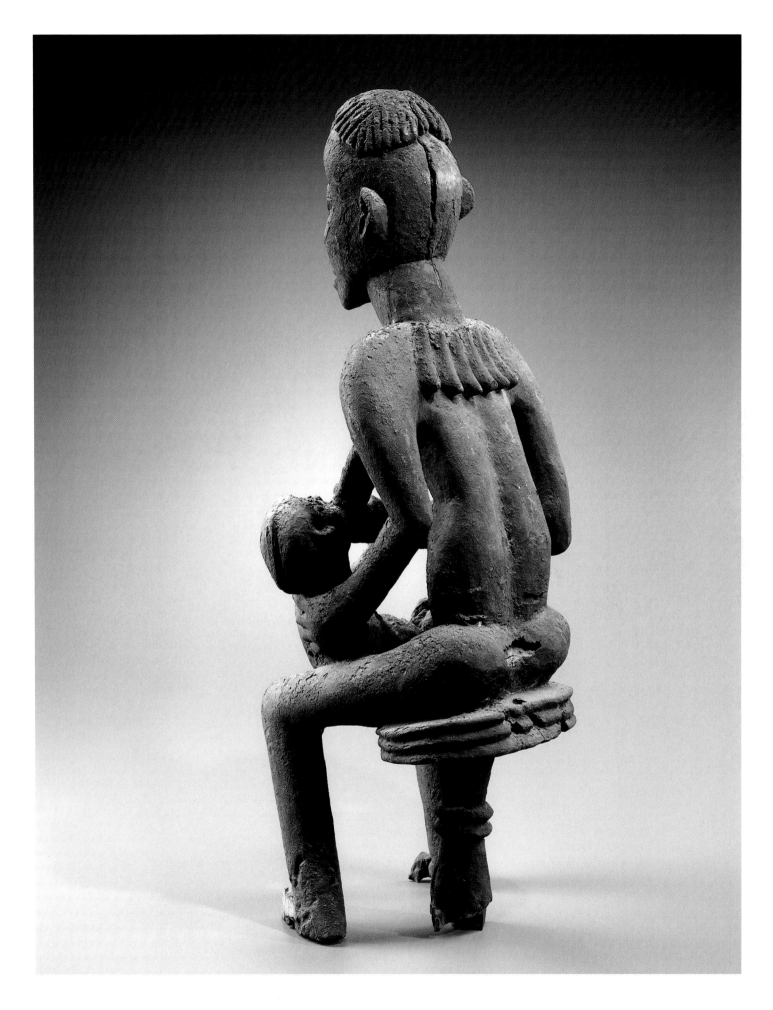

Sculpture from the kingdom of Isu or Esu (ex-Bafum-Katse)

18th-early 19th century
Region of Wum, northern Grassland, western Cameroon

Statue commemorating the victorious king *(batum)* Bay Akiy

Wood, beads, human hair, ivory, bone, cloth
H.115.9 cm
Formerly the Paul and Ruth Tishman Collection
On loan from the Walt Disney – Tishman African Art Collection
Inv. 1984.AF.051.110 a and b

Main Exhibitions
Los Angeles, 1968-69;
Richmond, 1970; Saint Louis,
1971; Des Moines, 1971;
Huntington, 1971; New York,
1981; London, 1995-96;
Berlin, 1996.

Main Publications
R. Sieber and A. Rubin, 1968
and 1970, no. 98, p. 9; P. Harter,
1986, figs. 2, 267 and 268, p. 9,
p. 234 and p. 235; J. Kerchache,
J.-L. Paudrat and L. Stéphan,
1988, no. 133, p. 224; T. Phillips
(ed.), 1995, no. 5.9, p. 352.

This monumental-looking sculpture, one of the most surprising masterpieces of Grassland art,[1] was collected in Isu (the Grassland's far northwest) and portrays Bay Akiy, the great conqueror and Isu's fourth sovereign, who ruled in the late 18th century. For a time, the piece was part of the Paul and Ruth Tishman Collection; today it belongs to the Walt Disney-Tishman Collection in Los Angeles. This statue made a strong impression on the museum public during "Africa: the Art of a Continent", a major show held at the Royal Academy in London in 1995. Stylistically and technically, the piece closely resembles a number of objects with a terrifying aspect carved by a great master sculptor in the early 19th century. All information touching on this sculptor was collected in the field in 1912.[2] Several other rare commemorative statues depicting triumphant kings holding a knife in one hand and brandishing the head of a defeated enemy in the other have been found in other parts of the Grassland.[3]

Isu or Bafum-Katse ("Bafum of the murderers"[4]) is one of the 21 small kingdoms or chiefdoms that the British grouped under the term Fungom (the name of the most important kingdom) to simplify administrative matters. Isu was an important metallurgy and artistic centre in the precolonial period. The art of this centre is akin to the output of the kingdoms of Kom and Oku, although it does present both local characteristics and some stylistic influences springing from the peoples of the Benue Valley and its surroundings. Nevertheless, the work shows the fundamental elements of the Grassland culture. The *batum* (king or chief, who fulfils important political and judicial functions) is above all a high priest who performs (occasionally bearing his buffalo-horn cup) periodic libations and sacrifices for the well-being of the kingdom. He is responsible for the proper growth of the kingdom's food plants, the abundance of the harvests, the fertility of the country and fecundity throughout the realm. He is a master of occult and supernatural forces. This is why the *batum* is secluded for eight weeks in a

place that holds the skulls of ancient kings and must submit to numerous initiation rituals in order to become an exceptional and sacred individual. On the other hand, his powers are limited by secret societies like the *nchu*, a religious association that attends to the royal cults and takes part in the initiation and installation of the new sovereign.

By formal signs the artist expresses the many functions of the *batum* through various works of art, the most important being the royal commemorative statues. The treatment of the example seen here displays great realism – and the same deference the artist would have shown the king he is portraying. The piece was exhibited during funerals and royal cults. The figure is seated on the back of an animal which is most probably a panther, the symbol of royal power throughout the Grassland.[5] The massive head is slightly tilted with respect to the central axis. The open mouth looks as if it were giving voice to a cruel, terrifying cry of victory, and is unequalled in African statuary outside the Grassland region. The treatment of the teeth, which are represented by real pieces of ivory, lends them emphasis. The long neck is cylindrical, like the elongated trunk. The bust is powerful, the backbone stylised. Bits of human hair appear on the chin. The worn legs also lend emphasis to the genitalia. The small breasts and navel stand out from the surface of the wood. The vigorous arms are detached from the body, the right hand holding a war knife, the left proudly displaying the head of a vanquished enemy which wears an expression of pain.

Few sculptures in sub-Saharan Africa treat a subject with as much realism and expressive force. The artist succeeded in deftly applying various representational techniques in order to both recall and relate King Bay's great victory over the Nshe population, whose chief, figured by the decapitated head, is rudely exposed for all to see.[6] Beyond the narrative function of the sculpture, moreover, the piece's great religious and symbolic meanings have been clearly laid out. The *batum* originally wore

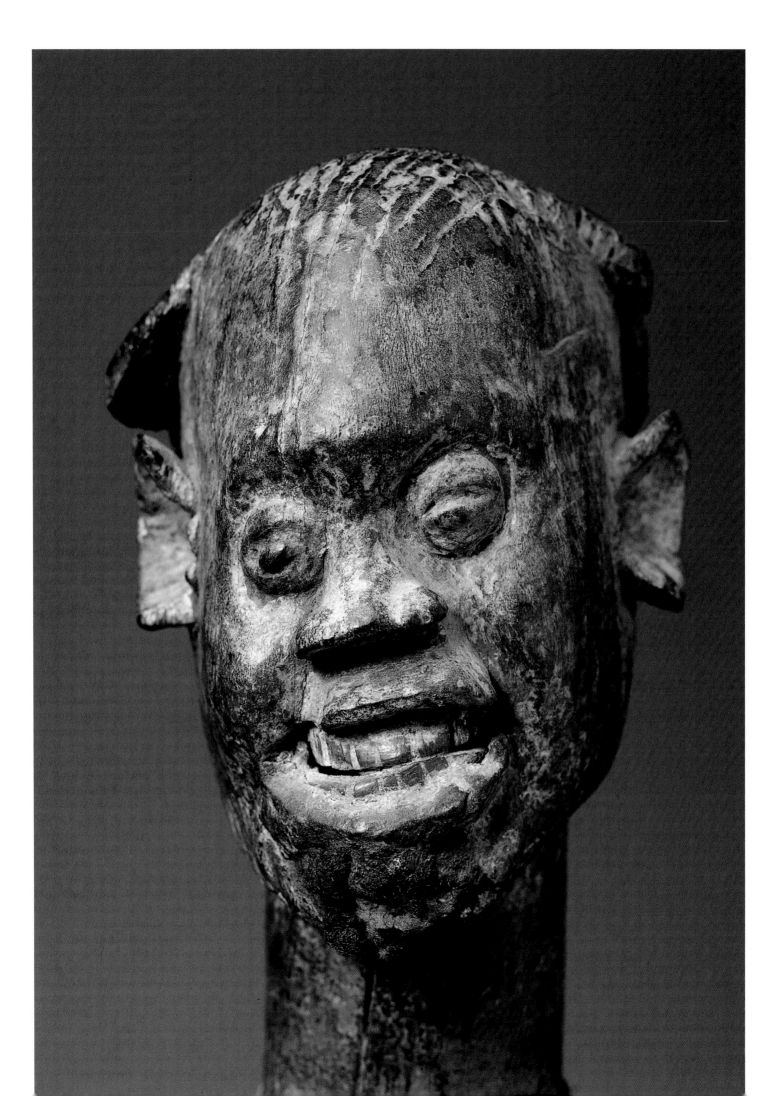

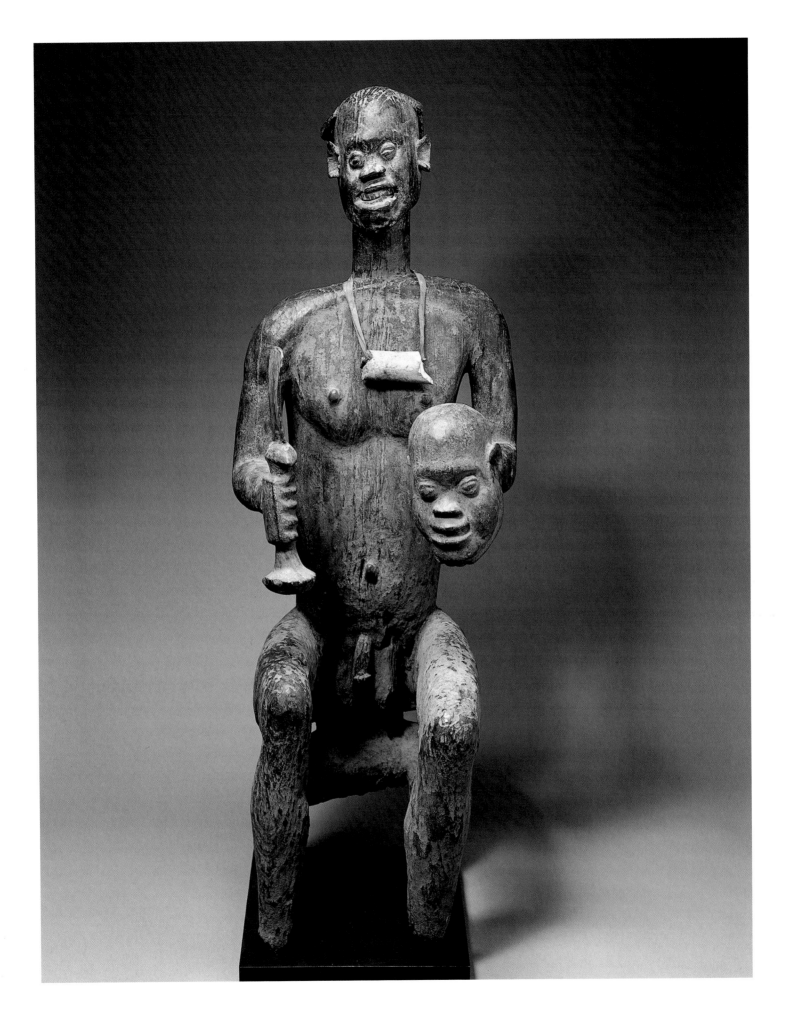

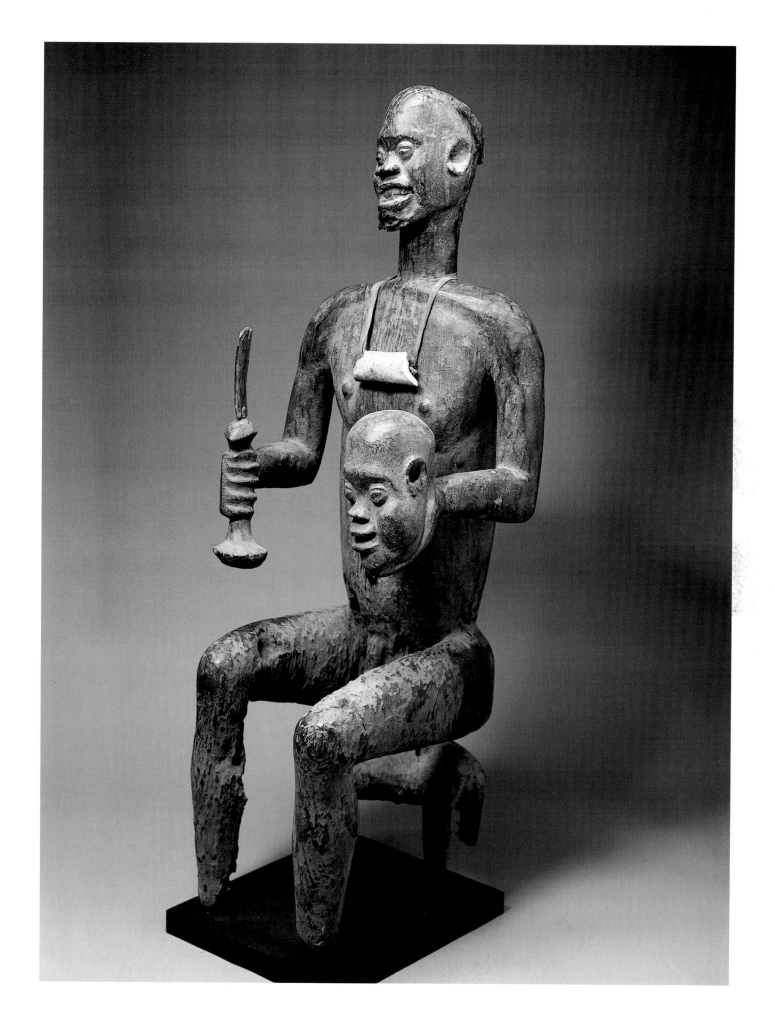

a string around his neck. To this were fastened a large striped glass bead (like the one worn by priest-diviners) and a section of human femur, which lent the statue its ritual character. The mahogany powder (mixed with palm oil) that covered the statue during rituals, which can be seen still in the layer of thick, fine red patina adorning the piece, symbolises the *batum*'s vitality and his power to fertilise the country, fecundate women, guarantee abundance in births and harvests, success in hunting and war. Moreover, during his initiation, the *batum*, bathed by the *natum* (the oldest royal woman), is completely naked save for a garland of climbing plants that he wears around his neck. He is also covered with the same reddish mahogany powder and mud which fulfil the symbolic functions mentioned above.[7] For its part the trophy head that the figure brandishes in his left hand symbolises the force of the enemy's valour as warriors and the victor's own valour. We might note that the *batum* is first of all the chief of the formidable warrior society *Ndea tsham*, which is responsible for peace and war in Isu and comprises the Isu's headhunters.[8] It was these great warriors who offered the *batum* the head of an enemy soldier killed in combat.

Generally, the theme of the victorious king exhibiting the head of a fallen enemy warrior in one hand and holding a cup, arm or pipe in the other is very common in Grassland art. If on the whole the theme evokes the country's victory over its enemies, its symbolic significance is profound and presents various nuances from one sector to the next. The theme appears on doorjambs, thrones, musical instruments, royal statues and so on.

According to the last custodian of the statue,[9] the great sculptor here was Bvu Kwam, who shows a remarkable, creative spirit, skilfully lending artistic form to abstract concepts (cry, victory, pain, strength, etc.) while admirably combining function, aesthetics, history and symbolism. These qualities, along with the statue's vigour, its fitness, the arrangement and balance of its volumes, the fine result of its composition and the expressive power of its forms, make this piece an original and exceptional work of art. It is clearly imbued with major aesthetic qualities, placing it amongst the premier examples of world sculpture.

JEAN-PAUL NOTUÉ
Translation: John O'Toole

1 P. Harter, 1986, p. 242.
2 *Ibid.*
3 This is the case of the statue portraying King Montieu of Bafu-Fondong (reproduced in P. Harter, 1986, fig. 281, p. 248), and the Baleng statue-throne set with glass beads (reproduced in J.-P. Notué, 1993, fig. 45), both photographed in Bamilekeland.
4 At the time of German colonial rule (1884-1914), the term *bafum* was used to refer to all objects found in the territory occupied by the kingdoms of Bum (Bafum-Bum), Mme (Bafum-Mme) and Isu (Bafum-Katse). The significant name of *katse* ("Bafum of the murderers") was given to the Isu "by the Hausa, because supposedly several Hausa traders had been killed there" (C. Geary, 1987, p. 73).
5 The *batum* calls himself "panther" and his children are "those" of this same animal. Like other Grassland monarchs, he is said to be able to transform himself at will into a panther or another royal animal and become a man in an instant (L. Perrois and J.-P. Notué, 1997, p. 197). The panther is famous for its power and vigilance, moreover, and is supposed to sleep without closing its eyes. This explains why the feline symbolises the king and the strength of warriors in this part of Africa.
6 P. Harter, 1986, p. 242.
7 J.-P. Warnier and P. Nkwi, 1982, p. 198.
8 *Ibid.*, p. 199; see also P. Harter, 1986, p. 242.
9 P. Harter, 1986, p. 242. The author points out that Elias Kum, the sculpture's last custodian, was the only person in the royal palace of Isu to offer this name for the talented artist.

Sculpture from the kingdom of Bamendu

First half of the 19th century
Bamileke Plateau, southern Grassland, western Cameroon

Royal mask (tukah)

Wood
H. 86 cm
Acquired by Pierre Harter in Bamendu in 1957
Formerly the P. Harter Collection
Musée National des Arts d'Afrique et d'Océanie (Harter Bequest 1992)
Inv. A.P.92.13

Main Exhibitions
Zurich, 1970; Essen, 1971;
Geneva, 1980; Florence, 1989;
Paris, 1992 and 1993b; London,
1995-96; Berlin, 1996.

Main Publications
E. Leuzinger, 1970, P2, p. 237;
E. Leuzinger, 1971, P2, p. 225;
E. Leuzinger (ed.), 1978, fig. 78;
C. Savary, 1980; P. Harter, 1986,
fig. IV, p. 35; L. Perrois
and J.-P. Notué, 1986, fig. 14,
p. 191; E. Bassani, 1989, no. 70;
E. Bassani, 1992, p. 125;
L. Perrois (ed), 1993, cover,
p. 121 and p. 122; T. Phillips
(ed.), 1995, no. 5.16, p. 357;
L. Perrois and J.-P. Notué,
1997, fig. 51, p. 128.

Dr Pierre Harter (1928-91) collected this monumental mask in 1957,[1] in the small kingdom of Bamendu on the western Bamileke Plateau. In recognition of the treatment the doctor provided him, and in memory of their friendship, the fo or fon (king, chief) Victor Dongmo authorised Harter to select this sculpture from amongst a number of pieces that were deemed too powerful to be touched by anyone.[2] These were in the ruins of a hut that was apparently abandoned, although the area remained sacred and no one dared to approach it. Thus one of the masterpieces of African sculpture worthy of figuring amongst the great works of world art came to enter P. Harter's collection and became its greatest treasure. At the end of his life, eager to ensure that this collection was not broken up and sold off piecemeal, Harter decided to bequeath this and other major pieces to the state, to the benefit of the Musée National des Arts d'Afrique et d'Océanie.

Giant masks displaying a similar treatment, with the same headdress decorated with lizards (or crocodiles), are quite rare in the Grassland.[3] Besides this specimen from Bamendu (the most important) and fragments of another (showing no patina from use) that P. Harter discovered in a Parisian gallery, only three masks of this type, all from the Bamileke Plateau, are known and conserved in the West.[4] Four others that are more or less similar have been located and photographed in the field.[5] All of these objects constitute a particular variant, a stylistic subgroup, of the category of - fatcheeked anthropomorphic masks found in various Grassland kingdoms.[6] These masks are adorned with reptiles and generally called katsho or akatsho.

Bamendu (25,000 inhabitants) is one of about a hundred gung (kingdoms, chiefdoms) that gradually took shape in Bamilekeland more than six centuries ago. Bamendu was apparently established sometime before the 17th century by a hunter king who succeeded, with a number of companions, in subjugating various small pre-established chiefdoms like Fola Deng Deng (the most important) and Fojeuzan. The kingdom is ruled by a sacred sovereign, the fo, whose powers are counterbalanced by notables in various secret societies or mkem, such as the kah. The kah brings together the kingdom's notables in the fam (the sacred wood and royal cemetery) and serves as a kind of high council. It is entrusted with protecting the chiefdom and can use both military and occult powers if need be.[7] It is divided into independent sections or lodges, which are distinguished by their masks and other specific objects. The tukah (literally "head of the kah"), emblem of the society and royalty, is the most important mask; it is kept by the section of elders, the most influential section. A single object of this type was used by the kingdom for its rites. When the piece became too worn for use, another was fashioned. The old mask was not abandoned, however, but piously kept as a relic in a place that was considered off limits.

The tukah mask shown here recalls the anthropomorphic decoration of certain Grassland pipe bowls. It looks like a human face, but one that has been completely reinterpreted. The present image boasts a high spherical open-work headdress decorated with six lizards (recalling crocodiles as well), each having a dynamic silhouette skilfully carved in one of the egg-shaped lobes, with strong, angular limbs, roughly diamond-shaped bodies covered with a number of pyramidal points, a head with stylised features, and clawed forefeet. The forehead is high and bulges out. The cheeks, exaggeratedly puffed up and ready to burst, and oblique coffee-bean eyes (whose corners are prolonged into an indented line that runs as far as the ears) are set on either side of a long sharp nose in a well-balanced design. The holes visible around the neck, ears and cheeks suggest that part of the mask could be fitted with a decorated piece of cloth. The artist spared no effort here to transform this sculpture into a powerful symbol.

According to P. Harter, the mask, which is indeed quite heavy, was carried every five years by royal servants during a procession that was related to the manjong warrior classes.[8] The mask was also

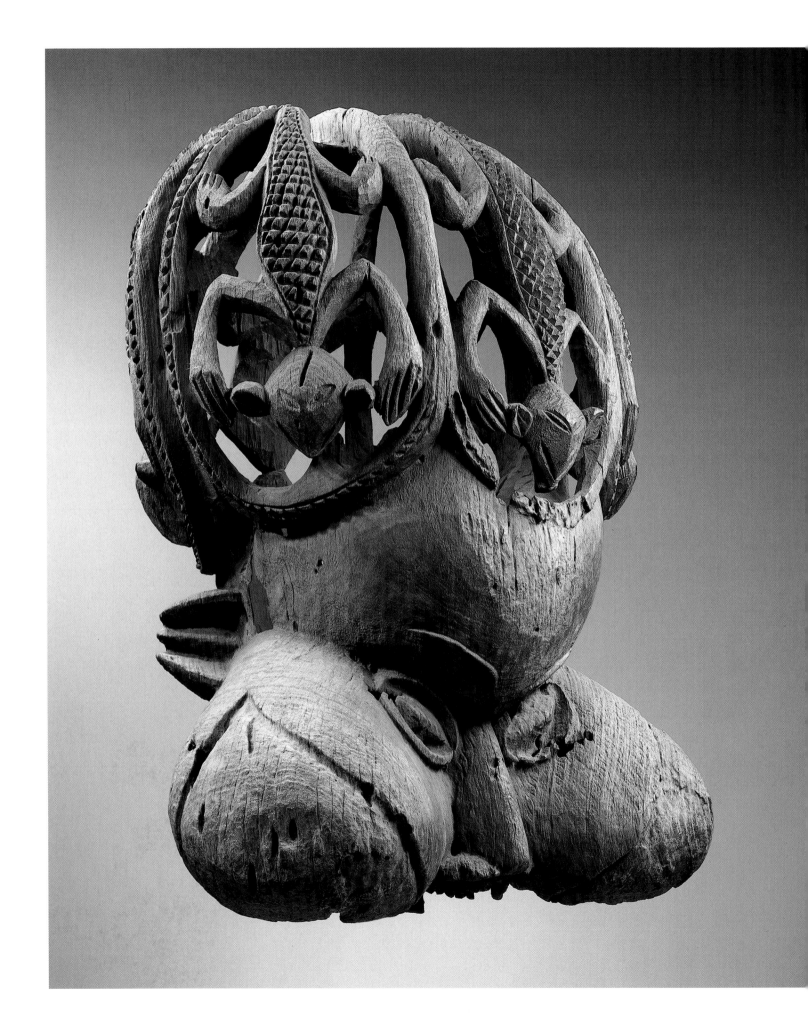

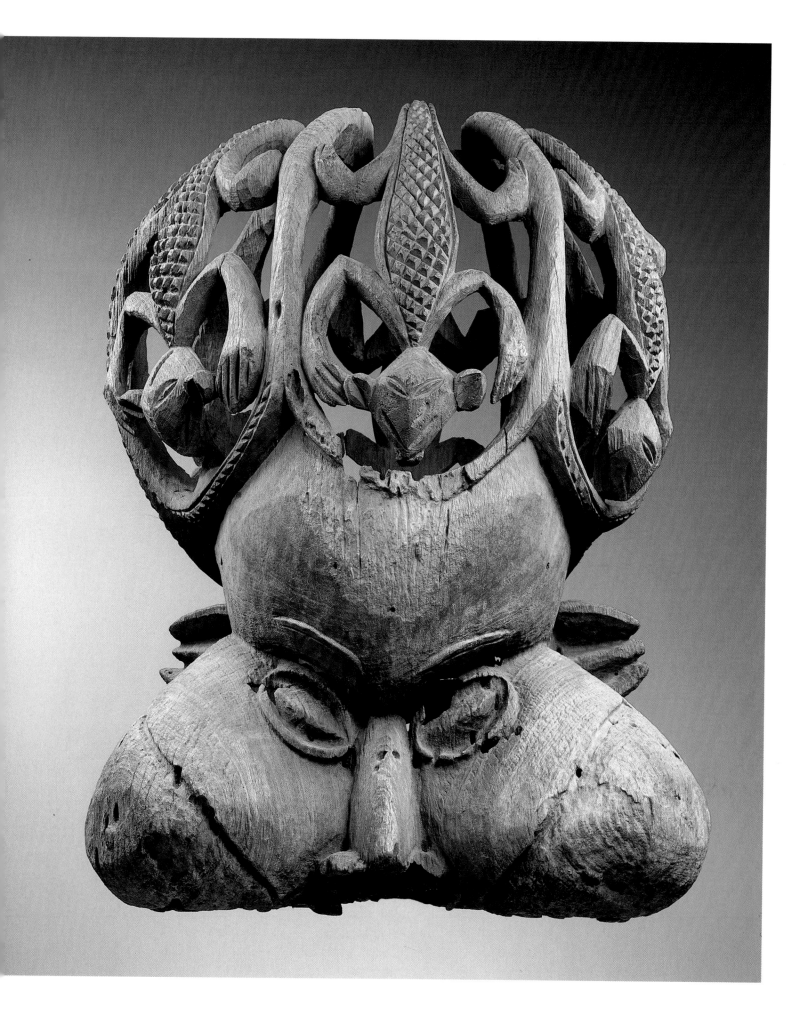

part of the ceremonies surrounding the designation and installation of the king's successor, the funerals of kings and other great dignitaries of the realm, and certain periodic celebrations of *ke* (initiation and fertility ritual, transcendent power, magic[9]). Exhibiting such a mask involved painstaking preparation within the sacred wood and the observation of certain taboos in order to infuse the mask with its occult power. Bearers took advantage of the holes in the neck and cheeks as points of leverage in a system for transporting the piece that made use of poles to take off some of the weight during the procession.

The *tukah* embodied considerable symbolic significance. It stood as a visualisation of the power of the *fo* and the notables who founded the kingdom. According to King Dongmo, as quoted by P. Harter, the mask represented the power, nobility and perpetuity of the Bamendu throughout several reigns.[10] All of this would be recalled during the liturgies and ceremonies mentioned above. The *kepak* lizard symbolised the power of fertility, life, rebirth of the kingdom, the agility and vigilance of the king and the notables. In another context, particularly when the rites of *ke* were celebrated, the mask evoked the malevolent force that could cast evil spells on the country's enemies.[11] The bulging forehead represented mystery, intelligence and an ambivalent power.[12] The cheeks (just like a protuberant abdomen) suggested fertility, abundance, wealth. Moreover, puffed out cheeks and humps linked to the power of fertility appear rather frequently in objects (stools, masks, drums, ceremonial staffs, etc.) that are associated with the power of the nine faunding notables (including the *fo*).

The geometric design over which the volumes are articulated, and the harmonious, balanced contrast of the nask's masses and lines, make this type of object an altogether extraordinary success as a piece of sculpture, a success that is all the more engrossing and impressive given that this giant mask measures 86 cm high. The expressive power of this sculpture, the force of its volumes and their remarkable interaction with the lines of the composition, the rich variety of the iconography, the monumentality of the forms, the happy solution to the design here – all of these aspects are concrete proof of the daring, the creativity, the originality, the aesthetic experimentation and other exceptional qualities of this master sculptor of Bamendu. He has indeed left posterity a genuine masterpiece. This anonymous artist succeeded in adapting local tradition to new forms. Let us hope that his name may one day come to light.

JEAN-PAUL NOTUÉ
Translation: John O'Toole

1 In 1957 a bloody civil war broke out that was to ravage the region of Bamileke and eventually destroy several royal treasuries and palaces, including those of Bamendu, one of the bastions of the opposition to colonial and postcolonial rule. The kingdom had already been the scene of bloodshed at the start of the 20th century when King Fojeu (grandfather of the *fon* Dongmo), refusing to accept German authority over his territory, was captured and later died from the brutal treatment his captors subjected him to (Fourneau [adm.], 1940, p. 1).

2 J.-P. Chazal, 1993, p. 32.

3 Production and use of these objects are severely regulated and restricted. Venerated, consecrated, surrounded with mystery and guarded by dreaded secret initiation societies, they were kept hidden away from foreigners for many years. Even locally they only appear in public on exceptional occasions.

4 The first (the largest) was collected in the kingdom of Bangang in 1905 (reproduced in E. Beumers and H.J. Koloss [ed], 1992, fig. 29, p. 123); it is now in Berlin's Museum für Völkerkunde (inv. IIIC.20.349). The second, brought back from the kingdom of Bamendjo in 1914, is part of the Field Museum of Chicago's collections (inv. 175.595). The third, collected in 1909, is found in Bremen's Übersee Museum (inv. 12.259; P. Harter, 1986, p. 250).

5 The four specimens in question are: the procession mask of Baleng, highly damaged and very old, identified by R. Lecoq in 1946 (P. Harter, 1986, fig. 283, p. 251); the bead-covered mask from the treasury of Bazu identified by

F.C. Egerton in the 1930s (F.C. Egerton, 1938, photograph 61, p. 185); a second mask of Baleng, still in use, (replica or restoration of the first-mentioned mask?); finally, a mask filmed with a Bamileke chief and several royal stools and drums, identified by a Protestant minister, F. Christol (series of photographs by F. Christol conserved at the Musée de l'Homme).

6 Called *katsho*, *akatsho*, *katshomena* etc., these masks are localised in Bamilekeland, in the regions of Ndop and Bamenda; they are part of an ancient style that goes back at least to the 18th century (L. Perrois and J.-P. Notué, 1997, p. 143 and p. 144). They are borne on the shoulder or the head, or carried in the hands. Veiled in secrecy, they are rare and difficult to observe in the field. Although they share numerous points in common, they show great diversity in the details, both in terms of morphology (treatment of the mass of the decoration) and function, according to the initiation societies that use them, the geographic sector, even the school that carved them. Finally, the *katsho* are part of the great family of fat-cheeked masks. These boast ample forms, a more or less "cubist" or "surrealist" treatment, and a decor that often features reptiles, spiders, toads or geometric figures. They are involved in the grand royal and funerary rites of various sectors of the Grassland, including the Bamum kingdom (J.-P. Notué, 1993, p. 99).

7 The members of the *kah* also discuss important affairs of the country and participate in the initiation and installation of the country's grand dignitaries. The *kah* society is linked with the

mkamvu'u (council of nine notables and institution that oversees the executive). This society is especially prevalent in the western Bamileke Plateau, in the regions of Dschang and Mbuda (more or less analogous associations exist elsewhere). The details of the society's function and structure vary from one sector to the next. It is a particular section of the *kah* that wears the so-called Batcham mask in this region.

8 P. Harter, 1986, p. 250.

9 On certain occasions, the object was rubbed with magic ingredients and decorated with plants that are associated with *ke*.

10 P. Harter, 1986, p. 250.

11 The role played by the lizard, the chameleon and the crocodile as privileged mediators b etween humans and the invisible spirit world explains their frequent use by the Bamileke as symbolic message-bearing motifs, decorating objects employed in ritual ceremonies. According to the context, their powers can be evil or good. I should also note that in the representation of lizards and crocodiles, it is often difficult to identify them outside the context of the ritual objects they adorn.

12 This force is especially fertile. Amongst the Bamileke, an individual who has a bulging forehead is liable to engender twins later. The same force can also be evil, however, because certain infants who show an overly prominent forehead are, like certain twins, supposedly able to transform themselves into snakes after death. They can therefore pose a danger.

Fang sculpture

19th century
Gabon

Reliquary figure (eyima bieri)

Wood, palm oil
H. 39 cm
Formerly the Paul Guillaume Collection
Acquisition of the Musée des Arts Africains et Océaniens, 9 November 1965, Hôtel Drouot
Musée National des Arts d'Afrique et d'Océanie
Inv. MNAAN 65.9.1

Main Exhibitions
Paris, 1923-24; New York, 1933 (?);[16] Dakar and Paris, 1966;[17] Paris, 1972-73; Marseille, 1992; Paris, 1993-94a; Bordeaux, 1997-98.

Main Publications
W. Hausenstein, 1922, pl. 49; *L'Esprit nouveau*, 1924, pl. VII; H. Clouzot and A. Level, [1925], pl. XXV; P. Guillaume and T. Munro, 1929, fig. 30, *Ancienne Collection Paul Guillaume – Art nègre*, 1965, no. 155; P. Meauzé, 1967, p. 196, fig. 1; *Sculptures africaines dans les collections publiques françaises*, 1972, no 55, p. 47; L. Perrois, 1972, p. 302; *Musée des Arts africains et océaniens, Guide*, 1987, no. 65, p. 111; L. Perrois, 1992, pp. 210-11; *Les Arts à Paris chez P. Guillaume*, 1993, no. 25, p. 60; E. Féau and H. Joubert, 1996, p. 56; *L'Esprit de la forêt. Terres du Gabon*, 1997, no. 271, p. 204.

This Fang reliquary figure was acquired by Paul Guillaume (1891-1934) before 1922. After the merchants dealing in curiosities in the late 19th century, P. Guillaume was one of the first to specialise, around 1911, in the sale of African objects,[1] which he soon combined with the sale of works by his contemporaries. With its rounded, well-balanced shapes and dark glossy patina, this piece is a perfect example of P. Guillaume's tastes. He in turn quite clearly helped to forge the 1920s' taste for a type of African statuary that is now considered classic. This collector and dealer contributed to developing in the West a connoisseurship with respect to so-called primitive sculpture. He was also one of the first before 1920, along with Guillaume Apollinaire, who wished to see the "Negro arts" (at the time the expression referred to both African and Oceanic arts) accorded a place in the Louvre and thus win full recognition from the art establishment.

Amongst the Fang, reliquary figures included heads, complete figures (the most frequent form of sculpture), even busts. These objects were placed on a cylindrical bark vessel (*nsuk*, a bark barrel) containing the skulls of the ancestors of descent lines or extended families (*ndebot*) which these relics watched over. The entire piece was called *bieri* (a word also referring to the cult devoted to ancestor spirits), the sculpture presenting a figure called *eyima bieri*. The sculpture was situated at the front of the container, as if it were seated on the lip, or at the rear, the legs resting on the lid, and was held in place by a rod extending from, and vertical to, the spine in the case of sculptures representing a complete figure.

Relic guardians are not specific to the Fang of southern Cameroon, Equatorial Guinea or Gabon. To the north and northeast of these regions similar sculptures are found amongst peoples akin to the Fang belonging to the so-called Pahuin group such as the Bulu, the Beti (not the same as the Fang-Betsi) and the Ngumba ("including the Mabea"[2]). Other cultures to the south and southeast also possessed reliquary figures. This is the case of the Tsogo (they were the origin of the *bwiti* cult which the Fang borrowed in the mid-1920s, and also carved figures that are quite similar to Fang sculpture), the Mbede (whose figures integrate the reliquary vessel), the Kota, and in particular the Mahongwe, whose stylised copper-covered sculptures, despite their radically different manner, had a use similar to the Fang's.

Aesthetic, stylistic and functional interpretation

In 1966 one of the first texts on the vernacular aesthetic of an African culture was devoted to Fang society and statuary. Basing his work on his ethnographic studies carried out between 1958 and 1961, the North American anthropologist James W. Fernandez,[3] subsequently published numerous articles that are now fundamental to the understanding of Fang culture, the study of Fang sculptors and the complex artistic context linked to the migrations of this people, and more generally the stylistic and historical analysis of their carvings.

J.W. Fernandez demonstrated that the key to any aesthetic, stylistic and functional interpretation[4] of these figures lies in a system of oppositions of complementary values. For the Fang, the figures guarding their relics are believed to be both children and ancient human beings whose age is generally embodied in them. Many sculptures thus boast infantile features easily identified as such. Clearly visible here, the phenomenon is seen in the "protruding stomach", or the "umbilical rupture" (comparable to the hernia affecting newborns), stylised, often round eyes suggesting the "wide open glare of an infant", and the statues' proportions. Indeed the "large torso, the big head, and the flexed, disproportionately small legs are definitely

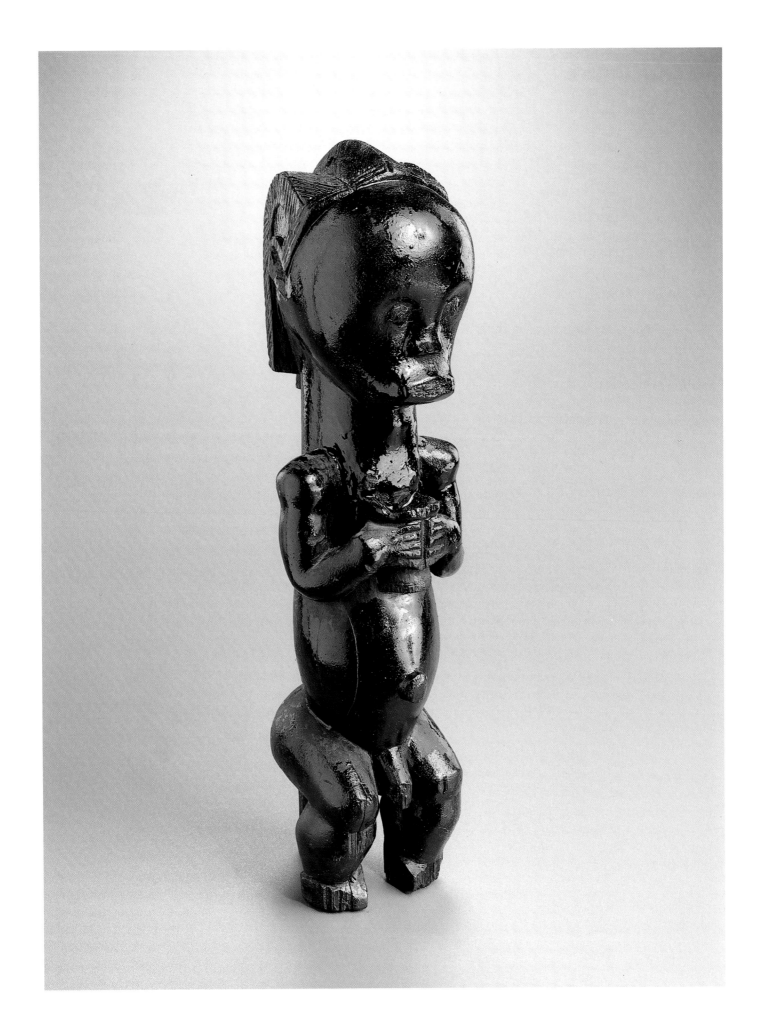

infantile in character".[5] In Fang thought, moreover, newborns are especially close to the ancestors, the infant gradually separating from the world of the elders and becoming an adult thanks to rituals (notably initiation rites) and the passage of time.[6]

The opposition between these two values (small child/ancient human being), while contradictory in Western thought, is in fact complementary for the Fang. This opposition[7] gives rise to the *raison d'être* of Fang sculpture, its "vitality". The term translates the word *eniñ*, which would be more accurately rendered by the expression "capacity to survive".[8] Thus, the two opposing elements are fused in a single value, a single specific concept; the notion of the ancestor cannot be simply reduced to that of an elderly human being.

This principle is part of a much larger context of complementary oppositions that exists throughout Fang society.[9] In the case of other figures, this principle can be expressed differently by associating, for example, an infant head with a muscular body and/or clearly delineated sexual traits.[10] What the Fang consider important is the effect of balance (*bibwe*[11]) that exists between opposite values, that is, the harmony of values and connotations expressed in volumes and shapes, in the aesthetic of the statues (the aesthetic, along with the iconography, forming the vectors of a piece's functional effectiveness).

Thus, the vitality of a figure cannot be reduced to its function as a protector of relics alone since, without its specific shapes, without the meanings attributed to those shapes by the Fang, without its particular aesthetic, the guardian statue has no singular identity that is its own and which enables it to best ensure its role as a sentinel and ancestral expression. Although modelled after the human form, these figures represent neither a precise person nor a particular ancestor; rather, they depict all the ancestors who are present in the reliquary.[12] A figure is thus the expression in a carved image of all these ancestors. The figure has its own identity (directly related to the socio-cultural and religious identity of the line of descent) that is founded on the relics contained in the receptacle. Conversely, the group of relics helps to legitimise the sociocultural and religious identity of the family conserving the relics. In turn the piece's vitality helps to lend the line of descent its identity through the relationship that exists between figure and relics; the figure stands as a

kind of expression identifying and summing up this lineage.[13]

According to Leon Siroto, the cup-bearing theme is a constant in Fang statuary amongst groups of central western and southwestern Equatorial Guinea and neighbouring Gabon; the theme "has been explained as either a warning gesture based on a poison ordeal or a supplication for some kinds of offerings".[14] Many Fang figures possess a dark patina that in some instances, here, continues to exude palm oil, giving the work a glossy aspect. This oil was used to protect the wood, both from the wood-eating insects that might attack it and, by hardening it, to make it better withstand the climate of the tropical forest. Like the round shining brass eyes of certain figures, the oil also made these statues visible in the semi-darkness, demonstrating their role as guardians in order to indicate the presence of the relics and to protect them. Considered extremely sacred, the relics were indeed only removed from their containers during *bieri* rituals and could only be viewed by the initiated. The oil was also supposed to clean and purify the figure in order to maintain its power to intercede with the preserved skulls and, by extension, with one's ancestors.[15] Like the iconography, the figure's aesthetic thus played an active part in its use, transmitting meanings that were indispensable to fulfilling its function successfully. This was the context in which sculptors exercised their craft, respecting the ritual and cultural imperatives of their society, and giving these concrete expression in their pieces, according to talents that ought to be judged in each artist's own terms. Here the sculptor of this *bieri* figure, while respecting the theme of childhood and great age that befits the notion of ancestors, succeeded in rendering this prescribed subject with outstanding ability. Above all, he was able to fashion a unique carved image within the strict constraints of the *bieri*'s functional and iconographic framework. This is the only example of his artistic identity. Indeed, only a few precious Fang sculptures revealing the same technique and skill have come down to us. Like the creator of this sculpture, acquired by P. Guillaume in the early years of the 20th century, most of these artists will remain anonymous forever.

VINCENT BOULORÉ
Translation: John O'Toole

1 J.-L. Paudrat, 1987, pp. 151-52.
2 L. Siroto, 1995, p. 16. According to Siroto, the origin, language and history of the Ngumba and Ngumba-Mabea are different from those of the Fang. Again according to Siroto, the style that is generally called Fang (which clearly includes the statue that once belonged to P. Guillaume) involves at least three other styles that can be attributed to peoples who are culturally distinct from the Fang: There is the style of the Ngumba, of certain populations of the Bube-Benga group along the coast, and of the northern populations akin to the Fang, although the last-named are different from the Fang (*ibid.*).
3 J.W. Fernandez, 1966 (this text – revised in 1971, the edition to which I refer here – was a lecture initially presented in 1963). Based on ethnographic studies, additional examinations of sub-Saharan aesthetics were published by R.F. Thompson (1971, 1973a, 1973b), and later S.M. Vogel (1977b, 1980). These investigations helped to create departments of African art history at universities in the United States.

AFRICA

4 Amongst the Fang, as in most traditional African societies, these areas closely overlap.
5 J.W. Fernandez, 1971, pp. 365-66.
6 Ibid.
7 Which also suggests for the Fang by analogy "pygmies, dwarfs, trolls – who combine in themselves the qualities of infancy and old age (a dwarf, for example, combines a child's body and an adult's head)", J.W. and R.L. Fernandez, 1975, p. 743. According to these two authors, the Fang's reliquary figures form "a 'little people' who mediate between the material and spiritual world" (ibid.).
8 J.W. Fernandez, 1971, p. 359 and p. 366. Fernandez adds that what is important here is "the fact that these contradictory qualities in the ancestor figure give it a vitality for the Fang that it would not possess if the eyima simply figures an aged person or an infant" (p. 366).

9 Spatial organisation, social structures, system of kinship (see J.W. Fernandez, 1977).
10 This is the case of one famous figure (Fang, 1991, pp. 158-59, and p. 161) that has been known since the 1930s as the "Pahuin Venus". The piece joins an adult male musculature to a female bust surmounted by an infant head.
11 J.W. Fernandez, 1971, pp. 362-63.
12 J.W. Fernandez, 1973, p. 205.
13 In Fang society, moreover, as in several other societies of equatorial Africa, the notion of the ancestor associated with relics that are linked to the specific identity of the group conserving them is part of a broader religious concept. According concept, in which the link with the afterlife, the invisible world, exists through ancestors, who act as mediators and as such intercede for humans in a number of rituals.
14 L. Siroto, 1995, p. 17.

15 J.W. Fernandez, 1981, p. 199.
16 This piece is mentionned in the catalogue African Negro Art (J.J. Sweeney, ed., 1935, no. 358, p. 46), although it probably was not featured in this exhibition, indeed, it is not reproduced by W. Evans [1936], who photographed the pieces that figured in the exhibition.
17 This work is mentionned in the catalogue L'Art nègre. Sources, évolution, expansion, 1966, no. 258, p. 93.

Fang sculpture

19th century
Gabon

Reliquary figure (eyima bieri)

Wood, brass, palm oil
H. 67 cm
Formerly the Alberto Magnelli Collection, Susi Magnelli donation, 1984
On loan from the Centre Georges Pompidou, Musée National d'Art Moderne, Centre de Création Industrielle
Inv. A.M. 1984.322

Main Exhibitions
Paris, 1984, 1995.

Main Publications
J. Kerchache, 1984, p. 8;
La Collection africaine d'Alberto Magnelli, Donation Susi Magnelli, 1995, p. 11.

This sculpture reflects the aesthetic, semantic and functional imperatives that are peculiar to bieri figures. Once the property of the painter Alberto Magnelli[1] (1888-1971), the piece is designed around three central elements in Fang art, viz., the delicately disproportionate volume of the head, the slight umbilical hernia and the strong musculature of the arms and legs (especially in the thighs), which lends the whole a singular, concentrated formal rhythm, reflecting both the inventiveness and dexterity of the statue's creator.

As in many decentralised sub-Saharan societies, Fang sculptors were not considered professional artists.[2] They would not work on their pieces continuously, but rather proceeded slowly, when their other activities (farming, voyages during which they were visiting their parents and so on) allowed them to take up their tools.[3] In such conditions, producing a piece of sculpture was a project lasting several months.[4] If in Fang society this

highly specialised activity apparently commanded no particular prestige, certain men would nevertheless spend a considerable amount of time working wood, developing a peerless mastery that was recognized in and closely associated with the quality of these pieces.[5] Thus, amongst the Fang, aesthetic concerns were always taken into account in sculpture; certain statues were preferred to others, and these choices implied the existence of a genuine art criticism. Accomplished sculptors were therefore widely known and enjoyed a great reputation.[6]

When a new lineage (ndebot) was created (springing from the division of an earlier one[7]), a new relic container (conserving elements borrowed in part from the original mother bieri) would be fashioned and a new piece of sculpture carved to "defend" the reliquary (aba'ale nsuk[8]).

There was but one talented sculptor for 30 to 40 villages. Each lineage (ndebot) had a reliquary,

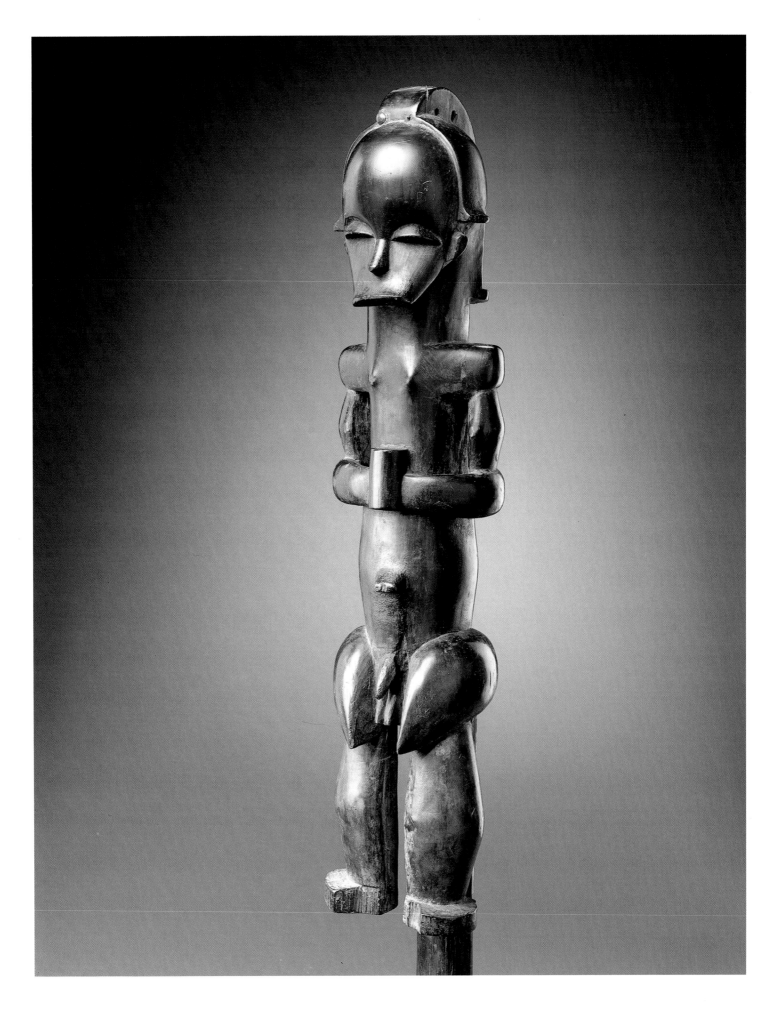

each village comprising on average two *ndebot*, or around one hundred people (50 per *ndebot*). Since the Fang population numbered around two hundred thousand people (a figure that J.W. and R.L. Fernandez considered a stable one for some two hundred years[9]), the Fang produced, up to the 1950s,[10] four thousand quality figures, about a thousand of which are now part of Western collections.[11]

It is difficult nowadays to establish reliable attributions of Fang sculptures. Indeed, figures sharing the same individual style are extremely rare. Moreover, if the names of the creators of these pieces were in fact known in their lifetimes, and their talent as sculptors recognised and identified as such, the names were often forgotten over the years. When a certain figure was used repeatedly on relic containers for several generations, it lost its specific attribution and became anonymous, "like the skulls in the reliquary".[12]

In such contexts, and given the absence of any documentation touching on Fang sculptors, the only tangible trace of their identity today remains their work. This artistic identity is all the more vivid and present to us in so far as the form embodying this identity offers, like the piece that once belonged to A. Magnelli, a virtuoso sculptural composition. The result of a culture that appreciated it on its own specific terms, such skilful aesthetic design, such mastery of the medium by the Fang has also found favour in the West since the early years of the 20th century and is now welcomed into the precincts of our museums. The mere presence of these sculptures there places this design in the universal, timeless world of art.

VINCENT BOULORÉ
Translation: John O'Toole

1 This piece may have been acquired from three specialised dealers, René Rasmussen, Olivier Le Corneur and Jean Roudillon, whom A. Magnelli met shortly before 1950 (J.-P. Ameline, 1995, p. 6). In 1913 A. Magnelli bought his first piece of African art (a Punu mask from Gabon) in Marseille (F. Marin, 1989, p. 164). Except for another Fang statue that was part of the 1967 exhibition *Arts primitfs dans les ateliers d'artistes* at the Musée de l'Homme (no. 59), the following Fang objects figured in A. Magnelli's collection: a figure (*ibid.*, p. 17) and two harps (respectively in *ibid.*, p. 19 and *Christie's*, 22 November 1996, p. 31). The exhibition *Les Arts africains* mounted at the Cercle Volney in 1955 featured two Fang figures that belonged to A. Magnelli (*Les Arts africains*, 1955, nos. 235 and 245); a statue whose size corresponds to the piece now on display at the Louvre is also mentioned in the catalogue (*ibid.*, no. 242, p. 142: "Collection P.-S. Vérité").
2 L. Perrois, 1972, p. 142; J.W. and R.L. Fernandez, 1975, p. 724.
3 Their styles could display moreover distinct variations for one and the same sculptor, particularly in the proportions of the various parts of a figure's body (J.W. and R.L. Fernandez, 1975, pp. 734-35.).
4 J.W. Fernandez, 1973, p. 200.
5 *Ibid.*
6 *Ibid.*, p. 199.
7 The divisions were the result of existing scissions in a single village "between two extended families (*ndebot*) who were no longer able to live together as one *mvogabot* – 'village of people'" (*ibid.*, p. 219). In the early years of colonisation (late 19th-early 20th century), the division of lineages began to accelerate, giving rise to a well-known increase in the demand for new sculptures (*ibid.*, p. 219), which were hastily executed by inexperienced sculptors and proved to be of little aesthetic worth.
8 *Ibid.*, p. 199.
9 Taking one generation to equal 25 years and bearing in mind that nothing seems to indicate that any extant figure dates from before 1750 (J.W. and R.L. Fernandez, 1975, pp. 724-25).
10 During which various movements against witchcraft and sorcery led many to abandon a great number of reliquary figures.
11 J.W. and R.L. Fernandez, 1975, pp. 724-25.
12 *Ibid.*, p. 725. This phenomenon, the loss of the sculptor's and the relics'identity, can be compared with the circumstances that surrounded Christian relics and decorated reliquaries. A number of medieval reliquary figures were indeed executed by artists whose names were often forgotten in the years following the period when they were active and well known to their contemporaries. In no way did this disturb the use of these pieces, in some instances into the 19th century (after which they were placed in museums and church treasuries). Christian relics, moreover, are explicitly attributed to a specific male or female saint, although it is almost never clear whether they really did come from the venerated saint. From the religious point of view, it is thus the identity attributed to the relic and its reliquary by the faithful that is important, not the real identity of these things.

Fang sculpture

19th century
Northeastern Equatorial Guinea, southern Cameroon or northern Gabon

Reliquary figure (*eyima bieri*)

Wood (*Alstonia congensis*, Apocynaceae)
H. 56 cm
Collected in 1905-06 by the Cottes Mission in southern Cameroon
Gift of Captain A. Cottes to the Musée d'Ethnographie du Trocadéro, 1908; formerly M.E.T.: 64 026[1]
On permanent loan from the Musée National d'Histoire Naturelle - Musée de l'Homme
M.H. 08.9.1

Main Exhibitions
Paris, 1965; Cologne, 1990;
The Hague, 1990-91; Marseille,
1992; Bordeaux, 1997-98.

Main Publications
*La Mission Cottes au Sud-
Cameroun (1905-08)*, 1911,
pl. XXXII; A. Basler, 1929,
fig. 43b; M. Griaule, 1947,
fig. 29, p. 39; W. Schmalenbach,
1953, fig 79, p. 85;
W. Muensterberger, 1955,
no. 27; *Chefs-d'œuvre du musée
de l'Homme*, 1965, no. 22. p. 83;
A. Terrisse, 1965, fig. 126,
p. 108; L. Perrois, 1972, p. 66;
J. Kerchache, J.-L. Paudrat
and L. Stéphan, 1988,
no. 568, p. 422; *Afrikanische
Skulptur: Die Erfindung der Figur
– African Sculpture: The Invention
of the Figure*, 1990, no. 67,
p. 160; *Fang*, 1991, p. 149;
L. Perrois, 1992,
pp. 130-31; *L'Esprit de la forêt.
Terres du Gabon*, 1997,
no. 270, p. 203.

*"My fathers have been Ntumu, my children, born here,
will be Mvai."*[2]

This piece was collected by Captain Cottes's mission in southern Cameroon (September 1905-January 1907),[3] when the region included part of present-day Gabon.[4] In the oldest reproductions and those up to 1929, the piece retained the vertical rod extending from the body (measuring 25 cm according to Dr Poutrin, who wrote the commentary on the objects brought back by the Cottes Mission[5]) with which it could be fixed to its bark reliquary-container. From 1947 the rod no longer appears in publications; study of the object shows that this rod must have been broken earlier. In marked contrast with the statue's face, which was probably preserved thanks to the oil repeatedly poured on it, the high degree of decomposition in the wood (clearly visible in the first publication of the object in 1911) surely indicates that the piece had already fallen out of use at the time of its collection.

The exact location of the piece's find site, the precise date of its collection, and the origin of the Fang group that once owned it are difficult to determine today. According to Dr Poutrin, all the objects collected by the Cottes Mission, with one exception,[6] came from "Pahuin Dzem and Fong tribes".[7] In the zone covered by the astronomical and topographical operations of the Cottes Mission, the "Dzem"[8] occupy a sector located around the borders of southern Cameroon, Gabon and Congo.[9] It is likely that the majority of the ethnographic objects were collected by the "main body" of the mission.[10] This piece of sculpture could therefore have been collected between northeastern Equatorial Guinea and the eastern limits of the Ivindo River. On the map published by G. Tessmann in 1913, these regions are called "Ntum" to the west and "Mvai" to the east.[11]

Stylistic and historical context, Fang migrations and seminomadism

Louis Perrois initially conducted a morphological study of 272 pieces attributed to the Fang. In 1972 the specialist proposed dividing reliquary figures into two major stylistic centres, one in the north and made up of statues having an elongated body ("longiform"); the other in the south, characterised by so-called "breviform" carvings. According to Perrois, the Fang developed these two main trends into a number of ethnic or tribal substyles (Ntumu, Mvai, Okak and so on[12]).

J.W. and R.L. Fernandez criticised this stylistic division, estimating the number of quality statues carved by the Fang over the years at four thousand.[13] In 1975 they proposed another way of categorising Fang styles, an interpretation based upon Fang population shifts. Indeed, until World War II, the Fang were constantly on the move, which renders attribution by localised ethnic substyles quite difficult, all the more so since the number of Fang pieces (mostly collected before the 1920s and the 1930s) that are now represented in the collections and documented in a reliable way are far fewer than the wealth of sculptures that have come down to us without the least scrap of ethnographic information.

According to the hypothesis proposed by J.W. and R.L. Fernandez, "there has been a dynamic diffusion process in Fang art more properly approached by something like an age-area explanation rather than from the perspective of tribal or subtribal style identifications".[14] This way of understanding Fang styles goes hand in hand with Fang migration patterns; rather than a number of shifts of entire Fang subgroups, movement involved partial migrations "in a 'saute-mouton' fashion",[15] or leapfrog movement. Villages and lineages (one village comprised two lineages, that is, a maximum of two hundred people) would have moved past one another down river and south/southwestward, progressing at a rate estimated at 10 kilometres per year at the end of the 19th century.[16] Along with the

practice of exogamy, [17] this displacement produced numerous interpenetrations amongst Fang groups. More generally, the sociopolitical structure of the Fang (living in village communities of quite limited numbers of inhabitants) was adapted to a state of seminomadism. [18]

J.W. and R.L. Fernandez posit a migration of proto-Fang from the grasslands region to the equatorial forest of Cameroon around the late 16th or early 17th century (this migration continuing along a northeast-southwest axis, as far as the shores of the Atlantic – reached in the late 19th century – and the Ogowe, the furthest point of migration to the south). These proto-Fang already recognised certain distinctions amongst themselves by subgroups such as the Mvai, the Betsi, the Mekeny Make and the Ntumu, although the borders between these subgroups remain highly permeable. [19] The Betsi and the Mekeny were at the forefront of this movement; the Okak and the Mvai were far fewer than the Ntumu, who made up the most important and the most stable group, at the rear. [20]

The Fang probably learned to fashion their bark reliquaries through contact with the Baka Pygmys of southern Cameroon, [21] and it is certainly during their migration that they developed their system of portable altars consisting of a bark barrel surmounted by a sculpture. [22]

During these migrations there occurred many interpenetrations between Fang groups through "leapfrogging", while several of the groups kept their clan name even when settling near or in the midst of other clans. For example, the Ntumu who were part of a certain clan would settle amongst the Betsi or the Make while retaining their initial clan name. In this way the same clan names can be found amongst different subgroups. [23] Furthermore, certain clans that are present in a single subgroup recognise their ties with other clans in other subgroups, which indicates that they spring in fact from the same main clan. [24] This brought about a process of division that, according to J.W. and R.L. Fernandez, gave birth to the Okak and Mvai in the 19th century and the early period of colonialisation (when the Fang were drawn to the trade with the colonial authorities along the coast). Later, following colonial stabilisation, there was a countermovement back to the north and an inverse process took place with the Okak and the Mvai now becoming Ntumu. [25] Western colonisation, moreover, encouraged sedentarisation, leading to a stabilisation of a Fang entity broken down by ethnic territorial subgroups.

Thus, Fang carvers worked and sculpture styles developed, [26] especially the styles of the Ntumu and the Mvai, within the infinitely complex geohistorical context of Fang seminomadism. In J.W. and R.L. Fernandez's interpretation, Ntumuland is the centre of creative activity in Fang sculpture, the place to which one can trace the origin of most styles and their diversification, even if Ntumuland

is in reality a "shifting locus". [27] In this respect, "'classic' Fang sculpture could be, in chronological terms [and not strictly territorial ones], Ntumu, or even Mvai"; [28] moreover, the permeability between different ethnic subgroups played an important role. These authors add that all or part of a village would move, often ten or even hundreds of kilometres, to join people of the same clan or parent clan in a region occupied by a subethnic group other than their own. In the course of such migrations, the group would bring with them their reliquary figures (heads or complete figures). [29]

Several Fang sculptures present a number of stylistic points in common (especially concerning the face) with the piece collected by the Cottes Mission. [30] These works also display a comparable treatment of the trunk and upright back with overhanging buttocks. Short legs, bent as if in a seated position, extend the buttocks' overhanging ridge towards the front of these same statues.

While all these statues were collected in regions dominated by the presence of the Ntumu and the Mvai at the dawn of the 20th century, there is no evidence to assert without hesitation that they were indeed executed by Ntumu or Mvai sculptors, or even kept in the possession of Ntumu or Mvai clans (bearing in mind that subethnic entities, as is clear by now, were never very important to the Fang).

Iconography

The headdress, hanging down in a helmetlike mass at the rear, bears a pair of crests at the top of the head. The Fang sported this type of hairstyle by creating deft arrangements of their long hair or by fashioning false headdresses. [31] Along with scarifications (represented here by a series of small incised points on the forehead [32]), these headdresses (often richly decorated with pearls) adorned both adult men and women. [33] The connotations of these disparate elements are apparently part of the network of complementary oppositions at work in reliquary statues, between infantile features (especially in the face of sculptures) and those that are characteristic of adults. While helmet headdresses are frequent in Fang sculpture, the presence of a "flute" is a less common iconographic detail. The instrument may be related to the sound of flutes that once accompanied ceremonies during which skulls were removed from their containers. [34] On the upper biceps the statue boasts a bracelet, an ornament found on other sculptures that was also worn by both men and women. [35] Finally, the figure displayed clearer traces of red at the start of the 20th century. [36] These were the remains of a powder that was also used to anoint skulls.

This piece probably originates from northeastern Equatorial Guinea or the region that has since become the border between Cameroon and Gabon. It

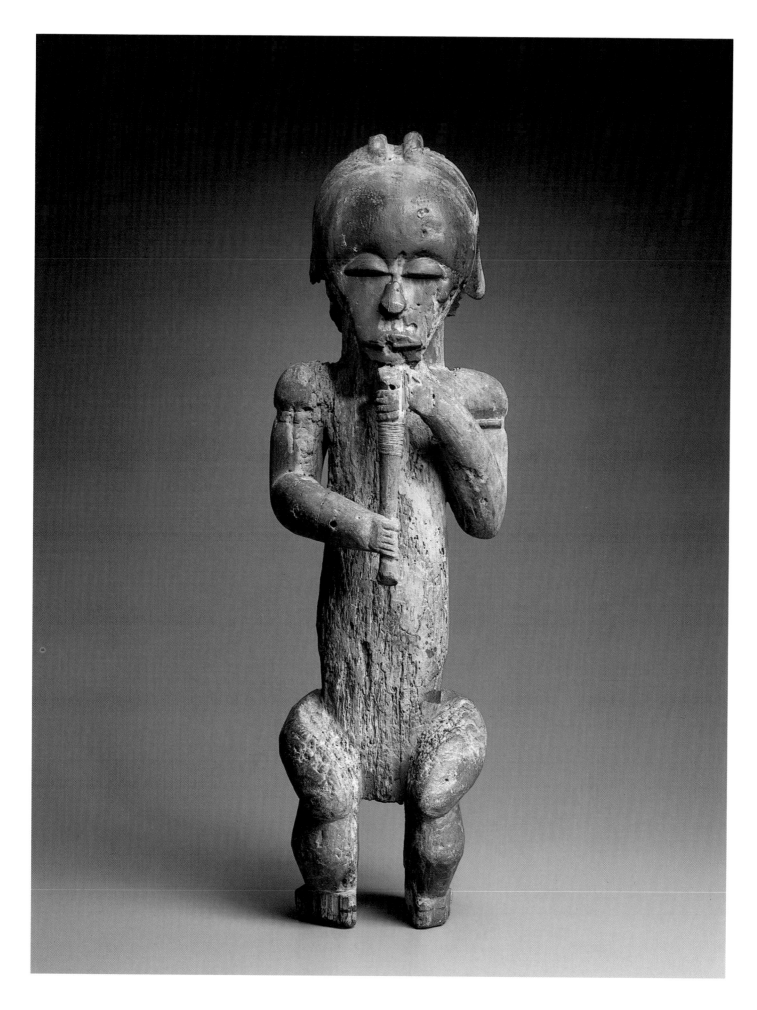

is part of a complex network in which multiple migrations and interpenetrations between groups and clans gave rise to constant internal reconfigurations. It was in this context then, one that is rather incompatible with the notion of a stylistic centre applied to a localised stable subgroup, that the sculptor of this "flutist" lived and worked. It was in the same context of course that his statue, one of the most striking that Fang culture has left us, was passed from keeper to keeper before being collected by one of the members of the Cottes Mission.

<div align="right">

VINCENT BOULORÉ
Translation: John O'Toole

</div>

1 This number corresponds to an attributed registry entry in the *Inventaire des collections du musée d'Ethnographie du Trocadéro* (cat. 26), "12 March 28". This date is preceded by the indication "1908", which also figures (along with the number 64026) on the object itself (left lateral section of the headdress). The date "12 March 28" quite probably indicates that this object, after being reproduced and analysed in *La Mission Cottes au Sud-Cameroun (1905-08)*, 1911 (see *infra*), was replaced in a box until 1928.

2 J.W. and R.L. Fernandez, 1975, p. 739.

3 Despite the year 1908 indicated in the title of the report touching on the Cottes Mission – *La Mission Cottes au Sud-Cameroun (1905-08)*, 1911 – the mission actually ended in January 1907 (see *ibid.*, p. IV and map 1).

4 Besides the collection (inv. 08.9) to which this figure belongs, the Musée de l'Homme possesses another donation made by Captain Cottes, registered in 1906 (inv. 06. 23) which includes in particular a mask (inv. M.H. 06.23.9, formerly M.E.T. 58350) from "Southern Cameroon D'Zem" (*Inventaire des collections du musée d'Ethnographie du Trocadéro*, cat. 25). This mask is doubtless the piece reproduced in *La Mission Cottes au Sud-Cameroun (1905-08)*, 1911, pl. XXXIII (above left).

5 *La Mission Cottes au Sud-Cameroun (1905-08)*, 1911, p. 195; Dr Poutrin declares moreover (*ibid.*, p. 194) that the figure "represents a man whose genital organs have been destroyed and now only form a slight projection". Working for the Muséum d'Histoire Naturelle, Dr Poutrin did not take part in the Cottes Mission (see *ibid.*, p. XIII).

6 "A fire lighter that is in use amongst the Ba-Binga" (*ibid.*, p. 192).

7 *Ibid.* Mentioned by G. Tessmann (see P. Laburthe-Tolra, 1991, p. 39), the Fong are also referred to by H. Trilles, 1912 (quoted by P. Alexandre, 1965, p. 507, although Alexandre believes that the Fong spoken of by H. Trilles in northern Gabon are Ntumu).

8 *La Mission Cottes au Sud-Cameroun (1905-08)*, 1911, map I.

9 A. Cottes also personally reconnoitred southern Equatorial Guinea, exploring the western part of this region. He passed a second time by way of the south from Libreville, then rounded Equatorial Guinea from the east. Other members of the mission followed different routes (notably Vervoni and Girant), delineating the future border between Gabon and French Congo (*ibid.*).

10 *Ibid.* The main body of the mission moved much slower and had greater means at its disposal to collect objects (including numerous natural history specimens).

11 See G. Tessmann, 1913, vol. I, map located before p. 1. After a number of sojourns between 1904 and 1907, G. Tessmann carried out his main expedition amongst the Pahuin between 1907 and 1909 (see P. Laburthe-Tolra, 1991, p. 27-30). J.W. and R.L. Fernandez, 1975, fig. 4, also point out the presence of Mvai in northeastern Equatorial Guinea.

12 See L. Perrois, especially 1972, 1979 and 1992. According to Perrois, reliquary heads were carved in particular by the Betsi subgroup or in northern Gabon. Although Perrois has maintained until the present that there were two main stylistic centres amongst the Fang, he has slightly modified the theory in a number of particulars (see L. Perrois, 1991, p. 16-17).

13 J.W. and R.L. Fernandez, 1975, p. 725.

14 *Ibid.*, p. 738.

15 *Ibid.*, borrowing an expression used by P. Alexandre, 1965, p. 532. I should mention in passing that the process described by the Fernandezes agrees in part with P. Alexandre's comments on the mechanisms of migration (1965, pp. 531-38).

16 P. Alexandre, 1965, p. 504.

17 J.W. and R.L. Fernandez, 1975, p. 738. The authors point out that the search for a wife often involved going far beyond the limits of a man's own ethnic subgroup.

18 *Ibid.*, referring to P. Alexandre, 1965, p. 521.

19 J.W. and R.L. Fernandez, 1975, pp. 738-39. The term "proto-Fang" implicitly excludes the other so-called Pahuin groups (Bulu and Beti – the latter include, according to L. Siroto, 1977, p. 39, the Ewondo), who are clearly distinct from the Fang and now live north of the Fang in Cameroon.

20 J.W. and R.L. Fernandez, 1975, pp. 738-39.

21 The Pygmys possess bark buckets with lids which they use to collect honey (S. Bahuchet, 1985, fig. 59, p. 218). These are very similar to Fang relic containers (see B. de Grunne, 1994a, p. 54).

22 B. de Grunne, 1994a, p. 54.

23 J.W. and R.L. Fernandez, 1975, p. 739.

24 *Ibid.* The authors add that "this recognition served to guarantee hospitality for a village or extended family which struck out to migrate into the area of another subtribe or into another part of the sparsely inhabited forest".

25 *Ibid.*

26 J.W. and R.L. Fernandez offer numerous examples of sculptors whose genealogies are made up of individuals of different subgroups and who work in styles that fall outside all categorisation by stylistic or ethnic substylistic centres (see *ibid.*, pp. 734-37). B. de Grunne (1994a, p. 54) sees a certain link between a number of phenomena here: on the one hand, the extreme diversity of Fang styles (which de Grunne suggests could be "the essential characteristic of Fang sculpture", *ibid.*, p. 53) and the Fang's ability to move about; and, on the other, several elements of Pygmy culture, especially their aptitude to pass from one language to another, change a style, or interrupt a motif (in their bark paintings and especially their polyphonic vocal music which employs yodelling), *ibid.*, p. 54, referring to R.F. Thompson, 1983.

27 J.W. and R.L. Fernandez, 1975, p. 741.

28 *Ibid.*

29 *Ibid.*, pp. 741-42.

30 See *Fang*, 1991, p. 148; L. Perrois, 1992, p. 215; *Fang*, 1991, p. 151; L. Perrois, 1992, p. 213.

31 See G. Tessmann, 1913, in *Fang*, 1991, p. 178, pp. 193-95, pp. 189-90.

32 Corresponding to the bow motif described by G. Tessmann in 1913 (see *Fang*, 1991, p. 224) which figures also in tattoos (*ibid.*, p. 228).

33 G. Tessmann, 1913, pointing out (*ibid.*, p. 189) that the heads of young children were completely shaved except for the occasional tuft or calotte of hair.

34 G. Tessmann, 1913, in *Fang*, 1991, p. 287. For L. Perrois (1997, p. 203), this would more accurately be described as a "long whistle (*ekyema*), a ritual instrument that allows one to communicate with spirits and drive away evil influences".

35 See *Fang*, 1991, p. 148 and p. 191.

36 See *La Mission Cottes au Sud-Cameroun (1905-08)*, 1911, p. 194.

Fang sculpture

Mid-19th century
Equatorial Guinea or Gabon

Reliquary figure (eyima bieri)

Wood, pearls, seeds
H. 60 cm
Collected before 1898
Purchase of the Musée d'Ethnographie du Trocadéro, 1898; formerly M.E.T.: 45477
On permanent loan from the Muséum National d'Histoire Naturelle – Musée de l'Homme
M. H. 98.1.1

Main Exhibitions
Paris, 1972-73, 1979; New York, 1984-85a; Cologne, 1990; The Hague, 1990-91; Paris, 1991-92; Bordeaux, 1997-98.

Main Publications
V. Markov, 1919, p. 99, p. 101 and p. 103, nos. 62-67; G.-H. Luquet, 1933, p. 419; E. Von Sydow, 1954, pl. 53B and 56B (detail); *Sculptures africaines dans les collections publiques françaises*, 1972, no. 299, p. 111; L. Perrois, 1972, p. 282; *Rites de la mort*, 1979, p. 49; L. Perrois, 1979, fig. 70; J.-L. Paudrat, 1987, p. 150 (reprint of the photographs published by V. Markov, 1919); S.M. Vogel and F. N'Diaye, 1985, no. 57, p. 40 and p. 144; *Afrikanische Skulptur: Die Erfindung der Figur – African Sculpture: The Invention of the Figure*, 1990, no. 63, p. 157; *Fang*, 1991, p. 154, p. 155 and p. 156; E. Féau and H. Joubert, 1996, p. 58; *L'Esprit de la forêt. Terres du Gabon*, 1997, no. 277, p. 206.

Purchased in early 1898 along with another sculpture ("a figure decorated with nails"[1]) by the Musée d'Ethnographie du Trocadéro from an unidentified seller, this piece was photographed in the museum by Vladimir Markov during the summer of 1913 and subsequently published for the first time in 1919 in a posthumous work by Markov.[2] As with most Fang pieces, the collection site is unknown. The object acquired at the same time as this piece figures in the registry of the Musée d'Ethnographie du Trocadéro with the notation "Southern Riv.", following the caption "Loango" (southwestern region of the present-day Republic of the Congo, formerly French Congo); it is the only indication that exists. The date mentioned is "12 January 98".[3]

Taking up the hypothesis proposed by G. Tessmann in 1913, J.W. Fernandez argues that sculptures placed on reliquaries amongst the Fang consisted of heads alone at first.[4] Together with the bark container, they formed a whole regulated by a dynamic system of oppositions between the recipient (nsuk, which the Fang assimilated with the belly or torso of the whole) and the carved head.[5] Through a phenomenon of transference, this opposition gradually shifted to sculpture alone, leading to the creation of complete figures.[6] This evolution also reflects, it would seem, the seminomadic lifestyle of the Fang since heads and small figures would have been easier to carry during periods of migration.

The obvious autonomy of the sculptures in relation to the bark containers is especially manifest in this figure, although it does include a rod that allowed it to be fixed to a reliquary. Carved figures could also be displayed independently during certain rituals when the skulls were removed from their container and the figures were shown behind a fibre curtain.[7] Later, certain sculptures were even made a part of the Bwiti cult and were carried like children.[8]

Clearly captured by V. Markov in his photographs,[9] the deft composition of the sculpture's volumes evinces the piece's independence with respect to the container it once adorned. Underscoring the large "infantile" head, a recurrent theme in Fang statuary, this sculpture was indeed modelled like a wholly independent figure. The eyes are made up of three blue pearls set into a kind of tar, a rare detail. Tar also highlights the mouth which thus seems like overmodelling. The headdress shows a kind of orifice at the top which apparently allowed one to fix feathers there; it is drawn back to the rear of the head following a movement that corresponds to the face's profile. The muscular arms with their joined hands come to a point along a perpendicular line directly below the figure's chin, mirroring the position of the statue's thighs (which extend the slight protruding ridge of the buttocks) and solidly modelled calves.

Should we associate this formal organisation with the fact that this piece is less easily transportable than others (the forearms, for example, detached from the body, are more fragile than if they were carved closer to the torso, as in a large number of Fang sculptures), and therefore that the statue has come down to us from a sedentarised group (bearing in mind that in the late 19th century the Fang clans that had halted their migrations were those that had reached the coast)?

Despite their different styles, the pieces fashioned by coastal peoples or those near the sea (the Benga of Equatorial Guinea, the Mabea of Cameroon[10]) use woods, like the figure photographed by V. Markov, that have light brown patinas free of any oils.[11] Moreover, when this statue was collected, the exchanges between the Fang and Europeans taking place near the coast probably implied a greater presence of such articles as pearls than in transactions occurring inland.

Pearl and seed necklaces (already present when the piece was registered at the Musée d'Ethnographie du Trocadéro) can be compared with pearls used to decorate Fang hairstyles and helmet-headdresses (some of which hang down in strings,[12] as here). Photographs published by G. Tessmann[13] also show figures with pearl necklace decorations. This is the case of a statue in the Dahlem Museum, Berlin, collected in 1897.[14] Yet no known piece

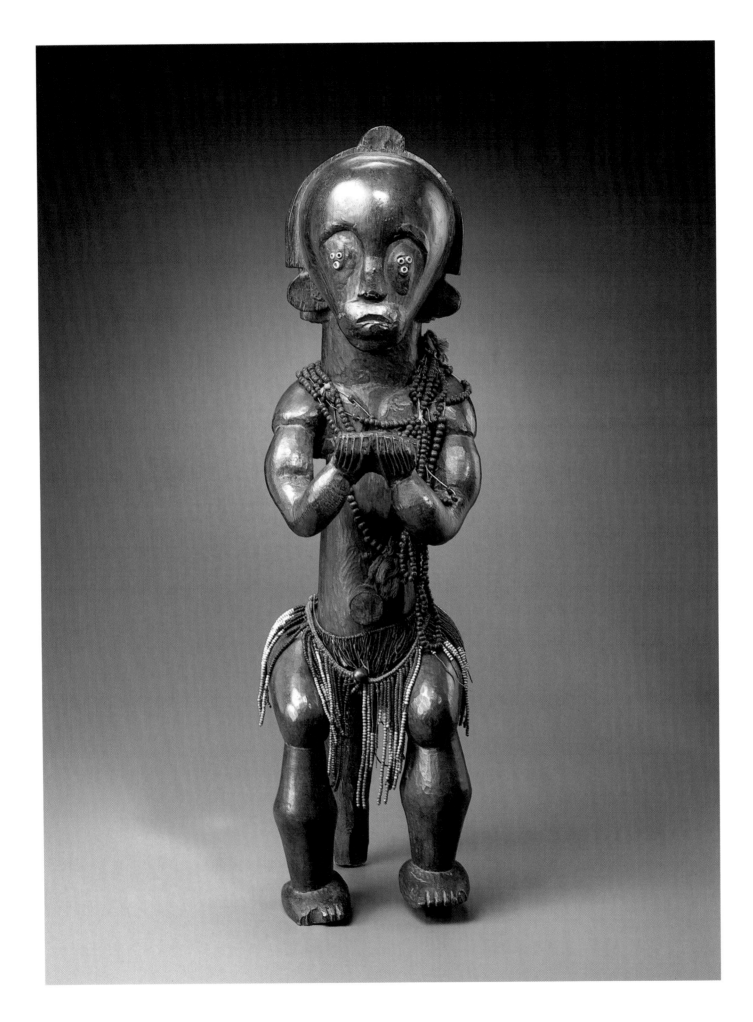

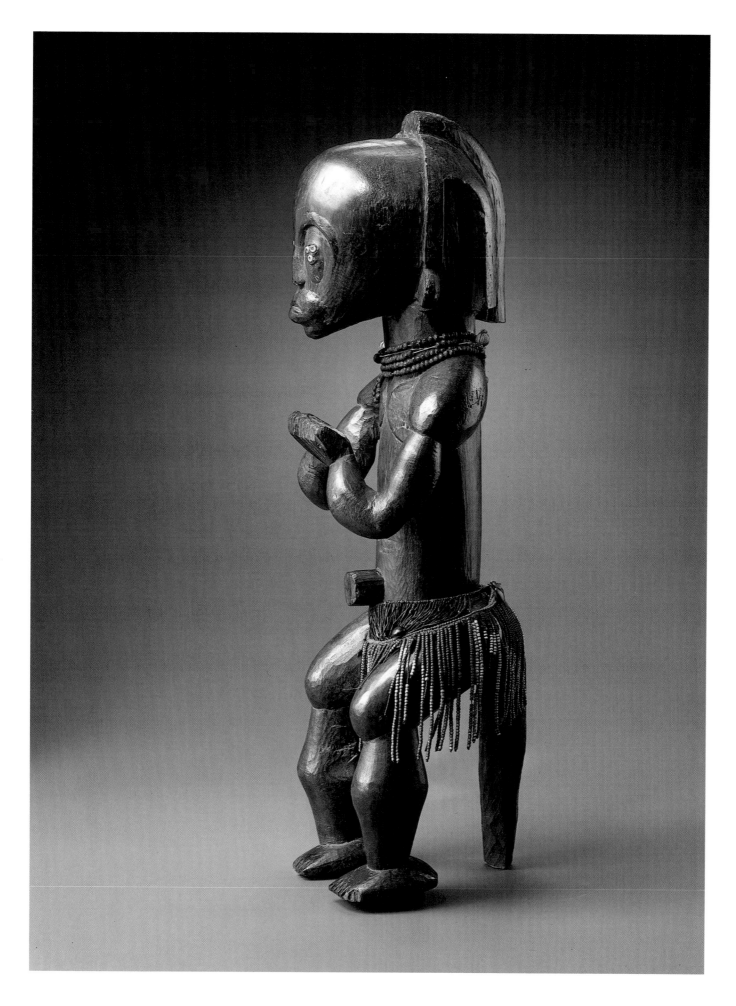

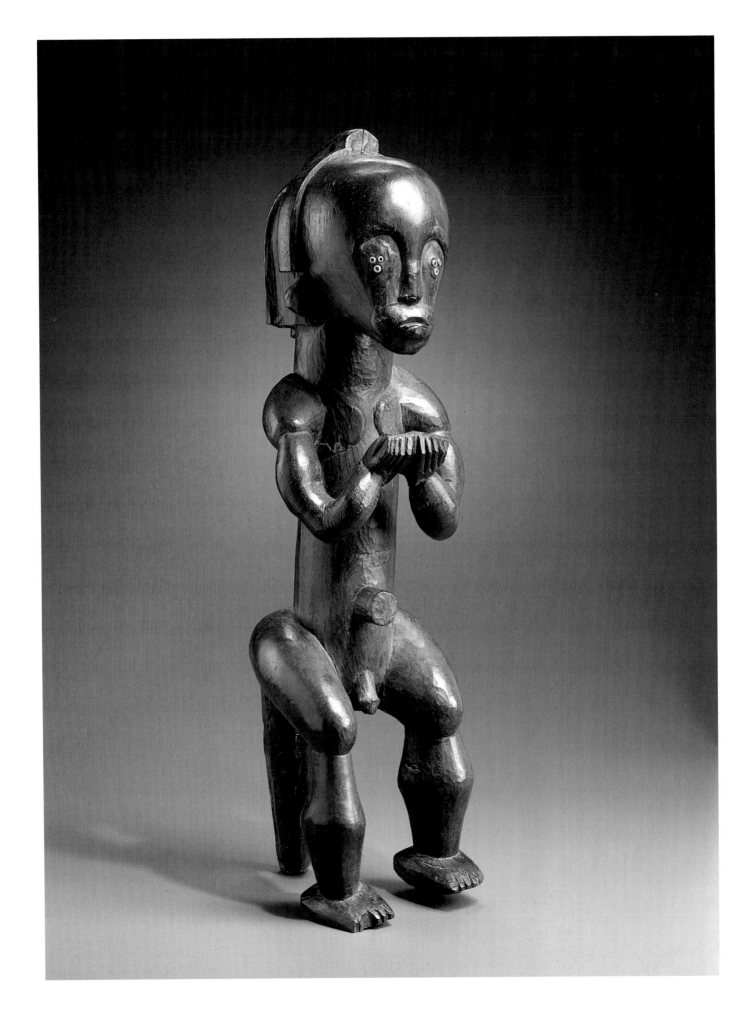

boasts such a wealth of necklaces. It is not impossible that some of these were added after the piece was collected in order to conceal the statue's genitalia in keeping with a widespread practice of the late 19th century. The belts of pearls thus hide the sculptor's arrangement of volumes between the trunk, the buttocks and the thighs.[15] Yet along with the highly refined movement imparted to the arms, which offers a stark contrast with the massive aspect of the head and neck, this arrangement forms one of the most striking features of a sculpture whose style remains absolutely unique in the art of the Fang.

<div align="right">

VINCENT BOULORÉ

Translation: John O'Toole

</div>

1 *Inventaire des collections du musée d'Ethnographie du Trocadéro*, cat. 21, no. 45 476 (M.H. 98.1.2). This object is reproduced in M. de Zayas, 1916, ill. 25 (personal com. J.-L. Paudrat, February 1999).
2 J.-L. Paudrat, 1987, p. 148.
3 *Inventaire des collections du musée d'Ethnographie du Trocadéro*, cat. 21.
4 According to G. Tessmann, "the 'most modern of forms', as the Pahuin say, is the independent wooden statue separated from the cask; generally it is carved larger (up to one metre high) [...]" (G. Tessmann, 1913, in *Fang*, 1991, pp. 285-86).
5 J.W. Fernandez, 1971, p. 361, points out that for the Fang, "The stomach, thorax, and sometimes viscera [...] are the centers of power and thought while the head is simply the organ of apprehension and direction enabling what fundamentally belongs to the torso willfully to be put to use. The Fang entertain a lively sense of opposition between the head and the torso that might be summed up appropriately in our aphorism 'your eyes are bigger than your stomach'.

The hope for the Fang is that the head and the stomach should work together in complementary fashion [...] The original reliquary (*bieri*) was conceived as a head (the carving) and a stomach (the bark barrel). These two elements had a relationship of complementary opposition. They worked together to accomplish the vital purposes of the cult though they were really in some sense opposing entities."
6 *Ibid.* See also J.W. and R.L. Fernandez, 1975, p. 740. In the context of Fang migrations then, there was certainly an overall evolution (with persistence of the original forms) from heads alone (practically all of these having been collected before World War I; see S.M. Vogel, 1985, p. 148) towards full figures by way of intermediary forms like half figures (these emerge from the rod/neck that allowed the head to be fixed to the bark container).
7 G. Tessmann, 1913, in *Fang*, 1991, pp. 286-87; see also photographs of this ritual in *ibid.*, ill. 43, p. 285, and ill. 47, p. 287.
8 See J. Kerchache, J.-L. Paudrat, L. Stéphan, 1988, fig. 975, p. 558.

9 See J.-L. Paudrat, 1987, p. 150.
10 See respectively *Fang*, 1991, p. 132 and p. 129 (this piece was reproduced in C. Einstein, 1915). I should also point out that at the end of the 19th century the British dealer W.D. Webster was offering pieces in his catalogue (these statues had no rods for attaching them to reliquaries) that were carved in a style comparable to what one sees in the statues mentioned above (W.D. Webster, no. 22, October 1899, nos. 49, 50, 52, 53).
11 This type of light patina may be a sign of ritual practices that differed from those in use amongst the Fang groups inhabiting the inland areas of Gabon, where figures with dark oily patinas seem to have predominated.
12 See *Fang*, 1991, pp. 66-7, pp. 194-95.
13 *Ibid.*, p. 286.
14 *Fang*, 1991, p. 54.
15 V. Markov clearly understood the artist's intentions, moreover. Before shooting his photographs, Markov took care to part these strings of pearls so he could better capture the volumes' arrangement (see J.-L. Paudrat, 1987, p. 150).

Fang sculpture

19th century
Gabon

Ngil mask (?)

Wood (*Ricinodendron heudelotii*, Euphorbiaceae), kaolin, brass
H. 66 cm
Formerly the André Lefèvre Collection
Purchase of the Musée de l'Homme, 1965
On permanent loan from the Muséum National d'Histoire Naturelle – Musée de l'Homme
Inv. M.H. 65.104

Main Exhibitions
Paris, 1972-73; Saint Paul, 1973;[18] Paris, 1979;[19] New York, 1984-85b; Washington, 1987-88; Washington, 1987-88; Florence, 1989; Paris, 1991-92; London, 1995-96; Bordeaux, 1997-98.

This Fang mask was probably collected in Gabon. It was purchased by the Musée de l'Homme in 1965 during the sale of the André Lefèvre Collection of African and Oceanic art.[1] The history of this piece before 1963, the year of A. Lefèvre's death, is unknown. According to Jérôme Peignot,[2] it was doubtless after meeting André Level (1863-1946) – himself a collector of African and Oceanic sculpture since 1914[3] – that A. Lefèvre began his collection (he would start collecting contemporary art as well after 1918[4]). He also lent several objects for the exhibition *L'Art indigène des colonies françaises d'Afrique et d'Océanie et du Congo belge*, which ran from October 1923 to January 1924 at the Pavillon

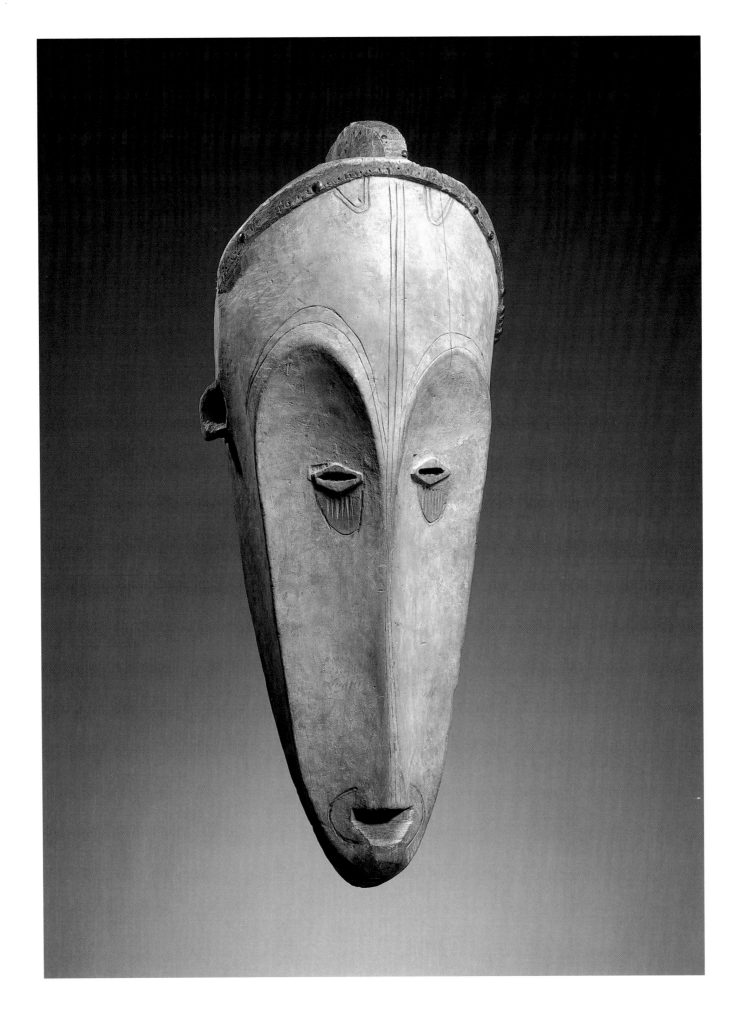

Main Exhibitions
Collection André Lefèvre – Art nègre Afrique, Océanie, Divers, 1965, no. 103; J. Delange, 1967, fig. 109, p. 142; P.S. Wingert (ed.), 1970a, N100; *Sculptures africaines dans les collections publiques françaises*, 1972, no. 233, p. 94; L. Perrois, 1979, fig. 99; S.M. Vogel and F. N'Diaye, 1985, p. 12; W. Rubin (dir.), 1987, p. 64 and p. 406; R. Sieber and R.A. Walker, 1987, fig. 37, p. 80; J. Kerchache, J.-L. Paudrat and L. Stéphan, 1988, no. 157, p. 252; E. Bassani, 1989, no. 85; *Fang*, 1991, p. 82; *A visage découvert*, 1992, p. 193; E. Bassani, 1992, p. 188; T. Phillips (ed.), 1995, 4.96b, p. 325; *L'Esprit de la forêt. Terres du Gabon*, 1997, p. 120.

de Marsan.[5] Like many other connoisseurs of his day, then, Lefèvre began acquiring African pieces along with Western painting sometime between 1918 and 1923.

Several Fang masks have a similar elongated face and were collected before the start of the 20th century. One has been in the Denver Art Museum since 1942 and was collected by "Albert L. Bennett in 1890 near Kango east of Libreville".[6] Two others were most probably collected in the late 19th century; the first, displayed in New York in 1935, belongs to Berlin's Museum für Völkerkunde, the second to Leipzig's Museum für Völkerkunde.[7] One of the various non-documented masks offers an arrangement of the nose and eyes that is quite similar to the composition seen in the piece displayed at the Louvre, while two others present elongated faces that are slightly less pronounced although stylistically comparable.[8]

Along with the *bieri* cult devoted to the skulls of lineage ancestors, Fang clans and communities of southern Cameroon, Equatorial Guinea and Gabon were structured by different socioreligious associations such as the *so* initiation society or the *ngil* judicial association. The *ngil* was "the local form of the Inquisition, with its threats and atrocities for drawing out confessions of witchcraft from unfortunate suspects amidst cruel tortures in a terrifying setting".[9] All Fang masks with a white elongated face have been attributed to the *ngil*. Although the association is mentioned by various authors before its disappearance around 1910,[10] none of these writers clearly refer to the large masks, which Westerners never managed to observe *in situ*. Thus, for Leon Siroto, their attribution to one and the same cult could be "a flagrant oversimplifications".[11]

Compared with the *bieri* reliquary figures, the large white masks are extremely rare. Certain of them may have been destroyed by initiates or European missionaries once the *ngil* had disappeared. It has never been demonstrated, furthermore, that all the societies that were part of this cult used wooden masks. Because *ngil* was distributed interclanically,[12] these associations were probably far fewer than the clans and families whose identity was linked to the *bieri* cult. There exists, moreover, little chronological information touching on the *ngil* before its disappearance, and, although the antiquity, development and preservation of *bieri*

until the 1950s (including the period beginning in the 1920s and the cult's ties to the new *bwiti* rite) appear well attested, the history of *ngil* before the end of the 19th century is a mystery. Whereas the cult prospered in Cameroon "at the dawn of the colonial era",[13] nothing is known of its origin amongst the Fang, for example, or of its earlier phases of development.

Given the Fang's great mobility before colonisation and the fact that the *ngil* could be moved from one village or clan to the next, the style of these masks is surely more of a reflection of the specific identity of the ritual association they were part of than that of any other unity (clan, subgroup, etc.). And because of the connections of *ngil* beyond groups that were strictly speaking Fang,[14] and the links that Fang groups may have established with the many other cultures they encountered throughout their history, this style must be understood within an interethnic context.

Despite our lack of ethnographic information, however, it is possible to comment on two singular features of these large kaolin-painted masks, namely, their colour and their highly elongated faces. White is the colour of mourning and death amongst the Fang and the other peoples of this region; the mask's colour then may be associated with the *ngil*'s inquisitorial function,[15] for the *ngil* cult not only hunted down and tortured those who were suspected of witchcraft, it was also responsible for executing them. The drawn-out face also offers a stark contrast with those seen on reliquary figures, which often have a round head that recalls a small child's.[16] Many of the relic guardians also have a glossy dark patina heightened with oil that contrasts strikingly with the matt white finish of these masks. The large masks thus seem to display opposite images, ones inspired by a contrary aesthetic, although the masks do have a number of stylistic points in common.[17] What we are left with in any case is the carved manifestation of their hypothetical function devoid of their true meaning, and the remarkable command of the artist who created the Lefèvre Collection piece to express the imperatives of the cult to which this beautiful mask was dedicated.

VINCENT BOULORÉ
Translation: John O'Toole

1 *Collection André Lefèvre – Art nègre Afrique, Océanie, Divers*, 1965, no. 103.
2 J. Peignot, 1966, pp. 41-42.
3 See A. Level, 1959, pp. 59-60 (originally written around 1938).
4 See *Collection André Lefèvre*, 1964, J. Cassou's introduction.
5 See S. Chauvet, 1924. In 1925, after the exhibition at the Louvre's Pavillon de Marsan

(mounted by the Union Centrale des Arts Décoratifs), A. Level and Henri Clouzot (1865-1941) published several of the show's pieces that belonged to A. Lefèvre (see H. Clouzot and A. Level, 1925). M. Delafosse, 1927, reproduced one of them (pl. LIX, 3) and published a Fang head as well (pl. XXXV, 2) that would later be part of the 1965 sale of the Lefèvre Collection (*Collection André Lefèvre – Art nègre Afrique,*

Océanie, Divers, 1965, no. 124) and would still later be reproduced in S.M. Vogel (ed.), 1981, no. 111, p. 188. I might also mention that A. Lefèvre lent a number of objects to the colonial exhibition of 1931 (J. Gallotti, July 1931).

6 C. Falgayrettes-Leveau, 1991, p. 88. The mask is reproduced in *The Journal of the Anthropological Institute*, 1899, pl. XIV, 1 (where it is attributed to the "Ngi" in the caption) as a frontispiece,

several pages before the text by A.L. Bennett, 1899 (in *ibid.*), who analyses the "Ngi". Only the "discussion" that concludes A.L. Bennett's notice mentions "the witch doctor who wore the white mask" (A.L. Bennett, 1899, p. 97, quoted in C. Falgayrettes-Leveau, 1991, p. 89).

7 For the Berlin piece, see W. Evans, [1936], nos. 351 and 352 (corresponding to no. 410, p. 49, not reproduced in J.J. Sweeney [ed.], 1935); for the Leipzig piece, see L. Perrois, 1979, fig. 100.

8 See respectively: for the first, W. Rubin, 1984, p. 13; for the next two, *Fang*, 1991, p. 83 and p. 86. Other Fang facial masks whose face is less drawn out include H. Clouzot and A. Level, 1919, pl. XX (which belonged to Picasso at the time); and the famous mask that Vlaminck was offered by a friend of his father's in 1906, an object that, in W. Rubin's words, "has since become the principal tribal icon of twentieth-century primitivism", despite its "strictly mediocre quality" (W. Rubin, 1984, vol. 1, p. 13, p. 12 repro.); *Fang*, 1991, p. 30, p. 84, p. 85 and p. 87.

9 P. Laburthe-Tolra, 1991, p. 54 and p. 56.

10 G. Tessmann is one of the last Europeans to refer to *ngil*, having himself attended two of the cult's ceremonies, the last one in May 1909 (see P. Laburthe-Tolra, 1991, p. 30, p. 53). He describes it and reproduces photographs of the sites where the cult was performed which show large clay figures (see *Fang*, 1991, pp. 268-75). However, P. Laburthe-Tolra (1991, pp. 53-56) believes that Tessmann's interpretation is mistaken. Before G. Tessmann, several authors (including A.L. Bennett, 1899 and H. Trilles, 1912, who states that he saw the *ngil* arrive without a mask [p. 175]) mention the *ngi* or *ngil* ritual. After Tessmann (1913), H. Nekes (1913) and after G.T. von Hagen (1914), either the *ngil* is absent from reports or the cult figures as an institution of the past (P. Alexandre and J. Binet, 1958, pp. 63-64).

11 See L. Siroto, 1995, p. 28. Indeed, it seems that the attribution of the Fang's large white masks to the *ngil* cult is essentially based upon A.L. Bennett's text (1899) and the legend he advances (see *supra*, note 6).

12 See P. Alexandre and J. Binet, 1958, p. 63. I should note that a cult of this type can, according to the economic, historical or political conjuncture, expand, give rise to new societies or, on the contrary, shrink and disappear, as in this case.

13 P. Laburthe-Tolra, 1985, p. 363. Generally, the *ngil* seems to have developed (unsuccessfully in the end) amongst the Fang and certain related peoples in the last two decades of the 19th century. The cult took shape as a reaction to the climate of insecurity and crisis that reigned in the period of colonial penetration.

14 The *ngil* was part of a network that extended in Cameroon to the Beti (who call the ritual *ngi*). Like the Fang and the Bulu, the Beti belong more generally to the so-called "Pahuin" linguistic and cultural group (P. Laburthe-Tolra, 1985, p. 351). As for the *ngi* in Cameroon, Laburthe-Tolra offers several details touching on its history and transmission: "Whereas the *melan* [cult linked with ancestor remains which is also found amongst the Fang] has left no precise recollections except amongst the Obghe of Minlaaba, the *ngi* had been flourishing there since around 1885 until its ban in 1910 [...] The *ngi* comes from the Mekuk" (*ibid.*). He also states that "the word *ngi* means 'gorilla' and was almost certainly a simple homonym at first, but we know that the word is a call to be [...] The initiation tends [...] to make the candidate inexorable and cruel, closed to any feeling of pity and dangerous like the gorilla" (*ibid.*, pp. 352-53). This is the same meaning of *ngi* that A.L. Bennett (1899, p. 92) had advanced earlier.

15 According to A.L. Bennett, 1899, p. 73, "The Ngi or witch doctor, when at work, in addition to his other paraphernalia smears his body with white chalk [i.e., kaolin]".

16 The Fang commonly associate this reference to early childhood with advanced age. The association constitutes a complementary opposition which, for the Fang, gives rise to the vital and complex notion that ancestors are incarnated by the *bieri*.

17 The crest that runs from front to back on the top of the A. Lefèvre mask also appears in this form on reliquary figures (see in particular: *supra* p. 159, inv. A.M. 1984.322; *supra* p. 166-67, M.H. 98.1.1; *Fang*, 1991, pp. 158-59).

18 Piece mentionned in the catalogue *André Malraux*, 1973, no. 761, p. 276.

19 See Y. Rebeyrol, 1979.

Sculpture from the Northern Kota Region

First half of the 19th century
Northern Basin of the Middle Ogowe River, Gabon

Reliquary Guardian Image

MaHongwe, BuShamaï and BaShake peoples (*buho-na-bwete* in MaHongwe, *paaza bwete* in BuShamaï)
Wood, brass, copper, plant fibres
H: 56.7 cm
Collected by Joseph Michaud ca. 1881 in an unspecified BiChiwa (Osyeba) village
between the present Booue and Lastoursville
Deposited in the Musée d'Etnographie du Trocadéro in 1886; former M.E.T. no. 15719
On permanent loan from the Muséum National d'Histoire Naturelle – Musée de l'Homme
Inv. M.H. 86.77.2

Main Exhibitions
New York, 1935a; Paris, 1965,
1972-73, 1979;[13] New York,
1984-85a; Bordeaux, 1997-98.

Main Publications
C Ratton, [1931], pl. 15;
J.J. Sweeney (ed.), 1935, no. 377;
W. Evans, [1936], pl. 326;
M. Griaule, 1947, fig. 26, p. 36;
A. Malraux, 1952, vol. I, pl. 407;
P. Radin and J.J. Sweeney, 1952,
pl. 142; W. Schmalenbach,
1953, fig. 84, p. 91;
E. von Sydow, 1954, pl. 131c;
D. Paulme, 1956, pl. XX (right);
D. Paulme, 1962, vol. II, pl. 20;
*Chefs-d'œuvre du musée
de l'Homme*, 1965, no. 24, p. 87;
Le Courrier de l'Unesco, p. 18 and
p. 20; A. Terrisse, 1965, fig. 131,
p. 111; J . Laude, 1966, fig. 76,
p. 141; M. Leiris and J. Delange,
1967, no. 19, p. 20; M. Trowell
and H. Nervermann, 1969,
p. 152 (left); L. Segy, 1936,
fig. 285, p. 219; P.S. Wingert
(ed), 1970a, N 102;
H. Himmelheber, 1971, fig. 5,
p. 53; *Sculptures africaines
dans les collections publiques fran-
çaises*, 1972, no. 220, p. 90;
E. Bassani, 1975, fig; 11, p. 27;
E. Leuzinger (ed.), 1978,
fig. 91b; A. and F. Chaffin, 1979,
no. 6, p. 84; S.M. Vogel and
F. N'Diaye, 1985, no. 65, p. 42
and p. 148; W. Rubin (dir.),
1987, p. 266; *Musée de l'Homme*,
1992, no. 13659; *L'Esprit
de la forêt. Terres du Gabon*, 1997,
no. 289, p. 211.

Simple in form, richly decorated and complex of meaning, this sculpture[1] stood guard over the relics of family leaders. It has since entered into many publications and exhibitions and eventually became one of the monuments of traditional African art. Such long renown – and a laconic attribution to one certain people in the region where it was used – established an assured sense of its ethnic background.

However, in the absence of conclusive proof of its invention and development within MaHongwe culture, its primal ethnic associations deserve further consideration. Satisfactory accounts of this form's traditional contexts and its mode of construction are now available. Yet, considering the transcendent strangeness of its presence, an understanding of the time, place and circumstances of its conception still eludes us. A brief resume of its traditional role should allow space for discussion of its ethnic history.

The ethnographic materials used here come to us from investigations among the MaHongwe, and these sources contributed to the implicit claim of an exclusive connection between MaHongwe society and this image. This need reflect no more than an investigator's choice of terrain, and we note that other peoples in the same region claim to have used the same form in the same way.

The guardian image was attached to a bundle containing the calvaria (skull-tops) and other bones of a few recent generations of clan-chiefs. The assemblage was kept in a basket or bark cylinder in which the image stood, to warn off unseen forces capable of diminishing the supernatural power of its wards.

Such reliquaries were entrusted to clan chiefs, who would keep them secreted and occasionally entreat their aid in the clan's interests. When large-scale crises affected the village, usually made up of a number of clans, the chiefs brought the reliquaries together for communal rites of prayer, sacrifice and celebration. The latter activity included manipu-

lating the guardian figures in a dance. These gatherings sometimes served to initiate young men into the cult; the contents and guardians of the reliquaries were then introduced to the candidates.

The cult was known to the MaHongwe and their neighbours, who were also its devotees, as *bwete*. Its reliquary guardians were thought of as the faces of *bwete*. They had their own names and imputed special powers which differed from those of the persons from whom the relics were taken.[2]

This work now in the Louvre comes from a village of the BiChiwa[3] people (then called Osyeba) on the north bank of the Middle Ogowe. The BiChiwa are Makaa-Njem speakers[4] who broke away from the Ngumba bloc (present-day south-west Cameroon and adjacent Equatorial Guinea) and went southward, mostly to the east of the ongoing Fang migration. They practised the western version of the reliquary cult and did not make metal-covered reliquary guardian images.[5] As great hunters and warriors, they eventually made alliances and villages with the BaShake, Kota-speaking kindred souls who lived in the country back of the north bank.[6]

In 1961 BaShake informants in the region of Makokou claimed that they had made and used this kind of image in the past.[7]

In 1887 the Museum für Völkerkunde in Berlin acquired a guardian image (no. IIIC.1088; fig. 1) apparently by the same hand as the one that fashioned the Paris example. The explorer Oskar Lenz found it among the "Adama [sic] and the Oschebo" peoples.[8] Njabi speakers, the ADuma were expert canoemen settled on the south bank of the Middle Ogowe around present-day Lastoursville. Now the Shebo seem to be known as the BaSsissiou; they are canoemen still found on the banks of the Middle Ogowe near the ADuma.[9] They belong to the Kele (Ngom) language group, which is very close to that of the Kota. Their land was close to BaShake country. These data are offered to indicate the ethnic complexity of the region and the possibility of a wider use for this kind of image than is now envisaged.

Caution is advised in accepting the indigenousness of objects attributed to riverine societies engaged in intensive trade.

The Musée de l'Homme sculpture and its Berlin counterpart are the only 19th-century examples to be dated and localised, even if seemingly marginal to the place of their conception. They have a distinctive balance and austerity that might lead us to regard them in a "classical" light, but the unique circumstances of their discovery preclude inferences as to the sequential development of their type.

The 20th-century evidence for the form's ethnic provenance came out of colonial change. Various forces working in the interests of the regional administration forced the northern Kota speakers to renounce *bwete* and its accessories. Even until the 1940s and early 1950s, guardian images were retired to pits, ponds and watercourses. This abandonment ironically served to fix their place in art history by keeping them moderately preserved until a growing interest in African art led to their salvage, restoration and publication.

Louis Perrois's reclamation and reconstruction of several water-logged images, apparently in BuShamaï country, [10] provided an insight into the image-maker's technique that would never have been gained from the examples treasured in museums and private collections. Other perspectives were gained through Jacques Kerchache's detailed publication of the 23 guardian images[11] that he brought out of a pit in what also seems to have been BuShamaï country

The Kerchache trove made two important points. First, the salvaged images included most of the basic variations on the northern reliquary guardian theme, thereby challenging the notion of discrete substyles limited to certain localities or certain times; all of this heterogeneous corpus must have been used by the same village prior to its burial. Second, the discovery of this assemblage in BuShamaï land would strengthen the likelihood of ethnic co-traditions and block the premature and unproved recognition of the MaHongwe as the inventors of the style.

In 1961, in the region of Makokou, BuShamaï informants claimed that their people had made and used such images in the past.[12]

Fig. 1
Sculpture from the northern Kota region, first half of the 19th century
Eastern basin of the Ivindo River, Gabon-Republic of the Congo
Wood, brass and copper
H. 53.5 cm
Museum für Völkerkunde, Berlin
Inv. IIIC. 1088

In this light, the guardian images of these northern Kota-speakers – and perhaps other groups as well – would seem to represent a regional pattern rather than a discrete ethnic phenomenon. The possibility of our finding enough data to sustain its rigorous attribution to a single 18th-19th-centuries culture seems remote. In the hope that it will eventually become unfashionable to seek ethnic equity in allocating one invention to one particular group, Africanists might begin to seek conventional terms that designate the "polyethnic" nature of works whose moment of conception cannot be retrieved.

LEON SIROTO

1 This representation's extreme departure from human form suggests that the designations "figure" and "statue" might be questionable. Therefore, the less biomorhic "image" and "form" will here be used in their place.
2 J. Kerchache, 1967; J. Craven, 1967; L. Perrois and G. Pestmal, 1971; L. Perrois, 1976; L. Siroto, 1968.
3 This people has long been known under a plethora of dissimilar names. H. Deschamps's deciding upon BiChiwa pffers us a way out of the reigning confusion.
4 This identification of regional ethnies as speakers of a language close to certain other languages follows Malcolm Guthrie's classification of 1953, an approach that can often throw light on primal relationships persisting through centuries of dispersal.
5 H. Deschamps, 1962, p. 78, p. 81.
6 L. Guiral, 1889, p. 51.
7 L. Siroto, notes of 24 May 1961.
8 K. Krieger, vol. III, 1969, pl. 126, p. 44, no. 122.
9 H. Deschamps, 1962, p. 129, p. 131.
10 L. Perrois, 1971, p. 367, p. 369.
11 J. Kerchache, 1967.
12 L. Siroto, notes of 22 May 1961.
13 Sculpture mentioned in *Rites de la mort* (1979), p. 48.

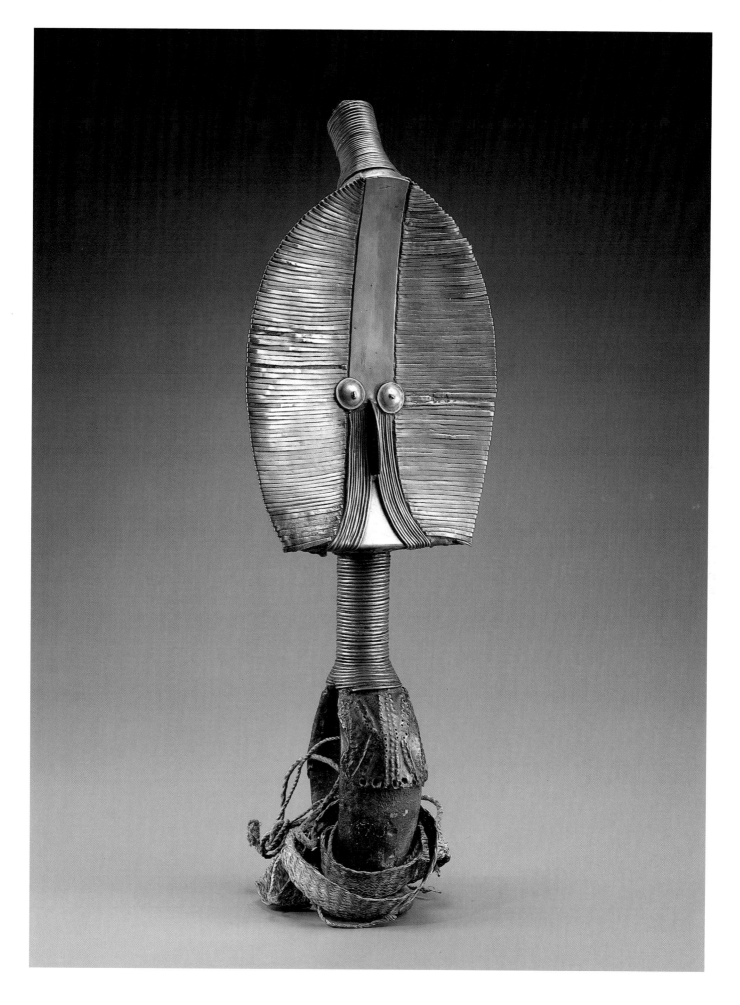

Sculpture by an Undetermined Sanaga-Speaking People

19th century
Near the confluence of the Sanaga and Mba Rivers, south-west Cameroon, region of Saa

Wood (probably *Bombax buonopozense*), shell, sacrificial encrustation, hide, glass beads
H: 26.6 cm
Collected by M. Ferrière at an unspecified locality in the Sangha basin
Donated to the Musée d'Ethnographie du Trocadéro in 1901; former M.E.T. no. 51017
On permanent loan from the Muséum National d'Histoire Naturelle – Musée de l'Homme
Inv. M.H. 01.4.4

Main Exhibitions
Paris, 1965, 1972-73, 1991-92.

Main Publications
M. de Zayas, 1916, pl. 23;
M. Griaule, 1947, fig. 31, p. 41;
Sculptures africaines dans
les collections publiques
françaises, 1972, no. 294,
p. 109; L. Siroto, 1977, fig. 14,
p. 49; S.M. Vogel and F. N'Diaye,
1985, no. 59, p. 41 et p. 145;
Fang, 1991, p. 94-95; *Musée*
de l'Homme, 1992, no. 13702,
p. 61.

In laconically attributing this remarkable work to "Sangha", an important north-western tributary of the Middle Congo River, M. Ferrière followed the minimal style conventionally used by most African explorers of his day. In doing so, he left a legacy of great uncertainly as to its origin. The Sangha drainage is quite extensive, including the northern People's Republic of the Congo, south-east Cameroon and the southwest of the Central African Republic. Moreover, the ethnic attribution for Ferrière's 1901 gifts to the Musée d'Ethnographie du Trocadéro[1] encompasses a range of societies between its mouth and its headwaters, from the Gbaya to the "Bafourou" (Babangi).

The statue was first published for a wide audience interested in African traditional art – for its own sake – in 1947.[2] Recognised as one of the masterpieces of the Musée de l'Homme in 1965, it was then attributed to "Congo Brazzaville. Haute-Sangha".[3] This decision to limit its region of origin to the Sangha, approximately between Wesso and nola, was arbitrary – the records do not mention the Upper Sangha.

The art of the Sangha has not been well-studied, and what is known clearly does not relate to this figure. Recently, the need to rescue a masterpiece from ethnographic limbo led to a return to the Ferrière accession data. The entry at the very top of the sheet of the *Inventaire des collections du Musée d'Ethnographie du Trocadéro* (catalogue 23) concerns "a quiver for crossbow darts from the N'djimou" [sic]. The Nzimu are a Makaa-Njem speaking people[4] of south-eastern Cameroon, one group near Molundu and the other to the north and east of Lomié.[5] The seventeenth entry on the register is "a small figure sculpted in wood, with an animal head,[6] ivory eyes and a collar of small beads". Its identification is no more than "Sangha".[7]

In 1991, this figure was published in a book focused on Fang art, and attributed to the Nzimu.[8]

At the onset of colonial times, the warlike nature of the Nzimu greatly concerned their German colonizers. One administrator, C.W.H. Koch, studied them well. Of their art he could note only the boldly polychromed wooden panels serving as façades for beds in the men's houses.[9] This sort of enhancement was common to many peoples of the region, however, like the distinctive kind of tripartite coiffure which has nothing in common with that of the Ferrière figure.

Nzimu culture has not yet yielded any representational art. The absence of comparative material would suggest a wider search for the statue's style in southern Cameroon, where its marked prognathism and tripodal stance leads us to think of the reliquary guardian tradition of its Ngumba, Beti and Bulu inhabitants. (No reliquary cult on the order of *melan* is reported east of these people).

By sheer chance, a museum specimen from this region does provide the strongest stylistic correspondence so far, as well as significant, if not conclusive, documentation.

Preparation for an article on the sculpture of the *so* initiation system of the Beti and Bulu peoples of south-west and south-central Cameroon[10] led to the recognition of a considerable resemblance between the Ferrière figure and one in the Museum für Völkerkunde. Tje latter is part of the most important field of imagery in the *so* rites in that region (fig. 1).

So is a complex rite that combines expiation and initiation. In traditional times a wealthy man would seek to offset a reversal of his well-being by sponsoring the initiation of a suitable group of youths into adulthood. At the climax of the rite each candidate would dance long and strenuously before the assembled local multitude. His dance-floor was a long, narrow platform trimmed down from a tree-trunk and mounted on forked posts raising it to the height of about two metres above

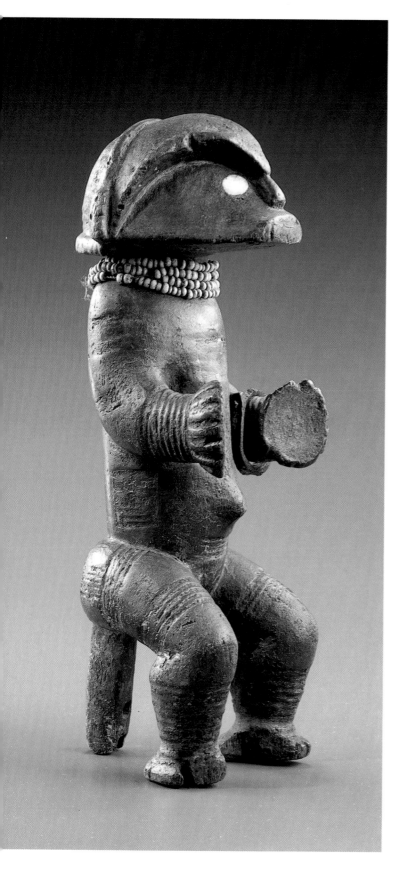
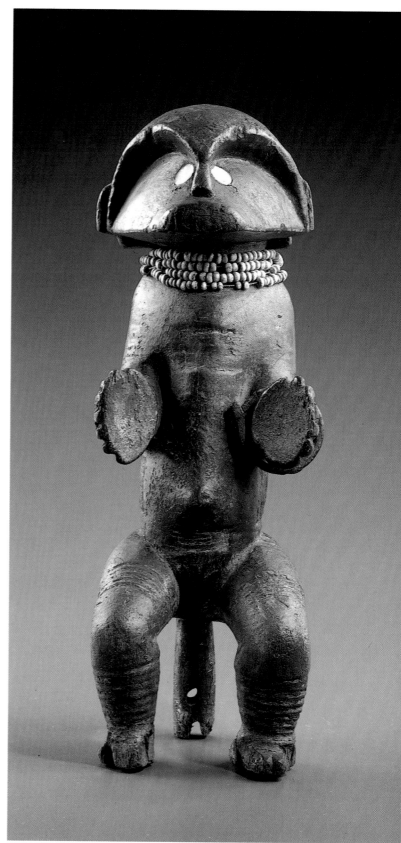

the ground. The forepart of this runway was reserved for the execution of a tableau consisting of the representation of diverse animal and human themes. Such scenes were carved out of the part of the trunk that was not levelled off for the dance-platform. The ensemble was called *nzom* (plural: *minzom*).[11]

The *nzom*-element in Berlin corresponds to the style of the Ferrière figure. It is a representation of a man seated on the ground with his knees raised.[12] He is reaching forward with his arms fully extended in a parallel alignment that continues into the opposition of the *palme*. The jawline extends forward horizontally and is defined by a ridge. This line reverses uninterruptedly in the same plane to the back of the head, thereby imparting a flat-bottomed quality to the entire mass perched upon the neck. The chinless face slants sharply back from the top of the mouth. The hairline transects the head almost symmetrically across its long axis. The protruding ears consist of nothing more than high semi-circular rims.

While this comparison involves two possibly extreme examples of a regional style, we should note that the convention of the horizontal jawline and backward-slanting face seems to occur commonly in art of the Middle Sanaga region. The relatively naturalistic human figures on an Eton *nzom* in the Museum für Völkerkunde in Munich bring this out in varying degrees.[13] Free figures from different ethnic groups in the region, for example, the Ewondo ("Jaunde") and Yambasa show the same tendency.[14]

The resemblance between the two forms is a close as we can discern within the range of regional styles. If we judge the Ferrière statue as a masterpiece, it would have to be in comparison with its perhaps close relative on the *nzom*. Its excellence would emerge in the extreme horizontalising of the head, the features of which become more reduced and, paradoxically, more imposing, through the lateral expansion of the cheeks and the deep underoutting of the supraorbital ridges. This effect is gained at the expense of the ears, which are comparatively reduced. The horizontality of the head follows into the shelf-like occipital element of the coiffure, a feature not apparent in most of the photographs of this figure.

If the perceived closeness of this stylistic relationship is tenable, a detail in the conception of the *nzom* figure may help to establish the gender of the Ferrière one. The penis of the seated figure is carved in relief from the ground of the *nzom*[15] Given the intent to represent its maleness, we can consider the Ferrière figure as female.

The institution of *so* and its *nzom* are said to have begun among the Mengisa, a Sanaga-speaking people who crossed the Middle Sanaga River around the 17th century to establish themselves on the south bank, more or less in the region of

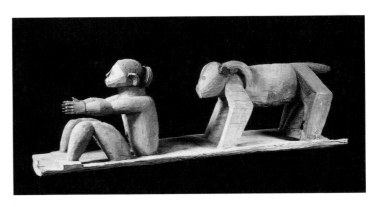

Fig. 1
Protome of a dance platform (*nzom* in Beti) for the *so* rite
19th century
Right bank of the Lower Sanaga river
Southwest Cameroun, region of Saa
Wood
L. 132 cm
Museum für Völkerkunde, Berlin
Inv. III C 18291 (1904)

Saa, where they met the Eton. The latter may also have been Sanaga-speakers, but in transition to the Yaunde-Fang language group,[16] However, the Berlin museum *nzom* comes from the north bank of the Sanaga bend across from the Mengisa and Eton.[17] Here a complex of diverse Sanaga-speakers, with the Tsinga predominant, appear to have had a tradition of *so* and *nzom*.[18] Since *minzom* in traditional times were unlikely to have been transported across the Sanaga, it seems reasonable to accept the Berlin museum record of local provenance.

This acceptance does not sustain a claim that a Tsinga carver made the Berlin *nzom*. Nor does it establish that the eminently portable Ferrière figure was made on the north bank. At most, this tentative localisation of a style would argue against the original presence of the Ferrière statue in the Upper Sangha basin, a region in which different canons of style prevailed, more in agreement with those of the Mandja peoples. This statue probably came into Ferrière's Sangha materiel fortuitously, since it was very likely to have been made more to the west.

Considering the Ferrière statue in the wider region of the Sanaga basin leads to awareness of a style-feature that it shares with such peoples as the BaFia and Yambasa. In all three traditions we find the hands out-thrust and held more or less parallel to each other; they also tend to be widely splayed.[19] The meaning of this gesture is not yet known.

Extending this overview to the wider region of south-central and south-west Cameroon, we find that in most statuary styles the arms are carved well away from the trunk, whether remaining free at their ends as in the above-mentioned societies, or coming together to hold an object before the trunk as in the Ngumba, or coming together under

the chin as in the Lundu-Mbo ("BaFo") complex. Most of the human figures on the *minjom* show this openness. The difficulty of carving and the subsequent risk of breakage pose an intriguing problem in the study of cultural choice as determined by prototype, technique and religion.

The unmistakable suggestion of reliquary guardian iconography in the Ferrière statue probably reflects the diffusion of *melan* cult ideas eastward into the lands of the Sanaga – and the BaFia-speakers. Tessmann noted two cults that used statues among the culturally similar but linguistically different BaFia and Yambasa. One was called *melan*, but his summary mention of it among the Yambasa deters any inferences regarding its similarity to the *melan* cults to the west.[20] The other association was *elume*, referred to as a "sorcery cult", doubtless one concerned with the control of harmful witchcraft. *Elume* is said to have used small, "rough" figures for unspecified purposes.[21]

<div align="right">LEON SIROTO</div>

1 This donation (M.H. collection no. 01.04) comprises 56 serial numbers.
2 M. Griaule, p. 10, fig. 31.
3 *Chefs-d'œuvres du Musée de l'Homme*, 1965, p. 74.
4 This identification of regional ethnies as speakers of a language close to certain other languages follows Malcolm Guthrie's classification of 1953, an approach that can often throw light on primal relationships persisting through centuries of dispersal.
5 I. Dugast, 1949, pp. 104-107.
6 The assumption of an intentional simian element in this statue's iconography deserves reconsideration. A review of regional style should indicate that this bold conventionalisation still lies within the human (or spirit-human) limits of representation.
7 My thanks to Jean-Louis Paudrat for this information.
8 C. Falgayrettes-Leveau, 1991, pp. 94-95, p. 163.
9 W. H. Koch, 1913, p. 269, fig. 15, p. 270.
10 L. Siroto, 1977.
11 P. Laburthe-Tolra, 1985, ch. VIII and IX; L. Siroto, 1977.
12 K. Krieger 1969, vol. III, pl. 124, no. 120, p. 44.
13 M. Kecskesi, 1982, pp. 250-252.
14 See von Sydow, 1954, pl. 51C, p. 163, and pl. 129B, p. 170, respectively.
15 K. Krieger, 1969, vol. II, pl. 120, p. 44.
16 C. Atangana, 1942-45, p. 157; P. Laburthe-Tolra, 1985, pp. 92-93.
17 K. Krieger, 1969, vol. II, pl. 120, p. 44.
18 P. Laburthe-Tolra, 1985, pp. 307-08.
19 K. Krieger, 1965, pl. 88, pl. 89, p. 56; Von Sydow, 1954, pl. 129B, p. 170.
20 G. Tessmann, 1934, p. 155, p. 196; K. Krieger, 1965, p. 56, no. 104.
21 G. Tessmann, 1934, p. 155, p. 196.

Master sculptor of the Mbédé region

Late 19th-early 20th century
East-central to southeast Gabon and west-central to south-central Republic of the Congo

Reliquary statue (presumably *mitsitsi-na-ngoye*)

Wood (Alstonia sp.), kaolin, brass[1]
H. 72 cm
Work apparently collected anonymously and recorded from "Gabon, region of Dwesse"
(sic: garbling of Louesse, a river in the south-central Republic of Congo?)
Deposited in 1938 in the Museum of Overseas France by the Pavillon of French Equatorial Africa in the
International Exposition of Arts and Techniques in Modern Life (old number: AF 11819)
Musée National des Arts d'Afrique et d'Océanie
MNAN 1963.67

Main Exhibitions
Paris, 1937, 1972-73; Cologne,
1990; The Hague, 1990-91;
Bordeaux, 1997-98.

Main Publications
P. Meauzé, 1967, fig. 1, p. 202;
*Sculptures africaines dans les col-
lections publiques françaises,*
1972, no. 215, p. 89; *La Voie des
ancêtres*, 1986, p. 66 (left); *Musée
des Arts africains et océaniens,
Guide,* 1987, no. 69, p. 114;
J. Kerchache, J.-L. Paudrat and
L. Stéphan, 1988, no. 587,
p. 426; L. Stéphan, 1990, p. 113;
*Afrikanische Skulptur: Die
Erfindung der Figur – African
Sculpture: The Invention of the
Figure,* 1990, no. 69, p. 167;
*L'Esprit de la forêt. Terres
du Gabon,* 1997, no. 308, p. 222.

The Mbédé people of the basins of the Upper Ogowe and its adjacent rivers made such hollow wooden statues to serve as reliquaries for skeletal remains of leaders. André Even, who conducted ethnographic inquiries among the central Mbédé ("Mbamba") in the region of Okondja in the 1920s and 30s, supplies information on an important, if not paramount, reliquary cult. This was *ngoye*, an exclusive and apparently wide-spread association of clan-chiefs believing in the supernatural power residing in certain bones of certain defunct predecessors whose relics were kept in figures of this kind. The example seen by Even was about 50 cm high. It was called *mitsitsi-na-ngoye*.[2] Unlike this figure, it was of a composite nature: its head, neck and shoulders formed a bust that covered the top of the container below.[3] These predominantly non-anthopomorphic lower parts are known from only a few examples. They are likely to have been hollowed-out tree trunks of about the same diameter as the shoulders of the bust that either plugged or lidded the aperture.[4]

When not in use, these statues were hung in special sheds housing other cult objects.[5] Their reported ritual use seems to have been initiatory. In a special ceremony, they were taken before the *ngoye* candidates in order to introduce them to the names and stories of the relics taken out and displayed before them. These sacra were usually specific parts of the skull and some finger-bones. When the remnants of one leader contained with those of others in the statue began to disintegrate, they were replaced with those of more recently departed members of *ngoye*.[6]

Most of these reliquaries represent men but, as we see here, some clearly represent women. Mbédé society is organised matrilineally: women occasionaly became chiefs.[7] Moreover, the mothers of twins are held in great esteem. Other women attained renown for divining by means of trance-dancing. Whether these statuses could lead to membership in *ngoye* and thus to idealisation in its statuary remains to be discovered. The minimal representation of breasts in female statues might bear upon the question.

Compared to the published range of Mbédé reliquary figures, the style of this one diverges strikingly from the apparent canon. In frontal silhouette, the swelling, rhythmic arrangement of its limbs and trunk break free of the prevailing columnar conception of human form. This departure pivots on the master's choosing to separate the arms from the trunk. The massive legs follow this outward movement in so far as they are bowed and rounded.

The head contrasts to a lesser extent, but is still unusual. Its indented, m-shaped hairline is not seen in works by other Mbédé hands. The arcuate but deeply undercut brow, almost on the same plane as the root of the convex nose, is also distinctive and might lead us to learn where this remarkable sculptor worked.

Mbédé migrations from east to south during the 19th century led to the occupation of a territory extending from the regions of Kelle and Ewo in the north to those of Zanaga, Mossendjo and Sibiti in the south. Lack of local documentation, however, forces us to despair of inferring the differentiation of sculptural style over space and time.

In this particular case we have some documentation and comparative material to indicate a direction for further inquiry into the region in which this master worked.

In the first quarter of this century the Swedish National Museum of Ethnography (Stockholm) acquired the bust of an Mbédé composite reliquary statue from the town of Mossendjo[8] in the then Moyen Congo colony. The similarity of its face to that of the Paris statue seems significant in the treatment of the brow, nose and mouth. The notched rendering of the teeth is not as eccentric as in the Paris statue, but it differs from the other conventions seen in the Mbédé corpus.

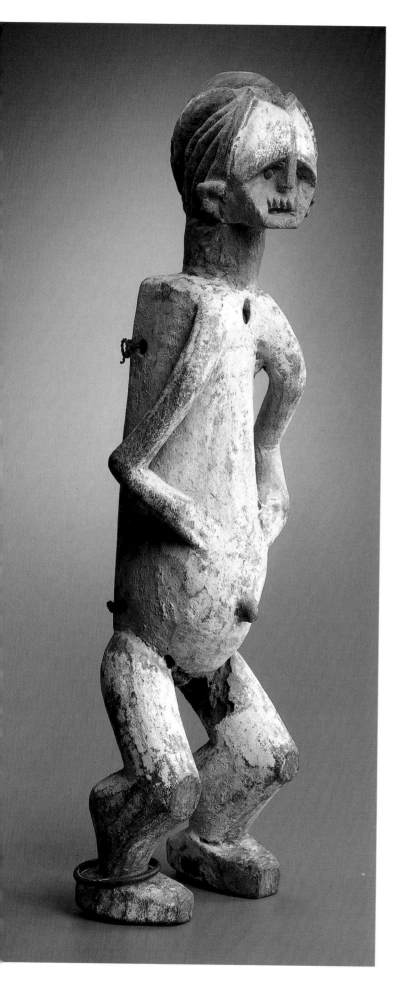

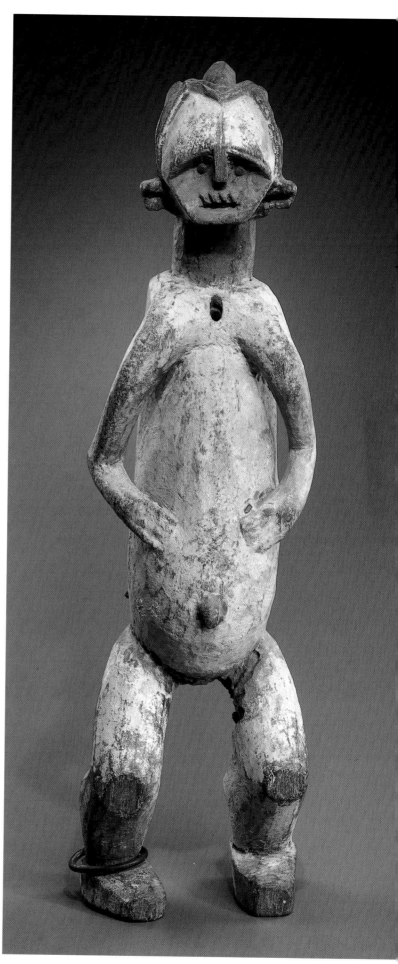

The possibility that the museum registration for the Paris statue might be Louesse rather than Dwesse[9] would suggest that the two works originate in the same region: the southwestern part of the Republic of the Congo. The Louesse River flows close to Mossendjo. Differences between the two styles indicate that they might not necessarily originate from the same master.

The works of this master might include another reliquary, formerly in the renowned collection of Josef Mueller of Solothurn, Switzerland.[10] Its present location is not known. The ex-Mueller statue greatly resembles the Paris one but lacks its expressiveness and grace. The slight differences in detail might indicate that it was intended to represent another personage.

The main stylistic quality that differentates these two works is the rounding off of the Paris sta-tue. The ex-Mueller example stands four-square. Its surface texture left by the carver's adze and the necklace of translucent blue beads underscore the likelihood that its origin is in the region of its counterpart. Its realisation before the 1950s seems implicit in view of Mueller's intensive collecting in Paris in the decades before World War II and of its base by the famous Japanese craftsman Inagaki, virtually a connoisseur's *sine qua non* of that era.

So far, the question of whether both statues were made by the same hand remains beyond rigorous proof. An artist as accomplished as the creator of the Paris statue might have carved in different modes, either out of caprice in his prime years, or out of natural limitations during his apprenticeship or in the twilight of his career.

LEON SIROTO

1 Moreover, C. Noll (1986, p. 67) points out that the statue "contained [...] some skeletal material: a vertebra of a small animal, and two fragments of the occiput [of a human skull] (at the level of the petrosal) [i.e., part of the temporal. bone]".

2 The Göteborg Etnographic Museum has an Mebe reliquary guardian bust (38.22.89) collected in the village of Ansogo (southwest Republic of the Congo). One of its original names is *tsita*, wich may be related to *mitsitsi*. These records concern *ngoye*' reliquary guardian busts. We assume that the terms can also apply to fully representational statues.

3 A. Even, 1937, p. 64.

4 The trunk of the unitary type of reliquary statue is hollowed out from the back. An oblong panel lashed to the torse usually covers the cavity.

5 F.W.H. Migeod, 1923, p. 107.

6 A. Even, 1937, pp. 64-66, P. Corre, 1912, pp. 49-50.

7 E. Anderson, 1953, p. 173.

8 I. Bolz, 1966, p. 150; S. Linne and G. Montel, 1947, fig. 326.

9 C. Noll, 1986, pp. 66-67.

10 Christie's, 1978, p. 54, no. 140.

Teke sculpture

19th century
Republic of the Congo

Bitegue statuette

Wood, brass tacks, mother-of-pearl buttons, cloth, string, magico-religious charge,
traces of sacrificial materials
H. 38.4 cm
Collected in 1924 in the village of Mayama (Wumu subgroup), some 65 km north of Brazzaville,
by Robert Lehuard
Formerly the Robert Lehuard and Raoul Lehuard collections
Musée du Quai Branly
Inv. 70.1998.7.1

Main Publications
Arts d'Afrique, no. 1, 1972,
cover; R. Lehuard, 1974b,
no. 63, p. 125; K.F. Schaedler,
1975, fig. 352; M.-L. Bastin,
1984, p. 290; J. Kerchache,
J.-L. Paudrat and L. Stéphan,
1988, no. 633, p. 434;
Afrikanische Skulptur:
Die Erfindung der Figur
– African Sculpture:
The Invention of the Figure, 1990,
no. 78, p. 175; R. Lehuard, 1996,
p. 28, no. 250; Téké – Collection
de Robert et Raoul Lehuard,
1999, p. 23.

Paradoxically, it was the relationship between the explorer Pierre Savorgnan de Brazza and the king of the Bateke, Illo I, that was to prove decisive in establishing France's presence in the Congo in the late 19th century. Yet to this day the art of the Bateke is the least known of all the artistic styles of the former French colonies. Of course descriptions of it have often been reduced to a standardised model in which the entire body, considered to be roughed out only, disappears beneath a resinous charge that contains incantatory and therapeutic components and is meant to receive propitiatory offerings, whereas the head, the most carefully executed part, is said to possess austere, angular features.

This statuette depicting a seated figure is, however, one of the most precious examples – if not the most precious example – of Bateke sculpture of the late 19th and early 20th centuries. It was collected in 1924 by Robert Lehuard in the village of Mayama, which lies north of Brazzaville, in the circumscription of Stanley-Pool. The area is inhabited by a population that is part of the Wumu subgroup and the piece was logically attributed to the "Mayama style" in a work devoted to Teke stylistic centres entitled Les Arts batéké.[1]

Did the artist who created this style really work in Mayama? One thing is certain, near this village Robert Lehuard collected two other statuettes carved by the same hand. As for the use of brass tacks and mother-of-pearl buttons from Europe, the practice could well date the period when these figurines were produced – and therefore the activity of this artist, then at the height of his creative powers – to the last quarter of the 19th century. The object already showed signs of great age when it was collected, including traces of past ritual use adhering to the surface as a sacrificial patina. It is not impossible then that via the circulation of imported goods, such additions to the wooden statue had reached Tekeland – even the Congo's extensive basin – before Savorgnan de Brazza had signed his treaty there placing the land under France's protection.

It is interesting to note that this piece belonged to a diviner (ngaa) of Sundi extraction (a neighbouring population located on the western Bateke plateaus) who practised his arts amongst the Bateke. Eighteen years earlier, the Englishman Robert Hottot had collected in the Teke village of Kinda a statuette representing a seated figure that he was able to photograph next to a Sundi musician.[2]

Prayers and sacrifices were the original raison d'être of these statuettes, whose powers ran from the therapeutic and the protective, to the political (through the power of chiefs), the magical (either beneficial or destructive, openly admitted or secret), even the goetic (i.e., sorcery). It is likely that an object in the possession of a diviner was infused with formidable powers and had to be handled in utmost secrecy.

The statuettes generally known as bitegue are almost always masculine – which is odd for a people whose recognised blood ties are based on matrilineage. They are placed in the care of the head of the family. He keeps them in a corner of the hut, in a triangular area set off by a plank. These small figures are set up in a standing position, eyes turned toward the entrance doorway, feet sunk into the sandy floor. This orientation is meant to block the entrance to any person bent on doing ill or any evil charm "cast" from afar by a jealous individual or a sorcerer capable of casting spells. Most of these bitegue serve as individual, familial or collective protection, if it is a question of objects with which a keeper of magic formulae and charms surrounds himself. Travellers, even quite recently, have indeed noted that the ethnic groups neighbouring the Bateke (Balari, Babembe, Basundi) have always obtained their magic and therapeutic formulae from that group's mangaa. The reputation

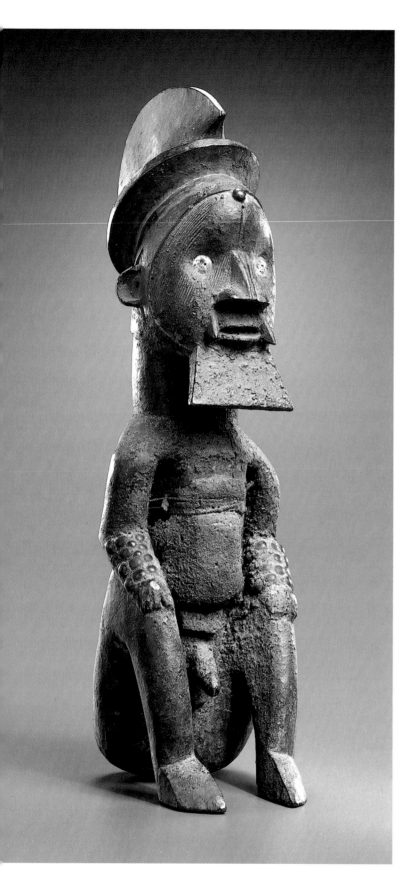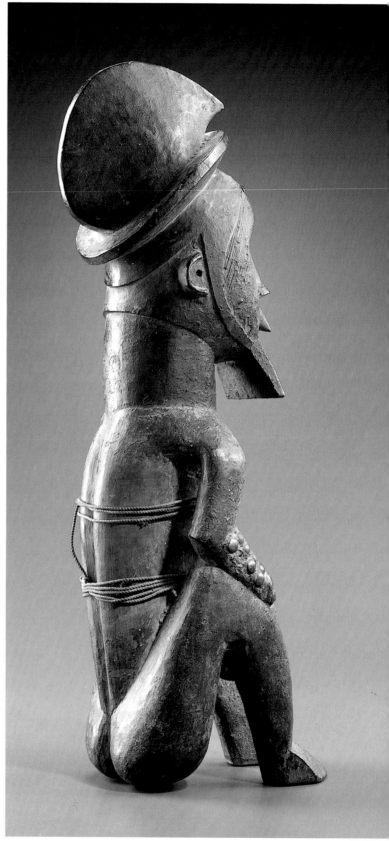

for effectiveness enjoyed by Bateke authors of spells extends well beyond their territory.

As regards the "Mayama style", two types of sculpture are known. One depicts a standing figure, legs bent, arms folded at right angles, head, trunk and lower members divided into three tiers with respect to the overall height of the piece. The second represents a figure in a seated position, whose head, including headdress and beard, takes up nearly half of the sculpture's overall height. The impression of elegance and nobility given off by the standing figures is, with the seated subject, rein-forced by the power that it seems to embody, by the broad, solid frame, by the fullness of the beard and the volume of the head with respect to the statue as a whole. The figure is indeed an imposing and impressive piece. Finally, viewers will note how the thrust of the shoulders justifies the armss detached position from the trunk, while the forearms, studded with brass tacks, partake of the nobility of the pose, with the hands solemnly resting on the knees.

RAOUL LEHUARD
Translation: John O'Toole

1 R. Lehuard, 1996.
2 See R. Hottot, 1972, fig. 8, p. 28.

Yangere sculpture

19th century
Central African Republic (?)

Slit-drum

Wood
H. 80 cm, L. 231 cm
Gift of Pierre Savorgnan de Brazza to the Musée d'Ethnographie du Trocadéro; formerly M.E.T.: 39093
On permanent loan from the Muséum National d'Histoire Naturelle – Musée de l'Homme
Inv. M.H. 96.28.72

nMain Exhibitions
Paris, 1930, 1964b, 1965; Zurich, 1970-71; Essen, 1971; Paris, 1972-73; New York, 1984-85a; Florence, 1989.

Main Publications
H. Labouret, 1923, pl. II, nos. 1 and 3; S. Chauvet, 1929, fig. 25, p. 181; *Exposition d'art africain et océanien*, 1930, no. 153; A. Schaeffner, 1936, cover; M. Griaule, 1947, fig. 107, p. 118; P. Radin and J.J. Sweeney, 1952, pl. 78; E. Leuzinger (drawing), 1959, fig. 133, p. 178; W.B. Fagg, 1964a and b, no. 58; *Chefs-d'œuvre du musée de l'Homme*, 1965, no. 26, p. 91; *Le Courrier de l'Unesco*, 1965, p. 11; J. Laude, 1966, fig. 75, p. 139; G. Balandier and J. Maquet (dir.), 1968, p. 398; R.S. Wassing, 1969, cat. 109, p. 275; P.S. Wingert (ed.), 1970, N143; E. Leuzinger, 1970 and 1971, X 6; *Sculptures africaines dans les collections publiques*

Although monoxylous drums (i.e., carved from a single piece of wood) were used to accompany dancing, they also ensured the transmission of messages over significant distances in certain circumstances. These instruments were carved from tree trunks that were hollowed out through a longitudinal slit with straight, parallel edges. Because of the varying thickness of these two edges, when they were struck with large hard-rubber mallets, sounds of different pitches are emitted and recognized as a tonal language.

Often projecting elements at either end, shaped like the head and tail of a quadruped (antelope or buffalo, as is the case here), lend the instrument its zoomorphic appearance.

While the large slit-drums that belonged to ru-lers were certainly emblems of authority and wealth, they were also genuine works of art in not a few instances, successfully combining functional forms and volumes with sculptural solutions that reveal remarkable mastery.

The drum shown here was acquired during the mission (1892-1894) that took Pierre Savorgnan de Brazza from Bania in the upper Sangha to Ngaundere in Adamaua. Although explicitly mentioned in the records of the Musée d'Ethnographie when the piece entered the collections in 1896,[1] the explorer's attribution of the piece to a Yangere sculptor remains hypothetical. Exhibited in 1930 at the Galerie Pigalle, this "*gasa bin* signal drum" was said to come from the "Baia of Southern Came-roon". Another instrument that is less daring in its conception is attributed by its collector, the Swedish missionary Aron Svensson, to the Baya. This piece, which joined the Göteborg Museum in 1952, had been collected by Svensson in 1951 in Bea-Basabo, a village situated some 30 kilometres from Berberati.

Nearly one century earlier, Georg Schweinfurth in his famous *Artes Africanae* (1875) illustrated[2] and attributed to the Niam-Niam (ethnonym that is in-correctly used to refer to the Zande) a drum (*gaza* or *guggoo*) that is fairly similar to the one brought back by Brazza. The German explorer had already re-marked the unequal thickness of the drum's edges which were designed to produce different sounds.

AFRICA

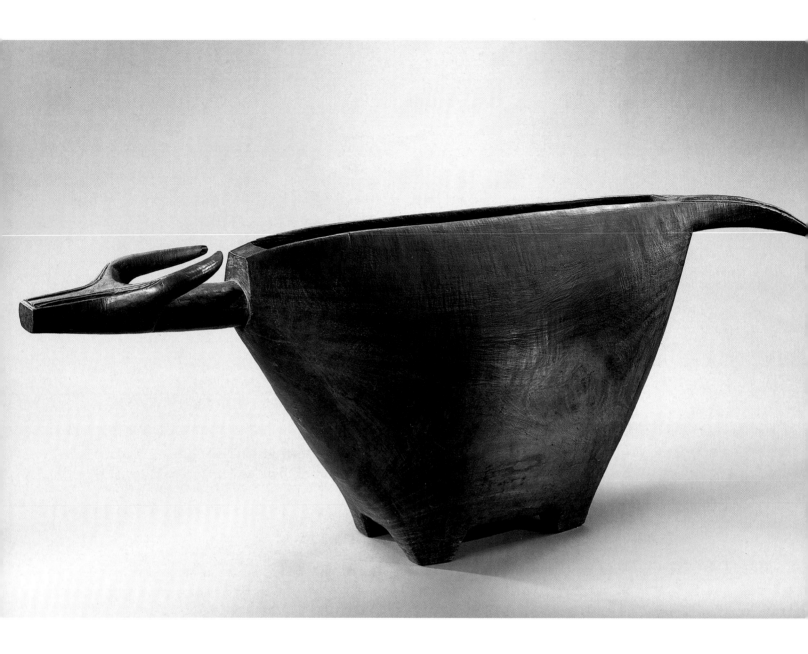

He also noted that this type of drum was used to "notify the people of meetings, announce a declaration of war or a hunt, give notice that a council, celebration or other event is to be held", adding that this boviform instrument "was never lacking in the residence of a chief or an authority of some importance amongst the Niam-Niam".

A photograph taken in 1913 in the village of Manziga, near Niangara in Zandeland (the present-day Democratic Republic of the Congo), shows a similar drum being played by two musicians, one of whom is seated on the instrument and covers part of the slit with his heel, which acts as a mute for the instrument itself.[3]

Finally, it has also been pointed out that the drum that interests us here recalls those – likewise attributed to the Yangere – that are kept in the American Museum of Natural History in New York and the Museum of Anthropology in Khartum.[4]

The information at our disposal concerning this piece is indeed summary. That lack, however, should not hinder us from considering the drum's exceptional formal qualities, which fully justify the presence of this work of art, and the singular beauty it embodies, in the Louvre's galleries.

The drum's robust corporeity, suggestive of the animal it imitates, is refined in a structure that is both immediately clear and masterfully controlled. Yet this imposing form continues to throb with a secret life.

The artist manages to reinvent the buffalo's volumes and their normal organisation while shaping them to his own designs, which he pursues to the end with a clear vision. To obtain such a result, the sculptor had to shorten the bovine's legs by both merging them with the compact, fundamental volume of the animal's body, and prolonging in them the daring lengthwise narrowing of the over-

françaises, 1972, no. 162, p. 72; S.M. Vogel and F. N'Diaye, 1985, no. 89, p. 106, p. 107 and p. 160; J. Kerchache, J.-L. Paudrat and L. Stéphan, 1988, no. 640, p. 436; E. Bassani and W.B. Fagg, 1988, fig. X, p. 17; E. Bassani, 1989, no. 143; E. Bassani, 1992, p. 244; S. Fuerniss, 1993, fig. 10, p. 103 (drawing).

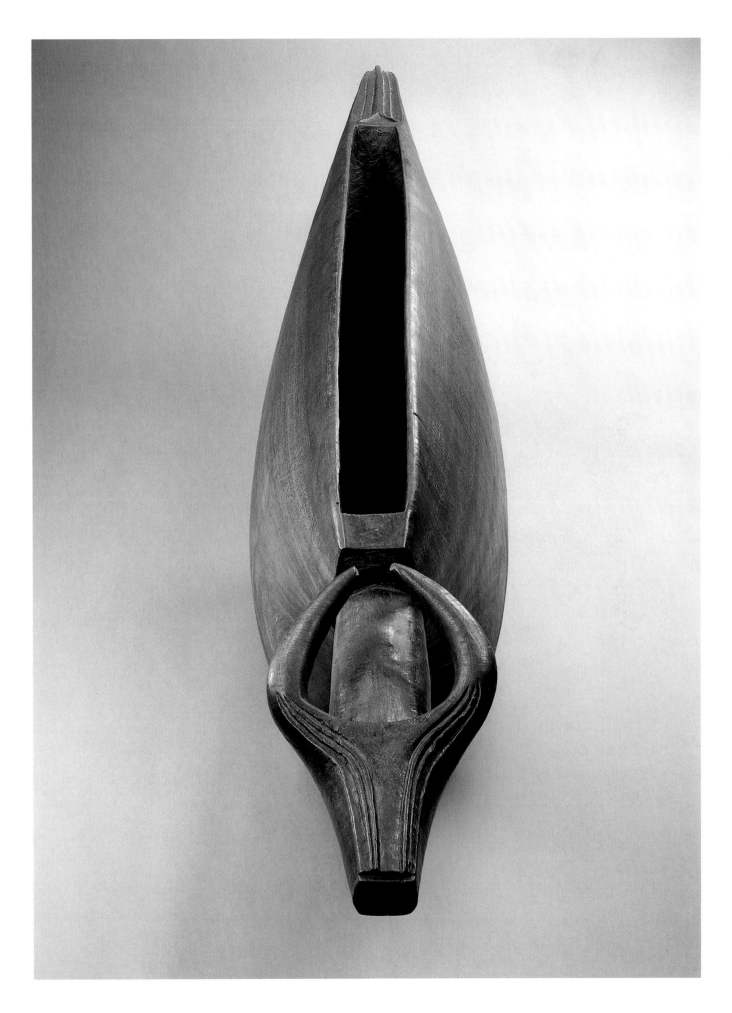

all form. The whole, seen from the side, corresponds to a form that is dilated above, as if ready to float away. Viewed head on, the drum is an unmistakable presence thanks to the triumphant fullness of its flanks heightened by the calculated flattening of its front surface, also shaped like a trapezium, but one that narrows at the top. The head and tail render the volume of the belly lean and airy, and enhance its elegance.

The way the movement of the piece's long horns manifestly complements that of the pointed tail, and the coherent incising that underscores their form, almost suggest that this monumental drum was modelled in some sort of aerodynamic wind tunnel, like the fuselages of modern aircrafts.

The traces of the flowing air that shaped the instrument's outlines seem incised on the wood's surface, adding to its beauty.

In reality, the formal perfection of this drum lay in the powerful imagination of an African sculptor whose name has not come down to us. He was unquestionably a great artist engaged in a stirring quest for the absolute.

EZIO BASSANI
Translation: John O'Toole

1 Registered 16 April 1896 under no. 39093: "large war tamtam, thick hollowed out tree trunk with carved bull's head. Two rubber mallets. Yangere."

2 G. Schweinfurth, 1875, pl. XI, fig. 8.
3 T. Ross-Miller, 1990, p. 211, fig. 10.18.
4 S.M. Vogel and F. N'Diaye, 1985, notice 89, p. 160.

Luba sculpture

19th century
"Master of the Cascade Coiffures" (workshop of Kinkondja)
Democratic Republic of the Congo

Headrest

Wood
H. 18.5 cm
Formerly the Baron Henri Lambert (Brussels) and Hubert Goldet collections
Musée du Quai Branly (donation 1999)
Inv. 70.1999.9.1

Main Exhibitions
Brussels, 1958;[5] Paris, 1989a; Paris, 1993-94b; Tanlay, 1997.

Main Publications
J. Cornet, 1972, no. 105; E. Bassani, 1976, fig. 22, p. 85; *Sotheby's*, 1988, no. 89; C. Falgayrettes, 1989, pp. 72-72; E. Bassani, 1989, p. 23; E. Bassani, 1992, p. 23; F. Neyt, 1993, p. 187; *Lumière noire, arts traditionnels*, 1997, no. 76.

Headrests have been quite common in Africa since antiquity. They are an indispensable furnishing for repose, allowing individuals to lie down without disturbing highly elaborate headdresses. When carved for an important person, chief or king, the headrest surpasses its function as a mere useful object to become a token of prestige, both a substitute of the person that the piece symbolically represents and often, as Albert Maesen notes, a marvellous work of art.

The headrests carved by the Luba artiste of the small kingdom of Kinkondja (a group that is part of the great Luba nation living in the region of Shaba, in the southeastern Democratic Republic of the Congo) are greatly prized precisely for their major formal qualities.

In 1976 I published a tentative list of the headrests (around 15 pieces) executed by what I thought was a single artist who was active between the end of the 19th century and the first quarter of the 20th, a great miniaturist whom William Fagg dubbed "the Master of the Cascade Coiffures".[1] The name springs from the particular modelling of the hair adorning the figures that sustain the upper shelflike support for the head. This style of hair is seen in nearly all of the pieces attributed to the artist.

Nine headrests have but one caryatid, each carved in a different pose, while five show two such figures seated face to face. All these figures are of undetermined sex. A fifteenth piece has come to light which displays a surprising image in as much as the caryatid is depicted astride a quadruped.

The headrest that once was part of the Lambert Collection, now on display in the Louvre, and another, very similar piece in the National Museum of Denmark (formerly the Kjersmeier Collection) are distinct from the three other double caryatid head-

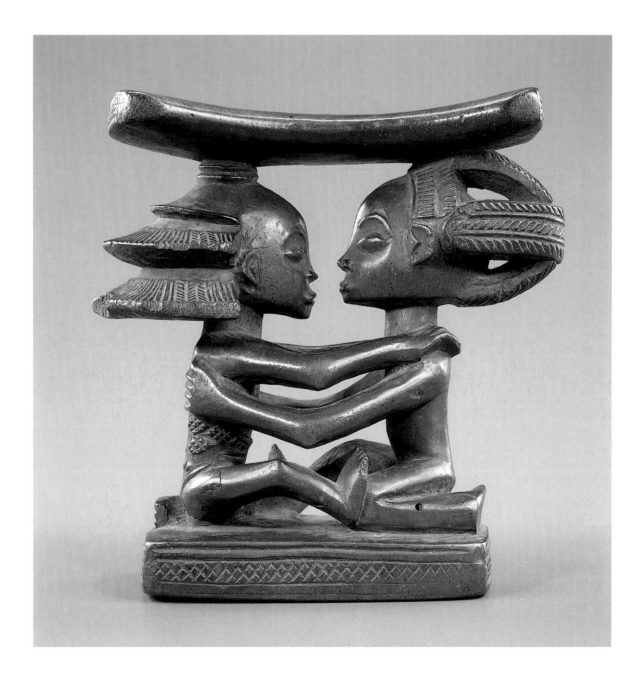

Fig. 1
"Master of the Cascade Coiffure", worshop of Kinkondja
19th century
Democratif Republic of the Congo
Wood
L. 19 cm
Formerly the Carl Kjersmeier collection
Nationalmuseet Copenhagen

rests because one of the two figures boasts a cruciform headdress. Closer comparison reveals a number of more subtle differences, either in the treatment of the faces (for example, the absence of slits representing eyes in the two specimens), or in the depiction of the caryatids bodies. This suggests the existence of a workshop in which more than one sculptor would have been active and which François Neyt[2] has located in the small kingdom of Kinkondja near Lake Kisale. We should recall that the first headrest about which some information exists, kept in the Florence museum, was found in 1901 in a village which the museum inventory designates as "Kikondja". If this hypothesis is correct, the two headrests in Paris and Copenhagen,

because of their formal quality, are the work of an artist of great maturity, a highly talented sculptor and heir to a tradition going back centuries.

The faces of the two figures give off a pure and imperturbable look. The heads boast elegant profiles, overly broad foreheads, small lips wearing a proud expression, and bulbous eyes set in shallow sockets – a truly harmonious composition. The mass of hair renders the heads, already quite sizable in their own right, even more imposing. Thrusting out into space, each of these incredible headdresses is quite distinct thanks to a unique structure whose volumes, however, beautifully counterbalance one another. Through a subtle play of correspondences, the cascading movement of one matches the other's cruciform mass of woven braids.

Whereas the cascade coiffure (*mikanda*), which has given its name to the presumed author of a large number of headrests, is typical of the Luba of Shaba,[3] the cruciform hairstyle is more associated with the Hemba living to the northeast.

The torso of the figure with the cascade headdress is decorated with scarifications. This is the sole example of the entire series and it is not unreasonable to conclude that this figure represents a woman. The rite of placing one leg on another's knee, pictured in this sculpture, is a sign of allegiance and alliance. These pieces might therefore illustrate the matrimonial politics of Kinkondja's sovereigns.[4]

The volumes of the large heads, upright torsos, long, smooth limbs of the two entwined figures and those of the upper tablet and the base are laid out according to a rigorous, monumental geometry. The inner tension passing through the bodies, the fluidity of the outlines and the delicacy of the surfaces lessen this rigour and infuse the entire sculpture with life. It is a life that, for all its secrecy, is no less perceptible to the eye.

EZIO BASSANI
Translation: John O'Toole

1 W. Fagg and M. Plass, 1964, no. 88.
2 F. Neyt, 1993, pp. 184-85.
3 See E. Bassani, 1977, nos. 28-30,
 and M. Nooter-Roberts, 1998, p. 65.
4 F. Neyt, 1993, p. 184 and p. 192.

Songye sculpture

1850-1892
Democratic Republic of the Congo

Headrest

Wood
H. 14 cm
Formerly the Stephen Chauvet, Maurice Ratton and Philippe Ratton collections
Musée National des Arts d'Afrique et d'Océanie
Inv. A. 86.1.3

Exhibition
Paris, 1930.[19]

Main Publications
V. Markov, 1919 (photograph of a plaster cast), p. 91, no. 55; A. Basler, 1929, no. 57; A. Portier and F. Poncetton, [1929], pl. XXII, no. 34; *Exposition d'art africain et d'art océanien*, 1930, p. 30, no. 260; S. Chauvet, 1930a, p. 854; R. Lehuard, 1974a, fig. 2, p. 10 (detail); *Collection d'objets d'Afrique et d'Océanie*, 25 June 1986, no. 86; *Musée des Arts africains et océaniens, Guide*, 1987, no. 83, p. 124; M.L. Felix, 1987, no. 20, p. 165 (drawing); J.-L. Paudrat, 1987, p. 169; J. Kerchache, J.-L. Paudrat and L. Stéphan, 1988, no. 725, p. 452; C. Falgayrettes, 1989, p. 82 (right).

The fortunes of this Songye headrest in Europe involve a little mystery. In 1919 a posthumous work by Vladimir Markov[1] reproduced an identical sculpture with the indication "Paris Trocadéro" printed under the photograph. V. Markov had indeed shot a series of photographs in the summer of 1913 at the Musée d'Ethnographie du Trocadéro (the future Musée de l'Homme). The series shows a number of objects that were then in the museum.[2] Yet no trace of the piece seen in Markov's photograph can be found today in the Musée de l'Homme; on the other hand, the museum has had in its collections since 1892 a plaster cast of the sculpture that is painted black; it was donated to the museum, along with a second cast, by the Société d'Anthropologie in Brussels.[3] It is surely this cast that Markov photographed in 1913.

The object was subsequently published in 1929.[4] The photograph in question shows the original piece, which belonged to Dr Stephen Chauvet (1885-1950). According to Colette Noll, S. Chauvet apparently obtained the work "before 1923",[5] the year that witnessed the opening of the exhibition *L'Art indigène des colonies françaises d'Afrique et d'Océanie et du Congo belge* at the Pavillon de Marsan. It was Dr Chauvet who wrote the guide, published in 1924.[6] Maurice Ratton (the brother of C. Ratton) bought the piece in 1967 along with several other works from Dr Chauvet's daughter.[7] M. Ratton's son in turn put the headrest up for sale at Merton Simpson's in New York in the early 1980s and subsequently in 1986 at the Hôtel Drouot, when it was acquired by the Musée des Arts Africains et Océaniens.

Culturally and historically the Songye[8] are linked with the Luba living to the west (especially in the Kasai) and south (Shaba). The Songye's neighbours from north to east are the Tetela, the Kusu, the Hemba and the Luba-Hemba. The Luba exercised a clear influence in the 19th century on the southern Songye, whose identity reflected the interpenetration of both cultures.[9]

These ties can be seen in the arts; like the Luba and the Hemba, the Songye possess ornate caryatid stools. Songye headrests and their carved cup-bearing figures also spring from a tradition shared with the Luba. Like the caryatid seats, several headrests have been attributed to Luba-Songye workshops, reflecting in their styles the mixture (in terms of both human origins and social, political or religious structures) that characterised the societies acquiring them. Like their counterparts settled in nearby Luba-Hembaland,[10] the sculptors who were responsible for the Luba-Songye styles[11] surely did not work for a single culture.

Evincing these interethnic stylistic links, a number of headrests constitute, in terms of form, veritable transitions between the styles of the Songye and the Luba.[12]

The Songye (whose *kifwebe* masks are also found amongst certain Luba) produced a great number of anthropomorphic statues and statuettes with expressive faces. These are called *mankishi* (*nkishi* in the singular). Several of these objects (the style of some being akin to that of the headrest from the former Chauvet Collection[13]) were linked to the powers of religious persons (*nganga*), like the statues studded with nails found amongst the Kongo peoples. Such pieces were heightened with materials meant to reinforce their power such as brass tracks, horns, animal skins, feathers or other elements forming the object's charge.

These singular figures (whose faces recall the more stylised ones seen in elongated *kifwebe* masks) were once quite common amongst the Songye and their aesthetic resurfaces in Songye caryatid stools, cup-bearing statues and headrests. Use of these last three types of sculpture, however, as well as their function and production, was far more developed amongst the Luba. Unlike the Songye's decentralised society,[14] Luba culture was made up of kingdoms which required, for Luba sovereigns and their courts, a greater number of prestige objects (including royal seats, cup-bearer figures and headrests enabling notables to lie down without disturbing their skilfully arranged headdresses). Nevertheless, it is quite possible that in Songye regions where the influence of the Luba was especially pronounced (in so-called Luba-Songye societies), sociopolitical structures were similar to such structures amongst

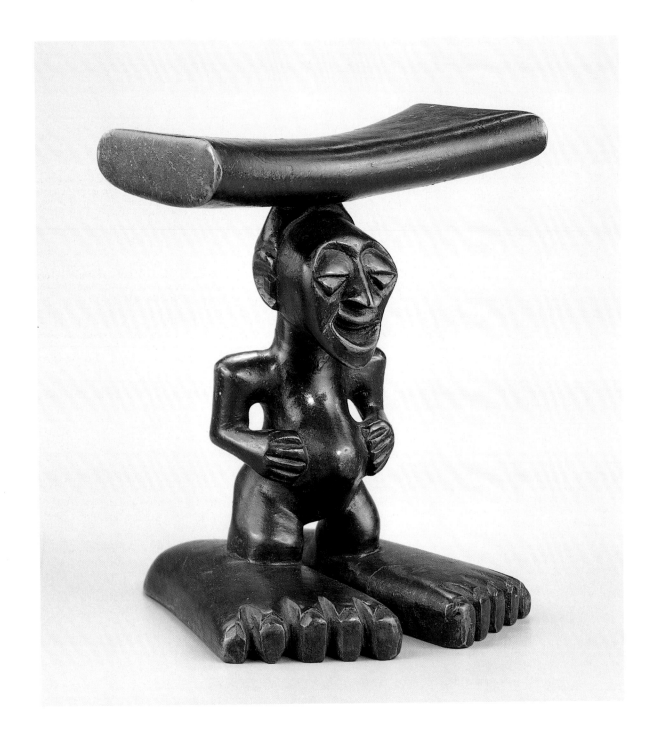

the Luba. In artistic terms, this would have meant the use of objects that were comparable to those commonly found in the other culture.

In contrast to most Luba headrests, the Songye's depict male figures. Carved in a style that is not unlike that of *mankishi*, the Louvre piece boasts enormous feet, a feature that never attains such gigantic proportions in Luba works. These immense feet have been with power and acquisition of territory.[15] Unlike Luba headrests, moreover, all of which have a more or less light brown finish, the Chauvet piece has a rich black patina that is comparable to the patinas of *mankishi*.[16] The position of the arms, with the hands placed on either side of the navel, is also found in Luba headrests and *mankishi*. According to F. Neyt, this position, which is frequent in Luba statuary, Hemba and Kusu effigies and Songye figures used in cults, shows "how much the ancestor is at the source of a lineage and watches over his own descendants".[17]

While the function of Songye headrests seems to spring from a Luba tradition, the style of the piece from the former Chauvet Collection (like the style of *mankishi*) is unquestionably part of Songye culture. The iconography of this style draws on a body of cultural references that was once shared by not only the Luba and the Songye, but others as well, including the Hemba and the Kusu. The sculptor of this piece worked in the 19th century in a context of intense cultural exchange.[18] This headrest offers us a kind of model in miniature of precolonial Songye culture. Precisely because the image's formal expression is such a virtuoso performance, concentrated into a true tour de force, this piece is indeed monumental despite its small size.

VINCENT BOULORÉ
Translation: John O'Toole

1 V. Markov's work was rediscovered by J.-L. Paudrat in 1972 during the 2nd Biennale du livre africain in Yaunde. Previously, the existence of Markov's work (no copies were available in Western Europe) was limited to a few mentions in other studies, by M. Leiris and J. Delange, 1967, and J. Laude, 1968 (p. 39), who refers to the painter Vladimir Matveï, Markov being a pseudonym (pers. com. J.-L. Paudrat, March 1999). J. Laude and M. Leiris learned of this publication's existence in 1966 in Dakar from D. Olderogge during the Festival Mondial des Arts Nègres (pers. com. J.-L. Paudrat, *ibid.*).

2 J.L. Paudrat, 1987, p. 148. V. Markov also shot photographs in other European museums including Berlin's Museum für Völkerkunde and London's British Museum (*ibid.*).

3 J.-L. Paudrat drew my attention to this cast in November 1998; it corresponds to no. M.H. 92.31.2 (formerly M.E.T.: 32 195). The second plaster headrest is listed as no. M.H. 92.31.1 (formerly M.E.T.: 32 194). Both were recorded on 10 June 1892 in the *Inventaire des collections du musée d'Ethnographie du Trocadéro* (cat. 17). Initially they were listed as "West African", before being ascribed to "Léo Congo", and attributed to the "Baluba" during reorganisation of the museum's inventory in the 1930s.

4 In A. Basler (1929), A. Portier and F. Poncetton (1929) and later the *Exposition d'art africain et d'art océanien* (1930), the piece was attributed to the Bambala, the last two publications adding the indications "Kwilu River region" and "Kioilu River" respectively. The Bambala were settled near the Suku and the Waan, in other words far to the west of the Songye region. This erroneous attribution might actually refer to one of the sectors through which the object passed before being collected by a European (almost certainly a Belgian national).

5 In *Musée des arts africains et océaniens, Guide*, 1987, p. 124.

6 S. Chauvet, 1924. Chauvet fails to mention the piece in this guide, but does reproduce it later in *Variétés* (S. Chauvet, 1930a, p. 854) and subsequently in *La Vie* (S. Chauvet, 1930b, p. 185 *sqq.*).

7 See P. Ratton, 1987, p. 6.

8 According to F. Neyt (1981, p. 259), the Songye term was applied during Belgian colonisation to peoples who referred to themselves as "Bayembe".

9 Besides their linguistic connection, both the Songye and the Luba mutually recognise the same mythic ancestor, Kongolo (M.L. Felix, 1987, p. 164), just one of the multiple links between the two groups. Until the end of the 19th century, the Luba empire (founded in the late 16th century according to oral tradition) also maintained important links with neighbouring peoples, the Lunda, the Kusu, the Zela, the Kanyok and the Hemba. Several of these groups in turn were in contact with the Songye.

10 Where the so-called "Buli master" (Ngongo Ya Chintu, a native Hemba) worked in the mid-19th century in Kateba, carrying out commissions from the Luba and the Hemba (in a region where the Kusu were also settled).

11 See F. Neyt, 1993, p. 91.

12 See for example the headrests reproduced in F. Neyt, 1993, p. 190 below (Luba-Songye master) and p. 191 (Luba workshop of the Lukuga).

13 *Afrikanische Skulptur: Die Erfindung der Figur – African Sculpture: The Invention of the Figure*, 1990, no. 102, p. 209.

14 In villages, power was partly exercised by the *nganga* and *kifwebe* mask societies, which did not exist amongst all the Songye however. *Kifwebe* societies notably served as a kind of police.

15 J.W. Mestach, quoted in C.D. Roy, 1992, p. 166.

16 See for example J. Kerchache, J.-L. Paudrat and L. Stéphan, 1988, no. 202, p. 308.

17 F. Neyt, 1993, p. 178. Stressing the symbolic importance that the umbilical area has for the Luba and the Songye, Neyt (*ibid.*) quotes Clémentine M. Faïk-Nzuji (1992, p. 86): "Because everything fits together, from the fetal state man is attached through his mother to his initial source, to ancestors, the living, the elements and the cosmic forces. It is through his navel that this contact is made. A proverb sums this thought up in the following terms: "Humanity begins through the navel." The navel is the "key" that opens the world, it is the opening through which man establishes his first contact with the universe, the centre towards which the forces that are favourable to fecundity converge, especially those springing from the spirits of nature. It is through the navel that man partook of the essences necessary to his growth and animation."

18 The second cast at the Musée de l'Homme indicates that a second piece, quite probably carved by the same sculptor, existed before 1892. This cast offers a singular trait, i.e., its left arm is missing; likewise the position of the piece's only arm, which is depicted touching the figure's beard, is rare in the iconography of Songye, Luba-Songye and Luba art. *Per contra*, a similar (albeit longer) beard is seen on a headrest with two figures in the Musée de Tervuren (*Trésors d'Afrique. Musée de Tervuren*, 1995, no. 149, p. 182). In this instance, the hands of the bearded figure are resting on its breast (a position frequently encountered in Luba art). The small triangular beard of the second also recalls those worn by certain *mankishi* (*Afrikanische Skulptur: Die Erfindung der Figur – African Sculpture: The Invention of the Figure*, 1990, no. 102, p. 209). Finally I should note that the second cast reveals on the lower back a group of triangular scarifications that are comparable to groups seen in Luba sculpture (see for example F. Neyt, 1993, p. 155); this motif appears on the back of one of the two figures forming the headrest in the Musée de Tervuren mentioned above (*Trésors d'Afrique. Musée de Tervuren*, 1995, no. 149, p. 182).

19 Piece mentioned in the catalogue *Exposition d'art africain et d'art océanien*, 1930, no. 260, p. 20.

AFRICA

Waan sculpture

19th century
Democratic Republic of the Congo

Ivory
H. 7.7 cm
Formerly the Charles Ratton and Guy Ladrière collections
Donated by Guy Ladrière, 1997
Musée du Quai Branly
Inv. 70.1997.1.1

Exhibition
Paris, 1986.

Main Publications
E. Elisofon and W.B. Fagg, 1958, no. 202, p. 161; W. Gillon, 1979, no. 26, p. 32; *Ouvertures sur l'art africain*, 1986, no. 1, p. 17; J. Kerchache, J.-L. Paudrat and L. Stéphan, 1988, nos. 213 and 214, p. 331; J. Cornet, 1989, p. 293.

The first Waan ivory carvings to appear in the West were collected at the close of the 19th century and are outstanding for the quality of their craftsmanship. In 1906 several pieces (all of which came from around the Djuma) were reproduced in the *Annales du musée du Congo* (the museum in question is now known as the Musée Royal de l'Afrique Centrale in Tervuren), giving a clear idea, even at this early date, of both the formal and iconographic diversity that characterises these carved miniatures. One of these, for example, depicts a small kneeling figure in the round, with a bulging belly, hands resting on the cheeks, and a crest-shaped headdress. Four other sculptures of the same series represent a kneeling low relief figure carved from a flat piece of ivory, shown facing the viewer and in frontal perspective. Finally, another piece boasts two symmetrical faces.[1]

Called variously the Huana, Bahuana, Hungana or Hungaan in ethnological literature, the Waan live in the southwest of the Democratic Republic of the Congo (former Zaire) between the Wamba and Kwilu rivers as well as along the right bank of the latter. They share the same area with a number of different groups such as the Ngongo, the Yansi, the Tsaam, the Pindi and the Mbala. Natives of the Kwanza region in Angola, the Waan migrated along with the Mbala to their present home. The language of the Mbala, moreover, reveals a number of affinities with the tongue spoken by the Waan. In the north certain Waan have ties with the Teke.

The function Waan ivory carvings served is largely a mystery. A great number, however, have holes cut through them, indicating that they were probably suspended. Daniel Biebuyck states that, according to Leo Frobenius (who collected the piece in 1904), one such ivory carving, a flat figure modelled frontally, would have been worn around the neck.[2]

Waan society is matrilineal. The activities of their ritual experts (*nganga* or *nga*) specialised in divination and therapeutic or prophylactic rites require the use of statuettes measuring 5 to 50 cm, known as *nkonki*.[3] In the past, moreover, some women wore very small *nkonki* on their forehead or pubis.[4] D. Biebuyck explains that "when such a woman marries, the husband must first remove the *nkonki* ceremonially; when she later bears a child, he must libate the image with blood".[5] This particular use is not attested for the ivory figurines (which are no longer produced today), but we can presume that they were used individually by women. Given the great care that clearly went into carving it, the piece now on display at the Louvre most probably belonged to a woman of high rank.

Linked with the idea of fecundity, Waan ivory carvings were very likely endowed with protective powers. With its prominent head, this figurine from the Charles Ratton Collection resembles a foetus in the womb that has raised its hands to its mouth. The exaggerated umbilical projection likewise recalls the same bulge in foetuses, newborns, or very young children (while also suggesting, like a number of other Waan sculptures carved in ivory[6] and wood, the round belly of a pregnant woman). The kneeling position, a recurrent motif in all Waan ivory carvings depicting a figure, might refer to the position of a foetus. This singular image then can be associated not only with childhood and pre-childhood, but also with labour and birth (which this amulet was meant to promote), the link between mother and child (given concrete expression with the highly developed umbilical protrusion and the belly), and fertility and fecundity. The figurine also boasts an elaborate headdress,[7] an adult hairstyle that contrasts with any connotations of childhood and children. This contrast is perhaps a way of insisting on the importance of other meanings, while underscoring both the high rank of the woman who owned the carving and the noble lineage of the child she was to bring into the world.

This piece, which was also part of the Guy Ladrière Collection (like C. Ratton, Ladrière owned numerous medieval ivory carvings as well), clearly rivals the finest carved miniatures of the European Middle Ages. It brings together a deft mastery of the low relief technique and a subtle treatment of the statuette's volumes in three dimensions. The quality of the low-relief carving is evident in the slender dimensions of the image whose elements (legs, buttocks, back, shoulders, facial features, headdress) have been modelled in slight relief. Yet

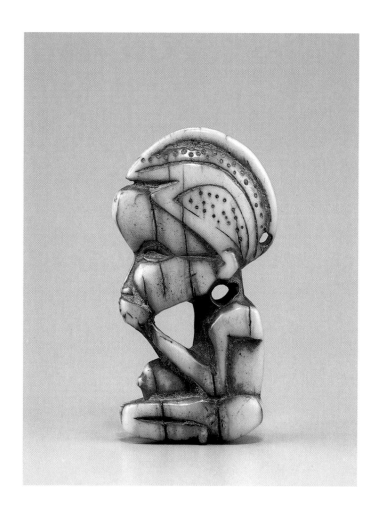

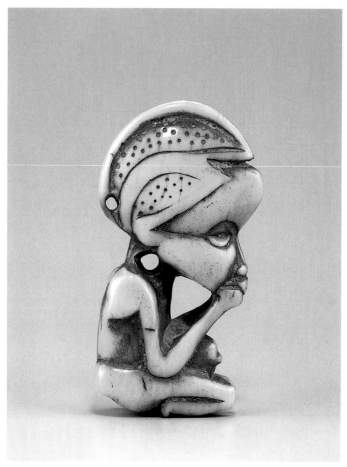

these volumes seem more developed than they are in reality, thus imbuing the little figure with life. By clearly detaching the arms from the body,[8] developing the navel or belly, and modelling both sides of the subject, the sculptor here transformed this low relief into a statue in the round. His unique talent is equally on display in the crested head-dress and its finely chiselled sides. This art of mixing low relief and modelling in the round (transcending the former while adroitly working the latter into thin piece of ivory, a form probably imposed by the fact that this pendant was worn over the pubic region) clearly distinguishes the singular style of this master ivory carver. The unknown African miniaturist reveals a sensibility and a dexterity that remain unparalleled today.

VINCENT BOULORÉ
Translation: John O'Toole

1 See respectively: E. Coart and A. de Hauleville, 1906, pl. XLVII, no. 579 a and b (a piece that seems akin to those reproduced in K. Krieger, 1969, fig. 184, and C. Einstein, 1922, pls. 42b and 43; the latter, once owned by C. Einstein, is conserved today in Zurich's Museum Rietberg); ibid., pl. XLVIII, nos. 586, 587, 588, 589, 590 (the last-mentioned miniature seems to have come from the same workshop as no. 588). See also two other figures depicted frontally that are reproduced in C. Einstein, 1922, pl. 47, and E. von Sydow, 1932, p. 117, fig. b.
2 D. Biebuyck, 1985, p. 157. This object, which L. Frobenius calls halskitekki, is reproduced in

K. Krieger, 1969, fig. 185; it can be compared with another ivory carving (formerly the C. Monzino Collection) reproduced in S. M. Vogel, 1985, no. 134, p. 184. D. Biebuyck (ibid. pp. 156-57) has classified these ivory carvings and Waan bone miniatures into two categories, namely, those representing a complete figure and those carved from a flat piece of ivory or a flat bone. The latter offer a greater diversity of forms, from complete figures, for example, to large heads either alone or in pairs.
3 Ibid. p. 155.
4 Ibid. p. 156.
5 Ibid. p. 156.

6 See, for example, the figure reproduced in C. Falgayrettes-Leveau, 1994, p. 230, although this piece clearly resembles a foetus.
7 This headdress can be compared with the one represented in several Mbala sculptures (D. Biebuyck, 1985, pl. 29; W.B. Fagg, 1964b, pl. 72).
8 This position of the arms with the hands resting on the mouth is also seen in Waan statuettes carved from wood, notably in one with an arrangement of the neck, arms and head that shows a virtuosity comparable to the technical brilliance of the ivory carving from the Ladrière Collection (see "Magies", 1996, p. 52).

Yombe Sculpture

19th century
Stylistically recalling "The Luozi Master"
North Kongo, lower Zaire, Republic of the Congo or Democratic Republic of the Congo

Figurated Finial in Ivory (zizi *a mpongi*) of the Staff (*mvwala*) of an Important Person

Ivory
H. 22.7 cm
Collected in Yombe before 1914
Gift of Anne and Jacques Kerchache
Musée du Quai Branly
Inv. 70.1998.10.1

Main Exhibitions
Zurich, 1970-71; Essen, 1971.

Main Publications
E. Leuzinger, 1970, S 17, p. 272;
E. Leuzinger, 1971, S 17, p. 276;
R. Lehuard, 1998, M 12, p. 983.

Other sceptres announced connection with power, the noble ancestors and their spiritual vision by means of the omniscient dog image, or the cryptic focus of eyes without pupils. Here connections with the authority of the dead are implied by a socket above the head of a personage. This socket once held a ball of medicated resin, translating the sceptre into a "medicine of God" (*nkisi*). Capturing spirit in the resin, the *nkisi*-sceptre commands the spirit to empower the holder of the staff, via various symbolic signs.[1] Lehuard, for example, illustrates an *nkisi* sceptre where the medicated charge carries the brisling tail of an athererus, a fast-moving species of porcupine.[36]

In such a case the *nkisi*-sceptre commands the spirit to protect the ruler from jealousy by giving him powers of fast evasion, like the fleetness of the atthererus,[3] and the power to discharge mystical quills, like a porcupine defending itself.[4]

Below the socket, where the medicated ball of resin anchored the spirit within the sceptre, a personage is shown chewing on a *munkwisa* root. This activates another line of spiritual defence. *Munkwisa* is a medicine for neutralising the jealous

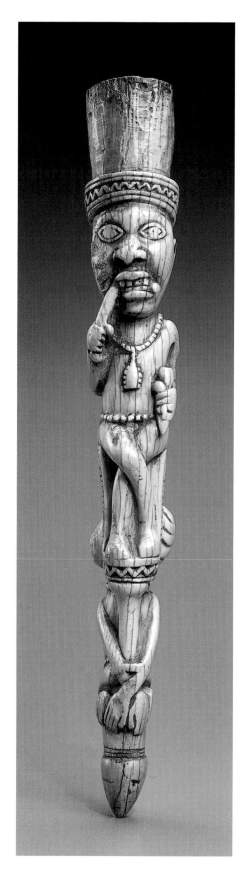
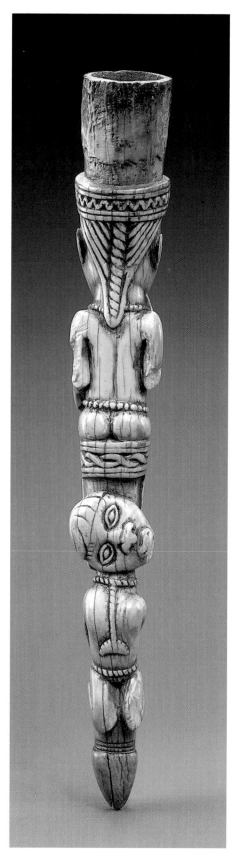
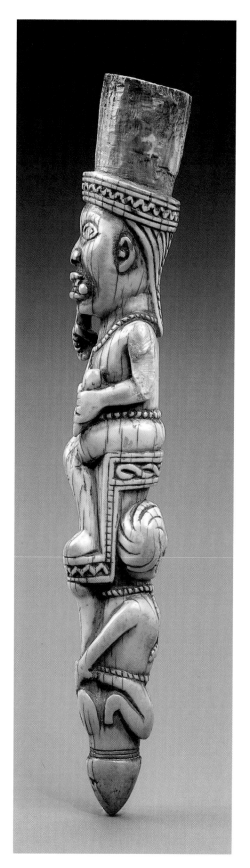

actions of the *ndoki*, that is, a dangerously anti-social person. By chewing on this herbal root, as rendered here, and spraying its juices in a mist over followers, the ruler builds a protective aura around them.[5]

The image is classically Yombe, matching the canonical picture of an enthroned Yombe chief, chewing on *munkwisa*, held in his right hand, and holding a sceptre of investiture in his left.[6] Above his head and below his feet appear zigzag bands reminiscent of the stylised boundary of Kalunga observed on the staff of a kneeling woman formerly in the Tishman collection (p. 200).

The left hand of the seated ruler translates spirit into action, crossing the little finger over the adjoining digit. Finger crossing (*bindika nlembo*)[7] is significant in Kongo life and art. It "ties" or mystically "targets"[8] a threatening or annoying person. If someone is talking out of turn before the chief, the latter makes this sign to tell him to shut up. It can be done with any digit, not just the little finger, as in the style of the Yombe sceptres. It also seals important agreements. "Do we have a deal?" an elder might ask the chief. Crossing two fingers, the chief confirms that "We do."

So the sign tells the spirit in the medicated sphere to silence enemies and enforce agreements that bind the community. Crossed fingers also cite the proverb, "Five fingers compose the hand", meaning that without solidarity the clan cannot function.[9]

The ruler does more than cross his fingers. He also passes his left leg over the right, forming the *kambika maalu*[10] gesture. In so doing, he adds to the protective aura of *munkwisa*. With this criss-cross motif he says, in effect: I work in the spirit, so I cross my legs to close the door to the royal enclosure (*kanga lyymb*). There no one can reach me, not even my wife. There I can concentrate on problems of government, hoping to arrive at the right decisions.[11]

In addition, the seated ruler wears a miniature representation of a dog-bell (*dibu*). Kongo dogs are barkless, hence men tie dibu bells to their necks to locate them when hunting without frightening the game away.[12] By analogy with the silence of the dog, *dibu* teach the ritual expert or chief the art of total silence – in order to know and hear what is going on around him (*dibu diasadulwa mu longa kwa nganga evo mfumu kinkete kia dingalala napi – mu zaaya ye ma mena mu kinzungidila*).[13]

The seated ruler on the sceptre meditates, maintaining a knowing silence, in a state of ritual nakedness. His only dress is a necklace and hip beads. Fu-Kiau explains: "Confronted by a crisis, a ruler, at night, when the whole village is sleeping, may take off his clothes to speak to Kalunga: Here I stand naked (*kala kimpene*) as I was when fashioned by your hand. Tell me (in a dream, or possession by the spirit) what is wrong with the community and what must be done to solve it."[14]

As the ruler ties himself to a realm of moral meditation, we note a literally tied-up captive below him, head bent down dramatically (*nsingu yakondama*). It is easy to read a master and slave relationship into this juxtaposition, like a page out of Hegel. But Kongo symbolism is often double-edged. Accordingly, we look for a plus behind a minus, a blessing behind a curse. Is the person bound up beneath the ruler a slave (*nkongo*) in an absolute sense? Note that he wears the prestigious miniature lemba slit-gong (*nkongo a lemba*) around his neck, hardly the accoutrement of a nonentity.

Note also that the slit-gong (*nkongo*) hangs more or less over the region of the navel (nkongo), itself a sign of heritage and descent. The problem of the interpretation of this subsidiary figure is far too complex to be solved in these pages. But the evident punning in Ki-Kongo alerts us that he is possibly a "slave" to the laws and taboos of the king and the kingdom, i.e., a subject, as opposed to someone without pedigree, the classic Kongo definition of a slave. Whatever the agony symbolised by his condition, the bound figure with bent-down head challenges the bearer of the sceptre to redress the problem – and liberate those of us who are bound by it.[15]

ROBERT FARRIS THOMPSON

1 For a superb elucidation of the *nkisi* process, see W. MacGaffey, 1993, pp. 21-103.
2 R. Lehuard, 1998, see detail, p. 947.
3 I thank the late Albert Maesen of the Royal Museum of Central Africa for a superb informal seminar on the role of the athererus in Kongo *nkisi*-making, summer 1977, in Tervuren, Belgium.
4 Interview with Balu Balila, Kinshasa, July 1997.
5 J. Cornet, 1975, p. 39.
6 R. Lehuard, 1998, pp. 925-951.
7 K. Laman, 1936, vol. I, p. 41.
8 *Ibid*.
9 R. Lehuard, 1998, p. 932.
10 K. Laman, 1936, vol. 1, p. 209. As to *kambika*, note the nuances embraced by this verb: "to tie by crossing", "to build a dike or barrier".
11 For more on *luumbu* see R.F. Thompson, 1981, ch. 1.
12 J. Janzen, 1982, p. 220.
13 Fu-Kiau, personal communication, 15 May 1999.
14 *Ibid*.
15 *Ibid*.

Kongo Sculpture

19th century
Master of the Dog Medium Sceptre
Yombe country, south-west republic of Congo or Democratic Republic of the Congo

Sceptre *(mvwala)* with Finial Showing Kneeling Ritual Leader with Dog's Head

Ivory, iron, brass
H: 19.6 cm
Formerly in the Paul and Ruth Tishman collection
On loan from The Walt Disney/Tishman Art Collection
Inv. AF. 051.121

Main Exhibitions
Los Angeles, 1968-69; Richmond, 1970; Austin, 1970; Saint Louis, 1971; Des Moines, 1971; Huntington, 1971; New York, 1981; Los Angeles, 1992-93; London, 1995-96; Berlin, 1996.

Main Publications
R. Sieber and A. Rubin, 1968 and 1970, no. 133, frontispiece; S.M. Vogel (ed.), 1981, no. 126 , p. 212; D.H. Ross (ed.), 1992, fig. C, p. 227; T. Phillips (ed.), 1995, no. 4.5b, p. 243; T. Phillips (ed.), 1996, no. 4.5b, p. 243.

This figure is aligning his fingers horizontally over the curve of his abdomen, a gesture that immediately indicates that this sceptre is highly charged with symbolic power. This is *ketikisa*[1] (literally, to place in doubt), a hand position assumed when one is questioning a person or a group. When something is wrong within the clan, and the elder wants to ask questions to pierce the *lungu*, the hidden difficulty that is blocking someone's life, he strikes this pose. Ketisa admonishes a person to *keba* (be careful!), because if we don't know what you are up to we do know that it is time to investigate. By covering his navel, the symbol of people's first channel of communication with the outside world (*nkumba i sensu ye ngogo yantambukusu ye ku mbazi*), the ruler-medium signals that an investigation is going on.[2] All channels of communication become classified and covert.

In this context, seeking hidden information, note that the head of the ritual leader turns into that of a dog (*mbwa*). The dog, in classical Kongo, is a mystic actor. Canines, perceiving things with superior scent and superior hearing, logically symbolise the power of a medium (*nkambakani*). The dog-medium crosses worlds and ferrets out the truth. The canine is seen as a questioning being (*mbwa i kadi kia biuvu*), a creature of inquiry (*mbwa i kudi mgyudi*).[3] He will use his superior sensory apparatus for the well-being of the clan. That power of surveillance requires, however, appropriate protection; hence the strand of cowries (*nsanga a nsungu*) the ritual leader wears about his neck. Bakongo believe that cowries, coming from the water and the shore, reflect the power of moving in two worlds.

Emphasising his role in the finding and destroying of unseen malfeasors, the dog bares his teeth. His tongue hangs out (*ludimi lweti lela*). Note that the dog-*nkondi* in the Musée de l'Homme (p. 205) underscores his ferocity in the very same way. The hanging tongue is, in fact, one of the signatures of the dog-medium.

The exposed canine teeth and tongue are intensified by concentric lines around the jaws and chevrons on the muzzle. These lines emphasise the power of the image (*nlonga minena mu ziamisa lendo kia zizi*).[4] This relates to a paradigm in the religion of Kongo, painting or drawing lines (*kila*) on the face of an *nkisi* priest and *nkisi* image to establish their magical protection.[5]

Despite these powers of surveillance the leader-medium kneels (*fukama*). This is a gesture that restores moral balance.[6] One kneels before a leader. But he, in turn, must "kneel" before his people when carrying out an investigation. This translates into humility and concern, without which the leader may not fully perceive what the people are thinking. Arrogance blocks intelligence.

With is canine face and brilliant metal eyes, the figure is every inch a medium. His powers of inquiry, symbolised in part by the superior scent of the canine – note the emphasised curve of the nostril of the dog, almost Chinese in its elegance – reemerge in the Kongo-derived *palo* religion of Cuba, particularly in the cities of Havana and Matanzas.[7]

There a priest in charge of Kongo-derived ritual takes the title of *mbwa nkisi* (dog of the sacred medicine). When he begins a ceremony, for example to cleanse a house of bad fortune, he traces a spiralling Kongo sign (*firma*) on the floor. This triggers possession by the spirit in the *nkisi* vessel. At this moment the priest becomes the "dog of the charm" (*perro de prenda*).[8]

One of the ways of rendering this moment, in Kongo and Cuba, is to show the ritual expert riding a dog across the boundary between worlds, as

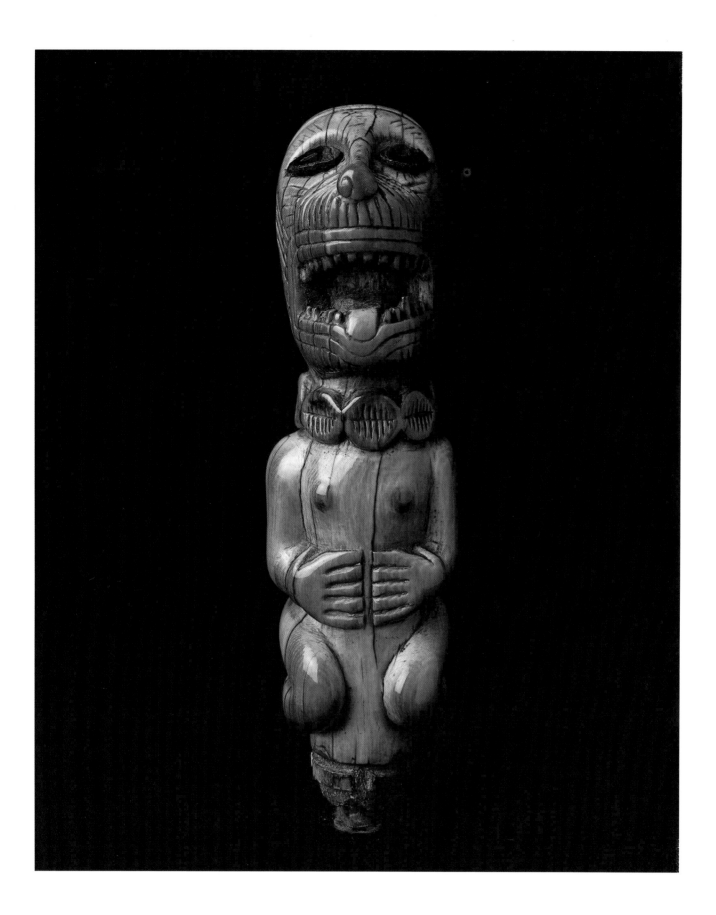

exemplified by a splendid Yombe *nkisi* in the collection of the Metropolitan Museum of Art.[9] This image compares with an Afro-Cuban street mask in Cuba, showing *nganga* and an *nkisi* riding a dog-medium into the other world.[10] Like many themes

in Kongo art, possession by the all-important dog-medium has become transatlantic.

ROBERT FARRIS THOMPSON

1 K. Laman, 1936, vol. I, p. 235. Fu-Ku Bunseki, personal communication, 15 January 1999.
2 Fu-Kiau, *ibid.*
3 Fu-Kiau Bunseki, personal communication, 14 May 1999.
4 *Ibid.*
5 K. Laman, 1936, vol. I, p. 235. W. MacGaffey, in E. Schildkrout and C.A. Heim, 1988, p. 231.
6 For more on kneeling in Kongo art, see R.F. Thompson, 1981.

7 For an exciting survey of Kongo religious impact on Cuba, see N.B. Aróstegui and C. Gonzales Díaz de Villegas, 1998.
8 Personal communication from a *palero* initiate, Barbaro Ruíz Martinez, 1 May 1999.
9 See D. Newton, 1978, illustration facing p. 184.
10 F. Ortiz, 195,1 fig. 108, p. 367. In this artist's rendering, the accoutrements of the *ngaga* and *nkisi* are

accurate but the mounted dog looks like a horse. Nevertheless who was mystically riding what would have been clear to initiate *paleros*. Ortiz (*op. cit*, p. 328) was one of the first scholars to report that Kongo religionists in Cuba, when possessed by the spirit, were called dogs.

Kongo Sculpture

19th century
Coast of northern Kongo, Congo Republic

Chief's Staff (*mvwala*) with Ivory Finial in the Form of a Kneeling Woman Holding a Vessel

Ivory, metal appliqué, wood
H: 78.7 cmFormerly in the Paul and Ruth Tishman collection.
On loan from The Walt Disney – Tishman Art Collection
Inv. AF. 051.122

Main Exhibitions
Richmond, 1970; Austin, 1970; Saint Louis, 1971; Des Moines, 1971; Huntington, 1971; New York, 1980-81, 1981; Los Angeles, 1992-93.

Main Publications
Special Addendum, Sculpture of Black Africa – The Paul Tishman Collection, 1970, VM 79; *Masterpieces of the People's Republic of the Congo,* 1980, no. 28, p. 30; S.M. Vogel (ed.), 1981, no. 127, p. 213; J. Kerchache, J. L. Paudrat and L. Stéphan, 1988, no. 240, p. 348; D. H. Ross (ed.), 1992, fig. D, p. 227.

The choice of ivory (*mpungi*) in the making of this finial automatically invokes longevity (*zingu*) – for the clan, and, ideally, for the holder of the staff. Elephant tusks do not readily decay. So they come to symbolise defiance of the organic process as we know it. Ivory also suggests the richness (*kivwama*) of the chief and his world. It even hints of music. "Blowing ivory" (*sika mpungi*), in Ki-Kongo, refers to playing trumpets. The sounding of an ivory horn, in traditional times, called all the people together to consider an important matter.

At such moments the sceptre-holder would normally be expected to solve social problems (*mambu*). The levels of such *mambu* – and their ideal resolution – are symbolised by spherical mnemonic knots (*makolo*) which appear below the finial. They

break up the flow of the sceptre, recalling vows taken, when peace was restored or initiations were completed, or important events in the tenure of a given chief, or even important chiefs associated with the usage of this sceptre. In addition, textile-like patterning, appearing between each represented knot on this staff, is said to represent the fabric of the community, the ground of the chief's existence.[1]

Another coded message emerges in the band of zigzag patterning, rendered in metal open-work, circling the staff between the uppermost "knot" (*kolo*) and the ivory image. This is a strong symbol. It registers the boundary between the world of the living and the world of God. As the northern Kongo sage Fu-Kiau Bunseki remarks, signs like these remind us of the presence of Kalunga, Great

Almighty, beyond the scalloped margin of the sea. It reminds the bearer of the sceptre to invoke heaven's insight when confronted by crisis, as in the prayer: "may Kalunga heal, from within, what I heal on the outside" (buka mu kati yabuka ku mbazi).[2]

Preoccupation with collective participation (kintwadi) in conflict resolution, the mindset demanded of the holder of this staff, continues with the sign of two linked lozenges shown between the breasts of the kneeling woman who surmounts the staff as a finial. Two lozenges equal two worlds. This repeats the invocation of the insights of Kalunga and the insight of the ancestors.[3]

The woman's main gesture, offering a palm wine vessel with both hands, recalls the sealing of the vows of marriage by the ritual drinking of this liquid. It also stands for the vows of unity between chief and community with the ritual drinking of the wine. In addition, an informant from Luozi in Kongo argues that the proffered vessel might have held water, a classic element for combating evil: "When you throw water at an enemy, you neutralise his evil and his power to create problems."

Finally, the holder of this sceptre can become spiritually inspired when working on behalf of justice. We see such power reflected in the eyes of the ivory figure, because they have no pupils. White vacant eyes (ngengele a meeso), when seen in sculpture, especially among Beembe, focus strongly on the other world. They identify the sceptreholder as a medium empowered to see across worlds.[4]

The mouth of the medium opens wide, revealing removed teeth. Laman, an authority on Kongo culture, reports that broad teeth – "like those of the goat" – were not considered beautiful in Kongo. Bayombe, for example, filed teeth to a point, or chiselled-out apertures in the upper front row. The people called this "laughing-teeth" (nsabi meeno).[5]

Reflecting this custom, there are many Kongo masks showing gaps in the teeth[6] and children in north Kongo paint out their centre teeth with charcoal, to make people laugh.

But with the Disney piece humour turns serious. This sceptre image of a woman with a huge gap between her teeth encodes a challenge: mswala yena ye mpwela i sinsu kia kiaaba, nzolele Iwaaka ya sina dia mamby – a sceptre with a gap-toothed image might seem funny (literally, a sign of humour), but it actually can symbolise most important matters. What has been removed that makes people angry? What must be given back to re-establish order?[7]

The missing teeth, the need for palm wine sacrifice, the presence of zigzags and bosses, multiply remind us that order is fragile, that problems recurrence, as the spiritualised eyes and kneeling gesture of the woman remind us, the ruler must be open to God and humble before people.

ROBERT FARRIS THOMPSON

1 See R.F. Thompson, in S.M. Vogel (ed.), 1981, pp. 212-214.
2 Fu-Kiau Bunseki, personal communication, 20 April 1999.
3 R.F. Thompson, in Vogel, 1981, p. 212.
4 From a forthcoming volume, by R.F. Thompson on Kongo art and gesture.
5 K. Laman, 195, vol. I., p. 70.
6 R. Lehuard, 1993, pls. 3.6.1., 3.13.1 and 3.142.
7 Fu-Kiau, personal communication, 1 May 1999.

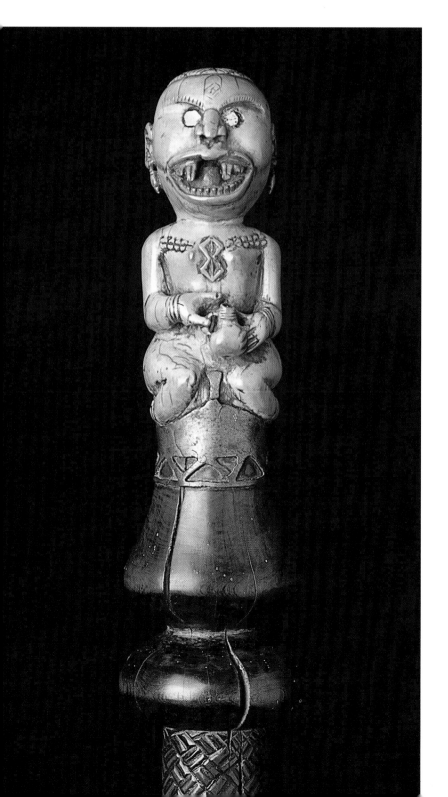

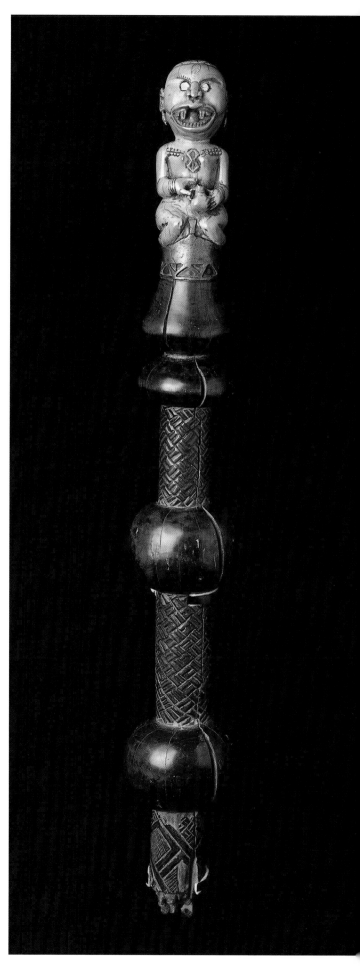

Vili Sculpture

18th-early 19th century[1]
Loango Coast, Congo Republic

Image in the Form of a Dog-Medium

(nkisi nkondi a mbwa – also known as kozo)
Wood, nail and blades
H. 43 cm, L. 88 cm
Collected in Vili country in the late 19th century and given to the Musée d'Ethnographie du Trocadéro
by Joseph Cholet in 1892 – Former M.E.T. no. 32 192
On permanent loan from the Muséum National d'Histoire Naturelle – Musée de l'Homme
Inv. M.H. 92.70.04

Main Exhibitions
Paris, 1965; Algiers, 1969; Paris, 1977; New York, 1980-81, 1984-85.

Main Publications
Musée de l'Homme en relief par les anaglyphes, (1939); E. Elisofon and W. B. Fagg, 1958, fig. 243, p. 193; P. Grimal (dir.), 1963, p. 234; Chefs-d'œuvre du musée de l'Homme, no. 25, p. 89; J. Laude, 1966, no. 57, p. 107; M. Leiris and J. Delange, 1967, no. 383, p. 331; B. Davidson, 1967, p. 123; L. Pericot-Garcia, J. Galloway, A. Lommel, 1967, fig. 269, p. 178; R. Lehuard, 1980, no. 75, p. 141; Masterpieces of the People's Republic of the Congo, 1980, no. 12, p. 23; S.M. Vogel and F. N'Diaye, 1985, no. 74, pp. 96-97, p. 152; J. Kerchache, J. L. Paudrat and L. Stéphan, 1988, no. 616, p. 43; Objets interdits, 1989, p. 40.

In the late 19th century, remarkable Kongo problem-solving images (zinkondi, singular: nkondi) entered European collections. Studded with blades, miniature hoes, needles, pins and nails, each insertion standing for an adjudicated problem, zinkondi attracted immediate attention.[2] Many took the form of standing images of priestly figures, bodies bristling with hammered-in signs of resolved conflicts, impressive collections of nails and blades, each testifying to some bitter grievance.[3] But a certain number bore the shape of dogs, as in the case of three zinkondi entering the Trocadéro in 1892.[4]

We have already noted the importance of dogs as spiritual mediums. As mirror-beings, dog zinkondi logically are sometimes carved as a Janus. Furthering the equation of their double existence, traditionalist Bakongo believe that between the city of the living and the city of the dead lies the city of dogs.[5]

Not all dog zinkondi are nailed with metal, however. In antiquity it is said that mambu could be sealed by the hammering-in of pieces of bone, or small wedges of wood, or thorns, knotted cords, plus different kinds of blades (baaku) made by traditional blacksmiths.[6] Tying on objects, as opposed to nailing them, could also record peacemaking treaties or the memorising of vows and solutions.

The Antwerp Ethnographic Museum had a nkondi-dog image, remembered among the Bawoyo of Mwanda as nkisi Ma Mbwa (Lord of the Canines medicine). To this nkisi was tied a miniature war club (mboondo) to attack jealous spirits in the night. Ma Mbwa is honoured with a song mentioning the "palaver tree", nti nsamu, under which serious legal matters were discussed, thus alluding to the role of the dog as a medium for justice. A staff tied to the neck of the Antwerp dog symbolises a wooden torch to light the way into the dark, where jealous persons hide. The ritual expert in charge of this charm nailed the tail of a porcupine, an athrerus, to a dog-bell, recalling a proverb that warns us to go carefully when solving delicate matters, like the children of the porcupine (baana ngumba jkwenda kamibana). That is a Woyo interpretation.[7]

In Manianga a similar text warns potential felons that porcupine quills go wherever the dog-nkondi goes. In short, the nails of the dog resemble the quills of the porcupine (nsonso zena mpila mosi mu fwanana bonso nsisi mia kinsaka).[8]

Thus the priest in charge of the spectacular dog-medium nkondi in the Musée de l'Homme seems to have shaped the flow of the nails to resemble the erect quills of the porcupine. He created a terrifying beauty, smooth and militant. It is believed that in the presence of an ndoki the nails will fly out, like bullets or quills, and kill him. Understandably, then, this kind of image was known on the coast of Kongo as kozo, meaning "scream of fear".[9]

But intimidation is not the only message written in iron on this object. Its heavy nails commemorated the settling of serious arguments and dangerous conflicts. Squarish blades related to certain kinds of issues, like land disputes, and pin-like elements commemorated other kinds of decisions.[10] In some instances psychosomatically afflicted patients who believed in the kozo's power to destroy unseen devouring forces were restored to health and then gave money to the kozo priest. At this point, a blade or pin was hammered into the kozo to commemorate the healing.[11]

In the search for evil, protected by his quill-like fur of blades and nails, the dog is constantly alert. Hence his nostrils (miela mia mbombo) are emphasised, as a sign of his power to follow the path (mu siamisa lendo kia fimba) of hidden jealousy and covert dissension. He wears a bell around his neck. This provides the ritual expert in charge of his operation with mystic means of sound location. He will know exactly where nkondi is, while combating bandoki in darkness, just as men keeping track of their dog on a hunt by following the sound of the bell on his neck.

In the process of tracking down mystically dangerous beings, the dog absorbs incredible amounts

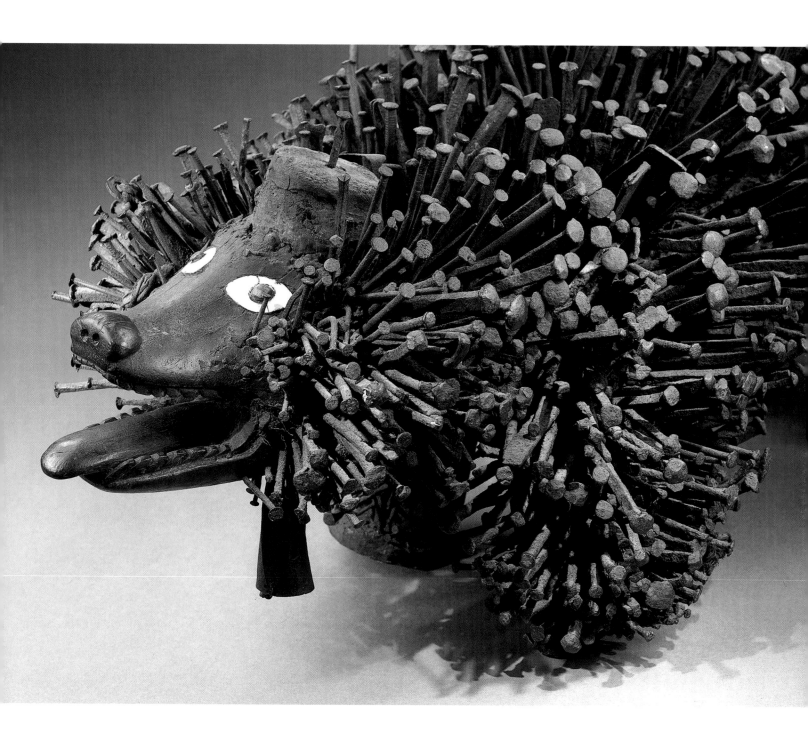

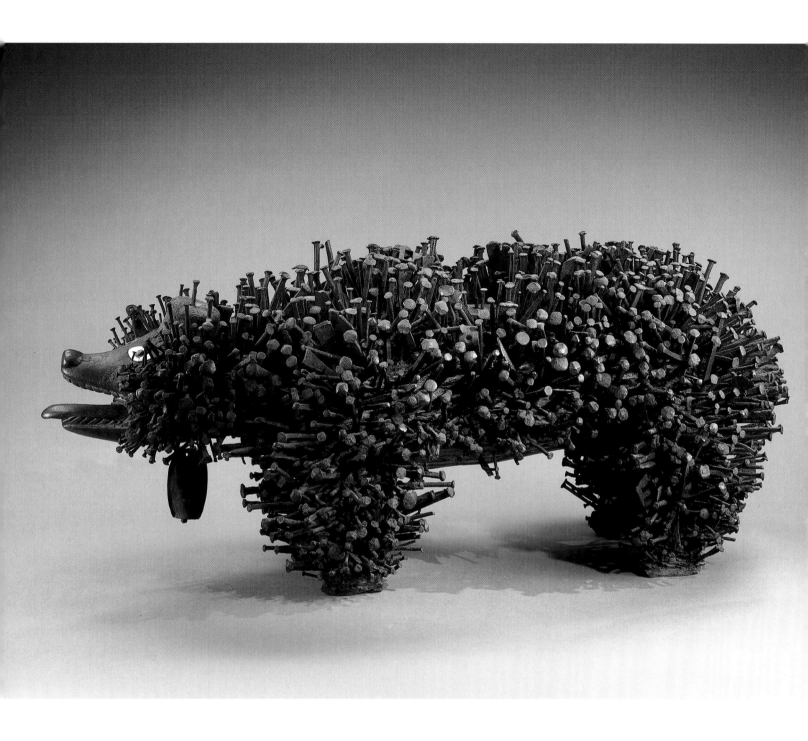

of negative energy, the contaminating spoor of anti-social beings. That is why the *nkondi*'s tongue is often hanging out (*ludimi lweti lela*). He is breathing heavily, expelling the evil absorbed in clearing paths for the clan and the people.[12] Hogarth criticised dissolute 18th century London and Goya seared into consciousness the horrors of war. But the master of this Kongo work did more. He not only shaped a complex instrument for moral intimidation, punning across guises human, canine, and quill-bearing, but the hammered in signs of moral decision, cutting through evil and rebuilding the culture.[13]

ROBERT FARRIS THOMPSON

1 The carbon-14 dating done on wood from this sculpture in 1999 by Dr Georges Bonani of the Eidgenössische Technische Hochschule, Institut für Teilchenphysik in Zurich yielded the following results: ETH-20617: 140 +/- 40. B. P.; ∂C-13 (%): -26.6 +/- 1.1; periods calibrated: CE 1673-1779 with a probability of 43%, CE 1797-1945 (this period should be pushed back to 1892, the year when this sculpture entered the Musée d'Ethnographie du Trocadéro), with a probability of 56.5%.
2 For an early article on *zinkondi kozo* and *mangaka*, see B.H. Mullen, 1909, pp. 102-104. See also R. Lehuard, 1980.
3 W. MacGaffey, in T. Phillips (ed.), 1995, p. 244.
4 I thank Vincent Bouloré for this information and for many other courtesies.
5 W. MacGaffey, personal communication, January 1980.
6 From an interview with Balu Balila (Kinshasa), July 1985.

7 From an interview with Balu Balila, (Kinshasa,) July 1997. The proverb about the children of the porcupine stems from Balu Balila's rich knowledge of the oral literature of the Bawoyo people in coastal Kongo.
8 Fu-Kiau, personal communication, 20 May 1999.
9 From an interview with Balu Balila (Kinshasa), July 1985.
10 For details on blades and nails in the *nkondi* ritual, see R.F. Thompson, 1978.
11 From an interview with Balu Balila (Kinshasa), July 1985.
12 Fu-Kiau, personal communication, 20 May 1999.
13 The last note encloses an omnibus acknowledgment. I salute the following colleague: Fu-Kiau Bunseki in Balu Bali, Wyatt MacGaffey, John Janzen, Vincent Bouloré, Brother Cornet, and the late Albert Maesen. Without their aid, especially Fu-Kiau Bunseki, these pages would have been diminished. *Bankundi zazo, ntondele!*

Zulu sculpture

19th-early 20th century
Region of Kwanzulu-Natal, South Africa

Spoon

(*ukhezo* in Zulu, plural *izinkhero*)
Wood
H. 57 cm
Édouard Saint-Paul Bequest, 1977
On permanent loan from the Muséum National d'Histoire Naturelle – Musée de l'Homme
Inv. M.H. 977.52.14

Main Exhibitions
New York, 1984-85a; Paris, 1986-87; Florence, 1989; Zurich, 1990-91; Paris, 1991.

Main Publications
S.M. Vogel and F. N'Diaye, 1985, no. 99, p. 49 and p. 165; *Côté femmes*, 1986, no. 42, p. 15; E. Bassani and W.B. Fagg, 1989, vo. VI, p. 16; E. Bassani, 1989,

The history of this anthropomorphic spoon is still partly veiled in mystery. The place, date and circumstances of its collection are unknown. Not the least scrap of information concerning the name or the precise region of the sculptor who fashioned it has come down to us. What we know is that the piece arrived in Paris at the dealer and collector C. Ratton's gallery and it was there that Édouard Saint-Paul acquired it.

Édouard Saint-Paul was a sculptor as well as a knowledgeable collector who, at his death in 1976, owned a collection of mostly of African and Oceanic pieces that displayed a very high level of art. Initially, when the collection was first registered at the Musée de l'Homme, this spoon was thought to come from Oceania because of its spare, simple forms which recall certain wood sculptures carved in Micronesia, notably in the Caroline Islands. The

spoon remained stored away in the reserves of the department of sub-Saharan Africa until it was rediscovered in 1984 by Susan Vogel and Francine N'Diaye while they were preparing the New York exhibition "African Masterpieces from the Musée de l'Homme". Published in the exhibition catalogue, the piece, attributed to the Zulu, immediately drew the highest admiration. In the early 1990s, the spoon appeared in public once again, in this case during the exhibition "Löffel in der Kunst Afrikas" at the Museum Rietberg in Zurich. The show later travelled to the Musée Dapper in Paris. The piece, which is without any known equal for the moment, was much sought after and remained on display in the permanent exhibition galleries until its recent move to the Louvre.

The Zulu, part of the Nguni linguistic group, inhabit a region that lies between the Indian Ocean and the Drakensberg Mountains. This people of herdsmen-farmers only became a group in the first third of the 19th century under the guidance of Shaka, who in a matter of years built up a veritable empire that was feared by all its neighbours. The reputation of the Zulu as warriors has often been cited to justify the apparent weakness of their artistic output. The term "Zulu", moreover, comprises numerous regional particularities and not a single homogeneous culture.

In the Zulu tradition, wooden spoons are widely used. They are carved by men in each familial hamlet, although at times they may be specially commissioned from a sculptor. While it is common to eat with the fingers, each individual nevertheless possesses a spoon that he uses on various occasions to serve himself a helping of food, usually a porridge of maize or sorghum, from a common platter. The spoon then is a personal item and is carefully slipped back into its wicker sheath after use. The personal nature of this object explains the infinite variety seen in the combinations of its forms and motifs within relatively homogeneous regional styles.

The bowl of the spoon is most often oval in shape and almost always boasts a distinctive fire-blackened lip. The ornamental vocabulary is mainly limited to the handle and comprises geometrical motifs like chevrons, triangles and diamonds which are incised or carved in relief. More rarely these motifs are figurative. In this regard then, the spoon shown here is an exception.

The very clear figurative intention of the Louvre spoon indeed sets it apart, although this intention is materialised in a very subtle, evocative manner. Carved in high relief in marked contrast with the handle's willowy slenderness, the breasts and buttocks are enough to lend the spoon its unmistakably feminine aspect. The grace of the spoon's silhouette is achieved notably through the delicate modelling of the body (which is expressed in a single line, the sculptor taking care to maintain its unity by sacrificing the figure's arms), and the elegant curve of the neck, greatly drawn out to achieve that very effect while justifying the tilt of head, which is cleverly suggested by the bowl of the spoon. The thighs and lower back are engraved with small window-like patches filled with two rows of tiny points in relief. These motifs, called *amasumpa* (literally "warts" or scarifications), are also used to decorate headrests, milk vessels, food platters, as well as pottery. Their origin seems to be linked to the emergence of groups of aristocrats close to the Zulu's royal house in the first third of the 19th century. The groups apparently used the motif as a mark of distinction.[1]

The *amasumpa* are, along with the blackened rim of the spoon's bowl, the only genuine clues that allow us to attribute this piece to a Zulu sculptor. It is not impossible then that the current attribution is mistaken. Anitra Nettleton has shown that many pieces previously attributed to the Zulu seem more akin to the work of Tsonga artists. The Tsonga were in fact quite active in producing carved objects, in both southern Mozambique and northeastern South Africa. Attributing the spoon from the Musée de l'Homme collection to the Tsonga is not without its risks, even though a few details, especially concerning the bowl of the spoon, do point to just such a conclusion. On the other hand, the very design of the piece, which naturally fuses female form and function, is not foreign to Nguni-speaking peoples, particularly the Zulu. In Nguni art ivory, horn and bone are commonly carved into minuscule spoons for taking snuff or collecting sweat. Most of these pieces are very similar to the wooden spoon here. I should also mention other interesting parallels with several other Nguni-speaking cultural groups, notably the Ngoni, a population that migrated northward from Natal in the early 19th century following the formation of the Zulu Empire. In the mid-19th century two groups definitively settled in Malawi, the Jere Ngoni and the Maseko Ngoni, each after conquering and assimilating numerous foreign cultural and ethnic elements. Yet these Ngoni retained the objects making up their original material culture as much as possible, despite change through contact with various influences of neighbouring populations. Examples are is the wooden dance staffs that are borne by warriors in public events and parades. These staffs are considered veritable dance partners whose presence is meant to excite the owner to dance with greater energy.[2] Many are decorated with female breasts and one of their ends boasts a spherical head, usually truncated on one section, with the surface being carved into a concave shape. This type of dance accessory was also common amongst the Yao and other neighbouring populations who used partly figurative staffs topped with human heads.

In light of the above then, the spoon attributed to the Zulu can be understood differently. Possible use as a dance staff could explain its size, which

no. 146; *Loeffel in der Kunst Afrikas*, 1990, no. 62, p. 98; *Spoons in African Art*, 1991, no. 62, p. 98; *Cuillers-sculptures*, 1991, p. 46; *Musée de l'Homme*, 1992, no. 14706, p. 62; E. Bassani, 1992, p. 248.

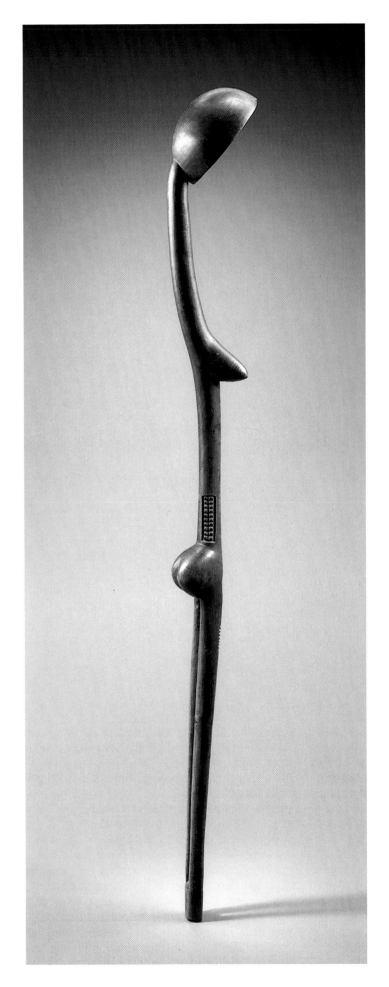
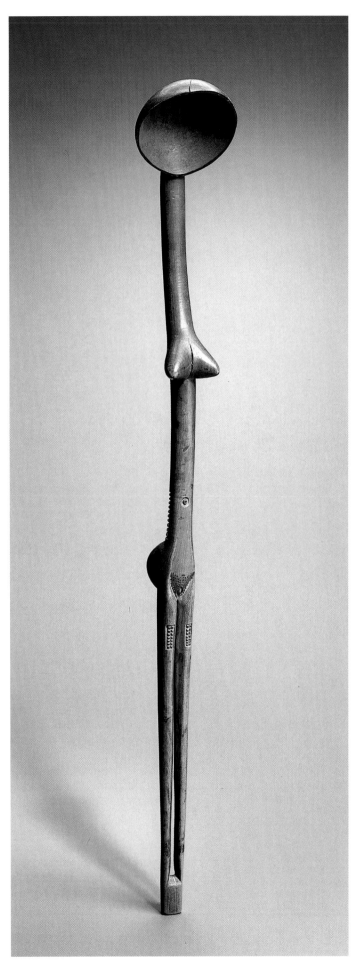

is larger than the average traditional Zulu spoon. The circle-and-point motif, indicating the navel, is more a part of the cultural traditions found further north, where in general it is more frequent than amongst the Zulu. The hemispheric shape of the bowl also seems to point to a ladle more than a spoon. The shape of this element might actually derive from the gradual hollowing out of the truncated heads of clubs and canes rather than a functional design for a ladle or spoon. Finally, the *amasumpa* motif, which is present on several parts of the figure's body and seems to indicate a Zulu work of art, is in fact quite distinct from Zulu practice because it is carved within a rectangle. This decorative pattern is always carved in relief on Zulu objects.

Despite this possible reattribution, the piece remains a fine achievement conceptually and plastically. Of course the inspired idea of joining the female form and the spoon was tried out in other parts of Africa and at different periods, witness the famous ceremonial spoons of the Ivory Coast. However, through its coherent, highly concentrated aspect, and the contrast between the slenderness of the resulting material and the object's impact as a carved work of art, the piece presented here clearly attains the highest levels of African sculpture.

MANUEL VALENTIN
Translation: John O'Toole

1 S. Klopper, 1991.
2 M.W. Conner, 1993.

Sakalava sculpture

17th-late 18th century[1]
The Sakalava region of Menabe, southwestern coast of Madagascar

Funerary post (haritsy)

Wood (*Albizia sp.*, Mimosaceae)
H. 215 cm
Collected by the Guillaume Grandidier Mission in 1898
Gift of the Committee of Madagascar to the Musée d'Ethnographie du Trocadéro, 1901;
formerly M.E.T.: 51384
On permanent loan from the Muséum National d'Histoire Naturelle – Musée de l'Homme
Inv. M.H. 01.6.12

Main Exhibitions
Paris, 1900, 1965; New York, 1984-85; Paris, 1989c; Florence, 1989.

Main Publications
A. and G. Grandidier, 1924, pl. XIV, 2; H. Clouzot and A. Level, [1925], pl. XXXXIV and XXXXV; M. Besson, 1929, pl. XXXVI, 2; E. von Sydow, 1931, p. 396; J. Faublee, 1946, insert between pp. 88 and 89; M. Leenhardt, 1947, no. 104, p. 122; *Chefs-d'œuvre du musée de l'Homme*, 1965, no. 27, p. 93; *Le Courrier de l'Unesco*, 1965, p. 12 (left); P.S. Wingert, 1970a, N150 (left); S.M. Vogel and F. N'Diaye, 1985, no. 100,

The French ethnographer and geographer Guillaume Grandidier (1873-1957) most likely collected this work for the Committee of Madagascar during a mission (2 April to 2 June 1898) in the western part of the island that took him from Majahanga to Tulear. The Committee exhibited the piece at the Universal Exhibition of 1900. This piece appeared in France around the same time as another work carved in a similar style (top of a post, formerly the Brummer and Epstein collections; fig. 1) which was probably produced in the same workshop. These two staffs were shown together but once, in Florence in 1989. The piece from the Brummer and Epstein collections is identified by certain authors[2] as an "*aloalo*, post (Betsileo, Madagascar)". The term *aloalo*, which is inappropriate in this case, desi-

gnates funerary sculptures that are characteristic of southern Madagascar's Mahafaly region; on the other hand, cenotaphs in Betsileoland (the Madagascar highlands) are never decorated with figurative ornamentation.

The Sakalava kingdom of Menabe gradually took shape starting in the 17th century, in the western lands of central Madagascar. The kingdom arose with the formation of a dynasty springing from one of the segments of the vast wave of migration that had begun in eastern Madagascar. This dynastic group was to spread the political and ideological principles of the Indonesian and Arabo-Muslim influences that were fuelling these migrations. The new kingdom would gradually "reorganise" the native groups that were settled on its

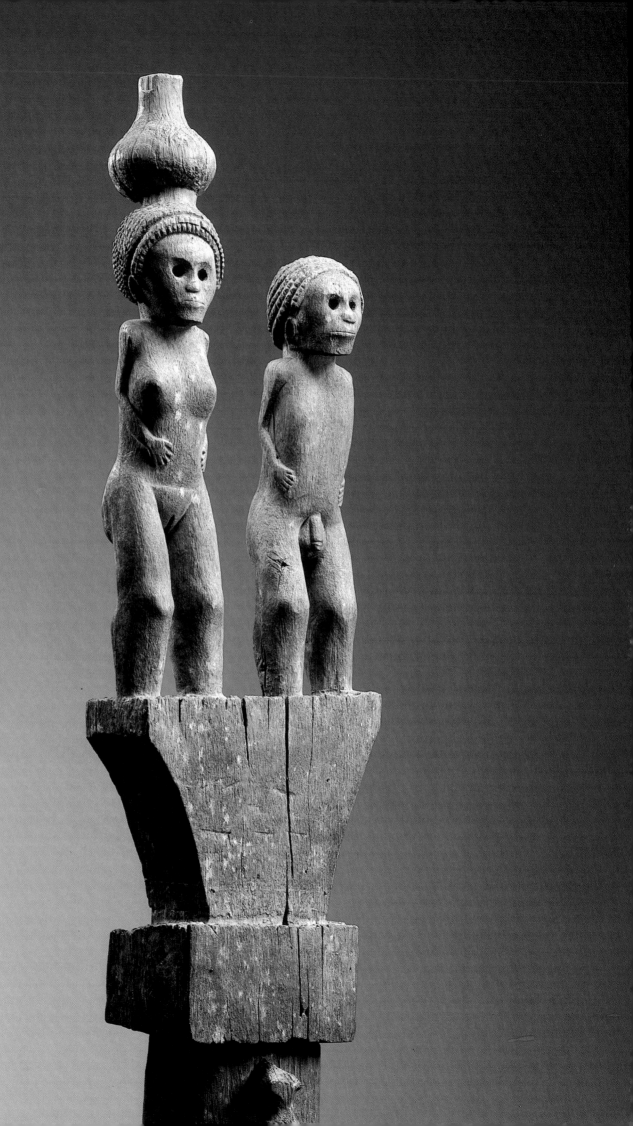

p. 50 and p. 165; *Madagascar, arts de la vie et de la survie*, 1989, cover; J. Kerchache, J.-L. Paudrat and L. Stéphan, 1988, no. 245, p. 355; E. Bassani, 1989, no. 148; E. Bassani, 1992, p. 250; *Musée de l'Homme*, 1992, no. 16693, p. 65; A.P. Kouwenhoven, 1998, fig. 17, p. 75.

territory, making intensive breeding and rearing of stock the foundation of wealth and social rank, and introducing political and religious institutions that were to uphold the legitimacy of the monarchy.

Caught at one particular moment in the general movement of its evolution, the funerary architecture here offers a clear window onto the nature and history of this political and social system. Based first of all upon the central importance that is given to the representation of death and links with ancestors, it is the symbol *par excellence* of the social hierarchy within the kingdom. The royal tomb indeed served as an incomparable model – translating the general principles of astrology – against which a certain number of objectified privileges were elaborated in accordance with a specific ornamental repertory. This store of decorative elements formalised the position of each lineage in the society.

The colonial period, which introduced important changes in the social order, can also be seen in the development of this architecture. Along with the invention of new forms, funerary architecture was to admit ancient dependents, who without a visible tomb were without an "image" in the ancient society.

Sakalava funerary architecture, which still employed wood just 30 years ago, endures today through the expression of its founding principles in a new material, concrete, a token of social prestige.

The original and important work displayed here, one of the few known examples of this funerary art, takes up the classic themes that are linked with astrology and peculiar to the ornamental vocabulary of tombs.

The man and the woman enthroned side by side on top of the post's capital not surprisingly refer to the couple, an element representing the complementarity of opposites that appears on tombs under many different guises, as entwined couples, depictions of paired objects or animals and so on. As the seat of the reincarnation of the sovereign, the crocodile is also a recurrent theme in the friezes decorating the enclosure of tombs. Here it is seen in relief, boldly cut away from the post's thick shaft.

The frontality and hieratic treatment of the figures' poses in this case, as well as their rigorous symmetry, clearly contrasts with colonial and post-colonial statuary. There the design of such scenes is coupled with an expression of movemen through

both the play of full and empty spaces, and the asymmetry achieved in the figures' gestures. The pair shown here have no necks, their arms are not separated from their bodies and their legs disappear into the base. The forms are superficially carved out. The modelling of the female figure's chest, for example, is only slightly more prominent than the torso of her male counterpart. Unlike later periods, where one sees greater and greater attention paid to details of clothing and an exuberant depiction of sexual characteristics, sobriety predominates in this brace of figures. Only the meticulous care taken in treating the headdresses and faces breaks with this overall impression. This "bonnet" headdress, worn by both men and women as late as the 1920s, comprises a band of fine knotted braids that encircles the forehead and several bands of larger knots that are gathered at the back of the skull and shaped into a bun. The power of these delicately modelled faces is wholly concentrated in the deep eye sockets. Loss of the elements that represented the pupils lends the eyes themselves a striking severity. Finally, traces of mineral pigments (red and white) indicate that ritual aspersions were performed over this piece.

SOPHIE GOEDEFROIT AND JACQUES LOMBARD

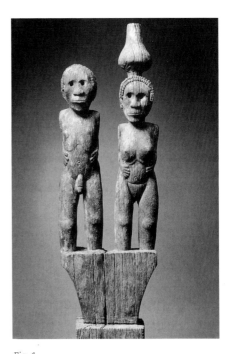

Fig. 1
Sakalava sculpture
17th-late 18th century
The Sakalava region of Menabe,
southwestern coast of Madagascar
Wood
H. 99 cm
Formerly the Émile Heymann,
Joseph Brummer, Jacob Epstein,
Carlo Monzino collections
Private collection

1 Carbon-14 dating carried out on the wood of this sculpture in 1999 by Dr Georges Bonani, Eidgenössische Technische Hochschule, Institut für Teilchenphysik, Zurich, has yielded the following results: ETH-20618: 245 +/- 40 B.P.; ∂13C [‰]: -23.8 +/- 1.1; calibrated period: CE 1518-1578, with a probability of 10.3%, CE 1625-1687, with a probability of 43.8%, CE 1736-1811, with a probability of 32.4%.
2 A. Basler, 1929, pl. 4.

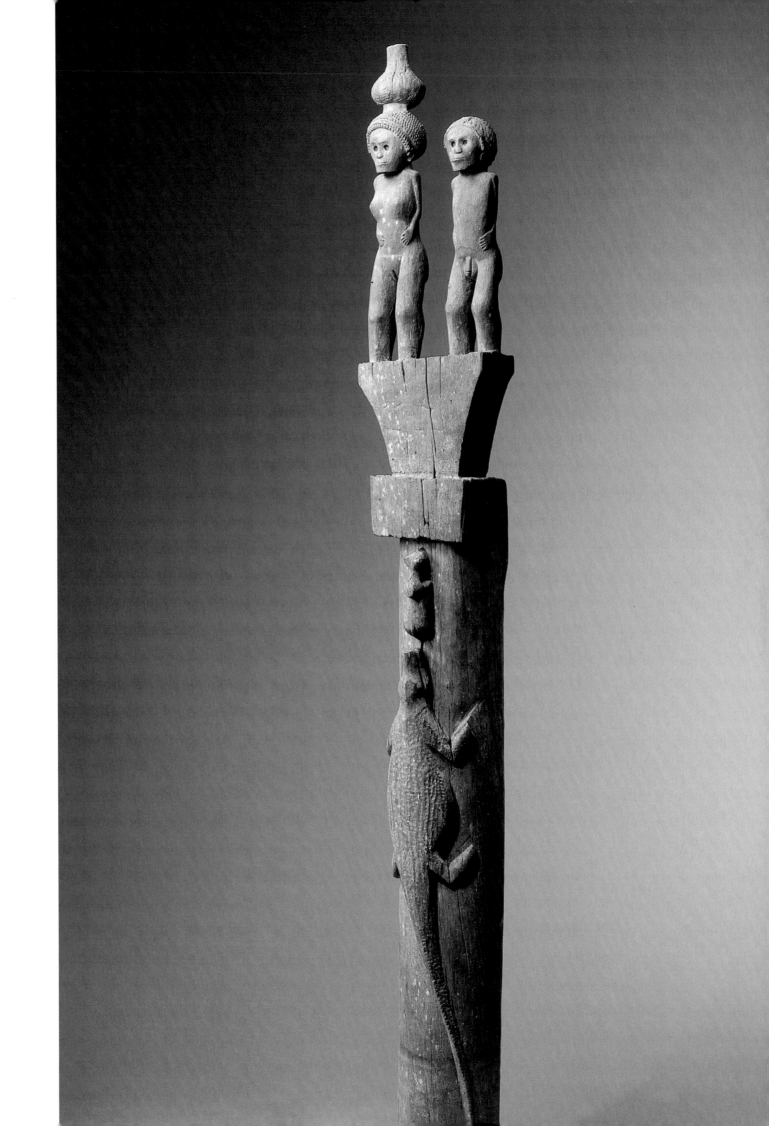

ASIA

Traditional Societies in Asia

It would be more appropriate to speak of "Asias", for the continent is multiple. The variety of its skin colours, languages, means of subsistence and climates would warrant the creation of several fictive subcontinents, distinguishing the Beduins of the Middle East, the Turkomans, the Siberian shamans and sub-Himalayan tribes (such as the Monpa and the Sherdukpen) that meld Buddhism with their ancient beliefs, or the Gonds, Santals or Bhils of India, the head hunters of the Philippines, those of Borneo and those of the Assam-Burma border. Not to mention the Negritos and Nicobar islanders, or those of Timor who speak Papuan languages.

Contrary to a widely held idea, Asia, the cradle of all the great religions (Judaism, Christianity, Islam, Hinduism, Buddhism, Jainism, Taoism, Confucianism, together with their dissident offshoots and numerous syncretic creeds), is also home to as many traditional, or "tribal" societies as Africa and the Americas. At the turn of the 21st century, many of its societies have retained their faith in the myths of the forefathers and still practise rites intended to regenerate the cosmic order and maintain the precarious balance between the human and spirit worlds. And even when they do finally convert to Islam or Christianity, the representatives of these societies continue more or less strictly to observe certain dictates and taboos that shape their everyday life. Such rules are (to borrow the expression of the mountain peoples of South Vietnam) laid down by the "Way of the Ancestors".

Generally speaking, individuals rarely abandon such rules if they are still living in the village of their birth. But if they emigrate to the city and are cut off from their community, then they will yield to the convenience of modern life.

Had not colonialism and two world wars disrupted these traditional societies, their development would have continued to follow the course set several thousand years ago, a course that does not exclude either the adoption of new technologies or the introduction of certain sociopolitical changes. The theory that "primitive societies" are somehow stuck in an authoritarian past is the result of a vision that seeks to oppose these societies to an intellectually open, and therefore superior, Western civilisation.

Leaving to one side the old Islamised tribes of Central, formerly Soviet Asia, and the Turko-Mongol shamanic societies and "pagan" groups of Central India, I would like to give a brief overview of three traditional Asian cultures.

The Kalash

Also known as the Black Kafir, the Kalash are one of the Caucasian peoples of Indo-European tongue found in the high valleys on the frontier of Pakistan and Afghanistan, in the south of the Hindu Kush chain. According to legend, they are descended from a lost column of Alexander the Great's soldiers! These autarchic farmers and cattle breeders wear the hides and wool of their goats and sheep and eat milk and cereals. What they cannot produce (metal, for example) they obtain by bartering with their neighbours. They do not worship any creator divinity but are highly attentive to the demands of benevolent spirits (*dewalog*) and to the manifestations of the malevolent spirits (*shaïtan*, a word taken from Arabic) that cause illnesses and natural catastrophes. When it is necessary, they consult the community's shaman, who inhales the smoke of certain grasses and enters into a trance in which he communicates with the beyond and finds out what sacrifices need to be made. Every supernatural being has a name. We could mention Jistak, who is the only one to have his own sanctuary, a "house of dance" (*Jistak-han*) where prayer meetings are held. Unlike actual dwellings, these edifices are decorated with low reliefs and sculpted columns or large monoxylous doors (carved from a single piece of wood) adorned with bull's or ram's heads. A number of them can be found in Western collections.

Fig. 1
Sculptures in the village
of Rotas,
Ahir Bihar culture
(India)

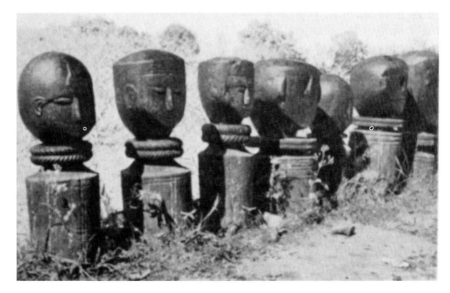

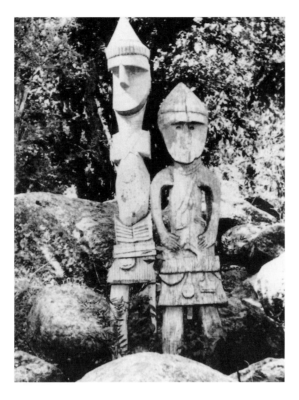

Fig. 2
Two Kalash (Black Kaffir) effigies
or funerary portraits (*gandaho*)
in the Hindu Kush.
Barbier-Mueller Archives

Fig. 3
Anthropomorphic post
in a Jorai funerary enclosure
South Vietnam
Photograph J. Dourmes
Photographic library of the Musée
de l'Homme, Paris

When a man who owns many head of cattle dies, his heirs are allowed, after a certain interval, to have a life-size portrait of the deceased sculpted in wood (*gandaho*). These effigies are placed in the open air, not far from the remains of the man whose memory they recall (fig. 2).

The Naga

Linguistically, this Mongoloid people belongs to the Tibeto-Burmese family. They have lived since time immemorial in Nagaland, a mountainous region in the north of Assam which became a member of the Indian confederation in 1964. The British colonial power had established its domination only over the southern Naga, and did no more than organise expeditions against the other groups whenever a Burmese village was raided by warriors. The Naga, who lived on their own harvests and the cattle they reared, believed that human trophies were the only way of ensuring the fertility of their wives and fields.

The activity of the head-hunters was such that village women could not carry out their work in the fields without the protection of armed men. There would be no contact between villages separated by a valley, so that the different hamlets'dialects had become mutually incomprehensible.

The Naga are thought, wrongly, to have produced very little wooden sculpture and, more accurately, to have been more interested in making jewellery relating to their warlike activities. Using brass

obtained by bartering, they cast pendants representing one, two or more heads, depending on their exploits. Most remarkable, though, was the finery they produced using ephemeral materials (feathers, wicker, seeds).

The "Mountain Peoples" of South Vietnam

"Mountain Peoples", the name given by the French colonial administration, is fallacious. In fact, a number of the societies that the Vietnamese contemptuously called *moï* (savages) lived in the plains. Jacques Dournes thought they were the autochthonous people of South Vietnam, for several groups of "Mountain Peoples" speak Austronesian (Malayo-Polynesian) languages. Today, archaeologists and linguists think instead that Austronesians came to Indochina from the Indian Archipelago in the second millennium BCE. The material culture produced by the "Mountain Peoples" right into the 20th century has numerous features in common with those of traditional Indonesian societies.

The "Mountain Peoples" pay little attention to the gods and a great deal to the *yang*, the supernatural beings upon which depend the wellbeing or misfortune of the community and of each individual. Farmers who have an innate gift communicate with them by going into a trance.

Funerary rites are pretty much the same for all the "Mountain Peoples". In the old days, slaves would be put to death to accompany a rich man into

the afterlife. The 19th century saw the appearance of tall poles surmounted with crouching human figures and called "the servants of death" (fig. 3). These replaced slaves. These sculptures bear a strong resemblance to the ones made to perform the same function in Borneo and Madagascar, which was the last stop in the Austronesians' westward migrations during the first millennium CE.

The archipelagoes of Southeast Asia

The traditional societies of Vietnam take us into the Malayo-Polynesian world. Some linguists hold that the great Austro-Asian and Austronesian families emerged from a common trunk that existed in southern China over two thousand five hundred years ago. Not much later, the Autronesians appeared somewhere between Taiwan and the Philippines. They knew how to cultivate rice and practised maritime navigation in outrigger canoes, but had only stone tools. This people took to the oceans, sailing both east and west. Today, Autronesian languages are spoken from Madagascar to Easter Island. Since it is unlikely that in all these places tiny groups of sailors could have managed to persuade much larger populations to speak their language, we cannot but accept that the Austronesian expansion represents the biggest movement of human masses in the history of the planet.

In approximately 1000 BCE, the so-called "Lapita" ceramics culture was flourishing in Melanesia. Without a doubt, it was due to Austronesian immigrants. Shards of pottery reveal a number of striking similarities with the production of central Indonesian Neolithic cultures. The decoration on fragments of terracotta found in Galumpang (Sulawesi) is very close to that of fragments found on Lapita sites in New Ireland and the Solomon Islands.

It is possible that a well-formed proto-Oceanian style may have existed several centuries before the so-called "Dongson" Indochinese bronze civilisation adopted (or reinvented?) a number of the Neolithic Autronesian motifs (the double spiral, "sawtooth" triangles, etc.) and spread metalworking techniques throughout the archipelago in the second half of the first millennium BC.

The above hypotheses take nothing away from the importance of the Dongson expansion, which was characterised by large bronze drums decorated at the top with frogs sculpted in the round (fig. 6). These drums are well known because of the small models made through to the 19th century by the Karen peoples of Southeast Asia for use in rituals to control rain, and even more so because of the artificially patinated modern versions turned out on an industrial scale in the shops of Bangkok.

The sides of these drums, which have been found all along the archipelago, are decorated with large boats steered by befeathered figures. They are taken to be "soul boats" by virtue of their similarity to the vessels rendered by the Dayaks of Borneo. These represent the deceased sailing towards his last home guided by benevolent spirits and surrounded by his treasures: gongs, drums and slaves.

On a number of Dongson drums we can make out familiar-looking houses whose roofs are pitched at the ends. No effort of the imagination is required here to be reminded of the traditional houses of certain Indonesian groups such as the Toba Batak of Sumatra (fig. 4) or the Sa'dan Toraja of west-central Sulawesi. They can also be compared to the structure of houses in certain parts of Melanesia and Micronesia where there was Austronesian settlement.

Dongson objects have been found as far afield as New Guinea where, even when shattered, they were kept as precious objects by groups unskilled in metalworking. And these drums, handles, daggers and other bronze objects were eagerly copied elsewhere in Indonesia. The discovery of moulds leaves no room for doubt. Formal and decorative developments show a move away from the continent with the introduction of new mythological themes and a new bestiary on the drums.

It is clear that the art of the Indian archipelago Austronesians cannot be dissociated from that of their relations in Melanesia. For example, the "archaic" Austronesians have always shown a marked taste for stone monuments (fig. 5) and mono-

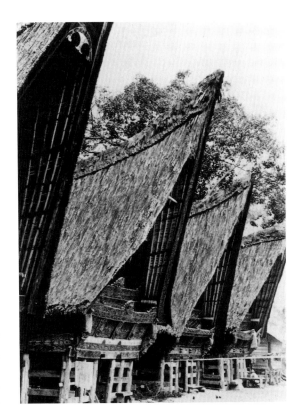

Fig. 4
Traditional Toba Batak house in northern Sumatra
Photograph J.P. Barbier
Barbier-Mueller Archives

Fig. 5
Tomb of Ubu Sappi Patedung
(died 1950)
which he had built
in about 1930
Anakalang, western Sumba
Photograph
Gabriel Barbier-Mueller

lithic statues, as attested by the ancestor effigies of Nias and Sumatra and those of the Poso-Bada region in Sulawesi, as well as the great *tiki* of the Marquesas and the giant *moai* of Easter Island. Such vestiges clearly belong to a very different world from the one that engendered the Hindu and Buddhist temples.

A museum that, in addition to African and Oceanian artworks, houses works from "outer Indonesia", the term used for the traditional societies of the smaller islands to distinguish them from Java or Bali, is in no sense a "rival" of the Musée Guimet, which seeks to showcase the art of the great Asian civilisations. It simply restores the historical balance that for so many centuries enabled the Batak in Sumatra, the Dayaks of Borneo and the islanders of Flores, Sumba and Timor, to preserve and enrich their cultural heritage in the shadow of the great Hindu-Buddhist empires and, later, the Muslim sultanates.

JEAN PAUL BARBIER
Translation: Charles Penwarden

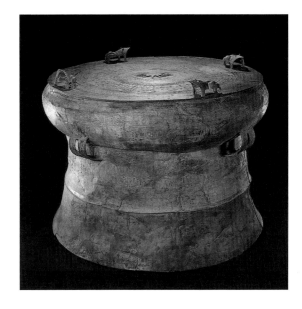

Fig. 6
The biggest known Dongson
bronze drum
Diameter of top: 150 cm
Last few hundred years BCE
Central Java
Barbier-Mueller Archives

Paiwan Sculpture

18th-19th century
Kapiyangan village, Mount Kavulungan, Taiwan

House Post (*queluz*)

Wood
H. 303 cm
On loan from the Institute of Ethnology, Academia Sinica, Taipei
Inv. 02736 10678

Situated at the intersection of the Ryukyu and Luzon island arcs on the western rim of the Pacific, Taiwan is almost exactly bisected by the Tropic of Cancer. It lies some 160 kilometres east of Fukien, on mainland China, about 600 kilometres south-west of the Ryukyu, and 300 kilometres north of the Philippine Islands. Taiwan is 308 kilometres long and 140 wide at its widest area. On maps, it is shaped like a sweet potato.

This rugged island has a land area of 35,774 square kilometres, 64% of which is mountains, 24% plains and basins, and 12% hills and table-lands. The central part of the island is made up of four parallel anticlinal ranges which thrust up many peaks of 3,000 metres or more in height. In the east, these ranges drop precipitously into the Pacific ocean, forming a spectacular coastline. In the west, however, the high mountains give way to foothills which gradually change to flat alluvial plains where many short, swift mountain streams become meandering rivers.

The mountains are significant to the island's Austronesian-speaking indigenes in a number of ways. All the indigenous groups that have managed to maintain their cultural identities nowadays live (or have been living until recently) either in the less accessible mountainous interior or on the eastern slopes of the ranges. They were relatively isolated from outside contacts, while their western, plains-dwelling counterparts experienced extensive acculturation from the latter part of the 17th century on.

Currently, Taiwan indigenes consist of ten culturally distinguishable groups and nine or ten almost entirely Sinicised "plains-dwelling" groups. The former are recognised, for administrative purposes, by the ruling Chinese authority as ethnic minorities, while the latter are nowadays almost indistinguishable from the Chinese in terms of language and life style

Paiwan: The People and Their Society

The Paiwan are the third largest group among the ten. The population of about 60,000 occupies the southern part of the Central Mountain Range of the island, living in villages of from 100 to 1,000 inhabitants. Paiwan genesis has it that the tribe originated on Mount Kavulungan and Mount Dja-kalaus, an area in the north of the tribal territory. Places around these two mountains are therefore known as *paumaumaq* (homeland). Areas to the south and the east are correspondingly called *pavua-vua* (new territories). Documents recording village surveys conducted by the Dutch in the mid 17th century show that this eastward and southward migration had been largely accomplished before the time of Dutch colonisation from 1624 to 1661.[1]

One of the principal features of traditional Paiwan society is a hierarchical system consisting of aristocratic landlords and landless commoners. The old subsistence economy of the Paiwan was a combination of slash-and-burn agriculture and casual hunting. Their diet consisted mainly of taro, sweet potatoes, millet and game animals such as boar and deer. Theoretically, the village land resources – farm land, hunting fields and building plots – belong to a few chiefly families. In general, each village is composed of a paramount ruling family and a certain number of minority families that may be related to and belong to the same family as the sovereign. The commoners are clients and tenants of these ruling families. As landlords, the chiefs collect rent from their tenants. As patrons, they also host religious ceremonies and settle disputes for their clients. And on the whole, as a class of aristocrats, they enjoy the privilege of employing fine works of art as family emblems.

Along with tattooing and the use of certain beded and embroidered designs, carving is one of the privileged crafts that Paiwan aristocrats utilise to distinguish their houses, household objects and personal belongings from those of commoners. Among all carved objects, house-related carvings are the most spectacular and have special socio-logical significance. A Paiwan house is more than a dwelling on a plot of land. It represents a perpetual

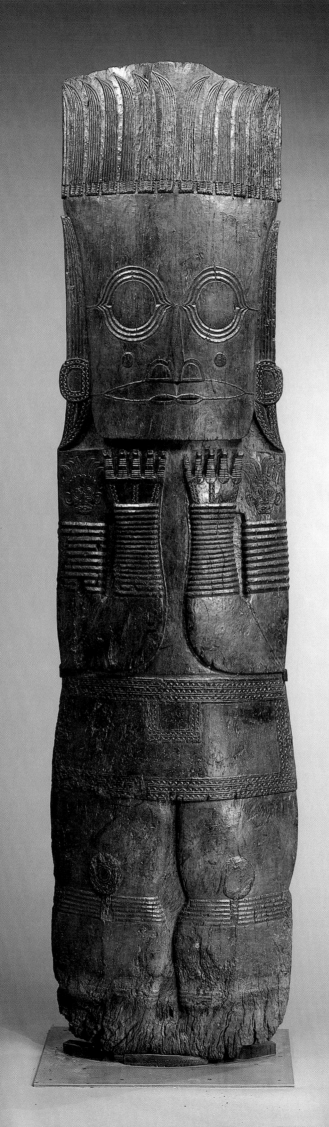

social entity that is distinct from the people who dwell there. In some cases, even after the original chiefly families who resided there have vacated their dwellings and moved to other villages, people continue to deliver tribute (mostly food) to the empty houses. Relatives who have the right to enter the houses can consume the tribute in the house. It is deemed transgression, however, to remove the tribute from the houses and consume them elsewhere, because the tribute is considered to belong to these houses. The Paiwan house, then, is a embodiment of the social status, the authority, the privileges and the very social existence of a fundamental social unit of the society. This applies to the commoner as well as the aristocratic class.

In every Paiwan village, several houses represent genealogical lines that reach far back into the mythical past. These may be regarded as principal houses, and one of them is the residence of the paramount chief. All other houses are seen as having hived off from principal houses. As for the people living in each house, the household group, each has a designated head called *vusam*. This word also means "seed millet"; thus it connotes the possibility that from each existing house and household, others may grow.

Usually, a head of household is succeeded by the eldest child, either male or female. However, there is often controversy over succession and political manipulation of the issue, particularly regarding the paramount chief's household. It is possible, for example, for an ambitious person who is not in a direct line of succession to usurp the paramount chieftainship by demonstrating that he or she can enhance the dignity of the chiefly line. One of the means by which this enhancement is achieved is by improving the condition of their house. It is therefore not difficult to understand the strong social motivation behind the concern that Paiwan people have about the appearance of their houses and the surrounding landscape. The highly developed crafts of carving and sculpture can be understood in light of related this motivation.

The Paiwan House:
A Representation of Continuity

The traditional Paiwan house is an asymmetrical, gabled building made of slate and wood. Slate slabs are used for walls, roofs, the sleeping platform, bench and all pavements inside and out. Wooden parts include posts, beams, ridge pole, rafters, and doors. The most luxurious residences of chiefly households have carving on the wooden eaves-beams, doors, screens, main posts (ancestor posts) and even walls. The usual or standard aristocratic house, however, is distinguished only by its carved eaves-beams and main post, or *qeluz*.

The *qeluz* is the main house post which supports the ridge pole. Most *qeluz* are made of wood, but slate *qeluz* are also found in areas where the material is abundant. Some houses of paramount chiefs of northern and eastern Paiwan have carved slate pillars called *saulaolai*, which are stone back-rests on the stone platform in the front courts of the houses. Here landowners and their tenants gather for sacred as well as secular events, such a settling disputes, discussing village affairs, or simply social chatting.

Usually a *qeluz* is carved with one entire human figure and figures of snakes or other animals. The human figures is either known by a personal name and remembered as the founder of the house, or known as an heroic ancestor of the household. The hundred-pacer snake (Agkistrodon acutus) is one of the major characters in Paiwan mythology, and it is generally considered to be the procreator of the nobles and, in some episodes, of the commoners as well. With local variations in details, the focal theme of the procreation myths is that a woman accepted a marriage proposal from a snake, but not without strong dissent from her family. The serpent gave the woman's family jars with snake designs and the privilege of using the snake design. These jars later became heirlooms of the family line that descended from this mythical reptile-human union. It is curious to note that, contrary to another popular theme – the conjugation between two human ancestors, which sometimes leads not to prosperity but to tragedy in Paiwan mythology – unions between women and snakes always foretell prosperity and abundance for the descendants. In some Paiwan carvings, the snake is depicted in a more realistic way, while in others it is highly conventionalised – represented, for instance, by a row of rhombuses or black and white triangles.

Traditionally, the Paiwan buried their dead inside the house. This custom was banned by the then ruling Japanese authorities in the 1930s. The indoor grave (*luvang*) was usually located underneath the central living floor in a house. It was a square pit with an opening of about 1 to 1.5 square metres, and a depth of 1.5 to 2.7 metres. The pit was covered by one layer of earth sandwiched between two pieces of slate, with the top slate level with the floor. In the old days, the Paiwan followed the custom of flexed burial. The deceased was put in a sitting/squatting position, dressed in fine clothing and wrapped in a blanket. The body was then lowered into the pit in the same upright position. The indoor grave was reusable; it served as the final resting place for all family members who died a natural death. If a house had only one carved main post, it usually stood right behind the spot of the grave. If it had two main posts, they were usually a few metres apart, with the grave situated between them. While the Paiwan sat, talked and lived their daily life on the top of the grave and showed no special restraint toward the burial site, they considered the space between the back wall and the posts to be sacred. On the back wall, there was usually a stone

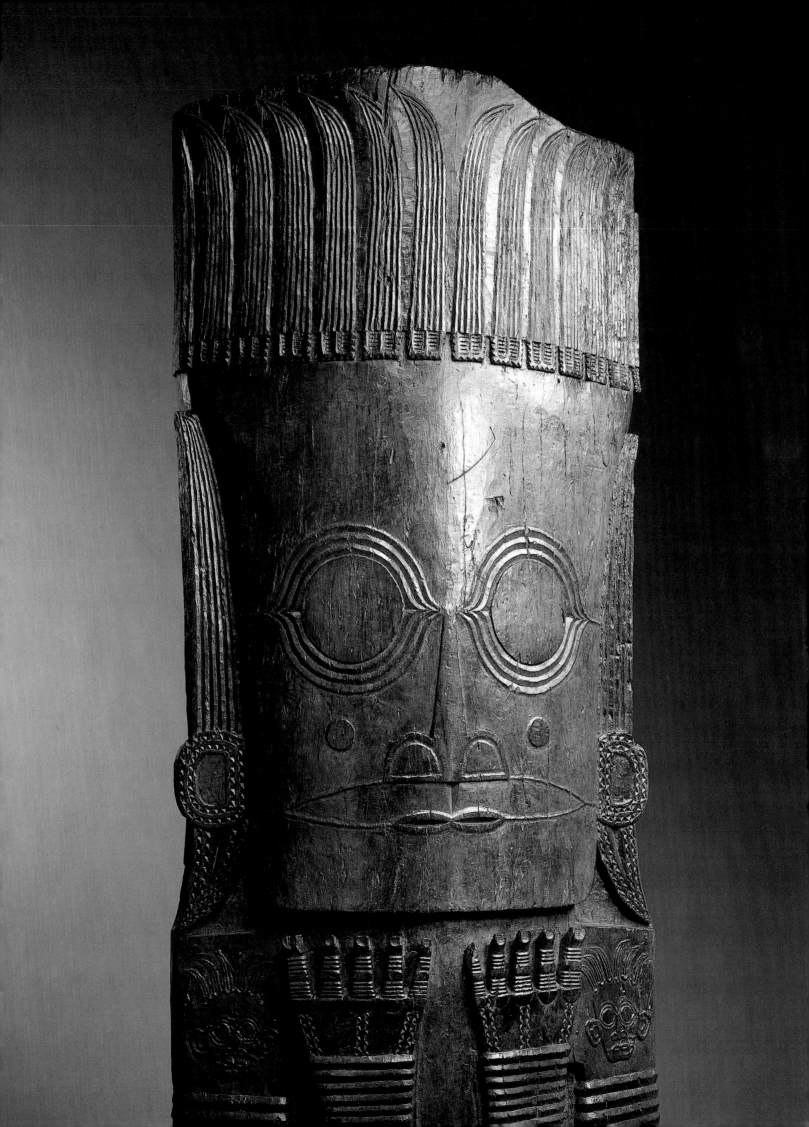

shrine for the family to keep their heirloom jars. The stone shrine and the carved main post were the major objects to which ritual offerings and chanting were dedicated. The grave underneath the floor, the main post with its carved ancestral figure and the shrine for the family heirlooms were, therefore, three sacred objects that symbolised the status and the continuation of the family line.

The Ingenuity of Paiwan Artists

Most Paiwan craftsmen, including the sculptors, are minor aristocrats.[2] They either own land and have tenants or are exempt from paying rent to a landlord. Sometimes, but not always, the status of craftsman becomes hereditary along a family line. In a few cases, talented commoners become renowned craftsmen, and as a consequence they, along with shamans and skilled warriors, are given special recognition by their patrons. For example, the patron may share with them part of the tribute paid to him by other clients. On the whole, Paiwan craftsmen do not form a special social stratum. They receive payment for their work, but it is more ceremonial than substantive.

Although the carvings on main posts are the most symbolically-loaded objects in Paiwan culture, they are remarkably varied and ingenious in terms of style and design. Most Paiwan artists were unrecognised as individuals before the 1950s, but the individuality of their work was nevertheless evident, as can be seen from pieces dating from the early decades of the 20th century currently in museum collections.

This particular piece on loan from the collection of the Institute of Ethnology, Academia Sinica, was originally from the Jigurul House of Kapiyangan village, one of the oldest Paiwan villages around Mount Kavulungan. Professor Chen describes the style of carved house posts in Kapiyangan area as having "a human figure with hands raised in front of the chest, both legs straight, parallel lines on the arms indicating armlets and a narrow strip of circles indicating a waistband with shell decorations".[3] The piece on exhibition measures 303 cm x 82 cm x 8 cm. In addition to the general characteristics of Kapiyangan style Chen described, the human figure on this post shows a number of prominent features that deserve attention. From the human head tattoo on both shoulders, we can tell that this figure represents a man. He is wearing head gear decorated with either eagle feathers or leopard tusks. The concentric circles representing the eyes are a rather unique feature. According to Chijiiwa[4] and Chen,[5] among all the Paiwan post carvings that have ever been documented, only the two posts in the Jigurul House have this feature. While concentric circles were a widespread motif among earlier Austronesian artefacts, we might still speculate about the possibility that these circles depict the eyes of the legendary Pali, the popular Paiwan hero whose burning eyes and fierce gaze killed foes and friends alike.

The full significance of Paiwan architectural carving can not be grasped by a single pillar on exhibit here. The carved eaves-beams, posts and back-rests are components only of finely decorated houses, and it is these houses standing in contrast to the more numerous undecorated dwellings in each community that express concretely and uniquely the important aspects of social life in each village: the social relationships of nobles to commoners, of patrons to clients, and of landlords to tenants.

BIEN CHANG

1 Mabuchi, 1953.
2 Jen, 1957.
3 Chen, 1968.
4 Chijiiwa, 1988.
5 Chen, 1968.

Nias: an Island of Stones and Feasts

The culture of Nias has much to amaze visitors. It possesses what is probably some of the most interesting architecture in Southeast Asia and, above all, it has quarried, erected and sculpted an incredible profusion of stone monuments which are among the most impressive of their kind.

The island is generally considered to comprise three distinct cultural regions of unequal geographical extent: the north, the centre and the south. Each has its own form of political organisation, architecture, spatial organisation of villages, marriage rules, language and types of statues.

Nevertheless, it is clear that all the Niha came from a common Austronesian substratum. When looking at this society, the first obvious point is that they were warriors. While there have always been agricultural activities, whether carried out by free men or by servile labourers, it is clear that primacy was given to the warlike virtues, to deeds of war rather than work on the land; to the manufacture of weapons (spears, swords, shields, armour) rather than agricultural tools; to laying out defensive systems rather than fields. This is the bellicose context in which we need to set its social and political structures and the megaliths that reflect them.

Festive practices are a key element in the social dynamic and aesthetic dimension of Nias life. They have always impressed visitors, whether with the massive slaughtering of pigs, which they occasioned at the beginning of the 20th century or, today, with the megaliths produced in relation to these events. Most authors speak of only one kind of festivity, the "feasts of merit",[1] in which category the various authors have included all the celebrations that, according to them, involved the erection of a megalith and a lavish slaughtering of pigs. It is important to note that pigs are an indispensable part of any festive practice on Nias, be it a simple manifestation of deference towards a guest or a feast with several hundred participants.[2] The Niha have highly developed festive systems whose main function is to ensure social cohesion and reproduction at different levels and by diverse processes. We can distinguish two levels. The first concerns classic life-cycle celebrations (births, weddings, funerals), to which can be added those designed to mark the successful integration of an individual into his community at the level which, according to customary law, he is supposed to occupy. The corollary of this is that, at the highest level, these feasts become means of access to power. These celebrations follow the logic of gift and counter-gift, a system of exchanges that, in Nias, operates throughout the life of each individual, and even beyond, since a son will inherit his father's obligations. A man's prestige is thus measured not by the material goods he has amassed, but by his capacity to produce them or have them produced in order to distribute them and, thereby, to ensure the proper working and reproduction of the community through the network of obligations that constitutes its dynamic structure. The second level is that of clan feasts. The two main ones are the *fondrakö* (throughout the island) and the *börö n'adu* (in the south).

ALAIN VIARO
Translation: Charles Penwarden

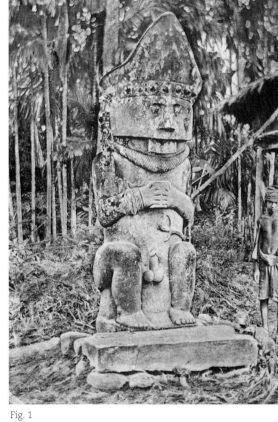

Fig. 1
Gowe sculpture
H. 270 cm
Photographed in 1914 in the north of Nias Island
and reproduced in E. Schröder, 1917

1 F.M. Schnitger (1939), C. von Fürer-Haimendorf (1939), P. Suzuki (1959), K. Birket-Smith (1967) and A. Beatty (1992) all use this term, whereas E. Modigliani (1890) prefers to speak of "feasts of honour" and E. Schröder (1917) of "feasts of rank" or "feasts of the bourgeoisie".

2 H. Sunderman (1905) tells how "the chief holds a great feast that they call *owasa*, during which as many as three hundred pigs are killed. [...] At best, they are unable to eat all the meat [...] The children then throw it onto the ground and the earth is all slippery with pork. "The author was no doubt shocked by this apparent waste. It should be noted that Nias is the only island in the archipelago where there are no buffaloes.

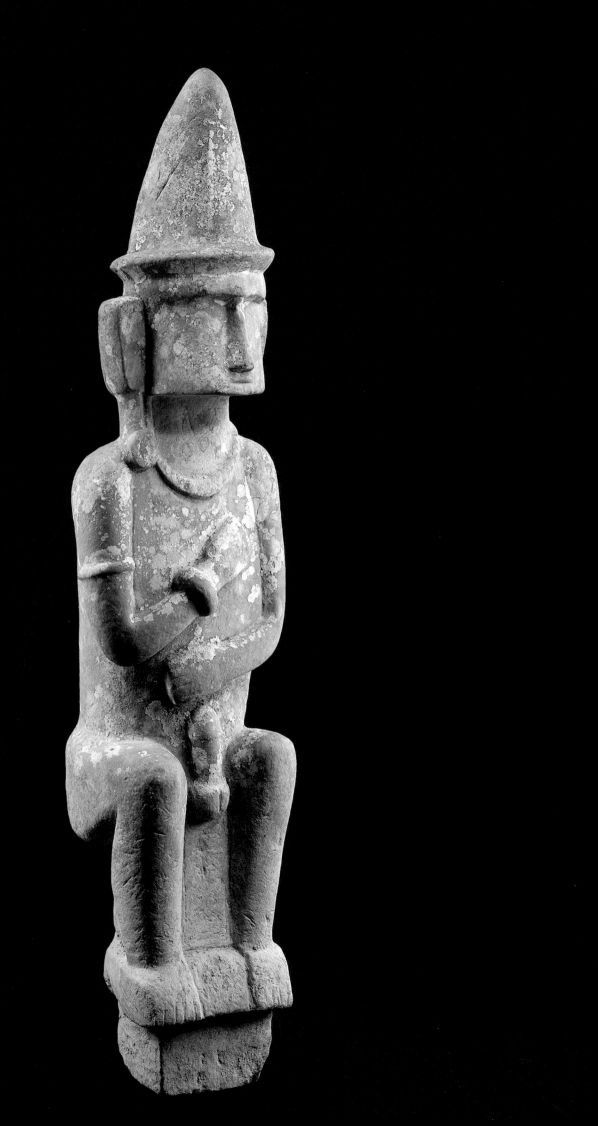

Sculpture from the northwest of Nias Island

19th century
Indonesia

Gowe salawa statue commemorating the power of a chief

Sandstone
H. 131 cm
Formerly the Barbier-Mueller Collection
Gift of Monique and Jean-Paul Barbier-Mueller, 1999
Musée du Quai Branly
Inv. 70.1999.5.1

Exhibition
Hannover, 1998.

Main Publications
"Dans la jungles des idoles",
Beaux-Arts, no. 83, 1990, p. 92;
Messages in Stone, 1998, cover
and p. 53; *Messagi di pietra*,
1998, cover and p. 53; *Botschaft
der Steine*, 1998, cover and
p. 53; *Arts des mers du sud*,
1998, p. 29.

The festive cycles in the north of the island were directly related to the process of the foundation of the öri (confederation of villages descended from the same ancestor) and disappeared with colonisation and the conversion to Christianity, which started earlier and went deeper in the north than anywhere else in Nias. Many of these feasts have now been forgotten, and it would seem that today they are an extremely rare occurrence in this part of the island. Nonetheless, it appears that the register of these celebrations was related to the notion of *bösi*, or rank. Each clan possesses a certain number of ranks (nine, ten or twelve), which was determined at its foundation, with the upper ranks corresponding to the nobility. It was however possible to move from one rank to another, and a commoner could rise to supreme power. Each man had to organise feasts in order to maintain, consolidate or improve his *bösi*. Held in honour of ancestors and allies, these feasts involved the inevitable giving and consuming of pigs and in some cases gave rise to the production of gold ornaments. For those who were simply consolidating a lower rank, they rarely involved the raising of stones, and in any case these were simple uncarved megaliths. In the case of attainment or consolidation of a higher rank, however, anthropomorphic statues (*gowe*) were made. These are among the most impressive pieces on Nias. They enabled their owner to enjoy the title of *balugu*.[1]

While the *gowe* are sometimes no more than raised slabs of stone, they could also take the form of impressive anthropomorphic statues. Between these two extremes we find a very broad range of expressive forms: a shaft of stone endowed with vigorous virile attributes and a head-cutter's necklace; a pillar with a rudimentary face; massive stelae ending with a human head bedecked with all the ornaments of a chief at the height of his prestige (headdress, earrings, necklace); noble-looking effigies squatting on their heels and holding in their two hands the betel pot of welcome. The biggest *gowe* are as much as 280 cm high, although most of them are less than a metre. Many villages own one or even two *gowe*. Even more impressive are the ensembles of some ten *gowe* placed on mounds, which can be admired in the historical sites deep in the forests of the Soliga region. These statues, which exude an extraordinary power, all belonged to the same clan and were apparently all carved by the same artist.

The *gowe salawa* illustrated here is squatting, his phallus erect between his knees. The right arm is folded over the chest, the left arm reaches down to the waist. This posture is found in several statues of the same type from the northwestern regions of the island. It is less common than the one with the arms bent and holding a bowl of betel nuts, a symbol of welcome. This *gowe salawa* wears the insignia of a chief: the tall hat is supported by a band with cabochons, a decoration that features often, if not always emphatically, in representations from the north of the island. There is a bracelet around the biceps, another on wrist of the right arm. The necklace is a torque, a piece of gold jewellery that was fastened at the nape of the neck. Although the statue is fairly old and worn, we can still see the care the artist has taken to show this detail. An earring hangs from the right ear. The crude form of the ears is typical of the style of pieces from the Lahömi River area, in the northwest of the island.

ALAIN VIARO
Translation: Charles Penwarden

1 The title of *balugu* was honorary and was not linked to the exercise of power. A village could have several *balugu*, and although a village chief was not necessarily a *balugu*, this was a rare occurrence. The title is still used today, and may sometimes serve as an equivalent to *salawa*, or village chief.

Sculpture from the north of Nias Island

19th century
Indonesia

Ancestor statue (*adu zatua*)

Wood, crusty red patina
H. 55.7 cm
Formerly in the collections of André Breton, Helena Rubinstein and Alain Schoffel
Donated by Alain Schoffel, 1999
Musée du Quai Branly
Inv. 7.0.1999.3.1

Exhibition
Paris, 1926.

Main Publications
Tableaux de Man Ray et objets des îles, 1926, cover; *Collection André Breton et Paul Éluard*, 1931, no. 173, pl. XVII; A Portier and F. Poncetton, [1929], pl. XXXIX, no. 48; *The Helena Rubinstein Collection*, 1966, no. 256; A. Schoffel, 1981, no. 71, p. 85.

Made by a master sculptor in the north of the Nias Island, this work was most probably acquired by André Breton in Amsterdam in January 1926.[1] It was first exhibited in the West at the exhibition *Tableaux de Man Ray et objets des îles*, which marked the opening of the Galerie Surréaliste in Paris (26 March 1926) and included a number of Oceanic sculptures from Breton's collection alongside "Dada-style" paintings.[2] It was photographed by Man Ray and shown on the cover of the exhibition catalogue (fig. 1) and was placed in the gallery window. The sculpture was auctioned at the sale of the André Breton and Paul Éluard Collection at the Hôtel Drouot in 1931, then sold in New York as part of the Helena Rubinstein Collection (Parke-Bernet Galleries, Inc.). In 1999 it was bequeathed to the French State by its last owner, Alain Schoffel.

Adu, the word used for all wooden statuettes, could be translated as "ancestor spirit" and all *adu* refer to the supernatural world, to the spirits of ancestors, gods or illnesses. The *adu zatua* are effigies of the deceased. They were sculpted only after death and were made expressly to provide a home for the deceased's soul. They were kept inside the house and it was in front of them that the blessings of ancestors were invoked and offerings were placed.

The origin of the *adu* is bound up with the story of the *bela*, the evil spirits who punished men for having used a stratagem to gain mastery of fire.[3] The wife of a brother of Hia, the patriarch of humanity, went up to the eighth globe (the home of the mythical ancestors, just above the earth) to ask Silewe Nazarata (the wife of one of Hia's sons), who gave mankind knowledge, for a remedy to the ills that beset them. The latter replied: "From thirty of my sons I will make thirty kinds of wood and I will send them to earth. When you feel ill, take one of these types of wood and make it into an idol with a human face, for in the old days these types of wood were men, and when you restore them to human form a soul (*noso*) will enter into them as before. Manawa[4] is my oldest son and therefore the most powerful idol, because from the mouth that you fashion for him will come forth an *eheha* (cry), as from the mouth of a rich chief in his death throes. To clothe and decorate the idols you must use coconut leaves, and as the price of the cure of the illnesses you will give him a jar of earth, which he will offer up to the *bela*. You must also sound the drums in order to call the *bela*."[5]

There are countless *adu*, ranging from simple pieces of wood decorated with leaves and with notches for the mouth and eyes, to consummately fashioned ancestor statues. *Ere* priests used to invoke them to cure illnesses, or whenever an event that was important to the household or village occurred. They were made to go head-hunting with, at the birth of a son, when a child was given its name, circumcised or married, during pregnancy, to counter the effects of bad dream, after seeing a ghost, to secure a good harvest or to ensure the

Fig. 1
Cover of the catalogue
for the exhibition
*Tableaux de Man Ray
et objets des îles*

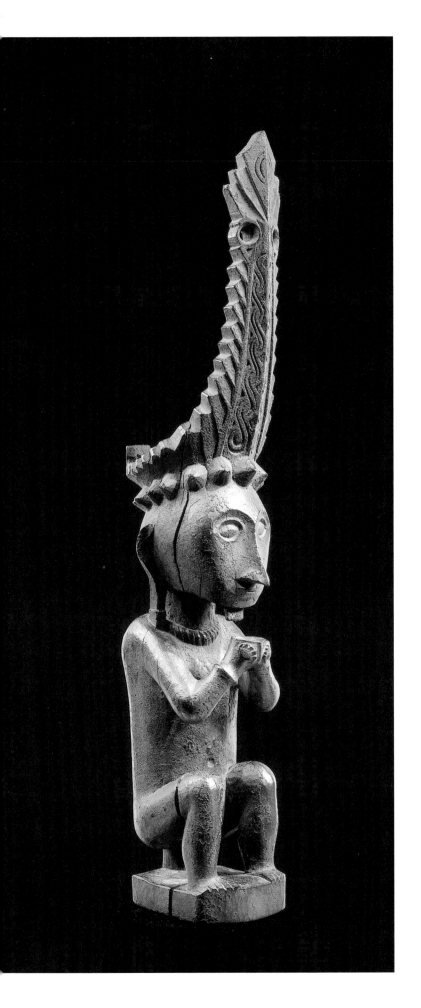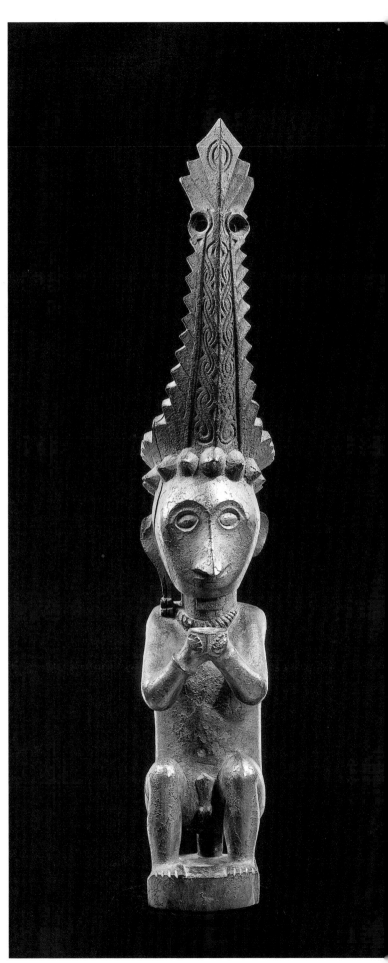

health of one's animals, when villagers planned to settle on a new site and wanted to honour its presiding *bela* spirit, for celebrations in honour of chiefs, to ward off or cure all kinds of illnesses, when making ceremonial golden ornaments, when building a house, for funerals, for hunting expeditions, to put an end to epidemics, and so on.[6] Those *adu* that served as intermediaries to convey the human desires indicated by the priest to the spirits of the upper world were thrown away once the goal for which they were made had been achieved.

In contrast, those *adu* that protected an individual, a house or a village, and that had a detailed human form, were kept as supremely precious possessions.

Adu zatua, or effigies of the deceased, were made immediately after death. The quality of their execution varied in accordance with the deceased's importance and wealth. For example, the *adu siraha salawa*, which protected the chief of the village, was always sculpted with great care. It was placed in front of the window of the house, hanging from a roof for all to see. It received offerings when the chief was sick or when he had to make a judgement or decide on a warlike undertaking.

According to local belief, when the deceased was buried the soul, *moko moko*, did not leave the body immediately, and when it eventually did, it took the form of a small spider. To facilitate its departure, the stem of a *tugala* plant was stuck into the ground beside the tomb for it to climb along. Some time after the burial, kinsfolk came and looked for the soul and, when they found it, took it to the figurine.[7] The statuette was placed beside statuettes of other members of the family, near the house, hanging

from a master beam or on a shelf, an altar. The *adu* brought blessings and prosperity to the household. On various occasions offerings were made to it, such as pigs' jaws, chickens' feathers and eggshells, and blood from sacrificed animals was poured over it.

During celebrations, a "ladder" of rattan rings was attached to the *adu*, extending all the way along the path to the stone bench in front of the house. The ancestor was thus able to participate fully in the festivities of the living.

The *adu zatua* sit on low stools, their hands holding a bowl. They can be anything from 20 to 90 cm high. The size of this particular piece suggests that it is an *adu siraha salawa*, or village chief. With its unusual rearward ears and pointed nose, this work is one of the most remarkable sculptures from Nias. Similar figures can be found in a number of public and private collections around the world.[8] All exhibit more or less the same ornaments: a tall headdress with fern decorations (*ni'o wöli wöli*) surmounting a band or a diadem of cabochons fixed on a strip of cloth; an earring on the right ear; a necklace, in this case twisted (*nifatali* or *nifato-fato*), and a metal or shell bracelet (*töla gasa*) on the right wrist. These gold ornaments,[9] which were made for the wearer on the occasion of the various feasts he organised during his lifetime, would also be worn at feasts given by other members of the group and indicated his high social position.

<div align="right">

ALAIN VIARO
Translation: Charles Penwarden

</div>

1 André Breton, *La Beauté convulsive*, 1991, p. 183.
2 *Ibid.*
3 See E. Modigliani, 1890, p. 630.
4 Name given to the wood from which most *adu* were made.
5 Quoted by E. Modigliani, 1890, p. 632, from J.W. Thomas, 1881, p. 135.
6 For more details, see E. Modigliani, 1890, p. 631-646; J.P. Kleiweg de Zwaan, 1913, vol. I, pp. 17-20, pp. 36-66; E.E.W.G. Schröder, 1917,

pp. 530-584, pp. 587-589, pp. 592-604.
7 J.P. Kleiweg de Zwaan, 1913, pp. 18-19.
8 For example, the VEM collection in Wuppertal (no. R6, H. 55 cm), RJM in Cologne (no. 51648, former collection of the missionary L. Borutta, 1907-20, H. 37 cm), TM-Amsterdam (no. A 3701-C, acquired before 1890, H. 44 cm), Barbier-Mueller (no. 3250/B, H. 68 cm), NUS-Delft

(no. 395-1, H. 79 cm). All these pieces come from the northern part of Nias, probably regions close to the eastern coast, which until 1914 was the only area covered by Dutch agents and missionaries.
9 There is no gold on Nias. This and other metals were obtained from Sumatra. There is evidence of exchange between the two islands going back into the remotest past.

Toba Batak sculpture

Mid-15th century[1]
Northern Sumatra, western Indonesia

Wood covered with a patina of soot
H. 128 cm
Formerly in the collection of Comte Baudoin de Grunne, Wezembeek-Oppem (Belgium)
Musée du Quai Branly
Inv. 70.1998.9.1

Main Exhibitions
Geneva, 1981; New York,
1981-82; Dallas, 1982.

Main Publications
W. Stöhr, 1981, pl. 18; *Regard
sur une collection*, 1995, fig. 53.

Most Batak pieces in public or private collections come without any indications as to their function or where they were collected. In general they were acquired from local antiques dealers, to whom villagers have brought massive quantities of sculptures in recent decades, no doubt after the death of those who knew their secret meanings (the vast majority of the Toba have converted to Christianity[2]).

Batak culture and religion

The Batak occupy most of the mountainous province of northern Sumatra, centring on the great volcanic Lake Toba, which was formed in the Pleistocene epoch. The Batak people comprise six groups that speak Austronesian dialects (Malayo-Polynesian). Going from north to south, those who call themselves Batak are the Karo (some of whom still practise their traditional religion), the Pakpak (to the west of Lake Toba), the Simalung (to the east), the Toba (around the southern half of the lake, as far as the Indian Ocean), the Angkola and the Mandailing (even further south[3]).

Even the Christian Toba obey the "law of the heavens", or *adat*. This for example considers endogamy as a form of incest for which, in the past, the penalty was death. For all the Batak, filiation is patrilineal.

We know of several versions of the Toba creation myth, although the personalities of the principal divinities change very little from one to another. The Toba did not make effigies of their gods but honoured them with prayers (*tonggo-tonggo*). Offerings and sacrifices (chickens, goats, buffaloes or dogs) were made essentially to win the favours of semi-divine ancestors, "spirits of nature" or magic statues that were invented by the "magician" (*datu*) and could influence harvests or fishing catches.

The *datu* have been erroneously described as "priests". They were in fact seers (*datu paralatan*), healers (*datu pandaoni*), wizards, makers of amulets, sculptors of wood or stone, casters (*datu panggana*) and specialists in the decoration of noble houses (*datu panggorga*), onto which they incised a light relief and which they painted in the sacred, cosmologically significant colours of red, white and black. They did not master the techniques of trance (shamanism), which they left to those who were naturally gifted for communicating with the supernatural world (*sibaso*) – usually women. Likewise, they left sacrifices and public prayer to political leaders (*raja*). These two functions (magic and politics) were complementary, but chiefs were often magicians. To be a good *datu* or respected *raja*, you had to have a powerful *sahala*, which is more or less the equivalent of the Polynesian *mana*, and can be translated as "vital force".

The Batak invented a script derived indirectly from Sanskrit via Old Javanese. Their books of magic (*pustaha*) contained recipes for curing illnesses (caused by evil spirits or enemies), to give protection against aggression and to bring about the ruin or death of an enemy. Among the many magical products (*aji*) listed we find simple philtres (*dorma*), medicines (*taoar* or *daon*), more sophisticated prophylactic mixtures (*minak*) and, most powerful of all (*sibiangsa, pupuk*), those that contained the viscera of a ritually slaughtered young child and were kept in a small Chinese ceramic jar (*guriguri*).

Toba sculpture

Apart from wearable amulets, we can distinguish three main types of Toba anthropomorphic sculptures. The first are the wooden statuettes (*silaon na bolon*) representing a human couple. Always small in size, these were placed in the roofs of houses and evoked fabulous ancestors from the remote past, protectors of the home.

The second type of sculpture consists of the stone or wooden statues of powerful (dead or living) figures,[4] often portrayed riding a buffalo, a horse or a mythical animal called the *singa*. The best known ones are the stone monuments, some of which can still be seen in Toba country, [5] and the wooden figurines used as stoppers for receptacles (*perminakan, guriguri*) containing magic substances (fig. 1). In the latter case, numerous sources suggest that this rider or seated figure represented the magician who would use the substances in question.

Finally, the third category of figures includes wood or stone magic statues in a wide variety of sizes whose function was either defensive (*pagar*) or offensive (*pangulubalang*). The figure is generally represented upright with bent legs, hands together or placed on the abdomen with the thumbs touching, or holding a separately sculpted knife or other weapon. Many of these magic sculptures have square holes made in their side, chest or belly, these being stopped up again with a protruding piece of square wood after the "medicine" is placed inside.[6] When the statues invested with a magical defensive or offensive power have no hole for the mixture prepared by the *datu*, it means that the "medicine" (and especially the dangerous *pupuk*) was placed beside the sculpture or buried in the ground close by.[7]

The statue presented at the Louvre is very enigmatic and manifestly has a very eventful history. Initially placed outside a house (which tends to indicate that it is a *pangulubalang*, capable of exterminating a specific attacker), it was attacked by a large wood-eating bee (*borongborong*) that makes round tunnels in the beams of houses and sculpted ornaments. There are 17 asymmetrical holes in all, with the entrances and exits of the tunnels, all made by insects. Some of the holes go all the way through the body.

Afterwards, the statue was placed inside a house, which the *borongborong* were prevented from entering by the smoke from the hearth to the left of the entrance. Since there was no real means of evacuation, this smoke covered the pillars and woodwork at the top of the roof, as well as the objects kept by the occupants. The slightly crusty black patina on this piece is a fine layer of soot, which also lines the insides of the holes made by the *borongborong*.

Was the statue too big for the emplacement attributed to it? Would that be why its head was sawn off at the top? This flat surface was more probably made in order to affix a headdress made of animal skin and hair of the kind seen on many magic Toba statuettes. This headdress protected the sawn area and prevented the formation of a layer of soot.

The work's slender, tall form is exceptional. The position of the extended, joined hands is familiar; it is called *manomba huasi* ("to ask, beseech with humility"[8]). According to several sources, the *manomba huasi* posture signifies that a divinity is being invoked, and that it is not just a matter of using magic to avert a danger. We have no way of knowing if the figure represents a spirit or the human victim sacrificed so that his organs could be used to make *pupuk*.[9] At any rate, it is very probably not a representation of a noble figure because portraits of men and women showed them in all their majesty, adorned with their jewels, riding a prestigious or divine (*singa*) steed, or even on a chair that only nobles, the wealthy, would possess. Such people would not be shown imploring or brandish-ing weapons, these postures being reserved for anthropomorphic sculptures relating to the spirit world. The fact that there is no orifice in which to place a magic substance (*minak* or *pupuk*), and that it was deemed necessary to carefully transport this sculpture into a house (to protect its inhabitants from a great danger?), would seem to suggest that the substance accompanying this figure was probably a *pupuk* so redoubtable that it was left in its recipient beside the statue on which it conferred its power.[10]

The piece as a whole shows that the *datu panggana* who made it was as much a gifted artist as he was a magician. Reverence is indicated not only by the joined hands but also by the slightly bent knees, the earnest expression of the face and the slight forward inclination of the head. Using neither a preparatory sketch nor any kind of model, the sculptor executed his conception with remarkable sureness of touch. Subtle ridges emphasise the jaw, the chignon of the hair, the hips, the popliteal hollow and the "heels". Seen in profile, the chest and the thighs form a single, gently incurvated line which is twice broken, but not abruptly: firstly by the arms, then by the erect sex organ. Generally, the proportions of this piece, the finesse of the body and the small size of the head all correspond to the – admittedly highly variable – stylistic canons for Batak wood sculpture.

There are few elements that can be used to identify the workshop or even the region or origin. The relatively simple shape of the ears does not have the question mark appearance which often charac-terises the "original style", nor does it have the "floral" lines seen on the stone statues of the Barus area. The ridge around the jaw is a constant. As for the chignon on the back of the neck, which is round-ed (from the back) and surrounded by a sharp ridge, it can be seen on sculptures from the Pakpak area[11] and Simalungun.[12] The helmet-like headdress (?) seems to go back a long way into the Sumatran past. Elsewhere, I have compared the Batak "helmeted rider" to a "helmeted" rider found in central Sumatra[13] and probably dating back to the first half of the first millennium. A number of authors have posited the existence of a megalithic civilisation linked with the introduction into Sumatra of Dongson Indochinese bronze culture. They point to the fact that one of the stone monuments in southern Sumatra represents a man carrying a typical Dongson bronze drum on his back. However, without further archaeological research in the Batak region, these questions remain moot.

When this work was exhibited in Geneva in 1981,[14] I showed the catalogue to many elderly men in the "country of origin" (the Samosir peninsula, southern Lake Toba), but only the people in the western region (inland from Barus) said that they had seen similar things in the past.[15] One of them expressed his admiration for the work with the adjective *lehet* ("correct, suitable"), which is used in

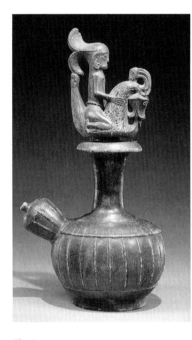

Fig. 1
Toba Batak sculpture surmounting a container of Chinese origin
H. 34.5 cm
The Metropolitan Museum of Art, New York
Donated by F. and R. Richman, 1988

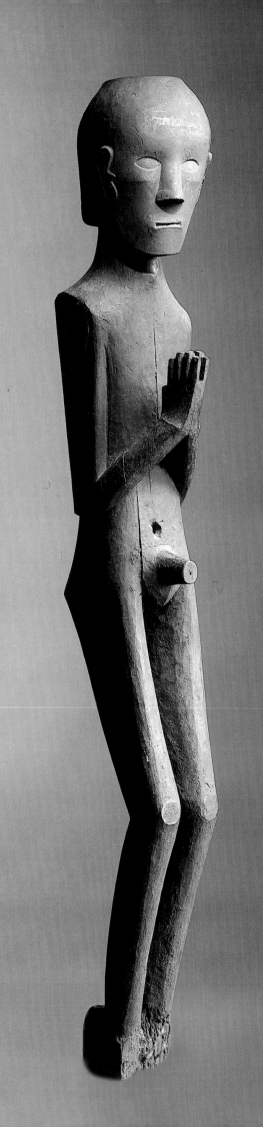

matters of tradition (for garments, ceremonies, etc.) to describe what is fitting, but also indicates aesthetic value.[16]

Toba sculptors were fairly free to give magical figures (as compared to prestigious or funerary effigies) the appearance they wanted. Moreover, it was common for the young sons of wealthy families to travel considerable distances to follow the teachings of a renowned *datu*. They would return home having learnt a new stylistic vocabulary, which means that the Toba country was more conducive than the territories of neighbouring groups to the emergence of unclassifiable objects.

JEAN PAUL BARBIER
Translation: Charles Penwarden

1 Carbon-14 tests carried out on the sculpture's wood in 1999 by Dr Georges Bonani of the Eidgenössische Technische Hochschule, Institut für Teilchenphysik, Zurich, have yielded the following results: ETH-20605: 540 +/- 40 B.P.; 13C [%]: -22.7 +/- 1.1. Calibrated periods: CE 1309-1355, with a probability of 22.5 ‰; 1384-1444, with a probability of 77.5%).
2 The evangelisation of the Toba was begun by the Dutch in 1907.
3 These last two groups were Islamised at the beginning of the 19th century.
4 Johannes Warneck and Johannes Winkler, who both lived in Toba country at the beginning of the 20th century, had differing views about ancestor effigies. While the latter categorically denied their existence (J. Winkler, 1925, p. 7 and p. 133), the former wrote that "portraits" were made of the *sombaon*, the most illustrious, quasi-deified ancestors (J. Warneck, 1909, p. 87; J. Warneck, 1915, p. 357). Both forgot the large (often equestrian) statues in stone which are also portraits of illustrious figures and, like some of the big sarcophagi, were made at the request of those who were very much alive. In the 1970s, the late lamented Jamaludin S. Hasibuan, a Toba psychiatrist in Medan, drew my attention to proof of the existence of these ancestor effigies. His personal research (J.S. Hasibuan, 1985, p. 141) had shown that they were carved only in stone. These statues can be recognised by the narrow, round-sectioned bracelets worn at the top of each arm. Although this cannot be proven, we cannot rule out the possibility that wooden *sombaon* effigies once existed and have since been lost. One thing is certain: in contrast with the situation observed on neighbouring Nias Island, the houses never contained statuettes representing more or less distant ancestors which were worshipped and presented with libations.
5 J.P. Barbier, 1988.
6 J.P. Barbier (ed.), 1998, fig. 190, p. 134.
7 H.H. Bartlett, 1930, caption pl. XIV.
8 The root of the verb *manomba* (variant: *marsomba*) is *somba* ("veneration"), from which derives *sombaon*, the highest rank that can be attained by the soul of the deceased.
9 See notes 10 and 15.
10 Of course, we are in the realm of hypothesis here. The only thing we know for sure is that this sculpture had a magical function. There is much confusion surrounding the classification of these objects. In a recent book, the author of these lines summed up the situation as follows: the *pagar* are activated by *minak* and the *pangulubalang* by *pupuk*, made with organic human matter. In fact, this basic explanation is inadequate and needs to be qualified. *Pagar* (whose function is purely defensive) can in fact be loaded with *pupuk* when the person to be defended is in serious danger or of high rank (W. Volz, 1909, p. 158). At the same time, it is true that only *pupuk* can be used to make a *pangulubalang*, the function of which is aggressive. However, none of the aforesaid tells us whether in both cases (*pagar* and *pangulubalang*) the magic substance could be placed beside the statue (as argued, with proof, by H.H. Bartlett, for the second category), or whether this practice was known in all the regions inhabited by the Toba (H.H. Bartlett made his observations in a rather particular Toba region, Asahan, in the south of Simalungun country).
11 See J.P. Barbier, 1988, fig. 66, p. 62.
12 *Ibid.*, fig. 67, p. 62.
13 *Ibid.*, fig. 68, p. 63.
14 This exhibition, which was shown in Geneva, Brooklyn and Dallas, received the patronage of the President of Switzerland and the Vice-President of the Republic of Indonesia. The National Museum of Jakarta lent two rare large wooden statues from Nias Island which had never been seen outside Indonesia before.
15 When writing this article I asked one of these locals, Maruli Tua Marpaung, for further information. Born in 1935 in the village of Sijungkang, near Barus, he confirmed that his grandfather had an identical statue. He said that the *pagar jabu* of his ancestor had been "fed" with *sibiangsa* (a synonym of *pupuk*) and reminded me quite clearly that the active principle of the *sibiangsa* is the *begu* (soul) of a child sacrificed by the *datu*, who uses the infant's fat (this is the exact translation of *miak*, a term equivalent to *minak*, which does not necessarily refer to animal or human fat: for example, *miak tano* = oil; literally, "earth oil").
16 In his Toba-German dictionary, J. Warneck (1977, p. 141) notes the verb *parlehetan*: "to make beautiful, to make fitting, to set in order".

Nage Sculptures

Late 18th century[1]
Flores Island, eastern Indonesia

Ana oleo Figures

Wood
H. 164 cm (figures alone: 34.5 cm and 35 cm)
Formerly in the Musée Barbier-Mueller collection, inv. 3525-10 A/B
Musée du Quai Branly
Inv. 70.1999.5.2.1. and 70.1999.5.2.2

Main exhibitions
New York, 1988-93.

Main publications
J.P. Barbier and D. Newton
(eds.), 1988, p. 107; *Sculpture:
Chefs-d'œuvre du musée Barbier-
Mueller*, 1995, p. 239; *Art des
mers du Sud*, 1998, fig. 11,
p. 111.

Carved from the trunk of a hebu tree (Cassia fistula), anthropomorphic figures called *ana deo* are erected on either side of a ladder that provides access to a cult house (*sa'o waja*), the ritual and political centre of a lineage or local segment of a Nage clan. Figures of the same type are also encountered in the Keo region, immediately to the south of Nage territory. Among the Keo they are placed in front of the entrance to small, normally uninhabited, ceremonial buildings called *nde*, which are erected at the seaward end of a village. Among both Nage and Keo, the male figure is placed on the right (reckoned from an interior position facing outwards towards the front of a building), and its female partner on the left. Similar, but not identical, wooden statuary is also found among neighbouring peoples on Flores, such as the Ngadha and Lio residing to the west and east respectively.

The name *ana deo* comprises *ana*, meaning "child" or "person", and *deo*, the sense of which is unknown. The significance of the statues themselves is similarly uncertain. In the older literature they are sometimes described as representations of ancestors, but this attribution is questionable. Nage more often associate them with the tutelary spirit of a cult house (*ga'e sa'o*), a being identified with the physical building and especially with the spirits of the wood from which it is constructed. Further identified with the main housepost that supports one part of the hearth, this guardian spirit is believed to protect human occupants of the house against the incursion of malevolent spirits and witches. Nage also describe *ana deo* as witnesses to binding decisions, contracts and reconciliations formally made within a cult house. If parties to these do not abide by their terms, then negative consequences will follow. A person's power and prestige may begin to wane or physical illness might result.

Ana deo statues are always naked. Owing to the influence of Catholicism, in the mid-20th century clothed statues were produced in some villages.

However, this innovation appears not to have found general acceptance, as the most recently carved statues are also naked. The reason for the nakedness of the figures is no longer know to their creators. Also designated as *ana deo* are the naked male riders mounted on wooden horse statues (*ja yeda*) erected in front of ceremonial buildings called *heda* in Nage, and *yenda* or *enda* in Keo. Buildings of this sort are found only in villages that contain forked sacrificial posts. The wooden horses resemble their male riders by virtue of their common possession of erect penises. The "horses", partly interpreted by Nage as manifestations of a mystical creature, half horse and half serpent, are more definitely connected in Nage thought with wealth and fertility. Hence there is reason to believe that these values may be associated with the naked human figures found in Nage cult houses as well. Alternatively, nakedness may signify a primordial condition consistent with their possible association with early ancestors. The functionary who first lights a fire in a new cult house should also do so naked.

The protuberances on the heads of the *ana deo* represent top-knots or buns of hair, as traditionally worn by adult Nage and Keo men and women. Although the figures are now occasionally depicted in a standing position, they are more typically carved sitting on rectangular or cubical platforms at the top of wooden posts. Planted in the ground, these posts do not differ significantly from other decorated posts found in ritually important buildings. The example shown here includes three common carving motifs. About halfway up the posts are several rows of triangular zigzags and semi-circles. Above these one can discern a single series of faintly inscribed shapes locally identified as fern fronds. Just above the "ferns", and in this instance also on the platforms supporting the human figures, are sets of four lozenges sometimes described as flowers or butterflies. Clearly visible in this case are several round indentations, in the

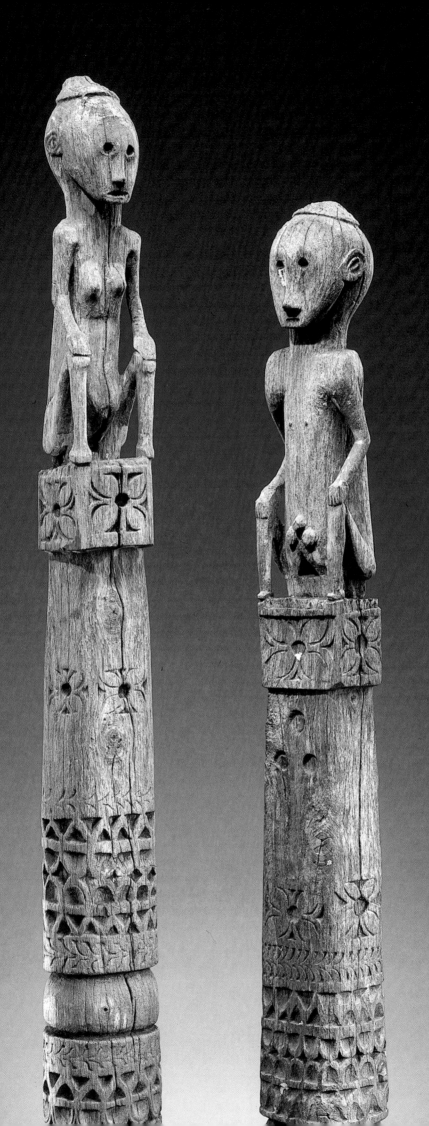

centre of the "flowers" and elsewhere on the posts. In accordance with a common Nage practice, these were probably fitted originally with white seashell discs. Sometimes pieces of shell, glass, or beads are fitted into the indentations that form the eyes of the anthropomorphic figures.

Variants of the foregoing motifs are widely encountered in Indonesian artistic traditions. Whether any culturally standardised symbolism can be attributed to them is doubtful. Nage express various opinions about what they might represent. Sometimes, the posts also feature a central bulbous shape designated as a "pot" (*podo, pondo*). Such "pots" further appear on the trunks of forked sacrificial posts (*peo*) erected in the centre of major Nage villages. Although local exegesis sometimes links these with commensality, nurture, and food offerings made to beneficent spirits, small pots are also used for storing heirloom valuables. The vessels are moreover kept in cult houses, the buildings in which one finds the naked human figures.

It is not know how long Nage have been producing statues of this sort or how they might have changed in form or significance over time. *Ana deo* and related Nage statuary may be produced by any man with the requisite skill, often someone from outside the village or group for whom the statues are made. It is said that nowadays there are fewer carvers able to produce statues in the traditional style. Recent statues, moreover, reveal modern influences, including a tendency towards greater naturalism.

GREGORY FORTH

1 The carbon-14 dating done on wood from this sculpture in 1999 by Dr Georges Bonani of the Eidgenössische Technische Hochshule, Institut für Teilchenphysik in Zurich yielded the following results: ETH-20606: 250 +/- 40 BP; ∂C-13 (%): -22.6 +/- 1.1; periods calibrated: CE 1622-1686, with a probability of 4.7%; CE 1740-1809, with a probability of 27.9%.

Ifugao Sculpture

15th century
Northern Luzon, Philippines

Sitting *Bulul* Figure Holding a Bowl

Narra wood and encrusted substances
H. 48 cm
Formerly in the William Beyer collection
Gift of Anne and Jacques Kerchache, 1999
Musée du Quai Branly
Inv. 7.0.1999.4.1

Main Exhibitions
Honolulu, 1981;
Los Angeles, 1981;
Oakland, 1982;
Chicago, 1982.

Publication
F.G. Casal, R.T. Jose, Jr.,
E.S. Casino, G.R. Ellis and
W.G. Solheim II, 1981, no. 183.

Northern Philippine wood carvings of human figures holding bowls entered Western collections in the second half of the 19th century,[1] Philippine public collections in the beginning of this century,[2] and, increasingly, local and foreign collections in the 1960s and 1970s.[3] William Beyer, son of H. Otley Beyer, the American founding dean of Philippine archaeology (1883-1966), acquired the Louvre example in the 1970s from the Hengyon district of north central Ifugao Province in Northern Luzon.[4] J. Kerchache subsequently purchased it from a private collection in Paris, and the Museum of Cultural History in Los Angeles first brought it to public attention in a major exhibition on the Philippines in 1981.

The Ifugao occupy the south-eastern face of the Cordillera Central mountain range and most closely relate to the language and customs of their Kan-kanay, Bontoc, and Kalinga neighbours,[5] although they maintain economic, religious and domestic similarities with the Ibaloi, Itneg, Isneg, Gaddang, and Ilongot highland groups. Linguistic studies trace some of their knowledge of rice agriculture and irrigation, domestication of pigs and chickens, use of tattooing and looms (probably back strap) for weaving, betel nut chewing, woodworking and carpentry to Austronesian-speaking peoples who migrated into the Philippines, eastern Indonesia, and North Borneo from their Taiwan homeland some 3,500 to 4,000 years ago.[6] With the exception of a southern language cluster, all Philippine languages are Austronesian.[7] Archaeology reveals that important features in northern Luzon (highland) and prehistoric lowland Philippine cultures were shaped at the time of these migrations, between 2000-

1500 BCE.[8] Early lowland Filipinos believed in life after death and in divinities who gave order to their world. The Ifugao religion and pantheon of 1,500 deities, in part descended from Austronesians and local responses to population and ecological changes, represent one of the most elaborate belief systems in Asia outside the influence of India. Spaniards arrived in the Philippines in 1521 but attempted to settle Ifugao towns only in 1867 and 1887. Initial attempts to Christianise local populations brought little change.[9] It was not until the first quarter of this century, when Americans established constabulary garrisons and educational, health and sanitation agencies, that Ifugao culture was profoundly altered by its exposure to the outside world.

A century ago, traditional religion and the supreme law of custom wholly ruled Ifugao life. The Ifugao employed technical ingenuity and skill to harness all available land for their swidden farms and famed walled rice terraces, sometimes transporting water by canal to distances of up to 6 kilometres. Their cultural and religious lives focussed on these elaborate systems from which they harvested an upland rice variety with a growth cycle of 200 days.[10] During the past 25 years, however, young, Christianised Ifugao have increasingly responded to the economic limitations imposed by a single annual rice harvest by opting to move to urban centres.[11] Many Christianised Ifugao who inherited ritual objects have sold their heirlooms, while others have reported theirs stolen. Moreover, numerous customs intimately linked with rice terrace culture have disappeared.

The north central Ifugao observe 23 rituals, or clustered series of rituals, associated with rice sowing, weeding, harvest, and bundling.[12] They empower anthropomorphic representations of rice deities called *bulul* to watch over rice seedlings prior to planting and to guard the fresh piles of grain at harvest time.[13] Although some wealthy terrace owners possess several pairs, not all households own a *bulul*. Their manufacture is costly and must be accompanied by a sequence of rituals varying in length from one village to the next.[14] A few important pieces carry names based on *bulul* legends.[15] As the rice cycle begins, Ifugao farmers remove these guardian figures from granaries or storage places in their homes and place them (usually) on the ground floor of their dwellings. Animal sacrifices and prayers directed to preselected classes of sprits follow. Ceremonies revolve around a presiding *mumbaki* and his attendant priests who singly or simultaneously invoke the help of their assigned deities. Depending on the importance of the rites and wealth of patrons, priests sacrifice one or several chickens or pigs and hand-daub blood on the *bulul*. They also offer betel leaves, areca nuts, as well as select rice seedlings or bundles of harvested rice, some of which they place in ritual boxes or on a mat to be guarded by these *bulul*. During rituals, the *bulul*, like the priests, personify the spirits whose benevolence and protection they have solicited. Priests drink rice beer (*bayah*), chew betel ingredients and, later, join the household in the consecrated meal consisting of the cooked sacrificed animal

Sitting figures carrying bowls have likely evolved from the Ifugao *bulul* which are carved usually, but not always, out of *narra* (Pterocarpus indicus).[16] The Ifugao of the central, western, southern and southwestern regions and the Kankanay of the eastern region employed such sitting figures for ritual purposes. A writer describes one "said to have belonged to a third-generation descendant of a high priest from Hapao".[17] Another identifies them as *bulul* empowered by the Banawe and Mayawyaw Ifugao, north-east of the province, for rice-planting and harvest rituals.[18] The Louvre bowl itself is of the deep, circular, scalloped-rimmed type called *duyu* utilised by families for regular meals and by priests for rice beer consumed during ceremonies. The Ifugao rub animal fat on the exterior of these bowls to preserve them. They keep them in their homes where, with the build-up of soot, the surfaces acquire a deep, dark polish.

This figure is a fine and exceptional example of its genre for several reasons. On the bowl's exterior surface there are grooved lines curving evenly from the notched-rim down to the ridged base. Layers of encrustation coat both figure and bowl. The bowl's bottom shows a great degree of erosion. Close chemical examination of the piece with a view to traditional ritual offerings would supply a clearer picture of how this object was used in the community.[19] Several collectors have divided Ifugao Province into stylistic areas, tracing the iconographic origins of the *bulul* to geographically distinct regions.[20] This figure may be compared to a large sitting *bulul* from the Thomas Murray collection in Mill Valley, California, carved in the style of the Hengyon *bulul*.[21] Both examples share numerous similarities and may have been carved by the same hand or by carvers trained by the same master.[22]

Heirloom *bulul*, as well as *bulul* figures supporting bowls, have become increasingly important additions to Island Southeast Asia collections. Their continued active presence in the cultural lives of Ifugao families, despite their trade value in the urban centres of Manila and Baguio, serves as evidence of a strong culture that may have survived one or several millennia. The intrinsic value of the *bulul* and, in fact, the very key to their survival, lies in the continued observance of rituals that accompany their manufacture and periodic supplication. Spanish records chronicle large numbers of *anito* and *diwata* deity images in pre-Christianised lowland Luzon, Visayas and pre-Islamised Mindanao communities,[23] but Western icons and religion have long ago supplanted them. In the early 1970s, there were about 300 *bulul* recorded still in Ifugao terrace houses;[24] far fewer remain today. If lowland Philippine archaeology and linguistic studies are any

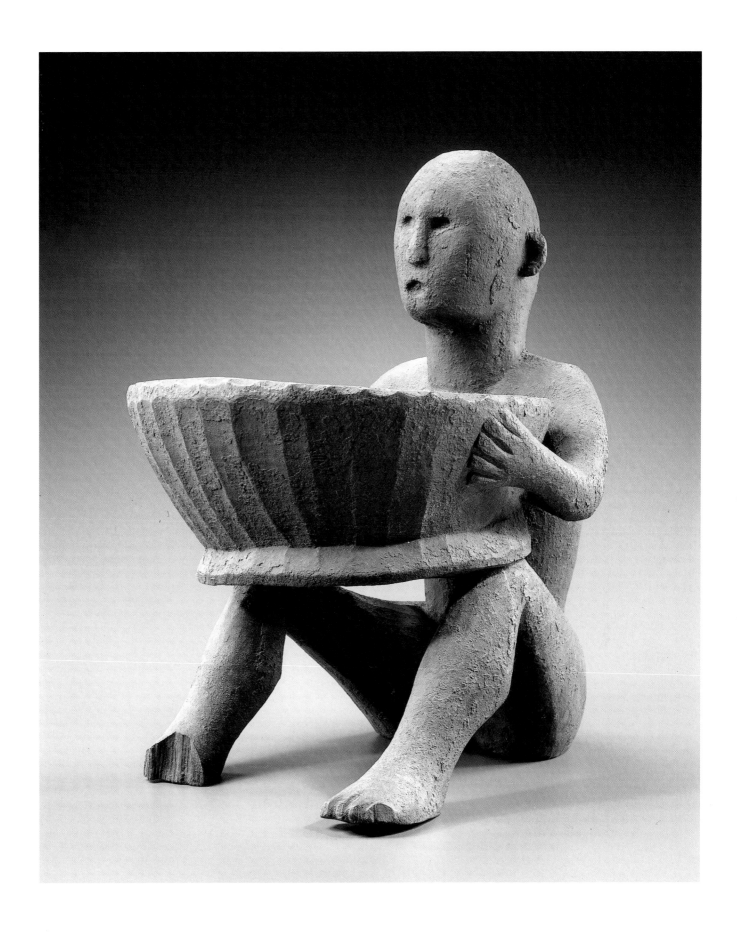

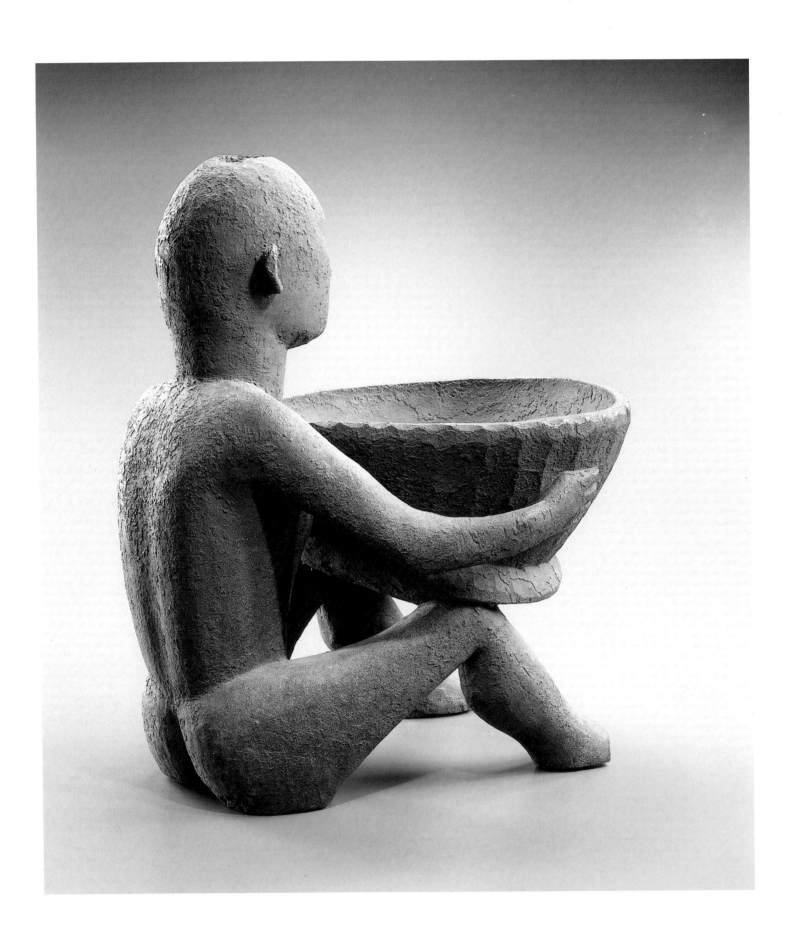

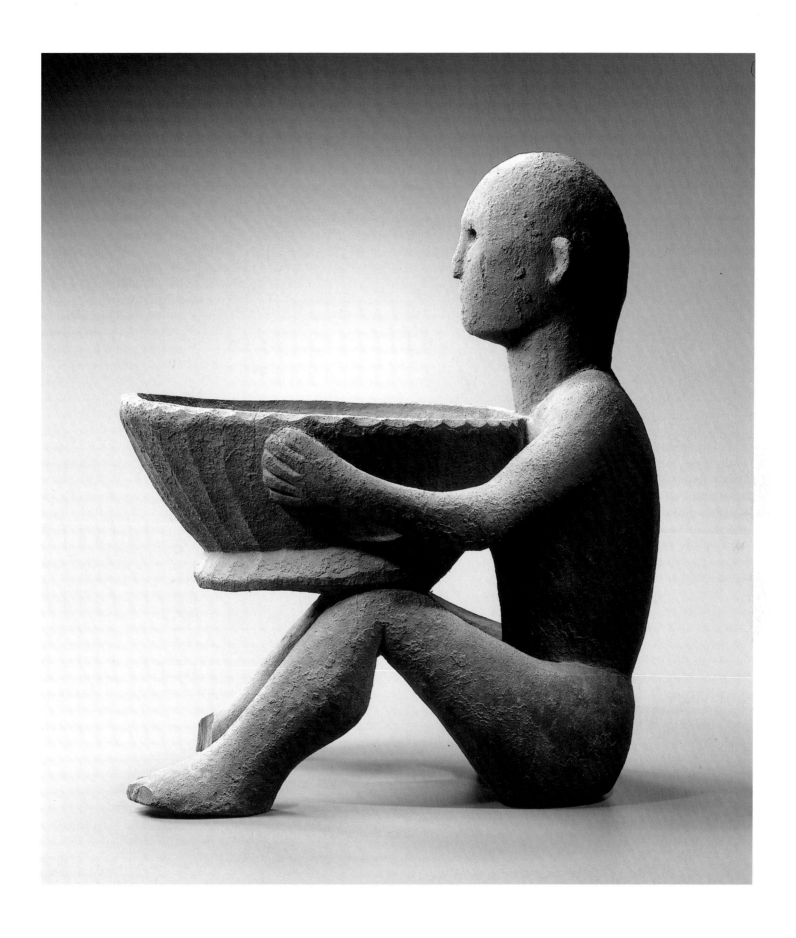

reflection of ritual life in the highlands, and radiocarbon dating in central Ifugao establishes a rice terrace culture going back to 1000 BCE,[25] the ritual use of the *bulul* and the various carved permutations that evolved from it may be dated to the prehistoric, that is, pre-Islamic (900-1100 CE)[26] period in the Philippines. It also could, by extension, be arguably regarded as a tradition which has stood witness to the changed and changing character, structure, and direction of Ifugao culture for possibly up to three thousand years. The wood used for the Louvre sculpture has been determined to date from the 14-15th centuries,[27] testament to the deep roots of Ifugao artistry.

PURISSIMA BENITEZ-JOHANNOT

1 There are two examples of Kankanay single sitting figures carrying bowls collected in 1887, in Madrid's Museo de Etnología (cat. 1.971) and in Leyden's Rijks Ethnographisch Museum (cat. 1183.158).

2 In 1906, C. Worcester published two examples of an Ibaloi single sitting figure carrying a bowl, double standing figures carrying a bowl from Burgias village in the Kankanay-Ibaloi border of Benguet Province, and an Ifugao *bulul*-type seated figure with a bowl on its head from Banawe, Ifugao Province (C. Worcester, 1906, pl. 48b, 48e, 48d and 46.4). A National Museum of the Philippines card catalogue describes the same bowl held by double standing figures serving as a food container for children of wealthy families (cat. no. E-IF-436); however G.R. Ellis doubts whether these objects were carved and used for traditional purposes (1981, p. 202).

3 Two examples of sitting double figures holding a bowl are in the Munich Völkerkunde Museum (cat. no. 97.165) and the Barcelona Museo de Etnología. See J. Roma, 1986, fig. 128. Also P. Gomez-García (1983, p. 90) and J.G. Palencia (1989, p. 142).

4 H. Beyer, Baguio City, personal communication, 25 January 1999. H.C. Conklin (1980, pl. 5 and 23) shows Hengyon district in north central Ifugao, surrounded by Kababuyan district to the west, Ogwag to the north, Luha-dan and Numpoliyan to the east, and Nung-gawa and Piwong to the south. These districts are independent agricultural units with at least one ritual field and several culturally important settlements. In 1980, Hengyon registered 243 house terraces, each with a dwelling and granary.

5 R.F. Fox, W. Sibley and F. Eggan, 1954; T.A. Llamzon, 1978, p. 24.

6 P. Bellwood (1998, pp. 8-17) notes that people who speak Austronesian languages, from the homeland region of southern China and Taiwan to distant Madagascar, Hawai'i and Easter Island, share not only cognate words, or words of common origin not due to borrowing, but features in their agriculture, residence, social and political organisation which can be traced to as far back as 5,000 to 6,000 years ago. See also R.F. Fox, 1979, p. 235. On the other hand, W.H. Scott (1994, p. 12) proposes that although Austronesian-speaking peoples who migrated into the Philippines would have contributed to local gene pools, their heritage would not have carried language skills nor tool-making techniques.

7 Various linguistic studies suggest that the majority of Philippine languages stem from one base (T.A. Llamzon, 1978, pp. 2-3) and the populations, from one basic stock (F. Eggan, 1966, p. VII). However, Scott (1994, p. 13) points out that a non-Austronesian language entered the Philippines with a seafaring people, whom the Spaniards called Litaw or Lutaya, giving rise to the Sama-Badjao languages spoken by pockets of boat- and land-dwellers in southern Sulu, as well as in the Mergui Islands and Sulawesi in Indonesia (H.A. Nimmo, 1972, p. 1).

8 Paraphrasing from W.G. Solheim (1981, p. 26), R.F. Fox (1979, p. 235) lists an inventory of tool types from the Late Neolithic period (jar burial sites in the Philippines circa 1000 BCE), which includes adzes, gouges and chisel-gouges. He adds that these were "used in working wood – a craft highly developed among Philippine groups in prehistoric times, as at present among the Ifugao, Tagalog, and Kapangpangan (the last two are lowland groups)."

9 Failing their first attempt to settle in the Ifugao towns of Kiangan and Lagawe in 1867, the Spaniards established a strong hold in the region in 1887, but abandoned it only after ten years. Although relations with Spanish authorities were limited, Scott (1974, pp. 205ff., 318ff.) writes that historic contacts among high-land communities and specific lowland settle-ments put into question the idea of the Ifugao developing their culture in total isolation.

10 Lowland rice harvests occur at an average of twice a year.

11 Juan Dait, Jr., Director, Ifugao Rice Terrace commission, Baguio City. Personal communication, 1 March, 1999.

12 H.C. Conklin, 1980, p. 13.

13 Jesus Peralta, retired head of anthropology at the National Museum of the Philippines, writes that *bulul* is a generic term describing all conse-crated images. He believes they were used not only at rice-related rituals, but also at prestige feasts or *honga* (J.C. Peralta, 1977, p. 316; and Peralta paraphrased in Casino, 1982, p. 243).

14 For rituals accompanying *bulul* manufacture, see R.F. Barton, 1956, pp. 8-10; F. Lambrecht, 1932, p. 30ff.; G.R. Ellis, 1981, pp. 195-196.

15 J.G. Palencia, 1998, p. 54. The Ifugao origin myth called *buad humidhid*, or the myth of Humidhid, relates that the deity Humidhid carved eight pairs of *bulul* and called the males Gamal, Hinayyupon, Nahipan, Punholdayan, Dangngu-nay, Ininlayyan, Wigan, and Panibugon. He named all their female partners Bugan (W. Beyer, 1980-81, pp. 51-52). Myths about *bulul* show them with human qualities, includ-ing the ability to kill mice in granaries or jump out of windows during village fires. A 70-year old woodcarver in Hapao, an Ifugao hamlet particularly renowned for its carving tradition, described to this writer *bulul* giving instructions, chewing betel ingredients, or walking in a drunken gait (Lopez Nauyac, personal communication, 6 January 1999), the last being a physical state not only tolerated and accepted in men, but regarded with respect after the ritual drinking of rice beer (F. Lambrecht, 1932, p. 52).

16 J.G. Palencia, 1989, p. 143.

17 Quoted from P. Gomez-García, 1983, p. 90; see also G.R. Ellis, 1981, p. 201. Henry Beyer, grand-son of H. Otley Beyer and long-time resident of Ifugao Province, witnessed two instances in the 1960s when priests, sitting huddled around ritual objects, used sitting figures holding bowls as rice beer vessels into which they would dip drinking cups made of halved coconut shells called *u'ngot* (personal communication, 21 January 1999).

18 J.G. Palencia, 1989, p. 14. Both Joaquin Palencia, a Filipino collector of *bulul* since 1979, and Roland Beday-Brandicourt, a French national living for some years outside Sagada, a Kanka-nay town, describe the Mayawyaw *bulul*: Beday-Brandicourt writes that there are a few, but very elegant, examples from this stylistic region; Palencia describes the Mayawyaw *bulul* as sitting figures carrying notched-rimmed bowls. Because cultures abandon or retain forms and create others which answer new needs, the Mayawyaw *bulul* may have developed as a consequence of the latter. Father Francis Lambrecht, a Catholic missionary priest who studied Mayawyaw myths and rituals in the 1920s and continued to write about them in the 1950s, and R.F. Barton (1955, p. 2), who studied Ifugao myths after him, noted that the Mayawyaw did not carve *bulul* figures nor use them in ceremonies. Their pantheon, ritual, language, and even colour and ornamentation preferences were different from other Ifugao. The Mayawyaw, however, invoked Buni ad Lagud, a harvest deity who takes the form of an *Imbulul* (the prefix *im* acts as *in*, with *n* changing to *m* before *b* and *p*, meaning simply "similar to"). He sits huddled in a blanket, chews and spits betel, and walks with a drunken gait (F. Lambrecht, 1932, pp. 51-52). In 1939, Lambrecht published a study of Maya-wyaw property and property customs, listing kinship and personal possessions from a wide cross-section of residents. No *bulul* were men-tioned. Ceremonial objects included ritual boxes, ritual drums, sticks with which to beat drums, and spears with bamboo blades. They were all regarded as personal property with no monetary value (Lambrecht, 1932, pp. 501-502, 524).

19 A yellowish dust-like spray lightly covers portions below the Louvre specimen's right arm, the right side of the torso, the right thigh and the right calf. Chromotography mass spectrometry tests will identify the residue left in the bowl's interior.

20 W. Beyer (1980-81, p. 53) briefly outlines these stylistic regions as western Ifugao (Hapao, Hungduan), northern Ifugao (Kambulo, Batad),

central Ifugao (Kababuyan, Banawe, Hengyon, Mumpolya and southern Ifugao (Kiangan). Beday-Brandicourt (1984, unpaginated) describes the stylistic regions as central Ifugao (Banawe, Kababuyan), south-east Ifugao (Apaho, Hungduan), southern Ifugao (Lagawe, Kiangan), south-west Ifugao (Tinok, Kalanguya) and north-west Ifugao (Mayawyaw). J.G. Palencia (1989, pp. 142-147; 1998, pp. 59-63) carefully maps out and explains in iconographic detail six stylistic regions which includes Banawe-Mayaoyao, Northern and Southern Hapao-Hungduan, Tinok, Hengyon, Kiangan, and Lagawe. Palencia aptly observes that intermarriage, migration, the porous nature of borders, and the natural ebb and flow of commerce account for a certain degree of admixture of styles. Nonetheless, his extensive study of *bulul* styles proves useful today and provides a more elaborate descrip-tion of each stylistic region than those earlier proposed.

21 J.G. Palencia, 1998, p. 61, fig. 23.

22 A mortar-shaped base supports the Murray *bulul*, whereas the Louvre's figure, like most examples of this genre, sits directly on the ground. Both were carved from a single, sizeable block of a fine-grained reddish hardwood, probably narra. Their crowns each contain a round cavity, a feature found in other *bulul* and often utilised as receptacles for poured offerings. The heads, eyes, and mouths are similarly ovoid-shaped. The lobes of their protruding ears were drilled for insertion of rice stalk ritual gifts. A soft but distinguishable "V" form may be traced from the temples to the cheekbones and down to the chin. Necklines and shoulders are clearly defined. On both sculptures, the right hands exhibit four fingers, the left, five. The torsos taper to a V-shaped waistline. The arms and thighs are slender, and calves show some muscular curvature. The Murray *bulul* is male. The Louvre piece gives no clear indication of gender; however, the buttocks are defined and an indentation in the centre is provided for the insertion of a g-string, a feature common among Hengyon-carved sitting male *bulul* figures.

23 F. Landa Jocano notes that *diwata* and *anito* are generic terms in precolonial Philippine cosmology referring to ancestral spirits, sculpted or bundled figures representing spirits, and ideas of symbols associated with supernatural powers of good and evil. He points out that contacts with other Asians during the Emergent period (circa 1000 CE) brought changes in their belief systems, particularly with the coming of Islam in the 14th century in parts of Mindanao and Sulu. Islam rapidly expanded until the Spaniards arrived and introduced further changes (F.L. Jocano, 1975, pp. 217-218). Among others, F. Lambrecht (1971, pp. 83-84), W.H. Scott (1974, p. IV) and G.R. Ellis (1981, p. 187) support the idea that Northern Luzon highland groups developed their cultural and social trait *in situ*, outside of direct Spanish and Islamic influence.

24 W. Beyer, 1980-81, p. 53.

25 Robert Maher, funded in part by the University of Western Michigan at Kalamazoo, published findings on radiocarbon tests performed on central Ifugao rice terrace settlements, one of which yielded a date of 2950-250 BP or 1000 BCE +/- 250. He concluded that the C-14 dates obtained from two house terrace sites (IF-2 and IF-2 and IF-3) support occupation periods similar to those earlier proposed by H.O. Beyer and R.F. Barton (R.F. Maher, 1973, pp. 56, 67, 68), although not Beyer's waves of migration theory. An unpublished radiocarbon test conducted in March 1999 of a sitting *bulul* obtained from Lagawe in the collection of the Barbier-Mueller Museum, Geneva (BMG 3501-A), dates the figure from 455 +/- 30 BP, i.e., 1416-1482 CE with a 100% calibrated (dendro-corrected) confidence limit, calculated using the Calibeth programme published in 1992 by T.R. Niklaus, G. Bonani, M. Simonius, M. Suter, and W. Wölfli (G. Bonani, Eidgenössische Technische Hochschule, Institut für Teilchenphysic in Zurich, letter to L. Mattet, Barbier-Mueller Museum, 19 March 1999).

26 Juan R. Francisco (1971, p. 15) cautiously sets 900-1100 CE as the period when Indian influence reached the Philippines in a linguistic form. A. Postma (1991, p. 1) describes an inscribed copper plate found 1990 in Laguna, a province south-east of Manila, dated 900 CE, as the oldest extant record found in the Philippines, which pushes the country's official historical period back by more than 600 years.

27 The C-14 dating carried out on the wood of this sculpture in 1999 by Dr Georges Bonani of the Eidgenössische Technische Hochschule, Institut für Teilchenphysic in Zurich yielded the following results: ETH-20604: 535 +/- 40 BP; ∂C-13 (%): -23.3 +/- 1.1, periods calibrated: 1310-1353 CE with a probability of 18.5%, 1386-1446 CE with a probability of 81.5%.

OCEANIA

Kanak sculpture

17th century (?)[1]
New Caledonia

Door panel of ceremonial house

(*jovo* in Ajië language, *jopo* in Némi, *jöpwö* in Paici, *jopö* in Xârâcuu)
Houp wood (*Montrouziera cauliflora*, Clusiaceae)
H. 138 cm
Collected by Pastor Rey-Lescure for the Musée de l'Homme in 1930 on an expedition financed
by Georges Henri Rivière
On permanent loan from the Muséum National d'Histoire Naturelle – Musée de l'Homme,
inv. M.H. 31.50.2

Exhibition
Paris, 1965.

Main Publications
L. Réau, 1934, fig. 26, p. 24;
M. Leenhardt, 1947, pl. 57;
A. Malraux, 1952, pl. 433;
J. Guiart, 1963, fig. 238; *Chefs-d'œuvre du musée de l'Homme*,
1965, no. 53, p. 151; R. Boulay,
1990a, fig. 67.

From a strictly technological point of view, this piece of wood cannot be described as a door jamb because it was not load-bearing. It is more a panel. Posts such as this were placed against the structure of slats holding together the fibres that constituted the wall of the hut and made it possible to decorate the extremities and to hold them in place more effectively on each side of the door. When there was no sculpture, a simple post was used. Indeed, in the Xârâcuu language of the Canala region, this piece (or the post replacing it) is known as the "holder of *niaouli* skin" (*niaouli* being the bark of the *Melaleuca* tree used to make the walls of round huts). The ornamental nature of this sculpture is confirmed by the fact that, in some cases, several such pieces are placed side by side near the door. These panels are lashed in place at the top by a tether fed through a hole (visible when the piece is intact) and, at the bottom, held in place by stones taken from the platform on which the hut is built. This method of attachment would explain why the wood has worn away at the bottom as a result of decomposition due to contact with the ground. The fixing system is often missing from museum pieces of this kind because the damaged area has been sawn off. This particular panel has lost its fastening system from the top but, because it was set in the well-drained ground at the foot of the const-ruction, has retained the marks of wear and decay on the wood.

As a general rule, such sculptures are also made for the Great House, the prestigious construction made available for the oldest son in the lineage of the local chief.

Excepting those in the far south, the tops of these panels always bear a sculpted face with a band of opposing chevrons around the forehead representing the frond that men tied around their hair or the *tidi*, a cylindrical headdress in blackened basketwork.

The nose is the dominant motif in this image. In most of the pieces from the north and centre-north, the nostrils are spread so as to occupy the main part of the face. The mouth is usually a fine line with the hint of a smile. The eyes seem to be shut, or at least suggest a peaceful, inward gaze. The lower part of the sculpture is always decorated from top to bottom with simple, repetitive geo-metrical motifs that vary from one region to another.

As can be seen from the treatment of the mouth, nose and eyes, the door panel presented here is characteristic of the region of the Ajië/Arô languages, which are spoken from Bourail to Houaïlou.[2] The faces on door panel figures in the Ajië area clearly lack the serenity and profound presence of those on the northern sculptures. From this point of view, the piece presented here is already marginal with regard to the oldest Kanak sculptural traditions. Moreover, the brutal quality of the ensemble, underlined by the extremely rigid and deliberately frightening treatment of the mouth, tends to suggest that the image was made to be more savage than was strictly necessary. In addition, this piece has none of the geometrical motifs found on nearly all the pieces of this kind. The judgement of Maurice Leenhardt, who no doubt supervised the expedition by Pastor Rey-Lescure, casts its own particular light on this sculpture's singularity: "style of the centre of the island. Sculpture remarkable for the absence of technique. No sense of ensemble or work on volume, but a juxtaposition of reliefs on the face. On each side, cheeks; at the end of the nose, nostrils; at the end of stalks, eyes."

How, without resorting to notions of artistic creativity, are we to account for this peculiarity? We might imagine that such sculptures in fact adopted the style of their particular region's masks, and that they followed the development of mask forms from the north of the island to the south. We know from

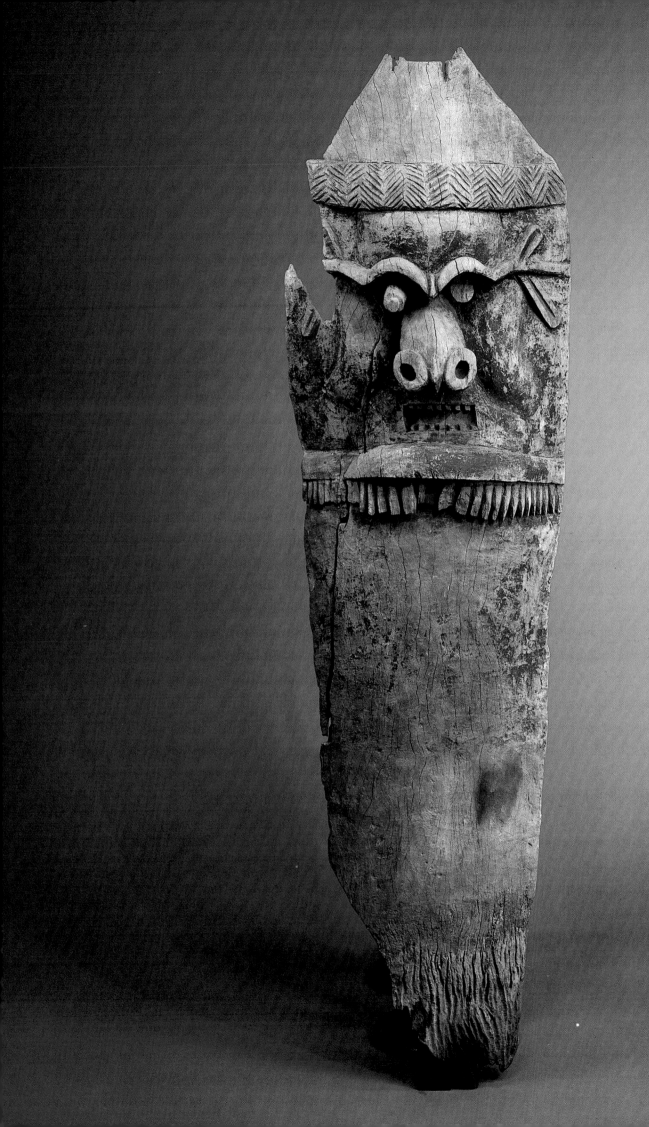

the work of Jean Guiart and Emmanuel Kasarherou that in this and the Canala regions the tradition of masks began later than in the northern regions. The makers of masks in this zone favoured a more brutal, violently expressive rendering than those of the northern traditions. Leenhardt argues that, as a relative latecomer to the local social system, the mask was used to denote the presence of the chief more than was the case elsewhere in New Caledonia. In that case, this door panel could be seen as a counterpart of the mask in terms of both its form and its function. It can thus be understood as an attribute of power more than as a representation of the ancestral gaze and image of the deceased, which is how such figures were perceived in the more northerly regions of Grande-Terre.

The wood is houp (*Montrouziera cauliflora*) and the traces of the work done on the concave side indicate that the piece was made from the remaining outer wood of a dead tree whose heart had rotted away. On most of the face we can see traces of the traditional black coating, probably made from burnt and ground candleberry nuts. The inside of the mouth and the motifs on the bottom of the face are coated with red ochre.

ROGER BOULAY
Translation: Charles Penwarden

1 Carbon-14 tests carried out on the sculpture's wood in 1999 by Dr Georges Bonani of the Eidgenössische Technische Hochschule, Institut für Teilchenphysik, Zurich, have yielded the following results: ETH-20611: 365 +/- 40 B.P.; 13C [0/00]: 23.1 +/- 1.1. Calibrated period: CE 1455-1637, with a probability of 100%.

2 The collections of the Staatliches Museum für Völkerkunde, Munich, include two works whose rendering is very close to that of the one from the Musée de l'Homme. Both have the classical geometrical decoration found on the lower part of such sculptures. They were brought back by E. Heindl in 1910. One of them was reproduced by Fritz Sarasin in his *Atlas* (1929, pl. 38).

Kanak sculpture

Late 14th-early 15th century (?)[1]
New Caledonia

Finial from a ceremonial Great House

(*hup* in the northern languages)
H. 228 cm
Houp wood (*Montrouziera cauliflora*, Clusiaceae)
Formerly in the Vicat Collection[2]
Acquired by the Musée de l'Homme in 1945[3]
On permanent loan from the Muséum National d'Histoire Naturelle – Musée de l'Homme, inv. M.H. 45.5.1

Exhibition
Saint-Paul-de-Vence, 1973.

Main Publications
F. Girard, 1945, fig. 7c, p. 126;
A. Malraux, 1954, pl. 388; *André Malraux*, 1973, no. 737, p. 268;
R. Boulay, 1984, pl. 9, no. 4.

Rooftop sculptures for large huts are monoxylous pieces of wood which always comprise three parts: a central face framed above and below by flat oval or circular motifs, a base allowing it to be inserted into the top of the roof and a comb formed by one or more spikes which support shells (usually conches, *Charonia tritonis*). Particularly in the northern regions, rooftop sculptures are considered as one of the attributes of the chieftainship, along with masks. This emblem is handed down to the eldest in the chief's lineage by the oldest clans who consider themselves as the truly autochthonic and creators of the land. More than a specific ancestor, it evokes the community of ancestral spirits.

As indicated by the name (*hup*) in the northern languages (Fwaï, Nemi), the sculpture is identified with the wood it must be sculpted from, in keeping with the most commonly accepted rule. Houp has powerful symbolic associations in traditional Kanak society and is used for all major sculptures. It is the ancestor of all other trees, the one that was there ever since the origin of the clans. Its hollow trunk is thought to house the spirits of ancestors, and it offers its wood for the sculpting of their effigy and for the central post of the Great House.

From an analysis of the motifs and the way they are combined we can define different stylistic zones. These were determined by M. Leenhardt and

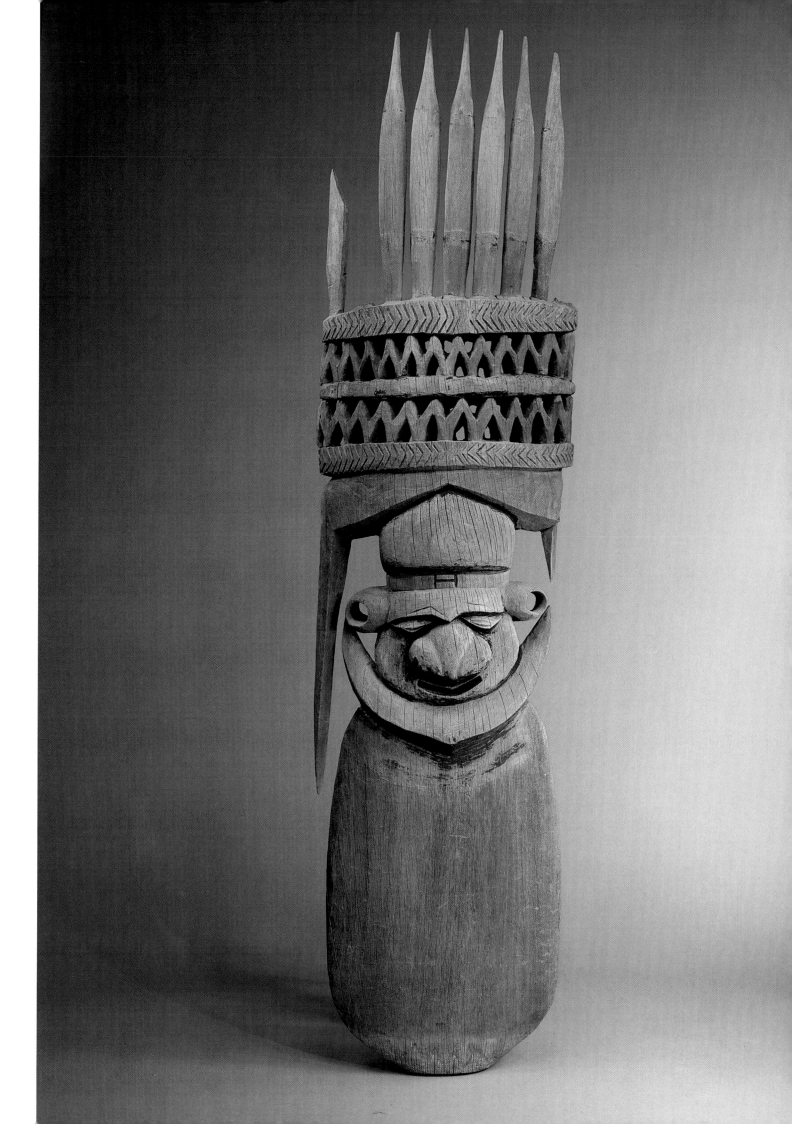

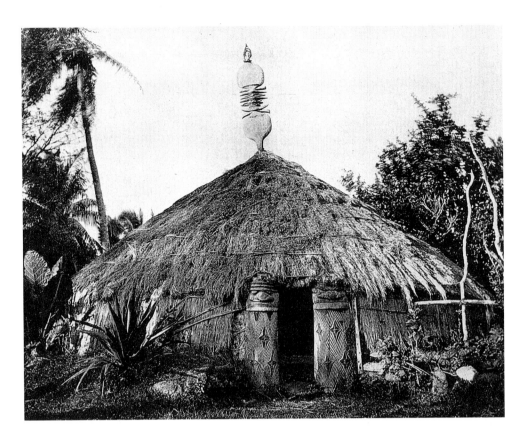

Fig. 1
Great House
near Tchambouenne,
photographed by
Fritz Sarasin in 1910-11
Museum der Kulturen,
Basel

adopted by J. Guiart. We thus find, for example, a northern style comprising the region north of the Hienghène perpendicular; a central-northern style covering essentially the zones of the Païci and Cemuhi languages, i.e., the region of Koné, Ponérihouen, Poindimié and Touho; a central style in the area covered by the Ajië/Arho languages around the Bourail-Houaïlou axis; and a central southern style including the Canala, La Fon and Thio regions. In the more southerly regions, on the Isle of Pines and Loyalty Islands, rooftop sculptures are either variants on those of the Canala region or take the form of a simple pole.

With its double row of chevrons, the rooftop sculpture presented here can be attributed to the northern style. However, a number of details such as the treatment of the ears, the lower part of the face and the prominent bust indicate affinities with the styles of the Païci languages region. The piece can be compared to one in the museum in Nouméa (inv. 86.5.7), which has the same stylistic characteristics and has been shown to come from Pwei country, that is to say, in the stylistic zone of the centre-north. This shows the difficulty of precisely attributing these sculptures, which are moved around a great deal between clans and, as a result of intermarriages, may be commissioned at a considerable distance from their actual place of use. The motifs too, as is the case throughout Melanesia, are the result of exchange and movement.

ROGER BOULAY
Translation: Charles Penwarden

1 Carbon-14 dating carried out on the sculpture's wood in 1999 by Dr Georges Bonani of the Eidgenössische Technische Hochschule, Institut für Teilchenphysik, Zurich, have yielded the following results: ETH-20610: 650 +/- 40 B.P.; 13C [%]: -21.1 +/- 1.1. Calibrated period: CE 1291-1397, with a probability of 100%.

2 In addition to this rooftop pole, the collection included a house pole, a sculpture, a doorpost, a cooking pot with a double opening, a spear and a shell fishhook.

3 The museum record indicates that "M. Vicat had these objects from M. Fabregnette, an industrialist in Algiers, who himself had them from M. Hugonniot, an engineer." The O'Reilly bibliography points out that Emile Hugo [n] niot, (born 1880, died 1928), was involved in mining in New Caledonia before 1914.

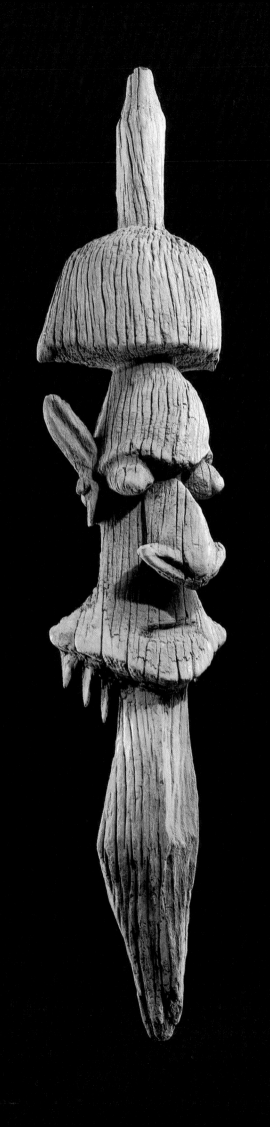

Kanak sculpture

18th-19th century
New Caledonia

Fragment of a finial from a ceremonial Great House

Houp wood (*Montrouziera cauliflora*, Clusiaceae)
H. 101 cm
Musée National des Arts d'Afrique et d'Océanie[1]
Inv. 96.2.1

Main Publications
M. Rousseau, 1951, p. 93,
fig. 164; P. Peltier, 1987, p. 122.

This is a fragment of a carved rooftop finial from a Kanak ceremonial house. Sculptures of this kind consist of a face, as preserved in the piece presented here, surmounted by a spike on wich shells were threaded, and with a bust and base enabling the sculpture to be inserted into the structure of the roof. Little is left of this work whose sculpted part must have been between 120 and 150 cm long, for a probable total height of between 350 and 400 cm. The tips protruding from under the lower jaw are the remains of thin rods that linked the jaw to a horizontal bar at the level of the remains of the lozenge-shaped bust seen here. These lost rods were supposed to represent either arms or ribs. There are a number of intact examples, such as one in the Musée Territorial de Nouvelle Calédonie (inv. 49.4.13) and one in the Museum der Kulturen in Basel, which was photographed in situ at the top of its house by Fritz Sarasin in 1911, and which still has its shell decoration. These rods naturally give the sculpture an overall lightness and elegance which the piece shown here has lost. We must content ourselves with the strong handling of the face, noting the flaring of the cheeks and protuberance of the eyes. These indicate a link between this sculpture, which is typical of the Canala zone, and the rendering of faces in the Ajië linguistic zone. One of the pieces of the collection allocated to the Musée des Arts d'Afrique et d'Océanie by the Musée des Antiquités Nationales (inv. 60.919), which was collected in 1910 at Houaïlou (Ajië area), displays this particular characteristic very clearly.

This sculpture was originally two-faced, and is no doubt very old. The various collections feature large numbers of damaged sculptures, and this damage may have been done deliberately during mourning rituals when they became the targets for the weapons of the deceased's uterine siblings. These events in effect involved the ritual destruction of the emblems attached to the Great House – the rooftop sculpture and the door panel figures. While the former was the target of those highly skilled with the sling, the fronts of the doorposts were struck with an axe. Under the force of the blows the more fragile elements such as the ears and the small arms were irremediably damaged. However, we have no evidence that the piece presented here was a target in a mourning ritual. Pieces showing traces of fire point more probably to the burning of the hut itself, which often occurred during military operations.

ROGER BOULAY
Translation: Charles Penwarden

1 To date, there is no known reference to where the object was collected. As part of Pierre Loeb's collection, it was photographed at his home by Denise Colomb in 1949, when it was placed near a self-portrait by Antonin Artaud and Giacometti's *La Main*.

The Banks Islands

Seen from a non-ethnological viewpoint, the figures of the Banks Islands can be taken as the epitome of elementary figurative sculpture: they have the overall form of a sculpted tree trunk, with rudimentary extremities, and sometimes no legs or feet at all. All the signs are there.

But we should not be deceived. The forms that strike us as rudimentary are the result of a history of local exploration of aesthetic expression, as regards both their form and their original raw material, the tree fern, which is a pioneer plant found in abundance on volcanic soil. To be convinced of this, we need only compare them with other sculptures from the Banks Islands, and especially the effigies made from flexible vegetal materials such as bark and palm leaf sheathes (see for example the superb effigy in the Musée de l'Aquitaine, Bordeaux [inv. 13.205], on the cover of the catalogue for the exhibition *Arts du Vanuatu*,[1] or the less well-known piece in the Australian Museum, Sydney[2]). The series of carved knives with figurative handles, or of pounders topped by a head, all of which relate to the hierarchical position of the individual who used them, indicate the cultural context of these monumental statues which signal the grade of the person who had them made.

First, we should note the use of a raw material that is very different from hardwood: the tree fern, a plant that, geologically, is extremely old. The lower part of the trunk is covered with a thick layer of intertwining aerial roots, reaching a height of between 180 and 250 cm on adult specimens. The diameter of this vegetal envelope is at its greatest at the foot of the trunk. When preparing the sculpture, the fern is cut at ground level and turned upside down, thus creating this initial image, with the trunk surmounted by the contours of a bulbiform head. The fibre of the aerial roots is fairly easy to work with when the tree has just been cut down but, as it dries, the fibres become like straw. The surface now takes on its very distinct character. Rather than a coherent surface, there is a system of severed fibres and holes which, from a distance, looks like an extremely porous surface.

Unfortunately, none of the sculptors from the Banks are known to us by name. Their work was no doubt facilitated by the introduction of metal blades (European sabot-maker's blades) in the period when trade in sandalwood was active – in other words, starting in the second third of the 19th century. Local sculptors no doubt set these in adze handles, as they did with blades of polished stone or shell. There is no known proof, negative or positive, as to the existence before 1825 of fern wood sculpture in the Banks, or in Malakula and Ambrym, the central islands of Vanuatu. The existence of a highly diverse vocabulary of forms of fern sculpture both at Port Sandwich (Malakula) and on Ambrym is attested by a series of watercolour paintings signed A.B.M. (most probably Adam B. Messner, a ship's surgeon from New Zealand[3]) and dated 1875. This makes it highly likely that this artistic tradition predated the arrival of metal blades. However, the examples presented here make it very clear that there was a flourishing technical tradition towards the end of the 19th century. In passing, it is worth noting the similarity between the head of one of these sculptures (M.H. 90.27.3, from Vanua Lava) – or, rather, what may be taken as its headdress – and the kind of head that surmounted *nalot* pounders and the handles of *nalot* dishes, as well as the heads on the beams of at least one ceremonial house in the northwestern part of Santo Island.[4] Thus at least some of the formal aspects take their place within the familiar vocabulary of a larger region crisscrossed by systems of exchange, which, depending on the materials being exchanged and the nature of the relations, operated along distances ranging from the immediate vicinity to the long routes once travelled by the outrigger canoes.

It is difficult to provide much detailed information on the religious and social context of the monumental statues. That they were among the emblematic images vital to the workings of the grade system, is obvious, and there is plenty of evidence to the effect that, placed in a public (or semi-public) space, they served to indicate the grade status of those who commissioned them. But what

kind of statue or form would have been linked to a given grade, and what particular element drew the attention to what specific signification? The answers often escape us. From the local forms represented in various collections or recorded in field photographs from the islands of Gaua and Vanua Lava, we can see that there was a considerable degree of variation. Does this fact reflect the sculptors' freedom of expression, or, on the contrary, the existence of rigorous stylistic canons that were closely followed by numerous local associations or different ranks? Thanks to his scrupulous analysis of the scattered data at his disposal, Kirk Huffman is the first to offer a more detailed reading of the possible answers. Three factors become evident here. Firstly, each grade

society's iconography was determined more by mythical models or motifs than by generalised typological references (for example, superposed heads). Secondly, as with many mythical narratives, the multiple levels of interpretation they contain is fully transposed into the sculptural work – indeed, it is to this profound ambiguity that the image created by the artist refers, especially in Melanesia. Thirdly, more than elsewhere in the region, the stylistic differences between the different local communities would seem to reflect a desire to give the works a strong socio-temporal identity.

CHRISTIAN KAUFMANN
Translation: Charles Penwarden

1 Vanuatu, Océanie. Arts des îles de cendre et de corail, 1996, fig. 2.
2 A.L. Kaeppler, C. Kaufmann and D. Newton, 1933, fig. 139.
3 Interpretation proposed by the librarian of the Alexander Turnbull Library, Wellington (see Vanuatu, Océanie. Arts des îles de cendre et de corail, 1996, figs. 276, 300 and 301.
4 Chief's stick and pounder: Vanuatu, Océanie. Arts des îles de cendre et de corail, 1996, figs. 200 and 211; dishes; ibid., fig. 186; beam and post: ibid., fig. 238 (Basel, Vb 4742 and Vb 4743).

Sculpture from Eastern Gaua (Gog) island

19th century
Banks Group, northern Vanuatu

Female statue for male graded rituals (*tamat doro*)

Tree fern
H. 182 cm
Collected by John Higginson (or one of his agents) in Vanuatu in the 1880s,
registered at the Musée d'Ethnographie du Trocadéro 15 February 1890[1]
Original MET no. 26695
On permanent loan from the Muséum National d'Histoire Naturelle – Musée de l'Homme
Inv. MH 90.27.2

Main Exhibitions
Paris, 1923-24, 1997-98.

Main Publications
The first illustration of the figure is probably the sketch done by N.N. von Mikloucho-Maclay during his 1879 tour through the Banks islands;[2] H. Clouzot and A. Level, 1919, pl. X; H. Clouzot and A. Level, 1925, pl. LIV; G.H. Rivière, 1926, p. 179 (centre); A. Warnod, 1930, p. 320 (centre); J. Guiart, 1949, fig. 14, p. 20; J. Guiart, 1963,

Businessman, political manipulator, anglophobe and francophile, English-born Irishman John Higginson (1839-1904) was seized with the belief that the New Hebrides, as it was then called, formed a natural addition to New Caledonia and spent his life trying to bring the islands under French control. Granted French citizenship in 1876, he was appointed commissioner to represent New Caledonia at the 1878 Universal Exposition in Paris. In 1882, in Nouméa, he founded the Compagnie Calédonienne des Nouvelles-Hébrides (CCNH) with the aim of buying up as much land as possible there. By the late 1880s, the CCNH claimed to hold

title to some 700,000 hectares, about 60% of the New Hebrides Group. The CCNH became the Société Française des Nouvelles-Hébrides (SFNH) in 1894 – and the name is still ominously familiar to many Ni-Vanuatu today.[3]

In return for "concessions" from the French government, Higginson donated 136 Vanuatu objects to the Musée d'Ethnographie du Trocadéro in 1883, with further donations in 1890 and 1893. The superb collection came with minimal collection data. Many of the objects are from the Efate region.

This piece carved in tree fern[4] may be the only surviving example of a particular style of Banks

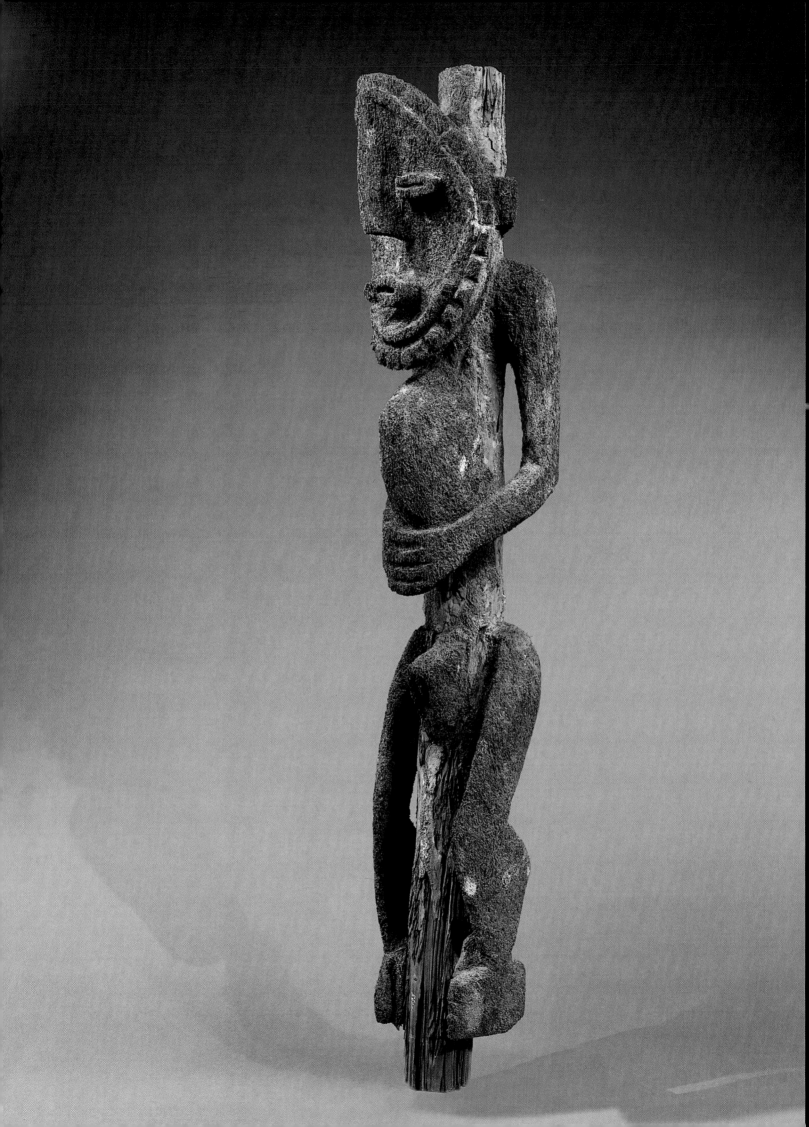

no. 212, p. 236; P.S. Wingert
(ed.), 1970b, N 226 (right);
A.L. Kaeppler, C. Kauffmann
and D. Newton, 1993, no. 446,
p. 443; W. Rubin, 1987, p. 33;
*Vanuatu, Océanie. Arts des
Iles de cendre et de corail*, 1996,
fig. 65, p. 46; J. Bonnemaison
et al., 1997, fig. 65, p. 46.

islands sculpture (other surviving female figures are less stylised).[5] Monumental ritual carvings in tree fern were widespread in the Banks, particularly on Gaua and Vanua Lava, but examples from Ambrym and Malakula are better known in the literature. The giant, prehistoric-like tree fern has an easily-removable segregated bark. Underneath, its inner trunk is surrounded by aerial roots, easy to carve – easier than wood – when freshly exposed. With advanced planning for rituals, selected specimens in the forest were sometimes tied with a strangulation cord several metres above the ground to increase the volume of aerial root growing below. When cut down for carving, its bulbous base formed the upper part of the sculpture. Such tree-fern carvings died out in the Banks in the early part of the 20th century[6] and to date there has been no in-depth coverage of them in the literature. The objects themselves may have disappeared from the Banks today, but much of the associated ritual knowledge[7] and some of the connected rites have not.

This sculpture is typically Gaua in style, and particularly eastern Gaua notably in the treatment of the eyes, nose and mouth. The adoption of the language of Mota island by the Melanesian Mission (Anglican) from 1867-1931 as the "lingua franca" of the Banks, Torres and south-east Solomons, and its consequent domination in the anthropological literature,[8] has tended to obscure the linguistic and cultural variations within the inter-linked cultures of the Banks group.[9] Even the names of the islands were "Mota-ised": Gaua's real name is Gog,[10] "Gaua" referring to the eastern side, "Lakona" to the western side.[11]

Gaua shared aspects of the Banks-wide Kwat cultural hero mythical cycles and the interlinked ritual institutions of *sukwe**, *tamate** *(salagoro**) and *kolekole**, but eastern Gaua had – and still has – its own language terms and variations of them, often with unique aspects.[12] Published literature has tended to obscure this.

The volcanic crater-lake island of Gaua (330 square kilometres) in the southernmost Banks island was culturally (at least the eastern half) somewhat isolated from its neighbours. With a possible pre-European contact'population of at least 20,000, it was estimated to have 1,800 inhabitants in 1996, speaking four different Gaua languages.[13] Tragic depopulation took many of the men and women who "knew" – but not all. The Anglican church had "difficulties" with Gaua, two converted eastern villages reverting to "kastom"[14] in the 1920s, and there were still small unconverted groups into the mid-1930s. Forming part of the Banks cultural complex, eastern Gaua had *wuswus wutve* (*sukwe**) public graded rituals for men, with a less complex one for women, called *tawaminar*. There were also numerous *tamat* (*tamate**) masked male secret

societies and *wetaramlei* (*kolekole**) the latter rituals to enhance the status of a new house, object or vision, etc., and the individual. Intense ritual payments necessitated an endless supply of *rao/rolas* (*rawe**) intersex pigs, castrated male tusker pigs and vast lengths of *sum* (*som**) made on Rowa (Reef islands). At the end of the *som** trade trail, though, *sum* was sometimes in short supply, so eastern Gaua also developed *sumtamin*, the red and white banded stringed feather money.[15] Pursuing this expensive ritual life with correctness and generosity enabled one's spirit to live in *bono* (*panoi**), the world of the dead, whose entrance was a *sura** – in this case, a volcanic fumarole – on the slopes of Mount Garat above the crater lake Tas in the centre of the island. As in the rest of the Banks, there was no circumcision. Men and women were traditionally naked, women wearing only the grass waistband *hopare** or the woven and dyed *pari** band for rituals,[16] and men wearing their status apparel for rituals. Part of northern Vanuatu's "traditional copyright" area, cultural items could be bought and sold following techniques similar to those used in islands further south.[17]

Eastern Gaua's *wuswus wutve* graded rituals were a spectacular variant of the Banks's system and it is here that the *Sukwe** has left its most massive permanent remains. "Man Gaua" were stonebuilders par excellence. Gaua (particularly east) is covered by hundreds of kilometres of high dry-stone walls (with pig doorways) flanking narrow paths. Each *gamal* (men's hut, *nakamal*) stood on huge stone platforms facing the *leisar* (*nasara*, dancing ground). The highest ranking men had their own personal stone-platformed dwelling also. Stone monoliths, stone altars and stone "dancing walls" spread onto the *leisar*[18] and immediately facing the public was a line of sacred *namele*[19] plants interspersed sometimes with up to a dozen large tree fern carvings representing the spirits associated with the rank or ranks being taken in *wuswus wutve*. Similar statues lined the facades of the *gamal* and the separated houses of the "highest" men.[20] According to Felix Speiser,[21] only male statues[22] stood on the dancing ground and female figures were confined to the fronts of (private) houses. This was not always the case, though.

Eastern Gaua had a different "spin" on the *Sukwe**. In most of the Banks, men spent years amassing the requisites to buy their way up the system to the defining grade *mwele** (*namele*), above and beyond which each step had an associated statue. In eastern Gaua, though, young men started near the top, from a grade just before *mwele**, making *wuswus wutve* more important. A young man from Gaua going to, say, Mota Lava, could have the right to eat at the sacred fire of a white-haired elder who had spent decades amassing and distributing wealth and riches to get that high!

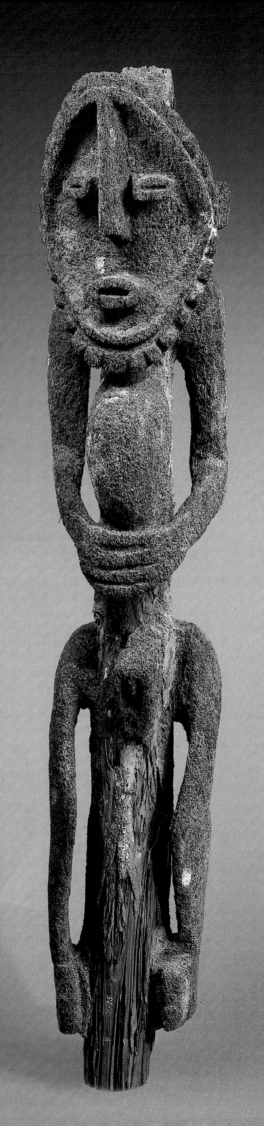

This statue is definitely female. A young eastern Gaua person today looking at it might say "O, tamat tawa natak 'wanaben'" ("Oh, this spirit woman is pregnant"), but an older, knowledgeable man would think beyond the large belly. Two steps above mwele* in the wuswus wutve was the grade gwurugwuru valuwo (kworokworo lava*, "ear/ear/big"). The spirit of this grade is female, sometimes "two-faced". On Mota, the statue (of which no Mota or Mota Lava examples survive) was said to have two big round ears. But there may be a double-entendre here, since gwurugwuru (kworokworo*) means "ear/ear" but also refers specifically to a type of bi-valve shell. Marine shell analogy is often, in Vanuatu, a polite way to refer to female genitalia. It is to be noted that the ter[23] carved on this figure[24] may also explain why on Gaua those men taking the grade gwurugwuru valuwo wore, as part of their dance costume, a pair of woven pandanus round "ears" not on their heads but attached to a woven waist strap with the "ears" displayed over each haunch.[25] Eastern Gaua's "heavier" position within the Banks Sukwe* network may have meant that they could get away with cultural statements[26] that other islands had to be slightly more circumspect about.

Readers will note that at the beginning of this article I have called the carving tamat doro, and that is the proper way to call it in eastern Gaua. Three types of tree fern are recognised there: doro, yumu-tutu and wosaket. This figure is carved from doro and as any grade carving represents a spirit, tamat, thus its name – general, but polite and correct.[27]

KIRK W. HUFFMAN

1 Originally this piece was incorrectly provenanced as "Ile Fate", i.e., Efate (Inventaire des collections du musée d'Ethno-graphie du Trocadéro, cat. 14). During the reorganisation of the MET in the 1930s, it was reprovenanced as "Gana" (sic).

2 Clearly the one published in N.N. von Mikloucho-Mackay, 1990, p. 292 (right).

3 This brief outline of Higginson's "Vanuatu affair" is the official version. The reality was rather different and aspects of this will be touched on in the introduction to the following object (see MH 90.27.3, p. 259), also donated by Higginson to the MET.

4 The giant tree-fern, blakpam in Bislama, is from the family of the Pteridophytes, a group of around 12,000 species reproducing by spores, not seeds. Those used in Vanuatu for ritual carvings are Cyathea and Dicksonia.

5 See Vanuatu, Océanie. Art des îles de cendre et de corail, 1996, fig. 333a and b, p. 337. Female tree-fern sculpture (carved by men) from East Gaua (collected by Felix Speiser in December 1911, Basel, cat. 4374, H. 195 cm). This is probably not a grade carving but a specially carved figure set up to decorate the front of a private house and for which a wetaramle (kolekole*) feast/dance was held. It may possibly commemorate the (male) house owner's surviving an attempt at seduction by Mae Tiratira*, one of the Banks islands infamous "sea-snake changeling women", turtur m'w'a ("stand/stand/banded sea snake"). The venomous banded sea snake, if it is one of these "spirits", can change into the form of a beautiful woman and attempt to seduce men. If the man succumbs, he dies shortly afterwards. They can be recognised as their limbs are "extremely flexible", sometimes bending backwards. Although this may possibly be a rare variant of Gwurugwuru valuwo, the naturalistic rendering of the face suggests it is not a grade figure. If it is therefore a figure for wetaramlei, its general Eastern Gaua name would be simply tisong (connected with a spirit) doro, thus tisong doro turtur M'w'a.

6 Or more probably "went to sleep" in Vanuatu.

7 Some early researchers sometimes asked people too low-ranking to really "know", or asked the wrong questions, or misunderstood answers, or information was purposely hidden from them. There were exceptions, though, but the easy answer from Ni-Vanuatu was often "all those who know are dead", and the "easy answer" in museum publications is "little is known".

8 E.G. Codrington, 1891; W.H.R. Rivers, 1914; F. Speiser, 1991.

9 An exception is Bernard Vienne's Gens de Motlav, Paris, 1984, concentrating on Mota Lava and closely-linked areas, but he faced similar linguistic problems with the early literature.

10 Most islands in the Banks have or had several different names: some had no name at all for their own island but names for other islands, some islands had several names depending on area and languages spoken, and then the islands had secret "trading voyage names" that were used to keep trading destinations hidden from potential rivals.

11 "Gaua" has been given numerous names on the map and in written accounts. The first European thought to have sighted it, Pedro Fernández de Quiros, in 1606, named it "Isla de la Virgen María", shortened to "La Virgen María". This name persists as "Santa María" on maps even today. It has also been variously called by early traders, missionaries or officials as "Lakoon", "Lacona", "Gow" and "Ganna". "Gaua" is the Mota language form of "Gog".

12 East Gaua language terms I will write thus: Tamat tamek varet ("A man's spirit goes [to the world of the dead]"); the corresponding (and more familiar) Mota language term will be written with an asterisk, e.g. Sukwe*.

13 The scale and rate of depopulation on Gaua was traumatic. Harrisson (1937, p. 268) says De Quiros (1606) estimated 200,000 inhabitants, although 20,000 may have been closer to reality. Epidemics of European diseases in 1875, 1876, 1882

and 1886 left circa 2,000 survivors in 1895 (*ibid*, p. 323). The British Government estimated 2,000 in 1910, F. Speiser (1991, p. 37) 3,000 in 1911. A 1918 estimate was 1,250. Measles in 1928 and flu in 1935 resulted in an all-time low of circa 650 in 1935. South-east Gaua has had, for some years, immigrant inhabitants from Mere Lava.

14 *Kastom* (Bislama): "La coutume" or traditional way of life.

15 For a similar example from Mere Lava, see F. Speiser, 1991, pl. 78, fig. 8.

16 See K. Huffman, 1996a.

17 See K. Huffman, 1996b.

18 See the plan of these massive stone constructions at Losalava in north-east Gaua in F. Speiser, 1991, pl. 91, fig. 12, and photos 1 and 2, pl. 89. Decorated high-ranking men danced in lines on the walls during *Tawaminar* rituals.

19 *Cycas circinnalis*, a cycad.

20 For photos of such houses taken in December 1911, see F. Speiser, 1991, pl. 89, figs. 3 and 4. Note also the painted board grade designs (often preliminary sketches for the grade carvings) behind the tree-fern figures. For examples of these boards, see

J. Bonnemaison *et al.*, 1996, fig. 71, p. 49 and figs. 334, 335, p. 338. The tree-fern grade statue corresponding to fig. 335 can be seen in fig. 3, p. 3.

21 F. Speiser, 1991, p. 353.

22 See for example *ibid.*, 1991, pl. 94, fig. 2; J. Bonnemaison *et al.*, 1996, fig. 251, p. 243.

23 *Ter* in eastern Gaua language is "vulva".

24 Definitely bigger than that of the sculpture reproduced in *Vanuatu, Océanie. Art des îles de cendre et de corail*, 1996, fig. 333a and b, p. 337.

25 See Speiser, 1991, pl. 46, fig. 3, Basel cat.4074, possibly the only one to have survived s– and only one "ear" too!

26 Such "two-faced" women are not necessarily always spirits! In the western part of Ambae they are called "*tapehugwile*".

27 I dedicate this brief, incomplete piece of ethno-detective work to the spirit of my old friend Chief Marsden Rongo (of the Mere Lava community in S.E. Gaua) who died in Cyclone Uma in 1987. *Bigfala tangyu* to numerous Ni-Vanuatu friends, the Vanuatu Cultural Centre and Chichinold Wetu of eastern Gaua.

Sculpture from eastern/south-eastern Vanua Lava Island

19th century
Banks Group, Vanuatu

Statue for male graded rituals (*kwetie tamat*)

Tree fern
H. 200 cm
Collected by John Higginson (or one of his agents) in Vanuatu in the 1880s, registered at the Musée d'Ethnographie du Trocadéro 15 February 1890[1]
Original MET no. 266956
On permanent loan from the Muséum National d'Histoire Naturelle – Musée de l'Homme
Inv. MH 90.27.3

Exhibition
Paris, 1997-98.

Main Publications
G.H. Rivière, 1926, p. 179 (right); A. Warnod, 1930, p. 320 (left); V. Gilardoni, 1948, pl. 142 (right); J. Guiart, 1949, fig. 15, p. 2; C. Roy, 1957, p. 78; *Vanuatu, Océanie, Arts des îles de cendre et de corail*, 1996, fig. 35, p. 26; J. Bonnemaison *et al.*, fig. 35, p. 26.

In 1882 Higginson's CCNH[2] bought up all the land titles in the New Hebrides claimed by Scottish businessman and trader Donald MacLeod (1845-1894).[3] They included an area at Port Patterson on the eastern/south-eastern side of the island of Vanua Lava.[4] This statue comes from that area, so may have originally been collected by MacLeod himself and then passed to Higginson as part of the purchase, or collected by Higginson or his agent on a visit to the area to view the claim in the 1880s. After the initial 1882 purchase of existing European land titles in the islands, CCNH engaged in a frantic flurry of land purchases from indigenous Ni-Vanuatu throughout the country in the following years. Although a secondary result of Higginson's activity was a superb collection of Vanuatu objects in the Musée d'Ethnographie du Trocadéro, the long-standing effect of his operations in Vanuatu was much understandable antagonism amongst the indigenous inhabitants that took nearly a century to resolve.[5]

This statue for[6] male graded society rituals is a superb (and rare) example of one of the many different highly stylised forms[7] formerly produced on Vanua Lava.[8] Styles varied from ritual to ritual, grade to grade and the area of the island. If of human-type form, facial features were often minimised, mere slits for the eyes and mouth and an often non-existent nose. The design of the hair-style (discussed below) is also found widely on other status-linked objects (graded wooden food knives, breadfruit pounders, etc.) throughout the Banks and as far away as Santo. Linguistic, cultural and stylistic variation on Vanua Lava was

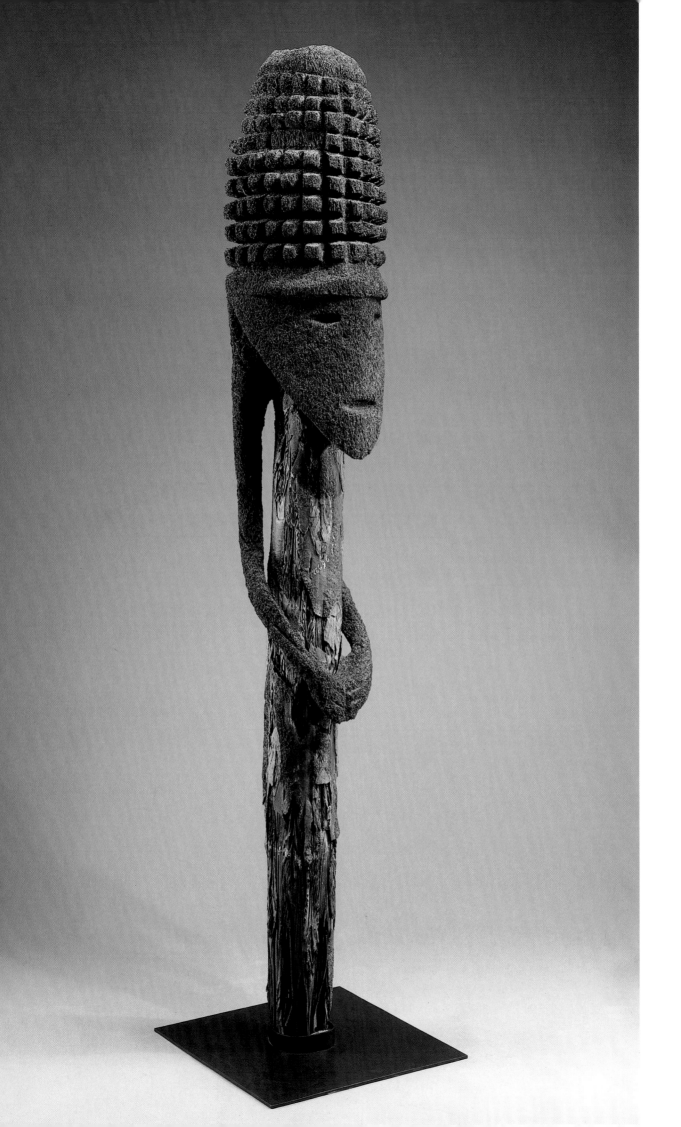

extremely complex and as yet little is known of the pre-contact situation. Two languages with a number of sub-dialects and possible remnants of disappeared languages are spoken on the island today. As the grade statue is almost certainly from the eastern/ south-eastern Vanua Lava, I will use, as much as possible, the language terms from that linguistic area. In this area, three varieties of tree fern are recognised, *kwetie*, *nowenwen* and *nasas*.[9] Carved from *kwetie*, the proper general "public" term for a grade figure of this type is *kwetie tamat* ("type of tree-fern/spirit").[10]

The Banks'largest island (343 square kilo-metres), Vanua Lava has had a particularly traumatic history of encounter with the "white man's world".[11] The population was decimated. In the early 19th century it may have been around 15,000; in 1996 it was estimated at 1,705. The Anglican church in the Banks was generally relatively lenient regarding traditional ritual, but stiffened its attitude against the *sukwe*[*] men's graded society from 1911.[12] This was compounded by at least one indigenous Anglican Father[13] placing a traditional taboo against participation in the *sukwe*[*].[14] The human tragedy was a cultural tragedy as well, not just for Vanua Lava, but for the Banks as a whole, since Vanua Lava was the *stamba*,[15] the origin of much of the Banks'cultural theme. But all is not completely lost.[16] There is a cultural re-awakening taking place amongst the island's survivors. The Vanuatu Cultural Centre Fieldworker there initiated, with the chiefs, relevant discussions with the local government in 1988, and by 1998 the resumption of grade-taking rituals was being planned. The eastern/south-eastern version of *sukwe*[*], *sok*[17] had 13/14 grades, the critical seventh grade *o'mwele* (*mwele*[*])[18] giving holders the title *ta tut'mwele* (*ta vus mwele*[*])[19] and spreading their status island-wide and beyond. Above this grade each step was associated with a particular type of tree-fern spirit carving. An associated graded system for women, *o sok movon ereve rekrekwe*, gave the title *mweter* (*motar*[*]), "high woman".[20] All this seems a much lengthier system than that of eastern Gaua, but then most things on Vanua Lava could be longer, or deeper spiritually, for here it all really began for the Banks, in south-eastern Vanua Lava.[21]

The Banks is the realm of the creator hero Kwat[*] (Qat), but Kwat was born in south-eastern Vanua Lava, from the mother stone Kwatgoro[*] which still exists there today, and he and his brothers, the 11 *Tangaro*[*], lived nearby at Leiseper (Alo Sepere[*]). Here he created man from the reddish Vanua Lava riverside clay, and then made the first woman.[22] His stunning wife, *Iro Lei*[*], was one of the winged spirit women who came from the skies.[23] Here, from where this statue comes from, was the Beginning of All Things [...] and then Kwat

left for Gaua [...] and from there left the world. But what he had started grew and spiralled across the Banks, developing into a scintillating array of brilliant multi-coloured rituals, song, dance and material spirit forms ("art"). Although gone from this world, it is said that he still watches and waits, for his time will come again.

From this *stamba*, with the intervention of spirits, *mana*[*],[24] men, women, shell money and pigs developed the interlinked *sok* (*sukwe*[*]) graded rituals, the masked *tamat* (*tamate*[*]) secret societies and the *o'kolkol* (*kolekole*[*]) feast-and-dance-giving social entrancement rituals. Giant men's huts, *gemel* (*gamal*[*]), with the ranked, graded sacred cooking areas inside, were often flanked by the separate, individual men's houses for those so high-ranking that their accumulated personal *mana*[*] would destroy the lower-ranking men in the large *gemel*, so it was safer for all concerned that they lived and ate alone. The facades of these houses were beautified with the tree-fern statues indicating the *sok* status of those within. Near the stone dancing walls of the *osar* (*nasara*, dancing ground) stood the tree-fern statues indicating recent *sok* rituals. The whole interlinked series of rituals, and life in general, was based upon the acquisition and manipulation of *mana*[*] and *som* (stringed shell money). Kwat was the first to wear *o som ta Ro* (*som ta rowa*[*]), the shining white fine polished shell money, coiled around his head or forehead to denote his status, and until the beginning of this century Vanua Lava men strove to obtain the right to wear them around their own head or neck. But the ordinary, everyday, shell money *o som taminin* (*som*[*]) that was the basis of everything was a darker, rougher variety, more rough-cut and not polished. The production centre for all this shell money, the basis of the whole Banks ritual system, was the small island of *Ro* (*Rowa*[*])[25] in the Reef Islands to the north/north-east of Vanua Lava.

Without Ro's perpetual production of shell money, the Banks'– and particularly Vanua Lava's – cultural system would be unsustainable, since everything had a price in *som*. Pigs (either castrated male tuskers or *rao* [*rawe*[*]] intersex) seem to have entered the Vanua Lava graded system at a later date, and the right to use pigs in *sok* was actually purchased by *som*. Incessant trade voyages from Vanua Lava and Mota Lava to Ro brought back *som* which then circulated Banks-wide. With *mana*[*] one attracted *som*, with *som*[26] one could increase *mana*[*], buy one's way up the *sok*, pay entry to the numerous *tamat* societies, make *o'kolkol*. If all this was done correctly, i.e., if one had the correct respect and essential generosity, one could hope for a better life after death in the underground world of the ancestral spirits, *o'pono* (*panoi*[*]) whose *o'sur* (*sura*[*]) (mouth or entrance) was at Serevuvu.

However, if one did not possess *o'es tamat*, a copyrighted spirit song belonging to one personally – and for which one had to pay *som* to a professional *o'es tamat* composer – one's entrance to *o'pono* could be barred. To have a mask or a tree-fern carving made for a *sok* grade, the professional artist, *mao**, able to produce the sacred object within strict narrow parameters without unacceptable innovations, had to be paid in *som*.

Everything linked together. Higher grades in *sok* (*sukwe**) linked men in "the road of peace" across and between islands; the links in the chains were oiled by *som*. Certain *sok* grades were linked to certain of the *tamat* societies. The most basic and important *tamate** society Banks-wide was and still is *Tamate Liwoa** ("Big" Tamate in "open" speech), whose *stamba* is in east/south-eastern Vanua Lava. *Tamate Liwoa** is spiritually linked to the grade above *Kworokworo Lava** (see *Wometeloa** ("eye [s] of the sun" – more deeply "sunbeam"), *o womoto'olo*). The tree-fern carving for *wometeloa** grade on Mota was a male (but sexless) figure, janus-faced, with a long straight body, arms vertical and cut away from the trunk, hands joining and no legs. Just like the statue shown here, except that it has only one face – but ours comes from the *stamba* area and therein lies the key. The spirit origin of this grade and the Banks-wide *Tamate Liwoa* society is in the Bwarangleilei area of east/south-eastern Vanua Lava. There, aeons ago, lived a beautiful girl, unmarried but already

mweter: she refused marriage proposals from high grade men of seven different islands. Her parents thought she was too choosy, but she was not impressed by ordinary high-ranking men and was willing to wait [...] Suddenly one day she was surprised by a multi-coloured shooting sunbeam of brilliant light in the sky over her head that disappeared into a hole in the ground. She rushed to the hole and therein found the handsome glowing sunbeam spirit man Wetmatliwo*.[27] She fell in love with him instantly and they lived together in perfect bliss, his goodness lighting up the inside of their hut like the sun. However, she eventually deceived him with O'ev (Weav*), the male fire spirit, so Wetmatliwoa decided he must leave her, ritually dancing backwards into his hole and as he did so changing is *Tamate Liwoa** – in our area of Vanua Lava he is called Tamat Lowo. Heartbroken, the beautiful *mweter* grabbed his head to prevent him going down the hole – but the top of his head broke off. That part of the head – the "other face" – is the giant blackstone Tanpatpat (Petanpatapata*) off the beach near Bwarangleilei today. In the *stamba* area of this grade ritual, the tree-fern statue[28] does not necessarily need a "second face" as the "sunbeam" spirit man's missing part is permanently there for all to see in the form of the tall stone. Only on islands far away from its source may the figure need that other face.[29]

KIRK W. HUFFMAN

1 Originally this piece was incorrectly provenanced as "Ile fate", i.e., Efate 5inventaire des collections du musée d'Ethnographie du Trocadéro, cat. 14). The provenance was corrected to Vanua Lava during the reorganisation of the MET in the 1930s.
2 See section on John Higginson in preceding article.
3 See P. O'Reilly, 1957, pp. 138-142. MacLeod had land titles on Tanna, Efate, S.E. Malakula, Epi and at Port Patterson. Many of them were rather dubious.
4 J. Guiart, 1986, p. 5.
5 Higginson himself said, "Henceforth, the only policy that can make the New Hebrides a French possession is to buy up as much land as possible, no matter how and no matter by what means." (Dr Auvrey, 1926, p. 24) Because of the rather unsavoury way most of these land purchases were done, and because of major fundamental differences in European and Ni-Vanuatu attitudes to land ownership and custodianship, the CCNH (later SFNH) land "problems" plagued the French colonial government up to Vanuatu's independence in 1980.
6 This piece should be compared to another tree-fern sculpture for male graded society rituals photographed by Felix Speiser in December 1911 in an unknown region

of Vanua Lava (Basel inv. Vb 1955; see Speiser, 1991, pl. 97, fig. 2). Note stone dancing wall. Female ritual hardwood statue in far background.
7 For other examples of Vanua Lava tree-fern carvings, see N. Mikloucho-Maclay, 1990, vol. V, sketch for heading of ch. II; F. Speiser, 1991, pl. 87, fig. 4, pl. 100, fig. 3 (Vb 1954) and pl. 104, fig. 5 (Vb 1949). Photos taken December 1911. For carved men's house posts (possibly wooden), see *ibid*., pl. 17, fig. 4 (Vb 1947); also published more clearly in C. Kaufmann, 1997, fig. 1, p. 12.
8 "Vanua Lava" is the "Mota-ised" form of the island's real name Vono Lav/Vono Lov ("land"/"big"). The problems with the long-standing use of Mota language as the "lingua franca'in the literature has been outlined in the preceding article. I will follow the same procedure in this article, writing the proper eastern/south-eastern Vanua Lava language terms thus: *nom* (mosquito) and the sometimes more commonly-known Mota term thus: *nam**.
9 To give an idea of linguistic variation within Vanua Lava, these three types of tree-fern are called *kwatiedewinian* and *dorut* in the neighbouring dialect from the west of the island and the main type is called *kwa'aga* from the language in the north. A general term for a male graded

society tree-fern statue from the former of the two dialects/languages would be *kwatie timiat*.

10 For a rare variant of this style in wood, see W. Stöhr, 1987, fig. 263, p. 275. Note hairstyle.

11 Sighting the island in 1606, De Quiros called it "Los Portales de Belén". It has also been mapped as "Great Banks Island" and "Varuka". Epidemics of introduced European diseases ravaged the population from probably the 1870s onwards, even into the 1920s and 1930s. The activities of "blackbirders" ("recruiters") severely affected the population in the Port Patterson area from the mid 1860s-late 1870s. Speiser (1991, p. 37) estimated the population at 1,500 (December 1911); the British Government official estimate for 1910 was 2,000. There were 688 Ni-Vanuatu there in 1966-67 (B. Vienne, 1984, p. 42). An all-time low of possibly around 400 may have existed in the early 1930s. The 1996 estimate is from the Vanuatu government's NPSO population progression estimates by province (September 1996). Indigenous reasons for the rapid population decline often differ radically from the "scientific" view. Some on Vanua Lava put it down to the escalating use of a type of magical poison called *botimiat* in the west and north of the island.

12 D. Hilliard, 1978, pp. 201-204.

13 To remain anonymous, but still alive (although very elderly) in 1990.

14 Thus, according to Vanua Lava belief, men who continued these rituals, or even partook of activities in the men's hut and who died suddenly were actually killed by this local aberrant decree.

15 The word *stamba* (Bislama) means "origin", "foundation", "base", "roots", "source of power", etc. – there is no exact equivalent translation in English or French.

16 See K. Huffman, 1995, especially pp. 98-99 about Vanua Lava.

17 As one travels west and north across the island this changes to *sok'*, then *sok'w*.

18 The word *namele* (Bislama) denotes a sacred plant, a cycad. In eastern/south-eastern Vanua Lava two variants are recognised: *o'mwele* and *o'mwele tangsar*.

19 "The man who touched/hit the (*na*) *mele'*."

20 Vanua Lava *mweter* were often easily recognisable from their beautiful, highly-stylised facial and body tattoos. These tattoos, though, were not part of the women's graded rituals, but were given to them as gifts in *o kolkol* rituals paid for by a girl's father or uncle, or a woman's husband. The tattooists were sacred female specialists. See the sketches in N. Mikloucho Maclay, 1990, vol. 5, pp. 260-261 and pp. 264-265; also see *Vanuatu, Océanie. Arts des îles de cendre et de corail* 1996, fig. 73, p. 50.

21 Ni-Vanuatu often disagree with the "white man's way" of describing their ritual objects. Years ago, looking at the written description of an object type he knew well in a highly respected publication on "Pacific Art", a well-educated (in *kastom* and "school") Ni-Vanuatu friend politely took the book down and said to me, "That's rubbish; the way they do it is like building their hut on the beach below the high tide mark – superficial and temporary." A proper description of an object can be rather like building a new hut in the jungle: one surveys the general area, clears the underground and looks for a spot that will give a good foundation. One "circles" the object in description, in a spiral fashion, moving along its connections to its *stamba* and only really then do its connections and meaning become clear – but then one never gives out the full meaning (unless proper ritual payment is respectfully agreed upon).

22 She was Iro Vilgale* (vil*/ "to bind"; gale*/ "to deceive"). She was not made from earth.

23 Stories of these beautiful winged women cover almost the whole of Vanuatu. Some Ni-Vanuatu claim descent from them today.

24 *Mana**: the spiritual influence or power inherent in certain natural objects or areas, which is transferable to man-made objects or people. One's life can be aimed towards obtaining it for oneself or trying to manipulate it for the benefit of oneself or others.

25 The population on Ro was always small, but they were specialist fishermen/women and full-time professional shell-money makers. Low-lying Ro and its neighbouring uninhabited islets provided an unlimited source of the shells needed to make *som*. No food gardens were planted on Ro – this would cause a famine on Vanua Lava. No female pigs were allowed on Ro – they would "devour the population". The Ro *som*-makers were fed by the other Banks islands (particularly Vanua Lava [taro and male pigs] and Mota Lava [yams]) in exchange for *som* and dried or salted fish. Ro was the Banks'"Royal mint". The small population was evacuated permanently to Ureparapara (where they had kinship links) in the 1950s after a disastrous cyclone.

26 *Som* could be lent out at interest: 100% irrespective of duration of the loan. For *som* illustrations, see Speiser, 1991, pl. 81, fig. 1.

27 In eastern/south-eastern Vanua Lava this could be *vot moto'olo* ("stone"/"eye"/"sun").

28 For Mere Lava painted representations of the face of Tamate Liwoa* and associated "suns", see W. Rivers, 1914, vol. I, pl. IX (opposite p. 89). The coiffure of the tree-fern statue, a style spread widely on various objects, could represent the special ritual coiffureof high-status men, often cut, pressed or tied in the Banks into complex shapes and patterns, or it could represent the head coiled with shining white *o som ta Ro*, or a combination of both.

29 I dedicate this lacunae-filled attempt at ethnographic puzzle-solving to Sylviane Jacquemin of the Musée des Arts d'Afrique et d'Océanie who died so tragically in Paris in March 1999 and to the spirit of *olfala* Vatvaës of Vetuboso, Vanua Lava, whose 1000-day funerary rituals were held on 16 June 1996. *Bigbigfala tangyu* to many Ni-Vanuatu friends, the Vanuatu Cultural Centre, Luke Dini, Eli Field, Henline Halele and especially to *olfala* David Melsiu Teltuk of eastern/south-eastern Vanua Lava.

Sculpture from Western Gaua (Lakona) Island

First half of the 19th century
Banks Group, northern Vanuatu

Statue for male graded rituals

(butoot doro nek'hetamat/kolkol wutuk)
Tree fern
H. 310 cm
Purchased in 1883 by the Musée Préhistorique et Ethnographique de la ville de Bordeaux
Former inv. 23.598
Collections of the Musée des Beaux-Arts de Bordeaux and later the Musée d'Aquitaine
On permanent loan from the Musée d'Aquitaine – Bordeaux
Loaned by the Musée d'Aquitaine to the Musée des Arts d'Afrique et d'Océanie in the early 1960s

Exhibition
Paris, 1997-98.[1]

Main Publications
F. Speiser, 1929; fig. 111, p. 94;
J. Faublée, 1961, fig. 5, p. 228.

Originally plundered from the area of a *nakamal* (men's sacred hut) during a "blackbirding" raid[2] in the late 1870s or early 1880s, this large carving and other Vanuatu objects were sold to the Bordeaux museum in 1883 by M. Savès, a rather unknown "Nouméa trader"[3] with the misleading information so typical of the time, a situation compounded by the then Curator of the Bordeaux museum, M. Camille de Mensignac, who believed and elaborated on this misinformation in an 1886 publication.[4] The 1883 Nouméa purchase included pieces listed as coming from Ambrym, Malakula and "Santa María",[5] including the beautiful *nalot* pounder[6] (Bordeaux 13.163[7]) obviously from the same area as

the statue. De Mensignac in his 1886 publication unfortunately says of this *nalot* pounder, "This commander's baton or chief's sceptre [...] comes from the island of Ambrym [...] [and] represents the god of that island."[8] Regarding the tree-fern carving, he continues, "another representation of the same god [...] shows the face of the Taboo (god) of the island and was displayed for worship by the indigenous people [...] in the forecourt of the chief's hut. They gathered around this idol during holidays and cannibalistic feasts."[9] He also hints that the pendant penis on both objects indicates a phallic cult. Luckily someone, possibly Marcel Mauss, between 1890-1902, found (or put?) a label on it, "Tabou de Santa María", and that is how this statue was known for many years, in Mauss'lectures, in Felix Speiser's 1929 article and Jacques Faublée's 1961 article. De Mensignac should have checked more closely with the original 1883 inventory which mentions "l'île Santa María ou Lacone".[10] "Lakona" is the proper language term for the western part of the island now generally called Gaua[11] in the Banks, but still often marked as "Santa María" even in some modern publications. Not only is the statue *not* a "god", but cannibalism was never part of Banks and Torres cultures and the latter areas were probably the least likely in the whole of Vanuatu to have a "phallic cult".[12]

Fig. 1
Sculptures standing
in front of a men's house
or the house of a high-ranking
man in eastern Gaua (Lakona).
Photo taken by
Reverend John Palmer
around 1880
Library of the Musée
de l'Homme, Paris

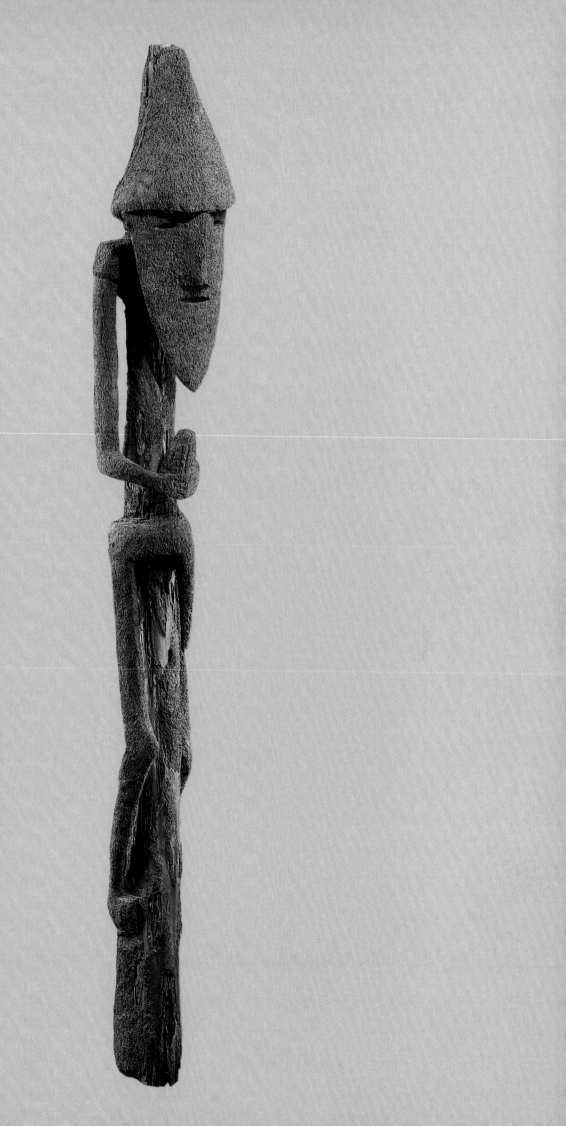

Stylistically, some scholars might think the statue to be from Vanua Lava,[13] but the key lies in a field photograph (Fig. 1) taken by the Anglican missionary Reverend John Palmer (1837-1902), who travelled intensively and deeply throughout the Banks 1863-1891 and upon whom even the erudite Rev. R.H. Codrington often relied for linguistic and cultural advice and assistance. Taken probably sometime in the late 1870s or early 1880s, Palmer lent this photograph to the Cambridge ethnologist W.H.R. Rivers years before Rivers'first visit to the Banks in 1908, telling him he had taken it on "Santa María" – and Palmer was almost invariably accurate. Rivers published the photo in 1914[14] and one can see two statues of the same form as the Bordeaux piece in the right and left background.[15] But Rivers continued the confusion by writing, "The figures are of solid stonework."[16] Only Faublée (1961) published the photo with a short relevant comment linking it with the Bordeaux figure.[17] In general, past scholarly treatment of this important carving is almost enough to make any long-dead Lakona high-ranking man want to come back to the world of the living from bono (panoi*)[18] to try and shake some patience and intelligence into the kwatu[19] of certain deceased white scholars!

Although the Bordeaux piece is one of the finest examples of a recognised type of particular male grade statue from western Gaua, it is neither unique[20] nor, in a "Lakona" sense, does it represent a highly stylised human form. Most grade figures from the Banks represent a spirit form and – as in European cultures as well – the form these spirits take is culturally and historically determined.[21] However, without actually taking a photograph of the figure to western Gaua to enquire today, it is not possible to determine which specific grade in the Lakona variant of the men's graded system (wutuk/sukwe*) the carving represents. This style, and the other forms also in the Palmer photo of Fig. 1 grouped in front of the wolwol (façade) of a western Gaua gemel (gamal*), men's hut, represent extremely important stylistic variants of the many early types of Gaua spiritual representations[22] (and possibly hint at traditional links with an area of Vanua Lava).

The traumatic recent history of Gaua has been briefly outlined in the preceding article relating to the eastern Gaua grade figure (see above). Anglican mission influence was already strongly felt on the eastern coast by the 1870s, but sporadic inter-group fighting continued into the 1880s on the Lakona side.[23] Introduced European diseases killed so many people, though, that at one time no canoe makers were left alive in the Lakona area, the populace reverting to bamboo rafts until canoe making was eventually reintroduced

But at one time western Gaua was a densely-populated, vibrant cultural area, one of the many variants of the numerous inter-linked Banks cultures. Lakona had complex wutuk (sukwe*) graded rituals for men; linked rituals to give women the high status title of mwetear'r (motar*); innumerable tamat (tamate*) masked male secret societies; stunning wetaramlei (kolekole*) rituals to enhance one's status above and beyond wutuk or to emphasise – with dances and feasts – the importance of a new house, ritual object, wife, niece, etc. Finally, the region manifested a typically Gauan expertise with stonework. Lakona's speciality in stonework was in using smaller stones than in the east for the foundation platforms of gemel, for the stone dancing-walls on the sar'r (nasara, dancing ground, leisar in eastern Gaua) and the kilometres of walled narrow paths. As for money, sum (som*) stringed shell money, the red-and-white banded stringed feather money called sumtameghin (sumtamin in eastern Gaua), rao (rawe*) intersex pigs and castrated male tusker pigs were the currency that funded the endless inter-connected ritual systems that brought meaning, joy and status to life. Essential, though, was the correctness, respect and generosity that one displayed during one's ritual life to both the living and the dead to merit peace and everlasting ritual in bono (panoi*), the underground world of the dead. Possession of a personally copyrighted (and paid for) oe'es nitamat (spirit song) was mandatory, though, as the final "key" to enter bono. In western Gaua, funerary feasting and dancing lasted five days for women, six for men. If a high-ranking Lakona man died, the final funerary meal, vulkwa,[24] was made on that sixth day after death. After vulkwat, the dead man's spirit made a dash for one of the several sur'mibunu (sura*), the entrances to bono, volcanic vents above Lakona on the western slopes of Mount Garat above the crater lake Letas (Tas in eastern Gaua). Other ancestral spirits from bono gathered to await the newcomer's arrival at the particular sur'mibunu. If the newly dead man has not paid off all his debts in life, his spirit is tied up until living relatives repay them.[25] These conditions satisfied and the possession of oe'es nitamat verified, the ancestors chopped up the dead person's spirit, each hold a piece, and then put him back together again once passed through the sur'mibunu to bono. However, if during life the dead man had slighted, wronged or insulted any of these particular ancestral spirits, those who were wronged retained the pieces they held, and when he was re-constituted again in bono those pieces were forever

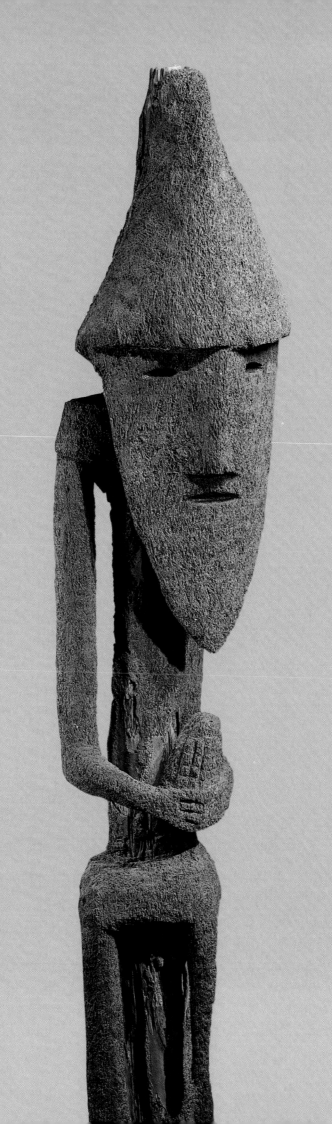

missing. One can thus see that strict accordance with traditional rules of politeness, respect and generosity to the living and the dead were absolutely essential for one's eternal afterlife to avoid spending ritual eternity missing a hand, foot or some more essential piece of equipment. De Mensignac, writing about the Bordeaux statue, says, "God [held] [...] in his hands a fruit resembling a pine cone." [26] However, one can now see why a short excursion into the particular West Gaua variant of death voyage beliefs may be relevant in the analysis of this carving: it is more likely that the statue may represent a particular spirit from *bono* holding in his hands an unreconstituted piece of the spirit body of the dead man who may not have lived up to the required spiritual ideals. This may have been a polite public reminder to all those partaking in or viewing the ritual for this object to live their lives with care, affection and generosity to the living and the dead. To become an important (and safe eternally) man in the Banks, one's whole life really consisted of giving (in the forms of rituals, feasts and respect) to all concerned. Rivers quotes an unnamed Anglican missionary who had seen Banks ritual life in full action: "To be a successful Melanesian citizen (i.e., one high in the Suqe) means that a man must have unlimited patience, indomitable perseverance, excellent health and a strong physique to enable him to recover from the perpetual succession of losses of which he runs the risk."[27]

As ritual carvings were made as much for the dead to see as the living, the artist of necessity worked within strict boundaries of material expression. One unacceptable innovation or variation could cost him his hands in eternity if he was a Lakona carver. Without originally knowing it, Anglican missionaries working in the Banks had actually stumbled into a complex spiritual world whose strict ideals were almost "more Christian than the Christians", but – at least in western Gaua – with a slight twist (or, more properly, chop) in the tail.[28]

KIRK W. HUFFMAN

1 Sculpture mentioned in the catalogue *Vanuatu, Océanie. Art des îles de cendre et de corail*, 1996, p. 339.
2 J. Faublée, 1961, p. 228.
3 *Ibid.*, p. 228.
4 C. de Mensignac, 1886, pp. 72-73.
5 See *supra*, footnote 8.
6 *Nalot* is the Bislama term for a type of staple food in northern Vanuatu, usually of breadfruit, but also often of taro, yam, banana, manioc, etc. The essence of *nalot* is in its mode of preparation, not content. It is pre-cooked, then pounded on a wooden platter or plate with a special pounder and flattened out, often with warm coconut milk poured over it. *Nalot* pounding is essentially a male activity and in the Banks particular high-ranking men had their own pounders often topped with a carving indicating their grade status. See Huffman, 1996, pp. 204-205; Huffman, 1997a, pp. 232-233. For the role of *nalot* and sacred plates further south on Malo, see Huffman, 1997b, pp. 37-41.
7 Originally catalogued, in 1883, as 23.597. Illustrated in *Vanuatu, Océanie. Art des îles de cendre et de corail*, 1996, figs. 200a and 200b, p. 205 and mistakenly labelled as a "bâton de chef" on p. 340 in the "catalogue" section.
8 C. de Mensignac, 1886, p. 72.
9 *Ibid.*, p. 72. Variations of the word *tapu** ("set apart", "prohibited") are widespread in Banks languages. It is not difficult to imagine shocked and enraged west Gaua men waving their hands and shouting their variation of "*tapu*! tapu*!*" at the white men pillaging the *gemel* area of the objects later sold to the Bordeaux museum.
10 Thanks to Paul Matharan, curator at the Musée d'Aquitaine, for this information. Personal communication, 20 April 1999.
11 "Gog" is the proper term for the eastern part of the island. The *Mota** form of "Gog" is *Gaua**, the name now used for the whole island.
12 There was no tradition of circumcision in the Banks and Torres, unlike certain islands further south. Men and women ordinarily went completely naked except for minor waist ornaments, body tattoos, cane ear decorations and certain rank insignias. In the areas of traditional circumcision, there were upright penis wrappers, such as those worn even to this day in areas of Malakula, Ambrym, south Pentecost and Tanna, or "hanging wrappers" of the *yelau* type previously worn on Erromango. These were never a part of Banks cultures, nor were woven and died mat costumes.
13 See J. Guiart, 1949, pp. 19-20, based on the existing collections in the Musée de l'Homme and written before fieldwork in Vanuatu. Guiart's later publications regarding Vanuatu art and material culture are models of detail and accuracy.
14 W.H.R. Rivers, 1914, vol. I, pl. III, fig. I, opposite p. 63.
15 An exhaustive (but rapid) enquiry search of major relevant photo archives in the UK in May-June 1999 failed to turn up the original Palmer photo.
16 W.H.R. Rivers, 1914, p. 63.
17 J. Faublée, 1961, p. 227.
18 *Bono*, the (underground) World of the Dead ("heaven") in both Lakona and eastern Gaua languages (*panoi** in Mota). I will follow the precedent of writing the Lakona language words thus: *wonwon* (fight) and the equivalent (and more widely known) Mota word thus: *vagalo** (fight). Only a few hundred Lakona-speakers survive today, most of them young and in school (education is not compulsory in Vanuatu) in the more densely populated east of Gaua, a different language area. The number of elderly speakers of Lakona language with deep cultural knowledge may be no more than a few dozen.
19 "Head". Although more traditionally, the basis of emotions, feelings, patience and the foundation of the way intelligence

is used is in the lower part of the *tokpw'a* (belly) and up through the throat.

20 A similar example is in the collections of the Department of the Arts of Africa, Oceania and the Americas at the Metropolitan Museum of Art, New York (cat. no. 1978.412.71). H. 265 cm. Nelson Rockefeller purchased it from the dealer Julius Carlebach in December 1956 and that same month loaned it to what was then the Museum of Primitive Art in New York, to which he donated it in 1972. No original collection data exists. Published in *Selected Works from the Collection. The Museum of Primitive Art*, New York University Press, Summer 1957, fig. 6, p. 8.

21 As are the Christian depictions of God, Satan, angels, etc. Vanuatu angels – winged individuals who come from the Sky World – always take the form of beautiful, soft-skinned women whose detachable wings are usually not like bird wings but more like the webbed wings of the *flaengfokis* fruit bat (*Pteropus sp.*) or *men wowon* (*k'p'waratu**). Different cultures perceive and translate differently visions, apparitions, reflections, etc. A Gaua example is the "spirit form" *tamate tironin** displayed on woven and dyed *pari** female ritual waistbands seen in W.H.R. Rivers, 1914, vol. I, pl. XI, fig. B, opposite p. 132. This design was actually copied from a reflection on a European lantern glass.

22 Despite Rivers' mistaken statement that these figures are in stone, the only large spirit stone carving in the round on Gaua is the so-called "Turosa" figure up on the eastern slopes towards Mount. Garat (see photo in T. Harrisson, 1937, opposite p. 322). The facial style of this ancient carving is more typically eastern Gaua. (and possibly hint at traditional links with an area of Vanua Lava).

23 So much so that the HMS *Miranda* had to mount a punitive retaliatory attack there after a boat from the HMS *Flora* had been fired on from western Gaua in 1884.

24 Containing meat from female pigs, an extremely unusual practice in Vanuatu where ritually important meals usually contain meat from male pigs.

25 As in most areas of Vanuatu there is regular communication between the world of the living and the world of the dead, so one's living relatives get to know rather quickly if one's spirit travel has been delayed.

26 De Mensignac, 1886, p. 73.

27 Quoted in W.H.R. Rivers, 1914, vol. I, p. 143.

28 The author dedicates this last of the three short articles on tree-fern carvings from the Banks to the ancestral spirits of Gaua and Vanua Lava. Contact with the white man's world has nearly wiped your memory from the face of the Earth; the writings here are my humble attempt to show that world the respect you deserve. I dedicate this, too, to my old colleague and friend Joël Bonnemaison of ORSTOM (d. 1997) and to the spirit of *yafu* Tofor Kon (Reng reng Mal) of Fanla village, north Ambrym, a life-long enemy of the missionaries, who held the stories of the spirit links from his Ambrym volcano to Lolo Manaro on Ambae and to the "sleeping fires" on Gaua and Vanua Lava. His 100-day funerary rituals were held in Fanla on 23 June 1999 whilst I wrote the last of these articles. I dedicate also to the spirit of Father Walter Lini ("Lipustaliure") whose 100-day funerary rituals were held in north Pentecost on 31 May 1999. Thanks to V. Bouloré, P. Matharan, L. Lindstrom, A. Herle, M.G. Thiam, M. Strathern, J. Coote, J. Tanner, H. Cornwall-Jones. *Bigfala tangyu* to numerous Ni-Vanuatu friends, the Vanuatu Cultural Centre, Ralph Regenvanu, Jacob Kapere, Hardy Ligo, Henline Halele, Chief Aiden, Chichinold Wetu of eastern Gaua and especially Jack Weller of western Gaua.

Sculpture from northern Ambrym Island

18th-early 19th century
Vanuatu

Magic stone for the acquisition of castrated male tusker pigs (*müyü ne bu*)

Stone (volcanic tufa)
H. 35.5 cm
Collected by Jean Guiart in northern Ambrym, September 1949, for the Institut Français d'Océanie (original field cat. no. 49.5.80)
On permanent loan from the ORSTOM to the Musée National des Arts d'Afrique et d'Océanie since 1961
Inv. D 62.1.1

Main Exhibitions
Port Vila, 1996; Nouméa, 1996; Basel, 1997; Paris, 1997-98.

Main Publications
J. Guiart, 1951, pl. VI, fig. 12, p. 71; J. Guiart, 1963, fig. 206, p. 232; J. Guiart, 1965, p. 55; E. Leuzinger (ed.), 1978,

I dedicate this article to the men and pigs of Ambrym.

Collected by the French ethnologist Jean Guiart (b.1925) on his first field trip to the island of Ambrym in 1949, this object is the most outstanding example of its type so far known outside of Vanuatu. Stylistically, it is typically Ambrym, with the stunning face encircled by the dentate lozenge ending in circular tusks near the ear areas.[1] Guiart made numerous field trips to Vanuatu from 1949-63[2] on behalf of the Institut Français d'Océanie (IFO) and the Office de la Recherche Scientifique et Technique Outre-Mer (ORSTOM), the Condominium of the New Hebrides and lastly the Musée National des Arts d'Afrique et d'Océanie. He published the results of his work in a vast number of superbly

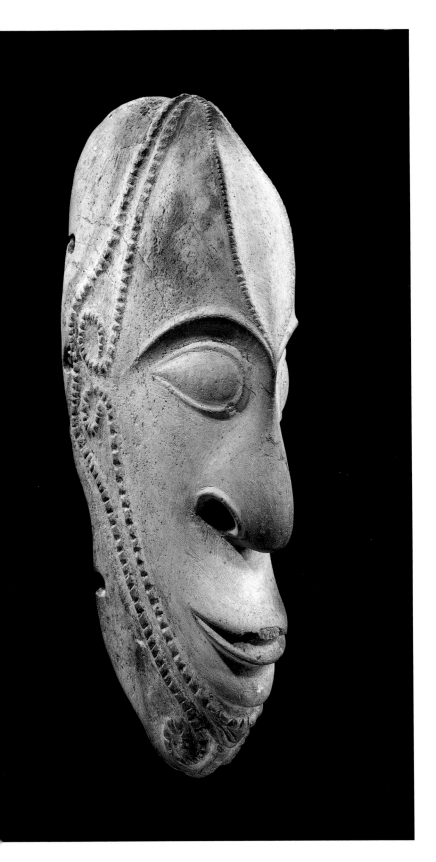
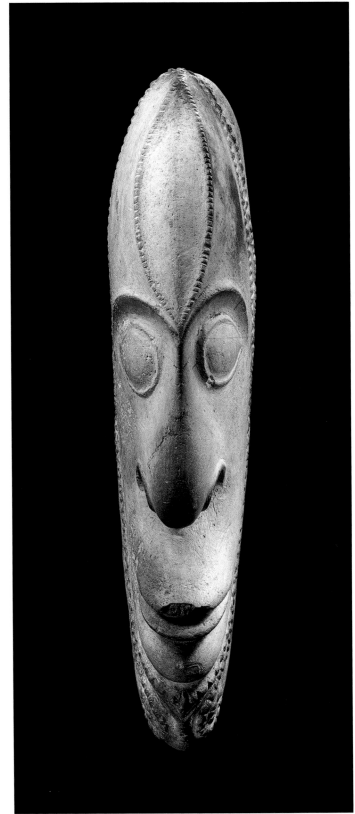

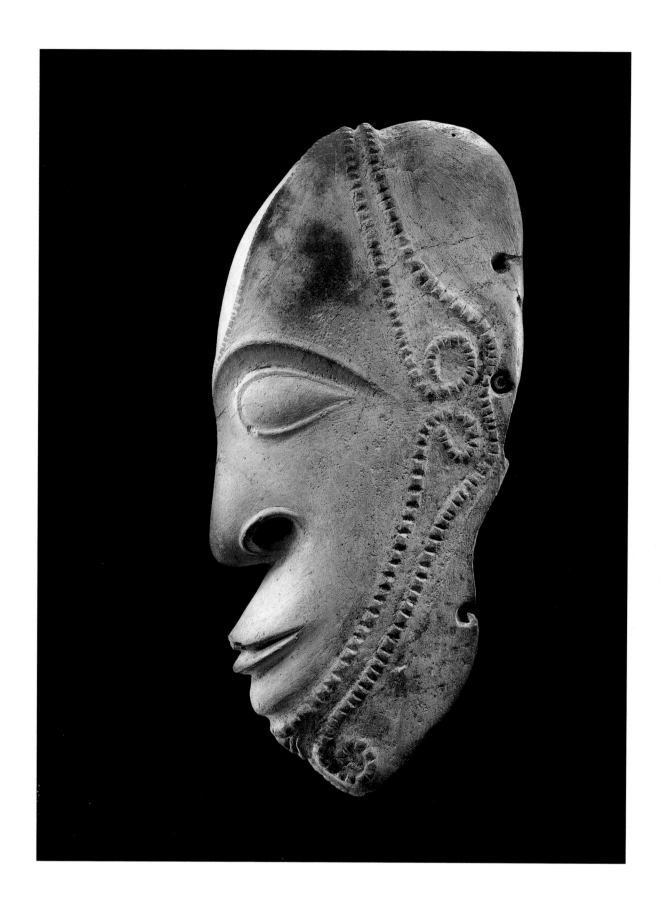

fig. 198; A.L. Kaeppler, C. Kauf-
mann, and D. Newton, 1993,
no. 123, p. 198; *Vanuatu. Océa-
nie. Arts des îles de cendre et de
corail*, 1996, fig. 165a; J. Bonne-
maison *et al.*, 1997, fig. 195,
p. 164; C. Kaufmann, 1997,
fig. 2, p. 14.

detailed ethnographic studies and built up one of
the widest-ranging and best-documented Vanuatu
collections in any museum today, the Musée
National des Arts d'Afrique et d'Océanie.[3] He was
able to obtain this particular piece in north Ambrym
in September 1949 because the owner at that time,
Urel Mweleun, blamed it for the illness of his eldest
son and wanted to get rid of it.[4] During this field trip
and a subsequent one in 1963 Guiart scrupulously
built up a major museum collection of such stones.[5]

Magic stones are still widely used in Vanuatu
today but kept strictly hidden, particularly because
mission influence has tended, largely wrongly, to
interpret their function as malicious. Traditionally
their use is usually beneficial: to make rain, ensure
sunshine and crops, increase animal and human
fertility and growth, etc. The particular stone here,
though, magically assists its owner to acquire
castrated male tusker pigs and is of a general type
known in north Ambrym as *müyü ne bu*.[6] The
economic and cultural importance of pigs[7] in
Vanuatu cannot be over-emphasised. Male, female
and intersex ("hermaphrodite") pigs are the major
traditional form of currency, but in various
northern areas of the country male and intersex
pigs have a higher sacred function as spiritual
currency, "money with legs, a soul and a language".
Avidly traded within and between islands[8] and lent
out at fixed and compound rates of interest, they
connect vast areas of the country into a "pig
internet" spanning cultures and generations.
Particularly sought after in various societies of
northern Vanuatu are castrated male or intersex
pigs whose upper canines have been removed to
permit the upward and circular growth of the lower
tusks. It takes six to eight years for the tusks to
form a complete circle, and such "full circle-
tuskers" are known in north Ambrym as *bumto*.[9]
Value depends solely on the varying tusk
curvature. Further, almost everything has its price
in pigs. With various amounts of these pigs men[10]
can buy and sacrifice their way up the different
types of graded ranking systems (in north Ambrym
called *maghe*) that can give one greater influence in
"the world of the living" and, in some areas, a better
life thereafter in "the world of the ancestral spirits".
For Ambrym men, possession of a powerful *müyü
ne bu* can bring an enormous advantage in the
complex negotiations often necessary to obtain the
types of pigs required for particular rituals by
magically influencing their present owner to sell
them at a favourable price. As the owner may also
be relying on his own stone during the negotiations
to keep the price high, such affairs can often be
looked upon as a "struggle between stones" rather
than men – and may the best stone win!

However, this particular *müyü ne bu* is not just
an ordinary stone. In Ambrym belief, it is the

materialised form (i.e., not carved by man) of the
man/spirit Lengnangoulong, from whom it takes
its proper name. Its adventures and travels have
been talked about for generations.[11] Lengnan-
goulong is particularly associated with the area of
Farbu and Magham in north Ambrym,[12] and
throughout the island various versions exist of the
Lengnangoulong song story cycle. What follows is a
highly condensed and modified version of these.[13]
Lengnangoulong was definitely a man – people
could talk to him – with magical powers and a
voracious appetite for tusker pigs. He originally
lived in a hollow *(Na) Biribiri*[14] tree on the coast near
Fantoro, south Pentecost island. Finding pig bones
around his tree, local inhabitants rightly accused
him of devouring their "tuskers". Challenging him,
one man discovered that the only thing Lengnan-
goulong was afraid of was strong wind. The former
then made wind magic, breaking Lengnan-
goulong's tree "house", and the latter was swept,
standing on one of the branches, across the straits
to north Ambrym, where he eventually ended up
living in a similar tree near Farbu, next to the
present-day village of Magham. He was already
there when the founding male of Farbu village,
Tubuvivi, was discovered there as a child by a man
from nearby Halhalfanbulvar (who had come
looking for the teeth of his pigs eaten by Lengnan-
goulong). This is said to have happened nine
generations ago.[15] As Farbu village grew up,
Lengnangoulong devoured its pigs, so the Farbu
men decided to chase him away. A Farbu man
challenged him, found out about his fear of strong
wind and so made the wind magic that swept
Lengnangoulong along the sea to Lolibiviri.
Devouring the pigs in this area, he was chased
again by wind magic and the south-east wind blew
him to Melvar on the north-west side of northern
Ambrym. Here he lived in a *fan bwehe* (cave) whilst
devouring the area's pigs. Melvar men found a way
to kill him in the cave and took away his bones.[16]
Shortly after this, Lengnangoulong's spirit
appeared in a dream to the Farbu man who had
made the first magic wind that began his Ambrym
travails. The dream spirit told the man to search
near the base of Lengnangoulong's tree home near
Farbu, where he would find a gift in recognition of
this struggle. The Farbu man thus found the
present stone, Lengnangoulong materialised in the
form of a *taeman*.[17] The proper use of this stone
enabled the Farbu holders to become rich in pigs
and high-ranking men over generations. Then
Berangsal, a woman from Halhalfanbulvar, illicitly
took the stone with her when she married Maro
Mal (Berang Wurmal) of Meltow in western
Ambrym. This enabled him to become a *yafu* ("high
man"). Their daughter, who kept the stone, married
Mal Mer'r of Fanla[18] village (N. Ambrym) who

became the highest-ranking man in the area, also aiding his sons. Due to be inherited by his youngest son, it was taken by his eldest, Merene (Worwor) Mal, who became a Christian [...] and died. The stone was then taken by Urel Mweleun as part payment for funerary pig prestations he had done on Worwor Mal's behalf. But Urel seemingly had not grasped the correct ritual procedure to keep the stone content. He became increasingly morose, his pigs began dying and his eldest son fell ill.[19] The stone was not happy. At this point, in late 1949, just when everyone was looking for a way to get rid of the stone, Jean Guiart appeared, and this, like the curve of a pig's tusk, brings us back to the beginning of the text.

KIRK W. HUFFMAN

1 A symbolism widespread on Ambrym and Malakula.
2 Notably Ambrym (1949), Malakula (1950-51), Tanna (1951-52), Espiritu Santo (1954), Malakula, Ambrym and Espiritu Santo (1963).
3 For a selection of these objects, see J. Guiart, 1965. He also bequeathed a number of objects in 1963 to help found the collections of the New Hebrides Cultural Centre (opened 1961).
4 This piece is first published in J. Guiart, 1951, pl. VI, no. 12. For details of its purchase, see J. Guiart, 1965, p. 54.
5 For a selection of these objects, see J. Guiart, 1965, p. 53, and *Vanuatu. Océanie. Arts des îles de cendre et de corail*, 1996, figs. 165b-e and 167-168, pp. 166-169.
6 *Müyü*: "ritual package" or "small (powerful) ritual object"; *bu*: "castrated tusker pig" in north Ambrym language. There are, at present count, 113 different languages in Vanuatu, and each has its own terms for such objects.
7 Vanuatu pigs, usually described as of the *Sus papuensis* type, are now thought possibly to be a hybrid of *Sus celebensis* and *Sus scrofa* (see W. Rodman, 1996, p. 162).
8 For aspects of this "*pig bisnes*", see J. Guiart, 1956; J. Bonnemaison, 1996; K. Huffman, 1996.
9 Intersex pigs are not culturally valued on Ambrym as they are on Malo, Ambae, Maewo, northern Pentecost and parts of Espiritu Santo.
10 There are also women's graded societies, usually less complex than the men's, but just as important in "the world of women".
11 It has been widely known throughout Vanuatu, too, since the early 1970s when its representation was put on the reverse side of the 10 FNH and 20 FNH coins of the French currency used in the Anglo-French Condominium of the New Hebrides.
12 See W. Paton, 1979, p. 19.
13 J. Guiart, 1951, p. 90; J. Guiart, 1965, p. 19. These outline one version, from John Manu of Linbul in 1949. The present author collected various versions from, amongst others, Tofor Kon of Fanla in 1978 and 1982; Chief Willy Taso of Wuro in 1981 and most recently Chief Zaki Tubuvivi of Farbu in 1996.
14 *Hernandia nymphaeifolia*.
15 Vanuatu male generations are slightly longer than European ones, men traditionally marrying later in Vanuatu.
16 As he was classed as a "*tabu*" (sacred) man, his bones were useful for ritual purposes.
17 *Taeman* (Bislama), from the English word "diamond", means a "good luck charm", in this case a *müyü ne bu*.
18 This brings us into living memory. Mal Mer'r died some time in the 1930s at an advanced age. His middle son, Tain Mal, died in 1971, aged possibly around 70. Tain Mal's eldest son, Tofor Kon (Rengreng Mal), died in December 1998.
19 Such stones are believed to remain "content" as long as their spiritual needs are satisfied. If not, their power eventually turns to its "bad" side and begins to adversely affect the owner.

OCEANIA

Sculpture from Malo Island

Early 19th century[1]
Village of Sakavas, Vanuatu

Large male sculpture (*Trrou Körrou*)

Wood (*Instia bijuga*, Caesalpiniaceae)
H. 300 cm
Object sent to France by the members of the Korrigane expedition in early 1935.
On permanent loan from the Muséum National d'Histoire Naturelle – Musée de l'Homme
(Desgranges donation)
Inv. M.H. 38.42.8

Main Exhibitions
Paris, 1957-58; Paris, 1975;
Orly-Sud, 1977; Basel 1997;
Paris, 1997-98.

Main Publications
J. Guiart, 1949, fig. 3, p. 60;
J. Guiart, 1963, no. 211, p. 235;
Nabanga, 1977, p. 17; *Musée
de l'Homme*, 1992, no. 43169,
p. 123; *A visage découvert*, 1992,
p. 113; A.L. Kaeppler,
C. Kaufmann and D. Newton,
1993, no. 451, p. 444; *Vanuatu,
Océanie. Arts des îles de cendre
et de corail*, 1996, fig. 34, p. 26;
C. Kaufmann, 1997, fig. 165,
p. 117.

In Tinjivo, one of the languages of Malo, this sculpture is called *Trrou Körrou*, which means "he who stands before you, who is looking at you". It is said to have been commissioned by the great chief Kana supé of the village of Savakas.[2] When he died, at the beginning of the 20th century, it was probably inherited by the members of his line; first by his son Molshanghavoulou, and then by his brother Ouarakess[3] In the opinion of many locals, this sculpture is very old. It was reportedly observed by Jean Jacquier in the 1930s in the ruins of an old *naghamal* that stood on the plantation of Monsieur and Madame Gardel,[4] which was established on the land of the old village of Savakas. Jacquier then negotiated with Ouarakess, obtaining the sculpture in exchange for a number of sticks of tobacco. Jacquier lost no time selling it "for forty dollars" to Marinoni, the local representative of the French government who had a collection of objects from the region.[5] However, Marinoni did not have much time to enjoy his new acquisition as his possessions were seized in lieu of payment for gambling debts. Along with other piece of sculpture, *Trrou Körrou* was sent to Port-Vila, where it was in the custody of the lawyer responsible for liquidating his assets, one Desgranges. He was struck by its beauty and, perhaps on the advice of Marinoni, who was his friend, decided to donate it to the Musée de l'Homme. On 23 May 1935, a letter addressed to Georges Henri Rivière from the members of the *Korrigane* expedition informed him that a "large tabu from Aoba Island"[6] was being sent to the Musée de l'Homme on a steamboat of the Commissaire-Ramel shipping company. And so the sculpture entered the Museum's collections in 1938. It was subsequently shown in the Oceania gallery and in numerous exhibitions before being put into storage.

Savakas was one of the two main villages on the island's south coast. Villages on Malo were built on a more or less circular plan, each one having at least one men's house, or *naghamal*.[7] The male community was divided up into a hierarchical system of grades.[8] In order to rise to a higher grade, a man had to sacrifice some of the curved-toothed pigs that were reared specially for that purpose. "Hermaphrodite" pigs were kept in reserve for accession to only the highest grades. Its geographical position made Malo the intermediary between the islands of Santo and Malakula, in the exchange of pigs for red pigments for colouring mats.[9] There were also long-established cultural relations between the various villages of northern Malakula and southern Malo. According to Chief Mataloué, from the village of Abakourrah, and Marcel Jacquier (the brother of Jean), both aged over 80 in 1972, Malo once had a population of several thousand and was divided into two rival parts. The men's only clothing was a loincloth made of pandanus leaves held in place between the legs by a belt, [10] while in the northern part of the neighbouring island of Malakula, they wore a penis wrapper called a *nambas* attached at the waist by a bark belt. At the end of the last century, the population of the villages shrank rapidly. According to Mataloué, this was due to the frequent raids by people from the north of Malakula, but the cause was more probably the epidemics resulting from the infectious diseases brought back by the menfolk in 1897, after several years working on the plantations in Queensland, Australia.[11] The island was then repopulated at the beginning of the 20th century by immigrants fleeing from northern Malakula, and then by the Europeans who created extensive plantations and imported manpower from the islands of Malakula and Ambrym. The descendants of these immigrants put down roots in the region.

Chief Mataloué remembers seeing the sculpture *Trrou Körrou* decorating the *nakamal* of the village of

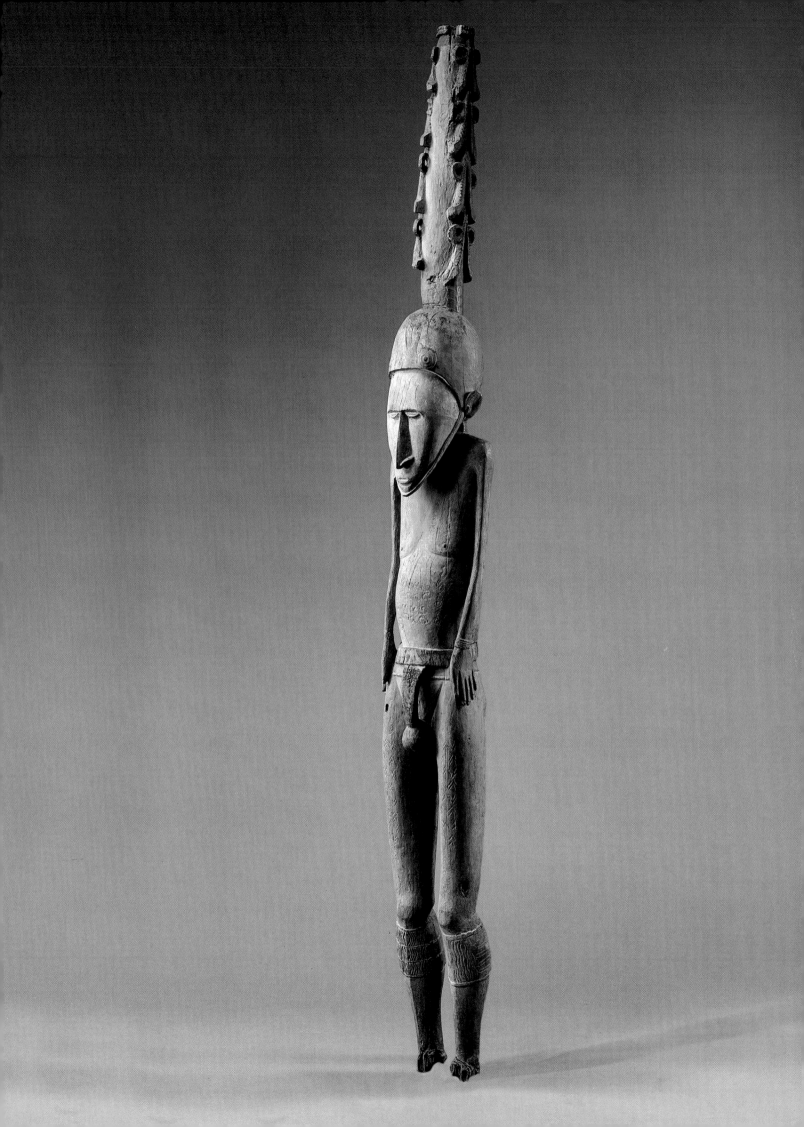

Savakas from his childhood onwards. He remembers having seen a statue of a man dressed in the Malo fashion adorning the *nakamal* in his own village. As for Marcel Jacquier, he remembered the statue of a female figure dressed in Malo costume adorning the vestiges of a *nakamal* in an old village located, at the end of the 19th century, on the site of his plantation, north of the Gardel family's plantation. These two statues were as old as those I have just mentionned, but probably did not survive the rigours of the weather because they were made in a softer wood. It would seem that the three works mentioned here are the only ones in this style that the inhabitants of Malo could remember seeing on the island at the beginning of the 20th century. *Trrou Körrou* was no doubt carved in Malo by a man from Malakula, who treated it in the style of his native region. According to the information given by Chief Mataloué, the expression and appearance of this statue's face, and its stature, would have compelled respect from any inhabitant of Malakula who saw it. Nonetheless, it was for his accession to one of the highest grades in the society of southeastern Malo that Kana supé ordered this sculpture to be made and raised. Félix Speiser[12] indicates that sculptures in this style were always placed outside, in front of the gable of the men's house, whereas the *rambaramb* funerary effigies of Malakula were kept inside.

There is no known equivalent for this work. Only one sculpture can be compared to it. This was collected by F. Speiser in 1910-12 in the eastern part of Malakula and is now kept at the Museum der Kulturen in Basel.[13] The style of the two sculptures is fairly similar in terms of the treatment of bodily proportions. They are exactly the same height and both have narrow torsos with very thin arms hanging parallel to their sides and their hands resting on their hips. There are five bracelets on the left hand. The thighs are much longer than the calves. The penis wrappers are both given a similar treatment. Although their respective expressions are very different, both heads have oval faces outlined by a slight ridge formed, at the top, by the beginning of the hair and, below, by a kind of "chin strap." The head of *Trrou Körrou* is sunk slightly between the shoulders,[14] and its long, pointed chin reaching far down onto the chest is a stylistic effect that is found frequently in representations of faces on statues and masks in the northern islands of Vanuatu. The mass of hair forms a kind of helmet, especially in the sculpture at Basel. This kind of coiffure and facial expression can also be seen in a drawing of a wooden sculpture made by Mikloucho-Mackay in 1879[15] and in a photograph by Layard.[16] The various facial elements, such as the elongated nose and small mouth, create a very serene expression quite different from that of the Basel sculpture. On the left side of the forehead, a kind of rosette in relief is reminiscent of the motifs engraved on the forehead of the Malakula sculpture kept at the museum in Geneva.[17] This piece can also be compared to the post surmounted by a sculpted bird collected at Vao by Patrick O'Reilly[18] and currently kept at the Musée des Arts d'Afrique et d'Océanie in Paris. Although the work on the head is less meticulous, the stature of the body and the position of the limbs are very similar. These posts were used to support small edifices built in ceremonial areas over the stone altars used in various rituals pertaining to the grade hierarchy.[19]

This statue was made in extremely hard *natora* wood (*Intsia bijuga*),[20] which is used extensively in Melanesia to make the posts of ceremonial edifices. Most of its surface is covered with a coloured coating which, according to Marcel Jacquier, was obtained by mixing lime, burned dead coral and blue washing power. Only the face, penis wrapper and belt are painted with a white coating through which, here and there, can be seen layers of pastel pink or greenish blue. Formerly, the colouring on the face divided it up into four parts, along the vertical axis down the middle of the nose and to the chin, and along the horizontal axis of the eyebrows. The left side of the forehead and the right side of the face below were painted pink, and the opposite sectors greenish blue. This kind of facial decoration, with a similar distribution of colours, can be found on the face of the sculpture collected by P. O'Reilly. It is indeed very common, in many Melanesian religions, to repaint sculptures on the occasion of important rituals. Lines of white can be seen all the way up the arms, continuing from there to the chest, where they curl around the breasts. According to Chief Mataloué, the bodies of the dead used to be covered with paintings in yellow, white and blue colours extracted from plants and minerals.

At various points on the body we can see carved marks evoking scarifications which, according to Speiser,[21] were not practised on Malo and only rarely on Malakula. Those on the chest are barely legible, but the ones on the belly constitute four series of motifs evoking pairs of curved pigs'tusks. Two of the series are positioned vertically and two horizontally. Different chevron motifs are incised on the front of the thighs down to the knees. On the outside of the right thigh are four motifs, opposing each other in groups of two, each consisting of four volutes. The calves are girt by bands of linear

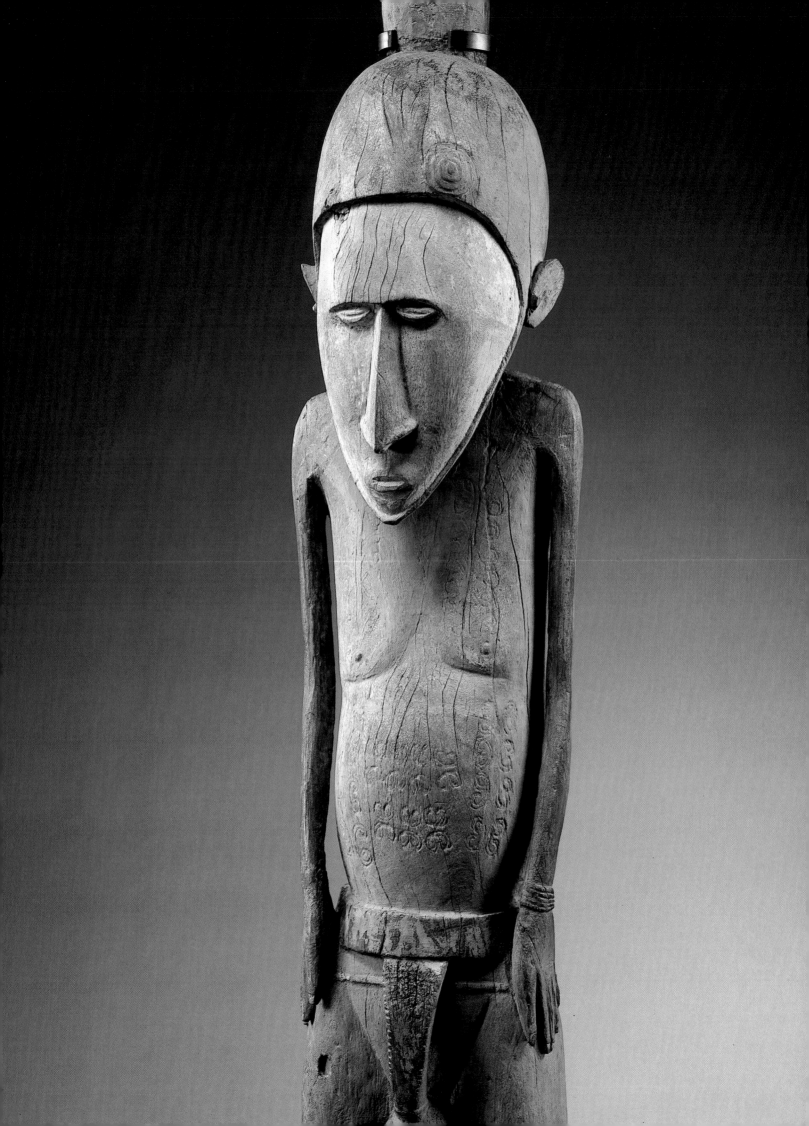

motifs and opposing chevrons in imitation of bead leg and arm bands. These imitations can also be seen on the sculpture collected by P. O'Reilly.

The upper part of the head is extended by a kind of crest 81 cm high, on which are sculpted four pairs of pigs'mandibles with curved teeth.[22] In the photograph of 1929, the sculpture has one curved pig's tooth on the right wrist and three on the left wrist. It may be that, in the local system of male societies, this sculpture celebrated one man's accession to a higher grade. The sculpted and engraved pigs'jaws would then indicate the sacrifice that the man who ordered the work had made in order to celebrate his new promotion. The number of teeth represented here must have had a specific meaning, one that has not come down to us. Most of the information we do have concerning this work confirms that the style is from the northeast of Malakula and that it was made in the 19th century. The anonymous creator of this sculpture focused all his attention on the expression of the face, while treating the rest of the body with great restraint. In doing so, he created a work whose intense aesthetic power places it among the treasures of world art.

CHRISTIAN COIFFIER
Translation: Charles Penwarden

1 Carbon-14 tests carried out on the sculpture's wood in 1999 by Dr Georges Bonani of the Eidgenössische Technische Hochschule, Institut für Teilchenphysik, Zurich, have yielded the following results: ETH-20615: 220 +/- 40 B.P.; 13C [0/00]: -21.6 +/- 1.1. Calibrated periods: CE 1634-1702, with a probability of 32%; CE 1718-1819, with a probability of 48.8%.

2 A letter from Michel Charleux dated 20 February 1978, referring to the information gathered from the widow of Eugène Gardel on Malo, indicates that the tomb of Kana supé was still visible on the Gardel plantation in 1975, albeit covered with a pile of stones. (The photos accompanying this letter are currently held by the Oceania department of the Musée de l'Homme.)

3 According to information from an uncertain source (possibly M. and Mme. Charpentier in a letter of 16 January 1978), kept at the Oceania department of the Musée de l'Homme.

4 M. et Mme. Gardel probably came to Malo in 1922. The Musée de l'Homme possesses a photograph taken in 1929 in which the sculpture can be seen in position, standing against the central post of an apparently ruined house. Beside it stands Eugène Gardel, carrying in his arms a young Vanuatuan child.

5 According to an article in the *Nabanga* newspaper (1977, p. 17) and a letter from Michel Charleux, the statue belonged to the chief of the village of Savakas, Kana supé.

6 In fact, this is a mistake since several persons have indicated that this sculpture does indeed come from Malo.

7 C. Coiffier, 1988.

8 There were specific insignia (face paint, jewellery, vegetal decorations, wooden sculptures, monoliths) corresponding to each level of this hierarchy. There was also a system of grades for women, but this was less complex than the one for men.

9 K.W. Huffman, 1997d, p. 216.

10 This loincloth was subsequently replaced by a mat in the Ambae Island style. It was worn like an apron and also held in place by a belt. Leaves were placed on the back, behind the belt.

11 According to information gathered by Marcel Jacquier.

12 F. Speiser, 1991, p. 351.

13 F. Speiser, 1991, pl. 95, fig. 2; *Vanuatu, Océanie. Arts des îles de cendre et de corail*, 1996, fig. 33, p. 26; C. Kaufmann, 1997, p. 116. Another sculpture from northwestern Malakula was very similar, but we have only a photograph (W. Stöhr, 1987, p. 267).

14 The position of the head, jutting slightly forward in relation to the line of the neck, recalls the human head handles on *nalot* plates used only by high-ranking men.

15 *Vanuatu, Océanie. Arts des îles de cendre et de corail*, 1996, fig. 15, p. 17.

16 J. Layard, 1942, pl. XVIII.

17 J. Guiart, 1963, no. 209.

18 P. O'Reilly, 1949, pp. 192-194.

19 J. Layard, 1942.

20 The term *natora* comes from Bislama, pidgin Neo-Melanesian, which is the official language of the Republic of Vanuatu. See C. Coiffier and C. Orliac, 2000.

21 F. Speiser, 1991, p. 171.

22 Hermaphrodite pigs with curved teeth represent the main money of exchange on local markets. The work of the breeders consists in modifying the normal biological growth cycle of the pigs'teeth by pulling out the upper canines. This has the effect of allowing the canines on the lower jawbone to grow to giant proportions and curve. The different phases of development of these tusks are seen as the equivalents of the various grades to which men can accede.

Sculpture from Nendö Island

Late 18th-early 19th century[1]
Village of Nimbelowi, Santa Cruz Islands, Solomon Islands

Duka or *munge-dukna* statuette representing a seated man

Blackened wood
H. 17,5 cm
Collected by Charles van den Broek, June 1935
Gift of Mrs Van den Broek to the Musée de l'Homme, 1969
On permanent loan from the Muséum d'Histoire Naturelle – Musée de l'Homme
Inv. M.H. 69.51.25

Exhibition
Paris, 1938.

Main Publications
Le Voyage de la Korrigane en Océanie, 1938, fig. 4; F. Girard, 1971, fig. 1, p. 274; *Musée de l'Homme*, 1992, no. 47931, p. 121; V. Bounoure, 1992, p. 176.

This statuette was collected by Charles van den Broek d'Obrenan in early June 1935, when the *Korrigane* expedition[2] was sojourning in the Santa Cruz archipelago. After searching in vain for a *munge-dukna* statuette in the various communal houses on the northwest coast of Nendo, Van den Broek made the two-hour walk to the village of Nimbelowi accompanied by his two guides to see if he could buy a statuette there. There he at last found what he was looking for outside the village itself, in a large men's house full of fishing equipment, standing near the sea. He described his find thus: "Finally, I found one of those figurines sculpted with incredible finesse from an old piece of wood blackened by the smoke from all the fires lit since the little masterpiece was finished. […]. It is the Shark-God, that character from countless legends." [3] The statuette was placed above a row of five skulls lined up on a shelf. The keeper of the place, a man with splendid shell earrings, was sitting with his back to one of the posts supporting the roof, like a living replica of the *munge-dukna* above his head.[4] Four other skulls placed on rolls of feather money were lined up along a partition. The man asked for a stick of tobacco as an offering to the divinity and said that the last time a man had dared remove a statuette, he had had his leg bitten off by a shark. At first, the man refused outright to sell him the statuette, but Van den Broek would not give up and, after two hours of negotiations, he managed to convince him to yield the object in exchange for two pounds sterling and a stick of tobacco for each of the men present during the negotiation. He had to grab the statuette himself in order to take it away because no one else would touch it and, on the way back, women ran away out of fright when they saw him coming.[5] The guides refused to go back with him in the boat.[6]

The *duka*[7] statuette was deposited at the Musée de l'Homme (inv. D39.3.1923). From June to October 1938 it was presented in the Santa Cruz Islands display case at the exhibition relating the voyage of the *Korrigane* in the Pacific. It was stored away for safety during the war before being exhibited again in January 1953 in a display case (no. 399) in the museum's Oceanic gallery. When the Korrigane collection was broken up at auction in 1961,[8] the statuette came into the possession of Régine van den Broek, who displayed it in her Parisian flat until 1969, when she decided to donate it to the Musée de l'Homme so that it could be enjoyed by the public. There the piece was placed in a discreet new display case that set off its aesthetic qualities. It stayed there until it was put into one of the Oceania department's storage cabinets.

Cultural context

The Santa Cruz Islands are among the most remote in the Solomon Islands archipelago. The population is of Polynesian origin but local techniques have undergone Melanesian influences. The fishing village of Nimbelowi is on the west coast of the island of Nendo (also known as Ndeni, Nitende or Nidu), to the east of Cape Mendana. The island was visited by Spanish explorers at the end of the 16th century but was then more or less forgotten by Europeans until 1923, when the British administration set out to consolidate its authority in the region. The *Korrigane* arrived at a moment of great cultural change on the island. A few years earlier, a Methodist mission had begun working from the coast of Graciosa Bay, exhorting the islanders to give up their "idols" and convert to Christianity. As a result of this, most of the hundreds of *munge-dukna* statuettes on the island were destroyed by their owners. This explains why Van den Broek was obliged to go beyond Graciosa Bay to obtain one. The few examples still to be found in the communal houses, or that had been hidden away, were collected by missionaries, anthropologists, travellers and administrators and are now kept in various museums. William

Davenport has listed 52 known statuettes, 14 of which are in the British Museum, while only one is in the National Museum of Honiara (Solomon Islands).[9] The majority represent men, the others women or couples. More often than not, they are rather roughly carved.[10] Each was given a specific name. The guardian divinities represented by these statuettes were honoured only by adult males, who thus hoped to obtain protection against hostile attacks from other divinities. The effigies were sometimes put up after the death of an eminent man in order to provide his spirit with a home and thus retain the supernatural powers he had acquired during his lifetime. There are numerous myths relating the miraculous effects of these effigies. These were passed on as heirlooms, but their power still had to be revived by offerings of food and public or private rituals. They were generally placed on altars located in a corner of the men's area of *mabau* houses, or in the centre of the communal house, or *madai*, along with the skulls, conches and old feather money. A sketch made by Régine van den Broek in a communal house outside the village of Nonnia provides a good idea of their presentation.[11] The miniature statuettes were sometimes moved in the men's nets, on their canoes, or placed in a tree by the shore.[12] The fishermen would make offerings to them before setting out on dangerous expeditions to fish for sharks with a lasso.[13] According to Davenport,[14] the skulls placed near to the statuettes were those of the divinity's old "customers". The rolls of old feather currency[15] on which they stood no longer had any monetary value but served to represent the economic prosperity that customers had acquired during their lifetime thanks to the power of the divinity. According to C. Van den Broek,[16] the skulls were those of former owners of the statuette and the money represented offerings. Special constructions, *madukna* or *mana duka*,[17] were sometimes built to house these statuettes. A man or group of men could eat there in communion with his or their guardian god. On such occasions, pieces of pork or fish were placed on the altar as an offering. The divinity ate the immaterial part.[18] Most of these *madukna* were burned down during the period of repression and Christian chapels were built in their place.[19]

Iconographic interpretation

We know of at least two other sculptures of a seated man like the one at the Musée de l'Homme. One of them, collected by Reverend G.H. West, and kept at the Otago Museum in New Zealand, is much bigger (39 cm). The second, at the British Museum in London, was collected in the village of Nelu and was part of the Beasley bequest. Known as *men-areta-lu*, it is slightly larger and better preserved than the statuette in Paris, but the closer

of the two in style.[20] *Munge-dukna* statuettes were never more than 70 cm high and all have wooden bases of varying degrees of thickness in which the work was carved. The one at the Musée de l'Homme is among the smallest known examples. It is possible that it was originally placed at the end of a long piece of wood that could be stuck in the ground, like the wooden posts decorated with animal motifs and also known as *duka*.[21] The postures of the three figures are fairly similar. However, whereas the hands of the Paris figure rest on its hips, those of the other two are holding the stool. In other examples we see a standing figure with his hands resting on supports.[22]

The presence of figurines in the cult houses of Graciosa Bay is signalled by Pedro Fernández de Quiros's account of his voyage[23] as early as 1595, but the oldest image we have of a statuette from the island of Nendo is a drawing published in the book by James Edge-Partington.[24] This shows a standing man on a base with a flattened face. This way of handling the face can also be found on the statuettes held in Berlin and at the British Museum.[25] Markedly prognathous, the head of the Paris statuette is somewhat oversized in relation to the rather slender body and limbs. The very finely drawn eyes are underlined by pronounced brow ridges which give the gaze a strong quality of concentration. They are unlike most of the known sculptures in that they are not encrusted with small shell discs. A part of the nose is missing. No doubt it was originally pierced in order to hold a nasal ornament. The right ear has been lost. The pierced lobe of the left ear is shattered, but no doubt used to have numerous tortoiseshell rings through it, like the statue in the Otago Museum. It is probable that, like other similar works, the Paris figurine wore various decorations in fibre and shell.[26] Like the piece in the British Museum, this one's mouth is open just enough to reveal the tip of the tongue between the lips.[27] This was a significant sign throughout Oceania. The fringe of the hair is visible on the forehead and, while the back of the head and its hair have been lost, we can assume that they were treated in the same way as on the other known figures. The conical form at the back of the head is in the style of the fashion for gathering and rolling hair in a piece of *tapa* characteristic of the neighbouring islands during this period.[28] The hair of the statuettes was sometimes wrapped in a palm leaf[29] or decorated with various fibres.[30] This type of headdress, known as *abe*, was reserved for mature adult males who were in charge of rituals. A bracelet is worn on the right arm, just above the elbow and, at the top of the left arm, a bracelet can be made out through the patina at the level of the armpit. The same applies to the ankle rings. The pectorals are highly pronounced and the sexual organs are voluminous in relation to the whole and, unlike those of other statues, not hidden by a loincloth.[31] A woven apron[32] was part of the costume for men's

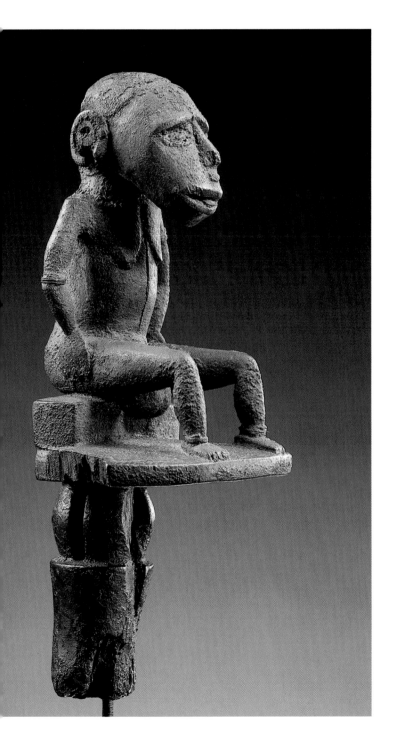
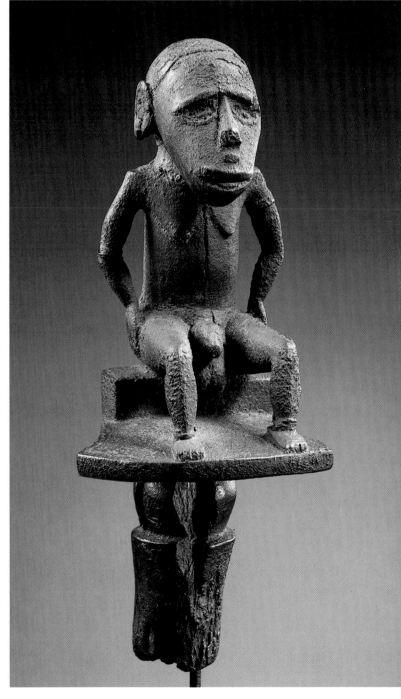

ritual dances devoted to the guardian divinity.[33] Two thirds of the platform on which the figure sits have been broken off. The upper part of the base is divided into four clearly separated sections, and its lower surface seems to have been burnt. The finesse of the sculpture suggests that it was wrought with a metal tool, but it is impossible to examine the cutting of the surfaces closely because of the thick, sometimes granular patina. It is likely that this patina is due to long exposure to the smoke of the house, but we cannot rule out the possibility that, in accordance with local custom, the statuette was coated in turmeric, a substance considered to have magical properties. W.H. Davenport[34] has put forward the hypothesis that the prognathous form of these figurine's faces is due to influences from the northwest of the archipelago. It recalls the faces that appear on bowls or the prows of *musumusu* canoes.

If the suggestion that the skulls placed beside the statuette represent nine generations of its guardians or "customers" is exact, then we can estimate that it was made some time in the late 18th century.

CHRISTIAN COIFFIER
Translation: Charles Penwarden

1 Carbon-14 tests carried out on the sculpture's wood in 1999 by Dr Georges Bonani of the Eidgenössische Technische Hochschule, Institut für Teilchenphysik, Zurich, have yielded the following results: ETH-20614: 170 +/- 40 B.P.; 13C [0/00]: -26.9 +/- 1.1. Calibrated periods: CE 1662-1823, with a probability of 68.7%, CE 1830-1885, with a probability of 13.1%.
2 While the *Korrigane* lay at anchor in a small natural harbour on the islet of Near (C. Van den Broek, 1939, p. 121), the explorer and his wife took one of the small boats to the island of Nendo, accompanied by guides.
3 C. Van den Broek, 1939, pp. 123-125.
4 On the basis of her husband's description, Régine van den Broek (1936, p. 51) made a small sketch which gives an idea of the position of the statuette. See also F. Girard, 1971, fig. 2, p. 276, and J. Gillett, 1939, p. 153.
5 C. Van den Broek expresses the doubts that seized him at this point: "I thought sadly of the now empty shelf in front of which nine generations of guardians had taken up their watch, represented by nine skulls. I was no better than a vandal [...] But I consoled myself by thinking of the fate that awaited this charming divinity. Missionaries were coming, and would surely have burned it. If it had been lucky it would have fallen into the hands of an American academic, who would have donated it to a museum in his country. I at least was taking it back to France, where there was not a single one."
6 C. Van den Broek, 1939, pp. 123-126.
7 The term *daka* or *duka* is a deformation of the word *munge-dunka*, the generic name for this kind of statuette, and refers to a transportable, family image (see W.H. Davenport, 1990, p. 101).
8 See note 4, p. 297.
9 W.H. Davenport, 1990, p. 110.
10 S. Hooper (ed.), 1997, p. 74; G. Koch, 1971, p. 17, W.H. Davenport, 1990, pp. 100-101.
11 F. Girard, 1971, fig. 2, p. 276.
12 J. Gillett, 1939, p. 154; W.H. Davenport, 1990, p. 102 and p. 103.
13 C. Van den Broek, 1939, p. 123.
14 W.H. Davenport, 1990, p. 102.
15 These rolls (*tea* or *tevau*), which could be up to 10 m long, consisted of an armature of plant fibres on which were fixed numerous small rectangular plates covered with tiny red feathers from a bird with scarlet plumage (*Myzomela cardinalis*). This feather currency was used to pay for certain kinds of work and to buy wives and pigs. Its value diminished with age.
16 See F. Girard, 1971, fig. 2, p. 276.
17 J. Gillett, 1939, p. 154.
18 R.H. Codrington, 1891, p. 139.
19 W.H. Davenport, 1990, p. 104.
20 J. Gillett, 1939, p. 154; F. Girard, 1971, p. 279; V. Bounoure, 1992, p. 177.
21 R.H. Codrington, 1891, p. 139; J. Gillett, 1939, p. 154.
22 W.H. Davenport, 1990, p. 104.
23 See G. Koch, 1971, p. 178.
24 J. Edge-Partington, 1890, p. 163, no. 1.
25 W.H. Davenport, 1990, pp. 99-104.
26 W.H. Davenport, 1990, p. 105.
27 This detail also characterises the statuette from the village of Nelu kept at the British Museum (see V. Bounoure, 1992, p. 177).
28 D. Waite, 1983a, p. 60 and p. 78.
29 W.H. Davenport, 1990, p. 104.
30 V. Bounoure, 1992, p. 179; F. Girard, 1971, fig. 2.
31 V. Bounoure, 1992, p. 179; W.H. Davenport, 1990, p. 101.
32 The men of the island of Nendo used small looms to weave the vegetable fibres from which they made the pieces they used as dance aprons.
33 W.H. Davenport, 1990, p. 105.
34 *Ibid.*, p. 209.

Sculpture from the Solomon Islands

First half of the 19th century

Parade shield

Coiled plant fibres covered with small pieces of nautilus shell inset in parinarium nut
H. 84 cm
Gift of Prince Roland Bonaparte to the Musée d'Ethnographie du Trocadéro, 1887
Former M.E.T. no. 19305
On permanent loan from the Muséum National d'Histoire Naturelle – Musée de l'Homme
Inv. 87.67.9

The collection history for this shell-inlaid shield indicates that it was purchased for Prince Roland Bonaparte (1858-1924) on 4 March 1887 at the sale of a collection belonging to a M. Bertin which the latter had built up over a period of 30 years, and subsequently donated to French museums. For the shield, the implication of this data is that it was probably removed from the Solomons sometime between 1850 and 1887.

The shield is comprised of concentrically-coiled lengths of cane secured by horizontally-lashed vines. Lawyer cane (*Calamus*) and asama vine (*Lygodium trifurcatum*) were the two materials commonly used for shields of this type. The rounded upper and lower contours and straight sides of the shield combine to create a straight-sided oval shape characteristic of shields produced in the interior of Guadalcanal. These shields were sold along the coast of that island, to the Nggela islands and Santa Isabel Island (Bugotu). It is not always easy to determine which shields were made locally on an island and which were imported. Clan affiliations between the Nggela islands (Sule and Pile) and Santa Isabel could explain the presence of these shields on Isabel, where several other types of shields were also produced. Ancestors of one of the three major clans on Santa Isabel, the Thonggokama, allegedly came to Isabel from Nggela.[1]

Two technical features link this and other similarly-ornamented coiled fibre shields with rectangular bark shields produced by Hograno Maringe people from Santa Isabel. Wooden braces lashed to the back of the coiled fibre shields are identical to braces attached to curved bark shields from Santa Isabel.[2] The braces would appear to be essential for securing the curved lengths of bark in position, but just how necessary they were for the fibre shields remains questionable.

The second connecting feature is the decoration of the obverse surfaces of both types of shield with hundreds of small pieces of nautilus shell inset in parinarium nut glue. The linear bands of shell conform to the contours of the respective shields.

Thus, they are rectilinear on the bark shields and curvilinear on the fibre shields. Areas of the shield surfaces between bands of inlay are painted red and black.

Small anthropomorphic faces comprised (like the bands) of inlaid shell are inserted into the linear design patterns. On the coiled fibre shields such as the one in this catalogue, one face slightly larger than the others is rendered in the centre of the upper part of the shield surface. A long rectangular shape defined by parallel bands of shell extends down from this face to create the effect of a long rectangular torso which is further defined by a pair of upraised arms rendered in shell immediately to right and left of the head. Approximately 21 coiled fibre shields display this ornamentation. The shields share the same design scheme, but each is slightly different in minor details. Shields with documentation appear to have been taken from the Solomon Islands in the 1840s-50s.[3] The consistency of design and fabrication would suggest a common period of production for all of the shields.

The early-mid 19th century date of this alleged production period allows only for conjecture about the significance of the shields. The central image and the small heads probably referenced head-hunting and the ritual importance of heads in the Western Solomons. Many raids were conducted to obtain these necessary heads during the 19th century. C.M. Woodford, the first British Commissioner of the British Solomon Islands, drew attention to a resemblance between the linear design scheme as it appears on the bark shields and shell-inlaid designs rendered on the prows of war canoes on Santa Isabel.[4] Such a correlation may well have been an intended aspect of the shield design signification. Like the miniature heads, this analogue reiterated the context of war, and in particular, head-hunting. Shells and parinarium nut glue were also used on war canoes from Santa Isabel and other islands in the Western Solomons. On canoes the glue was not only used to adhere pieces of shell ornamentation but also to seal the

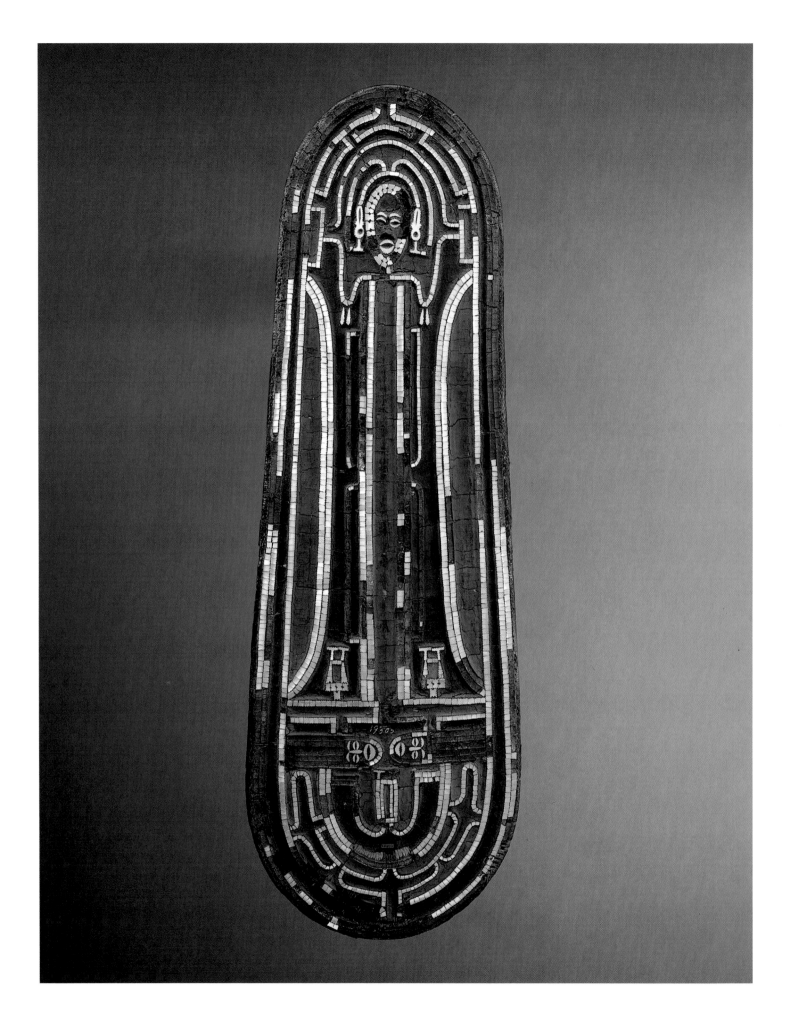

canoe planks. A repeated use of these materials was in part practical but may well have also constituted a form of indexical signification linking shields with war canoes.

What was the contextual significance of beautifully-ornamented shields like this one? It may be difficult to imagine such an intricately-ornamented shield having been used in battle and far easier to envision its presence at ceremonial occasions. The latter was probably true, and it is also fairly safe to assume that the relatively small number of shell-inlaid coiled fibre shields (in comparison with the much larger number of coiled fibre shields without inlay) were owned by important leaders of social groups.

However, the elimination of shell-inlaid shields from battle contexts may not be a correct assumption. At least one surviving account describes the display of an ornamented shield (with clusters of feathers, not shells) being prominently displayed by its owner who stood in a canoe. The situation was not one of actual battle, but war was a potential outcome in the meeting of two groups of related peoples with a long history of rivalry in the Nggela islands.[5] Similar situations could easily have provided the context for shell-inlaid shields, the visibility of the ornamented shield signalling the prestige and power of its bearer and his people.

DEBORAH WAITE

1 Bogesi, 1948, pp. 213-214.
2 D. Waite, 1983, pp. 126-127.
3 D. Waite, 1983, pp. 120-124.
4 M.C.M. Woodford, 1926, p. 456.
5 C. Brooke, 1874, pp. 191-198.

Sculpture from Makira Island (San Cristobal)

17th century[1]
Ancient village of Magura, Solomon Islands

House post for a ceremonial building or sacred boat shelter

Wood
H. 211 cm
Collected by Pierre Langlois circa 1960
Formerly in the Musée Barbier-Mueller, inv. 4500 C (acquired 1980)
Gift of Monique and Jean Paul Barbier-Mueller, 1999
Musée du Quai Branly
Inv. 70.1999.5.3

Exhibition
Paris, 1965.

Main Publications
G.H. Rivière, 1929, p. 55;
A. Portier and F. Poncetton, 1931, pl. 36; M. Leenhardt, 1947, no. 32, p. 44; V. Galardoni, 1948, pl. 141; *Chefs-d'œuvre du musée de l'Homme*, 1965, no. 48, p. 141; *Le Courrier de l'Unesco*, 1965, p. 18 (detail), p. 25 (detail); *Musée de l'Homme*, 1992, no. 47969, p. 120.

This exceptional sculpture is part of a group of house posts acquired during the 1960s by the French collector Pierre Langlois. Most of them come from ancient or abandoned villages situated between Gheta and Mwakorukoru west of the Star Harbour point in the southern part of the island of Makira (formerly known as San Cristobal). S.W. Mead noted in 1971 that in the village of Gheta, "There still exist the ruins of what was once a magnificent *aofa* [traditional house]. There were also *aofa* in the abandoned villages of Nasui and

Funukumwa, but people in Mwakorukoru recall that a French buyer came in 1965 and they sold him seven house posts. Four of them came from Nasui and three from Funukumwa." [2]

According to Langlois, the pole shown here came from the ancient village of Magura, near Star Harbour. H. Bernatzik photographed the sculpture on site in 1932 or 1933.[3]

Traditional and ceremonial houses were a particular feature of villages in the south-eastern Solomon Islands (Makira, Santa Catalina and the

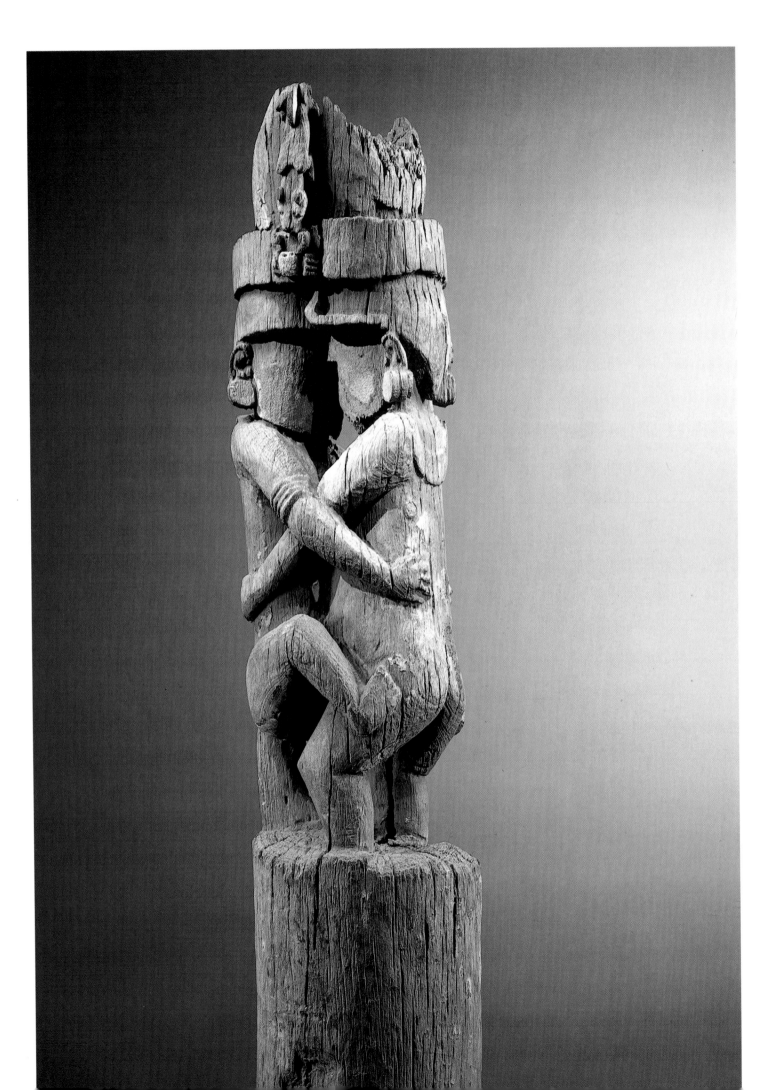

three "sister islands", Uki Ni Masi, Ulawa and Santa Ana) for a long time. These large and often elaborately decorated structures sheltered boats and chests holding the bones of one or more dignitaries. They also served as sites for festivals and other important occasions. The house poles were often the main decorative element. They were sculpted into anthropomorphic shapes, often accompanied by representations of birds and fish.

Many visitors described and photographed these traditional house posts. A photo taken by the Reverend R. Codrington of the Melanesian Mission was published as an illustration in J.L. Brencheley's account of his 1865 visit to the Solomons.[4] In 1851, J. Webster, from the ship the *Wanderer*, observed that in the village of Makira on the eponymous island, "The rafters of many houses are held up by statues of people about eight feet tall, very skilfully carved in wood and decorated with lines drawn with red and white chalk. These figures stand on representations of birds sculpted in the same piece of wood. The figures also carry a fish and a bird, one in each hand on either side of their head." [5]

A particular characteristic of the anthropomorphic posts of this region is that the statues carved out of round tree trunks have sharply angular curves and flat surfaces, especially when it comes to the head and arms. Most poles show only one figure, usually a man. This rare example with two has far more rounded curves than found on most posts. The couple is apparently in the midst of having sex, but it is impossible to explain the significance of this representation with any certitude. They could be an ancestor couple of the village, but we do not know whether they are remote forebears or more recent relatives. They could also represent a contemporary couple with a particular historical significance for the people of this village.

DEBORAH WAITE

1 The carbon-14 dating done on wood from this sculpture in 1999 by Dr Georges Bonani of the Eidgenössische Technische Hochshule, Institut für Teilchenphysik in Zurich yielded the following results: ETH-20607: 315 +/- 40. B.P.; ∂C-13 (%): -25.4 +/- 1.1; periods calibrated: CE 148-1657, with a probability of 100%.

2 S.W. Meade, 1973, p. 13.
3 See D.` Waite, 1983a, p. 7.
4 J.L. Brenchley, 1873, pl. facing p. 262.
5 J. Webster, 1866, p. 82.

Sculpture from New Ireland

19th century
Environs of Kapsu village, Tigak language region, northern New Ireland

Malagan figure

Wood (*Alstonia*), red ochre, powdered lime, black charcoal, coconut fibre, resin
H. 122 cm
Acquired from F.E. Hellwig in May 1904 by the Museum für Völkerkunde, Hamburg
(registered as no. 2618.05). Later owned by André Breton
Musée du Quai Branly
Inv. 70.1999.6.1

Malagan is the principal artistic tradition in northern New Ireland, where many artists have worked over a long period of time to produce a wide range of sculpture. *Malagan* art includes free-standing sculptural forms, architectural elements, wooden and bark-cloth masks, as well as more ephemeral items made of feathers and leaves. Most of these artworks were used in a ritual context, then destroyed or sold to outsiders so that the influence and evidence of the dead was removed from society.

Two main ritual cycles were the occasion for the production of *malagan* artworks: funerals and a separate sequence of ceremonies held to honour the dead in the clan belonging to the *malagan* owner's spouse. During these ceremonies, men wearing masks would perform specialised tasks

often related to the manipulation of levels of taboo. Sculptures were placed in a specially-constructed display enclosure, and at the climax of the ceremony the copyright to the various designs was handed over to the next generation of owners.

Researchers working in New Ireland early in the 20th century[1] found that there were two main types of images used in *malagan* art: stylised representations of ancestors and images of mythological beings. More recently, anthropologists have found that all *malagan* figures were created from pre-existing named designs related to each other within a taxonomic system of classification.[2] A sculptor in northern New Ireland was not able to create new forms outside the recognised art tradition, but was commissioned by a person who owned the copyright to one of the strictly controlled designs. In a secret meeting, the owner and the sculptor, watched by the owner's sister's son, would decide on the most appropriate representation, select a tree, and the sculptor would then spend between three and nine months creating the work of art.

As each *malagan* sculpture is a series of interconnected images, the symbolism linked to these sculptures is complex and operates on many levels. At the primary level, each *malagan* sculpture represented some of the social bonds[3] which had previously connected the deceased to society. Those viewing the artworks on display in ritual context would understand the reletionship that each sculpture represented and would be able to purge their souls of grief. At the conclusion of the ceremonial sequence, the sculptures were traditionally destroyed so as to mark the rupture of death and break the bonds that the dead person had held with the living. People in New Ireland use a metaphor: the dead person is like a tree in the forest which has fallen across the garden, people must adapt to the loss of the tree and remove its presence from the living. Losing a tree creates space for others to grow.

Symbolism in *malagan* extends to many levels beyond the social context. For example, this wooden figure is a version of a specific type of image created in a number of forms: wooden masks, architectural elements featuring the mask or head, and wooden statues with an anthropomorphic form underneath the mask or mask-like head. The key element of this subtype is the very distinctive head, the defining feature common to all three categories. It is characterised by a central nose-plank, often engraved with images of birds and fish. The two sides of the face are each a framed rectangle with a flat convex surface, and in the centre of each rectangle is a sloping eye. In some variants, a disembodied mouth is found underneath the main body of the mask-like head.

Although we know exactly where this piece was collected, in Kapsu village in the Tigak language region of northern New Ireland, the specific name of this image is not known to us and thus we cannot say precisely why the sculptor created this piece. Museum collections hold *malagan* images of this type collected from several regions in New Ireland.

A key to the attribution for this type of image can be found on the islands of Tabar, north of the central island, where similar *malagan* images were collected in the late 19th century. In recent years, anthropologists working on Tabar and on other regions of mainland New Ireland have recorded a type of image represented in the *malagan* art tradition in forms such as distinctive masks, wooden figures and also other sculptures with the mask. On Tabar, and in a number of language groups on mainland New Ireland, generically this type of *malagan* is referred to as *ges*.[4] Tabar sculptures represent either the *marumarua*, a person's social image, or the *ges*, an image of a person's spirit double, part of a person's life force linked to the totemic source of a clan's identity.

From an examination of similar pieces in museums, we find that about one third are wooden figures and two thirds wooden masks either worn on the head by men or placed on a human-like body made of bush materials. This image was also found on architectural elements, such as the outer walls of the special houses for young children being trained

Exhibition
New York, 1966.

Main Publications
Architectural Sculptures of the Salomon Islands, pl. V; D. Waite, 1983, pl. 21, p. 77; *Sculptures. Chefs-d'œuvre du musée Barbier-Mueller*, 1995, p. 326-327; *Arts des mers du Sud*, 1998, no. 9, p. 274.

Fig. 1
Photograph taken by Sabine Weiss at the home of André Breton and published by A. Jouffroy ("La collection André Breton", L'Œil, October 1955)

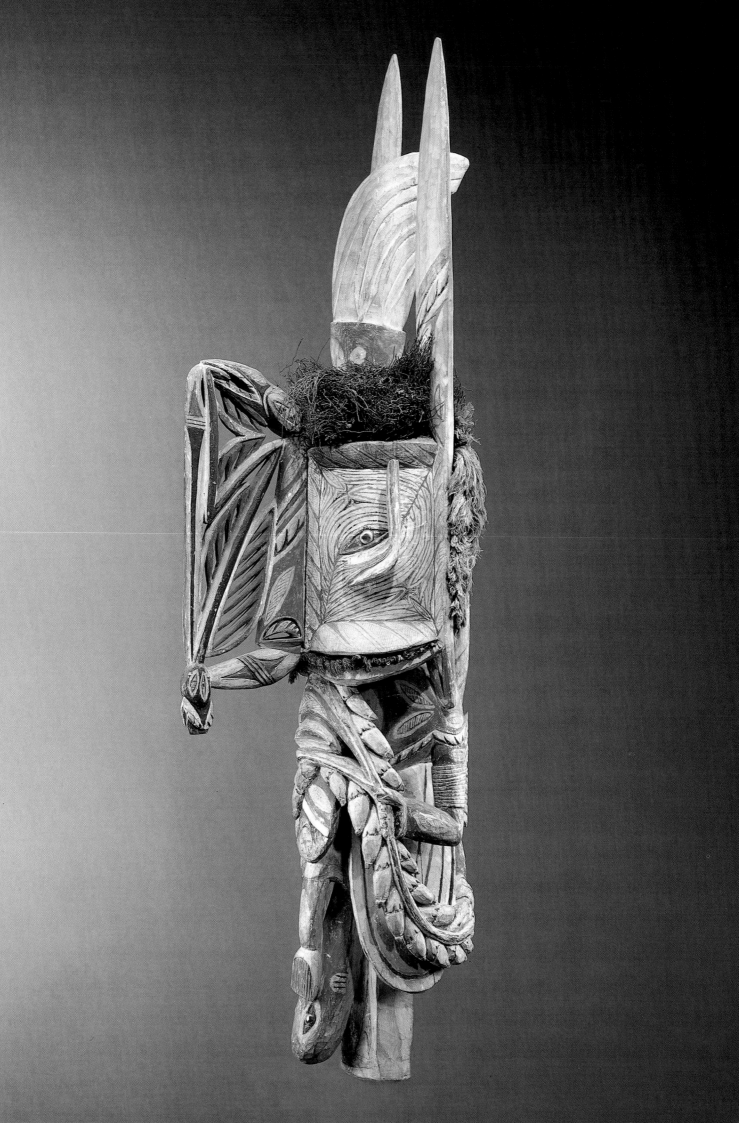

in the art of leadership. Only a few of these images are found in museum collections.

On top of the head is a feather decoration. Most likely it represented the sea-eagle, a totemic bird in northern New Ireland. Instead of ears, the head bears two large ear planks. They may have originally represented the planks attached to the head of a corpse in previous times in order to keep it upright. The flat face with slanting eyes placed within a rectangular frame is very typical of its type. The separately sculpted plank attached to the front of the face that replaces the nose features a bird eating a snake, most likely a totemic image.

The figure holds in its hands a wreath of betel nuts. They are used as social lubricant, for when a person offers betel nuts he is offering continuation of friendship.

The figure terminates at the rib-cage like many *malagan* figures, indicating the dissolution of the flesh after death. The careful execution of this sculpture makes it an exceptional artwork.

MICHAEL GUNN

1 In particular, Richard Parkinson, Augustin Krämer and Edgar Walden of the German Marime Expedition of 1907-09, as well as Pater Gerhard Peekel, Hortense Powdermaker and Alfred Bühler.
2 Recent researchers documenting late 20th century *malagan* traditions include Elizabeth Brouwer, Brigitte Derlon, Michael Gunn, Dieter Heintze, Susanne Kuechler, Phillip Lewis, and Nick Wilkinson.
3 These were bonds such as marriage, friendship, land ownership, and other social connections including warfare and trade alliances.
4 This term has also been recorded as *gas* and *ngeis*.

Sculpture from New Ireland

18th-early 19th century[1]
Northern part of central New Ireland

Uli figure (*ealandik* type)

Hardwood, red ochre, black charcoal, lime, rootlet fibres, resin, *Turbo petholatus* catch-shell
H. 150 cm
Collected in New Ireland by Franz Boluminski and acquired in 1908 by the Museum für Völkerkunde, Leipzig (registered as Me 8126); formerly in the A. Schoeffel collection
Musée du Quai Branly
Inv. 70.1999.2.1

Publication
V. Bounoure, 1964, fig. 4.

Standing as if emerging from his mortal coil, this superbly balanced *uli* figure represents the best of an art tradition that flourished in the tiny villages and hamlets of the heavily forested mountains north of the Lelet Plateau in central New Ireland. Until this tradition became extinct in the early part of the 20th century, these remarkable wooden figures were used in ritual context to honour the dead.

Although *uli* was a separate part of the much larger *malagan* ritual system used over much of the northern part of New Ireland, oral traditions indicate that the prototype of the unique *uli* figure was created several centuries ago by a man called Lavangge in the village of Kanagot[2] in the Madak linguistic region. Other *uli* figures were then made and used in a number of inland bush villages in the mountainous region north of the Lelet Plateau.

Eventually *uli* spread to a number of related villages on both coasts and to villages on the Lelet Plateau, and in time became especially honoured for its oldness and sacredness. By the early 20th century it was known as *málanggan vúruk*, the "great cult".[3]

Working from a typology recorded by the German ethnographer Augustin Krämer[4] and by analysing the characteristics of more than 240 *uli* figures known to exist in museums and private collections, we can distinguish eight major subtypes accounting for 80% of all *uli* figures. Although these subtypes were most likely regional developments, we have no evidence to support this supposition. Between the various subtypes there are differences in the position of the arms, the presence and position of smaller figures or "children" attached to the main figure, and the presence or absence of external "bars" or struts such as the suspended wreath-like

object found looping around the torso on this *uli* figure.

As physical images, *uli* figures are characterised by almost dwarfish proportions. They stand on very short powerful legs, with a stocky torso surmounted by a large, bearded head. Most are between 90 and 160 cm in height. These strongly masculine figures have that ultimate determinant of masculinity, a well-sculpted penis, but also possess a pair of very noticeable breasts resembling those of a pubescent young woman. Below the breasts is a carved and painted shape encircling the body. New Irelanders have described this bottom part of the rib cage as a "coral shelter" or "barrier reef".[5]

Traditionally, *uli* figures were not destroyed after use, but instead were wrapped and stored in the men's house until needed again. Then they were washed clean of soot and repainted with ochres and other substances. A number of *uli* figures in Western collections have numerous layers of paint under the overhang of this "coral shelter", but many others appear to have been painted only once, suggesting that they are more recent examples purchased by traders before they could be reused. There is some evidence suggesting that the earliest *uli* figures were carved from hardwood, and that the later figures carved from the softwood *Alstonia scholaris* were made during the period of contact with the West.[6]

In aesthetic terms, there is a distinct difference between the few *uli* figures which are major works of art, and the majority which lack any real appeal or presence. The finest are usually made from hardwood and can be characterised by a sense of dynamic balance and an attention to detail lacking in the others. Another feature that most often separates the elegant from the mundane is found in the bars positioned near the sides of the body, which on some examples encircle the torso. On a top-quality *uli* figure, these bars become flying buttresses or wings, considerably enriching the composition.

Most *uli* ceremonies took place in 13 or more stages spread over a period of one to three months.[7] These ceremonies, held to honour a dead leader, would begin with the burial of a skull together with a number of seedling plants which would gain nourishment from the contents of the skull and within a short time developed into a magnificent arrangement of yellow leaves. Towards the end of the sequence, as many as ten *uli* figures would be brought to the ceremonial ground in secret, repainted, and placed in special houses built for them in the sacred enclosure. Some of these houses would contain a particular U-shaped bench featuring enormous fish-head sculptures placed at each end.[8] Two or three beautifully painted *uli* figures were positioned on top of this bench. Other houses contained boat-shaped structures called *lemaut*, "graves", with an *uli* figure tied to a post placed at each end. Although women were not permitted to see the *uli* figures, their presence in public dances was an essential part of the ritual.

From the evidence handed down to us, it seems that *uli* figures were ancestral images representing the power and strength needed by a New Ireland clan leader. The ideal leader was aggressive and strong, yet nurturing, feeding his people when they needed his strength. In this view, the feminine breasts represented the fertile potential of a young woman at the threshold of puberty, almost ready to nourish the next generation.

Although we do not know the name of the artist, it is obvious that he produced a major work of art, for this *uli* figure has a presence and power that has transcended the cultural differences between New Ireland and the West. With his beard bristling and his breasts aroused, he stands to show the world the unspoken strength of New Ireland. His superb balance gives this figure a commanding presence, testament to the genius at the origin of the *uli* tradition.

MICHAEL GUNN

1 The C-14 dating on wood from this sculpture in 1999 by Dr Georges Bonani of the Eidgenössische Technische Hochshule, Institut für Teilchenphysik in Zurich yielded the following results: ETH-20608: 150 +/- 40 B.P.; ∂C-13 (%): -21.4 +/- 1.1; periods calibrated: CE 1670-

1784 with a probability of 47%, CE 1793-1894 with a probability of 35.5%.
2 A. Krämer, 1925, p. 59.
3 *Ibid.*
4 *Ibid.*, p. 61.
5 *Ibid.*
6 This evidence is largely derived

from personal examination of more than 80 *uli* figures in museum collections.
7 E. Krämer-Bannow, 1916, pp. 277-278; A. Krämer, 1925, 62-66; G. Peekel, 1935, pp. 48-71.
8 Illustrated by E. Krämer-Bannow in A. Krämer, 1925, p. 64, fig. 13.

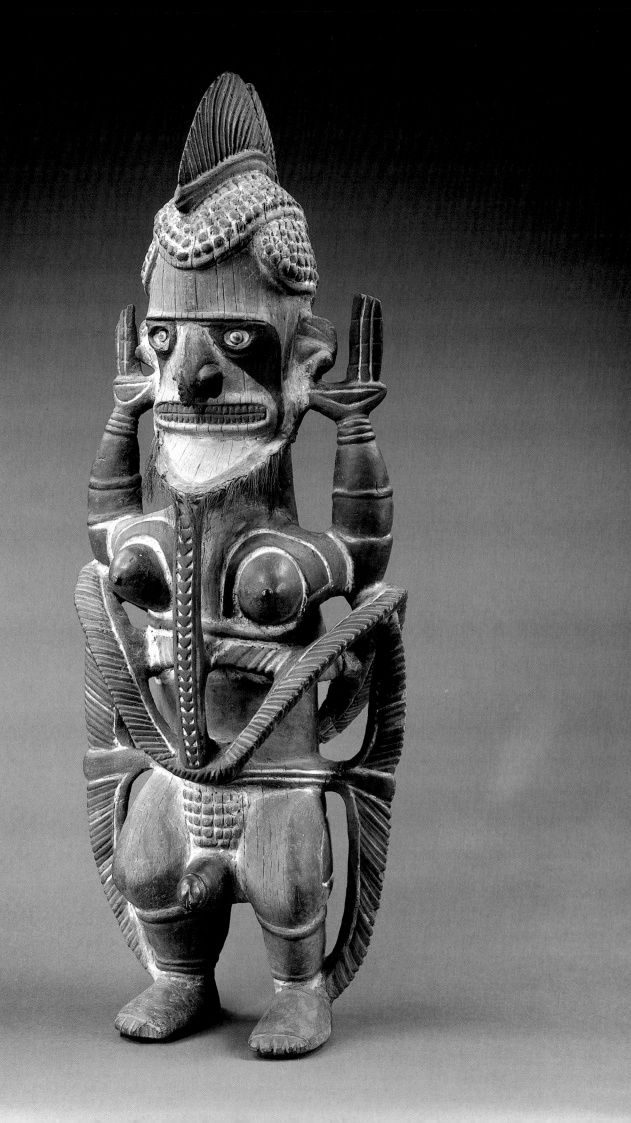

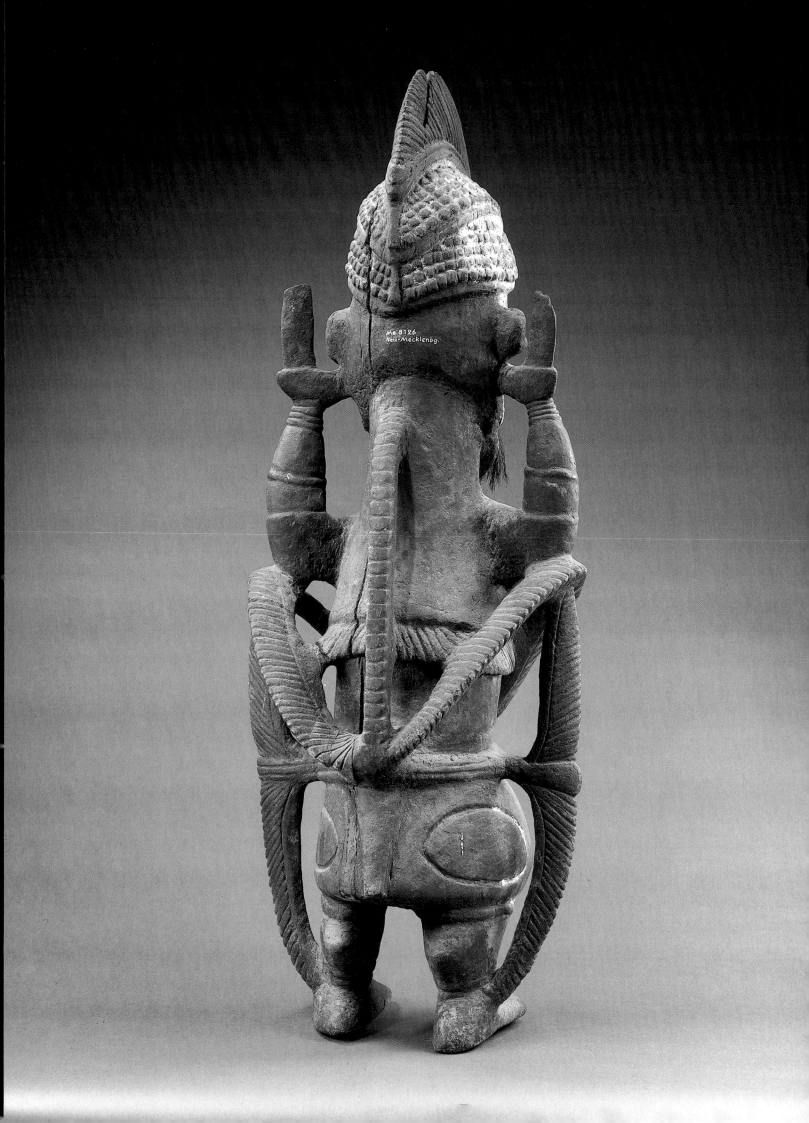

Sculpture from the Sepik River region

17th-late 18th century[1]
Village of Tungimbit, Papua New Guinea

Hook representing a woman named Klingenmas

Wood (*Vitex sp.*, Verbenaceae)
H. 103 cm
Collected by Mr and Mrs C. Van den Broek, October 1935
Gift of the De Ganay and Van den Broek families to the Musée de l'Homme, 1961
On permanent loan from the Muséum d'Histoire Naturelle – Musée de l'Homme
Inv. M.H. 61.103.305

Exhibition
Paris, 1992-93b.

Main Publications
C. Valluet, 1991, p. 37;
V. Bounoure, 1992,
pp. 152-153.

This hook was obtained by barter from Wanimbank,[2] a man from the village of Tungimbit, when the *Korrigane* expedition[3] was staying in the Sepik River region. Wanimbank introduced himself as the great grandson of the first known owner, Ashibuli. The members of the expedition took the sculpture back to Paris in 1936 and deposited it at the recently built Musée de l'Homme (D 39.3.848). From June to October 1938 it was presented in a display case at the exhibition relating "The Voyage of the *Korrigane* in Oceania". In 1940, along with numerous other objects, it was apparently packed in a crate for protection against bombs during World War Two. In 1953 the sculpture was exhibited in display case no. 391 of the Oceania room at the Musée de l'Homme. The exhibits were reordered in 1961 after most of the Korrigane collection was sold off at auction.[4] This sculpture of Klingenmas was one of three hundred works donated to the museum by the Van den Broek and De Ganay families (M.H. 61.103.1 to M.H. 61.103.302). It was displayed in an exhibition of masterpieces from the Musée de l'Homme from April to October 1965 and then put back in a display case in the Oceania gallery, where it remained until its transferral to the reserves in July 1985.

The central basin of the Sepik River has been a site for the exchange of foodstuffs and building materials for several centuries. It is a marshy region rich in sago palms, whose starchy cereal provides the staple food in these parts. According to local oral tradition, during the 1840-1860 period the region witnessed a conflict during which Iatmul conquerors, coming from today's Sawos country, exterminated their southern neighbours on the banks of the lower Korosameri River. The conquerors encouraged the inhabitants of the neighbouring hills to form an alliance with them and thus created the six villages of today's Kapriman territory, between the Korosameri and Karawari rivers.[5] Large numbers of Iatmul families emigrated into the region at this time, and there is considerable evidence indicating that ritual objects were exchanged in order to seal the peace and establish commercial relations.[6] It is thus highly likely that this hook was a gift to the Kapriman from

the Iatmul, who had themselves acquired it from their neighbours and occasional allies, the Sawos.

Suspension hooks can be found over a huge area stretching from Indonesia (Sumatra, Borneo and Sulawesi) to the western Pacific. In New Guinea they exist on the north coast and in many societies of the Sepik valley, and in Polynesia they are present in Fiji and Tonga. There is little doubt that suspension hooks were introduced into Oceania from Southeast Asia in around 1000 BCE. This kind of sculpted hook can be seen hanging under the roofs of the great houses along the Sepik River. Every adult man has one or several hooks. From them are hung rope nets in which the wives place the family's food for the day (smoked fish and sago cakes). In some cases a disc was cut out from a sago palm leaf and placed above the head of the sculpture in order to prevent rodents from sliding down the rattan strap from which it hung. One end of this strap was attached to the head of the sculpture and passed around a roof beam, thus making it possible to raise or lower the hook to a height of several metres above the floor of the house by pulling on the other end. In esoteric thought, this kind of object represents the primordial principle of the division of the cosmos into two parts, like the skull and jaws of the ancestral crocodile.[7] The right tip of the hook is associated with good luck, the left with bad luck.[8] This belief is borne out by the story told to the collector by the object's last owner, one of whose children died after the left tip of the hook was shattered during an earthquake. Being broken can only have reinforced the spiritual power that this antique object had acquired over the years. The Sepik peoples say that in such circumstances the object becomes hot and dangerous. The anthropomorphic sculpture has the role of a guardian spirit that protects the household: it keeps away sickness and evil spirits and watches over children left at home when their mother is out fishing. When an inhabitant of the house is ill, the owner makes an offering of areca nuts, placing them in a small net suspended from the hook. The swinging of the hook from the roof beam expresses the continuity of life, like a metronome marking time. It is likely that

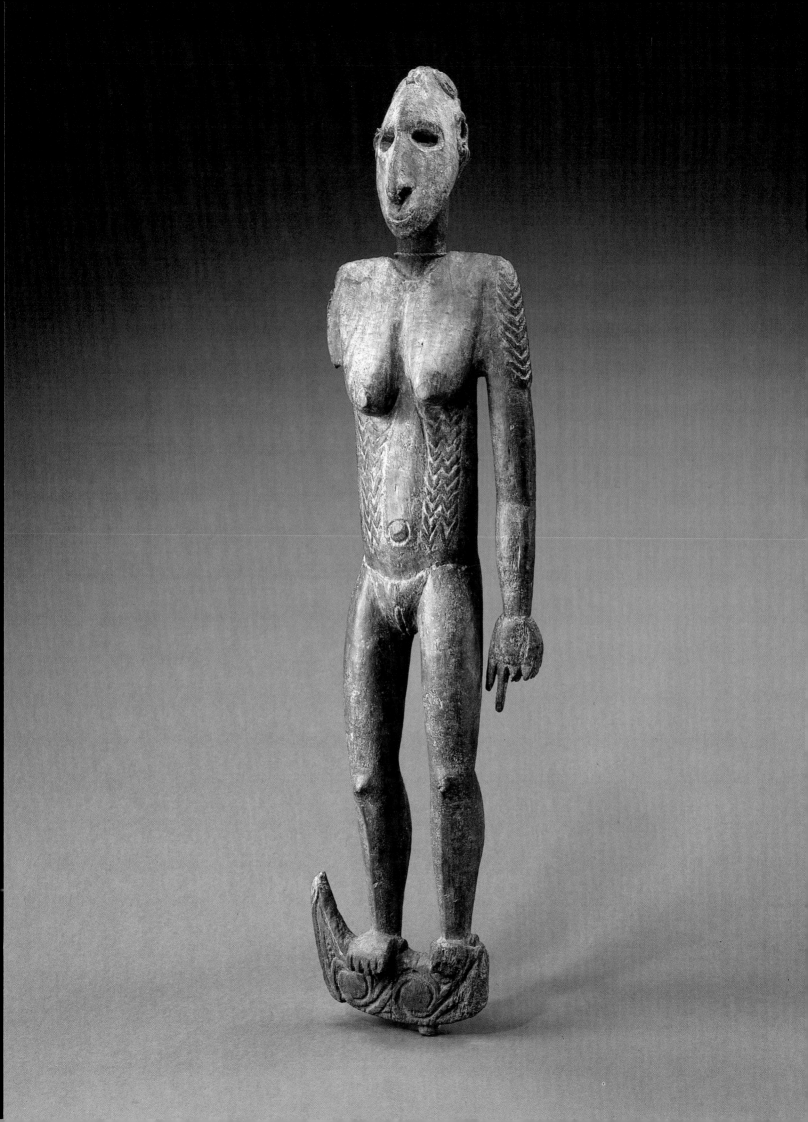

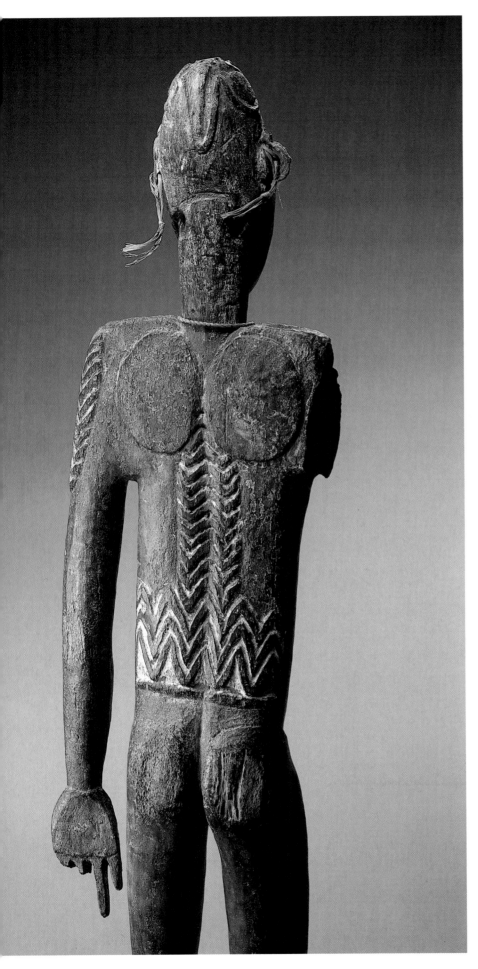

these hooks used to have a function in hunting and war, the spirit represented being expected to help the owner on his expeditions.[9] In such cases they were decorated with the totemic plants of the owner, who suspended offerings from them to implore the god's help and to thank him when the expedition was successful. There were many different kinds of hooks.[10] Some of them were used to present ancestors'skulls or overmodelled trophies which were impaled on each of its points.[11] The sculpted hooks of the middle Sepik region are among the objects most commonly produced to be sold to travellers and tourists. Consequently, there are thousands of examples in Western museums, but in most cases the sculpture is of mediocre quality. The figures represented on the hooks always have a name, often several, and they are frequently anthropomorphic. Others represent fish, birds, crocodiles or flying foxes. The statues attached to the pillars of Sawos ceremonial houses were often full-length portraits of ancestors similar to the figures on these hooks.[12]

Iconographic interpretation

This hook has none of the known characteristics of Kapriman sculpture. In contrast, it does have numerous stylistic features of Sawos work. In contrast to most of the hooks collected in the middle Sepik region, which usually have rather vague, ill-defined lines, the proportions of the various parts of the body, which are sculpted in the round, are realistic. The posture of the torso, with the arms along its sides, corresponds to local stylistic canons. The right arm has been broken off at the shoulder and the left hand, from which three fingers are missing, is held with the palm facing backwards. The feet are in plantigrade position. All these details are characteristic of the western Sawos. The expression and oval modelling of the head are most unusual. The motif carved into the crown is like a kind of star with four points of differing lengths (two by two). This pattern reminds us that the hook is also an *axis mundi*. The elongated nose is a sign of great beauty by local criteria. A knotted string has been passed through the hole of the septum. The ears, too, have holes made in them and have various knotted strings through them, three of which are in reed fibre (*scirpus grossus*). The use of these different cords must have had a protective function. The eyes are two fairly deep, almond-shaped holes. No doubt they were originally inlaid with shells held in place by *yimba* paste, [13] of which a few fragments remain in the right-hand socket. A perpendicular hole at the back of the neck would have been used for attaching the rattan winch. Around the neck is a cord in sago leaf fibre. Below the breasts and on each side of the navel, two parallel vertical bands are decorated with W motifs going all the way down to the pelvic girdle. These motifs are also carved on the upper arms and

back, where a single band follows the line of the spine, while another forms a belt around the loins. This kind of corporeal scarification, as practised during initiations, is typical of the West Sawos region. Among the Iatmul and Sawos, women's bodies were scarified less often than men's. Stratigraphic analysis reveals layers of white and red pigment all over the body, and especially in the concave areas. The volute motifs carved onto the base of the hook at the front are seen frequently in the decorative schemes of numerous Sepik peoples, but the proportions are larger in Sawos art. The style of this work, especially the rendering of the head, recalls other known West Sawos works, including the one in the Rockefeller Collection exhibited at the Metropolitan Museum in New York[14] and the one at the Museum voor Volkenkunde in Rotterdam.[15] Made from extremely hard wood, it was carved using an adze with a stone blade.[16] This helps establish its degree of antiquity, metal tools having been introduced into the region only at the beginning of the 20th century. The decorations were made using animal teeth (pig, rat). The master sculptor has shown himself a consummate master of his material, using rudimentary tools to produce a work of rare beauty. This figure represents a remarkable variation on the Sawos style.

CHRISTIAN COIFFIER
AND DOUGLAS NEWTON
Translation: Charles Penwarden

1 Carbon-14 tests carried out on the sculpture's wood in 1999 by Dr Georges Bonani of the Eidgenössische Technische Hochschule, Institut für Teilchenphysik, Zurich, have yielded the following results: ETH-20611: 265 +/- 40 B.P.; 13C [0/00]: -23.4 +/- 1.1. Calibrated periods: CE 1507-1602, with a probability of 30.8%, CE 1615-1681, with a probability of 47.2%, CE 1750-1804, with a probability of 15%.
2 The name Wanimbank does not sound Kapriman. It could be Iatmul or Sawos. In these languages, *wani* means tree (*Octomeles sumatrana*). The Iatmul and Sawos languages are very different from those of the Kapriman, the former belonging to the Ndu family, the latter to the Sepik Hill family. All are non-Austronesian languages (C. Laycock, 1973, pp. 24-29).
3 After sailing round the world in the *Korrigane* from March 1934 to June 1936, the organisers of the voyage, Count and Countess Etienne de Ganay, Mr and Mrs Charles van den Broek and Jean Ratisbonne, brought back to France some 2,500 objects, several thousand photographs and much documentation on the peoples of the Pacific islands. The entire collection remained on deposit at the Musée de l'Homme for over twenty years.
4 In 1956, the death of C. Van den Broek put a question mark over the status of the entire Korrigane collection, which hitherto had been the joint property of the four expedition members. Half of the collection was sold at auction on 4-5 December 1961, where it aroused keen interest from collectors around the world (see *Collection océanienne du voyage de la Korrigane*, 1961).
5 See D. Newton, 1997, p. 376. The photographs, information and objects brought back from this region by the *Korrigane* expedition are among the first documents on Kapriman society seen in the West. At the time, the region was still at the edge of a zone that the Australian government had decreed a "closed area" (C. Van den Broek, 1939, pp. 207-221). The photograph library of the Musée de l'Homme holds many of these documents.
6 The anthropologist G. Bateson (1929-30, vol. VIII, p. 30) noted one of the big *yipwon* hook-figures from the southern Sepik region in a Iatmul village. It had been offered by the Kapriman in compensation for the murder of a Iatmul. Inter-village feuding had been banned by the colonial administration in 1925 in its efforts to gain control of the region. Many exchanges of this type took place between previously hostile villages. In the region upriver of Iatmul country, for instance, the exchanges involved ancestral skulls and pottery heads made by the Kwoma.
7 G. Bateson, 1932, p. 405.
8 In the Iatmul language, the *furcula* of a chicken (wishbone) is named using a generic word that also serves to designate this kind of hook.
9 D. Smidt, 1975, p. 74.
10 R. Schefold, 1966.
11 D. Smidt, 1990, p. 265; *La Rime et la raison*, 1984, no. 332; M. Rousseau, 1951, no. 38, p. 25, fig. 38.
12 M. Pfeiffer (1983) attributes many anthropomorphic sculptures to the Sawos villages of Yamok and Torembi.
13 *Yimba* paste is made by mixing red clay, lime and the sap of the *Campnosperma sp.* tree. This paste was once used for overmodelling skulls.
14 D. Newton, 1979, p. 107.
15 S. Greub (ed.), 1988, pp. 156-157. For other comparative examples, see D. Smidt, 1975, pp. 72-75. The examples in the National Museum of Papua New Guinea (*ibid.*, p. 75), the Museum voor Volkenkunde, Rotterdam (S. Greub, [ed.], 1988, p. 156) and the Musée de l'Homme, Paris are all about the same height, give or take a few centimetres. A large number of hooks from the village of Torembi are currently held in private collections. See C. Coiffier and C. Orliac, 2000.
16 We know that the western Iatmul acquired their first metal-bladed axes in 1909, in an exchange with members of the Hamburgischen Südsee-Expedition, and that it was A. Roesicke, an ethnologist on the Berliner Expedition, who supplied the inhabitants of various Iatmul villages with their first metal axes in 1913.

OCEANIA

Sculpture from East Sepik Province, Papua New Guinea

18th-early 19th century
Papua New Guinea

Squatting Figure

Wood, blackened, traces of light paint
H. 45.5 cm
Formerly the collections of Georges de Miré and Louis Carré, acquired by Pablo Picasso 1944
On permanent loan from the Musée Picasso
Inv. M.P. 3638

Main Exhibitions
Paris, 1930, 1931, 1936.

Main Publications
C. Zervos (dir.), 1929, p. 67, fig. 24; *Vente de sculptures d'Afrique, d'Amérique et d'Océanie, 3 mai 1931, salle 8, sous le ministère de M. Alphonse Bellier*, 1931, no. 133; E. Quinn, 1987, p. 261, pp. 262-263, pp. 266-267; W. Rubin (dir.), 1984, vol. I, p. 48; H. Seckel-Klein, 1998, fig. 90, p. 243.

That creator of innumerable masterpieces Pablo Picasso had a voracious collector's appetite for the work of many other artists, including in Africa and the Pacific islands. Without doubt, one of the most important – not only because Picasso selected it, but because of its inherent qualities – is this figure from the Sepik River area of Papua New Guinea. It is well-known that many of Picasso's early purchases of African and Pacific objects were inferior owing to his strained circumstances and limited availability, but here he found a magnificent work

Nothing seems to be known of the figure's earliest history. It emerged into public view when it was first published in *Cahiers d'Art* in 1929 and said to be from "Dutch New Guinea", an obvious mistake. At that time it was in the collection of Georges de Miré, a cousin of Roger de la Fresnay, who also possessed African and pre-Columbian works of art. The following year it appeared in an exhibition of African and Oceanic art organised by Charles Ratton at the Galerie Pigalle. Next, in 1931, the figure was put up for auction at the Hotel Drouot, when Louis Carré bought it. Much later, Picasso acquired it from the Galerie Louis Carré on 6 September 1944. It was the last of a series of paintings and African sculptures he obtained from the Galerie that summer.[1] What it meant to Picasso we cannot tell. Nobody seems to have suggested that it ever had any direct influence on his work, and this is not the place to discuss the influence of African and Pacific island art on his own. Perhaps he simply admired this sculpture, which he kept near him for the rest of his life.[2]

Numerically speaking, the majority of figure sculptures from the Sepik River show the body standing upright. Nevertheless, in the approximately 40 human figure positions appearing in painting and sculpture from this region, almost half (19) are seated or squatting. The Picasso figure is one of them. The lower body is at a backward angle from the upper torso, which is almost upright. On it sits a large, neckless head. The head and face, seen frontally, form a smooth oval; the forehead is a rounded bulge, with deeply cut eyebrows from which springs a short nose with a pierced septum. The eyes are set in narrow bands that taper to the sides (the ears are not shown). At the lower end of the face is a small mouth, and on both sides of the chin grooves extend to the tips of the eyes. A low ridge, now damaged, haloes the back of the head. It once had three perforations, no doubt for the attachment of a cassowary feather headdress, while the chin groove held a false beard of human hair. Traces of white paint on the face, once perhaps patterned, enhance the features. Early photographs show that the eyes and mouth were outlined in white.[3]

The arms spring out from the shoulder (ridges demarcate the points at which the latter begin), and curve forward to clasp the raised legs. Small knobs indicate the elbow joints. The legs themselves are the distinguishing features of this figure: the blade-like knees rise high enough to frame the lower part of the face. The feet and lower legs are broken away. Though probably male, the sex is not present, though there may have been some alterations to this part of the sculpture. In any case, it was evidently carved with native tools, and as European metal tools were introduced to the lower Sepik area by 1900 or slightly before, the figure is clearly of considerable age.

As far as the extraordinary configuration of the legs is concerned, the Picasso figure has its closest counterpart in a sculpture in the Sainsbury collection.[4] Besides being larger than Picasso's (it is 94.6 cm. high), the figure is complete, that is, the feet still exist, though again the sex is absent. The feet are shown as a solid block; they are turned at right angles to the legs, so that the tips of the toes (engraved on the block's surface) meet. Given the other consonances between the two figures, there can be little doubt the Picasso figure had similar feet.

A further comparison with the Sainsbury statue produces another interesting point. In de Miré's time and ever since, the footless figure has been seated on a base that elevates it slightly and this endows it with a dramatic and dynamic air of forward propulsion. This effect was clearly unintended by the sculptor. The heavy block of the feet would have anchored it to the ground and made it more static in general appearance.

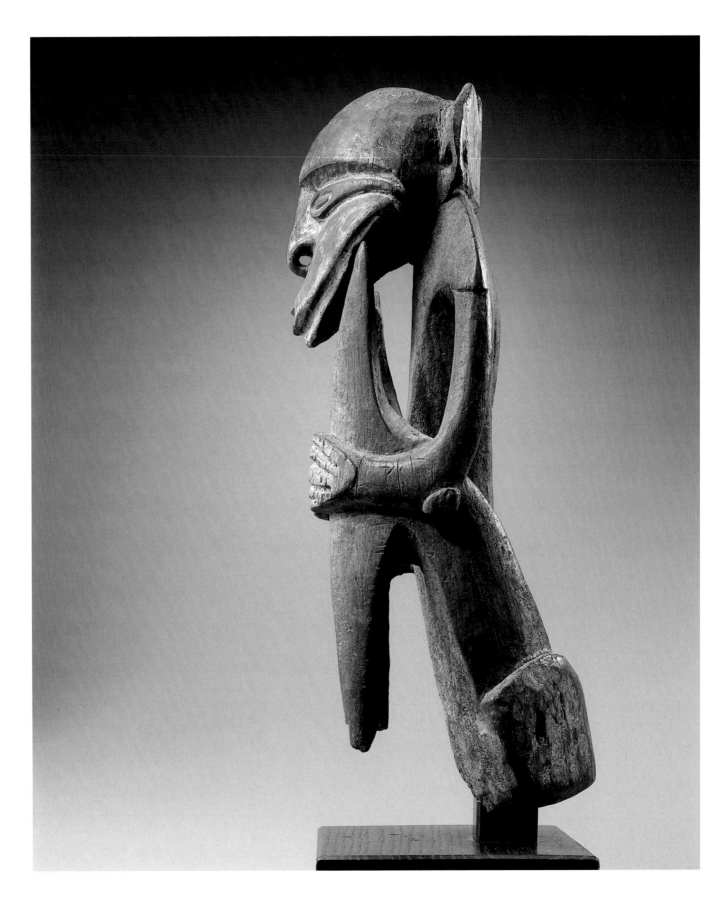

What can be said about the actual provenance of these unusual figures can only be based on a consideration of their stylistic features, as no documentation exists. Although it would be going too far to suggest that they were made by the same hand – Picasso's figure certainly has a greater vitality and tension than the Sainsbury one – they are close enough to suggest that the carvers were neighbours. While they certainly came from the lower Sepik River, the question remains exactly where. This is hard to determine.

The Yuat and Keram Rivers, with their respective populations of the Biwat and Kambot peoples, are two southern tributaries that meet the Sepik River in the territory of the Angoram people. East of them live the Kopar. To different degree, the art of these peoples share certain motifs. One of the defining features of Kambot painting (of which a great deal exists) and sculpture (of which there is very little) – all the more a marker because it is seldom found anywhere else – is that the feet adopt precisely the position of the feet in the Sainsbury figure. The facial features of this figure reoccur, more or less, in the art of other Sepik River groups including the Angoram and Kopar. The combination of the brow, the eyes, and the perpendicular feet exists in several sculptures from Angoram villages, and three superior works from the Kambot village of Kambaramba which was in touch with the others both on friendly and hostile terms.[5] The Picasso figure certainly comes from this general area, and probably Kambaramba.

As to the significance or function of the work, we are at a loss. A number of small squatting figures have emerged from this area, often with their hands to their chins or on their knees, seated on low bases. One such figure, formerly in the Raymond and laura Wielgus collection, shares the face and feet of the Picasso and Sainsbury figures.[6] Of another, Richard Thurnwald, an anthropologist on the Berlin Sepik-Expedition of 1912-13, reported that it was a "love charm" – which is not very enlightening.[7]

Other large figures perched on vertical series of truncated cones come from both Angoram and Biwat villages; they were made both before and after the importation of metal tools. Sometimes they were used as finials on ceremonial houses, as the worn surfaces of some evidence, but the pristine condition of a number of them suggests others were kept indoors as cult objects.[8] This was no doubt the case with Picasso's figure.

DOUGLAS NEWTON

1 Musée Picasso archives. Here special thanks is due to Mrs H. Seckel-Klein. See also H. Seckel-Klein, 1998.
2 Quinn, 1987, shows it in Picasso's last studio, at Mougins.
3 These photographs of the 1936 Galerie Carré exhibition are in the collection of Stéphane Mangin, Paris.
4 Others of the type must exist, but they have not been traced. Formerly in the collections of Walter Bondy and Pierre Loeb, from whom it was acquired by the Sainsburys in 1954. Now the Robert and Lisa Sainsbury Collection, Norwich, the University of East Anglia, inv. UEA 157. See M. Rousseau, 1951, p. 69,

fig. 57; P. Gathercole, A.L. Kaeppler and D. Newton, 1979, no. 22.10; S. Hooper (ed.), 1997, vol. II, pp. 42-43.
5 See H. Kelm, 1968, figs. 58-64.
6 The Raymond Wielgus Collection, 1960, fig. 2. It formerly belonged to Werner Muensterberger, and was acquired by Wielgus from the New York dealer Julius Carlebach in 1956. It was published as having been collected by Father F. Kirschbaum, the famous missionary, at "Tchessbandai" (i.e., Japandai, a village in western Iatmul area). It is evident on stylistic grounds that this information is incorrect.
7 In the Lowis Museum of Anthropology, Berkeley. Still in Papua New Guinea at the onset of the

First World War, though technically a German enemy alien Thurnwald was permitted by the Australian authorities to continue his work, and eventually travelled to San Francisco. He presented a dozen Sepik objects to the museum, of which this is one. His piece is evidently from the Yuat River area, but is said to have been collected at Bien, an Angoram village on the lower Sepik 50 km away.
8 A notable figure of this type in the Barbier-Mueller collection (inv. BMG 407; see Newton and Waterfield, 1995, pp. 274-275) is possibly from the Yuat River, and has feet of the "Kambot style".

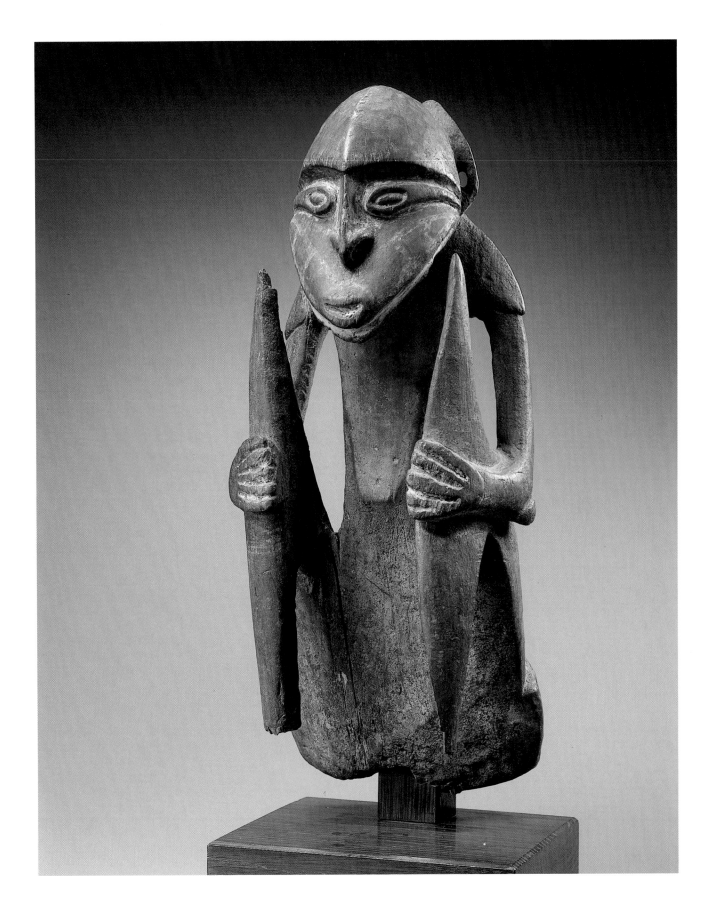

Korwar sculpture

Late 18th century
Geelvink Bay, Irian Jaya (western New Guinea)

Reliquary

Wood, skull, glass beads
H. 55 cm
Collected during the Duperrey expedition in 1824
Formerly in the Lesson et Garnot collection
In the Musée d'Ethnographie du Trocadéro from 1885
On permanent loan from the Muséum National d'Histoire Naturelle – Musée de l'Homme
Inv. 34.87

Main Publications
L.-I. Duperrey, 1826, pl. 29,
nos. 1-3; D. de Rienzi, 1837,
pl. 304; S. Chauvet, 1930, p. 9;
M. Leenhardt, 1947, no. 17;
L. Dérobert and H. Reichlen,
n.d., pl. 34; M. Rousseau, 1951,
fig. 15, p. 15; *Le Musée de
l'Homme*, 1964, p. 21, no. 4;
V. Bounoure, 1971, p. 8;
J. Kerchache (ed.), 1994, p. 148.

Going by the three views of this piece in the atlas of Louis-Isidore Duperrey's *Voyage autour du monde*, we can say that it was collected during the explorer's round the world voyage on board the *Coquille* (1822-1825). But it is more probably the surgeons R. P. Lesson and P. Garnot whom we have to thank for bring this *korwar* with skull back to France after their 1824[1] stay in the harbour of Doreh in Geelvink Bay, in northwestern New Guinea.[2]

Generally known as *korwar*, reliquary statues soon aroused the curiosity of travellers, as is attested by the descriptions from the mid-19th century.[3] Easy both to identify and to transport, these wooden pieces were brought back to Europe in considerable quantities. However, reliquaries with skulls were much rarer.

Fig. 1
Plate from the *Atlas*
of L.-I. Duperrey's
Voyage autour du monde, 1826

Here, as in other New Guinean and Melanesian cultures, death was seen as a catastrophe, an imbalance whose repercussions one had to do one's utmost to attenuate. In the intangible spirit world, the dead had more power than the living, especially if they were chiefs or redoubtable men who had died early.

The *korwar* was a receptacle for a spirit and a channel of communication with the deceased individual who, in the afterlife, continued to belong to the group and to act for – or even against – his relations. The term *korwar* referred simultaneously to the soul or the spirit, the skull and the bones and the figure in which it was housed. Although the name varied from one group to another, it is the generic term *korwar* that has been retained. Such pieces were produced in an area that includes Geelvink Bay and the Schouten Islands, especially Biak and Japen.

The *korwar* might be used exclusively for those who died at war, or outside their village (Ron, south coast of Japen, and Waropen), or, on the contrary, for those who died at home and not at war (the islands off the west coast). It could be domesticated or dedicated to an entire village. The statue was consulted for purposes of divination or magic, often by a shaman (*mon*). The deceased manifested themselves by a trembling or by the suggestion of a thought in the petitioner'mind. The *korwar* was an object of respect, but it could also be vilified, abandoned, sold or even destroyed if the oracle did not come true.

The sculptor was often a shaman, who made the *korwar* in communion with the spirit of his father, who had taught him the art of sculpture. He would draw on his own unique repertoire of forms, proportions and designs.[4]

In the case of a *korwar* with a skull, instead of a face the sculptor carved a semicircular open receptacle covering the back of the head (Rotterdam, inv. 47868). This "collar" could also take on more importance and become an important

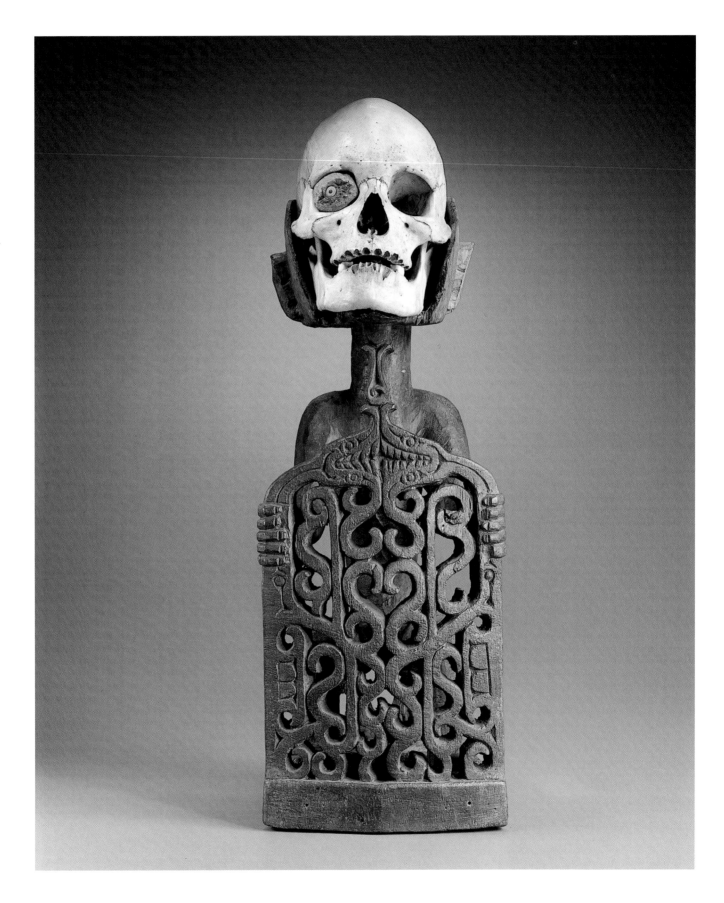

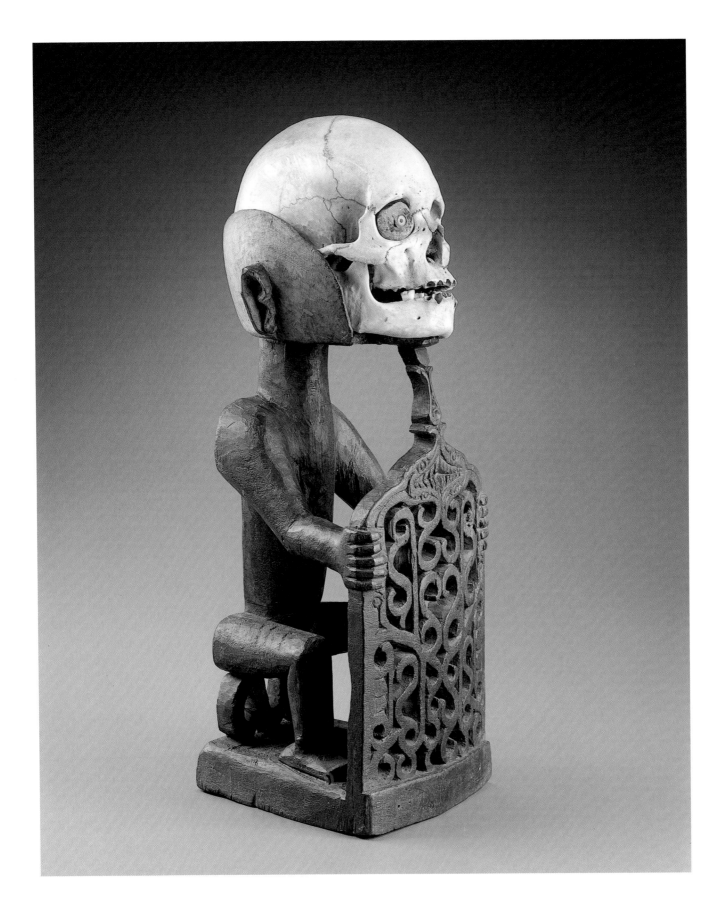

element, a container, with an opening at the top or the back for the skull, which was only partly visible. In such cases the relic was almost completely hidden and might also be covered with material (Leiden, inv. Rv 2242-1). Several of these *korwar* have complete sculpted heads which divide into two to house the skull, in the manner of Catholic reliquaries (Dresden, inv. 15376). When the skull was visible, it was often given a false nose and wooden eyes with glass beads and was painted, wrapped in cloth or overmodelled. There was a special ceremony for the "placing" of these features (described by Goudswaard in 1863[5]), at the end of which the *korwar* was installed in a corner of the house, often behind a shield.

The openwork screen held by the figure was usually taken as a shield.[6] We are uncertain as to how to interpret it, and the symbolism of the arabesques is not clearly established.

The volutes on this piece have been carved with great care. At the top there is a mouth motif which can be read frontally as either the jaw of an animal of which the screen would then be the body, or as two clashing jaws of snake-like animals whose bodies would then be constituted by the sides of the screen. This play of combining shapes is a frequent feature of Pacific island art. Van Baaren has shown that neither the myths nor the other information obtained are enough to confirm the thesis of symbolism involving snakes. Perhaps information on the trading relations of this culture at the junction of the Indonesian and Melanesian worlds would tell us more about this apparently strange form that death is holding out to the living.

YVES LE FUR
Translation: Charles Penwarden

1 From 26 July to 9 August 1824. "He [Duperrey] spent thirteen days at the anchorage of Dori and surveyed the coast over an area of twenty-five to thirty leagues west of that harbour. The naturalists on the expedition carried out fruitful research and studies." (D. de Rienzi, vol. III, p. 317.) My thanks to S. Jacquemin for this information.
2 It would seem that S. Chauvet's attribution of this piece to the Hagen collection must be rejected. In 1823 Lesson collected skulls on "Tomb island" in Offach Bay (Waigeo), which

he deposited at the Muséum in Paris, along with his natural history collections (R.P. Lesson, p. 97). It is therefore likely that this *korwar* with skull was also donated to the Muséum's collections.
3 G.F. de Bruyn Kops, 1850, pp. 163-235. T.P. Van Baaren's study (1968) gathers together the major historical sources concerning these works, from which most of the information here has been drawn.
4 See T.P. Van Baaren, 1968, p. 82.
5 Goudswaard, 1863, quoted in T.P. Van Baaren, 1968, p. 24.

6 Whether standing or sitting, the *korwar* figures generally either proffer a smaller figure or hold in each hand either snake-shaped posts or a screen which can be like the one here or Y-shaped. Others are simply presented with their arms folded. Different kinds of *korwar* can be found in the same zone. See for example the 28 pieces in different styles and shapes studied at Padwa (Biak) by W.G. Solheim II (1985, p. 135).

Sculpture from Nukuoro

Late 18th century[1]
Caroline Islands

Sculpture *(dinonga eidu or te tino aitu)*

Wood
H. 35 cm
Gift of Georges Henri Rivière to the Musée de l'Homme, 1933
Inv. M.H. 33.2.1

Main Exhibitions
Paris, 1965; Washington, 1979.

Main Publications
M. Leenhardt, 1947, pl. 71, p. 8; A. Malraux, 1952, pl. 441; C. Roy, 1957, p. 81; J. Guiart, 1963, no. 409, p. 39; P. Grimal (dir.), 1963, p. 225; *Chefs-d'œuvre du musée de l'Homme*, 1965, no. 28, p. 101; *Le Courrier*

The atolls of Nukuoro and Kapingamarangi in Micronesia lie geographically outside of the Polynesian triangle, but their inhabitants are linguistically and culturally Polynesian. These "Polynesian outliers", like similar societies to the south in Melanesia, share concepts of hierarchy and rank with their West Polynesian counterparts, but have also incorporated cultural ideas from their geographic neighbours. Nukuoro art combines the

Micronesian aesthetic concept based on simplicity of form and design with Polynesian artefact types. Nukuoro sculptures are reminiscent of West Polynesian sculptures, with a well-developed chest, straight arms and slightly bent knees.

In 1874, the American missionary E.T. Doane on the ship *Morning Star* visited Nukuoro and noted that "Idols carved from wood are common here, a very large one being in their temple."[2] Doane

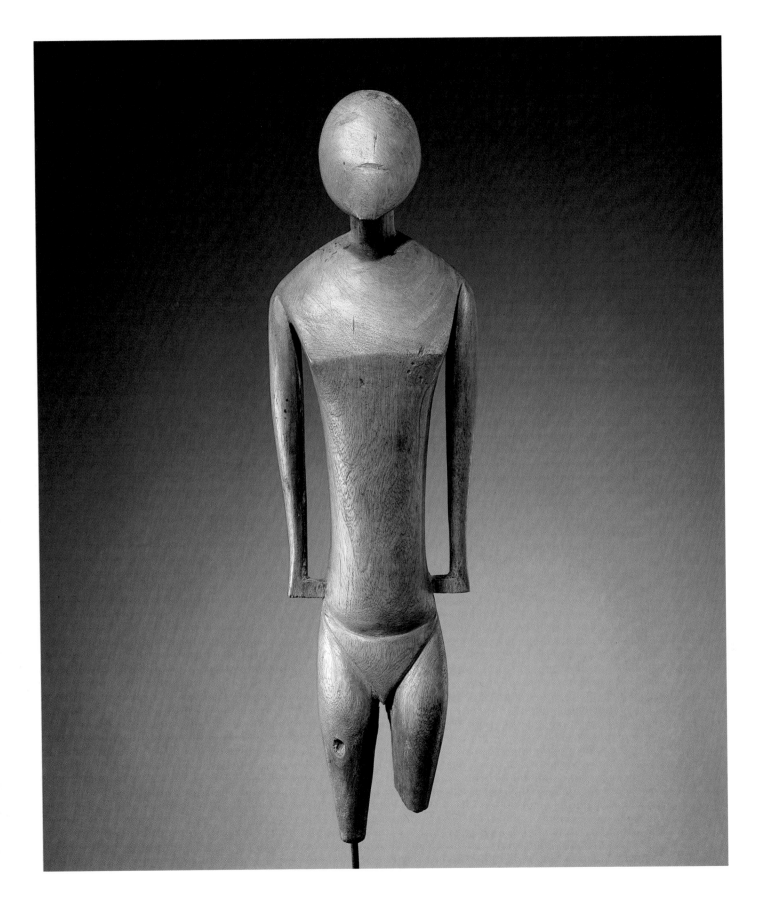

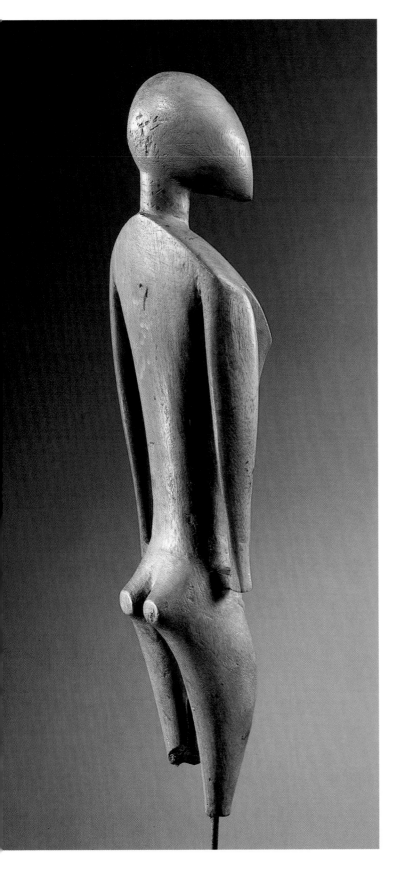
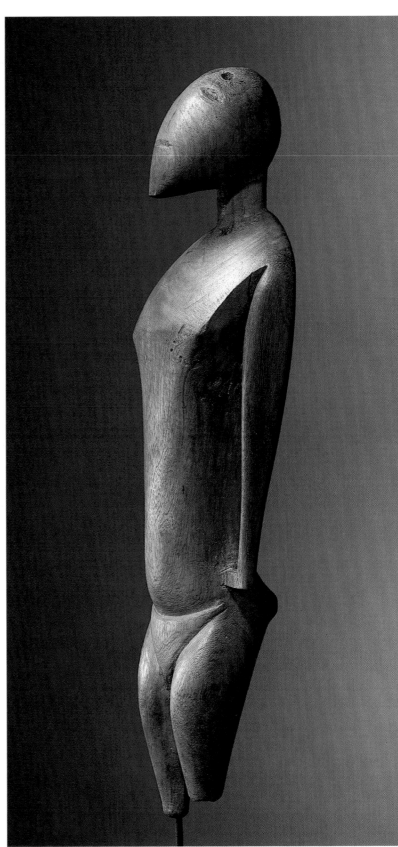

acquired one of these "idols" and gave it to the American Board of Commissioners for Foreign Missions. His fellow missionary, A. Sturgis, acquired one on Ponape in 1878.[3] In 1877, Johann Kubary, an ethnographer working for the German trading company Godeffroy, collected ten human statues,[4] and in 1878 the largest known Nukuoro figure was presented to the Auckland Museum.[5] Although Nukuoro had been visited several times before Doane, no one seems to have collected any human figures, and it was probably the influence of Christianity that persuaded the Nukuoroans to trade so many figures, at least thirteen, in such a short time.

Of the thirty of these sculptures known, most were collected between 1874 and 1913.[6] The Musée de l'Homme figure is very similar to those documented to the 1880s. It was presented to the museum in 1933 by Georges Henri Rivière, but may have already been there by 1929, perhaps on loan from Rivière who was working on the renovation of the museum with Doctor Rivet.[7] In 1929, Alberto Giacometti made a drawing of a Nukuoro figure in this museum.[8] It may have been the same one, and possibly influenced Giacometti's famous sculpture *Invisible Object*.

Nukuoro figures were the embodiment of certain male and female gods. The large female figure in Auckland Museum is said to be the goddess Kawe and has tattoo designs echoing the tattoos of Nukuoro women.[9] The large male figures have tattoo designs on the shoulders and upper arms in the same style as the tattoos of chiefly men. Two of the male figures collected by Kubary were named Sope and Tehi Tapu.[10] The smaller figures, such as the Musée de l'Homme example, usually do not have painted tattoo designs, although it is possible that the paint has disappeared. The figures were placed in the central temple called *amalau* and in smaller houses belonging to each clan. Food, clothing, flowers, and ornaments were presented to them during religious rituals and tattooing ceremonies. Little is known of the actual content of the rituals, but it is likely that they were similar to West Polynesian ceremonies that honoured the gods and ancestors with first fruits at harvest time in gratitude for the fertility of the land, sea, and people.

The Nukuoro area of the Pacific ocean was part of the central cross-roads of Pacific cultures. The placement of the god figures at the end of an enclosed sacred house combines the layout of outdoor Polynesian *marae* with an enclosed space more characteristic of Micronesia and Melanesia. In Luangiua (Ontong Java), a Polynesian Outlier in the Solomon Islands, a similar type of image was attached to the outside face of a housepost.[11] Polynesian in terms of their function and Micronesian and Melanesian in terms of their placement, Nukuoro sculptures are a true Pacific art form.

ADRIENNE L. KAEPPLER

de l'Unesco, December 1965, pp. 18-19; E. Dodd, 1967, p. 262; E. Leuzinger (ed.), 1978, fig. 253; P. Gathercole, A. L. Kaeppler and D. Newton, 1979, p. 269; P.S. Wingert ed.), 1970b, N 242 (right); *Musée de l'Homme*, 1992, no. 52835, p. 129.

1 The C-14 dating on wood from this sculpture in 1999 by Dr Georges Bonani of the Eidgenös-sische Technische Hochschule, Institut für Teil-chenphysik in Zurich yielded the following results: ETH-20609: 135 +/- 40 B. P.; ∂C-13 (%): -25.8 +/- 1.1; periods calibrated: CE 1675-1777 with a probability of 41.3%, CE 1798-1944 with a probability of 58.5%. This last date must be pushed back to 1933 at the latest, when the figure was acquired by the Musée de l'Homme.
2 E.T. Doane, 1874, p. 205.

3 Both were included in the ABCFM collection that was purchased by Bishop Museum, Hono-lulu, in 1885. The figure collected by Doane was exchanged from Bishop Museum to the Hono-lulu Academy of Arts.
4 A. Eilers, 1934, p. 275.
5 See J.N. Davidson, 1968. It was presented in 1878 by a trader, Mr Cousens, but it is not known if he acquired it in Nukuoro or if he traded it with a third party.
6 See B. de Grunne, 1994, for an inventory.

7 J.-L. Paudrat, 1996, p. 56.
8 R. Krauss, 1984, p. 521.
9 Davidson, 1968, p. 78.
10 J.D.E. Schmeltz and R. Krause, 1881, quoted in de Grunne, 1996, footnote 21. They also name a male figure in Hamburg "Ko Kwave", but this is unlikely, as Kawe was a female god.
11 See E. Sarfert and H. Aamm, 1931.

Sculpture from the island of Mangareva

10th century (?)
Gambier Islands

Statue of the god Rao

Wood (*Thespesia populnea*, Malvaceae)
H. 106 cm
Work collected by the congregation of Picpus, 1836
Entered the Musée de la Marine du Louvre, date unknown; on loan to the Musée des Antiquités
Nationales from 1908 to 1911, then to the Musée des Arts d'Afrique et d'Océanie in 1992
Musée National des Arts d'Afrique et d'Océanie
Inv. SG.53.287

Main Exhibitions
Paris, 1972;Washington D.C.,
1979;Paris, 1985, 1992-93a,
1992-92b;Bordeaux, 1996.

Main Publications
R.P. Mouly, 1938, p. 64; E. Dodd,
1967, p. 260; *La Découverte
de la Polynésie*, 1972, no. 152;
T.T. Barrow, 1973, p. 119; *The
Art of Oceania*, 1975, pl. 38
(left); A. Wardwell, 1967, p. 39;
Sillages polynésiens, 1985, p. 123;
Encyclopédie de la Polynésie, 1986,
vol. V, p. 96; *Archéologie compa-
rée*, vol. II, 1989, p. 234;
S. Jacquemin, 1992, p. 65;
V. Bounoure, 1992, p. 66 (right);
*Le Grand Atlas Universalis de
l'Art*, vol. II, 1993, p. 515;
A.L. Kaeppler, C. Kaufmann
and D. Newton, 1993, p. 74,
fig. 40; A. Meyer, 1995, p. 540;
Voyage vers l'île mystérieuse,
1996, p. 169, no. 60.

The society and art of the Gambier Islands are intimately linked to the history of the missionary settlements established in the archipelago in the early 19th century. So aggressive was their evangelical drive that all activities related to pagan cults were swept away within only two years. This radical conversion had irreversible consequences, including the wholesale destruction of temples, *marae* and representations of idols. Studying the art of the Gambier Islands thus means working on the extremely limited corpus of objects that escaped these auto-da-fés, and with ethnographic information taken directly from missionary sources.

The main protagonist of this evangelical episode was Abbé Coudrin, the founder of a congregation devoted to the Sacred Hearts of Jesus and Mary based at Rue de Picpus, Paris from 1805 onwards. From the outset, this congregation had missionary ambitions, hoping to lay the foundations for a great apostolic empire. This led to the establishing of a curacy of Western Oceania in 1833.

Pères Laval, Caret and Liausu set sail on the *Sylphide*, reaching the Gambier Islands in August 1834. Two years later, they had converted the inhabitants; king Té-Maputeoa was baptised under the name Grégoire-Stanislas on 25 August 1836.[1]

That same year, Caret sent Abbé Coudrin a crate of numbered objects from the Gambier Islands. These idols that had survived the auto-da-fés were to have a new pedagogical function as vivid proof and testimony of the victory over paganism, which was colourfully related in many a tale conflating cannibalism and idolatry: "A fire was built up. Even in the flames, the grimacing idols seemed for a moment to be mocking the sacrificers." [2] Père Mouly very pertinently acknowledges the exceptional nature of what had been salvaged: "We were careful to save the most remarkable specimens of Mangarevan art from the hecatomb [...] A trunk [...] contained Mainaraughi or Kotu (a god with four feet), Minita (a rope idol), Rao and Tupo, idols of impurity, Rongo (idol of the rainbow) [...]."[3]

In this batch of articles, the statue of the god Rao was numbered 3. He was presented as the god of shameful passion and vice: "To him was dedicated a plant called Ranga whose yellow flower has a very powerful smell. Young people used to wear *tapas* dyed yellow with this flower during days of debauchery."[4]

For reasons that remain unexplained, the statue was sent to the Musée de la Marine et d'Ethnographie du Louvre, while the other statues were sent to Rome and to Braine-le-Comte. It would stay there until the beginning of the 20th century before being placed on permanent loan at the Musée des Antiquités Nationales. In 1992, Rao was sent to the Musée des Arts d'Afrique et d'Océanie.

For the reasons mentioned above, it is impossible to have an overall view of the art of the Gambier Islands, or at least to generalise about their artistic production when all that remains are nine sculptures, six of which are statuettes. In the same way, the ethnographic information conveyed through the filter of the missionary outlook is to be treated with caution. Indeed, we have very little precise information and this tends above all to point to a highly complex cosmogony and polytheism, constants which can be found elsewhere in the Polynesian mythological corpus.

The statues called *eketea* were kept in religious buildings – the "are tiki or 'temples of the idols", to use the missionaries" own terms. They were made to represent specific divinities – the gods, say, of the breadfruit tree, rain, turmeric, agriculture and so on. According to Père Laval, "inferior" or (to use a more appropriate term) secondary divinities were divided into several categories: the descendants of Tangaroa, gods of unknown origin, deified ancestors and deified foetuses.[5]

In fact, these statuettes were very likely metaphorical images of the divinities; they were not substitutes for the gods themselves, their sole function being to represent them at a given moment during particular rites. This makes it

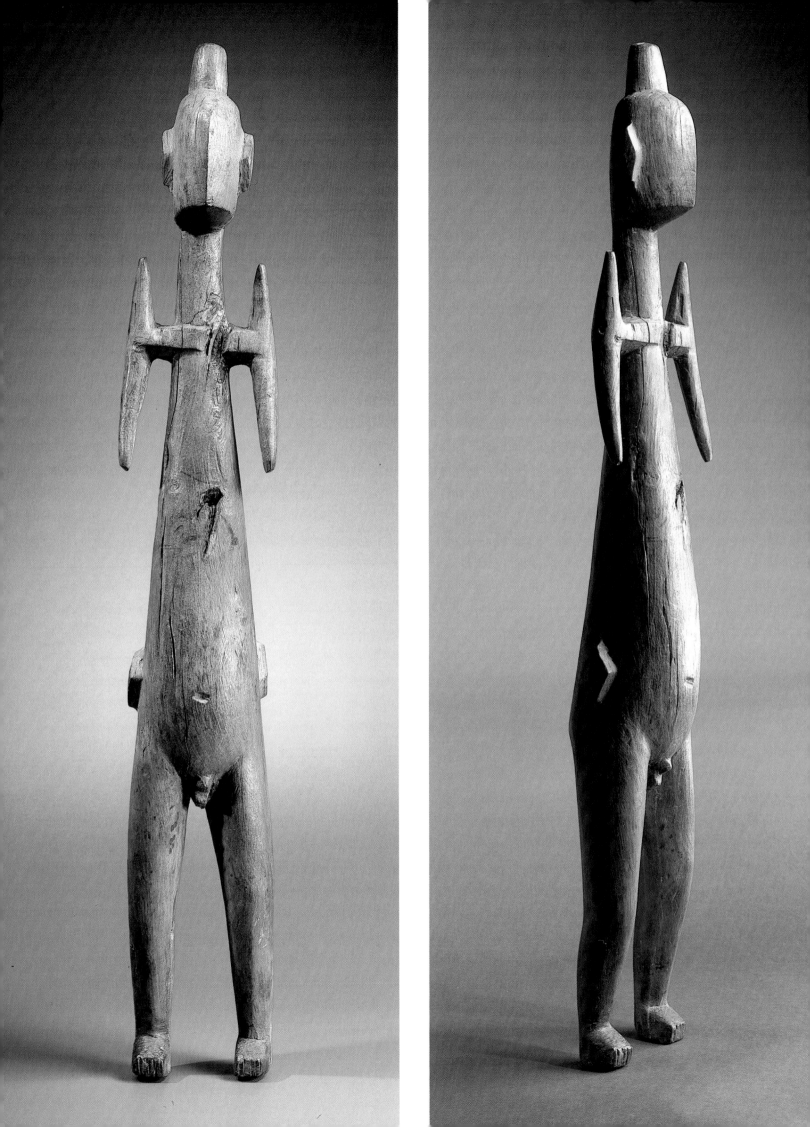

easier to understand why the Mangarevians allowed the idols to be destroyed. Père Laval relates that during the second wave of auto-da-fés the natives came to the missionaries and said: "Missionaries, allow us to hold a feast, that of eating the effigies of our gods." [6] This "ritual cannibalism" was directed more at the empty image than at the gods themselves. Thus the figures served to feed the fire for the preparation of the *ma*, a food made from fruit and roots.

This phenomenon of fairly "spontaneous" conversion, which also occurred in elsewhere in Polynesia, is to some extent linked to the many political strategies pursued by the local chiefdoms. These were pursued through complex networks of alliances which were constantly shifting, and ensured the supremacy of certain chiefdoms over others and the appropriation of property. In some cases, the Catholic or Protestant missionaries were actively involved in these struggles and redistributions of power, and their outcome was the adoption of a new religion.

There are two distinct categories of object. The first includes pieces with a forking extension at the level of the arms and the legs. These would appear to be supports or shelves for offerings. The most accomplished example is manifestly the post with

four raised hands at the Musée de l'Homme.[7] The second, more numerous category covers pieces sculpted in the round and conceived after the same naturalistic model, like the one at the Muséum in La Rochelle.

Rao represents an intermediary stage. He is halfway between deliberate abstraction, as expressed in the upper part of the body (the face is blank and featureless and the arms are no more than small wings at its side) and a more realist tendency in the sculpting of the lower half. Without a doubt, this is one of the most remarkable pieces of Pacific art.

SYLVIANE JACQUEMIN
Translation: Charles Penwarden

1 F. Vallaux, 1994, p. 46.
2 R.P. Mouly, 1938, p. 165.
3 *Ibid.*, p. 147.
4 Archives of the Picpus congregation, Rome, 1836.
5 R.P. Laval, 1938, p. 297.
6 R.P. Laval, 1938, pp. 124-125.
7 *La Découverte de la Polynésie*, 1972, no. 130. In this catalogue the object is attributed to the Marquesas Islands.

Sculpture from the Marquesas Islands

Late 18th-early 19th century

Tiki

Stone
H. 15.1 cm
Acquired by the Louvre in 1851; transferred to the Musée d'Ethnographie du Trocadéro in 1887; former M.E.T. no. 20018 b
On permanent loan from the Muséum National d'Histoire Naturelle – Musée de l'Homme
Inv. M.H. 87.50.1

Main Exhibitions
Shown for the first time in the Musée Américain (a subsection of the Antiquities department) of the Louvre in 1851 or 1852;[12] Paris, 1932-35, 1965; Saint-Paul-de-Vence, 1973 (?);[13] Paris, 1995-99.[14]

Main Publications
K. von den Steinen, 1928, figs. 63 and 64, p. 86; M. Radiguet, 1929, fig. 152, p. 104; A. Warnod, 1930,

We do not know exactly when or where this figurine was made or collected, although we do know that it was acquired by the Louvre in 1851. It was sent from the Louvre to the Musée d'Ethnographie du Trocadéro in 1887. Interestingly, it was the only Oceanic piece inventoried amongst a large group of pre-Columbian objects.[1] While Marquesan artefacts such as wooden clubs, stilt steps and articles of personal adornment were collected in large numbers before 1850, this was not the case for human figures in wood and stone, known generically in the

Marquesas as *tiki*.[2] In fact, this is one of the very few *tiki* to be found in museum collections before the 1880s, making it a very special and notable piece.[3] We do not know why so few *tiki* made their way to museums until late in the 19th century.

The Marquesas Islands are part of eastern Polynesia. Settled no later than 150 BCE, probably from Samoa or Tonga in Western Polynesia, the islands are rugged and isolated. The Marquesas, along with the Society Islands, were nevertheless an important dispersal point in the history of

Fig. 1
Display case in the Hall of Treasures (1932-35)
at the Musée d'Ethnograpie du Trocadéro
Photographic library of the Musée de l'Homme, Paris

Polynesian migrations. From this central homeland, the culture of eastern Polynesia spread as far as Hawai'i, Easter Island and New Zealand.

Some variant of the word *tiki* is used throughout Polynesia to designate carved statues, usually in human form. In the Marquesas, they ranged in size from 3 cm to 253 cm, and were commonly made of stone, wood and human bones. The term derives from Tiki, the Marquesan name for the god who engendered the human race.[4] Because he had a body, he is often considered the first human. In one Marquesan creation story, the first stone statue was carved to honour Tiki. He left Hawai'i, the home of the gods, to create the Marquesas islands one by one, beginning with Nuku Hiva. When that island became too crowded, he moved on to create Ua Pou. Realising he would never see Tiki again, a "wise man" on Nuku Hiva made a stone image to remember him.[5]

Rather than Tiki himself, however, the statues came to represent the *etua*, deified ancestors. Large figures of stone and wood stood on sacred ritual sites called *me'ae* where the inspirational priests, the *ta'ua*, lived; at the chief's residence; and at the public ceremonial centre, the *tohua*. They served as receptacles or vehicles for the ancestor's spirit when summoned by the *ta'ua*. They were considered *tapu*, or sacred, and they were made by *tohuna* (*tohuka* in the southern dialect), skilled artists who were also ritual specialists, and who ensured the efficacy of the objects they made. Offerings, including fruits, vegetables, animals and human victims were placed on or near them on the *me'ae* to honour and please the ancestors.[6] *Tiki* large and small wore clothing of sacred white *tapa* (barkcloth) made by special *tuhuna*, and the statues were often decorated with wreaths of flowers, shells or other materials.

None of the early visitors to the Marquesas mention small stone *tiki* on their journals, so we have no description of them or their function through the 19th century. Ralph Linton, who worked in the Marquesas in 1921, wrote that they were used in healing the sick and as votive offerings left on the *me'ae* by people desiring success in an undertaking.[7] This figure, like a number of other small *tiki*, has a hole drilled through the back of the head through which a cord could be passed, suggesting it was meant to be worn, or perhaps suspended from something.

Marquesan *tiki*, regardless of size or material, share similar style characteristics, as can be seen by comparing this statuette with the figure of Takai'i, named for a great warrior and chief from the island of Hiva Oa.[8] Despite the differences in their sizes (Takai'i is 253 cm, while this figure measures 15.1 cm), they are similar stylistically. They face forward and have heavy, squat bodies with bent knees. The arms are close to the body and the hands usually rest on a rounded, swelling stomach. Little attention is paid to hands or feet. The head, the most sacred or *tapu* part of the body, is always big, sometimes nearly half of the body size, with very large eyes, a broad, flat nose and wide mouth. The eyes are often emphasised. For example, this figurine has raised bands that outline the eyes and a ridge that cuts across them horizontally. The Marquesan word *mata* means both face and eye, and also refers to genealogy. *Mata tatau* is the counting of one's ancestor who, like Takai'i, have become gods. This perhaps explains the Marquesan attention to the eyes.[9] Though most *tiki* are considered male, some are female, and the gender, as is the case with the statue of Takai'i, is most often not shown.[10] This small *tiki* is male, as indicated by the small knob below the navel. Its head is a little smaller and the planes of the body are more angular than those of many similar pieces. The chest area is accentuated by sharply cut curved collar bones, similar to those seen on Takai'i's chest, raising the possibility of a stylistic link with Hiva Oa. The sharpness of the

fig. 364, p. 332; M. Leenhardt, 1947, pl. 81, p. 96; H. Tischner and F. Hewicer, 1954, fig. 92; W. Muensterberger, 1955, no. 110; A. Bülher, T. Barrow and C. Mountford, 1962, p. 150; *Chefs-d'œuvre du musée de l'Homme*, 1965, no. 33, p. 111; E. Dodd, 1967, p. 307; P.S. Wingert (ed.), 1970b, N253; V. Bounoure, 1992, p. 45; P. and M.N. Ottino-Garanger, 1998, p. 142.

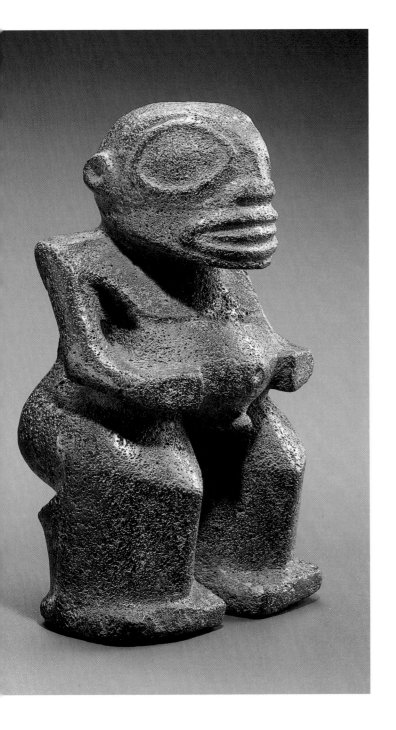
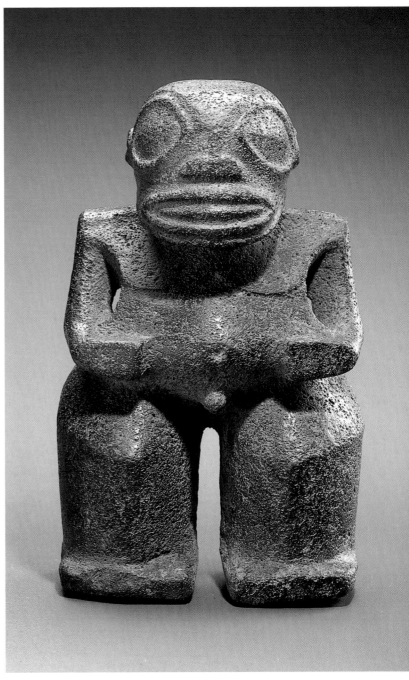

lines and the depth of the cutting in the small *tiki* suggest that it may have been made with metal tools. Metal was introduced into the Marquesas no later than 1774 and avidly sought out by the Marquesans from the beginning.[11] Metal tools made carving easier and faster, but did not significantly change the Marquesan aesthetic sense or style, at least not before the middle of the 19th century.

CAROL IVORY

1 It was V. Bouloré (personal communication, April 1999) who pointed out that this work is mentioned in the catalogue of American objects exhibited in the Louvre (see footnote 4). Bouloré suggested that it was perhaps first identified at the Louvre as being American because of its material, stone.

2 These conclusions are based on my study of 193 *iki* (116 stone, 77 wood) in 65 museums world-wide. Nearly all wooden and stone *tiki* in museum collections were accessioned between 1880 and 1930.

3 A wooden *tiki* was collected in the 1840s and is now at the Musée de l'Homme (A. Lavondès and S. Jacquemin in M. Panoff [dir.], 1995, p. 30). Henri Jouan collected two stone heads in 1854, one in the form of a human head and one of a pig, according to Karl von den Steinen (1928, vol. III). In 1874, C.D. Voy collected five stone and six wooden *tiki* which are now in the University Museum, University of Pennsylvania, Philadelphia.

4 H. Le Cléac'h, 1997, p. 120; R. Dordillon, 1931, p. 384. The Marquesans also use *tiki* to indicate any carved statue. It is also used as a verb meaning to sculpt, draw or tattoo.

5 R. Aitken in E. Handy, 1929, pp. 122-23.

6 E. Handy, 1923, p. 238; C.S. Stewart, 1831, p. 272.

7 The stone *tiki* called Takai'i is on the Tipona *me'ae* in Puama'u, Hiva Oa. Takai'i was a powerful chief and warrior. His statue, 2.53 m in height, is the biggest stone *tiki* in Polynesia outside of Easter Island.

8 R. Linton, 1923, p. 345.

9 See Ivory, 1990, 1993.

10 In a recent study of 81 stone *tiki* still in the Marquesas, nearly 73% were genderless, 20% depicted males and the remaining 7% females (S. Millerstrom and E. Edwards, 1998, p. 58).

11 The Marquesas were visited in 1595 by Alvaro de Mendana, on his way to the Solomon Islands. Whether or not his expedition left metal in the Marquesas is not known, but it was certainly introduced with Cook's visit in 1774.

12 This work is mentioned in A. de Longpérier, 1852, no. 18 b, pp. 15-16, with this note: "Acquired in 1851."

13 Although not reproduced, this is probably the object mentioned in A. Malraux, 1973, no. 739, p. 266.

14 Although not reproduced, it is mentioned in M. Panoff (dir.), 1995, no. 156, p. 132.

Sculpture from the Austral Islands

18th century

Fly whisk (*tahiri raa*)

Wood (*Casuarina equisetifolia*, Casuarinae)
L. 80 cm (including fibre), W. 8 cm
Formerly in the Férussac collection (?)
Entered the Musée de la Marine du Louvre in 1827; on loan to the Musée des Antiquités Nationales between 1908 and 1911, then to the Musée des Arts d'Afrique et d'Océanie in 1992
Musée National des Arts d'Afrique et d'Océanie
Inv. SG.84.369

Exhibition
Paris, 1992-93.

Main Publications
Archéologie comparée, vol. II, 1989, p. 231; S. Jacquemin, 1992, p. 62.

In 1831 (?) the Baron de Férussac submitted a report to the King concerning plans to create an ethnographic museum next to the Musée de la Marine du Louvre. Unfortunately, the document is not dated. However, we can put forward an approximate date of 1831 because the report was a kind of response to the plan written in 1828 by Edmé Jomard, the keeper at the Bibliothèque Royale who hoped to install an ethnographic museum at the library.[1]

In his proposition, Férussac provides some interesting information on the constitution of the ethnographic collections which, for lack of space, had been installed in the galleries of the Musée de la Marine. He informs the King that he has himself helped to enrich the collections, notably as regards

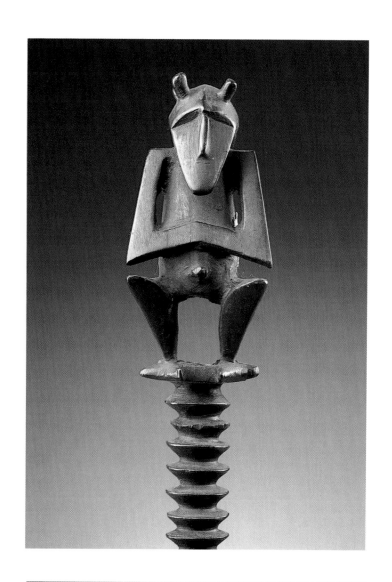

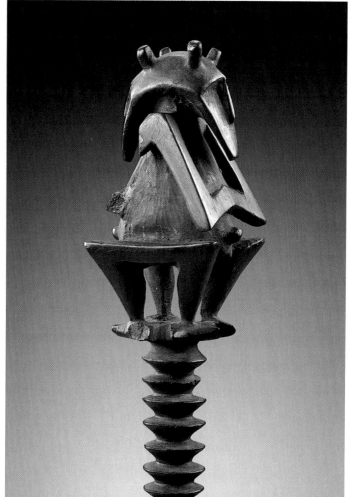

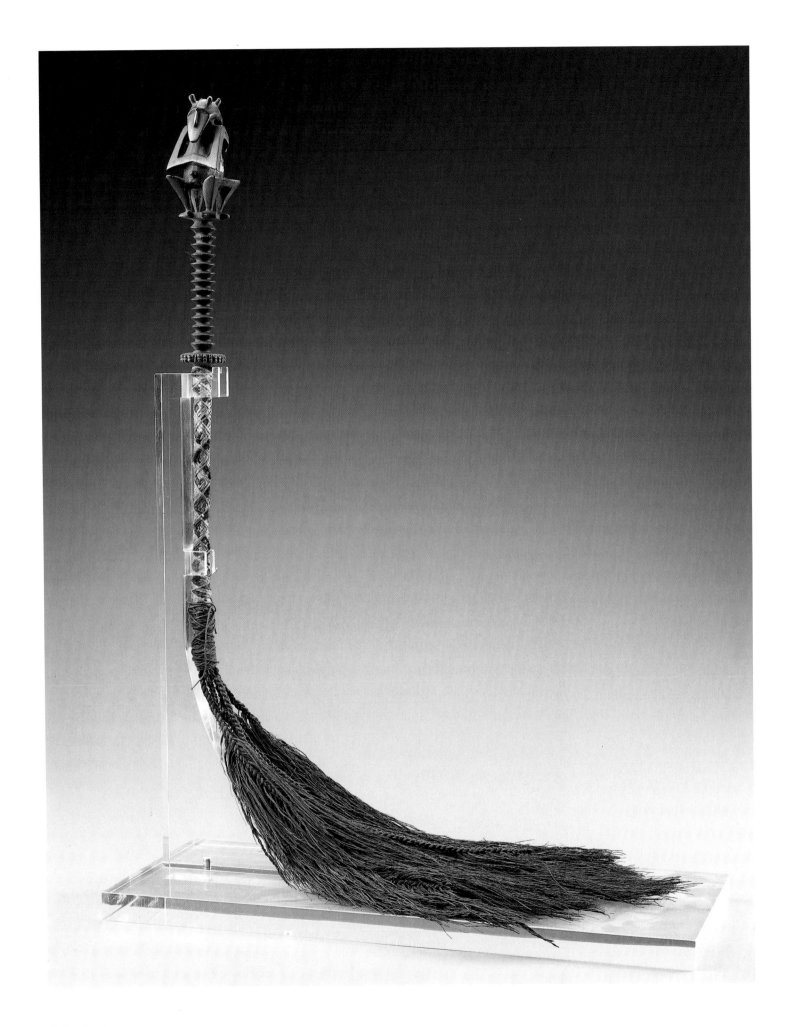

the Pacific islands: "I myself have delivered a fairly large quantity, which I owed to the kindness of the officers of the two expeditions commanded by Freycinet and Duperrey."[2]

Indeed, in the first inventory of the Musée de la Marine, known under the name Duhamel de Monceau, we find, in the preamble to the inventory proper, a list of 21 objects deposited by Férussac. Number 21 is a "Sacred fly whisk used by the priests of the Society Islands to repel insects that settled on the corpses offered in sacrifice to their divinities".[3] While this definition needs to be taken with a certain amount of caution, the religious emphasis does provide precious information about the ritual use of fly whisks. The geographical indication is also to be taken with the same circumspection, since the Society Islands, and in this case Tahiti, were often used as generic terms to define the artistic production of a part of eastern Polynesia. Nevertheless, we do know that numerous artists from the Austral Islands settled in the neighbouring archipelago during the early 19th century and worked on specific commissions. It was, then, possible that pieces from the Austral Islands should turn up in the Society Islands.

That the piece belonged to the Férussac collection is not absolutely certain. However, it is the only fly whisk found in the collections of the Musée de la Marine. As for its historical provenance, Férussac mentions two sources: Louis-Claude de Saulces de Freycinet (1817-1820) and Louis-Isidore Duperrey (1822-1825). The second source would appear to be the more probable. In effect, the list given in the inventory of the Musée de la Marine mentions mainly pieces form Tahiti, New Zealand and the Caroline Islands, all ports of call for Duperrey, whereas Freycinet never stopped at the Society Islands.

Fly whisks were commonly used in Polynesia, mainly in the Society Islands, the Austral Islands, Samoa and Tonga. Like the fan, the fly whisk was used primarily to repel flies. It is reported that the Polynesians, and particularly the people of the Austral and Society Islands, manifested real disgust for these creatures and were careful to prevent them touching their food or their bodies, washing themselves whenever this happened.[4]

Another type of fly whisk was distinguished by its carved handle or handle end. The use of such whisks was governed by a precise code. They served as visible statements of the authority and rank of a dignitary. They were used to signal a presence, manifest authority or punctuate an important speech. In this last instance, they were carried by a spokesman, who served as a herald.[5] Their use was similar to that of the feather wands of Hawai'i (*kahili*) or the ceremonial axes of New Caledonia. It would seem that these fly whisks were also used by priests in certain funerary rituals.

Their forms varied. They could be simple sticks with a few tufts of coconut fibre at the end, or, at the opposite extreme, have a remarkable anthropo-morphic figure carved at the holding end, reproducing the generic motif (used throughout Polynesian art) of the *ti'i* or *tiki*.

The choice of materials used to make these objects was itself codified. Ivory from sperm whales, human hair, feather, stone (jade or nephrite, used for ear pendants and *hei tiki* in New Zealand), tortoise shell, shells (tridacna), all durable materials, bore a special relation to the sacred.

Austral Islands sculpture achieved a high degree of abstraction. The pared down, angular appearance of the compact figure, forming a combination of sharp-angled geometric forms, has replaced the in-the-round sculpture more commonly used in the Society Islands. The simple or Janus-type figure generally stands on a pedestal made up of a series of small discs. There are also rare examples of handles in walrus ivory from the Society Islands. The symbolic motifs probably refer to the myths concerning the foundation of the ruling families (like the Pomare), and are redolent of the superposed figures found on the big Tahitian canoes.[6]

SYLVIANE JACQUEMIN
Translation: Charles Penwarden

1 E.-T. Hamy, 1988, pp. 145-153.
2 *Ibid.*, p. 146.
3 Archives of the Musée de la Marine du Louvre, Duhamel de Monceau inventory.
4 R. Rose, 1997, pp. 161-165.
5 *Ibid.*, 1997, pp. 161-165.
6 *Encyclopédie de la Polynésie*, 1986, vol. V, p. 87.

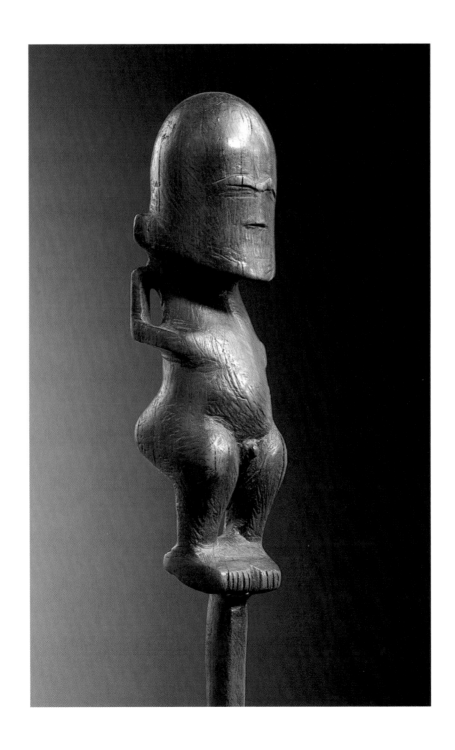

Sculpture from the Society Islands archipelago (Tahiti?)

18th century

Fan handle (tahiri)

Wood (*Casuarina equisetifolia*, Casuarinae)
L. 18 cm
Date of entry into the Cabinet des Médailles et Antiques (Bibliothèque Nationale) unknown
Deposited at the Musée
d'Ethnographie du Trocadéro in 1878; former number M.E.T.: 593
On permanent loan from the Muséum d'Histoire Naturelle – Musée de l'Homme
Inv. M.H. 78.30.8

Main Exhibitions
Paris, 1965, 1972;
Bordeaux, 1996.

Main Publications
*Chefs-d'œuvre du musée
de l'Homme*, 1965, no. 36, p. 117;
La Découverte de la Polynésie,
1972, no. 20; *Voyage vers l'île
mystérieuse*, 1996, p. 159, no. 14.

This is probably one of the oldest Oceanic acquisitions in French collections. However, the date of its arrival in Paris remains uncertain, and could be anywhere between the 1760s and the 1790s. The absence of museums likely to exhibit these kinds of pieces at the end of the 18th century constitutes a major obstacle to the precise dating of their movements.

In this period exotic collections tended to go either to the Muséum d'Histoire Naturelle or to the numerous cabinets of curiosities which combined natural history and ethnography. Moreover, the areas these covered was not the reflection of a special interest in a specific population and its material productions, but simply the result of a natural propensity to accumulate picturesque objects. Thus, in the few inventories we have of these cabinets, it is extremely unusual to find a geographical reference for the objects, let alone the identity of the donors. In fact, the only sure historical source we have to confirm this fan handle's longstanding presence in French collections is its inclusion in the set of works transferred on permanent loan from the Cabinet des Médailles at the Bibliothèque Nationale to the Musée d'Ethnographie du Trocadéro in 1878.

In 1786 the Americanist Dombey donated part of his collection to the Cabinet des Médailles at the Bibliothèque Royale. Although this consisted mainly of Peruvian objects, mention is made of an unusual "wooden idol from Otaïti", numbered 68 in the inventory. This is surprising, since there is nothing to indicate that Dombey went to Tahiti, but it is confirmed in the other inventories made in Lima before the crates were sent to Paris. These mention "several curiosities from Othaiti [and] a few shells".[1]

In 1795 the Muséum des Antiques took over from the Cabinet des Médailles at the Bibliothèque. In 1797 it acquired important ethnographic collections from the *Cabinet* at Sainte-Geneviève, from the Muséum d'Histoire Naturelle and from the Gauthier, Condé and Bertin private collections. Once again, the descriptions of their contents are vague. Nevertheless, mention is made of pieces from Tahiti.[2]

The fact remains that the only people to have disembarked at Tahiti by this time were Bougainville and Cook. The Cook hypothesis can certainly be rejected, but the Bougainville link seems more plausible in light of other accounts from the period confirming the presence of Tahitian objects collected during the voyage.

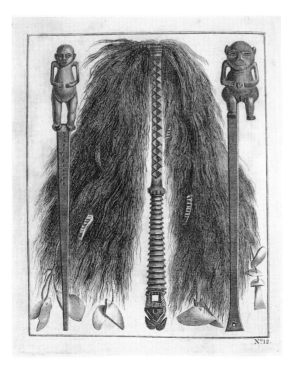

Fig. 1
Plate from *Cook's Voyage*.
*An Account of the Voyages Undertaken
by James Cook*,
vol. II, pl. MDCCLXXIII

There is, however, no factual confirmation for either of these hypotheses, which rest solely on the dates of the travellers' and navigators' expeditions. In 1799, at the death of its curator Barthélémy de Courcay, the Muséum des Antiquités was closed down and the Cabinet des Médailles ceased to register ethnographic collections.

As for the list drawn up by the Cabinet des Médailles in 1879 after its collections were transferred to the Musée d'Ethnographie du Trocadéro, it is hardly any more informative. The "catalogue of Chinese and Indian objects"[3] supplies a list of numbered items with extremely vague descriptions, so that it is almost impossible to identify the piece with any formal certainty.

Fans were common articles and can be found pretty much all over Polynesia. Everyday utensils with an obvious practical function (to counter the heat and keep flies away), they were usually made of woven coconut leaves and had no other form of decoration.

However, there was also another kind of fan which can be clearly distinguished by its sculpted handle. These served as genuine insignia, markers of authority, prestige and rank. They were the symbol and guarantee of chiefdom, aristocracy and priesthood within what were the extremely complex and hierarchical caste systems of Polynesia. These objects were not simple ceremonial accoutrements, they were very real embodiments of power, the support for sacralisation. Hence the care taken in making them. They could be compared to the fly whisks of the Society and Austral islands, the chairs of the Cook Islands, and the chiefs' staves of the Cook, Marquesas, Tonga and Fiji islands, which were inlaid with ivory and often used as weapons. Feather belts (Society Islands) and capes (Hawai'i) were probably supremely sacred items, feathers being intimately linked with the divine.[4]

During the investiture of the king in Tahiti, the priest would point out to him the royal symbols and their position: "Pointing to the pillar, he said: 'the rock of your investiture'; pointing to the wooden headrest on the throne, he said: 'your headrest laid out'; presenting the *tahiri*, he said: 'your fan, nation of peace'. Then came the cap, the stick, the lance and the long feather belt."[5]

The finely carved handles or handle-ends must have fascinated Europeans, so much so that they kept only the proximal part. They are characterised by a figure sculpted in the round from the wood, prolonged by a tip that fits into the triangle or semi-ellipse of the fan itself. These figures are anthropomorphic and represent *ti'i* or *tiki*, gods or deified ancestors. This again confirms their sacred connotations.

Fans were family heirlooms which were passed down from generation to generation. Some of them even had names. They could be carried by both men and women. Some authors also think that these fans were used to set off the decorative tattoos worn on the arms and hands. And indeed, 19th-century prints do show Marquesan women ostentatiously displaying their fans. In fact, one carried these fans in the same way as one "carried power".[6]

SYLVIANE JACQUEMIN
Translation: Charles Penwarden

1 Archives of the Cabinet des Médailles, Bibliothèque Nationale; E.-T. Hamy, 1988, p. 73.
2 E.-T. Hamy, 1988, pp. 76-89.
32 Archives of the Cabinet des Médailles, Bibliothèque Nationale.
4 *Encyclopédie de la Polynésie*, 1986, vol. V, pp. 85-88.
5 A. Babadzan, 1993, p. 279.
6 H. Forment, 1981, p. 102.

Sculpture from Hawai'i

18th century

Sculpture of a god (ki'i hulu manu)

Wicker, aerial rootlets, cordage, feathers, pearl shell, dogs'teeth, wood
H. 67 cm
Collected before 1796 and transferred to the Musée d'Histoire Naturelle at the Musée des Antiques in 1797
Gift of the Bibliothèque Nationale to the Musée d'Ethnographie du Trocadéro, 1878, former M.E.T. no. 10697
On permanent loan from the Muséum National d'Histoire Naturelle – Musée de l'Homme
Inv. M.H. 78.30.15

Main Exhibitions
Paris, 1965; Bordeaux, 1986.

Main Publications
E. von Sydow, 1929, fig. 8, p. 62;
A. Portier and F. Ponceton,
1929, cover and pl. XLIX;
S.M. Luquiens, 1931, p. 34;
M. Leenhardt, 1947, pl. 74.
p. 88; V. Gilardoni, 1948, cover
and pl. 148; A. Malraux, 1952,
pl. 437, p. 751; W. Muenster-
berger, 1955, no. 122;
W. Schmalenbach, 1956, pl. 5;
*Chefs d'œuvre du musée de
l'Homme*, 1965, no. 29, p. 103;
Le Courrier de l'Unesco, 1965,
p. 17; P.S. Wingert (ed.), 1970b,
N 273 (right); *Musée de l'Homme*,
1992, no. 5054, p. 124; *Voyage
vers l'île mystérieuse*, no. 62,
p. 170.

One of the Polynesian treasures at the Musée de l'Homme is a feathered image that served as a receptacle for one of the Hawaiian state gods (*akua*). As a group, feathered images are known as *ki'i hulu manu*, images made of the feathers of birds. The manufacturing techniques were similar to those used in making Hawaiian helmets (*mahiole*). A basketry base of'ie'ie vines (*Freycinetia arborea*) was covered with red feathers attached to a netting made of olona fibre (*Touchardia latifolia*). The red feathers were from'i'iwi birds (*Vestiaria coccinea*) and yellow and black feathers from other honey creepers were used to highlight features of the sculpture. Dogs'teeth lined the mouth and the eyes were inset pearl shell with wooden pupils.[1] These were the most important sculptures in 18th century Hawai'i, not only because of their imposing physical appearance but also because they were difficult to fabricate and the materials used were rare – they activated the whole social system and necessitated the labour of a wide group of people with a variety of skills. Hawaiian aesthetic genius in making use of the colourful avian part of their environment speaks eloquently of their artistic mastery in fashioning objects for sacred and ceremonial use.

Feathered images are often called *Kuka'ilimoku*. Ku, the snatcher of land, was a war god, but the early literature does not mention specific gods in relation to these images. Early visitors who bought or traded these images took them to Europe and did not record this information. Even the journals and other accounts from Cook's voyage do not associate the figures with names of specific gods. During the voyage of the HMS *Blonde* (1824-26), Lord Byron noted that the feathered image given to him by Chief Naihi was called *Keolo'eva* (a war god of the Chiefs of Maui). Reverend Bloxam, on the same voyage, described two feathered images given to him. One was placed in a temple with human bones and the other, adorned with a helmet, was a god of war and black magic.[2] Indeed, the only feathered image specifically associated with Kuka'ilimoku is one in the Bishop Museum in Hawai'i, and that is because it is associated with Kamehameha, whose war god was Kuka'ilimoku.

There are three types of feathered image: those with a crest, those with hair and those with neither crest nor hair, such as the Musée de l'Homme example. Chiefs wore crested helmets into battle, and it is likely that a feathered god carried into battle would be similarly attired. These figures usually incorporate a distended open mouth, the "mouth of disrespect", a violent expression suitable for receptacles into which the various forms of Ku as a war god could be called.[3] Images with human hair may be associated with Lono, god of agriculture, fertility and peace, whose priests wore head coverings of human hair. The facial expression of these images is less violent and can be characterised as pleasant or serene. Images with neither crest nor hair may have been receptacles into which either Ku or Lono could be called.

Several European and American explorers who visited Hawai'i before 1796[4] could have collected this feathered image. Because of its early date and the fact that by the time it was first mentioned in

Fig. 1
Plate (no. 67) from the Atlas
recording Captain James Cook's
third voyage
Bishop Museum, Honolulu

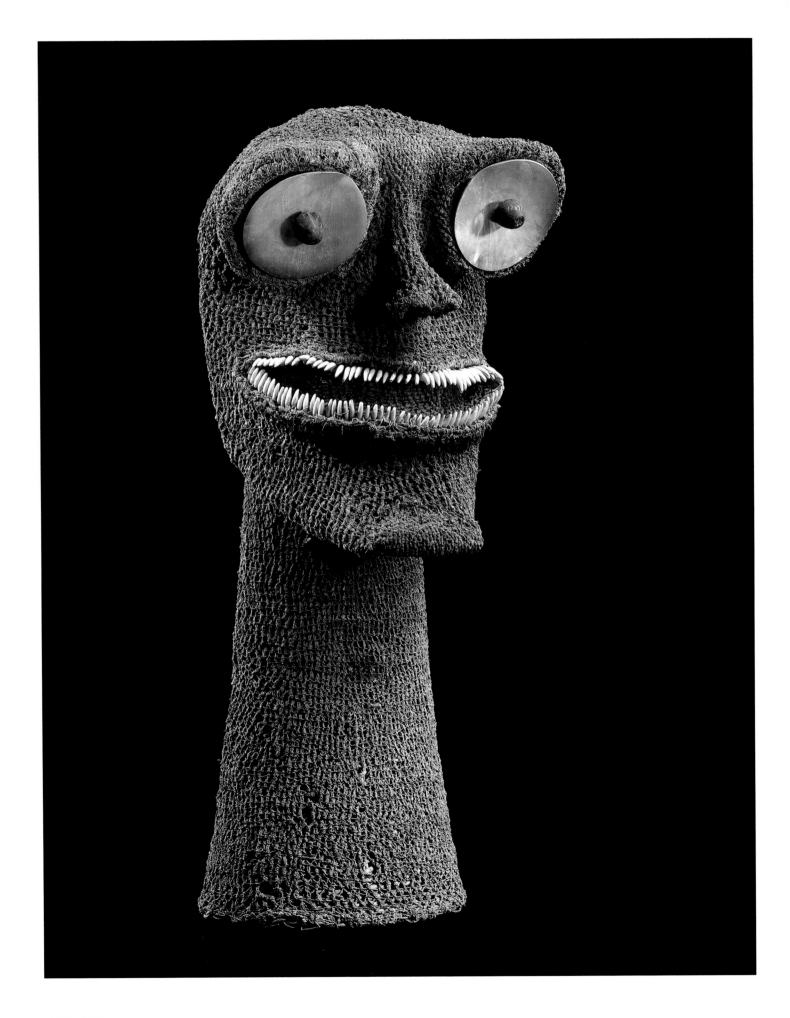

the inventory of the Museum d'Histoire Naturelle (21 July 1796) its feathers had already deteriorated, it has been assumed that it was collected during Cook's third voyage, which visited Hawai'i in 1778 and 1779. Unfortunately, its original documentation is unknown.

During Cook's explorations of the Hawaiian islands, the high chief of the island of Hawai'i was Kalani'opu'u and the high chief of Maui was Kahikili, both of whom were visited. Nearly three months after Cook's arrival off the coast of Hawai'i, on 26 January 1779, Kalani'opu'u made a ceremonial visit to Cook's ships. He did not come on board, however, but indicated that Cook should visit him on shore. The occasion was depicted by John Webber and recorded in the official account of the voyage: "At Noon Terreeoboo (Kalani'opu'u) in a large canoe attended by two others set out from the Village, & paddled towards the Ships in great state. In the first Canoe was Terreeoboo, In the Second Kao with 4 Images, the third was fill'd with hogs & vegetables [...] in the Centre Canoe were the busts of what we supposed were their Gods made of basket work, variously covered with red, black, white, & Yellow feathers, the Eyes represent'd by a bit of Pearl Oyster Shell with a black button, & the teeth were those of dogs, the mouths of all were strangely distorted, as well as other features [...]"[5]

At least eight feathered images were acquired during Cook's third voyage[6] and probably included the four in the canoe with Kao, Kalani'opu'u's priest on this ceremonial occasion. Feathered objects were given away and traded by the chiefs. They were not needed often and new ones could be made. However, in 1819 the gods were overthrown from within, and in 1820 Christian missionaries arrived from America. Feathered images were made no more.

ADRIENNE L. KAEPPLER

1 See P.H. Buck, 1957, for the technology of making feathered images.
2 See R.R. Bloxam, 1824-26. This information is from his notes.
3 See A.L. Kaeppler, 1982.
4 See A.L. Kaeppler, 1970.
5 See J. Cook and J. King, 1784.
6 See A.L. Kaeppler, 1978, p. 53.

Sculpture from Hawai'i

Late 18th century[1]

Sculpture, probably of the god Lono (ki'i akua)

Wood (Apocynaceae)
H. 85 cm
Found in a cave on the island of Hawai'i
Given by Théo Ballieu to the Musée d'Ethnographie du Trocadéro, 1879; former M.E.T. no. 10703
On permanent loan from the Muséum National d'Histoire Naturelle – Musée de l'Homme
Inv. M.H. 79.10.11

Exhibition
Paris, 1972.

Main Publications
Warnod, 1930, fig. 357, p. 327;
H.M. Luquiens, 1931, p. 10;
G. Behm-Blancke, 1955, fig. 5;
P.H. Buck, 1957, fig. 304;
J. Guiart, 1963, no. 400, p. 387;
E. Dodd, 1967, p. 276;
R. Poignant, 1967, p. 50;
P.S. Wingert (ed.), 1970a, N 271;

The *Hawaiian Gazette* for 25 April 1877 noted that a wooden figure had been found in a cave on the slope of Mauna Kea on the island of Hawai'i: "It is cut out from a solid log of some light-coloured wood, probably Mamane, and stands just three feet in height, including pedestal. The image has the usual squat position [...] and the features, especially the mouth, are hideously distorted. The most remarkable thing about the statue is a broad, flat arched projection, springing from the back of the head, extending down in front of the face to about the level of the mouth. From the upper periphery of this projection radiate a number of long spikes."[2]

The figure was acquired by Théo Ballieu, French consul in Hawai'i, and sent to Paris. It probably was included in an exhibition of Hawaiian pieces owned by Ballieu at the Musée des Missions Ethnographiques in 1878[3] and became part of the Musée d'Ethnographie du Trocadéro in 1879. During the 1870s and 1880s interest in old Hawaiian traditions

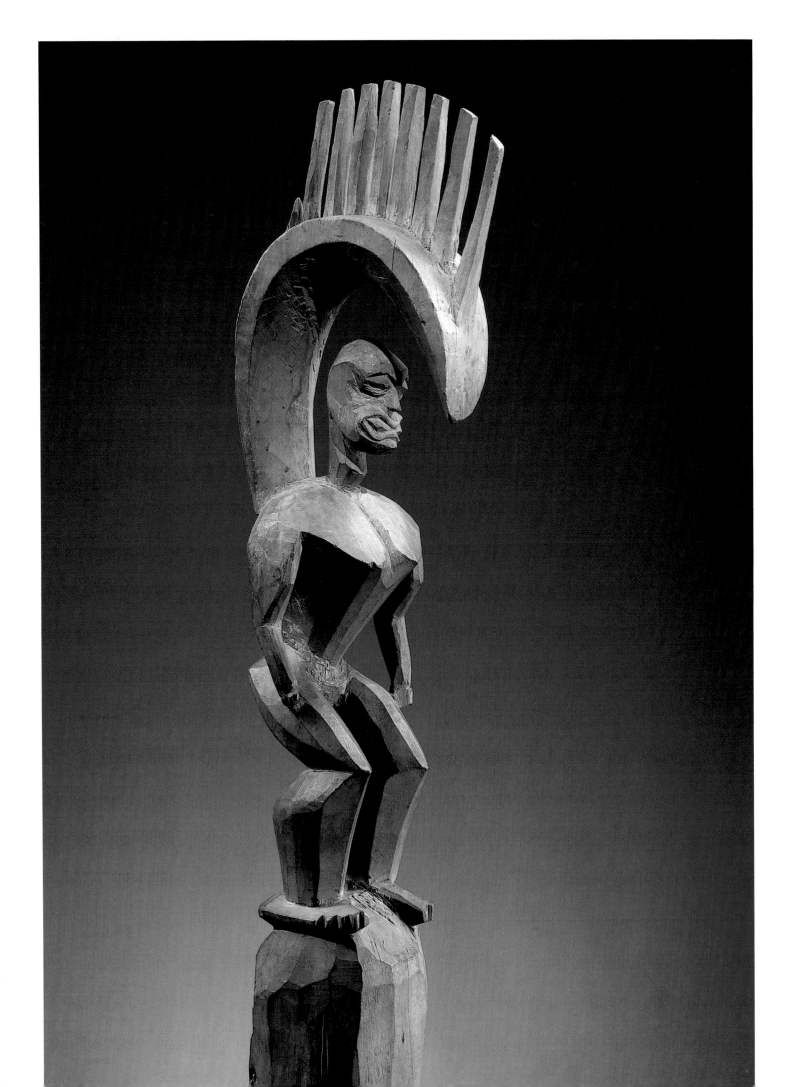

La Découverte de la Polynésie, 1972, no. 175; J.H. Cox and W.H. Davenport, 1974, p. 132; A.L. Kaeppler, 1982, p. 89; A.L. Kaeppler, C. Kaufmann and D. Newton, 1993, fig. 299, p. 412.

and traditional objects was rekindled by King Kalakaua (reigned 1874-1891) and his semi-secret society called Hale Naua, as well as by resident and visiting foreigners. About the same time, a number of important Hawaiian figures were found in caves and other hidden areas. Several of these figures became part of museum collections overseas, including in France and Germany. A figure very similar to this one was given by King Kalakaua to the Mormon church (fig. 1) and is now in the collection of the Temple Square Museum in Salt Lake City.[4]

The Paris figure is noted in the Musée de l'Homme catalogue as Pele, the volcano goddess. This is unlikely, as Pele manifested herself as the volcano itself and was not invoked through carved figures. Gods rendered into visual form were the state gods (akua) Lono and Ku, gods of peace and war, as well as a number of lesser gods (aumakua). Sculptures were not considered the gods themselves but their symbolic physical qualities were probably calculated to lure the spirits of the gods invoked. It is most likely that the Paris statue was a temple figure into which Lono could be called.

Lono was a social metaphor for the importance of genealogy and of the family that works together in peace and harmony, manifested in agriculture and other peaceful pursuits. In contrast, Ku was a social metaphor on a larger scale in contexts that emphasised competing groups, such as warfare. Lono and Ku were symbolic of these conflicting social forces and were manifested visually in sculpture as the genealogical backbone of Lono and the "mouth of disrespect" of Ku.[5]

The Hawaiian word for backbone is iwikuamo'o, which also means family. One traces genealogy in steps, just as one can follow the step-like vertebrae of the spine. An image that has a definite association with Lono and a specific ceremony is the pole image of Lono-makua illustrated by John Webber during Cook's third voyage. The only existing pole image, now in the Bishop Museum in Honolulu,[6] has joints carved at intervals and a head carved at the upper end, exactly as described by the Hawaiian historian

David Malo for use during the Makahiki, the harvest festivals: "This Makahiki idol was a stick of wood having a circumference of about ten inches and a length of about two fathoms. In form, it was straight and staff-like, with joints carved at intervals [...] and it had a figure carved at its upper end."[7]

An abstract backbone, along with an abstract head, were all that were necessary to symbolise the essence of genealogy and of Lono. The backbone was sacred, as was the top of the head, and some Hawaiian sculptures have vertebrae extensions elaborated as a crested overarch as in the example in the Musée de l'Homme. The crested overarch of this figure incorporates an abstracted extension of the spinal column that protects the top of the head. Further, its face and Adam's apple is virtually identical to the Bishop Museum pole figure of Lono. Hawaiian images were often androgynous rather than distinctly male or female, although these also occurred. Wooden figures, known generically as ki'i, included ki'iakua, receptacles into which the state gods were called in the interest of the state, and ki'i 'aumakua, receptacles into which the lesser gods were called for family, personal, craft or sorcery reasons. This figure is most likely a ki'i akua from the outdoor temple (heiau). An indication of this is its bent knees and straight back, thought to be a visual objectification of ritual movements performed on heiau.[8] This stance objectified the movements of the priests (kahuna) as they moved about "with bent knees to the voice of the drums being sounded in the hale pahu'(drum house) and the words of a prayer.[9]

Hawaiian heiau and the sculptural representations of the gods fell into disuse in 1819, when Hawaiians overthrew their state religious system and many of the sculptures were hidden in caves. What remains of heiau are mute walls and platforms, while the images of the gods have been rediscovered and now reside in museums.

ADRIENNE L. KAEPPLER

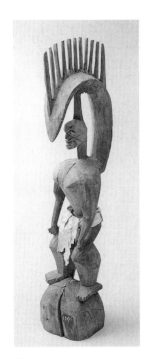

Fig. 1
Sculpture from Hawai'i in the Temple Square Museum, Salt Lake City

1 The carbon-14 dating done on wood from this sculpture in 1999 by Dr Georges Bonani of the Eidgenössische Technische Hochschule, Institut für Teilchenphysik in Zurich yielded the following results: ETH-20612: 175 +/- 40 B.P.; ∂C-13 (%): -23.6 +/- 1.1; periods calibrated: CE 1659-1823 with a probability of 70.7%, CE 1832-1883 (this period should be pushed

back to 1877, the year when this sculpture was found in Hawai'i before being acquired by the Musée d'Ethnographie du Trocadéro two years later), with a probability of 10.9%.
2 Quoted in R.G. Rose, 1978, p. 279.
3 P. Peltier, 1984, p. 100.
4 See A.L. Kaeppler, 1979, p. 13.
5 See A.L. Kaeppler, 1982.

6 See ibid., figure 3
7 D. Malo, 1951, p. 143.
8 See A.L. Kaeppler, 1993.
9 Quoted in S.M. Kamakau, 1976, p. 143.

Easter Island (Rapanui)

In 1722 Jacob Roggeveen discovered an inhabited island in the east Pacific which he dubbed Easter Island. In 1888 the island was annexed by Chile under the name of Isla de Pascua. As for the islanders themselves, who had never put a name to their land, they adopted Rapanui ("Big Rapa"). Rapa was one of the Austral Islands in French Polynesia. Today, the islanders refer to themselves as the Rapanui.

Rapanui is very small (165 square kilometres) and extremely remote (3,800 km from the Chilean coast, 2,500 km from the Gambier Islands) territory. Its population dates back to between 500 and 1000 CE. In cultural terms, this isolated human outpost is closest to eastern Polynesia.

The Rapanui economy was based on fishing and horticulture. It had to adapt to the island's cool climate and to the disappearance of trees in the 16th to 17th centuries. As elsewhere in Polynesia, the *ariki mau*, a leader of divine ancestry, passed on his title and rights to his oldest son. The hereditary aristocracy was at the head of numerous territorial units (*mata*), which were organised in two opposing confederations. The lineages of each *mata* possessed a narrow strip of land (*kainga*) reaching from the fishing areas off the coast into the hinterland. Before the 17th century, the lineages would display their power by building a monument (*ahu*) surmounted by giant stone statues (*moai*). Temporal power was in the hands of the warrior chiefs, the *matatoa*. They vied for supremacy in the "bird-man" competition, the winner of which was given, for that year, the same powers over nature as the *ariki*.

The priesthood was also drawn from the nobility. They comprised the *ivi atua*, the wizards and medicine men, and the *maori* or *tahonga*, who were experts in all matters but particularly sculpture and *rongorongo* writing. The more thankless tasks were performed by commoners, the *hurumanu*, and the *kio*, prisoners who were at everyone else's beck and call.

The arrival of Europeans in the 18th century caused an upheaval in the cosmogony and demography of the Rapanui. The first Easter Island sculptures reached Europe after the voyage of James Cook (1774). Relations grew apace in the 19th century, mainly with whalers. In 1863 several hundred Rapanui were deported to Peru. Between 1864 and 1868 conversion to Christianity ran parallel to epidemics. Then, in 1871, conflicts between a colonist and missionaries led to the departure of the latter, along with many of the inhabitants. In 1882 the population stood at only 150. Today it is approximately 3,000, of which 2,500 are of Rapanui origin.

CATHERINE AND MICHEL ORLIAC
Translation: Charles Penwarden

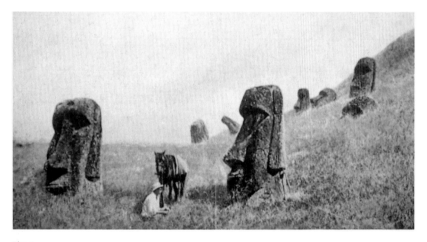

Fig. 1
Monumental heads on Easter Island
Photograph illustrating Georges Salles'text
"Une sculpture de l'île de Pâques, à Paris"
Cahiers d'Art, 4-5, 1927

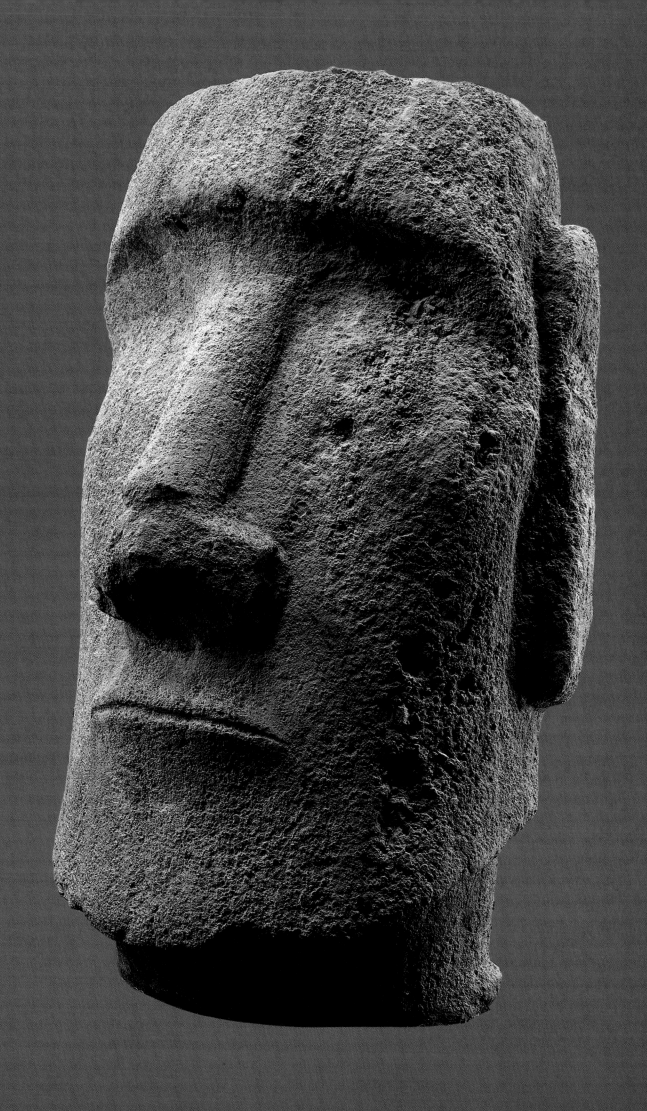

Sculpture from Easter Island

11th-15th century
Anakena Bay

Monumental head (*moai*)

Basaltic tuff
H. 170 cm
Piece brought back by the Métraux-Lavachery expedition
Gift of the Chilean government to the Musée de l'Homme, 1935
On permanent loan from the Muséum National d'Histoire Naturelle – Musée de l'Homme,
inv. M.H. 35.61.1

Exhibition
Paris, 1965, 1995-99.

Main Publications
T. Lavachery, 1935, p. 84-85;
M. Leenhardt, 1947, p. 112,
pl. 96; *Chefs-d'œuvre du musée
de l'Homme*, 1965, no. 39, p. 123;
J. Guiart, 1963, fig. 388, p. 37.

In 1934, France and Belgium mounted a scientific expedition to Easter Island overseen by the Musée de l'Homme in Paris. It was directed by Alfred Métraux, who was to make an in-depth ethnographic study for the French, and Henri Lavachery, who had been mandated by the Belgians to carry out archaeological research. A month after their arrival on Easter Island, in September 1934, Lavachery was exploring the surroundings of the ceremonial site of Anakena, in the northeastern part of the island, where he discovered a monumental head. "On the other side of the beach, at the foot of the first hill, lies the third Ahu Anakena group. They are royal *ahus* [...] the glory [of the second *ahu*] was its statues [...] we excavated at the spot where the sloping platform enters the sand. And that one morning is where we discovered [...] the head that is now at the Trocadéro museum. One of the ears was sticking out, but I was struck by the very particular form of this stone. The head was revealed after an hour of effort. It was a great day, which I celebrated with Métraux that evening."[1]

A few months later, this sculpture from the Nau Nau *ahu*[2] was hauled on board the *Mercator*. "[...] wrapped in a big hemp net then placed on a sled and dragged a hundred metres to the shore [...] the statue was then dragged underwater from the study ship, using the capstan. When it reached a sufficient depth, a dinghy [...] positioned itself above the head. We were able to attach the hemp rope to its spars [and] attached to the ship by a rope, the dinghy was slowly pulled to the side [...] It was taken out of its net, which was tied by straps to a hoist set on the foreyard. Soon we had raised the Anakena head. It and its sled were hauled over the ship's rail at around midday on 20 December. In all it had taken us some thirty hours."[3]

Carved from the soft rock of the Rano Raraku volcano,[4] the sculpture must have been about 5 m high. The head, which represented about two fifths of the whole, is long and narrow, almost rectangular. The top of the skull is flat[5] and its morphology recalls that of the *moai* of the Nau Nau *ahu* with their large headdresses in red tuff, or *pukao*. The forehead is low with marked eyebrows. The eye sockets are not hollowed, as is the case with the others statues on the Anakena platforms. The nose, the tip of which is broken, is straight at the nostrils, these being indicated by two circular holes. The small, pursed mouth recalls the characteristic moue of the sculptures from the so-called *ahu moai* period, between the year 1000 and the end of the 15th century.[6] The chin, which is delimited by angular edges, shows the piece to be in good condition. The ears are fine and stylised, with a highly elongated lobe. There are traces characteristic of work with a stone adze on the back and behind the left ear. The face has traces of a white colorant, possibly obtained by soaking *Sapindus saponaria* roots[7] or made from gypsum (going by the analysis of the colorant found an other *moai* from the Tongariki *moai* and on the rock paintings of the north coast).

The *moai* probably represents a god or deified ancestor of a family group. It was raised on a ceremonial platform called an *ahu* which served as a clan shrine and receptacle for the bones of ancestors. The *ahu* was an eminently sacred spot on which stood one or more statues, depending on the social importance of the group who occupied it. The Nau Nau royal *ahu*, which was restored in 1978 by Sergio Rapu, now has seven *moai* with their backs to the sea, facing what was once the meeting place and site of the lineage's houses and gardens, which they protected with their gaze.

CATHERINE AND MICHEL ORLIAC
Translation: Charles Penwarden

1 H. Lavachery, 1935, p. 128.
2 A. Sköjlsvold, 1994, p. 9.
3 From the account given by Thomas Lavachery (1995, pp. 28-29), based on his great grandfather's notes.
4 This rock is a finely stratified and light sideromelane tuff (density < 1.7). See C. Royer, 1993, p. 187.
5 There are three cupules on the top of the head.
6 The Rapanui began building raised platforms (ahu) as soon as they settled on the island. On them they placed statues (moai) made of basalt or scoria. These were smaller and more naturalistic in style than those they erected later, around the year 1000, at the architectural apogee of the ahu moai (platforms with statues). The main period for the production of statues in the standardised style was between the year 1000 and the late 15th century.
7 A. Métraux, 1971, p. 17.

Sculpture from Easter Island

17th-18th century

Breastplate (rei miro)

Wood (Sophoro toromiro, Fabaceae)
L. 46 cm
Gift of Prince Roland Bonaparte to the Musée Ethnographique du Trocadéro, 1887;
formerly numbered M.E.T.: 21500
On permanent loan from the Muséum National d'Histoire Naturelle – Musée de l'Homme
Inv. M.H. 87.31.75

Exhibition
Paris, 1965.

Main Publications
S. Chauvet, 1935, fig. 83; Chefs-d'œuvre du musée de l'Homme, 1965, p. 124, fig. 40; C. and M. Orliac, 1988, p. 746; Bois à cœur ouvert, 1990, fig. 4, p. 68; C. and M. Orliac, 1995, p. 76.

Rei is a common Polynesian term used for a kind of neck ornament that used to be made from the tooth of a sperm whale. According to Alfred Métraux, it was also used to designate the pearl oyster. On Easter Island, as throughout Polynesia, the name miro refers to trees and, more specifically, to wood. The rei miro is thus a pectoral ornament in wood.

The Musée de l'Homme's rei miro is flat, adorned at each end by an anthropomorphic sculpture carved in relief. This narrow, curving and pointed form represents a human head with an aquiline profile and thin chin. The face, with its hollowed eye, [1] two thick eyebrows and grimacing mouth, is not dissimilar to those of the moai kava kava.

On the smooth, slightly convex side of the rei miro there are two suspension holes made through two very worn bumps. A crescent-shaped hollow is carved in the other side, which also shows signs of wear. Its significance remains a mystery. It is unlikely to have been shown by the wearer: some rei miro carry rongorongo inscriptions on the other side, and if these were to be visible, it follows that the side with the cavity could not be.

The Musée de l'Homme breastplate can be described as medium-sized if we compare it to the other rei miro collected between 1867 and 1886. Their dimensions vary considerably, from 28 to 92 cm long and 10 to 30 cm wide, with an average length of 40 to 60 cm and width of 10 to 15 cm.

With the exception of a whalebone piece at the Bishop Museum in Hawai'i, these objects are generally fashioned from wood. Most of them are decorated with human heads at their extremities (Avignon, inv. 16802; Cologne, inv. 32601; London, inv. 6847), a few with stylised shell motifs (Avignon, inv. 16800; Oslo, inv. 2437) and one, in the Ratton-Ladrière collection, Paris, with two cockerel heads. The form of the breastplate may evoke the body of an animal such as a fish (Göttingen, inv. OZ 1546; Berlin, inv. VI 24947) or a cockerel (Bishop Museum, inv. 3642).

Rei miros incised with rongorongo motifs are rare.[2] The one held at the Australian Museum in Sydney, collected by Weisser when the Hyäne made landfall at Easter Island, bears the following inscription: "Rei miro, breastplate of the king of Rapanui 1882, dating back 250-300 years. Gift of A.A. Salmon, Rapa nui 23.9.82 [...] belonged to the chief of the Hangeto tribe, 19-23 September 1882."

Finally, it should be noted that one of the rongorongo signs has the same shape as a rei miro. It can be seen on the two tablets in Saint Petersburg, on the large tablet in Santiago and on the so-called "Marimari" tablet.[3] The morphology of this sign is the same as for the petroglyphs observed by Georgia Lee on the site of Hua, in the cave on the islet of Moto Nui and at Orongo, where it is sometimes combined with the head of the god Make Make.[4]

A number of authors have put forward the hypothesis that the form of the *rei miro* alludes to the large double canoe used by the first settlers, but this looks rather unlikely[5] in the light of the information collected by Young in 1888.[6]

These breastplates were worn by men and women of the aristocracy for certain dances.[7] The women's ones were probably smaller[8] and were called *rei mata puku* ("chicken embryo"). The *rei miro* was also a sign of royal authority; during ceremonies, the king of the island wore two of them on his chest and two on his shoulders.

There is no equivalent of the *rei miro* in Polynesia. However, it may have derived from the mother-of-pearl ornaments that are widespread there. Certainly, it has affinities with the breastplates used in Tahiti as parts of mourners'costumes.

CATHERINE AND MICHEL ORLIAC
Translation: Charles Penwarden

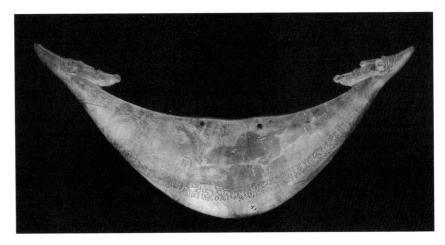

Fig. 1
Rei miro with *rongorongo* motifs
17th-18th century (?)
British Museum, London, inv. 9295

1 The eye cavities with their steep sides may have contained two discs of obsidian as pupils.
2 This is the case with the *rei miro* in London (inv. 9295).
3 S.R. Fisher, p. 476 (sign 17V5), p. 480 (sign 18R3), p. 445 (sign 9R3), p. 447 (signs 9V1 and 9V2); A. Métraux, sign 63 of the Aruku-Kurenga tablet, pp. 407-411.
4 All the *rei miro* petroglyphs identified by G. Lee have tips in the form of a half-moon, as on the *rongorongo* signs, with the exception of the one on the island of Motu Nui, the extremities of which are adorned by cockerels'heads (see G. Lee, p. 40 and pp. 101-102). This figuration evokes the *rei miro* in the Charles Ratton collection (see *L'Île de Pâques: une énigme?*, 1990, p. 215).

5 This argument was put forward by S. Chauvet in 1935. However, comparing the *rei miro* petroglyphs with the boat ones (see G. Lee, pp. 40-41) it is clear that the breastplate does not represent a canoe with a decorated prow and stern. According to A. Métraux (1971, p. 233), there is no evidence to support this hypothesis. It seems far-fetched indeed to compare the Easter Island *rei miro* with figures engraved in the stone of the Peruvian site of Tiahuanaco (see T. Heyerdahl, 1976, p. 197).
6 "These objects are furnished with holes for strings to enable them to be worn as breastplates on ceremonial occasions. Hence the native name *rei* (breastplate). But they were also called *rei-marama* (marama, moon) and the old natives declared that the shapes of the

different crescents were meant to represent different phases of the luminary and were worn at feasts held at the time of the planting of the Kumara [sweet potatoes]."
7 According to Palmer's account from 1868, the men when dancing used a "crescent-shaped breastplate made from hardwood, each extremity ending with a head; the concavity was turned upwards, and the profile of the faces on the oldest breastplates is very aquiline."
8 According to K.S. Routledge (1920, p. 268), the *rei miro* "was a specifically feminine attribute, but small *rei miro* may have been worn by Ngaara (the island's last king)."

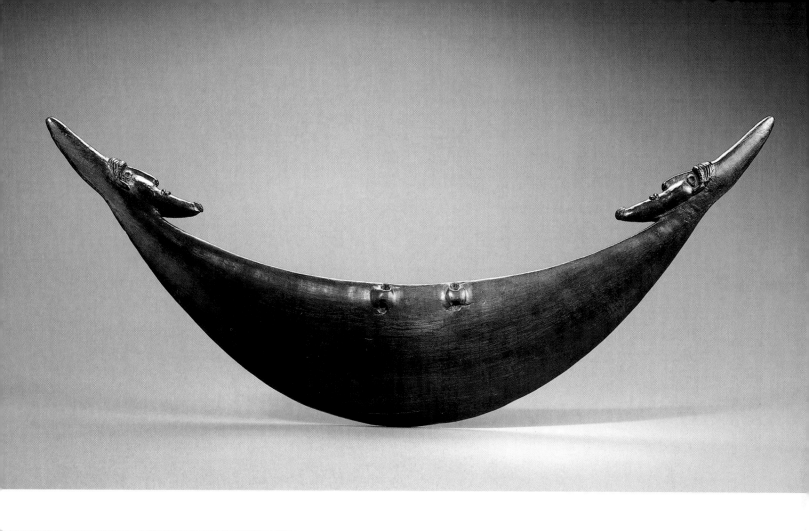

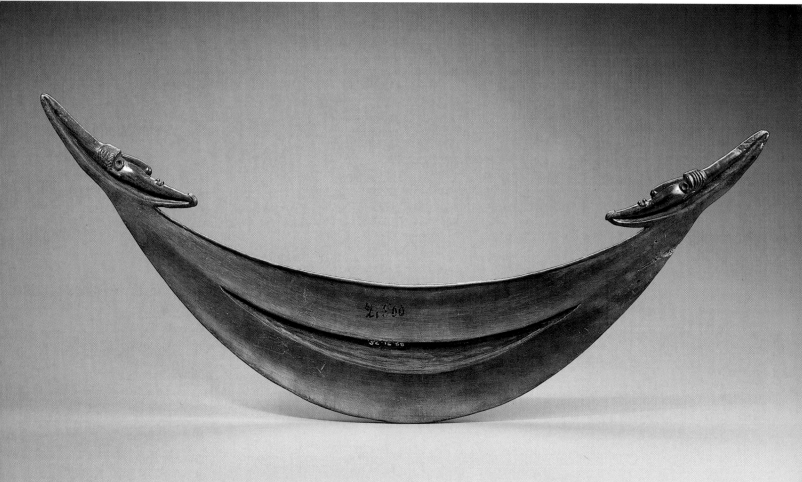

Sculpture from Easter Island

17th-18th century (?)

Male figure (*moai kavakava*)

Wood (*Sophora toromiro*, Fabaceae), obsidian, bone
H. 30 cm
Work collected between 1842 and 1843 by Captain Collet; recorded in 1845
in the Louis-Philippe inventory
Musée National des Arts d'Afrique et d'Océanie (collection of the Musée des Antiquités Nationales)
Inv. SG 53.288

Exhibition
Paris, 1992-93a.

Main Publications
S. Chauvet, 1935, pl. XLIX,
fig. 132; S. Jacquemin, 1992,
p. 75; A.L. Kaeppler,
C. Kaufmann and D. Newton,
1993, fig. 68, p. 117; C. and
M. Orliac, 1995, p. 61.

In 1842-1843, Lieutenant Commander Collet, then in a special posting in the Marquesas Islands, acquired a number of objects from Easter Island, including two figures with protruding ribs (*moai kavakava*) and a female sculpture (*moai papa*). Recorded in 1845 in the Louis-Philippe inventory, these objects come from the short stopover at Easter Island made by the *Vénus*, under the command of Abel Aubert Dupetit-Thouars, on 25 February 1838. The ship stayed out to sea but welcomed several Easter Islanders on board for the customary exchange of gifts.[1]

The most striking feature of Collet's statuette is its very visible rib cage. Ribs (*kavakava*) evoke revenants. According to Father Roussel, a missionary on Easter Island from 1865 to 1871, these ghosts manifested themselves in the form of "a kind of spectre with no head and only ribs". The Rapanui appealed frequently to the priest to ward off "these evil spirits that took the form of their father or of their mother, that tormented them and tore at their guts"[2] A myth collected by A. Métraux concerning the origins of the *moai kavakava* describes the two spirits, *akuaku*, seen in their sleep by Tuu-ko-Ihu, the father of the arts in the Easter Islands, who sculpted the first images in piece of *toromiro*,[3] as "ribs and bones, without bodies".

In keeping with the legend, this *moai kavakava* shows not only its ribs, but also part of its skeleton in the pronounced arch of the eyebrows, the protuberant cheeks and sharp chin. The skin of the face seems to be stretched over the bones. The clavicles, shoulder blades, spine and pelvis are also very prominent. However, the lower part of the body is rather fleshy, with a round belly and buttocks and full thighs and calves. The distended ear lobes, probably a sign of great age, are pierced by a disc-shaped ornament, a social attribute which connects the *kavakava* with the world of humans.

This statue may represent the metamorphosis that accompanies the passage from this world to that of the dead. The curve of the body, obtained by a marked bending of the spinal column at the level of the dorsal vertebrae, can also be found on two kinds of hybrid representations with conspicuous ribs: the lizard-men (*moko*) and the bird-men (*tangata manu*). This curve is characteristic of petroglyphs representing birds seen in profile. It also occurs on statues of men wearing bird masks,[4] or of bird-men.[5] The ribcages of these composite creatures are marked with ambiguous carvings in relief: wing-shaped ribs or hands; their arms are transformed into wings.

The break in the cervical curve whereby the head of the Collet statue is redressed also recalls the position of the head of the frigate bird, which was associated with Make Make, the god who created all things. Like the neck of the bird, the necks of most of the *kavakava* tend to swell in the middle and form a slight ridge. The *moai kavakava* might therefore represent an ancestor in the process of mutating into an ornithomorph.

Collet's *kavakava* belongs to a family of objects whose sixty or more authenticated members[6] are kept in collections all over the world. The first *kavakava* were acquired during Cook's second voyage in 1774, but Collet's is one of the eleven oldest known examples. A number of its features set it apart from the typical objects in this category: it is rather small (30 cm high, against an average of 43 cm), has no lumbar ring and no perforations on the excrescence of its nape; its teeth are not represented, nor is its navel. There are no bony contours at its wrist and no grooves separating its toes from the rest of the foot. Its skull is simply decorated with a double volute.

The large population of *moai kavakava* displays a clear thematic unity, but with numerous individual variations. The most obvious ones concern the figures adorning the skull of most of these sculptures: volutes, hair, bearded human heads, birds, lizards, fish, octopus, starfish, lobster, porcelain, etc. These glyphs could be the distinguishing marks for a particular lineage, society or some other form of social subdivision. Other differences are due to the talent of the sculptor-priests and, probably too, to the manifestation of territorial identities, even on an island as small as this one.

Finally, the long tradition of wood sculpture on Easter Island is also a key factor in the variety of styles. The oldest proofs of its existence go back to

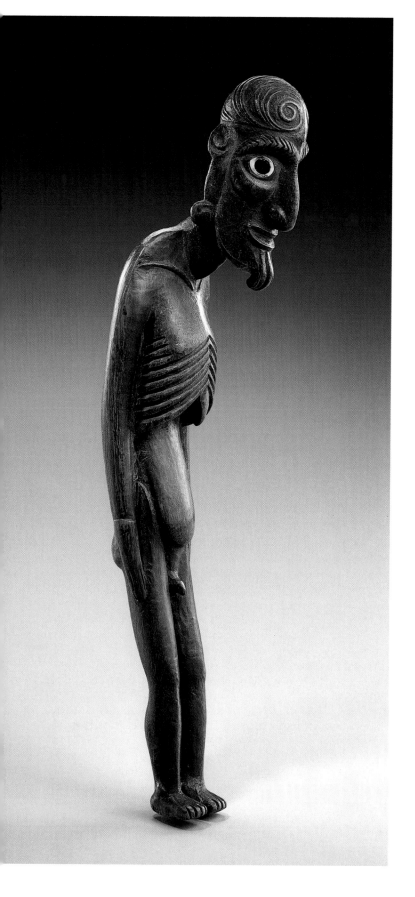
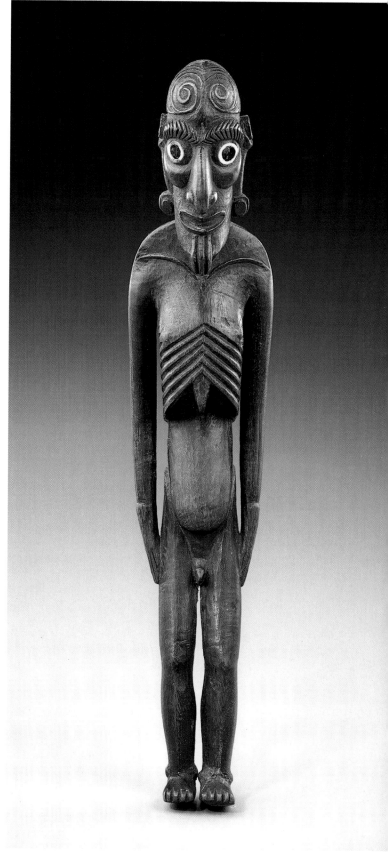

the 13th-14th centuries.[7] The way these statues were looked after, and the deep shine that many of them have gained through use give reason to believe that they were handed down from generation to generation and that some of them were kept for many centuries.

CATHERINE AND MICHEL ORLIAC
Translation: Charles Penwarden

1 A. Dupetit-Thouars, 1841.
2 H. Roussel, 1869, p. 9.
3 A. Métraux, 1971, pp. 260-261.
4 T. Heyerdahl, 1976, pl. 40-41 (London, Museum of Mankind, inv. 1928.5.17.1).

5 T. Heyerdahl, 1976, pl. 38-39. (Saint Petersburg, Peter the Great, inv. N 739-204).
6 They were not made to be traded with sailors.
7 The little discs of obsidian forming

the pupils of the wooden *moai* come from structures containing the materials from the cremation of corpses. These date from the 13th-14th centuries (see J. Seaver, 1993, p. 192).

Sculpture from Easter Island

17th-18th century (?)

Female anthropomorphic sculpture (*moai kavakava*)

Wood, obsidian, bone
H. 34 cm
Work brought back from Tahiti by Captain Méry of the colonial infantry.
Bequeathed to the Musée Calvet by E. Raynolt in 1922
Musée Calvet, Avignon
Inv. 16745

Exhibition
Bordeaux, 1996.

Main Publications
J. Gagnière, 1971; F. Forment, 1993, fig. 133, p. 209; *La terra dei Moai*, 1995, p. 146; *Voyage vers l'île mystérieuse*, 1996, p. 103 and index p. 218, fig. 282; C. and M. Orliac, 1995, p. 35 and p. 65.

Seven Easter Island objects – four anthropomorphic sculptures and three *rei miro* pectoral ornaments from the collections of Captain Méry – were bequeathed to the Musée Calvet in Avignon by E. Raynolt in 1922.[1] Joseph Méry, a captain in the naval artillery, took part in an expedition to Rapa (Austral Islands, French Polynesia) on the *La Touche-Tréville*. During this expedition, on 28 April 1867, he drafted a request to make the island a French protectorate.[2] Méry thought that the inhabitants of Rapa originated from Easter Island.[3] Méry probably acquired his Rapanui objects in Tahiti from Picpus missionaries, as did other collectors at the time.[4]

Méry's rangy, twisting figure follows the contortions of a branch.[5] The standardised sculptures (*moai tangata*: young men; *moai papa*: flat woman figure; *moai kavakava*: old man with protruding ribs; *moko*: lizard-man) were carved from logs or flitches cut from regular trunks. These were sometimes chosen for their curve when the artist was

representing composite entities (*kavakava, moko tangata manu* or bird-man).

Easter Island's scant ligneous flora was completely destroyed in the 1880s by thousands of sheep. Before that time, however, there were always enough trees and shrubs to meet the needs of sculptors.[6] The use of twisted wood was not, therefore, imposed by shortage. Twisted branches were chosen to represent rare beings from the protean family of *akuaku* (supernatural beings[7]), as well as several bird-men,[8] with their folded legs to the fore, like those of this woman with protuberant ribs.

Méry's statuette, indeed, combines the characteristics of the female *moai papa* with those of the *moai kavakava*, which were usually male. The morphology of the raised, hollowed thorax, with its fourteen pairs of very visible ribs, is very much that of the *kavakava*, as is the shape of the spinal cord which ends with a lumbar disc. In contrast, the breasts are more pendulous than those of the

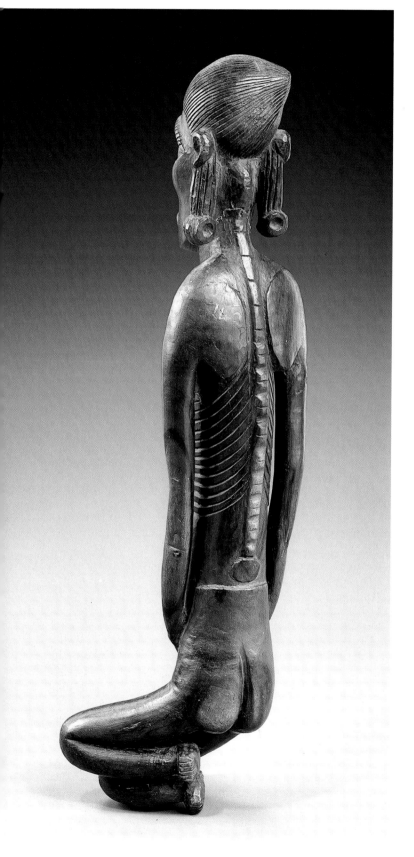
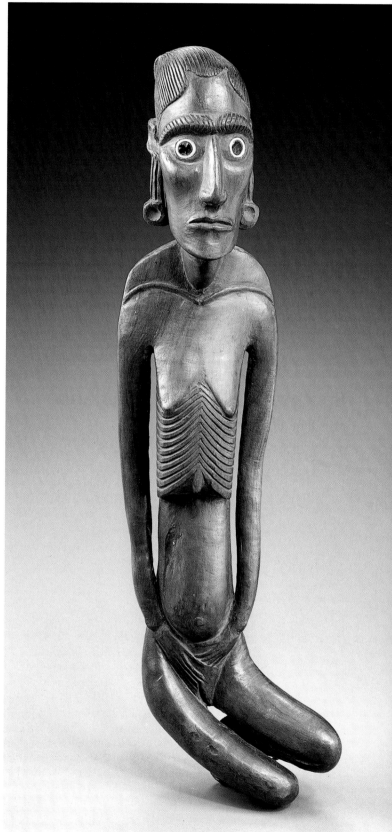

masculine figures. The architecture of the head, which is less bony than that of the *kavakava*, is very much that of the *moai papa*, but the ear lobes are distended here, as in the case of the protruding rib sculptures, and the neck has the same curve as these figures. The asymmetrical conical hair is characteristic of one of the two types of *moai papa*.[9] The crossed hands joining on the pubis are not intended to hide the sex, which the figure's position does not reveal anyway.

The Méry sculpture clearly illustrates the transformative aspect of Easter Island art and the concept, found frequently in Polynesia, of the plural essence of supernatural entities and, no doubt, of human beings too: hence the double bodies, double heads, ambiguous sexual characteristics and mixtures of human and animal features. Thus the very classical *moai papa* in Saint Petersburg[10] wears a goatee, as does the one in Belfast, which also has a penis. The Méry statuette, which expresses the links between bird man, *moai kavakava* and *moai papa*, might also represent an avatar of a given being in the process of metamorphosis.

CATHERINE AND MICHEL ORLIAC
Translation: Charles Penwarden

1 J. Gagnière, 1971.
2 P. O'Reilly and E. Reitman, 1967 (see references nos. 2269-70 and 6474).
3 J. Méry, 1867.
4 J. Gagnière, 1971.
5 This may be in Pacific rosewood (*Thespesia populnea*). From Catherine Orliac's examination of the object at the Bordeaux exhibition using a magnifying glass.
6 Trees disappeared in the 16th or 17th century, but there were still plenty of shrubs when the missionaries arrived (see C. Orliac, 1998).
7 See T. Heyerdahl, 1976: Leiden, inv. 547.N3; Hamburg, inv. 3778b; Leipzig, inv. PO436.
8 See T. Heyerdahl, 1976: London, inv. C.C. 1979; Oslo, inv. 2438; Bremen, inv. D 319; Paris, Ratton coll. n. n; Cologne, inv. 40586.
9 The bare skull of the other type sometimes has glyphs on it, as does that of the *moai tangata* and the *moai kavakava*.
10 See T. Heyerdahl, 1976: Saint Petersburg, inv. 402-1.

Sculpture from Easter Island

17th-18th century (?)

Male anthropomorphic sculpture (*moai tangata*)

Wood (*Sophora toromiro*, Fabaceae), obsidian, bone
H. 46 cm
Gift of the chief doctor Aze, 1872
On permanent loan from the Musée National de la Marine (formerly Ecole de Médecine Navale, Rochefort)
Inv. 39 EX 28 D

Exhibition
Bordeaux, 1996.

In 1872, Doctor Aze donated four objects from Easter Island to the naval medical school in Rochefort, namely a stone head, insignia of rank (*ua* stick) and two anthropomorphic sculptures, one feminine and the other masculine. The first class surgeon Joseph Théophile Alfred Aze[1] was the head of the health department in Tahiti from 1868 to 1872. In this capacity, his monitoring of the health of two to three hundred Rapanui who were expatriated to the island in 1871[2] meant having frequent contacts with the missionaries who had taken them away from their island. Aze probably acquired his objects from the preachers or their flock, though he may also have obtained them on board the *Flore*.[3] In effect, before stopping at Tahiti and, perhaps, before picking up Doctor Aze for the voyage to France,[4] this frigate commanded by Rear Admiral Lapelin had anchored off Easter Island from 3 to 7 January 1872.[5] Numerous objects were collected during this call, which has been charmingly related by Pierre Loti.[6]

The two anthropomorphic figures donated by Aze could be by the same sculptor, for both are modelled in a similar way, and both have six-fingered hands.[7] The female statuette, which has a goatee, is recorded under the Rapanui name of *moai vie* ("female statue"[8]); the male one is named, just as simply, *moai tangata* ("male statue").

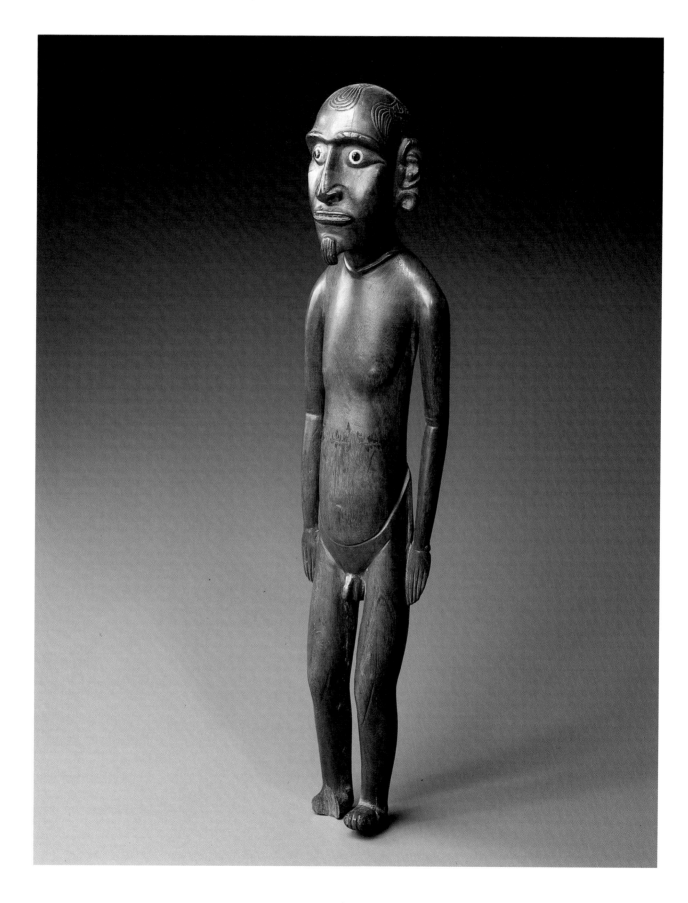

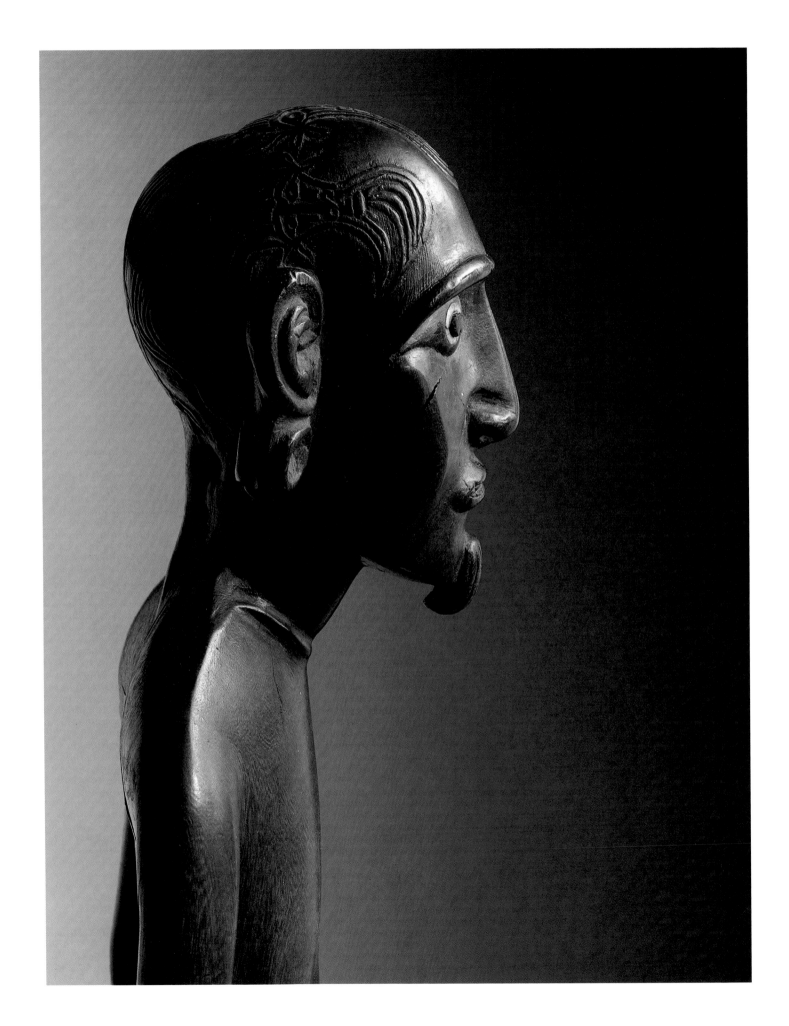

The supple, slender form of this *moai tangata* diverges from the usual stylistic canons of Polynesian sculpture, according to which the head and belly are pronounced, the back is powerful, the legs short and the volumes rigid. This *moai tangata* is erect, its feet slightly apart. Its posture is relaxed, with the arms and legs slightly bent. The curve of the nape, the back and the loins is picked up by that of the neck and the slight relief of the ribcage and the abdomen. This naturalistic treatment of the anatomy is in harmony with the scrupulous, fluid and sensual modelling of the organs, the muscles and the bones. The exaggerated length of the back, the hollowing of the pelvis and the architecture of the head undermine the "classicism" of the construction. The features of the face's severe expression are underlined by the pronounced relief of the nose and eyebrows, under which the obsidian pupils burn darkly against their bone sclera. The straight mouth gives a glimpse of two meticulously sculpted rows of teeth.

Its high social rank is indicated by the small ring carved in relief above the pelvis. Such rings can sometimes be found on some of the monumental stone statues, very often on wood sculptures with protruding ribs (*moai kavakava*) and always on the flat female statuettes (*moai papa*). The ear ornaments and the well-groomed goatee are also hierarchic attributes. Three bearded heads are finely sculpted on the skull; their long fusiform hair ends in a forking tail with a double curve, like the one that characterises marine mammals (seals and cetaceans) in petroglyphs.[9] Sculpted on the head, the most sacred part of the sculpture, these figures indicated the close connection between this representation and a trinity of supernatural oceanic creatures.

A low axial ridge at the bottom of the nape and the neck has a hole in it for the strap from which it was suspended. The beginnings of another hole can be seen on the right. While oral tradition tells us nothing about the *moai tangata*, it is likely that these works were used at public feasts, as were the other wooden statuettes that were proudly exhibited by the dancers who sometimes wore as many several dozen of them around their necks and chests. The shiny smoothness of the salient parts could then be explained by frequent handling, but that cannot account for the greater wear and tear on the feet. This may have been caused by hitting the statuette on the ground or by standing it up in gravel, as related to Henry Lavachery by Juan Tepano, his informer.[10] Other traces of unknown rituals are the bits of yellow colouring in the nostrils and red between the teeth.[11]

This kind of sculpture belongs to a very small corpus of ten or more objects with similar characteristics. Their height varies between 25 and 46 cm. The bearded marine trinity can be found on four other *moai tangata*, probably carved in *toromiro* wood.[12]

CATHERINE AND MICHEL ORLIAC
Translation: Charles Penwarden

1 Born 2 April 1828.
2 T. Jaussen, 1874.
3 S. Chauvet, 1935, p. 12.
4 4 July 1872.
5 F.-T. de Lapelin, 1872.
6 During this call, the head of a giant statue on the Orongo *ahu* at Hanga Roa was sawn off. It now stands in the entrance hall of the Musée de l'Homme, Paris.

7 The female figure has seven toes, and the hands of the *moai tangata* each have five fingers plus a thumb.
8 More commonly known as the *moai papa, papa'a* or *pa'apa'a*.
9 G. Lee, 1992.
10 H. Lavachery, 1942, quoted by F. Forment, 1991, p. 34.
11 According to T. Heyerdahl (1976), the statuette at the Saint Petersburg Museum has orange colouring in the nostrils and the mouth; tiny pieces of wood fill the drying holes made in the back. A circular, flat-bottomed cavity was made in the top of the skull of the Edinburgh statuette, after the carving of the bearded heads.
12 Rome, SSCC; London, Museum of Mankind; Edinburgh; Saint Petersburg, Peter the Great.

AMERICAS

Tolima sculpture

1st-10th century
Colombia

Pectoral

Gold, copper, silver[1]
H. 23.4 cm; W. 25.7 cm
On loan from the Museo del Oro, Bogota
Inv. 6.029

This sculpture was discovered in 1922 by *guaqueros*[2] in a prehispanic cemetery on the Buenos Aires hacienda in Calarcá, in the mid Cauca river valley (department of Quindío). Many magnificent pieces of gold and silver work and ceramics were found at this site. It was purchased in 1948 by the Bogota Gold Museum, where it has been on exhibition ever since.[3]

The pectoral is attributed to the early Tolima style found widely in the Magdalena river valley in the department of Tolima, dating from the 1st-10th centuries CE. Since it was found outside of that area, it was probably the fruit of an exchange between the Tolima culture and other contemporary societies.

The piece was made by the lost-wax method from a mainly gold and copper alloy called *tumbaga*. The perforations in the headdress and the four small disks decorating the lower part of the head were cast along with the rest of the personage rather than added later.

This is an anthropo-zoomorphic figure schematised according to the canons of the Tolima style. The body is composed of straight lines at right angles to one another; the symmetrical extremities extend outwards. The semi-circular head is decorated with a perforated headdress that undoubtedly represents a feathered ornament. The two straight lines ending in spirals that run through the eyes transversally probably symbolise the body paintings used at that time. The prominent, rectangular mouth exhibits two sets of incised teeth, expressing the ferocity of this man-animal. This piece very likely represents a shaman or cacique transformed into an animal, and the skill with which it was made clearly testifies to his high rank. Prehispanic societies believed that masks, body painting and ornaments, as well as the consumption of hallucinogenic substances, would enable them to transform themselves into certain animals such as felines, birds, bats, etc., to see the world as they do and acquire their powers.

MUSEO DEL ORO
Translation: L.-S. Torgoff

1 The alloy is 56% gold, 24.2% copper and 11.6% silver.
2 *Guaqueros* are people who loot Indian tombs or *guacas*, a Spanish word which comes from the Quechua *huaca* ("idol, sacred object").
3 It has also been lent for other temporary shows, notably in 1994-95 to the Munich Museum für Völkerkunde and the Berlin Kunsthalle der Hypo-Kulturstiftung, during the exhibition "El Dorado. Das Gold der Fürstengräber".

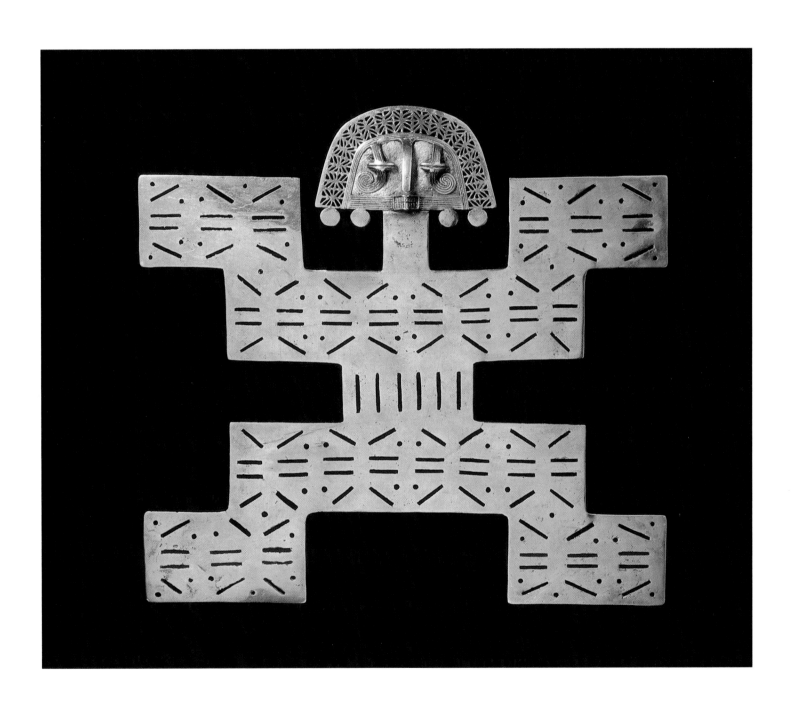

Taino Society

The Taino were the first Amerindians Christopher Columbus encountered when he landed in the Americas in 1492. They inhabited the Greater Antilles – Cuba, Santo Domingo (Hispaniola), Puerto Rico and Jamaica – from about 850 CE, and belonged to the Arawak group that originated on the South American continent (the Orinoco Delta and the Guyana plateau).

Because the Taino world disappeared almost overnight, European observers had little time to describe and analyse it. Thus our knowledge of it is far from complete. Yet there are numerous historical documents that allow us to attempt to reconstitute Taino culture, notably Columbus's *Journal*, *Relaciones de las Antigüedades de las Indias* by Ramón Pané (1498), *Décadas del Nuevo Mundo* by Pedro Martir de Angleria and Bartolomé de las Casas's *Historia de las Indias*.

Taino society was organised into hereditary chiefdoms. At the top, the cacique concentrated the political power of the warriors. He was assisted by a council of dignitaries, the *naitanos*, from whose name the designation for the Greater Antilles culture was derived. It is estimated that caciques governed some three hundred different polities on the island of Hispaniola alone. Religious power was held by the shamans (*behique*) chosen at birth and believed to be predestined for the office.

The Taino economy was largely agricultural. In raised circular plots called *conucos* they grew the yucca (manioc) from which they made *cazabe* (unlevened bread), as well as sweet potatoes, maize, beans, chili peppers, tomatoes and squash. They also cultivated cotton for making cloth, and tobacco, which was indispensable for rituals. The forests supplied fruit and small game, while seafood supplemented their protein intake. The Taino were expert navigators. They made long sea voyages throughout the Caribbean and established robust cultural and economic exchanges with South America, Central America and Mexico.

Ninety percent of the indigenous population of Hispaniola was exterminated within twenty years of the discovery of the Americas. But the Tainos did not die without leaving a profound mark on our collective memory. As the first Amerindians to be contacted, they understandably served as models for the Old World's representation of the inhabitants of the New World. It was through their society that the West forged its image of the Indian. Since the Tainos were also the first people to disappear, repentant and remorse-ridden European humanists were later to enshrine them in myth.

CHRISTIAN DUVERGER
Translation: L.-S. Torgoff

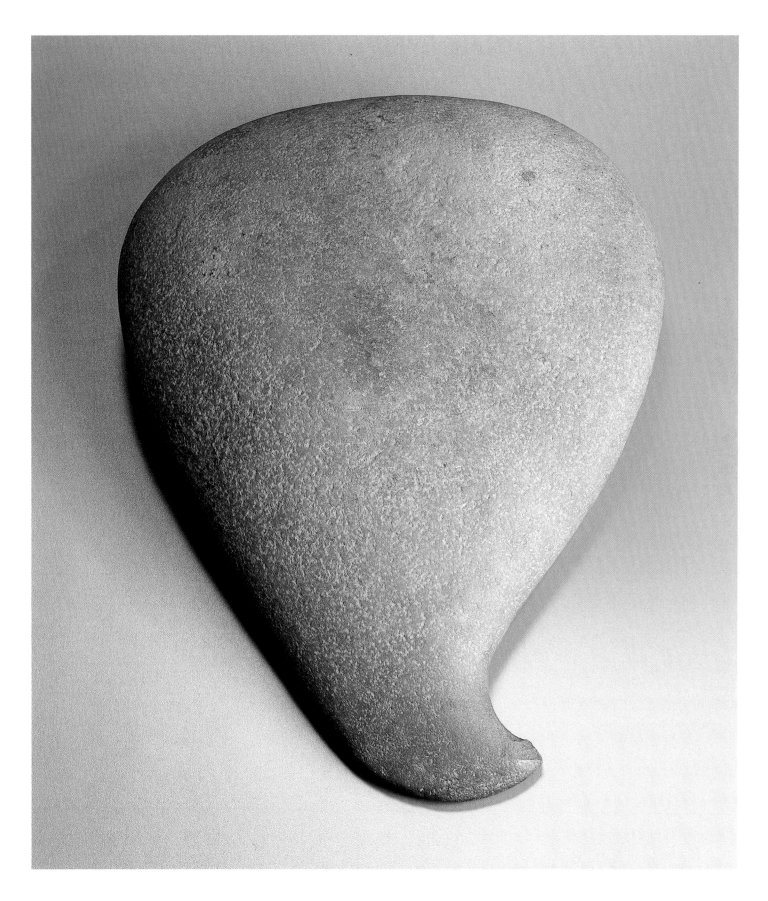

Taino sculpture

12th century-1492
Puerto Rico

Large ceremonial axe

Polished grey stone
L. 45.5 cm, W. 35.5 cm
Donated by Alphonse Pinart to the Musée d'Ethnographie du Trocadéro, 1878
On permanent loan from the Muséum National d'Histoire Naturelle – Musée de l'Homme
Inv. M.H. 78.1.2699

Main Exhibitions
Paris, 1947,[1] 1994.

Main Publications
J. Kerchache (ed.), 1994, p. 13;
C. Duverger, 1994, p. 12.

This exceptionally large object was once a part of the collection of Alphonse Pinart, one of the main donators of Amerindian objects when the Musée d'Ethnographie du Trocadéro was founded in 1878. At that time, collectors were more interested in the intrinsic exoticism of anthropological artefacts than their cultural context. As a result, like hundreds of others, this stone object has come down to us without the slightest supporting information, totally stripped of its history. However, according to the oral tradition at the Musée de l'Homme, this piece came from Guadeloupe.

Stone axes circulated in the Antilles since very early on. The first, often pear-shaped, are associated with the Ciboney populations established throughout the arc of the Antilles 25 centuries BCE. Starting around the beginning of the Christian era, under the influence of the Arawak migrations from the South American continent, axes began to appear in other shapes as well, such as oval, single-edge petaloid and double-edged quasi-rectangular. The materials used also underwent an evolution as the Ciboney blond stone was followed by carefully polished hard stone, black, grey or green in colour. There were even obsidian axes from Mexico and jade hatchets from Central America. These pieces bear lithic witness to pre-Columbian navigation in the Caribbean, which was far more extensive than previously imagined. In fact, axes became a medium of exchange, almost a form of money. It is because of this value and the esteem in which they were held by the people of the islands that axes were often used as funerary offerings. A great many of these objects ended up buried as part of a cache meant to consecrate a territory, a sacred area or a place of worship. This large and highly elaborate axe from the Musée de l'Homme surely belongs in this category. It is likely to have been made expressly for such a purpose, since is lower face, upon which it must have rested, is flat, with a large rectangular area whose high polish leads us to suspect that it was once painted with a text recording the reasons for this offering.

CHRISTIAN DUVERGER
Translation: L.-S. Torgoff

1 Piece mentioned in the catalogue
 Chefs-d'œuvre de l'Amérique précolombienne,
 1947, no. 153, p. 46.

Taino sculpture

14th century
Island of Hispaniola (Haiti and the Dominican Republic)

Ceremonial chair (*duho*)

Guayac wood
H. 42 cm, W. 30.3 cm
Donated by David Weill to the Musée de l'Homme, 1950
On permanent loan from the Muséum National d'Histoire Naturelle – Musée de l'Homme
Inv. M.H. 50.77.1

Main Exhibitions
Paris, 1965, 1994.

Main Publications
H. Lehmann, 1951, pls. 1 & 2, pp. 153-161; H. Lehmann, 1960, fig. 88, pp. 73-74; *Chefs-d'œuvre du musée de l'Homme*, 1965, no. 84, p. 220; D. Lévine, 1992, pp. 38-39; *Musée de l'Homme*, 1992, no. 41500, p. 109; J. Kerchache (ed.), 1994, pp. 42-45; C. Duverger, 1994, p. 58.

Although we know nothing about the history of this finely polished and engraved monoxylous object sculpted out of the enormous trunk of a guayac tree, clearly it is a masterpiece of Taino art. It belongs to a category of somewhat odd objects called *duho* in the Taino language. The Spanish conquistadors brought back descriptions of them, and the 16th-century chronicler Pedro Martir de Angleria had the highest praise for the technical skill and inspiration of the artists who produced them. When the Spanish first arrived they mistook these objects for simple ceremonial chairs because they saw certain dignitaries sit on them. The *duho,* four-legged low seats, were in fact emblems of power, but the anthropo-zoomorphic *duho* such as the one shown here should be considered as *zemi* (see p. 350). They were the prerogative of the *behique*, the Taino shaman, who used a hallucinogenic powder called *cohoba*. Taken after a strict fast, it put them in a trance that allowed them to speak with the gods and deliver pronouncements and prophecies concerning harvests, wars, political alliances and the organisation of worship. A shaman could also heal individuals. Through the use of hallucinogenic drugs he could explore the netherworld in search of the cause of an illness, whether external (an evil spirit at work) or internal (a sin that had provoked divine punishment). He would then treat the patient by means of a magical laying of hands and suction intended to extract the malign agent from the body.

As a particular kind of *zemi*, the *duho* constitute an interesting case of cultural hybridisation. They were derived from the Central American *metate*. The original *metates* in Honduras, Costa Rica and Panama were simple mortars used for grinding maize. Later they were zoomorphised by the addition of a jaguar head and transformation of the feet of the grindstone so that they resembled four cat paws. In Central America these objects, invariably made of stone, remained grindstones conceptually, and were thus linked to the cycle of agriculture. These Central American *metates* were gradually introduced into the Greater Antilles where, for several reasons, their significance necessarily underwent a change. First of all, since jaguars were unknown on the islands, they could hardly be counted among the Taino divinities. Further, the diet in the Antilles was based on yucca, not maize. Yucca, also known as manioc and cassava, is a root that is grated and not a grain to be ground up. Even though the Taino consumed maize, it did not have the central importance for them that it had in Mexico and Central America. Thus in Taino hands the Costa Rican *metate*-jaguar became an anthropomorphic quadruped *zemi*, as likely to be sculpted in wood as in stone. Obviously the use of wood distanced this object even further from its function as a primitive agricultural tool but its general form remained unchanged. At the time of the Conquest the *duho* was considered to be a representation of Opiyelguoviran. This untamed *zemi* who symbolised the faculty of movement could not stand captivity and loved to wander in the forests. It was because of Opiyelgouviran's ambulatory power that the shaman would sometimes sit on this *zemi* in the course of a trance so that it would carry him during his ecstatic voyage. Although it is impossible to verify, this piece from the Musée de l'Homme is said to be one of the fourteen given to Columbus' brother Bartolomé by the beautiful Anacaona, the cacique of Hispaniola, in 1494.

CHRISTIAN DUVERGER
Translation: L.-S. Torgoff

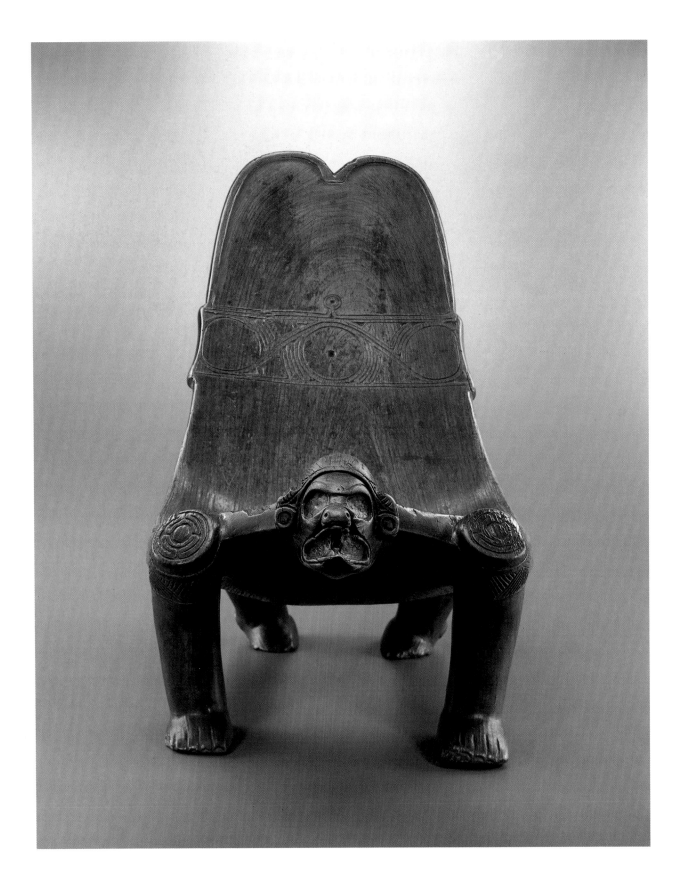

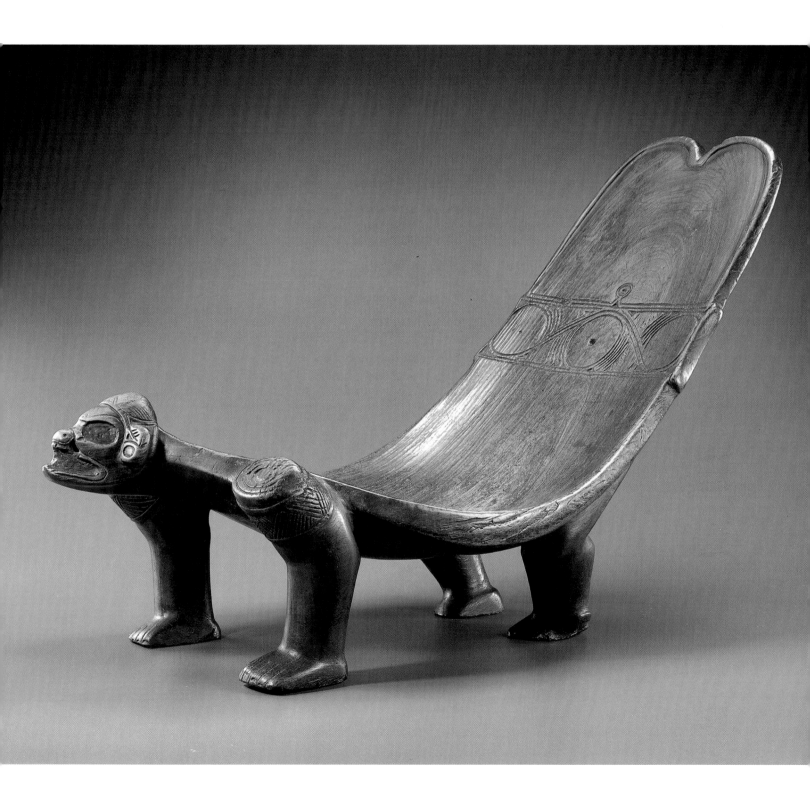

Taino sculpture

13th century-1492
Originally from Puerto Rico, Greater Antilles, and later taken to Dominica in the Lesser Antilles

Trigonolith

Stone (calcite rock with anatase)
H. 22 cm, W. 42 cm
Donated by the Duc de Loubat to the Musée d'Ethnographie du Trocadéro, 1893;
former M.E.T. number: 33442
On permanent loan from the Muséum National d'Histoire Naturelle – Musée de l'Homme
Inv. M.H. 93.60.1

Main Exhibitions
Paris,[1] 1947, 1974.

Main Publications
J. Soustelle, 1934-35, p. 13;
Bulletin du musée d'Ethnographie du Trocadéro, 1934-35, no. 8, cover; D. Lévine, 1992, p. 30; J. Kerchache (ed.) 1994, pp. 218-19; C. Duverger, 1994, pp. 38-39.

This "three-pointed stone" is a kind of sacred object fairly common in Greater Antilles Taino culture. It is a *zemi*, i.e. a representation of a defied ancestor. The word *zemi* applies to both the god himself and his representation, here in stone. *Zemi* were also made of wood, clay, shells and cotton. Some were the spirits of people and others of nature. Each kind of plant, tree and animal species had its own *zemi*; for human beings there were tribal, family and individual *zemi*.

There were probably *zemi* associated with specific hierarchical functions such as chief or shaman. Depending on which sort they were, these statues were buried in the fields and under houses or placed inside temples. Household *zemi* were hung from the roof, some inside the hut and others outside. In the case of the three-pointed stones, their function was explained by the Hieronymite friar Ramón Pané, one of the first chroniclers of Taino culture. He mentions an interesting myth in his *Relaciones de las Antigüedades de las Indias* written about 1498. When time began, there were no women on the island of Haiti. In the rivers lived certain sexless creatures. They were highly elusive, but one day some men succeeded in catching them. The men tied them to a tree where the *inriri*, a sort of green woodpecker, opened up a vagina in each of them with its beak and transformed them into women. These three-pointed stones probably represent *inriri*. According to the writings that have come down to us, these birds had the power of fertilisation and aided women in childbirth. The Taino fit them with a handle and used them above all for the symbolic first spade thrust in the fields (the *conuco*), opening the earth in the same way that the mythological bird "opened" women at the dawn of time, thus creating the faculty of fecundity. Sometimes these three-pointed stones bear engravings that seem to invoke the feathers of the *inriri*; their shape, both triangular and curved, seems to simultaneously represent the breast and the vagina. The *zemi* occasionally shown on these trigonoliths is very likely to be Caracaracol, the mythological hero who was the first to capture and "invent" women. The object shown here is especially notable because it was found in a cave in Dominica in the 19th century by a priest named Vergne. Since the diffusion of sculpted trigonoliths seems to have been restricted to the Greater Antilles occupied by the Taino from 1250, this object was probably foreign to the place in which it was found – it may have come from Puerto Rico. Yet it signals a certain Taino presence in the eastern Lesser Antilles, just outside their traditional territory.

CHRISTIAN DUVERGER
Translation: L.-S. Torgoff

1 Piece mentioned in the catalogue
 Chefs-d'œuvre de l'Amérique précolombienne,
 1947, no. 152, pp. 45-46.

Taino sculpture

13th century-1492
Puerto Rico

Stone (marble)
L. 45 cm, W. 38 cm
Donated by M. Rupalley to the Musée d'Ethnographie du Trocadéro, 1927; former M.E.T. number: 63475
On permanent loan from the Muséum National d'Histoire Naturelle – Musée de l'Homme
Inv. M.H. 27.4.1

Exhibition
Paris, 1994.

Main Publications
D. Lévine, 1992, p. 41;
J. Kerchache (ed.), 1994,
pp. 260-61.

This object belongs to one of the most enigmatic categories of Greater Antilles archaeological objects. We know nothing at all about their origin or purpose. We do not even know what to call them. Traditionally, they are named "collars" but it is obvious that these massive ellipsoidal stone rings were not meant as jewellery and could never been worn around someone's neck. We have no descriptions of similar pieces by Christopher Columbus or any other conquistador, and there is no mention of them in any of the scholarly chronicles of the 16th century such as that of Oviedo, who complied a great many eyewitness accounts. These Taino "collars" seem to have been ignored until the end of the 19th century, when certain collectors began to take an interest in them. The examples in museums and private collections were dug up illegally and thus their archaeological context is undocumented. This is the case here. Objects with no memory, stripped of their function in modern Western eyes, for want of anything better these "collars" have been compared to Mexican pre-Columbian objects. By the mid-20th century almost all Americanists agreed that the Greater Antilles "collars" were related to the massive greenstone, U-shaped archaeological pieces from the state of Veracruz in Mexico traditionally called "yokes".

According to this hypothesis, these objects could be votive representations of a wooden or leather accessory worn around the waist by ball players. The ancient Mexicans had a number of ritual ball games played on special courts. The most common game required vertical walls and a low ledge against which the hardened rubber ball bounced back at hip level. Thus the idea arose that perhaps these athletes wore a kind of padded belt around their waist to add extra power to their hip motions. One reason that there may be a parallel between the Mexican "yoke" and the "collars" of Puerto Rico and Santo Domingo is that a ball game (called *batey*) also existed in the pre-Columbian Greater Antilles, so that the "collars" could be a ring-like and closed version of the horseshoe-shaped stones of ancient Mexico. Thus various authors have presented them as associated with *batey*, without any agreement among them as to why such a thing would be made of stone. Votive offering, a winner's trophy, object of worship – the proliferation of hypotheses has long been rather embarrassing.

There is nothing absurd or impossible about an association between the "collars" and the *batey*, but this explanation does run into a number of difficulties. First, so far there has been no evidence, either archaeological or ethnographic, that such a relationship did in fact exist. Further, the attempt to find an explanation in an analogy with the Veracruz "yokes" has been considerably weakened by the evolving interpretation of the Mexican objects. Currently the "yokes" are no longer considered true stone sculptures reproducing athletic accessories but rather objects with their own intrinsic significance, a sort of three-dimensional glyph associated with caves and the earth's interior. Today the tendency would be to link them to a territorial celebration (the capture of a real or mythical city, for instance). Finally, Americanist archaeology as a whole is trying to rid itself of Eurocentrism and the problematics with which it is currently grappling represent an attempt to access the spirit of autochthonous thought.

With all this in perspective, let's take another look at these "collars" and how to analyse them. First, we observe that they conform to a pattern that is repeated with only the most minor variations. Thus, this is a religious object whose highly codified form seems to derive from the essence of what it symbolises. A "collar" is made up of two basic parts:

an angular stone in the shape of an inverted V with a thick, rounded point, and a thinner, arch-shaped piece. The arch and the V combine to create this odd almond-shaped structure. All authors have noted that these stone "collar" seemed to be a rigid representation of an object that is in fact made up of two separate parts, a wooden arch affixed to the angular stone part. In these sculptures something resembling a fastening device is clearly visible. In the example presented here, it consists of a lug caught between two stops.

The angular part of the object is itself divided into two symmetrical halves. On one of the exterior faces there is always a trapezium with a hollow in the middle, usually oval, made to receive a thin stone cabochon. The same glyphic composition is always represented on the other outer face: on the lower part there is a bat in a highly flattened arc symbolising a cave and the underworld. The bat may be represented in an almost figurative fashion (fig. 1) or simply by a very stylised indication of its

outstretched wings. Above the bat there is a symbol of the earth, with variations ranging from the simplest herringbone pattern to the most elaborate glyphic compositions. From this analysis it follows that the "collar" are an expression of a dualistic outlook, manifested in a number of paired concepts: above/below, right/left, semicircle/angle.

These objects clearly transcribe a complex mode of thought. It would seem appropriate to conclude that these "collar" dating from the 13th-15th century were very much related to the earth. They were made to be buried, and because of their links with cosmic movements they played a role in the "cosmicisation" of the territory. In this sense they should be considered another kind of *zemi*, idols that concentrated natural and supernatural forces and inhabited the hidden side of the world.

CHRISTIAN DUVERGER
Translation: L.-S. Torgoff

Fig. 1
Stone (albite and quartz)
L. 44 cm, W. 28 cm
Musée de l'Homme, Paris

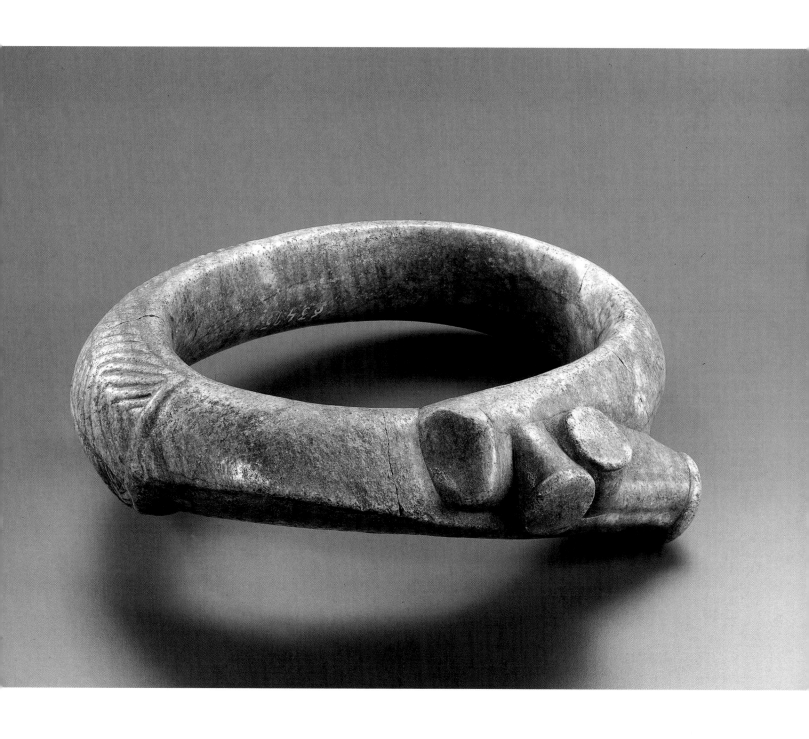

The People of the Jaguar and the Serpent: Olmec Culture

The various cultures of Mesoamerica took shape during the Preclassical period, from 2000 BC to 300 AD. This advance was especially rapid in some regions, such as Mexico's Gulf Coast, birthplace of the well-known Olmec civilization.

This culture was developed by a people whose name and language remain unknown to us. They are called the Olmecs because many centuries after them, the Nahua gave the name Olmán (which means "place of rubber") to the main region where that culture had arisen, in southern Veracruz and northern Tabasco. Bordered by the Papaloapan and Grijalva rivers, the Olmec heartland extends for about 18,000 square kilometres. The Olmec were able to make these rainy, swampy tropical lowlands yield a flourishing agriculture and used the rivers as a means of transport.

Between 1200 and 100 BC the people of Olmán produced monumental sculpture and buildings, along with pieces in clay and stone that evidence a high level of technological development and a profound artistic sensibility. Their art indicates the existence of a powerful ruling group, a division of labour and a complex religion. Particularly noteworthy are the ceremonial centres of San Lorenzo, Laguna de los Cerros, Tres Zapotes and Las Limas in the state of Veracruz and La Venta in Tabasco. San Lorenzo is the oldest site; it was founded circa 1500 BC, and by 900 BC ceased to be the main centre. Its flat areas created by levelling hilltops and filling the shallow valleys with rows of stones represented the earliest city planning. Subsequently La Venta came to the fore and reached a high point between 800 and 100 BCE.

The Olmec made figurines and clay vessels with the features of the jaguar and serpentine attributes. The figures are seated, ungendered and hollow, childlike in appearance – which is why this type of object is generically known as a "baby face". Their skulls are deformed and teeth mutilated. Such alterations of the body for aesthetic and religious purposes were a common feature of Mesoamerican cultures.

High Olmec style is characterized by the production of magnificent monumental sculpture and the carving of semi-precious greenstones, testimony of a great formal tradition that was developed over many centuries. The Olmec were masters of the lapidary arts, making jade figurines, votive axes, mosaic tiles and various kinds of ornaments. The most famous of their monumental sculptures are the enormous basalt heads depicting rulers (fig. 1), whose slightly strabismic eyes and calm faces express a state of intense concentration and deep spirituality. Ten such heads come from San Lorenzo and four from La Venta.

The great monolithic altars from La Venta are equally extraordinary. They show priests emerging from the huge jaws of half-feline, half-serpent beings emblematic of the earth. This symbol of the origin of mankind was common among Mesoamerican cultures. The priest of altar no. 5 carries a dead child in his arms, while other personages at the sides of the altar carry live children, a reference to the sacrifice of infants which was to become integral to the worship of the gods of fertility in other cultures. Further, the bodiless heads and various sculptures of headless seated figures may signal the beginning of ritual decapitation. There are indications of other religious ceremonies in La Venta, such as the large offerings and stone mosaics of dragons, and the various types of graves.

In general this work reveals the rising importance of the worship of the forces of nature, principally represented by animals. Here we see the

Fig. 1
Monumental head, Olmec civilisation
Monument 4, La Venta, Mexico
Stone, H. 226 cm
Museo de La Venta, Tabasco

jaguars, birds and serpents which were to become central symbols in later societies. The Olmec were also the originators of the supreme Mesoamerican religious icon, the Feathered Serpent or dragon, represented notably on La Venta Monument 33.

Remnants of Olmec culture are found beyond the confines of the Gulf Coast, not as a sign of influence through trade or war but rather of a strong expansionism and the establishment of fixed settlements, such as Teopantecuanitlán in the state of Guerrero, where the Olmec built an enormous temple guarded by cat-men. In Chalcatzingo, Morelos, they sculpted extraordinary reliefs at the base of a great sacred mountain, showing Olmec figures arising out of the earth. At Monte Albán, in the state of Oaxaca, there are sculptures of Olmec dancers, and various Olmec-style figurines have been discovered in Tlatilco and Teotenango in the Valley of Mexico.

Early signs of the emergence of numeration, the calendar and writing are evident in many Olmec sites. Their intense intellectual activity led them to create a systematic representation of time and a recorded history. Olmec culture was the first to feel the need to write in order to consolidate their knowledge of themselves and their understanding of the cosmos.

Between 200 BC and 200 AD Olmec sites went into a rapid decline. But clearly they contributed to the development of other great Mesoamerican cultures, such as the Maya, the Zapotec, the culture of Mezcala (in Guerrero) and Teotihuacán.

Cerro Manatí is a characteristic Olmec site. It arises from the lagoons and swamps of the southern part of the state of Veracruz in the Coatzacoalcos river basin. It was clearly a "sacred mountain", a concept shared by all the Mesoamerican groups, and seems to have been a ritual space used by various Olmec communities from 1600-1200 BC. The many offerings found there give evidence of funeral rites, the ball game and infant sacrifice. The most outstanding of these offerings, dating to circa 1200 BC, contains thirty-seven anthropomorphic wooden sculptures wrapped in plant fibres, jadeite axes and other objects buried in human tombs. The wooden statues seem to represent rulers and may have been intended to preserve the spirit of the deceased, in a way similar to the wooden sculptures found in Egyptian tombs.

Many springs flow from the west side of Cerro Manatí. Near one of them was uncovered a seated figurine made of greenstone (inv. no. 10.582852), with an intentionally deformed skull, thick lips and a broad nose. One of the legs is bent backwards and the other, apparently extending forward, is broken off at the thigh.

MERCEDES DE LA GARZA
Translation: L.-S. Torgoff

Fig. 2
Olmec sculptures showing kneeling dignitaries
El Azuzul, Veracruz, Mexico

Olmec sculpture

1200-900 BCE
El Manatí, Veracruz, Mexico

Stone (serpentine)
H. 13 cm
On loan from the Instituto Nacional de Antropología y Historia, INAH Centro de Veracruz
Inv. 10.582852

The Olmec culture was one of the most important Mesoamerican civilisations. It reached its height between 1200 and 900 BCE and was centred in what are now the states of Veracruz and Tabasco. The Olmec achieved an extraordinary mastery of sculpture and the polishing of semi-precious stones and basalt. Their magnificent pieces in jadeite and serpentine represent anthropomorphic figures in a very distinctive style. The skull is misshapen, the eyes open wide and the lips thick with the corners pointed downwards.

In May 1988, the Instituto Nacional de Antropología y Historia and the University of Veracruz launched an archaeological rescue mission in El Manatí in the municipality of Hidalgotitlán (Veracruz). The aim was to confirm and recontextualise the earlier discovery of an ensemble of Olmec cultural objects. Anthropomorphic busts in wood, rubber fragments, greenstone axes and ceramic remains had been found on the west flank of Cerro Manatí, at the foot of several springs.

Cerro Manatí is a salt dome rising from the Veracruz coastal plain. Along with the El Mije and La Encantada hills, it overlooks the Coatzacoalcos river basin. While not very high (barely 100 metres above sea level), it is clearly visible from as far away as the San Lorenzo plateau in Tenochtitlan, which is probably why it served as a landmark in the prehispanic era. Further, this hill is surrounded by a series of small lakes draining into one another, among them the Manatí and Colmena lagoons.

An analysis of the configuration in which these objects were found confirmed that this had been considered a sacred space. The hill, its springs and the surrounding area certainly played a significant role in the selection of this site for religious practices. All the paraphernalia deposited here must have been highly charged semiotically and symbolically in that society, especially in the worship of mountains, springs, lakes and other natural features in general.

The evidence indicates that the oldest offerings date back to 1500 BCE. In the main, they comprise axes made of greenstone such as jadeite, serpentine and various schists, and rubber balls, all scattered with no apparent pattern in most cases. In the subsequent period, the items were placed in groups varying from simple heaps to symmetrical

Fig. 1
Sculpture and objects found at El Manatí, Mexico, during excavations carried out by the INAH and the University of Veracruz between 1988 and 1996. In the middle, one of the wooden Olmec pieces found at this site.

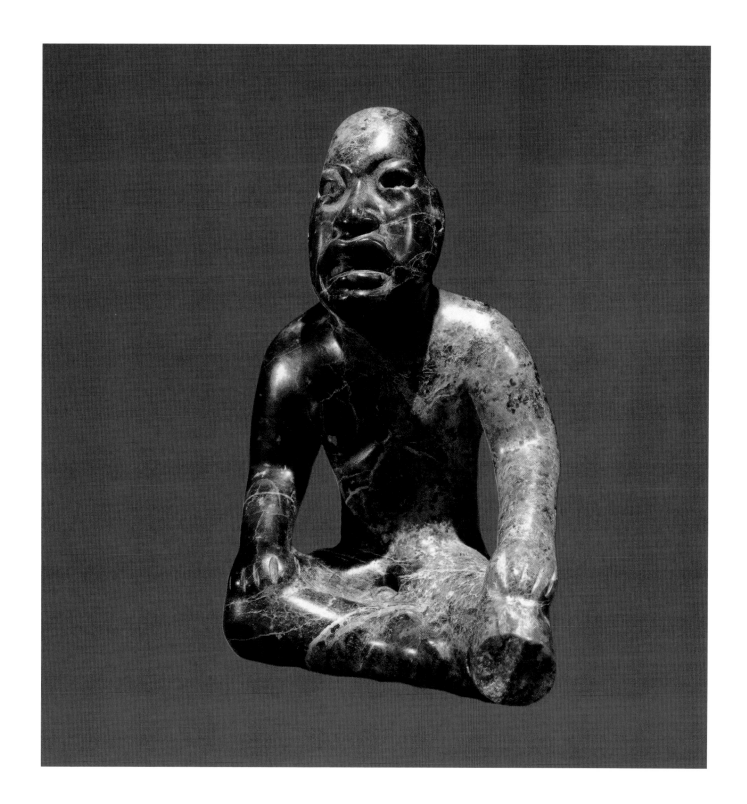

Fig. 2
Olmec sculpture
1200-900 BCE
Jade
H. 29 cm
British Museum, London

arrangements aligned north-south or east-west. Sometimes the pattern was petal-shaped, with the cutting edge of the axes pointing upward.

Recent information obtained from excavations at the La Merced site, very near El Manatí, led to the discovery of an enormous number of axes – more than eight hundred. Perfectly arranged, most of them are placed with the cutting edge upward, accompanied by a tablet with a face that is half feline and half human. Associated materials, especially ceramics, indicate that this deposit occurred after that of El Manatí and must have been contemporaneous with the massive offerings at La Venta. Although its significance remains unclear, this may be a representation, as we have pointed out previously, of a "sacred milpa" (maize field) in which the axes symbolise individual grains. They may also symbolise the heavens. At any rate, the rites practised here must have been related to the worship of fertility and agriculture.

During the last excavation season in 1996, we also found rubber balls dating from the first El Manatí period. This is a set of seven balls of varying sizes (the biggest is 41 cm in diameter), grouped with more than forty axes sculpted out of semi-precious stones and perfectly finished.

In this same context we found remains of ceramics and mortars. It is worth noting the virtual absence of obsidian and figurines. The ceramics do not vary much in type and size. All of the mortars are broken and are identically decorated on the outside. This seems to indicate that these are vessels and other objects used for religious rituals rather than ordinary and secular domestic purposes. This set of ceramics is similar to one found in Chiapas that has been dated to the pre-Olmec Barra and Locona periods.

Around 1200 BCE, judging by the carbon-14 dating of a wood sculpture, a major and much more complex event took place involving a very rich group of items: the burial of numerous anthropomorphic wooden busts in various positions along a north-south axis, individually or in groups of twos and threes, accompanied by different associated elements, according to what appears to be a preconceived plan.

The busts are all similar. Only the upper torso has been sculpted, leaving out the arms; the head is shaved and the ears are barely outlined. In contrast, the face is far more carefully rendered and detailed. Each sculpture has its own unique features, as if the artist sought to represent particular individuals.

Placed alongside and above most of these busts are wooden "staffs", some lanceolate and others serpentine in shape, as well as floral bouquets tied at both ends with thread. They must have been of great significance. Perhaps they indicated a social rank in the same way as the "staff of command" currently used among the Zoque and Mixe. Various Olmec stelae found in the region and elsewhere dating from a later period represent these staffs as profusely decorated insignia of power. For instance, a staff not directly linked to the El Manatí wooden sculptures was painted red and a shark's tooth inlaid in the hilt.

Some of these sculptures were accompanied by the remains of the bones of new-born and perhaps unborn children, most of them dismembered. Only two of them were placed in a foetal position. From the very beginning our study of Olmec iconography in both minor statuary and monumental sculpture has underscored the importance of infants in their system of beliefs. Perhaps the most popular or best-known representations are the clay figurines known as "baby faces" associated with tigers because of the particular shape of their thick lips. On the basis of this evidence researchers such as Roman Piña Chan[1] have suggested that Olmec society was totemic or organised into clans and that the principal totem was the jaguar, judging by depictions of this feline in Olmec sculpture.

In 1977, Piña Chan wrote, "The jaguar was the totemic animal of these Olmec village dwellers. It was associated with the soil and protected new people, infants who ensured the group's survival. This is why they made the figurines now known as 'baby faces', characterised by their half-open, toothless, almost triangular mouths with the lips turned down at the corners, and their short, stocky bodies. They suggest a cult of new-born children, the product of maternal fertility simultaneously associated with the soil and birth."[2]

Many other researchers, such as Sterling, Drucker, Coe, de la Fuente, Joralemon, Poharalenco and others, have recognised the importance of infant worship and their probable sacrifice as offerings. One exception has been Bonifaz Nuño Ruben, who believes these traits to be serpentine and not feline.[3]

Although no archaeological evidence yet exists, Linda Mazanilla and her team recently found, in a room they were excavating in Las Varillas, seven graves of new-born children arranged in a circle under an opening in the roof of the cave. According to Doris Heyden, this burial may have been associated with water worship, since the opening let in the rain.[4] Children's tombs associated with water divinities were also found in the Templo Mayor at Tenochtitlan.[5]

The discoveries at El Manatí are considered similar. They suggest that the offering of infants was associated with the worship of the mountain and water since the Olmec period.

The importance of this sacred ritual is underlined not only by the quantity of buried busts but also the complexity inferred by the associated paraphernalia. The excavation team has uncovered 18 complete pieces in context and two fragments (earthenware heads). Together with thirteen other pieces handed over by peasants, these add up to a considerable quantity of objects.

A study of the local geography sheds light on the sacred character of this unusual place. Clearly the site was picked for its special configuration and not by accident. This choice not only reveals the Olmec understanding of the natural elements but also reflects a developed ideology and the degree to which their religious cosmogony was highly structured even in the earliest period.

It is now known that the site was used as a sacred space. No evidence of domestic activity has been encountered in the area so far.

It is very likely that various elements in this space were modified or reconfigured so as to create a more theatrical setting. For instance, the water from the springs was canalised and trees and other plants of a sacred character were planted. Further, it must be pointed out that the cultural materials offered, such as the axes and wooden busts, have been rigorously arranged in a pattern aligned with the cardinal points of the compass, and all the ritual paraphernalia is rich in symbolic elements of the Olmec ideology underlying this major ceremony.

Cerro Manatí clearly represents the *axis mundi*, the link between the earth and heavens. The mountain touches the sky and represents the world's highest point, and consequently becomes a "holy" or sacred space.[6]

In a way perhaps similar to Aztec beliefs, the Olmec held that within the mountain lived the gods of water and sustenance. It was protected by these small beings, "the associates of the Lord of the Mountain and owner of all animals, guardians of nature and of the subterranean dwelling of the gods, bearers of rain and lightening. Protectors of sacred places such as caves and hollows, streams and springs."[7] To this day, in some regions of this state, people speak of *chaneques*, little elves with similar powers.

Among the Olmec of the Gulf coast and the states of Morelos and Guerrero, clear evidence has been found of worship of the sacred mountain and water. These religious elements are a permanent feature of all subsequent Mesoamerican periods and cultures.

CARMEN RODRIGUEZ AND PONCIANO ORTIZ
Translation: L.-S. Torgoff

1 R. Piña Chan, 1977.
2 *Ibid.*, p. 12.
3 B. Nuño Ruben, 1996.
4 D. Heyden, 1998.
5 Lopez Lujan, 1993; R. Berrellez and A. Torres, 1998.
6 M. Eliade, 1994.
7 B. Sahagún, 1975.

Sculpture from Chupícuaro

600-100 BCE
Mexico

Terracotta figurine

H. 31 cm
Formerly the Guy Joussemet collection
Musée du quai Branly
Inv. 7.0.1998.3.1

Main Publications
M. Porter-Weaver, 1969;
J. Alcina Franch, 1996, cover;
Mexique terre des dieux, Trésors de l'art précolombien, 1998, no. 54, p. 65.

Mexico is a land where time converges, where the sense of history and of place unfold at the same time. This is so today and was certainly so in antiquity. For 2,500 years before the Spanish encounter with the Aztecs in 1519, a succession of indigenous peoples gave rise to societies with complex economic, military, and religious organisations and symbolic systems in art, architecture, and ritual performance. Though different in style and reflecting distinct ethnic histories and customs, these arts were rooted in a vast subsoil of shared cultural themes and images. Inherited, adapted, and transmitted anew, their most basic purpose was to affirm the idea of the human community as an integral part of the order of nature and the life-giving forms of the land.

All the traditions of Mesoamerican civilisation featured female figures in their arts. In the most varied cultural contexts, figures could be abstractions or generalised types, likenesses of once-living women, or mannequins displaying the attire of deities; still others were designed as ideographs in systems of picture-writing. They range in size from clay figurines to colossal monoliths of architectonic proportions. The female sphere of life was of fundamental importance in the Meso-american world-view, forming an essential part of social and cosmological order, embracing human endeavour, the earth and the seasons, food and fertility, and the cycle of birth, death, and renewal.

The terracotta figure from Chupícuaro in the Palais du Louvre in Paris is a significant icon in this long tradition. The artist was not primarily interested in anatomically accurate proportions or detail. Instead, the human form is treated in an abstract manner. Standing in frontal pose with annular, protruding shoulders and tubular arms bent at right angles with the hands symmetrically resting on the midriff, the body presents an approximate trapezoidal silhouette. The torso is subtly modelled as a convex shape that abruptly swells outward in the bulbous belly, hips and thighs. The limbs, hands, and the lower legs are abstracted as flattened, concave shapes that sweep downward to meet the indented lines of the toes. By contrast the head is more detailed. The top of the head is cleft,

possibly representing a fontanel. The rounded face with its prominent nose and receding chin takes on an intense expression with staring eyes and open mouth. The figure is dramatised by its deep red body colour and the bold cream and black stepped-diamond patterns covering the face and the front of the torso. Black-on-white geometric designs cover the loins and thighs. Such intricate designs would correspond to the body paint displayed by Chupí-cuaro women on ceremonial occasions. The highly polished surface is the result of burnishing coloured clay slips, followed by oxidation firing at earthenware temperature. The uncanny, commanding presence of the figure thus stems from its hieratic pose, the abstraction of the human form, lively expression, strong colour and emblematic designs of status or rank.

Dating between 600 and 100 BCE, this figure comes from a time and place that had no hieroglyphic writing or pictorial manuscripts. Our approach to interpretation thus relies partly on archaeological information and partly on analogies and comparisons drawn from related Meso-american cultural and artistic systems of which more is known.

The name Chupícuaro is from a village near a cluster of ancient hill-top burial grounds all now covered by the waters of a dam on the Lerma River, near Acambaro, Guanajuato, in central highland Mexico. This is a basin on a tableland about 2,000 m above sea level, with mountain ranges defining the distant horizons. The Chupícuaro archaeological sites were first explored in 1927, and salvage excavations were carried out during the dam construction of 1946-47. No monumental architecture was excavated, although the reports mention a circular building. Houses would have been made of thatch with wattle-and-daub walls. Yet these were not simple village-farming settlements, for Chupícuaro was the centre of a sophisticated long-lasting earthenware ceramic industry with important trading connections to major urban communities of the Valley of Mexico and far-flung settlements to the west and north-west.

The Chupícuaro figure from the Palais du Louvre stands as an artistic and symbolic statement in a

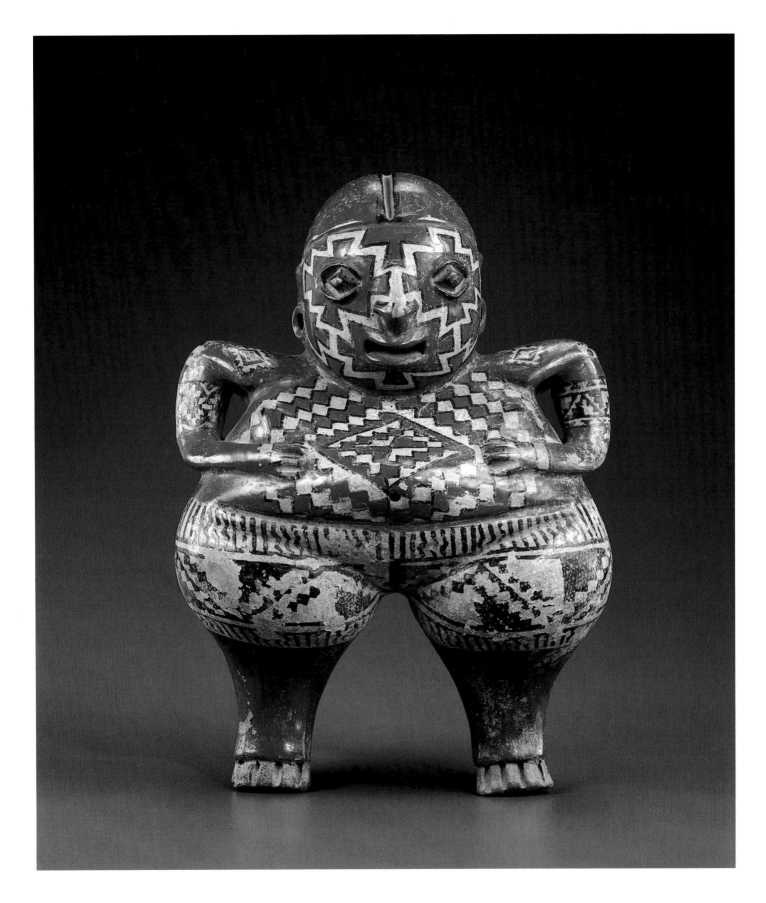

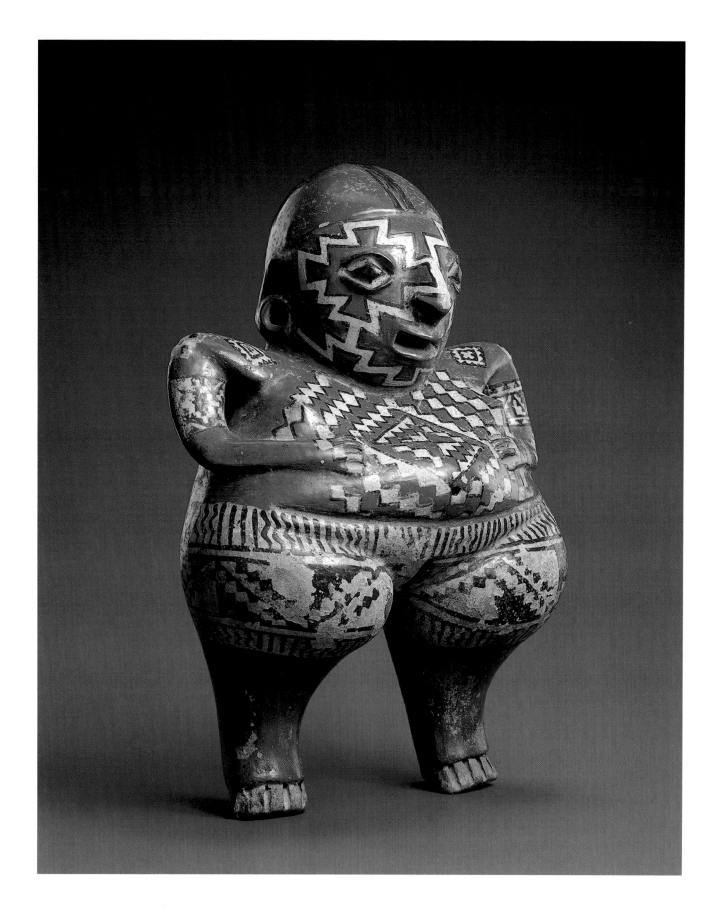

long tradition of portraying the earth and its annual cycle in terms essentially female, a tradition in which female rites of passage were linked to the idea of seasonal periodicity and renewal. It is possible that the Chupícuaro figurine commemorates a feminine initiation rite linked to these basic themes. As part of a burial offering, the figurine would also testify to the status of the ancestor as a participant or sponsor in rites devoted to the earth's fertility. Many other Mesoamerican peoples expressed these concerns, each producing variant forms with their own style, adapting the basic principle to the circumstances of their particular time and place. Artists and ritualists of later urban societies were heirs of a still older tradition, reaching much deeper into a past before towns and agriculture, before kings, and even before the names of the gods, to the time of early hunter-gatherers. Surely it was in these remote times that the land was first seen to be charged with special meanings and powers. In that oldest cultural milieu the mountains, caves, springs, lakes and rivers, and all the phenomena of the day and night skies, were first identified with the events of creation-time, the deeds of ancestor-heroes, the dwelling-places of powerful spirits. In that most ancients level of reverie, the universe was seen as a reflection of life-forces, and objects perceived by the eye were automatically translated on another level. Boundaries between perceptive and objective become blurred, dream and reality are one, and everything is alive and intimately relatable.

RICHARD F. TOWNSEND

The Teotihuacán Culture

Teotihuacán is the name of an ancient city about an hour from Mexico City with pyramids that rival in size those of Egypt. Long considered "Aztec", we now know that Teotihuacán was in ruins at least 6-700 years before the Aztecs arrived in the valley of Mexico. The Nahuatl name means "the place of the gods" because the Aztec felt it was too grand to have been built by humans. They imagined that the last creation of the world took place there. No historical information survives from Teotihuacán; we do not even know what language was spoken.[1]

Archaeological excavations have established that Teotihuacán lasted from about 1 CE to 650 CE and held a population of at least 200,000 at its height. The great pyramids were built early, and more than 2,000 apartment compounds were built later to house the population.[2] Although Teotihuacán had contacts with the Maya and the Zapotecs, and perhaps also had colonial outposts, there are only minor signs of writing in the surviving materials. In the absence of internal and external textual sources, we have to rely on the images to tell us about this ancient civilisation.

One of the mysteries of Teotihuacán is that unlike most Mesoamerican sites, there are very few stone sculptures. Many Mesoamerican sites are covered in relief sculpture or have monuments with people or gods showing costumes and various activities. Teotihuacán has some murals in the apartment compounds, but mysteriously few public sculptural monuments, although there is plenty of available stone for carving.

The type of objects that have been found at Teotihuacán, as early as the time of the Aztecs, are masks in a variety of hard stones or in alabaster. (One was found in the main temple offerings at Tenochtitlán). These masks also appealed to Western collectors since the 19th century, and a great number exist in collections world-wide. Their appeal lies in the material and the workmanship. Paul Westheim, writing in 1950 put it most succinctly: "The artist aspires to both plasticity and to the plane, and with an unparalleled sensibility [...] he achieves the exact point where the two opposing tendencies seem reconciled in a happy balance."[3]

The Teotihuacán faces on the masks render an idealised facial type with horizontally aligned eyes, a strongly modelled nose an open mouth sometimes showing teeth. The eyes were often inlaid with pyrite or shell. Unlike the images of other contemporary traditions, such as the Maya, where portraiture has been noted recently, the Teotihuacán masks represent the same facial type without any individualisation. It is the same facial type found on figurines and mural paintings. In the absence of dynastic carvings and inscriptions at Teotihuacán, I interpreted the anonymity shown in the masks as an indication that Teotihuacán wished not to glorify and commemorate its rulers in representations. This makes Teotihuacán an unusual culture in Mesoamerica, since much of Mesoamerican imagery deals with rulers, conquests, or their interaction with the supernatural. Teotihuacán images are difficult to interpret not just because they avoid the dynastic, but also because they are not narrative and usually do not tell a story.[4]

ESTHER PASZTORY

1 L. Lopez Lujan, 1989.
2 R. Million, 1973.
3 P. Westheim, 1950.
4 E. Pasztory, 1997.

Teotihucán figure

Classic Period, 200-600 CE
Mexico

Greenstone
H: 76 cm
Collected by Eugene Pepin, 1928
Musée du quai Branly
Inv. 70.1998.2.1.

Publication
Mexique, terre des dieux, 1998,
no. 129, p. 127.

One of the first major finds of a Teotihuacán greenstone figure was by Leopoldo Batres in a building near the Pyramid of the Sun he name the "House of the Priests".[1] Since then, nearly half a dozen figures, both male and female, have come to light in the excavations of the important state buildings along the Avenue of the Dead.[2] One of these in particular is significant, since it had been broken and scattered around a small temple near the Ciudadela.[3]

This destruction is now believed to relate to the destruction of the city at its collapse. Similarly, the Batres figure has its head missing and was found with masks and other figure parts in fill dating to the latter part of the city. Most recently, a smaller figure with pyrite inlaid eyes was found inside the excavations of the Pyramid of the Moon.[4]

What these bits of evidence indicate is that large figures in precious stone were usually found in the major structures along the Avenue and were probably the most important images of Teotihuacán. We do not know if their mutilation was ritual or political, or both, but in any case this indicates their great importance.

A few figures are female and dressed in skirt and *huipil*, but most are nude males with or without an indication of genitals. Most figures have faces similar to the masks, with holes for the attachment of earplugs and usually no carved headdresses. This has led me to suggest that the figures were sacred images once dressed, like the masks, in composite materials.[5] The figures, fewer in number, appear to be the cult statues of the ruling elite, while the masks were perhaps more widespread.

One of the striking features of the figures is their variety of materials and style.[6] Musculature, proportion, flatness and facial features all vary from one to the other suggesting they were either carved at infrequent intervals by different carvers, or that they may have come from different times and places and were collected as heirlooms. Their discovery in later contexts merely means that they were used in late times, not that they were necessarily made then.

The Pepin figure is one of the largest – it is close in size to the Batres figure and to the Ciudadela figure found in fragments in 1982. It is a male figure with dramatically modelled shoulder blades and a head with a large mouth with down-turned corners associated with the earlier "Olmec" style. A number of precious stone figures with Olmec features have come to light in Teotihuacán excavations.[7] The significance of this is unclear, especially since we do not really know the relationship of Teotihuacán and Mezcala, in Guerrero,[8] one source of precious stone, where many contemporary stone pieces were made and where Olmecoid figures are common. Olmec culture had disappeared in most of Mesoamerica by about 500 BCE but some features of Olmec style remained as religious or elite symbols. An Olmec aspect such as the mouth of the Pepin figure could be a survival of an Olmec idea into later times, but it cannot be ruled out that this figure is some kind of heirloom or of origin outside of Teotihuacán. Certainly the Aztecs collected precious stone objects from all over Mexico for the Templo Mayor.

Some of these figures may have been meant to be dressed. Many have inlays on their bodies and

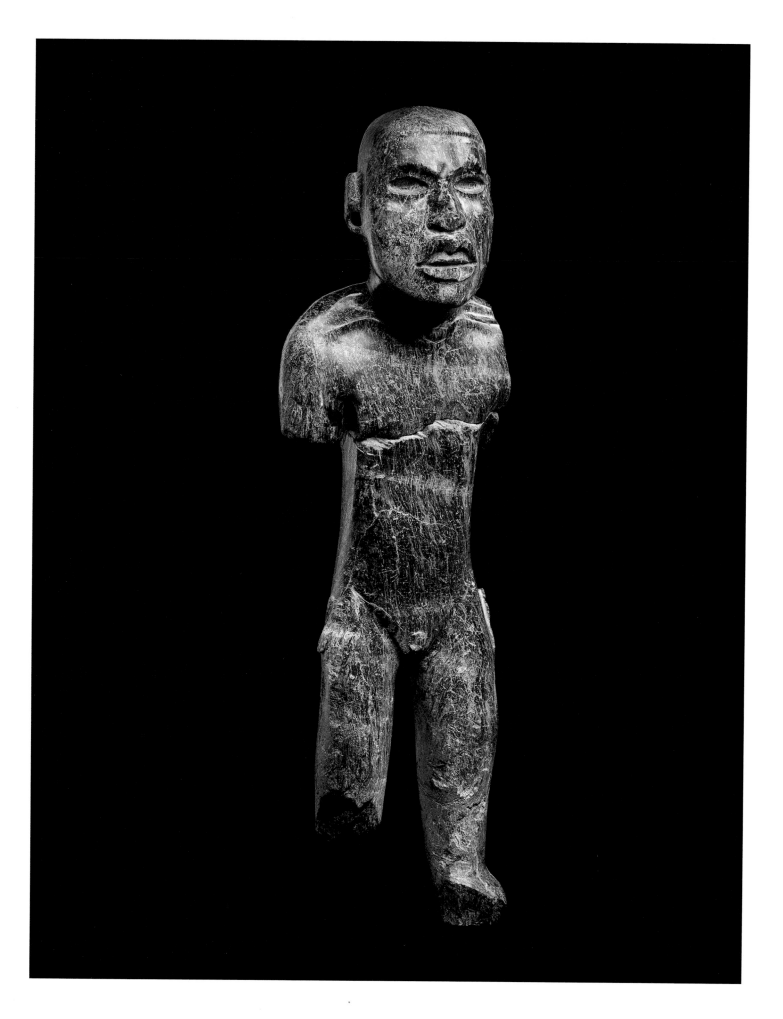

presumably had inlays in their facial features. Their very varied appearance suggests that they may have belonged to different social groups (perhaps elite families) and that each figure probably had its own history. Like the masks, which I see as smaller versions of them, I think the figures represented legendary ancestor/nature spirit combinations. The violence enacted against them at the end of their use indicates the power they once had.

ESTHER PASZTORY

1 L. Batres, 1906; K. Berrin and E. Pasztory, eds., 1993, p. 177, fig. 13.
2 R. Cabrera Castro, I. Rodriguez Garcia and N. Morelos Garcia, eds., 1982a, no. 1; R. Cabrera Castro, I. Rodriguez Garcia and N. Morelos Garcia, eds., 1982b, no. 132.
3 K. Berrin and E. Pasztory, p. 178, fig. 14
4 M. D. Lemonick, 1998, p. 61. The statue measures 48 metres in height.
5 E. Pasztory, 1997, pp. 177-181.
6 K. Berrin and E. Pasztory, pp. 176-183.
7 K. Berrin and E. Pasztory, p. 179, fig. 15.
8 J. Jones, 1987. The date of the Mezcala material is still unclear. Because of the find of a number of Mezcala style objects in the Aztec Templo Mayor, there is now a tendency to date Mezcala to a later time.

Teotihucán Sculpture

Classic Period, 200-600 CE
Mexico

Mask

Stone
H. 20 cm
Formerly in the collections of Diego Rivera and André Breton
Musée du quai Branly
Inv. 70.1999.12.1

Fig. 1
André Breton in his studio
on rue Fontaine, 1961
Photo by Henri Cartier-Bresson

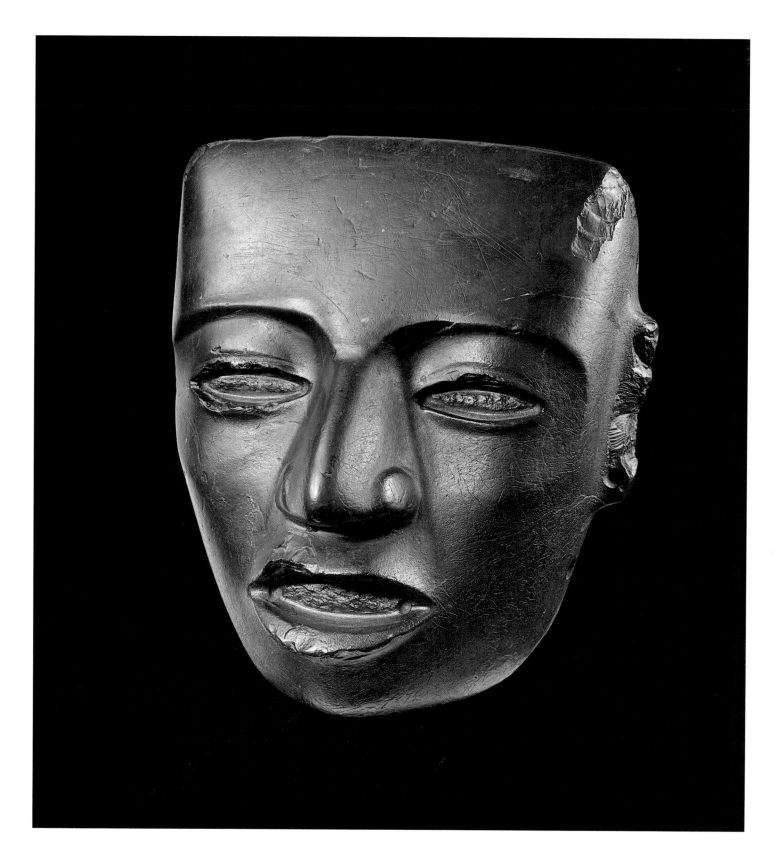

Teotihuacán Sculpture

Classic Period, 200-600 CE
Mexico

Mask

Marble
H. 17 cm
Collected by Eugene Boban who claimed to have found it in a Tepanec cemetery in Azcapotzalco.
Gift of Alphonse Pinart to the Musée d'Ethnographie du Trocadéro, 1878; former M.E.T. number: 2991
On permanent loan from the MuséumNational d'Histoire Naturelle – Musée de l'Homme
Inv. 78. 1. 187

Main Exhibitions
Paris, 1928,[11] 1947,[12] 1965.

Main Publications
E.-T. Hamy, 1897, pl. XI, no. 30; A. Basler and E. Brummer, 1928, pl. 47; R. d'Harcourt, 1948, fig. 73, p. 90; *Chefs-d'œuvre du musée de l'Homme*, 1965, no. 61, p. 175.

There are more masks from Teotihuacán than from any other Mesoamearican culture. Even so, so far only four have been archaeologically excavated. Sigvald Linne found the fragment of a small mask at the Xolalpan apartment compound in 1934.[1] Excavators under the direction of Cabrera Castro found three masks in the areas of the Ciudadela and the Avenue of the Dead Complex in 1982.[2] Until recently, therefore, all of our ideas about the masks were conjectural.

Most controversy has centred on the function of the masks. It is clear that the masks were probably not worn by people. Their eyes are usually not cut out and some of them are quite heavy. They are made of a variety of materials – from granitic stone to slate to greenstone and alabaster. They vary in size and in shape, despite their apparent standardisation. The granitic masks tend to be large and heavy, the alabaster ones often are quite small. The Boban mask is quite flat with the facial features indicated by raised rims. Most masks have holes drilled in the back and the edges suggesting that they were attached to something. Larger masks also have a rim on the back suitable for placing the mask on a support of some kind.

Some masks have surviving paint or carving on the cheeks and often inlays of pyrite or shell in the eyes. Holes in the ears suggest that they formerly had earplugs. The straight line of the forehead may indicate that a headdress was placed on top.[3] Many figurines and mural painting figures are shown with big horizontal frame headdresses with a wide array of quetzal feathers. Like the masks in the *incensarios*, which are a part of a censer made up of complex symbolic elements, far from being abstract sculptures, Teotihuacán masks may have been the centre of an ornate and composite whole.

The standard idea about the masks, going back to the 19th century or earlier, is that they were funerary and were perhaps placed over the face or remains of the dead. Boban's imaginary information about finding the mask in a "cemetery" fits this idea. Neither the people of Teotihuacán nor the Aztecs had cemeteries. They mostly practised cremation and buried their dead under the floors of their houses. In the 19th century, Teotihuacán was considered to be an Aztec site, and therefore the mask appears to have been attributed to the Tepanec allies of the Mexica of Teochtitlán. Azcapotzalco was a Tepanec city built on the remains of a Teotihuacán centre and therefore not unreasonable as a potential finding place for the mask. However, many 19th-century objects are attributed to Aztec cities – Texcoco is a favourite – and this may not mean anything about actual origins. Collectors liked to have their piece come from a romantic sounding place resonant with Aztec history. The Aztecs did not have mortuary masks.

The Mexican excavations of the 1980s have finally given us some information about masks. The three masks found were all excavated in the most important public buildings, not in burial contexts. They were found on floors, sometimes in passageways, and some near niches. A review of the literature on apartment compounds indicates that with the exception of the little mask fragment found by Linne, masks were not found in them. This is unusual in that there are many offerings associated with burials under the floors of the apartment compounds, and some had a huge number. (Tlami-

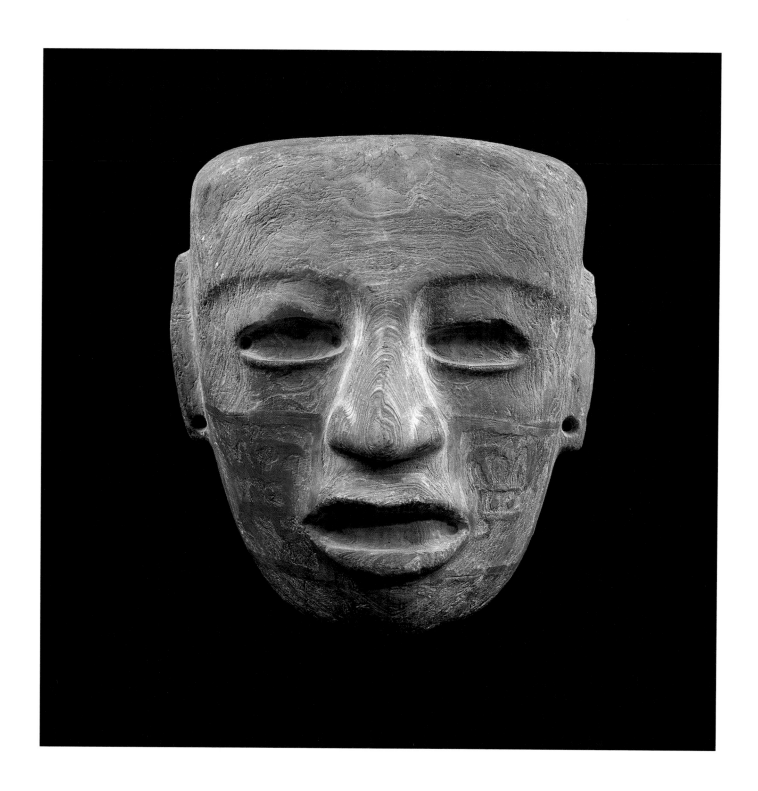

milolpa Grave 1 had over 6,000.) In fact, there is very little jade or greenstone in the apartment compounds in general.[4] Most precious stone appears to have come from buildings along the Avenue that had religious and/or state functions.[5] I have suggested that the stone pieces were not just elite in context but associated with more public rather than purely kin or family functions.

Looking at the many beautifully dressed Virgins, attired by local women in many Mexican Colonial churches, and at the mural paintings at Teotihuacán showing richly dressed figures of perhaps both gods and men, I suggested the possibility that the masks were attached to frameworks, perhaps of wood, and dressed in the costume of a particular deity or ancestor. I feel these objects were in fact the images in the temples, palaces, administrative buildings of the city.[6] This suggestion seems reinforced by a find by Cabrera Castro of a ceramic bust with a separately attachable mask.[7] I feel this indicates how the masks were attached to a bust. For some reason that is not clear to us, Teotihuacán chose to make its images out of precious stone. There was plenty of volcanic basalt from which to make statues had they so desired. The use of precious stone seems to have been important. Clothing is significant from another point of view: the women dressing colonial statues made separate dresses for different occasions for the Virgins, such as an everyday dress, a birthday dress, etc. Attaching separate mantles, earplugs and headdresses would have allowed for changing the masked cult figures for different occasions. Given the clay incense burners with the interchangeable symbols attached, such variety seems also to have been a Teotihuacán desire.[8]

Who do the masks represent? There is no absolute answer to this question. Anabeth Headrick suggests that the masks were attached to mummy bundles and were therefore ancestors.[9] This is an interesting suggestion, although no one in Mesoamerica used mummies like this and the wet weather is not auspicious for the survival of mummies on altars. (such a use was more common in the Andes with its deserts and cold altitudes.) In either case, Headrick seems to follow my suggestion that the masks were attached to something and displayed rather than buried. I have suggested that they were deities, although only a few deities are really recognisable at Teotihuacán. There is no reason why they could not have been a combination of both: legendary ancestors in charge of the forces of nature – somewhat like the *kachinas* of the Hopi peoples of the American Southwest. Multiple costumes attached to the masks would have meant multiple identities for the masks.

The standardisation of the masks themselves suggests the Teotihuacán idea of a collective entity, whether supernatural or human, represented in the facial features. There is no difference between the facial features of the little clay "portrait" figurines, found in the tens of thousands and the more precious masks. Whether they are gods, elite, or ordinary farmers, all Teotihuacán human faces are the same incrustable masks. The mask is the only face of Teotihuacán that we know.[10]

If they were not in burials, where do they all come from? We must assume that in Teotihuacán times and later the masks were either handed down as heirlooms or were buried in the rubble of the temples during the destruction of the city.

ESTHER PASZTORY

1 S. Linné, 1934, fig. 275. The drawing is just a reconstruction.
2 A.M. Jarquin Pacheco and E. Martinez Vargas, 1982, n° 132, p. 110, p. 113; J.E. Sanchez Sanchez, 1982, p. 270, fig. 8.
3 K. Berrin and E. Pasztory, pp. 184-193.
4 M. Sempowski, 1983.
5 L. Batres, 1906.
6 E. Pasztory, 1992, pp. 294-95.
7 K. Berrin and E. Pasztory, 1993, p. 209, pl. 60.
8 E. Pasztory, 1997.
9 A. Headrick, 1999.
10 E. Pasztory, 1993, pp. 44-63.
11 This piece is mentionned in the catalogue *Les Arts anciens de l'Amérique*, 1928, no. 127, p. 12.
12 This piece is mentionned in the catalogue *Chefs-d'œuvre de l'Amérique précolombienne*, 1947, no. 17, p. 18.

Painted Maya vase

Late classic period, 600-900 CE
Northern Petén, Guatemala

Polychrome codex-style vase: "The Deity Maize Stripping the Main Deity of the Underworld"

Polychrome terracotta
H. 16.3 cm
Musée du Quai Branly
Inv. 70.1998.5.1.

Main Publications
F. Robicsek and D. Hales, 1981, fig. 2, p. 13, pp. 36-37; J. Kerr, 1989, vase no. 1560, p. 98; R. Johnson, 1986; D. Dutting and R. Johnson, 1993, fig. 4, p. 199; K. Taube, 1992, fig. 39a, p. 82.

This vessel has never been publicly shown before. It was published for the first time by Francis Robicsek and Donald Hales as a part of a group of what are known as codex-style vessels. They placed it in the series "codex fragment 1: the codex of elderly divinities". These authors tell us nothing about the circumstances of their archaeological discovery, but it can be presumed that this vase came from the tomb of a high Maya dignitary. They carried out an epigraphic and iconographic study of it, using the Eric Thompson catalogue[1] for the numerical transcription of the glyphs. Broadly speaking they see it as depicting a young nobleman humiliating an elderly divinity, probably the divinity conventionally called God L. The young lord, who strips God L of his garments and headdress, is assisted by a humpback and a dwarf. The elderly divinity makes a sacrifice of his own blood by mutilating his penis. Justin Kerr[2] catalogued this vessel as number 1560, indicating only that this scene shows Hunahpu restored to life, seizing the garments of the main deities of the underworld. Richard Johnson[3] carried out an unpublished study of Kerr vases 1560 and 1398, and later, in 1993 published (with Dieter Dutting) the study of vase 1398. This vessel shows a scene somewhat similar to the one presented here, in other words the stripping of God L by the divinity Bolon Yocte assisted by a rabbit, although the style of the glyphs is different.

The Maya civilisation flourished from the 4th-10th centuries CE in what is now south-eastern Mexico, Guatemala, Belize and Honduras. It was characterised by numerous urban centres (more than 200 sites with hieroglyphic inscriptions), each of which had a ceremonial centre made up of courts, platforms, temples, palaces, ball courts, stelae and altars. These monuments often bore the painted or sculpted hieroglyphic inscriptions also found in codex and polychrome ceramics with figurative motifs. Presently more than a thousand vessels, bowls and plates with inscriptions are in private and public collections dispersed throughout Guatemala, Mexico, the U.S., Canada and Europe, but few of them were found in an archaeological context (which is also the case with this vessel). According to Michael Coe,[4] the subjects treated on these vessels are mainly funerary and associated with the underworld, in the manner in which the epic text *Popol Vuh* describes the voyage of the Hero Twins to the world of Xibalba. But they also dealt with other mythological subjects, and the scenes on these vessels may be drawn from codices that have since disappeared. Thanks to recent progress in the decipherment of Maya script, we can now read a part of the texts written on these vessels.

Iconographic study

Reading the glyphic text from left to right, we can distinguish eight figures distributed in three distinct sequences. Out of their mouths emerges a sort of volute indicating spoken words. These volutes are linked to secondary phrases.[5]

First sequence:
Stripping of God L by the Maize god,
attended by a hunchback

This sequence is composed of three figures. The one on the left shows a young hunchback standing and in profile. He is wearing the hair net headdress of the deity Bacab, and holds the headdress and clothing of the recumbent figure, who could be God L, although his eye is square-shaped as on Kerr vase 1398, instead of oval as in other representations of this deity. The latter figure is naked but still retains the sign of the mirror on his arms and legs, indicating his divine nature. He is stretched out on the ground, with his left arm raised halfway and the index finger of the right handing pointing towards the earth. The third figure is the young Maize god, who wears jade ornaments on his high forehead. He resembles the dancers on the Homul vessel as well as the Maize god emerging from a turtle shell on Kerr plate 1892 (fig. 1) with the same headdress and jade ornaments, while the bodies of

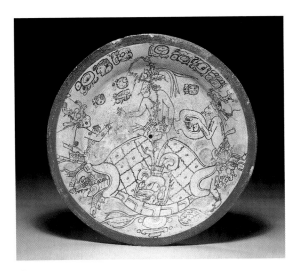

Fig. 1
Codex-style polychrome plate
Late classic period, 600-800 CE
Petén, Guatemala
Private collection

the twin gods are marked with black stains and pieces of jaguar skin. His foot is resting on the chest of the recumbent God L, and the little finger of his right hand is pointing at his headdress.

Second sequence:
Self-sacrifice of the blood of God L standing naked in the presence of the Maize God and a dwarf

As in the previous sequence, this, too, is comprised of three figures, but here the figure on the left is a dwarf. In his left hand he holds the headdress and cape of God L, made of an owl, with the feathers attached to the border of the headdress. In his right hand he holds a sort of staff similar to the *chicahuaztli* of the Aztec merchants of the Mexican highland.[6] Facing him, God L stands naked, now without the mirror signs, but on his head is the ear of a jaguar. He is pulling a cloth band across his genitals, which is probably an act of self-mutilation of the penis, a common practice among the Maya. Behind him stands the Maize God, his right hand behind God L's head. He is raising his left thigh with the leg bent backwards while holding the index finger of his left hand pointed downwards.

Third sequence:
The Maize God restores God L's adornments

This sequence contains only two figures. God L is still on the left, sitting on the ground and looking to the left, and once again wearing the mirror signs on his arms and thighs. On the right the Maize God holds the other's headdress above his head and in his left hand he holds the L God's forearm, perhaps to restore his attributes after the self-sacrifice of his blood.

Epigraphic study

In 1973 Michael Coe analysed a hieroglyphic text recurring on many vessels. They are presented horizontally on the upper edge of the vessel. Coe called it the "primary standard sequence". Sometimes texts associated with the figures in a scene are found under the standard phrase on a vessel. These have been called secondary texts.

The text consists of two parts, the horizontal standard phrase made up of eleven glyphs, along the upper edge of the vessel, and the secondary text of twenty-eight glyphs, divided into nine phrases associated with the eight figures. The text can be read in Yucatec or Cholan.

The standard sequence. Glyphs A-J

This phrase is found on vessels contain a young, green cacao bean. The phrase ends with the name Toat Balam ("Jaguar with the erect penis"), a name similar to that of the first sovereign of Yaxchilán, Yoat Balam. It is followed by the toponymic title *Kul chahtan winic* ("divine man in a dark place"). This may be the name of a ceased and deified sovereign to whom this vessel is dedicated. Other vessels bearing this toponym of the underworld present scenes of human sacrifice or self-sacrificial behaviour.[7]

The secondary texts

First phrase. Glyphs K-M. This phrase is associated with figure 1 representing a hunchback, perhaps a Bacab. While the first glyph is difficult to read, the second can be read *ah tz'on* (he with a blowpipe – a hunter?). The third glyph can be read *Pawah at.* In fact, the superfix represents a net (*paw*), part of the name *pawah*, which, according to Landa,[8] is the name for the Bacab divinities and is associated with the headdress of God N. But this glyph seems to be associated with God L represented by figures 2, 5 and 7. Element 761 in the Thompson catalogue is read *at* ("penis") in Cholan. This logographic reading is confirmed by Kerr vase 1398 in example 64.761.59 by the presence of the phonetic complement *ti* ("59"), in other words *Pawah ah (ti)*. This was Dutting and Johnson's reading. Thus it is a possible name for God L.

God L here takes the appearance of God N. On Kerr vase 1398 God L is shown naked, with a headdress made of a merchant's staff.

Second phrase. Glyphs N1-O1. The first verbal glyph has been read *ma-chi-l (a) machil* by Johnson[9] in an unpublished study. According to the Cordemex Yucatec dictionary, *machil* means "to grasp".[10] The second object glyph is the nominal glyph for God L, *Pawah at*, and the third subject glyph is the nominal glyph of the Maize God (figures 3, 6 and 8). It can be read *ah nal cut* ("the young maize of clay"). *Cut* does mean clay in Yucatec, but in Chorti it means "to hit" or "to strike".[11] On such vessels, the usual nominal glyph for the Maize God is *Hun nal ye'* ("the first revealed maize"). This is what is on Kerr plate 1892 (fig. 1), for example, which shows him emerging from a turtle shell surrounded by the Hun ahau twins and Yax Balam.

Third phrase. Glyphs P1-P3. These glyphs are difficult to interpret, except for the second, which can be read "he looks?)".

Fourth phrase. Glyphs Q1-Q4. The first two glyphs could refer to the celestial Xoc, not represented here. In fact, the monster Xoc plays a mythological role associated with the Maize God. The latter seems to be coming out of the maw of a monster attacked by the "disorderly" deities.[12] The third glyph could represent the verb *becah* ("had captured"). Once again it is followed by the name of God L, *Pawah at*. It suggests the capture of God L by the monster Xoc, as in the case of the Maize God.

Fifth phrase. Glyphs R1-R3. The first glyph could be read provisionally as *nu-lo-l (a) nulol*. This means "to touch or rub oneself" according to the Cord-

emex dictionary.[13] The following glyph cannot be read, and the last could be *wahan* (?).

Sixth and seventh phrases. Glyphs S1-S3 and T1-T2 respectively. The first verb event is identical to that in phrase 2, *machil* ("was seized"). It is followed by the title *ti kul* ("the divine") and the name of God L, *Pawah at* (associated with figure 5). The glyph T1 can be read as "he (looks?)" and the following as *ahan* ("creation").

Eighth phrase. Glyphs U1-VA. While the first glyph cannot be read, the second could be *ah ol nal* ("he of the underground entrance"). *Ol* designates the heart and the subterranean entrance to monuments. It is followed by a title that is difficult to read and the name of God L associated with figure 7.

Ninth phrase. Glyphs W1-W2. The first glyph has been partially effaced and the second could be read as *ahan*, like the two other glyphs in phrases 5 and 6.

We do not know the name of the artist who painted this vase or where it was made. It undoubtedly came from the northern Petén region in Guatemala, and probably dates from the end of the classic period (600-900 CE). In the case of Kerr vase 1398, we know that it came from the Naranjo region because it bears the name of a sovereign of that city. It dates to 700 CE. These two vessels must have been placed in the tombs of high-level Maya dignitaries. Kerr vase 1560, now on exhibition at the Louvre, seems to depict a mythological scene in

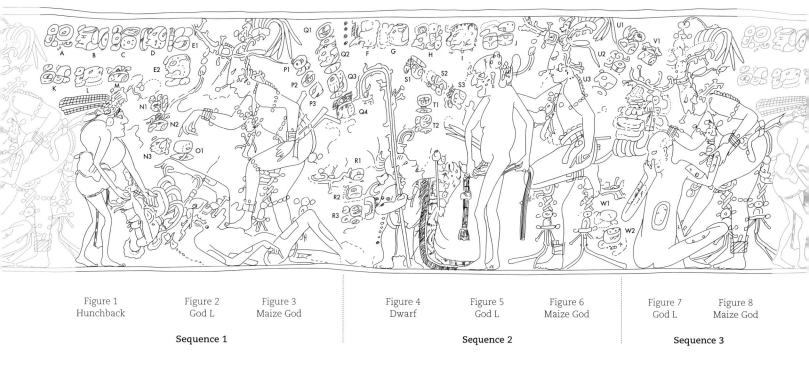

| Figure 1 | Figure 2 | Figure 3 | Figure 4 | Figure 5 | Figure 6 | Figure 7 | Figure 8 |
| Hunchback | God L | Maize God | Dwarf | God L | Maize God | God L | Maize God |

Sequence 1 Sequence 2 Sequence 3

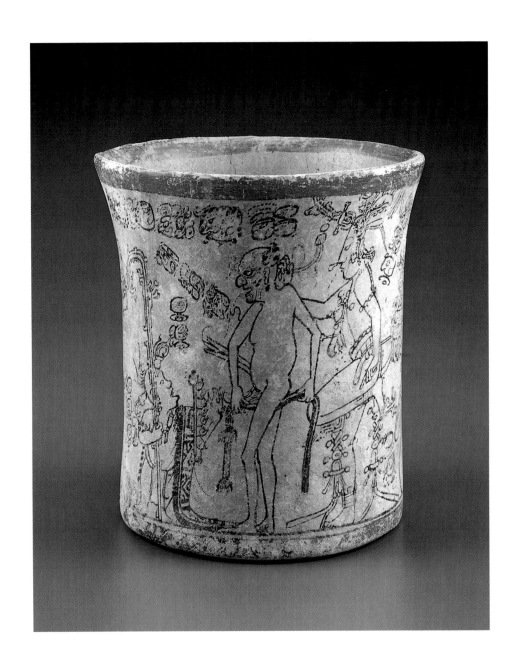

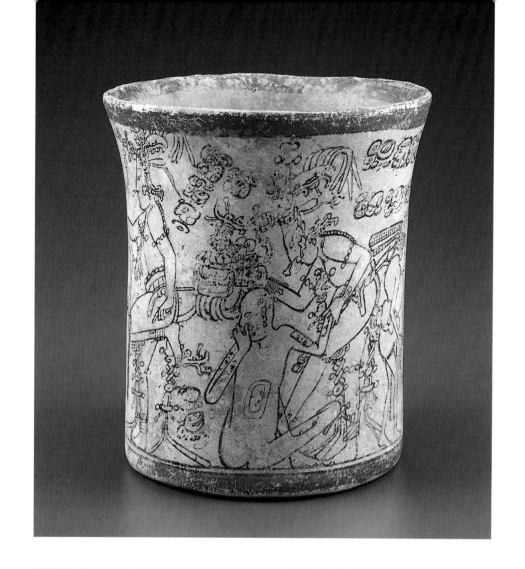

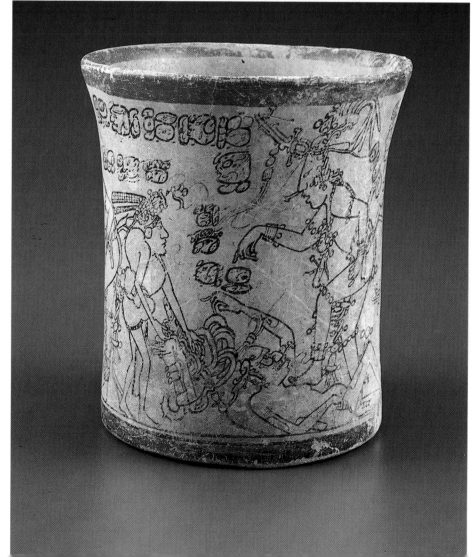

which the young Maize God strips the elderly God L (the sovereign of the underworld) with the aid of two figures, a hunchback and a dwarf. In this episode, God L makes a self-sacrifice of blood by mutilating his penis. Nevertheless, this episode in Maya mythology remains to be confirmed by other, variant scenes and to be contextualised in the mythological biographies of the Maize God and God L, of which some episodes have been studied by a number of researchers.

MICHEL DAVOUST
Translation: L.-S. Torgoff

1 E. Thompson, 1962.
2 J. Kerr, 1989.
3 R. Johnson, 1986.
4 See M. Coe, 1975.
5 See *infra*, "Epigraphic Study".
6 K.A. Taube, 1992, pp. 81, 84, fig. 41.
7 I. Calvin, 1997, p. 873.
8 J. Genet, 1929.
9 R. Johnson, 1986.
10 A. Barrera Vasquez, 1986, p. 473.
11 C. Wisdom, 1950, p. 81.
12 M. Quendon and G. Le Fort, 1997.
13 A. Barrera Vasquez, 1986, p. 473.

Maya sculpture

Late Classic period, 600-900 AD
Palenque, Chiapas, Mexico

Human face

Stucco
H. 24.5 cm
Donated by Désiré Charnay to the Musée d'Ethnographie du Trocadéro, 24 February 1882;
former M.E.T. number: 8015
On permanent loan from the Muséum National d'Histoire Naturelle – Musée de l'Homme
Inv. M.H. 82.17.26

In the old catalogue of the Musée d'Ethnographie du Trocadéro, there is a phrase next to the register of objects from the Charnay expedition: "These fragments fell from walls Mr. Charnay cleaned." In fact, this face came from a building in the city of Palenque that Désiré Charnay visited on two occasions, the first in 1860 and the second in 1881, producing significant accounts of the slow destruction of this great city that had been discovered in the middle of the jungle during the 18th century. In 1863, Charnay published *Le Mexique, 1858-1861. Souvenirs et impressions de voyage*, where he describes his travels to five prehispanic cities, including Palenque. This perceptive, well-written book and the album of photographs he took himself[1] are an extraordinarily rich source of information about Palenque, one of the most beautiful cities of the Classic Period Maya. In great detail, Charnay describes the buildings of the city visible at that time, notably the Palacio, where he took up residence despite the insects and jaguars. He wrote that in preparing to shoot these photos, he cleaned the surfaces of facades and reliefs and cut away the calcite deposits covering them, inadvertently knocking down numerous reliefs. During his second trip, he continued in the same manner, which surely was

what led this face to fall off, perhaps from the Palacio itself, since the base of that building is decorated with other stucco visages. Charnay took this piece and several others in the hope of saving them from pillage and destruction. In 1882 he donated it to the Trocadéro ethnography museum, in the conviction that, as he put it in his first book, "Is it not right that a nation such as ours, at the head of the world, should take possession of these precious monuments and accord them their rightful place in our museums?"[2] In his second magnificent publication, *Les Anciennes Villes Du Nouveau Monde*, which appeared in 1885, he expressed his admiration for this beautiful abandoned city: "There is nothing so strange as to walk among these extraordinary edifices, with their abandonment, their silence, their solitude; the thick shadow of the trees that crown the buildings and the pyramids give an even grander dimension to the mystery that covers the ruins and plunges us into an indescribable sadness."[3]

This heavily damaged face of a man is oval in shape, with an intentionally elongated skull, a religious custom and aesthetic choice among the Maya. The deformation is of the "oblique tabular" type, in which the skull is elongated upward and toward the back, causing an inclined forehead as can be seen in the prominent nasal bone extending upward. The eyes are almond-shaped and the lips smooth. This is a portrait in sculpture and the features are typically Maya.

Despite its damaged state, the face testifies to the superb sculptural work done in Palenque. The principal subject of this art was humanity, embodied in particular individuals portrayed in stone and stucco, and often accompanied by hieroglyphic texts telling the history of their lives. Palenque artists chose stucco for its ability to reproduce infinite and subtle variations in facial expressions, hands and the body as a whole. In general, their sculptural work was in relief, sometimes almost fully in the round. Particularly noteworthy are the pillars of the Palacio, which represent the ruler with his symbols of power, accompanied by secondary figures. The heads and faces are remarkably expressive and individualised, extraordinarily natural in appearance. Stucco and stone reliefs decorated public and religious buildings. The most important of these was the palace, a complex comprising the residences of the elite; the Temple of Inscriptions, a large pyramidal mausoleum where the city's most powerful sovereign, Pacal ("Shield"), was buried in the 7th century; and the temples of the Cross, the Sun and the Foliated Cross, all built by his son, Kan Balam ("Jaguar Serpent") at the end of that century.[4]

The Maya civilization, one of the most outstanding in Mesoamerica, arose around 300 BC and continued until the Spanish conquest (1525-1698 AD). It covered a vast territory extending through central and southern Mexico and the Central American countries of Guatemala, Belize and parts of Honduras and El Salvador. The Maya were notable for their extraordinary sculpture and architecture, their remarkable knowledge of mathematics and astronomy, and an exceptional sense of history evidenced in many texts written in the most advanced written language of the Americas. Further, they were skilful warriors and merchants and developed a complex social and political structure.

MERCEDES DE LA GARZA
Translation: L.-S. Torgoff

1 This album's 49 photos were the first ever published of the architecture of ancient Mexican civilisations.
2 D. Charnay, 1863.
3 D. Charnay, 1885.
4 M. de la Garza, 1992.
5 Piece mentioned in the catalogue *Chefs-d'œuvre de l'Amérique précolombienne*, 1947, n° 118, p. 38.

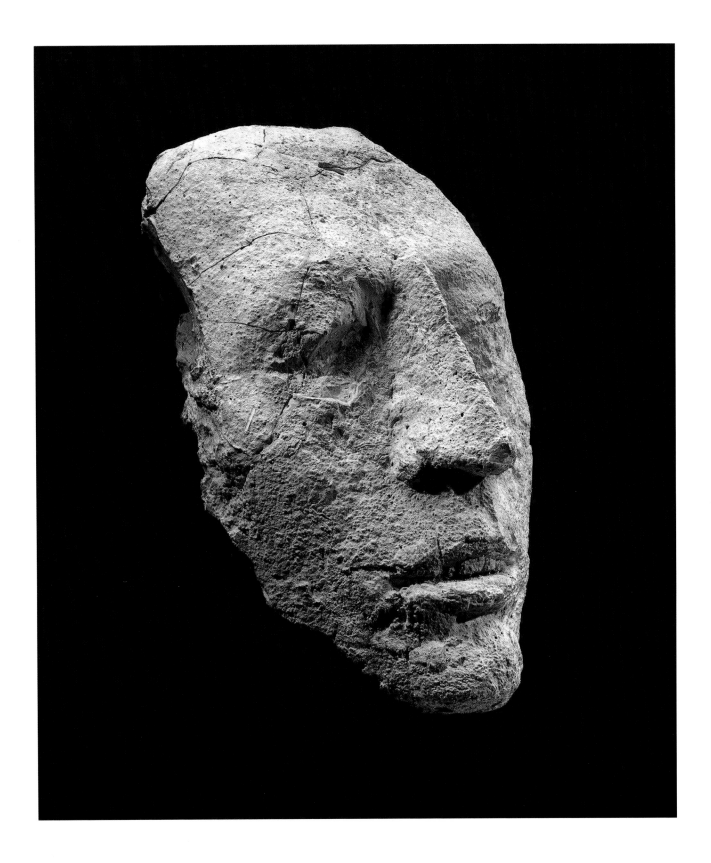

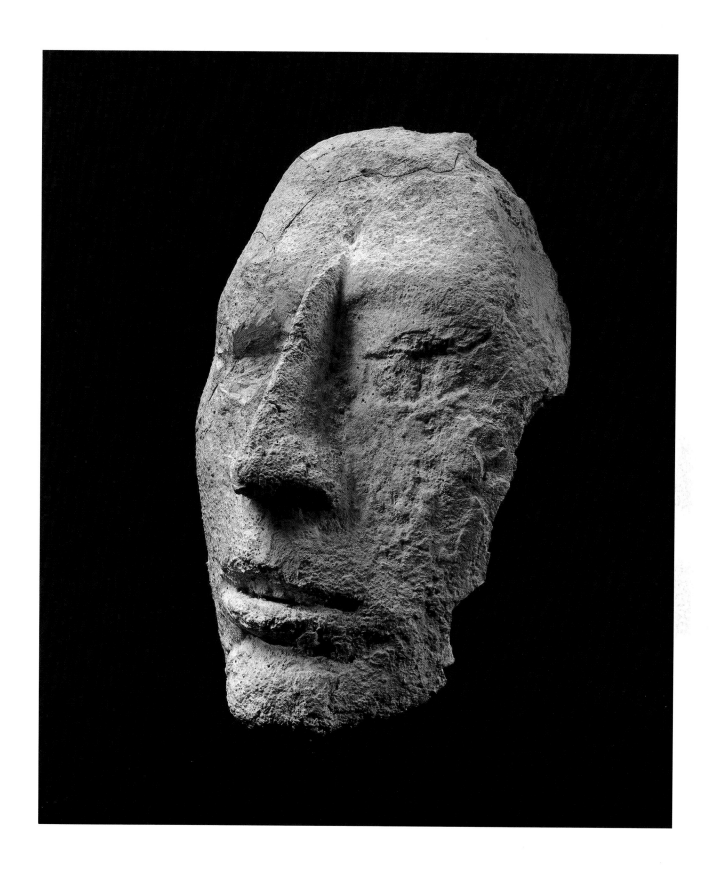

Maya sculpture

Late Classic period, 600-900 AD
Jaina Island, Campeche, Mexico

High-ranking woman

Terracotta
H. 20 cm
Donated by Mr Labadie to the Musée d'Ethnographie du Trocadéro, 15 October 1887;
former M.E.T. number: 19424
On permanent loan from the Muséum National d'Histoire Naturelle – Musée de l'Homme
Inv. M.H. 87.101.21

Main Publications
R. d'Harcourt, 1948, p. 55,
no. 40; A. Malraux, 1952,
vol. I, no. 337; *Musée
de l'Homme*, 1992,
no. 40334, p. 106.

Jaina Island lies in the Gulf of Mexico, 32 kilometres north-east of the port city of Campeche on the Yucatan peninsula. It is 3 kilometres long and only 800 metres wide. Two ensembles of prehispanic monuments have been found there, called Zayosal and Sacpol, but it is most renowned for the many sepultures around the borders of these structures. These graves are of two types: the bodies of children, in jars, and the bodies of adults, in funerary bundles. Since such a large number of burials were deposited on Jaina Island, some 2,500 in all, it is considered a necropolis where people living in other cities came to bury their dead. The graves contain ceramic offerings and other objects meant to accompany the spirit of the deceased in his voyage to the farthest reaches of the netherworld.[1] They also contain clay figurines that seem to represent the deceased and perhaps were supposed to house his spirit. A great deal of our information about the customs, physical appearance and activities of the Maya come from these tombs. Further, "because of their elegance, their subtlety and their stylistic coherence [...] they deserve their own chapter in the universal history of art, comparable to the place enjoyed by the Hellenic funerary terracottas of Tanagra."[2] They are an outstanding example of the degree to which the ancient Maya developed the art of sculpture. The representations of people from various regions in the Maya realm exhibit a particular humanism unknown among other prehispanic cultures. This aspect of their art coincides with their cosmogenic myths recounting the creation of the world for the express purpose of serving as home to humanity, which in turn was created to worship and nourish the gods, making mankind the motor force and centre of the universe. These myths are known to us because the Maya wrote them down, at the beginning of the colonial era, in their own various languages, employing the phonetic Latin alphabet taught them by Spanish friars. The most important indigenous book among Maya colonial literature is *Popol Vuh*, from the Quiché culture in Guatemala.

Like many other objects from Jaina island, this figurine was given to the Musée d'Ethnographie du Trocadéro during the 19th century. It is a whistle-statuette representing a seated woman. She holds her torso straight and her hands rest on her knees. Her bare left foot sticks out from under her skirt. The blouse leaves her shoulders and forearms uncovered. The skirt and blouse bear traces of blue paint, like many other figurines of this group. The eyes are almond-shaped, the mouth half-open and the bridge of the aquiline nose extends up into the forehead, the result of the intentional skull deformation the Maya achieved, among other methods, by tightly tying splints on either side of the heads of new-born children. The purpose was not only aesthetic but also religious, since it was believed that this endowed human beings with certain powers associated with felines.[3]

Two scarification lines run from the corners of her mouth through her cheeks. This is also found on masculine figurines portraying rulers and high priests.[4] She wears her hair in a pyramid, with stepped layers coming down over her temple; in the centre is a fissure that may symbolise an open fontanelle, a symbol of supernatural powers and link to the gods. This belief persists to this day among some groups of Maya origin. The woman wears the jewellery customary among the ruling elite: a large necklace of round and tubular beads, round ear disks and very wide bracelets with longitudinal incisions. These elements, and the many almost identical figurines that have been found, indicate that this is an idealised portrait of a priestess.

MERCEDES DE LA GARZA
Translation: L.-S. Torgoff

1 M. de la Garza, 1992.
2 M. Foncerrada de Molina
 and A. Carlos de Méndez, 1988, vol. IX.
3 L.E. Sotelo and M. del Carmen Valverde,
 1992, vol. XIX.
4 C. Corson, 1976.

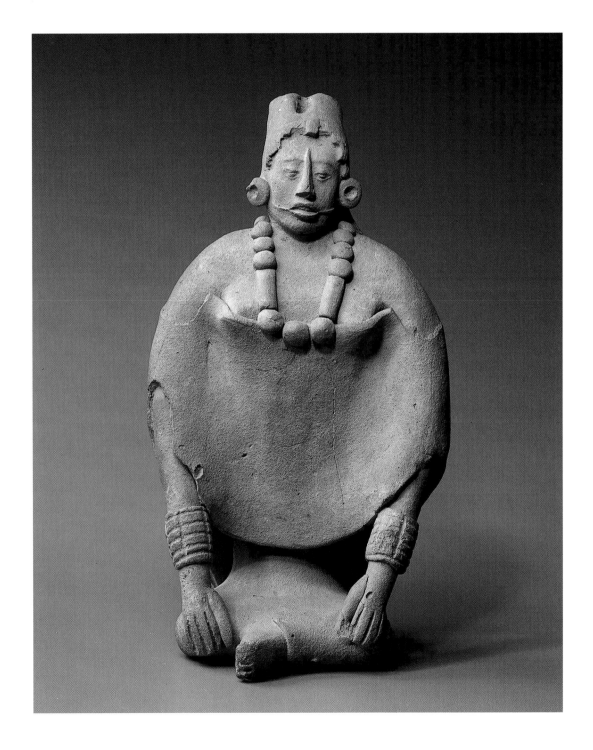

Maya sculpture

Late Classic period, 600-900 AD
Jaina Island, Campeche, Mexico

High-ranking woman

Terracotta
H. 19.3 cm
Donated by Mr Goldstein to the Musée d'Ethnographie du Trocadéro, 1893; former M.E.T. number: 33701
On permanent loan from the Muséum National d'Histoire Naturelle – Musée de l'Homme
inv. M.H. 93.4.2

Main Exhibitions
Paris, 1928, 1947, 1965.

Main Publications
H. Lehmann, 1935, p. 335;
Chefs-d'œuvre du musée de l'Homme, 1965, no. 79, p. 211.

This female figure is seated with her legs crossed and her face hieratic, in a highly dignified ritual position similar to many other figurines of women.[1] Her erect torso is broad and her legs small. The feet cannot be seen, and her hands rest on her knees. The mouthpiece of the whistle is found behind, on the right arm. Her skirt, called a *pik* in some languages of Maya origin, covers the body down to the ankles, and her low-necked blouse, called a *k'ub* by the Maya and *huipil* in Náhautl, leaves her shoulders bare. She is also wearing a necklace of heavy beads, with large ear discs and a very long bracelets made up of several rows of quadrangular beads. These sculpted jewels represent the jewellery made of jade and other precious materials worn by the nobility. The head may have been cast in a mould. Her eyes are almond-shaped, the nose aquiline, the skull deformed and the nasal bone protrudes upward. Scarification lines come out of the corners of her mouth and extend over her cheeks, an adornment very commonly found on figurines of great rulers and high priests. The hair, which women wore very long, is gathered on top of the head and tied into a squarish shape, with locks hanging down in stepped layers on both sides of her forehead; in the middle, over short bangs, she wears an ornament. Behind it there is a fissure, which may be simply a part in her hair, but which also alludes to an open fontanelle, a symbol of supernatural powers and a link to the deities. Together with the posture, jewellery and scarifications, this seems to indicate that figures such as this portray priestesses. Similar figurines are in the Museo Nacional de Antropología in Mexico, the Museo del Camino Real in Hekelchak[2] and many other museums. Some of them carry children or manuscripts on their knees; in these cases, they may represent midwives or scribes who were part of the priesthood.

Maya society was stratified in three broad groupings: the nobility or *almehenoob*, "children of someone", in other words, of illustrious lineage. This class included the political rulers, priests, architects responsible for city planning, warrior chiefs and perhaps merchants. Artists, artisans and farmers constituted the people, the *ah chembal uinicoob*, "inferior people". Finally, there were the slaves, the *pentacoob*, the children of slaves and criminals, who acted as personal servants. In each of the languages of Maya origin, which number about 28, the social groups had different names.

The female figurines from Jaina and other sites attest to the high position of women in Maya society. This is confirmed by the images of women of illustrious lineage in Maya sculpture. Inscriptions show that they played important political roles in relation to their children and husband,[3] even though, like other women, their principal functions were childbearing, the preparation of food, the cultivation of family gardens, the care of domestic animals and the education of the children until puberty. Women were not allowed to participate in major community rites until after menopause, but certain occupations, such as that of midwife, had a priestly character. As shamans, midwives enjoyed a high social status. They carried out initiation rites in addition to those associated with pregnancy, childbirth and the integration of the new-born into the community. Thus some figurines that are part of the same group carry a baby on their knees.

MERCEDES DE LA GARZA
Translation: L.-S. Torgoff

1 Called "Group C" by C. Corson (1976).
2 See R. Piña Chan, 1968.
3 L. Schele, 1997, pp. 19-43.

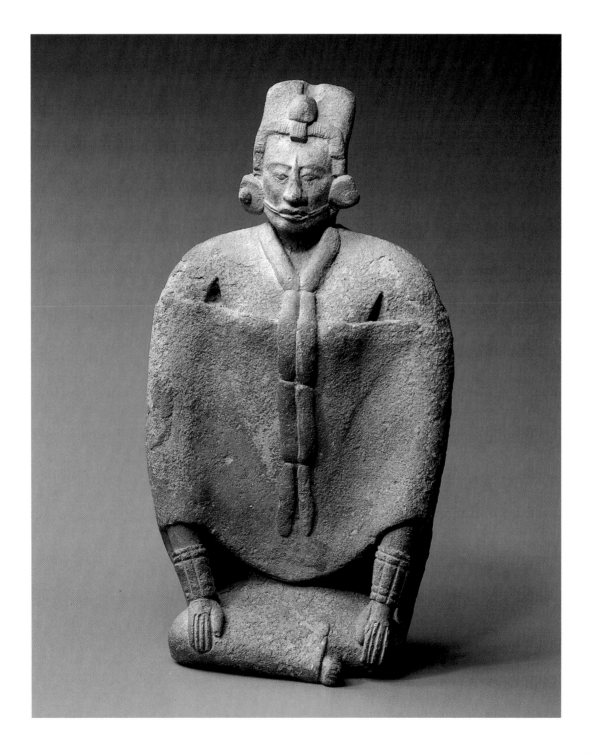

Maya sculpture

Late Classic period, 600-900 AD
Jaina Island, Campeche, Mexico

Warrior (?)

Terracotta, pigment (indigotin and gypsum)
H. 15 cm
Donated by Alphonse Pinart to the Musée d'Ethnographie du Trocadéro, 1878; former M.E.T. number: 8059
On permanent loan from the Muséum National d'Histoire Naturelle – Musée de l'Homme
Inv. M.H. 78.1.120

Main Exhibitions
Paris, 1928, 1947, 1965.

Main Publications
E.-T. Hamy, 1897, p. XXIX, fig. 29; A. Basler and E. Brummer, 1928, fig. 10a; H. Lehmann, 1960, dust jacket; *Chefs-d'œuvre du musée de l'Homme*, 1965, no. 79, p. 208.

This statuette is one of a group of modelled masculine figures painted red and blue, with their arms crossed around their chest and legs spread apart. Christopher Corson named them "group M".[1] They were made of reddish or greyish coffee-coloured clay. These modelled figurines are more realistic and dynamic than the moulded ones made of creamy, orange-coloured clay.

The figure shown here is a man standing upright with his arms crossed. The clay was modelled, baked and incised. The feet are missing, and the hands cannot be seen from the front. The nude torso is subtly modelled, while the legs are tubular and rigid, obviously because the feet were spread apart and turned outward, as in many male figures of this type. He wears a belt and a loincloth with traces of blue paint still visible. Equally blue fragments of large beads can be seen on his chest. He wears ear discs of the same colour, which may symbolize jade, since for the Maya blue and green were considered a single colour, called *yax*. His hair is arranged in stepped layers and covered with a large turban made of strips of canvas. His face is serene, the mouth partly open, with a slightly aquiline nose and almond-shaped eyes typical of the Maya. The prominent nasal bone protruding from the forehead is a sign of an intentional cranial deformation, accentuating the verticality and fineness of the face. The mouthpiece of the whistle is on the back, on the right arm.

Many such statuettes are hollow and functioned as whistles or rattles. This seems to indicate that they were used in funerary rites and later served to announce the passage of the spirit of the deceased to the beings that populated the nine levels of the lower world. The funeral ceremony consisted of dressing the deceased, adorning him with his jewellery, placing a jade bead in his mouth to symbolize the vital energy residing in the heart, then placing the figurine in his arms and wrapping the body in canvas or palm matting to be buried.

Paradoxically, these mortuary figurines convey a tremendous vitality which reinforces a belief in the immortality of the spirit. They portray various layers of society: richly dressed rulers, ball players, women carrying out the occupations assigned to them, priests, people with deformities (such as dwarfs and hunchbacks), human figures emerging from a flower (an allusion to some rite of initiation), people engaged in prayer, elderly couples, a woman embracing an animal and many others.[2] The faces are always lifelike and expressive, and the great variety in their dress, their adornment and the objects they carry, as well as aesthetic customs – such as cranial deformation and faces bearing designs through scarification – offer, more than in any other works, a rich vision of the social groups, the diverse activities and the way of life of the Maya of the Classic period.

MERCEDES DE LA GARZA
Translation: L.-S. Torgoff

1 C. Corson, 1976.
2 R. Piña Chan, 1968.

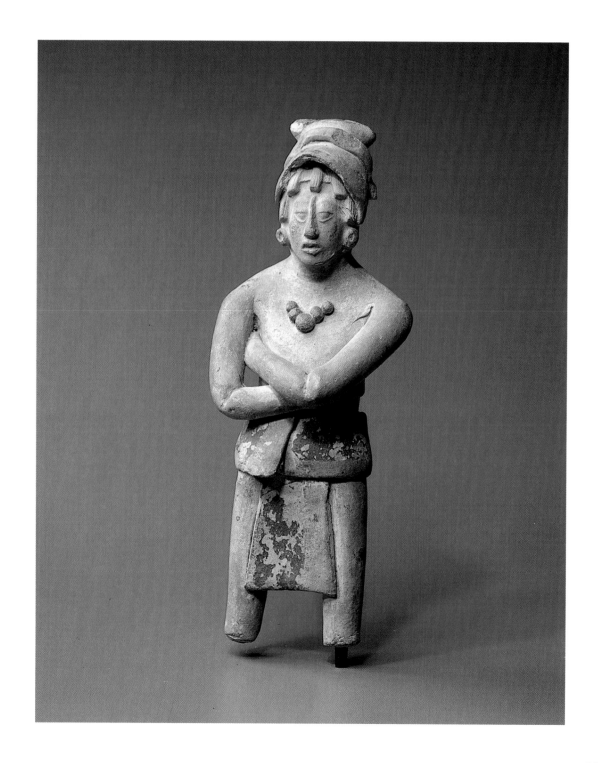

Sculpture from Veracruz

300-900 CE
Mexico (Puebla)

Yoke

Stone (diorite)
L. 42.5 cm; W. 38 cm
Gift of Labadie to the Musée d'Ethnographie du Trocadéro, 1887, former M.E.T. number: 194220
On permanent loan from the Muséum National d'Histoire Naturelle – Musée de l'Homme
Inv: 87.101.26

Main Exhibitions
Paris, 1928,[10] 1947,[11] 1965.

Main Publications
H. Strebel, 1890, pl. 6;
E.-T. Hamy, 1897, pl. XX;
no. 68, p. 85; *Chefs-d'œuvre du musée de l'Homme*, 1965, no. 75, p. 203.

The ball game, with a bouncing rubber ball, was one of the most amazing sights the Spanish experienced in Mesoamerica.

Rubber itself comes from a latex-bearing tree in the tropics and had no parallel in Europe. The complex rules of the rubber ball game in Mesoamerica – the use of hoops, not touching the ball with certain parts of the anatomy, etc. – were extremely influential on subsequent Western team sports. Mesoamericans played ball probably from the earliest times – circa 1,500 BCE to the Conquest, and in some areas to the present. Much of this play was entertainment associated with heavy betting.[1]

In the Classic Period (300-900 CE), especially, a great deal of ritual activity was associated with the game. This is evident in the large number of masonry ball courts that were built.[2] Because these courts and the associated ball game gear vary so much in size and form, it may be that rather than one game there were many different types of games. The analysis of the game is made easier by the fact that there are a number of narrative scenes depicted on ball courts. Further, we have at least one major myth that deals with the ball game.

There has been a great deal of interest in the symbolism of the ball game. The *Popol Vuh*, a Quiché Maya myth recorded in the early Colonial Period, tells the story of hero twins who played ball and whose gear was coveted by the Lords of the Underworld who invited them down to play in Xibalba.[3] The twins were killed by the death gods and the decapitated head of one was placed in a tree. A daughter of one of the lords became pregnant from the spittle of the head and went up to earth to bear a second set of magic twins. These twins also played ball with the Lords of the Underworld, but this time they were victorious and killed the gods of death and rose into the sky as the sun and moon (or Venus). The myth therefore deals with two descents into the underworld, one ending in death, the other with rebirth. Most scholars see this as a dualistic symbolism dealing with alternating cycles such as night/day, dry/rainy season, death/life. Much of the relief imagery deals with death (skulls, heads with closed eyes, decapitation) and/or with life (water, plants such as water lilies, and the maguey cactus).[4] Because a number of reliefs show decapitated ball players, it is believed that ritual games ended with the sacrifice of the losing player.

Why was the ball game so much a part of ritual life in the Classic Period and why did it require so much architecture and sculpture? Additionally, why was the story of the alternation of life/death, so basic to Mesoamarican belief, put in the framework of the ball gam? The ball game is a form of structured hostility and rivalry – not unlike football (i.e., soccer) in our time, and perhaps associated with strong group and ethnic identity. Mesoamerica was divided into many small polities that shared trade, intermarried and went to war against each other. Late codices show us that the ballgame was sometimes used as an alternative to war. The Classic Period is unusual in Mesoamerican history for the stylistic and ethnic differentiation of its polities while at the same time there was intense interaction between them. Ball game ritualism seems to have been a perfect way to channel interaction between groups within cities and perhaps even between cities. Besides its religious meanings, the game seems to have had important social and political functions.[5]

Three types of beautifully carved, mysterious objects were found from the 19th century in most parts of Mesoamerica: U-shaped stones called "yokes", which were originally thought to be used to hold down a victim in sacrifice; thin heads called *hachas*, thought to be ceremonial axes; and stones with a curving top called *palmas*. Only in the 1940s did Gordon Ekholm show quite conclusively that these objects were associated with the ball game.[6] He showed that the yokes were padded belts and that the *hachas* and *palmas* were attached to them. Such depictions are found in relief at Bilbao, Guatemala, Chichén Itzá and El Tajín in Mexico.

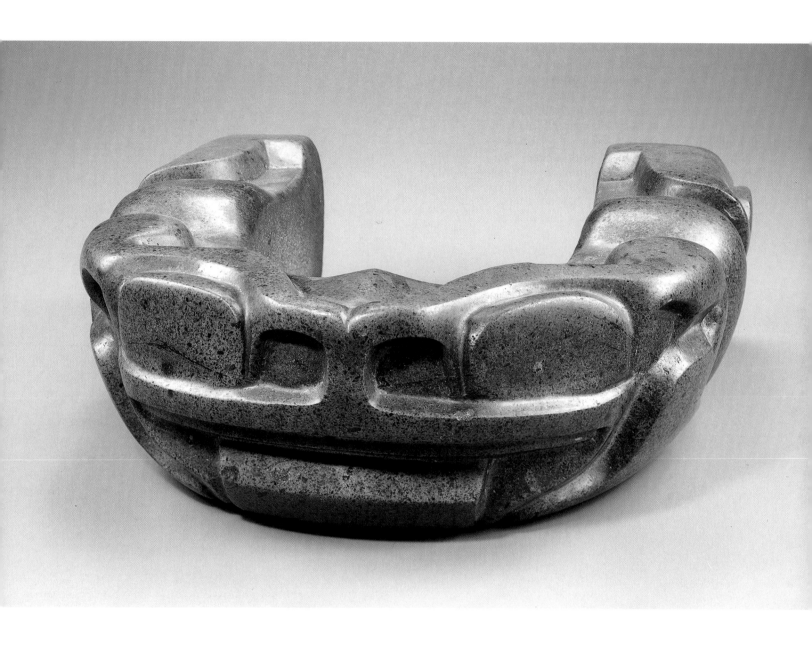

Ekholm believed that the actual stone forms were used in the game. Others feel that given the weight of the yokes (up to 20 kilos), their beautiful carving and lack of breakage and wear suggest that the actual playing gear was made of a perishable material and the stone images were used in a ritual and symbolic way, perhaps after the game. Unfortunately very few of these objects have been archaeologically excavated. In one example, a yoke may have been buried with a ball player.[7]

Of all ball game paraphernalia, stone yokes are the easiest to understand. They are clearly related to the heavy belt worn by the player to protect himself and deflect the ball. The stone versions are highly symbolic and carved with animal and human forms. The toad, the form of the Labadie yoke, is found frequently. There are also serpents and human parts attached to a plain yoke form. Yoke symbolism has been seen as dealing with the underworld and placing the player wearing it within the underworld.[8] As an aquatic animal, the frog is an underworld creature and may symbolise many aspects of the ball game myth. Frog yokes are noteworthy for their dramatic modelling into sectioned parts and the precisely cut detail of the features of the animal. The Labadie yoke is one of the most powerfully shaped frog yokes known.[9]

ESTHER PASZTORY

1 T. Stern, 1949.
2 E. Taladoire, 1981.
3 D. Tedlock, 1985.
4 E. Pasztory, 1972, pp. 441-55.
5 S.D. Gillespie, 1991; E. Pasztory, 1989.
6 G. Elkholm, 1946, vol. XLVIII, pp. 503-606.
7 S.J. Wilkerson, 1970, pp. 41-45.
8 P.J. Sarro, 1998.
9 I. Bernal, 1970.
10 Piece mentioned in the catalogue *Les Arts anciens de l'Amérique*, 1928, no. 255, p. 21.
11 Piece mentioned in the catalogue *Chefs-d'œuvre de l'Amérique précolombienne*, 1947, no. 115.

Huastec sculpture

1300-1500 CE
Tampico, Mexico

Stone
H. 163 cm
Gift of Gabrielle Ravar on behalf of his brother Henry Duprat (died January 1877 in Tampico)
to the Musée Préhistorique et Ethnographique de Bordeaux, August 1877; transferred to the Musée
des Beaux-Arts de Bordeaux in 1952, then to the Musée d'Aquitaine in January 1993.
On permanent loan from the Musée d'Aquitaine de Bordeaux
Inv. D. 94.20.600

Exhibition
Geneva, 1998-99.

Main Publications
I. Bernal and M. Simoni-Abbat, 1986, nos. 305-06, p. 333; *Trésors du Nouveau Monde*, 1992, p. 178; F. Solis, 1994, p. 220; *Mexique terre des dieux*, 1998, n° 208, p. 189.

Very little is known about the more than four hundred Huastec sculptures that have been catalogued so far.[1] The Huastec region is in the north of the Gulf Coast area, at the edge of what is called Mesoamerica. The Huastec language is related to Maya, but Huastec culture is closer to that of Veracruz and Central Mexico. Occupation in the region goes back to the Preclassic period, but this distinctive sculptural tradition dates to the Classic (300-900 CE) and mostly to the Postclassic period (900-1500 CE). The area was conquered by the Aztecs – Aztec style sculptures are known from near the site of Castillo de Teayo. The Huastecs were not unified in a centralised kingdom, but consisted of many small warring polities. The sculptures probably belonged to a number of small cities with temple centres, which explains the duplication of themes and perhaps the relatively large number of statues.[2]

The most common Huastec sculptures represent women with prominent breasts, young men, and old men hunched over a staff. The men and women often have a similarly big semicircular headdress with a conical central section. Women's heads often emerge from the maw of an animal, while the men's usually do not. Nevertheless, the Bordeaux figure has an animal helmet. The male figures are distinctive because much more curvilinear ornament covers their body or dress than the females. There are a few examples that have figures on their backs.

There has been little work on interpretation and the details of the figures do not lend themselves to easy decoding. Generally speaking the Huastec sculptures are said to deal either with themes of fertility (the women's breasts) or with war (the elaborately rendered men).[3] Since fertility and war are the major themes of Mesoamerican art in general, neither of these is specific enough really to explain these statues. It seems that Huastec figures, in their glorious male/female forms, have been admired and interpreted as Jungian archetypes. Judging by information on Aztec sculpture, even very similar looking images often had very specific and idiosyncratic names and histories that gave them a personality not necessarily visible in their form.[4] If these figures were deities, they could have belonged to specific cities and their founding religious myths.

The Bordeaux figure is one of the three most elaborate Huastec sculptures known. Another is in Mexico in the Museo Nacional de Antropología and one the third is New York's Brooklyn Museum. Of the three, the Bordeaux figure is the tallest, and like the figure in Mexico its sculpted base projects from the feet so that it can be stood up.

The Bordeaux figure has been infrequently published and is not included in the de la Fuente catalogue.[5] It represents a standing male with ornamented headdress, collar and skirt. The hands, as is usual, are asymmetrical: the left hand is at the waist, the right hand is raised to the chest and hollowed out as if it held an object – a staff, a weapon, or a standard. The figure on the back is particularly remarkable and bears some similarities with the other two figures. Like the Brooklyn figure, the Bordeaux one is skeletal and rendered three-dimensionally. Moreover, it is placed on the back at the level of the head in the front. On the other hand, the Bordeaux figure is small, unlike the Brooklyn one that is closer in size to the full figure. The Mexico City back figure is not only small, it is childlike in its soft modelling and crouching pose. The Bordeaux figure is therefore a little of both, but all three figures are quite individual.

How much can one interpret in the absence of an informant? As suggested earlier, because the very specific level of meaning is lost to us, we have to make do with generalities. The Janus arrangement of a living and skeletal figure in Mesoamerica is quite common and known from Preclassic times to the Conquest. It is generally interpreted as the Mesoamerican belief of life emerging from death and

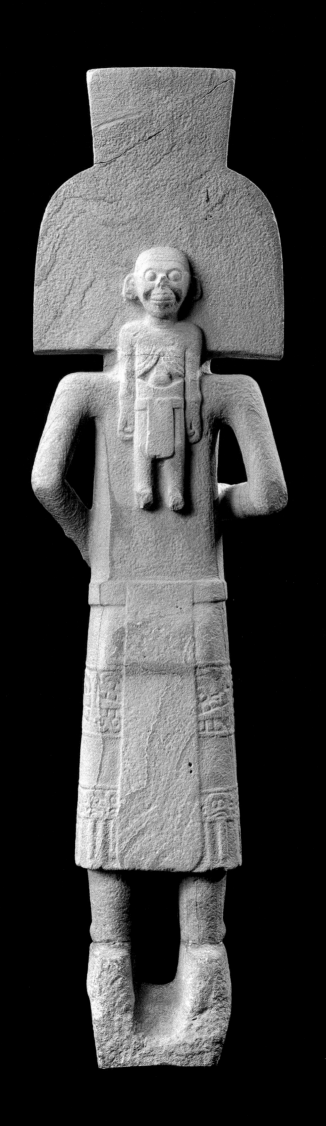

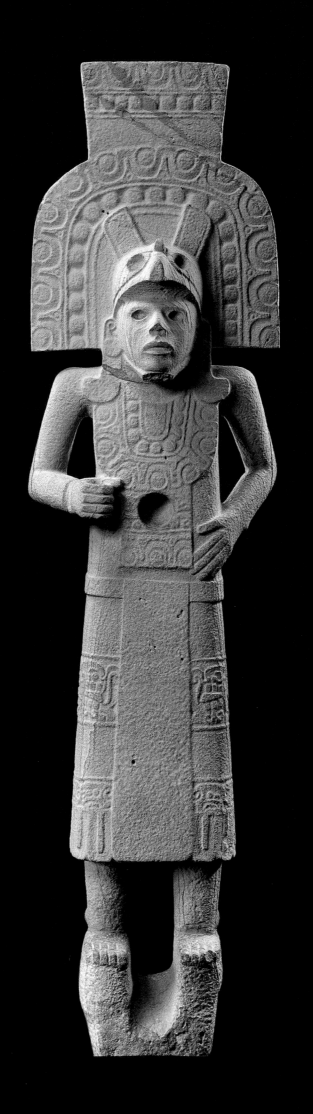

necessarily also ending in death, in a cycle metaphorically similar to the daily rising and setting of the sun. The child image, though not as frequent as the death image in Mesoamerica, can also be found in a number of cultures, most prominently among the Olmec. When it is associated with the figures of women, as it is in figurines, we tend to think of them as "fertility" images. But when they are found with male figures, they may represent concepts such as rebirth in the cycle of death and rebirth. The Bordeaux figure is curious in that death and rebirth are in one. In any case, these secondary figures are on the backs of otherwise young, impassive, powerful beings. There is no way to tell whether the front figures are humans, "warriors" or gods.

Huastec sculpture has come to Western attention because of its formal qualities that combine geometric abstraction as in the headdress or skirt, a sensitive but simple modelling of the body, sometimes relatively naturalistic, idealised facial features, and an enriching ornament that does not disrupt the clarity of the design.[6] Given these values, the Bordeaux figure is one of the most interesting.

ESTHER PASZTORY

1 B. de la Fuente and N. Gutierrez, 1980.
2 G. Stresser-Péan, 1971, vol. II,
 pp. 582-602.
3 F. Solís, 1994, pp. 183-241.
4 E. Pasztory, 1997, p. 70.
5 Trésors du Nouveau Monde, 1992.
6 F. Solís, 1994, p. 234. An example of a Huastec pottery
 vessle is discussed and illustrated with designs similar
 to the sculptures.

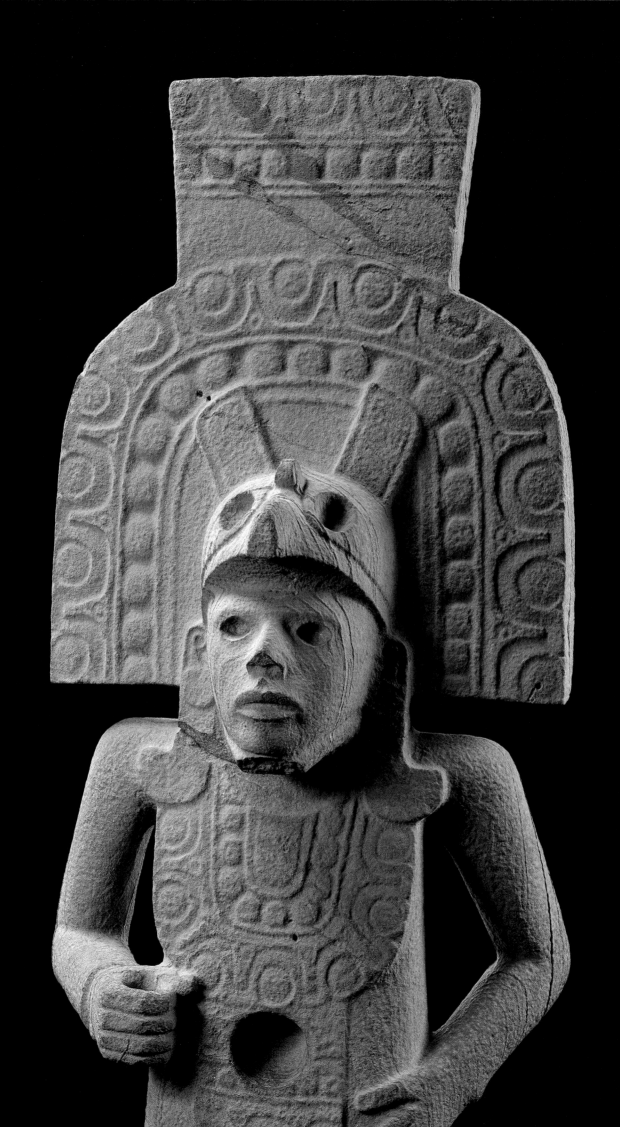

Aztec sculpture

14th century
Valley of Mexico, Mexico

Drum (teponaztli)

Wood
L. 62 cm
Piece brought from Mexico in 1855 by the painter Édouard Pingret
Bought by the Musée de l'Homme at the Kelekian sale, 15 November 1952
On permanent loan from the Muséum National d'Histoire Naturelle – Musée de l'Homme
Inv. M. H. 52.71.1

Aztec culture was devastated in the Spanish Conquest in 1521 in which Cortés and his men literally destroyed the capital city of Tenochtitlán. The only ones to see Aztec life and ritual still functioning were the conquistadors. A number of them, such as Bernal Diaz del Castillo, wrote eyewitness accounts of their experiences.[1] Of special importance are the letters Cortés wrote to Charles V in order to justify his actions.[2] Soldiers were followed by missionaries such as Bernardino de Sahagún, who arrived with twelve Franciscan friars in 1524.[3] While they saw a culture decimated by disease and disorganisation due to the collapse of the Aztec empire, they collected vast amounts of information about Aztec life in the schools they founded.

Teaching the sons of the native lords the alphabet, they devised a written form of the Nahuatl language in which information was recorded about everything from history, religion, mercantile activity, concepts of nature, and even rhetorical speeches appropriate for various occasions and poetry. From these very diverse textual sources, from the limited amount of archaeology that has been possible in a modern day Mexico City built over the ruins of Tenochtitlán, and from the surviving images in a variety of media, we try to put together a view of Aztec life and their relation-ship to their things. Aztec objects are particularly important because they were made for their own purposes and are not filtered through colonial ideas.

The Aztecs were late-comers in the Valley of Mexico, which had settled civilisation going back at least to 1,000 BCE. According to their own traditions, the Aztecs were nomadic barbarians who came into the Valley of Mexico area following their god Huitzilopochtli, who promised them greatness. On their way they saw the impressive ruins of cities like Tula and Teotihuacán, and the Aztecs seem to have wanted to rival the past in their monuments. However, they were never secure and powerful rulers in their realm. They came to power in a military alliance with other cities, and up until the time of the Spanish Conquest rule was shared in a Triple Alliance between Tenochtitlán, Texcoco and Tlacopán. The Aztecs of Tenochtitlán saw themselves as a special people and called themselves the "Mexica". The term "Aztec" is a general term for all the people of the Valley of Mexico whose ruling group were the Mexica. Most significant Aztec architecture and sculpture belongs to the later part of Aztec history, circa 1430-1521, when the Aztecs were acquiring wealth and tribute from their empire.[4]

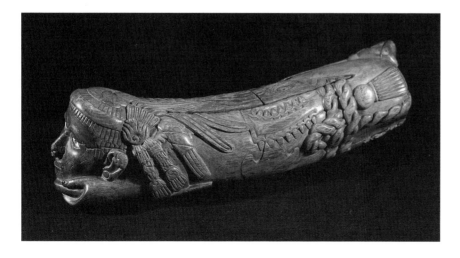

Fig. 1
Aztec sculpture
1400-1521 CE
Drum (teponaztli)
Tlaxcal, Mexico
Wood, mother-of-earl, obsidian
L. 60 cm
Museo Nacional de Antropología, Mexico

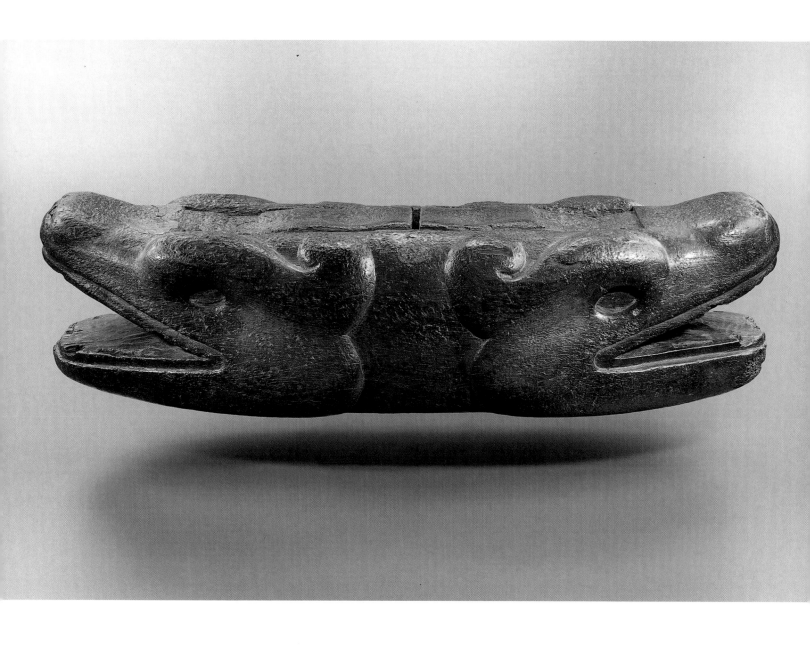

Because of the Spanish zeal to destroy idols and the destruction of Tenochtitlán, only a fraction of its sculptures have survived. Due to the tropical climate of Mexico, most of these are in stone. Although we know that there was a great deal of wood sculpture as well, and that even some of the sculpture of the major deities of the Temple Precinct were made of wood, today only a small quantity of wooden things has come down to us. The wooden objects that survived are either costly items that were covered in turquoise mosaic and sent to Europe as curiosities by the conquerors, or more humble objects such as musical instruments which did not fall under the persecuted category of "idol" and were maintained in local hands. These are merely an indication of the richness of wooden sculpture among the Aztecs.

The horizontal drum, or *teponaztli*, was one of the most common types. It is cut open in the bottom and has a slit on the top in the form of an H. It was played with sticks with rubber tips. Drums and flutes (Mesoamerica had no stringed instruments) were played for entertainment, in most rituals, and urged soldiers on in war. The *teponaztli* was usually played together with a vertical drum known a *huehuetl*. Because these drums were not considered idols, not only did they survive, but new ones were made in the early colonial period. Every village had its own set of musical instruments for fiestas. One famous drum from Malinalco was still being used in the 19th century. Since drums continued to be made, it is not always easy to tell which are Aztec and which are Colonial. About twenty drums are known to exist in collections, in various human and animal shapes.[5]

The Pingret drum is in the category of effigy figures, with two open-mouthed animal faces placed back to back. Although the curving scroll of the eye-brow suggests a serpent, the square muzzle of the creatures is more like a feline. Thus the identity of the animal is hard to determine. Woodcarvings are stylistically more diverse than stonework, which perhaps came out of fewer workshops. Existing drums may have a glyph, mask or flower in relief or effigies. The modulated surfaces and sinuous curves of the animals on the Pingret drum make it very appealing to a European sensibility. Since we do not know what locality and what level of class had this drum made, it is difficult to assign an Aztec aesthetic value to it. In general, roundedness of modelling was usually present in important Aztec stone sculptures and was considered a sign of beauty.

ESTHER PASZTORY

1 B. Diaz del Castillo, 1963.
2 H. Cortés, 1971.
3 B. de Sahagún, 1950-1978;
 T. Todorov, 1982.
4 E. Pasztory, 1983; J. Soustelle, 1955.
5 M.H. Saville, 1925; E. Pasztory,
 1983, pp. 269-277.

Aztec sculpture

1400-1521 BCE
Valley of Mexico, Mexico

Coiled serpent

Stone (andesite)
H. 29.9 cm; D. 54 cm
Formerly in the Latour-Allard collection (before 1830)
Gift of Latour-Allard to the Muséed'Ethnographie du Trocadéro, 1887; former M.E.T. number: 20059
On permanent loan from the Muséum National d'Histoire Naturelle – Musée de l'Homme
Inv. M.H. 87.155.1

Main Exhibitions
Sculpture shown at the Musée américain (Antiquities sub-department), Louvre, Paris, 1850;[7] Paris, 1928,[8] 1947,[9] 1965.

Main Publications
Antiquities of Mexico, 1830, vol. IV, pl. 6 (engraving); E.K. Kingsborough, 1831, vol. IV, pl. 6 (engraving); A. Basler and E. Brummer, 1928, pl. 80; R. d'Harcourt, 1948, fig. 80, p. 97; *Chefs-d'œuvre du musée de l'Homme*, 1965, no. 67, p. 187.

Neither the Spanish conquistadors nor the missionaries wrote much in their voluminous descriptions of Aztec life about sculpture. Sculptures were either "idols" to be destroyed or, to the Renaissance mentality, ugly and monstrous things. Sculptures were routinely smashed until the late 18th century when Europeans were discovering the monuments of various ancient civilisations such as Greece, Rome and Egypt and considering them "works of art". With the 1790 find of three major Aztec sculptures, in Mexico City, including the famous Calendar Stone, Mexicans, European settlers and the increasing number of visitors became curious about Aztec sculptures. Collections were formed based on very little knowledge, no archaeology, and not surprisingly, a great many fakes.[1] Desiré Charnay wrote extensively about the problem of discerning fakes from originals.[2]

Except for the "idols" described in the texts, which were often located in the small chambers on top of the pyramid temples, we do not know where most Aztec sculpture was located. (One archaeological exception to this is the three meter oval relief of Coyolxauhqui found at the base of the Huitzilopochtli temple in 1978 in Mexico City). The rock-cut temple of Malinalco has sculptures carved in the interior of the temple chamber, flanking the entrance and on the stairways. Presumably, sculptures were similarly arranged in a variety of ways inside and outside temples.

Because most sculptures, especially the smaller ones, have no provenance, we have no clear knowledge of what types of temples they were associated with. A study of Aztec sculpture has demonstrated that there were different sizes and styles that perhaps correlated with different levels of Aztec society.[3] We are fairly certain that the large, important and complex images, often found near the Zocalo, were probably on the Templo Mayor – the main temple precinct of Tenochtilán. These works were commissioned by the rulers in consultation with the priests, and made by the most favoured carvers. We have more difficulty with the smaller sculptures. Some of them are as well carved as the Templo Mayor images, while others range from elegantly stylised to totally crude. Many of the rough images represent the maize goddess, Chicomecoatl, the most common type of Aztec sculpture and the most common deity in the rural areas. The other sculptures could belong to the temples of Tenochtilán or to many of the other towns and even larger villages.

The coiled serpent in the Musée de l'Homme is stylistically similar to the major monuments of Tenochtilán, but in its small scale it could also have been on a temple in Texcoco or Tlacopán. Aztec human figures usually depict deities or humans representing "service personnel" – standard bearers, burden carriers, etc. However, the category of stone sculptures, of animals is unique to the Aztecs and harder to contextualise. The most common animal carved in stone is the serpent, but there are also felines, frogs, eagles, and even insects. Most mysterious are the related carvings of vegetables such as squash. Presumably, these were placed in the temples of deities whose nature was related to them.

Westerners have been fascinated by the form of Aztec coiled serpents as sculptures in the 20th century. (The sculptor John Flannagan made modern versions of them in the 1930s.) Aztec serpents are either coiled in a circle, or more irregularly, in a ball. They are usually rattlesnakes, and come with or without feathers. Several, including the Musée de l'Homme serpent, have an Earth Monster carved on the bottom. The presence of Earth Monsters symbolises the resting of the figure on the earth – the womb and tomb of all life.

The meaning of the feathered serpent in Mesoamerican iconography is both easy to understand and very complicated. The feathered serpent was a pre-Aztec image, dating at least to Teotihuacan times, circa 100 CE, and most likely earlier. The serpent itself is a symbol of renewal. Mesoamericans were most impressed by its ability to shed its skin and saw it as a symbol of transformation and immortality. The serpent is not evil, as in the Judeo-Christian tradition, but benevolent.

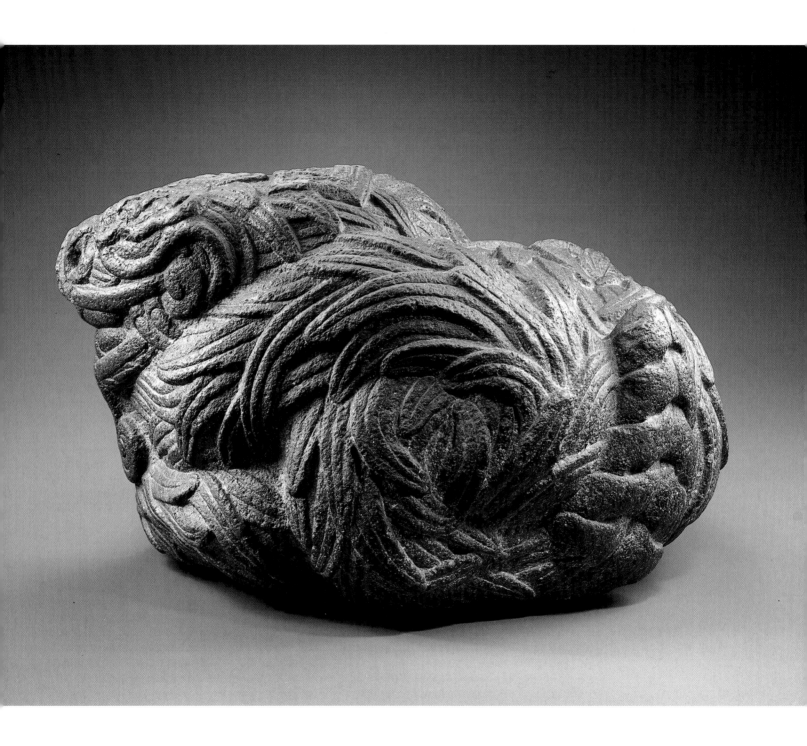

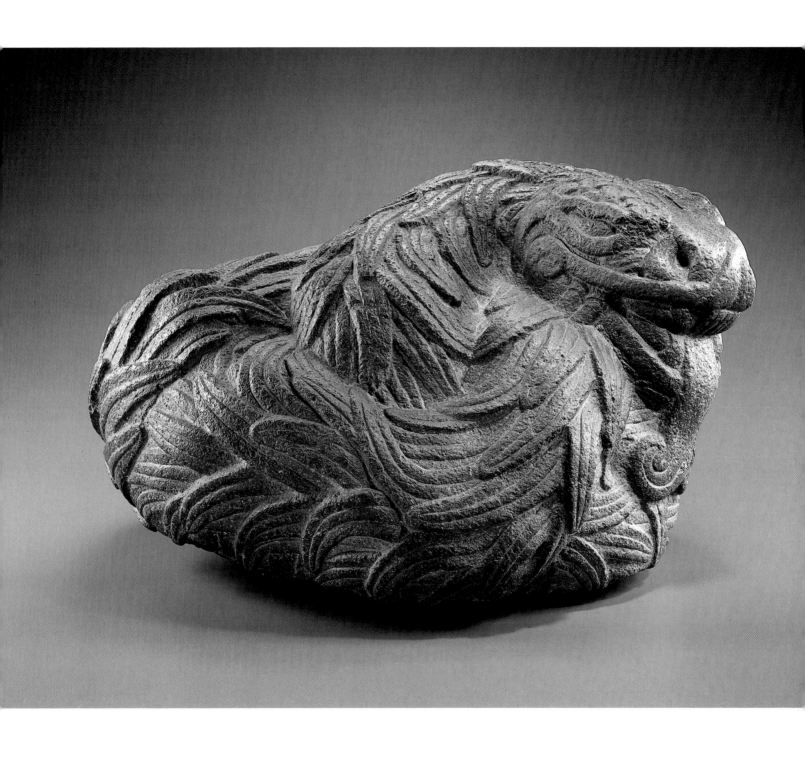

The feathers on the serpent were presumably green quetzal feathers, imported from Guatemala. These were rare and expensive and their greenness symbolised the color of vegetation and therefore life. The feathered serpent, therefore, at its most basic level, represents life and renewal perhaps in relation to nature and the rainy season. The Earth Monster at its base represents the opposite – death. Mesoamericans saw life as an endless cycle of death and rebirth. For their religious and royal symbols, Mesoamericans looked for images of power. Animals such as venomous serpents, jaguars and eagles were used to represent the power of nature and the gods as well as elite humans. The choice of the rattlesnake is not so much due to its danger to humans, but is an indication of the power of the supernatural and the cosmos, hopefully directed towards the benefit of humans.

There is a tendency to equate all feathered serpents with the personage of Quetzalcoatl, whose name means literally quetzal serpent. According to Aztec legend, Quetzalcoatl was a ruler of the earlier culture of Tula forced out of his city by a rival faction led by Tezcatlipoca. According to one version, he left on a raft saying he would return. His birth date in the calendar and hence his name is 1 Reed. In 1519, when Cortés appeared off the shore of Mexico, it happened to be the Aztec year 1 Reed. As Montezuma tried to figure out who Cortés might be from his books, the legend of Quetzalcoatl loomed large and ominous. The Aztecs (Mexica) felt that they were the usurpers of power in the Valley of Mexico and the rightful ruler of a previous dynasty had come to take it back. Hearing of this legend, Cortés made the most to live up to it. Because of this historical circumstance, both the conquistadors, missionaries and even the Aztecs were especially interested in the personality of Quetzalcoatl. The Spanish asked many questions, wrote many folios and ended up turning him into a kind of Christian saint or Western precursor. Jacques Lafaye discussed in detail how much of this myth is a Colonial creation of the encounter and not prehispanic.[4] The figure of the historical ruler – whose reality is still not certain – is mixed up with the cosmic feathered serpent of renewal and a creator deity in the religious codices in the various colonial records. This confusion has been feeding our fantasies of ancient Mexico for several centuries. (See D.H. Lawrence's novel, *The Plumed Serpent*.)

There is no evidence that Montezuma was particularly concerned with Quetzalcoatl, the historical figure, in the sculptures he commissioned until after the arrival of Cortés.[5] We do know that most Aztec sculptures were specially commissioned for a particular time, place, and occasion. While not all serpents have glyphs or refer to Quetzalcoatl, the Musée de l'Homme serpent has a cartouche with the 1 Reed glyph on the back of the head, as does a very similar feathered serpent in the National Museum of Anthropology in Mexico.[6] Unfortunately, too little is known of its context to be able to attribute it to a particular location, ruler or occasion and to be able to interpret what it means more precisely.

ESTHER PASZTORY

1 E. Pasztory, 1982, pp. 77-106.
2 D. Charnay, 1885.
3 E. Pasztory, 1983.
4 J. Lafaye, 1974.
5 E. Pasztory, 1984, pp. 101-126.
6 H.B. Nicolson and E. Quiñones Keber, 1983, pp. 134-142.
7 Piece mentioned and commented on by A. de Longpérier, 1850, no. 59, pp. 23-24, and A. de Longpérier, 1852, no. 59, p. 22.
8 Piece mentioned in the catalogue *Les Arts anciens de l'Amérique*, 1928, no. 41, p. 5.
9 Piece mentioned in the catalogue *Chefs-d'œuvres de l'Amérique précolombienne*, 1947, no. 56, p. 25.

Aztec sculpture

1400-1521 CE
Valley of Mexico, Mexico

Statue of Quetzalcoatl

Stone
H. 44 cm
Formerly part of the Eugène Boban and Alphonse Pinart collections
Donated by Alphonse Pinart to the Musée d'Ethnographie du Trocadéro, 1878; former M.E.T. number: 10412
On permanent loan from the Muséum National d'Histoire Naturelle – Musée de l'Homme
Inv. M.H. 78.1.59

Main Exhibitions
Paris, 1878, 1928, 1947, 1952, 1965; New York, 1970-71; Washington, 1983, 1991; Tampere, 1997.

Main Publications
E.-T. Hamy, 1897, pl. XII, no. 36; A. Basler and E. Brummer, 1928, pls. 82-83; H. Lehmann, 1960, pp. 34-35, pl. 36; L. Réau, 1934, fig. 15, p. 16; *Flor et Canto del arte prehispanico en México*, 1964, note and pls. 409-410; G. Willey, 1966, p. 161, fig. 3-116; J. López Portillo, D. Sodi and F. Díaz Infante, 1977, p. 54; R. Piña Chan, 1977, cover and back cover; J. Alcina Franch, 1983, p. 285, pl. 144; B. Keen, 1984, pl. 8; S. Toscano, 1984, p. 115, pl. 163; I. Bernal and M. Simoni-Abbat, 1986, p. 113; P. Prem and U. Dyckerhoff, 1986, p. 236; S.N. Gutierrez, 1987, pp. 60-61, pls. 26-27; I. Clendinnen, 1991, pp. 233-234, plate following p. 240; J. Alcina Franch, M. Léon Portilla and E. Matos Moctezuma, 1992, p. 352; E. Matos Moctezuma, 1994, pp. 190-191; F. Solís, 1997, p. 237.

After winning independence in 1821, Mexico opened its doors to many travellers fascinated by its previous civilisations. In the middle of the 19th century, the Frenchman Eugène Boban journeyed throughout the country, amassing an extensive archaeological collection comprised mainly of objects from the Valley of Mexico, especially the capital of the new republic and its suburbs and surrounding towns. According to Henry Nicholson, Boban acquired this statue of Quetzalcoatl and brought it back with him to France. It was probably shown for the first time during the second International Congress of Prehistoric Anthropology and Archaeology in Paris.[1] A few years later, another French voyager, Alphonse Pinart, well versed in ethnography and linguistics, bought the sculpture from Boban for his own extensive collection of Mexican works. It was one of the main attractions at the 1878 Universal Exhibition in Paris.[2] That same year, Pinart donated his collection to the recently-founded Trocadéro ethnography museum.[3]

As part of the celebration of the 500th anniversary of Columbus's voyage to the New World, the French government financed in 1992 the remodelling of the exhibition halls at the Musée de l'Homme. The Quetzalcoatl was installed in a display case in the centre of a room dedicated to the metropolis of Teotihuacan. This sculpture of the Feathered Serpent is one of the most outstanding Mexican archaeological pieces in France. Its importance is such that it has been featured at all the major 20th century international exhibitions of Aztec art.

Like many other masterpieces of the Aztec era, it comes from the sculpture workshops that burgeoned in the main cities of the Valley of Mexico starting with the rein of Moctezuma-Ilhuicamina (1440-1469), king of Tenochtitlan (now Mexico City). Between the mid-1400s and the Spanish conquest beginning in 1519, the states of central Mexico carried out successful military campaigns and dominated a great deal of the country. As a result, many artists from the conquered regions were forced to move to the urban centres where spoils of war, along with prized raw materials, had been taken in tribute, notably extremely hard stone such as porphyry from which this statue of Quetzalcoatl is made. Chief among these ateliers was that of Tezcoco, a city that prospered since the time of Nezahualcoyotl, who made it the cultural capital of the region. This piece, in which the artist has brought out the god's sacred, dual animal/ human nature, was surely meant to preside over the main alter of one of the many temples dedicated to the worship of the wind god.[4]

This Feathered Serpent is an example of the way in which pre-Columbian societies represented the benevolence and importance of their gods by covering their bodies, in this case that of a powerful reptile, with the magnificent, emerald-green feathers of the *quetzal*. Quetzalcoatl is considered one of prehispanic Mexico's oldest deities.[5] During the Aztec era, he was considered the chief creator, a god who transformed himself into the sun, gave form to the earth, made mankind and provided it with maize for its basic sustenance. Quetzalcoatl is also Ehecatl, god of the wind, recognisable as such by his ornamentation and characteristic insignias.[6] In mythological and historical narratives, the Feathered Serpent is both a god and a man, and was once the king of Tula.[7]

This statue of Quetzalcoatl is a capital work of pre-Columbian art and represents its highest level of formal synthesis. The sculptor exhibited tremendous mastery in the carving of this coiled figure, imparting a strong sense of spiral motion. There is a perfect equilibrium between the snake-like body and the arms and feet of the man-god. Quetzalcoatl's head emerges from the reptile's open jaws, which are thus transformed into his signature helmet. He wears hooked earpieces called *epcololli*, which indicate that he is the wind god.

There are other known sculptures of the Feathered Serpent: a Quetzalcoatl with a mutilated face and the sign of the "flowery war" held by the Museo Nacional de Antropología in Mexico;[8] a similarly

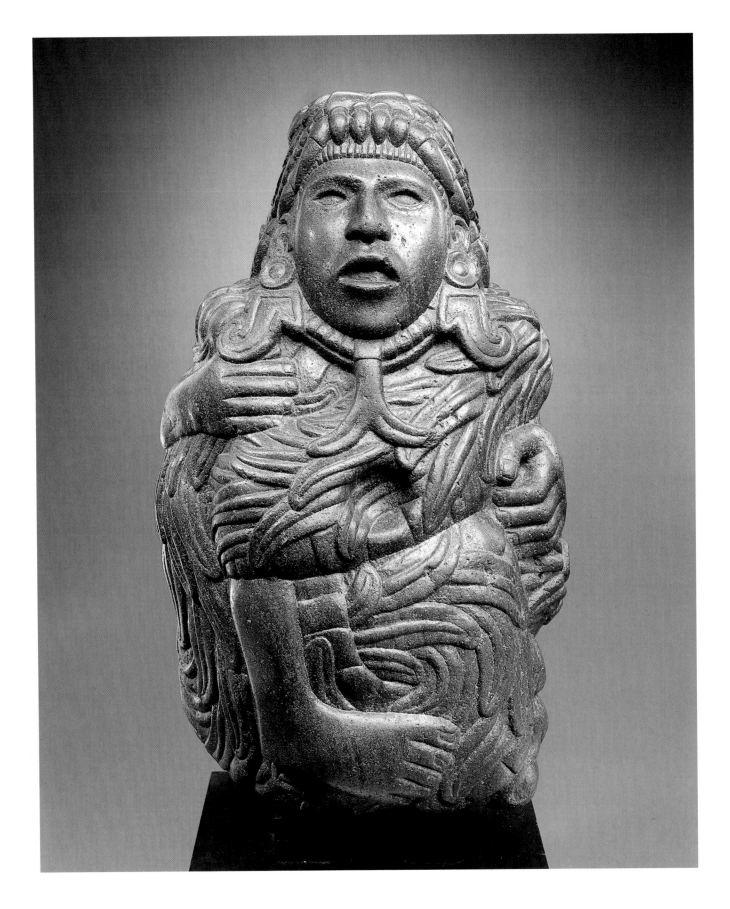

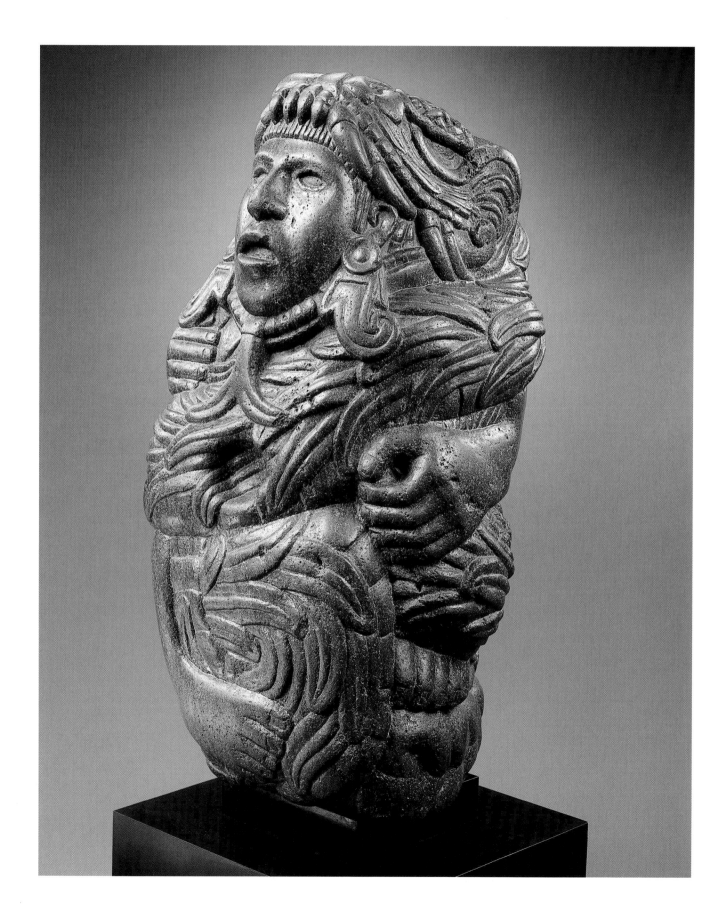

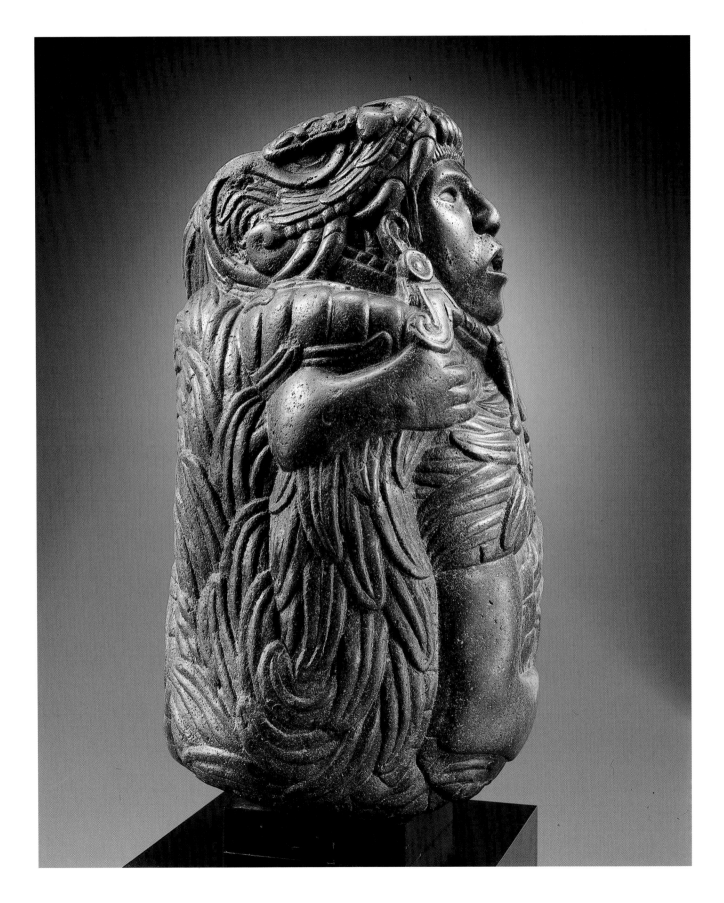

spiral-shaped one in New York's Metropolitan Museum of Art that was formerly part of Nelson Rockefeller's primitive art collection;[9] and, finally, another one recently discovered in Apaxco and now on exhibit in the museum there.[10] Nevertheless, none of them rivals the perfection of this statue from the old Trocadéro museum of ethnography.

<div style="text-align:right">

FELIPE SOLÍS
Translation: L.-S. Torgoff

</div>

1 H. Nicholson, 1983, p. 143.
2 *Ibid.*
3 Jacques Soustelle (1967, p. 44) reports that Pinart gave the Trocadéro museum more than 3,000 vases, sculptures and so on, including a famous rock crystal skull.
4 The Temples of Ehecatl-Quetzalcoatl are characterised by a cylindrical room with a conical roof. The facade of the pyramid that supports it is rectangular, while the rear part is circular. The finest surviving examples are the Calixtlahuaca temple in the state of Mexico and the Temple of the Divine Twin in Zempoala, on the Veracruz coast. See I. Marquina, 1951, pp. 224-229 and pp. 469-473.

5 R. Piña Chan (1977, pp. 14-15, fig. 9) believes that the worship of the Feathered Serpent arose in Tlatilco around 1200 BCE.
6 Ehecatl wears a conical cap and a half-mask in the shape of a bird's beak, which he uses to make the wind blow; his curved earpieces are made of conch shells called *epcololli*; and his pectoral is a snail shell whose shape invokes the spiral motion of whirlpools and hurricanes. See S. Mateos Higuera, 1993, vol. II, pp. 185-209.
7 See A. Lopez Austin, 1973.
8 The statue in the Museo Nacional de Antropología represents a coiled Feathered Serpent composed of circles of increasing diameter. The human aspect of the god is shown in the

face, which comes out the snake's jaws. See S.N. Gutierrez Solana, 1987, p. 92, pls. 44-46.
9 The serpent from the Rockefeller collection is particularly lithe. The reptile is formed of a single coiled circle with what seems to be a leg under its feathers, which allows it to stand and open its jaws so that it is identified as the god.
10 A magnificent sculpture of Quetzalcoatl was found during the recent excavation of the centre of the city of Apaxco. Its undulating body covered with feathers resembles a large sphere, and in this example, too, the god's head emerges from the reptile's jaws. See M. de la Torre (ed.), 1991, p. 57.

Aztec sculpture

1400-1521 CE
Valley of Mexico, Mexico

Deformed figure with crossed legs

Stone, pigment
H. 16.3 cm
Formerly part of the Labadie Collection
Donated by Mr Labadie to the Musée d'Ethnographie du Trocadéro, 1878; former M.E.T. number: 26113
On permanent loan from the Muséum National d'Histoire Naturelle – Musée de l'Homme
Inv. M.H. 87.101.3

Main Exhibitions
Paris, 1928, 1947, 1965.

Main Publications
R. d'Harcourt, 1948, p. 92, fig. 75; H. Nicholson, 1971, p. 425, fig. 37; J. Bernal and M. Simoni-Abbat, 1986, p. 113.

Prior to its acquisition by a Frenchman named Labadie, the provenance of this object is unknown. Labadie donated it and the hundred and sixty-one other objects in his Mexican archaeology collection to the Musée d'Ethnographie du Trocadéro in 1887. It was officially registered on 15 January 1889. Thus it has been in the museum's collection for well over a hundred years.

In Mesoamerican society,[1] people with unusual physical characteristics – hunchbacks, dwarfs, Siamese twins, albinos, etc. – were considered to have been touched by the gods or to have a special relationship with supernatural forces.[2] The legend of the cosmogenic suns tells of the birth at Teotihuacan of the Fifth Sun thanks to the self-sacrifice of a sick and deformed god named Nanahuatzin. Some 16th-century chronicles recount that in the pre-Conquest period the elite and especially the lords preferred that their servants be hunchbacks. Women of noble lineage also sought deformed women and dwarfs to attend to them.[3] Accounts of the Conquest describe the Spaniards' visit to the palace of Moctezuma, where the Lord of Mexico kept hunchbacks and dwarfs to entertain him with jokes, singing and dancing.[4]

In the second *Relación de la Conquista de la Nueva España*, Hernán Cortés gives a detailed description of his trip to the prehispanic city of Mexico-Tenochtitlan. He mentions a house Moctezuma had built very near his palace, a sort of human zoo full of men and women with terrible deformities. They were kept enclosed in separate rooms grouped according to their particular misfortune. A large number of servants were assigned to their care and feeding.[5] Historical accounts also mention that the supreme rulers of various kingdoms in central Mexico used dwarfs and other handicapped people as messengers to communicate with each other.[6]

This figurine represents a stocky, squat man, sitting with his legs crossed. His deformity is indicated by the fact that his head is sunken between his shoulders and his voluminous chest. Although the back of the figure was destroyed, it almost certainly had a hump. His posture, seated on his buttocks with his legs crossed in front of him, is uncommon in Aztec sculptural iconography. It gives him a relaxed, calm appearance. His hair and headdress are detailed, but the statuette's most distinctive feature is the large, circular ornament called a *besote* fastened between the lips and chin. In a public ceremony, a small obsidian knife was used to pierce the skin under the lower lip all the way through to the inside of the mouth. This ornament gives the wearer a very particular expression, curving the lips sharply downward. In these militaristic Mesoamerican societies, the wearing of a *besote* was the exclusive privilege of great warriors who had become famous for their feats in battle.[7]

Hunchbacks are common figures in Aztec art, especially clay figurines, both moulded and modelled. But it is only in carved stone works that physically deformed individuals are portrayed wearing hair styles and ornaments that indicate the social rank of warrior.[8] They have been interpreted as symbolic images of the warriors associated with the sun, since this god, the warrior par excellence, was created by a deformed being.

Aztec anthropomorphic sculpture is well-known to the public because it has been so widely exhibited in galleries in Mexico, Europe and the United States. These collections often contain representations of hunchbacks and other people with deformities. Aside from those in Mexico, the most outstanding, in terms of their aesthetic quality, are those in museums in Berlin[9] and Vienna.[10] Still, this statue from the Musée de l'Homme is one of a kind because the figure is wearing a *besote*, conferring the dignity of a noble on a malformed individual.

<div style="text-align: right">

FELIPE SOLÍS
Translation: L.-S. Torgoff

</div>

1 The concept of Mesoamerica as an over arching cultural region made up of various high civilisations was first put forward in 1943 by Paul Kirchhoff. After analysing historical chronicles and archaeological studies, he mapped out a geographical area comprising part of Mexico and the neighbouring Central American countries. This region was the cradle of complex cultures whose mixed economy was based on intensive agriculture. These societies were highly stratified and their political structures reached the level of a state. See M. Porter Weaver, 1993, pp. 1-3.

2 The indigenous people who helped Father Sahagún record the events associated with solar eclipses described how the people were terrified and immediately sacrificed albinos to the sun god. See B. Sahagún, Vol. 2, 1989, pp. 478-479.

3 In *Historia de las Indias de Nueva España e Islas de la Terra firme* (D. Durán, 1995, Vol. II, p. 65), a chapter describing the worship of Tzcatlipoca emphasises the nobles'pleasure at using people with deformities such as hunchbacks and dwarfs.

4 Bernal Díaz de Castillo (1980, pp. 166-170) describes King Moctezuma, his life style and the way in which hunchbacks, dwarfs and other misshapen people entertained him during his meals.

5 H. Cortés, 1963, p. 55.

6 The life story of Nezahualcoyotl, lord of Texcoco, is recounted in numerous chronicles and histories written by both Spaniards and indigenous people in the 16th century. R. Granados García (1953, vol. II, p. 22) assembled all the available information on this celebrated ruler of ancient Mexico who used dwarfs to carry messages to his subordinate dignitaries.

7 In some sculptural representations of warriors, the wearing of a *besote* clearly endows the face with a fierce expression. The ornament was fastened inside the mouth by two straps held by the tongue so that the jewel – usually of jade, obsidian or gold – would not dangle due to its own weight and the slight resistance of the soft walls of the flesh around the chin. See F. Solís and M. Carmona Macias, 1997, p. 146.

8 The statue reproduced in Solís, 1991 (p. 233,

piece 342) shows a person with a double hump and the coiffure of a great warrior. These warriors would cut off a lock of their hair and decorate it with eagle feathers and cotton tassels to indicate that they were beloved children of the Sun.

9 The Museum für Völkerkunde in Berlin has a statue of a deformed person with a broad torso and the head sunk between the shoulders. See D. Eisleb, 1983, pp. 83-84, figs. 11-14.

10 Vienna's Museum für Völkerkunde holds many statues of hunchbacks from the Aztec era. One of them in particular (inv. 107) shows a figure in a posture identical to the one pictured here, sitting with his head sunk between his shoulders. See E. Becker-Donner, 1965, p. XIX, pl. 59.

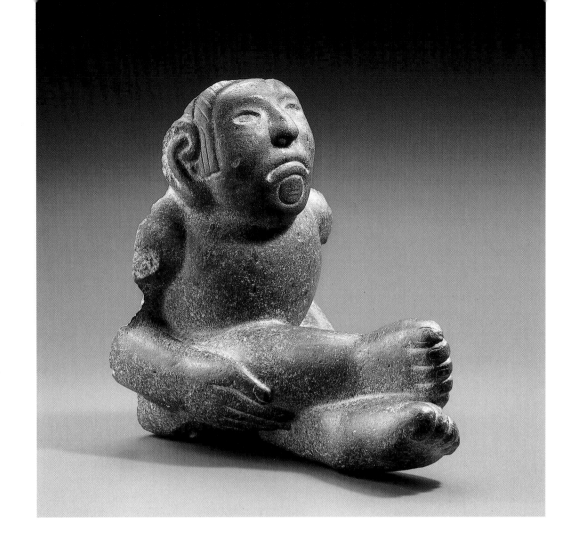

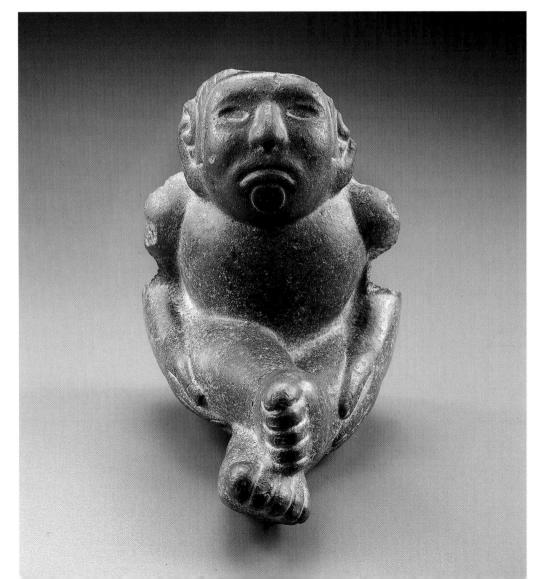

Aztec sculpture

1400-1521 CE
Valley of Mexico, Mexico

Mask of Xipe Totec

Stone
H. 10.9 cm
Formerly part of the collections of the Conde de Peñasco, Eugène Boban (no. 19901)
and Alphonse Pinart.
Donated by Alphonse Pinart to the Musée d'Ethnographie du Trocadéro, 1878;
former M.E.T. number: 25887.
On permanent loan from the Muséum National d'Histoire Naturelle – Musée de l'Homme Inv. 78.1.60

Main Exhibitions
Paris, 1878, 1928, 1947, 1965;
Glasgow, 1992.

Main Publications
E.-T. Hamy, 1897, pl. XI, no. 32:
A. Basler and E. Brummer,
1928, pl. 49; R. d'Harcourt,
1948, p. 76, fig. 93; P. Kelemen,
1956, p. 303, pl. 250A; H. Leh-
mann, 1960, pp. 35-36, pl. 36;
I. Bernal and M. Simoni-Abbat,
1986, p. 322; J. Alcina Franch,
M. Léon Portilla and E. Matos
Moctezuma, 1992, pp. 55-56.

Towards the end of the colonial epoch in Nueva España, some eminent members of the local Creole nobility combined their collections of pre-Columbian objects. One of the most recognised of these was that of Don José María Sánchez y Mora, the Count of Peñasco. This collection was very carefully studied by Brantz Mayer, Secretary of the U.S. diplomatic mission, who lived in Mexico from December 1841 to November 1842. Mayer wrote that the Peñasco collection contained some 3,000 highly varied objects.[1] Among the finest pieces was a pendant carved in rhyolite representing the face of the god Xipe Totec, which Franck had sketched in 1829.[2]

Eugène Boban acquired this beautiful ornament during his 25 years in Mexico, and later brought it back to his native France along with the rest of his collection. Alphonse Pinart purchased a number of items from him, thus expanding his own considerable archaeological holdings, which in turn he donated to the newly established Musée d'Ethnographie du Trocadéro in 1878. There it was shown in the Mexican archaeology section.

The origin of objects in private collections is occasionally embellished or wholly invented, which can be a serious obstacle to scientific invesstigation. This was the case with the Xipe Totec mask. The documentation for the Conde de Peñasco's collection failed to indicate its precise provenance. Later the Pinart catalogue, which used Boban's numbering, indicated that the object came from Oaxaca. In some subsequent exhibition catalogues, its place of origin is given as Teotitlan del Camino. Actually, the attribution to Oaxaca was very much influenced by the erroneous 19th century notion that there had been a special cult of Xipe in that region and even that the Codex Borgia had been written there.[3] It is far more probable that like all the other objects in the Count de Peñasco collection, this mask came from the Valley of Mexico.

The Spanish Conquistadors undoubtedly considered Xipe Totec one of the most repulsive Aztec divinities. The patron of goldsmiths,[4] he was also intimately associated with war. A terrible sacrifice in his honour was celebrated during the month of Tlacaxipehuatiztli, the second of the twenty months in the Aztec calendar.[5] In this festival, one after another, prisoners who had been captured in battle were forced to fight against five warriors on top of a large stone alter called tamalcatl. The combat with swords with sharpened obsidian edges was extremely bloody, and the victim bled heavily. Finally, still living, the victim was taken to the sacrificial stone of the Templo Yopico, where his heart was torn out. The corpse was thrown on the stairs, where priests cut the skin off the face to make a mask. The legs where used to make a sacred meal. Then they carefully peeled the skin from the body, especially the dangling arms, to complete the garments of the worshipers of Xipe Totec, who would wear the face mask and body skin for 20 days.

This pendant-mask of Xipe Totec is of a very high artistic quality. Finely sculpted and exquisitely polished, it reproduces the facial skin of a victim. The half-open eyes denote that he is dead. The distended lips reveal the underlying lips of the man wearing this mask. The elegant coiffure, with the hair parted in the middle, is indicated by parallel lines. The hair hangs halfway down over the ears, whose perforated lobes may have held ear pieces made of a different material.

On the upper part of this ornament, in the middle of the hair, there is a hole which would allow it to be worn as a pendant, like those seen in numerous sculpted and painted representations. It is very likely that this was an emblem worn by a high-ranking warrior, perhaps Tlatoani himself, since in certain portraits of the rulers of Tenochtitlan they are attired as Xipe, indicating that they are sacred warriors.

This is one of the most elegant extant examples of Aztec ritual jewellery. Vienna's Museum für Völkerkunde holds a larger but similar piece, also made of greenstone, apparently a variety of jade in

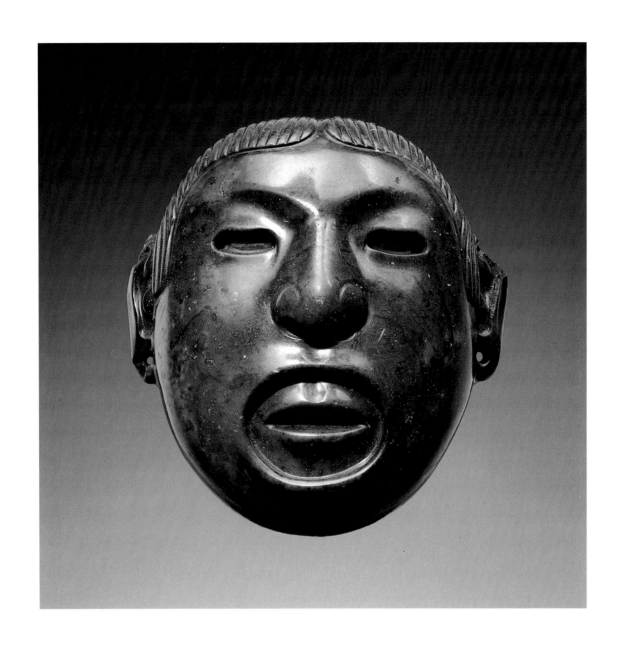

that case. In that mask the hair is not visible, and the artist has made the eye holes larger, so as to insert an inlay.[6] The British Museum in London has two masks of this god which previously were part of the Christy collection. They were certainly meant to adorn a statue of the deity or a funerary bundle of a warrior dignitary associated with the cult of Xipe. The coiffure is identical to that of the mask in the Musée de l'Homme.[7] In the collection assembled by Robert Woods Bliss, today in the Dumbarton Oaks Museum in Washington, there is an excellent greenstone sculpture of Xipe from Tenango del Valle which is almost identical to the mask in Paris. The eyes and the hair have the same distended shape representing the face of a corpse tied by the scalp around the neck of a living man.[8]

FELIPE SOLÍS
Translation: L.-S. Torgoff

1 Mayer recounts (1953, Letter XXV, pp. 358-366) that the Count Peñasco's museum was divided into four sections: antiquities, natural history, painting and scientific instruments. Mayer also includes several reproductions, thanks to which we know that the majority of these pieces are now in Mexico's Museo Nacional de Antropología.

2 The British Museum Library holds the originals of Franck's drawings (1829), assembled under the heading *Catalogue of Drawings of Mexican Antiquities – Description Feuille par Feuille de la Collection de Dessins d'Antiquités Mexicaines.* The Xipe Totec mask is registered as number 3 on page 30, where it is said that the piece is made of serpentine and once belonged to the Conde de Peñasco, and that this sort of object represents the ornamentation worn by Aztec chieftains (p. 13).

3 In his study of the Xipe mask in the Christy collection, E. Seler (1992, vol. III, p. 198) writes that this god was linked to the renewal of vegetation and the changes undergone by the earth with the arrival of heat and rain, and that the cult of Xipe existed in the Teotitlan del Camino region, which is probably where the Codex Borgia also originated.

4 There is a direct association between the ceremonial dismemberment and flaying of the sacrificial victim – where the bloody skin was worn by a young man until it rotted, taking it off after 20 days in a celebration of rebirth, once again showing the smooth skin living undneath – and the metallurgical process known as lost wax, where a rough earthen mould is used to contain the golden object cast within. When

the mould cools, the cover is broken off and the object appears in all its shining splendour. There exist many representations of the god Xipe wearing the bloody skin of the face and body of a human sacrifice. See *Tesoros de México*, 1997, nos. 30-32.

5 B. Sahagún, 1956 (vol. 1, pp. 110-111) gives a detailed description of the ceremonies during the festival of Xipe Totec during the month of *Tlacaxipehuatiztli*.

6 The Xipe Totec mask in Vienna measures 21.5 cm in height and 19.5 cm in width. The lips are perforated in four places, clearly so as to receive an ornament. There are also perforations for ear pieces and on the upper part of the head so that the object could be used as a pendant. See E. Becker-Donner, 1965, pl. VIII.

7 The two masks in the Christy collection today in the British Museum are very similar to each other. On one of them the mouth is perforated so that the dignitary wearing this mask could speak through it during ceremonies; on the other the lips are indicated. Both are 22 cm high. The authenticity of one of them has recently been questioned by several researchers. See J. Alcina Franch, 1983, p. 391, nos. 311-312.

8 The sculpture in the Bliss collection shows Xipe Totec standing, leaning against a rock, with one foot forward. He is wearing a human skin, with two hands hanging from it, and certain details suggest the manner in which it was hung from the wearer's head and tied around his neck with three thick cords so that it would not slip off as the skin dried. See S.K. Lothrop, 1959, p. 251, pls. XLIV and XLV.

Kwakwaka'wakw (Kwakiutl) sculpture

Second half of the 19th century,
British Columbia, Canada

Gwasila house post

Cedar
H. 325 cm
Piece collected by Charles F. Newcombe at Smith Inlet in 1905; formerly in the Brooklyn Museum
collection (Stewart Culin inv. 7417), acquired by Max Ernst in 1942
Donated by Max Ernst to the Musée de l'Homme, 1975
On permanent loan from the Muséum National d'Histoire Naturelle – Musée du l'Homme
Inv. M.H. 975.123.1

Exhibition
Paris, 1967.

Main Publications
*Arts primitifs dans les ateliers
d'artistes,* 1967, pl. 6;
J. Spalding, 1979; I. Jacknis,
1991, p. 236, pl. 59; D. Tanning,
1989.

This house post was collected in July 1905 by the doctor and naturalist Charles F. Newcombe (1851-1924) from Chief Walas Penquit in the Gwasila (Kwakwaka'wakw) village of Smith Inlet (Newcombe Papers). It was bought a month later by Stewart Culin, at that time curator for the new Ethnology Department at the Brooklyn Institute of Arts and Sciences. In 1903, Culin began assembling a collection of native North American ethnological objects for the museum. In August 1905, during a three-day visit to Victoria in British Columbia, Culin acquired a hundred and eighty-four Northwest Coast pieces for the sum of $752.75. Among the most important are two house poles and a Kwakwaka'wakw potlach figure.[1] The carved pole representing the ogress Dzonoqwa had been estimated at $50. In 1912, a group of nine thousand pieces was shown in the museum's new gallery of American ethnology. Julius Carlebach, an antique

dealer on New York's Third Avenue, obtained the pole in exchange for a set of objects from the Marquesas Islands and in turn sold it to Max Ernst in June 1942.[2] For a decade this statue of Dzonoqwa kept watch over the house of Ernst and Dorothea Tanning in Sedona, Arizona. Ernst donated it to the Musée de l'Homme in 1975.[3]

The Kwakwaka'wakw, called Kwakiutl in ethnographic literature, live along the Canadian Pacific coast (from Smith Inlet in the north to Bute Inlet to the south) and on adjacent Vancouver Island (along the eastern shores down to Campbell River in the south, and as far as Cape Cook on the western side). They were divided into some 20 groups, in turn subdivided into smaller units called *numayma* (singular: *numaym*). Kwakwaka'wakw society was hierarchcal, and, like all Northwest Coast coastal societies, its ranking system was characterised by the ownership of names and prerogatives that

Fig. 1
Sculpture of the ogress
Dzonoqwa
in front of Max Ernst's
home in Sedona,
Arizona, 1947

determined the holder's position in the *numaym* hierarchy. The chiefs and nobles alone enjoyed the privilege of owning names and the associated heraldic crest, and particular elite families (or individuals, usually by inheritance or marriage) had the exclusive right to sing certain songs and perform certain dances. They hired professional artists to represent their crests on objects such as boxes, totem poles and house posts. These cultures and many of their practices are still maintained today, as is the production of traditionally inspired art.

Dzonoqwa played a major role in their mythology, and her image adorns the crest of many families. This giantess lives in the forest; her sunken eyes make her look as if she is always asleep. A cannibalistic creature, Dzonoqwa carries a basket on her back into which she sticks the children she will later eat. She possess great riches (dried meat and berries). Several myths recount how human beings obtained these things from her and thus were able to give the first potlatches. As a result of their encounter with Dzonoqwa, heroic ancestors were able to appropriate her name and her mask and have statues of her likeness sculpted to commemorate their feats. She can be recognised by her pendulous breasts, hollow cheeks, deeply sunken eyes and full, pursing lips.

A superb example of Kwakwaka'wakw statuary, this particular representation of the giant Dzonoqwa is carved in full relief out of the trunk of a red cedar. It has been worked with an adze, giving the entire surface a highly textured effect. The ogress is shown standing, with powerful thighs, her knees slightly bent and her arms extended outward. Her kneecaps are flattened and the contours of parts of her face (chin and ears) are marked by parallel lines in relief and highlighted in red. The upper part of her trunk is also decorated with parallel relief lines emphasised by a flattened area on her neck. According to C.F. Newcombe, the family tradition of the pole's original owner, chief Walas Penquit, held that Dzonoqwa had breast-fed a dying woman named Aoweku (Newcombe Papers), here depicted by a head whose features are identical to those of Dzonoqwa herself.

MARIE MAUZÉ
Translation: L.-S. Torgoff

My thanks to Diana Fane, Alan Hoover, Shelagh Graham and Ira Jacknis for providing me with information for this article.

1 D. Cole, 1985, p. 223; I. Jacknis, 1991, pp. 235-236.
2 According to J. Spalding (1979, p. 49), the pole was the first piece Ernst acquired after leaving Europe for exile in the U.S. in 1941. Nevertheless, Brooklyn Museum documents indicate that the piece was withdrawn from the museum's inventory in 1942 (D. Fane, personal correspondence, February 1999; see also I. Jacknis, 1991, p. 236). See also T. Carpenter, 1975, p. 9.
3 The inventory taken in 1976 after Ernst's death notes nine objects from the Northwest Coast (S. Mekten, 1991, p. 362) that then became a part of the collection of Jimmy Ernst (see J. Spalding, 1979).

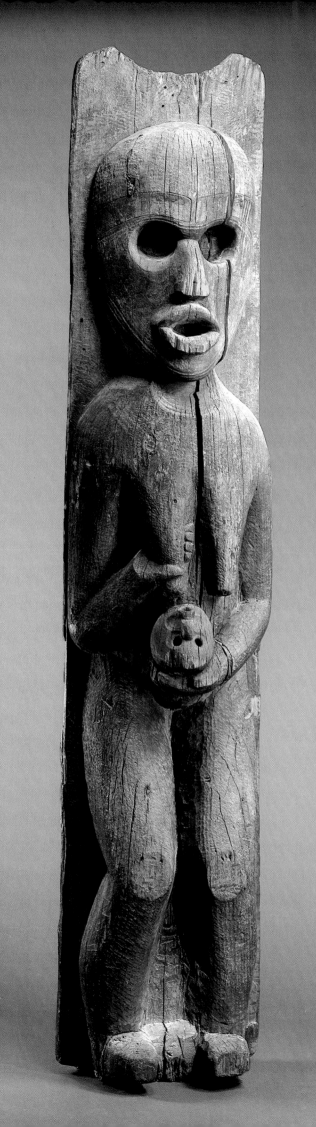

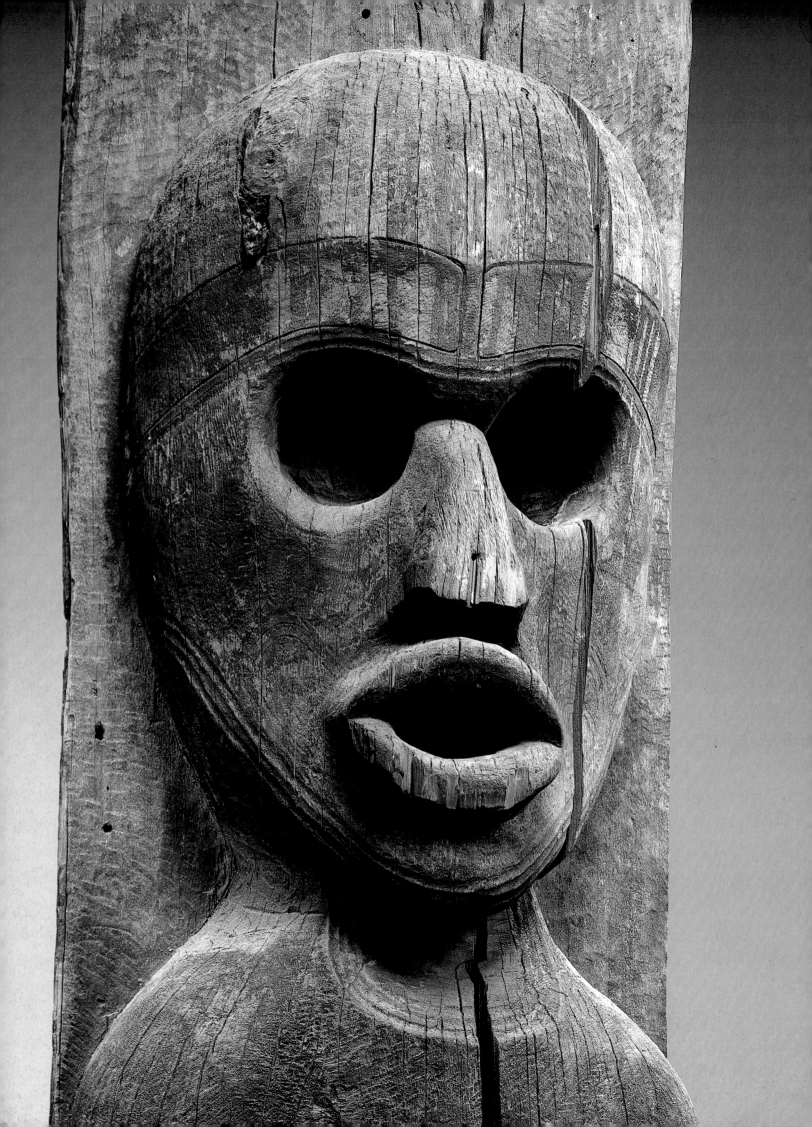

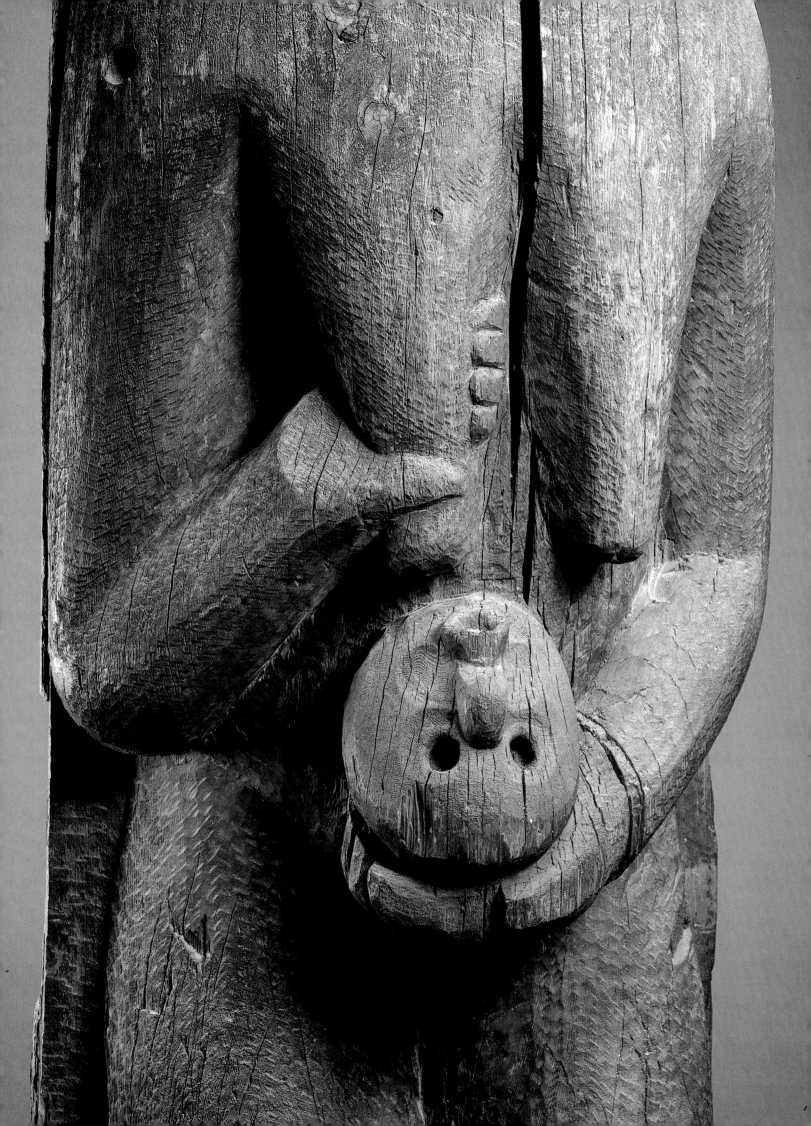

Nisga'a sculpture

18th-early 19th century
British Columbia, Canada

Mask

Stone, pigment
H. 21.6 cm
Collected by Alphonse Pinart in 1876 in British Columbia
Donated by Alphonse Pinart to the Musée d'Ethnographie du Trocadéro, 1881,
former M.E.T. number: 8654
On permanent loan from the Muséum National d'Histoire Naturelle – Musée de l'Homme
Inv. M.H. 81.22.1

Main Exhibitions
Paris, 1947, 1965; Victoria
(Canada), 1975; Paris, 1989-90.

Main Publications
E.-T. Hamy, 1897, pl. 8, no. 28;
A. Basler and E. Brummer,
1928, no. 1; *Chefs-d'œuvre
de l'Amérique précolombienne*,
1947, no. 15; W. Duff, 1975,
pp. 161-163; W. Duff, 1981,
p. 223; H. Stewart, 1981, p. 263;
E.N. Anderson, 1996, p. 141.

Alphonse Pinart (1852-1911) was an explorer and linguist. He collected this mask during his second expedition to the Pacific Northwest. After travelling through the American Southwest and California, he headed north from San Francisco and reached British Columbia during the summer of 1876.[1] He probably acquired this mask featuring wide-open eyes in Victoria, the region's most important trading centre, from or through the intermediary of William Duncan, who had founded a City of God in Meqlatqatla (Metlakatla) in hopes of protecting the Tsimshian people assembled around the Fort Simpson trading post from the perils of civilisation. The heir to a steelworks in Marquise, near the seaside city of Boulogne, Pinart had previously financed his voyages out of his own pocket. But after being ruined by the crisis that devastated the steel industry he offered his ethnographic and archaeological collections to the French Ministry of Public Education, to be housed at the Musée d'Ethnographie du Trocadéro, in exchange for a stipend that would allow him to undertake a new, five-year-long expedition.[2] This trip through the Southwest U.S., Mexico, Peru and Ecuador began in May 1881.

A "twin" mask featuring closed eyes had been collected in Kitkala in 1879 by the Canadian Indian Affairs Commissioner Israel W. Powell. This second mask was acquired by the National Museum in Ottawa, now the Canadian Museum of Civilization.[3] The two masks make up a single set. The odd stylistic resemblances between the two were noted by Wilson Duff, who reunited them for the first time in January 1975 for the *Images Stone B.C.* exhibition at the Art Gallery of Greater Victoria.[4] Rather than simply two similar masks, this sculptural tour de force was intended to represent two states of the same being.

The two pieces are from the Nisga'a. The Nisga'a who live in the Nass River valley are a part of the Tsimshian linguistic stock, along with the Gits'kan (the upper Skeena River), the coastal Tsimshian (the lower Skeena River and the adjoining Pacific Coast) and the southern Tsimshian. Their matri-lineal society is divided into clans (*ptEx*) common to the whole group, including the Eagle, Raven and Wolf. The clans themselves are subdivided into houses (*welp*). Each house owned certain inalienable property – the names or titles associated with particular territories, heraldic crests, songs, myths and legends. Masks representing the spirits called *naxnox* were used in the winter ceremonies (*halait*). These ritual complexes often involved dramatic performances. Working "behind the scenes" in the strictest secrecy were specialists called *gitsonk* – artists, composers and "scenographers". The *naxnox* masks enabled their wearers to transgress social rules and unleash the kind of chaos necessary for society's reproduction.

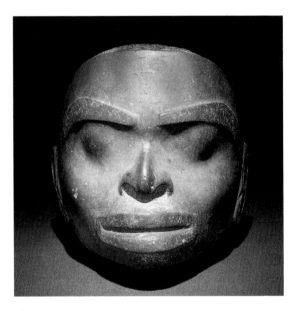

Fig. 1
Nisga'a sculpture, early 19th century
Stone mask with eyes closed collected in 1879
by I.W. Powell in Kitkatla
H. 23 cm
Canadian Museum of Civilization, Hull (inv. VII-C-329)

Sculpted in *gabbro*, a greenish rock, this open-eyed mask represents a human face. The eyebrows are indicated by a broad, rough-hewn band incised with a chisel, while the rest of the outer surface of the mask is highly polished. The eyes are simple holes; the nostrils are flared, the cheekbones pronounced and the mouth stylistically reminiscent of that of a frog. The ears, lips, nostrils and eyebrows are painted red. Hollowed out inside, at its base the mask has two holes through which a length of wicker is attached, so that despite its weight, the dancer can hold it on tightly with his teeth.[5] This left his hands free so that he could gesture during the dance, and even more importantly, use them to cover this mask with its closed-eyed "twin". The second mask was fastened by cords running through holes in the top of the head and the rim of each ear. The fact that these twin masks show two states of the same face, they are similar to the transformation masks that use cords and pulleys to open up, enabling successive figures or different aspects of the same being to appear one after another.

These two masks are conceptually inseparable from each other. When the blind external mask is taken off, it reveals an internal *sighted* mask. It may be that the artist was seeking to express an essential aspect of Tsimshian thought, the power of light to pierce the darkness in which humanity lived before it was granted the faculty of vision. It is also possible that this is an allusion to the time of the creation of the world, when people resembled frogs. The frogs themselves were turned to stone after Raven stole the light of the Heavens and created the world as it is today.[6] A reflection on these twin masks presents us with an enigma: why is it that the sightless mask, the mask we cannot help associating with meditation, is the one that faces the world?

MARIE MAUZÉ
Translation: L.-S. Torgoff

1 R. Parmenter, 1966.
2 Correspondence of A. Pinart with the Minister of Public Education (11 February 1878), archives of the Musée de l'Homme.
3 Canadian Museum of Civilization, Hull, Quebec, inv. VII-C-329; H. 22.5 cm. See D. Cole, 1985, p. 52 and p. 320; W. Duff, 1975, p. 164.
4 H. Stewart, 1981, pp. 262-263.
5 E.-T. Hamy, 1897.
6 M. Halpin, 1984, pp. 301-30; W. Duff, 1975, p. 166. In regard to these two masks, M. Reid (1989, p. 226) emphasises that they are emblematic of a core concept in Northwest Coast thought – transformation. It would seem that this is an iconic reference to binary states such as day/night or life/death. According to this author, these two masks are two representations of Crow, the outstanding trickster in Tlingit mythology.

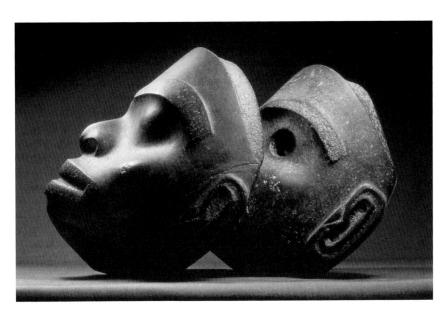

Fig. 2
Collected separately, these two Nisga'a masks represent two aspects of the same figure. They were brought together for the first time by the anthropologist Wilson Duff during the *Images Stone B.C.* exhibition in Victoria
Museum of Anthropology, Vancouver

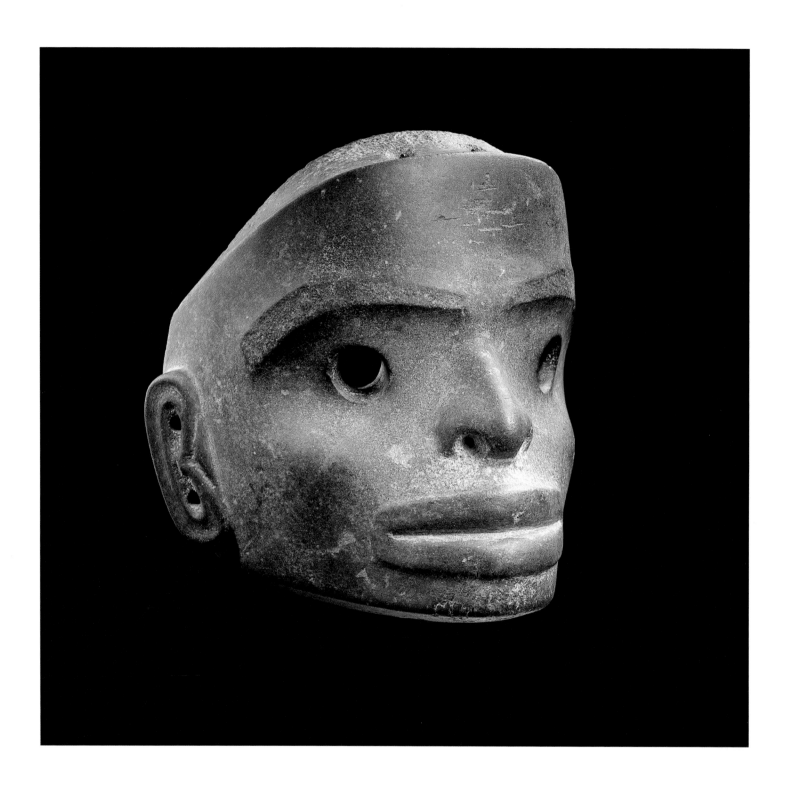

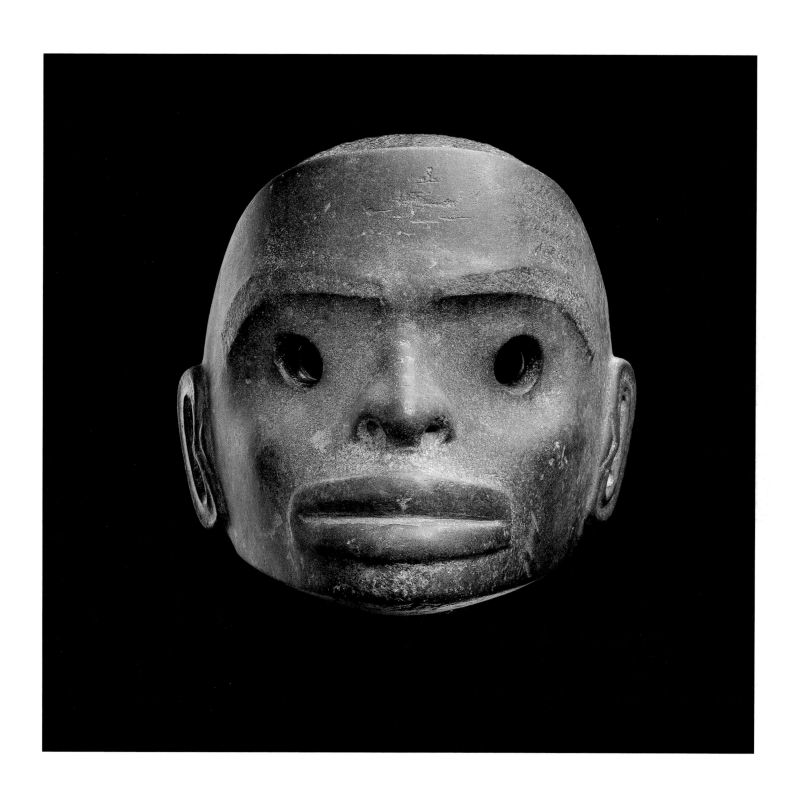

Nisga'a sculpture

19th century
British Columbia, Canada

Headdress

Wood, graphite, paint, abalone shell fragments, shellfish opercula
H. 16 cm, L. 38 cm
Collected by George T. Emmons in the lower Nass River region; formerly in the collection of the Museum of the American Indian, Heye Foundation, New York;
acquired by Julius Carlebach through an exchange in July 1944;
purchased by Claude Lévi-Strauss the same year; former Claude Lévi-Strauss collection
Anonymous gift through the intermediary of Mme Georgette Soustelle, 1951
On permanent loan from the Muséum National d'Histoire Naturelle – Musée de l'Homme

Main Exhibitions
Paris, 1951, 1989-90.

Publication
Collection Claude Lévi-Strauss, 1951, pl. II.

This mask was collected by George Thornton Emmons,[1] an American Navy lieutenant and ethnographer known for his work on the Tlingit.[2] Between the 1880s and the end of the 1920s, Emmons gathered extensive collections of materials from the Northwest Coast for the American Museum of Natural History and the Smithsonian Institution (Washington, D.C.). In 1905, the philanthropist George Heye asked for Emmons'help in bringing together a Northwest Coast ethnographic collection. This collaboration continued until 1943. It led to the acquisition of some 2,200 pieces for the Heye Foundation's Museum of the American Indian, which opened to the public in 1916.[3] Today the museum's North American collections comprise about a million objects, including many thousands of works of the highest aesthetic quality.[4]

The Nisga'a belong to the Tsimshian linguistic stock. Their homeland was at the mouth of the Nass River. They were divided into three exogamous, matrilineal clans (*ptEx*), each subdivided into several houses or *welp*. Superimposed on their organisation in clans and houses was a religious organisation led by those who possessed and mastered supernatural powers. The winter ceremonies were controlled by lineages and secret societies, a model the Tsimshian had borrowed from the Heiltsuq in the early 19th century.[5] The great winter ritual, called *halait*, was divided into two separate parts. The first, the *simlahait*, included most notably a series of *naxnox* dances performed by the chiefs and an initiation rite in which the chief cast his power on the young novices. The second part culminated with an initiation into secret societies such as the cannibal society (Olala or Xgeket) or an advance in rank within them.

This black painted mask very likely represents a man-eating dragonfly. The same motif appears on the painted panels inside the ceremonial house, for example.[6] The dragonfly's eyes are inlaid with fragments of abalone shell, and the jaws are decorated on both sides and the bottom with human faces engraved in low relief. The mouth is lined with teeth made of shellfish opercula. A frieze of human heads in the shape of a crown adorns the top of the mask. Red paint highlights the nostrils, lips and eyebrows. This piece is clearly the work of a remarkable artist, an expert in both sculptural carving and surface decoration with a perfect grasp of the stylistic canons of Northwest Coast art. Although there is no supporting documentation, one cannot fail to note the stylistic similarities between this piece and certain shaman masks Emmons collected among the Tlingit.[7] There is a striking resemblance between this Nisga'a dragonfly mask and the Tlingit mask of a raven[8] whose beak and crown are adorned with finely incised faces representing spirits. Almost certainly this Nisga'a mask appeared in cannibal society ceremonies.

MARIE MAUZÉ
Translation: L.-S. Torgoff

1 A. Drumheller (National Museum of the American Indian), personal communication, December 1998.
2 G.T. Emmons, 1991.
3 D. Cole, 1985, pp. 215-216.
4 K. Wallace, 1960.
5 F. Boas, 1916, and M.-F. Guédon, 1982.
6 *Chefs-d'œuvre des arts indiens et esquimaux du Canada*, 1969, no. 42; M. Barbeau and W. Benyon, 1987, p. 66, no. 19.
7 A. Wardwell, 1996.
8 Mask from the collection of the American Museum of Natural History, New York, E 2512 (A. Wardwell, 1991, p. 134).

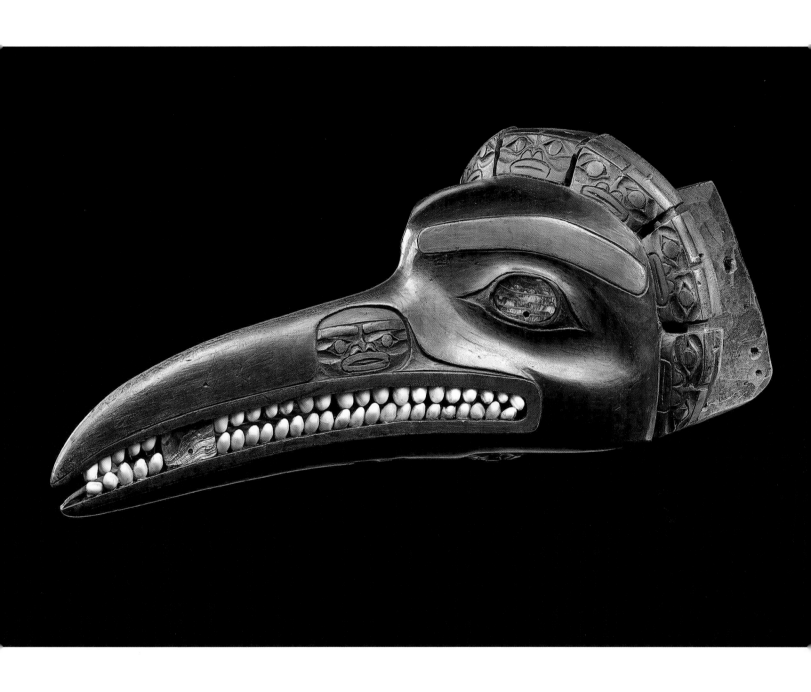

Kwakwaka'wakw (Kawakiutl) sculpture

19th century,
British Columbia, Canada

Transformation mask *(tatltatlumtl)*

Painted wood, graphite, cedar, canvas, cord
H. 34 cm, L. 53 cm closed, 130 cm open
Collected by D.F. Tozier at the beginning of the 20th century; purchased by George Heye in 1921;
formerly in the collection of the Museum of the American Indian, Heye Foundation, New York (inv. 06.9155);
acquired by Julius Carlebach through an exchange in August 1944; then sold to Claude Lévi-Strauss;
former Claude Lévi-Strauss collection
Anonymous gift through the intermediary of Mme Georgette Soustelle, 1951
On permanent loan from the Muséum National d'Histoire Naturelle – Musée de l'Homme
Inv. M.H. 51.35.1

Main Exhibitions
Paris, 1951, 1989-1990.

Main Publications
Collection Claude Lévi-Strauss,
1951, pl. 1, no. 8; *Le Petit Journal*
du musée de l'Homme, 1989,
fig. 4; M. Mauzé, 1994, p. 40.

This mask was collected at the beginning of the 20th century by D.F. Tozier,[1] captain of the *Grant*, a cutter belonging to the U.S. Revenue Service (a forerunner to the Coast Guard) based in Port Townsend (Washington). Tozier, known among his colleagues for his often highly questionable collection techniques, stored the several thousand items he amassed at the Ferry Museum in Tacoma on the border with British Columbia. In 1907 the whole collection was acquired by the Washington State Arts Association headed by the businessman F.E. Sander, and then dispersed among a number of American museums. George Heye bought a large part of this collection in 1921 for his Museum of the American Indian, paying $12,500.[2]

In Kwakwaka'wakw society, located in British Columbia, masks are a part of the symbolic inheritance of a noble or chief. Masks and other dance paraphernalia are made by professional artists conversant with the mythological origins of the crests of the powerful families and the secrets of the initiation societies. These masks are exhibited in the religious/theatrical performances known as the winter ceremonies (*Tsetséqa*), marked by the presence of spirits. Some feature the supernatural beings encountered by a group ancestor and are considered to be the private property of that group.

This representation of a raven (or eagle?) is a transformation mask, or *tatltatlumtl*, often called folding-out masks in English. It was used in the winter ceremonies when the chiefs displayed their prerogatives and held secret society initiations. The mask is equipped with a simple mechanism that allows the two side panels to open and close. Wearing an articulated mask was a very difficult task for a dancer, who had to strictly follow a choreography evoking the behaviour of the animal or personage he was portraying. A single misstep devaluated the status and prestige of the mask's owner; any violation by the wearer was punished by a fine. This mask illustrates the metamorphosis of the mythical

hero of the group with which he is associated. When closed, it represents a raven (or eagle?). The upper part of the beak is covered with a layer of graphite. By means of a string attached behind the pupils of the eyes, the two panels fold out and there appears a human face with a hooked nose and a black-painted moustache on the upper lip, signifying the double nature of the being represented. On the inside of the outer mask, visible when it is opened wide, the two panels are covered with canvas painted with U-shaped motifs and ovoids indicating the eyes and the articulations. Parallel lines painted inside the shapes represent the bird's plumage. The colours – black, red, green and blue – follow the symbolic conventions of Kwakwaka'wakw painting. The mask is topped with hair made of shredded cedar bark. This piece is a remarkable example of the exuberance of late 19th-century Kwakwaka' wakw art. Northwest Coast native society was unique in its inclination for theatrical "machinery". Transformation masks never failed to surprise and please the public gathered in the ceremonial house.[3] As Claude Lévi-Strauss wrote, "For the spectators at initiation rites, the dance masks (which opened suddenly like two shutters to reveal a second face, and sometimes a third one behind the second, each one imbued with mystery and austerity) were proofs of the omnipresence of the supernatural and the proliferation of myths."[4]

MARIE MAUZÉ
Translation: L.-S. Torgoff

1 A. Drumheller (National Museum of the American Indian), personal communication, December 1999.
2 D. Cole, 1985, p. 220.
3 The Kwakwaka'wakw sense of surprise is unique among Amerindians. The point of this object was above all to carry out a sudden transition from one form of appearance to another, from one meaning to another." (A. Breton, 1950, p. 39).
4 C. Lévi-Strauss, 1979, pp. 11-12.

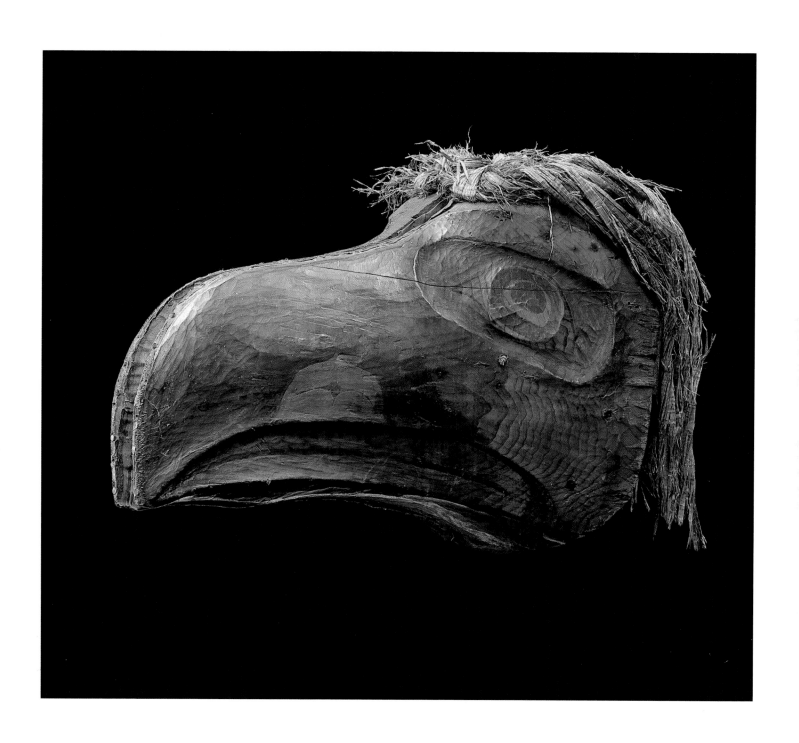

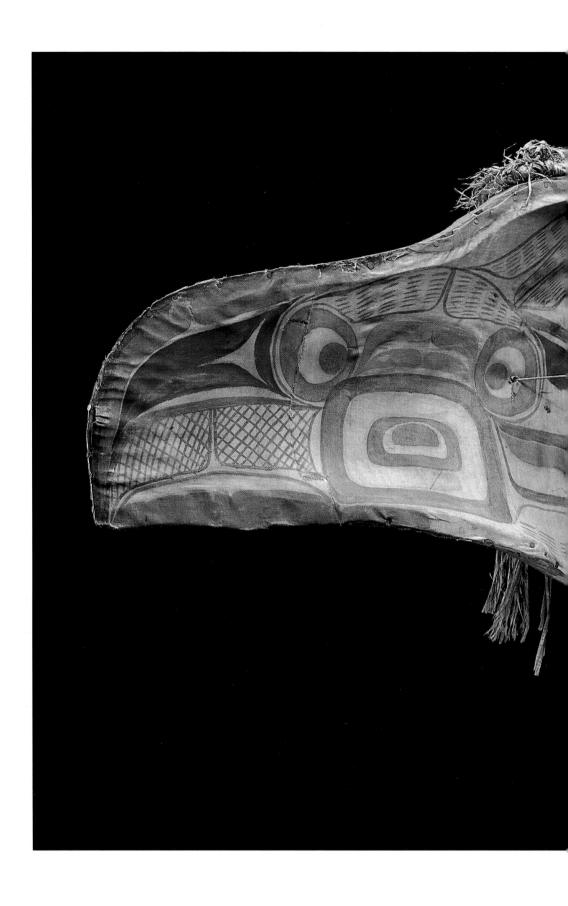

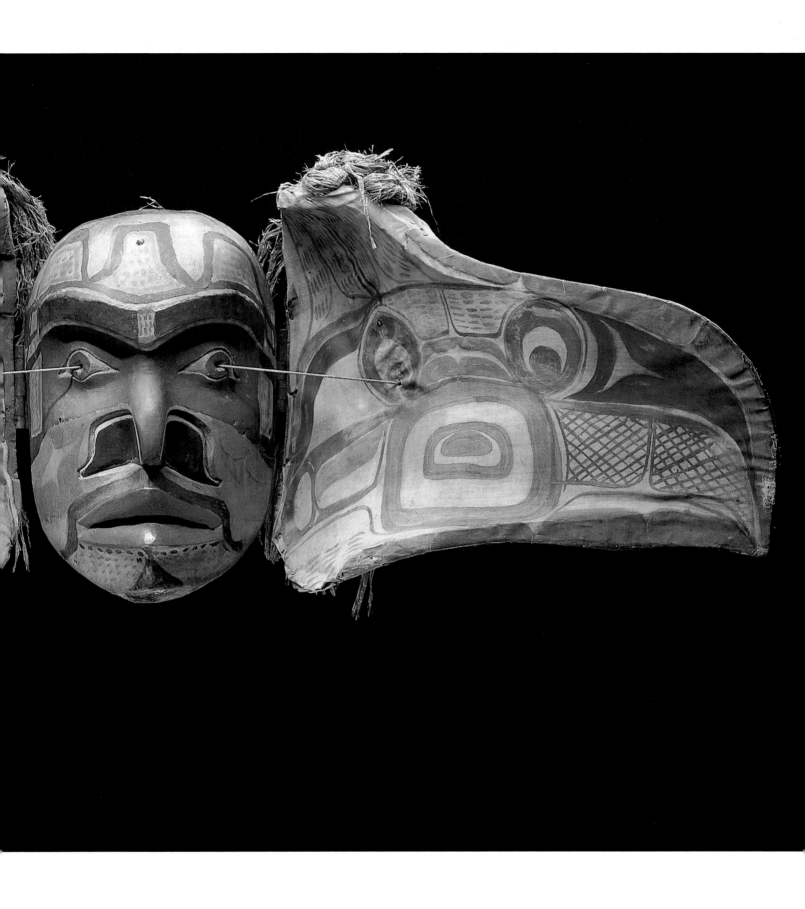

Tlingit sculpture

First half of the 19th century
Southeastern Alaska

Helmet (shadaa)

Wood, polychrome traces, plant fibres
H. 24 cm
Formerly in the collections of Count Colonna[...]wski and Max Ernst; purchased from Max Ernst
by Claude Lévi-Strauss in New York, 1944; former Claude Lévi-Strauss collection
Donated by Georges Wildenstein, 1951
On permanent loan from the Muséum National d'Histoire Naturelle – Musée de l'Homme
Inv. M.H. 51.34.1

Main Exhibitions
Paris, 1951, 1965, 1989-90.

Main Publications
Collection Claude Lévi-Strauss, 1951, no. 8; *Chefs-d'œuvre du Musée de l'Homme*, 1965, p. 162, pl. 55.

There is no contextual documentation on the collection of this Tlingit helmet and its provenance is somewhat obscure. Inside of it is imprinted a seal bearing a coat of arms and a half-effaced inscription reading "Count Colonna [...]wski". Max Ernst probably acquired it between 1941-43 from Julius Carlebach, whose Manhattan antique shop was a favourite haunt for exiled European artists and intellectuals. This was a highly productive period for Ernst, who liked to reward himself by purchasing an art object made by Native North Americans, South Americans or Pacific islanders whenever he completed one of his own works.[1] When Ernst was in the process of breaking up with Peggy Guggenheim in 1944, André Breton got Claude Lévi-Strauss to buy this helmet from his fellow Surrealist for the sum of $100.[2] When Charles Ratton organised the sale of the Lévi-Strauss collection in 1951, the piece was acquired by Georges Wildenstein, who gave it to the Musée de l'Homme.

The Tlingit lived on the Pacific Coast in southeastern Alaska and the offshore islands. They were divided into 18 local groups or tribes (*kwaan*), including the Yakutat, Hoonah, the Stikine and the Tongass. Their social organisation was based on clans grouped into two exogamous, matrilineal moieties, the Wolves and the Ravens. The clans (singular: *naa*), subdivided into lineages, owned territories, trade routes, fishing and hunting sites and immaterial wealth such as names, crests, myths, songs and dances. Tlingit society was hierarchical, comprised of nobles (clan and lineage chiefs and their immediate family), commoners and slaves. Wars took place not between tribes, but clans, usually to avenge an insult or other wrong. After a hand-to-hand combat, the heads or scalps of enemies would be kept as trophies and the captured women and children enslaved.[3] In the latter 19th century, as conflicts with Russian and later American settlers made internecine warfare increasingly rare, these helmets found a new use. Helmet-masks, also called "head masks" by the first Russian ethnographers, began to be worn in ritual dances.

A Tlingit warrior's outfit[4] consisted of a seal or elk skin shirt and a breastplate. These were made of wooden slates woven together with a strip of animal sinew into panels which were in turn held together with strips of leather. On the front or sometimes on the back was a crest. His head was protected by a helmet and visor with holes for the eyes. Usually the helmet was painted and inlaid with seashells or covered with animal fur. Worn over a sort of fur hood, it was held on by two leather straps tied under the chin.

Of course, the warrior's gear also included weapons: a knife, spear, club, bow and arrow. Sometimes, in order to be able to move more freely, a warrior would tie his hair up on top of his head in a chignon and wear simple animal skin tunic. His face and tunic would be emblazoned with the family crest.[5]

This particular helmet, carved from the hollowed-out knot of a tree, is in the shape of a woman's face. On her lower lip she wears a labret, an insignia of noble status among the Tlingit. She has high, prominent cheekbones and Asian eyes. Her eyebrows are emphasised by a line incised with a chisel; a reddish-brown pigment colours the finely sculpted ears. An inlay of abalone shell was very

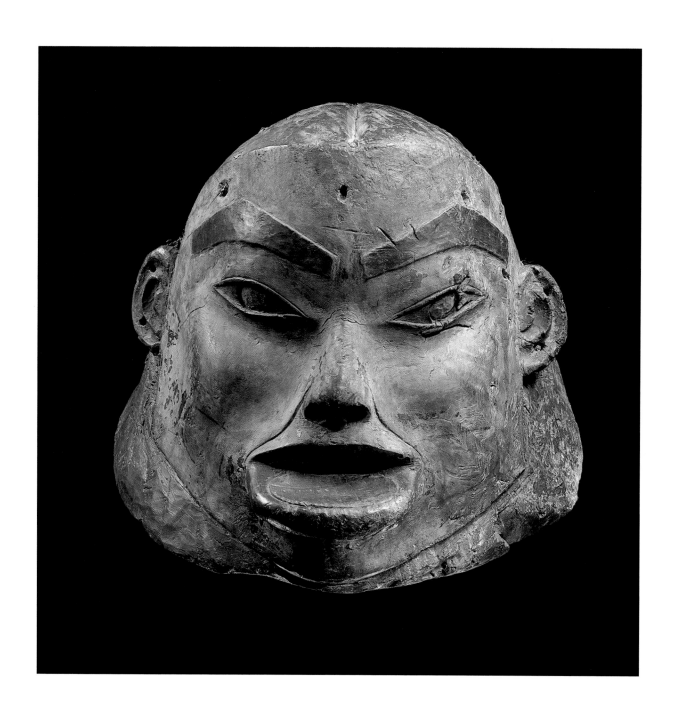

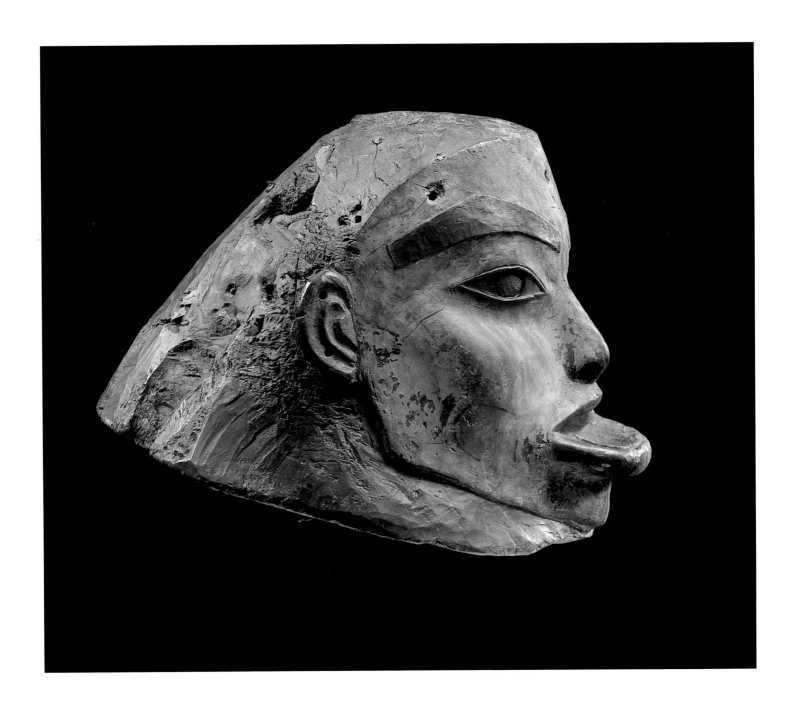

likely placed in the slightly concave pupils. There was probably once a strip of fur across the top. The wood was covered with a thin blue-green layer obtained from copper rust. Traces of red and black painted motifs can still be seen. Perhaps this "mask" represents the spirit of an elderly noblewoman assigned to protect the warrior. In addition to a guardian spirit or a family crest (*ata. oaw*), some helmets represented bears, sea lions or other animals admired for their aggressiveness, an exemplary quality in a warrior.

<div align="right">
MARIE MAUZÉ

Translation: L.-S. Torgoff
</div>

1 L. Tacou-Rumney, 1996, p. 115.
2 Letter from Isabelle Walberg to Patrick Walberg, 5 June 1944; C. Lévi-Strauss, personal communication, 18 December 1998. See also C. Lévi-Strauss and D. Eribon, 1998, p. 49; P. Walberg and I. Walberg, 1992, p. 223.
3 F. de Laguna, 1972; G.T. Emmons, 1991, p. 329.
4 The oldest collections of Tlingit helmets and armour are in the Museo de America in Madrid. (C. Paz, 1992, *The Malespina Expedition*, 1977) and in Saint Petersburg's Museum of Anthropology and Ethnology (E. Siebert and W. Forman, 1969; W. Fitzhugh and A. Crowell, 1988).
5 G.T. Emmons, 1991; W. Fitzhugh and A. Crowell, 1988; E. Siebert and W. Forman, 1969.

Yup'ik (Inuit) sculpture

Early 20th century
Goodnews Bay village, southern coast of Kuskokwim Bay, Alaska

Fish mask

Polychrome wood, feathers
H. 48 cm
Collected by Adams Hollis Twitchell in the early 1920s
Museum of the American Indian, Heye Foundation, New York (inv. 12.909)
Former André Breton collection
Musée du Quai Branly
Inv. 70.1999.1.2

Exhibition
Paris, 1959-60.

Main Publications
A. Jouffroy, 1955, p. 34;
A. Breton, 1957; E. Lot-Falck *et al*, 1960, p. 108, pl. XIII;
A. Lommel, 1966, p. 29;
W. Rubin *et al*, 1985, p. 579;
A. Breton, 1991, pp. 375-376;
J.-L. Rousselot *et al*, 191, cover and pp. 232-233;
A. Fienup-Riordan, 1996, p. 270.

An American from Vermont, Adams Hollis Twitchell (1879-1949), collected this mask in the early 1920s. Twitchell went to Nome, Alaska, in 1898 to try his luck at prospecting for gold. In 1905, he opened a store in Bethel, in the Kuskokwim valley, which he ran until 1916, when he turned to raising reindeer for a few years before opening a trading post in Takotna, on a tributary of the Kuskokwim River. He stayed there for the rest of his life. Twitchell was fascinated by the region's fauna and flora. The major collection of stuffed birds he assembled is now in the Smithsonian Institution in Washington, D.C. He sold the Yup'ik masks he had acquired to the New York collector George Gustav Heye, founder of the Museum of the American Indian. After a reversal of fortune in the 1940s, Heye was forced to sell a part of his collections through Julius Carlebach. The New York dealer resold masks and other items to expatriates like Max Ernst, Robert Lebel and André Breton,[1] who bought this fish mask (fig. 2).

Cultural context

The Yup'ik of the Yukon-Kuskokwim region (still called the central Yup'ik) lived mainly by fishing and hunting sea mammals. These bountiful resources enabled them to forgo the rigours of a nomadic existence for the most part. Their large villages were made up of one or more community houses (*kasgi*), where the men lived and worked in normal times. There they sculpted masks, often following under the guidance of a shaman. The whole village and guests from other settlements took part in the propitiatory celebrations and ceremonies held in the big house. During the festivities, masked dancers would act out mythological events, moralistic fables or comic skits, depending on the circumstances.[2]

Iconographic interpretation

This fish mask is clearly sacred, even though the story associated with it has been lost. The fact

Fig. 1
Yup'ik (Inuit) sculpture, early 20th century
Seal mask, forming a pair with the fish mask
once owned by André Breton
Wood, pigment, feathers
National Museum of the American Indian, Washington

that it appertains to the domain of rituals is indicated by its component elements. It is part of an almost symmetrical pair – its mate is the seal mask in the Museum of the American Indian (fig. 1).[3] Both masks represent half of a face showing its teeth. On each of them, the vertically fastened fish or the seal covers the middle of this face where it was sundered.

This is not meant to be a human countenance decorated with a fish, as one might think on first glance. What it represents are the seen and unseen attributes of the fish. The half-face peering from behind the body of the creature hanging head-down is very likely the visage of the fish's *yua* or soul (*yua*, from the word *yuk* or "person" means "the person's owner"). Animal *yua* always had a human physiognomy. The sculptor of this mask was able to correctly represent it because he had seen it in a dream. Making such a mask was not something that could be undertaken lightly, because it is the fish's soul that decides whether or not to make his body available to humans. This fish's example would then be followed by many others of his kind – the decision of the *yua* could herald a season of abundance or famine.

The mask's monstrous mouth is a frequent symbol in Inuit mythology. Some beings have mouths all over their bodies; others a head that is basically nothing but an oversized mouth. The grimacing expression reflects the ambivalence of the situation: the fish offers itself, but at the same time it is destroyed by the person who eats it. The menacing mouth indicates the fish's vigilance. It is a warning that people must strictly observe the rules and taboos governing fishing, at the risk of

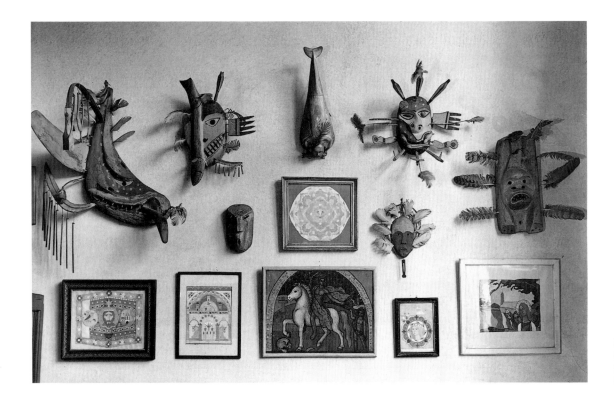

Fig 2
Inuit masks
photographed by Sabine Weiss
at Breton's home in Paris, 1955

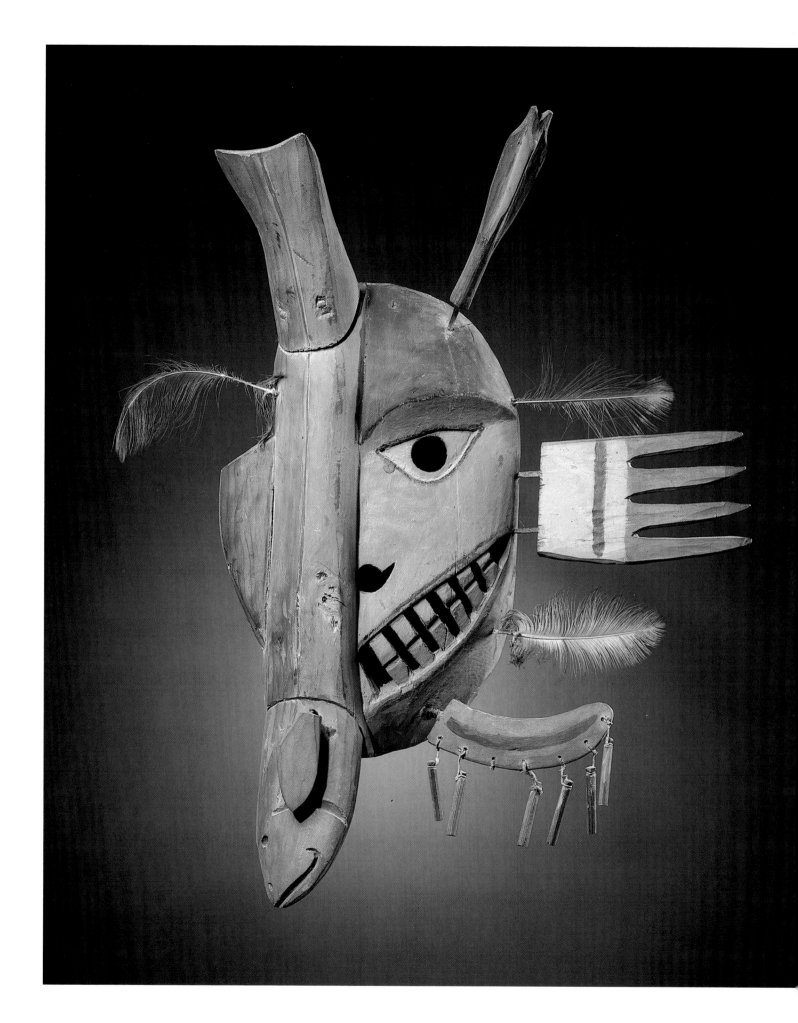

the wrath of the animal world. If the rituals are followed, the *yua* will not die. Only the body that carries it will be eaten. The four-fingered hand protruding from the side of the head is that of the *yua*. It denotes the role of the *yua* in giving animals to mankind by allowing them to come to people. Certain hands have a hole through which animals can pass.[4] The importance of hands for the Inuit is also underscored by the taboo against dancing with naked hands. The Yup'ik dancer had to wear either gloves or finger masks (miniature masks worn in pairs and held by two fingers).

Sticking out from the mask's outer edges are feathers, an arrow and a wing from which small cylinders hang. The sculptor saw these things in his dream. They distinguish this particular *yua* from others; the representation cannot be considered complete without the addition of these incongruous objects. Attached with strips of flexible whalebone, they jingle and made a noise as the wearer dances.

This powerful mask with its half-human, half-animal figure expresses the duality that presided over this people's system of beliefs. Beings can alternately taken on the appearance of people or animals because these are just external appearances, like a parka or a fur coat that one slips on and off. Underneath this covering, human beings and animals each have a soul, and in this sense are all the same.

JEAN-LOUIS ROUSSELOT
Translation: L.-S. Torgoff

1 A. Fienup-Riordan, 1996, pp. 249-260.
2 J.-L. Rousselot, 1996a.
3 F.H. Douglas and R. d'Harnoncourt, 1941, p. 171; A. Fienup-Riordan, 1966, p. 207; J.M. Vastokas, 1967, fig. 31.
4 G. Nelson, 1899, p. 395.

Yup'ik (Inuit) sculpture

Early 20th century
Village of Napaskiak, Kuskokwim River area, Alaska

Swan and white whale mask

Polychrome wood, feathers
H. 72 cm
Collected by Adams Hollis Twitchell, 1908
Museum of the American Indian, Heye Foundation, New York (inv. 9.3410)
Former André Breton collection
Musée du Quai Branly
Inv. 70.1999.1.1

Exhibition
Paris, 1959-60.

Main Publications
A. Jouffroy, 1955, p. 34;
A. Breton, 1957; E. Lot-Falck *et al*, 1960, p. 99, pl. IV;
H. Hipszer, 1965, p. 400, fig 9:
A. Lommel, 1966, p. 31;
A. Breton, 1991, p. 375;
J.-L. Rousselot *et al*, 1991, pp. 92-93; A. Fienup-Riordan, 1996, pp. 270-271.

The American store owner Adams Hollis Twitchell, who lived in the Kuskokwim valley from 1905-1916, collected this mask in 1908 in Napaskiak, a Yup'ik village on the lower Kuskokwim. Probably thanks to his Yup'ik wife, Twitchell attended a week-long Napaskiak ceremony, taking copious notes and acquiring a number of masks that had been made for this occasion.[1]

Unfortunately, the notes are lost. Instead of the detailed description of the use of these objects which they probably contained, all that remains is a letter dated 4 March 1908 regarding their shipment.[2] Amongst the dozen masks in this lot were two swan masks, almost identical except for the colour of the whale and the direction in which it is turned. The pair was acquired by George Heye, the founder of the Museum of the American Indian in New York. Beset with financial difficulties in 1944, he sold both of them to the New York art merchant Julius Carlebach. Shortly after, André Breton bought the red mask (inv. 9.3410) and Georges Duthuit the blue one (inv. 9.3409). The latter object had been published a few years previously in the catalogue of the Museum of Modern Art's maiden exhibition, which presented Amerindian and Western works on an equal footing.[3]

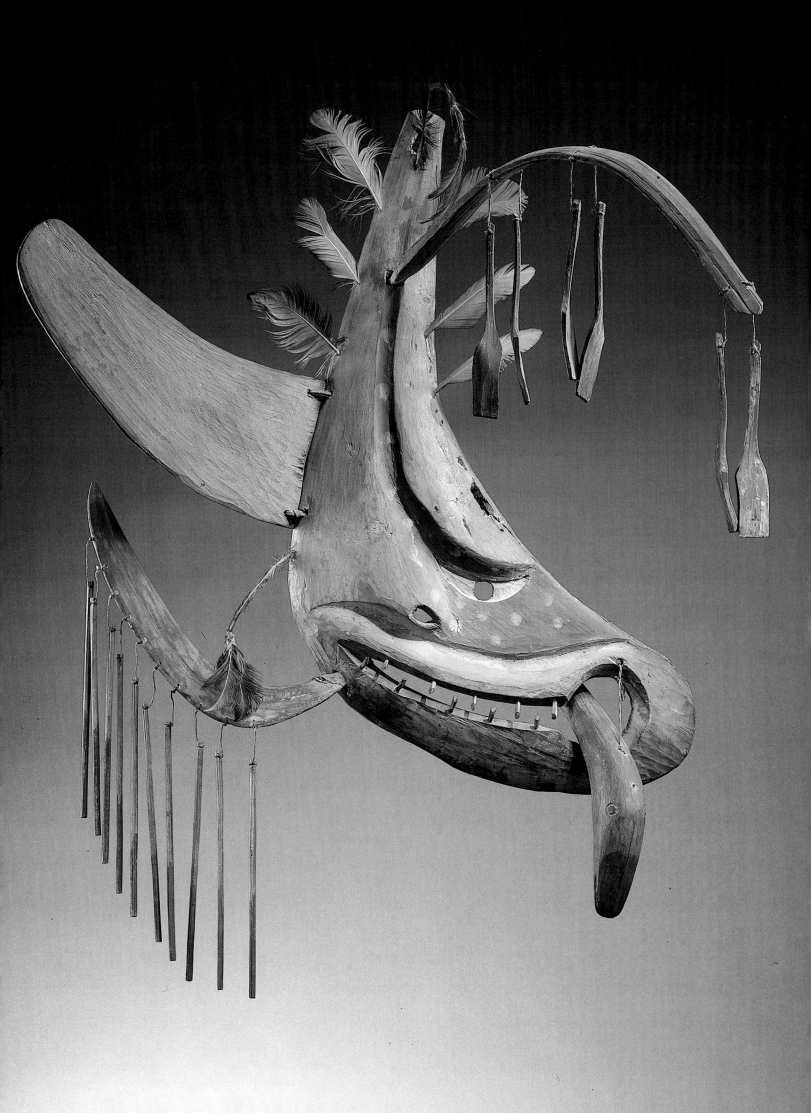

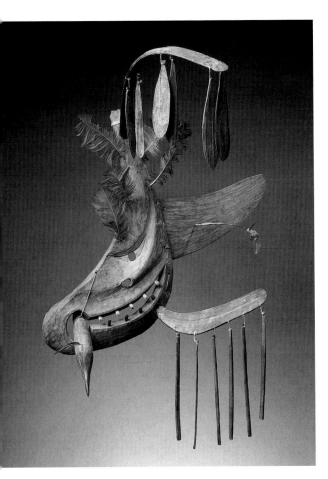

Fig. 1
Yup'ik (Inuit) sculpture, early 20th century
This mask is half of a pair also comprising the swan
and white whale once owned by André Breton
Wood, pigment, feathers
Former collection of Georges Duthuit
Private collection

Cultural context

What we know about the mask Twitchell collect-
ed is its name: "The Swan Guides the White Whale
towards the Hunter in Winter". In fact, the name
constitutes a narrative that helps to culturally
contextualise the object. Its mate bears a similar
name, indicating that the white whale is being
guided to the hunter in the spring. Hunting the
white whale (beluga) gave Yup'ik life its heartbeat.
Its copious meat was the basis of their diet. The
white whales would swim into the Kuskokwim delta
and sometimes a short way up the river in search of
fish. Hunters in kayaks drove them towards sand
banks, where the beluga were easily killed with
spears once they ran aground. This collective hunt
often provided spectacular results, but the
community lived at the mercy of the slightest
change in the habits of these sea mammals on
which they came to depend almost exclusively.
When schools of fish became less numerous, the
beluga would move on, seeking richer estuaries, and
a great hunger stalked the shorelines they deserted.
To prevent this, propitiatory ceremonies were held
where the people called on their auxiliary spirits to
aid them. The swan – only its head can be seen
sticking out of the whale's mouth – was probably the
spirit helper of the hunter who wore this mask. In
order to win the swan's cooperation, the dancer had
to promise to respect the taboos concerning swans
and those governing whale hunting. In short, the
swan, the whale and the hunters were all linked
together by a sort of contract that strictly defined
their relationship and respective obligations.

Iconographic interpretation

Since the flesh of the whale was so vital to the
Yup'ik's survival, the body of the whale makes up
most of the mask. After all, that is what the dancer
sought to appropriate. The animal's weight and size
made it very dangerous to a hunter in a fragile
kayak, and he had to make full use of intelligence
and stratagems if he was to succeed. He could not
hope to do so without the aid of the barely visible
swan, his discrete ally in the animal world. The
feathers and pendants are not only decorative
elements glimpsed in dreams; they are also moving
parts whose noise during the dance would attract
the attention of the spirits which the hunter
wanted to address.

Even the composition of the mask is emblematic
of the elements involved in hunting whales. The
aim, capturing a beluga, is the main component.
The animal is monstrous, aggressive, displaying his
teeth. He looks invincible. Miraculously, a frail swan,
as audacious as he is unassuming, appears between
those formidable jaws and very subtly guides the
enormous creature toward the men who await it.
This extremely significant story is rendered by the
explanatory title that has come down to us with the
mask. Without it, no amount of scrutinising the
object alone would have made it possible to recons-
titute its meaning, which contributes so much to the
significance of this piece and ensures it a central
place in Yup'ik art collections. The short phrase
illuminates the life and thinking of the people who
made this mask a century ago, sharply expressing
the reality of the delicate predatory relationship
between man and nature.

JEAN-LOUP ROUSSELOT
Translation: L.-S. Torgoff

1 A. Fienup-Riordan, 1996, p. 257.
2 A. Fienup-Riordan, 1996, p. 251.
3 F.H. Douglas and R. d'Harnoncourt, 1941, p. 175.

Koniag (Inuit) sculpture

First half of the 19th century
Kodiak archipelago, Alaska

Mask

Wood
H. 49 cm
Collected by Alphonse Pinart in the Kodiak archipelago, 1871-1872
Donated by Alphonse Pinart to the Musée de Boulogne-sur-Mer, 1875
On permanent loan from the Château-Musée, city of Boulogne-sur-Mer
Inv. 988.2.150 (M.H.D. 47.13.016)

Exhibition
Paris, 1872.

Main Publications
E. Lot-Falck, 1957, p. 9,
pls. I, f; H. Hipszer, 1965,
fig. 15; D. Desson, 1995,
p. 286.

Alphonse Pinart (1852-1911), heir to the Marquise ironworks, collected this sculpture during his Alaskan expedition in 1871-72. Having left San Francisco on 27 April 1871, in May he crossed the Aleutian islands and entered the Bering Straight, where he remained until August, visiting Nunivak Island and the American and Siberian mainlands. He then spent three months travelling by kayak through the eastern Aleutians to Kodiak Island in the North Pacific, staying there for the next six months. He returned to San Francisco on 21 May 1872.[1] During his long stay in Alaska he devoted himself mainly to linguistic studies, since the purpose of his voyage was to prove the Asian origins of the Amerindians.[2] But in addition to his notes on the indigenous languages and observations covering nearly every domain, this 20 year-old also brought back a multitude of ethnographic materials that were put on display at the Muséum de Paris from November 1872.[3] Three years later he donated the bulk of his collection to his native Boulogne, where the municipal Château-Musée still holds 221 pieces, including 70 Koniag masks.[4]

The mask shown here was undoubtedly collected while wintering in the Kodiak archipelago. Pinart failed to give the precise location for its origin in his catalogue published on the occasion of the exhibition at the Muséum d'Histoire Naturelle,[5] and the data has not been found in his handwritten notes now in the Bancroft Library at the University of California (Berkeley).[6]

In her study of the Pinart collection masks, Eveline Lot-Falck[7] attributed this mask to the Chugach, an Alutiit group (then also called Pacific Yup'ik) on the southeastern shores of Alaska. Her main argument was that it is identical to another pointed-headed mask published by William H.Dall[8] and represented a second time by Kaj Birket-Smith in a monograph on the Chugach.[9] But Lot-Falck neglected to point out that in the accompanying commentary, Birket-Smith had written that the mask was probably Aleutian.[10] This mask is currently in the Smithsonian Institution (inv. 20265), a gift from the Alaska Commercial Company (ACC).

When Alaska was sold to the U.S. government in 1867, the ACC, founded by a San Francisco businessman, bought the Russian-American Fur Company. Thus these California merchants inherited not only trading posts but also the curio collections assembled by Russian buyers. At the turn of the century most of these materials were donated to the University of California; but some, like the mask that Lot-Falck referred to,[11] were given to other museums. The provenance of these pieces is often uncertain, since they were shipped along with furs to warehouses and were not necessarily labelled as to their exact origin.

In the case of the Pinart mask, it seems to have come from the Kodiak archipelago, whose inhabitants are called the Koniag. At least this is what archaeological excavations undertaken since Lot-Falck's article suggest.[12] Moreover, it does not seem likely that Pinart ever went to Prince William Bay on the southeast Alaskan mainland, where the Chugach lived.

Cultural context

Dancers wore masks on different kinds of occasions, both shamanic rituals and celebrations of life events. For example, a boy's first successful hunt was marked by public rejoicing as his parents invited the whole village and neighbouring communities to a feast. There would be three days of dancing, singing and especially eating on a grand scale, and the prey, a sea lion or sea wolf, would be prominently displayed. The completion of a boat (a sea kayak or oumiak) could also be marked by inaugural festivities in which the whole community participated, with masked dancing.[13]

Iconographic interpretation

In the smaller, treeless Aleutian islands to the West, driftwood was used for sculpture. But on the heavily forested Kodiak island and its smaller

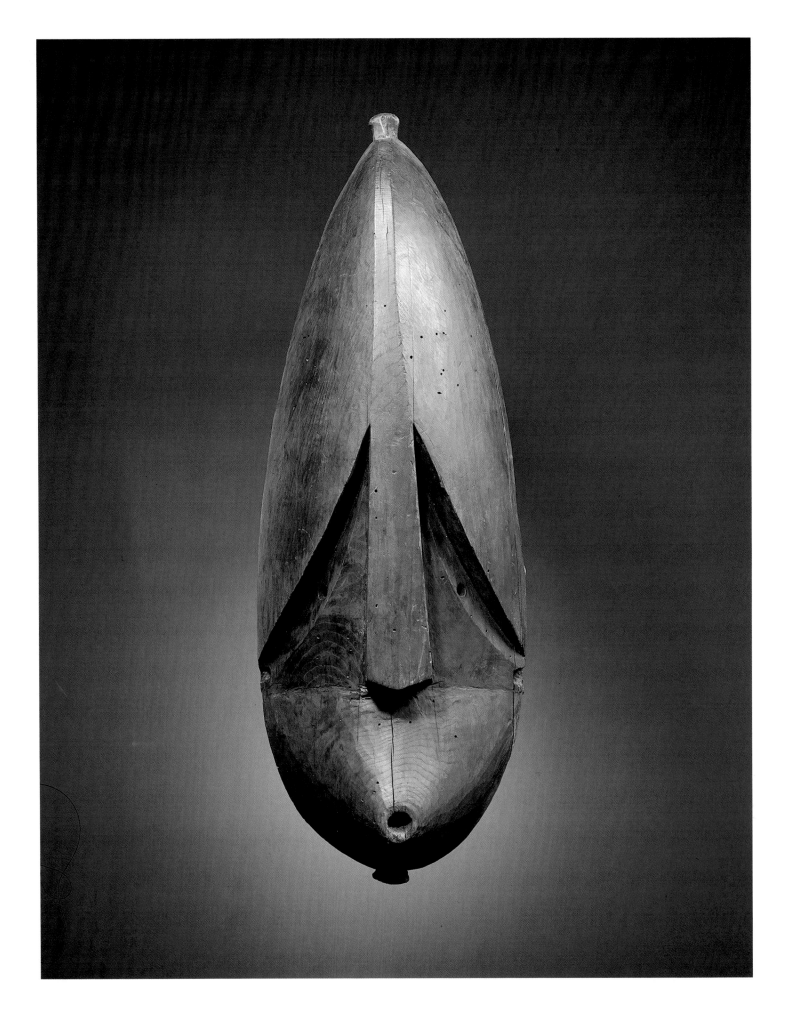

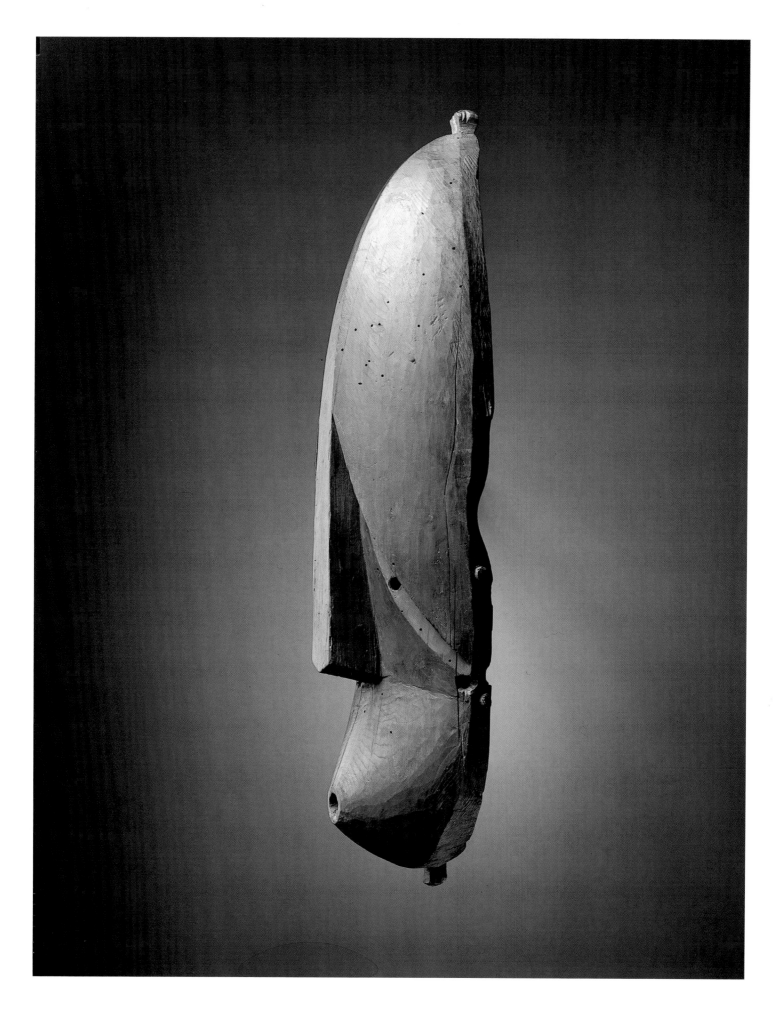

neighbours near the Alaskan mainland end of the Aleutian chain, artists preferred greenwood. The outside of this massive, heavy mask is polished, while its rough-hewn inner surface plainly shows the marks of the adze with which it was carved. The edges on both sides are worn down, indicating that this mask was in frequent use for a long time. The signs of a repair job on the edge of the left cheek also indicate repeated use. At some point the wood cracked and two pins were used to fasten the broken piece back on. Two tenons coming out of the mask at the top and bottom along the vertical axis held a decorative element wrapped around it, similar to other masks in this collection.

A dancer could tie on this mask with a cord that passed through two holes. Two small, scarcely visible eye holes allowed him to see. Another possible usage is suggested by the sturdy rim inside at the level of the forehead which would allow it to be hung on the wall for display during ceremonies.

This mask has several highly unusual facial features: the small, round mouth with puckered lips; a long, straight nose with flared nostrils; elegant curved, drooping eyelids over barely visible eyes; and a very high, elongated forehead. This pointed head and the eyes on the inside of the mask, which are more notable than those on the outside, recall the evil spirits or *igak*, which Pinart described in one of his publications,[14] although he does not refer to this mask in particular. The temptation to see every pointed-headed mask as an incarnation of an evil spirit should be avoided, but in this case, such an interpretation is especially supported by the decoration on the inside.

This masterwork on show in Boulogne from 1988 to 1998 represents a Koniag sculptor's striking vision of a human being condemned to an existence as an evil spirit. The artist made the outside well-proportioned and perfectly finished, its ghostly shape following the conventions dictated by tradition and mythology. Inside, the workmanship is both more crude and realistic, as befits the depiction of the unfortunate man who met this fate. But this is not a terrifying spectre. The face is calm and infused with dignity, whereas its hidden side expresses the enormous solitude of a person destined to torment others for all eternity.

JEAN-LOUP ROUSSELOT
Translation: L.-S. Torgoff

1 R. Menuge-Wacrenier, 1994; R. Parmenter, 1966; A. Pinart, 1875; J. Robert-Lamblin, 1976.
2 A. Lionnet, 1984, p. 275.
3 A. Pinart, 1872.
4 J.-L. Rousselot, 1996b.
5 A. Pinart, 1872.
6 D. Desson, 1995, p. 282.
7 E. Lot-Falck, 1957, p. 9.
8 W.H. Dall, 1884, pl. 43, figs. 54-56.
9 K. Birket-Smith, 1953, fig. 41.
10 *Ibid*, p. 109.
11 N. Graham, M. Lee and J.-L. Rousselot, 1996.
12 R.H. Jordan, 1994, p. 162.
13 J.-L. Rousselot, 1990.
14 A. Pinart, 1873, p. 678.

Maps

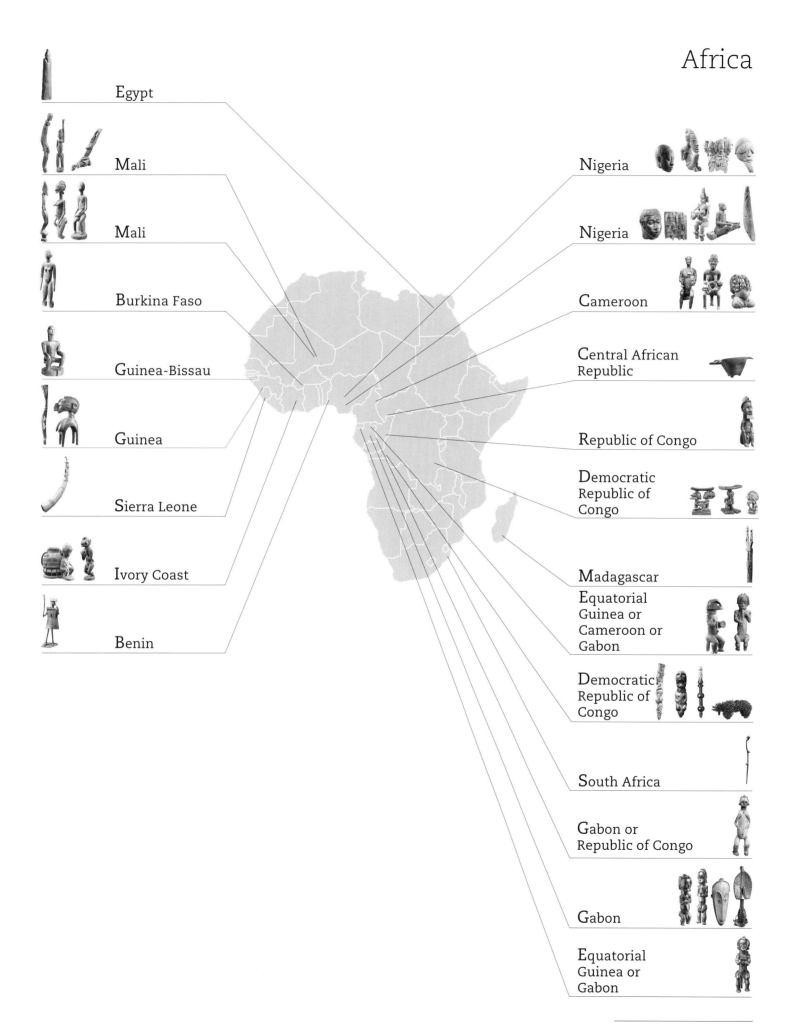

Africa

Egypt

Mali

Mali

Burkina Faso

Guinea-Bissau

Guinea

Sierra Leone

Ivory Coast

Benin

Nigeria

Nigeria

Cameroon

Central African Republic

Republic of Congo

Democratic Republic of Congo

Madagascar

Equatorial Guinea or Cameroon or Gabon

Democratic Republic of Congo

South Africa

Gabon or Republic of Congo

Gabon

Equatorial Guinea or Gabon

Asia

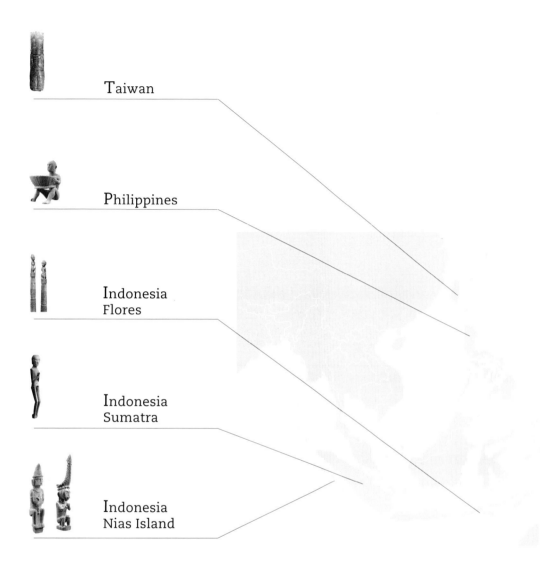

Taiwan

Philippines

Indonesia
Flores

Indonesia
Sumatra

Indonesia
Nias Island

Oceania

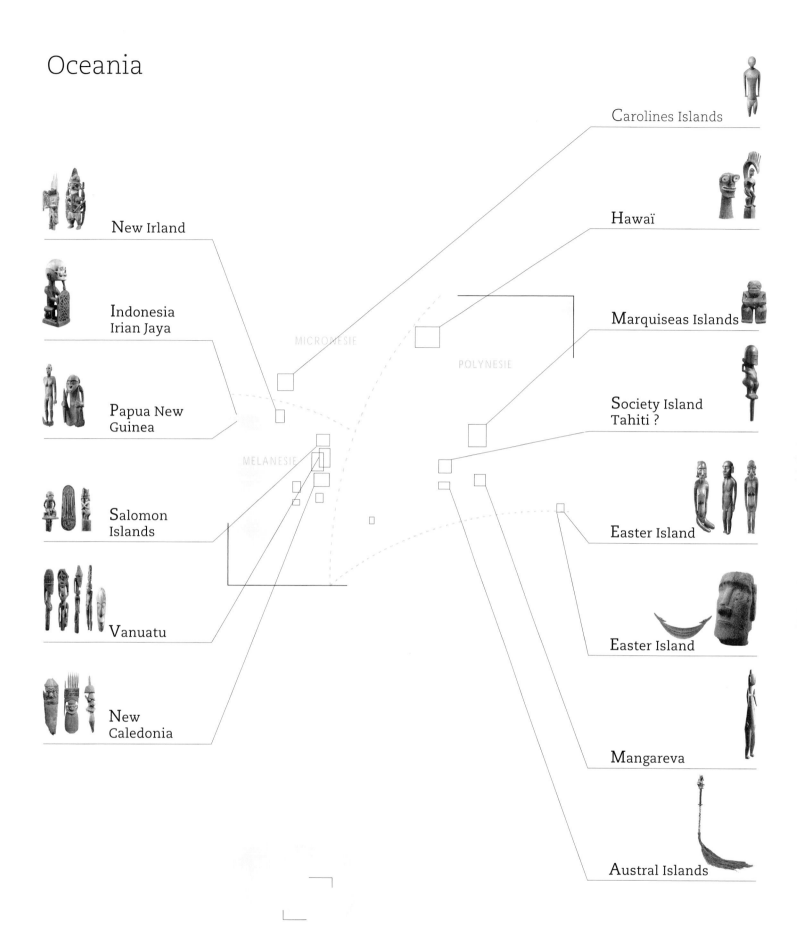

New Irland

Indonesia
Irian Jaya

Papua New
Guinea

Salomon
Islands

Vanuatu

New
Caledonia

Carolines Islands

Hawaï

Marquiseas Islands

Society Island
Tahiti ?

Easter Island

Easter Island

Mangareva

Austral Islands

MICRONESIE

POLYNESIE

MELANESIE

America

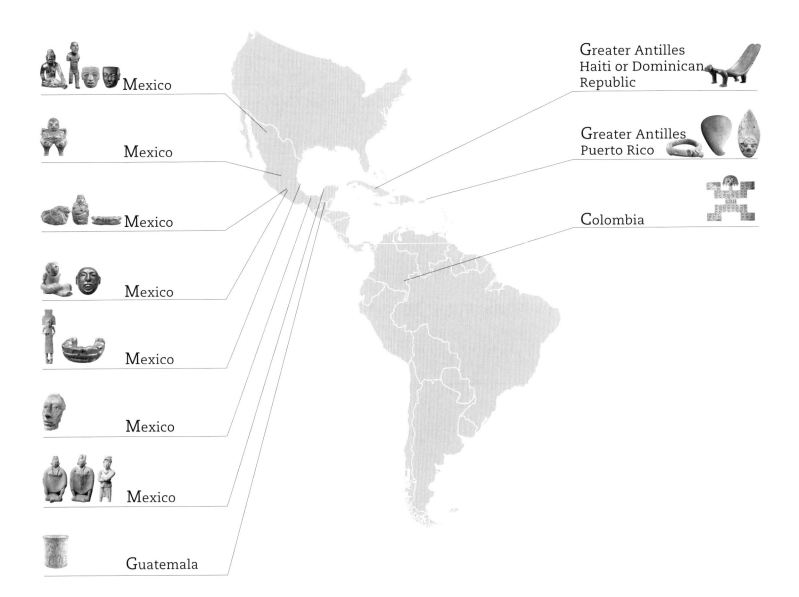

Mexico

Mexico

Mexico

Mexico

Mexico

Mexico

Mexico

Guatemala

Greater Antilles
Haiti or Dominican
Republic

Greater Antilles
Puerto Rico

Colombia

America

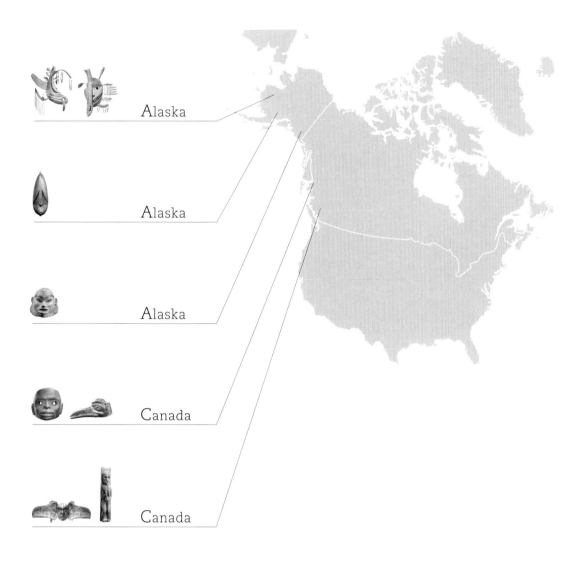

Alaska

Alaska

Alaska

Canada

Canada

Chronological list of exhibitions quoted in abbreviated form

Paris, 1850
Opening of the American Antiquities gallery (Mexico and Peru) int the Palais du Louvre.

Paris, 1872
Collection A.-L. Pinart, Muséum d'Histoire Naturelle.

Paris, 1878
Exposition universelle.

Paris, 1900
Exposition Universelle, 15 April-4 November.

Paris, 1923-24
"Art indigène des Colonies françaises d'Afrique et d'Océanie et du Congo belge", Pavillon de Marsan, Palais du Louvre, Union Centrale des Arts Décoratifs, October 1923-January 1924.

Paris, 1926
"Tableaux de Man Ray et objets des îles", Galerie Surréaliste, 26 March-10 April.

Paris, 1928
"Les arts anciens de l'Amérique", Musée des Arts Décoratifs, Palais du Louvre, Pavillon de Marsan, May-June.

Paris, 1930
"Exposition d'art africain et d'art océanien", Galerie Pigalle, 28 February-1 April.

Bruxelles, 1930
"Art nègre. Les arts anciens de l'Afrique noire", Palais des Beaux-Arts, 15 November-31 December.

Paris, 1932
"Exposition de bronzes et ivoires du royaume de Bénin", Muséum National d'Histoire Naturelle, Musée d'Ethnographie, Palais du Trocadéro, 15 June-15 August.

Paris, 1932-35
"Salle du Trésor", Musée d'Ethnographie du Trocadéro, 15 June 1932-August 1935.

New York, 1933
"Exhibition of Paintings by Derain organized by Paul Guillaume of Paris (32 Works of Derain and 30 Sculptures from the Pahouin Tribe, Gabon)", Durand-Ruel Galleries, 15 February-10 March.

New York, 1935a
"African Negro Art", The Museum of Modern Art, 18 March-19 May.

New York, 1935b
"The Art of the Kingdom of Benin – Bronzes and Ivories from the Old Kingdom of Benin", Galleries of M. Knoedler and Company, 25 November-14 December.

Paris, 1937
"Exposition internationale des arts et techniques dans la vie moderne", May-November.

Paris, 1938
"Le voyage de la Korrigane en Océanie", Musée de l'Homme, June-October.

Paris, 1947
"Chefs-d'œuvre de l'Amérique précolombienne", Musée de l'Homme.

Paris, 1951
"Collection C. L.-S., Arts primitifs, Objets de haute curiosité", Hôtel Drouot, 20 June.

Paris, 1952
"Art Mexicain, du précolombien à nos jours", Musée Nnational d'Art Moderne.

Paris, 1955
"Les arts africains", Cercle Volney, June-July.

Paris, 1957-58
"Cinquantenaire du condominium franco-britannique", Musée de l'Homme, May 1957-May 1958.

Bruxelles, 1958
"Exposition Universelle et Internationale", 17 April-19 October.

Londres, 1959
"Sculpture of the Tellem and the Dogon", Hanover Gallery, October-November.

Pittsburgh, 1959-60
"Exotic Art from Ancient and Primitive Civilizations, Collection of Jay C. Leff", Carnegie Institute, 15 October 1959-3 January 1960.

Paris, 1959-60
"Le masque", Musée Guimet, December 1959-September 1960.

New York, 1960
"Sculpture of the Tellem and the Dogon", Pierre Matisse Gallery, 16 February-5 March.

Paris, 1962
"Art primitif", Galerie Pierre, 25 October-25 November.

Paris, 1964a
"Collection André Lefèvre", Musée National d'Art Moderne, March-April.

Paris, 1964b
"Afrique. Cent Tribus – Cent Chefs-d'œuvre", Musée des Arts Décoratifs, Palais du Louvre, Pavillon de Marsan, 28 October-30 November.

Paris, 1965
"Chefs-d'œuvre du musée de l'Homme", Musée de l'Homme, April-October.

Toulouse, 1965
Centre culturel.

New York, 1966
"Architectural Sculpture of the Solomon Islands", Galerie Kamer.

Paris, 1966
"Arts connus et arts méconnus de l'Afrique noire – Collection Paul Tishman", Musée de l'Homme, March-December.

Dakar, Paris, 1966
"L'Art nègre. Sources Évolution Expansion", Grand Palais.

Paris, 1967
"Les arts primitifs dans les ateliers d'artistes", Musée de l'Homme.

Marseille, 1970
"Arts africains", Musée Cantini, March-May.

Los Angeles, 1968-69
"Sculpture of Black Africa – The Paul Tishman Collection", Los Angeles County Museum of Art, 16 October 1968-5 January 1969.

Alger, 1969
"Art africain", Premier Festival Culturel Panafricain, July-August.

Richmond, 1970
"Sculpture of Black Africa – The Paul Tishman Collection", Virginia Museum, 31 August-1 November.

Austin, 1970
"Sculpture of Black Africa – The Paul Tishman Collection".

New York, 1970-71
"Before Cortés. Sculpture of Middle America. A Centennial Exhibition at the Metropolitan Museum of Art", 30 September 1970-3 January 1971.

Zurich, 1970-71
"Die Kunst von Schwarz-Afrika", Kunsthaus, 31 October-17 January.

Essen, 1971
"Afrikanische Kunstwerke Kulturen am Niger", Villa Hügel, 25 March-13 June.

Saint Louis, 1971
"Sculpture of Black Africa – The Paul Tishman Collection", 20 August-17 October.

Des Moines, 1971
"Sculpture of Black Africa – The Paul Tishman Collection".

Huntington, 1971
"Sculpture of Black Africa – The Paul Tishman Collection".

Paris, 1972
"La découverte de la Polynésie", Musée de l'Homme, January-June.

Paris, 1972-1973
"Sculptures africaines dans les collections publiques françaises", Orangerie des Tuileries, 7 November 1972-26 February 1973.

Paris, 1973
"L'Égypte avant les pyramides, IVe millénaire", Grand Palais, 29 May - 3 September.

Saint-Paul-de-Vence, 1973
"André Malraux", Fondation Maeght, 13 July-30 September.

Victoria, 1975
"Images Stone B.C.", Art Gallery of Greater Victoria.

Paris, 1975
"Art Phila", Grand Palais, 6-16 June 1975.

Anvers, 1975
"Sculptures africaines – Nouveau regard sur un héritage", Marcel Peeters Centrum, 16 November-2 December.

Paris, 1976
"La France des quatre coins du monde", Palais des Congrès, 24 September-10 October 1976.

Orly-Sud, 1977
"L'arbre", February-December.

Bruxelles, 1977a
"La maternité dans les arts premiers", Société Générale de Banque, 13 May-30 June.

Bruxelles, 1977b
"Arts premiers d'Afrique noire", Studio 44/Crédit Communal de Belgique, 5 March-17 April.

Paris, 1977
"Présentation inaugurale", Musée National d'Art Moderne, Centre National d'Art et de Culture Georges Pompidou.

Paris, 1977-78
"Collections de Louis XIV – Dessins, albums, manuscrits", Orangerie des Tuileries, 7 October 1977-9 January 1978.

Washington D.C., 1979
"The Art of the Pacific Islands", National Gallery of Art, 1 July-14 October.

Paris, 1979
"Rites de la mort", Musée de l'Homme, June-September.

Paris-Bruxelles, 1979
"L'aventure de Pierre Loeb. La galerie Pierre, Paris 1924-1964", Musée d'Art Moderne de la Ville de Paris, 7 June-16 September; Musée d'Ixelles, 4 October-23 December.

Nice, 1980
"Esprits et dieux d'Afrique", Musée National Message Biblique Marc Chagall, 5 July-3 November.

Genève, 1980
"Cameroun: arts et cultures des peuples de l'Ouest", Musée d'Ethnographie.

New York, 1980-81
"Masterpieces of the People's Republic of the Congo", The African-American Institute, 25 September 1980-24 January 1981.

Genève, 1981
"Art des indonésiens archaïques", Musée Rath.

New York, 1981
"For Spirits and Kings – African Art from the Tishman Collection", The Metropolitan Museum of Art, 30 May-6 September.

Honolulu, 1981
"The People and Art of the Philippines", Honolulu Academy of Arts.

Los Angeles, 1981
"The People and Art of the Philippines", The Frederick S. Wight Art Gallery, University of California.

New York, 1981-1982
"Art of the Archaïc Indonesian", Brooklyn Museum.

Dallas, 1982
"Art of the Archaic Indonesian", Museum of Fine Art.

Oakland, 1981-1982
"The People and Art of the Philippines", The Oakland Museum.

Chicago, 1982
"The People and Art of the Philippines", Field Museum of Natural History.

Washington D.C., 1983
"Art of Aztec Mexico – Treasures of Tenochtitlan", The National Gallery of Art.

Paris, 1984
"La collection d'art primitif de Magnelli", Musée National d'Art Moderne, 8 July-September.

New York, 1984-1985a
"African Masterpieces from the Musée de l'Homme", The Center for African Art, 17 September 1984-6 January 1985.

New York, 1984-85b
"Primitivism in 20th Century Art", Museum of Modern Art, 27 September 1984-15 January 1985.

Paris, 1985
"Musée imaginaire des arts de l'Océanie", Musée National des Arts Africains et Océaniens, 18 April-1 July.

Paris, 1986
"Ouvertures sur l'art africain", Musée des Arts Décoratifs, 13 May-29 June.

Paris, 1986-87
"Côté femmes", Musée de l'Homme.

Washington D.C., 1987-1988
"African Art in the Cycle of Life", National Museum of African Art, Smithsonian Institution, 28 September-20 March.

Bruxelles, 1988
"Utotombo. L'art d'Afrique noire dans les collections privées belges", Palais des Beaux-Arts, 25 March-5 June.

Düsseldorf, 1988
"Afrikanische Kunst", Kunstsammlung Nordrhein-Wesfalen, 27 February-17 April.

Francfort-sur-le-Main, 1988
"Afrikanische Kunst", Schirn Kunsthalle, 4 June-14 August.

New York, 1988
"Africa and the Renaissance. Art in Ivory", The Center for African Art.

Munich, 1988-89
"Afrikanische Kunst", Haus der Kunst, 17 December-19 February.

New York, 1988-93
"Islands and Ancestors – Indigenous Styles of Southeast Asia", 10 November 1988-December 1993.

Berne, 1989
"Afrikanische Kunst", Kunstmuseum, 15 August-15 October.

Saint-Paul-de-Vence, 1989
"Arts de l'Afrique noire dans la collection Barbier-Mueller", Fondation Maeght, 15 March-15 June.

Washington D.C., 1989
"Sounding Forms, African Musical Instruments", National Museum of African Art, 26 April-18 June.

Richmond, 1989
"Sounding Forms, African Musical Instruments", The Virginia Museum of Fine Arts, 16 July-10 September.

Kansas City, 1989
"Sounding Forms, African Musical Instruments", The Nelson-Atkins Museum of Art, October-December.

Florence, 1989
"La grande scultura dell'Africa nera", Forte di Belvedere, 15 July-29 October.

Paris, 1989a
"Supports de rêves", Musée Dapper, 19 April-6 September.

Paris, 1989b
"Corps sculptés, corps parés, corps masqués", Galeries Nationales du Grand Palais, 18 October-15 December.

Paris, 1989c
"Madagascar arts de la vie et de la survie", Musée des Arts Africains et Océaniens, 1 March-21 May.

Paris, 1989-1990
"Les Amériques de Claude Lévi-Strauss", Musée de l'Homme, 10 October-24 April.

Paris, 1990
"Afrique: formes sonores", Musée National des Arts Africains et Océaniens, 7 February-2 April.

Marseille, 1998
"L'Égypte des millénaires obscurs", Centre de la Vieille Charité.

Cologne 1990
"Afrikanische Skulptur: Die Erfindung der Figur – African Sculpture: The Invention of the Figure", Museum Ludwig, 27 July-30 September.

La Haye, 1990-91
"Afrikanische Skulptur: Die Erfindung der Figur – African Sculpture: The Invention of the Figure", Gemeentemuseum, November-January.

Zurich, 1990-91
"Löffel in der Kunst Afrikas", Museum Rietberg, 21 September-20 January.

Paris, 1991
"Cuiller-sculptures", Musée Dapper, 31 January-28 April.

Paris, 1991-92
"Fang", Musée Dapper, 21 November-15 April.

Washington D.C., 1991-1992
"Circa 1492 – The Art in the Age of Exploration", The National Gallery of Art.

Paris, 1992
"Le Grand Héritage", Musée Dapper, 21 May-15 September.

Marseille, 1992
"Byeri Fang – Sculptures d'ancêtres en Afrique", Musée d'Arts Africains, Océaniens, Amérindiens, Centre de la Vieille Charité, 6 June-6 September.

Glasgow, 1992
"America Lost 1492-1713. The First Encounter".

Los Angeles, 1992-93
"Elephant: The Animal and its Ivory in African Culture", J. Paul Getty Trust Gallery of the UCLA Fowler Museum of Cultural History, 30 September 1992-16 May 1993.

Paris, 1992-93a
"Rao – Polynésies", Musée National des Arts d'Afrique et d'Océanie, October 1992-March 1993.

Paris, 1992-93b
"Vision d'Océanie", Musée Dapper, 22 October-15 March.

Paris, 1993a
"Formes et couleurs", Musée Dapper, 1 April-15 September.

Paris, 1993b
"Les rois sculpteurs. Art et pouvoir dans le Grassland camerounais. Legs Pierre Harter", Musée National des Arts d'Afrique et d'Océanie.

Paris, 1993-94a
"Les arts à Paris chez P. Guillaume 1918-1935", Musée de l'Orangerie, 14 September-3 January.

Paris, 1993-94b
"Luba, aux sources du Zaïre", Musée Dapper, 25 November 1993-17 April 1994.

Paris, 1994
"L'art des sculpteurs taïnos – Chefs-d'œuvre des Grandes Antilles pré-colombiennes", Musée du Petit Palais, 24 February-29 May.

Paris, 1994-95
"Dogon", Musée Dapper, 26 October-13 March.

Paris, 1995
"La collection africaine d'Alberto Magnelli, Donation Susi Magnelli", Musée National d'Art Moderne, Centre Georges Pompidou, 1 February-20 March.

Paris, 1995-1999
"Trésors des îles Marquises", Musée de l'Homme.

Zurich, 1995
"Die Kunst der Dogon", Museum Rietberg, 7 May-3 September.

Paris, 1995-1996
"Masques", Musée Dapper, 26 October 1995-30 September 1996.

Londres, 1995-1996
"Africa. The Art of a Continent", Royal Academy of Arts, 4 October-21 January.

Berlin, 1996
"Afrika. Die Kunst eines Kontinents", Martin-Gropius-Bau, 1 March-1 May.

New York, 1996
"Africa. The Art of a Continent, 100 Works of Power and Beauty", Solomon R. Guggenheim Museum New York, 7 June-29 September.

Bordeaux, 1996
"Voyage vers l'île mystérieuse, de la Polynésie à l'île de Pâques", Musée d'Aquitaine, 20 April-15 September.

Port Villa, 1996
"Spirit blong Bubu i Kam Bak", Centre culturel du Vanuatu, Musée National, 28 June-10 August.

Nouméa, 1996
"Vanuatu, Océanie. Arts des îles de cendre et de corail", Musée Territorial de Nouvelle-Calédonie, 3 September-30 October.

Paris, 1996-97
"Réceptacles", Musée Dapper, 23 October-30 March.

Zurich, 1996-97
"Die Baule (Elfenbeinküste 1933 + 1935 – Fotografien und Objekte eines westafrikanischen Volkes. Ethnographische Dokumentation von Hans Himmelheber)", Museum Rietberg, 13 December-23 February.

Tampere, 1997
"Sulkakäärma ja Jaguaarijumala – Meksikon ja Guatemala intiaani-kulttuurit", Tampereen Taidemuseo.

Bâle, 1997
"Vanuatu – Kunst der Südsee/Arts du Pacifique", Museum der Kulturen, 1 March-10 August.

Paris, 1997
"Arts du Nigeria - Collection du musée des Arts d'Afrique et d'Océanie", Musée National des Arts d'Afrique et d'Océanie, 22 April-18 August.

Tanlay, 1997
"Lumière noire, arts traditionnels", castle of Tanlay (Yonne), 7 June-5 October.

Düsseldorf, 1997
"Erde und Erze", Kunstsammlung Nordrhein-Westfalen, 20 June-11 November.

New Haven, 1997-98
"Baule. African Art Western Eyes", Yale University Art Gallery.

Paris, 1997-98
"Vanuatu, Océanie. Arts des îles de cendre et de corail", Musée national des Arts d'Afrique et d'Océanie, 2 October 199-2 February 1998.

Bordeaux, 1997-98
"L'esprit de la forêt. Terres du Gabon", Musée d'Aquitaine, 19 December-3 May.

Barcelone, 1998
"Africa: magia i poder. 2500 anyos d'art a Nigeria – África: magia y poder. 2500 años de arte en Nigeria", Fundación La Caixa, 23 September-13 December.

Stuttgart, 1998
"Dogon-Meisterwerke der Skulptur – Chefs-d'œuvre de la statuaire dogon", Galerie der Stadt, 26 April-2 August.

Luxembourg, 1998
"Naissance de l'art en Afrique noire. La statuaire Nok au Nigeria", Banque générale du Luxembourg, 13 October-13 December.

Chicago, 1998
"Baule. African Art Western Eyes", The Art Institute of Chicago.

Hanovre, 1998
"Botschaft der Steine, Indonesische Skulpturen aus der Sammlung Barbier-Mueller", Kestner-Gesellschaft, 13 June-6 September.

La Rochelle, 1998-99
"Le voyage exotique".

Genève, 1998-99
"Mexique terre des dieux – Trésors de l'art précolombien", Musée Rath, 8 October-24 January.

Madrid, 1999
"África: magia y poder. 2500 años de arte en Nigeria", Fundación La Caixa, 20 January-28 March.

Séville, 1999
"África: magia y poder. 2500 años de arte en Nigeria", Santa Inés, 15 April-30 May.

Paris, 1999
"Picasso collectionneur", Musée Picasso, 23 June-27 September.

Paris, 2001
"Arts primitifs, arts d'Asie", Hôtel Drouot, February.

Select bibliography

The asterisk in front of certain names or titles indicates an abridged reference, details of the publication in question being given under the alphabetical entry mentioned.

A

Abbot (ed.), 1981
Abbot (Donald) [ed.], *The World is sharp as a knife. An Anthology in Honour of Wilson Duff*, Victoria, British Columbia Provincial Museum, 1981.

Abraham, 1958
Abraham (R.C.), *Dictionary of Modern Yoruba*, London, University of London, 1958.

Adam, 1959
Adam (Leonhard), *Art Primitif*, Arthaud, 1959.

Ademuwagun et al., 1979
Ademuwagun (Z.A.) et al., *African Therapeutic Systems*, Waltham (Massachusetts), Crossroads Press, 1979.

***Africa. The Art of a Continent, 100 Works of Power and Beauty*, 1996**
Africa. The Art of a Continent, 100 Works of Power and Beauty, New York, Guggenheim Museum, 1996.

***Africa: magia y poder. 2500 años de arte en Nigeria*, 1998**
Africa: magia y poder. 2500 años de arte en Nigeria, Barcelona, Fundación La Caixa, 1998.

***African Arts*, 1997**
African Arts, The Benin Centenary, 1st part, vol. XXX, no. 3, summer 1997; 2nd part, vol. XXX, no. 4, autumn 1997.

***Afrikanische Skulptur: Die Erfindung der Figur – African Sculpture: The Invention of the Figure*, 1990**
Afrikanische Skulptur: Die Erfindung der Figur – African Sculpture: The Invention of the Figure, Cologne, Museum Ludwig/The Hague, Gemeentemuseum, 1990.

Aksamit, 1989
Aksamit (Joanna), "The Gold Handle of a Fishtail Dagger from Gebelein (Upper Egypt)", *Late Prehistoric of the Nil Basin and the Sahara, Studies in African Archaeology*, vol. II, Poznan Archaeological Museum, 1989, p. 325-332.

Alcina Franch, 1983
Alcina Franch (José), *Pre-Columbian Art*, New York, Harry N. Abrams, Inc., Publishers, 1983.

Alcina Franch, León Portilla and Matos Moctezuma, 1992
Alcina Franch (José), León Portilla (Miguel), Matos Moctezuma (Eduardo), *Azteca mexica – Las culturas del México antiguo*, Madrid, Sociedad Estabal Quinto Centenario y Lunwerg Editores, 1992.

Alegría, 1983
Alegría (Ricardo E.), *Ball Courts and Ceremonial Plazas in the West Indies*, New Haven, Yale University Publications, 1983.

Alexandre, 1965
Alexandre (Pierre), "Proto-histoire du groupe beti-bulu-fang: essai de synthèse provisoire", *Cahiers d'études africaines*, vol. V, no. 20, 1965, p. 503-560.

Alexandre and Binet, 1958
Alexandre (Pierre), Binet (Jacques), *Le Groupe dit Pahouin (Fang-Boulou-Beti)*, Paris, PUF, 1958.

Allen, 1967
Allen (M.), *Male Cults and Secret Initiations in Melanesia*, Melbourne, 1967.

Allison, 1968a
Allison (Philip), *The Cross River Monoliths*, Lagos, Department of Antiquities, Federal Republic of Nigeria, Government Printer, 1968.

Allison, 1968b
Allison (Philip), *African Stone Sculpture*, London, Percy Lund, Humphries and Co Ltd, 1968.

Ameline, 1995
Ameline (Jean-Paul), preface to *La Collection africaine d'Alberto Magnelli, Donation Susi Magnelli*, Paris, Centre Georges Pompidou, 1995, p. 4-7.

***Ancienne Collection Paul Guillaume – Art nègre*, 1965**
Ancienne Collection Paul Guillaume – Art nègre, Paris, Hôtel Drouot, 9 November 1965.

Anderson, 1996
Anderson (E.N.), *Bird of Paradox. The Unpublished Writings of Wilson Duff*, Surrey, Hancock House Publishers, 1996.

Andersson, 1953
Andersson (Efraïm), "Contribution à l'ethnographie des Kuta", *Studia Ethnographica Upsaliensia*, vol. VI, Uppsala, 1953.

***André Breton, la beauté convulsive*, 1991**
André Breton, la beauté convulsive, Paris, Musée National d'Art Moderne, Centre Georges Pompidou, 1991.

***André Malraux*, 1973**
André Malraux, Saint-Paul-de-Vence, Fondation Maeght, 1973.

***Antiquities of Mexico*, 1830**
Antiquities of Mexico, comprising Facsimiles of Ancient Mexican Paintings and Hieroglyphics, 7 vols., London, 1830.

Apollinaire, 1991
Apollinaire (Guillaume), "Sur les musées", *Le Journal du soir*, 3 October 1909, in *Œuvres en prose complètes*, vol. II, Paris, Gallimard, Bibliothèque de la Pléiade, 1991, p. 122-24; "Exotisme et ethnographie", *Paris-Journal*, 10 September 1912, in *ibid.*, p. 473-476.

Appia, 1943
Appia (Béatrice), "Masques de Guinée française et de Casamance", *Journal de la société des africanistes*, vol. XIII, 1943, p. 153-82.

Appia, 1944
Appia (Béatrice), "Notes sur le génie des eaux en Guinée", *Journal de la société des africanistes*, vol. XIV, 1944, p. 33-41.

***Archéologie comparée*, 1989**
Archéologie comparée, Catalogue des collections de Saint-Germain, vol. II, Paris, RMN, 1989.

***Architectural Sculpture of the Solomon Island*, 1966**
Architectural Sculpture of the Solomon Island, New York, Kamer, 1966.

Arcin, 1911
Arcin (André), *Histoire de la Guinée française*, Paris, Éditions A. Challamel, 1911.

***Arman et l'art africain*, 1996**
Arman et l'art africain, Marseille, Musées de Marseille/Paris, RMN, 1996.

***Art mexicain, du précolombien à nos jours*, 1952**
Art mexicain, du précolombien à nos jours, vol. 1, Paris, Musée National d'Art Moderne, 1952.

***Art nègre. Sources, évolution, expansion*, 1966**
L'Art nègre. Sources, évolution, expansion, Dakar, Commissariat du Festival Mondial des Arts Nègres/Paris, RMN, 1966.

***Art of Aztec Mexico – Treasures of Tenochtitlan*, 1983**
Art of Aztec Mexico – Treasures of Tenochtitlan, Washington, The National Gallery of Art, 1983.

***Art of Oceania*, 1975**
The Art of Oceania, Paris, Unesco, 1975.

***Art of Oceania, Africa and the Americas from the Museum of Primitive Art*, 1969**
Art of Oceania, Africa and the Americas from the Museum of Primitive Art, New York, The Metropolitan Museum of Art, 1969.

***Art tribal, Bulletin du musée Barbier-Mueller*, 1992**
Art tribal, Bulletin du musée Barbier-Mueller, Geneva, Musée Barbier-Mueller, 1992.

***Arte en el Antiguo Perú*, 1994**
Arte en el Antiguo Perú, National Cultural Institute of Peru, 1994.

***Arts africains*, 1955**
Les Arts africains, Paris, Cercle Volney, 1955.

***Arts africains*, 1970**
Arts africains, Marseille, Musée Cantini, 1970.

***Arts africains dans les collections genevoises*, 1973**
Arts africains dans les collections genevoises, Geneva, Musée d'Ethnographie, 1973.

***Arts anciens de l'Amérique*, 1928**
Les Arts anciens de l'Amérique, Paris, Éditions G. Van Oest, 1928.

***Arts à Paris chez Paul Guillaume*, 1993**
Les Arts à Paris chez Paul Guillaume, 1918-35, Paris, RMN, 1993.

***Arts connus et arts méconnus de l'Afrique noire – Collection Paul Tishman*, 1966**
Arts connus et arts méconnus de l'Afrique noire – Collection Paul Tishman, Paris, P. Tishman/Société des Amis du Musée de l'Homme, 1966.

***Arts d'Afrique*, 1972**
Arts d'Afrique, no. 1, Villiers-le-Bel, 1972.

***Arts d'Afrique intertropicale*, 1963**
Arts d'Afrique intertropicale (Monuments et Sculptures), La Documentation photographique, special issue, no. 55-16, Paris, La Documentation française, 1963.

***Arts d'Afrique noire*, 1989**
Arts d'Afrique noire, no. 71, Arnouville, autumn 1989.

***Arts de l'Afrique noire dans la collection Barbier-Mueller*, 1988**
Arts de l'Afrique noire dans la collection Barbier-Mueller, Paris, Fernand Nathan, 1988.

***Arts des mers du Sud*, 1998**
Arts des mers du Sud (Insulinde, Mélanésie, Polynésie, Micronésie), Marseille, Musées de Marseille/Paris, Adam Biro, 1998.

***Arts du Nigeria – Collection du musée des Arts d'Afrique et d'Océanie*, 1997**
Arts du Nigeria – Collection du musée des Arts d'Afrique et d'Océanie, Paris, RMN, 1997.

***Arts premiers d'Afrique noire*, 1977**
Arts premiers d'Afrique noire, Brussels, Studio 44/Crédit Communal de Belgique, 1977.

***Arts primitifs*, 1977**
Arts primitifs – Collections de MM. Paul Éluard, Pierre et Albert Loeb, René Rasmussen et appartenant à divers amateurs, Paris, Palais d'Orsay, Saturday 3 December 1977/Drouot Rive Gauche, Monday 5 December 1977.

***Arts primitifs dans les ateliers d'artistes*, 1967**
Arts primitifs dans les ateliers d'artistes, Paris, Musée de l'Homme/Société des Amis du Musée de l'Homme, 1967.

***Art primitif et psychanalyse*, 1929**
Dr. O., "Art primitif et psychanalyse d'après Eckart von Sydow", *Cahiers d'art*, no. 2-3, March-April 1929, p. 65-72.

Atangana, 1942-45
Atangana (Charles), "'Aken So' chez les Yaoundés-Banés'", *Anthropos*, vols. XXXVII-LX, 1942-45, p. 149-57.

Auboyer, 1968
Auboyer (J.), *L'Afghanistan et son art*, Paris, Cercle d'Art, 1968.

Augé (ed.), 1995
Augé (Jean-Louis) [ed.], *Image du Nouveau Monde en France*, Paris, La Martinière, 1995.

Auvrey, 1926
Auvrey (Dr.), *Les Nouvelles-Hébrides. Mémoires de John Higginson*, Coutances, 1926.

Aventure de Pierre Loeb.
La Galerie Pierre, 1979
L'Aventure de Pierre Loeb. La Galerie Pierre, Paris 1924-64, Paris, Musée d'Art Moderne de la Ville de Paris/Brussels, Musée d'Ixelles, 1979.

À visage découvert, 1992
À visage découvert, Jouy-en-Josas, Fondation Cartier/Paris, Flammarion, 1992.

Awolalu, 1979
Awolalu J.O., *Yoruba Beliefs and Sacrificial Rites*, London, Longman, 1979.

Ayoade, 1979
Ayoade (J.A.A.), "The Concept of Inner Essence in Yoruba Traditional Medicine", in *Ademuwagun et al (eds.), 1979.

Ayrton and Loat, 1911
Ayrton (Edward R.), Loat (William J.), *Pre-Dynastic Cemetery at El Mahasna*, London, 1911.

B

Babadzan, 1993
Babadzan (Alain), *Mythes tahitiens réunis par Teuira Henry*, Paris, Gallimard, 1993.

Bacon, 1897
Bacon (R.H.S.), *Benin. The City of Blood*, London, 1897.

Bahuchet, 1985
Bahuchet (Serge), *Les Pygmées aka et la forêt centrafricaine*, Paris, SELAF, 1985.

Baker, 1928
Baker (J.), "Depopulation in Espirito Santo, New Hebrides", *Journal of the Royal Anthropological Institute*, vol. LVIII, London, 1928, p. 279-303.

Baker, 1929
Baker (J.), *Man and Animals in the New Hebrides*, London, 1929.

Balandier and Maquet (dir.), 1968
Balandier (G.) and Maquet (J.) [dir.], *Dictionnaire des civilisations africaines*, Paris, Fernand Hazan, 1968.

Barbier, 1984a
Barbier (Jean Paul), *Art of Nagaland*, Los Angeles, County Museum of Art, 1984.

Barbier, 1984b
Barbier (Jean Paul), *Indonesian Primitive Art*, Dallas Museum of Art, 1984.

Barbier, 1984c
Barbier (Jean Paul), "Une statue en pierre pangulubalang des Batak de Sumatra", *Art tribal, Bulletin du musée Barbier-Mueller*, no. 22, 1984.

Barbier, 1988
Barbier (Jean Paul), "A Stone Rider of the Batak of Sumatra", in *Barbier and Newton (eds.), 1988, p. 50-65.

Barbier, 1993
Barbier (Jean Paul), "De pierre et d'orgueil: une statue commémorative toba batak", *Art tribal, Bulletin du musée Barbier-Mueller*, 1993, p. 3-35.

Barbier (ed.), 1993
Barbier (Jean Paul) [ed.], *Arts de la Côte d'Ivoire*, Geneva, Musée Barbier-Mueller, 1993.

Barbier, 1998
Barbier (Jean Paul), "Batak Monuments: In the Shade of the Petrified Ancestors", in *Messages in Stone, 1998, p. 79-155.

Barbier (ed.), 1998
Barbier (Jean Paul) [ed.], *Messages in Stone. Statues and Sculptures from Tribal Indonesia in the Collections of the Barbier-Mueller Museum*, Geneva, Musée Barbier-Mueller/Milan, Skira, 1998.

Barbier and Newton (eds.), 1988
Barbier (Jean Paul), Newton (Douglas) [eds.], *Islands and Ancestors – Indigenous Styles of Southeast Asia*, Munich, Prestel Verlag, 1988.

Barnes and Ben-Amos, 1989
Barnes (S.), Ben-Amos (P.), "Ogun, the Empire Builder", *Africa's Ogun: Old World and New*, Bloomington, Indiana University Press, 1989.

Barnes and Melion (eds.), 1989
Barnes (Susan J.), Melion (Walter S.) [eds.], *Cultural Differentiation and Cultural Identity in the Visual Arts*, National Gallery of Art, Washington, 1989.

Barrera Vasquez, 1980
Barrera Vasquez (Alfredo), *Diccionario Maya Cordemex. Maya español/español maya*, Mérida, Ediciones Cordemex, 1980.

Barrow, 1973
Barrow (Terence T.), *Art and Life in Polynesia*, Rutland, Charles E. Tittle Co., 1973.

Bartlett, 1930
Bartlett (Harley Harris), *The Labors of the Datoe*, part 1, Papers of the Michigan Academy of Science, Arts and Letters, Ann Arbor, University of Michigan, 1930.

Bartlett, 1934
The Sacred Edifices of the Batak of Sumatra, Ann Arbor, University of Michigan, 1934.

Barton, 1955
Barton (Roy Franklin), *The Mythology of the Ifugaos*, Philadelphia, American Folklore Society, Memoirs of the American Folkore Society, 46, 1955.

Bascom, 1973
Bascom (William), *African Art in Cultural Perspective, an Introduction*, New York, W.W. Norton and Company, Inc., 1973.

Basler, 1929
Basler (Adolphe), *L'Art chez les peuples primitifs*, Paris, Librairie de France, 1929.

Basler and Brummer, 1928
Basler (Adolphe), Brummer (Ernest), *L'Art précolombien*, Paris, Librairie de France, 1928.

Bassani, 1975
Bassani (Ezio), "Le figure da reliquiario dei Kota", *Critica d'arte*, XL, no. 139, January-February 1975, p. 21-32.

Bassani, 1976
Bassani (Ezio), "Il maestro della capigliatura a cascata", *Critica d'arte*, XLI, no. 148-149, July-October 1976, p. 75-87.

Bassani, 1977
Bassani (Ezio), *Scultura africana nei musei italiani*, Bologna, Calderini, 1977.

Bassani, 1981
Bassani (Ezio), "Les cornes d'appel en ivoire de la Sierra Leone (XVIᵉ siècle)", *L'Ethnographie*, vol. LXXVII, no. 85, 1981, p. 151-68.

Bassani, 1989
Bassani (Ezio), *La grande scultura dell'Africa Nera*, Florence, Artificio, 1989.

Bassani, 1992
Bassani (Ezio), *Le Grand Héritage*, Paris, Musée Dapper, 1992.

Bassani and Bellini, 1992
Bassani (Ezio), Bellini (Rolando), "Notices", in *Bassani, 1992, p. 255-279.

Bassani and Fagg, 1988
Bassani (Ezio), Fagg (William B.), *Africa and the Renaissance, Art in Ivory*, New York, Center for African Art/Munich, Prestel Verlag, 1988.

Bastin, 1984
Bastin (Marie-Louise), *Introduction aux arts d'Afrique noire*, Arnouville, Arts d'Afrique Noire, 1984.

Bateson, 1929-30
Bateson (Gregory), *Field Notebooks*, Washington, The Library of Congress, 1929-30.

Bateson, 1932
Bateson (Gregory), "Social Structure of the Iatmul People of the Sepik River", *Oceania*, vol. II, 1932, p. 245-291 and p. 401-453.

Batres, 1906
Batres (Leopoldo), *Teotihuacan*, Fidencia S. Soria, 1906.

Battesti, 1993
Battesti (M.), *Images des mers du Sud. Le voyage de la corvette "La Coquille" (1822-1825)*, Paris, Du May, 1993.

Beatty, 1992
Beatty (Andrew), *Society and Exchange in Nias*, Oxford, Clarendon Press, 1992.

Becker-Donner, 1965
Becker-Donner (Etta), *Die Mexikanischen Sammlungen des Museums für Völkerkunde, Wien*, Vienna, Museum für Völkerkunde, 1965.

Bedaux, 1972
Bedaux (Rogier M.A.), "Tellem, reconnaissance archéologique d'une culture de l'Ouest africain au Moyen Âge: recherches architectoniques", *Journal de la Société des africanistes*, vol. XLII, fasc. 2, 1972, p. 103-85.

Bedaux, 1974
Bedaux (Rogier M.A.), "Tellem, reconnaissance archéologique d'une culture de l'Ouest africain au Moyen Âge: les appuis-nuque", *Journal de la Société des africanistes*, vol. XLIV, fasc. 1, 1974, p. 7-42.

Bedaux, 1988
Bedaux (Rogier M.A.), "Tellem and Dogon Material Culture", *African Arts*, vol. XXI, no. 4, August 1988, p. 38-45, p. 91.

Bedaux and Bolland, 1980
Bedaux (Rogier M.A.) and Bolland (R.), "Tellem, reconnaissance archéologique d'une culture de l'Ouest africain au Moyen Âge: les textiles", *Journal de la Société des africanistes*, vol. L, fasc. 1, 1980, p. 9-23.

Bedaux and Lange, 1983
Bedaux (Rogier M.A.) and Lange (A.G.), "Tellem, reconnaissance archéologique d'une culture de l'Ouest africain au Moyen Âge: la poterie", *Journal de la Société des africanistes*, vol. LIII, fasc. 1 and 2, 1983, p. 5-59.

Beday-Brandicourt, 1984
Beday-Brandicourt (Roland), "Les Buhlul ifugao du Nord-Luzon", *Connaissance des arts tribaux*, Newsleter of the Freinds of the Musée Barbier-Mueller, Geneva, no. 23, June 1984.

Before Cortes – Sculpture of Middle America, 1970
Before Cortes – Sculpture of Middle America, New York, Metropolitan Museum of Art, 1970.

Béhar, 1990
Béhar (Henri), *André Breton. Le grand indésirable*, Paris, Calmann-Lévy, 1990.

Behm-Blancke, 1955
Behm-Blancke (G.), "Zum Problems des Nordwestpolynesischen Ahnenfiguren des Primärstil", *Weimarer Ethnographische Mitteilungen*, Weimar, 1955, p. 2-22.

Belwod, 1985
Belwod (Peter), *Prehistory of the Indo-Malaysian Archipelago*, Ryde, N.S.W., Academic Press, 1985.

Belwod, 1998
Belwod (Peter), "La dispersion des Austronésiens", in *Arts des mers du Sud, 1998, p. 8-17.

Ben-Amos, 1979
Ben-Amos (Paula), *L'Art du Bénin*, Paris, Rive Gauche Production, 1979.

Ben-Amos, 1980
The Art of Benin, London, 1980.

Ben-Amos and Rubin (eds.), 1983
Ben-Amos (Paula) and Rubin (Arnold) [eds.], *The Art of Power, The Power of Art, Studies in Benin Iconography*, Los Angeles, 1983.

Benitez-Johannot, 2000
Benitez-Johannot (Purissima), "Le plus ancien bulul connu: témoignage du passé ifugao", *Arts et cultures*, no. 1, 2000, p. 94-110.

Bennet, 1899
Bennett (Albert L.), "Ethnographical Notes on the Fang", *The Journal of the Anthropological Institute of Great Britain and Ireland*, vol. XXIX, 1899, p. 66-98.

Benson, 1972
Benson (Elizabeth P.) [ed.], *The Cult of the Felin*, Dumbarton Oaks, Dumbarton Oaks Research Library and Collections, 1972.

Bernal, 1970
Bernal (Ignacio), "Yugos de la colección del Museo Nacional de Antropología", *Corpus Antiquatum Americanensium*, Mexico City, INAH, 1970.

Bernal and Simoni-Abbat, 1986
Bernal (Ignacio), Simoni-Abbat (Mireille), *Le Mexique – Des origines aux Aztèques*, Paris, Gallimard, 1986.

Bernatzik, 1933a
Bernatzik (Hugo Adolf), *Äthiopen des Westens, Forschungsreisen in Portugiesisch-Guinea*, Erster Band, Zweiter Band, Vienna, Verlag von L.W. Seidel und Sohn, 1933.

Bernatzik, 1933b
Bernatzik (Hugo Adolf), *Geheimnisvolle Inseln Tropen – Afrikas – Frauenstaat und Mutterrecht der Bidyogo*, Berlin, Deutsche Buch-Gemeinschaft, 1933.

Bernatzik, 1936
Bernatzik (Hugo Adolf), *Owa Raha*, Vienna, Bernina Verlag, 1936.

Bernatzik, 1944
Bernatzik (Hugo Adolf), *Im Reich der Bidyogo. Geheimnisvolle Inseln in Westafrika*, Innsbruck, Kommissionsverlag Österreichische Verlagsanstalt, 1944.

Bernet, 1984
Bernet (Kempers A.J.), "The Kettledrums of Southeast Asia. A Bronze Age World and its Aftermatch", *Modern Quaternary Research in Southeast Asia*, 10, Rotterdam, 1984.

Berrin and Pasztory (eds.), 1993
Berrin (Kathleen), Pasztory (Esther) [eds.], *Teotihuacan: Art from the City of the Gods*, San Francisco, Thames and Hudson, 1993.

Berlo, 1992
Berlo (Janet C.) [ed.], *Art, Ideology and the City of Teotihuacan*, Dumbarton Oaks, 1992.

Besson, 1929
Besson (Maurice), *Le Totémisme*, Paris, Rieder, 1929.

Beyer and Boulay (eds.), 1985
Beyer (Victor), Boulay (Roger) [eds.], *Musée imaginaire des arts de l'Océanie*, Paris, 1985.

Beumers and Koloss (eds.), 1992
Beumers (Erna), Koloss (Hans Joachim) [eds.], *Kings of Africa. Art and Authority in Central Africa. Collection Museum für Völkerkunde*, Berlin/Maastricht, Fondation Kings of Africa, 1992.

Beyer, 1980-81
Beyer (William), "Ifugao Art", *Event*, Manila, 1980-81, p. 50-58.

Bicentenaire du Muséum d'histoire naturelle de La Rochelle, **1982**
Bicentenaire du Muséum d'histoire naturelle de La Rochelle, 1782-1982, La Rochelle, 1982.

Biebuyck, 1985
Biebuyck (Daniel), *The Art of Zaire*, vol. I, *Southwestern Zaire*, Berkeley/Los Angeles/London, University of California Press, 1985.

Biebuyck, 1986
Biebuyck (Daniel), *The Art of Zaire*, vol. II, *Eastern Zaire*, Berkeley/Los Angeles/London, University of California Press, 1986.

Biebuyck, Kelliher and McRae, 1996
Biebuyck (Daniel), Kelliher (Susan), McRae (Linda), *African Ethnonyms, Index to Art-Producing Peoples of Africa*, 1996.

Billings and Peterson, 1967
Billings (Dorothy), Peterson (Nicolas), "Malanggan and Memai in New Ireland", *Oceania*, no. 38, 1967, p. 24-32.

Biobaku (ed.), 1973
Biobaku (S.O.) [ed.], *Sources of Yoruba History*, Oxford, Clarendon Press, 1973.

Birket-Smith, 1953
Birket-Smith (Kaj), *The Chugach Eskimo*, Nationalmuseets Skrifter, Etnografisk Raekke, vol. VI, Copenhagen, 1953.

Birket-Smith, 1967
Birket-Smith (Kaj), *Studies in Circumpacific Culture Relations*, I, *Potlach and Feasts of Merit*, Historisk-filosofiske Meddelelser XLII, 3, Copenhagen, 1967.

Biton, 1992
Biton (Marlène), "Fers forgés de l'ancien Dahomey", in *Blandin, Biton, Celis et al., 1992.

Biton, 1993
Biton (Marlène), "Gou, son évolution", *2e Colloque international sur les Arts africains*, Paris, Musée des Arts d'Afrique et d'Océanie, 1993.

Biton, 1994
Biton (Marlène), "Question de Gou", *Arts d'Afrique noire*, no. 91, autumn 1994, p. 25-34.

Biton, 1996
Biton (Marlène), *Les Bas-reliefs des palais d'Abomey, Bénin*, doctoral thesis, Université de Paris I, 1996.

Biton, 1999
Biton (Marlène), "Le statut de l'artiste dahomien, un exemple: Akati Ekplekendo, le Maître de Gou", *Ni anonyme, ni impersonnel*, *3e Colloque européen sur les Arts d'Afrique noire*, Vanves, 1999, pp. 19-26.

Blandin, Biton, Celis et al., 1992
Blandin (A.), Biton (Marlène), Celis (G.) et al., *"Fer noir" d'Afrique de l'Ouest*, Marignane, 1992.

Blier, 1998
Blier (Suzanne Preston), *L'Art royal africain*, Paris, Flammarion, 1998.

Bloxam, 1824-26
Bloxam (R.R.), *A Narrative of a Voyage to the Sandwich Islands in HMS Blonde*, National Library of Australia, ms. 4255 (Nan Kivell item 6958), 1824-26.

Boas, 1916
Boas (Franz), "Tsimshian Mythology", *Thirty-first Annual Report of the Bureau of American Ethnology (1909-10)*, Washington, Government Printing Office, 1916.

Boas, 1927
Boas (Franz), *Primitive Art*, Oslo, Aschehoug and Co., 1927.

Boas, 1970
Boas (Franz), *The Social Organization and the Secret Societies of the Kwakiutl Indians*, New York, Johnson Reprint, 1970.

Bodrogi, 1967
Bodrogi (Tibor), "Malangans in North New Ireland. L. Biro's Unpublished Notes", *Acta Ethnographica Academiæ Scientarum Hungaricæ*, vol. XVI (1-2), 1967, p. 61-77.

Bogesi, 1948
Bogesi (F.), "Santa Isabel, Solomon Islands", *Oceania*, vol. XVIII, 1948, p. 208-232, p. 327-357.

Bois à cœur ouvert, **1990**
Bois à cœur ouvert, Paris, Muséum National d'Histoire Naturelle, 1990.

Boisragon, 1897
Boisragon (A.), *The Benin Massacre*, London, 1897.

Boliver Aróstegui and Gonzales Dias de Villegas, 1998
Boliver Aróstegui (Natalia), Gonzales Dias de Villegas (Carmen), *Ta Makuende Yaya y las reglas de Palo Monte*, La Havane, Ediciones Union, 1998.

Bolz, 1966
Bolz (Ingeborg), "Zur Kunst in Gabon", *Ethnologica*, vol. III, 1966, p. 85-221.

Bonifaz, 1993
Bonifaz (Nuño Ruben), *Hombres y Serpientes*, Mexico City, UNAM, 1993.

Bonnemaison, 1996
Bonnemaison (Joël), "La coutume ou les formes du pouvoir politique traditionnel au Vanuatu", in *Vanuatu, Océanie. Arts des îles de cendre et de corail*, 1996, p. 212-229.

Bonnemaison et al., 1997
Bonnemaison (Joël) et al., *Arts of Vanuatu*, Bathurst, Crawford House Publishing, 1997.

Boone (ed.), 1982
Boone (Elizabeth Hill) [ed.], *Falsifications and Misreconstructions in Pre-Columbian Art*, Dumbarton Oaks, 1982.

Boone (ed.), 1993
Boone (Elizabeth Hill) [ed.], *Collecting the Pre-columbian Past*, Dumbarton Oaks, Harvard University, 1993.

Bosman, 1704
Bosman (Willem), *Nauwkeurige beschryving van de Guinese Goud-, Tand- en Slave- Kust*, Utrecht, 1704.

Bosman, 1967
Bosman (Willem), *A New and Accurate Description of the Coast of Guinea*, London, 1967 (reprint).

Bosse, 1853
Bosse (A.), "Rapport sur l'expédition des Bissagos", *Revue coloniale*, Paris, June 1853, p. 395-409.

Botschaft der Steine, **1998**
Botschaft der Steine, Indonesische Skulpturen aus der Sammlung Barbier-Mueller, Geneva, Musée Barbier-Mueller/Milan, Skira, 1998.

Bouju, 1994
Bouju (Jacky), "La statuaire dogon au regard de l'anthropologue", in *Dogon*, 1994, p. 221-237, p. 256-259.

Boulay, 1984
Boulay (Roger), *Sculptures kanak*, Nouméa, Office Culturel Scientifique et Technique Kanak, 1984.

Boulay, 1990a
Boulay (Roger), "La grande case: célébration de la société kanak", *De jade et de nacre*, Paris, RMN, 1990, p. 102-127.

Boulay, 1990b
Boulay (Roger), "De Cook à Picasso. Histoire des objets et des collections. Objets kanak dans les collections européennes", *De jade et de nacre*, Paris, RMN, 1990, p. 208-243.

Boulay, 1990c
Boulay (Roger), *La Maison kanak*, Marseille, Parenthèses/ADCK/ORSTOM, 1990.

Boullier, 1996
Boullier (Claire), *Les Sculptures en terre cuite de style Nok: approche pluridisciplinaire*, Université de Paris I, Panthéon-Sorbonne, 1996.

Boullier and Person, 1999
Boullier (Claire), Person (Alain), "La statuaire masculine Nok, iconographie des personnages assis", *Tribal Arts – Le Monde de l'art tribal*, no. 21, summer-autumn 1999, p. 98-113.

Bouloré, 1990
Bouloré (Vincent), "L'art baoulé, une esthétique de l'équilibre", *De l'art nègre à l'art africain*, Arnouville, Arts d'Afrique Noire, 1990, p. 86-92.

Bouloré, 1993
Bouloré (Vincent), "Au-delà de l'ethnie: styles collectifs et individuels dans la région baoulé", *Créer en Afrique*, Arnouville, Arts d'Afrique Noire, 1993, p. 25-31.

Bouloré, 1996a
Bouloré (Vincent), *Les Masques baoulé dans la Côte-d'Ivoire centrale (approches historique et stylistique comparées)*, doctoral thesis, Université de Paris I, 1996.

Bouloré, 1996b
Bouloré (Vincent), "Les objets de pouvoir dans les statuaires baoulé et sénoufo (esthétiques, styles et artistes)", in *Magies*, 1996, p. 175-215, p. 239-242.

Bouloré, 1997a
Bouloré (Vincent), "Réceptacles ouvragés de Côte-d'Ivoire centrale", in *Réceptacles*, 1997, p. 215-231, p. 307-308.

Bouloré, 1997b
Bouloré (Vincent), "Hans Himmelheber en région baoulé (1933, 1934-1935), photographies et objets – Museum Rietberg Zürich", *Arts d'Afrique noire*, no. 102, 1997, p. 11-13.

Bouloré, 1999
Bouloré (Vincent), "Afrique de l'Ouest (sculpture)", *Encyclopædia Universalis*, Paris, 1999.

Bounoure (G.), 1999
Bounoure (Gilles), "Les crânes des îles Marquises", *Arts d'Afrique noire*, no. 109, 1999.

Bounoure (V.), 1964
Bounoure (Vincent), "Clés pour l'art malangan", *L'Œil*, no. 112, Paris, 1964, p. 20-27, p. 66.

Bounoure (V.), 1971
Bounoure (Vincent), "Les Korwars de Nouvelle-Guinée hollandaise", *L'Œil*, no. 197, Paris, 1971, p. 8-15.

Bounoure (V.), 1992
Bounoure (Vincent), *Vision d'Océanie*, Paris, Musée Dapper, 1992.

Bowman, 1995
Bowman (Sheridan), *Radiocarbon Dating. Interpreting the Past*, London, British Museum Press, 1995.

Boyer, 1993
Boyer (Alain-Michel), "L'art yohouré", *Arts de la Côte-d'Ivoire*, vol. I, Geneva, Musée Barbier-Mueller, 1993, p. 246-89, p. 414-415.

Bradbury, 1957
Bradbury (R.E.), *The Benin Kingdom and the Edo-speaking Peoples of Southwestern Nigeria, with a section on the Itsekiri*, Ethnographic Survey of Nigeria, Western Africa, London, 1957.

Bradbury, 1973
Bradbury (R.E.), *Benin Studies*, Oxford/London, 1973.

Brain, 1980
Brain (Robert), *Art and Society in Africa*, London/New York, Longmans, 1980.

Brain andt Pollock, 1971
Brain (Robert), Pollock (Adam), *Bangwa Funerary Sculpture*, London, Gerald Duckworth, 1971.

Braunholtz, 1922
Braunholtz (H.J.), "Two bronze plaques from Benin", *Man*, vol. XXII, no. 91, November 1922, p. 161-162.

Brenchley, 1873
Brenchley (J.L.), *Jottings during the Cruise of H.M.S 'Curacoa'among the South Sea Islands in 1865*, London, Longmans/Green and Co., 1873.

Brenner (von), 1894
Brenner (Joachim von), *Besuch bei den Kannibalen Sumatras. Erste Durchquerung der unabhängigen Batak-Lande*, Wurtzbourg, Leo Woerl, 1894.

Bresc-Bautier, 1998
Bresc-Bautier (Geneviève), "L'histoire des collections et des présentations jusqu'à la fin du XIXᵉ siècle au musée du Louvre" [chronologie], *Le Musée et les cultures du monde, Enjeux culturels et choix professionnels*, Paris, École Nationale du Patrimoine, 1998.

Breton, 1957
Breton (André), *L'Art magique*, Paris, Club Français du Livre, 1957.

Breton, 1985
Breton (André), "Note sur les masques à transformation de la côte Pacifique nord-ouest", *Neuf*, 1950, p. 36-41 (*Pleine Marge 1*, 1985, p. 8-17).

Breton, 1991
Breton (André), *Souvenir du Mexique*, [1938], Éditions du Sagittaire, 1953 (*La Clé des champs*, Paris, Le Livre de Poche, 1991).

Breton, 1992
Breton (André), *Œuvres complètes*, vol. 2., Paris, La Pléiade, 1992.

Brigham, 1898
Brigham (William T.), "Director's Report", in *Bernice P. Bishop Museum Occasional Papers*, vol. I (1), 1898, p. 1-72.

Brincard (ed.), 1989
Brincard (Marie-Thérèse) [ed.], *Sounding Forms, African Musical Instruments*, New York, The American Federation of Arts, 1989.

Brincard (dir.), 1990
Brincard (Marie-Thérèse) [dir.], *Afrique: formes sonores*, RMN, Paris, 1990.

Bronzes and Ivories from the Old Kingdom of Benin, **1935**
Bronzes and Ivories from the Old Kingdom of Benin, New York, M. Knoedler and Company, 1935.

Brooke, 1874
Brooke (C.), "The Last Cruise of the Second Southern Cross", *Mission Life: Home and Foreign Church Work*, London, 1874, p. 191-196.

Brosse, 1983
Brosse (Jacques), *Les Tours du monde des explorateurs. Les grands voyages maritimes, 1764-1843*, Paris, Bordas, 1983.

Brouwer, 1979
Brouwer (Elizabeth C.), *The Malagans of the Collection of the Australian Museum; a Report on a Field Trip to Central New Ireland*, P. N. G., Australian Museum Library, ms. 51775, 1979.

Brouwer, 1980
Brouwer (Elizabeth C.), *A Malagan to Cover the Grave – Funerary Ceremonies in Mandak*, thesis, University of Queensland, 1980.

Brown (G.), 1881
Brown (George), "A Journey along the Coasts of New Ireland and Neighbouring Islands", *Proceedings of the Royal Geographical Society*, London, no. 3, 1881, p. 313-320.

Brown (G.), 1887
Brown (George), "Notes on the Duke of York Group, New Britain and New Ireland", *Proceedings of the Royal Geographical Society*, London, no. 47, 1887, p. 137-150.

Brown (S.C.), 1997
Brown (Steven C.), *Native Visions. Evolution in Northwest Coast Art from the Eighteenth through the Twentieth Century*, Seattle, The Seattle Art Museum/The University of Washington Press, 1997.

Bruyn Kops, 1850
Bruyn Kops (G.F.), "Bijdrage tot de kennis der Noord- en Oostkusten van Nieuw Guinea", *Natuurk. T. Ned. Ind.*, 1, 1850, p. 163-235.

Buck, 1957
Buck (Peter H.) [T. Rangi Hiroa], *Arts and Crafts of Hawaii*, Bernice P. Bishop Museum Special Publication, no. 45, Honolulu, Bishop Museum Press, 1957.

Bühler, 1931
Bühler (Alfred), *Neu Irland. Reisetagebuch*, Basel, Museum für Völkerkunde, 1931.

Bühler, 1933
Bühler (Alfred), "Die Totenfeste in Nord Neu Irland", *Verhandlungen der Schweizerischen Naturforschende Gesellschaft*, no. 114, 1933, p. 243-270.

Bühler, Barrow and Mountford, 1962
Bühler (Alfred), Barrow (Terry), Mountford (Charles P.), *Océanie et Australie*, Paris, Albin Michel, 1962.

Bulletin du musée d'Ethnographie du Trocadéro, **1988**
Bulletin du musée d'Ethnographie du Trocadéro, Paris, Jean-Michel Place, 1988 (reprint).

C

Cabello, 1992
Cabello (Paz), "Ancient Spanish Collections from North America", *European Review of Native American Studies* 6 (2), 1992, p. 13-20.

Cabrera Castro, Rodríguez García and Morelos Carcía (eds.), 1982a
Cabrera Castro (Rubén), Rodriguez Garcia (Ignacio), Morelos Garcia (Noel) [eds.], *Teotihuacan 80-82. Primeros resultados*, Mexico City, INAH, 1982.

Cabrera Castro, Rodríguez García and Morelos Carcía (eds.), 1982b
Cabrera Castro (Rubén), Rodriguez Garcia (Ignacio), Morelos Garcia (Noel) [eds.], *Memoria del proyecto arqueológico Teotihuacan 80-82*, Colección Científica, vol. I, no. 132, Mexico City, INAH, 1982.

Calame-Griaule, 1968
Calame-Griaule (Geneviève), *Dictionnaire dogon, dialecte tòro. Langue et civilisation*, Paris, Klincksieck, 1968.

Calvin, 1977
Calvin (Inga), "Where the Wayob live: a Further Examination of Classic Maya Supernaturals", *The Maya Vase Book*, vol. V, New York, 1977, p. 868-879.

Camara, 1972
Camara (Sékou Béka), *Croyances et pratiques religieuses des Baga sitemu*, Kankan, Institut Polytechnique Julius-Nyerere, 1972.

Capart, 1904
Capart (Jean), *Les Débuts de l'art en Egypte*, Brussels, Vromant, 1904.

Carpenter, 1975
Carpenter (Edmund), "Collecting Northwest Coast Art", in *Holm and Reid, 1975.

Casal, José Jr, Casiño, Ellis and Solheim II, 1981
Casal (Father Gabriel), José Jr (Regalado Trota), Casiño (Eric S.), Ellis (George R.), Solheim II (Wilhelm G.), *The People and Art of the Philippines*, Musem of Cultural History, University of California, Los Angeles, 1981.

Casino, 1982
Casino (Éric), *The Philippines: Lands and Peoples, A Cultural Geography*, Grolier International, 1982.

Catlin, 1959
Catlin (George), *Les Indiens de la Prairie*, (preceded by Baudelaire's writings on their art), Paris, Club des Librairies de France, 1959.

Chaffin, 1979
Chaffin (Alain and Françoise), *L'Art kota. Les figures de reliquaire*, Meudon, 1979.

Chapman, 1965
Chapman (Anne), *Mâts totémiques, Amérique du Nord, Côte nord-ouest*, Catalogues du Musée de l'Homme, H series, 1965.

Charnay, 1885
Charnay (Désiré), *Les Anciennes Villes du Nouveau Monde, Voyages d'Explorations au Mexique et dans l'Amérique Centrale*, Paris, Librairie Hachette, 1885.

Charnay, 1863
Charnay (Désiré), *México, 1858-1861. Recuerdos e impresiones de viaje*, 1863 (reprint, 1994).

Chauvet, 1924
Chauvet (Stephen), *Les Arts indigènes des colonies françaises*, Paris, Maloine et Fils, 1924.

Chauvet, 1929
Chauvet (Stephen), *Musique nègre*, Paris, Société d'Éditions Géographiques, Maritimes et Coloniales, 1929.

Chauvet, 1930a
Chauvet (Stephen), "À propos de l'exposition à la Galerie Pigalle à Paris – Les arts indigènes d'Afrique et d'Océanie", *Variétés*, Brussels, April 1930.

Chauvet, 1930b
Chauvet (Stephen), "Considérations sur les expositions d'art africain et océanien", *La Vie*, no. 9, Paris, 1 May 1930, p. 185-189.

Chauvet, 1930c
Chauvet (Stephen), *Les Arts indigènes en Nouvelle-Guinée*, Paris, Société d'Éditions Géographiques, Maritimes et Coloniales, 1930.

Chauvet, 1935
Chauvet (Stephen), *L'Île de Pâques et ses mystères*, Paris, 1935.

Chazal, 1993
Chazal (Jean-Paul), "L'aventure d'une vie et d'une collection", in *Perrois (ed.), 1993, p. 30-35.

Chefs-d'œuvre de l'Amérique précolombienne, **1947**
Chefs-d'œuvre de l'Amérique précolombienne, Paris, Société des Aamis du Musée de l'Homme, 1947.

Chefs-d'œuvre des arts indiens et esquimaux du Canada, **1969**
Chefs-d'œuvre des arts indiens et esquimaux du Canada/Masterpieces of Indian and Eskimo Art from Canada, Paris, Société des Amis du Musée de l'Homme, 1969.

Chefs-d'œuvre du musée de l'Homme, **1965**
Chefs-d'œuvre du musée de l'Homme, Paris, Musée de l'Homme/ Caisse Nationale des Monuments Historiques, 1965.

Chen, 1968
Chen (Chi-lu), *Material Culture of the Formosan Aborigines*, Taipei, The Taïwan Museum, 1968.

Chevrier, 1906
Chevrier (M.-A.), "Note relative aux coutumes des adeptes de la société secrète des Scymos", *L'Anthropologie*, no. 17, 1906, p. 362.

Chiapelli (ed.), 1976
Chiapelli (F.) [ed.], *First Images of America*, 2 vols., Berkeley, University of California Press, 1976.

Chijiiwa, 1988
Chijiiwa (S.), *Houses of the Formosan Mountain Tribes*, Taipei, Southern Material, 1988 (in Japanese).

Christie, 1979
Christie (A.H.), "The Megalithic Problem in Southeast Asia", in *Smith and Watson (eds.), 1979, p. 242-251.

Christie's, 1978
Christie's African Art from the Collection of the Late Josef Mueller of Solothurn, Switzerland, London, 13 June 1978.

Christie's, 1989
Christie's, London, 4 July 1989.

Christie's, 1996
Christie's Important Tribal Art Including a Selection from the Collection formed by Alberto Magnelli, New York, 22 November 1996.

Chronique du musée, **1931**
"Chronique du musée", *Bulletin du musée d'Ethnographie du Trocadéro*, no. 2, July 1931, p. 58-63.

Circa 1492 – The Art in the Age of Exploration, **1992**
Circa 1492 – The Art in the Age of Exploration, Washington, The National Gallery of Art, 1992.

Cissé, 1998
Cissé (Youssouf Tata), "Cavaliers et chevaux de guerre du Mali (des origines à la décadence des grands empires)", *Chasseurs et guerriers*, Paris, Musée Dapper, 1998, p. 71-128, p. 244-245.

Clapperton, 1829
Clapperton (Hugh), *Second Voyage dans l'intérieur de l'Afrique depuis le golfe de Bénin jusqu'à Sackatou; pendant les années 1825, 1826 et 1827. Suivi du voyage de Richard Lander, de Kano à la côte maritime*, Paris, Arthus-Bertrand, Mongie Aîné, 1829.

Clark (ed.), 1994
Clark (John E.) [ed.], *Los olmecas*

en Mesoamérica, Mexico City,
El Equilibrista, 1994.

Clay, 1987
Clay (Brenda J.), "A Line
of Tatanua", in *Lincoln (ed.), 1987.

Clendinnen, 1991
Clendinnen (Inga), *Aztecs.
An Interpretation*, New York,
Cambridge University Press, 1991.

Clouzot and Level, 1919
Clouzot (Henri), Level (André),
L'Art nègre et océanien, Paris,
Devambez, 1919.

Clouzot and Level, 1922
Clouzot (Henri), Level (André),
"L'art des Noirs", *La Renaissance
de l'art français et des industries
de luxe*, no. 4, Paris, April 1922,
p. 216-222.

Clouzot and Level, [1925]
Clouzot (Henri), Level (André),
*Sculptures africaines et océaniennes
(Colonies françaises et Congo belge)*,
Paris, Librairie de France, [1925].

Coart and Hauleville, 1906
Coart (E.), Hauleville (A. de),
*Notes analytiques sur les collections
ethnographiques du musée du Congo:
la religion. Annales du musée du
Congo*, vol. I, fasc. 2, Brussels,
1 July 1906.

Codrington, 1881
Codrington (R.H.), "Religious Beliefs
and Practices in Melanesia", *Journal
of the Anthropological Institute
of Great Britain and Ireland*, vol. X,
London, 1881, p. 261-316.

Codrington, 1891
Codrington (R.H.), *The Melanesians.
Studies in their Anthropology and
Folklore*, Oxford, 1891.

Coe, 1973
Coe (Michael D.), *The Maya Scribe
and his World*, New York,
The Grolier Club, 1973.

Coe, 1975
Coe (Michael D.), *Classic Maya
Pottery at Dumbarton Oaks*,
Washington, 1975.

Coffinière de Nordeck, 1886
Coffinière de Nordeck (André),
"Voyage au pays des Baga et du Rio
Nuñez (1884-1885)", *Le Tour du
monde, Nouveau journal des voyages*,
Paris, 1886, p. 273-304.

Coiffier, 1988
Coiffier (Christian), *Traditional
Architecture in Vanuatu*, Suva,
Institute of Pacific Studies/Vanuatu
Extension Centre of the University
of the South Pacific, 1988.

Coiffier and Orliac, 2000
Coiffier (Christian), Orliac
(Catherine), "Vitex et Instia:
bois d'œuvre d'exception pour
la statuaire de Nouvelle-Guinée
et du Vanuatu", *Techne*, no. 11, 2000.

Cole (D.), 1985
Cole (Douglas), *Captured Heritage.
The Scramble for Northwest Coast Art*,
Vancouver, Douglas and McIntyre,
1985.

Cole (H.M.), 1990
Cole (Herbert M.), *Icons, Ideals
and Power in the Art of Africa*,
Washington, National Museum
of African Art, Smithsonian
Institution, 1990.

**Collection africaine d'Alberto Magnelli,
Donation Susi Magnelli, 1995**
*La Collection africaine d'Alberto
Magnelli, Donation Susi Magnelli*,
Paris, Centre Georges Pompidou,
1995.

**Collection André Breton et Paul Éluard,
1931**
*Collection André Breton et Paul Eluard.
Sculptures d'Afrique, d'Amérique,
d'Océanie*, Paris, Hôtel Drouot,
2-3 July 1931.

Collection André Lefèvre, 1964
Collection André Lefèvre, Paris,
Musée National d'Art Moderne,
1964.

**Collection André Lefèvre – Art nègre
Afrique, Océanie, Divers, 1965**
*Collection André Lefèvre – Art nègre
Afrique, Océanie, Divers*, Paris,
Hôtel Drouot, 13 December 1965.

Collection C. L.-S, 1951
*Collection C. L.-S, Arts primitifs,
Objets de haute curiosité*, Paris,
Hôtel Drouot, June 1951.

Collection Kerbourc'h, 1993
Collection Kerbourc'h, Paris,
Alain de Monbrison, 1993.

**Collection d'objets d'Afrique
et d'Océanie, 1986**
*Collection d'objets d'Afrique
et d'Océanie*, Nouveau Drouot,
25 June 1986.

Collections de Louis XIV, 1977
Collections de Louis XIV, Paris,
Édition des Musées Nationaux,
1977.

**Collection océanienne du voyage
de la Korrigane, 1961**
*Collection océanienne du voyage
de la Korrigane*, Paris, Hôtel Drouot,
4-5 December 1961.

Conklin, 1980
Conklin (Harold C.),
*Ethnographic Atlas of Ifugao: A Study
of Environment, Culture and Society
in Northern Luzon*, London/New
Haven, Yale University Press, 1980.

Connah, 1975
Connah (G.), *The Archeology of Benin,
Excavations and other Researches
in and around Benin City*,
Nigeria/Oxford, 1975.

Conner, 1993
Conner (Michael Wayne),
*The Art of the Jere and Maseko
Ngoni of Malawi. 1818-1964*,
New York/Saint Petersburg, 1993.

Cook and King, 1784
Cook (James), King (James),
A Voyage to the Pacific Ocean,
London, 1784.

Coombes, 1994
Coombes (Annie E.), *Reinventing
Africa*, London/New Haven,
Yale University Press, 1994.

Coote and Shelton (eds.), 1992,
Coote (Jeremy), Shelton (Anthony)
[eds.], *Anthropology, Art and
Aesthetics*, Oxford, Clarendon Press,
1992.

Copans and Jamin, 1978
Copans (Jean), Jamin (Jean),
*Aux origines de l'anthropologie
française, Les Mémoires de la Société
des observateurs de l'Homme en
l'an VIII*, Paris, Le Sycomore,
1978.

Cordier, 1924
Cordier (H.), "Le prince Roland
Bonaparte", *La Géographie*, vol. LXI,
Paris, Société de Géographie,
1924, p. 525-542.

Cornet, 1972
Cornet (Joseph), *Art de l'Afrique noire
au pays du fleuve Zaïre*, Brussels,
Arcade, 1972.

Cornet, 1975
Cornet (Joseph), *Art from Zaïre:

**100 Masterworks from the National
Collection/L'Art du Zaïre: cent chefs-
d'œuvre de la collection nationale*,
New York, The African-
American Institute, 1975.

Cornet, 1989
Cornet (Joseph), *Zaïre, peuples –
art – culture*, Antwerp, 1989.

**Corps sculptés, corps parés,
corps masqués, 1989**
*Corps sculptés, corps parés,
corps masqués*, Paris, A.F.A.A., 1989.

Corre, 1912
Corre (P.), "Dans le haut Ogowe",
Les Missions catholiques, 44, Lyon,
1912, p. 533-550.

**Correspondance de Deborah Lifchitz
et Denise Paulme avec Michel Leiris,
1987**
"Correspondance de Deborah
Lifchitz et Denise Paulme avec
Michel Leiris – Sanga 1935",
Gradhiva, no. 3, 1987, p. 44-58.

Corson, 1976
Corson (Christopher), *Maya
Anthropomorphic Figurines from Jaina
Island, Campeche*, Ramona, Ballena
Press, 1976.

Cortés, 1963
Cortés (Hernán), *Cartas de Relacion
de la Conquista de Nueva España*,
Mexico City, Editorial Porrua, 1963.

Cortés, 1971
Cortés (Hernán), *Hernan Cortes:
Letters from Mexico*, trans. Anthony
R. Pagden, New York, 1971.

Cortés, 1982
Cortés (Hernán), *La Conquête
du Mexique*, trans. D. Charnay
[1896], Paris, Maspero-
La Découverte, 1982.

Coste-Messelière, 1957
Coste-Messelière (Pierre de la),
Delphes, Paris, Hachette, 1957.

Côté femmes, 1986
Côté femmes, Paris, Musée
de l'Homme/Muséum National
d'Histoire Naturelle, 1986.

Courrier de l'Unesco, 1965
Le Courrier de l'Unesco, Paris,
December 1965.

Cowling, 1978
Cowling (Elizabeth), "The Eskimos,
the American Indians and the
Surrealists", *Art History* 1 (4), 1978.

Cowling, 1992
Cowling (Elizabeth), "'L'œil
sauvage': Oceanic Art and the
Surrealists", *Art of Northwest New
Guinea (From Geelvink Bay, Humbolt
Bay and Lake Sentani)*, New York,
Rizzoli, 1992, p. 177-89.

Cox et Davenport, 1974
Cox (J. Halley), Davenport
(William H.), *Hawaiian Sculpture*,
Honolulu, University of Hawaii
Press, 1974.

Craven, 1967
Craven (John), "Importante
découverte au Gabon",
Connaissance des arts, no. 163,
May 1967, pp. 100-103.

Cuillers-sculptures, 1991
Cuillers-sculptures, Paris,
Musée Dapper, 1991.

Curtis, 1996
Curtis (Marie-Yvonne), *L'Art nalu,
l'art baga – Approches comparatives*,
doctoral thesis, Université
de Paris I, 1996.

Curtis et Sarro, 1997
Curtis (Marie-Yvonne), Sarro
(Ramón), "The Nimba Headdress:

Art, Ritual and History of the Baga
and Nalu Peoples of Guinea",
*African Art at the Art Institute
of Chicago, Museum Studies*, vol. XXIII,
no. 2, 1997, p. 121-33, p. 196-97.

D

Dagen, 1986
Dagen (Philippe), *La Peinture
en 1905*, Paris, Minard, 1986.

Dagen, 1998
Dagen (Philippe), *Le Peintre, le Poète,
le Sauvage*, Paris, Flammarion, 1998.

Dahomey, s.d.
Dahomey, Boulogne,
Éditions Delroisse, s.d.

Dall, 1884
Dall (William Healey), "On Masks,
Labrets and Certain Aboriginal
Customs with an Inquiry into
the Bearing of their Geographical
Distribution", *Third Annual Report
of Bureau of Ethnology for 1881-82*,
1884, p. 67-203.

Dans la jungle des idoles, 1990
"Dans la jungle des idoles, l'art
primitif indonésien réhabilité
par Jean Paul Barbier et Jérôme
Coignard", *Beaux-Arts Magazine*,
no. 83, October 1990, p. 88-99.

Danse des Kachina, 1998
*La Danse des Kachina. Poupées hopi
et zuni dans les collections surréalistes
et alentour*, Paris, Paris-Musées,
1998.

Dapper, 1686
Dapper (Olfert), *Description
de l'Afrique*, Amsterdam, 1686.

Dark, 1962
Dark (Philip J.C.), *The Art of Benin:
A Catalogue of an Exhibition of
the A.W.F. Fuler and Chicago Natural
History Museum*, Chicago, 1962.

Dark, 1973
Dark (Philip J.C.), *An Introduction
to Benin Art and Technology*, Oxford,
Clarendon Press, 1973.

Dark, 1975
Dark (Philip J.C.), "Benin Bronze
Heads: Styles and Chronology",
*African Images, Essays in African
Iconology*, New York/London,
Africana Publishing Co., 1975,
p. 25-103.

Dark, 1982
Dark (Philip J.C.), *An Illustrated
Catalogue of Benin Art*, Boston,
G.K. Hall and Co., 1982.

Dark, 1984
Dark (Philip J.C.), *Developments
in the Arts of the Pacific*, Pacific Arts
Association Occasional Papers,
no. 1, 1984.

Dark and Rose (eds.), 1993
Dark (Philip J.C.), Rose (Roger G.)
[eds.], *Art, Artist of Oceania*,
Honolulu, University of Hawaii
Press, 1993.

Davenport, 1958
Davenport (William), "Sculpture
of the Eastern Solomons",
Expedition, vol. X, no. 2,
Philadelphia, The University
Museum, 1958, p. 4-25.

Davenport, 1958
Davenport (William), "The
Figurative Sculpture of Santa Cruz
Island", *Art and Identity in Oceania*,
Bathurst, 1990, p. 98-110.

Davidson (B.), 1959
Davidson (Basil), *The Lost Cities*

of Africa, Boston, Little, Brown and Co., 1959.

Davidson (B.), 1961
Davidson (Basil), *Old Africa Rediscovered*, London, V. Gollancz, 1961.

Davidson (B.), 1959
Davidson (Basil), *Les Royaumes africains*, Time-Life, Inc., 1967.

Davidson (J.M.), 1968
Davidson (Janet M.), "A Wooden Image from Nukuoro in the Auckland Museum", *Journal of the Polynesian Society*, vol. LXXVII (1), 1968, p. 77-79.

Davis, 1981
Davis (Whitney M.), "An Early Dynastic Lion in the Museum of Fine Arts", *Studies in Ancient Egypt, the Aegean and the Sudan. Essays in Honor of Dows Dunham*, Boston, Museum of Fine Arts, 1981.

Davoust, 1975
Davoust (Michel), *L'Écriture maya et son déchiffrement*, Paris, Éditions du CNRS, 1975.

De Bry, 1600-09
De Bry (J.D. and J.I.), *Wahrhaftige und eigentliche Abbidungen*, Frankfurt am Main, 1600-09.

***Découverte de la Polynésie*, 1972**
La Découverte de la Polynésie, Paris, Société des Amis du Musée de l'Homme, 1972.

***Découverte du paradis*, 1997**
La Découverte du paradis. Océanie. Curieux, navigateurs et savants, ed. Annick Notter, Paris, Somogy, 1997.

Delafosse (L.), 1976
Delafosse (Louise), *Maurice Delafosse, le Berrichon conquis par l'Afrique*, Paris, Société Française d'Histoire d'Outre-mer, 1976.

Delafosse (M.), 1894
Delafosse (Maurice), "Une statue dahoméenne en fonte", *La Nature*, no. 1105, 4 August 1894.

Delafosse (M.), 1900
Delafosse (Maurice), "Sur des traces probables de civilisation égyptienne et d'hommes de race blanche à la Côte-d'Ivoire", *L'Anthropologie*, vol. XI, Paris, 1900, p. 431-451, p. 543-568, p. 677-690.

Delafosse (M.), 1927
Delafosse (Maurice), *Les Nègres*, Paris, Rieder, 1927.

De la Fuente and Guttierez, 1980
De la Fuente (Beatriz), Gutierrez (Solana Nelly), *Escultura huasteca en piedra. Catalogo*, Mexico City, UNAM, 1980.

De Laguna, 1972
De Laguna (Frederica), *Under Mount Saint Elias: The History and Culture of the Yakutat Tlingit*, Washington, Smithsonian Contributions to Anthropology, vol. VII, part 2, 1972.

Delange, 1962
Delange (Jacqueline), "Le Bansonyi du pays baga", *Objets et mondes*, Paris, vol. 2, fasc. 1, spring 1962, p. 3-12.

Delange, 1965
Delange (Jacqueline), "Afrique Noire", in *Chefs-d'œuvre du musée de l'Homme*, 1965, p. 44-45.

Delange, 1967
Delange (Jacqueline), *Arts et peuples de l'Afrique noire*, Paris, Gallimard, 1967.

De la Torre, 1991
De la Torre (Mario) [ed.], *Apaxco-Museo Arqueologico*, Mexico City, Cementos Apaxco, 1991.

De Marees, 1602
De Marees Pieter, *Beschryvinghe ende Historische Verhael van het Gout Koninckrijck van Gunea*, Amsterdam, 1602 (reprint. 1912).

Derlon, 1991
Derlon (Brigitte), "L'Objet malanggan dans les anciens rites funéraires de Nouvelle Irlande", *Res* 19/20, 1991.

Derlon, 1997
Derlon (Brigitte), *De mémoire et d'oubli. Anthropologie des objets malanggan de Nouvelle-Irlande*, Paris, Éditions du CNRS, 1997.

Derobert and Reichlen, s.d.
Derobert (L.), Reichlen (H.), *Les Momies*, Paris, Prisma, s.d.

Deschamps, 1962
Deschamps (Hubert), "Traditions orales et archives au Gabon", *L'Homme d'outre-mer*, no. 6, Paris, 1962.

Deschamps, 1975
Deschamps (Hubert), *Roi de la brousse – Mémoires d'autres mondes*, Paris, Berger-Levrault, 1975.

Desplagnes, 1907
Desplagnes (Louis), *Le Plateau centrale nigérien: une mission archéologique et ethnographique au Soudan français*, Paris, Larose, 1907.

Desson, 1995
Desson (Dominique), *Masked Rituals of the Kodiak Archipelago*, thesis, Fairbanks, University of Alaska, 1995.

Diallo, 1977
Diallo (T.), *Dinah Salifou, roi des Nalous*, Paris/Abidjan, ABC, 1977.

Dias, 1991
Dias (Nélia), *Le Musée d'Ethnographie du Trocadéro (1878-1908). Anthropologie et muséologie en France*, Paris, Éditions du CNRS, 1991.

Diaz del Castillo, 1963
Diaz del Castillo (Bernal), *The Conquest of New Spain*, trans. John M. Cohen, New York, 1963.

Diaz del Castillo, 1980
Diaz del Castillo (Bernal), *Historia verdadera de la conquista de la Nueva España*, Mexico City, Editorial Porria, 1980.

Dieterlen, 1941
Dieterlen (Germaine), *Les Âmes des Dogons*, Paris, Institut d'Ethnologie, 1941.

Dieterlen, 1975
Dieterlen (Germaine), "Premier aperçu sur les cultes des Soninké émigrés au Mandé", *Système de pensée en Afrique noire*, Paris, Éditions du CNRS, 1975, p. 5-18.

Dieterlen, 1981
Dieterlen (Germaine), "Female Figure" and "Stool", in *Vogel (ed.), 1981, pp. 16, 17, 19.

Dioszegi (ed.), 1968
Dioszegi (V.) [ed.], *Popular Beliefs and Folklore Tradition in Siberia*, Bloomington/Budapest, 1968.

Doane, 1874
Doane (R.P.), "The Caroline Islands (Cruise of the Star)", *Geographical Magazine*, vol. 1, 1874, p. 203-205.

Dodd, 1967
Dodd (Edward), *Polynesian Art*, New York, Dodd, Mead and Co., 1967.

***Dogon*, 1994**
Dogon, Paris, Musée Dapper, 1994.

***Dogon-Meisterwerke der Skulptur*, 1998**
Dogon-Meisterwerke der Skulptur – Chefs-d'œuvre de la statuaire dogon, Stuttgart, Galerie der Stadt, 1998.

Domeni de Rienzi, 1837
Domeni de Rienzi (G.L.), *Océanie ou cinquième partie du monde*, vol. III, Paris, Firmin Didot, 1837.

Donadoni Roveri (dir.), 1988
Donadoni Roveri (Anna Maria) (dir.), *Civilta degli Egizi. Le credenze religiose*, Milan, Electa, 1988.

Donadoni Roveri (dir.), 1989
Donadoni Roveri (Anna Maria) (dir.), *Civilisation des Égyptiens. Les arts de la célébration*, Milan, Electa, 1989.

Dordillon, 1931
Dordillon (René), *Grammaire et dictionnaire de la langue des îles Marquises. Marquisien-français*, Paris, Institut d'Ethnologie, 1931.

Doshi, 1990
Doshi (S.L.), *Tribal Ethnicity, Class and Integration*, Jaipur, 1990.

Douglas and d'Harnoncourt, 1941
Douglas (F.H.), d'Harnoncourt (René), *Indian Art of the United States*, New York, The Museum of Modern Art, 1941.

Dournes, 1988
Dournes (Jacques), "Autochthonous Peoples of Central Vietnam", in *Barbier and Newton (eds.), 1988, p. 24-33.

Drewal, 1976
Drewal (H.J.), *African Artistry: Technique and Aesthetics in Yoruba Sculpture*, Atlanta, High Museum, 1976.

Duchateau, 1990
Duchateau (A.), *Bénin, trésor royal*, Vienna, Museum für Völkerkunde/Paris, Musée Dapper, 1990.

Duff, 1975
Duff (Wilson), *Images Stone B.C.: Thirty Centuries of Northwest Coast Indian Sculpture*, Saanicton, Hancock House Publishers, 1975.

Duff, 1981
Duff (Wilson), "The world is as sharp as a knife: Meaning in Northern Northwest Coast Art", in *Abbot (ed.), 1981, p. 209-224.

Dugast, 1949
Dugast (I.), "Inventaire ethnique du Sud-Cameroun", *Mémoires de l'Institut français d'Afrique noire (centre du Cameroun)*, *Populations*, no. 1, Douala, 1949.

Dumont d'Urville, 1830-35
Dumont d'Urville (Jules Sébastien César), *Voyage de la corvette "L'Astrolabe" exécuté par ordre du roi pendant les années 1826, 1827, 1828 et 1829 sous le commandement de M. J. Dumont d'Urville, capitaine de vaisseau*, Paris, 1830-35.

Dumont d'Urville, 1841-54
Dumont d'Urville (Jules Sébastien César), *Voyage au pôle Sud et dans l'Océanie sur les corvettes "L'Astrolabe" et "La Zélée" exécuté par ordre du roi pendant les années 1837-1840 sous le commandement*
de Dumont d'Urville, 23 vol., 7 atlas, Paris, 1841-54.

Duperrey, 1826
Duperrey (Louis Isidore), *Voyage autour du monde exécuté par ordre du roi sur la corvette de sa majesté "La Coquille" pendant les années 1822-1825*, Paris, 1826.

Dupetit-Thouars, 1840-41
Dupetit-Thouars (Abel), *Voyage autour du monde sur la frégate "La Vénus" pendant les années 1836-1839*, 2 vols., Paris, 1840-41.

Duran, 1995
Duran (Diego), *Historia de las Indias de Nueva España e islas de tierra firme*, 2 vols., Mexico City, 1995.

Dürer, 1956
Dürer (Albrecht), *Schriftlicher Nachlass*, Berlin, Hans Rupprich, 1956.

Duthuit, 1974
Duthuit (Georges), "Le don indien sur la côte Nord-Ouest de l'Amérique (Colombie britannique)", [1946], reprinted in *Représentation et présence. Premiers écrits et travaux 1923-1952*, Paris, Flammarion, 1974, p. 315-319.

Dutting and Johnson, 1993
Dutting (Dietter), Johnson (Richard E.), "The Regal Rabbit, the Night-sun and God L: an Analysis of Iconography and Texts on a Classic Maya Vase", *Baessler-Archiv*, Berlin, Museum für Völkerkunde, 1993.

Duval, 1829
Duval (Amaury), *Monuments des arts du dessin chez les peuples tant anciens que modernes, recueillis par le baron Vivant-Denon pour servir à l'histoire des arts; lithographiés par ses soins et sous ses yeux décrits et expliqués par Amaury Duval*, vol. I, Paris, Firmin Didot, 1829, 61 pl.

Duverger, 1994
Duverger (Christian), *Art taïno*, Paris, Connaissance des Arts, 1994.

Duviols, 1985
Duviols (Jean-Paul), *L'Amérique espagnole vue et rêvée*, Paris, Promodis, 1985.

Dyn, 1942-43
Dyn, 1942-43, reprinted in *Pierre, 1970.

E

Edelman, 1983
Edelman (D.I.), *The Dardic and Nuristani Languages*, Moscow, 1983.

Edge-Partington, 1890-98
Edge-Partington (James), *An Album of the Weapons, Tools, Ornaments, Articles of Dress, etc. of the Natives of the Pacific Islands, drawn and described from examples in Public and Private Collections in England*, Manchester, 1890-98.

Egerton, 1938
Egerton (F.C.), *African Majesty, A Record of Refuge at the Court of the King of Bangangté in the French Cameroon*, London, Routledge, 1938.

Eggan, 1966
Eggan (Fred), "Préface", *On the Cordillera: A look at the Peoples and Cultures of the Mountain Province*, Manila, 1966, p. V-VII.

Egharevba, 1968

Egharevba (J.U.), *A Short History of Benin*, Ibadan, 1968.

L'Égypte avant les Pyramides, 1973
L'Égypte avant les pyramides, VIe millénaire, Paris, Éditions des Musées Nationaux, 1973.

L'Égypte des millénaires obscurs, 1990
L'Égypte des millénaires obscurs, Paris, Hatier/Marseille, Musées de Marseille, 1990.

Eilsers, 1934
Eilers (Anneliese), *Inseln um Ponape: Kapingamarangi, Nukuor, Ngatik, Mokil, Pingelap*, in *Thilenius, 1934, vol. VIII.

Einstein, 1915
Einstein (Carl), *Negerplastik*, Leipzig, Verlag der Weissen Bücher, 1915.

Einstein, 1922
Einstein (Carl), *La Sculpture africaines*, Paris, Éditions G. Grès et Cie, 1922.

Eisleb, 1983
Eisleb (Dieter), *Alt-Amerika – Führer durch die ausstellung der Abteilung Amerikanische Archäologie*, Berlin, Museum für Völkerkunde/Staatliche Museen Preussischer Kulturbesitz, 1983.

Ekholm, 1946
Ekholm (Gordon), "The Probable Use of Mexican Stone Yokes", *American Anthropologist*, vol. XLVIII, 1946, p. 593-606.

El Dorado, Das Gold der Fürstengräber, 1946
El Dorado, Das Gold der Fürstengräber, Munich and Berlin, 1994.

Eliade, 1994
Eliade (Mircea), *Lo sagrado y lo profano*, Colombia, Éditions Labor, 1994.

Elisofon and Fagg, 1958
Elisofon (Eliot) and Fagg (William B.), *The Sculpture of Africa*, London, Thames and Hudson, 1958.

Ellis, 1981
Ellis (George R.), "Arts and Peoples of the Northern Philippines", in *Casal, José Jr, Casiño, Ellis and Solheim II, 1981, p. 183-263.

Eluyemi, 1977
Eluyemi (Omotoso), "Terracotta Sculpture from Obalara's Compound, Ile-Ife", *African Arts*, vol. X, no. 3, April 1977.

El ojo del totem, 1988
El ojo del totem. Arte y cultura de los Indios del Noroeste de America, Madrid, Biblioteca V Centenario, 1988.

Emmons, 1991
Emmons (Georges Thornton), *The Tlingit Indians*, New York, American Museum of Natural History, 1991.

Encyclopédie de la Polynésie, 1986
Encyclopédie de la Polynésie – La vie quotidienne dans la Polynésie d'autrefois, Papeete, Gleizal Multipress, vol. V, 1986.

Escultura africana no Museu de etnologia do ultramar, 1968
Escultura africana no Museu de etnologia do ultramar, Lisbon, Junta de investigaçães do ultramar, 1968.

L'Esprit de la forêt, 1997
L'Esprit de la forêt – Terres du Gabon, Bordeaux, Musée d'Aquitaine/Paris, Somogy, 1997.

Esprits et dieux d'Afrique, 1980
Esprits et dieux d'Afrique, Paris, RMN, 1980.

L'Esprit nouveau, 1924
L'Esprit nouveau, no. 22, April 1924.

Étienne, 1962-1964
Étienne (Pierre), "Deux cultes récents dans un village Ouarébo (Tété-kpâ et Tigari)", *Études régionales de Bouaké*, 1962-64, document no. 9, p. 21-38.

Even, 1937
Even (André), "Les confréries secrètes chez les Babamba et les Mindassa d'Okondja", *Bulletin de la Société de recherches congolaises*, no. 23, Brazzaville, 1937, p. 31-114.

Evans, [1936]
Evans (Walker), *African Negro Art*, New York, The Museum of Modern Art, [1936].

Exotic Art from Ancient and Primitive Civilizations, 1959
Exotic Art from Ancient and Primitive Civilizations, Collection of Jay C. Leff, Carnegie Institute, Pittsburgh, 1959.

Exposition d'art africain et d'art océanien, 1930
Exposition d'art africain et d'art océanien, Paris, Galerie Pigalle, 1930.

Exposition de bronzes et ivoires du royaume de Bénin, 1932
Exposition de bronzes et ivoires du royaume de Bénin, Paris, Musée d'Ethnographie, 1932.

Exposition universelle et internationale de Bruxelles, 1958
Exposition universelle et internationale de Bruxelles, 1958. Section du Congo Belge et du Ruanda-Urundi, Groupe 2/3. Les arts et leurs moyens d'expression/Algemeene wereldtentoonstelling te Brussels, 1958. Sectie van Belgisch Congo en Ruanda-Urundi, Groep 2/3. De kunsten en haar uitdrukkingsmiddelen Traditionele kunst.

Eyo, 1974a
Eyo (Ekpo), *Recent excavations at Ife and Owo and their Implications for Ife, Owo and Benin Studies*, thesis, University of Ibadan, 1974.

Eyo, 1974b
Eyo (Ekpo), "Odo Ogbe Street and Lafogido: Contrasting Archeological sites in Ile-Ife, Western Nigeria", *West African Journal of Archeology*, no. 4, 1974, p. 99-109.

Eyo, 1977
Eyo (Ekpo), *Two Thousand Years of Nigeria Art*, Lagos, Federal Department of Antiquities, 1977.

Eyo, 1984
Eyo (Ekpo), "Archéologie du Nigeria", *Trésors de l'ancien Nigeria*, Paris, Association Française d'Action Artistique, 1984, p. 17-35.

Eyo, 1986
Eyo (Ekpo), "Alok and Emangabe Stone Monoliths: Ikom, Cross River State of Nigeria", *Arte in Africa*, dir. Ezio Bassani, Modena, Edizioni Panini, 1986, p. 101-104.

Eyo and Willett, 1980
Eyo (Ekpo), Willett (Frank), *Treasures of Ancient Nigeria*, New York, Alfred A. Knopf, 1980.

Eysseric, 1899
Eysseric (Joseph), *Rapport sur une mission scientifique à la Côte d'Ivoire*, Paris, Nouvelles Archives des Missions Scientifiques, 1899.

Ezra, 1988a
Ezra (Kate), *Art of the Dogon Selections from the Lester Wunderman Collection*, New York, The Metropolitan Museum of Art, Harry N. Abrams, Inc., 1988.

Ezra, 1988b
Ezra (Kate), "The Art of the Dogon", *African Arts*, vol. XXI, no. 4, August 1988, p. 30-33, p. 90-91.

F

Fabunmi, 1969
Fabunmi (M.A.), *Ife Shrines*, Ile-Ife, University of Ife Press, 1969.

Fadipe, 1970
Fadipe (N.A.), *The Sociology of the Yoruba*, Ibadan, Ibadan University Press, 1970.

Fagg (B.), 1968
Fagg (Bernard), "The Nok Culture: Excavations at Taruga", *West African Archaeological Newsletter*, no. 10, 1968, p. 27-30.

Fagg (B.), 1977
Fagg (Bernard), *Nok Terraccottas*, Lagos, Ethnographica for the National Museum, 1977.

Fagg (W.B.), 1960
Fagg (William B.), "The Ritual Stools of Ancient Ife", *Man*, vol. LX, August 1960, p. 113-115.

Fagg (W.B.), 1963
Fagg (William B.), *Merveilles de l'art nigérien*, Paris, Chêne, 1963.

Fagg (W.B.), 1964a
Fagg (William B.), *Afrika: 100 Stämme – 100 Meisterwerke. Africa: 100 Tribes – 100 Masterpieces*, Berlin, Kongress für kulturelle Freiheit, 1964.

Fagg (W.B.), 1964b
Fagg (William B.), *Afrique: 100 tribus – 100 Chefs-d'œuvre. 100 Tribes – 100 Masterpieces*, Paris, Musée des Arts Décoratifs, 1964b.

Fagg and Plass, 1964-1966
Fagg (William B.), Plass (Margaret), *African Sculpture - an Anthology*, London, Studio Vista/New York, Dutton, 1964-1966.

Faïk-Nzuji, 1992
Faïk-Nzuji (Clémentine M.), *Symboles graphiques en Afrique noire*, Paris, Karthala/Ciltade, 1992.

Falgayrettes, 1989
Falgayrettes (Christiane), *Supports de rêves*, Paris, Musée Dapper, 1989.

Falgayrettes-Leveau, 1991
Falgayrettes-Leveau (Christiane), "Pour un autre regard sur l'art fang", in *Fang*, 1991, p. 81-163.

Falgayrettes-Leveau, 1991
Falgayrettes-Leveau (Christiane), *Corps sublimes*, Paris, Musée Dapper, 1994.

Falgayrettes-Leveau and Stéphan, 1993
Falgayrettes-Leveau (Christiane), Stéphan (Lucien), *Formes et couleurs*, Paris, Musée Dapper, 1993.

Fane, Jacknis and Breen (eds.), 1991
Fane (Diana), Jacknis (Ira), Breen (Lise M.) [eds.], *Objects of Myth and Memory. American Indian Art at the Brooklyn Museum*, Brooklyn, The Brooklyn Museum/Seattle, University of Washington Press, 1991, p. 233-279.

Fang, 1991
Fang, Paris, Musée Dapper, 1991.

Faublée, 1946
Faublée (Jacques), *Ethnographie de Madagascar*, Paris, Les Éditions de France et d'Outre-mer/La Nouvelle Édition, 1946.

Faublée, 1961
Faublée (Jacques), "Une statue des îles Banks au musée de Bordeaux", *La Revue du Louvre et des musées de France*, 1961, nos. 4-5, p. 223-228.

Féau and Joubert, 1996
Féau (Étienne), Joubert (Hélène), *L'Art africain*, Paris, Scala, 1996.

Feest, 1984
Feest (Christian), "From North America", in *Rubin (ed.), 1984, p. 85-97.

Feest, 1992
Feest (Christian), "North America in the European Wunderkammer Before 1750", *Archiv für Volkerkunde*, no. 46, 1992, p. 61-109.

Feest, 1993
Feest (Christian), "Amérique du Nord", in *Rubin (ed.), 1987, p. 85-87.

Feest, 1993a
Feest (Christian), "Incredible Shrinking Robes", *European Review of Native American Studies*, 7 (2), 1993.

Feest, 1993b
Feest (Christian), "European Collecting of American Indian Artefacts and Art", *Journal of the History of the Collections*, 5 (1), 1993, p. 1-11.

Feldman, 1985
Feldman (Jerome Allen), "Ancestral Manifestations in the Art of Nias Island", *The Eloquent Dead, Ancestral Sculpture of Indonesia and South East Asia*, UCLA Museum of Cultural History, University of California, 1985.

Feldman, 1988
Feldman (Jerome Allen), "The Seat of the Ancestors in the Homeland of the Nias People", in *Barbier and Newton (eds.), 1988, p. 34-49.

Felix, 1987
Felix (Marc Leo), *100 Peoples of Zaïre and their Sculpture. The Handbook*, Bukavu, Zaïre Basin Art History Research Foundation, 1987.

Fénéon, 1920a
Fénéon (Félix), "Enquête sur les arts lointains (Seront-ils admis au Louvre ?)", *Le Bulletin de la vie artistique*, vol. I, no. 24, 15 November 1920, p. 662-669.

Fénéon, 1920b
Fénéon (Félix), "Enquête sur les arts lointains (Iront-ils au Louvre ?)", *Le Bulletin de la vie artistique*, vol. I, no. 25, 1 December 1920, p. 693-703.

Fénéon, 1920c
Fénéon (Félix), "Fin de l'enquête sur les arts lointains", *Le Bulletin de la vie artistique*, vol. I, no. 26, 15 December 1920, p. 726-738.

Fergie, 1989
Fergie Deane, "Limits of Commitment: the Resilience of a Ritual System in Island Melanesia", *Canberra Anthropology*, vol. XII (1-2), 1989, p. 99-119.

Fernandez, 1966
Fernandez (James W.), "Principle of Opposition and Vitality in Fang Aesthetics", *The Journal of Aesthetics and Art Criticism*, vol. XXV, no. 1, 1966, p. 53-64.

Fernandez, 1971
Fernandez (James W.), "Principle

of Opposition and Vitality in Fang Aesthetics", *Art and Aesthetics in Primitive Societies*, New York, E.P. Dutton and Co., Inc., 1971, p. 356-373.

Fernandez, 1973
Fernandez (James W.), "The Exposition and Imposition of Order: Artistic Expression in Fang Culture", *The Traditional Artist in African Societies*, Bloomington/Indianapolis, Indiana University Press, 1973, p. 194-220.

Fernandez, 1977
Fernandez (James W.), *Fang Architectonics*, Philadelphia, Institute for the Study of Human Issues, 1977.

Fernandez, 1981
Fernandez (James W.), "Reliquary Head", in *Vogel (ed.), 1981, p. 189.

Fernandez (J.W. and R.L.), 1975
Fernandez (James W. and Renate L.), "Fang Reliquary Art: Its Quantities and Qualities", *Cahiers d'études africaines*, no. 60, XV-4, 1975, p. 723-746.

Fienup-Riordan, 1996
Fienup-Riordan (Ann), *The Living Tradition of Yup'ik Masks, Agayuliyararput. Our Way of Making Prayer*, London/Seattle, University of Washington Press, 1996.

Filipinas, 1993
Filipinas: población, económica, familia, creencias, Madrid, Museo Nacional de Antropologia, 1993.

Finkenstaedt, 1979
Finkenstaedt (Elisabeth), "Egyptian Ivory Tusks and Tubes", *Zeitschrift für aegyptische Sprache*, no. 106, 1979, p. 51-59.

First Papers of Surrealism, 1942
First Papers of Surrealism, New York, Coordinating Council of French Relief Societies, Inc., 1942.

Fischer and Homberger, 1985
Fischer Eberhard and Homberger Lorenz, *Die Kunst der Guro, Elfenbeinküste*, Zürich, Museum Rietberg, 1985.

Fischer, 1997
Fischer (S.R.), *Rongorongo, The Easter Island Script, History, Traditions, Texts*, Oxford, Oxford Studies in Anthropological Linguistics, Clarendon Press, 1997.

Fitzhugh and Crowell, 1988
Fitzhugh (William), Crowell (Aron), *Crossroads of Continents: Cultures of Siberia and Alaska*, Washington, Smithsonian Institution Press, 1988.

Fitzhugh and Chaussonnet (eds.), 1994
Fitzhugh (William W.), Chaussonnet (Valérie) [eds.], *Anthropology of the North Pacific Rim*, 1994, p. 147-173.

Flor y canto del arte prehispanico de México, 1964
Flor y canto del arte prehispanico de México, Mexico City, Fondo Editorial de la Plastica Mexicana, 1964.

Foncerrada de Molina and Cardós de Méndez, 1988
Foncerrada de Molina (Martha), Cardós de Méndez (Amalia), *Las figurillas de Jaina, Campeche, en el Museo Nacional de Antropologia*, Mexico City, UNAM/INAH, 1988.

Fondation Beyeler, 1998
Fondation Beyeler, New York/Munich, Prestel Verlag, 1998.

Forment, 1981
Forment (Hélène), *Le Pacifique aux îles innombrables, île de Pâques*, Brussels, Musées Royaux d'Art et d'Histoire, 1981.

Forment, 1991
Forment (F.), "Les figures moai kavakava de l'île de Pâques", *Werkdocumenten over etnische Kunst*, no. 5, 1991.

Forment, 1993
Forment (F.), "You are crab, crayfish and octopus: Personal and Group Symbols in Rapanui Wood Sculpture", *Easter Island Studies: Contributions to the History of Rapanui in memory of William T. Mulloy*, Oxford, Oxbow Monograph 32, 1993.

Forth, 1998
Forth Gregory, *Beneath the Volcano: Religion, Cosmology and Spirit Classification among the Nage of Eastern Indonesia*, Leiden, LITLV Press, 1998.

Foss, 1976
Foss (Perkins) "Urhobo Statuary for Spirits and Ancestors", *African Arts*, vol. IX, no. 4, July 1976, p. 12-23, 89-90.

Fourneau, 1940
Fourneau (administrator), *Rapport de la tournée effectuée du 12 au 28 août 1940 par le chef de Région dans la chefferie de Bamendou*, Yaoundé, ISH, no. III 352.

Fox, 1979
Fox (Robert B.), "The Philippines during the First Millennium B.C.", in *Smith and Watson (eds.), 1979, p. 227-241.

Fox, Sibley and Eggan, 1954
Fox (Robert B.), Sibley (Willis E.), Eggan (Fred), "A Preliminary Glottochronology for Northern Luzon", *Asian Studies*, no. 3, 1954, p. 103-113.

Franch José, 1996s
Franch José Alcina, *L'Art précolombien*, Paris, Citadelles et Mazenod, 1996.

Francisco, 1971
Francisco (Juan R.), *The Philippines and India: Essays in Ancient Cultural Relations*, Manila, National Book Store, 1971.

Franck, 1829
Franck, *Catalogue of Drawings of Mexican Antiquities – Description feuille par feuille de la collection d'antiquités mexicaines*, London, British Museum Library, 1829.

Fraser (ed.), 1966
Fraser (Douglas) [ed.], *The Many Faces of Primitive Art. A Critical Anthology*, Englewood Cliffs, Prentice Hall, Inc., 1966, p. 266-300.

Freyer, 1987
Freyer (B.), *Royal Benin Art in the Collection of the National Museum of African Art*, Washington/London, 1987.

Frobenius, 1949
Frobenius (Leo), *Mythologie de l'Atlantide, le Poséidon de l'Afrique noire, son culte chez les yorouba du Bénin*, Paris, Payot, 1949.

Fry (ed.), 1978
Fry (Jacqueline) [ed.], *Vingt-cinq sculptures africaines – Twenty-five African Sculptures*, Ottawa, Galerie nationale du Canada, 1978.

Fuente, 1984
Fuente (Beatriz de la), *Los hombres de piedras, Escultura olmeca*, Mexico City, UNAM, 1984.

Führer-Haimendorf, 1939
Führer-Haimendorf (C. von), "The Megalithic Sculpture of Assam", in *Schnitger, 1939.

Fürniss, 1993
Fürniss (Susanne), "Les instruments de musique de Centrafrique au musée de l'Homme. Collections et collecteurs", *Journal des africanistes*, vol. LXIII, fasc. 2, 1993, p. 81-119.

Fussman, 1972
Fussman (G.), *Atlas linguistique des parlers dardes et kafirs*, vols. I-II, Paris, 1972.

G

Gagnière, 1971
Gagniere (J.), *Sculptures pascuanes en bois du musée Calvet d'Avignon*, Saint-Michel-de-Provence, 1971.

Gallois-Duquette, 1976
Gallois-Duquette (Danielle), "Informations sur les arts plastiques des Bidyogo", *Arts d'Afrique noire*, no. 18, Arnouville, summer 1976, p. 26-43.

Gallois-Duquette, 1978
Gallois-Duquette (Danielle), "Personnage assis sur un siège, iran", in *Fry (ed.), 1978, p. 88-96.

Gallois-Duquette, 1979
Gallois-Duquette (Danielle), "Woman Power and Initiation in the Bissagos Islands", *African Arts*, vol. XII, no. 3, May 1979, p. 31-35, p. 93.

Gallois-Duquette, 1981a
Gallois-Duquette (Danielle), "Les masques bovins des îles Bissagos (Guinée-Bissau)", *Connaissance des arts tribaux*, no. 12, Association des Amis du Musée Barbier-Müller, 1981.

Gallois-Duquette, 1981b
Gallois-Duquette (Danielle), "1853: une date dans l'histoire de l'art noir", *Antologia di belle arti*, 5th year, nos. 17-18, 1981, p. 69-82.

Gallois-Duquette, 1983
Gallois-Duquette (Danielle), *Dynamique de l'art bidjogo*, Lisbon, Instituto de Investigação Científica Tropical, 1983.

Gallotti, 1931a
Gallotti (Jean), "Les arts indigènes à l'Exposition coloniale", *Art et décoration*, July 1931, p. 69-100.

Gallotti, 1931b
Gallotti (Jean), "Le Palais permanent des colonies", *L'Illustration*, no. 4616, 22 August 1931, p. 556 sq.

Garcia Arévalo, 1977
Garcia Arévalo (Manuel), *El arte taíno de la República dominicana*, Museo del Hombre Dominicano, 1977.

Garcia Granados (Rafael), 1953
Garcia Granados (Rafael), *Diccionario biografico de historia antigua de Méjico*, Mexico City, Instituto de Historia, no. 23, vol. II, 1953.

Garfield, 1939
Garfield (Viola), *Tsimshian Clan and Society*, University of Washington Publications in Anthropology, vol. 7, Seattle, University of Washington, 1939.

Garrard, 1995
Garrard (Timothy F.), "Male figure. Gurunsi or Dagara (?)" in *Phillips (ed.), 1995, p. 449.

Garza, 1992
Garza (Mercedes de la), *Palenque*, Mexico City, Ediciones Gobierno del Estado de Chiapas/Miguel Angel Porrúa, 1992.

Gathercole, Kaeppler and Newton, 1979
Gathercole (P.), Kaeppler (Adrienne), Newton (Douglas), *The Art of the Pacific Islands*, Washington, National Gallery of Art, 1979.

Geary, 1987
Geary (Christraud), "Arts anciens du Cameroun, Pierre Harter", *African Arts*, vol. XXI, no. 1, Los Angeles, November 1987, p. 24-26, p. 73-74.

Genet, 1928-29
Genet (Jean), *Relation des choses du Yucatan de Diego de Landa*, 2 vols., Paris, 1928-29.

Gheerbrant, 1988
Gheerbrant (Bernard), *À La Hune*, Paris, Adam Biro/Centre Georges Pompidou, 1988.

Gilardoni, 1948
Gilardoni (Virgilio), *Naissance de l'art*, Paris, Édition de Clairefontaine/ Lausanne, La Guilde du Livre, 1948.

Gille, 1998
Gille (Vincent), "Partie liée. Le surréalisme et les Hopi", in *Danse des Kachina*, 1998, p. 19-30.

Gilles, 1974
Gilles (Xavier), "Collectionneurs de rêve: Olivier Le Corneur, Jean-Claude Bellier", *L'Œil*, no. 227, June 1974, p. 10-23.

Gillespie, 1991
Gillespie (Susan D.), "Ballgames and Boundaries", *The Mesoamerican Ballgame*, ed. V.L. Scarborough and D.R. Wilcox, Tucson, University of Arizona Press, 1991.

Gillet, 1939
Gillett (Joyce), "'Dukas' of Santa Cruz", *Man*, vol. XXXIX, no. 147, 1939, p. 153-154.

Gillon, 1979
Gillon (Werner), *Collecting African Art*, London, Studio Vista/Christie's, 1979.

Girard, 1945
Girard (Françoise), "Récentes acquisitions du musée de l'Homme", *Journal de la Société des océanistes*, vol. 1, no. 1, December 1945, p. 125-128.

Girard, 1952
Girard (Françoise), "L'Océanie", in *Malraux, 1952.

Girard, 1971
Girard (Françoise), "Statuette du dieu requin de Santa Cruz", *Objets et mondes*, vol. 9, fasc. 3, autumn 1971, p. 273-280.

Glover, 1998
Glover (Ian C.), "The Archeological Past of Island Southeast Asia", in *Barbier (ed.), 1998, p. 17-34.

Goldwater, 1988
Goldwater (Robert), *Primitivism in Modern Art*, Cambridge/London, Belknap Press, (1938) 1986 (enlarged edition.).

Gomez-Garcia, 1983
Gomez-Garcia (Pynky), "Northern Philippine Primitive Wooden Art", *Arts of Asia*, vol. XIII, no. 4, Hong Kong, July-August 1983, p. 84-93.

Gonzalez-Lauck, 1994
Gonzalez-Lauck (Rebeca), "La zona del Golfo en el Preclásico: la etapa olmeca", in *Manzanilla and Lopez Lujan (eds.), 1994.

Goudswaard, 1863
Goudswaard (A.), *De Papoewa's van de Geelvinksbaai. Hoofdzakelijk naar mondelinge mededeelingen van oogge-tuigen*, Schiedam, 1863.

Gowing and Scott (eds.), 1971
Gowing (Peter G.), Scott (William Henry) (eds.), *Acculturation in the Philippines: Essays on Changing Societies*, Quezon City, New Day Publishers, 1971.

Graburn, Lee and Rousselot, 1996
Graburn (Nelson), Lee (Molly), Rousselot (Jean-Loup), *Catalogue Raisonné of the Alaska Commercial Company Collection*, Phoebe Apperson Hearst Museum of Anthropology/Berkeley, University of California Press, 1996.

Grand Atlas Universalis de l'art, **1993**
Le Grand Atlas Universalis de l'art, Paris, Encyclopædia Universalis, 1993.

Grandidier, 1924
Grandidier (Alfred and Guillaume), *Ethnographie de Madagascar*, Paris, Librairie Hachette/ Société d'Édition Géographiques, Maritimes et Coloniales, 1924.

Green, 1979
Green (R.C.), "Lapita", in *Jennings (ed.), 1979, p. 27-60.

Greenhalgh and Megaw (eds.), 1978
Greenhalgh (Michael), Megaw (Vincent) [eds.], *Art in Society*, New York/London, Duckworth, 1978.

Greub (ed.), 1988
Greub (Suzanne) [ed.], *Expressions of Belief, Masterpieces of African, Oceanic and Indonesian Art from the Museum voor Volkenkunde, Rotterdam*, New York, Rizzoli, 1988.

Greub (ed.), 1992
Greub (Suzanne) [ed.], *Art of Northwest New Guinea (From Geelvink Bay, Humbolt Bay and Lake Sentani)*, New York, Rizzoli, 1992.

Griaule, 1947
Griaule (Marcel), *Arts de l'Afrique noire*, Paris, Chêne, 1947.

Griaule, 1950
Griaule (Marcel), *Arts of the African Native*, London, Thames and Hudson, 1950.

Griaule, 1957
Griaule (Marcel), "L'Afrique", in *Huyghe (ed.), 1957, fasc. 3.

Griaule, 1966
Griaule (Marcel), *Dieu d'eau. Entretiens avec Ogotemmêli*, Paris, Chêne, 1948 (reprint A. Fayard, 1966).

Griaule and Dieterlen, 1965
Griaule (Marcel), Dieterlen (Germaine), *Le Renard pâle*, Travaux et Mémoires de l'Institut d'Ethnologie, vol. LXXII, Paris, Institut d'Ethnologie, 1965.

Grimal (ed.), 1963
Grimal (Pierre) [ed.], *Mythologie des steppes, des forêts et des îles*, Paris, Librairie Larousse, 1963.

Groves, 1934-36
Groves (William), "Tabar Today: a Study of a Melanesian Community in Contact with Alien Non-primitive Cultural Forces", *Oceania*, vol. V (2), p. 224-240, vol. V (3), p. 346-360, vol. VI (2), p. 147-157, 1934-36.

Groves, 1936
Groves (William), "Secret Beliefs and Practices in New Ireland", *Oceania*, vol. VII (2), 1936, p. 220-246.

Grunne, 1987
Grunne (Bernard de), "Figures équestres", *Aethiopia, vestiges de gloire*, Paris, Éditions Dapper, 1987, p. 9-13.

Grunne, 1988
Grunne (Bernard de), "Ancient Sculpture of the Inland Niger Delta and its Influence on Dogon Art", *African Arts*, vol. XXI, no. 4, Los Angeles, 1988, p. 50-55, p. 92.

Grunne, 1991
Grunne (Bernard de), "Heroic Riders and Divine Horses: An Analysis of Ancient Soninke and Dogon Equestrian Figures from the Inland Niger Delta Region in Mali", *The Minneapolis Institute of Arts Bulletin*, vol. LXVI, Minneapolis, 1991, p. 78-96.

Grunne, 1993
Grunne (Bernard de), "La sculpture classique tellem: essai d'analyse stylistique", *Arts d'Afrique noire*, no. 88, winter 1993, p. 19-30.

Grunne, 1994a
Grunne (Bernard de), "La statuaire fang. Une forme d'art classique?", *Tribal Arts – Le Monde de l'art Tribal*, no. 2, June 1994, p. 47-56.

Grunne, 1994b
Grunne (Bernard de), "La quintessence de la beauté: la statue de Nukuoro du musée Barbier-Mueller", *Art tribal, Bulletin du musée Barbier-Mueller*, 1994.

Grunne, 1998
Grunne (Bernard de), *Naissance de l'art en Afrique noire – La statuaire Nok au Nigeria*, Luxembourg, Banque Générale du Luxembourg/Paris, Adam Biro, 1998.

Grunne, [forthcoming]
Grunne (Bernard de), "Vers une définition du style soninké", *Arts et Cultures*, no. 2, Geneva, Musée Barbier-Mueller.

Grunne and Thompson, 1988
Grunne (Bernard de), Thompson (Robert Farris), *Chefs-d'œuvre inédits de l'Afrique noire*, Paris, Éditions Dapper/Bordas, 1988.

Guédon, 1982
Guédon (Marie-Françoise), "Problèmes de définition du chamanisme chez les Amérindiens de la côte Nord-Ouest, l'exemple tsimshian", *Culture*, vol. II (3), 1982, p. 129-143.

Guggenheim, 1960
Guggenheim (Peggy), *Confessions of an Art Addict*, London, André Deutsch, 1960.

Guiart, 1949
Guiart (Jean), "Les effigies religieuses des Nouvelles-Hébrides", *Journal de la Société des océanistes*, vol. 5, 1949, p. 51-86.

Guiart, 1951
Guiart (Jean), "Sociétés, rituels et mythes du Nord-Ambrym (Nouvelles-Hébrides)", *Journal de la Société des océanistes*, vol. 7, 1951, p. 5-103.

Guiart, 1953
Guiart (Jean), *L'Art autochtone de Nouvelle-Calédonie*, Nouméa, Éditions des Études Mélanésiennes, 1953.

Guiart, 1956
Guiart (Jean), "Unité culturelle et variations locales dans le centre-nord des Nouvelles-Hébrides", *Journal de la Société des océanistes*, vol. 12, no. 2, December 1956, p. 217-225.

Guiart, 1963
Guiart (Jean), *Océanie*, Paris, Gallimard, 1963.

Guiart, 1965
Guiart (Jean), *Nouvelles-Hébrides*, Auvers-sur-Oise, Archée Editeur, 1965.

Guiart, 1966
Guiart (Jean), *Mythologie du masque en Nouvelle-Calédonie*, Paris, Société des Océanistes, 1966.

Guiart, [1986]
Guiart (Jean), "La conquête et le déclin. Les plantations, cadre des relations sociales et économiques au Vanuatu, ex-Nouvelles-Hébrides", [1986].

Guichard, 1993
Guichard Camille, *Louise Bourgeois*, Terra Luna Films/Centre Georges Pompidou, 1993.

Guillaume, 1920
Guillaume (Paul), "Enquête sur les arts lointains", in *Fénéon, 1920b.

Guillaume and Munro, 1926
Guillaume (Paul), Munro (Thomas), *Primitive Negro Sculpture*, New York, Harcourt, Brace and Company, 1926.

Guillaume and Munro, 1929
Guillaume (Paul) and Munro (Thomas), *La Sculpture nègre primitive*, Paris, Éditions G. Crès et Cie, 1929.

Guimaraes, 1994
Guimaraes (Susana), *Le Musée des Antiquités américaines du Louvre (1850-1887). Une vision du collection-nisme américain au XIX^e siècle*, thesis, Paris, Université de Paris I, Panthéon-Sorbonne, 1994.

Guiral, 1889
Guiral (Léon), *Le Congo français du Gabon au Brazzaville*, Paris, Éditions Plon, Nourrit et Cie, 1889.

Gunn, 1984
Gunn (Michael), "Tabar Malagan. An Outline of the Emic Taxonomy", in *Dark (ed.), 1984, p. 81-92.

Gunn, 1985
Gunn (Michael), "A brief Note on the Malagan *Churwunawungga* from Tabar, New Ireland Province", *Oral History*, vol. XIII (1), 1985, p. 15-18.

Gunn, 1987
Gunn (Michael), "The Transfer of Malagan Ownership on Tabar", in *Lincoln (ed.), 1987.

Gunn, 1988
Gunn (Michael), "Transformers and Terrorists – The Usage of Malagan Masks on Tabar, New Ireland, Papua New Guinea", *The Beagle – Occasional Papers of the Northern Territory Museum of Arts and Sciences*, vol. V (1), 1988, p. 175-183.

Gunn, 1993
Gunn (Michael), *Fieldwork Report – Malagan Ritual Art on Tabar, New Ireland, Papua New Guinea, 1982-84*, Darwin, Northern Territory Museum, 1993.

Gunn, 1997
Gunn (Michael), *Arts rituels d'Océanie, Nouvelle-Irlande, dans les collections du musée Barbier-Mueller*, Milan, Skira, 1997.

Gunther, 1966
Gunther (Erna), *Art in the Life of the Northwest Coast Indians*, Portland, Portland Art Museum, 1966.

Guthrie, 1953
Guthrie (Malcolm), *The Bantu Languages of Western Equatorial Africa. Handbook of African Languages*, London, New York, Toronto, International African Institute/Oxford University Press, 1953.

Gutierrez, 1987
Gutierrez (Solana R. Nelly), *Las serpientes en el arte mexica*, Mexico City, UNAM, 1987.

H

Hagen, 1914
Hagen (Günther Tronje von), *Lehrbuch der Bulu Sprache*, Berlin, Druck und Verlag von Gabr. Radetzki, 1914.

Halpin, 1973
Halpin (Marjorie), *The Tsimshian Crest System: A Study Based on Museum Specimens and the Marius Barbeau and William Beynon Field Notes*, thesis, Vancouver, University of British Columbia, 1973.

Halpin, 1981
Halpin (Marjorie), *Totem Poles. An Illustrated Guide*, Museum Notes, no. 3, Vancouver, University of British Columbia/UBC Museum, 1981.

Halpin, 1984
Halpin (Marjorie), "'Seeing' in stone: Tsimshian Masking and the Twin Stone Masks", in *Seguin (ed.), 1984, p. 281-308.

Hamayon, 1990
Hamayon (R.), *La Chasse à l'âme: esquisse d'une théorie du chamanisme sibérien*, Nanterre, 1990.

Hammerle, 1984
Hammerle (Johannes), "Die Megalithkultur im Susua-Gomo Gebiet, Nias", *Anthropos*, no. 79, 1984, p. 587-626.

Hamy, 1897
Hamy (Ernest-Théodore), *Galerie américaine du musée d'Ethnographie du Trocadéro – Choix de pièces archéologiques et ethnographiques*, Paris, Ernest Leroux, part 1, 1897.

Hamy, 1888
Hamy (Ernest-Théodore), *Les Origines du musée d'Ethnographie*, Paris, 1890 (reprint, Jean-Michel Place, 1988).

Handy, 1923
Handy (Edward Smith Craighill), "The Native Culture in the Marquesas", *Bernice P. Bishop Museum Bulletin*, no. 9, Honolulu, 1923.

Handy, 1927
Handy (Edward Smith Craighill), "Polynesian Religions", *Bernice P. Bishop Museum Bulletin*, no. 34, Honolulu, 1927.

Handy, 1929
Handy (Edward Smith Craighill), "Marquesan Legends", *Bernice P. Bishop Museum Bulletin*, no. 69, Honolulu, 1929.

Harcourt, 1948
Harcourt (Raoul d'), *Arts de l'Amérique*, Paris, Chêne, 1948.

Harris, 1965
Harris (Rosemary), *The Political Organisation of the Mbembe, Nigeria*, London, Her Majesty's Stationery Office, 1965.

Harrisson, 1936
Harrisson (T.), "The New Hebrides People and Culture", *The Geographical Journal*, vol. LXXXVIII, London, 1936, p. 330-341.

Harrisson, 1937
Harrisson (T.), *Savage Civilization*, New York, Alfred A. Knopf, 1937.

Harter, 1981
Harter (Pierre), "King Returning from Victory", in *Vogel (ed.), 1981, p. 192.

Harter, 1986
Harter (Pierre), *Arts anciens du Cameroun*, Arnouville, Arts d'Afrique noire, 1986.

Harter, 1991
Harter (Pierre), "Peuples des falaises de Bandiagara et de la plaine de Gondo", *Primitifs*, no. 2, January-February 1991, p. 14-26.

Hasibuan, 1985
Hasibuan (Jamaludin S.), *Art et Culture/Seni Budaya*, Djakarta, May 1985.

Hausenstein, 1922
Hausenstein (Wilhelm), *Barbaren und Klassiker*, Munich, R. Piper Verlag, 1922.

Hauser, 1997
Hauser (Stephan E.), *Kurt Seligmann 1900-1962. Leben und Werk*, Basel, Schwabe und Co. Ag Verlag, 1997.

Hawthorn, 1967
Hawthorn (Audre), *Kwakiutl Art*, Vancouver, Douglas and McIntyre, 1967.

Hazoume, 1937
Hazoume (Paul), *Le Pacte de sang au Dahomey*, Paris, Institut d'Ethnologie, 1937.

Headrick, 1999
Headrick Anabeth, "The Street of the Dead… It Really Was: Mortuary Bundles at Teotihuacán", *Ancient Mesoamerica* 10 (1), 1999.

Heine-Geldern, 1928
Heine-Geldern (R. von), "Die Megalithen Südostasiens und ihre Bedeutung für die Klärung der Megalithenfrage in Europa und Polynesia", *Anthropos*, no. 23, 1928, p. 276-315.

Heintze, 1969
Heintze (Dieter), *Ikonographische Studien zur Malanggan-kunst Neuirlands. Untersuchungen an ausgewählten Vogeldarstellungen,* Tübingen, Schwitalla Himmelsthür, 1969.

Heintze, 1987
Heintze (Dieter), "On Trying to Understand some Malagans", in *Lincoln (ed.), 1987.

Helena Rubinstein Collection, 1966
The Helena Rubinstein Collection, New York, Parke-Bernet Galleries, Inc., April 1966.

Helfrich, 1973
Helfrich (Klaus), *Malanggan I: Bildwerke von Neuirland*, Berlin, Museum für Völkerkunde, 1973.

Hendrickx, 1995
Hendrickx (Stan), *Analytical Bibliography of the Prehistory and the Early Dynastic Period of Egypt and Northern Sudan*, Louvain, Leuven University Press, 1995.

Herreman, Holsbeke and Alpen, 1991
Herreman (Frank), Holsbeke (Mireille), Alpen (Jan van), *Musée d'Ethnographie d'Anvers*, Brussels, Crédit Communal/Ludion s.a. Cultura Nostra, 1991.

Heyden, 1998
Heyden Doris, "Las cuevas de Teotihuacán", *Arqueologia Mexicana*, vol. VI (34), Mexico City, Editiones Raices, 1998, p. 18-27.

Heyerdahl, 1976
Heyerdahl (T.), *The Art of Easter Island*, London, George Allen and Unwin, 1976.

Hier, aujourd'hui et demain, 1987
Hier, aujourd'hui et demain, regards sur les collections et sur les activités du musée Barbier-Mueller 1977-1987, Geneva, Musée Barbier-Mueller, 1987.

Hilliard, 1978
Hilliard (D.), *God's Gentlemen: A History of the Melanesian Mission*, Saint Lucia, 1978.

Himmelheber, 1935
Himmelheber (Hans), *Negerkünstler*, Stuttgart, Strecker und Schröder Verlag, 1935.

Himmelheber, 1960
Himmelheber (Hans), *Negerkunst und Negerkünstler*, Braunschweig, Klinkhardt und Biermann, 1960.

Himmelheber, 1971
Himmelheber (Hans), "The Concave Face in African Art", *African Art*, vol. IV, no. 3, spring 1971, p. 52-55.

Hipszer, 1965
Hipszer (Hermine), "Un masque-calembour: l'oiseau-homme", *Anthropos*, no. 60, 1965, p. 387-409.

Hodgkint, 1960
Hodgkint (ed.), *Nigerian Perspectives: An Historical Anthology*, London, 1960.

Holas, 1947
Holas (Bernard) [Bohumil], "Danses masquées de la Basse-Côte", *Études guinéennes*, no. 1, Conakry, 1947, p. 61-67.

Holas, 1954
Holas (Bernard) [Bohumil], *Sur quelques divinités baoulé (Côte d'Ivoire)*, Madrid, 1954.

Holas, 1956
Holas (Bernard) [Bohumil], "Sur quelques divinités baoulé de rang inférieur; leurs figurations, leur rôle liturgique", *BIFAN*, série B, nos. 3-4, Dakar, July-December 1956, p. 408-432.

Holm, 1972
Holm (Bill), *Crooked Beak of Heaven. Masks and Other Ceremonial Art of the Northwest Coast*, Seattle, University of Washington Press, 1972.

Holm and Reid, 1975
Holm (Bill), Reid (Bill), *Indian Art of the Northwest Coast. A Dialogue on Crafsmanship and Aesthetics*, Houston, Institute for the Arts, Rice University/Seattle, University of Washington Press, 1975.

Homer, 1982
Homer, *City of Blood Revisited: A New Look at the Benin Expedition of 1897*, London, R. Collings, 1982.

Honour, 1975
Honour (H.), *The New Golden Land, European Images of America*, London, Allen Lane, 1975.

Hoop and Thomassen, 1932
Hoop (A.N.J. van der), Thomassen (A. Thuessink), *Megalithic Remains in South Sumatra*, Zutphen, W.J. Thieme, 1932.

Hooper (ed.), 1997
Hooper (Steven) [ed.], *Robert and Lisa Sainsbury Collection*, vol. II, New Haven, London, Norwich, Yale University Press and University of East Anglia, 1997.

Hottot, 1956
Hottot (Robert), "Teke Fetishes", *Journal of the Royal Anthropological Institute of Great Britain and Ireland*, vol. LXXXVI, part 1, London, 1956, p. 25-36 (French translation, see *Hottot, 1972).

Hottot, 1972
Hottot (Robert), "Fétiches téké", *Arts d'Afrique*, no. 1, Villiers-le-Bel, 1972, p. 17-33.

Huet, Laude and Paudrat, 1978
Huet (Michel), Laude (Jean), Paudrat (Jean-Louis), *Danses d'Afrique*, Paris, Chêne, 1978.

Huffman, 1995
Huffman (Kirk W.), "Travails and Travels with Speiser: A Personal Commentary", *Journal of the Pacific Arts Association*, Honolulu, 11-12, July 1995, p. 90-102.

Huffman, 1996a
Huffman (Kirk W.), "Les ceintures de femmes du nord du Vanuatu", in *Vanuatu, Océanie. Arts des îles de cendre et de corail*, 1996, p. 304-306.

Huffman, 1996b
Huffman (Kirk W.), "Échanges, liens culturels et droits d'auteur: leur importance dans les arts du Vanuatu", in *Vanuatu, Océanie. Arts des îles de cendre et de corail*, 1996, p. 190-203.

Huffman, 1996c
Huffman (Kirk W.), "Pilon de nalot en bois", in *Vanuatu, Océanie. Arts des îles de cendre et de corail*, 1996, p. 204-205.

Huffman, 1997a
Huffman (Kirk W.), "Wooden Nalot Pounders", in *Bonnemaison et al., 1997, p. 232-234

Huffman, 1997b
Huffman (Kirk W.), "'Eating with the Ancestors': A Rare Plate from Malo, Northern Vanuatu", *Journal of the Pacific Arts Association*, Honolulu, no. 15-16, July 1997, p. 37-41.

Huffman, 1997c
Huffman (Kirk W.), "'Spirit blong Bubu i Kam Bak': The 'Arts of Vanuatu' exhibition at the National Museum, Vanuatu Cultural Centre, Port-Vila, Vanuatu, 28th June-10th August 1996", *Journal of the Pacific Arts Association*, Honolulu, no. 15-16, July 1997, p. 1-14.

Huffman, 1997d
Huffman (Kirk W.), "Manger le nalot avec les ancêtres", in *Découverte du paradis*, 1997, p. 215-218.

Huffman, Rengenvanu and Sam, 1997
Huffman (Kirk W.), Regenvanu (R.), Sam (J.), *Spirit blong Bubu i Kam Bak*, Port Vila, Kaljoral Senta blong Vanuatu, 1997.

Huyghe (ed.), 1957
Huyghe (R.) [ed.], *L'Art et l'Homme*, Paris, Larousse, 1957.

I

Ile de Pâques: une énigme?, 1990
L'Île de Pâques: une énigme?, Brussels, Musées Royaux d'Art et d'Histoire, 1990.

Il y a cent ans… Pierre et Édouard Loeb, 1997
Il y a cent ans… Pierre et Édouard Loeb, Paris, Galerie Albert Loeb, 1997.

Impey and McGregor, 1985
Impey (O.), McGregor (A.), *The Origins of the Museums: the Cabinets of Curiosities in 16th and 17th Century Europe*, Oxford, Clarendon Press, 1985.

Instructions sommaires pour les collecteurs d'objets ethnographiques, 1931
Instructions sommaires pour les collecteurs d'objets ethnographiques, Paris, Musée d'Ethnographie/ Mission Dakar-Djibouti, May 1931.

Inventaire des collections du musée d'Ethnographie du Trocadéro
Inventaire des collections du musée d'Ethnographie du Trocadéro, 27 vols., Paris, Archives du Musée de l'Homme, 1878-1933.

Inventaire des collections, 1883
Inventaire des collections, Bordeaux, Musée Préhistorique et Ethnographique, 1883.

Ivory, 1990
Ivory (Carol), *Marquesan Art in the Early Contact Period, 1774-1821*, University of Washington, 1990.

Ivory, 1993
Ivory (Carol), "Re-viewing Marquesan Art", in *Dark and Rose (eds.), 1993.

Izard, 1970
Izard (Michel), *Introduction à l'histoire des royaumes mossi*, Ouagadougou, Centre Voltaïque de la Recherche Scientifique/Paris, Éditions du CNRS, 1970.

J

Jacknis, 1986
Jacknis (Ira), "Letter to Charlotte Stokes", 22 September 1986, Archives of the Brooklyn Museum, 1986.

Jacknis, 1991
Jacknis (Ira), "The Northwest Coast", in *Fane, Jacknis and Breen (eds.), 1991, p. 233-279.

Jacquemin, 1991
Jacquemin (Sylviane), *Objets des mers du Sud. Histoire des collections océaniennes dans les musées et établissements parisiens, XVIII^e-XX^e siècles*, research paper for the École du Louvre, 1991.

Jacquemin, 1992
Jacquemin (Sylviane), *Rao – Polynésies*, Marseille, Parenthèses/Paris, RMN, 1992.

Jacquemin, n.d.
Jacquemin (Sylviane), "Dossier personnel", Service historique de la Marine, Vincennes.

Jamin, 1982
Jamin (Jean), "Objets trouvés des paradis perdus. À propos de la mission Dakar-Djibouti", *Collections Passions*, Neuchâtel, Musée d'Ethnographie, 1982.

Jamin, 1989
Jamin (Jean), "Le musée d'Ethnographie en 1930", *La Muséologie selon Georges Henri Rivière*, Paris, Dunod, 1989, p. 110-121.

Janzen, 1982
Janzen (John M.), *Lemba, 1650-1930. A Drum of Affliction in Africa and the New World*, New York, Garland, 1982.

Jarquin Pacheco and Martinez Vargas, 1982
Jarquin Pacheco Ana Maria, Martinez Vargas Enrique, "Las excavaciones en el conjunto ID", in *Cabrera Castro, Rodriguez Garcia and Morelos Garcia (eds.), 1982b.

Jaussen, 1874
Jaussen (Tepano), "Ile de Pâques, destruction d'une chrétienté", *Les Missions catholiques*, vol. 6, no. 270, Lyon, 1874, p. 382-386.

Jemkur, 1985
Jemkur (J.F.), "Polished Stone Axes from the Nok Culture Area of Central Nigeria", *Nyame Akuma*, no. 26, June 1985, p. 34-36.

Jen, 1957
Jen (Shien-min), "Notes on a Païwan Carver", *The Bulletin of the Institute of Ethnology, Academia Sinica*, no. 4, 1957, p. 109-122 (in Chinese).

Jennings (ed.), 1979
Jennings (J.D.) [ed.], *The Prehistory of Polynesia*, Cambridge/London, Harvard University, 1979.

Jocano, 1975
Jocano (F. Landa), *Philippine Prehistory: An Anthropological Overview of the Beginnings of Filipino Society and Culture*, Quezon City, Philippine Center for Advanced Studies, University of the Philippines, 1975.

Johnson (R.E.), 1986
Johnson (Richard E.), *Two Maya Vases: Suggested Readings of the Secondary Texts*, 1986.

Johnson (S.), 1921
Johnson (S.), *The History of the Yorubas. From the Earliest Times to the Beginning of the British Protectorate*, Lagos, 1921.

Jonaitis, 1988
Jonaitis (Aldona), *From the Land of the Totem Poles. The Northwest Coast Indian Art Collection at the American Museum of Natural History*, New York, American Museum of Natural History/Seattle, University of Washington Press, 1988.

Jonaitis (ed.), 1991
Jonaitis (Aldona) [ed.], *Chiefly Feasts. The Enduring Kwakiutl Potlatch*, New York, American Museum of Natural History, 1991.

Jones, 1987
Jones (Julie), *Houses for the Hereafter, Funerary Temples from Guerrero*, New York, The Metropolitan Museum, 1987.

Jordan, 1994
Jordan (Richard H.), "Ceremonialism among the Traditional Koniag", in *Fitzhugh and Chaussonnet (eds.), 1994, p. 147-173.

Jouffroy, 1955
Jouffroy (Alain), "La collection d'André Breton", *L'Œil*, no. 10, 1955, p. 32-39.

Juynboll, 1928
Juynboll (H.H.), *Philippinjnen*, Leyde, E.J. Brill, 1928.

K

Kaeppler, 1970
Kaeppler (Adrienne L.), "Feather Cloaks, Ship Captains and Lords", *Bernice P. Bishop Museum Occasional Papers*, vol. XXIV (6), 1970, p. 91-114.

Kaeppler, 1978
Kaeppler (Adrienne L.), *'Artificial Curiosities'. An Exposition of Native Manufactures Collected on the Three Pacific Voyages of Captain James Cook*, Honolulu, Bishop Museum Press, 1978.

Kaeppler, 1979
Kaeppler (Adrienne L.), *Eleven Gods Assembled: An Exhibition of Hawaiian Wooden Images*, Honolulu, Bishop Museum Miscellaneous Publication, 1979.

Kaeppler, 1982
Kaeppler (Adrienne L.), "Genealogy and Disrespect. A Study of Symbolism in Hawaiian Images", *Res*, no. 3, 1982, p. 82-107.

Kaeppler, 1993
Kaeppler (Adrienne L.), *Hula Pahu: Hawaiian Drum Dances*, Honolulu, Bishop Museum Press, 1993.

Kaeppler, Kaufmann and Newton, 1993
Kaeppler (Adrienne L.), Kaufmann (Christian), Newton (Douglas), *L'Art océanien*, Paris, Citadelles et Mazenod, 1993.

Kaiser, 1957
Kaiser (Werner), "Zur inneren Chronologie der Naqadakultur", *Archaeologia Geographica*, Hamburg, August 1957, p. 69-77.

Kamarau, 1976
Kamarau (Samuel Manaiakalani), *The Works of the People of Old*, Honolulu, Bishop Museum Press, 1976.

Kamer (Hélène), 1974
Kamer (Hélène), *Ancêtres M'Bembé*, Galerie Hélène Kamer, 1974.

Kamer (Henri), 1973
Kamer (Henri), *Haute-Volta*, Paris, Henri Kamer, 1973.

Kaplan (ed.), 1981
Kaplan (F.S.) (ed.), *Images of Power. Art at the Royal Court of Benin*, New York, 1981.

Kasarherou, 1993
Kasarherou (Emmanuel), *Le Masque kanak*, Marseille, Parenthèses/ADCK, 1993.

Kaufmann, 1993
Kaufmann (Christian), "Vanuatu", in *Kaeppler, Kaufmann and Newton, 1993.

Kaufmann, 1997
Kaufmann (Christian), *Vanuatu – Kunst der Südsee*, Bâle, Museum der Kulturen/Christoph Meriab Verlag, 1997.

Kecskési, 1982
Kecskési (Maria), *Kunst aus dem Alten Afrika*, Innsbruck, Pinguin Verlag/Frankfurt am Main, Umschau Verlag, 1982.

Keen, 1971
Keen (Benjamin), *The Aztec Image*, New Brunswick, Rutger University, 1971.

Keen, 1984
Keen (Benjamin), *La imagen azteca*, Mexico City, Fondo de Cultura Económica, 1984.

Keesing (F.M. and M.), 1934
Keesing (Felix M. and Marie), *Taming Philippine Headhunters: A Study of Government and of Cultural Change in Northern Luzon*, London, George Allen and Unwin, 1934.

Kelemen, 1956
Kelemen (Pal), *Medieval American Art – Masterpieces of the New World Before Columbus*, New York, The Macmillan Company, 1956.

Kelm, 1968
Kelm (Heinz), *Kunst von Sepik*, vol. III, Berlin, Museum für Völkerkunde, 1968.

Kerchache, 1967
Kerchache (Jacques), *Le M'boueti des Mahongoué, Gabon* (text by Claude Roy), Paris, Jacques Kerchache, 1967.

Kerchache, 1971
Kerchache (Jacques), *Iles Tabar, Océanie*, Paris, 1971.

Kerchache, 1984
Kerchache (Jacques), "La collection Magnelli", *CNAC Magazine*, no. 22, July-August 1984, p. 8-10.

Kerchache (ed.), 1994
Kerchache (Jacques) [ed.], *L'Art des sculpteurs taïnos – Chefs-d'œuvre des Grandes Antilles précolombiennes*, Paris, Paris-Musées, 1994.

Kerchache, Paudrat and Stéphan, 1988
Kerchache (Jacques), Paudrat (Jean-Louis), Stéphan (Lucien), *L'Art africain*, Paris, Mazenod, 1988.

Kerr, 1989
Kerr (Justin), *The Maya Vase Book*, vol. I, New York, 1989.

King, 1992
King (Jonathan), "Surrealism, Structuralism and the French Collecting of American Ethnography", *Matisse, The Inuit Face*, London, Cultural Center Canadian High Commission, 1992.

Kingsborough, 1831-48
Kingsborough (Edward King), *Antiquities of Mexico, Comprising Facsimiles of Ancient Mexican Paintings and Hieroplyphics*, London, Robert Haveland Colnaghi, Son and Co., 1831-48.

Kjersmeier, 1935-38
Kjersmeier (Carl), *Centres de style de la sculpture nègre africaine*, 4 vols., Paris/Copenhagen, 1935-38.

Kleiweg de Zwaan, 1913
Kleiweg de Zwaan (J.P.), *Die Insel Nias bei Sumatra*, 3 vols., The Hague, 1913.

Klopper, 1991
Klopper (Sandra), "'Zulu' Headrests and Figurative Carvings: the Brenthurst Collection and the Art of South-East Africa", *Art and Ambiguity*, Johannesburg, Johannesburg Art Gallery, 1991.

Koch (C.W.H.), 1913
Koch (Carl W.H.), "Die Stämme des Bezirks Molundu", *Baessler-Archiv*, no. 3, Berlin, 1913, p. 257-312.

Koch (G.), 1971
Koch (Gerd), *Materielle Kultur der Santa Cruz-Inseln, Unter besonderer Berücksichtigung der Riff-Inseln*, Berlin, Museum für Völkerkunde, 1971.

Kohzad, 1948
Kohzad (A.), "La statuaire au Nuristan et le travail du bois", *Afghanistan*, 1948.

Koppers (dir.), 1928
Koppers (W.) [ed.], *Festschrift – Publication d'hommage offerte au Pr. W. Schmidt*, Vienna, 1928.

Kouwenhoven, 1998
Kouwenhoven (Arlette P.), "L'art funéraire de Madagascar", *Tribal Arts – Le Monde de l'art tribal*, no. 19, autumn-winter 1998, p. 72-82.

Krauss, 1984
Krauss (Rosalind), "Giacometti", in *"Primitivism" in 20th Century Art*, New York, The Museum of Modern Art, 1984, p. 99-122.

Krämer, 1925
Krämer (Augustin), *Die Malanggane von Tombara*, Munich, 1925.

Krämer, 1927
Krämer (Augustin), "Tombarisisches, Ältes und Neues", *Anthropos*, vol. XXII, 1927, p. 803-810.

Krämer-Bannow, 1916
Krämer-Bannow (Elisabeth), *Bei Kunstsinnigen Kannibalen der Südsee: Wanderungen auf Neu-Mecklenburg 1908-1909*, Berlin, 1916.

Krieger, 1965-69
Krieger (Kurt), *West Afrikanische plastik*, Berlin, Museum für Völkerkunde; vol. I, 1965; vol. II and III, 1969.

Kubary, 1900
Kubary (J.S.), "Beitrag zur Kenntnis der Nukuoro – oder Monteverd Inseln", *Mitteilungen der Geographischen Gesellschaft in Hamburg*, vol. XVI, 1900.

Küchler, 1985
Küchler (Susanne), *Malanggan: Exchange and Regional Integration in Northern New Ireland*, thesis, London School of Economics, 1985.

Küchler, 1987
Küchler (Susanne), "Malanga: art and memory in a Melanesian society", *Man*, vol. 22 (new series), 1987, p. 238-255.

Küchler, 1988
Küchler (Susanne), "Malangan: Objects, Sacrifice and the Production of Memory", *American Ethnologist*, vol. 15 (4), 1988, p. 625-637.

Küchler, 1992
Küchler (Susanne), "Making Skins: Malangan and the Idiom of Kinship in Northern New Ireland", in *Coote and Shelton (eds.), 1992, p. 94-112.

Kultur der Baule, **1997**
Die Kultur der Baule – Fotodokumentation an der Elfenbeinküste 1933-1935 von Hans Himmelheber mit Martin Lippmann, Zurich, Museum Rietberg, 1997.

Kunst der Dogon, **1995**
Die Kunst der Dogon, Zurich, Museum Rietberg, 1995.

Kupka, 1972
Kupka (Karel), *Peintres aborigènes d'Australie*, Paris, Société des Océanistes, 1972.

L

Labouret, 1923
Labouret (Henri), "Langage tambouriné et sifflé", *Bulletin du comité d'études historiques et scientifiques de l'Afrique-Occidentale française*, Dakar, January-February 1923, p. 120-158.

Labouret, 1934-35
Labouret (Henri), "La divination par les souris en Côte d'Ivoire", Paris, *Bulletin du musée d'Ethnographie du Trocadéro*, no. 8, 1934-35, p. 4-11.

Laburthe-Tolra, 1985
Laburthe-Tolra (Philippe), *Initiations et sociétés secrètes au Cameroun (Essai sur la religion beti)*, Paris, Karthala, 1985.

Laburthe-Tolra, 1991
Laburthe-Tolra (Philippe), "Des fragments du ciel aux cultes du mal", in *Fang, 1991, p. 11-79.

Lafaye, 1974
Lafaye (Jacques), *Quetzalcoatl et Guadalupe*, Paris, Gallimard, 1974.

La Fizeliere, 1873
La Fizeliere (A. de), *L'Œuvre originale de Vivant-Denon. Collection de 317 eaux-fortes dessinées et gravées par le célèbre artiste avec une notice très détaillée sur sa vie intime, ses relations et son œuvre*, vol. 1., Paris, A. Barraud, 1873.

Laman, 1936
Laman (Karl), *Dictionnaire ki-kongo/français*, vol. I, 1936.

Laman, 1953
Laman (Karl), *The Kongo*, vol. I, Uppsala, Studia Ethnographica Uppsaliensia, 1953.

Lamb and Holmes, 1980
Lamb (V.), Holmes (J.), *Nigerian Weaving*, Oxford, 1980.

Lambrecht, 1932
Lambrecht (Francis), "The Mayawyaw Ritual. Rice and Rice Ritual", *Publications of the Catholic Anthropological Conference*, vol. IV, no. 1, Washington, 1932, p. 1-167.

Lambrecht, 1939
Lambrecht (Francis), "The Mayawyaw Ritual. Property and Property Ritual", *Publications of the Catholic Anthropological Conference*, vol. IV, no. 4, Washington, 1939, p. 495-711.

Lambrecht, 1941
Lambrecht (Francis), "The Mayawyaw Ritual. Go-betweens and Priests", *Publications of the Catholic Antropological Conference*, vol. IV, no. 5, Washington, 1941, p. 713-754.

Lambrecht, 1971
Lambrecht (Francis), "The Main Factors of Resistance to Culture Change in Ifugaoland", in *Gowing and Scott, 1971, p. 83-155.

Lamp, 1992
Lamp (Frederick), *La Guinée et ses héritages culturels*, Conakry, Usis, 1992.

Lamp, 1996
Lamp (Frederick), *Art of the Baga: A Drama of Cultural Reinvention*, New York, The Museum for African Art/Munich, Prestel Verlag, 1996.

Langlois, 1954
Langlois (Pierre), *Art soudanais, tribus dogons*, Brussels, Éditions de la Connaissance/Lille, Librairie Marcel Evrard, 1954.

Laniel-Le François, Pierre and Camacho, 1992
Laniel-Le François (M.-E.), Pierre (José), Camacho (Jorge), *Kachina des Indiens hopi*, Saint-Vit, Éditions Amez, 1992.

Lapelin, 1872
Lapelin (F.T. de), "L'île de Pâques (Rapa Nui)", *Revue maritime et coloniale*, vol. 35, November 1872, p. 105-125, December 1872, p. 526-544.

Laroche, 1962
Laroche (M.C.), "Vente de la collection Korrigane", *Journal de la Société des océanistes*, no. 18, 1962.

Laude, 1964a
Laude (Jean), "La statuaire du pays dogon: une approche esthétique", *Revue d'esthétique*, vol. XVII, fasc. 1 and 2, 1964, p. 46-68.

Laude, 1964b
Laude (Jean), *La Statuaire du pays dogon, contribution à l'esthétique des arts soudanais*, doctoral thesis, Paris, 1964.

Laude, 1966
Laude (Jean), *Les Arts de l'Afrique noire*, Paris, Librairie Générale Française, Le Livre de Poche, 1966 (reprint. 1990).

Laude, 1968
Laude (Jean), *La Peinture française (1905-1914) et l'"art nègre" (Contribution à l'étude des sources du fauvisme et du cubisme)*, Paris, Klincksieck, 1968.

Laude, 1973
Laude (Jean), *African Art of the Dogon. The Myths of the Cliff Dwellers*, New York, The Brooklyn Museum/The Viking Press, 1973.

Laude, 1988
Laude (Jean), *Les Arts de l'Afrique noire*, Paris, Chêne, 1988.

Laude, 1994
Laude (Jean), "Le sens de la forme, une approche des arts dogon", in *Dogon, 1994, p. 169-218, p. 253-256.

Laurencich Minelli (ed.), 1983
Laurencich Minelli (Laura) [ed.], "American Objects – 16th-18th centuries – in European Collections", *Archivio per l'Antropologia e la Etnologia*, vol. CXIII, Florence, 1983, p. 109-247.

Laurencich Minelli, 1989
Laurencich Minelli (Laura), "Atti del Simposio collezionismo americanista durante il 19-20 secolo: tradizioni, proposte ed investigazioni", *Museologia scientifica*, nos. 1-4, Milan, 1989, p. 69-320.

Lavachery, 1935
Lavachery (H.), *Ile de Pâques*, Paris, Grasset, 1935.

Lavachery, 1942
Lavachery (H.), *La Statuaire en bois de l'île de Pâques*, ms., Brussels, Musées Royaux d'Art et d'Histoire, 1942.

Lavachery, 1995
Lavachery (H.), *Ile de Pâques 1934-1935. Expédition Métraux-Lavachery*, Belgium, Buch, 1995.

Laval, 1938
Laval (R.P.), *Mangareva. L'histoire ancienne d'un peuple polynésien*, Braine-le-Comte, Maison des Pères des Sacrés-Cœurs, 1938.

Laval, 1968
Laval (R.P.), *Mémoires pour servir à l'histoire de Mangareva, ère chrétienne 1834-1871*, Paris, Société des Océanistes, 1968.

Lavondès, 1986
Lavondès (Anne), "Les collections ethnographiques polynésiennes dans les musées français", *Nouvelles des musées classés et contrôlés*, Paris, Direction des Musées de France, 1986, p. 5-26.

Lavondès, 1990
Lavondès (Anne), *Vitrine des objets océaniens. Inventaire des collections du Muséum de Grenoble. Cultures matérielles et histoire dans le Pacifique au XIXe siècle*, Grenoble, Orstom/Mission Musées, 1990.

Lavondès and Jacquemin, 1995
Lavondès (Anne) and Jacquemin (Sylviane), "Des premiers écrits aux collections d'objets", in *Panoff (dir.), *Trésors des îles Marquises*, Paris, Musée de l'Homme/Orstom/RMN, 1995, p. 26-30.

Lawal, 1985
Lawal (Babatunde), "Ori: The Significance of the Head in Yoruba Sculpture", *Journal of Anthropological Research*, vol. XLI (1), 1985.

Layard, 1942
Layard (John), *Stone Men of Malekula, Vao*, London, Chatto and Windus, 1942.

Laycock, 1973
Laycock (Don C.), "Sepik Languages. Checklist and Preliminary Classification", *Pacific Linguistics*, B series, no. 25, Canberra, The Australian National University, 1973.

Lebar, 1972
Lebar (Frank M.), *Ethnic Groups of Insular Southeast Asia*, 2 vols., New Haven, Human Relations Files Press, 1972.

Leblond, 1924
Leblond (Marius-Ary), *Ulysse, cafre, ou l'histoire dorée d'un Noir*, Paris, Éditions de France, 1924.

Le Cleach, 1997
Le Cleach (Hervé), *Pona Tekao Tapapa 'Ia – Lexique Marquisien-Français*, Papeete, STP Multipress, 1997.

Lee, 1992
Lee (G.), "The Rock Art of Easter Island", *Monumenta Archaeologica* 17, Los Angeles, The Institute of Archaeology, UCLA, 1992.

Leenhardt, 1930
Leenhardt (Maurice), *Notes d'ethnologie néo-calédonienne*, Travaux et mémoires de l'Institut d'ethnologie, vol. VIII, Paris, Institut d'Ethnologie, 1930.

Leenhardt, 1937
Leenhardt (Maurice), *Gens de la Grande Terre*, Paris, Gallimard, 1937.

Leenhardt, 1947
Leenhardt (Maurice), *Arts de l'Océanie*, Paris, Chêne, 1947.

Legs Pierre Harter, **1993**
Legs Pierre Harter – Les rois sculpteurs. Art et pouvoir dans le Grassland camerounais, Paris, RMN, 1993.

Lehmann, 1935
Lehmann (Henri), "Le fonds maya du musée d'Ethnographie du Trocadéro de Paris", *Maya Research*, vol. II, no. 4, New York, October 1935, p. 345-366.

Lehmann, 1951
Lehmann (Henri), "Un 'duho' de la civilisation taïno au musée de l'Homme", *Journal de la Société des américanistes*, vol. XL, Paris, 1951, p. 153-161.

Lehmann, 1960
Lehmann (Henri), *L'Art précolombien*, Paris, C. Massin, 1960.

Lehuard, 1974a
Lehuard (Raoul), "La collection Maurice Ratton", *Arts d'Afrique noire*, no. 9, spring 1974, p. 8-17.

Lehuard, 1974b
Lehuard (Raoul), *Statuaire du Stanley Pool*, Villiers-le-Bel, Arts d'Afrique Noire, 1974.

Lehuard, 1980
Lehuard (Raoul), *Fétiches à clous du Bas-Zaïre*, Arnouville, Arts d'Afrique Noire, 1980.

Lehuard, 1986
Lehuard (Raoul), "Charles Ratton et l'aventure de l'art nègre", *Arts d'Afrique noire*, no. 60, winter 1986, p. 11-33.

Lehuard, 1993
Lehuard (Raoul), *Art bakongo: les masques*, Arnouville, Arts d'Afrique Noire, 1993.

Lehuard, 1996
Lehuard (Raoul), *Les Arts batéké*, Arnouville, Arts d'Afrique Noire, 1996.

Lehuard, 1998
Lehuard (Raoul), *Art bakongo: insigne de pouvoir, le sceptre*, Arnouville, Arts d'Afrique Noire, 1998.

Leiris, 1934a
Leiris (Michel), *L'Afrique fantôme*, Paris, Gallimard, 1934.

Leiris, 1934b
Leiris (Michel), "L'activité du département d'Afrique du musée d'Ethnographie en 1934", *Journal de la Société des africanistes*, vol. IV, fasc. 2, 1934, p. 325-326.

Leiris, 1936
Leiris (Michel), "Bois rituels des falaises", *Cahiers d'art*, vol. XI, no. 6-7, 1936, p. 192-199.

Leiris, 1938
Leiris (Michel), "Du musée d'Ethnographie au musée de l'Homme", *La Nouvelle Revue française*, no. 299, August 1938, p. 344-345.

Leiris, 1953
Leiris (Michel), "Les nègres

d'Afrique et les arts sculpturaux", *L'Originalité des cultures*, Paris, Unesco, 1953.

Leiris and Damase, 1959
Leiris (Michel) and Damase (Jacques), *Sculpture of the Tellem and the Dogon*, London, Hanover Gallery, 1959.

Leiris and Delange, 1967
Leiris (Michel) and Delange (Jacqueline), *Afrique noire – La création plastique*, Paris, Gallimard, 1967.

Leloup, 1988
Leloup (Hélène), "Dogon Figure Styles", *African Arts*, vol. XXII, no. 1, November 1988, p. 44-51, p. 98-99.

Leloup, 1994
Leloup (Hélène), *Statuaire dogon*, Strasbourg, Amez, 1994.

Leloup, 1998
Leloup (Hélène), notices des œuvres in *Dogon-Meisterwerke der Skulptur – Chefs-d'œuvre de la statuaire dogon*, Stuttgart, Galerie der Stadt, 1998.

Lemonick, 1998
Lemonick (Michael D.), "City of the Gods", *The Times*, 21 December 1998.

Lerouge, 1911-1912
Lerouge (Raymond), *Carnets de route des tournées pastorales*, vol. I (1911-1912), Archives of the congregation of the Pères du Saint-Esprit, Fonds Bernier, box 269 B.

Lesson, 1838-1839
Lesson (René Primevère), *Voyage autour du monde entrepris par ordre du Gouvernement sur la corvette "La Coquille"*, vols. 1 and 2, Paris, P. Pourrat Frères, 1838-1839.

Lestringant, 1991
Lestringant (Frank), *L'Atelier du cosmographe ou l'image du monde à la Renaissance*, Paris, Albin Michel, 1991.

Leuzinger, 1959
Leuzinger (Elsy), *Afrika Kunst der Negervölker*, Baden-Baden, Holle und Co Verlag, 1959.

Leuzinger, 1962
Leuzinger (Elsy), *L'Art des peuples noirs*, Paris, Albin Michel, 1962.

Leuzinger, 1970
Leuzinger (Elsy), *Die Kunst von Schwarz-Afrika*, Kunsthaus Zurich, Recklinghausen, Verlag Aurel Bongers, 1970.

Leuzinger, 1971
Leuzinger (Elsy), *Afrikanische Kunstwerke Kulturen am Niger*, Villa Hügel Essen, Recklinghausen, Verlag Aurel Bongers, 1971.

Leuzinger, 1972
Leuzinger (Elsy), *The Art of Black Africa*, London, Studio Vista, 1972.

Leuzinger, 1978
Leuzinger (Elsy), *Afrikanische Skulpturen-African Sculptures*, Zurich, Museum Rietberg, 1978.

Leuzinger (ed.), 1978
Leuzinger (Elsy) [ed.], *Propyläen Kunstgeschichte. Kunst der Naturvölker*, Frankfurt am Main/Berlin/Vienna, Propyläen Verlag, 1978.

Level, 1959
Level (André), *Souvenirs d'un collectionneur*, Paris, Alain C. Mazo, 1959.

Lévine, 1992
Lévine (Daniel), "Les Américains de la première rencontre", *Amérique, continent imprévu*, Paris, Bordas, 1992, p. 28-54.

Lévine (ed.), 1992
Lévine (Daniel) [ed.], *Americas Lost 1492-1713. The First Encounter*, Milan, Bordas, 1992.

Lévi-Strauss, 1943
Lévi-Strauss (Claude), "The Art of the Northwest Coast at the American Museum of Natural History", *La Gazette des beaux-arts*, 1943.

Lévi-Strauss, 1944-45
Lévi-Strauss (Claude), "Le dédoublement de la représentation dans les arts de l'Asie et de l'Amérique", *Renaissance*, vol. II-III, École Libre des Hautes Études de New York, 1944-45, p. 168-186, reprinted in *Lévi-Strauss, 1958, p. 269-299.

Lévi-Strauss, 1958
Lévi-Strauss (Claude), *Anthropologie structurale*, Paris, Plon, 1958, p. 269-299.

Lévi-Strauss, 1975
Lévi-Strauss (Claude), *La Voie des masques*, vols. 1 and 2, Geneva, Albert Skira, 1975.

Lévi-Strauss, 1977
Lévi-Strauss (Claude), "New York post- et préfiguratif", *Paris-New York*, Paris, Centre Georges Pompidou, 1977, p. 79-83.

Lévi-Strauss, 1979
Lévi-Strauss (Claude), *La Voie des masques*, revised and enlarged edition, Paris, Plon, 1979.

Lévi-Strauss, 1983
Lévi-Strauss (Claude), *Le Regard éloigné*, Paris, Plon, 1983.

Lévi-Strauss, 1989
Lévi-Strauss (Claude), *Des symboles et leurs doubles*, Paris, Plon, 1989.

Lévi-Strauss and Éribon, 1988
Lévi-Strauss (Claude), Éribon (Didier), *De près et de loin*, Paris, Éditions Odile Jacob, 1988.

Lewis, 1961
Lewis (Phillip H.), "The Artist in New Ireland Society", in *Smith (M.W.) [ed.], 1961.

Lewis, 1964
Lewis (Phillip H.), "A Sculptured figure with a modelled skull from New Ireland", *Man*, vol. LXIV (176), 1964, p. 133-136.

Lewis, 1969
Lewis (Phillip H.), *The Social Context of Art in Northern New Ireland*, Chicago, Field Museum of Natural History, 1969.

Lewis, 1973
Lewis (Phillip H.), "Changing Memorial Ceremony in Northern New Ireland", *Journal of the Polynesian Society*, vol. LXXXII (2), 1973, p. 141-153.

Lewis, 1975
Lewis (Phillip H.), "Notes on a Friction Drum Collected at Amba, New Ireland, in 1970", *Abhandhingen und Berichte Staatlichen Museums für Völkerkunde*, vol. XXXIV, 1975, p. 581-592.

Lewis, 1979
Lewis (Phillip H.), "Art in Changing New Ireland", in *Mead (ed.), 1979, p. 378-391.

Lincoln, 1987
Lincoln (Louise), "Art and Money in New Ireland: History, Economy and Cultural Production", in Lincoln (ed.), 1987.

Lincoln (ed.), 1987
Lincoln (Louise) [ed.], *An Assemblage of Spirits: Idea and Image in New Ireland*, New York, George Braziller, 1987.

Ling Roth, 1903
Ling Roth (H.), *Great Benin, its Customs, Art and Horrors*, Halifax, 1903.

Linné, 1934
Linné (Sigvald), *Archeological Researches at Teotihuacan, Mexico*, vol. I, Stockholm, Ethnographical Museum of Sweden, 1934.

Linné and Montell, 1947
Linné (Sigvald) and Montell (G.), *Primitiv Konst*, Stockholm, Statens Ethnografiska Museum, 1947.

Linton, 1923
Linton (Ralph), "The Material Culture of the Marquesas Islands", *Memoirs of the Bernice P. Bishop Museum*, vol. VIII, no. 5, Honolulu, 1923.

Lionnet, 1984
Lionnet (André), "L'apport linguistique d'Alphonse Pinart", *Amerindia 6*, 1984, p. 273-281.

Litvinsky, 1996
Litvinsky (B.A.), "Languages, Literature, Coinage, Architecture and Art", *History of Civilizations of Central Asia*, vol. III, Paris, Unesco, 1996.

Llamzon, 1978
Llamzon (Teodoro A.), *Handbook of Philippine Language Groups*, Quezon City, Ateneo de Manila University Press, 1978.

Löffel in der Kunst Afrikas, 1990
Löffel in der Kunst Afrikas, Zurich, Museum Rietberg, 1990.

Lomas, 1979
Lomas Peter, "Malanggans and Manipulators: Land and Politics in Northern New Ireland", *Oceania*, vol. L (1), 1979, p. 53-66.

Lommel, 1966
Lommel (Andreas), *Prehistoric and Primitive Man, Landmarks of the World's Art*, London, 1966.

Longpérier, 1850
Longpérier (Adrien de), *Notice des monuments exposés dans la salle des Antiquités américaines (Mexique et Pérou) au musée du Louvre*, Paris, Vinchon, 1850.

Longpérier, 1852
Longpérier (Adrien de), *Notice des monuments exposés dans la salle des Antiquités américaines (Mexique, Pérou, Chili, Haïti, Antilles) au musée du Louvre*, Paris, Vinchon, 1852.

Lopez Austin, 1973
Lopez Austin (Alfredo), *Hombre-dios religión y política en el mundo nahuatl*, Mexico City, UNAM, 1973.

Lopez Lujan, 1989
Lopez Lujan (Leonardo), *La recuperacion mexica del pasado teotihuacano*, Mexico City, INAH, 1989.

Lopez Portillo, Sodi and Díaz Infante, 1977
Lopez Portillo (José), Sodi (Demetrio), Díaz Infante (Fernando), *Quetzalcoatl*, Mexico City, Secretaria de Asentamientos Humanos y Obras Publicas, 1977.

Lortet and Gaillard, 1909
Lortet (Charles), Gaillard (Claude), *La Faune momifiée de l'Ancienne Égypte – Recherches anthropologiques*, Archives du Muséum d'Histoire Naturelle de Lyon, vol. 10, 1909.

Lot-Falck, 1957
Lot-Falck (Éveline), "Les masques eskimo et aléoutes de la collection Pinart", *Journal de la Société des américanistes*, vol. XLVI, 1957, p. 5-43.

Lot-Falck, 1960
Lot-Falck (Éveline), "Les masques sibériens, aléoutes et eskimo", in *Lot-Falck et al., 1960, p. 9-20.

Lot-Falck et al., 1960
Lot-Falck (Éveline) et al., *Le Masque*, Paris, Musée Guimet, 1960.

Lothrop, 1959
Lothrop (S.K.), *Robert Woods Bliss Collection – Pre-Columbian Art*, London, Phaidon Press, 1959.

Luckert, 1976
Luckert (Karl W.), *Olmec Religion*, Norman University of Oklahma Press, 1976.

***Lumière noire, arts traditionnels*, 1997**
Lumière noire, arts traditionnels, Tanlay, Centre d'Art, 1997.

Luquet, 1933
Luquet (G.H.), "L'art Nègre", *L'art des origines à nos jours*, vol. 2, Paris, Larousse, 1933, p. 417-423.

Luquiens, 1931
Luquiens (Huc Mazelet), *Hawaiian Art*, Honolulu, Bernice P. Bishop Museum, 1931.

Luschan, 1919
Luschan (Felix von), *Die Altertümer von Benin*, Berlin/Leipzig, 1919.

M

Mabuchi, 1954
Mabuchi (Toichi), "Migration and Distribution of the Formosan Aborigines", *Japanese Journal of Ethnology*, vol. XVIII, nos. 1-2 and 1-4, 1954 (in Japanese).

Macgaffey, 1993
Macgaffey (Wyatt), "The Eyes of Understanding: Kongo Minkisi", *Astonishment and Power*, Washington, National Museum of African Art, 1993.

Mack (ed.), 1994
Mack (John) [ed.], *Masks. The Art of Expression*, London, British Museum Press, 1994.

***Madagascar, arts de la vie et de la survie*, 1989**
Madagascar, arts de la vie et de la survie, Paris, ADEIAO, 1989.

***Magies*, 1996**
Magies, Paris, Musée Dapper, 1996.

Maher, 1973
Maher (Robert F.), "Archeological Investigations in Central Ifugao", *Asian Perspectives. Bulletin of the Far Eastern Prehistory Association*, vol. XVI, no. 1, Honolulu, 1973, p. 39-70.

***Malespina Expedition*, 1977**
The Malespina Expedition. "In the Pursuit of Knowledge", Santa Fe, Museum of New Mexico Press, 1977.

Malin, 1978
Malin (Edward), *A World of Faces. Masks of the Northwest Coast*, Portland, Timber Press, 1978.

Malo, 1951
Malo (David), *Hawaiian Antiquities*,

Honolulu, Bernice P. Bishop
Museum, 1951.

Malraux, 1952
Malraux (André), *Le Musée
imaginaire de la sculpture mondiale*,
Paris, Galerie de la Pléiade,
vol. I, 1952.

Malraux, 1954
Malraux (André), *Le Musée
imaginaire de la sculpture mondiale.
Des bas-reliefs aux grottes sacrées*,
Paris, Galerie de la Pléiade,
vol. II, 1954.

Malraux, 1957
Malraux (André), *La Métamorphose
des dieux*, Paris, Galerie de la
Pléiade, 1957.

Malraux, 1976
Malraux (André), *L'Intemporel*, Paris,
Gallimard, 1976.

Manzanilla and Lopez Lujan, 1994
Manzanilla (Linda), Lopez Lujan
(Leonardo) [eds.], *Historia antigua
de México*, 3 vols., Mexico City,
INAH/UNAM, 1994.

Maquet, 1962
Maquet (Jacques), *Afrique,
les civilisations noires*, Paris,
Horizons de France, 1962.

Marin, 1989
Marin (Françoise), "La collection
africaine d'Alberto Magnelli",
Magnelli, Paris, Centre Georges
Pompidou/ADAGP, 1989, p. 164-169.

Markov, 1919
Markov (Vladimir), *Iskusstvo negrov*,
Saint Petersburg, 1919 (partial
French trans. by Jacqueline and
Jean-Louis Paudrat, "L'art des
nègres", *Cahiers du Musée National
d'Art Moderne*, no. 2, October-
December 1979, p. 316-327).

Marquina, 1951
Marquina (Ignacio), *Arquitectura
prehispanica*, Mexico City, INAH,
1951.

Martinelli, 1995
Martinelli (Bruno), "Trames
d'appartenances et chaînes
d'identité. Entre Dogons
et *Moose* dans le Yatenga
et la plaine du Séno (Burkina
Faso et Mali)", *Cahiers des sciences
humaines*, vol. XXXI, no. 2, Paris,
Orstom, 1995, p. 365-405.

Masques, 1995
Masques, Paris, Musée Dapper, 1995.

Mateos Higuera, 1993
Mateos Higuera (Salvador), "Dioses
Creadores", *Enciclopedia Grafica del
México Antiguo*, vol. II, Mexico City,
1993.

**Masterpieces of the People's Republic
of the Congo, 1980**
*Masterpieces of the People's Republic
of the Congo*, New York, The African-
American Institute, 1980.

Maternité dans les arts premiers, 1977
La Maternité dans les arts premiers,
Brussels, Société Générale
de Banque, 1977.

Matos Moctezuma, 1992
Matos Moctezuma (Eduardo),
"The Aztecs", in *Lévine (ed.), 1992.

Matos Moctezuma, 1994
Matos Moctezuma (Eduardo),
"Los Mexicas... y llegaron los
Españoles...", *Mexico en el mundo de
las colecciones de arte, Mesoamerica 2*,
Mexico City, Editorial Azabache,
1994, p. 178-243.

Mauss, 1995
Mauss (Marcel), "Essai sur le don.
Forme et raisons de l'échange dans

les sociétés archaïques", *Sociologie
et anthropologie*, Paris, PUF, 1995
(1st édition, 1950).

Mauzé, 1994
Mauzé (Marie), "Le tambour d'eau
des castors. L'art de la côte nord-
ouest et le surréalisme", *Arts
d'Afrique noire*, no. 89, spring 1994,
p. 35-45.

Mauzé, 1999
Mauzé (Marie), "L'éclat de l'halio-
tide. De la conception du beau dans
les sociétés de la côte nord-ouest",
Terrain, no. 32, 1999, p. 83-98.

Mayer, 1953
Mayer (Brantz), *México lo que fue
y lo que es*, México, Fondo de
Cultura Economica, 1953.

McCall and Bay, 1975
McCall (D.F.), Bay (E.G.), *African
Images: Essays in African Iconology*,
New York, 1975.

Mead, 1973
Mead (Sidney Moko), "Material
Culture and Art in the Star Harbour
Region, Eastern Solomon Islands",
Ethnography Monograph I, Royal
Ontario Museum/Toronto,
University of Toronto, 1973.

Mead (ed.), 1979
Mead (Sidney Moko) [ed.], *Exploring
the Visual Art of Oceania*, Honolulu,
University of Hawaii Press, 1979.

Mead and Kernot (ed.), 1983
Mead (Sidney Moko) and Kernot (B.)
[dir.], *Art and Artists of Oceania*,
Palmerston North, The Dunmore
Press, 1983.

Meauzé, 1974
Meauzé (Pierre), *L'Art nègre.
Sculpture*, Paris, Hachette, 1967.

Meauzé, 1967
Meauzé (Pierre), "Un chef-d'œuvre
inédit de la sculpture africaine",
*La Revue du Louvre et des musées de
France*, 1974, no. 3, p. 205-206.

Mekten, 1991
Mekten (Sigrid), "'Dix mille Peaux-
Rouges'. Max Ernst chez les Indiens
d'Amérique du Nord", in *Spies
(ed.), 1991, p. 357-362.

Melzian, 1937
Melzian (Hans), *A Concise Dictionary
of the Bini Language of Southern
Nigeria*, London, Kegan Paul,
Trench, Trubner & Co., Ltd., 1937.

Mensignac, 1889
Mensignac (C. de), [refers to
the piece from the Banks Islands
at the Musée d'Aquitaine,
Bordeaux, inv. 13.162], *Bulletin
de la Société d'anthropologie
de Bordeaux et du Sud-Ouest*,
vol. III, 1889, p. 72-73.

Menuge-Wacrenier, 1994
Menuge-Wacrenier (Raymonde),
"Qui était donc Alphonse-Louis
Pinart?", *Bononia*, no. 25, 1994,
p. 27-32.

Méry, 1867
Méry (J.), "Notes sur l'île Rapa",
Messager de Tahiti, Papeete,
14-21 September/19 October 1867.

Messages in Stone, 1998
*Messages in Stone, Statues and
Sculptures from Tribal Indonesia
in the Collections of the Barbier-Mueller
Museum*, Geneva, Musée Barbier-
Mueller/Milan, Skira, 1998.

Messagi du pietra, 1998
*Messagi di pietra, Sculture in pietra
dell'Indonesia dalle collezioni del museo
Barbier-Mueller*, Geneva, Musée
Barbier-Mueller/Milan, Skira, 1998.

Messner, 1980
Messner (Gerald Florian), "Sind
die auf Neu-Irland verwendeten
Zeichen und Symbole
Ideogramme?", *Wiener
Völkerkundliche Mitteilungen*,
vol. XXI-XXII, 1980, p. 49-52.

Messner, 1983
Messner (Gerald Florian),
"The Friction Block Lounuat
of New Ireland: Its Use and Socio-
cultural Embodiment", *Bikmaus*,
vol. IV (3), 1983, p. 48-55.

Mestach, 1985
Mestach (Jean Willy), *Études songyé.
Formes et symbolique – Essai
d'analyse*, Munich, Galerie Jahn,
1985.

Métraux, 1940
Métraux (Alfred), "Ethnology
of Easter Island", *Bernice P. Bishop
Museum Bulletin*, no. 160, Honolulu,
1940 (reprint. 1971).

Métraux, 1941
Métraux (Alfred), *Ile de Pâques*, Paris,
Gallimard, "L'Espèce humaine",
1941.

Meyer (A.B.), 1889
Meyer (A.B.), *Masken von Neu Guinea
und dem Bismarck Archipel*, Dresde,
Königlichen ethnographischen
Museum, 1889, vol. VII.

Meyer (A.B.) and Parkinson, 1895
Meyer (A.B.), Parkinson (Richard),
*Schnitzereien und Masken vom
Bismarck-Archipel und Neu-Guinea*,
Dresde, Königliches ethno-
graphisches Museum,
vol. X, 1895.

Meyer (A.J.P.), 1995
Meyer (Antony J.P.), *Art océanien*,
Paris, Gründ, 1995.

Meyer (L.), 1991
Meyer (Laure), *Afrique noire.
Masques, Sculptures, Bijoux*, Paris,
Pierre Terrail, 1991.

Meyer (P.), 1981
Meyer (Piet), *Kunst und Religion
der Lobi*, Zurich, Museum Rietberg,
1981.

Mexique terre des dieux, 1998
*Mexique terre des dieux, Trésors
de l'art précolombien*, Geneva,
Musée d'Art et d'Histoire, 1998.

Midant-Reynes, 1992
Midant-Reynes (Béatrice),
*Préhistoire de l'Égypte. Des premiers
hommes aux premiers pharaons*,
Paris, Armand Colin, 1992.

Migeod, 1923
Migeod (F.W.H.), *Across Equatorial
Africa*, London, Heath Cranton,
1923.

Mikloucho-Mackay, 1990
Mikloucho-Mackay (N.N. von),
Sobranijé Sotchinenij, [1905-54],
5 vols., Leningrad, 1990
(revised ed.).

Millerstrom and Edwards, 1998
Millerstrom (Sidsel), Edwards
(Edmundo), "Stone Sculptures
of the Marquesas Islands (French
Polynesia)", in *Stevenson, Lee
and Morin (eds.), 1998.

Millon, 1973
Millon (René), *Urbanization
at Teotihuacan, Mexico*, vol. 1,
The Teotihuacan Map, Austin,
University of Texas Press, 1973.

**Mission Cottes au Sud-Cameroun
(1905-1908), 1911**
*La Mission Cottes au Sud-Cameroun
(1905-1908)*, Paris, Ernest Leroux,
1911.

Modigliani, 1890
Modigliani (Elio), *Un viaggio a Nias*,
Milano, Fratelli Treves, 1890.

Modigliani, 1892
Modigliani (Elio), *Fra i Batacchi
indipendenti*, Roma, Società
Geografica Italiana, 1892.

Mole, 1970
Mole (R.L.), *The Montagnards
of South Vietnam. A Study of Shine
Tribes*, Rutlands, 1970.

Mongne, 1998
Mongne (Pascal), *Américanisme et
muséologie: les collections américaines
dans les musées de France*, report
given to the Direction des Musées
de France, Paris, 1998.

Montebello, 1981
Montebello (Philippe de),
"Foreword", *For Spirits and Kings –
African Art from the Tishman
Collection*, New York, The
Metropolitan Museum of Art,
1981, p. 5.

Moore, 1997
Moore (Robert), *Les Indiens
d'Amérique. Œuvres et voyages
de Charles Bird King, George Catlin,
Karl Bodmer*, Paris, Herscher, 1997.

Morgenstierne, 1944-73
Morgenstierne (G.), *Indo-Iranian
Frontier Languages*, Oslo, vol. III-2,
1944, vol. III-3, 1967, vol. IV, 1973.

Mota, 1972
Mota (Avelino Teixeira da),
"Mar além-mar, estudos e ensaios
de história e geographica", vol. I,
Lisbon, JIU, 1972.

Mouly, 1938
Mouly (R.P.), *Cannibales à genoux.
L'extraordinaire conversion des îles
Gambier*, Paris, Tolra, 1938.

Muensterberger, 1955
Muensterberger (Werner), *Primitieve
Kunst, uit West-en Midden-Afrika,
Indonesië, Melanesië, Polynesië en
Noordwest-Amerika*, Amsterdam,
Antwerp, Uitgeverij Contact, 1955.

Mullen, 1909
Mullen (Benjamin H.), "Fetishes
from Landan, South-West Africa",
Man, vol. V, no. 59, 1909, p. 102-104.

Murray, 1961
Murray (K.), "Benin Art", *Nigeria*,
no. 71, 1961, p. 370-378.

Musée de l'Homme, 1964
Le Musée de l'Homme,
La Documentation Française
illustrée, no. 196, Paris, April 1964.

**Musée de l'Homme en relief
par les anaglyphes, [1939]**
*Musée de l'Homme en relief par les
anaglyphes, Laboratoire d'ethnologie,
des hommes actuels et des hommes
fossiles*, Paris, Muséum National
d'Histoire Naturelle/Les Éditions
en Anaglyphes, [1939].

**Musée de l'Homme, Muséum National
d'Histoire Naturelle, 1992**
*Musée de l'Homme, Muséum National
d'Histoire Naturelle*, Paris, ODA Laser
Edition/Muséum National
d'Histoire Naturelle, 1992.

**Musée des Arts africains et océaniens,
Guide, 1987**
*Musée des Arts africains et océaniens,
Guide*, Paris, RMN, 1987.

**Musée des Colonies et de la France
extérieure, Cahier des entrées, 1933**
*Musée des Colonies et de la France
extérieure, Cahier des entrées*, 28 July-
15 November 1933, Paris, 1933.

Musée permanent des colonies, 1931
"Le Musée permanent des

Colonies", *Livre d'or de l'Exposition coloniale internationale de Paris 1931*, Paris, Librairie Ancienne Honoré Champion, 1931, p. 19-24.

Museo del Oro. Catálogo de la exposición permanente, 1994
Museo del Oro. Catálogo de la exposición permanente, Bogotá, Banco de la República, 1994.

Museo del Oro. Sus mejores piezas, 1997
Museo del Oro. Sus mejores piezas, Bogotá, Banco de la República, 1997.

Muséologie selon Georges Henri Rivière, 1989
La Muséologie selon Georges Henri Rivière, Paris, Dunod, 1989.

N

Nabokov and Easton, 1989
Nabokov (Peter), Easton (Robert), *Native Architecture*, Oxford, Oxford University Press, 1989.

Natalie Wood Collection, 1969
The Natalie Wood Collection of Pre-Columbian Ceramics from Chupícuaro, Guanajuato, México at UCLA, Los Angeles, University of California, 1969.

N'Diaye, 1995
N'Diaye (Francine), *L'Art du pays dogon dans les collections du musée de l'Homme*, Zurich, Museum Rietberg, 1995.

Needler, 1984
Needler (Winifred), *Predynastic and Archaic Egypt in the Brooklyn Museum (Wilbour Monographs IX)*, The Brooklyn Museum, 1984.

Needler, 1996
Needler (Winifred), "Six Predynastic Human Figures in the Royal Ontario Museum", *Journal of the American Research Center in Egypt*, vol. V, 1996, p. 11-17.

Nekes, 1914
Nekes (Herman), "Totemistische manistische Anschauungen der Jaunde in ihren Kultfeiern und Geheimbünden", *Koloniale Rundschau*, vol. III, p. 134-153, vol. IV, p. 207-221, Berlin, 1914.

Nelson, 1899
Nelson (Edward William), *The Eskimo about Bering Strait*, Bureau of Am. Ethn. Annual Rep. for 1896-1897, vol. XVIII (l), Washington, 1899.

Nettleton, 1988
Nettleton Anitra, "History and the Myth of Zulu Sculpture", *African Arts*, vol. XXI, no. 3, May 1988, p. 48-51, p. 86-87.

Nevadomsky
Nevadomsky (Joseph), "Kingship Succession Rituals in Benin. Part 2: The Big Things", *African Arts*, vol. XVII, no. 2, p. 41-47, p. 90-91; "Kingship Succession Rituals in Benin. Part 3: The Coronation of the Oba", *African Arts*, vol. XVII, no. 3, p. 48-57, p. 91-92.

Nevermann, 1956
Nevermann (Hans), "Tiergesichten und mythische Stammbäume aus Neumecklenburg aus dem Nachlass Augustin Krämers", *Zeitschrift für Ethnologie*, vol. LXXII, 1956, p. 11-38.

Nevermann (ed.), 1940
Nevermann (Hans) [ed.], *Zeitschrift für Ethnologie*, vol. LXXII, 1940.

Newton, 1978
Newton (Douglas), *The Nelson A. Rockefeller Collection: Masterpieces of Primitive Art*, New York, Alfred A. Knopf, 1978.

Newton, 1979
Newton (Douglas), *Chefs-d'œuvre de l'art primitif – Collection Nelson A. Rockefeller*, French trans. M.F. de Paloméra, Paris, Le Seuil, 1979.

Newton, 1997
Newton (Douglas), "Materials for a Iatmul Chronicle, Middle Sepik River (East Sepik Province, Papua New Guinea)", *Baessler-Archiv*, no. 45, 1997, p. 367-385.

Newton and Waterfield, 1995
Newton (Douglas), Waterfield (Hermione), *Tribal Sculpture*, London, Thames and Hudson, 1995.

Neyt, 1981
Neyt (François), *Arts traditionnels et histoire au Zaïre, cultures forestières et royaumes de la savane – Traditional Arts and History of Zaïre, Forest Cultures and Kingdoms of the Savannah*, Brussels, Société d'Arts Primitifs/Institut Supérieur d'Archéologie et d'Histoire de l'Art, 1981.

Neyt, 1993
Neyt (François), *Luba aux sources du Zaïre*, Paris, Musée Dapper, 1993.

Nicholson, 1971
Nicholson (Henry B.), "Religion in Pre-Hispanic Central Mexico", *Handbook of Middle American Indians*, Austin, University of Texas Press, 1971, p. 395-345.

Nicholson and Quiñones Keber, 1983
Nicholson (Henry B.), Quiñones Keber (Éloise), *Art of Aztec Mexico: Treasures of Tenochtitlan*, Washington, National Gallery of Art, 1983, p. 134-142.

Nicklin, 1981
Nicklin (Keith), "Pillages et restitution: à propos de la région de Cross River, Nigeria", *Museum*, Unesco, vol. XXXIII, no. 4, 1981, p. 259-260.

Nicklin, 1995
Nicklin (Keith), "Drum Finial: Seated Figure; Standing Figure", in Phillips (ed.), 1995, p. 370-371.

Niklaus, Bonani, Simonius, Suter and Wölfli, 1992
Niklaus (Thomas R.), Bonani (Georges), Simonius (Markus), Suter (Martin), Wölflo (Willy), "CalibETH: An Interactive Computer Program for the Calibration of Radiocarbon Dates", *Radiocarbon*, vol. XXXIV, no. 3, 1992, p. 483-492.

Nimmo, 1972
Nimmo (H. Arlo), *The Sea People of Sulu: A Study of Social Change in the Philippines*, San Francisco/Scranton/London/Toronto, Chandler Publishing, 1972.

Noll, 1984
Noll (Collette), "Paris, le musée des Arts africains", *Critica d'arte*, Africa supplement, spring 1984, p. 54-65.

Noll, 1986
Noll (Collette), "Les statues reliquaires ambété du musée des Arts africains et océaniens", in *Voie des ancêtres*, 1986, p. 66-67.

Noll, 1987
Noll (Collette), "Les arts africains", *Musée des Arts africains et océaniens, Guide*, Paris, RMN, 1987, p. 52-63.

Nooter-Roberts, 1998
Nooter-Roberts (Mary), "The Naming Game – Ideologies of Luba Artistic Identities", *African Arts*, vol. XXXI, no. 4, 1998, p. 56-73, p. 90-92.

Nooter-Roberts and Roberts, 1996
Nooter-Roberts (Mary), Roberts (Allen F.), *Memory, Luba Art and the Making of History*, Munich, Prestel Verlag/New York, The Museum for African Art, 1996.

Notué, 1993
Notué (Jean-Paul), *Batcham. Sculptures du Cameroun. Nouvelles perspectives anthropologiques*, Marseille, Musées de Marseille/Paris, RMN, 1993.

Nuoffer, 1925
Nuoffer (O.), *Afrikanische Plastik in der Gestaltung von Mutter und Kind*, Dresden, Carl Reissner, 1925.

O

Objets et mondes, 1968
Objets et mondes, vol. 8, fasc. 2-4, 1968.

Objets interdits, 1989
Objets interdits, Paris, Musée Dapper, 1989.

Olivier (ed.), 1932-34
Olivier (Marcel) [ed.], *Exposition coloniale internationale et des pays d'outre-mer, rapport général*, Ministère des Colonies, Paris, Imprimerie Nationale, 9 vols., 1932-34.

O'Reilly, 1949
O'Reilly (Patrick), "Une sculpture des Nouvelles-Hébrides au musée de la France d'outre-mer", *Journal de la Société des océanistes*, vol. 5, no. 5, December 1949, p. 192-194.

O'Reilly, 1953
O'Reilly (Patrick), *Calédoniens. Répertoire bio-bibliographique de la Nouvelle-Calédonie*, Paris, Société des Océanistes, no. 3, 1953.

O'Reilly, 1957
O'Reilly (Patrick), *Hébridais. Répertoire bio-bibliographique des Nouvelles-Hébrides*, Paris, Société des Océanistes, 1957.

O'Reilly and Reitman, 1967
O'Reilly (Patrick), Reitman (E.), *Bibliographie de Tahiti et la Polynésie française*, Société des Océanistes, Paris, 1967.

Orliac (C.), 1998
Orliac (Catherine), "Données nouvelles sur la composition de la flore de l'île de Pâques", *Journal de la Société des océanistes*, no. 107, 1998, p. 135-143.

Orliac (C. and M.), 1988
Orliac (Catherine and Michel), *Des dieux regardent les étoiles. Les derniers secrets de l'île de Pâques*, Paris, Gallimard, 1988.

Orliac (C. and M.), 1995
Orliac (Catherine and Michel), *Bois sculptés de l'île de Pâques*, Marseille, Parenthèses/Paris, Éditions Louise Leiris, 1995.

Orliac (C. and M.), 1996
Orliac (Catherine and Michel), "Bois sculptés de Rapa Nui", in *Voyage vers l'île mystérieuse*, 1996, p. 103-115.

Ortiz (F.), 1951
Ortiz Fernando, *Los bailes y el teatro de los Negros en el folklore de Cuba*, Havana, Cárdenas y Cia, 1951.

Ortiz (P.) and Rodriguez, n.d.
Ortiz (Ponciano), Rodriguez (Carmen), "Los espacios sagrados olmecas: El Manatí, un caso especial", *Los olmecas en Mesoaméricas*, Mexico City, n.d., p. 69-91.

Ottino-Garanger, 1998
Ottino-Garanger (Pierre and Marie-Noëlle), *Te Patu Tiki. Le tatouage aux îles Marquises*, Gleizal Éditeur, 1998.

Ouvertures sur l'art africain, 1986
Ouvertures sur l'art africain, Paris, Éditions Dapper, 1986.

P

Paalen, 1943
Paalen (Wolfgang), "Totem Art", *DYN*, 1943.

Paalen, 1994
Paalen (Wolfgang), "Voyage sur la côte de l'Amérique", presented by Christian Kloyber and José Pierre, *Pleine Marge*, no. 20, 1994, p. 8-34.

Pacheco, 1956
Pacheco (Pereira Duarte), *Esmeraldo de situ orbis (1506-08)*, Lisbon, 1956.

Palau-Marti, 1967
Palau-Marti (Montserrat), "Les sabres décorés du Dahomey au musée de l'Homme", in *Objets et mondes*, Paris, vol. 7, fasc. 4, 1967.

Palau-Marti, 1969
Palau-Marti (Montserrat), "Le sabre du dieu Gu", *Notes africaines*, no. 121, Dakar, January 1969.

Palencia, 1989
Palencia (Joaquin G.), "The Ifugao Bul-ul and its Regional Styles", *Arts of Asia*, vol. XIX, no. 6, Hong Kong, 1989, p. 142-417.

Palencia, 1998
Palencia (Joaquin G.), "Art as Life: The Ifugao Bul-ul", *Tribal Arts – Le monde de l'art tribal*, spring 1998, no. 4, p. 52-63.

Palmer, 1870
Palmer (J.L.), "A Visit to Easter Island, or Rapa Nui, in 1868", *The Journal of the Royal Geographical Society*, vol. XL, 1870, p. 167-181.

Panoff (ed.), 1995
Panoff (Michel) [dir.], *Trésors des îles Marquises*, Paris, Musée de l'Homme/Orstom/RMN, 1995.

Parkinson, 1907
Parkinson (Richard), *Dreissig Jahre in der Südsee*, Stuttgart, Strecker und Schröder, 1907.

Parmenter, 1966
Parmenter (Ross), *Explorer, Linguist and Ethnologist. A Descriptive Bibliography of the Published Works of Alphonse Pinart, With Notes on his Life*, Los Angeles, Southwest Museum, 1966.

Partridge, 1905
Partridge (Charles), *Cross River Natives*, London, Hutchinson and Co., 1905.

Pasztory, 1972
Pasztory (Esther), "The Historical and Religious Significance of the

Mesoamerican Ballgame", *Religion en Mesoamerica*, Mexico City, Sociedad Mexicana de Antropología, 1972, p. 441-455.

Pasztory, 1982
Pasztory (Esther), "Three Aztec Masks of the God Xipe", in *Boone (ed.), 1982, p. 77-106.

Pasztory, 1983
Pasztory (Esther), *Aztec Art*, New York, Abrams, 1983.

Pasztory, 1984
Pasztory (Esther), "El arte mexica y la conquista española", *Estudios de Cultura Nahuatl* 17, Mexico City, 1984, p. 101-126.

Pasztory, 1989
Pasztory (Esther), "Identity and Difference: The Uses and Meanings of Ethnic Styles", in *Barnes and Melion (ed.), 1989.

Pasztory, 1992
Pasztory (Esther), "Abstraction and the Rise of the Utopian State at Teotihuacan", in *Berlo, 1992.

Pasztory, 1993
Pasztory (Esther), "Teotihuacan Unmasked: A View through Art", in *Berrin and Pasztory (eds.), 1993.

Pasztory, 1997
Pasztory (Esther), *Teotihuacan: An Experiment in Living*, Norman, University of Oklahoma Press, 1997.

Paton, 1979
Paton (W.), "Customs of Ambrym", *Pacific Linguistics*, D series, no. 22, Canberra, 1979.

Patterson, 1996
Patterson (Mary), "La production artistique à Ambrym: contexte et évolution", in *Vanuatu, Océanie. Arts des îles de cendre et de corail*, 1996, p. 262-270.

Paudrat, 1984
Paudrat, "Africa", in Rubin (ed.), p. 124-175, 1984.

Paudrat, 1987
Paudrat (Jean-Louis), "Afrique", in *Rubin (ed.), 1987, p. 124-175.

Paudrat, 1994a
Paudrat (Jean-Louis), "Le pays et la culture dogon", in *Dogon, 1994, p. 11-16.

Paudrat, 1994b
Paudrat (Jean-Louis), "Résonances mythiques dans la statuaire du pays dogon", in *Dogon, 1994, p. 55-81, p. 251-253.

Paudrat, 1996
Paudrat (Jean-Louis), "Les 'arts sauvages' à Paris au seuil des années trente", *Art tribal, Bulletin du musée Barbier-Mueller*, 1996, p. 43-57.

Paulme, 1956a
Paulme (Denise), *Les Sculptures de l'Afrique noire*, Paris, PUF, 1956.

Paulme, 1956b
Paulme (Denise), "Structures sociales en pays baga", *Bulletin de l'IFAN*, vol. XVIII, B series, 1956, p. 98-116.

Paulme, 1957
Paulme (Denise), "Des riziculteurs africains: les Baga (Guinée française)", *Les Cahiers d'outre-mer*, vol. X (39), 1957, p. 257-278.

Paulme, 1958
Paulme (Denise), "La notion de sorcier chez les Baga", *Bulletin de l'IFAN*, vol. XX (3-4), B series, 1958, p. 406-416.

Paulme, 1962
Paulme (Denise), *L'Art sculptural nègre*, vol. I and II, nos. 62-63, Paris, Art et Style, 1962.

Paulme, 1977
Paulme (Denise), "Sanga 1935", *Cahiers d'études africaines*, vol. XVII (1), no. 65, Paris, 1977, p. 7-12.

Paulme, 1979
Paulme (Denise), "Quelques souvenirs", *Cahiers d'études africaines*, vol. XIX (1-4), nos. 73-76, Paris, 1979, p. 9-17.

Paulme, 1988
Paulme (Denise), "The Paulme-Lifchitz Collection at the Musée de l'Homme", *African Arts*, vol. XXI, no. 4, August 1988, p. 46-49.

Paulme, 1992
Paulme (Denise), *Lettres de Sanga à André Schaeffner*, Paris, Fourbis, 1992.

Peekel, 1926-27
Peekel (Gerhard), "Die Ahnenbilder von Nord-Neu-Mecklenburg. Eine Kritische und positive Studie", *Anthropos*, vol. XXI, p. 806-824, vol. XXII, p. 16-44, 1926-27.

Peekel, 1928
Peekel (Gerhard), "Lang-Manu, die Schlussfeier eines Malagan- (Ahnen-) Festes auf Nord-Neu-Mecklenburg", in *Koppers (ed.), 1928, p. 542-555.

Peekel, 1931
Peekel (Gerhard), "Religiose Tänze auf New Irland (Neu Mecklenburg)", *Anthropos*, vol. XXVI, 1931, p. 513-532.

Peekel, 1935
Peekel (Gerhard), "Uli und Ulifeier, oder, vom Mondkultus auf Neu Mecklenburg", *Archiv für Anthropologie*, vol. XXIII, 1935, p. 41-75.

Peignot, 1966
Peignot (Jérôme), "Jérôme Peignot parle d'André Lefèvre", *Connaissance des arts*, no. 168, February 1966, p. 40-47.

Peltier, 1979
Peltier (Philippe), "L'art océanien entre les deux guerres: expositions et vision occidentale", *Journal de la Société des océanistes*, vol. 35, no. 65, 1979, p. 271-282.

Peltier, 1984
Peltier (Philippe), "From Oceania", in *Primitivism'in 20th Century Art*, New York, The Museum of Modern Art, 1984, p. 98-123.

Peltier, 1987
Peltier (Philippe), "Océanie", in *Rubin (ed.), 1987, p. 98-123.

Peltier, 1992
Peltier (Philippe), "Jacques Viot, the Maro of Tobati and Modern Paintings: Paris-New Guinea 1925-35", in *Greub (ed.), 1992, p. 155-175.

Peralta, 1977
Peralta (Jesus T.), "Wooden Gods and Other Carvings. Early Ifugao Art is Based on Ritual", in *Roces (ed.), 1977, p. 314-318.

Péré, 1991
Péré (Josette), *Origine et constitution des collections ethnographiques. De l'espace marquisien au Muséum d'histoire naturelle de La Rochelle: un catalogue commenté et descriptif*, Paris, 1991.

Pericot-Garcia, Galloway and Lommel, 1967
Pericot-Garcia (Louis), Galloway (John), Lommel (Andreas), *La preistoria e i primitivi attuali*, Florence, Sansoni, 1967.

Pericot-Garcia, Galloway and Lommel, 1969
Pericot-Garcia (Louis), Galloway (John), Lommel (Andreas), *Prehistoric and Primitive Art*, London, Thames and Hudson, 1969.

Perrois, 1972
Perrois (Louis), *La Statuaire fan – Gabon*, Paris, Orstom, 1972.

Perrois, 1976
Perrois (Louis), "L'art kota-mahongwé (Gabon)", *Arts d'Afrique noire*, no. 20, Arnouville, 1976, p. 15-37.

Perrois, 1979
Perrois (Louis), *Arts du Gabon*, Arnouville, Arts d'Afrique Noire, 1979.

Perrois, 1985
Perrois (Louis), *Art ancestral du Gabon*, Geneva, Musée Barbier-Mueller/Paris, Nathan, 1985.

Perrois, 1991
Perrois (Louis), *L'Art fang – Guinée-Équatoriale*, Paris, Aurore Éditions d'Art/Cercle d'Art, 1991.

Perrois, 1992
Perrois (Louis), *Byeri fang – Sculptures d'ancêtres en Afrique*, Marseille, Musées de Marseille/Paris, RMN, 1992.

Perrois, 1997
Perrois (Louis), articles on Fang objects in *Esprit de la forêt*, 1997.

Perrois (ed.), 1993
Perrois Louis (ed.), *Legs Pierre Harter*, 1993.s

Perrois and Notué, 1986
Perrois (Louis), Notué (Jean-Paul), "Contribution à l'étude des arts plastiques du Cameroun", *Muntu*, no4-5, Libreville, 1986, p. 165-222.

Perrois and Notué, 1993
Perrois (Louis), Notué (Jean-Paul), "Arts et cultures du Grassland camerounais", in *Legs Pierre Harter, 1993, p. 37-91.

Perrois and Notué, 1997
Perrois (Louis), Notué (Jean-Paul), *Rois et sculptures de l'ouest Cameroun. La panthère et la mygale*, Paris, Karthala/Orstom, 1997.

Perrois and Pestmal, 1971
Perrois (Louis), Pestmal (Gérald), "Note sur la découverte et la restauration de deux figures funéraires kota-mahongwé (Gabon)", *Cahiers de l'Orstom*, human sciences series, vol. VIII, no. 4, Paris, 1971, p. 367-386.

Peter, 1978
Peter (H.), *Polynesier. Vikinger der Südsee, die Polynesiensammlung des Museums für Völkerkunde Wien*, Vienna, 1978.

Petit Journal du musée de l'Homme, 1989
Le Petit Journal du musée de l'Homme, "À l'occasion de l'exposition 'Les Amériques de Claude Lévi-Strauss'", Paris, 1989.

Petrie, 1920
Petrie (W.M. Flinders), *Prehistoric Egypt. Illustrated by over 1,000 Objects in University College, London (British School of Archaeology in Egypt, 1917)*, London, BSAE/B. Quaritch, 1920.

Petrie and Quibell, 1895
Petrie (W.M. Flinders), Quibell (James E.), *Naqada and Ballas*, vol. I (1), British School of Archaeology in Egypt, London, 1895.

Pfeiffer, 1983
Pfeiffer (Marian), *Monumental AncestorFigures of the Sawos: Identification of the Yamok Style Group, Middle Sepik, Papua New Guinea*, thesis, Tuscaloosa, Southern Methodist University, 1983.

Philippinen: Perle im östlichen Meer, 1985
Die Philippinen: Perle im östlichen Meer, Munich, Staatlichen Museums für Völkerkunde/Karl M. Lipp, 1985.

Phillips, 1995
Phillips (Tom) [ed.], *Africa. The Art of a Continent*, London, The Royal Academy of Arts/Munich, Prestel Verlag, 1995.

Phillips, 1996
Phillips (Tom) [ed.], *Afrika. Die Kunst eines Kontinents*, New York/Munich, Prestel Verlag, 1996.

Pierre, 1970
Pierre (José), *Domaine de Paalen*, Paris, Éditions Galianis, 1970.

Piña Chan, 1968
Piña Chan (Román), *Jaina. La Casa en el Agua*, Mexico City, INAH, 1968.

Piña Chan, 1977
Piña Chan (Román), *Quetzalcoatl Serpiente Emplumada*, Mexico City, Fondo de Cultura Económica, 1977.

Piña Chan, 1997
Piña Chan (Román), *Quetzalcoatl Serpiente Emplumada*, Mexico City, FCF, 1997.

Pinart, 1872
Pinart (Alphonse Louis), *Catalogue des collections rapportées de l'Amérique russe (aujourd'hui Territoire d'Alaska) exposées dans l'une des galeries du Muséum d'histoire naturelle de Paris*, Paris, Imprimerie J. Claye, 1872.

Pinart, 1873
Pinart (Alphonse Louis), "Eskimaux et Koloches, idées religieuses et traditions des Kaniagmioutes", *Revue d'Anthropologie*, vol. 2, 1873, p. 673-680.

Pinart, n.d.
Pinart (Alphonse Louis), *Lettres et documents divers*, Paris, Bibliothèque du Musée de l'Homme, n.d.

Pitt-Rivers, 1900
Pitt-Rivers (A.), *Antique Works of Art from Benin*, London, 1900.

Poignant, 1967
Poignant (Roslyn), *Oceanic Mythology*, London, Paul Hamlyn, 1967.

Pomian, 1987
Pomian (Krysztof), *Collectionneurs, amateurs et curieux. Paris – Venise. XVIIᵉ-XVIIIᵉ siècles*, Paris, Gallimard, 1987.

Popol Wuj, 1992
Popol Wuj – Antiguas historias de los indios quiché de Guatemala, Mexico City, Porrúa Sepan Cuantos, 1992.

Porter, 1956
Porter (Muriel N.), "Excavations at Chupícuaro, Guanajuato, Mexico", *American Philosophical Society. Transactions*, no. 46, part 6, 1956.

Porter Weaver, 1969
Porter Weaver (Muriel), "A Reappraisal of Chupícuaro", in *Natalie Wood Collection*, 1969, p. 3-15, p. 81-92.

Porter Weaver, 1993
Porter Weaver (Muriel), *The Aztecs, Maya, and their Predecessors: Archaeology of Mesoamerica*, San Diego, Academic Press, Inc., 1993.

Portier and Poncetton, [1929]
Portier (André), Poncetton (François), *Les Arts sauvages. Océanie*, Paris, Albert Morancé, [1929].

Portier and Poncetton, [1931]
Portier (André), Poncetton (François), *Décoration océanienne*, Paris, Librairie des Arts Décoratifs/A. Calavas, [1931].

Postma, 1991
Postma Antoon, "The Laguna Copper-Plate Inscription (LCI): A Valuable Philippine Document", *National Museum Papers*, vol. II, no. 1, Manila, 1991.

Powdermaker, 1931a
Powdermaker (Hortense), "Report on Field-work in New Ireland", *Oceania*, vol. I, 1931, p. 355-365.

Powdermaker, 1931b
Powdermaker (Hortense), "Mortuary Rites in New Ireland", *Oceania*, vol. II, 1931, p. 26-43.

Powdermaker, 1932
Powdermaker (Hortense), "Feast in New Ireland; The Social Functions of Eating", *American Anthropologist*, vol. XLIII, 1932, p. 236-247.

Powdermaker, 1933
Powdermaker (Hortense), *Life in Lesu*, London, Williams and Norgate, 1933.

***Precolumbian Collections in European Museums*, 1987**
Precolumbian Collections in European Museums, ACCRDSS/Budapest, Akademiai Kiado, 1987.

Prem and Dyckerhoff, 1986
Prem (Hanns J.Y.), Dyckerhoff (Ursula), *El Antiguo México – Historia y Cultura de los Pueblos Mesoamericanos*, Barcelona, Plaza y Janés Editores, 1986.

Pukui and Elbert, 1986
Pukui (Mary Kawena), Elbert (Samuel H.), *Hawaiian Dictionary*, Honolulu, University of Hawaii Press, 1986.

Q

Quenon and Lefort, 1997
Quenon (Michel), Lefort (Geneviève), "Rebirth and Resurrection in Maize God Iconography", *The Maya Vase Book*, vol. V, New York, 1997, p. 884-902.

Quenum, 1936
Quenum (Maximilien), *Au pays des Fon. Us et coutumes du Dahomey*, Paris, Larose, 1936.

Quinn, 1987
Quinn (Edward), *Picasso avec Picasso*, Paris, Pierre Bordas et Fils, 1987.

Quintino, 1964
Quintino (Fernando Rogado), "A pintura e a escultura na Guiné portuguesa", *Boletim cultural da Guiné Portuguesa*, vol. XIX (75), 1964, p. 227-288.

R

Racinet, 1869
Racinet (A.), *L'Ornement polychrome*, 2 vols., Paris, Firmin Didot, 1869.

Racinet, 1888
Racinet (A.), *Le Costume historique*, Paris, Firmin Didot, 1888.

Radiguet, 1929
Radiguet (Max), "Légendes religieuses et croyances des Marquises", *Cahiers d'art*, Paris, 1929.

Radin and Sweeney, 1952
Radin (Paul), Sweeney (James Johnson), *African Folktales and Sculptures*, New York, Pantheon Books, 1952.

Rajput, 1985
Rajput (A.B.), "The Little-known Tribe of Kafiristan", *Connaissance des arts tribaux*, no. 27, 1985.

Rajput, 1998
Rajput (A.B.), "Une ethnie peu connue du Kafiristan", *Art tribal, Bulletin du Musée Barbier-Mueller*, Geneva, 1998, p. 81-88.

Ratton (C.), [1931]
Ratton (Charles), *Masques africains*, Paris, Librairie des Arts Décoratifs, A. Calavas, [1931].

Ratton (P.), 1987
Ratton (Philippe), "Lettre ouverte à Jean Paul Barbier", *Arts d'Afrique noire*, no. 63, autumn 1987, p. 6.

Ravenhill, 1980
Ravenhill (Philip L.), *Baule Statuary Art: Meaning and Modernization*, *Working Papers in the Traditional Arts*, no. 5, Philadelphia, Institute for the Study of Human Issues, 1980.

Ravenhill, 1992
Ravenhill (Philip L.), "Of Pachyderms and Power: Ivory and the Elephant in the Art of Central Côte d'Ivoire", in *Ross (ed.), 1992, p. 115-133.

Ravenhill, 1994
Ravenhill (Philip L.), *The Self and the Other – Personhood and Images among the Baule, Côte d'Ivoire*, Los Angeles, Fowler Museum of Cultural History, 1994.

Ravenhill, 1996
Ravenhill (Philip L.), "Baule", *Dictionary of Art*, vol. III, London, Macmillan Publishers Limited/New York, Grove Dictionaries, Inc., 1996, p. 404-409.

***Raymond Wielgus Collection*, 1960**
The Raymond Wielgus Collection, New York, The Museum of Primitive Art, 1960.

Read and Dalton, 1899
Read (C.H.), Dalton (O.M.), *Antiquities from the City of Benin and from other parts of West Africa in the British Museum*, London, 1899.

Réau, 1934
Réau (Louis), *L'art primitif – L'art médiéval*, Paris, Armand Colin, 1934.

Rebeyrol, 1979
Rebeyrol (Yvonne), "Rites de la mort", about the exhibition in the Musée de l'Homme, *Le Monde*, 1979.

***Réceptacles*, 1997**
Réceptacles, Paris, Musée Dapper, 1997.

***Regard sur une collection*, 1995**
Regard sur une collection, Brussels, Philippe Guimiot Éditeur, 1995.

Reichlen and Heizer, 1963
Reichlen (Henry), Heizer (Robert F.), "La mission de Léon de Cessac en Californie, 1877-1879", *Objets et monde*, vol. 3, fasc. 1, 1963, p. 17-34.

Reid, 1989
Reid (Martine), "Le courage de l'art", in *Lévi-Strauss, 1989, p. 221-252.

Rey, 1974
Rey (Jean Dominique), "Les Lobi", *Les Lobi*, Paris, Galerie Jacques Kerchache, 1974, p. 7-18.

Reynaud, 1978
Reynaud (Nicole), "Les Maîtres à 'noms de convention'", *Revue de l'art*, no. 42, Éditions du CNRS, 1978, p. 41-52.

Rice, 1990
Rice (Michael), *Egypt's Making. The Origins of Ancient Egypt 5000-2000 B.C.*, London/New York, Routledge, 1990.

Riesenfeld, 1950
Riesenfeld (A.), *The Megalithic Culture of Melanesia*, Leyden, 1950.

***La Rime et la Raison*, 1984**
La Rime et la Raison – Les Collections Ménil (Houston, New York), Paris, RMN, 1984.

***Rites de la mort*, [1979]**
Rites de la mort, Paris, Musée de l'Homme, [1979].

Rivers, 1906
Rivers (W.H.R.), *The Todas*, London, Macmillan and Co., Ltd, 1906.

Rivers, 1914
Rivers (W.H.R.), *The History of Melanesian Society*, 2 vols., Cambridge, Cambridge University Press, 1914.

Rivet and Rivière, 1931
Rivet (Paul), Rivière (Georges Henri), "La réorganisation du musée d'Ethnographie du Trocadéro", *Bulletin du musée d'Ethnographie du Trocadéro*, no. 1, January 1931, p. 3-11.

Rivière, 1926
Rivière (Georges Henri), "Archéologismes", *Cahiers d'art*, vol. I, no. 7, 1926, p. 177-180.

Rivière, 1929
Rivière (Georges Henri), "Le musée d'Ethnographie du Trocadéro", *Documents*, no. 1, April 1929, p. 54-58.

Rivière, 1930
Rivière (Georges Henri), "De l'objet d'un musée d'ethnographie comparé à celui d'un musée de Beaux-Arts", *Cahiers de Belgique*, November 1930, no. 9, p. 310-314.

Rivière, 1931
Rivière (Georges Henri), "Musée des Beaux-Arts ou musée d'ethnographie", *Cahiers de la République des lettres, des sciences et des arts*, vol. XIII, 1931.

Rivière, 1932
Rivière (Georges Henri), "L'Exposition du Bénin et les transformations du musée d'ethnographie", *Nouvelles littéraires*, 9 July 1932.

Rivière, 1935
Rivière (Georges Henri), "Introduction", in *Bronzes and Ivories from the Old Kingdom of Benin*, 1935.

***Robert and Lisa Sainsbury Collection*, 1963**
The Robert and Lisa Sainsbury Collection, New York, The Museum of Primitive Art, 1963.

Robert-Lamblin, 1976
Robert-Lamblin (Joëlle), "Exploration de l'archipel aléoute (Alaska) par le Français A.-L. Pinart en 1871-1872", *Bulletin de la société suisse des américanistes*, vol. XL, 1976, p. 19-27.

Robicsek and Hales, 1981
Robicsek (Francis), Hales (Donald M.), *The Maya Book of the Dead, The Ceramic Codex. The Corpus of Codex Style Ceramics of the Late Classic Period*, Charlottesville, University of Virginia Art Museum, 1981.

Roces (ed.), 1977
Roces (Alfredo R.) [ed.], *Filipino Heritage, The Making of a Nation: The Metal Age in the Philippines*, Manila, 1977.

Rodgers, 1985
Rodgers (S.), *Power and Gold*, New York, 1985.

Rodman, 1996
Rodman (W.), "Les cochons du Paradis", in *Vanuatu, Océanie. Arts des îles de cendre et de corail*, 1996, p. 160-170.

Roma, 1986
Roma (Josefina), *Ethnografica de Filipines*, Barcelona, Fundació Folch/Ajuntament de Barcelona, 1986.

Román Berrelleza, 1990
Román Berrelleza (Juan), *Sacrificio de niños en el Templo Mayor*, Mexico City, GV Editores/INAH, 1990.

Román Berrelleza and Torres Blanco, 1998
Román Berrelleza (Juan), Torres Blanco (Alfonso), "Los sacrificios de niños en el Templo Mayor. Un enfoque interdisciplinario", *Arqueologia Mexicana*, vol. VI (31), Mexico City, Raices, 1998, p. 28-33.

Romilly, 1886
Romilly (Hugh Hastings), *The Western Pacific et New Guinea. Notes on the natives, Christian and cannibal, with some account of the old labour trade*, London, John Murray, 1886.

Rose, 1978
Rose (Roger G.), "Reconstructing the Art and Religion of Hawaii", *Journal of the Polynesian Society*, vol. LXXXVIII (3), 1978, p. 267-278.

Rose, 1997
Rose (Roger G.), "Les chasse-mouches des îles Australes", in *Océanie. Curieux, navigateurs et savants*, 1997, p. 160-165.

Ross (ed.), 1992
Ross (Doran H.) [ed.], *Elephant: the Animal and its Ivory in African Culture*, Los Angeles, Fowler Museum of Cultural History, 1992.

Ross Miller, 1990
Ross Miller (Thomas), "Collecting Culture: Musical Instruments and Musical Change", in *Schildkrout and Keim (eds.), 1990.

Rousseau, 1951
Rousseau (Madeleine), *L'Art océanien, sa présence*, Paris, Association Populaire des Amis des Musées, collection "Le Musée vivant", 1951.

Roussel, 1869
Roussel (H.), *Notice sur l'île de Rapanui*, Archives de l'archevêché de Papeete, document no. I 24-1-3, 1869.

Rousselot, 1990
Rousselot (Jean-Loup), "Walfängergemeinschaften der Eskimo in Alaska", in Völger Gisela, Welck Karin von (eds.), *Männerbande-Männerbünde*, Köln, Rautenstrauch-Joest-Museum, 1990, p. 225-230.

Rousselot, 1996a
Rousselot (Jean-Loup), "Le chamane yup'ik et l'attirail cérémoniel", *Boréales*, no. 65-69, 1996, p. 131-140.

Rousselot, 1996b
Rousselot (Jean-Loup), "La collection Pinart et la culture des eskimo yupik", *Bononia*, no. 29, 1996, p. 12-16.

Rousselot, Abel, Pierre and Bihl, 1991
Rousselot (Jean-Loup), Abel (Bernard), Pierre (José), Bihl (Catherine), *Masques eskimo d'Alaska*, Saint-Vit, Éditions Amez, 1991.

Routledge, 1919
Routledge (Katherine Scoresby), *The Mystery of Easter Island: The story of an Expedition*, London, 1919.

Roy (C.), 1957
Roy (Claude), *Arts sauvages*, Paris, Robert Delpire, 1957.

Roy (C.D.), 1987
Roy (Christopher D.), *Art of the Upper Volta*, Meudon, Alain et Françoise Chaffin Éditeurs, 1987.

Roy (C.D.), 1988
Roy (Christopher D.), articles on the Bwa, Mossi and Nuna of Burkina Faso in *Arts de l'Afrique noire dans la collection Barbier-Mueller*, 1988.

Roy (C.D.), 1992
Roy (Christopher D.), *Art and Life in Africa. Selections from the Stanley Collection*, Exhibition of 1985 and 1992, The University of Iowa Museum of Art, 1992.

Roy (C.D.), 1996
Roy (Christopher D.), "Nuna", *Arman et l'art africain*, Marseille, Musées de Marseille/Paris, RMN, 1996, p. 244.

Royer, 1993
Royer (C.), "Mission Rapa Nui 1989, géologie appliquée à l'archéologie", *Les Mystères résolus de l'île de Pâques*, Évry, STEP, 1993, p. 181-240.

Rubin, 1987
Rubin (William), "Le primitivisme moderne: une introduction", in *Rubin (ed.), 1987, p. 1-81.

Rubin (ed.), 1984
Rubin (William), *Primitivism in the 20th Century. Affinity of the Tribal and the Modern*, New York, The Museum of Modern Art, 1984.

Rubin, 1987
Rubin (William), "Picasso", in W. Rubin (dir.), *Le Primitivisme dans l'art du XXᵉ siècle*, Paris, Flammarion, 1987.

Rudolf, 1985
Rudolf (H.), *Der Turkmenschmuck*, Stuttgart/London, 1985.

Rushing, 1988
Rushing (W. Jackson), "The Impact of Nietzsche and Northwest Coast Indian Art on Barnett Newman' Ideas of Redemption in the Abstract Sublime", *Art Journal*, 1988, p. 187-195.

Rushing, 1995
Rushing (W. Jackson), *Native American Art and the New York Avant Garde*, Austin, University of Texas Press, 1995.

Ryder, 1969
Ryder (A.F.C.), *Benin and the Europeans 1485-1897*, London, 1969.

S

Sahagún, 1950-78
Sahagún (Bernardino de), *Florentine Codex, General History of the Things of New Spain*, trans. Arthur O. Anderson and Charles E. Dibble, Santa Fe, The School of American Research/The University of Utah, 1950-78.

Sahagún, 1975
Sahagún (Bernardino de), *Historia general de las cosas de Nueva España*, 4 vols., Mexico City, Editorial Porrua, S.A., 1975.

Sahagún, 1989
Sahagún (Bernardino de), *Historia general de las cosas de Nueva España*, 2 vols., Mexico City, Consejo Nacional para la Cultura y las Artes/Alianza Editorial Mexicana, 1989.

Sampil, 1961
Sampil (Mamadou), "Une société secrète en pays nalou: le Simo", *Recherches africaines*, no. 1, Conakry, 1961, p. 46-49.

Sanchez, Alvaro and Moret Altorre, 1998
Sanchez (Fernando M.), Alvaro (José Luis), Moret Altorre (Luis), "Las Cuevas del Gallo y la Chagüera. Inventario Arqueobotánico e inferencias", *Arqueologia*, 19, Mexico City, INAH, 1998, p. 81-90.

Sanchez Sanchez, 1982
Sanchez Sanchez (Jesus E.), "Zona central del complejo Calle de los Muertos", in *Cabrera Castro, Rodriguez Garcia and Morelos Garcia (eds.), 1982b.

Sarasin, 1917
Sarasin (Fritz), *La Nouvelle Calédonie et les îles Loyalty. Souvenirs de voyage d'un naturaliste*, trans. Jean Roux, Basel, 1917.

Sarasin, 1929
Sarasin (Fritz), *Ethnologie der Neu-Caledonier und Loyalty*, Munich, C.W. Kreidel, 1929.

Sarfert and Aamm, 1931
Sarfert (E.), Aamm (H.), *Luangiua und Nukumanu. Ergebnisse der Sudsee-Expedition II. Ethnographie*, Hamburg, De Gruyter, 1931.

Sarro, 1998
Sarro (Patricia Joan), "The Stone Yokes of Mesoamerica", *Congreso de la XXV Mesa Redonda de la Sociedad Mexicana de Antropología*, San Luis Potosi, 1998.

Savary, 1980
Savary (Claude), *Cameroun: arts et cultures des peuples de l'Ouest*, Geneva, Musée d'Ethnographie, 1980.

Saville, 1925
Saville (Marshall H.), *The Woodcarver's Art in Ancient Mexico*, New York, Museum of the American Indian, Heye Foundation, 1925.

Sawim, 1995
Sawim (Martica), *Surrealism in Exile and the Beginning of the New York School*, Cambridge (Mass.)/London, MIT Press, 1995.

Scarduelli, 1990
Scarduelli (Pietro), "Accumulation of Heads, Distribution of Food: The Image of Power in Nias", *Bijdragen KITLV*, 146, no. 4, 1990, p. 448-462.

Schädler, 1975
Schädler (Karl Ferdinand), *Afrikanische Kunst. Stilformen und Kultgegenstände von mehrals 100 Stämmen*, Munich, Wilhelm Heyne Verlag, 1975.

Schädler, 1997
Schädler (Karl Ferdinand), *Earth and Ore. 2500 Years of African Art in Terra-cotta and Metal*, Munich, Panterra Verlag, 1997.

Schaeffner, 1936
Schaeffner (André), *Origine des instruments de musique*, Paris, Payot, 1936.

Schefold, 1966
Schefold (R.), *Versuch einer Stilanalyse der Aufhängehaken vom Mittleren Sepik in Neu-Guinea*, Basler Beiträge zur Ethnologie, 1966.

Schele, 1997
Schele (Linda), *Rostros ocultos de los mayas*, Impetus Comunicación, 1997.

Schildkrout and Keim (eds.), 1990
Schildkrout (Enid), Keim (Curtis A.) [eds.], *African Reflections: Art from Northeastern Zaïre*, Seattle, University of Washington Press/New York, The American Museum of Natural History, 1990.

Schildkrout and Keim (eds.), 1998
Schildkrout (Enid), Keim (Curtis A.) [eds.], *The Scramble for Art in Central Africa*, Cambridge, Cambridge University Press, 1998.

Schmalenbach, 1953
Schmalenbach (Werner), *L'Art nègre*, Basel, Éditions Holbein/Paris, C. Massin, 1953.

Schmalenbach, 1956
Schmalenbach (Werner), *Plastik der Südsee*, Stuttgart, H.E. Günther, 1956.

Schmalenbach, 1959
Schmalenbach (Werner), *Primitive Kunst. Eine Einführung in die Plastik Afrikas und der Südsee*, Munich, Knorr und Hirth Verlag, 1959.

Schmeltz and Krause, 1881
Schmeltz (J.D.E.), Krause (R.), *Die Ethnographisch-Anthropologische Abteilung des Museum Godeffroy in Hamburg*, Hamburg, L. Friederichsen, 1881.

Schnapper, 1988
Schnapper (Antoine), *Le Géant, la licorne et la tulipe: collections et collectionneurs dans la France du XVIIᵉ siècle*, Paris, Flammarion, 1988.

Schnitger, 1939a
Schnitger (F.M.), *Forgotten Kingdoms in Sumatra*, Leyden, E.J. Brill, 1939.

Schnitger, 1939b
Schnitger (F.M.), "Les monuments mégalithiques de Nias", *Revue des arts asiatiques* 13, 1939, p. 78-84.

Schnitger, 1941-42
Schnitger (F.M.), "Megalithen von Batakland und Nias", *IPEK, Jahrbuch für prähistorische und ethnographische Kunst* 16, 1941-42, p. 220-252.

Schoffel, 1981
Schoffel (Alain), *Arts primitifs de l'Asie du Sud-Est (Assam, Sumatra, Bornéo, Philippines) Collection Alain Schoffel*, Meudon, Alain et Françoise Chaffin Éditeurs, 1981.

Schröder, 1917
Schröder (E.E.W.), *Nias. Ethnographische, geographische en historische aanteekeningen en studien*. Leyden, E.J. Brill, 2 vols., 1917.

Schweinfurth, 1875
Schweinfurth (Georg), *Artes Africanae*, Leipzig/London, 1875.

Scott, 1974
Scott (William Henry), *The Discovery of the Igorots: Spanish Contacts with the Pagans of Northern Luzon*, Quezon City, New Day Publishers, 1974.

Scott, 1994
Scott (William Henry), *Barangay. Sixteenth Century Philippines Culture and Society*, Quezon City, Ateneo de Manila University Press, 1994.

Scott Robertson, 1974
Scott Robertson (S.G.), *The Kafirs of the Indu-Kush*, Oxford, U.P. Karachi, 1974 (1st edition 1896).

***Sculpture. Chefs-d'œuvre du musée Barbier-Mueller*, 1995**
Sculpture. Chefs-d'œuvre du musée Barbier-Mueller, Paris, Imprimerie Nationale, 1995.

***Sculpture from three African Tribes Senufo Baga Dogon*, 1959**
Sculpture from three African Tribes Senufo Baga Dogon, New York, The Museum of Primitive Art, 1959.

***Sculptures africaines dans les collections publiques françaises*, 1972**
Sculptures africaines dans les collections publiques françaises, Paris, Éditions des Musées Nationaux, 1972.

***Sculptures africaines – Nouveau regard sur un héritage*, 1975**
Sculptures africaines – Nouveau regard sur un héritage, Antwerp, Marcel Peeters Centrum, 1975.

***Sculptures d'Afrique*, 1978**
Sculptures d'Afrique – 1977 – Collection Barbier-Mueller, Geneva, Musée Barbier-Mueller, 1978.

Seaver, 1993
Seaver (J.), "Rapanui Crafts: Wooden Sculptures Past and Present", *Oxbow Monograph* 32, p. 191-200, Oxford, 1993.

Seckel-Klein, 1998
Seckel-Klein (Hélène), *Picasso collectionneur*, Paris, RMN, 1998.

Seguin (ed.), 1984
Seguin (Margaret) [ed.], *The Tsimshian. Images of the Past; Views for the Present*, Vancouver, University of British Columbia Press, 1984.

Segy, 1969
Segy (Ladislas), *African Sculpture Speaks*, New York, Da Capo Press, Inc., 1969.

***Selected Works from the Collection*, 1957**
Selected Works from the Collection, Museum of Primitive Art, New York, New York University Press, 1957.

Seler, 1992
Seler (Eduard), "Two Notable Specimens Among Relics of Ancient Mexico in the Christy Collection in London", *Collected Works in Mesoamerican Linguistics and Archaeology*, Culver City, 1992.

Seligmann, 1939a
Seligmann (Kurt), "Le mât-totem de Gédem Skanish (Gyaedem Skanees)", *Journal de la Société des américanistes*, vol. XXXI, 1939, p. 121-128.

Seligmann, 1939b
Seligmann (Kurt), "Entretien avec un Indien tsimshian", *Minotaure*, no. 12-13, 1939.

Seligmann, 1939cs
Seligmann (Kurt), "Keigyett: Myth of the Totem Gyaedem Skanees", *Revue du vingtième siècle*, nos. 5-6, 1939.

Sempowski, 1983
Sempowski (Martha), *Mortuary Practices at Teotihuacan, Mexico: Their Implications for Social Status*, University of Rochester, 1983.

Shaw, 1969
Shaw (Thurstan), "Further Spectrographic Analyses of Nigerian Bronzes", *Archeometry*, no. 11, 1969, p. 85-98.

Shaw, 1977
Shaw (Thurstan), *Unearthing Igbo-Ukwu, archeological discoveries in eastern Nigeria*, London, Oxford University Press/Ibadan, Ibadan University Press, 1977.

Shaw, 1978
Shaw (Thurstan), "The Art of Benin through the Eyes of the Artist, the Art Historian, the Ethnographer and the Archeologist", in *Greenhalgh and Megaw (eds.), 1978.

Shorto, 1979
Shorto (H.L.), "The Linguistic Protohistory of Mainland South East Asia", in *Smith and Watson, 1979, p. 273-280.

Sieber and Rubin, 1968
Sieber (Roy), Rubin (Arnold), *Sculpture of Black Africa – The Paul Tishman Collection*, Los Angeles, County Museum, 1968.

Sieber and Rubin, 1970
Sieber (Roy), Rubin (Arnold), *Sculpture of Black Africa – The Paul Tishman Collection*, International Exhibitions Foundation, 1970.

Sieber and Walker, 1987
Sieber (Roy), Walker (Roslyn A.), *African Art in the Cycle of Life*, Washington/London, Smithsonian Institution Press, 1987.

Siebert and Forman, 1969
Siebert (Erna), Forman (Werner), *L'Art des Indiens d'Amérique*, Paris, Cercle d'Art, 1969.

Silva, 1956
Silva (Artur Augusto da), "Arte nalu", *Boletim Cultural da Guiné Portuguesa*, vol. XI (44), 1956, p. 27-47.

Siroto, 1961
Siroto (Leon), *Notes personnelles*, May 1961.

Siroto, 1968
Siroto (Leon), "The Face of the Bwiiti", *African Arts*, vol. I, no. 3, Los Angeles, spring 1968, p. 22-27, p. 86-89, p. 96.

Siroto, 1977
Siroto (Leon), "Njom: The Magical Bridge of the Beti and Bulu of Southern Cameroon", *African Arts*, vol. X, no. 2, January 1977, p. 38-51, p. 90-91.

Siroto, 1995
Siroto (Leon), "Reflections on the Sculpture of a Region: the Dwight and Blossom Strong Collection" and "Catalogue of Objects", *East of the Atlantic, West of the Congo, The Dwight and Blossom Strong Collection*, San Francisco, The Fine Arts Museum of San Francisco, 1995, p. 6-53.

Skjölsvold, 1994
Skjölsvold (A.), "Archaeological Investigations at Anakena, Easter Island", *The Kon-Tiki Museum Occasional Papers*, vol. III, Oslo, 1994.

Smidt, 1975
Smidt (Dirk), *The Seized Collections of the Papua New Guinea Museum*, Port-Moresby, University of Papua New Guinea/The Creative Arts Centre, 1975.

Smidt, 1990
Smidt (Dirk), Oceania articles in the catalogue *Sculptuur uit Afrika en Oceanië, Sculpture from Africa and Oceania*, Otterlo, Rijksmuseum Kröller-Müller, 1990.

Smith (M.W.) [ed.], 1961
Smith (Marian W.) [ed.], *The Artist in Tribal Society*, London, Routledge and Kegan Paul, 1961.

Smith (R.S.), 1969
Smith (R.S.), *Kingdoms of the Yoruba*, London, Methuen, 1969.

Smith (R.B.) and Watson (eds.), 1979
Smith (R.B.), Watson (W.) [eds.], *Early South East Asia*, New York/Kuala Lumpur/Oxford University Press, 1979.

Solheim II, 1981
Solheim II (Wilhelm G.), "Philippine Prehistory", in *Casal, José Jr, Casiño, Ellis and Solheim II, 1981, p. 17-83.

Solheim II, 1985
Solheim II (Wilhelm G.), "Korwar of the Biak", *The Eloquent Dead*, UCLA, 1985.

Solís, 1991
Solís (Felipe), *Tesoros artísticos del Museo Nacional de Antropología*, Mexico City, Aguilar Editor, 1991.

Solís, 1994
Solís (Felipe), "La costa del Golfo: el arte del centro de Veracruz y del mundo huasteco", *Mexico en el mundo de las colecciones de arte*, Mexico City, 1994, p. 183-241.

Solís, 1997
Solís (Felipe), "Asteekit" en *Sulkakäärme ja Jaguaari Jumala Meksikon ja Guatemalan Intiaani-Kulttuurit*, Tampere, Tampereen Taidemuseo, 1997.

Solís and Carmona, 1997
Solís (Felipe), Carmona (Macias Martha), "El oro en el Mexico precolombino", *Tesoros de México – Oro precolombino y plata virreinal*, Seville, Fundacion El Monte/Mexico City, INAH, 1997, p. 54-71, p. 86-189.

Sotelo and Valverde, 1992
Sotelo (Laura Elena), Valverde (Ma. del Carmen), "Los senores de Yaxchilan, un ejemplo de felinización de los gobernantes mayas", in *Estudios de Cultura Maya*, vol. XIX, Mexico City, UNAM, 1992.

Sotheby and Co., **1963**
Sotheby and Co., Primitive Works of Art from the collection formed by the late Mr. Frederick Wolff-Knize, London, 10 June 1963.

Sotheby Parke Bernet Inc., **1975**
Sotheby Parke Bernet Inc., Important African, Oceanic and Pre-Columbian Art. Property of Jay C. Leff, Uniontown, Pennsylvania, 10-11 October, New York, 1975.

Sotheby's, **1985**
Sotheby's, African and Oceanic Art, New York, 16 May 1985.

Sotheby's, **1986**
Important Tribal Art, New York, 18 November 1986.

Sotheby's, **1988**
Important Tribal Art, New York, 10 May 1988.

Soustelle, 1934-35
Soustelle (Jacques), "Une pierre à trois pointes de la Dominique", *Bulletin du musée d'Ethnographie du Trocadéro*, no. 8, 1934-35, p. 12-14.

Soustelle, 1955
Soustelle (Jacques), *La Vie quotidienne des Aztèques à la veille de la conquête espagnole*, Hachette, Paris, 1955.

Soustelle, 1967
Soustelle (Jacques), *Mexique*, Paris, Nagel, 1967.

Spalding, 1979
Spalding (Jeffrey), *Max Ernst from the Collections of Mr. and Mrs. Jimmy Ernst*, Calgary, Glenbow Museum, 1979.

Special Addendum, Sculpture of Black Africa, **1970**
Special Addendum, Sculpture of Black Africa – The Paul Tishman Collection, Richmond, Virginia Museum, 1970.

Speiser, 1929
Speiser (Felix), "L'art plastique des Nouvelles-Hébrides", *Cahiers d'art*, 1929 no. 2-3, mars-avril 1929, p. 91-94.

Speiser, 1991
Speiser (Felix), *Ethnology of Vanuatu: An Early Twentieth Century Study*, Bathurst, Crawford House Press, 1991 (1st edition, Berlin, 1923).

Spies, 1991
Spies (Werner) [ed.], *Marx Ernst. Rétrospective*, Paris, Centre Georges Pompidou/Munich, Prestel Verlag, 1991, p. 357-362.

The Spirit Within, **1995**
The Spirit Within. Northwest Coast Native Art from the John H. Hauberg Collection, New York, Rizzoli/Seattle Art Museum, 1995.

Spoons in African Art, **1991**
Spoons in African Art, Zurich, Museum Rietberg, 1991.

Steinen, 1928
Steinen (Karl von den), *Die Marquesaner und Ihrer Kunst, Plastik* (vol. II), *Die Sammlungen* (vol. III), Berlin, Dietrich Reimer, 1928.

Stéphan, 1988
Stéphan (Lucien), "La sculpture africaine, essai d'esthétique comparée", in *Kerchache, Paudrat and Stéphan, L'Art africain, Paris, Mazenod, 1988.

Stéphan, 1990
Stéphan (Lucien), "Du masque considéré comme sculpture", *De l'art nègre à l'art africain*, Arnouville, Arts d'Afrique Noire, 1990, p. 108-113.

Stéphan, 1993
Stéphan (Lucien), "Les pieds des tabourets et les jambes des humains", *Créer en Afrique*, Arnouville, Arts d'Afrique Noire, 1993, p. 101-108.

Stern, 1949
Stern (Theodore), *The Rubber-Ball Games of the Americas*, Seattle, University of Washington Press, 1949.

Stevenson, Lee and Morin (eds.), 1998
Stevenson (C.), Lee (G.), Morin (F.J.) [eds.], *Easter Island in Pacific Context, South Seas Symposium*, Fos Osos, The Easter Island Foundation, 1998.

Stewart (C.S.), 1831
Stewart (Charles S.), *A Visit to the South Sea*, New York, J.P. Haven, 1831.

Stewart (H.), 1981
Stewart (Hilary), "Stone Mask Reunion", in *Abbot (ed.), 1981, p. 261-264.

Stöhr, 1981
Stöhr (Waldemar), *Art des Indonésiens archaïques*, Geneva, Musée d'Art et d'Histoire, 1981.

Stöhr, 1987
Stöhr (Waldemar), *Kunst und Kultur aus der Südsee Sammlung Clausmeyer Melanesien*, Cologne, Rautenstrauch-Joest-Museum für Völkerkunde, 1987.

Stöhr and Zoetmulder, 1968
Stöhr (Waldemar), Zoetmulder (P.), *Les Religions d'Indonésie*, Paris, Payot, 1968.

Strebel, 1890
Strebel (Hermann), "Studien über Steinjoche aus Mexico und Mittel-Amerika", *Internationales Archiv für Ethnographie*, vol. 3, 1890, p. 49-61.

Stresser-Péan, 1971
Stresser-Péan (Guy), "Ancient Sources on the Huasteca", *Handbook of Middle American Indians*, vol. II, no. 2, Austin, University of Texas Press, 1971, p. 582-602

Sulkakäärmz ja Jaguaarijumala – Meksikon Ja Guatemala Intiaani-Kulttuurit, **1997**
Sulkakäärmz ja Jaguaarijumala – Meksikon Ja Guatemala Intiaani-Kulttuurit, Tampere, Tampereen Taidemuseo, 1997.

Sunderman, 1905
Sunderman (H.), "Die Insel Nias und die Mission daselbst", *Rheinische Missionschriften*, no. 125, 1905.

Suzuki, 1959
Suzuki (Peter), *The Religious System and Culture of Nias, Indonesia*, thesis, University of Leyden, 1959.

Sweeney (ed.), 1935
Sweeney (James Johnson) [ed.], *African Negro Art*, New York, The Museum of Modern Art, 1935.

Sydow, 1929
Sydow (Eckart von), "Polynésie et Mélanésie. L'art régional des mers du Sud", *Cahiers d'art*, nos. 2-3, March-April 1929, p. 61-64.

Sydow, 1931
Sydow (Eckart von), "Les sculptures malgaches

au musée du Trocadéro", *Cahiers d'Art*, nos. 9-10, 1931, p. 396-398.

Sydow, 1932
Sydow (Eckart von), *Kunst der Naturvölker: Sammlung Baron Edouard von der Heydt*, Berlin, Verlag B. Cassirer, 1932.

Sydow, 1954
Sydow (Eckart von), *Afrikanische Plastik*, Berlin, Gebr. Mann, 1954.

Sylla, 1985-86
Sylla (Issiaga), *Cheick Aboubakar contre les pratiques de l'animisme à Boffa et à Boké*, Conakry, IPGAN, 1985-86.

T

Tableaux de Man Ray et objets des îles, 1926
Tableaux de Man Ray et objets des îles, Paris, Galerie Surréaliste, 1926.

Tacou-Rumney, 1996
Tacou-Rumney (Laurence), *Peggy Guggenheim*, Paris, Flammarion, 1996.

Taffin, 1993
Taffin (Dominique), "Le musée des Colonies et l'imaginaire colonial", *Images et colonies (1882-1962)*, Paris, ACHAC, 1993, p. 140-144.

Taffin, 1999
Taffin (Dominique), "Du musée de la France d'outre-mer au musée national des Arts d'Afrique et d'Océanie (1960-1980)", *Le Musée et les cultures du monde, Les Cahiers de l'École nationale du patrimoine*, no. 5, 1999, p. 113-127.

Taladoire, 1981
Taladoire (Éric), *Les Terrains de jeu de balle*, Études mésoaméricaines, 2nd series, 4, Mission Archéologique et Ethnologique Française au Mexique, 1981.

Tanning, 1989
Tanning (Dorothea), *Birthday*, Paris, Christian Bourgois, 1989.

Taube, 1992
Taube (Karl A.), *The Major Goods of Ancient Yucatan. Studies in Pre-Columbian Art and Archaeology*, Dumbarton Oaks Research Library and Collection, 1992.

Tauxier, 1924
Tauxier (Louis), *Nègres gouro et gagou*, Paris, Librairie Orientaliste Paul Geuthner, 1924.

Tedlock, 1985
Tedlock (Dennis), *Popol Vuh*, New York, Simon and Schuster, 1985.

Téké - Collection de Robert et Raoul Lehuard, 1999
Téké - Collection de Robert et Raoul Lehuard, Paris, Galerie Ratton-Hourdé, 1999.

Terra dei Moai, 1995
La terra dei Moai, dalla Polinesia all'isola di Pasqua, Venice, Erizzo Editrice, 1995.

Terres d'échanges, 1998
Terres d'échanges. Les collections publiques océaniennes en Aquitaine, Bordeaux, ACMA, 1998.

Terrisse, 1965
Terrisse (André), *L'Afrique de l'Ouest, berceau de l'art nègre*, Paris, Fernand Nathan, 1965.

Tesoros de México, 1997
Tesoros de México - Oro precolombino

y plata Virreinal, Seville, Fundación El Monte/Mexico City, INAH, 1997.

Tessmann, 1913
Tessmann (Günter), *Die Pangwe. Völkerkundliche Monographie eines westafrikanischen Negerstammes. Ergebnisse der Lübecker Pangwe-Expedition 1907-1909 und früherer Forschungen 1904-1907*, vols. 1-2, Berlin, Ernst Wasmuth, 1913.

Tessmann, 1934
Tessmann (Günter), *Die Bafia und die Kultur der Mittelkamerun-Bantu. Ergebnisse der 1913 vom Reichs-Kolonialamt. Ausgesandten völkerkundlichen Forschungsreise nach Kamerun*, Stuttgart, Strecker und Schröder, 1934.

Tessmann, 1991
Tessmann (Günter), "Les Pahouins", French trans. (excerpts) by *Tessmann, 1913, in *Fang, 1991, p. 167-313.

Theile, 1963
Theile (Albert), *Les Arts de l'Afrique*, Paris, Arthaud, 1963.

Thiam, 1965
Thiam (Bodiel), "'Nimba', déesse de la fécondité des Baga et Nalou", *Notes africaines*, no. 108, October 1965, p. 128-130.

Thilenius (Georg) [ed.], 1934
Thilenius (Georg) [ed.], *Ergebnisse der Südsee-Expedition 1908-1910. II. Ethnographie: B. Mikronesien*, Hamburg, 1934.

Thomas, 1881
Thomas (J.W.), "Godsdienst en Bijgeloof der Niassers", *Tijdschrift Van Ind. Taal. Land. En Volkenkunde*, 1881.

Thompson (E.), 1962
Thompson (Eric), *A Catalog of Maya Hieroglyphs*, Norman, University of Oklahoma Press, 1962.

Thompson (R.F.), 1971
Thompson (Robert Farris), *Black Gods and Kings: Yoruba Art at UCLA*, Los Angeles, University of California Press, 1971.

Thompson (R.F.), 1973a
Thompson (Robert Farris), "An Aesthetic of the Cool", *African Arts*, vol. VII, no. 1, UCLA, 1973, p. 40-43, p. 64-67, p. 89-91.

Thompson (R.F.), 1973b
Thompson (Robert Farris), "Yoruba Artistic Criticism", *The Traditional Artist in African Societies*, Bloomington/Indianapolis, Indiana University Press, 1973b, p. 19-61.

Thompson (R.F.), 1978
Thompson (Robert Farris), "The Grand Detroit N'kondi", *Bulletin of Detroit Institute of Arts* 56, no. 4, 1978, p. 207-221.

Thompson (R.F.), 1981
Thompson (Robert Farris), *The Four Moments of the Sun: Kongo Art in Two Worlds*, Washington, National Gallery of Art, 1981.

Thompson (R.F.), 1983
Thompson (Robert Farris), *Painting from a Single Heart, Preliminary Remarks on Bark-Cloth Designs of Mbute Women of Haut-Zaïre*, Munich, Fred und Jens Jahn, 1983.

Thompson (R.F.), [forthcoming]
Thompson (Robert Farris), *Shaping the Thunder and the Light: Kongo Gestures in the Black Atlantic*.

Tichelman and Voorhoeve, 1938
Tichelman (G.L.), Voorhoeve (P.), *Steenplastiek in Simaloengoen. Inventaris van steenen beelden, reliefs, steenen kisten en dergelijke*, Medan, Köhler, 1938.

Tichelman and Voorhoeve, 1949
Tichelman (G.L.), Voorhoeve (P.), *Batakse Kunst*, newsletter no. 33 of the Royal Institute for the Indies, Amsterdam, 1949.

Tischner and Hewicker, 1954
Tischner (Herbert), Hewicker (Friedrich), *L'Art de l'Océanie*, Paris, Braun, 1954.

Todorov, 1982
Todorov (Tzvetan), *La Conquête de l'Amérique*, Paris, Le Seuil, 1982.

Toscano, 1984
Toscano (Salvador), *Arte precolombino de México y de la America Central*, Mexico City, UNAM, 1984.

Tour du Monde, 1888
Le Tour du Monde, July 1888, 1437e livraison.

Trésors d'Afrique, 1995
Trésors d'Afrique – Musée de Tervuren, Tervuren, Musée Royal de l'Afrique Centrale, 1995.

Trésors de l'ancien Nigéria, 1984
Trésors de l'ancien Nigéria, Paris, Association Française d'Action Artistique, 1984.

Trésors des muséums de France, 1994
Trésors des muséums de France, Paris, Éditions de la Martinière, 1994.

Trésors du Nouveau Monde, 1992
Trésors du Nouveau Monde, Brussels, 1992.

Trilles, 1912
Trilles (Henri), *Chez les Fang ou quinze années de séjour au Congo français*, Lille/Paris/Bruges, Desclée de Brouwer, 1912.

Trowell, [1954]
Trowell (Margaret), *Classical African Sculpture*, London, Faber and Faber, [1954].

Trowell and Nevermann, 1969
Trowell (Margaret), Nevermann (Hans), *L'Afrique et l'Océanie*, Lausanne, Éditions Rencontre, 1969.

Tryon, 1976
Tryon (Darrel), *New Hebrides Languages: An Internal Classification*, Canberra, Australian National University, 1976.

Tsimshian Narratives. Tricksters, Shamans and Heroes, 1987
Tsimshian Narratives. Tricksters, Shamans and Heroes, Hull, Canadian Museum of Civilization, 1987.

Tucci, 1977
Tucci (G.), "On Swat. The Dards and Connected Problems", *EW*, vol. XXVII (1-4), Rome, 1977.

Tunis, 1981
Tunis (Irwin L.), "The Benin Chronologies", *African Arts*, vol XIV, no. 2, February 1981, p. 86-87.

Tunis, 1982
Tunis (Irwin L.), "The Benin Plaque", *Connaissance des arts tribaux*, no. 4, 1982.

U

Ucko (Peter J.), 1968
Ucko (Peter J.), *Anthropomorphic Figurines of Predynastic Egypt and*

Neolithic Crete with Comparative Material from the Prehistoric Near East and Mainland Grece (Royal Anthropological Institue Occasional Papers)*, London, Andrex Szmidla Edition, 1968.

Utotombo, 1988
Utotombo. L'art de l'Afrique noire dans les collections privées belges, Brussels, Société des Expositions du Palais des Beaux-Arts, 1988.

V

Vallaux, 1994
Vallaux (François), *Mangareva et les Gambier*, Tahiti, ETAG, 1994.

Valluet, 1991
Valluet (Christine), "Uli. La Grande Cérémonie", *Primitifs*, no. 6, September-October 1991, p. 36-50.

Van Baaren, 1968
Van Baaren (T.P.), *Korwars and Korwar style, Art and Ancestor Worship in North-West New Guinea*, Paris, Mouton, 1968.

Van Beek, 1988
Van Beek (Walter), "Functions of Sculpture in Dogon Religion", *African Arts*, vol. XXI, no. 4, August 1988, p. 58-65, p. 91.

Van den Broek (C.), 1939
Van den Broek d'Obrenan (Charles), *Le Voyage de la Korrigane*, Paris, Payot, 1939.

Van den Broek (R.), 1936
Van Den Broek d'Obrenan (Régine), *Les Korrigan autour du monde*, Paris, Librairie François Ier, 1936.

Van den Broek (R.), 1984
Van Den Broek d'Obrenan (Régine), *Les Korrigan autour du monde*, Paris, L'Asiathèque, 1984.

Van Geertruyen, 1976
Van Geertruyen (Godelieve), "La fonction de la sculpture dans une société africaine: les Baga, Nalu et Landuman", *Africana Gandensia*, no. 1, 1976, p. 63-117.

Van Geertruyen, 1979
Van Geertruyen (Godelieve), "Le style nimba", *Arts d'Afrique noire*, Arnouville, no. 31, autumn 1979, p. 20-37.

Vanuatu, Océanie. Arts des îles de cendre et de corail, 1996
Vanuatu, Océanie. Arts des îles de cendre et de corail, Paris, RMN, 1996.

Varnedoe, 1987
Varnedoe (Kirk), "Préface", in *Rubin (ed.), 1987, p. XIII.

Vastokas, 1967
Vastokas (Joan M.), "The Relation of Form to Iconography in Eskimo Masks", *The Beaver*, autumn 1967, p. 26-31.

Vente de sculptures d'Afrique, d'Amérique et d'Océanie, 1931
Vente de sculptures d'Afrique, d'Amérique et d'Océanie, Paris, Hôtel Drouot, 7 May 1931.

Vente de sculptures anciennes d'Afrique, d'Amérique et d'Océanie, 1932
Vente de sculptures anciennes d'Afrique, d'Amérique et d'Océanie, Paris, Hôtel Drouot, 22 June 1932.

Vercoutter, 1992
Vercoutter (Jean), *L'Égypte et la vallée du Nil*, vol. 1, *Des origines à la fin de l'Ancien Empire, 1200-2000 avant J.-C.*, Paris, PUF, 1992.

Verger, 1957
Verger (Pierre), *Notes sur le culte des orisa et vodun à Bahia, la Baie de tous les saints, au Brésil et à l'ancienne côte des esclaves en Afrique*, Institut Français d'Afrique Noire, Dakar, 1957.

Verger, 1982
Verger (Pierre), *Orisha: les dieux yorouba en Afrique et au Nouveau Monde*, Paris, A.M. Métaillié, 1982.

Vergouwen, 1964
Vergouwen (J. C.), *The Social Organisation and Customary Law of the Toba-Batak of Northern Sumatra*, The Hague, Martinus Nijhoff, 1964.

Verneau, 1916
Verneau (René), "Les Hindenburg en bois des Nègres du Loango", *L'Anthropologie*, vol. XXVII, 1916, p. 111-133.

Viaud, 1990
Viaud (J.) [Pierre Loti], *Journal d'un aspirant de La Flore*, Ville-d'Avray, 1990.

Vienne, 1984
Vienne (Bernard), *Gens de Motlav*, Paris, 1984.

Vienne, 1996
Vienne (Bernard), "Visages masqués du pays des morts", in *Vanuatu, Océanie. Arts des îles de cendre et de corail*, 1996, p. 240-253.

Villages polynésiens, 1985
villages polynésiens, Paris, l'Harmattan, 1985.

Vitart, 1993
Vitart (Anne), *Parures d'histoire*, Paris, RMN, 1993.

Vogel, 1977a
Vogel (Susan M.), *Baule Art as the Expression of a World-view*, Ann Arbor, University Microfilms International, New York, 1977a.

Vogel, 1977b
Vogel (Susan M.), "Baule and Yoruba Art Criticism. A Comparison", *The Visual Arts. Plastic and Graphic*, The Hague/ Paris/New York, Mouton, 1977b, p. 309-325.

Vogel, 1980
Vogel (Susan M.), "Beauty in the Eyes of the Baule. Aesthetics and Cultural Values", *Working Papers in the Traditional Arts*, no. 6, Philadelphia, Institute for the Study of Human Issues, 1980.

Vogel, 1985
Vogel (Susan M.), *African Aesthetics (The Carlo Monzino Collection)*, Venice, 1985.

Vogel, 1997
Vogel (Susan M.), *Baule: African Art, Western Eyes*, New Haven and London, Yale University Press, 1997.

Vogel (ed.), 1981
Vogel (Susan M.) [ed.], *For Spirits and Kings – African Art from the Tishman Collection*, New York, The Metropolitan Museum of Art, 1981.

Vogel (ed.), 1987
Vogel (Susan M.) [ed.], *Perspectives, Angles on African Art*, New York, The Center for African Art, 1987.

Vogel (ed.), 1991
Vogel (Susan M.) [ed.], *Africa Explores. 20th Century African Art*, New York, The Center for African Art/Munich, Prestel Verlag, 1991.

Vogel and N'Diaye, 1985
Vogel (Susan M.), N'Diaye (Francine), *African Masterpieces from the Muséum de l'Homme*, New York, The Center for African Art, 1985.

Voie des ancêtres, 1986
La Voie des ancêtres, Paris, Musée Dapper, 1986.

Volz, 1909
Volz (Wilhelm), *Nord-Sumatra*, vol. I, *Die Batakländer*, Berlin, Dietrich Reimer, 1909.

Voyage de la Korrigane en Océanie, 1938
Le Voyage de la Korrigane en Océanie, Paris, Muséum National d'Histoire Naturelle/Musée de l'Homme, 1938.

Voyage exotique, carnet de voyage, 1998
Le voyage exotique, carnet de voyage, Association La Rochelle-Rochefort, 1998.

Voyage vers l'île mystérieuse, 1996
Voyage vers l'île mystérieuse, de la Polynésie à l'île de Pâques, Bordeaux, Musée d'Aquitaine/Amilcare Pizzi, 1996.

W

Waite, 1966
Waite (Deborah), "Kwakiutl Transformation Masks", in *Fraser (ed.), 1966, p. 266-300.

Waite, 1983a
Waite (Deborah), *Art des îles Salomon dans les collections du Musée Barbier-Müller*, Geneva, Musée Barbier-Müller, 1983.

Waite, 1983b
Waite (Deborah), "Shell-inlaid Shields from the Solomon Islands", in *Mead and Kernot (eds.), 1983, p. 114-136.

Waite, 1998
Waite (Deborah), "Les îles Salomon", in *Arts des mers du Sud*, 1998, p. 268-283.

Waldberg, 1958
Waldberg (Patrick), *Max Ernst*, Paris, Jean-Jacques Pauvert, 1958.

Waldberg (P. and I.), 1992
Waldberg (Patrick and Isabelle), *Un amour acéphale: correspondance 1940-1949*, edition edited and introduced by Michel Waldberg, Paris, La Différence, 1992.

Walden, 1940
Walden (Edgar), "Totenfeiern und Malagane von Nord-Neumecklenburg – Nach aufzeichnungen von E. Walden", in *Nevermann, 1940, vol. LXXII, p. 11-38.

Wallace, 1960
Wallace Kevin, "A Reporter at Large. Slim-shin's Monument", *The New Yorker*, 19 November 1960.

Wardwell, 1967
Wardwell (Allen), *The Sculpture of Polynesia*, Chicago, The Art Institute of Chicago, 1967.

Wardwell, 1996
Wardwell (Allen), *Tangible Visions. Northwest Coast Indian Shamanism and its Art*, New York, The Monacelli Press, Inc., 1996.

Warneck, 1909
Warneck (Johannes), *Die Religion der Batak. Ein Paradigma für die animistischen Religionen des indischen Archipels*, Göttingen, Vandenhoeck und Ruprecht/Leipzig, J.C. Hinrichs, 1909.

Warneck, 1977
Warneck (Johannes), *Toba-Batak deutsches Wörterbuch*, The Hague, Martinus Nijhoff, 1977.

Warnier and Nkwi, 1982
Warnier (Jean-Pierre), Nkwi (Paul. N.), *Elements for a History of The Western Grassfield*, Yaoundé, 1982.

Warnod, 1930
Warnod (André), "L'art océanien", *Le Domaine colonial français*, vol. 4, Paris, Éditions du Cygne, 1930, p. 319-336.

Wassing, 1969
Wassing (René S.), *L'Art de l'Afrique noire*, Fribourg, Office du Livre/ Paris, Bibliothèque des Arts, 1969.

Webster (J.), 1866
Webster (J.), *Last Cruise of the 'Wanderer'*, Sydney, F. Cunningham, 1866.

Webster, 1899a
Webster (W.D.), *Illustrated Catalogue of Ethnographical Specimens, European and Eastern Arms and Armor, Prehistoric and other Curiosities*, Bicester, Oxford House, 1899.

Webster, 1899b
Webster (W.D.), *Illustrated Catalogue of Ethnographical Specimen in Bronze, Wrought Iron, Ivory and Wood, from Benin City, West Africa*, Bicester, Oxford House, 1899.

Westheim, 1950
Westheim (Paul), *The Art of Ancient Mexico*, New York, Doubleday, 1950 (reprint 1965).

Wild, 1948
Wild (Henri), "Choix d'objets pré-pharaoniques appartenant à des collections de Suisse", *Bulletin de l'Institut français d'archéologie orientale*, vol. XLVII, IFAO, Cairo, 1948, p. 1-58.

Wilkerson, 1970
Wilkerson (S. Jeffrey K.), "Un yugo in situ de la région d'El Tajín", *Boletin*, no. 41, Mexico City, INAH, 1970, p. 41-45.

Wilkinson, 1978
Wilkinson (G. Nick), "Carving a Social Message: the Malanggans of Tabar", in *Greenhalgh and Megaw (eds.), 1978.

Willett, 1967
Willett (Frank), *Ife in the History of West African Sculpture*, New York, McGraw Hill, 1967.

Willett, 1973
Willett (Frank), "The Benin Museum Collection", *African Arts*, vol. VI, no. 4, summer 1973, p. 8-17, p. 94.

Willett, 1986
Willett (Frank), *African Art*, London, Thames and Hudson, 1986.

Willey, 1966
Willey (Gordon R.), *An Introduction to American Archaeology: North and Middle America*, vol. 1, Englewood Cliffs, Prentice Hall, Inc., 1966.

Wingert, 1970a
Wingert (Paul S.) [ed.], *African Art. University Prints*, N series, section I, Winchester (Mass.), The University Prints, 1970.

Wingert, 1970b
Wingert (Paul S.) [ed.], *Oceanic Art. University Prints*, N series, section II, Winchester (Mass.), The University Prints, 1970.

Winkler, 1925
Winkler (Johannes), *Die Toba-Batak auf Sumatra in gesunden und kranken Tagen*, Stuttgart, Belfer, 1925.

Winter, 1992
Winter (Amy), "The Germanic Reception of Native American Art: Wolfgang Paalen, as Collector, Scholar and Artist", *European Review of Native American Studies*, vol. VI (1), 1992, p. 17-26.

Wisdom, 1950
Wisdom (Charles), *Chorti-English Dictionary, Extracted from Materials on the Chorti Language*, University of Chicago, 1950.

Woodford, 1926
Woodford (C.M.), "Notes on the Solomon Islands", *Geographical Journal*, vol. LXVIII, 1926, p. 481-486.

Worcester, 1906
Worcester (Dean C.), "The Non-Christian Tribes of Northern Luzon", *Philippine Journal of Science*, vol. I, no. 8, Manila, October 1906.

Y

Yoruba, Nine Centuries of Art and Thought, 1989
Yoruba, Nine Centuries of Art and Thought, New York, The Center for African Art, 1989.

Young, 1904
Young (J.L.), "Remarks on Phallic Stones from Rapa Nui", *Bernice P. Bishop Museum Occasional Papers*, vol. II, no. 25, 1904.

Z

Zarader, 1998
Zarader (Jean-Pierre), *Malraux ou la pensée de l'art*, Paris, Ellipses, 1998.

Zayas, 1916
Zayas (Marius de), *African Negro Art, its Influence on Modern Art*, New York, Modern Gallery, 1916.

Ziegler, 1986
Ziegler (Arlette), "Pratiques festives et mégalithisme dans le centre de Nias", *Bulletin du musée d'ethnographie de Genève*, no. 28, 1986, p. 53-75.

Ziegler, 1990
Ziegler (Arlette), "Festive Areas. Territories and Feasts in the South of Nias", *Nias: Tribal Treasures. Cosmic Reflections in Stone, Wood and Gold*, Delft, Volkenkundige Museum Nusantara, 1990, p. 78-104.

Ziegler and Viaro, 1998a
Ziegler (Arlette), Viaro (Alain), "Stones of Power, Statuary and Megalithism in Nias", in *Messages in Stone*, 1998, p. 35-77.

Ziegler and Viaro, 1998b
Ziegler (Arlette), Viaro (Alain), "Die Steine der Macht, Statuen und Megalithismus auf Nias", in *Botschaft der Steine*, 1998. p. 35-77.

Ziegler and Viaro, 1998c
Ziegler (Arlette), Viaro (Alain), "Le pietre del potere, scultura ed epoca megalitica di Nias", in *Messagi di pietra*, 1998, p. 35-77.

Drawn up by Vincent Bouloré

Indexes

Index of place names

Index of peoples and divinities names

Photograph credits

All photographs Hughes Dubois, Paris, Brussels, except:

Basel, Museum der Kulturen: p. 250
Copenhagen, Nationalmuseet: p. 190
Geneva, Archives Barbier-Muller: p. 45, 98 (P.A. Ferrazzini), 218, 219
Honolulu (Hawaii), Bishop Museum: p. 312
Hull (Quebec), Musée Canadien des Civilisations: p. 420
Cairo, Egyptian Museum: p. 64
London, British Museum: p. 330, 360
Los Angeles, Dysney, photo Jess Allen, all rights reserved: p. 146, 200, 203
Lyon, Muséum d'Histoire Naturelle: p. 64
Mexico City, Museo Nacional de Antropologia: p. 398
Munich, Bayerisches Staatsbibliothek: p. 21
Schatzkammer der Residenz: p. 23
New York, American Museum of Natural History: p. 31, 232
The Metropolitan Museum of Art: p. 82, 232
Justin Kerr: p. 91, 376
Paris, Bibliothèque du Musée de l'Homme:
 p. 18, 24, 25, 26 (Lanièpce),
 28, 29, 32, 38, 48 (Sage),
 49, 50, 51 (Lanièpce),
 52, 53 (Oster),
 112, 217 (J. Dourmes),
 312, 354, 421 (H. Stewart)
Bibliothèque Nationale de France: p. 19, 35, 37
Bibliothèque Sainte-Geneviève: p. 22
Réunion des musées nationaux: p. 30, 41 (A. Villers)
Centre National d'Art Moderne, Georges Pompidou: p. 39
Ministère de la Culture: p. 40
Agence Rapho, S. Weiss: p. 288, 434
Agence Magnum, H. Cartier-Bresson: p. 370
Salt Lake City, Temple Square Museum: p. 325
Vancouver, Museum of Anthrolopolia: p. 421
Vienna, Museum für Völkerkunde: p. 23, 174 (Hesmerg), 178 (Fotoatelier),
Villahermosa, Museo de la Venta: p. 356
Washington, National Museum of the American Indian: p. 434

René-Jacques: p. 45,
M. Rivière: p. 103,
M. Carrieri: p. 212,
Photo Hugues Dubois p. 438,
with the kind permission of Michèle Polack: p. 302,
Archives Dorothea Tanning, G. Dagli: p. 398,

All rights reserved for photographs supplied by the authors and not
mentioned in this list, and in particular for those on p. 342, 359, 369.

Published by the Département de l'Edition
directed by Béatrice Foulon

Coordinating editor
Bernadette Caille

Rereading of texts and index
Elisabeth Boyer

Iconography
Muriel Lardeau

Translations
John O'Toole
Charles Penwarden
L-S Torgoff

Drawings and sketches
Hélène David

Maps
Jean Grisoni
Virginie Jamin

Graphic design
Bruno Pfäffli

Production
Jacques Venelli

Secretariat
Gaelle Masse

Photoengraving Bussières, Paris

Printed by Imprimerie Mame, Tours
June 2001

1er dépôt légal: avril 2000
dépôt légal: juin 2000